Fine Arts Periodicals

An International Directory of the Visual Arts

Doris Robinson

Fine Arts Periodicals

An International Directory of the Visual Arts

Doris Robinson

The Peri Press

Hemlock Ridge, P.O. Box 348
Voorheesville, New York

F-A Ref
Z 5937
.R63
1991 X

To

Vicki, Susan, and Al

for their

continuing understanding, support,

interest, and patience

TABLE OF CONTENTS

Decorative Arts & Crafts

Lettering & Fine Printing

Commercial Art

The Arts

Buildings & Interiors

Photography

Miscellaneous

Indexes

This directory contains data in an annotated listing by broad subject areas of more than 2,790 currently published periodicals, newsletters, and newspapers. It is intended to provide comprehensive international coverage of the visual arts field. Fine arts areas covered include antiques, archaeology, architecture, collectibles, crafts, decorative arts, drawing, furniture, graphic arts, interior design, landscape architecture, museums, painting, photography, sculpture, textiles, weaving, and writing. Fashion and the performing arts are excluded. However, periodicals dealing with both fine art and literature or performing arts are to be found in the section on "The Arts". Numismatics is also excluded since periodicals on that subject are listed in the directory *Stamps, Coins, Postcards & Related Materials* (Peri Press, 1991). Coverage includes any publication issued at least once a year with the exception of biographical or membership directories which are not included. Foreign language publications are included if they are indexed by at least one of the indexing or abstracting services or if they contain English language summaries or abstracts. Annotations are intended to be descriptive rather than critical and to describe the scope, purpose, and reference features of each periodical. Subscription and advertising costs are presented as a relative figure only. Current costs are likely to be higher. Where advertising rate cards were available, the effective date was provided.

Ulrich's International Periodicals Directory, 27th-29th editions, and other sources cited in the bibliography were used as a guide for building a database of periodicals. A questionnaire was mailed to all editors and a majority replied. Sample copies were also received in many instances. A serious attempt was made to obtain the publication cited and examine it where the information was not provided by the editor. From the replies to the questionnaires and the examination of the journals, the list of entries was compiled. Major art libraries (Sterling and Francine Clark Art Library, the Metropolitan Museums of Art, the Museum of Modern Art, The National Gallery of Art), the Library of Congress, and the New York Public Library were visited to examine numerous periodicals. The descriptive annotations were based primarily on information provided by the journal, either from the editor's response or its own masthead and edited only for brevity or clarity. Where post office returns were received, an effort was made to ascertain if the periodical had ceased publication or to provide a current address. Entries were deleted where a current address was not available. Some entries are not as complete as others because additional information was not forthcoming or available or they were new publications. It was felt, however, that even entries with little information should be included as an aid to researchers.

Indexes are provided for subject, title, publisher and organization, ISSN number, and country of publication. Numbers listed in the indexes refer to the citation number rather than the page number. See references appear in the title index in lower case.

Information regarding periodicals is constantly in flux. New titles appear while existing journals may change their names or occasionally even cease to exist. With changes in editors or other officers often comes a change in address. Many periodicals of smaller organizations are not found listed in standard reference sources. Over the two years that I worked on this project numerous such changes occurred. Every effort was made to regularly search for and correct the database of periodical information. Users are encouraged to bring any errors, corrections, omissions or new titles to the compiler's attention, in order that they may be added to the next edition.

ACKNOWLEDGMENTS

I particularly wish to thank The Sage Colleges for providing me first with a faculty grant to begin undertaking this project and then granting me a sabbatical to carry the project forward. Access to an OCLC terminal at the college library enabled me to verify entries using the OCLC data base. I am indebted to the college for this support. In addition, Kingsley Greene, Assistant Director of the The Sage Colleges Libraries has lent his support and backing.

Throughout the project I have relied heavily on the interlibrary loan services of the Albany Campus Library. Frank McCarthy has my special thanks for processing my voluminous requests.

I wish to thank the numerous editors who responded graciously and promptly to my questionnaire. Several included additional information and notes of encouragement. I appreciate Susan Halle's efforts in data collection and in verifying information from Israeli periodicals.

I am indebted to several individuals for their translating skills. Once again Deborah Priest, Librarian of the New York State Assembly Ways and Means Committee Library, has tirelessly translated German language material while Susan Halle provided Hebrew translations.

I also appreciate the cooperation, assistance, and encouragement I received from numerous librarians, art historians, and others with whom I came in contact.

Finally I would like to thank my publisher, Janet Grimes, for her continued support.

Doris Robinson

HOW TO USE THIS DIRECTORY

Sample Entry

[1]AMERICAN COMPOSITE ENTRY: A Fictional Entry. [2]1946. [3]m. [4]EN & SP. Summaries in EN, FR & SP. [5]137

[6]American Society, Box 784, Schenectady, NY 12305. Phone 518-273-1905. [7]Wilma Jones, Editor. (Oxford Hts., Albany, NY 12203)

[8]Subscription: included in membership, US $18 personal, $27 institutional; Canada $30; foreign $33 surface, $50 air. [9]Microform available from UMI. [10]Sample $1. Back issues. [11]Illus. b&w, color occasionally, photos, cartoons. [12]Annual index in Dec. issue, cum. index every five years. [13]7 x 10, 80p. Web.

[14]ISSN: 0008-0347. [15]OCLC: 1480732. [16]LC: NX7.H57. Dewey: 700. [17]Formerly: *Colonial Composite.*

[18]**Architecture. Decorative Arts. Historic Preservation. Interior Design. Landscape Architecture.**

[19]An international journal intended for those who work in architecture, as well as interior planning and decoration. Its editorial content deals with interior as well as exterior design in the conception of a building, keeping in mind artistic, technical and socio-economic aspects. [20]Reviews: exhibition 1, length 500 wds.; book 1, length 1000 wds. [21]Interviews: of noted collectors and dealers. Biographies: occasionally. Obits. [22]Listings: regional-international. [23]Calendar of events. Exhibition information. [24]Freelance work: yes (details in *ArtMkt.*). Contact editor. [25]Opportunities: employment positions; study – courses, conferences; competitions – fellowships and grants. [26]Indexed: ArchPI. ArtHum. ArtI. Avery. [27]Reviewed: Katz. *New Art Examiner* 17:9, May 1990, p.67-68.

[28]Advertising: full page $805, ½ page $577, ¼ page $151, covers +15%. Preferred positions +10%. Classified: $2.25/line, min. 3 lines. Frequency discount. Inserts available. Mailing lists: available to members only. Albert Pauli, Ad. Director. [29]Demographics: collectors in 100 countries, most in US. [30]Circulation: 17,500. [30]Audience: architects and planners.

Sample Entry Explained

1 *Title.* The main title appears in boldface type. For multi-language periodicals, the title also appears in the additional language(s) separated from the main entry title by a slash. The subtitle appears after the title in lower case.

2 *Date of first issue.* The year first published is given if provided by the editor or determined from reference sources. If this information is unavailable, a volume number and specific year may be given to indicate the date of the publication.

3 *Frequency.* The frequency of the publication is given in abbreviated form. All such abbreviations are listed under "General Abbreviations" on p. xv.

4 *Language of publication and summaries or abstracts.* The language of the publication appears as a two or three letter code. The complete list appears on p. xvi. The language of summaries, abstracts, table of contents and translations are also provided.

5 *Entry number.* Citations are numbered sequentially. The entry number rather than a page number is used in the indexes to refer to the citation.

6 *Publisher, address, country, phone number and fax number.* Telephone and Fax numbers are given where provided by the editor and are listed in the format supplied by the editor. Information concerning distributors is given where available.

7 *Editor.* Name of the editor or editors. The editor's address is provided only where it differs with the publisher's address. It then appears within parenthesis immediately following the editor's name.

8 *Subscription price.* The prices listed are the annual U.S. individual subscription rate unless indicated otherwise. In addition the following rates may appear: subscription rates for countries outside of the U.S., both surface and air mail rates, rates for specific groups (institutions, students, members, and non-members), or if a periodical is free. The subscription address is given only where it differs from the publisher's address. A list of the currency abbreviations used appears on p.

9 *Format.* Lists the availability of microformats. Microformats listed are mainly available from University Microfilms or Bell & Howell.

10 *Sample copy and back issues.* Indicates whether the publisher will supply a sample copy and the availability of back issues.

11 *Illustrations.*

12 *Index.* Indicates how often an index is issued and the availability of cumulative indexes.

13 *Size of publication, number of pages, printing and binding.* The size of the periodical is given in inches unless otherwise specified. The number of pages is intended as an approximation of the average number of pages per issue.

14 *ISSN number.* The International Standard Serial Number has been supplied where available.

15 *OCLC number.* The OCLC number has been provided as an aid to librarians in cataloging and for interlibrary loans.

16 *Call number.* Library of Congress Classification numbers and Dewey decimal number are provided where available. More than one number occasionally has been assigned if a periodical covers multiple subjects.

17 *Former title.* Previous title (if any).

18 *Type.* Lists the subject areas regularly covered where this informations has been provided.

19 *Annotation.* Intended as a descriptive guide to the scope of the publication. Generally the information has been supplied by the publisher or from an examination of the periodical and is edited only for brevity and clarity.

20 *Reviews.* Indicates the presence of reviews of books, exhibitions, journals or equipment. The average number and length of reviews is provided where available.

21 *Bibliographies. Biographies. Interviews. Obituaries.*

22 *Listings.* Indicates whether information provided is for local, regional, national or international events or meetings.

23 *Calendar of events* and exhibition information.

24 *Freelance work and contact person.* Included only where supplied by the editor. Indicates whether or not freelance work is accepted and the person to contact. *Art Market Report*, and *Photographer's Market* provide detailed information concerning specifications. Periodicals listed in these publications are indicated by *ArtMkt.* or *PhMkt.*

25 *Opportunities.* Indicates the presence of information regarding employment, courses, workshops, conferences, competitions or grants.

26 *Indexed.* Consists of a list of abbreviations for the abstracting and indexing services which cover the periodical on a regular basis. The list of abbreviations appears on p.

27 *Reviewed.* Citations of reviews of the periodical.

28 *Advertising, classified ads, mailing lists, advertising director.* The rates listed are the latest figures provided by the publisher. They are intended as a guide. For the current rates, consult the advertising director. Indicates the availability of mailing lists. The address of the Advertising Office is provided only where it differs with the publisher's address. It then appears within parenthesis immediately following the director's name.

29 *Demographics.* Included where provided by the publisher.

30 *Circulation.* Circulation figures are given where provided by the publisher.

31 *Audience.* Intended audience included where provided by the publisher.

Abbreviations

GENERAL ABBREVIATIONS

/	per
3/yr	three times per year
a.	annual
A4	210 x 297 mm. (8.27 x 11.69 in.)
A5	148 x 210 mm. (5.83 x 8.27 in.)
Ad. Director	Advertising Director
add.	additional
ads	advertisements
air	air mail
Apr	April
ArtMkt.	*Artist's Market<M>*
Aug	August
B&H	Bell & Howell
b&w	black & white
bi-m.	every two months
bi-w.	every two weeks
cm.	centimeter
col.	column
col.in.	column inch
cum.	cumulative
Dec	December
Dist.	Distributor/Distributed by
ed.	edition
Editor & Pub.	editor & publisher
Exec.	Executive
Feb	February
fortn.	fortnightly
illus.	illustrated
irreg.	irregular
Jan	January
Jl	July
m.	monthly
Mar	March
max.	maximum
min.	minimum
mm.	millimeter
no.	number
Nov	November
ns	new series
obit	obituaries
Oct	October
p.	page, pages
photo.	photographs
PhMkt.	*Photographer's Market<M>*
q.	quarterly

s-a.	semi-annual
SASE	self addressed stamped envelope
s.c.c.	single column centimeter
Sec.	Secretary
Sec./Treas.	Secretary/Treasurer
Sept	September
Spr	Spring
Sum	Summer
surface	surface mail
tr.	translated/translation
Treas.	Treasurer
UK	United Kingdom
UMI	University Microfilms
U.S. or US	United States
USSR	Soviet Union
v.	volume
vol.	volumes
w.	weekly
wd.	word
Win	Winter
yr.	year

CURRENCY ABBREVIATIONS

¢	cents	
$	United States	dollar
$A	Australia	
$C	Canada	
$HK	Hong Kong	
$M	Mexico	
$NZ	New Zealand	
$S	Singapore	
$US	United States	$ in US currency
£	Great Britain, Ireland	pound
B	Thailand	
BFr	Belgium	franc
Cr$	Brazil	cruzeiro
din	Yugoslavia	dinar
DKr	Denmark	krona
DM	West Germany	deutsche mark
EAs	East Africa, Kenya	shilling
F	France	franc
fl	Netherlands	florin
Fmk	Finland	mark, markka
Ft	Hungary	forint
Kcs	Czechoslovakia	koruny
Kr	Scandinavia	krona, krone
L	Italy	lira

lei	Rumania	lei	mark
M	East Germany		mark
NLG	Netherlands		Dutch guilders
NKr	Norway		krona
p	Great Britain, Ireland		pence
ptas	Spain		peseta
R	South Africa		rand
Rs	India		riel, rial, rupee
Rub	USSR		ruble
Sch	Austria		schilling
SFr	Switzerland		franc
sh	Israel		shekel
SKr	Sweden		krona
Tl	Turkey		pound
won	Korea		won
Yen	Japan		yen
Zl	Poland		zloty

LANGUAGE ABBREVIATIONS

AF	Afrikaans
AR	Arabic
BU	Bulgarian
CA	Catalan
CH	Chinese
CZ	Czech
DA	Danish
DU	Dutch, Flemish
EN	English
FI	Finnish
FR	French
GE	German
GR	Greek
HE	Hebrew
HI	Hindi
HU	Hungarian
IN	Indic
IR	Irish
IT	Italian
JA	Japanese
KO	Korean
NOR	Norwegian
POL	Polish
POR	Portuguese
RO	Rumanian
RU	Russian
SA	Sandskrit
SCR	Serbo-Croatian
SL	Slovenian
SP	Spanish
SW	Swedish
TA	Tagolog
TH	Thai
TU	Turkish
UKR	Ukrainian
WEL	Welsh
YI	Yiddish

ABSTRACTS AND INDEXES

AmH&L.	*America: History and Life*
ArchI.	*Architectural Index*
ArchPI.	*Architectural Periodicals Index*
ArtArTeAb.	*Art and Archaeology Technical Abstracts*
ArtBibCur.	*Art Bibliographies Current Titles*
ArtBibMod.	*ARTbibliographies Modern*
ArtHum.	*Arts and Humanities Citation Index*
ArtI.	*Art Index*
Avery.	*Avery Index to Architectural Periodicals*
BHA.	*Bibliography of the History of Art*
BioI.	*Biography Index*
BkReD.	*Book Review Digest*
BkReI.	*Book Review Index*
BrArchAb.	*British Archaeological Abstracts*
BrHumI.	*British Humanities Index*
BusPI.	*Business Periodicals Index*
CanMagI.	*Canadian Magazine Index*
CanPI.	*Canadian Periodical Index*
CerAb.	*Ceramic Abstracts*
CIJE.	*Current Index to Journals in Education*
CloTAI.	*Clothing and Textile Arts Index*
CurCont.	*Current Contents*
Des&ApAI.	*Design & Applied Arts Index*
EdI.	*Education Index*
GrArtLAb.	*Graphic Arts Literature Abstract*
Hand.	*Handicraft/Hobby Index*
HistAb.	*Historical Abstracts*
HumI.	*Humanities Index*
IBkReHum.	*Index to Book Reviews in the Humanities*
LibLit.	*Library Literature*
MLA.	*Modern Language Abstracts*
Photohi.	*Photohistorica*
PhotoMI.	*Photography Magazine Index*
PsyAb.	*Psychological Abstracts*
RG.	*Readers Guide*
RILA.	*RILA*
Search.	*Search*
SocSciI.	*Social Sciences Index*

REVIEW SOURCES

Katz	Katz. *Magazines for Libraries.*
Katz *School*	Katz. *Magazines for School Libraries.*

Bibliography of Sources Consulted

American Art Directory 1991-1992. 53rd ed. New York: Bowker, 1991.

Art & Architecture Thesaurus. 3 v. New York: Oxford University Press, 1990.

Art Documentation. v.5-10, 1986-1991.

Artist's Market. 1991 ed. Cincinnati: Writer's Digest Books, 1990.

Arntzen, Etta and Robert Rainwater. *Guide to the Literature of Art History*. Chicago: American Library Association, 1980.

Current Contents. Arts & Humanities. v.10-12, 1988-90.

EBSCO Bulletin of Serial Changes. v.15-17 no.4, 1989-91.

Encyclopedia of Associations. Association Periodicals. Detroit: Gale, 1987.

Encyclopedia of Associations: Volume 1, National Organizations of the U.S. 26th ed. Detroit: Gale, 1991.

Encyclopedia of Associations: Volume 4, International Organizations. 25th ed. Detroit: Gale Research, 1991.

Gretes, Frances C. *Directory of International Periodicals and Newsletters on the Built Environment*. Van Nostrand Reinhold, 1986.

Jones, Lois Swan. *Art Information*. 3rd ed. Dubuque, Iowa: Kendall/Hunt Pub. Co., 1990.

Katz, William A and Linda S. Katz. *Magazines for Libraries*. 6th ed. New York: Bowker, 1989.

Library of Congress Subject Headings. 11th ed. Washington: Library of Congress, 1991.

New Art Examiner. v.14-19, 1986-91.

New Serials Titles. Washington: Library of Congress, 1953–.

Newsletters Directory. 3rd ed. Detroit, MI: Gale Research Co., 1987.

OCLC Database. Dublin, Ohio: Online Computer Library Center.

The Official Museum Directory. 1990 ed. Washington, DC: American Association of Museums, 1990.

Photographer's Market. 1991 ed. Cincinnati: Writer's Digest Books, 1990.

The Serials Directory: An International Reference Book. 5th ed. 3 v. Birmingham, AL: Ebsco Industries, 1991.

Serials Review. v.11-17, 1985-91.

Standard Periodicals Directory. 14th ed. New York: Oxbridge Communications, Inc., 1991.

Ulrich's International Periodicals Directory 1988–89. 27th ed.- New York: Bowker, 1989-.

Union List of Serials in Libraries of the United States and Canada. 3rd. ed. 5 v. New York: H.W. Wilson Co., 1965. T

INFORMATION SOURCES

Indexes & Abstracts

ARCHITECTURAL INDEX. 1951. a. EN. 1
3498 Iris Court, Boulder, CO 80304. Phone 303–449–3748. Ervin J. Bell, Editor & Pub.
Subscription: $US 20 worldwide (Helen Papania, Circulation Mgr., Architectural Index, P.O. Box 1168, Boulder, CO 80306).
Sample, 10 day approval. Back issues. No Illus.
ISSN: 0570–6483. OCLC: 2204032. LC: Z5941.A66 NA1. Dewey: 016.7205.
Architecture. Interior Design. Landscape Architecture.

An index to architectural and interior design magazines, articles are indexed under subject, building type, location and architect or designer. Indexes articles published in *Architecture, Architectural Record, Progressive Architecture, Interior Design, Interiors, Landscape Architecture, Builder, Custom Builder*, and the *Journal of Architectural Education*.
Freelance work: none. Reviewed: Katz.

Advertising: none. Audience: architects & designers.

ARCHITECTURAL PERIODICALS INDEX. 1973. q, with 4th issue being a. cum. EN. 2
RIBA Publications Ltd., Finsbury Mission, 39 Moreland St., London EC1V 8BB, England. Phone 071–251 0791. C. Dembsky, Editor (British Architectural Library, 66 Portland Place, Lindon W1N 4AD 01 580 5533, Fax 01 255 1541).
Subscription: £95 UK, overseas £115 (by accelerated surface mail); cum. vol. only £90 UK, £100 overseas. 10% agency discount on cum. vol. Also available online on Dialog (File 179, Architecture Database). Sample pages available on request. Back issues. Annual cum. index. A4, 150p q., 480 a.
ISSN: 0266–4380. OCLC: 1588199. LC: Z5941.A69, NA1.A1. Dewey: 016.72. Formerly: *RIBA Annual Review of Periodical Articles (1964–82); RIBA Library Bulletin (1946–1972)*.
Primary interest: Architecture. Historic Preservation. Interior Design. Landscape Architecture. Environment. Construction. Secondary interest: Archaeology. Art History. Crafts. Decorative Arts. Drawing. Furniture. Photography. Sculpture. Town Planning.

The published version of British Architectural Library's own periodicals subject index. Designed as an up–to–date general, though selective, index to some 450 of the world's architectural periodicals, from more than 45 countries. About 44,000 entries each year are listed by subject headings, by names of people and organizations, and by places and names of buildings. Covers architecture world–wide with a greater emphasis placed on architecture and design in Great Britain and British work abroad. Notes amplifying information in title and headings regularly provided; no formal abstracts. Articles on both current practice and historical aspects are included.

In areas such as interiors, decoration, painting, sculpture, furniture, landscaping and the like, the criterion is normally the involvement of, or the direct significance of the work, to the architect. In planning the stress is on actual schemes, conservation and urban history rather than on pure theory and research. In professional practice statistics or case law are excluded. Product information, highly technical material written for other disciplines, book reviews, letters and news items are not indexed.
Obits. of architects. Reviewed: Katz.

Advertising: none. Circulation: 800. Audience: architects, planners, environmentalists, those interested in conservation/restoration/preservation, art and architecture historians, designers, interested laymen, the media.

ART AND ARCHAEOLOGY TECHNICAL ABSTRACTS. 1966. s–a. EN. 3
Getty Conservation Institute, 4503 Glencoe Ave., Marina del Rey, CA 90292–6466. Phone 213–822–2299, fax 213–821–9409 and International Institute for Conservation of Historic and Artistic Works, 6 Buckingham St., London WC2N 6BA, England, phone 071 8395975, fax 071 9761564. Jessica S. Brown, Editor.
Annual cum. index. 5½ x 8½.
ISSN: 0004–2994. OCLC: 1514256. LC: AM1.A7. Dewey: 016.0695. Formerly: *I.I.C. Abstracts*.

Archaeology. Art.

Abstracts of the technical literature on archaeology and the fine arts. Abstracts articles, reports, news items, books, and other publications as well as audiovisual and machine–readable media. Sources cited deal specifically with the technical examination, investigation, analysis, restoration, preservation and technical documentation of works of art and monuments having historic or artistic significance. Provides complete bibliographic information for the periodicals indexed.

Reviewed: Katz.

Advertising: none.

ART INDEX. 1932. q. EN. 4

H. W. Wilson Co, 950 University Ave., Bronx, NY 10452. Phone 212–588–8400. Bertrun Delli, Editor.

Subscription: service basis. Also available on CD–Rom, $1,495 yr., online (Wilsonline) and on tape. Annual cum. ISSN: 0004–3222. OCLC: 1514289. LC: Z5937.A78. Dewey: 016.7.

General. Archaeology. Photography.

An author and subject index to 221 domestic and foreign art periodicals, museum bulletins and yearbooks covering archaeology, architecture, art history, city planning, computer graphics, crafts, film, folk art, graphic arts, industrial design, interior design, landscape architecture, museology, photography, sculpture, television, textiles, and video. Online, CD–Rom, and tape coverage available from Sept 1984.

Reviewed: Katz. *ARBA* 19, 1988, p.407. *Art Documentation* 10:1 Spr 1991, p.13-17.

Advertising: none.

ARTBIBLIOGRAPHIES CURRENT TITLES. 1972. bi–m. EN. 5

Clio Press Ltd., 55 St. Thomas' St., Oxford OX1 1JG, England. Phone 0865 250333. US & Canada: ABC–Clio, Inc. Riviera Campus, 2040 Alamdea Padra Serra, Box 4397, Santa Barbara, CA 93103. Tony Sloggett, Editor.

Subscription: service rate principle, varies according to the annual budget for books, articles and exhibition catalogs. Sample. Back issues, 33% discount. No illus. 11½ x 8¼, 32p.

ISSN: 0307–9961. OCLC: 1783670. LC: Z5937.A793. Dewey: 016.7.

General. Modern Art.

Current awareness service reproduces the table of contents of approximately 300 art and architecture periodicals. Also includes annuals, museum bulletins and other publications.

Reviewed: Katz.

Advertising: none. Demographics: circulates to major libraries and art institutions. Audience: researchers in the history of modern art, design and photography.

ARTBIBLIOGRAPHIES MODERN. 1969. s–a. EN, FR, or GE. 6

Clio Press Ltd., 55 St. Thomas' St., Oxford OX1 1JG, England. Phone 0865 250333. US & Canada: ABC-Clio, Inc., P.O. Box 1911, Santa Barbara, CA 93116–1911, phone 805–968–1911, fax 805–685–9685. Tony Sloggett, Editor.

Subscription: service rate principle, vary according to the annual budget for books, periodicals and binding. Available online Dialog File 56. Sample. Back issues, price varies, 25% discount for 2 or more volumes. Cum. index every 5 yrs., 3 year index v.16–18, 1985–1987. 12 x 8½, 665p.

ISSN: 0300–466X. OCLC: 1796113. Dewey: 016.709. Formerly: *LOMA (Literature on Modern Art)*.

General. Modern Art.

Provides comprehensive bibliographical coverage of the current literature on art and design. Approximately 12,000 entries annually. Abstracts 500 worldwide art and related periodicals, as well as books, exhibition catalogs, museum bulletins, and dissertations. Predominantly devoted to abstracting the contents of all literature, in books, magazines and exhibition catalogs. The subject field starts at the year 1800 through volume 18. Commencing with volume 19 (1988) coverage is exclusively 20th century art. Abstracts, varying from 50 to 200 words in length, are provided for major books, articles and exhibition catalogs. Annotations are provided for other material and for visual material whose nature can be greatly clarified by a brief description. Classification headings are extensively cross–referenced. Separate author index and location index for the exhibitions documented.

Freelance work: yes, abstractors. Contact: John Chignall. Reviewed: Katz.

Advertising: none. Circulation: major libraries and art institutions.

ARTS & HUMANITIES CITATION INDEX. 1976. s–a. EN. 7

Institute for Scientific Information, 3501 Market St., Philadelphia, PA 19104. Phone 215–386–0100 ext 405, fax 215–386–6362, telex 84–5303. European branch: 132 High St., Uxbridge, Middlesex UB8 1DP, United Kingdom, phone 44–895–70016, fax 011–44–895–56710, telex 933693 UKISI)).

Subscription: (1991) $4,050, 1975–79 cum. $12,250. ISI offers a grant program which enables eligible organizations to purchase at reduced rates. Available online on Dialog and BRS as *Arts & Humanities Search*. Back year annuals from 1976 on, price varies per year. Cum. index 1975–79.

ISSN: 0162–8445. OCLC: 4122996, 15203217 (5 yr cum.). Dewey: 016.05.

General. Archaeology

An in–depth multidisciplinary index to the worldwide literature of the arts and humanities. Includes the disciplines of: archaeology, architecture, art, Asian studies, and film. Each semi–annual hardbound edition contains: the *Citation Index* which lists all cited authors/artists and their works, together with all authors who have discussed these cited works in current articles; the *Source Index* which provides complete bibliographic information for each article, including a list of the references cited in the article; the *Corporate Index* which provides access to publishing authors and their articles by corporate or academic affiliation; and the *Permuterm Subject Index* which provides access by way of the key words appearing in article titles.

Over 115,000 new items are indexed each year. Listings include cover–to–cover indexing of every substantive item from more than 1,400 of the world's leading arts and humanities journals. Also selectively indexes 4,600 journals from the sciences and social sciences. The inclusion of these additional items of interest to arts and humanities scholars enables scholars to locate relevant articles which might otherwise have been missed. Coverage includes reviews of books, films, art exhibits, and performances. Indexed articles can be ordered through ISI's document delivery service.

Reviewed: Katz.

AVERY INDEX TO ARCHITECTURAL PERIODICALS (SUPPLEMENT). 1934. a. EN. 8

G.K. Hall & Co., 70 Lincoln St., Boston, MA 02111. Phone 617–423–3990. Ted Goodman (Avery Architectural and Fine Arts Library, Columbia University, New York, NY 10027).

Subscription: available on standing order. $375 US & Canada, $425 foreign. prepublication discount. US: phone 1–800–343–2806. UK & Europe order from Henry Thompson Ltd. (London Rd., Sunningdale, Berks SL5 OEP, England). Japan & Korea order from United Publishers Service Ltd. (Kenkyu–sha Building, 9 Kanda Surugadai 2–chome, Chiyoda–ku, Tokyo, Japan). Also available online on RLIN. Microform available from publisher. No sample. Back issues. No illus. 8½ x 11, 2500p.

ISSN: 0196–0008. OCLC: 18980221 (8th suppl.); 14690204 (6th suppl.); 3417556 (2nd ed., rev. and enl.). LC: Z5945.C653. Dewey: 016.72.

Archaeology. Architecture. Art History. Historic Preservation. Interior Design. International. Landscape Architecture. City Planning.

An operating program of the J. Paul Getty Trust's Art History Information Program compiled by the Avery Architectural and Fine Arts Library at Columbia University. Comprehensive indexing of architectural journals includes citations (approximately 50,000 entries) to articles in all significant periodicals on architecture and architectural design and history, historic preservation, city planning and interior design. More than 800 periodicals are covered, 75% are not indexed elsewhere. Journals indexed are from many countries and regions, particularly strong on U.S. titles including state and regional publications. All types of articles are indexed, including book and exhibition reviews as well as obituaries.

Provides extensive international coverage of literature dealing with architectural subjects in arts–related and architectural periodicals. Arranged in dictionary format, entries appear in one alphabetically interfiled sequence, and may be accessed by subject, author, architect, architectural firm, and/or geographical location. Also included are building names, building types, place names, period or style designations, names of exhibitions, awards, competitions, conferences and their sponsoring institutions.

Reviews: exhibition, book, film, equipment. Freelance work: none. Reviewed: Katz.

Advertising: none. Audience: scholars.

BHA/BIBLIOGRAPHY OF THE HISTORY OF ART/BIBLIOGRAPHIE D'HISTORIE DE L'ART. Spring 1991. q. EN & FR. 9

The Getty Art History Information Program, Sterling and Francine Clark Art Institute, Williamstown, MA 01267. Phone 413–458–8260, fax 413–458–8503. Michael Rinehart, Editor.

Subscription: $325, FF1895 (Dist.: Getty Trust Publications, Maligu, CA & INIST Diffusion, 2, allee du Parc de Brabois, F–54514 Vandoeuvre–les–Nancy Cedex, France). Available on–line on Dialog File 191 and Questel. No illus. 8½ x 11, 1000p projected.

LC: Z5937.R16 N7510. Dewey: 016.7. Supersedes: *RILA* (International Repertory of the Literature of Art) and, *Repertoire d'Art et d'Archaeologie*.

Art History.

An abstracting and indexing service for the current literature of art history incorporating *RILA* (International Repertory of the Literature of Art) and *RAA* (Repertoire d'Art et d'Archaeologie). A joint venture of AHIP (The Getty Art History Information Program) and INIST (Institut de l'Information Scientifique et Technique – CNRS). At full production will contain 24,000 citations per year from 4000 periodical titles, selected art dealers' catalogues, books, conference proceedings, Festschriften, exhibition catalogues, dissertations, microform publications, and machine–readable data files. Coverage includes the visual arts in

all media, construed in the broadest sense including the decorative and applied arts, industrial art and design, popular art, folk art, photography, and all objects of material culture that are of interest to the art historian. Covers the literature of Western art from late antiquity to the present, including the entire artistic production of the European and New World successors to the Greco–Roman world and those peoples and cultures that are studied in relation to them. Further coverage of Eastern European, Latin American, and Scandinavian literature will be provided. A complete subject index will be in both languages. Coverage begins with 1989 publications in order to maintain continuous coverage from *RILA* and *RAA*. The abstracts, written by art professionals, will provide concise, objective summaries of the subjects, arguments, and conclusions from the cited publications.

Bibliographies, biographies interviews, and obits. are cited. Indexed: author, journal and bilingual subject indexes. Annual cum. index planned. Reviewed: *Art Documentation* 9:3, Fall 1990, p.134–6. *Choice* Sept 1991, p.52.

Advertising: none. Audience: art history community.

THE CLOTHING AND TEXTILE ARTS INDEX. 1979. a. EN. 10

Box 1300, Monument, CO 80132. Phone 719–488–3716. Dr. Sandra S. Hutton, Editor.

Subscription: $75 printed index worldwide surface, CD–Rom $395. No sample. Back issues. Cum. index, 1970–1979 and 1980–84. 8½ x 11, 100p.

ISSN: 0887–2937. OCLC: 12046991. LC: TT507.C6. Dewey: 016.391. Formerly: *Clothing Index*.

Clothing. Crafts. Decorative Arts. Fabrics. Interior Design. Jewelry. Textiles.

An index to serial literature dealing with all aspects of clothing and textile arts. Some periodical titles are reviewed issue by issue, but English citations from any known source are collected and reviewed. Volumes covering 1970–1986 contain a total of 15,734 citations published in over 1900 periodical/serial titles. Citations are arranged under relevant key terms. A guide to clothing behavioral, historic and artistic literature provides citations of periodical and serial articles. Summary or description of each article is contained in the CD–Rom edition, available September 1989, but not in the printed index.
Freelance work: none.

Advertising: none. Circulation: 150. Audience: textile artists, theatrical costumers, clothing designers, libraries, researchers of textiles and clothing, and costume and textile historians.

DESIGN AND APPLIED ARTS INDEX. 1988. s–a. EN. 11

Design Documentation, Gurnleys, Burwash, Etchingham, E. Sussex, TN19 7HL, England. Phone 0435–882438, fax 04352–3184. C.J. Mees, Editor.

No illus. Cum. index planned for every 3 yrs. 8½ x 11.

ISSN: 0953–0681.

Design.

Comprehensive international index to current design and design–related journals. Provides title, author, journal and full citation. Criterion for inclusion is not only its research but also its current interest value. Thus in addition to major articles, also lists short articles, news items, conference and seminar reports, reviews of books, video, films, and exhibitions, obituary notices and illustrations. Single alphabet consisting of multiple headings and subheadings with comprehensive see references. Approximately 250 journals are covered. Details of single illustrations are noted if they are felt to be of a good enough quality (possibly for slide–making purposes) or are in some other way significant. Does not attempt to provide full abstract of article contents. Brief annotative descriptions are given when these are thought to be useful, together with basic biographical, historical data about designers, architects, craftspeople, design consultancies, companies, etc.

In the process of retrospectively indexing certain journals, concentrating on journals which have previously not been indexed. Will index these journals back to the first issue. Introduction appears also in GE & FR (1p.).

Reviews: citations for reviews to book, film, and exhibition are listed by subject with full publication details. Obits. cited. Reviewed: Katz. *Art Libraries Journal* 13:2, 1988, p.44; 13:4, p.32–3. *Art Documentation* 9:3, Fall 1990, p.160–2.

Advertising: ads (2 full pages in back of issue).

DESIGN INTERNATIONAL INDEX: An Information and Bibliographic Data Base. 1984. a. EN. 12

Emmet Publishing Ltd., West House, 21 West St., Haslemere, Surrey GU27 2AB, England. Phone 0428 54443, fax 0428 61582. Mona Lloyd & Janette Jagger, Editors.

Subscription: COMfiche: £199, $398 US. Sample. Illus. Annual cumulation.

ISSN: 0265–1092. OCLC: 11480060.

Design.

A microfiche index and information resource on design, designers, design history and design related areas created by art & design librarians at Leicester Polytechnic Library covering 1850 to the present day. International in scope and coverage it indexes any information from any source with an emphasis on material not otherwise indexed. Sources include foreign and English language journals, books, theses, conference papers and reports, reviews, bibliographies, unpublished papers, exhibition catalogues, videos, films, etc. Any source is indexed if the information is design related, over 1000 sources are indexed.

The main sequence is arranged alphabetically by designer, firm, etc. with indexes of 26 design fields and country of association.

Advertising: none. Audience: designers, design students, researchers, design firms, librarians, craftspeople.

EKISTIC INDEX OF PERIODICALS. 1991, v.25. s–a. EN. 13

Athens Technological Organization, Athens Center of Ekistics, P.O. Box 3471, 102 10 Athens, Greece. Phone 3633216, telex 215227, fax 3633395. Myro Konnow, Editor.

Subscription: (1991) $US150. Back issues $US75.

ISSN: 0013–2934. OCLC: 13500532. LC: Z5942.E38. Dewey: 016.307. Formerly: *Ekistic Index*.

Architecture. Environment. Planning

Indexes 750 journals from approximately 60 countries, the majority are overseas publications. Selection is based on the interest of the articles to planners, architects, social scientists, engineers, economists, ecologists, environmentalists and others concerned with developments in the field of Human Settlements – small and large, rich and poor – in the past, present and future. Articles are indexed by author, country and subject.

Reviewed: Katz.

ETHNOARTS INDEX. 1983. q. EN. 14

Data Arts, P.O. Box 30789, Seattle, WA 98103–0789. Phone 206–783–9580. Dr. Eugene C. Burt, Editor.

Subscription: $30 individual, $40 institution US & Canada; foreign surface $43, air $50. Sample free. Back issues $10, $12 foreign. Also available on microcomputer floppy diskette in many formats. No illus. 5 yr. cum. index. 8½ x 11, 50p.

ISSN: 0893–0120. OCLC: 15313640. LC: N5310.7.T74. Dewey: 709. Formerly: *Tribal Arts Review*.

General.

Bibliography of recent publications and unpublished materials on the visual arts of the indigenous peoples of Africa, Oceania, and the Americas. Access to hierarchically arranged bibliographic entries is provided by subject and author indexes. Occasionally a special bibliographic article is included. Some bibliographic entries provided with brief annotations.

Indexes all publications relevant to the study of ethnoart: books, periodical articles (regularly scans over 300 serials but includes references to many others), catalogs, book reviews, exhibition reviews, conference papers, theses and dissertations, and other special publication types. To qualify for inclusion an item must have as its primary focus the visual art, architecture or the artistic aspects of material culture or archaeology of any of the indigenous peoples. Titles originally in a foreign language are translated into English. Provides descriptive abstracts for some entries in order to reveal the geographical, cultural, media, historical period, and methodical focus of the entry.

Reviews: book 4, length 500–1000 wds. Freelance work: book reviews and articles. Preference given to bibliographies, bibliographic essays, historiographic or theoretical studies. Reviewed: (Tribal Arts Review) *Library Journal* 110:14, Sept 15, 1985, p.64.

Advertising: full page $60, ½ page $35, ¼ page $20, no color, no classified. Frequency discount. Mailing lists: none. Audience: anyone interested in non–Western art.

GRAPHIC ARTS LITERATURE ABSTRACTS. See no. 1615.

HANDICRAFT/HOBBY INDEX. 1980. bi–m. EN. 15

Metropolitan Library Service Agency (MELSA), 1821 University Ave., Rm. S–222, 1821 University Ave., St. Paul, MN 55104–3083. Phone 612–645–5731. Sylvia Welygan, Editor.

Subscription: $78 US & Canada. Sample free. Back issues $35 for 5 yr. cumulation. Cum. index 1980–84, 1985–89; last issue of calendar year contains complete year, plus as many as 4 previous years. Microfiche format, 1–8 fiche/issue.

ISSN: 0730–6466. Dewey: 745.5. Formerly: *MELSA How–to–do–it Periodical Index*.

Collectibles. Crafts. Decorative Arts. Furniture. Hobbies. Needlework.

A cooperative effort of public librarians. Guide to do–it–yourself projects on many subjects, as found in 33 periodicals (most of a popular, newsstand issue). Annotations indicate size, style, material components, etc. Index is cumulative to a maximum 5 year period. Detailed subject headings (2,000+) and cross references provide access to specific information. A list of subject headings used appears at the end of each issue. Began in 1980 in 3 x 5 card format; cards were copied onto fiche in 1981; and computer–generated as com in 1984.

Reviewed: *Microform Review* 15:1, Win 1986, p.50–51.

Advertising: none. Circulation: 275. Audience: public libraries.

INDEX TO REPRODUCTIONS IN ART PERIODICALS. 1987. q. EN. 16

Data Arts, Box 30789, Seattle, WA 98103–0789. Phone 206–783–9580. Dr. Eugene C. Burt, Editor.

Subscription: $44 North America, $50 air elsewhere. Sample free. Back issues $12. No illus. 5 year cum. index. 8½ x 11, 50p.

ISSN: 0893–0139. OCLC: 15313739. LC: N8580.I53.

General.

Provides the means to locate published photographic reproductions of art objects. Presents cover–to–cover indexing of virtually all art objects illustrated in five popular art periodicals (*Art in America, American Craft, Arts of Asia, African Arts*, and *American Indian Art*) including covers and advertisements. Multiple access points are provided through four indexes: artist or culture, title, media, and subject.

Advertising: full page $60, ½ page $35, no color. No classified. Mailing lists: none. Audience: students, scholars, teachers, artists, librarians, or anyone interested in the arts.

PHOTOGRAPHY MAGAZINE INDEX. See no. 2681.

PHOTOHISTORICA: Literary Index of the European Society for the History of Photography.
1978. EN, GE or FR.

17

Museum voor Fotografie, Waalse Kaai 47, 2000 Antwerpen, Belgium. Karel van Deuren, Editor.

Subscription: included in membership. Cum. index no.1-20/21, 1978-1984.

Photography.

International index of over 45 photography magazines. Citation and abstract appears in the language of the magazine only.
Advertising: none.

REVIEW OF THE ARTS: FINE ARTS AND ARCHITECTURE. 1975. m. with a. cum. EN.

18

NewsBank, Inc., 58 Pine St., New Canaan, CT 06840. Phone 203–966–1100. Barbara Goldsampt, Editor.

Subscription: rates on request. Microform available from NewsBank, Inc. Sample. Back issues. No illus. Annual cum. index. 5–6 microfiche, index paper 8½ x 11, 15p.

ISSN: 0737–4003. OCLC: 2487504, 13074593 (index), 12009729 (microform). LC: N1.N4. Formerly: *Newsbank. Fine Arts and Architecture*.

General.

A current awareness service for the fine arts. It consists of articles selected from over 450 U.S. newspapers that are reproduced on microfiche accompanied by a comprehensive printed index. Regional artists and exhibits are covered as well as renowned artists and shows. Types of articles in the service are reviews of exhibits, interviews with artists, and news reports on art forms. Also included are awards and prizes and acquisitions of art by museums.

Reviews: exhibition approx. 300. Interviews: regional and nationally known artists. Biographies: "News Report" on artists' lives. Listings: regional–national. Exhibition information. Opportunities: competitions, regional & national.

Advertising: none. Mailing lists: none. Audience: school, university, public libraries.

RILA (International Repertory of the Literature of Art). 1975–1989. q with a. cum. index. EN & FR.

19

J. Paul Getty Trust, c/o Clark Art Institute, Williamstown, MA 01267. Phone 413–458–8260. Michael Rinehart, Editor.

Available online on Dialog. No illus. Index. Cum. index vols. 1–5, 1975–79. 8½ x 11, 1000p.

OCLC: 2408596 (RILA), 8415296 (cum. index). LC: Z5937.R16 N7510. Dewey: 016.7. Superseded by *BHA*.

General.

Abstracted material from approximately 500 journals, books, exhibition catalogs, etc. covering the 4th century to the present. *RILA* concluded publication with v.15 (1989). A five year cumulated index for vols. 11–15 will appear subsequently.

Reviews: book, 1200 are cited. Bibliographies, biographies interviews, and obits. are cited. Reviewed: Katz.

Advertising: none. Audience: art history community.

SEARCH: The Periodical Index for Architecture, Interior Design, Housing and Construction.
1988. q. EN.

20

Search Pub. Inc., 102 Brighton Circle, Devon, PA 19333. Phone 215–889–0535. Don Colangelo, Editor.

Subscription: $85 + $8 shipping US, + $20 Canada, + $32 foreign surface. Sample $5 (full credit with subscription). Back issues $40. Illus. Annual cum. index. 8½ x 11, 120p q., 520 p. a.

ISSN: 1043–0946. OCLC: 19277180. LC: NA1.S53. Dewey: 016.72.

Architecture. Ceramics. Furniture. Graphic Arts. Interior Design. Landscape Architecture. Sculpture. Textiles.

A research tool that taps into the diverse resources of over 20 major magazines for architects, interior designers and builders, the popular magazines most often found in professional offices. Divided into four sections, fully cross–referenced: "picture file" catalogs selected illustrations by keyword; "projects" an alphabetical list of over 1500 projects by name; "person/teams" full listing of all persons & firms noted in articles including all major participants; and a "keywords" index. Includes references to specific photographs within articles organized by key word. Photocopies are available for sale of all material indexed.

Obits. are indexed.
Advertising: none. Audience: architects, interior designers, Schools of Fine Arts, retail stores with interior design service.

Reference Works

Annual Guide to Galleries, Museums, and Artists. See no. 133.

ART AND ARCHITECTURE BIBLIOGRAPHIES. 1973. irreg. EN. **21**
Hennessey & Ingalls, Inc, 8321 Campion Dr., Los Angeles, CA 90045. Phone 213–458–9074.
Architecture.

ART BOOKS BULLETIN. 1986. bi–a. EN. **22**
T.C. Farries & Co., Ltd., Irongray Rd., Lochside, Dumfires, Scotland.
Subscription: free.
A computer–produced list of news books on art, architecture, photography, and design.

ART REFERENCE COLLECTION. 1980. irreg. EN. **23**
Greenwood Press, Inc, 88 Post Rd. W., Box 5007, Westport, CT 06881–9990. Phone 203–226–3571. Pamela J. Parry, Editor.
ISSN: 0193–6867. OCLC: 5251656.

**ARTISTS IN CANADA: UNION LIST OF ARTISTS FILES/ARTISTES DU CANADA. LISTE
COLLECTIVE DES DOSSIERS D'ARTISTES.** 1970. irreg. EN & FR. **24**
National Museums of Canada, Ottawa, Ontario K1A 0M8, Canada. Phone 613–990–0587.
Dewey: 708.11. Formerly: *Artists in Canada; National Gallery of Canada. Library. Checklist of Canadian Artists Files.*

BIBLIOGRAFI OVER DANSK KUNST. 1971. a. DA. **25**
Kunstakademiets Bibliotek – Academy of Fine Arts, Library, Kongens Nytorv 1, DK–1050 Copenhagen K, Denmark. Emma
Salling, Editor.
Subscription: free.
OCLC: 2253271. LC: Z5961.D4B5. Dewey: 709.
Bibliography of Danish art.

BIBLIOGRAPHIC GUIDE TO ART AND ARCHITECTURE. a. 2 vol. EN. **26**
G.K. Hall & Co., 70 Lincoln St., Boston, MA 02111. Phone 617–354–4398.
Subscription: $275 US, foreign $300. Back issues from 1984 on. 350p.
ISSN: 0360–2699. LC: N7420. Dewey: 016.7. Formerly: *Art and Architecture Book Guide.*
General. Architecture.

A bibliography of publications in art and architecture catalogued during the past year by the New York Public Library and the
Library of Congress. Contains books, serials, and nonbook materials in all languages. Provides complete cataloging informa-
tion, ISBN number, and identification of the New York Public Library holdings.
Advertising: none.

FANDOM DIRECTORY. 1979. a. EN. **27**
Fandata Publications, 7761 Asterella Court, Springfield, VA 22152–3133. Phone 703–644–7354. Harry A. Hopkins, Editor.
Subscription: $13.95 + $2.50 shipping US, + $3.50 Canada & foreign, + $8 air. Back issues, ½ cover price. Illus. b&w, color,
photos, cartoons. 7 x 8½, 500+p.
ISSN: 8756–8349. OCLC: 7344904. LC: HS2509.F36. Dewey: 808.3.
Collectibles. Comics. Films. Hobbies.

Over 20,000 names, addresses and phone numbers. Lists organizations and clubs worldwide. Information includes indexes to
fan clubs, fanzines, and fan gatherings. Covers science fiction, fantasy, horror, humor, comics, Star Trek, Star Wars, anima-
tion, space interests, costumes, filking, props, Superheroes, fantasy games, pulps, Sword & Sorcery, Dr. Who, fan art, movie
material, Darkover, old time radio, collecting and many related fandoms. Plus a listing of research libraries of interest to fan-

dom — where all the manuscripts and rare published works have been donated and a "Retail Stores Index" which lists over 3500 retail outlets which cater to fans and collectors. Interest counts: animation 1500, artzines 450, Big Little Books 400, comic books & strips 7600, foreign comics 500, original artwork 2000, posters 2600, and counts for individual comics. Listings: international. Freelance work: yes. Contact: Mariane. Opportunities: study, conventions; competitions, artwork contest.

Advertising: full page $150, ½ page $80, ¼ page $45, color (outside back cover) $750. Classified: 20¢/wd., $4 min. No frequency discount. Circulation: 5000. Audience: science fiction and fantasy fans, collectors and retailers.

FINE ARTS AND ARCHITECTURE. See no. 18.

HUMANITIES EXCHANGE INC. NEWSLETTER: Traveling Exhibition Information [North American edition]. 1980? bi–m. EN.

29

P.O. Box 1608, Largo, FL 34649. (European address: Privatstrasse 8–10, CH–4563 Gerlafingen, Switzerland). Phone 813–581–7328, fax 813–585–6398. Shirley Reiff Howarth, Editor.
Subscription: $30. No illus. 8½ x 11, 12p.
OCLC: 21709406. LC: N4396.H86x.

Information on traveling exhibitions. Provided for each exhibit: description of exhibitions, fee, dates available, contact person, organizer, and space required.

INTERNATIONAL DIRECTORY OF EXHIBITING ARTISTS. 1981. irreg. EN.

30

Clio Press Ltd., 55 St. Thomas' St, Oxford OX1 1JG, England. Phone 0865–250333, fax 0865–790358, telex 83130.
Formerly: *Dictionary of Contemporary Artists*.

NEW PUBLICATIONS FOR ARCHITECTURE LIBRARIES. See no. 2105.

NEWSLETTER - TRAVELING EXHIBITION INFORMATION SERVICE. North American edition. 1981. bi–m. EN. Also available in FR & GE editions.

31

Humanities Exchange, Inc., Box 1608, Largo, FL 34649. Phone 813–581–7328. S.R. Howarth, Editor.
Subscription: included in membership; non–profit organizations $30; rest $35.
ISSN: 0733–463X. OCLC: 7709978. Dewey: 707.4.

REVIEW OF THE ARTS: FINE ARTS AND ARCHITECTURE. See no. 18.

RIDIM/INTERNATIONAL REPERTORY OF MUSICAL ICONOGRAPHY. 1986. irreg. EN.

32

Research Center for Musical Iconography, Graduate School and University Center, City University of New York, 33 W 42nd St., New York, NY 10036. Phone 212–642–2336. Terence Ford, Editor.
Subscription: varies/issue. No sample. No back issues. No illus. 8½ x 11, 16p.
ISSN: 0889–6607. OCLC: 13987957. LC: ML85.I6. Dewey: 704.9.

An itemization and description of virtually all the pre–1900 artworks of musical interest (paintings, drawings, sculpture, decorative arts, and manuscript illustrations, but excluding prints) in different museums. The first six issues cataloged the National Gallery of Art, the Art Institute of Chicago, the Walters Art Gallery, the Pierpont Morgan Library (manuscripts only), the Philadelphia Museum of Art, and the Metropolitan Museum of Art. Basic information on each work: the artist, title, museum collection and accession number, the medium and dimensions, and a brief description.
Circulation: 400.

SLOVENSKA NARODNA BIBLIOGRAFIA SERIA G: GRAFIKA. 1975. a. CZ, EN, FR, GE, RU, SL. EN, FR, GE, SL summaries.

33

Matica Slovenska, Mudronova 35, 036 52 Martin, Czechoslovakia. Anna Kucianova, Editor.
Dewey: 740. Formerly: *Katalog Slovenskych Plagatov*.
Bibliographies.

SPONSORED RESEARCH IN THE HISTORY OF ART. 1983. a. EN.

34

Center for Advanced Study in the Visual Arts, National Gallery of Art, Washington, DC 20565. Claire Sherman, Editor.
Cum. index every 5 volumes.
ISSN: 0742–0242. OCLC: 9447156. LC: Z5931.S78. Dewey: 709. Formerly: *Research Reports, History of Art*.

Includes lists of fellowships and grants awarded by museums, public and private foundations, and U.S. government agencies for research in the humanities and social sciences.
Reviewed: *ARBA* 21, 1990, p.403–4.

THE WORLDWIDE ART CATALOGUE BULLETIN. 1963. q. EN. **35**
Worldwide Books, 1001 W. Seneca St., Ithaca, NY 14850–3329. Phone 607–272–9200. Christine James, Editor.
Subscription: $52.50. Illus. 5½ x 8½, 115p.
ISSN: 0043–9363. OCLC: 1785805. LC: N1.W67. Dewey: 016.708.
Reference and acquisition guide to art exhibition catalogues from around the world.
Indexed: Index. Reviewed: Katz.
Advertising: none. Circulation: 1,000.

Auctions & Auction Houses

ANNUAIRE INTERNATIONAL DES VENTES. 1963. a. FR & EN editions. **36**
Librairie Fischbacher, 33 rue de Seine, 75006 Paris, France. E. Mayer, Editor.
Subscription: 990 F. Illus.
ISSN: 0066–3263. Dewey: 700.
Annual international of sale prices at auctions.

ART & AUCTION: The Magazine of the International Art Markets. 1979. 11/yr. EN. **37**
Auction Guild, 250 W. 57th St., New York, NY 10019. Phone 212–582–5633, Fax 212–246–3925. Lin Smith, Editor.
Subscription: $42 US, $54 Canada, foreign air $90. No sample. Back issues $6. Illus. b&w, color, photos, cartoons. 8½ x 11, 180–220p. Web offset.
ISSN: 0197–1093. OCLC: 5966296. LC: N8602 .A83.
General. Antiques. Ceramics. Decorative Arts. Furniture.

Provides in depth analyses of auction and trade activities in the international art markets. Profiles important members of the art world, discusses issues (ethical, economic, political) which arise, reviews fairs and shows, and prints stories both humorous and serious of lawsuits and forgeries. Includes art & financial issues, art related travel, and advice to collectors such as shipping, customs, preservation, financing, etc.
Reviews: auction 6, length 500 wds. Bibliographies where necessary in articles on less well–known collecting areas. Biographies & interviews: profiles of collectors, dealer auction house staff, museum staff, etc. Listings: international. Calendar of events for galleries & auctions. Exhibition information for fine art and antiques shows. Freelance work: yes. Reviewed: *Wilson* 63:3, Nov. 1988, p.119.
Advertising: (rate card Jan '89): b&w full page $2205, ½ page $1300; 2 color full page $2950, ½ page $1900; 4 color full page $3375, ½ page $2075, covers $4050–4350. Frequency discount. 15% agency discount for camera–ready copy. 10% discount for spreads. Bleed + 10%. Mailing lists: available. Heidi Rustin, Ad. Director. For Britain & France, Robert Logan & Assoc. (64 The Mall, Ealing, London, W5 5LS, phone 01–579–4836, fax 01–579–5057). Circulation: 40,000. Audience: those involved with any facet of the international art markets.

THE ART SALES INDEX: Oil Paintings, Drawings, Water Colours and Sculpture.
1974/75. a. 2 vol. EN. **38**
Apollo Book Distributor, 5 Schoolhouse Ln., Poughkeepsie, NY 12603. Phone 914–462–0040. Richard Hislop, Editor.
Subscription: $195. Available online as *ArtQuest*. Microform available. Back issues. No illus. 2000+p.
ISSN: 0143–0688. OCLC: 12827444. LC: N8670.A66. Formerly: *Annual Art Sales Index*.
Drawing. Painting. Sculpture.

International art auction record book includes results from over 81,000 sales for over 28,000 artists, 1,500 international art auctions and over 300 auction houses worldwide. All prices given in U.S. dollars and pounds plus the original currency of sale. Contains the most complete record of all paintings, watercolors and drawings sold worldwide.
Reviews: auction sales. Listings: international. Indexed: CloTAI. Hand. Reviewed: *ARBA* 19, 1988, p.407.
Advertising. Glenn Opitz, Ad Director.

ARTS, ANTIQUES ET AUCTIONS. 1971. m. DU, EN, FR.

39

Arts Advertising Association, Boite 22, 79 Bd. Ed. Machtens, 1080 Brussels, Belgium. J.P. Corne, Editor.
Subscription: 2300 BFr.

Antiques. General.

Contains prices for antiques and art sold at auction.
Advertising.

AUCTION FORUM U.S.A. 1989. m. EN.

40

341 W. 12th St., New York, NY 10014.
Subscription: $90 (introductory rate).
Opportunities: employment. Reviewed: *Art Documentation* Sum 1989, p.82.
Advertising.

AUCTION NEWS FROM CHRISTIE'S. 1980. 9/yr. EN.

41

Christie's, US: 502 Park Ave., New York, NY 10022. Phone 718–784–1480. UK: 8 King St., St. James, London SW1Y 6QT England. Phone 071–582–1282. R. Starr Collins, Editor.
Subscription: $15 US & Canada, $20 foreign (US: Christie's Publications, 21-24 44th Ave., Long Island City, NY 11101. UK: Subscription Dept., Landley Lane, London SW8 1TH. Illus. b&w, color, photos. 9 x 12, 12p.
OCLC: 11603525, 19026523. LC: N8610.C55a.

General. Auctions.

Brief description of some upcoming auctions (1/2–1p. each) together with an illustration.
Calendar of future sales in New York.
Advertising.

BUTTERFIELD BULLETIN. 1980. 9–12/yr. EN.

42

Butterfield & Butterfield, 220 San Bruno Ave., San Francisco, CA 94103–5018. Phone 415–861–7500. Lauren Howard, Editor.
Subscription: $12 US, $15 foreign, free with any catalogue subscription. Illus.
OCLC: 10111656. LC: N1.B96.

General. Antiques.

Newsletter of the California auction firm.
Audience: buyers and collectors.

BUTTERFIELD CATALOGS. 2–8/yr/category. EN.

43

Butterfield & Butterfield, 220 San Bruno Ave., San Francisco, CA 94103–5018. Phone 415–861–7500, fax 451–861–8951.
Subscription: price varies/category, 2 or more categories 10% discount; all categories 15% discount, $808 US, $1466 foreign. All subscriptions include *Butterfield Bulletin*. Illus. b&w, color, photos.

Auctions. Decorative Arts. General.

Catalogues are published for all major, intermediate and special auctions held at the San Francisco or Los Angeles auction house. Description of items includes illustration and estimated value. Subscriptions are available for individual subject areas in the following categories: fine arts, furniture and decorative arts, jewelry, oriental works of art, and special auctions. More than 50 catalogues are published each year. Post–sale results are mailed to all subscribers.
Audience: buyers and collectors.

CANADIAN ART SALES INDEX. 1980. a. EN.

44

Westbridge Publications Ltd., 2245 Granville St., Vancouver, B.C. V6H 3G1, Canada. Phone 604–734–4944. Anthony R. Westbridge, Editor.
Subscription: $C39.95 Canada, $US39.95 US & foreign. No sample. Back issues. No illus. Annual index. Cum. index to vol.1–10 available early 1990. 5½ x 8½, 170p.
ISSN: 0229–8961. OCLC: 8079098. LC: N6540.C33. Dewey: 709.

Auctions. General.

Index to Canadian works sold at auction in Canada and abroad, over 5,500 auction prices and more than 1,000 artists. Covers paintings, watercolors, sculpture and books. Includes name of artist, titles of works sold, whey they sold, size, medium and price. Price index with market trend analysis is presented.
Advertising: full page $580, ½ page $360, ¼ page $215; color full page $950. No classified. No frequency discount. Mailing lists: none. Heather Bradshaw, Ad. Director. Circulation: 2000. Audience: investors and collectors of Canadian art.

CHRISTIE'S CATALOGUES. irreg. EN. **45**

Christie's, US: 502 Park Ave., New York, NY 10022. UK: 8 King St., St. James, London SW1Y 6QT England.
Subscription: (US: Christie's Publications, 21–24 44th Ave., Long Island City, NY 11101, phone 718–784–1480. UK: Subscription Dept., Landley Lane, London SW8 1TH, phone 071–582–1282). Illus. color, photos.
Auctions. General.

Calendar of forthcoming sales.

CHRISTIE'S INTERNATIONAL MAGAZINE. 1984? 9/yr. EN. **46**

Christie's, US: 502 Park Ave., New York, NY, 10022. UK: 8 King St., St. James, London SW1Y 6QT England. Mark Wrey & Adam Hogg, Editors.
Subscription: $45 US, £24 UK, 67,000 L Italy, £33 Continental, £48 air (US: Christie's Publications, 21–24 44th Ave., Long Island City, NY 11101, phone 718–784–1480. UK: Subscription Dept., Landley Lane, London SW8 1TH, phone 071–582–1282). Illus. color. 9¼ x 11½, 136p.
ISSN: 0266–1217. OCLC: 11561288. LC: N8610.C55.
Auctions. General.

Principal contents, over 100 pages, present illustrations and date of sale for their London auctions. Auction results for seven other locations are also given. In addition contains a few articles.
Listings: salesrooms and representatives. Calendar of forthcoming sales.

CHRISTIE'S REVIEW OF THE SEASON. 1972. a. EN. **47**

Christie's, US: 502 Park Ave, New York, NY 10022. UK: 8 King St., St. James, London SW1Y 6QT England, phone 071–582–1282.
Subscription: US: Christie's Publications, 21–24 44th Ave., Long Island City, NY 11101, phone 718–784–1480. UK: Subscription Dept., Landley Lane, London SW8 1TH. Illus.
OCLC: 2758874, 9068056. LC: N8640.C52 C49, N8660.C5 A36. Dewey: 707. Formerly: *Christie's Review of the Year.*
General.

GORDON'S PRINT PRICE ANNUAL. 1984. a. EN. **48**

Martin Gordon, Editor & Pub., 1000 Park Ave., New York, NY 10028. Phone 212–249–7350.
Subscription: $325 US. Available online as *Gordon's in Print Services.* Back issues $260–$300. 8¼ x 9½, 900p.
ISSN: 0160–6298. OCLC: 3719502. LC: NE85.G67. Dewey: 769.
Prints.

"The world's foremost print price book" lists single prints, pair, set, groupings and portfolios sold over the past year in the world's major auctions and galleries, including those in New York, London, Paris, Vienna, Hamburg, Zurich, etc. Over 26,000 entries arranged alphabetically by artist and title. Each entry provides artist, title, print description, medium, edition, size, date, references, measurements, notations, margins, condition and sales information.
Advertising: none.

INTERNATIONAL AUCTION RECORDS. 1972. a. EN. **49**

Editions Publisol, Box 339, Gracie Station, New York, NY 10028: (Dist.: Apollo Book, 5 Schoolhouse Lane, Poughkeepsie, NY 12603). E. Mayer, Editor.
Subscription: $199. Back issues. Illus. 450 b&w & 50 color photos. 6 x 9.
ISSN: 0074–1922. OCLC: 1442496, 6777181. LC: N8640.I5. Dewey: 700.29. Formerly: *International Yearbook of Sales.*
Auctions. Drawing. Painting. Sculpture.

Price guide to paintings, drawings, watercolors, engravings and sculpture, listing over 55,000 works of art, 25,000 American and 30,000 international, and their listed world–wide auction prices. Each volume covers the preceding calendar year.
Circulation: 5000.

LEONARD'S ANNUAL PRICE INDEX OF ART AUCTIONS. 1980. a. EN. **50**

Auction Index Inc., 30 Valentine Park, Newton, MA 02165.
Subscription: $195.
ISSN: 0747–6566. OCLC: 9295343. LC: N8602.L46. Dewey: 707. Formerly: *Leonard's Annual Index of Art Auctions.*
Auctions. General.

Listings of sales from 19 major American auction galleries. Covers the auction season. Cumulation of: *Leonard's Price Index of Art Auctions.*

LEONARD'S PRICE INDEX OF ART AUCTIONS. 1980. q. EN.

51

Auction Index Inc., 30 Valentine Park, Newton, MA 02165.
OCLC: 9295302. LC: N8670.L462. Dewey: 707. Formerly: *Leonard's Index of Art Auctions.*
Auctions. General.

Listings of sales from 19 major American auction galleries. Cumulates annually in: *Leonard's Annual Price Index of Art Auctions.*

THE LYLE OFFICIAL ARTS REVIEW. 1975. a. EN.

52

Dealer's Choice, 2677 Tower Rd., Land O'Lakes, FL 34639. Phone 813–996–6599. (Dist.: Apollo Book, 5 Schoolhouse Lane, Poughkeepsie, NY 12603). Anthony Curtis, Editor.
Subscription: $35. No back issues. Illus. b&w, some color, photos. 6½ x 9¾, 606p.
ISSN: ISBN: 0–86248–111–2. OCLC: 3553378. LC: N8610.L9. Dewey: 707.
Auctions. Modern Art. Painting.

Contains details of thousands of oil paintings, watercolors and prints. Each entry is listed alphabetically under the artist's name and includes a description of the work, its size, medium, auctioneer and the price brought at auction for the twelve month period prior to publication. Extensive illustrations.
Freelance work: none. Reviewed: *Booklist* 82:11, Feb 1, 1986, p.788.
Advertising: none. Audience: art lovers.

PHILLIPS LONDON AUCTION CATALOGS. irreg, number varies according to category selected. EN.

53

Phillips, Son & Neale, 101 New Bond St., London, W1Y 0AS England. US: 406 E 79th St., New York, NY 10021. Phone UK: 071–629 6602, fax 071–629 8876. US: 212–570–4830, fax 212–570–2207.
Subscription: Catalogs available thru all branch salesrooms. Subscriptions available for any category, write for relevant leaflets. Illus. color, some b&w, glossy photos. Index.
Auctions. General.

Separate catalogues available by subject for London auctions. Catalogues provide description and illustration of auction items together with an estimated price. Brief biographic information on artist and/or background information concerning the work is often provided.

PHOTOGRAPHIC ART MARKET. See no. 2669.

PICTURE PRICE GUIDE TO THE AMERICAN AND CANADIAN ART MARKET. a. EN.

54

Art Sales Index Ltd., Weybridge, Surrey, England.
Illus.
LC: 90-660289.
Listings: international.

SOTHEBY'S ART AT AUCTION. 1967. a. EN.

55

Sotheby's, US: 1334 York Ave., New York, NY 10021. Phone 212–606–7000. UK: 34-35 Bond St., London W1A 2AA England. (Dist.: Rizzoli International Publications, Inc., 300 Park Ave. South, New York, NY 10010. Phone 212–982–2300.) Sally Prideaux, Editor.
Subscription: $75 North Mexico; $85 elsewhere (Sotheby's Subscriptions, P.O. Box 5111, Norwalk, CT 06856–9851, phone 1–800–447–6843). Includes *Newsletter.* Illus. (600+), mainly color, photos. 450+p. hardbound.
ISSN: 0084-6783. OCLC: 17429721. LC: N8640.A784. Dewey: 745.1. Formerly: *Art At Auction.*
Auctions. General.

An international review of the auction season with more than 400 full–color photographs showing the variety of works. Includes articles by scholars and experts on the year's extraordinary collections and objects.

SOTHEBY'S CATALOGUES. irreg. Number varies/category selected. EN.

56

Sotheby's, US: 1334 York Ave., New York, NY 10021. UK: 34-35 Bond St., London W1A 2AA England. Phone 1–800–447–6843. Outside Continental U.S. 203–847–0465.
Subscription: price varies/subject category; 10% discount for all catalogs of an auction locale, $2,710 New York, $3,591 London; 25% discount for all international + New York & London, $6,005. (Southeby's Subscriptions, Box 5111, Norwalk, CT 06856–5111). *Sotheby's Newsletter* included with any subscription. Options include an international subscription to all catalogs on a specific collecting area or by auction locale (New York, London, Amsterdam, Geneva and Monaco).
General. Auctions.

A comprehensive catalogue which precedes each Sotheby's auction contains a thorough description of each lot including size, provenance, condition, and often a photograph as well as a Sotheby expert's pre–sale estimate of the expected sales price. Art, antiques and collectibles are divided into seven major categories: paintings, drawings, sculpture & prints; furniture & decorative works of art; jewelry, precious objects, ceramics & glass; oriental works of art; Near Eastern art, Judaica, antiquities, & ethnographic art; books & manuscripts; and other collecting categories. These categories are further subdivided into at least 70 subjects. Post–sale price results are mailed to subscribers after each auction in their collecting area.
Audience: art experts and collectors.

SOTHEBY'S INTERNATIONAL PRICE GUIDE. 1986. a. EN. 57

Sotheby's, US: 1334 York Ave., New York, NY 10021. Phone 212–606–7000. UK: 34-35 Bond St., London W1A 2AA England. John L. Marion, Editor.
Subscription: $40 North America, $55 elsewhere (Southeby's Subscriptions, Box 5111, Norwalk, CT 06856–5111, phone 1–800–447–6843, outside continental U.S. phone 203–847–0465). Includes *Newsletter*. Illus. b&w, some color, photos. 600+p., hardbound.
OCLC: 12769434. LC: NK1133.S68. Dewey: 707.
Auctions. Decorative Arts.
Price guide to the decorative arts gives prices achieved at auctions in 16 locations around the world during the past year. Contains more than 8,000 illustrations, identified, and auction–priced. Edited by the chairman and chief auctioneer of Sotheby's North America.
Indexed: Index. Reviewed: *Art Documentation* Fall 1986, p.139.
Audience: collectors, connoisseurs and students.

SOTHEBY'S NEWSLETTER. 1973. 10/yr. EN. 58

Sotheby's, US: 1334 York Ave., New York, NY 10021. Phone 212–606–7000. UK: 34-35 Bond St., London W1A 2AA England. Elizabeth White, Editor.
Subscription: free with any Sotheby subscription (phone 1–800–447–7684, outside Continental U.S. phone 203–847–0465). Illus. b&w, color, glossy photos. 8½ x 11, 12–16p.
OCLC: 14156290. Dewey: 706.99405.
Auctions.
Articles cover Sotheby's New York auctions and special events. Important objects are shown in full color photographs. Auction highlights, provides 3–4 overview descriptions of major auctions.
Listings: Sotheby's only. Calendar of New York auctions with separate calendar of auctions at other offices worldwide.
Advertising: none.

SOTHEBY'S PREVIEW. 1986. 9/yr. EN. 59

Sotheby's, US: 1334 York Ave., New York, NY 10021. Phone 212–606–7000. UK: 34-35 Bond St., London W1A 2AA England.
Subscription: (P.O. Box 5111, Norwalk, CT 06856–9851, phone 1–800–444–6843, outside Continental U.S. phone 203–847–0465). Illus. four color, photos. 9 x 11¾, 128p.
ISSN: 0144–8277. OCLC: 20910416. LC: N8640.S63 S67a. Dewey: 707. Formerly: *Sotheby's International Preview*.
Auctions. General.
Purpose to enrich people's enjoyment of the arts and stay current on what's happening in the art world. Each issue illustrates the most important beautiful works of art and jewels currently on the market, giving their history and their significance as well as their value. Covers all periods, artists and collectors as well as presenting news of new discoveries. The main portion of each issue is devoted to sales announcements by category worldwide. Information consists of one large illustration with location and date of sale. Also contains several articles, not limited to auction information.
Listings: international listing of offices with principal officers and experts. Calendar of important auctions worldwide.
Advertising.

Appraisal

AMERICAN SOCIETY OF APPRAISERS NEWSLINE. bi–m. EN. 60

American Society of Appraisers, Box 17265, Washington, DC 20041. Phone 703–620–3838. Shirley Belz, Editor.
Subscription: included in membership.

Includes reviews of auction sales.
Advertising.

ANTIQUE APPRAISAL ASSOCIATION OF AMERICA. NEWSLETTER. m. EN.

61

11361 Garden Grove Blvd., Garden Grove, CA 92643. Phone 714–530–7090.

ANTIQUE MARKET REPORT. 1981. bi–m. EN.

62

Web Communications, P.O. Box 12830, Wichita, KS 67277. Phone 316–946–0600. Debra Roark, Editor.
Subscription: $24. Illus.
ISSN: 8750–9024. OCLC: 11921757. LC: N8670.A668. Dewey: 707.5. Formerly: *Antique Auction Report.*
Reports sales prices from the major antiques auction houses.
Reviews: book.
Advertising. Circulation: 10,000.

ANTIQUE TRADER PRICE GUIDE TO ANTIQUES AND COLLECTORS' ITEMS. See no. 1108.

THE APPRAISERS STANDARD. 1982. 10/yr. EN.

63

New England Appraisers Association, 5 Gill Terrace, Ludlow, VT 05149. Phone 802–228–7444. Linda L. Tucker, Editor.
Subscription: $25 US, $30 Canada, foreign $45. tabloid.
ISSN: 1051–0869. OCLC: 21707898. LC: N5198.N4. Dewey: 705. Formerly: *NEAA News.*
Assists appraisers of all types in their profession.

ART MARKET REPORT. EN.

64

Centaur Ltd., St. Giles House, 50 Poland St., London W1E 4JZ England.
Formerly: *Auction Market Bulletin.*

ART THEFT NOTICES. 1981. q. EN.

65

Art Dealers Association of America, 575 Madison Ave., New York, NY 10022. Phone 212–940–8590. Susan Wasserstein, Editor.

THE ART/ANTIQUES INVESTMENT REPORT. 1976. bi–w. EN.

66

Wall Street Reports Publishing Corp., 120 Wall St., New York, NY 10005. Richard Holman, Editor & Pub.
Subscription: $125. Illus. 8½ x 11.
ISSN: 0161–1232. OCLC: 3822512. LC: N8600.A73. Dewey: 332.6. Formed by the merger of: *Art Investment Report*, & *Antiques Investment Report.*
Antiques.

Newsletter containing information on buying collectibles profitably.
Advertising.

THE ARTnewsletter. 1975. bi–w. EN.

67

ARTnews Associates, 48 W. 38th St., New York, NY 10018. Phone 212–398–1690. Bonnie Barrett Stretch, Editor.
Subscription: $179 US, $201 Canada & foreign, + $22 foreign air. Sample free. Back issues $7.46. Illus. b&w, photos. No index. 8½ x 11, 8p.
ISSN: 0145–7241. OCLC: 2776465. LC: N1.A839. Dewey: 338.4.
Collectibles. Decorative Arts. Drawing. Furniture. Modern Art. Painting. Photography. Sculpture.

An international report on the art market. Punctually reports on current markets for every period and style of art. Global coverage on world art market is provided through a staff of foreign correspondents. Previews and price–reporting of gallery and auction house sales. Covers auction sales, active private art markets, complete gallery price–reporting, legislative decisions, controversial acquisitions, de–accessions, art theft and forgery. Sister–publication of *ARTnews* magazine.
Interviews: with top dealers, curators auctioneers, scholars, artists.
Advertising: none. Mailing lists: none. Audience: art dealers, collectors, gallery owners, museum directors/curators, investors.

CARTER'S PRICE GUIDE TO ANTIQUES IN AUSTRALIA. See no. 1120.

THE EVALUATOR. 1979. q. EN. 68
International Society of Fine Arts Appraisers, P.O. Box 280, River Forest, IL 60305. Phone 312–848–3340. Elizabeth Carr, Editor & Pub.
Subscription: included in membership. Sample free. Back issues free. Illus. b&w, color, photos. 8½ x 11, 8–12p.
ISSN: 8756–775X. OCLC: 11653081. Dewey: 332.
Antiques. Ceramics. Decorative Arts. Furniture. Jewelry. Modern Art. Painting. Sculpture. Textiles.

Newsletter for those concerned with appraising fine art.
Reviews: exhibition 2, book 4. Interviews: current people. Listings: national–international. Freelance work: none. Opportunities: study.
Advertising: none. Mailing lists: none. Circulation: 1000.

FINE ART & AUCTION REVIEW. 1974. 10/yr. EN. 69
Westbridge Publications Ltd, 2245 Granville St., Vancouver, B.C. V6H 3G1, Canada. Phone 604–734–4944. Anthony R. Westbridge, Editor.
Subscription: $C67 Canada, $80 US, foreign $US94. Sample. Back issues $7. Illus b&w, photos. 8 x 10.5 trim, 36p.
ISSN: 0833–0891. OCLC: 16073631. LC: NK1125. Dewey: 707.5. Formerly: *Antiques and Art; Antiques Gazette.*
Antiques. Art Education. Ceramics. Crafts. Decorative Arts. Drawing. Jewelry. Modern Art. Painting. Photography. Sculpture.

Canada's "business journal for fine art collectors and investors" covers national and international antique and fine art market with results, previews, market analysis and opinion.
Reviews: exhibition, book. Biographies of prominent Canadian artists. Interviews: personalities involved in the fine art market. Listings: national. Calendar of auctions. Freelance work: none.
Advertising: ads, no color. No classified. Frequency discount. Heather Bradshaw, Ad. Director. Mailing lists: none. Demographics: upper income professionals & corporate executives interested in art as an investment. Circulation: 2000. Audience: national and international art & antique collectors and investors.

IFAR REPORTS. 1980. 10/yr. EN. 70
International Foundation for Art Research, Inc., 46 E. 70th St., New York, NY 10021. Phone 212–879–17803, Fax 212–734–4174. Elizabeth Hayt–Atkins, Editor.
Subscription: included in membership, $50 individual, $65 commercial & institution, + $20 overseas. Illus. b&w, photos. Issue index. 11 x 8½, 24p.
ISSN: 8756–7172. OCLC: 11635845. LC: N8554.I34. Dewey: 364.1. Formed by the union of: *Stolen Art Alert*, and *Art Research News.*
Antiques. Ceramics. Decorative Arts. Drawing. Graphic Arts. Jewelry. Painting. Photography. Sculpture. Textiles.

Purpose is to prevent the circulation of stolen, forged or misattributed works of art. In addition to articles pertaining to art theft, fraud and forgery the magazine includes the "Stolen Art Alert". This section publicizes information on the most recently stolen works of art in a specific catalogue form.
Bibliographies: art fraud and forgery, art law. Interviews: police activity, art thefts and recoveries. Freelance work: none. Reviewed: Katz.
Advertising: none.

INTERNATIONAL JOURNAL OF PERSONAL PROPERTY APPRAISING. 1985. q. EN. 71
International Society of Appraisers, P.O. Box 726, Hoffman Estates, IL 60195. Phone 312–882–0706. C. Van Northrup, Editor.
ISSN: 8755–4305. Dewey: 333.33.

THE LYLE OFFICIAL ANTIQUES REVIEW. 1972. a. EN. 72
Apollo Book (Distributor), 5 Schoolhouse Lane, Poughkeepsie, NY 12603. Anthony Curtis, Editor.
Subscription: $11.95 + $2 postage US. No back issues. Illus. b&w, photos. Extensive index. 5½ x 8⅜, 672p.
ISSN: ISBN: 0–399–51484–8. OCLC: 1791366. LC: NK1133.L9. Dewey: 745.1.
Antiques. Ceramics. Furniture.

Over 5,000 items illustrated, described, and given a current market value. All values given are prices actually paid based on accurate sales records for the past 12 months, with sources listed. Called "The Dealer's Bible". Arranged by subject areas.
Freelance work: none. Reviewed: *Booklist* 82:11, Feb 1 1986, p.788; 86:14, May 15 1990, p.1493-4.
Advertising: none. Audience: antiques people, dealers and collectors.

MID-AM ANTIQUE APPRAISERS ASSOCIATION. NEWSLETTER. a. EN. 73

Mid–Am Antique Appraisers Association, Box 9681, Springfield, MO 65801. Phone 417–865–7269.
Dewey: 745.1.

MILLER'S ANTIQUE PRICE GUIDE: Handbook for Professionals. a. EN. 74

Apollo Book (Distributor), 5 Schoolhouse Ln., Poughkeepsie, NY 12603. Phone 914–462–0040. Judith & Martin Miller, Editors & compilers.
Subscription: $24.95 + $2 postage US. Illus. b&w, some color, photos. 6⅜ x 11, 632p.
ISSN: 0893–8857. ISBN 0–670–82489–5. OCLC: 11031556, 18903580. LC: NK1125.M54. Dewey: 745.1075.
Antiques. Collectibles. Decorative Arts. Furniture. Jewelry.

The American edition of Britain's leading antiques reference book. Contains 10,000 photographs and price values, each with complete text descriptions. Fifty separate categories of antiques and collectibles are evaluated and described with a cross–reference index for rapid location of individual items, materials and makers. Prices are listed in American currency. Also includes dating tips, investment pointers, a glossary and a recognition chart.
Reviewed: *ARBA* 19, 1988, p.386-7. *Booklist* 82:11, Feb 1 1986, p.788; 86:14, Mar 15 1990, p.1494.
Advertising: none.

THE NEW YORK ANTIQUE ALMANAC. 1975. 10/yr. EN. 75

New York Eye Publishing Co., Inc., Box 335, Lawrence, NY 11559. Phone 516–371–3300. Carol Nadel, Editor & Pub.
Subscription: $8 US, foreign $16. Illus. 11½ x 16, 25p.
ISSN: 0738–8365. OCLC: 9694504. Dewey: 745.1.
Antiques.

Tabloid format emphasizing the investment value of antiques, art and collectibles. Information on current trends, auctions, financial news and shows is presented.
Reviews: book.
Advertising.

THE OFFICIAL PRICE GUIDE TO POTTERY & PORCELAIN. 1989, 7th edition. irreg. EN. 76

Random House, Special Sales, 400 Hahn Rd., Westminister, MD 21157.
Illus.
ISSN: 0747–5705. LC: NK4005.

THE PERSONAL PROPERTY JOURNAL. 1988. q. EN. 77

The American Society of Appraisers, 7 Kent St., Brookline, MA 02146. Phone 617–566–1339. Nancy A. Smith, Editor.
Subscription: $40 US, + $8 foreign. Sample & back issues $10. Illus. b&w.
ISSN: 1042–6477.
General.

The journal of the Society's Personal Property Committee.
Listings: regional–national. Calendar of events. Exhibition information. Opportunities: study.
Advertising: none at present. Circulation: under 1000. Audience: professional appraisers and 3rd party users of appraisal reports: lawyers, insurance agents, trust officers, IRS etc.

VALUATION. 196? 3/yr. EN. 78

American Society of Appraisers, Box 17265, Washington, DC 20041. Phone 703–478–2228. Shirley Belz, Editor.
Illus.
ISSN: 0042–238X. OCLC: 6541015. Dewey: 338. Formerly: *Technical Valuation*.

WORLD COLLECTORS ANNUARY. 1949. a. EN. 79

World Collectors Publishers, P.O. Box 263, 2270 AG Voorburg, Netherlands. A.M.E. Van Eijk Van Voorthuijsen, Editor.
Subscription: $130. Illus. Cum. index 1942–82.
ISSN: 0084–1498. OCLC: 1770130. LC: ND47.W6. Dewey: 759.085.

Periodicals for Librarians

ARLIS/ANZ NEWS. 1977. q. EN. 80
Queensland College of Art, P.O. Box 84, Morningside, Queensland 4170 Australia. Phone 07–395–9166, fax 399–7419.
Subscription: included in membership, $20 individual, $40 institution (Liz Agnew, Treas.). No illus. 6 x 8¼, 24p.
ISSN: 0157–4043. OCLC: 10628254.
Newsletter of the Art Libraries Society/Australia and New Zealand.

ARLIS/MIDSTATES NEWS. 1984. s–a. EN. 81
ARLIS/Midstates, Art Institute of Chicago, Michigan Ave. & Adams St., Chicago, IL 60603.
Subscription: free.
OCLC: 12251577. LC: Z675.A85 A74x.

ARLIS/NA UPDATE. 1984. q. EN, FR, or SP. No abstracts or tr. provided. 82
Art Libraries Society of North America, 3900 E. Timrod St., Tucson, AZ 85711. Phone 602–881–8479. Pamela J. Parry, Editor.
Subscription: included in membership together with *Art Documentation*, $55 individual, $75 institution US; foreign $85, air $95. Sample. Back issues $2/issue. Illus. b&w, photos. 8½ x 11, 10p.
ISSN: 0743–040x.
General. Art Librarianship.

Society and other news of interest to art librarians and visual resources curators, plus classified ads for job listings.
Listings: international. Calendar of events. Freelance work: none. Opportunities: employment found in classified job listings, study, competitions.
Advertising: Classified: 10¢/wd. members, 35¢/wd. non–members. Mailing lists: available. Circulation: 1300+. Audience: members.

THE ARLIS/NEW YORK NEWS. 1980. q. EN. 83
Art Library Society of New York, P.O. Box 212, Red Hook Station, Brooklyn, NY 11231. Hikmet Dogu, Editor.
Subscription: included in membership (Paula Beversdorf Gabbard, Sec.). No illus. 8½ x 11, 8p.
ISSN: 0894–3133. OCLC: 15989909.
Regional Chapter of ARLIS contains general art news, member news and employment ads.
Listings: regional. Exhibition information. Opportunities: "Placements".

ART DOCUMENTATION. 1982. q. EN, FR, SP. 84
Art Libraries Society of North America, 3900 E. Timrod St., Tucson, AZ 85711. Phone 602–881–8479. Beryl K. Smith, Editor (Art Library, Voorheer Hall, Rutgers University, New Brunswick, NJ 08903).
Subscription: included in membership together with *ARLIS/NA Update*, $55 individual, $75 institution US & Canada. Microform available from UMI. Sample. Back issues $5/issue. Illus. b&w, photos. Index in first issue of next vol. Cum. index vol. 1–6, 1982–87. ($10). Cum. index, author/subject index to articles, author/title index to book and serial reviews. 8½ x 11, 48p.
ISSN: 0730–7187. OCLC: 8046519. LC: Z5937.A19 Z674.2. Dewey: 026. Formerly: *ARLIS/NA Newsletter*.
General. Art Librarianship.

Bulletin has a two–fold mission: to encourage the discussion of issues relating to the documenting of art, and to report the activities of its sponsoring body, the Art Libraries Society of North America. Presents articles on topics of current interest in the field — including automation, technical and public services — some society news, lengthy book review section, publications of interest, reports of conferences and meetings, and annual conference proceedings. Regular columns on architecture, computers, cataloging, serials, visual resources, preservation, and professional literature.
Reviews: book 30 & journal 2, length 2000 wds. each. Bibliographies occasionally. Freelance work: none. Opportunities: study. Indexed: ArtBibMod. Des&ApAI. LibLit. RILA. Reviewed: Katz. *Library & Information Science Annual* 44, 1988, p.268–9.
Advertising: full page $300, ½ page $200, ¼ page $100, no color. No classified. Frequency discount. No agency discount. Kate Shanley, Ad. Director (521 Fifth Ave., New York, NY 10175, Phone 212–PL7–6454). Mailing lists: available. Demographics: art librarians, slide and photograph curators and art book publishers and art book dealers throughout the U.S., Canada, Mexico, Australia, New Zealand, Israel, Japan, and Western Europe. Circulation: 1300. Audience: professional art librarians and visual resources curators.

ART LIBRARIES JOURNAL/Revue de Bibliotheques d'Art/Zeitschrift fuer Kunstbibliotheken/Revista de Bibliotecas de Arte. 1976. q. EN, FR, GE, & SP. All articles accompanied by EN abstract. **85**
Art Libraries Society, Central St. Martins College of Art & Design, 109 Charing Cross Rd., London WC2H 0DU, England. Phone 071–437 0611x212. Philip Pacey, Editor (Lancashire Polytechnic Library, St. Peter's Square, Preston PR1 2TQ).
Subscription: included in membership to ARLIS/UK, £33 non–members (UK: Sally Bannard, Art and Design Library, Harrow College of Higher Education, Watford Rd., Northwick Park, Harrow HA1 3TP. Overseas: Deborah Shorley, The Library, University of Ulster, Belfast, BT15 1ED, UK). Microform available. Sample. Back issues £7. Illus. occasionally. Annual author/subject index in issue no.4. A4, 48p.
ISSN: 0307–4722. OCLC: 2591913. LC: Z675.A85 A78. Dewey: 026. Formerly: *ARLIS Newsletter*.
Librarianship. Libraries (Art and Design).

An international forum for art librarians and for all those whose interests include art librarianship, art libraries, art departments and art collections within libraries, and art documentation of all kinds including visual resources. Regularly includes conference papers of the IFLA Section of Art Libraries. Aims to provide regular current awareness of art bibliographies of all kinds including bibliographic databases. Contains articles on all aspects of art librarianship and art publishing, and offers a forum for discussion on new publications. Comments on the quality and content of slides, journals, tapes, new equipment and materials. It contains reviews of art bibliographies and books on art librarianship.
Reviews: book 4 & journal occasionally, length 1–3p. each. Limited to publications about art librarianship or art libraries, and art bibliographies or reference works. Bibliographies: regular column contributed by the IFLA Section provides current awareness of art bibliographies. Freelance work: Contributions are warmly invited. Contact: editor. Indexed: ArtBibMod. CloTAI. Des&ApAI. LibLit. LibSciAb. Reviewed: Katz. *Art Documentation* Spr 1987, p.42. *Library & Information Science Annual* 44, 1988, p.269.
Advertising: full page £82, ½ page £50, ¼ page £35, cover £90–100. 15% frequency discount. Inserts. Meg Duff, Ad. Director (The Tate Gallery Library, Millbank, London SW1P 4RG, phone 018211313 ext. 222). Mailing lists: none. Demographics: over 50% overseas, with subscribers in over 30 countries; over 50% of members are institutions: academic libraries, public libraries, special libraries and assorted art galleries, museums, booksellers, publishers, educational establishments and art organizations. Individual members are art librarians, lecturers, students and others with an interest in the art and design area. Circulation: 700. Audience: art librarians, visual resources, curators.

ART REFERENCE SERVICES QUARTERLY. 1991 (Sept.). q. EN. **86**
Haworth Press, 12 W 32nd St., New York, NY 10001. Phone 1–800–342–9678. Edward Teague, Editor.
Subscription: $18 individual, $24 institution, North America; $33.60 rest.
ISSN: 1050–2548. OCLC: 21431329.
Will contain articles about a wide range of reference issues focusing on the services needed in architecture and the visual arts. Pre–publication notice. Publication expected Fall 1991.
Reviews: book.

ARTS NEWSLETTER. 1985. s–a. EN. **87**
Association of College and Research Libraries, Art Section, American Library Association, 50 E. Huron St., Chicago, IL 60611.
Subscription: included in membership.
ISSN: 0886–2427. LC: Z675.A85 A878. Dewey: 026.

BULLETIN OF THE JOHN RYLANDS UNIVERSITY LIBRARY OF MANCHESTER. 1972. 3/yr. EN. **88**
John Rylands University Library, Manchester M13 9PP, England. C.D. Field, Editor.
Microform available from UMI. Illus. Cum. index.
ISSN: 0301–102X. OCLC: 1780973. LC: Z921.J643. Dewey: 017.1. Formerly: *John Rylands Library. Bulletin*.
Indexed: BHA. BrArchAb. CurCont. HistAb. RILA.

CARLIS NEWSLETTER. 1977. q. EN. **89**
Canadian Art Libraries, 2976 McBride St., Surrey BC V4A 3G6, Canada. Melva J. Dwyer, Editor.
No illus. 5½ x 8½, 13p.
ISSN: 0702–7249.
Contains news of people, recent publications, and exhibitions plus information regarding new periodicals and those which have ceased. Cites Canadian periodical articles of interest (5p. listings not reviews).

Reviews: book. Listings: international. Calendar of meetings.
Advertising: none.

FINE ARTS LIBRARY BULLETIN. 1965. 3/yr. EN. 90

University of Auckland, Fine Arts Library, Private Bag, Auckland, New Zealand. Phone 064–737–999 x8078. Valerie Richards, Editor.
Subscription: free or on exchange. Some back issues. Illus color, b&w occasionally; cover original design, designed by students of School of Fine Arts. A4, 24p.
ISSN: 0041–9400.
Art Bibliography.

Consists mainly of list of recent additions to the collection. "News and Notes" contains library events, staff changes, new publications, notable purchases, ARLIS/ANZ news, etc.
Freelance work: none.
Advertising: none. Mailing lists: none. Circulation: 140. Audience: University staff and students.

NEWS-SHEET / ARLIS, UK & EIRE. 1976. bi–m. EN. 91

Art Libraries Society, The Library, Polytechnic of East London, 89 Greengate St., London E13 0BG, England. Phone 081–590 7722 x3418. Judith Preece & Philippa Sutherland, Editors.
Subscription: included in membership, £1.50 members, £2.00 non–members (Pat Christie, Epsom School of Art, Ashley Rd., Epsom Surrey, KT18 5BE). Sample. Back issues. Illus. b&w, photos. A4, 14p.
ISSN: 0308–809X. OCLC: 15350369. LC: Z675.A85 A7. Formerly: *ARLIS Newsletter/Art Libraries Society News–Sheet.*
General. Art Librarianship.

News and announcements of interest to members of the Society. Includes Conference reports, selected gallery listings, publications news and A/V developments.
Bibliographies in every issue. General selection of art books, exhibition catalogues, artists books, and books on art librarianship. Listings: international. Exhibition information. Freelance work: yes. Contact: editor. Opportunities: study – anything in the subject area of art, architecture or design. Competitions.
Circulation: 500. Audience: art librarians working in the fields of art, architecture and design.

NEWSLETTER - INTERNATIONAL FEDERATION OF LIBRARY ASSOCIATIONS AND INSTITUTIONS, SPECIAL LIBRARIES DIVISION, SECTION OF ART LIBRARIES.
1981. 3/yr. EN. 92

International Federation of Library Associations and Institutions, Section of Art Libraries, Scott Library, York University, North York, Ontario M3J 1P3, Canada. Rosella Todros, Editor & Sec. (Biblioteca Marucelliana, Via Cavour 43, 50129 Florence, Italy).
Subscription: included in membership. Illus. b&w. A4, 8–12p.
ISSN: 0261–152X. OCLC: 9032960. LC: Z675.A85 I57x. Formerly: *Roundtable of Art Librarians Newsheet.*
News including upcoming conferences and new art library literature.
Bibliographies: "Professional Literature Update", column. Calendar of events. Opportunities: conferences.

VISUAL RESOURCES: VR: An International Journal of Documentation. 1980. q. EN & Western European languages. 93

Gordon and Breach Science Publishers, US: 50 West 23rd St., New York, NY 10010. UK: P.O. Box 90, Reading RG1 8JL England. Phone US: 212–206–8900. UK: 0734–560080. Helene E. Roberts & Christine L. Sundt, Editors.
Subscription: (available by 2 vol. block only) $72 members, $114 individual, $188 university & academic, $272 corporate (Marketing Dept., Box 786, Cooper Station, New York, NY 10276). Microform available. Illus. 7 x 10.
ISSN: 0197–3762. OCLC: 6017386. LC: N3998.V57. Dewey: 025.177.
Journal of the Visual Resources Association is devoted to the study of images and their use. Those images which depict architecture and works of art are of primary concern. The process by which these images are made, organized and ultimately utilized is investigated. The journal explores how visual language is structured and visual meaning communicated and also illustrates how picture collections are acquired, organized, indexed and preserved. Its scope delves into the past and looks toward the future. Examines early attempts to document the visual, reports on the state of visual resources, assesses the effect of electronic technology on the future state of visual materials, and provides a platform for the reporting of new ways to organize and access visual information.
Reviews: book. Indexed: ArtBibMod. RILA. Reviewed: Katz. *Library Journal* 113:14, Sept 1, 1988, p.150. *Art Libraries Journal* 13:2, 1988, p.32–36. *Art Documentation* Fall 1987, p.138–9.

VISUAL RESOURCES ASSOCIATION BULLETIN. 1974. q. EN. **94**
Visual Resources Association, University of Michigan, History of Art Dept., Ann Arbor, MI 48109–1357. Phone 313–7673–6114, fax 313–936–7787. Joy Blouin, Editor.
Subscription: included in membership, $25 North America, foreign air $50. Sample free. Back issues $5. Illus., few small b&w. Index. Cum. index every 5 years. 8½ x 11, 50p.
ISSN: 1046–8020. OCLC: 19653660. LC: N72.P5 I57. Dewey: 778.9. Formerly: *International Bulletin for Photographic Documentation of the Visual Arts; Mid–America College Art Association. Slides and Photographs Newsletter.*
Provides news of the association and articles presenting technical and cataloging information.
Reviews: journal. Exhibition information. Opportunities: study – conferences and workshops.
Advertising: (rate card Jl '87): camera ready copy only, full page $125, ½ page $70, ¼ page $35; covers full page $150–175, ½ page $85–100. Frequency discount. Mailing lists: available. Demographics: subscribers are individuals who have charge of slide and photograph collections in the U.S. and around the world. Circulation: 711. Audience: visual resources collections.

Opportunities for Artists

ARCHAEOLOGY ABROAD BULLETIN. See no. 404.

ARCHITECTS' EMPLOYMENT CLEARINGHOUSE. See no. 1935.

ARCHITEKTUR + WETTBEWERBE/ARCHITECTURE + COMPETITIONS. See no. 2005.

ART CALENDAR. 1986. 11/yr. EN. **95**
Box 1040, Great Falls, VA 22066–9040. Phone 703–430–6610. Carolyn Blakeslee, Editor.
Subscription: $29 2nd class, $39 1st class US; $40 Canada 1st class, foreign rates vary, write for information. Sample $4. Back issues $3.50. Illus. b&w, photos. Index. Cum. index. 8½ x 11, 40p.
ISSN: 0893–3901. OCLC: 15538688. Dewey: 705. Formerly: *Art Calendar/D C.*
General. Art Law. Marketing Strategies. Federal Updates.
A one–stop newsletter/directory listing the entire variety of upcoming opportunities available. A resource publication for visual artists, a comprehensive reference available to artists seeking timely information about upcoming professional opportunities and markets for their art. Lists are arranged chronologically by deadline within each category. Other features include articles on marketing strategies; legislative updates; a monthly competition for the *Art Calendar* cover; an illustrated column featuring artworks which have won awards or commissions; museums, galleries, and art consultants interested in reviewing portfolios; alternative spaces; residencies/artists' colonies; and publication opportunities. Provides up to four months lead time on deadlines.
Interviews: curators, etc —what they are look for. Listings: regional–international. Calendar of events. Exhibition information. Freelance work: Welcomes marketing how–to's; interviews with successful artists; and articles on business practice, managing one's career as a self–employed artist, and other topics of use to visual artists. Query first. Contact: editor. Opportunities: employment—positions open in the visual arts including professorships and other teaching posts; study—internships, grants, fellowships, scholarships and emergency funds available from foundation and government agencies; competitions—upcoming juried exhibitions, arranged chronologically by submission deadlines and by geographic area, for U.S. and foreign shows.
Advertising: full page $400, ½ page $275, ¼ page $200, no color. Classified: 75¢/wd. Frequency discount. Mailing lists: available. Demographics: nationwide US. Circulation: 10,000. Audience: visual artists.

ART CALL MAGAZINE. 1991. bi–m. EN. **96**
R.J. Publishing, 2888 Bluff St., Suite 397, Boulder, CO 80391. Phone 303–444–0636. Jean Pfleiderer, Editor.
Subscription: $14 practicing artist, $18 US, $32 Canada & foreign. Illus. 8½ x 11, 16p.
Primary goal is that of serving the needs of visual artists who are actively pursuing their careers in art. Focuses exclusively on open juried art shows, publishing the information necessary to bring these shows together with the artists to enter them. Offers announcements for open shows together with entry forms, workshop, grant, residency and fellowship announcements, and visual arts position announcements, all on a national level. Future issues to add articles and presentations of the art and artists in open shows in full color.
Freelance work: yes. Contact: editor. Opportunities: employment ads of a regional or national interest.

Advertising: ¼ page $75, other rates on request. Display ads for non–profit organizations advertising for entrants to open, competitive art shows are ½ regular non–profit rate. $25 prepaid for position announcements. Shari Van Alsburg, Ad. Director. Demographics: national distribution to artists, colleges, universities, art schools and art organizations. Circulation: 10,000+.

ARTIST UPDATE. 10/yr. EN. 97

Foundation for the Community of Artists, 280 Broadway, Suite 412, New York, NY 10007. Phone 212–227–3770. Troy Frank, Editor.

Subscription: $25. 8p.

Newsletter contains information for visual artists regarding opportunities available, member news and an artists bulletin. Includes notices of spaces available.

Calendar of events. Opportunities: study – workshops, seminars; competitions.

ARTIST'S MARKET: Where and How to Sell Your Artwork. 1979. a. EN. 98

Writer's Digest Books, 1507 Dana Ave., Cincinnati, OH 45207. Phone 513–531–2222. Susan Conner, Editor.

Illus. b&w, cartoons. Cum. index. 6 x 9½, 600p.

ISSN: 0161–0546. OCLC: 3818412. LC: N8600 .A76. Dewey: 380.1. Former title: with *Craftworker's Market*, supersedes: *Art & Crafts Market; Artist's and Photographer's Market; Artist's Market.*

Graphic Arts. Interior Design. Painting. Sculpture.

Directory listing over 2,500 places to sell art for ads, cartoons, graphic design, greeting cards, illustrations, fine art, prints. Also includes interviews with artists and art directors in each field that purchases freelance artwork. Provides detailed information containing specifications, tips, and interests of purchasers.

Interviews: artists and art directors in all fields. Listings: national. Freelance work: buy reprints of work published by freelancers. Contact: editor.

Advertising: none. Mailing lists: none. Audience: graphic and fine artists.

ARTISTS NEWSLETTER: AN. 1980. m. EN. 99

Artic Newsletters Publications, P.O. Box 23, Sunderland SR4 6DG, England. Phone 091 567 3889, Fax 091 510 9637. David Butler, Editor.

Subscription: £11 individuals, £20 institutions UK; £27.50 US & Canada; £18.50 Europe/Eire. Sample, free. Back issues £1.

Illus. b&w, photos. A4, 40–42p.

ISSN: 0261–3425.

General.

An information service providing substantial listings of opportunities for artists, craftspeople, photographers and performing artists, with the objective of supporting artists' practice, and to back their improved status and economic position. Also covers, business and working practices, art news and views. Listings cover opportunities available in the following areas: open exhibitions, exhibition, photography, international, competitions, commissions, awards and grants, scholarships, courses, fellowships, conferences, craft fairs, jobs, agents and craft retail outlets, studios (available for rent or sale), facilities available to artists, talks, events, and mail art.

Reviews: book & journal, "Publications Quarterly," 4p. every 3 months. Listings: regional–international. Freelance work: yes. Contact: editor. Opportunities: employment, study, competitions. Indexed: Des&ApAI.

Advertising: (rate card 1989): full page £350, ½ page £180, ¼ page £100, semi–display £7/col. cm., spot color +33%, small ads 23p/wd., min. £3.45, pre–paid [camera ready, V.A.T. +15%]. Frequency discount. 10% agency discount. Inserts. Catherine Thornhill, Ad. Director. Mailing lists: none. Demographics: readership 24,000. Readership surveys show that the listing of opportunities is the most valued section and the main reason for purchasing the newsletter. Circulation: 8000. Audience: practicing artists, craftspeople, photographers, performing artists, purchased by art colleges and visual arts administrators.

ARTISTS RESOURCE GUIDE TO NEW ENGLAND GALLERIES, GRANTS AND
SERVICES. a. EN. 100

Artist Foundation, Inc, 10 Park Plaza, Boston, MA 02116–3902. Phone 617–227–1787.

ARTQUEST NEWSLETTER & ARTQUEST UPDATE. See no. 1593.

ARTSEARCH: The National Employment Service Bulletin for the Performing Arts.

1983. 1–2/m. EN. 101

Theatre Communications Group, Inc, 355 Lexington Ave., New York, NY 10017. Phone 212–697–5230. Christina Colando, Editor.

Subscription: $48, foreign $52.
ISSN: 0730–9023. OCLC: 8006311. LC: PN1560.A7.
Job listing service for employment in the arts focusing on the performing arts. Each issue lists an average 250 positions in all the arts related fields. Categories include administration, artistic, education, arts management.

ARTSREVIEW. 1987. q. EN. 102
National Endowment for the Arts, 2401 E St., NW, Washington, D.C. 20506. Dodie Kazanijan, Editor.
Provides information on programs and grant deadlines.
Interviews.

DEADLINES. See no. 2047.

EMPLOYMENT OPPORTUNITIES. m. EN. 103
National Guild of Community Schools of the Arts, Box 8018, Englewood, NJ 07631. Phone 201–871–3337.
ISSN: 0046–1865. Dewey: 949.4.

ENTRY. See no. 2585.

FAIRS AND FESTIVALS IN THE NORTHEAST. See no. 1235.

FAIRS AND FESTIVALS IN THE SOUTHEAST. See no. 1236.

FREELANCE PHOTO NEWS. See no. 2599.

FREE-LANCE REPORT. 1931. fortn. EN. 104
John Liggins Ltd., Fleckney, Leicester, England.
ISSN: 0016–0377. Formerly: *Free–Lance Weekly*.
Market information for writers, artists and photographers.

FREE-LANCE WRITING & PHOTOGRAPHY. 1965. q. EN. 105
Weavers Press Publishing, Tregeraint House, Zennor, St. Ives, Cornwall TR26 3DB, England. Phone 0736–797061. John T. Wilson, Editor.
Subscription: £11.50. Back issues.
ISSN: 0016–0385. Dewey: 770. Formerly: *Free–Lance Writing*.
Photography.

GUIDE TO NATIONAL ENDOWMENT FOR THE ARTS. 1972. a. EN. 106
National Endowment for the Arts, Office of Communication, 1100 Penn Ave., N.W., Washington, DC 20506. Phone 202–682–5400.
Subscription: limited free distribution.
Dewey: 700. Formerly: *National Endowment for the Arts. Guide to Programs*.

NATIONAL CALENDAR OF OPEN COMPETITIVE ART EXHIBITIONS. 1968. q. EN. 107
5423 New Haven Ave., Fort Wayne, IN 46803. Phone 219–749–8014. Mildred Niles, Editor & Pub.
Subscription: $12 US & Canada. Sample $4. Back issues free. No illus. 9 x 7, 8p.
ISSN: 0889–003X. OCLC: 5880418. Dewey: 707.
Ceramics. Crafts. Drawing. Painting. Photography. Sculpture.

Directed to the creative professional artists/craftspeople interested in participating in juried, competitive exhibitions as sponsored by museums, art organizations, etc. Lists arts and craft exhibitions throughout the U.S. and Canada. Information includes exhibition dates, accepted media, entry deadlines, contact person, entry fee, etc.
Listings: national. Calendar of exhibitions and shows.
Advertising: none. Demographics: longest subscribers are big city libraries and big colleges and a few art organizations. Circulation: 1000. Audience: professional artists and craftspeople.

NFAA NEWSLETTER. See no. 1779.

PHOTOBULLETIN. See no. 2658.

PHOTOGRAPHER'S MARKET. See no. 2668A.

PHOTOMARKET. See no. 2688.

THE PHOTOLETTER. See no. 2685.

RESOURCE, THE NEWSLETTER FOR GRADUATE ART HISTORIANS. 1989. s–a. EN. **108**
Rutgers University, New Brunswick, NJ 08903. Phone 201–932–7041.
Subscription: included with subscription to *Rutgers Art Review*, $11 individual $9 student North America, + $2 foreign.
OCLC: 22883988. LC: N347.R42.
Art Education. Art History.

Alerts students to opportunities, events and information that will benefit them academically and professionally.

SUNSHINE ARTISTS U.S.A.: The Voice of the Nation's Artists & Craftsmen. 1972. m. EN. **109**
Sun Country Enterprises, Inc., 1700 Sunset Dr., Longwood, FL 32750–9697. Phone 407–323–5927/5937. Joan Wahl, Editor.
Subscription: $20 US, $28 Canada; foreign rates on inquiry. Sample $2.50 & back issues each. Illus. b&w, color, photos (25–30/issue), cartoons. 8½ x 11, 92–100p.
ISSN: 0199–9370. OCLC: 4895497.
Art Education. Ceramics. Crafts. Decorative Arts. Drawing. Graphic Arts. Jewelry. Painting. Photography. Sculpture. Textiles. Handmade Toys.

A magazine directed at artists, craftsmen, art schools, museums, galleries, colleges and craft shows with the express purpose of rendering marketing direction for arts and crafts. The prime editorial concern is to help the readers find places and opportunities to sell their products. Provides information concerning arts and crafts opportunities both in malls and outdoors. Reports from state reporters offer current events and news of arts and crafts in those states. Monthly ratings on show sales. Articles regarding displaying, taxes, pricing, insurance, etc.
Listings: regional–international. Calendar of events, 1000–1500 listings/issue, shows, exhibitions. Freelance work: yes, send query letter. Contact: editor. Opportunities: study, competitions. Reviewed: Katz.
Advertising: (rate card Jan '89): full page $495, ½ page $258, ¼ page $139, covers + 15–20%; spot color + $300 1 color, + $595 2 color; process color $1150. Classified: $1/wd., $22 min. Frequency discount. No agency discount. Angel Ross, Ad. Director. Mailing lists: none. Demographics: pass–on readership estimated at 50,000. Circulation: 15,000. Audience: artists, craftsmen & photographers earning with their talents.

VISUAL ARTISTS FELLOWSHIPS. 1983. a. EN. **110**
National Endowment for the Arts, Office of Communication, 1100 Penn Ave., N.W., Room 729, Washington, DC 20506.
Phone 202–682–5448.
OCLC: 18377254. Dewey: 700.79. Formerly: *Visual Arts*.
Application guidelines. Report covers fiscal year.

VISUAL ARTS. ORGANIZATIONS / National Endowment for the Arts. 1983. a. EN. **111**
National Endowment for the Arts, Office of Communication, 1100 Penn Ave., N.W., Washington, DC 20506. Phone 202–682–5448.
OCLC: 18154792, 9252748. Dewey: 700.68. Formerly: *Visual Arts Grants to Organizations*.
Application guidelines.

Fine Arts - General Works

A.S.A. ARTISAN. 1983. q. EN. 112
American Society of Artists, Inc, P.O. Box 1326, Palatine, IL 60078, Phone 312–751–2500.
Subscription: Included in membership.
ISSN: 0892–3582. OCLC: 15176732. Formerly: *A.S.A. Bulletin.*
Art Education. Ceramics. Crafts. Decorative Arts. Drawing. Painting. Photography. Sculpture. Textiles.
Information for and about members includes listing of shows and competitions across the nation together with galleries/shows that are seeking artists/craftspeople.
Listings: regional–national. Calendar of events. Opportunities: employment.

ACADEMIA NACIONAL DE BELLAS ARTES. ANUARIO. 1973. a. 113
Emece Editores S.A., Apdo. Especial Numero 84, 1000 Buenos Aires, Argentina.
Subscription: $120. Illus.
Dewey: 700.

ACASA NEWSLETTER. EN. 114
Arts Council of the African Studies Association, c/o Editor (University of Minnesota, Goldstein Gallery, 250 McNeal Hall, St. Paul, MN 55108). Maria Berns, Editor.
Subscription: included in membership. No illus. 8½ x 11, 12–24p.
Newsletter of African art and material culture. Information about news, exhibitions, research projects, publications, symposia, conferences, and other activities.
Listings: national. Exhibitions. Opportunities: employment.

AEROART. 1988. q. EN. 115
American Society of Aviation Artists, 15 W. 44th St., 9th Floor, New York, NY 10036. Phone 212–921–2473. Bernard Kent, Associate Editor.
Subscription: included in membership, $35, nonmembers $19.50 US, Canada & foreign + $US10. Sample $9. Limited back issues $9. Illus. color, photos. 8½ x 11, 4p.
Painting. Sculpture.
Official publication of the Society covers all forms of art related to aeronautics and space flight.
Reviews: book 3, length 1/2p. Interviews: famous artists profiles. Listings: national–international. Freelance work: yes. Contact: editor. Opportunities: study, annual forum; competitions.
Advertising: accepted. Contact Robert Rosenbaum, Ad. Director. Demographics: nationwide, galleries, artists, aviation historians, enthusiasts, etc. Circulation: 12,500.

ALLIANCE FOR CULTURAL DEMOCRACY—REGIONAL BULLETIN. 1980. bi–m. EN. 116
Alliance for Cultural Democracy, P.O. Box 7442, Minneapolis, MN 55407. Phone 617–423–3711. Judy Branfman, Editor.
Subscription: included in membership.
Newsletter describing community and political art programs with articles and news on cultural policy.
Advertising: none.

ALLIED ARTISTS OF AMERICA EXHIBITION CATALOG. 1914. a. EN. 117
Allied Artists of America, 15 Gramercy Park South, New York, NY 10003. Phone 212-582-6411.
Subscription: $3. Illus. photos. 5 x 7¾, 80p. Offset.
ISSN: 0065-6410. LC: N4390.A4. Dewey: 709.75.
Information in the catalog consists of a listing of artists' names, addresses, titles of paintings and sculpture appearing in the annual exhibition together with photographs of prize winning works.
Advertising. Catherine Ballantyne, Ad. Director. Circulation: 3000.

THE AMERICAN ART JOURNAL. 1969. q. EN. 118
Kennedy Galleries, 40 W. 57th St., 5th Floor, New York, NY 10019. Phone 212-541-9600. Jane Van Norman Turano, Editor.
Subscription: $35. Microform available from UMI. Illus. b&w. Index.
ISSN: 0002-7359. OCLC: 1000070. LC: N6505.A618. Dewey: 709.
General. Art History.
Scholarly journal devoted to American art of the 18th, 19th, and early 20th centuries. Articles on a wide range of topics cover painting, sculpture, prints, photography, the decorative arts, and cultural history.
Indexed: AmH&L. ArtBibCur. ArtBibMod. ArtHum. ArtI. BHA. CloTAI. CurCont. RILA. Reviewed: Katz.

AMERICAN ARTIST: The Leading Magazine for Fine Artists. 1940. m. EN. 119
Billboard Publications, Inc., 1515 Broadway, New York, NY 10036. Phone 212-764-7300, Fax 212-536-5236, Telex 710-581-6279. M. Stephen Doherty, Editor.
Subscription: $24.95 US, $US34.95 Canada & foreign. Microform available from B&H, UMI. Sample. Back issues $3. Illus. b&w, color, photos. Annual index. 10¾ x 8, 100p. Web offset.
ISSN: 0002-7375. OCLC: 1479320. LC: N1.A243. Dewey: 707. Formerly: *Art Instruction*.
General. Art Education. Drawing. Painting. Printmaking. Sculpture.
A magazine about figurative artists living in the United States, edited for those interested in how artists work: their inspiration, their techniques, their media. Service articles provide advanced and unusual methods by which artists can improve their skills and collectors can expand their knowledge of fine art. The magazine covers oil painting, watercolor, acrylics, drawing, sculpture and printmaking. Includes the *Annual Directory of Art Schools & Workshops*.
Interviews: profiles of contemporary realist artists. Calendar of exhibitions. Freelance work: yes. Contact: editor. Opportunities: study, in March issue. Indexed: ArtBibCur. ArtBibMod. ArtI. BioI. BkReI. RG. Reviewed: Katz.
Advertising: full page $6080, ½ page $3910, ¼ page $2210, 4 color $700-$900. Classified: (payment with order) $3.50/wd., $75 min. Frequency discount. 50% discount to art educators (museum, gallery, travel, book publishers, crafts and video advertisers). Gail Fishback, Ad. Director (212-536-5162). Kathleen Thomas, Classified (212-536-5165). Mailing lists: available. Demographics: 95% US, Canada 3.4%, foreign 1.2%. Circulation: 160,000. Audience: amateur and professional artists.

AMERICAN LIVING. 1982. q. EN. 120
Box 901, Allston, MA 02134. Phone 617-522-7782. Angela Mark & Michael Shores, Editors.
Subscription: $10 US, + $2 Canada & foreign, + $3 air. Sample. Back issues. Illus. b&w. 8½ x 5½, 32p.
Drawing. Graphic Arts. Collages.
Primarily a visual magazine consisting of original collages and drawings. Using few or no words, its theme, size and paper change with each issue. Usually printed on an array of color paper.
Freelance work: some. Contact: editor. Reviewed: Katz. *School*.
Advertising: none. Circulation: 150.

ANTICHITA VIVA. 1962. bi-m. IT, occasionally in EN. EN summaries (end of issue, 1p. total). 121
Casa Editrice Edam, Via Pier Capponi, 34, Florence, Italy. Phone 576.974. Dir. Pietro Milone.
Subscription: L 80,000 Italy, elsewhere L 95,000. Illus. b&w, glossy photos. Annual index. Cum. index 1962-88 (table of contents and author). 9¼ x 11½, 60p.
ISSN: 0003-5645. OCLC: 2166390. LC: N4.A257. Dewey: 709.
Art History.
Covers Italian art of all periods.
Reviews: book. exhibition. Indexed: ArtArTeAb. ArtBibMod. Avery. RILA.

APOLLO. 1925. m. EN. 122
Apollo Magazine Ltd., Anthony Law, Publisher, 22 Davies St., London W1Y 1LH, England. Phone 071-629 3061, Fax 071-491 8752. Anna Somers Cocks, Editor.

Subscription: £62 UK & Eire; overseas £66, $112 US & South America (air speeded only), £70 Canada (air speeded only) (US: PO Box 47, N. Hollywood, CA 91603–0047). Microform available from UMI. Sample free. Back issues £4.50 last 6 months, £5 last yr., £5.50 previous yrs. + £1.50 postage worldwide. Illus. b&w, some color, photos. 12 x 9⅜, 150p, off–set litho printed on quality art paper.
ISSN: 0003–6536. OCLC: 1481683. LC: N1.A255. Dewey: 705.
General. Antiques. Decorative Arts. Fine Arts.

An international magazine devoted to art and antiques. Articles, written by experts and lavishly illustrated, cover all periods from ancient Greece and Persia to the diverse movements of the twentieth century. In addition to paintings, sculpture and architecture, English, American and Continental furniture, Far East and Near Eastern art, silver, porcelain and pottery, glass, drawings, manuscripts and jewellery are just some of the subjects covered. Patronage and the history of particular collections are regularly featured in special issues. Also presents art market reports and profiles of leading people in the art world.
Reviews: book & exhibition, 10 each, variable length. Biographies of artists and craftsmen. Interviews: "Apollo Portrait".
Listings: international. Sales calendar for auction houses. Exhibition information. Freelance work: yes. Indexed: ArchPI. ArtArTeAb. ArtBibCur. ArtBibMod. ArtHum. ArtI. Avery. BHA. BioI. BkReI. CloTAI. CurCont. Des&ApAI. IBkReHum. RILA. Reviewed: Katz.
Advertising: (rate card 1988): b&w full page $972, ½ page $486, ¼ page $243; color full page $1400, ½ page $972, ¼ page $486. Frequency discount. 15% agency discount. Inserts. Mrs. Valerie Allan, US Ad. Director (10828 Peach Grove St., N. Hollywood, CA 91601, phone 818–763–7673). Mailing lists: none. Demographics: worldwide. Audience: collectors, dealers, academics, connoisseurs.

ARCHITECTURAL DIGEST. THE ARTS AND ANTIQUES ANNUAL. 1984. a. EN. 123
Knapp Communications Corp., 5900 Wilshire Blvd., Los Angeles, CA 90036.
Illus.
ISSN: 0743–5517. OCLC: 10595589. LC: N9.A377.
Antiques. Architecture.

ARISTOS: The Journal of Esthetics. 1982. bi–m. EN. 124
Aristos Foundation, Box 1105, Radio City Station, New York, NY 10101. Phone 212–678–8550. Louis Torres, Editor.
Subscription: $25, US, $US26 Canada, foreign air $US30, libraries $30. Sample $2. Back issues. Illus. b&w, photos. Annotated table of contents. Cum. annotated table of contents, no index. 8½ x 11, 6p.
ISSN: 0737–0407. OCLC: 9293173. Dewey: 701.
Architecture. Art Education. Art History. Drawing. Films. Juvenile. Painting. Sculpture.

Dedicated to the preservation and advancement of traditional values (as opposed to modernism) in the arts. Seeks to bring serious critical attention to neglected twentieth–century artists, both past and present, whose work reflects a concern with fundamental values and a high level of craftsmanship. In the visual arts *Aristos* advocates realism based on the close study of nature. Also covers architecture, the literary and performing arts and music. Concerned with the esthetic principles underlying the arts and with objective standards in criticism.
Reviews: book, journal, exhibition. Bibliographies: brief, following selected articles. Biographies. Interviews: occasionally.
Freelance work: yes. Contact: Michelle Marder Kamhi, Associate Editor. Reviewed: Katz. *Library Journal* May 15 1988.
Advertising: none. Mailing lists: none. Audience: general, academic, and specialized.

ART (Hamburg): Das Kunstmagazin. 1979. m. GE. EN Supplement (6p. insert). 125
Gruner und Jahr AG & Co., Warburgstrasse 50, 2000 Hamburg 36, West Germany. Phone 040–4118–1, fax 040 4118–2568, telex 21952–23. Axel Hecht, Editor.
Subscription: DM 144 Germany, Switzerland & Austria; DM 171 surface, DM 197,40 air, Europe; DM 177 surface, outside Europe, air DM 258 North America, Africa & Middle East; DM 290 Latin America & Far East; DM 322.80 Australia & New Zealand (Art Magazine, P.O. Box 101602, 2000 Hamburg 1). Back issues. Illus. (many full page) mainly color, photos. 8½ x 11, 192p.
ISSN: 0173–2781. Dewey: 701.18.
Sections include "Art before 1900", "Art after 1900", "Art today" (8 articles), exhibits, brief news, and columns on major European cities. The Supplement is a translation of the feature article, journal section, and news in brief.
Listings: national–international. Calendar of galleries. Indexed: ArtBibCur. ArtBibMod.

ART (Paris): Le Porte–parole de l'Artiste Professionnel. 1953. a. FR, EN, & SP. 126
Unesco, International Association of Art, 1 rue Miollis, 75015 Paris, France. Phone 33 1 568–10–00, fax 1 45675976. Dunbar Marshall–Malagola, Editor.
Subscription: free. Illus.

ISSN: 0004–5535. OCLC: 5202079. LC: N10.I482. Dewey: 705. Formerly: *International Association of Art. Information Bulletin.*
"The journal of the professional artist".

ART (San Francisco). 1988. q. EN. 127
The American Federation of Arts, 74 New Montgomery St., San Francisco, CA 94105. Phone 415–974–1230, fax 415–974–5121. Nancy Jones, Editor.
Illus. b&w, photos. 11 x 17, 12p.
A tabloid newsletter of a national not–for–profit art museum service organization.
Opportunities: competitions.

ART & ANTIQUES. See no. 1118.

ART AND AUSTRALIA. 1963. q. EN. 128
Fine Arts Press Pty. Ltd., 653 Pacific Highway, Suite 2, Killara 2071, Australia. Phone 02 498 4933, Fax 02 498 2775. Leon Paroissien & Jennifer Phipps, Editors.
Subscription: $A40 Australia, $A48 overseas. No sample. Back issues. Illus. b&w, color, photos. Annual index. Cum. index vol. 1–26. 242 x 225 mm. trim size, 160p., sheet–fed offset.
ISSN: 0004–301X. OCLC: 4087074. LC: N1 .A59. Dewey: 709.94. Formerly: *Art in Australia.*
General. Architecture. Art History. Decorative Arts. Drawing. Films. Modern Art. Museology. Painting. Photography. Printing. Sculpture.

Aims to keep its readers informed about the important aspects of the visual arts, particularly contemporary painting and sculpture, as well as the history of Australian art within an international context. Regular features include a report on the art scene in major city centers, a pictorial commentary in full–color of exhibitions over a quarterly period, written commentary including Australian art book reviews and short articles on issues relevant to contemporary art. "Art Directory" at the back of the journal includes recent and forthcoming exhibitions, major acquisitions by State galleries, art auction prices, gallery prices, art competitions, prize winners, and books received.
Reviews: exhibition 4, length 1500 wds.; book 2, length 800 wds. Biographies: monographs on artists. Interviews: occasionally. Listings: regional–international. Calendar of exhibitions, annually. Freelance work: none. Opportunities: study listed in ads, competitions. Indexed: ArtBibCur. ArtBibMod. Reviewed: Katz.
Advertising: (rate card Jan 89): full page $745, ½ page $525, ¼ page $325, color full page $970, covers + 10–33%. Classified. 5% frequency discount. 10% agency discount. Inserts. Ms. Anna Bosman, Ad. Manager. Mailing lists: available for lease. Demographics: 50% individuals and 50% institutional (schools, public libraries, teachers, colleges, universities, government), Australia and overseas. Circulation: 11,000. Audience: individuals and institutions.

ART AND CURSIOSITE. q. 129
International Confederation of Art Dealers, 20 Rutland Gate, London 5W7 1BD, England. Phone 071 5894128.
Demographics: members of national trade associations and federations in 13 countries.

ART AND PHILOSOPHY. 1983. irreg. EN. 130
Haven Publishing Corporation, Box 2046, New York, NY 10001. Hugh Curtler & Doug Bolling, Editors.
Illus.
OCLC: 13673126.

ART AND THE ARTIST. 1962. irreg. EN. 131
Academy of Fine Arts, 14–2 Old China Bazaar St., Calcutta 1, India.
Subscription: Rs 3. Illus.
OCLC: 1514263. LC: N1.A386. Dewey: 705.

ART CRITICISM. 1979. q. EN. 132
State University of New York at Stony Brook, Dept. of Art, Stony Brook, Long Island, NY 11794–5400. Donald Kuspit, Editor.
Subscription: $15 US, $17 outside US. 5¼ x 8½, 80p.
ISSN: 0195–4148. OCLC: 5518918. LC: N7475.A77. Dewey: 709.
Scholarly articles with notes and bibliographies. Covers all time periods.
Freelance work: yes. Contact: editor. Prospective contributors are asked to send abstract. Indexed: ArtBibMod. ArtHum.

Avery. CloTAI. CurCont. RILA.
Advertising: none.

ART IN AMERICA. 1913. m. EN. **133**
Brant Art Publications Inc., 575 Broadway, New York, NY 10012. Phone 212–941–2800, fax 212–941–2885. Elizabeth C. Baker, Editor.
Subscription: $39.95 US, + $20 US possessions & Canada, + $25 elsewhere (Art in America, 542 Pacific Ave., Marion, OH 43305). Microform available from UMI, B&H. Back issues (Lawrence McGilvery, PO Box 852, La Jolle, CA 92038). Illus. b&w, color, photos. Annual index. 9 x 10¾, 180–240p.
ISSN: 0004–3214. OCLC: 1514286. LC: N1.A43. Dewey: 705. Formerly: *Art in America and Elsewhere*.
A fine arts publication presenting a wide range of information, criticism and analysis covering the entire field of visual and performing arts – classics and future masters, contemporary American painting, sculpture, architecture, photography, theater and modern dance. Feature articles probe "beneath the surface" of great art, examining the relationship between artist's role in the changing society and the personal conflicts and convictions. Presents timely reviews of exhibitions and special reports on artworld happenings and developments here and abroad. "Art Services Directory" includes workshops and competitions. Articles about 50 pages, ads occupy good portion of journal. Exhibition reviews cover major cities (New York, Chicago, Los Angeles, San Diego, Washington, Seattle, London). Occasional special sections focus on an artist or country.
The August issue also contains the annual index. Articles and reviews are indexed by author as well as by artist and/or subject with an additional index for book reviews. The Guide is a comprehensive alphabetical listing, which contains more than 3500 annotated listings arranged by state and city, of U.S. museums, galleries, university galleries, nonprofit exhibition spaces, corporate consultants, private dealers and print dealers. It also presents the year in review and a museum preview for the coming year.
Reviews: book 3 signed, length½p. each; exhibition approx. 35, length½p. each with illustrations, mainly color. Obits. Opportunities: study – ads for schools; competitions – announces awards. Indexed: AmH&L. ArtArTeAb. ArtBibCur. ArtBibMod. ArtHum. ArtI. Avery. BHA. BioI. BkReD. BkReI. CloTAI. CurCont. Des&ApAI. HumI. RG. RILA. Reviewed: Katz. *Wilson* 63:3, Nov. 1988, p.118–119. *New Art Examiner* 14:1, Sept 1986, p.16–17; 16:6, Feb 1989, p.17–18; 16:10, Jun 1989, p.59–60.
Advertising. Gallery ads. Readers service card. Contact: Lee Weber, Margof Connors, Kathryn Jennings.

ART IN ISRAEL. 1989. q. EN. **134**
6 Laskov St., Tel Aviv 64736, Israel. Phone 03–264134, fax 03–258652 (US: The Soho Building, 110 Greene St., New York, NY 10012). Israel Perry, Editor.
58p.
Dewey: 700.
The magazine of art and culture.

ART MAGAZINE. 1971. q. EN. **135**
Federation of British Artists, 17 Carlton House Terrace, London SW1Y 5BD, England. Phone 071–930–6844. Bruce Wilson, Editor.
Formerly: *F.B.A. Quarterly*.

ART MONTHLY. 1976. 10/yr. EN. **136**
Britannia Art Publications Ltd., 36 Great Russell St., London WC1B 3PP, England. Phone 071–580 4168. Peter Townsend & Jack Wendler, Editors.
Subscription: $27.50 US, $US27.50 Canada & foreign. Sample free. Back issues. Illus. b&w, photos. Cum. index. A4, 40–48p.
ISSN: 0142–6702. OCLC: 4547163. LC: N1.A57. Dewey: 705.
Art Education. Art History. Films. Graphic Arts. International. Modern Art. Painting. Photography. Sculpture.
Carries criticism, reviews, articles about the art world; video, performance, salesrooms, art law, and artists' books also covered. Issued in an Australian and international edition with title: *Australian and International Art Monthly* beginning in 1987.
Reviews: exhibition 4, length 1000 wds.; book 1, length 1500 wds.; film 1, length 2000 wds. Interviews: with artists and dealers. Listings: London, national–international. Freelance work: yes. Contact: editor. Opportunities: study, competitions. Indexed: ArtBibCur. ArtBibMod. RILA.
Advertising: [camera ready copy, VAT extra] full page £400, ½ page £230, ¼ page £108, back cover £450, no color. Frequency discount. 10% agency discount. 5% pre–payment discount. H. Wendler, Ad. Director. Mailing lists: none. Circulation: 4000. Audience: artists, students, art trade, laypeople.

ART NEW ZEALAND. 1976. q. EN.

137

Art Magazine Press Ltd., Box 10–249, Balmoral, Auckland 4, New Zealand. William Dart, Editor.
Subscription: $NZ27.50. Illus.
ISSN: 0110–1102. OCLC: 5719053. LC: N7406.A74. Dewey: 709.
Reviews: book. Indexed: ArtBibCur. ArtBibMod. BHA.
Advertising.

THE ART QUARTERLY OF THE NATIONAL ART COLLECTIONS FUND. 1990. q. EN.

138

National Art–Collections Fund, 20 John Islip St., London SWIP 4JX, England. Phone 071–821 0404.
Subscription: included in membership. Illus.
OCLC: 22760673. Formerly: *NACF Magazine.*
Discusses art patronage in Great Britain.

ART SPECULATOR. 1984. m. EN.

139

P.O.Box 4526, Albuquerque, NM 87196–4526. Phone 505–843–7749. Dr. C.M. Flumiani, Editor.
Subscription: $10 US. Sample. 8½ x 11, 8p.
Art Education. Art History. Modern Art. Classical Art.
Reviews: book.
Advertising: none. Mailing lists: none.

ART&ARTISTS. 1982. bi–m. EN.

140

Foundation for the Community of Artists, 280 Broadway, Suite 412, New York, NY 10007. Phone 212–227–3770. Elliott Barowitz, Editor.
Subscription: included in membership $25; non–members $17.50 individual, $27.50 institution US; $19.50 Canada, foreign $21. Sample. Back issues $2. Illus. b&w, photos, cartoons. tabloid, 24p.
ISSN: 0740–5723. OCLC: 9105218. LC: N1.A7. Formerly: *Art Workers News; Art Workers Newsletter.*
General.
Dedicated exclusively to the dissemination of information of use and of interest to working artists. Articles, features, and editorials on current issues that affect artists in the areas of legislation, finances, funding sources, advocacy and service groups, arts management, and informational programs.
Reviews: book, Aug/Sept issue devoted entirely to book reviews of varying length. Freelance work: yes. Contact: Virginia Maksymowicz. Indexed: ArtBibCur. Reviewed: Katz. *School.*
Advertising: full page $450, back cover $506, ½ page $225, ¼ page $112, no color. No classified. No frequency discount. Virginia Maksymowicz, Ad. Director. Mailing lists: available. Demographics: distributed internationally. Circulation: 6000.
Audience: working artists and arts professionals.

ART-EXPO. 1984. a. GE only.

141

Gerd Braun, Weltanschaun, P.O. 427, CH 6340, Baar Oberneuholfstrasse 1, Switzerland.
Illus. color.
OCLC: 19258263. LC: N9.3.A77. Dewey: 705.
The international review of major exhibitions and events of the past year. Formerly published also in an English language edition.

ARTA. 1968. m. RO. RO & FR table of contents and summaries.

142

Uniunea Artistilor Plastici din Republica Socialista Romania, 42–44 Nicolae Iorga St., Bucharest, Romania. (Dist.: Rompresfilatelia, P.O. Box 12–201, Calea Grivitei 64–66, Bucharest). Vasile Dragut, Editor.
Subscription: 180 lei, $20. Illus., some color.
ISSN: 0004–3354. OCLC: 2069830. Formerly: *Arta Plastica Review.*
Reviews: book. Indexed: ArtBibMod. BHA.

ARTE. 1970. 11/yr.

143

Giorgio Mondadori e Associati S.p.A., Centro Direzionale, Palazzo Canova, 20090 Milan 2 – Segrate, Italy. Renato Olivieri, Editor.
Subscription: L 60000. Illus.
Dewey: 745.2. Formerly: *BolaffiArte.*
Indexed: ArtBibCur. ArtBibMod.

ARTE & CORNICE. 1984. q. IT. EN sum. 144
Editore Rima s.r.l., Via Luigi Barzini 20, 20125 Milan, Italy.
Subscription: L 28000.
ISSN: 0393–439X. Dewey: 700. Formerly: *Arte e Cornici.*

ARTES DE MEXICO. 1953, ns. 1988 (suspended 1982-87). q. SP. EN tr. (end of issue). 145
Artes de Mexico y del Mundo, S.A. Miembro numero 127 de la Camera Nacional de la Industria Editorial Mexicana, Tonala
90, Colonia Roma, 06700 Mexico D.F., Mexico. Phone 525–0083. Alberto Ruy Sanchez, Editor.
Subscription: $100. Illus. mainly color, photos. 8¾ x 12½, 96p.
ISSN: 0300–4953. OCLC: 1514326, 21576819. LC: N7.A768. Dewey: 709.972.
Articles on the art of Mexico contain many full page color illustrations. Certain issues are dedicated to important Mexican
museums.
Interviews. Bibliographies. Reviewed: Katz.
Advertising: none.

ARTEunesp: Universidade Estadual Paulista. 1985. a. POR. POR & EN table of contents. Brief abstracts in
POR and either EN or FR. 146
FUNDUNESP, Av. Rio Branco, 1210 Campos Eliseos, 01206 San Paulo SP Brazil. Phone 011–223–7088. Regis Duprat, Edi-
tor (Rua D. Luis Lasagna, 400 04266, San Paulo).
Subscription: $US30 US & Canada, (CGB/GFDC, Intercambio, Av. Vicente Ferreira 1278, Caixa Postal 603, 17500 Marilia
SP). Sample. Back issues $US30. Illus. b&w, photos. Annual subject index in EN & POR, author index. 6¼ x 9, 130p.
ISSN: 0102–6550. OCLC: 18592759. LC: NX7.A853. Dewey: 700.
Art Education. Art History. Drawing. Modern Art. Painting. Photography.
Major focus is on the art of Brazil covering all time periods and presenting its history, origin and style. Usually includes one
article on music. Publishes works written by teachers and researchers of the University and, exceptionally by other specialists
not from UNESP.
Reviews: book 2. Freelance work: none.
Advertising: none. Audience: specialists in the area.

ARTFUL REPORTER. 1977. 10/yr. EN. 147
North West Arts, 12 Harter St., Manchester M1 6HY, England. Phone 061–228–3062, fax 061–236–5631. Margaret Wyatt,
Editor.
Subscription: free.

ARTIFACTS: Monthly Fine–Art Magazine. 1991. m. EN. 148
Artifacts Ltd., 28, Buraimon St., Obanikoro, Lagos, Nigeria.
Illus.
OCLC: 24112946. LC: NX705.5N62A7.

ARTIS. 1949. 11/yr. GE. 149
Hallwag AG, Nordring 4, CH–3001 Berne, Switzerland. Phone 031–423131, fax 031–414123, telex 912661 hawa ch. Peter
Vetsch, Editor.
Subscription: SFr 68.40, DM 81, oS 576, elsewhere SFr 75. Illus. 62p.
ISSN: 0004–3842. OCLC: 9551310. LC: N3.S595. Formerly: *Speculum Artis.*
Interviews. Calendar of exhibitions.
Advertising. Theo Foffa, Ad. Director.

THE ARTIST Incorporating Art & Artists. 1931. m. EN. 150
Artist's Publishing Co. Ltd., Caxton House, 63–65 High St., Tenterden, Kent TN30 6BD England. Phone 05806–3673. Sally
Bulgin, Editor.
Subscription: $44 US, $55 Canada, £23 foreign. Sample & back issues, cover price + postage. Illus. b&w, some color, photos.
A4, 52p.
ISSN: 0004–3877. OCLC: 3290536. LC: N1.A815. Formerly: *Art & Artists.*
Art Education. Art History. Drawing. Modern Art. Painting. Sculpture.
Consists of educational/instructional articles contain practical information, product reports, materials, gallery guide, news,
views, and advice.

Reviews: exhibition, book. Interviews: with practicing artists featuring their working methods. Biographies: profiles of artists. Listings: national. Exhibition information. Freelance work: none. Opportunities: study, competitions. Indexed: ArtBibMod. ArtI. BioI. CloTAI. Reviewed: Katz.

Advertising: rate card on request. Penny Hunter, Ad. Director. Mailing lists: none. Circulation: 17,000. Audience: professional and amateur artists.

THE ARTIST'S MAGAZINE. 1984. m. EN. Also published in IT edition. 151

F&W Publications, Inc., 1507 Dana Ave., Cincinnati, OH 45207. Phone 513–531–2222. Michael Ward, Editor. Subscription: $24 US, Canada & foreign + $4 postage, air $35 (Box 2120, Harlan, IA 51593). Microform available from UMI. Sample & back issues $2.75. Illus. b&w, color, photos, cartoons. Annual index in Dec issue. 8½ x 11, 96–100p. offset lithography. saddle stitched.
ISSN: 0741–3351. OCLC: 10131531. Dewey: 740.
Art Education. Art History. Drawing. Graphic Arts. Painting.

Edited for the serious artist. The approach is instructional, based on step–by–step presentations in all major mediums. Includes practical and technical advice about tools, materials and techniques as well as marketing information. Also translated into Italian edition, *Disegnare & Dipingere*.

Reviews: book 50, length 200 wds. Listings: available only through classified ads. Freelance work: yes (details in *ArtMkt*). Contact: editor. Opportunities: study (annually in March issue); annual art competition. Reviewed: Katz. *Library Journal* 110:9, May 15, 1985, p.52.

Advertising: (rate card Sept '89): full page $4785, ½ page $3115, ¼ page $1725; color full page + $795, fractionals + $595. Classified: $120/inch, $3.50/wd. Frequency discount. 15% agency discount. 20% discount off b&w for crafts, museums, galleries, publishers, non–profit art associations and qualified graphic arts materials advertisers. Inserts. Gigi Grillot, Ad. Director (phone 800–543–2610). Mailing lists: available. Demographics: international magazine, 78% female, average age 51, income $40,288, 14 yrs. education. Circulation: 212,816. Audience: professional artists.

ARTISTAS ECUATORIANOS. 1976. irreg. SP, EN. 152

Ediciones Paralelo Cero, Box 1135, Av. 12 de Octubre 186, Quito, Ecuador. Dir. Hector Merino Valencia. Subscription: $30. Illus.
Dewey: 700.

ARTISTS NEWSLETTER: AN. See no. 99.

ARTnews. 1902. 10/yr. EN. 153

Artnews Associates, 48 W. 38th St., New York, NY 10018. Phone 212–398–1690. Milton Esterow, Editor & Pub. Subscription: $32.95 US, +$10 Canada & foreign (Artnews c/o FAI/Fulfillment Assoc., Inc., P.O. Box 969, Farmingdale, NY 11737). Microform available from UMI & B&H. Sample $5.50. Back issues $5.50 each + postage. Illus. b&w, color, photos, cartoons. 8½ x 11, 200p., Web–offset.
ISSN: 0004–3273. OCLC: 2392716. LC: N1.A6. Dewey: 705.
General.

International magazine dedicated to all aspects of the fine arts for those who make a business of art, or just plain art lovers. Monthly feature articles on artists, artistic movements past and present, as well as art market reports. Special departments include "Vasari Diary," "Artful Traveler," "Living with Art," "Design," "Perspective," and "Nation". Monthly array of previews, interviews, critiques, museum–quality reproductions. Classified section includes art for sale, business opportunities, services listings, exhibition information, and competitions.

Reviews: exhibition 15, length 1/2p.; book 10, length 1/4p. Interviews: with leading artists, art–historians critics, museum & gallery officials, educators, etc. Listings: regional–international. Freelance work: yes. Contact: Steven H. Madoff, Executive Editor. Opportunities: employment and competitions listed in classified section. Indexed: ArtArTeAb. ArtBibCur. ArtBibMod. ArtHum. Avery. BHA. BioI. BkReI. CloTAI. CurCont. Des&ApAI. IBkReHum. RG. RILA. Reviewed: *Wilson* 63:3, Nov. 1988, p.119. *New Art Examiner* 14:1, Sept 1986, p.16–17; 16:6, Feb 1989, p.151; 16:10, Jun 1989, p.59–60.

Advertising: (rate card Jan '89): b&w full page $3890, ½ page $2130, ¼ page $1220; 2 color full page $4500, ½ page $2740, ¼ page $1540; 4 color full page $5075, ½ page $3315, spread $9370; covers + $875–$1525. Bleed + 15%. Frequency discount. 15% agency discount. Inserts. Joel Kessler, Ad. Director. Mailing lists: available contact list broker: Media Marketplace (6 Penns Trail, P.O. Box 500, Newtown, PA 18940–0500 Phone 215–968–5020). Circulation: 77,390. Audience: consumer/business.

ARTVIEWS. 1972? irreg. EN. 154

Artists' Guild of Australia, 156 Banksia St., Pagewood, N.S.W. 2035, Australia.

Subscription: $A.40/issue.
ISSN: 0311–0095.

ASMA NEWS. 1978. q. EN. 155
American Society of Marine Artists, c/o Nancy Stiles, 91 Pearsall Pl., Bridgeport, CT 06604–3521. Phone 203–877–7305.
Jack Kennedy, Editor.
Back issues.
ISSN: 0192–5067. Dewey: 720.
Newsletter for marine artists.

BEAUX ARTS: Actualite des Arts. 1961. 11/yr. FR. EN summaries (4p. end of issue). 156
Editions Nuit et Jour, 9, rue Christiani 75018, Paris, France. Phone 49.25.17 17, telex 281–544F, fax 49251721. Jean–Noel
Beyler, Editor.
Illus. b&w, some color, photos. 8¾ x 11¼, 200p.
ISSN: 0757–2271. OCLC: 9739357. LC: N1.B43. Dewey: 705. Formerly: *Beaux Arts Magazine*.
Covers all Europe. Extensive advertising. Many illustrations. Extensive list of exhibits, museum shows, crafts.
Reviews: exhibition. Interviews. Listings: international. Calendar of events. Indexed: ArtBibCur. ArtBibMod. Reviewed:
Katz.
Advertising.

BILDENDE KUNST. 1947. m. GE. 157
Henschelverlag Kunst und Gesellschaft, Oranienburger Str. 67–68, 1040 Berlin, E. Germany.
Subscription: M 144. Illus.
ISSN: 0006–2391. OCLC: 2258339. LC: N3.B53. Dewey: 700.
Reviews: book. Indexed: ArtArTeAb. ArtBibCur. ArtBibMod. BHA. RILA.
Advertising.

BLOCK. 1979. irreg. EN. 158
Middlesex Polytechnic, Related Studies Office, Cat Hill, Cockfosters, East Barnet, Hertfordshire EN4 8HU, England. Phone
081–368 1299 x5024. (US: Ubiquity Dist., 1050 East 4th St., Brooklyn, NY 11230).
Subscription: £8 individual, £20 institution UK; overseas £10 individual, £20 institution. Limited back issues. Illus. b&w, pho-
tos, cartoons. 8½ x 11, 60–80p.
ISSN: 0143–3245. OCLC: 8044538. LC: AP1.B637.
Modern Art.

A journal devoted to the theory, analysis and criticism of art, design, and the mass media. Particularly interested in bridging
the gap between theory and practice and in discussion of relationship between different forms and media. Primary concern is
to address the problem of the social, economic and ideological dimensions of the arts in societies past and present. The inten-
tion is to stimulate debate around specific issues. Supported by the Arts Council of Great Britain.
Freelance work: yes, no payment. Contact: editor. Indexed: ArtBibMod. Des&ApAI. RILA.
Advertising. Rasaad Jamie, Business Manager. Audience: artists, art teachers and students and anyone interested in visual cul-
ture and its role within society.

THE BRITISH JOURNAL OF AESTHETICS. 1960. q. EN. 159
Oxford University Press, Pinkhill House, Southfield Road, Eynsham, Oxford OX8 1JJ, England. Phone 0865–882283. Dr.
T.J. Diffey, Editor (University of Sussex, School of Cultural & Community Studies, Arts Building, Falmer, Brighton, BN1
9QN).
Subscription: £40 UK, $75 US. Microform available from UMI. Sample available from publisher. Illus. b&w, photos. Index
in Autumn/Oct number. 6 x 9, 104p.
ISSN: 0007–0904. OCLC: 1537270. LC: BH1.B7. Dewey: 1.11.85.
General. Philosophy of Art.

A journal for the understanding of the principles of criticism and appreciation. Journal of the British Society of Aesthetics es-
tablished to promote study, research, and discussion of the fine arts and related types of experience from a philosophical, psy-
chological, sociological, scientific, historical, critical and educational standpoint.
Reviews: book 10+, length 900 wds. Freelance work: none. Opportunities: study. Indexed: ArtBibCur. ArtBibMod. ArtI.
CloTAI. CurCont. HumI. IBkRcHum. Philosopher's Index. RILA.
Advertising: rates available from publisher. Sarah L.M. Hobbs, Journals Co–ordinator. Audience: interdisciplinary academic
with bias towards philosophers.

CANADIAN ART. 1984. q. EN. 160
Key Publishers Co. Ltd., 70 The Esplanade, 4th Floor, Toronto, Ontario M5E 1R2, Canada. Phone 416–364–0044. Jocelyn Laurence, Editor.
Subscription: $20 Canada, $24 US, foreign $30 (MacLean Hunter, 777 Bay St., 7th Floor, Toronto, Ontario M5W 1A7). Microform available from Micromedia. Sample & back issues S6. Illus b&w, color, photos. 120p.
ISSN: 0825–3854. OCLC: 12045245. LC: N1. Dewey: 709. Formerly: *Arts Canada*.
Architecture. Drawing. Films. Furniture. Modern Art. Painting. Photography. Sculpture.

Focuses on the visual arts in Canada, including painting, sculpture, installation art, design, architecture, photography, film. Contains news, profiles, and other articles on a wide variety of topics, from historical to contemporary art, from conceptual and video art to painting and sculpture, all in a format that shows off art and artists/designers to their best advantage.
Freelance work: yes. Contact: Ellen Vanstone, Managing Editor. Indexed: ArtBibMod. CanMagI. CanPI. Reviewed: Katz.
Advertising: (rate card Fall 1989): b&w full page $3210, ½ page $2329, ¼ page $1738; color + $300–$600, 4 color full page $3894, ½ page $2740, ¼ page $2045. Madeleine Hague, Ad. Director. Mailing lists: available. Circulation: 20,000. Audience: gallery–goer, art collector, and general patron of the arts.

CAR/FAC NEWS / CANADIAN ARTISTS' REPRESENTATION. 1975. 3/yr. EN & FR on
 inverted pages. 161
Canadian Artists' Representation–Le Front des Artistes Canadiens, 189 Laurier E., Ottawa, Ontario, Canada K1N 6P1. Phone 613–235–6277, fax 235–235–7425. Greg Graham, Editor.
Subscription: included in membership. Illus.
ISSN: 0705–2650. OCLC: 8767135, 8767142. LC: N8350. Dewey: 706. Formerly: *C.A.R. News*.
Bilingual journal publishes news and articles of interest to Canadian visual artists. Both national and international subjects are covered. The aim of the Association is the improvement of the financial and professional status of all Canadian artists through research and public education.
Audience: professional artists.

CARIBE MAGAZINE: Visual Arts in the Caribbean. 1977. irreg. EN. 162
Caribbean Cultural Center, 408 W. 58th St., New York, NY 10019. Phone 212–307–7420. Marta Vega, Editor.
Subscription: $3/issue. Illus.
Dewey: 700. Formerly: *Pre–Columbian Research Resources Review*.
Explores the African diaspora and the cultures of all its descendants residing around the world.
Reviews: book.

CIELO DEI VICHINGHI. 1984. 3/yr. DA, EN & IT. 163
Institut of Actual Art, Taastrup, Denmark.
Subscription: Kr 150.
ISSN: 0109–7687. Dewey: 700.

CIRCA ART MAGAZINE. 1981. bi–m. EN. 164
CIRCA Publications Ltd., 67 Donegal Pass, Belfast BT7 1DR, N. Ireland. Phone 0232 230375. Mark Robinson, Editor.
Subscription: $16 individual, $25 institutions US & Canada, foreign £individual, £15.50 institutions. Sample £1.50. Back issues £2. Illus. b&w, color, photos, cartoons. A4, 46p.
ISSN: 0263–9475. OCLC: 9983837. LC: N6490.C555. Formerly: *Circa*.
General.

Only periodical in Ireland devoted exclusively to the visual arts. Includes film/media issues, news, interviews, articles, reviews, and art work.
Reviews: exhibition 10, book & film 1–2, length all 1,000 wds. each. Bibliographies: with long academic articles. Interviews: detailed interviews with artists, critics and art historians. Listings: all Ireland. Freelance work: yes. Contact: editor. Indexed: ArtBibMod.
Advertising: (rate card Mar 88, VAT extra): b&w full page £250, ½ page £100, ¼ page £75; spot color full page £295, ½ page £150, ¼ page £130; back cover b&w £250, full color £450. Inserts. Christine Hamill, Ad. Director. Circulation: 1,000. Audience: artists & art historians in Erie, UK, Europe and U.S.

CLARION: America's Folk Art Magazine. 1971. q. EN. 165
Museum of American Folk Art, 444 Park Ave., S. 4th Floor, New York, NY 10016–7321. Phone 212–481–3080. Didi Barrett, Editor.
Subscription: included in membership. Illus.

Journal of traditional and contemporary American folk art presents ideas on art and becoming artists.
Indexed: ArtArTeAb. ArtBibCur. ArtBibMod. ArtI. BioI. CloTAI. RILA. Reviewed: Katz. *Art Documentation* Spr 1986, p.19;
Fall 1986, p.132.
Advertising. Marilyn Brednner, Ad. Director.

CORREO DEL ARTE: Revista Mensual de las Artes Plasticas. 1980. 10/yr. 166
Movipress, S.A., Santa Engracia, 60 6 lzd., 28010 Madrid, Spain. Phone 22775899. Antonio Morales, Editor.
Subscription: 40000 ptas.
Dewey: 700.
Covers painting, sculpture, photography, design and architecture.
Indexed: ArtBibMod.
Advertising. Circulation: 5,000.

CRISS-CROSS ART COMMUNICATIONS. 1976. q. EN. 167
Criss–Cross Foundation, Box 2022, Boulder, CO 80306.
Illus. some color. 21 x 23 cm.
ISSN: 0270–6857. OCLC: 4186498. LC: NX1.C63. Formerly: *Criss–Cross Communications.*
Advertising.

DISEGNARE & DIPINGERE (D&D). 1984. m. IT. 168
Nuove Edizioni Internazionali, Via Pergolesi, 29, 20124 Milan, Italy. Phone 02–66987700. Pat Nesi, Editor.
Subscription: L 72000 Italy, foreign L 144000. Illus., b&w, color, photos, cartoons. Annual index. 8½ x 11, 96–100p. Offset
lithography, saddle stitched.
Dewey: 700.
Art Education. Art History. Drawing. Graphic Arts. Painting.

Edited for the serious artist. The approach is instructional, based on step–by–step presentations. Features selected artists and
their work methods. It includes practical and technical advice about tools, materials and techniques as well as marketing infor-
mation. Articles describe drawing, designing, and painting techniques. Translated edition of *The Artist's Magazine*.
Reviews: book 50, length 200 wds. Listings: available only through classified ads. Freelance work: yes. Contact: editor. Op-
portunities: study, annually in March issue; annual art competition.
Advertising: (rate card Sept. 1989): full page $1500, ½ page $800, ¼ page $400; color full page + $795, fractionals + $595.
Frequency discount. 15% agency discount. Advertisers in *The Artist's Magazine* eligible for volume discounts. 20% discount
off b&w for crafts, museums, galleries, publishers, non–profit art associations and qualified graphic arts materials advertisers.
Inserts. GiGi Grillot, Ad. Director (phone 800–543–2610). Mailing lists: available. Circulation: 50,000. Audience: profes-
sional artists.

DU: die Zeitschrift fuer Kunst und Kultur. 1941. m. GE. EN summaries. 169
Verlag Conzett und Huber AG, Baslerstr. 30, Postfach, 8048 Zurich, Switzerland. Phone 01–492 25 00. Wolfhart Draeger, Edi-
tor.
Illus.
ISSN: 0012–6837. OCLC: 3836381. LC: AP32.D78. Formerly: *Du–Atlantis.*
Journal of art and culture.
Indexed: ArtBibCur. ArtBibMod. ArtI. Avery. BioI.

DUTCH ARTS. 1985. irreg, 1–2/yr. EN. 170
Ministry of Welfare, Health, and Cultural Affairs, Directorate–General for Cultural Affairs, Postbus 5406, 2280 HK Rijswijk,
The Netherlands. Phone 31–70–3405755. Hugo Verschoor, Editor.
Subscription: free available through direct mailing and via Dutch embassies. Illus. b&w 10, color 50, photos. 50p.
General.

Information about and promotion of Dutch culture and art on behalf of a wide audience.
Freelance work: yes. Contact: editor. Indexed: Dutch National Index.
Advertising: none. Audience: general.

ESTETIKA/AESTHETICS. 1964. q. CZ. Table of contents in EN, FR, GE and/or RU. Multi-lingual summaries for
some articles. **171**
Academia, Publishing House of the Czechoslovak Academy of Sciences, Vodickova 40, 112 29 Prague 1, Czechoslovakia.
Phone 221–413. Antonin Sychra, Editor.
Subscription: DM 79. Illus. 130p.
ISSN: 0014–1291. OCLC: 2302050.
Bibliographies.

FMR. International. English edition. 1984. 10/yr. EN & IT editions published simultaneously. **172**
Franco Maria Ricci International, Inc, 130 1–4 E. 65th St., Suite 7C, New York, NY 10021. Phone 212–794–0080, fax 212–
734–6189. Franco Maria Ricci, Publisher and Art Director.
Subscription: $90 US, $100 Canada, £51, L120,000, DM 165, FS 144 (US: Box 906, Farmingdale, NY 11737–9806. UK: 16
Royal Arcade, London W1X 3HB, phone 71–4998363, fax 71–4910662. Others: FMR Editore S.p.A., Via Montecuccoli 32,
Milan, Italy). Illus. 5–color. 9 x 11¾, 144p.
ISSN: 0747–6388. OCLC: 10764669 (EN ed.). 8956598 (IT ed.). LC: N4.F583. Dewey: 705.
The magazine of Franco Maria Ricci. Beautiful all full page color illustrations. Published in Milan, Italy and the U.S. Exten-
sive international calendar lists exhibitions by country providing museum, exhibition title and dates and a brief description.
Listings: international. Calendar of events. Indexed: ArtBibMod. Avery. Des&ApAI. Reviewed: Katz. *Art Documentation*
Sum 1986.
Advertising on covers only.

FOLK ART FINDER. 1980. q. EN. **173**
Gallery Press, 117 North Main St., Essex, CT 06426. Phone 203–767–0313. Florence Laffal, Editor.
Subscription: $12 US, $14 Canada, foreign $18. Sample $4. Back issues (photocopies) $4–$4.50. Illus b&w, photos. 5½ x
8½, 20p.
ISSN: 0738–8357. OCLC: 8067457. LC: N5312.F6.
Folk Art.

The leading source of information on 20th century American folk art. The aim of the newsletter is to foster an exchange of in-
formation among artists, collectors, galleries, and museums in the field of folk art. Contains feature stories on 20th century
folk artists, a reader's exchange, and news items. The "Sketches" column introduces new folk artists. Information about im-
portant exhibitions both nationally and internationally. Special areas of interest are state and regional shows, black folk art,
bloutsider art, and environmental art. The newsletter also addresses such topical issues as folk art preservation, laws affecting
the arts, and funding for the arts.
Reviews: exhibition 2–3, length 5p.; book 1–2, length 1–2½p.; film occasionally. Biographies: articles on folk artists in each
issue. Listings: national. Calendar of events. Exhibition information. Opportunities: study, competitions. Reviewed: *Art Docu-
mentation* Fall 1986, p.132.
Advertising: (camera–ready) full page $180, ½ page $90, $15/col. inch. Classified: 50¢/wd., $10 min. 10% frequency dis-
count. Audience: collectors, galleries, museums, artists in the field of folk art.

FOLK ARTS QUARTERLY. 1983. q. EN. **174**
Hebitage Farm, Richmond, NH 03470. Phone 603–239–6231. Barbara R. Rogers, Editor.
12p.

FORUM. s–a. EN. **175**
Society of Bead Researchers, Canadian Parks Service, 1600 Liverpool Ct., Ottawa, Ontario, Canada K1A 0H3. Phone 613–
993–9717.
Aim is to further research on beads of all periods and to disseminate the results of this research.
Audience: archaeologists, museologists, and collectors.

IL GIORNALE DELL'ARTE: Mensile di Informazione, Cultura, Economia. 1983. m. IT. **176**
Societ'a Editrice Umberto Allemandi & C. srl, 8 via Mancini, 10131 Turin, Italy. Phone 011–8825567. Umberto Allemandi,
Editor.
Subscription: L 60000. Illus.
ISSN: 0394–0543. OCLC: 9739371. LC: N6911.G55.
Also published in English edition as *Journal of Art*.

GNSI NEWSLETTER. 1969. 10/yr. EN. 177
Guild of Natural Science Illustrators, Inc., Box 652, Ben Franklin Station, Washington, DC 20044. Greg Lum, Editor.
Subscription: included in membership. 8½ x 11, 12p.
ISSN: 0199–5464. OCLC: 5978832.
Contains news of Guilds activities as well as information of interest to members. Examples of members' works are included.
Reviews: book. Freelance work: yes. Opportunities: study.
Audience: professional scientific illustrators and technical artists.

GOYA: Revista de Arte. 1954. bi–m. SP only. 178
Fundacion Lazaro Galdiano, Serrano 122, 28006 Madrid, Spain. Phone 563–55–35. Dir. Enrique Pardo Canalis.
Subscription: 3.500 ptas. Spain & Portugal, elsewhere $US50. Illus. b&w, some color, photos. 9¼ x 12¼, 62p.
ISSN: 0017–2715. OCLC: 1605491. LC: N7.G6.
Architecture. Art History. Decorative Arts.
Scholarly articles, richly illustrated covering all periods of Spanish art, painting, sculpture, and architecture.
Reviews: (international) book, exhibition. Calendar of events. Indexed: ArtBibCur. ArtHum. ArtI. Avery. BioI. CurCont.
RILA. Reviewed: Katz.
Advertising on back cover only.

THE GPA IRISH ARTS REVIEW YEARBOOK. 1984. a. EN. 179
Eton Enterprises Ltd., Stokes House, College Square East, Belfast BT1 6HD, Northern Ireland. Brian de Breffny, Editor.
Illus. some color.
ISSN: 0791–038X. OCLC: 19988829. LC: N6782.G63. Dewey: 709. Formerly: *Irish Arts Review*.
An international magazine for connoisseurs.
Indexed: ArtBibMod. RILA.

HOOFSTRIKES NEWSLETTER. q. EN. 180
Horseback Writers and Artists, International, P.O. Box 106, Mt. Pleasant, MI 48858.
Formerly: *Horseback Writers International*.
Newsletter for artists and writers who works depict horses.

IKONENKALENDER. a. 181
Verlag Aurel Bongers, Dortmunder str.67, Postfach 100 264, 4350 Recklinghausen, W. Germany.
Subscription: DM 34. Illus.
Dewey: 700.
Calendar of events.

THE ILLUSTRATOR. 1916. s–a. EN. 182
Art Instruction Schools, 500 S. Fourth St., Minneapolis, MN 55415. Phone 612–339–8721. Dr. Don L. Jardine, Editor.
Subscription: $4. Illus. 8½ x 11, 4p.
ISSN: 0019–2465. OCLC: 7352095. LC: NC997.A1I62a. Dewey: 741.6.
Presents articles on art, advertising art, illustration, cartooning, painting, designing, sculpture, lettering, and photography.
Reviewed: Katz. *School*.
Advertising. Circulation: 70,000.

InSight. 11/yr. EN. 183
Artnet, 5757 Friendship Station, Washington, DC 20016–1356. Phone 202–364–4331.
Subscription: included in membership.
Newsletter available to members only.
Advertising.

INTERNATIONAL ART BULLETIN. q. EN, FR, GE, & IT. 184
International Art Guild, 218–221, palais de la Scala, MC–98000 Monte Carlo, Monaco. Phone 93 256614.

THE INTERNATIONAL REVIEW OF AFRICAN AMERICAN ART. 1976. q. EN. 185
Oxum International, 3000 Biscayne Blvd., Suite 505, Miami, FL 33137. Phone 305–573–2343. Samella Lewis, Editor.

Subscription: $20 US & Canada, foreign $US25. Microform available from University of Michigan/Black Art. Sample free. Back issues $5. Illus. b&w 15, color 15, photos. Index. 8½ x 11, 64p., perfectbound.
ISSN: 0145–8116. OCLC: 10955508. LC: NX164.N4B5. Formerly: *Black Art, An International Quarterly.*
General.

Devoted exclusively to featuring the visual arts of African Americans. Has as its primary focus the United States but also gives considerable attention to the Caribbean and South America. An educational journal which documents written and visual information on the works of contemporary artists, and provides extensive, comprehensive presentation of the art of Black cultures. Editorial material derives from the Black Diaspora.

Interviews: artists—visual and performing. Biographies: visual artists of historical importance. Freelance work: yes. Contact: editor. Indexed: ArtBibMod. ArtHum. CurCont. Reviewed: Katz.

Advertising: (rate card '86): b&w full page $975, ½ page $510, ¼ page $275 spread $1850; 2 color full page $1225, ½ page $700, spread $2325; 4 color full page $1475, ½ page $750, spread $375015% agency discount. 2% cash discount. Mailing lists: none. Demographics: subscribers include professionals, artists, students, critics, collectors, libraries, and museums throughout the U.S., the Caribbean, Central America, South America, Europe, Africa, and the Orient. Circulation: 8000. Audience: art interest/national and international.

THE JOURNAL OF AESTHETICS AND ART CRITICISM. 1942. q. EN. 186
University of Wisconsin Press, 114 N. Murray St., Madison, WI 53715. Phone 608–262–4950. Dean Donald Crawford, Editor (Dept. of Philosophy, University of Wisconsin–Madison, 600 N. Park St., Madison, WI 53706).
Subscription: included in membership, $30 US, $C42 Canada; student $15 US, $30 Canada; foreign $35. Microform available from UMI. Sample free. Back issues $10. Illus. b&w. Annual index. 7 x 9½ 105p., offset.
ISSN: 0021–8529. OCLC: 1800235. LC: N1.J6. Dewey: 701.1.
Architecture. Art History. Decorative Arts. Films. Landscape Architecture. Painting. Sculpture.

Published by the American Society for Aesthetics at the University of Wisconsin–Madison and the University of Alberta, Edmonton, Canada. An interdisciplinary journal which promotes study, research, discussion and publication in aesthetics. Publishes current research articles and reviews of books in aesthetics and the arts as well as work dealing with the theoretical interfaces of the arts and other disciplines, both humanistic and scientific. "Aesthetics" is understood to include all studies of the arts and related types of experience.

Reviews: book 8, length 2–3p. Indexed: ArtBibCur. ArtHum. ArtI. BkReI. CurCont. HumI. IBkReHum. RILA. Reviewed: Katz.

Advertising: (rate card Jan '89): full page $225, ½ page $120, cover $250, no color. No classified. Frequency discount. No agency discount. Adrienne Omen, Ad. Director (phone 608–262–5839). Mailing lists: none. Circulation: 2,700. Audience: academics in Philosophy, English Literature, Comparative Literature, Art, Music, Theatre & Drama, Art History & Law.

THE JOURNAL OF ART: The Definitive Art Periodical. 1988. 9/yr. EN. 187
The Journal of Art Enterprises, Inc., 140 Sullivan St., New York, NY 10012. Phone 212–598–0417, fax 212–353–8941. Barbara Rose, Editor–in–chief.
Subscription: $40 US, $US55 Canada & foreign (P.O. Box 693, New York, NY 10013–0693. Phone 1–800–937–2131). Sample. Back issues. Illus. b&w, photos. Cum. index. 11 x 15, 64–88p.
ISSN: 1044–9140. OCLC: 19415753. LC: NX1.G56. Dewey: 705.
Antiques. Archaeology. Art History. Modern Art. Museology. Painting. Photography. Sculpture.

Journal of news, culture, economics and auctions. Tabloid format with two sections, the first contains news and articles including a special report. The second section, "Economics", consists of articles and market information summarizing auction results worldwide. International edition of *Giornale dell' Arte.*

Reviews: exhibition & book, 2–3 each. Interviews: members of art community. Listings: international. Auctions, exhibition. Freelance work: yes. Contact: Daniela Giuglielmino. Indexed: ArtBibMod. Avery. Reviewed: *Art Documentation* Sum 1989, p.82. *Small Press Review* 7:5, Oct 1989, p.280. *New Art Examiner* 16:11, Sum 1989, p.57–58.

Advertising: full page $5000, ½ page $2500. Commercial rates write or call for "gallery rates". Frequency discount. Michael Benevento, Ad. Director. Circulation: 10,000. Audience: anyone interested in art.

JULIET ART MAGAZINE. 1980. bi–m. IT. EN tr. feature article (1p.) EN summaries (2p.). 188
Associazone Juliet, via della Guardia 16, 34137 Trieste, Italy (US dist.: Ubiquity, 1050 E 4th St., Brooklyn, NY 11230). Phone 040/9478333, fax 040/9478333. Roberto Vidali, Editor (via Belpoggio 13, 34123 Trieste).
Subscription: L 35.000 Italy, elsewhere L 60.000, $US55. No sample. Back issues, cover price. Illus. b&w, color, photos, cartoons. 8¼ x 10½, 84p.
Architecture. Modern Art. Photography. Design. Dance. Theater.

Contains reports on artists in Italy and Europe with illustrations of their works.

Interviews: artists, designers gallerists, art critics. Listings: national–international. Calendar of events. Exhibition information. Freelance work: yes. Contact: Gabriella Gabiella. Indexed: ArtBibMod.
Advertising: full page $1.200, ½ page $650, ¼ page $400; 4 color: full page $1,500. Frequency discount. Rolan Marino, Editor.

KRITISCHE BERICHTE. 1973. q. GE. 189
Jonas–Verlag, Rosenstr. 12–13, D–3550 Marburg, W. Germany. Phone 06421–63773.
Subscription: DM 50, foreign DM 55. Illus.
ISSN: 0340–7403. OCLC: 1964601. LC: N3.K75. Dewey: 709.
Zeitschrift fuer Kunst– und Kulturwissenschaften.
Reviews: book. Indexed: ArtBibMod. Avery. BHA. RILA.

DIE KUNST. 1899. m. GE. EN summaries occasionally. 190
Karl Thiemig AG, Pilgersheimer Str. 38, 8000 Munich 90, W. Germany. Antonie Modes, Editor.
Subscription: DM 120. Illus. color; beautifully done.
Dewey: 700. Formerly: *Die Kunst und das Schoene Heim.*
Indexed: ArtBibCur. ArtI. Avery. BioI.
Advertising.

KUNSTCHRONIK: Monatsschrift fuer Kunstwissenschaft, Museumswesen und Denkmalpflege.
1948. m. 191
Verlag Hans Carl GmbH, Breite Gasse 58–60, Postfach 9110, 8500 Nuremberg 11, W. Germany. Phone 0911–2383–0. P. Diemer, Editor.
Subscription: DM 44. Illus.
ISSN: 0023–5474. LC: N3. Dewey: 069.
Journal of art, science, and memorial care. International in scope, contains news of museums, exhibitions, research and congresses.
Obits. Indexed: ArtArTeAb. Avery. RILA.
Advertising.

KURIO AFRICANA: Journal of Art and Criticism – Focus on Contemporary Nigerian Arts. 1989.
s–a. EN & YORUBA. 192
Ona Artists, Dept. of Fine Arts, Obafemi Awolowo University, Ile–Ife, Nigeria. Moyo Okediji, Editor.
Subscription: US $20, air + $5. Sample fee. Back issues. Illus. b&w. 9½ x 7½, 140p.
ISSN: 0795–8560.
General. Modern Art.

Focuses on African art, particularly the visual arts. Also featured is African art in the diaspora as well as ethnic studies of African art.
Reviews: exhibition, book, journal or film, length 2p. each. Interviews: with African artists. Biographies: biographical or autobiographical articles on African artists. Listings: international. Calendar of events. Freelance work: yes. Contact: editor. Ethnic studies of African art are most welcome. Illustrations are not encouraged. If included, are b&w only. Opportunities: study, competitions.
Advertising: none.

LANTERN. 1952. q. AF or EN. 193
Foundation for Education, Science and Technology, Box 1758, Pretoria 0001, South Africa. Riena van Graan, Editor.
Subscription: R 16. Illus.
ISSN: 0023–8422. OCLC: 2361847. Dewey: 052.
Journal for art, knowledge and culture.
Indexed: ArtBibMod.

LATIN AMERICAN ART: An International Magazine. 1989. q. EN. 194
Latin American Art Magazine, Inc., Box 9888, Scottsdale, AZ 85252. Phone 602–947–8422, fax 602–947–8497.
Subscription: $24 individual, $36 institution US; foreign $36 individual, $48 institution. Illus.
ISSN: 1042–9808. OCLC: 19275113. LC: N6502.L37. Dewey: 709.
Covers a wide variety of Latin American art of all time periods.

LOG OF THE BRIDGETENDER. q. EN.

195

Friends in Art of American Council of the Blind, c/o American Council of the Blind, 1155 15th St., NW, Suite 720, Washington, DC 20005. Phone 1–800–424–8666.

Newsletter promotes access to the arts by blind and visually impaired persons.

MARG. 1947. q. EN.

196

Marg Publications, Army–Navy Bldg., 3rd floor, 148 Mahatma Gandhi Rd., Fort, Bombay 400 023, India. Phone 242520. Ms. Radhika Sabavala, Editor.

Subscription: Rs 295. Illus. b&w, some color.

ISSN: 0025–2913. OCLC: 1756680. LC: N1.M46. Dewey: 700.

Art History.

All arts and time periods of India are covered. Occasionally issues are devoted to a single theme or area.

Reviews: book. Indexed: ArchPI. ArtBibMod. ArtI. CloTAI. Reviewed: Katz.

Advertising.

MEXICO EN EL ARTE. 1983. q. SP only.

197

Reforma Y Campo Marte, S/N 20 Piso, Modulo "A", 10590 Mexico City D.F., Mexico. Phone 5.20.90.60. Felipe Garrido, Editor.

Illus. b&w, photos. 8¼ x 10¾, 92p.

ISSN: 0185–4569. OCLC: 12782541. LC: N7.M42.

Advertising: none.

MISHKAFAIM. 1987. q. HE only.

198

Yedioth Ahronot, 5 Mikunis St., Tel Aviv 67772, Israel. Phone 03–380355. Tamir Rauner, Editor (Israel Museum, Youth Department, Jerusalem 91012).

Subscription: 30 sh. back issues. Illus., color, photos, cartoons. 22.7 x 30 cm., 62–80p.

ISSN: 0334–9810. Dewey: 028.5.

Juvenile.

Published in cooperation with the daily newspaper *Yedioth Ahronot*. By courtesy of the British Friends of the Art Museums of Israel.

Freelance work: yes. Contact: editor.

Advertising. Dalia Shlonsky, Ad. Director.

MOSAICO. a. EN & IT.

199

International Association of Contemporary Mosaicists, Via di Roma 13, I–48100 Ravenna, Italy. Phone 544 23935.

Newsletter which promotes the art of mosaics.

NAAO NEWSLETTER. bi–m. EN.

200

National Association of Artists Organizations, 918 F St., N.W., No.502, Washington, DC 20004. Phone 202–347–6350. 11½ x 14½, 12p.

Tabloid serves as a clearinghouse for information on legislation and activities of interest to art organizations. Advocacy for artist–run and directed contemporary art organizations.

Audience: contemporary art centers and individuals committed to supporting artists and their work.

NAPLES. ISTITUTO UNIVERSITARIO ORIENTALE. SEZIONE ORIENTALE. ANNALI.

1928. q. EN & IT.

201

Istituto Universitario Orientale, Sezione Orientale, Piazza San Giovanni Maggiore 30, 80134 Naples, Italy.

Contains articles on art, archaeology, literature and history.

NASAA NEWS. 1981. q. EN.

202

National Assembly of State Arts Agencies, 1010 Vermont Ave., N.W., Suite 920, Washington, DC 20005. Phone 202–347–6352.

Subscription: included in membership, $35.

ISSN: 8756–0925. OCLC: 9443652. LC: NX1.N18. Dewey: 700.

Newsletter on art education and policy including articles on legislation and economics affecting the arts. Contains articles clipped from national publications.

Reviews: book. Opportunities: employment.
Advertising: none.

NATIONAL ART MUSEUM OF SPORT NEWSLETTER. 1962. s–a. EN. 203

National Art Museum of Sport, 108 N. Pennsylvania St., 12th Floor, P.O. Box 44002, Indianapolis, IN 46204. Phone 317–687–1715. Russell Sullivan, Editor.
Subscription: included in membership. Illus., b&w, photos. 8½ x 11, 4–6p.
Dewey: 796.
Devoted to sports of all kinds as depicted in art works. Includes news, information on art lent by the Museum for exhibitions, new acquisitions, and photos of new works and artist.
Calendar of events. Freelance work: yes. Contact: editor.

NATIONAL ARTISTS EQUITY NEWS. 1983. q. EN. 204

Artists Equity Fund, Inc., P.O. Box 28068, Central Station, Washington, DC 20038. Phone 202–628–9633. Olive Mosier, Editor.
Subscription: included in membership.
Newsletter providing news of membership activities together with information concerning the professional welfare of visual artists, particularly on economic and legal matters.
Advertising.

NEW ENGLISH ART CLUB. a. EN. 205

17 Carlton House Terrace, London SW1Y 5BD, England.
Dewey: 701.18.

THE NEW YORK SPANNER. 1978. s–a. EN. 206

Aloes Books USA, Box 5, Canal St. Station, New York, NY 10013. Dick Miller & Terry Slotkin, Editors.
Illus.
OCLC: 8094532. LC: AP2.N658.
General.

NEWSLETTER / RESEARCH CENTRE FOR ISLAMIC HISTORY, ART AND CULTURE.

 1982. q. AR, EN, & FR. 207
Research Centre for Islamic History, Art and Culture, P.O. Box 24, Besiktas, TR–80692 Istanbul, Turkey. Phone 1–1605989, fax 1–1584365.
Illus.
OCLC: 14991347.
Studies the common cultural legacy of Islamic countries in order to foster understanding among Muslims.
Demographics: scholars and university students in 46 countries.

NOTIZIARIO D'ARTE. 1949. bi–m. IT. EN, FR and GE summaries. 208

Ennio Francia Editor & Pub., Via del Babuino 197, Rome, Italy.
Subscription: L 2000. Illus.
ISSN: 0029–4322. Dewey: 700.

THE ORIGINAL ART REPORT. 1967. irreg. EN. 209

Box 1641, Chicago, IL 60690. Phone 312–588–6897. Frank Salantrie, Editor & Pub.
Subscription: $15.50/12 issues, $9.95 all artists, $3.95 trial 3 issues $US, + postage Canada & foreign. Group rates available, 25 min. mailed directly to members or bulk to one address. Sample $1.29 + postage. Back issues $2.50 each. No illus. 8½ x 11, 6–8p.
ISSN: 0030–5529. OCLC: 5284208. LC: N1.O78. Dewey: 700.
"Committed to the preservation, comprehension, and progress of artists and art". Examination and analysis of visual arts condition from artists' and publics' perspectives. Opinionated and outspoken. Covers politics, business, philosophy of art in existential reality.
Reviews: book & journal, length short.
Advertising: none. Audience: visual arts insiders and thinkers.

ORIGINS. 1977. m. EN. 210
Primitive Art Society of Chicago, P.O. Box A3989, Chicago, IL 60690. Phone 312–787–0072. Jeanne Zasadil, Editor.
Subscription: included in membership. 8½ x 11.
Aim is to increase appreciation of cultural and folk art of Africa, the Americas, and Oceania.
Calendar of events.

OXFORD ART JOURNAL. 1978. s–a. EN. 211
Oxford University Press, Pinkhill House, Southfield Rd., Eynsham, Oxford OX8 1JJ, England. Phone 0865 56767, Fax 0865 882890, Telex 837330 OXPRES G. Richard Wrigley, Editor.
Subscription: £24 UK, $56 No. America, elsewhere £30. Cum. index v.1–10 in v.11 1988. 120p.
ISSN: 0142–6540. OCLC: 4893476. LC: N1.O98.
New research in the visual arts, drawing from a wide spectrum of academic disciplines. Modern languages, history and cultural studies feature prominently. Publishes innovative critical work in art history.
Reviews: book. Indexed: ArtBibMod. ArtI. Avery. BHA. BioI. Des&ApAI. HistAb. RILA. Reviewed: Katz.
Advertising: rates on request. Circulation: 800.

PAINT RAG. 1926. m. EN. 212
Association of Honolulu Artists, Box 10202, Honolulu, HI 96816. Phone 808–455–7154.
Dewey: 700.

PALETTEN. 1940. q. SW. 213
Karl Gustavsgatan, 10 C, S41124 Goeteborg, Sweden. Acke Janson, Editor & Pub.
Subscription: Kr 55, $40.54. Illus.
ISSN: 0031–0352. OCLC: 1761787. LC: N8.P25. Dewey: 705.
Indexed: ArtBibCur. ArtBibMod.

PENFINDER. 1989. bi–m. EN. 214
World Publications, Box 6666, Kingwood, TX 77325. Phone 713–359–4363, fax 713–359–4468. Nancy Olson, Editor.
Subscription: $30.
Dewey: 700.

POLSKA SZTUKA LUDOWA. 1947. q. POL. EN, RU & FR summaries. 215
Ossolineum, Publishing House of the Polish Academy of Sciences, Rynek 9, 50–106 Warsaw, Poland. (Dist.: Ars Polona–Ruch, Krakowskie Przedmiescie 7, Warsaw). A. Jackowski, Editor.
Illus.
ISSN: 0032–3721. OCLC: 2148488. LC: NK7.P6.
Devoted to Polish folk art.
Indexed: ArtBibMod.

POSTCARD ART/POSTCARD FICTION. 1974. irreg. (1–2/yr.). EN. 216
143 McGuinness Blvd., Brooklyn, NY 11222. Phone 718–834–1466. Martha Rosler, Editor & Pub.
Subscription: $5 copy. postcard size, 12p.
Dewey: 738.
All writing done by the editor. Subjects covered arts, film/video, and photography.

PUBLIC ART FUND NEWSLETTER. 1983. s–a. EN. 217
Public Art Fund Inc., 25 Central Park W., Suite 25R, New York, NY 10023. Phone 212–541–8423.
Subscription: free.
Dewey: 701.18.
Covers issues related to the field of public art.

PUBLIC ART REVIEW. 1989. s–a. EN. 218
Forecast Public Artworks, 2955 Bloomington Ave. South, Minneapolis, MN 55407. Phone 612–721–4394. Cheryl Miller, Editor.
Subscription: $10 individuals, $8 for artists. Back issues, $5. Illus. b&w, photos. tabloid, 10½ x 15, 18p.
ISSN: 1040–211x. OCLC: 18352903. Dewey: 711.

The only national news journal devoted to art in public places. Public art incorporates a wide range of sculptural, painted, performance, and electronic artforms. It can be defined most broadly as aesthetic expression intended for a public space rather than for a museum, gallery, or private house. Each issue concentrates on a key area of art in public places. Articles by experts in their fields explore the latest in techniques, accomplishments, and theories. Illustrations and photographs explain new concepts and the finished art. Reviews major projects around the country, searching out new collaborations in infrastructure, park, and urban design. Made possible with support from the National Endowment for the Arts.
Reviews: book, projects.
Advertising. Kathryn Nobbe, Ad. Director.

QUARTERLY IMPRESSIONS. irreg. EN. 219
Friends of the Royal Society of Painter–Etchers and Engravers, 40 Hopton St., Blackfriars, London SE1 9JH, England. Phone 071 928 7521, fax 071 928 2820.

RA. q. EN. 220
The Friends of the Royal Academy of Arts, Burlington House, Piccadilly, London W1V ODS, England. Phone 071–439 7438. Nick Tite, Editor.
Subscription: included in membership, £8 non–members.
The magazine for the Friends of the Royal Academy covers exhibitions both within and outside the Academy, profiles Academicians and includes Friends' news and events.
Indexed: Des&ApAI.

REAL LIFE MAGAZINE. 1979. q. EN. 221
Box 1564, Madison Sq. Station, New York, NY 10159. Phone 718–852–8085. Thomas Lawson, Editor.
Subscription: $10, air $20. Illus. b&w, photo. 8½ x 11, 44p.
ISSN: 0739–196X. OCLC: 8576392. LC: N1.R4 R42.
Modern Art. Literature.
Magazine offers a window on today's art world. The emphasis is on connections between art and mass media. Supported in part by grants from the New York State Council on the Arts and NEA.
Interviews. Indexed: ArtBibMod.

RES: Anthropology and Aesthetics. 1981. s–a. EN, FR occasionally. 222
Peabody Museum of Archaeology & Ethnology, Publications Dept., Harvard University, 11 Divinity Ave., Cambridge, MA 02138. Phone 617–495–3938. Francesco Pellizzi, Editor (12 East 74th St., New York, NY 10021).
Subscription: $26 individual, $50 institution US, Canada & Mexico; elsewhere £19 individual, 35 institution (No. America: Cambridge University Press, 32 E 57th St., New York, NY 10022; other countries, Cambridge University Press, The Edinburgh Building, Shaftesbury Rd., Cambridge CB2 2RU Great Britain). Back issues. Illus. b&w, photos. 8 x 10¾, 140–180p.
ISSN: 0277–1322. OCLC: 7569829. LC: N5310.7.R47. Dewey: 709.
Aesthetics. Anthropology.
A multi–disciplinary journal of anthropology and comparative aesthetics dedicated to the study of the object, in particular culture and belief objects and objects of art. The journal brings together, in an anthropological perspective contributions by philosophers, art historians, and critics, linguists, architects, artists and others. Its field of inquiry is open to all cultures, regions, and historical periods. Also seeks to make available previously unpublished documents — both textual and iconographic — of importance for the theory of the arts. 10–12 scholarly articles per issue. Published in collaboration with the Laboratoire d'Ethnologie, University of Paris X, Nanterre.
Indexed: ArtBibMod.
Advertising: none.

REVISTA DE ESTETICA/AESTHETICS MAGAZINE. 1983. irreg. EN & SP. 223
Centro de Arte y Comunicacion, Escuela de Altos Estudios/School of High Studies, Elpidio Gonzalez 4070, 1407 Buenos Aires, Argentina.
Dewey: 700.

RIDIM-RCMI NEWSLETTER. 1975. s–a. EN. 224
Research Center for Musical Iconography, Graduate School and University Center, City University of New York, 33 W 42nd St., New York, NY 10036. Phone 212–790–4282. Terence Ford, Editor.
Subscription: $7.50 individual, $15 institution. Sample. Back issues. Illus. b&w. 8½ x 11, 12–32p.
ISSN: 0360–8727. OCLC: 2158955. LC: ML26.I71965. Dewey: 780.

The newsletter contains short articles, reports, notices, and abstracts of papers read at conferences, all on music iconography, the description of artworks that contain musical subject matter. Also reports on the Center's progress cataloging musical iconography both in the United States and abroad.
Reviews: book. Bibliographies. Calendar of events. Freelance work: yes. Contact: editor.
Circulation: 250. Audience: music and art historians.

RIVISTA DI STUDI CROCIANI: Dedicated to Work of Benedetto Croce. 1964. q.

225

EN, FR & SP. IT summaries.
Maschio Angioino, 80133 Naples, Italy.
ISSN: 0035–659X. Dewey: 182.
Benedetto Croce, the Italian aesthetics philosopher and art critic, is the subject of this journal.

ROOPA-LEKHA. 1929–34, ns. 1939. irreg. EN. Title also in HI.

226

All–India Fine Arts and Crafts Society, Rafi Marg, New Delhi 1, India. Ram Dhamija, Editor.
Illus., some color.
ISSN: 0035–8215. OCLC: 1697061. LC: N8.R6. Dewey: 745.5.
Journal of Indian painting, arts, and crafts. Covers both contemporary and historical material.
Reviews: book.

ROYAL SOCIETY OF BRITISH ARTISTS. PUBLICATION. 1890. a. EN.

227

Royal Society of British Artists, 17 Carlton House Terrace, London SW1Y 5BD, England.
Dewey: 706.
Catalogue of exhibitions. Co–sponsored by the Federation of British Artists.

ROYAL SOCIETY OF MARINE ARTISTS. PUBLICATION. 1946. a. EN.

228

Royal Society of Marine Artists, 17 Carlton House Terrace, London SW1Y 5BD, England.
Dewey: 706.
Catalogue of exhibitions. Co–sponsored by Federation of British Artists.

ROYAL SOCIETY OF MINIATURE PAINTERS, SCULPTORS AND GRAVERS. PUBLICATION. a. EN.

229

Royal Society of Miniature Painters, Sculptors and Gravers, 17 Carlton House Terrace, London SW1Y 5BD, England.
Subscription: Mrs. M. Burton, Sec. (15 Union St., Wells, Somerset BA5 2PU, phone 0749–74472).
Dewey: 700.
Catalogue of exhibitions. Co–sponsored by the Federation of British Artists.

SERMENT DES HORACES (LE): Revue d'Art Internationale/International Art Review.

230

1988. s–a. EN, FR & SP (side by side).
16, rue Saint–Gilles, 75003 Paris, France. Phone 1–42 72 84 20, fax 1–42 77 01 72. Martine Bernard, Editor.
Subscription: 240 F France, foreign 280 F. Illus. b&w, some color, photos. 8 x 10½, 160p.
ISSN: 0995–6824. OCLC: 20282837. LC: N2.S47. Dewey: 705.
Each issue consists of a selection of the works of one sculptor and one painter. Reports on recent academic studies. Dedicated to the support of contemporary creation in sculpture and painting. In the future will also cover architecture.
Bibliographies: works of artists featured in issue.
Advertising.

SILPAKON. 1957. bi–m. TH. EN table of contents.

231

Government House Press, Samsen Rd., Bangkok 3, Thailand. Nai Prapat Treenarong, Editor.
Subscription: B.40. Illus.
ISSN: 0037–5314. Dewey: 709.

SITELINE. 1990, no.31. EN.

232

Smithsonian Institution Traveling Exhibition Service, Washington, DC 20560. Phone 202–357–3168. Melisa Hirsch, Editor.
Illus. b&w, photos. 11½ x 18, 8p.
A newsletter about the Smithsonian traveling exhibitions and exhibitors. SITES is a program activity of the Institution that organizes and circulates exhibitions on art, history, and science to institutions in the U.S. and abroad.

SOCIETY OF ANIMAL ARTISTS NEWSLETTER. 1960. q. EN. 233
Society of Animal Artists, 151 Carroll St., Box 24, City Island, Bronx, NY 10464. Phone 212–885–2181. Patricia Bott, Editor.
Subscription: included in membership. Illus. 8½x11, 6–8p.
Dewey: 750.
Information on Society activities, news of members and advice on wildlife art studies. Includes articles written by member–artists.
Reviews: book. Exhibition information for exhibitions by Society members.
Advertising.

SOCIETY OF WILDLIFE ARTISTS. PUBLICATION. a. EN. 234
Society of Wildlife Artists, 17 Carlton House Terrace, London SW1Y 5BD, England.
Dewey: 706.
Catalogue of exhibitions. Co–sponsored by the Federation of British Artists.

STUDII SI CERCETARI DE ISTORIA ARTEI. SERIA ARTA PLASTICA. 1964. a.
RO. EN, FR, GE, RU summaries. 235
Editura Academiei Republicii Socialiste Romania, Calea Victoriei 125, 79717 Bucharest, Romania. (Dist.: Rompresfilatelia, Calea Grivitei 64–66, P.O. Box 12–201, 78104 Bucharest).
Illus.
ISSN: 0039–3983. OCLC: 8243277. LC: N8.S86.
Devoted to the art of Romania.

T & C (Theorie et Critique): Theory and Criticism, Teoria y Critica. 1979. irreg. SP, EN, & FR. 236
International Association of Art Critics, Elpidio Gonzalez 4070, 1407 Buenos Aires, Argentina.
Dewey: 701.18.

TABLEAU: Fine Arts Magazine. 1978. bi–m. DU or EN. EN summaries. 237
Burgmeester Stramanweg 102, 1101AA Amsterdam Z.O., The Netherlands. Phone 020–919566, fax 020–919586. Anja Frenkel & Marlot Bloemhard, Editors.
Subscription: fl 77,50 Netherlands, BFr 1450 Belgium, DM 88 Germany, elsewhere $US45 (US & Canada: Expeditors of the Printed Word Ltd., 11–35 45th Ave., Long Island City, NY 10001, phone 718–729–6232. Rest: PVO Abonnementenadministratie Postbus 77, 5126 ZH Gilze 01615–7450, The Netherlands). Illus. color. 9½ x 12½.
ISSN: 0166–4492. OCLC: 8541868. LC: N1.T12.
Extensive listing of Netherlands exhibitions. Columns "Letter from London", "Letter from New York", and "Letter from California" are written in English and contain listings of exhibitions (with illustrations), fairs, and auctions. Many color illustrations include advertisements of art works.
Listings: national. Exhibition information. Indexed: ArtBibMod.
Advertising color. Welmoed Laanstra, US Representative (2238 Ontario Rd., Washington, DC 20009, phone 202–667–3386, fax 202–328–4138).

TAIDE: Konsttidskrift/Art Magazine. 1960. a. FI. EN summaries of each article (2p. total, end of issue). 238
Suomen Taiteilijaseura – Artists' Association of Finland, Ainonkatu 3, 00100 Helsinki 10, Finland. Carolus Enckell, Editor.
Subscription: Fmk 190. Illus., some color, glossy photo. A4, 80p.
ISSN: 0039–8977. OCLC: 5131090. LC: N8.T33. Dewey: 700. Formerly: *Suomen Taide*.
Indexed: ArtBibCur. ArtBibMod.
Advertising.

TOMODACHI. 1987. bi–m. EN, JA. Occasional abstracts, tr. provided for some articles. 239
Institutes and Associations Publishing Services Pty Ltd., 16/1 HELP St., Chatswood, NSW Australia 2067. Phone 02 4132533. Editor c/o Australia–Japan Society of New South Wales, (G.P.O. Box 3802, Sydney Australia 2001).
Subscription: included in membership. Sample free. Limited back issues. Illus. b&w, color, photos. Cum. index v.2, no.4. 275mm x 210mm, 40p.
Dewey: 700. Formerly: *A J S Newsletter*.
Matters relating to Australia and Japan include business, art, photography, travel, sport, and the functions and membership of the Australia–Japan Society of New South Wales.
Reviews: exhibition 6, book 2, journal 1, film 3. Interviews: art & photography. Biographies: profiles (1/issue). Freelance work: yes. Contact: Society.

Advertising: full page $1385, ½ page $750, ¼ page $460, covers $2020–2280; color full page $1760, ½ page $990. Classified: $1/wd. Inserts. David O'Sullivan, Ad Manager. Mailing lists: none. Circulation: 4000.

TSIYUR U-FISUL. 1972. q.　　　　　　　　　　　　　　　　　　　　　　　　　　240
Israel Painters and Sculptors Association, 9 Alharizi St., Tel–Aviv, Israel. Ilan Tamir, Editor.
Illus.
Dewey: 700.

TURKISH TREASURES: Culture–Art–Tourism Magazine. 1978. q. EN.　　　　241
Ilbas A.S., Alaykosku Cad. 9 Cagaloglu, Istanbul, Turkey. Nevzat Ilhan, Editor.
Subscription: $4.

TUSCIA. 1973. q. IT. EN summaries.　　　　　　　　　　　　　　　　　　　242
Provincial Tourist Board of Viterbo, Piazza dei Caduti 16, 01100 Viterbo, Italy. Phone (0761) 22.61.61. Vincenzo Ceniti, Editor.
Subscription: L 10000. Cum. index.
ISSN: 0390–4555. Dewey: 398.

TVORCHESTVO. 1934. m. RU.　　　　　　　　　　　　　　　　　　　　　243
Izdatel'stvo Sovetskii Khudozhnik, Ul. Chernyakhovskogo, 4a, Moscow A–319, Russian S.F.S.R., U.S.S.R. Juri Nehorochew, Editor.
Subscription: 22.20 Rub. Illus.
ISSN: 0041–4565. OCLC: 4099208. LC: N6.T96. Dewey: 709.
Indexed: ArtBibCur. ArtBibMod.

UMETNOST: Casopis za Likovne Umetnosti i Kritiku. 1949. bi–m. SCR. EN & FR summaries.　　　244
Turisticka Stampa, Knez Mihailova 21, Belgrade, Yugoslavia. Zivojin Turinski, Editor.
ISSN: 0041–6320. Dewey: 700.

WIENER JAHRBUCH FUER KUNSTGESCHICHTE. 1922. a. GE.　　　　　　245
Hermann Boehlaus Nachf., c/o Dr. Karl Lueger, Ring 12, A–1010 Vienna, Austria. E. Frodl–Kraft & G. Schmidt, Editors.
Subscription: DM 112. illus.
ISSN: 0083–9981. OCLC: 1769865. LC: N9.W5. Formerly: *Jahrbuch des Kunsthistorischen Institutes.*
Scholarly articles specializing in Austrian art and collections. Other European countries and styles are also presented.
Indexed: Avery. RILA.

WILDFOWL ART JOURNAL. 1970. q. EN.　　　　　　　　　　　　　　　246
Ward Foundation, 655 S. Salisbury Blvd., Salisbury, MD 21801. Phone 301–742–4988. Curtis J. Badger, Editor (P.O. Box 580, Onley, VA 23418).
Subscription: included in membership, $25 US; Canada & foreign $50. Sample. Some back issues, $3–$4.95. Illus. b&w, color, photos. 8½ x 11, 60p.
Dewey: 790.13. Formerly: *Ward Foundation News.*
Antiques. Art Education. Crafts. Modern Art. Museology. Painting. Sculpture.
The journal of the Ward Foundation, America's foremost authority of wildfowl art. Each issue features articles on carvers, painters, and other artists, stories on competitions and exhibitions, profiles of contemporary artists, as well as those who pioneered the art form, and features on the tradition and history of wildfowl hunting.
Reviews: exhibition 1, length 2 pages; book 1, length 1 page. Interviews: with outstanding artists. Biographies: of artists. Listings: national–international. Calendar of events covering the activities of the wildfowl art world. Exhibition information. Freelance work: yes. Contact: editor. Opportunities: study, competitions.
Advertising: (rate card Jan '89): full page $575, ½ page $395, ¼ page $220; 4 color full page $935, covers $1060–1180. Classified: "Buy, Sell, Swap" (prepaid) $1/wd., $25 min. 15% agency discount. Frequency discount. Harry Gehring, Ad. Director (Lee Communications, 1815 Bay Ridge Ave., Annapolis, Md. 21403). Demographics: members are well educated, at least 60% have a college degree, 50% earn $45,000 or more, most upper middle income. Readers survey indicated a high percentage interested in bird watching, hunting, photography, travel, wildlife conservation, art, and wooodworking other than carving. Circulation: 8500. Audience: wildfowl artists, collectors of bird carvings.

WORLD OF ART. 1977. s–a. Text in EN & HE. 247
World of Art Publishing Co., 190 Ben–Yehuda St., Tel Aviv 63471, Israel. Phone 03–237115. Joseph A. Melamed, Editor.
Subscription: $25. 31p.
Dewey: 700.

WROCLAWSKIE TOWARZYSTWO NAUKOWE. KOMISJA HISTORII SZTUKI.
 ROZPRAWY. 1960. irreg. POL. EN & FR summaries. 248
Ossolineum, Publishing House of the Polish Academy of Sciences, Rynek 9, Warsaw, Poland. (Dist.: Ars Polona–Ruch,
Krakowskie Przedmiescie 7, Warsaw).
ISSN: 0084–2982. Dewey: 700.
Covers all areas of Polish art and crafts.

WYDZIAL FILOLOGICZNO-FILOZOFICZNY. PRACE. 1948. irreg. POL. EN, FR, GE summaries. 249
Towarzystwo Naukowe w Toruniu, Ul. Wysoka 16, 87–100 Torun, Poland. (Dist.: Ars–Polona Ruch, Krakowskie
Przedmiescie 7, 00–068 Warsaw).
ISSN: 0208–497X. Dewey: 709.

ZEITSCHRIFT DES DEUTSCHEN VEREINS FUER KUNSTWISSENSCHAFT.
 1963. v.17. q. GE only. 250
Deutscher Verlag fuer Kunstwissenschaft, Postfach 11 03 03, 1000 Berlin 11, W. Germany.
Illus. b&w, glossy photos. 8¼, 10½, 93p.
ISSN: 0044–2135. OCLC: 5034121. LC: N3.D55. Formerly: *Zeitschrift fuer Kunstwissenschaft.*
Journal of the German Society for art aesthetics.
Bibliographies with articles. Indexed: ArtBibCur. ArtHum. ArtI. CurCont. RILA.
Advertising: none.

ZEITSCHRIFT FUER AESTHETIK UND ALLGEMEINE KUNSTWISSENSCHAFT.
 1906. a. GE. 251
Bouvier Verlag Herbert Grundmann, Am Hof 32, Postfach 1268, 5300 Bonn 1, W. Germany.
Subscription: DM 65.
ISSN: 0044–2186. OCLC: 5662998. LC: N9.J26. Formerly: *Jahrbuch fuer Aesthetik und Allgemeine Kunstwissenschaft.*
Art History.
Focuses on art aesthetics. Contains scholarly articles on art history, criticism and aesthetics of the visual arts plus literature
and music.
Reviews: book, lengthy. Indexed: ArtBibMod. CurCont. RILA.

ZYGOS: Annual Edition on the Hellenic Fine Arts. 1982. a. EN. 252
Zygos Ltd., 33 Iofontos St., GR11634 Athens, Greece. Ion F. Frantzeskakis, Editor.
Subscription: $30. Illus. mainly color.
ISSN: 0252–8150. OCLC: 8620555. LC: N6891.Z9. Dewey: 709.
General. Modern Art.
Lavishly illustrated coverage of contemporary art and artists in Greece. Covers painting, sculpture, engraving, ethnology, ar-
chaeology, Hellenic studies, architecture, decoration, and applied arts.
Biographical notes on the artists.

Fine Arts - Regional

ALLIED ARTS NEWSLETTER. 10/yr. EN. 253
Allied Arts of Seattle, 107 S. Main St., Suite 201, Seattle, WA 98104. Phone 206–624–0432. Richard Mann, Editor.
Subscription: included in membership. Sample. No back issues. Illus. b&w. 8½ x 11, 12p.
Historic Preservation. Arts Education. Arts Legislation. Urban Design Advocacy.

The association supports the arts and artists of the Northwest. The newsletter presents advocacy issues which are the focus of the five standing committees devoted to the areas of arts and urban design. Regular articles on the activities and positions of each committee are balanced by feature articles focusing on external and internal Allied Arts issues pertaining to the mission of the entire organization or one of the committees and the interests of the membership.
Freelance work: none.
Advertising: none. Mailing lists: none. Audience: membership of arts advocacy urban design organization.

ART ALLIANCE BULLETIN. 1943. bi–m. EN. 254
Philadelphia Art Alliance, 251 S. 18th St., Philadelphia, PA 19103. Emily Schilling, Editor.
Subscription: available to membership only. Illus.
ISSN: 0004–296X. OCLC: 1741336. LC: N1.A776. Dewey: 705.
Circulation: 2500.

ART AND ARTISTS OF THE MONTEREY PENINSULA. 1960. irreg. EN. 255
Art and Artists of the Monterey Peninsula, Box 1310, Monterey, CA 93940. Phone 408–372–6118. Lee C. Harbick, Editor.
ISSN: 0066–7927.

ART NEW ENGLAND. 1979. 10/yr. EN. 256
Art New England, Inc, 425 Washington St., Brighton, MA 02135. Phone 617–782–3008. Stephanie Adelman & Carla Munsat, Editors.
Subscription: $20 US, $32 Canada & foreign. No sample. Back issues $3 + postage. Illus. b&w, photos. 13½ x 9⅝, 47p.
ISSN: 0274–7073. OCLC: 6516895. Dewey: 709.
General.

Deals with the aesthetic and business aspects of making, understanding, and collecting art. Every issue includes articles devoted to a variety of subjects on the arts, profiles of artists, a unique visual guide to area galleries, and regional gallery reviews. Provides a stimulating look at the visual arts in New England and across the nation. Each issue has a different focus with the July/August issue including a Summer Getaway Guide to guide the summer tourists through the galleries of New England. Other directories include "Film, Video, Photography," "Art School and Art Supply," "Architecture and Design," "Holiday Gift," "New York Art Gallery," and "Summer Workshop".
Reviews: (per vol.): exhibition 350, length 350–2000 wds.; book 10 & architecture 2, length 800 wds.; film 2, length 600 wds. Biographies: articles on works and/or lives of artists, designers architects, 5/vol., length 2000 wds. Interviews: one profile interview with an artist in each issue, length 2000 wds. Listings: mainly regional, some national–international. Calendar of events includes exhibits, lectures, films, festivals. Regional exhibition listings includes gallery, regional museum, school & library exhibits. Freelance work: yes. Contact: personnel manager. Opportunities: employment: regional & national listings; study – listed in "Summer Workshop Directory" in March – May issues; competitions: regional–international, listed free of charge. Reviewed: Katz.
Advertising: full page $1365, ½ page $718, ¼ page $378, no color. Classified: $7/line, min. 3 lines, payment with order. 10–20% frequency discount. 15% agency discount. Susan Barahal and Julie Marcinek, Ad. Directors (phone display & classified 617–782–4218, calendar & listings 782–3008). Mailing lists: none. Demographics: readers represent an affluent audience who collect art, buy art books and support cultural activities. Also read by artists and craftsmen as a resource for art competitions, job opportunities, and a source for supplies and services. Individual issues have free distribution to targeted audiences.
Circulation: 26,000. Audience: artists, designers, collectors, architects.

ART OF CALIFORNIA. 1988. bi–m. EN. 257
Greg Saffell Communications, Subscription Dept., 1125 Jefferson St., Napa, CA 94559–2416. Phone 707/226–1776. Janet B. Dominik, Editor.
Subscription: $24.95. Illus. color, glossy. 8½ x 11, 74p.
ISSN: 1045–8913. OCLC: 19009782. LC: N6530.C2 A7. Dewey: 709.
General.

The only magazine devoted to articles on the arts and artists of California from the landscape painters of the 19th century to contemporary artists of today. Articles of interest to the art community.
Reviews: exhibition, collections. Interviews. Biographies. Freelance work: yes, manuscripts, photos and original art. Contact: editor.
Advertising: b&w & color rates on request. Douglas Corwin, Ad. Director.

ART OF THE WEST. 1987. bi–m. EN. 258
Duerr and Tierney Ltd, 15612 Highway 7, Suite 235, Minnetonka, MN 55345. Phone 612–935–5850. Vicki Stavig, Editor.
Subscription: $21 US. Index. Cum. index. 8½ x 11, 92p.

Observes Western art through profiles on the artists providing Native American art, cowboy art, landscape, seascape and western wildlife art.

Calendar of events.

Advertising. Allan Duerr, Ad. Director. Circulation: 15,000.

ART POST MAGAZINE. 1983. q. EN. 259

Art Post Productions, Inc., 80 Spadina Ave., Suite 206, Toronto, Ontario M5V 2J4 Canada. Phone 416–364–5541.

Subscription: $C15 Canada, $20 elsewhere. Illus.

ISSN: 0829–0784. OCLC: 10954115. LC: N1.A776. Dewey: 709. Formerly: *Art Post*.

Specializes in the art of Ontario.

Indexed: ArtBibMod.

ARTLETTER. 1980. m. EN. 260

Virginia Beach Arts Center, 1711 Arctic Ave., Virginia Beach, VA 23451.

Back issues.

ARTS. 1978. m. EN. 261

MSP Publications, Inc, Plymouth Bldg., 12 S. 6th St., Suite 1030, Minneapolis, MN 55402. Phone 612–339–7571.

Illus.

OCLC: 20944668.

The magazine for members of the Minneapolis Institute of Fine Arts.

Advertising: none.

ARTWEEK. 1970. w. (Sept-May, bi–w. June-Aug). EN. 262

Kitty Spaulding, Publisher, 12 So. First St., Suite 520, San Jose, CA 95113. Phone 408–279–2293, fax 408–279–2432. Patricia Au, Managing Editor.

Subscription: $28 individuals, $32 institutions US; elsewhere +$12 postage, air +$33. Microform available from Artweek. Sample free. Back issues. Illus. b&w, photos. Cum. index: vols.1–7, 1977. 10 x 17, 20p.

ISSN: 0004–4121. OCLC: 1385458. LC: N1 .A78.

Architecture. Art Education. Art History. Drawing. Films. Modern Art. Painting. Photography.

Covers West Coast art news. The preferred information source on West Coast fine arts, photography, and crafts. Includes screened gallery guide.

Reviews: exhibition 10 & film 3, length 1/2p.; book 2, length 1/4p. Listings: regional, competitions international. Calendar of events. Exhibition information. Freelance work: yes. Contact: editor. Opportunities: employment—national listings, study, competitions. Indexed: ArtI. CloTAI. RILA. Reviewed: Katz.

Advertising: display $45/in. Competitions listing for nonprofit organizations without charge. Classified: $4/line, min. $8, payment with order. Garrett Cullen, Ad. Director. Mailing lists: available. Circulation: 15,000. Audience: art professionals.

BOMBAY ART SOCIETY'S ART JOURNAL. 1971. q. EN. 263

Bombay Art Society, Jehangir Art Gallery, 16–B Mahatma Gandhi Rd., Bombay 1, India. Harish Raut, Editor.

Subscription: Rs 4. Illus.

OCLC: 10193729. LC: N1.B65a. Dewey: 701.

CENTRAL HALL ARTISTS NEWSLETTER. 1974. q. EN. 264

Central Hall Artists Inc., c/o L. Cohen, 84 Allenwood Rd., Great Neck, NY 11023. Ed.Bd.

Illus.

Dewey: 705.

CHEEKWOOD BOTANICAL GARDENS AND FINE ARTS CENTER (CALENDAR).

1961. m. EN. 265

Botanical Gardens and Fine Arts Center at Cheekwood, Forrest Park Dr., Nashville, TN 37205. Phone 615–352–5310. Gardner O'Smith, Editor.

Subscription: included in membership. 11 x 17, 2p.

Formerly: *Cheekwood Mirror*.

Purpose is to inform the membership about fine art and botanical exhibits and other activities at Cheekwood. Focus is on American art with special emphasis on the work of regional Tennessee artists.

Calendar of events. Opportunities: study – classes.
Advertising: none.

CHICAGO ARTISTS' NEWS. 1975. m, 11/yr. EN.
266

Chicago Artists' Coalition, 5 W. Grand, Chicago, IL 60610. Phone 312–670–2060. Elizabeth Rigdon, Editor.
Subscription: included in membership, $30 individual, $18 student, $20 senior. Sample free. Back issues. Illus b&w, photos, cartoons. 16p.
ISSN: 0890–5908. OCLC: 13585370. Dewey: 709. Formerly: *CAC News; CAC Newsletter; Chicago Artists' Coalition Newsletter.*
General.

Newspaper informs artists of current art issues, legislation, health hazards, etc. Profiles area galleries. Extensive classified listings ranging from members' announcements to nationwide art exhibition opportunities.
Interviews: visual artists, gallery owners, museum personnel, etc. Biographies. obits. Listings: regional–national. Calendar of Coalition events, gallery openings. Freelance work: yes. Contact: editor. Opportunities: employment, study, competitions.
Advertising: ½ page $300, ¼ page $150. Classified: $5/25 wds. Frequency discount. Mailing lists: occasionally available.
Circulation: 2700. Audience: visual artists.

DETROIT FOCUS QUARTERLY. 1982. q. EN.
267

Detroit Focus Gallery, 743 Beaubien, 3rd Floor, Detroit, MI 48226. Phone 313–962–9025. Sheree Rensel, Editor.
Subscription: included in membership, free. Sample. Back issues. Illus b&w, photos. 8½ x 11, 16p.
OCLC: 11936962.
General.

A visual arts publication containing news, reviews, interviews, features, and opportunities.
Reviews: exhibition 7, length 300 wds. Interviews: artist. Freelance work: yes. Contact: editor.
Advertising: full page $340, ½ page $185, ¼ page $95. Mailing lists: none. Demographics: distribution metropolitan Detroit area. Circulation: 12,500. Audience: artists, collectors and fine arts enthusiasts.

DIALOGUE: Arts in the Midwest. 1978. bi–m. EN.
268

Dialogue, Inc., Box 2572, Columbus, OH 43216–2572. Phone 614–621–3704. Lorrie Noel Dirkse, Editor.
Subscription: $16 individuals, $20 institutions. Microform available. Illus. b&w, photos. 11 x 14, 36p.
ISSN: 0279–568X. OCLC: 4730991. LC: N6530.03.D52.
Devoted to the development and growth of art in the Midwest. Provides in–depth information about the visual arts in Indiana, Kentucky, Michigan, Ohio, West Virginia, and western Pennsylvania. Dialogue, Inc. is a non–profit arts organization supported by grants from the Ohio Arts Council, the Kentucky Arts Council, the Illinois Arts Council and others. Its purpose is to foster the growth of the visual arts by stimulating critical activity, reportage, and a sense of community. Presents previews of upcoming exhibitions presented by art organizations in the region, one page per organization, together with illustrations. It also serves to inform a broader national audience of artistic activity in the region.
Listings: regional. Calendar of events. Freelance work: yes. Contact: editor before submitting a manuscript. "Writers Guidelines" available on request. Opportunities: call for entries. Indexed: ArtBibMod. Reviewed: *New Art Examiner.* 15:1, Sept 1987, p.17–18.
Advertising: display & classified rates on request. Lorrie N. Dirkse, Ad. Director.

FINE ARTS WORK CENTER IN PROVINCETOWN. VISUAL CATALOGUE. a. EN.
269

Fine Arts Work Center in Provincetown, Inc, 24 Pearl St., Box 565, Provincetown, MA 02657. Phone 617–487–9960.
Subscription: free. Illus.
Dewey: 700. Formerly: *Fine Arts Work Center in Provincetown. Newsletter.*

HIGHLANDER: The Bulletin of the Directorate of Art and Culture, Nagaland, Kohima.
1973. s–a. EN.
270

Cultural Research and State Museum, Kohima, Nagaland, India. M. Alemchiba Ao, Editor.
Illus.
ISSN: 0376–9569. OCLC: 2256103. LC: DS432.N3H54. Dewey: 954.
Devoted to presenting the research on the life, history and culture of the different Naga tribes of the state. The Bulletin is issued in addition to the research publications of the Department of Art & Culture.

HUDSON CENTER JOURNAL. 1984. 10/yr. EN. **271**
Cazana Group, Inc, 105 Hudson St., No. 300, New York, NY 10013. Phone 212–925–7290. Joseph Cazana, Editor.

NAPOLI NOBILISSIMA: Rivista di Arti Figurative, Archeologia e Urbanistica.
1961 (3rd series v.1). bi–m. IT. **272**
Societa l'Arte Tipografica, Via S. Biagio dei Librai 39, 80100 Naples, Italy. Roberto Pane, Editor.
Illus.
ISSN: 0027–7835. OCLC: 1758998. LC: N6919.N27 N36. Dewey: 709.4.
General.
Scholarly treatment of art and architecture in the city of Naples and the surrounding area. First published in 1892 (v.1-15 1892-1906, ns. 1920-22, 3rd s. v.1, 1961/62-).
Reviews: book. Indexed: RILA.

SOUTHERN AFRICAN ART. **273**
The National Gallery of Zimbabwe, Julius Nyerere Way, Harare, P.O. Box 8155, Causeway, Harare, Zimbabwe. Phone 704666. Cyril A. Rogers, Director.
Scholarly journal covering the art of the SADCC grouping of nine states. Planned to replace *Zimbabwe Insight.* Notice of this new journal appeared in *ACASA Newsletter* v.27, June 1990, p.7.

SOUTHWEST ART: The Collector's Preference. 1971. m. EN. **274**
CBH Publishing Inc., Box 460535, Houston, TX 77256–8535. Phone 713–850–0990. Susan H. McGarry, Editor.
Subscription: $27.50 US, foreign $45.50. Microform available from UMI. Illus. Index. 8½ x 11, 160p.
ISSN: 0192–4214. OCLC: 5143351. LC: N6525.S58. Dewey: 705. Formerly: *Southwest Art Gallery Magazine; Western Art Digest* (formed by the merger of *Art West & Artists of the Rockies and the Golden West*).
Focuses on artists and art works from the region west of the Mississippi River or depicting this region.
Interviews: artists. Listings: regional. Calendar of sales and auctions, museum exhibitions, gallery showings. Indexed: ArtBibCur. ArtBibMod. ArtI. BioI. CloTAI. Reviewed: Katz.
Advertising. "The Gallery" special section for art related products or services, price 35% less than standard ⅙ page ad. Readers service card. Shari H. Carman, Marketing Director (602–951–8121).

SYMBOL: Kunst im Rheinland. 1971. q. **275**
Ubierring 6–8, D–5000 Cologne 1, W. Germany. Phone 0221–314499. Wolfgang Wangler, Editor.
Subscription: DM 3.
ISSN: 0172–3456. Dewey: 700.
Presents art in the Rhineland.

TIMELINE. 1984. bi–m. EN. **276**
Ohio Historical Society, 1982 Velma Ave., Columbus, OH 43211. Phone 614–297–2360. Christopher S. Duckworth, Editor.
Subscription: included in membership, $18. Sample free. Back issues $5.22. Illus. b&w, photos. 8½ x 11, 56p.
ISSN: 0748–9579. Dewey: 917.
Antiques. Archaeology. Architecture. Art History. Decorative Arts. Painting. Photography. History.

A popular magazine featuring authoritative, well–illustrated articles. Its subject matter encompasses history, archaeology, art, and natural history, especially of Ohio and the Midwest.
Reviews: book 4, length 750 wds. Biographies. Freelance work: yes. Contact: editor.
Advertising: none. Mailing lists: none. Circulation: 11,000. Audience: general.

U.S. ART. 1988. 9/yr. EN. **277**
Dorn Communications, Inc., 7831 E. Bush Lake Rd., Minneapolis, MN 55435. Phone 612–835–6855. Paul Froiland, Editor.
ISSN: 0899–1782. OCLC: 18025453. Dewey: 750. Formerly: *Midwest Art (Minneapolis, MN)*.

VENEZIA ART: Bollettino del Dipartimento di Storia e Critica delle Arti dell'Universita di Venezia. 1987. a. IT chiefly, occasionally FR or EN. **278**
Viella s.r.l., Libreria Editrice, Via delle Alpi 32, 00198 Rome, Italy. Phone 06–841 77 58, fax 06–844 17 82. Wladimiro D'Origo, Editor (Dipartimento di Critica Arti, University de Venezia, Dorsoduro 3199, 30123 Venice).
Back issues. Illus. b&w, some color, plans. 21 x 29 cm., 216p.

ISSN: 0394–4298. OCLC: 18062313. LC: N6921.V5V36. Dewey: 709.

Art History.

Subjects covered include art, architecture, film, music and theater in Venice, with short articles and news items.
Reviews: exhibition, book. Indexed: Avery. BHA. RILA.
Advertising: none.

VISTI/NEWS/UKRAINIAN CULTURAL AND EDUCATIONAL CENTRE. 1976. 2–3/yr. UKR. Includes some text in EN.

279

Ukrainian Cultural and Educational Centre, 184 Alexander Ave. East, Winnipeg, Man. R3B 0L6, Canada. Phone 204–942–0218. Sophia Kachor, Editor.
Subscription: included in membership. Illus.
ISSN: 0824–5991. OCLC: 10845183. LC: DK508. Dewey: 971.
News of the Ukrainian Cultural and Educational Centre.

WESTART: West Coast's Art News Scene. 1962. s–m. EN.

280

WestArt Publications, Box 6868, Auburn, CA 95604. Phone 916–885–0969. Martha Garcia, Editor.
Subscription: $15. Microform available from UMI. Illus.
ISSN: 0043–3357. OCLC: 3961334. Dewey: 700.
Tabloid newspaper consisting of West Coast art news. Presents feature articles, news of exhibitions, competitions, winners, and arts and crafts.
Advertising. Circulation: 7500.

ZIMBABWE INSIGHT. 1977. s–a. EN.

281

National Gallery of Zimbabwe, Julius Nyerere Way, Harare, P.O. Box 8155, Causeway, Harare, Zimbabwe. Phone 704666. Jarmila Hava, Editor.
Subscription: free. Illus.
ISSN: 0258–1868. OCLC: 14341590. LC: N3885.S3A33. Formerly: *Insight*.
Notice in *ACASA Newsletter* v.27, June 1990 reports that this periodical, a local publication, is to be phased out and replaced by a scholarly journal *Southern African Art*.

Art History

ACADEMIA SCIENTIARUM HUNGARICA. ACTA HISTORIAE ARTIUM/MAGYAR TUDOMANYOS AKADEMIA. ACTA HISTORIAE ARTIUM. 1953. s–a. EN, FR, GE, IT or RU. No summaries.

282

Akademiai Kiado, Publishing House of the Hungarian Academy of Sciences, P.O. Box 24, H–1363 Budapest, Hungary. L. Vayer, Editor.
Subscription: $68. Illus.
ISSN: 0001–5830. Dewey: 709.
Reviews: book.
Advertising.

ACHADEMIA LEONARDI VINCI: JOURNAL OF LEONARDO STUDIES AND BIBLIOGRAPHY OF VINCIANA. 1988. a. EN, FR, GE & IT.

283

Armand Hammer Center for Leonardo Studies, Casalini Libri, Via Benedetto da Maiano, 3, 50014 Fiesole, Italy. US: University of California at Los Angeles, Los Angeles, CA. Carlo Pedretti, Editor.
Illus. b&w, some color.
ISSN: 0394–8501. OCLC: 19520357. LC: ND623.L5 A252.

Art History.

"Journal of Leonardo studies and bibliography of Vinciana". A yearbook of the Armand Hammer Center for Leonardo Studies at UCLA.
Indexed: Avery.

ACTA HISTORIAE ARTIUM. 1953. s–a. EN, FR, GE, IT or RU. No summaries. 284
Acta Historiae Artium Academiae Scientarium Hungaricae, H–1368, P.O. Box 24, Budapest, Hungary. Gyorgy Rozsa, Editor.
Illus. b&w, photos, line drawings. Index. 8 x 11¼, 180p.
ISSN: 0001–5830. OCLC: 1460899. LC: N6.A25.
Art History.
Scholarly, covers European art of all time periods.
Reviews: book. Bibliographies with articles. Indexed: ArtArTeAb. ArtBibCur. ArtBibMod. ArtHum. Avery. CloTAI. HistAb.
RILA.
Advertising: none.

AMERICAN JOURNAL OF ARCHAEOLOGY. See no. 391.

AMERICANA. 1973. bi–m. EN. 285
Americana Magazine, Jack Armstrong, Publisher, 29 W. 38th St., New York, NY 10018. Phone 212–398–1550. Sandra
Wilmot, Editor.
Subscription: $14.97 US, $16.97 Canada. Microform available from UMI. No sample. Back issues $3 (Americana Subscription, 205 West Center St., Marion, Ohio 43302). Illus. b&w, color, photos & original art. 8⅛ x 10¾, 80p. Web offset, saddle–stitched.
ISSN: 0090–9114. OCLC: 4938125. LC: E171.A444a. Dewey: 973. Formerly: *American Heritage Society's Americana.*
General. Crafts. Historic Preservation.
Americana takes a contemporary approach to historical subjects. It shows how people today use the American past to broaden and enrich their lives—by visiting historical places, restoring and preserving old structures, collecting, making craft items, decorating, and many other activities. Articles are heavily illustrated with photographs and with original art. Craft stories stress contemporary applications of the skills. Articles include practical information to help readers who wish to follow up a subject. Regular departments include stories about current exhibits with ties to the American past, roundups of events or activities, and a how–to article.
Reviews: exhibition 5, length 400 wds., book 3, length 1,000 wds. Biographies: often run profiles of collectors, craftsmen curators, or others actively involved with the American past. Listings: regional–national. Calendar of events. Exhibition information. Freelance work: use free–lance photographers both for stock pictures and for photo assignments. Feature stories run between 2,000–2,500 wds. and short pieces about 500 wds. Articles should give the reader an opportunity to participate in the activity covered. Suggestions that have a timeliness or "peg"—a special anniversary, completion of a major project—will receive priority. Contact: editor. Reviewed: Katz. *Art Documentation* Fall 1986, p.132.
Advertising: (rate card Jan–Feb. 1989): display: b&w full page $8120, ½ page $4880, ¼ page $2550, 2–page spread $14,630; 2–color full page $10,200, ½ page $6150, ¼ page $3115, 2–page $18,350; 4–color full page $12,190, ½ page $7350, ¼ page $3725, 2–page $21,945; cover (4–color only) $13,320–$14,615. "Americana Exchange" (for collectibles, miscellaneous merchandise, wanted, etc.), $3.95/wd., $300/in. (check with order). Frequency discount. 15% agency discount. Inserts. Bleed no charge. Liz Jensen, Ad. Director. Send "Americana Exchange" to Sharon Borno. Mailing lists: available, contact publisher. Demographics: 1986 readers survey: 58% female, 42% male; median age 43, 30% 18–34 yrs., 21% 55–64 yrs., 14% 65+; median income $34,262, 23% $50,000+, 21% under $25,000; 88% graduated high school, 29% graduated college. Circulation: 300,000.

AMS STUDIES IN THE EMBLEM. 1988. irreg. EN. 286
AMS Press, Inc., 56 E. 13th St., New York, NY 10003. Phone 212–995–5413. Peter M. Daly & Daniel S. Russell, Editors.
ISSN: 0892–4201. OCLC: 15187867. Dewey: 686.
Works on the tradition, art and cultural significance of the emblem in history.

ANADOLU SANATI ARASTIRMALARI/RESEARCHES ON ANATOLIAN ART.
1968. irreg. EN & TU. EN summaries. 287
Technical University of Istanbul, Department of the History of Architecture and Preservation – Istanbul Teknik Universitesi, Gumussuyu Caddesi 87, Beyoglu, Istanbul, Turkey. Dogan Kuban, Editor.
Subscription: TL.35.
ISSN: 0066–1333. Dewey: 709.

ANZEIGER DES GERMANISCHEN NATIONALMUSEUMS UND BERICHTE AUS DEM
FORSCHUNGSINSTITUT FUER REALIENKUNDE. 1886. a. GE. 288
Germanisches Nationalmuseum, Nuernberg, Postfach 9580, D–8500 Nuernberg 11, W. Germany. Phone 0911–1331–0. G.
Bott, Editor.

Subscription: DM 65. Illus.
ISSN: 0934–5191. OCLC: 1772302 [former title]. LC: DD1.A61. Formerly: *Anzeiger des Germanischen Nationalmuseums*.
Art History.

Some volumes also have a distinctive title.
Indexed: RILA.

ARCHIVES OF AMERICAN ART JOURNAL. 1960. q. EN. 289

Archives of American Art, Smithsonian Institution, 8th & G St., NW, Washington, DC 20560. Phone 202–357–2781. Garnett McCoy, Editor.
Subscription: included in membership, $65, $35 subscription only. Sample. Back issues $8. Illus. b&w, photos. 11 x 8½ x 11, 40p.
ISSN: 0003–9853. OCLC: 9475849. LC: N11.A735 A15. Dewey: 709. Formerly: *Journal*.
Art History. American Studies.

History of the visual arts in America from the 18th century to the present. Articles are usually based on research conducted at the Archives of American Art. The journal includes reports from Archives regional offices and publication of significant documents.
Reviews: book 2, length 1500 wds. Bibliographies: annual listing of dissertations in progress. Interviews: occasional oral histories. Freelance work: yes. Contact: editor. Indexed: AmH&L. ArtBibMod. ArtHum. ArtI. BioI. CurCont. RILA.
Advertising: none. Circulation: 2400. Audience: art historians.

ARCHIVO ESPANOL DE ARTE. 1925. q. SP only. 290

Consejo Superior de Investigaciones Cientificas, Departamento de Historia del Arte, Diego Velazquez, Centro de Estudios Historios, Duque de Medinaceli 6, 28014 Madrid Spain. (Dist.: Servicio de Publicaciones del C.S.I.C., Vitrivuio 8, 28006 Madrid).
Subscription: 4000 ptas, foreign 6000 ptas. Illus., b&w, glossy photos, plates, plans. Annual index. 7½ x 10½, 130p.
ISSN: 0004–0428. OCLC: 1513944. LC: N7.A68. Continues in part: *Archivo Espano De Arte Y Arqueologia*.
Art History.

Scholarly articles related to Spanish art covering all time periods.
Bibliographies: current books on Spanish art. Indexed: ArtBibMod. ArtBibCur. ArtHum. ArtI. Avery. BioI. CurCont. IBkReHum. RILA. Reviewed: Katz.

ARS. 1967. s–a. SL. Table of contents in SL, RU, EN, GE & FR. RU & EN summaries. 291

Veda, Publishing House of the Slovak Academy of Sciences, Klemensova 19, 814 30 Bratislava, Czechoslovakia. Ladislav Saucin, Editor.
Illus.
ISSN: 0044–9008. OCLC: 5627933. LC: N6.A7. Dewey: 709.4.
Art History.

Summaries are a full page each at the end of each article.
Indexed: ArtBibCur. ArtBibMod. BHA.

ARS HUNGARICA. 1973. s–a. HU. GE summaries mainly, occasionally EN. 292

Hungarian Academy of Sciences, Institute of Art History, Uri u. 62, 1014 Budapest, Hungary. Maria Bernath, Editor.
Subscription: exchange. Illus. b&w, photos. 6½ x 9¼, 240p.
ISSN: 0133–1531. Dewey: 700.
Art History.

Scholarly, covers all periods of Hungarian art.
Indexed: ArtBibMod.

THE ART BULLETIN. 1912. q. EN. 293

College Art Association of America, 275 Seventh Ave., New York, NY 10001. Phone 212–691–1051. Walter Cahn, Editor.
Subscription: available only through membership. Microform available from UMI. Back issues. Illus. b&w, photos. Annual index. Cum. index 1913-48, 1949-73. 9 x 11½, 168p.
ISSN: 0004–3079. OCLC: 5784747. LC: N11 .C4. Dewey: 705. Formerly: *Bulletin of the College Art Association of America*.
Art History.

Scholarly, covers all areas and time periods.

Reviews: book 5, length 136–166p. Bibliographies: accompany articles, Books Received" (2 page list). Freelance work: yes. Contact: editor. Indexed: ArchPI. ArtBibCur. ArtBibMod. ArtHum. ArtI. BHA. BioI. BkReI. BrArchAb. CloTAI. CurCont. HumI. IBkReHum. RILA. Reviewed: Katz.

Advertising: accepts ads of interest to art historians and artists. Information and rates upon request.

ART HISTORY. 1978. q. EN. 294

Basil Blackwell Ltd., 108 Cowley Rd., Oxford OX4 1JF, England. Phone 0865–791100. Neil McWilliam, Editor (School of Art History, University of East Anglia, Norwich NR4 7TJ).

Subscription: included in membership, UK & Canada £35.75 individuals, £51 institutions; US $61.50 individuals, $87.50 institutions. No sample. Back issues, contact publisher. Illus. b&w, photos. Annual index in Dec issue. Cum. index, v.1–11 in v.12, no. 2, June 1989. 140p.

ISSN: 0141–6790. OCLC: 3952807. LC: N7480.A77. Dewey: 709.

General. Archaeology. Architecture. Art History. Drawing. Graphic Arts. Modern Art. Painting. Sculpture.

Journal of the Association of Art Historians. Publishes original research relating to all aspects of the historical and theoretical study of visual imagery. The journal is committed to the publication of innovative, synthetic work which extends understanding of the visual within a well–developed inter–disciplinary framework and raises significant issues of interest to those working both within the history of art and in related fields.

Reviews: book 6, length 3,000 wds. Freelance work: none. Indexed: AmH&L. ArtBibMod. ArtHum. ArtI. BHA. BioI. CloTAI. CurCont. Des&ApAI. HumI. IBkReHum. RILA. Reviewed: Katz.

Advertising, no color. No classified. No frequency discount. Pamela Courtney, Ad. Director (Albert House, Monnington–on–Wye, Hereford HR4 7NL). Mailing lists: none. Demographics: UK & US. Circulation: 2,000. Audience: academic art historians and historians.

DE ARTE. 1967. s–a. EN mainly or AF. 295

University of South Africa, Department of History of Art and Fine Arts, Box 392, Pretoria 0001, South Africa. Phone 012–429–3051. Dr. Marion Arnold, Editor.

Subscription: included in membership, $US27. Sample. Back issues. Illus. b&w, some color, photos. A4, 80p.

ISSN: 0004–3389. Dewey: 709.

General.

Officially accredited journal. Refereed journal serves the visual arts as a whole with special focus on the art/craft of Southern Africa. Will publish any research, discussion or polemic about any aspect of art and architecture, historic or contemporary, international or local. Research articles which appear can earn subsidy. New acquisitions presented.

Reviews: book, exhibition. Bibliographies. Obits. Freelance work: yes. Contact: editor.

Advertising: none. Audience: academic, art–interested.

ARTE LOMBARDA: Nuova Serie. 1955, ns 1957. irreg. IT or EN. Summaries in alternate language,

(4p. end of issue); occasionally FR or GE summaries. 296

Il Vaglio Cultura Arte s.r.l., Via Vitruvio 39, 20124 Milan, Italy. Phone 02–28.46.903. Maria Luisa Gatti Perer, Editor.

Subscription: L 190000, foreign L 300000. Illus. some color, many full page. Index, Cum. index. 9 x 12, 140p. Each issue hardcover.

ISSN: 0004–3443. OCLC: 1514321. LC: N4.A53. Dewey: 709.452.

Art History.

Scholarly journal presents articles concerning the history of art in Lombardy.

Reviews: book, exhibition. Bibliographies. Indexed: ArtArTeAb. ArtBibMod. RILA.

Advertising.

ARTIBUS ET HISTORIAE. 1980. s–a. EN, IT, GE, or FR. EN & GE sum., end of issue. 297

IRSA Verlag GmbH, Auhofstrasse 112/5, 1130 Vienna, Austria. Jozef Grabski, Editor.

Subscription: $120, L 170,000. Illus. b&w, some color.

ISSN: 0391–9064. OCLC: 7377675. LC: NX1.A1A77. Dewey: 705.

Art History.

Scholarly international journal for visual arts. Publishes articles on arts in a broad sense thus including films and photography. The journal particularly encourages interdisciplinary research on art, for example in areas of art history overlapping with other humanistic disciplines such as psychology, sociology, philosophy, literature, etc. Articles appear in one language only.

Indexed: ArtBibMod. Avery. RILA. Reviewed: Katz.

ASSOCIATION OF ART HISTORIANS BULLETIN. 1975. 3/yr. EN. 298
Association of Art Historians, c/o Flavia Swann, Editor, Dept. of History of Art & Design, North Staffordshire Polytechnic, College Rd., Stoke–on–Trent ST4 2DE, England. Flavia Swann, Editor.
Subscription: included in membership.
ISSN: 0307–9163.
Art History.

Concerned with the advancement of the history of art and design.
Circulation: 2500. Audience: art and design historians.

ATHANOR. 1981. a. EN. 299
Florida State University, Fine Arts, 250 FAB/Gallery, Tallahassee, FL 32306.
Illus.
ISSN: 0732–1619. OCLC: 8142249. LC: N1.A92. Dewey: 705.
Sponsored by the Art History Students' Organization of Florida State University.
Indexed: RILA.

BHA/BIBLIOGRAPHY OF THE HISTORY OF ART/BIBLIOGRAPHIE D'HISTORIE DE L'ART. See no. 9.

BIBLIOTEKA KRAKOWSKA. 1897. irreg. EN. 300
Towarzystwo Milosnikow Historii i Zabytkow Krakowa, Ul. Sw. Jana 12, 31–018 Krakow, Poland. (Dist.: Ars Polona–Ruch, Krakowskie Przedmiescie 7, Warsaw). Janina Bieniarzowna, Editor.
Illus.
ISSN: 0067–7698. OCLC: 4039418. LC: DK4700.B52. Dewey: 700.

BIJUTSU KENKYU: The Journal of Art Studies. 1932. bi–m. JA. EN table of contents & 2p. summaries of articles. 301
Tokyo National Research Institute of Cultural Properties, Dept. of Fine Arts, 13–27 Ueno Park, Taito–Ku, Tokyo 110, Japan.
Illus. b&w, some color, photos, plates. A4.
ISSN: 0021–907X. OCLC: 1532940. LC: N8.B89. Dewey: 707.
The English table of contents includes identification of the plates. Scholarly journal covers art and archaeology of all periods up to but not including Modern.
Advertising: none.

BIJUTSU SHI/JOURNAL OF ART HISTORY. 1950. q. JA. EN titles. 302
Japan Art History Society – Bijutsu–shi Gakkai, c/o Tokyo National Research Institute of Cultural Properties, Ueno Park, Tokyo, Japan. Kaho Yonezawa, Editor.
Subscription: $22.25. Illus.
ISSN: 0021–907X. OCLC: 2782857. LC: N8.B6. Dewey: 709.
Art History.

BLAKE. 1967. q. EN. 303
Publishease, 300 East River Road, Rochester, NY 14623. Phone 716/275–3820. Morris Eaves (Dept. of English, University of Rochester, Rochester, NY 14627) & Morton D. Paley (Dept. of English, University of California, Berkeley, CA 94720), Editors.
Subscription: $20 individual, $40 institution, US, Canada & Mexico; foreign + $6 surface, + $15 air (Patricia Neill, Managing Ed., Dept. of English, Univ. of Rochester, Rochester, NY 14627)). Sample. Back issues, $6; out–of–print issues available as photocopies $9. Illus. b&w, some color, some photos. Annual index. 8½ x 11, 36p.
ISSN: 0006–453X. OCLC: 3160132. LC: PR4147.B47. Dewey: 760. Formerly: *Blake Newsletter*.
Art History. Painting. Engraving.

Covers the work of William Blake, the English Romantic engraver, painter, and poet. Includes both an annual list of recent Blake scholarship and a bi–annual list of sales of Blake's art. Published under the sponsorship of the Dept. of English, University of Rochester. Scope has been widened to include feature articles and reviews on English art and literature of the late 18th and early 19th centuries.

Reviews: 2–3/issue, exhibition, book, film. Bibliographies: Annual annotated romantic bibliography, an international bibliography of Blake scholarship. Listings: regional–international. Exhibition information. Freelance work: yes. Contact: editor. Opportunities: call for papers; competitions. Indexed: ArtHum. CurCont. IBkReHum. RILA.
Advertising: (b&w only) full page $120, ½ page $80. Inserts. Patricia Neill, Ad. Director. Circulation: 650. Audience: romantic scholars, Blake scholars, art historians, literary critics.

BOLLETTINO D'ARTE. 1907 (suspended 1939–47). q. IT only. 304
Ministero per i Beni Culturali e Ambientali, Ufficio Centrale per i Beni Ambientali, Architettonici, Archeologici, Artistici e Storici, Piazza del Popolo 18, Rome, Italy. Guglielmo B. Triches, Editor.
Subscription: L 180000. Illus. b&w, photos, drawings.
ISSN: 0391–9854. OCLC: 1536690. LC: N4.B6. Formerly: *Bollettino D'Arte Del Ministero Della Educazione Nazionale*.
Archaeology. Art History.
Scholarly articles on Italian art and archaeology of all periods.
Reviews: book. Indexed: ArtArTeAb. ArtBibMod. ArtI. Avery. RILA. Reviewed: Katz.

BRUCKMANNS PANTHEON. 1980. a. GE mainly, EN or FR. Table of contents GE only.
EN, GE & FR abstracts. 305
Bruckmann Verlag und Druck GmbH, Nymphenburger Str. 86, 8000 Munich 20, W. Germany. Phone (089)1257340. Erhardt D. Stiebner, Editor.
Subscription: DM 98. Illus. b&w, few color, glossy photos, many ½ page or larger. 9¾ x 13, 208p. hardcover.
ISSN: 0720–0056. OCLC: 7090303. LC: N3.P3N4.P35x. Dewey: 705. Formerly: *Pantheon*.
Art History.
Scholarly history of Western art. International art journal richly illustrated with many larger illustrations. A few articles are translated into both other languages.
Reviews: book & exhibition, lengthy reviews. Indexed: ArtBibMod. ArtI. Reviewed: Katz.
Advertising.

BULLETIN MONUMENTAL. 1834. q. FR only. 306
Societe Francaise d'Archeologie, Musee des Monuments Francais, Palais de Chaillot, 1 Place du Trocadero, 75116 Paris, France.
Subscription: included in membership, 320 F. Illus. b&w, photos, plans. Index. Cum. index 1834–1925, 1926–1954, 1955–1975. A4, 112p.
ISSN: 0007–473X. OCLC: 1537742. LC: N2.B95. Dewey: 913.
Art and architecture of medieval France.
Reviews: book, lengthy. Indexed: ArtArTeAb. ArtHum. ArtI. Avery. BHA. BrArchAb. CurCont. RILA. Reviewed: Katz.
Advertising.

BULLETIN OF NEW ZEALAND ART HISTORY. 1972. a. EN. 307
University of Auckland, Department of Art History, Private Bag C. 1, Auckland, New Zealand. Tony Green & Michael Dunn, Editors.
Dewey: 709.
Art History.
Reviews: book. Indexed: ArtBibMod.

BULLETIN OF THE IRISH GEORGIAN SOCIETY. 1958. a. EN. 308
Irish Georgian Society, Leixlip Castle, Leixlip, Co. Kildare, Ireland. Phone & fax 01–6244211. Desmond Guinness, Editor.
Subscription: included in membership, £10, $US25 US & Canada. Microform available from Irish Georgian Society. Sample free. Back issues. Illus. b&w, some color. Index.
ISSN: 0021–1206. OCLC: 11947474. LC: DA900.I6295 A34. Dewey: 720. Formerly: *Quarterly Bulletin of the Irish Georgian Society*.
Architecture. Art History. Decorative Arts. Historic Preservation.
Devoted to Georgian architecture in Ireland and to its preservation.
Freelance work: yes. Contact: editor. Indexed: ArchPI. RILA.
Advertising: none. Circulation: 3500.

BULLETIN OF THE SOCIETY FOR RENAISSANCE STUDIES. 1983. s–a. EN.

309

Society for Renaissance Studies, c/o Mr. Patrick Sweeney, Membership Secy., Department of History of Art, Westfield College, Univ. of London, Kidderpore Ave., London NW3 7ST., England. Constance Blackwell, Editor.
Subscription: included in membership.
ISSN: 0264–8571. OCLC: 13022887. LC: CB3.B84.
Art History.

Reviews: book.

THE BURLINGTON MAGAZINE. 1903. m. EN.

310

Burlington Magazine Publications Ltd., 6 Bloomsbury Sq., London WC1A 2LP, England. Phone 071 430 0481, telex 291 072. Caroline Elam, Editor.
Subscription: £103 UK, US $285 air, rest of world £114. 50% discount for academics & curators. Microform available from UMI. Back issues £7.50. Illus. b&w, color, photos. Annual index. Cum. index to 1982. 64p.
ISSN: 0007–6287. OCLC: 5461534. LC: N1.B95. Dewey: 705. Formerly: *Burlington Magazine for Connoisseurs.*
Architecture. Art History. Decorative Arts. Drawing. Furniture. Graphic Arts. Historic Preservation. Modern Art. Museology. Painting. Sculpture. Textiles.

A scholarly art historical journal, international in scope, which focuses on new discoveries, documents, conservation of works of art, history of collecting, etc. Covers all periods from antiquity to the present day.
Reviews: exhibition & book, 8–15 each, length 700–2000 wds. Listings: international. Calendar of events. Exhibition information. Freelance work: occasionally. Contact: editor. Opportunities: employment listed in advertising pages; study and competitions listed occasionally. Indexed: ArchPI. ArtArTeAb. ArtBibCur. ArtBibMod. ArtHum. ArtI. Avery. BHA. BioI. BkReI. CurCont. Des&ApAI. IBkReHum. RILA.
Advertising: rates available on request. Audience: art historians in universities and museums, collectors.

COMPUTERS AND THE HISTORY OF ART. See no. 1670.

COURTAULD INSTITUTE OF ART ILLUSTRATION ARCHIVE. ARCHIVE 1: CATHE-DRALS & MONASTIC BUILDINGS IN THE BRITISH ISLES. 1976. irreg. EN.

311

Harvey Miller Publishers, 20 Marryat Rd., London SW19 5BD, England. Phone 081–946 4426. George Zarnecki, Peter Kidson, & Lindy Grant, Editors (Courtauld Institute of Art, Somerset House, Strand, London WC2R 2LS).
Subscription: $30/issue, special discounts for sets. No sample. Back issues. Illus., photos, plans. Index. 297 x 210 mm.
ISSN: 0307–8051. OCLC: 3998376.
Architecture. Art History. Historic Preservation. Sculpture.

A series of bound paperback publications consisting almost entirely of pictures. The aim is to make available the vast photographic resources of the Institute to students, scholars, and art–lovers all over the world. The Archives are intended to provide a visual reference library of European sculpture and architecture and to supplement existing illustration resources by making material available that would not readily be found in books, nor covered anywhere in such detail. At present the Archives are published in four separate series, each devoted to a specific area of study. Each individual part contains between 150 and 200 illustrations; plans, diagrams and elevations where relevant.
Buildings covered in Archive 1 are among the greatest monuments of Romanesque and Gothic art, and also among the most widely taught in the History of Art and Architecture. Each building is here illustrated in great depth, with many detail views of architecture and decorative features rarely seen with such precision and frequently inaccessible.
Advertising: none. Audience: art history students.

COURTAULD INSTITUTE OF ART ILLUSTRATION ARCHIVE 2: 15TH & 16TH CENTURY SCULPTURE IN ITALY. See no. 733.

COURTAULD INSTITUTE OF ART ILLUSTRATION ARCHIVE 3: MEDIEVAL ARCHITEC-TURE & SCULPTURE IN EUROPE. See no. No. 734.

COURTAULD INSTITUTE OF ART ILLUSTRATION ARCHIVE 4: LATE 18TH & EARLY 19TH CENTURY SCULPTURE IN THE BRITISH ISLES. See no. 735.

CURRENT DEBATES IN ART HISTORY. 1989. a. EN. 312

State University of New York At Binghamton, Dept. of Art and Art History, Vestal Parkway East, Binghamton, NY 13901.
Phone 607–777–2605.
OCLC: 23605756.

Art History.

Based on the proceedings of an annual symposium.

DUMBARTON OAKS PAPERS. 1941. a. EN. 313

Dumbarton Oaks Center for Byzantine Studies, Dumbarton Oaks Publications Office, 1703 32nd St., N.W., Washington, DC 20007.
Illus. b&w. Cum. index, v.1–20, 1941–1966 in v.20. 8 x 11¼, 200–250p.
ISSN: 0070–7546. OCLC: 1567085. LC: N5970.D8. Dewey: 709.495.

Art History.

Published with the assistance of the Getty Grant Program. Scholarly, 9–12 articles per issue on Byzantine and Medieval art.
Obits. Indexed: BHA. RILA.
Advertising: none.

EARLY DRAMA, ART AND MUSIC REVIEW. 1978. s–a. EN. 314

Medieval Institute Publications, Western Michigan University, Kalamazoo, MI 49008. Phone 616–387–4153. Clifford David-son, Editor.
Subscription: $4 individuals, $5 institutions. Back issues $2. Illus b&w, photos. Index every five yrs. only. 5 x 8½, 28–32p.
ISSN: 0196–5816. OCLC: 5851714. Formerly: *EDAM Newsletter.*

Art History.

Articles, notes, and reviews of interest to persons working in field of visual representations somehow related to the stage or theater as well as research in music related to the production of early drama. Also contains some news items and notices of major conferences as well as a listing of recent publications, mainly articles, in the field. The publication is sponsored by the Early Drama, Art, and Music project.
Reviews: book 3. Bibliographies: in each issue. Listings: international. Freelance work: none.
Advertising: none. Mailing lists: CARA lists only. Circulation: 200. Audience: scholars, students working in iconography or early theater.

L'ECRIT-VOIR: Revue d'Histoire des Arts. 1982. s–a. FR. 315

Collectif d'Histoire de l'Art de l'Universite de Paris I, 3 rue Michelet, 75005 Paris, France.
Subscription: 70 F. Illus. b&w.
ISSN: 0752–5222. OCLC: 15476998. LC: N5300.E27. Dewey: 700.

Art History.

Written and produced by a student collective of the Sorbonne.
Reviewed: *Art Documentation* Sum 1986, p.64.

EIGHTEEN NINETIES SOCIETY JOURNAL. a. EN. 316

Eighteen Nineties Society, 17 Merton Hall Rd., Wimbledon, London SW19 3PP, England. Phone 071 582 4690.
Encourages studies of the art and literature of the 1890s.

EIGHTEENTH-CENTURY STUDIES. 1967. q. EN. 317

American Society for Eighteenth–Century Studies, University of Cincinnati, 721 Old Chem M.L. 368, Cincinnati, Ohio 45221–0368. Phone 513–556–3820. Ann F. Scheuring, Managing Editor (Dept. of English, University of California, Davis, CA 95616).
Subscription: included in membership, $52 worldwide + $4 postage, air + $10. Sample. Back issues (available AMS Press, 56 East 13th St., New York, NY 10003). Illus b&w. Annual index. Cum. index vol. 1–20. 5 x 8, 150p.
ISSN: 0013–2586. OCLC: 1567675. LC: NX452.E54. Dewey: 700.5.

General – 18th Century.

The only interdisciplinary journal in its field in North America. International in scope, addresses any field of research which has an 18th century component, and includes articles, notes, a forum, and book reviews in all fields of the humanities. Editorial policy "blind submissions".
Reviews: book 15. Biographies: occasionally on 18th century figures. Freelance work: none. Indexed: AmH&L. ArtHum. BkReI. CloTAI. CurCont. HumI.

Advertising: (rate card 1989): (camera ready) full page $205, ½ page $125. No color. No bleed. Frequency discount. Mailing lists: available. Demographics: individual members 1,900, U.S. & foreign libraries 1,100. Circulation: 3200. Audience: all persons interested in field.

EMBLEMATICA. 1986. s–a. EN. 318

AMS Press, Inc, 56 E. 13th St., New York, NY 10003. Phone 212–777–4700. Peter M. Daly & Daniel Russell, Editors.
Subscription: $30 individuals, $55 libraries US & Canada; foreign + $5, air + $10. Back issues. Illus b&w, photos. Annual index. 200p.
ISSN: 0885–968X. OCLC: 12795693. LC: CR1.E42. Dewey: 929.8.
Art History. Decorative Arts. Drawing. Graphic Arts. Interior Design. Painting. Printing.

An interdisciplinary journal publishing original articles, essays, and specialized bibliographies in all areas of emblem studies. Also contains, review articles, reviews, research reports (work in progress, including theses, conference reports and abstracts of completed theses), notes and queries, notices of forthcoming conferences and publications, and various types of documentation. Its purpose is to serve as a forum for researchers working in the field, and as a clearinghouse for information about progress and problems in emblem studies.
Reviews: book 3, length 3–8p. Bibliographies. Listings: international. Exhibition information. Opportunities: study, competitions. Reviewed: Katz.
Advertising: full page $100, no color. No classified. No frequency discount. Mailing lists: none. Audience: Renaissance scholarship in art, literary, cultural and intellectual history.

THE FRANKLIN D. MURPHY LECTURES. 1983. a. EN. 319

The Helen Foresman Spencer Museum of Art, University of Kansas, Lawrence, KS 66045. Phone 913–864–4710. Carol Shankel, Editor.
Subscription: $12. No sample. Back issues $12. Illus. photos. 8½ x 11, 100p.
OCLC: 14055351.
Architecture. Art History. Ceramics. Decorative Arts. Drawing. Modern Art. Painting. Sculpture.

The Franklin D. Murphy Lectures in Art is a series that brings a figure of international stature to the University of Kansas campus each year. This person conducts a two–week art history symposium and delivers two major lectures – one at the Spencer Museum of Art and one at the Nelson–Atkins Museum of Art in Kansas City.
Bibliographies: extensive bibliography in each volume.
Advertising: none.

GAVEA. 1985. s–a. 320

Curso de Especializacao em Historia da Arte e Arquitectura no Brazil, Pontificia Universidade Catolica do Rio de Janeiro, Centro de Cienias sos de Extensao, Rua Marques de Sao Vicente 225, Gavea, 22543, Rio de Janeiro, Brazil.
23cm.
LC: N6650G38. Dewey: 709.81.
Architecture. Art History.

Indexed: Avery.

GAZETTE DES BEAUX-ARTS. 1859. 10/yr. FR (chiefly) or EN. Articles in one language with summaries in the other. Book reviews in FR, IT, or GE. 321

Imprimerie Louis Jean, B.P. 87, 05002 Gap Cedex, France. Francois Souehal, Editor.
Subscription: 1100 F. Illus. b&w. Annual index.
ISSN: 0016–5530. OCLC: 1570479. LC: N2.G3. Dewey: 705.
Art History.

Scholarly journal with research articles on wide variety of topics covering all time periods and all styles through the early 20th century.
Reviews: book, journal, exhibition. Bibliographies. Exhibition information. Indexed: ArtArTeAb. ArtBibCur. ArtBibMod. ArtHum. ArtI. Avery. BHA. BioI. CloTAI. CurCont. RILA. Reviewed: Katz.

GESTA. 1963. s–a. EN. 322

International Center of Medieval Art, The Cloisters, Fort Tryon Park, New York, NY 10040. Phone 212–928–1146. William W. Clark, Editor (Dept. of Art., Queens College CUNY, Flushing, NY 11367).
Subscription: included in membership together with *Newsletter*, $30 individual US, $35 outside US, student $15 all, institutions $50 all. No sample. Back issues. Illus b&w, photos. Cum. index through vol. 20. 8½ x 11, 80p.

ISSN: 0016–920X. OCLC: 1606201. LC: N6280.G4.
Art History.

Dedicated to the study of art and civilization of the Middle Ages. This scholarly journal presents new research on medieval art. Includes information on exhibits, conferences and publications.
Reviews: exhibition. Bibliographies: occasionally a list of PhD. dissertations on medieval art. Obits. of prominent medievalists. Indexed: ArtI. Avery. BrArchAb. CloTAI. CurCont. RILA. Reviewed: Katz.
Advertising: full page $200 camera ready. Mailing lists: available at discretion of board. Demographics: worldwide. Circulation: 1100. Audience: scholars, museum personnel and lay persons interested in Medieval art.

THE GILCREASE MAGAZINE OF AMERICAN HISTORY AND ART. 1979. q. EN. 323

Thomas Gilcrease Museum Association, 1400 Gilcrease Museum Rd., Tulsa, OK 74127. Phone 918–582–3122. Paula Hall, Editor (4828 S. Peoria, No. 12, Tulsa, OK 74105).
Subscription: included in membership, $35 all. Sample. Back issues $6. Illus b&w, color, photos. 8½ x 11, 32+p.
ISSN: 0730–5036. OCLC: 5111161. LC: E151.G54. Dewey: 704.9. Formerly: *American Scene.*
Archaeology. Art Education. Art History. Drawing. Historic Preservation. Painting. Pottery. Sculpture. Textiles.

Articles concern American art and history through art works, books, documents, maps and artifacts in the Gilcrease collection. Occasionally special exhibitions are featured.
Reviews: exhibition 1, variable length; book 1, length 1p. Interviews: with living featured artists. Biographies: artists in collection or explorers or ethnologists. Freelance work: occasionally. Contact: editor.
Advertising: none. Circulation: 4,200.

GREEK, ROMAN AND BYZANTINE STUDIES. 1959. q. EN. 324

Duke University, Department of Classical Studies, Box 4715, Duke Station, Durham, NC 27706. Phone 919–684–6456. Keith Stanley, Editor.
Subscription: 930 US. Illus.
ISSN: 0017–3916. OCLC: 6415521. LC: DE1.G73. Formerly: *Greek and Byzantine Studies.*
Art History.

Research articles on all aspects of the classical world, from the prehistoric through the Hellenic, Hellenistic, Roman and Byzantine periods.
Indexed: CloTAI. CurCont. HumI. RILA.

HISTORIA SZTUKI. 1959. irreg. POL. GE or EN summaries. 325

Adam Mickiewicz University Press, Marchlewskiego 128, 61–874 Poznan, Poland. Phone 699–221.
ISSN: 0083–4270. Dewey: 700. Formerly: *Uniwersytet im. Adama Mickiewicza w Poznaniu. Zeszyty Naukowe. Seria Historia Sztuki.*
Art History.

Presents the results of current scholarly research on art history conducted by members of the university. Each volume consists of a single author's work.

HOOGSTEDER-NAUMANN MERCURY. 1985. irreg. EN. 326

Davaco Publishers, Beukenlaan 3, 8085 RK Doornspijk, The Netherlands. Albert Blankert, Editor (Koningsplein 25, 2518 JE, The Hague).
Subscription: (4 issues) $24 air US, elsewhere Dfl.45 (US: 4 East 74th St., New York, NY 10021. All other countries: Surinamestraat 28, 2585 GJ The Hague, The Netherlands). Illus.
ISSN: 0169–1198. OCLC: 12791394. LC: N6750.H663.
Art History.

Features Northern European art of the high period. Intended for short articles focusing on one or a few findings in the field of northern European art. Supported by Galerie Hoogsteder B.V., The Hague, and Otto Naumann Ltd., New York.
Freelance work: yes. Contact: editor. Reviewed: *Art Documentation* Sum 1986, p.64.

ICMA NEWSLETTER. 1979. 3/yr. EN. 327

International Center of Medieval Art, The Cloisters, Fort Tryon Park, New York, NY 10040. Phone 212–928–1146. Jane Rosenthal, Editor (Dept. of History, Columbia University).
Subscription: included in membership. Sample. Back issues. No illus. 8½ x 11, 4p.
Dewey: 709.
Antiques. Archaeology. Architecture. Art History.

Newsletter covers ICMA news, Conference news, and news of academic and museum events related to the study of art of the Middle Ages.
Bibliographies: list of publications. Exhibition information. Opportunities: competitions, call for papers.
Advertising: none. Circulation: 1400. Audience: members.

IMAGO MUSICAE: International Yearbook of Musical Iconography. 1984. a. EN, FR or GE. 328

Duke University Press, 6697 College Station, Durham, NC 27708. Published in Germany by Baerenreiter–Verlag. Phone 919–684–2173. Tilman Seebass, Editor.
Back issues. Illus. b&w, glossy photos, drawings. Cum. index v.1–5 in v.5. hardcover.
ISSN: 0255–8831. OCLC: 12368429. LC: ML85.I5. Dewey: 704.9.
Art History.

The official organ of the International Repertory of Music Iconograpy. Purpose is the publication of original musicological and art–historical articles on the representation of music in the visual arts. Articles appear in one language only with no abstracts or translations.
Bibliographies: lengthy in each issue. Indexed: RILA.
Advertising: none.

IMPOSTURE. 1988. q. FR. 329

Universite de Montreal, Dept. d'Histoire de l'Art, local 5048, rue Jean–Brillant, Montreal, Quebec H3C 3J7 Canada.
Subscription: $C3. Illus.
ISSN: 0838–2239. OCLC: 18595871. LC: N2. Dewey: 709.
Art History.

IMPRINT. 1976. s–a. EN. 330

American Historical Print Collectors Society, P.O. Box 1352, Fairfield, CT 06430. Rona Schneider, Editor.
Subscription: membership only, $30 includes subscription to *Newsletter*. Illus. b&w. Index. 8½ x 11, 26–30p.
ISSN: 0277–7061. OCLC: 6212941. LC: NE505.I48. Dewey: 769.973.
Art History. Prints.

Journal of the Society whose purpose is to foster the collection, preservation, study and examination of original historical American prints produced from the beginnings of the 17th to the end of the 19th centuries; and to support and encourage research and development of publications helpful to the appreciation and conservation of such historical prints. Scholarly articles convey the history and techniques of such prints.
Indexed: AmH&L. RILA.
Advertising: none.

THE J. PAUL GETTY TRUST BULLETIN. 1986. EN. 331

The J. Paul Getty Trust, 1875 Century Park East, Suite 2300, Los Angeles, CA 90067–2561.
Illus. b&w. 11 x 14, 16p.
Tabloid.
Indexed: Avery.

JAHRBUCH DES ZENTRALINSTITUS FUER KUNSTGESCHICHTE. 1985. a. GE. 332

C.H. Bech, Munich, Germany.
Illus.
ISSN: 0177–9878. OCLC: 13138545. LC: N9.3.J34. Dewey: 709.
Art History.

Indexed: ArtBibMod. RILA.

THE JOURNAL OF CANADIAN ART HISTORY/ANNALES D'HISTOIRE DE L'ART CAN-ADIEN. 1974. s–a. EN or FR. 333

Concordia University, 1455 de Maisonneuve Blvd. West, S–VA432, Montreal, Quebec H3G 1M8, Canada. Phone 514–848–4699. Sandra Paikowsky, Editor & Pub.
Subscription: $C14 Canada, $US16 US & foreign, no air. Microform available from Micromedia. Sample. Back issues. Illus. b&w. 7¼ x 10¼, 90p.
ISSN: 0315–4297. OCLC: 1794618. LC: N6540.J67. Dewey: 700.
Architecture. Art History. Decorative Arts. Modern Art. Photography. Native and Inuit Art.

Provides an opportunity for the publication of scholarly writings in the field of the history of Canadian art, architecture, photography and the decorative arts. Covers Canadian art of all periods and media within a historical framework, using the methodologies of art history. Articles, documents and reviews are published in either English or French dependent upon the language in which they are submitted. Abstracts are provided by the authors of all articles and these are then translated and published at the end of the article in the appropriate other language. Short notes, reviews, and letters to the editors are not translated.

Reviews: (4–6/vol.) exhibition catalogues, book. Bibliographies: individual artists and architects major themes in Canadian artlist of graduate thesis and dissertations in Canadian art and architecture. Listings: national. Freelance work: none. Indexed: ArchPI. ArtBibMod. ArtHum. ArtI. Avery. BHA. CanPI. CloTAI. CurCont. RILA. Reviewed: Katz.

Advertising: (camera ready only): full page $400, ½ page $250, ¼ page $150. No color. No frequency discount. Rose Mary Schumacher, Editor. Demographics: circulated in Canada, U.S., Europe, Japan, and Australia. Audience: scholarly.

THE JOURNAL OF THE WALTERS ART GALLERY. See no. 1027.

JOURNAL OF THE WARBURG AND COURTAULD INSTITUTES. 1937. a. EN. 334

Warburg Institute, University of London, Woburn Square, London, WC1H 0AB, England. Phone 071–580–9663. D.S. Chambers, Peter Kidson & Elizabeth McGrath, Editors.

Subscription: £30 US & Canada. No sample. Back issues £10–20. Illus. b&w, photos. Index. Cum. Author & subject index v.1–37, cum. author index v.1–50. 8 x 10¼, 275p.

ISSN: 0075–4390. OCLC: 8364251. LC: AS122.L8515. Dewey: 052. Formerly: *Journal of the Warburg Institute.*

Archaeology. Architecture. Art History. Ceramics. Decorative Arts. Drawing. Graphic Arts. Landscape Architecture. Modern Art. Painting. Pottery. Sculpture.

A journal of cultural history, providing a common forum for historians and scholars. The continuity of the classical tradition in western civilization is seen as one theme which should encourage an interdisciplinary approach. The aim is also to arouse a non–specialist's unexpected interest in specialized material.

Freelance work: none. Indexed: ArtBibMod. ArtI. BrArchAb. CloTAI. CurCont. RILA.

Advertising: none. Mailing lists: none. Demographics: available in libraries all over the world. Circulation: 1300. Audience: historians or art, religion, science, literature, social & political life, philosophers & anthropologists.

JOURNAL - UNIVERSITIES ART ASSOCIATION OF CANADA. 1972. q. EN, some text in FR. 335

University of Regina, Department of Visual Arts, Regina, Sask. S4S 0A2, Canada. Phone 306–584–4880. Roger Lee, Editor.

ISSN: 0315–940X. OCLC: 2210254. LC: N346.5. Dewey: 700.

Art Education. Art History.

KEYNOTES. q. EN. 336

Eighteen Nineties Society, 17 Merton Hall Rd., Wimbledon, London SW19 3PP, England. Phone 071 5824690.

Newsletter of the Society which promotes the study of the art and literature of the 1890s.

KONSTHISTORISK TIDSKRIFT. 1932. q. Scandinavian languages, some EN (approx. 1 article/issue). EN summaries with many articles, occasionally FR or GE. 337

Almqvist & Wiksell International, P.O. Box 638, 101 28 Stockholm, Sweden. Phone 08–23 7990. Patrik Reuterswaerd, Editor.

Subscription: SEK 185 individual, SEK 215 institution. Illus. b&w, color occasionally. Annual index. 8¾ x 11, 186p/vol.

ISSN: 0023–3609. Dewey: 709.

Art History.

Journal of art history published by the Society of Art History, Stockholm University.

Reviews: book. Indexed: ArtBibCur. ArtBibMod. ArtHum. ArtI. Avery. BHA. CurCont. RILA.

Advertising: none.

KUNSTHISTORISCHES JAHRBUCH GRAZ. 1978. a. GE. 338

Universitat at Graz, Institut fuer Kunstgeschichte, Graz, Austria.

Illus.

OCLC: 5158411. LC: N386.G7A3. Dewey: 709.

Art History.

Published by the Institute of Art History, University of Graz.

Indexed: RILA.

LABYRINTHOS: Studi E Ricerche Sulle Arti dul Medioevo a Barocco Raccolti da Gian Lorenzo Mellini. 1982. s–a. IT. EN summaries. 339

Casa Editrice Felice Le Monnier, Via A. Meucci 2, Grassina (Florence) 50015, Italy. Gian Lorenzo Mellini, Editor.
Subscription: L 53000. Illus. b&w, photos (full page). 7 x 10, 160p.

Art History.

Critical studies of art and aesthetics from the Middle ages through the 19th century.
Indexed: RILA.
Advertising: few ads, b&w only.

LEIDS KUNSTHISTORISCH JAARBOEK. 1982. a. DU, EN, GE, FR, & IT. 340

Staatsuitgeverij, Chr Plantijnstr 129, 2515 TZ Den Haag, Netherlands.
Illus.
ISSN: 0169–4855. OCLC: 9379203. LC: N5.L45.

Art History.

The work of the students and faculty of the History of Art Dept. of the State University of Leiden (Rijkuniversiteit te Leiden). Some volumes also have a distinctive title.
Indexed: RILA. Reviewed: *Art Documentation*, Sum 1986, p.64.

MAINFRAENKISCHES JAHRBUCH FUER GESCHICHTE UND KUNST. 1949. a. GE. 341

Freunde Mainfraenkischer Kunst und Geschichte, Karl–Straeub–Str. 9, 8700 Wuerzburg, W. Germany. Dr. Ernst G. Krenig, Editor.
Subscription: DM 80. Illus.
ISSN: 0076–2725. OCLC: 2354604. LC: DD801.B49M3. Dewey: 943. Formerly: *Archiv des Historischen Vereins Fuer Unterfranken und Aschaffenburg.*

MEDIAEVALIA. 1975. a. EN, FR, GE or LATIN. 342

State University of New York at Binghamton, Center for Medieval and Early Renaissance Studies, Binghamton, NY 13901. Phone 607–777–2730. Bernard S. Levy, Editor.
Illus.
ISSN: 0361–946X. OCLC: 2157383. LC: CB351.M38. Dewey: 940.1.

Art History.

A journal of mediaeval studies.

MEDIEVALIA ET HUMANISTICA. 1943. a. EN. 343

Medieval and Renaissance Society, Box 13348, North Texas Station, Denton, TX 76203. Phone 817–565–2101. Paul Maurice Clogan, Editor.
ISSN: 0076–6127. OCLC: 1587726. LC: D111.M5. Dewey: 940.105.

Art History. Literature. Philosophy.

Studies in medieval and renaissance culture, art, literature, and philosophy.
Reviews: book.

MEMOIRS OF THE AMERICAN ACADEMY IN ROME. 1916. irreg. EN. 344

American Academy in Rome, Library, Via Angelo Masina, 5, Rome, 00153, Italy. (US Dist.: Pennsylvania State University Press, 215 Wagner Building, University Park, PA 16802, Attn. Mrs. Janet Dietz).
Illus., plans.
ISSN: 0065–6801. OCLC: 1479252. LC: DG12.A575. Dewey: 913.37.

MITTEILUNGEN DES KUNSTHISTORISCHES INSTITUTES IN FLORENZ. 1908 (Suspended 1914-1915, 1918, and 1942-1952). 3/yr. IT, EN or GE. IT summaries. Titles in table of contents appear in language of article. 345

Kunsthistorisches Institut in Florenz, Via G. Giusti 44, I-50121 Florence, Italy. Phone 055-24/79/161. Gerhard Ewald & Guenter Passavant, Editors.
Illus. b&w, glossy photos. Annual index. 8 x 10½, 246p.
ISSN: 0342–1201. OCLC: 1569388. LC: N6911.A1F63.

Art History.

The Institute promotes international cooperation in art history, emphasizing works pertaining to all Italian art from the time of the Renaissance. Includes foreign artists who worked in Italy. Each issue contains approximately 15 scholarly articles. Bibliographies with articles. Indexed: ArtI. Avery. CurCont. RILA.

MUENCHENER JAHRBUCH DER BILDENDEN KUNST. 1906. a. GE. 346
Prestel–Verlag, Mandlstr. 26, 8000 Munich 40, W. Germany.
Illus., some color.
ISSN: 0077–1899. OCLC: 1716068. LC: N9.M8. Dewey: 709.433.
Art History.

Published for the Staatliche Kunstsammlungen in Munchen. Art historical journal with emphasis on archeology, architecture, painting and sculpture.
Indexed: ArtBibMod. ArtI. RILA.

MUVESZETTORTENETI ERTESITO. 1952. q. HU. Table of contents in HU, RU & FR. EN, FR or GE summaries occasionally. 347
Akademiai Kiado, Publishing House of the Hungarian Academy of Sciences, P.O. Box 24, H–1363 Budapest, Hungary. M. Mojzer, Editor.
Subscription: $28.50. Illus.
ISSN: 0027–5247. OCLC: 4583631. LC: N8.M995. Dewey: 709.
Art History.

Journal for history of Hungarian art throughout the world and foreign art in Hungarian collections.
Reviews: book. Bibliographies: annual international bibliography of Hungarian art history. Indexed: ArtBibCur. ArtBibMod. RILA.

NEDERLANDS KUNSTHISTORISCH JAARBOEK: Netherlands Yearbook for History of Art.
1947. a. DU or EN. EN summaries (2p.). 348
Free University of Amsterdam, De Boelelaan 1105, 1081 HV Amsterdam, Netherlands. E. de Jong, Editor.
Subscription: fl 145. Illus.
ISSN: 0169–6726. OCLC: 2556028. LC: N5.N4. Dewey: 705.
Art History.

Scholarly coverage of all art history with emphasis on the art of the Netherlands.
Indexed: ArtBibMod. ArtI. CloTAI. RILA.

NEWSLETTER FOR LEONARDISTI. 1983. 3/yr. EN. 349
Western Kentucky University, Department of Art, Bowling Green, KY 42101. Phone 502–745–3944. Patricia Trutty–Coohill, Editor.
Sample free. Back issues. Illus. occasionally, b&w. 8½ x 11, 4p.
ISSN: 0741–9597. OCLC: 10025145. LC: N6923.L33N48. Dewey: 709.
Architecture. Art History. Drawing. Painting.

Provides scholars with news in Leonardo scholarship. It includes announcements of exhibitions, lectures, and current bibliography. Contributions from Leonardo scholars are welcomed.
Bibliographies: current Leonardo related, every issue. Listings: international. Calendar of events. Exhibition information. Opportunities: study, competitions.
Advertising: none. Circulation: 150. Audience: Leonardo da Vinci specialists.

NIEDERDEUTSCHE BEITRAEGE ZUR KUNSTGESCHICHTE. 1961. a. GE. 350
Deutscher Kunstverlag GmbH, Vohburger Str. 1, 8000 Munich 21, W. Germany. Hans Werner Grohn, Editor.
Illus., plans. 200+p.
ISSN: 0078–0537. OCLC: 2661605. LC: N3.N5303.N66. Dewey: 709.
Art History.

Indexed: ArtBibMod. Avery. BHA. RILA.

OCULI. 1987. irreg. EN. 351
John Benjamins Publishing Co., 821 Bethlehem Pike, Philadelphia, PA 19118. Phone 215–836–1200. Rob Ruurs & Bert W. Meijer, Editors.

Illus.
OCLC: 17190656. Dewey: 700.
"Studies in the Arts of the Low Countries" from the 14th century to the present.
Reviewed: Katz.

OUD-HOLLAND. 1885. q. DU or EN. GE & FR occasionally. EN summaries. 352
Staatsuitgeverij, Christoffel Plantijnstraat, The Hague, Netherlands.
Subscription: fl 120. Illus. b&w. Annual index. Cum. author/subject index, A. van Leijenhorst–Wit, comp. *Oud Holland: The First 100 Years, 1883–1982.* (1986). 8¼ x 11½, 60p.
ISSN: 0030–672X. OCLC: 1761581. LC: DJ1.09. Dewey: 949.2.
Art History.

Published by the Netherlands Institute for Art History. Covers Dutch art history of all periods.
Reviews: book, lengthy in language of text. Bibliographies: publications received. Indexed: ArtBibMod. ArtHum. ArtI. Avery. BHA. CurCont. RILA. Reviewed: Katz.
Advertising: none.

OXFORD ART JOURNAL. See no. 211.

PHOEBUS: A Journal of Art History. 1979. a. EN. 353
Art History Faculty, School of Art, College of Fine Arts, Arizona State University, Tempe, AZ 85281. Phone 602–965–3468.
Subscription: $12. Illus. b&w, photos. 6 x 9, 200p.
ISSN: 0193–8061. OCLC: 4378581. LC: N5300. Dewey: 709.
Art History.

Scholarly papers, each issue is devoted to a single theme. Publishes in revised form the papers from the international symposium.
Reviews: book. Indexed: RILA.
Advertising: none.

THE POLISH REVIEW. 1956. q. EN. 354
Polish Institute of Arts and Sciences in America, 51 Pardee Place, New Haven, CT 06515.
Subscription: $25 US individual, $30 institution, + $5 Canada & foreign. Annual index in Dec issue.
ISSN: 0032–2970. OCLC: 1762556. LC: DK4010.P64. Dewey: 943.8.
Indexed: ArtBibMod.

PRINT QUARTERLY. See no. 2780.

PROSPETTIVA: Rivista di Storia dell'Arte Antica e Moderna. 1975. q. 355
Centro Di della Edifimi s.r.l., 1 Costa Scarpuccia, 50125 Florence, Italy. Mauro Cristofani, Editor.
Subscription: L 120000. Illus.
ISSN: 0394–0802. Dewey: 709.
Archaeology. Art History.

Art history from antiquity up to modern times. Presents methodological problems, essays, contributions, and exhibitions.
Indexed: Avery. RILA.

RACAR (REVUE D'ART CANADIENNE)/CANADIAN ART REVIEW. 1974. s–a. EN & FR.
 Brief summaries in other language. 356
Society for the Promotion of Art History Publications in Canada, P.O. Box 68, Station Ahunstic, Montreal, Quebec H3L 3NE, Canada. C. Bergeron & W. McA. Johnson, Editors.
Subscription: Canada $20, foreign $30. Microform available. Illus. b&w.
ISSN: 0315–9906. OCLC: 2247889, 2247890. LC: N1.R17. Dewey: 705.
Art History.

Reviews: book. Indexed: ArtBibMod. CanPI. CloTAI. CurCont. RILA. Reviewed: Katz.

RENAISSANCE QUARTERLY. See no. 1793.

RENAISSANCE STUDIES: Journal of the Society for Renaissance Studies. 1987. q. EN. **357**

Oxford University Press, Oxford Journals, Pinkhill House, Southfield Road, Eynsham, Oxford OX8 1JJ, England. Phone 0865–882283, fax 0865–882890. Dr. Gordon Campbell, Editor (Dept. of English, University of Leicester, Leicester LE1 7RH).

Subscription: ½ price to members, non–members £35, $US68 North America, £40 elsewhere (Journal Subscriptions, Oxford University Press, Walton St., Oxford OX2 6DP). Illus. b&w, photos.

ISSN: 0269–1213. OCLC: 16402936. LC: CB361.R46.

Art History.

Multi–disciplinary scholarly paper covering all aspects of Renaissance history and culture. Documents are printed in their original language.

Reviews: exhibition 1, length 4p. + 3p. illus.; book 10–12, length 2–4p.. each. Obits. Freelance work: Welcomes papers on the history, art, architecture, religion, literature and language of any European country or any country influenced by Europe during the period of the Renaissance. Will send 30 offprints of paper and copy of journal. Contact: editor. Indexed: HistAb. Advertising: rates quoted on request. Isobel Bunn, Ad. Co–ordinator.

REVUE BELGE D'ARCHEOLOGIE ET D'HISTOIRE DE L'ART. 1931. a. FR or EN. **358**

Academie Royale d'Archeologie de Belgique, c/o Musee Bellevue, 7 Place de Palais, 1000 Brussels, Belgium.

Subscription: 1200 BFr. Illus.

ISSN: 0035–077X. OCLC: 1607886. LC: N2.R45. Dewey: 913. Formed by the union of: *Academie Royale d'Archeologie de Belgique Bulletin* and, *Academie Royale d'Archeologie de Belgique. Annales*.

Archaeology. Art History.

Scholarly coverage of painting, sculpture, architecture, and archaeology. Flemish predominates.

Bibliography. Obits. Indexed: ArtBibMod. ArtI. BioI. Reviewed: book.

REVUE DE L'ART. 1968. q. FR only. **359**

Editions du CNRS, 1 Place Aristide Briand, 92195 Meudon Cedex, France. Andre Chastel, Editor.

Subscription: 325 F France, 385 F elsewhere (Centrale des Revues, 11, rue Grossin, 92543, Montrouge, Cedex). Back issues. Illus. b&w, glossy photos. Cum. indexes no.11–41, 1971–78; no.42–70, 1978–85. A4, 96p.

ISSN: 0035–1326. OCLC: 1645554. Dewey: 700.

Art History.

Scholarly publication of the Comite Francais d'Histoire de l'Art covers all time periods. "Presents for reflection and criticism those activities, proceedings and interpretations roused or being roused by art and its history as well as works and their creators throughout time and civilization".

Reviews: book. Biographies. Bibliographies. Listings: national. Calendar of museum events. Indexed: ArtArTeAb. ArtBibCur. ArtBibMod. ArtI. Avery. BHA. CurCont. RILA. Reviewed: Katz.

Advertising: Few ads at end of issue.

REVUE ROUMAINE D'HISTOIRE DE L'ART. SERIE BEAUX-ARTS. 1970. a. FR mainly, EN or GE occasionally. **360**

Editura Academiei Republicii Socialiste Rumania, Calea Victoriei 125, 79717 Bucharest, Rumania. (Dist.: Rompresfilatelia, Calea Grivitei 64–66, P.O. Box 12–201, 78104 Bucharest).

Illus. cum. index v.1–15, 1964–78 in v.17 (1980).

ISSN: 0080–262X. OCLC: 1881514. Dewey: 709. Supersedes in part: *Revue Roumaine de l'Histoire de l'Art* and continues its numbering.

Art History.

Covers Rumanian art history, contemporary art, and folk art.

Reviews: book. Obits. Indexed: ArtBibMod. CloTAI.

RILA (International Repertory of the Literature of Art). See no. 19.

RIVISTA D'ARTE: Studi Documentari per la Storia delle Arti in Toscana. 1903. bi-m. IT. **361**

Casa Editrice Leo S. Olschki, Casella Postale 66, 50100 Florence, Italy. Phone 055 6530684. Dir. Ugo Procacci, Editor.

Illus. Cum. index v.1-24, 1903-1942 in v.25.

OCLC: 1680960. LC: N4.R5. Dewey: 700.

Art History. Painting.

Scholarly articles on Italian art with emphasis on Tuscan painting.
Reviews: book. Indexed: ArtArTeAb. HistAb. RILA.

ROCZNIK HISTORII SZTUKI. 1956. irreg. POL. FR summaries occasionally EN or GE. 362
Ossolineum, Publishing House of the Polish Academy of Sciences, Rynek 9, Warsaw, Poland. (Dist.: Ars Polona–Ruch, Krakowskie Przedmiescie 7, Warsaw). Andrzej Ryszkiewiz, Editor.
Illus.
ISSN: 0080–3472. OCLC: 1764466. LC: N9.6.R58. Dewey: 709.
Art History.

Devoted to the history of art in Poland and Europe. Coverage includes contemporary art.
Indexed: ArtBibMod. RILA.

THE RUTGERS ART REVIEW. 1980. a. EN. 363
Rutgers University, Graduate Program in Art History, New Brunswick, NJ 08903. Phone 201–932–7041.
Subscription: $11 individual, $9 student North America; + $2 foreign includes newsletter *Resource*. Illus. b&w, photos. Cum. index v.6–10 in v.10. 7 x 10, 140–160p.
ISSN: 0194–049X. OCLC: 5319937. LC: N1.R87. Dewey: 705.
Art History.

The journal of graduate research in art history, a student run journal. Articles cover all periods, Classical to 20th century.
Interviews: 1/issue. Indexed: AmH&L. ArtBibMod. Avery. HistAb. RILA.
Advertising: none.

THE SHAKER MESSENGER. 1978. q. EN. 364
World of Shaker, Box 1645, Holland, MI 49422–1645. Phone 616–396–4588. Diana Van Kolken, Editor.
Subscription: $14 US, $14 + postage Canada & foreign. Sample $3.50. Back issues $2.50. Illus. b&w, photos. 8½ x 11, 36p.
Formerly: *World of Shaker (1971–1977)*.
General. Antiques. Archaeology. Architecture. Crafts. Furniture. Historic Preservation. Museology. Textiles.

Devoted to information about the Shakers and the Shaker lifestyle. Current events and historical research relating to their lifestyle and philosophy; persons involved in reproducing Shaker items; Shaker music; Shaker cooking and nutrition. Research papers dealing with the Shaker tradition. Home notes from the two remaining Shaker communities and reports from the Shaker restorations and museums.
Reviews: book 1, length 1–12 inches. Listings: regional–national. Calendar of events. Exhibition information. Freelance work: yes. Contact: editor. Opportunities: study, competitions.
Advertising: (rate card Jan '84): full page $160, ½ page $80, ¼ page $45, business card $25. Classified: (prepaid) 25¢/wd., $5 min. Frequency discount for classified ads only. 15% agency discount. Mailing lists: available only to non–profit Shaker institutions. Demographics: New England states, Ohio, Michigan, California mostly; ages 30 and up; higher income. Circulation: 1000. Audience: persons with working knowledge of Shakers.

SIMIOLUS. 1967. q. EN. 365
Foundation for Dutch Art–Historical Publications, c/o P. Hecht, K H I, Kromme Nieuwegracht 29, 3512 HD Utrecht, The Netherlands. P. Hecht, Editor.
Subscription: fl 85 individual, student fl 45, fl 140 institution. Illus. b&w.
ISSN: 0037–5411. OCLC: 1928395. LC: N5S55. Dewey: 709.
Art History.

"Netherlands quarterly for the history of art" contains scholarly articles focusing on 15th to 18th century art of the Netherlands. Presents a bibliographic survey of books and articles in art history and related fields.
Reviews: book. Indexed: ArtBibCur. ArtBibMod. ArtHum. ArtI. CurCont. IBkReHum. RILA. Reviewed: Katz.

SMITHSONIAN STUDIES IN AMERICAN ART. 1987. q. EN. 366
Oxford University Press, Journals, 200 Madison Ave., New York, NY 10016. Phone 212–679–7300. Lisa Siequist, Editor.
Subscription: $35 individual, $60 institution, + $10 outside US (Journals Dept., 16–00 Pollitt Dr., Fair Lawn, NJ 07410). Illus. b&w, color, photos. 8½ x 11, 84p.
ISSN: 0890–4901. OCLC: 14252662. LC: N6505.S56. Dewey: 709.
General.

Published in association with the National Museum of American Art, Smithsonian Institutions. Articles on the arts in America. Fine Arts are the journal's primary focus, but its scope encompasses all aspects of the nation's visual heritage, including

decorative arts and crafts, architecture and landscape design, film and video, commercial and graphic design. Through an interdisciplinary approach, the publication provides an understanding not only of specific artists and art objects, but also of the cultural factors that have shaped American art from colonial to contemporary times.

Freelance work: yes, manuscripts 10–15 pages. Contact: editor. Indexed: AmH&L. ArtBibMod. Avery. RILA. Reviewed: Katz. *Art Documentation* Fall 1988, p.122. *Library Journal* 112:18, Nov 1, 1987, p.74.

Advertising: none.

SOCIETY FOR RENAISSANCE STUDIES. OCCASIONAL PAPERS. 1973. irreg. EN. 367

Society for Renaissance Studies, c/o Mr. Patrick Sweenwey, Department of History of Art, Westfield College, University of London, Kidderpore Ave., London NW3 7ST, England. Peter Denley, Editor.

Art History. Literature.

Covers art, literature and philosophy of the Renaissance era.

SOURCE: NOTES IN THE HISTORY OF ART. 1981. q. EN. 368

Ars Brevis, Inc., 1 E. 87th St., Suite 7A, New York, NY 10128. Phone 212–369–1881. Laurie Adams, Editor.

Subscription: $20. Illus. b&w. 7 x 9, 32p.

ISSN: 0737–4453. OCLC: 7885191. LC: N5300.S687. Dewey: 709.

Archaeology. Art History.

Publishes short articles (none may exceed 2,000 words), notes and reviews on art and archaeology from antiquity to the present.

Indexed: ArtBibCur. ArtBibMod. ArtHum. Avery. BHA. CurCont. RILA. Reviewed: Katz.

Advertising: none. Circulation: 1000.

SOUTH AFRICAN JOURNAL OF ART AND ARCHITECTURAL HISTORY. 1990. q. EN & AF. 369

Bureau for Scientific Publications, P.O. Box 1758, Pretoria 001, South Africa. Phone 012–3226422. N.J. Coetzee, Editor.

Subscription: included in membership, R 40 (South Africa Association of Art Historians, P.O. Box 16043, Vlaeberg, Cape Town 8018, South Africa). Illus.

OCLC: 22886787. LC: N1.S726. Continues in part: *South African Journal of Cultural and Art History.*

Architecture. Art History.

Produced in collaboration with the South African Association of Art Historians.

SOUTHEASTERN COLLEGE ART CONFERENCE REVIEW. See no. 621.

SPECULUM: A Journal of Medieval Studies. 1926. q. EN. 370

Medieval Academy of America, 1430 Massachusetts Ave., Cambridge, MA 02138. Phone 617–491–1622. Luke Wenger, Editor.

Subscription: included in membership, non–members $60. Microform available. No illus. Cum. index v.1–40 (1988). 6¾ x 10, 520p.

ISSN: 0038–7134. Dewey: 909.07.

Art History.

The purpose of the Academy is "the promotion of research, publication and instruction in medieval records, art, archaeology, history, law, literature, music, philosophy, science, social and economic instruction and all other aspects of medieval civilization. Lengthy scholarly articles, mainly history occasionally art.

Reviews: book approx. 50, length 1–3p. each. Bibliographies. Indexed: ArtI. BkReI. BrArchAb. CloTAI. CurCont. HumI. IBkReHum. RILA.

Advertising.

SPONSORED RESEARCH IN THE HISTORY OF ART. See no. 34.

STORIA DELL'ARTE. 1969. 3/yr. IT or EN. 371

Nuova Italia Editrice, Casella Postale 183, 50100 Florence, Italy.

Illus. b&w, glossy photos. 8¼ x 10¾, 94p.

ISSN: 0392–4513. OCLC: 1185167. LC: N4.S84. Dewey: 709.

Art History.

Art history, primarily of Italy.
Indexed: ArtBibCur. ArtBibMod. CurCont. RILA.

STUDIA Z HISTORII SZTUKI. 1953. irreg. POL. EN, FR & GE summaries. 372
Ossolineum, Publishing House of the Polish Academy of Sciences, Rynek 9, 50–106 Warsaw, Poland. (Dist.: Ars Polona–
Ruch, Krakowskie Przedmiescie 7, Warsaw).
ISSN: 0081–7104. Dewey: 701.

STUDIES IN ICONOGRAPHY. 1975. a. EN. 373
Arizona State University, School of Art, Tempe, AZ 85287–1505. Phone 602–965–6439. Anthony Lacy Gully, Editor.
Subscription: $12 individual, $25 institution. Illus. b&w, photos. 6½ x 9¾, 186p.
ISSN: 0148–1029. OCLC: 2924022. LC: NX1.S84. Dewey: 700.

Art History.

Articles focus on the literary as well as the pictorial use of iconography. Essays from all historical periods.
Freelance work: yes. Contact: editor. Indexed: ArtBibMod. CurCont. RILA. Reviewed: Katz.
Advertising: none.

I TATTI STUDIES. 1985. a. EN, FR, GE, IT & SP. 374
Ursus Books, Via di Vincigliata 26, Florence 50135, Italy. Phone 39–55–608–909, fax 39–55–603–383.
Subscription: The Editors, I Tatti Studies, Via di Vincigliata 26, 50135, Florence, Italy. Illus. b&w, photos. 8½ x 11, 16p.
ISSN: 0393–5949. OCLC: 13745700. LC: DG445.T29. Dewey: 945.

Art History.

Covers the arts and humanities of Renaissance Italy.
Bibliography of recent publications. Calendar of events. Freelance work: Welcomes submissions from Renaissance scholars,
manuscripts 7000–10,000 words. Indexed: HistAb. RILA. Reviewed: *Art Documentation* Sum 1986, p.64.
Advertising: none.

THE TURNER SOCIETY NEWS. See no. 770.

TURNER STUDIES: His Art and Epoch 1775–1851. 1981. s–a. EN. 375
Tate Gallery, Milbank, London SWIP 4RG, England. Phone 081–992 7985. (US dist: 85 Ash St., Hopkinton, MA 01748).
Eric Shanes, Editor (7 Cumberland Rd., London W3 6EX).
Subscription: £16 UK, overseas $43 post free (Carfax Publishing Co., P.O. Box 25, Abingdon, Oxfordshire, OX14 3UE).
Back issues£8.50, $23. Illus. Index.
ISSN: 0260–597X. OCLC: 7605713. LC: ND497.T8T87. Dewey: 760.

Art History.

Material on the art and life of J.M.W. Turner, RA and his contemporaries as well as articles or notices on other aspects of the
artistic, social and historic, background appertaining to the period of Turner's lifetime. Will also include material on the art-
ists who may be deemed to have exercised an influence on him. "News and Sales Records" section includes information on
sales (date, place, description and price), lectures, symposia, public and private collections, and works in progress.
Reviews: exhibition 3, length 1p.; book 1, length 3p. Bibliographies: new books. Indexed: RILA.
Advertising: only ads, 1–2 on back covers.

UNSERE KUNSTDENKMAELER ALER/NOS MONUMENTS D'ART ET D'HISTOIRE.
1950. q. GE, FR or IT. 376
Gesellschaft fuer Schweizerische Kunstgeschichte – Society of Swiss Art History, Postfach 1480, 3001 Berne, Switzerland.
Nott Caviezel, Editor.
Subscription: 30 SFr. Illus. Index.
ISSN: 0566–263X. OCLC: 2142005. LC: N7141.U59.

Architecture.

Indexed: Avery. RILA.

VAN GOGH BULLETIN. 1986. q. DU & EN, occasionally FR, GE, IT, SP, or JA. 377
Rijksmuseum Vincent van Gogh, Paulus Potterstraat 7, 1071 CX Amsterdam, The Netherlands. Phone 020–5705200, fax
6735053. Ineke Middag, Editor.

Subscription: Dfl 50. Sample. Back issues. Illus. color, photos. A4, 16p.

Architecture. Art History. Decorative Arts. Drawing. Graphic Arts. Modern Art. Painting. Printing. Sculpture.

Focuses on information about the exhibition program of the Museum. The main articles describe the exhibitions. Also a column on the Van Gogh Research Project, the Mesdag Museum in The Hague, and new acquisitions.

Calendar of Museum events. Exhibition information. Freelance work: yes. Contact: editor. Opportunities: museum conferences.

Advertising: none. Audience: museum visitors and Van Gogh researchers.

THE VICTORIAN. 1969. q. EN. 378

Victorian Society in America, 219 S. Sixth St., Philadelphia, PA 19106. Phone 215–627–4252. Penny Morrill, Editor (1010 Shipman Lane, McLean, VA 11202).

Subscription: included in membership, $25. Sample. Some back issues. Illus. b&w, photos, cartoons. 8½ x 11, 16p.
Dewey: 709.03. Formerly: *The Bulletin.*

General. Victorian customs.

Provides members with information about current exhibitions, lectures, tours, and schools which would interest them. Will print anything about the period from 1800–1917.

Reviews: exhibition 15, book 2, other 4. Listings: national–international. Calendar of events. Exhibition information. Freelance work: yes. Contact: editor. Opportunities: study, competitions.

Advertising: full page $200 members, $300 non–members; ½ page $150, $200; ¼ page $100, $150. Classified: $2/line members, $6/line non–members. Mailing lists: available. Circulation: 2700. Audience: Victorian Society members.

THE VICTORIAN SOCIETY ANNUAL. 1959–60. a. EN. 379

Victorian Society, 1 Priory Gardens, Bedford Park, London W4 1TT, England. Phone 081–994 1019. Ian Sutton, Editor (47 Linton St., London N1 7AN).

Subscription: included in membership, non–members £3. No sample. No back issues. Illus. b&w, photos. 24 x 19 cm., 48p.
ISSN: 0083–6079. OCLC: 5179942. LC: NA12.V513.

Architecture. Art History. Ceramics. Crafts. Decorative Arts. Drawing. Furniture. Historic Preservation. Interior Design. Photography. Sculpture. Textiles.

The annual report of the Society includes summaries of all the planning application cases in which the Society was involved throughout the year and a checklist of all the other events organized. Reviews of recent art books and exhibitions with a Victorian theme are included as well as one or two general articles on Victorian art or architecture. Includes notes on the main conservation cases of the past year.

Reviews: exhibition 3 & book 2, length 600 wds. Biographies: profiles of leading Victorian architects, artists and builders. Listings: national. Calendar of events. Freelance work: yes. Contact: editor. Opportunities: lectures, walks, excursions. Indexed: RILA.

Advertising: full page £165, ½ page £85, back cover £180, no color. No classified. No frequency discount. Mailing lists: none. Circulation: 3200. Audience: Society members & individuals seriously interested in Victorian studies.

THE VOLUME OF THE WALPOLE SOCIETY. 1917. a. EN. 380

Walpole Society, History of Art Dept., Westfield College, London NW3 75T England. Diana Dethloff, Editor.

Subscription: members only, £18 individual, 30£ institution (Reginald Williams, Treas., Dept. of Prints & Drawings, British Museum, London WC1A 2NP). Back issues. Illus. b&w, photos. Index. Cum. index. 250p + approx. 40p. plates, hardcover.
ISSN: 0141–0016. OCLC: 7374030. LC: N12.W3. Dewey: 709. Formerly: *Annual Volume of the Walpole Society.*

Art History.

Society was formed in 1911 with its purpose to collect and publish archieval and other material relating to the history of the arts in Great Britain. Each volume, devoted to the life and works of artists of any period of British art, consists of essays and editions of original documents and includes a catalog. From World War II until 1983 was published biennially.

Freelance work: Contributions welcome from scholars. Indexed: RILA.

WALLRAF-RICHARTZ-JAHRBUCH: Westdeutsches Jahrbuch fuer Kunstgeschichte. Neue Folge. 1924. a. 381

Dumont Buchverlag, Mittelstr. 12-14, D-5000 Cologne 1, W. Germany.
Subscription: DM 120.
ISSN: 0023–5474. Dewey: 709.

Art History.

West German yearbook of art history. Scholarly coverage, mainly of Germany art, with some articles on other European countries.

Reviews: book. Indexed: ArtBibMod. ArtI. BHA. RILA.

WARBURG INSTITUTE SURVEYS AND TEXTS. 1963. irreg. EN. 382
Warburg Institute, University of London, Woburn Square, London WC1H 0AB, England.
Illus.
ISSN: 0266–1772. OCLC: 13410143. Dewey: 700. Formerly: *Warburg Institute Surveys*.
Presents texts, survey studies and colloquium papers in the field of medieval and Renaissance philosophy, science, literature and art.

WINTERTHUR PORTFOLIO: A Journal of American Material Culture. 1964. 3/yr. EN. 383
University of Chicago Press, Journals Division, P.O. Box 37005, Chicago, IL 60637. Phone 312–702–7359. Ian M.G. Quimby (Winterthur Museum, Winterthur, DE 19735).
Subscription: $27.50 US, elsewhere + $7. Microform available from UMI. No sample. Back issues $9.25. Illus. b&w, some color. Index. 9 x 12, 112p.
ISSN: 0084–0416. OCLC: 1332742. LC: N9.W52. Dewey: 709. Formerly: *Winterthur Portfolio 1 (–13)*.
General. American Studies.

Published for the Henry Francis Du Pont Winterthur Museum. An interdisciplinary journal committed to fostering knowledge of the American past by publishing articles on the arts in America and the historical context within which they developed. "Arts" is used in its broadest sense to include all products of human ingenuity that satisfy functional, aesthetic, or symbolic needs. Preference is given to articles that are analytical rather than descriptive and to studies that integrate artifacts into their cultural framework.

Reviews: exhibition 1, book 12–15, length 1000–3000 wds., journal; occasional review essays of 6000 wds. Bibliographies & biographies:: occasionally, related to fields of inquiry. Freelance work: none. Indexed: AmH&L. ArchPI. ArtBibCur. ArtBibMod. ArtHum. ArtI. Avery. BHA. CurCont. IBkReHum. MLA. RILA. Reviewed: Katz. *Art Documentation* Fall 1986, p.133.

Advertising: full page $200, ½ page $140, no color. No classified. Frequency discount. Cheryl Jones, Ad. Director (5720 S. Woodlawn Ave., Chicago, IL 60637). Mailing lists: available. Circulation: 1747. Audience: scholars in museums and universities.

YORK GEORGIAN SOCIETY ANNUAL REPORT. 1943. a. EN. 384
York Georgian Society, Kings Manor, York YO1 2EW, England. Nancy Sumner, Editor.
Subscription: included in membership. Illus.
OCLC: 2246401. LC: NA12.Y6718. Dewey: 720.
Architecture.

Reviews: book. Indexed: ArchPI. RILA.

ZEITSCHRIFT FUER KUNSTGESCHICHTE. 1932 (suspended 1944-48). q. GE or EN. 385
Deutscher Kunstverlag, Postfach 21 04 23, Vohburger Str. 1, D–8000 Munich 21, W. Germany. Prof. Dr. Georg Kauffmann (Institut fuer Kunstgeschichte, Universitat Muenster, Domplatz 23, D–4400 Meunster).
Subscription: DM 170. Illus. b&w, glossy photos. Index. Cum. index v.1–40, 1932–77. 7¾ x 10¼, 148p.
ISSN: 0044–2992. OCLC: 930029. LC: N3.Z53. Dewey: 705. Formed by the union of: *Repertorium fuer Kunstwissenschaft, Zeitschrift fuer Bildende Kunst* and, *Jahrbuch fuer Kunstwissenschaft*.
Art History.

Scholarly articles on the history of Western art. Covers all periods.
Reviews: book, lengthy. Indexed: ArtBibMod. ArtHum. ArtI. Avery. BHA. CurCont. IBkReHum. RILA. Reviewed: Katz.

ZEITSCHRIFT FUER SCHWEIZERISCHE ARCHAEOLOGIE UND KUNSTGESCHICHTE /REVUE SUISSE D'ART ET D'ARCHEOLOGIE/ RIVISTA SVIZZERA D'ARTE E D'ARCHAEOLOGIA. 1939. q. GE, FR & IT. EN, FR, GE, & IT summaries (1 paragraph/language). 386
Verlag Karl Schwegler AG, Postfach, CH–8050 Zurich, Switzerland. L. Wuethrich, Editor.
Subscription: 55 SFr. Illus.
ISSN: 0044–3476. OCLC: 1770534. LC: DQ30.Z4. Dewey: 913.494. Formerly: *Anzeiger fuer Schweizerische Alterumskunde*.
Archaeology. Art History.

Comprehensive coverage of Swiss art history and archaeology.

Reviews: book. Indexed: ArchPI. ArtBibCur. ArtBibMod. Avery. RILA.

ZENTRALINSTITUT FUER KUNSTGESCHICHTE. JAHRBUCH. 1985. a. GE. EN & FR

summaries. **387**
C.H. Beck'sche Verlagsbuchhandlung, Wilhelmstr. 9, 8000 Munich 40, W. Germany.
Subscription: DM 98.
ISSN: 0177–8978. Dewey: 700.
Architecture History. Art History.

Indexed: CurCont.

Archaeology

AEGYPTOLOGISCHE FORSCHUNGEN. irreg. EN. **388**
J. J. Augustin, Inc., Locust Valley, NY 11560. Phone 516–676–1510.
Archaeology.

AERIAL ARCHAEOLOGY: The Journal for Air Photography and Archaeology. 1977. a. EN. **389**
Aerial Archaeology Publications, 15 Colin McLean Rd., East Dereham, Norfolk NR19 2RY, England. Derek A. Edwards, Editor.
Some back issues. Illus. b&w, photos. A4, 80–100p.
ISSN: 0140–9220. OCLC: 5915830. LC: DA670.E13 A37. Dewey: 930.1.
Archaeology. Photography.

A journal devoted entirely to matters relating to air photography and archaeology. Annuals contain various papers, 70–100 half–tone plates plus line figures and tables. Some special editions have specific theme.
Bibliographies.

AIA BULLETIN. 1973? q. EN. **390**
Association for Industrial Archaeology, School of Humanities & Cultural Studies, Wolverhampton Polytechnic, Castle View, Dudley, West Midlands DY1 3HR, England. Phone fax 952 452204. Peter Wakelin, Editor.
Subscription: included in membership (Sec., The Wharfage, Ironbridge, Telford, Shropshire TF8 7AW, phone 095245–3522).
Illus. b&w, photos, line drawings. A4, 8p.
ISSN: 0309–0051.
Archaeology. Historic Preservation.

The purpose of the Association is to promote the study of industrial archaeology and encourage improved standards of recording, research, conservation and publication. Stresses the importance of preserving historic industrial sites.
Listings: regional. Calendar of events. Opportunities: study – conferences, workshops; competitions – entries, deadlines, awards.

AMERICAN JOURNAL OF ARCHAEOLOGY. 1885 1st series, 1897 2nd series. q. EN. **391**
Archaeological Institute of America, 675 Commonwealth Ave., Boston, MA 02215. Phone 617–353–9364. Fred S. Kleiner, Editor.
Subscription: included in membership, $70, student members $25, non–members $50, institution $90 US & Canada; foreign individuals $60, institution $100. No sample. Back issues, individuals $20–$25, institutions $40–$50. Microform available from UMI, v.53, 1949 on. Illus. b&w, photos, drawings, maps, line–cuts and half–tones. Annual index in Oct issue. Cum. index v.11–70, 1907–1966. 8½ x 11, 160p.
ISSN: 0002–9114. OCLC: 5696010. LC: CC1.A6. Dewey: 930. Formerly: *American Journal of Archaeology and of the History of the Fine Arts.*
General. Archaeology. Architecture. Art History. Ceramics. Painting. Pottery. Sculpture.

Scholarly articles on the art and archaeology of ancient Europe and the Mediterranean world, including the Near East and Egypt, from prehistoric times to the Middle Ages.
Reviews: book, 30/issue. Bibliographies: substantial bibliographical data included in footnotes for every article. Obits. Listings: international. Exhibition information. Freelance work: none. Opportunities: study; competitions. Indexed: ArtHum. ArtI. Avery. BkReI. BrArchAb. CloTAI. CurCont. HumI. Reviewed: Katz.

Advertising: none. Mailing lists: available. Circulation: 4000. Audience: scholars (archaeology, art history, history, etc.).

AMICI DI SPANNOCCHIA. 1981. 3/yr. EN. 392

Etruscan Foundation, 16 Country Club Dr., Grosse Pointe Farms, MI 48236. Phone 313–886–6654. Margaret W. Young, Editor.

Archaeology.

Newsletter reporting on classical archaeology, architectural preservation, and cultural programs conducted at the Foundation's headquarters in Spannocchia, Italy.

ANTIKE KUNST. 1958. s–a. GE, FR, or EN. FR or GE abstract. 393

Vereinigung der Freunde Antiker Kunst, c/o Archaeologisches Seminar der Universitaet, Schoenbeinstr. 20, CH–4056 Basel, Switzerland.

Subscription: included in membership, SFr 88 individual, SFr 40 student. Illus. b&w, some color, glossy photos, plans. Index. Cum. index. 8½ x 11, 160p. + 24p. plates.

ISSN: 0003–5688. OCLC: 2254516. LC: N5320.A55. Dewey: 709.

Archaeology.

Scholarly, classical subjects, often thematic studies. Each article appears in a single language.

Indexed: ArtI. Avery. CloTAI.

Advertising.

THE ANTIQUARIES JOURNAL. 1921. s–a. EN. 394

Oxford University Press, Oxford Journals, Pinkhill House, Southfield Rd., Eynsham, Oxford OX8 1JJ, England (US: 200 Madison Ave., New York, NY 10016). Phone 0865–56767. Christopher Chippendale, Editor.

Subscription: £40. Microform available from UMI. Illus. b&w, glossy photos, maps, drawings. Index. Cum. index: vols. 1–10; vols.21–30, 1941–50; vols. 31–40, 1951–60. 7½ x 9¾, 180p.

ISSN: 0003–5815. OCLC: 1481608, 8496365 (microform). LC: DA20.S612. Dewey: 930.1. Formerly: *Proceedings of the Society of Antiquaries of London.*

Archaeology.

The journal of the Society of Antiquaries of London. Scholarly international journal of record within archaeology. Includes fold–out drawings.

Reviews: book. Bibliography included with articles. "Publications Received" in each issue. Indexed: ArchPI. ArtArTeAb. Avery. BkReI. CloTAI. CurCont. RILA. Reviewed: Katz.

Audience: archaeologists, art historians and historians.

ANTIQUITY. 1927. q. EN. 395

Oxford University Press, Oxford Journals, Pinkhill House, Southfield Rd., Eynsham, Oxford OX8 1JJ, England. Phone 0865 56767, fax, 0865 882890, telex 837330 OXPRES G. Christopher Chippindale, Editor.

Subscription: £36 UK, $US75 North America, £42 elsewhere. Microform available. Illus., plans. Annual index. 160p.

ISSN: 0003–598x. OCLC: 1481624. LC: CC1.A7. Dewey: 930.

Archaeology.

International journal of record within archaeology, reporting specialist work to the wider readership and larger issues that concern every archaeologist.

Reviews: book. Indexed: ArtArTeAb. ArtHum. Avery. BHA. BrArchAb. CloTAI. CurCont. HumI. Reviewed: Katz.

Advertising. Circulation: 3000.

ARCHAEOLOGICAL INSTITUTE OF AMERICA. ABSTRACTS. 1976. a. EN. 396

Archaeological Institute of America, 675 Commonwealth Ave., Boston, MA 02215. Phone 617–353–9361.

Subscription: $7.50 US. No sample. Back issues. no illus. Index of authors at end of each volume. 50p.

ISSN: 0162–6469. OCLC: 4201937. LC: GN701.A73.

General. Archaeology. Architecture. Art History. Ceramics. Painting. Sculpture. Textiles.

Contains abstracts of the annual general meeting of the Institute.

Freelance work: none.

Advertising: none. Circulation: ca.500. Audience: scholars (archaeology, art history, history, etc.).

ARCHAEOLOGICAL JOURNAL. 1844. a. EN. 397

Royal Archaeological Institute, 96 New Walk, Leicester LE1 6TD, England. R.T. Schadla–Hall, Editor (Leicestershire Museums, Art Galleries, and Records Service, 96 New Walk, Leicester, LE1 6TD).
Subscription: included in membership, non–members £20. Illus. Index. Cum. index every 25 vols. 500+p.
ISSN: 0066–5983. OCLC: 1481817. LC: DA20.R86. Dewey: 913.42.

Archaeology.

Contains articles, a report of the Council of the Institute for the previous year, and a list of new members. Reports on projects funded by the Institutes Research Grants.
Reviews: book, 60p. Freelance work: yes. Contact: editor with papers. Send books for review to M.J. Millett, , Assistant Editor (Dept. of Archaeology, University of Durham, Durham, DH1 3NU). Indexed: ArchPI. ArtI. Avery. BrArchAb. CloTAI. RILA.

ARCHAEOLOGICAL NEWSLETTER. 1965, ns 1981. bi–m. EN. 398

Royal Ontario Museum, Committee for Field Archaeology, 100 Queen's Park, Toronto, Ontario M5S 2C6, Canada. Phone 416–586–5698. David M. Pendergast, Editor.
Subscription: included in membership, free to others on request (Attn. Imogene M. Friedman). Microform available from Micromedia Ltd. (158 Pearl St., Toronto M5H 1L3). Sample free. Back issues. Illus. b&w, photos, cartoons. 8½ x 11, 4p.
ISSN: 0563–9239. OCLC: 2280610. LC: CC1.A65. Dewey: 914.03.

Archaeology.

Reports by Royal Ontario Museum archaeologists and associates on current fieldwork in Canada, Belize, Yemen, Crete, Jordan, Turkey, Iran, Yugoslavia, and elsewhere. Looseleaf format.
Freelance work: none.
Advertising: none. Circulation: 4800. Audience: museum members, archaeologists, students, universities, libraries.

ARCHAEOLOGICAL REPORTS (Durham). 1977. a. EN. 399

University of Durham & University of Newcastle–upon–Tyne, Dept. of Archaeology, 46 Saddler St., Durham, DH1 3NU England. Phone 091 374 3630. A.F. Harding & P.C. Lowther, Editors.
Subscription: foreign £3.50. Sample. Back issues. Illus. b&w line drawings. A4, 60p.
ISSN: 0141–8971. OCLC: 9631388. LC: DA90.A72. Dewey: 913.

Archaeology.

Short reports on fieldwork undertaken by members of the two universities and published in advance of the main report.
Freelance work: none.
Advertising: none. Circulation: 150. Audience: fellow professionals.

ARCHAEOLOGICAL REPORTS (London). 1955. a. EN. 400

Society for the Promotion of Hellenic Studies, 31–34 Gordon Square, London WC1H OPP, England. Phone 071–387–7495. Dr. Lyn Radley, Editor.
Subscription: included in membership as supplement to *Journal of Hellenic Studies*, £20 or $US45 individuals, £26 or $US60 institutions, students £7.50, no air. Illus. b&w, photos, maps,plans. A4, ca.120.
ISSN: 0570–6084. OCLC: 1196515. LC: DF10.J8. Dewey: 930.1.

Archaeology. Architecture. Art History. Ceramics. Decorative Arts. Historic Preservation. Painting. Sculpture.

The purpose of the Society is the study of Greek language, literature, history and art in the ancient, Byzantine and modern periods. Published by the Council of the Society and the Managing Committee of the British School at Athens as a supplement to the *Journal of Hellenic Studies*. Scholarly journal contains an annual summaries of recent archaeological work in Greece and in other areas of Hellenic settlement. Includes bulletins concerning new acquisitions by museums in Great Britain.
Reviews: book 60. Freelance work: none.
Advertising: [VAT included, camera ready only] back cover full page £230, ½ page £115, no color. No classified. Leaflets. (Contact Secretary). Demographics: individual members UK 1,200, overseas about half Europe, half USA, Canada, Australia, Far East; institutions, libraries UK 150, overseas ca. 300 Europe, 700 USA, Canada, Australia, Far East. Circulation: 3000. Audience: scholarly.

ARCHAEOLOGICAL REVIEW FROM CAMBRIDGE. 1983. s–a. EN. 401

Dept. of Archaeology, Cambridge University, Downing St., Cambridge CB2 3DZ, England.
Illus.
ISSN: 0261–4332. OCLC: 9856618. LC: CC1.A65. Formerly: *Archaeological Reviews from Cambridge*.

Archaeology.

Produced by graduate students the goal is to concentrate on research in progress and on critiques and reviews of all theoretical aspects of the discipline.
Reviews: book. Bibliographies accompany articles. Reviewed: *Art Documentation* Sum 1987, p.68.
Audience: primarily professional archaeologists.

ARCHAEOLOGY: Bulletin of the Israel Association of Archaeologists. 1986. q. HE. 402
Ariel Publishing, P.O. Box 3328, Jerusalem, Israel.
Illus. 69p.
Dewey: 913.
Archaeology.
Advertising.

ARCHAEOLOGY (New York). 1948. bi–m. EN. 403
Archaeological Institute of America, 15 Park Row, New York, NY 10038. Phone 212–732–5154. Peter Young, Editor.
Subscription: $20. Illus. color, photos, maps. Index. Cum. index.
ISSN: 0003–8113. OCLC: 1481828. LC: GN700.A725. Dewey: 913.
Archaeology.

A magazine dealing with the antiquity of the world. Presents worldwide coverage of current excavations. Includes regular departments on photography, science and news. Offers two yearly travel sections with comprehensive information on how to reach active sites all around the world.
Indexed: ArtArTeAb. ArtHum. ArtI. Avery. BioI. BkReD. BkReI. BrArchAb. CloTAI. CurCont. HumI. Reviewed: Katz.
Advertising. Audience: general public, appeals to the art lover, to the sophisticated traveler, and to all those interested in the artistic, scientific and social achievements of mankind.

ARCHAEOLOGY ABROAD BULLETIN. 1973. a. EN. 404
Archaeology Abroad, 31–34 Gordon Square, London WC1H OPY, England. M. Roxan, Editor.
ISSN: 0140–7880.
Archaeology.

Provides information on opportunities for fieldwork outside England.
Audience: Archaeologists and students in Britain.

ARCHAEOMETRY. 1958. s–a. EN. 405
University of Oxford, Research Laboratory for Archeology & the History of Art, 6 Keble Road, Oxford OX1 3QJ, England. Editorial Board.
Microform available. Illus.
ISSN: 0003–813X. OCLC: 1481830. LC: CC75.A66. Dewey: 913.
Archaeology. Art History.

Scholarly research journal showing the relationship of the physical sciences to both archaeology and art.
Indexed: ArtArTeAb. ArtHum. BrArchAb. CloTAI. CurCont. Reviewed: Katz.
Advertising.

ART AND ARCHAEOLOGY TECHNICAL ABSTRACTS. See no. 3.

ARTIFACTS / The Shepaug Valley Archaeological Society. 1972. q. EN. 406
American Indian Archaeological Institute, Box 260, Washington, CT 06793. Phone 203–868–0518. Editorial Board.
Subscription: included in membership. Illus.
OCLC: 15338955. Dewey: 917.
Archaeology.

THE ASOR NEWSLETTER. 1938. q. EN. 407
Johns Hopkins University Press, Journals Publishing Division, 701 W. 40th St., Suite 275, Baltimore, MD 21211. Phone 301–338–6987, fax 301–889–1157. James A. Sauer, Editor (American Schools of Oriental Research, The Rotunda, 711 W. 40th St., Suite 354, Baltimore, MD 21211, phone 301–889–1383).
Subscription: $16 individual, $23 institution US; foreign $16.50 individual, $23.50 institution. Microform available from UMI. 8p.

ISSN: 0361–6029. OCLC: 4660377. LC: DS101.A46. Dewey: 950. Formerly: *Archeological Newsletter*.

Archaeology.

Designed as a means of communicating news to members of the American Schools of Oriental Research (ASOR) and others interested in ASOR's activities in the Middle East. Contains reports about important research and excavation results as well as news of members.

Calendar of events. Opportunities: study; information regarding fellowships and grants and announcements of recipients.

ATHENS ANNALS OF ARCHAEOLOGY. 1968. s–a. GR, EN, FR, GE, or IT. 408

Ministry of Culture, Archaeological Receipts Fund (TAP Service), 57, Panepistimiou St., Athens 105 64, Greece. (Dist.: Wasmuth K.G., Hardenbergstrasse 9A, 1 Berlin 12, W. Germany).

Illus.

ISSN: 0004–6604. OCLC: 2244116. LC: DF10.A69. Dewey: 913.

Archaeology.

Archaeological news from Greece.

THE BIBLICAL ARCHAEOLOGIST. 1938. q. EN. 409

Johns Hopkins University Press, Journals Publishing Division, 711 W. 40th St., Suite 354, Baltimore, MD 21211. Phone 301–889–1383. Eric M. Meyers, Editor.

Microform available from UMI. Illus., maps, plans. Index.

ISSN: 0006–0895. OCLC: 1519716. LC: BS620.A1 B5. Dewey: 220.93.

Archaeology.

Published for the American Schools of Oriental Research. Contains scholarly articles.

Reviews: book. Indexed: ArtI. CloTAI. HumI. Reviewed: Katz.

THE BIBLICAL ARCHAEOLOGY REVIEW. 1975. bi–m. EN. 410

Biblical Archaeology Society, 3000 Connecticut Ave., N.W., Suite 300, Washington, DC 20008. Phone 202–387–8888. Hershel Shanks, Editor.

Illus.

ISSN: 0098–9444. OCLC: 2242487. LC: BS620.A1 B52. Dewey: 220.9.

Archaeology.

Indexed: Avery.

BOLLETTINO DEL CENTRO CAMUNO DI STUDI PREISTORICI. 1964. a. EN, FR, GE, or IT. 411

Centro Camuno di Studi Preistorici, 25044 Capo di Ponte, Brescia, Italy. Emmanuel Anati, Editor.

Illus.

ISSN: 0577–2168. OCLC: 3032336. LC: GN818.C3C46a. Dewey: 945.

World journal of prehistoric and primitive art. Contains reports of research. Articles presented in the language of the author.

Calendar of events.

BRITISH ARCHAEOLOGICAL ABSTRACTS. 1968. s–a. EN. 412

Council for British Archaeology, 112 Kennington Rd., London SE11 6RE, England. Phone 071–582 0494. Cherry Lavell, Editor.

Subscription: £35 individual, £75 institution.

ISSN: 0007–0270. OCLC: 1537129. LC: DA90.B82. Dewey: 913.

Archaeology.

Abstracts of current research being published in archaeology.

Reviewed: Katz.

BRITISH ARCHAEOLOGICAL ASSOCIATION JOURNAL. 1843. a. EN. 413

British Archaeological Association, c/o Institute of Archaeology, 35 Beaumont St., Oxford, England. M. Henig, Editor.

Subscription: included in membership, non–members £13.50. Cum. index every 5 yrs.

ISSN: 0068–1288.

Archaeology.

Reviews: book. Indexed: ArtArTeAb. RILA.

BRITISH ARCHAEOLOGICAL ASSOCIATION. CONFERENCE TRANSACTIONS. 1980. a. **414**
EN.
W.S. Maney & Son. Ltd., Hudson Rd., Leeds LS9 7DL, England.
Archaeology.

BULLETIN OF THE AMERICAN SCHOOLS OF ORIENTAL RESEARCH. 1921. q. EN. **415**
Johns Hopkins University Press, Journals Publishing Division, 701 W. 40th St., Suite 275, Baltimore, MD 21211. Phone 301–
338–6987. Walter E. Rast, Editor.
Subscription: included in membership, $42 individual, $57 institution US; foreign $53 individual, $68 institution. Microform
available from UMI. Illus. Index.
ISSN: 0003–097X. OCLC: 5748058. LC: DS101. Dewey: 913. Formerly: *Bulletin of the American School of Oriental Research in Jerusalem.*
Archaeology.

Presents technical reports of original research and ASOR–sponsored excavations, and reviews of current scholarship in archaeological, historical and biblical fields.
Indexed: ArtHum. ArtI.

BULLETIN OF THE ARCHAEOLOGICAL INSTITUTE OF AMERICA. 1897. a. EN. **416**
Archaeological Institute of America, 675 Commonwealth Ave., Boston, MA 02215. Phone 617–353–9361. Kaelyn A.
McGrergor, Editor.
Subscription: $6. Microform available from UMI. No sample. Back issues $6. Illus. b&w. 120p.
LC: CC1.A6. Dewey: 930.
Archaeology. Art History.

The annual report of the AIA includes committee reports, affiliated organizations, meeting minutes, donor lists, lecture program descriptions, membership analysis, award winners, and a directory.
Obits. Listings: national. Freelance work: none. Opportunities: study – lecture program.
Advertising: none. Audience: AIA membership.

THE CONFLUENCE. 1984. q. EN. **417**
North Central Washington Museum Association, 127 S. Mission St., Wenatchee, WA 98801. Phone 509–664–5989. Mary L.
Thomsen, Editor.
Subscription: included in membership, individual $20, family $25, student & senior $15. Sample. Back issues $1.50. Illus.
b&w, photos, cartoons. tabloid, 16p.
Archaeology. Art History. Ceramics. Painting. Photography. Sculpture. Textiles. Regional History.

Content is mainly of a historical nature, with a wide range of topics relating to the development of the region. Carries information about upcoming Gallery exhibits and related events. The Museum Art Gallery features a variety of exhibits which change about every 2–3 months. The exhibits contain paintings, sculpture, ceramics, textiles, including both the traditional and non–traditional media.
Reviews: exhibition 1. Biographies: material involving individuals in relation to the history of the area. Listings: Art Gallery exhibits. Freelance work: yes. Contact: editor.
Advertising: 4/issue, 1/16 page $250. Mailing lists: none. Circulation: 1200. Audience: members.

CONGRES ARCHEOLOGIQUE DE FRANCE. 1834. a. FR. **418**
Societe Francaise d'Archeologie, Musee National des Monuments Francais, Palais de Chaillot, 1 Place du Trocadero, 75116
Paris, France.
Subscription: 320 F. Illus. Cum. index 1834–1925, 1926–1954, 1955–1975.
ISSN: 0069–8881. OCLC: 6079331. LC: DC30.S6.
Archaeology.

CORNISH ARCHAEOLOGY. 1962. a. EN. **419**
Cornwall Archaeological Society, c/o Royal Institution of Cornwall, River St., Truro, Cornwall TR1 9XX England. Phone
0872 72205.
Subscription: included in membership, non–members £10. Illus.
ISSN: 0070–024X. OCLC: 8562888. LC: DA670.C78 C6. Dewey: 913.
Archaeology.

Furtherance of Cornish studies.
Indexed: ArtArTeAb.

CORSI INTERNAZIONALI DI CULTURA SULL'ARTE RAVENNATE E BIZANTINA.
ATTI. 1953. a. IT, EN, FR, GE. **420**
Angelo Longo Editore, Via Paolo Costa 33, P.O. Box 431, 48100 Ravenna, Italy. Phone 0544 27026.

CRONACHE DI ARCHEOLOGIA. 1962. s–a. IT, EN, FR, GE. **421**
Istituti di Archeologia e Storia dell'Arte, Universita di Catania, Catania, Italy.
Subscription: L 100000. Illus.
Formerly: *Cronache di Archeologia e di Storia dell'Arte.*
Archaeology.

CURRENT ARCHAEOLOGY. 1967. 6/yr at irreg. intervals. EN. **422**
9 Nassington Rd., London NW3 2TX, England. Phone 071–435 7517. Andrew Selkirk & Wendy Selkirk, Editors & Pubs.
Subscription: (7/1990 with no.121): £12 UK, $24 surface US, foreign £14. Illus. Index published every other year, included in magazine.
ISSN: 0011–3212. OCLC: 3672481. LC: DA90.C87. Dewey: 913.362. Formerly: *Archaeological Newsletter.*
Archaeology.
Specializes in British archaeology.
Reviewed: Katz.
Advertising: (prepaid + 15% VAT): full page £300, ½ page £160, ¼ page £90. Inserts. Circulation: 5500–6000.

EARLY MAN. 1979. q. EN. **423**
Northwestern Archaeology, P.O. Box 1499, Evanston IL 60204. Phone John B. Carlson, Editor.
Illus.
ISSN: 0197–9930. OCLC: 6137845. LC: CC1.E18. Dewey: 973.
Archaeology.
"Magazine of modern archeology".
Reviewed: Katz.

EXPEDITION. 1958. 3/yr. EN. **424**
University of Pennsylvania, University Museum, 33rd & Spruce Sts., Philadelphia, PA 19104. Phone 215–898–4000. M. Voight, Editor.
Microform available from UMI. Illus.
ISSN: 0014–4738. OCLC: 1568625. LC: GN1.E9. Dewey: 301.2. Formerly: *University of Pennsylvania. University Museum Bulletin.*
Anthropology. Archaeology.
"The magazine of archaeology/anthropology". Presents articles on current research in archaeology and anthropology.
Indexed: ArtArTeAb. ArtI. Avery. CloTAI. Reviewed: Katz.

HADASHOT ARKHEOLOGIYOT. 1961. s–a. HE. Table of contents in EN. EN edition also. **425**
Department of Antiquities and Museums, Box 586, Jerusalem 91 004, Israel. Phone 02 278627, fax 02 278628. Ayala Sussmann, Editor.
Illus.
ISSN: 0047–1569. LC: DS111.A1. 84-647959. Dewey: 933.005. Formerly: *Archaeological News.*
Archaeology.
Presents summarized initial reports regarding all excavations and surveys being undertaken in Israel. Issued in English edition as *Excavations and Surveys in Israel.*

HISTORICAL ARCHAEOLOGY. 1967. s–a. EN. **426**
Society for Historical Archaeology, P.O. Box 231033, Pleasant Hill, CA 94523. Phone Ronald L. Michael, Editor.
Illus. Index.
ISSN: 0440–9213. OCLC: 1752118. LC: E11.S625. Dewey: 970.
Archaeology.

Journal of the Society.
Reviews: book. Bibliographies. Reviewed: Katz.

INDUSTRIAL ARCHAEOLOGY REVIEW. 1976. 3/yr. EN. 427

Association for Industrial Archaeology, c/o Sec., The Wharfage, Ironbridge, Telford, Shopshire TF8 7AW England.
Back issues £2.50. Illus. b&w, photos, drawings, plans. 7 x 9, 124p.
ISSN: 0309–0728. OCLC: 3423583. LC: T37.I53. Dewey: 609.
Archaeology.

Reviews: book. Indexed: BHA. BrArchAb. Avery. CloTAI. HistAb. RILA.
Advertising. Demographics: individuals, libraries and museums involved in the study and practice of industrial archaeology.
Circulation: 1000.

INTERNATIONAL JOURNAL OF NAUTICAL ARCHAEOLOGY AND UNDERWATER EXPLORATION. 1972. q. EN. 428

Academic Press Ltd. (London), 24–28 Oval Road, London NW1 7DX, England. Phone 071–267 4466, fax 071–482–2293, telex 25775 ACPRES G. J. Kirkman, Editor.
Illus.
ISSN: 0305–7445. OCLC: 1037043. LC: CC77.I58. Dewey: 913.
Archaeology.

Published for the Council for Nautical Archaeology.
Indexed: ArtHum. BHA. CurCont. Reviewed: Katz.

ISRAEL EXPLORATION JOURNAL. 1950/51. q. EN & FR. 429

Israel Exploration Society, 5 Avida St., P.O. Box 7041, Jerusalem, Israel. J.C. Greefield, Editor.
Subscription: $36. Illus. b&w, photos, plates, tables. Cum. index every 10 yrs. 6¾ x 9½.
ISSN: 0021–2059. OCLC: 1623888. LC: DS111.A1 I87. Dewey: 933.
Archaeology.

Includes excavations on biblical archaeology and ancient history as well as archaeology of later periods. Reports on preliminary excavation reports, special discoveries and finds.
Reviews: book. Indexed: ArtHum. RILA. Reviewed: Katz.

JOURNAL OF ANTHROPOLOGICAL ARCHAEOLOGY. 1982. q. EN. 430

Academic Press, Inc., Journal Division, 1250 Sixth Ave., San Diego, CA 92101. Phone 619–230–1840. Robert Whallon, Editor.
Illus.
ISSN: 0278–4165. OCLC: 7810050. LC: CC79.E85J68. Dewey: 306.
Archaeology.

Reviewed: *Choice* 22:11–12, Jl–Aug 1985, p.1602.

THE JOURNAL OF EGYPTIAN ARCHAEOLOGY. 1914. a. EN. Occasionally FR & GE. 431

Egypt Exploration Society, 3 Doughty Mews, London WC1N 2PG, England. Phone 071–242–1880. M.A. Leahy, Editor.
Illus. Cum. index vols. 1–20, 1914–1934, with v.20; vols. 21–40, 1935–1954, with v.42.
ISSN: 0075–4234. OCLC: 1641765. LC: DT57.E332. Dewey: 913.32. Formerly: *Archaeological Report (London, England)*.
Archaeology.

Primarily excavation reports.
Bibliographies. Indexed: ArtHum. ArtI. CloTAI. CurCont.

JOURNAL OF FIELD ARCHAEOLOGY. 1974. q. EN. 432

Boston University, Field Archaeology, 675 Commonwealth Ave., Boston, MA 02215. Phone 617–353–2000. James Wiseman, Editor.
Subscription: included in membership, $25. Microform available from UMI. Illus. Annual index.
ISSN: 0093–4690. OCLC: 1798634. LC: CC1.J69. Dewey: 913.
Archaeology.

Published for the Association for Field Archaeology.

Indexed: ArtArTeAb. ArtI. Avery. BrArchAb. CurCont. Reviewed: Katz.
Advertising.

THE JOURNAL OF HELLENIC STUDIES. 1880. a. EN. 433

Society for the Promotion of Hellenic Studies, 31–34 Gordon Square, London WC1H OPP, England. Phone 071–387 7495.
Professor A.H. Sommerstein, Editor.

Subscription: included in membership together with supplement *Archaeological Reports*, £20 or $US45 individuals, £26 or
$US60 institutions, students £7.50, no air. Microform available from UMI. No Sample. Back issues. Illus. b&w, photos,
maps. Cum. Index 1955–70, new index in progress. A4, ca.200, ads 6p.
ISSN: 0075–4269. OCLC: 1754613, 7250805 (microfilm). LC: DF10.J8. Dewey: 938.

Archaeology. Architecture. Art History. Decorative Arts. Historic Preservation. Painting. Pottery. Sculpture.

Scholarly journal covering Greek history, art, archaeology, philosophy, literature, etc. of all periods, but with emphasis on an-
cient and Byzantine periods. Supplementary papers accompany some volumes.
Reviews: book 60. Freelance work: none. Indexed: ArtI. CloTAI. CurCont.
Advertising: [VAT included, camera ready only] full page £195.50, ½ page £103.50, no color. No classified. Leaflets. Demo-
graphics: individual members UK 1,200, overseas about half Europe, half USA, Canada, Australia, Far East; institutions, li-
braries UK 150, overseas ca. 300 Europe, 700 USA, Canada, Australia, Far East. Circulation: 3000. Audience: scholarly.

JOURNAL OF ROMAN ARCHAEOLOGY. 1988. a. EN. 434

University of Michigan, Department of Classical Studies, Ann Arbor, MI 48109. Phone 313–763–1414. John H. Humphrey,
Editor.
Dewey: 913.

Archaeology.

Devoted to all aspects of Roman archaeology covering the period from 700 BCE to about 700 CE.
Reviews: book.

JOURNAL OF ROMAN STUDIES. 1911. a. EN, FR, GE, GR & LATIN. 435

Society for the Promotion of Roman Studies, 31–34 Gordon Sq., London WC1H 0PP, England. Phone 071–387 8157. Averil
Cameron, Editor.
Subscription: £17 individual, £18 institution. Back issues. Illus., plates, maps, plans. Cum. index v.21–60.
ISSN: 0075–4358. OCLC: 1782277. LC: DG11.J7.
Articles on the history, archaeology, literature and art of Rome, Italy and the Roman Empire to 700 A.D. Includes the Proceed-
ings of the Society.
Indexed: BrArchAb. CurCont. IBkReHum.

JOURNAL OF THE AMERICAN RESEARCH CENTER IN EGYPT. 1962. a. EN. 436

American Research Center in Egypt, Kevorkian Center, New York University, 50 Washington Sq. So., New York, NY 10012.
Phone J. J. Augustin, Inc., Locust Valley, NY 11560, 516–676–1510. Gerald E. Kadish, Editor.
Subscription: (Eisenbrauns, P.O. Box 275, Winona Lake, IN 46590). Back issues. Illus. b&w, some color, photos, line draw-
ings, maps. 8 x 10¾, 160+p.
ISSN: 0065–9991. OCLC: 1480668. LC: DT57.A57.

Archaeology.

The aim of the Center is to foster research in the history, language, and archaeology of the Egyptian people in all periods. The
first publication in the U.S. devoted exclusively to Egyptian studies. Contains contributions from both American and foreign
scholars.
Reviews: book. Obits.

KOKOGAKU ZASSHI/JOURNAL OF THE ARCHAEOLOGICAL SOCIETY OF JAPAN.

1910. q. JA. EN summaries. 437
Archaeological Society of Japan – Nihon Koko Gakkai, c/o Tokyo National Museum, 13–9 Ueno Park, Daito–ku, Tokyo 110,
Japan.
Illus.
ISSN: 0003–8075. OCLC: 1696225. LC: DS11.K65. Dewey: 913. Formerly: *Kokokai*.

Archaeology.

KUNGLIGA VITTERHETS-, HISTORIE- OCH ANTIKVITETS AKADEMIEN. ANTI-KVARISKT ARKIV. 1954. irreg. SW, EN, GE.

Kungliga Vitterhets–, Historie– och Antikvitets Akademien – Royal Academy of Letters, History and Antiquities, Villagatan 3, 114 32 Stockholm, Sweden.
ISSN: 0083–6737.

MAINZER ZEITSCHRIFT: Mittelrheinisches Jahrbuch fuer Archaeologie, Geschichte und Kunst. 1906. a. GE.

Mainzer Altertumsverein e.V., Rheinallee 3b, 6500 Mainz, W. Germany. Friedrich Schuetz, Editor.
Illus., plans, plates.
ISSN: 0076–2792. OCLC: 1413993. LC: DD901.M2M25. Formerly: *Mainzer Altertumsverein. Zeitschrift.*
Archaeology.

Indexed: RILA.

MEDIEVAL ARCHAEOLOGY. 1957. a. EN.

Society for Medieval Archaeology, University College, Gower St., London WC1E 6BT, England. D. Hinton, Editor.
Subscription: included in membership, non–members £11 individual, £18 institution. Illus. Cum. index v.1–5, 1957–61; v.6–10, 1962–66; v.11–15, 1967–71; v.16–20, 1972–76.
ISSN: 0076–6097. OCLC: 1607565. LC: D111.M46. Dewey: 913.05.
Archaeology.

Journal of the Society.

Indexed: ArtArTeAb. Avery. BrArchAb. RILA.

MINERVA: The International Review of Ancient Art and Archaeology. 1990. 10/yr. EN.

Aurora Publications, 7 Davies St., London W1Y 1LL England. Phone 071–495 2590, fax 071–491 1595. Jerome Eisenberg, Editor (Suite 2D, 153 E. 57th St., New York, NY 10022. Phone 212–355–3033, fax 212–688–0412).
Subscription: £17.50 UK, £20 air Europe; $US48, air $60, US & Canada. Sample. Back issues. Illus. b&w, color, photos. A4, 48p.
Incorporates *Archaeology Today.*
Archaeology.

A news and review magazine devoted to ancient art, antiquities, and archaeological discoveries worldwide from prehistory to the 18th century. Provides information about changing interpretations and methods in the various fields or archaeology, ancient art, numismatics, connoisseurship, art technology and conservation. International in scope with regular contributors from around the world. Feature articles emphasize newly discovered works of art and objects of archaeological importance leading to a better understanding of the past. Notes significant articles in other journals and papers presented at professional meetings. Includes museum acquisitions, auction previews and reviews, numismatic reviews, courses, archaeological tours, announcements of excavations.

Reviews: exhibition 2–4, book 5. Listings: international. Send to Calendar editor (Martha Steele, 332 North Beverly Drive, Beverly Hills, CA 90210) schedules for all U.S. and Canadian Museum exhibitions, art gallery exhibitions, fairs, auctions, conferences and national meetings. Calendar of events. Exhibition information. Freelance work: yes. Contact: editor. Opportunities: meetings and symposia. Indexed: Des&ApAI.

Advertising: (rate card Jan '90): b&w full page $1000 £650, ½ page $600 £375, ¼ page $350 £215; color full page $1500 £950, ½ page $900 £565, ¼ page $500, £315, covers $1650–1800, £1045–1140. No classified. Frequency discount. Inserts. Bleed + 10%. Ad. Directors: (except U.S.) Colin Clarke (Clarke Media Services Ltd., 40 Bowling Green Lane, London EC1R 0NE). U.S. East: Suzanne Verdugo (editorial office), U.S. West: William Ward (332 North Beverly Drive, Beverly Hills, CA 90210, phone 213–550–1198, fax 213–550–1395). Mailing lists: none. Demographics: sold to subscribers throughout the world and through leading bookshops, museum shops, galleries, and newsstands in every major city in the UK, Canada and the U.S. as well as select bookshops internationally. Audience: academics, professionals, and laypeople interested in ancient art, archaeology and antiquities.

NEWSLETTER (Archaeology Abroad). s–a. EN.

Archaeology Abroad, 31–34 Gordon Square, London WC1H OPY, England.
Archaeology.

Audience: archaeologists and students.

NEWSLETTER OF THE AMERICAN COMMITTEE TO ADVANCE THE STUDY OF PETRO-GLYPHS AND PICTOGRAPHS. 1980. q. EN. 443

ACASPP, c/o Joseph J. Snyder, Editor and Exec. Sec., Box 158 Shepherdstown, W. Va. 25443. Phone 304–876–9431. ISSN: 0278–2871. OCLC: 7764442.

Archaeology.

Reports on the study of petroglyphs ("rock" + "carving") and pictographs ("picture + writing). Objectives are to maintain consistent standards of recording for petroglyphs and pictographs and the broad dissemination of results of study and analysis. Audience: professionals and students.

NEWSLETTER OF THE AMERICAN RESEARCH CENTER IN EGYPT. q. EN. 444

American Research Center in Egypt, Kevorkian Center, New York University, 50 Washington Sq. So., New York, NY 10003. Subscription: included in membership.

Archaeology.

Informs membership of Center activities and news of cultural significance from Egypt and the Middle East. Audience: members.

OXFORD JOURNAL OF ARCHAEOLOGY. 1982. 3/yr. EN. 445

Basil Blackwell Ltd., 108 Cowley Rd., Oxford OX4 1JF, England. Phone 0865–791100, fax 0865–791347. (US dist.: Expediters of the Printed Word Ltd., 515 Madison Ave., New York, NY 10022). Prof. B.W. Cunliffe, Sir John Boardman, & Prof. R.M. Harrison, Editors (Institute of Archaeology, 36 Beaumont St., Oxford OX1 2PG).

Subscription: £33.50 individual, £82.50 institution UK; £36, £89 Europe; £43, £105 rest of world. Sample free. Back issues. Illus. b&w, photos. 17 x 24.5 cm, 126p. ISSN: 0262–5253. OCLC: 8673843. LC: CC1.O9. Dewey: 930.

Archaeology. General.

The journal's geographical scope covers Europe, Mediterranean lands and the classical world from the earliest days to the end of the medieval period. Subject areas include archaeology, art and art history, architecture, numismatics, the applications of scientific analysis and theoretical approaches. General reviews of major excavation programs may appear but interim or final reports on excavations are not normally published.

Freelance work: none. Indexed: ArtArTeAb. Avery. BHA. BrArchAb. Reviewed: *Art Documentation* Summer 1987, p.68. Advertising: full page £165, ½ page £105 [+ VAT]. 15% frequency discount. Bill Drake, Ad. Director (Loke Cottage, Deddington, Oxon, OX5 4TE). Mailing lists: available. Circulation: 311. Audience: academic.

PAMYATNIKI KUL'TURY. NOVYE OTKRYTIYA/MONUMENTS OF CULTURE. NEW DISCOVERIES. 1974. irreg. RU. EN summaries. 446

Izdatel'stvo Nauka, Profsoyuznaya 90, 117864 GSP–7 Moscow, V–485, Russian S.F.S.R., U.S.S.R. Illus.

PAYS LORRAIN. 1904. m. FR. 447

Societe d'Archeologie Lorraine, Palais Ducal, Grande–Rue 64, Nancy, France. Phone 8332–1874. P. Sadoul, Editor. Illus. ISSN: 0031–3394. OCLC: 2718679. LC: DC611.L84P39. Dewey: 944.

Archaeology. Architecture.

Presents the archeology, arts, history, geography, literature, sciences and folklore of the French province of Lorraine. Indexed: ArtArTeAb. RILA.

PHOENIX: Bulletin Uitgegeven Door Het Voorazlatisch–Egyptisch Genotschap. 1955. s–a. DU. 448

Vooraziatisch–Egyptisch Genootschap "Ex Oriente Lux", Postbus 9515, 2300 RA Leiden, Netherlands. K.R. Veenhof, Editor. Illus. b&w. 76–106p. ISSN: 0031–8329.

Archaeology.

Focuses on recent discoveries in the ancient Near East and Egypt. Advertising.

PICTOGRAM. 1987. 3/yr. EN.

Southern African Rock Art Research Association (SARARA), P.O. Box 81292, Parkhurst 2120, South Africa. Phone 011–880–4782. Shirley–Ann Pager, Editor.

Subscription: included in membership, R 25 individual, R 10 student, R 50 institutions; elsewhere $US20, $A20, £10, DM 20. Sample. Back issues R 5. Illus. b&w. Index. A4, 12p. Ventura desktop, laser printer.

ISSN: ISBN: 0–620–11709–5.

Archaeology. Art History. Historic Preservation.

The aim of the Association is to provide a medium for the dissemination of research findings and to promote and encourage rock art research. *Pictogram* provides information on the activities of the Association and carries articles written by rock art researchers. Covers petroglyphics, rock art, and rock painting. Brief articles include references.

Advertising: none. Mailing lists: none. Circulation: 250. Audience: anthropologists, archaeologists, rock art researchers.

PLAINS ANTHROPOLOGIST. 1954. q. EN.

University of Iowa, Iowa City, IA 52242.

Illus.

ISSN: 0032–0447. OCLC: 1640279. LC: E78.G73P52. Dewey: 913.78. Formerly: *Plains Conference. News Letter.*

Archaeology.

"Journal of the Plains Conference".

Reviewed: Katz.

POPULAR ARCHAEOLOGY. 1972. bi–m. EN.

P.O. Box 4211, Arlington, VA 22204. William J. Hranicky, Editor.

Illus.

ISSN: 0300–774X. OCLC: 1359689. LC: CC1.P63. Dewey: 913.

Archaeology.

Reviewed: Katz.

POST-MEDIEVAL ARCHAEOLOGY. 1967. a. EN.

Society for Post–Medieval Archaeology, c/o P. Davey, Hon, Treas., P.O. Box 147, Liverpool L69 3BX, England. D.W. Crossley, Editor.

ISSN: 0079–4236. Dewey: 913.

Archaeology.

Indexed: BrArchAb. CloTAI. RILA.

PROCEEDINGS OF THE SOCIETY OF ANTIQUARIES OF SCOTLAND. 1851. a. EN.

Society of Antiquaries of Scotland, Royal Museum of Scotland, Queen Street, Edinburgh EH2 1JD, Scotland. Ian A.G. Shepherd, Editor.

Subscription: included in membership. Illus. Cum. index.

ISSN: 0081–1564. OCLC: 1589079. LC: DA750.S67.

Archaeology.

Studies in Scottish archaeology and history.

Indexed: BrArchAb. HistAb. RILA.

PROSPETTIVA. See no. 355.

REVUE BELGE D'ARCHEOLOGIE ET D'HISTOIRE DE L'ART. See no. 358.

REVUE DES ARCHEOLOGUES ET HISTORIENS D'ART DE LOUVAIN. 1968. a. FR or SP.

Universite Catholique de Louvain, Association des Diplomes en Archeologie et Histoire de l'Art, College Erasme, Place Blaise Pascal 1, B–1348 Louvain–la–Neuve, Belgium. Phone 10–47–48–80. Tony Hackens, Editor.

Subscription: 1800 BFr. Illus.

ISSN: 0080–2530. OCLC: 1893853. LC: CC3.R44. Dewey: 930.

Archaeology. Art History.

Reviews: book. Indexed: ArtArTeAb. RILA.

RIVISTA DI ARCHEOLOGIA. 1977. a. IT, EN or GE. 455

Giorgio Bretschneider Editore, Via Crescenzo 43, 00193 Rome, Italy. Phone 06–6879361. Gustavo Traversari, Editor (Universita degli Studi Dipartimento di Scienze, Storico–Archeologiche e Orientalistiche, Palazzo Bernardo S. Polo, 1977/A, 30125 Venice, phone 041–5287992).

Illus.

ISSN: 0392–0895. OCLC: 6177485. LC: CC9.R58. Dewey: 930.1.

Archaeology.

Indexed: Avery. RILA.

ROCK ART. 1980. s–a. EN. 456

American Committee to Advance the Study of Petroglyphs and Pictographs, Box 158, Shephardstown, WV 25443–0158. Phone 304–876–9431. Joseph J. Snyder, Editor & Exec. Sec.

ISSN: 0278–2871. Formerly: *ACASPP Newsletter*.

Archaeology.

Journal.

Reviews: book.

Advertising. Audience: professionals and students.

ROCK ART RESEARCH. 1984. s–a. EN mainly, occasionally FR, SP, GE. Abstracts tr. 457

Archaeological Publications, P.O. Box 216, Caulfield South, Victoria 3162, Australia. Phone 03–523–0569. Robert G. Bednarik, Editor.

Subscription: included in membership, $11.25 all, foreign air $17.25. Sample free. Back issues. Illus. b&w, photos. 29 x 20.5 cm., 80–92p.

ISSN: 0813–0426. OCLC: 17668761.

Archaeology. Art History. Graphic Arts. Historic Preservation.

Devoted to developing theory and methodology for the systematic and rigorous understanding of prehistoric arts worldwide. Focus includes: conservation and protection of rock art; computer–assisted rock art studies; major scientific syntheses dealing with origins of art, human intellect and cognition, and early cultural development; regional studies of significance in any part of the world.

Reviews: exhibition 1, book 4, journal 8. Bibliographies: articles are extensively referenced. Listings: international primarily. Calendar of events. Exhibition information. Freelance work: only contributions of high scientific calibre can be considered. Opportunities: study; competitions. Indexed: ArtArTeAb.

Advertising: none. Circulation: 1000. Audience: prehistoric art specialists, cognitive archaeologists.

SOCIETY FOR POST-MEDIEVAL ARCHAEOLOGY JOURNAL. a. EN. 458

Society for Post–Medieval Archaeology, Museum of London, London Wall, London EC2Y 5HN, England. Phone 071 6003699.

Archaeology.

Promotes the study of archaeology specializing in the period following the Middle Ages until the start of industrialization. Audience: archaeologists, historians, and interested people.

STUDIES IN ANCIENT ART AND ARCHAEOLOGY. irreg. EN. 459

Cornell University Press, 124 Roberts Pl., Ithaca, NY 14850. Phone 607–257–7000.

Dewey: 700, 913.

Archaeology.

SUOMEN MUINAISMUISTOYHDISTYKSEN AIKAKAUSKIRJA. 1874. irreg. FI, SW, EN, & GE. 460

Suomen Muinaismuistoyhdistys, Nervanderinkatu 13, 00100 Helsinki 10, Finland.

ISSN: 0355–1822.

SYRIA: Revue d'Art Oriental et d'Archeologie. 1920. q. FR mainly. EN occasionally. 461

Librairie Orientaliste Paul Geuthner, 12 rue Vavin, 75006 Paris, France. E. Will & J. Caquot, Editors.

Illus., plates, plans. Vols. 1–10, 1920–29, in v.10; vols. 11–20, 1930–39, in v.20; vols. 21–30, 1940–53, in v.30; vols. 31–40, in v.40. 368p./yr.

ISSN: 0039–7946. OCLC: 998956. LC: DS94.5.S8. Dewey: 913.394.

Archaeology. Art History.

Covers Syrian art and archaeology, ancient and Islamic.
Bibliographies. Obits. Indexed: Avery.

TRIERER ZEITSCHRIFT FUER GESCHICHTE UND KUNST DES TRIERER LANDES UND SEINER NACHBARGEBIETE. 1936. a. GE. 462

Rheinisches Landesmuseum Trier, Ostallee 44, D–5500 Trier, W. Germany.
Subscription: DM 72. Illus.
ISSN: 0041–2953. OCLC: 2092948. LC: DD901.T8T81. Formerly: *Trierer Zeitschrift.*
Reviews: book 8, length 1–3p. Bibliographies. Obits.

W.A.S. NEWSLETTER. 1971. irreg. EN. 463

World Archaeological Society, Lake Rd. 65–48, Box 445, HCR 1, Hollister, MO 65672. Phone 417–334–2377. Ron Miller, Editor.
Subscription: included in membership, $6 US & Canada, $8 foreign. 8½ x 11, 10p.
ISSN: 0738–8063. Dewey: 913.
Archaeology. Art History.

Newsletter promoting the scientific and constructive study of antiquity within the international fields of archaeology, anthropology, and art history.
Reviews: book. Obits.
Advertising.

WORLD ARCHAEOLOGY. 1969. 3/yr. EN. 464

Routledge & Kegan Paul, 11 New Fetter Lane, London EC4P 4EE, England. Phone 071–583 9855.
Subscription: £32. Illus. Cum. index, v.1–10, 1969–79; v.11–20, 1979–89.
ISSN: 0043–8243. OCLC: 2243103. LC: CC1.W6. Dewey: 905.
Archaeology.

Indexed: ArtArTeAb. ArtHum. BHA. CurCont.

YORKSHIRE ARCHAEOLOGICAL JOURNAL. 1864. a. EN. 465

Yorkshire Archaeological Society, Claremont, 23 Clarendon Rd., Leeds LS2 9NZ, England. R.M. Butler, Editor.
Subscription: £15 individual, £18 institution. Illus.
ISSN: 0084–4276. OCLC: 1770350. LC: DA670.Y59 Y5.
Archaeology.

ZEITSCHRIFT FUER SCHWEIZERISCHE ARCHAEOLOGIE UND KUNSTGESCHICHTE.
See no. 386.

Contemporary Art

108 REVIEW. 1986. bi–m. EN. 466

108 Magazine, Inc., Box 432, Prince St. Station, New York, NY 10012. Phone 718–965–4882.
Subscription: $8 individual, $10 institution.
Formerly: *108: An East Village Review.*

A + T/ART & TEXT. 1981. 3/yr. EN. 467

Art & Text, City Art Institute, P.O. Box 259, Paddington, N.S.W., 2021, Australia. Phone 02–339–9535, fax 02–339–9506. Paul Foss, Editor.
Subscription: $A32 (Manic Exposeur, P.O. Box 39, World Trade Centre, Melbourne, Vic. 3005, Australia 03–429–1915).
Illus. b&w, photos. 6½ x 9½, 124p.
ISSN: 1727–1182. OCLC: 10976893. LC: NX1.A77. Formerly: *Art & Text.*
Modern Art.

Bibliographies. Listings: national. Calendar of galleries & bookshops.
Advertising: Jeff Gibson or Ross Harley, Advertising (phone 02–339–9535, 02–332–2997).

AGAR: Avant Garde Art Review. 1988. EN. 468
c/o Editor, 79 Mercer St., New York, NY 10012. Stephen Soreff, Editor.
Subscription: free mail subscription may be obtained by writing to the editor your reasons for wishing to receive future issues. Illus. b&w, photos. 8½ x 11, 2p. glossy.
Modern Art.

"The future–art journal" consists of descriptive reviews of art–works, events or techniques which may exist in the future. Issues are dated in the future. An art–work, its form, an art magazine published one page at a time to add to the areas of prediction, speculation, and suggestion to art commentary. Issues made possible by a grant from the Research Committee C.W. Post, Long Island University.

AICARC: Bulletin of the Archives and Documentation Centers for Modern and Contemporary
Art. 1974. s–a. EN & FR. 469
International Association of Art Critics, Swiss Institute for Art Research, P.O. Box CH–8024, 8008 Zurich, Switzerland.
Phone 01/257.24.86. Hans–Joerg Heusser, Editor; Karin Rosenberg, English Editor.
Subscription: SFr 30. Sample. Back issues. Illus. b&w, photos. A4, 60p.
ISSN: 0347–4240. OCLC: 12098952. LC: N7475.A15. Dewey: 700. Formerly: *AICARC Bulletin*.
Art History. Modern Art. Museology. Painting. Sculpture.

Published with the assistance of UNESCO. The object of AICARC is to promote the documentation of modern and contemporary art and to create a forum for scholars interested in the field. Each issue is devoted to a single theme. Two types of issues produced alternately: (1) "art geographical" devoted to the contemporary art and art research of the region or country where the annual Congress of the IAAC/AICA takes place, prepared with collaboration of prominent art historians and art critics of the country; and (2) "country" also issued in the language of the country. Issue on Soviet Art (double issue, no.1 & 2, 1989) appeared in both English and Russian editions. Devoted to primary sources, archives and documentation centers, archival techniques, and the "documentary" approach to art, in relation to the art of this century.
Biographies: brief biographies of authors. Freelance work: none. Indexed: ArtBibMod.
Advertising: none. Demographics: circulation in 50 countries. Audience: art historians, art critics, scholars.

ARCHIVIO. 1987. a? IT chiefly, some articles also in GE. EN summaries. 470
Centro Internazionale di Documentazione e Informazione sull'Arte Contemporanea, Segreteria Palazzo Novellucci, Via Cairoli 25, 50047 Prato, Italy. Phone 0574–452014.
Illus. b&w, some color, photos. 6¾ x 9½, 220p.
ISSN: 0394–8072. OCLC: 16893465. LC: N6480.A73.
Modern Art.

Presents a series of projects "aimed at providing accurate information on artistic developments, giving due recognition to the major art of our time, and voicing and solving the problems connected with artistic endeavor".

ART AND DESIGN: Architectural Design Publications. 1985. bi–m. EN. 471
Academy Editions Ltd., 42 Leinster Gardens, London W2 3 AN, England. Phone 071–402 2141. Andreas C. Papadakis, Editor.
Illus. color.
ISSN: 0267–3991. OCLC: 11981997. LC: NX1.A772.
Architecture. Graphic Arts. Modern Art.

Examines the vital issues and leading figures of contemporary art establishing the trends of our Age. Specially designed to provide a lasting record of some of the most significant current debate, with contributions from well–known experts in their respective fields. A free graphic by a notable contemporary artist can be found in each issue. Each issue deals with a specific theme.
Indexed: ArchPI. ArtBibMod. Des&ApAI. Reviewed: *Art Documentation*. Sum 1986, p.64. *Choice* 23:2, Nov 1985, p.418.

ART GALLERY INTERNATIONAL: A Magazine of Fine Art & Photography. 1980. bi–m. EN. 472
Timothy J. Nelson, Publisher, Box 52940, Tulsa, OK 74152. Phone 918–587–8787. Debra Carter Nelson, Editor.
Subscription: $21 US, $31 Canada & foreign, air rates on request. Sample free. Back issues $3.95. Illus. b&w, color. 8⅜ x 10⅞, 64p.
ISSN: 0884–8769. OCLC: 12169670. Dewey: 709. Formerly: *Art Gallery*.

Ceramics. Furniture. Jewelry. Modern Art. Painting. Photography. Sculpture.

Presents a diversity of styles, mediums and subject matter in the contemporary visual arts, from traditional works on canvas to new art forms in glass, the applied arts and photography. Focusing on artists working today, AGI features numerous artist profiles developed from in–depth personal interviews, illustrated with full color images of the artist's recent works. Regularly included are important new talents who are emerging on the international art scene. Offers artists an opportunity to express their views and concepts directly to a national audience of collectors, curators, gallery directors and fellow artists. Articles address techniques and mediums, art trends, collecting and art appreciation. News, museum events of note and exhibition information are also covered.

Reviews: exhibition, book 1, length 1p. Listings: national. Calendar of events. Exhibition information. Freelance work: writers. Contact: Senior editor. Opportunities: employment in classified ads.

Advertising. Circulation: 25,000. Audience: visual arts audience.

ART INFORMATION REPORT. 1987. 10/yr. EN. 473

La Guardia Pl, New York, NY 10021.

OCLC: 19977728.

"The essential information for the art world". National and international reporting on current happenings.

Advertising: none.

ART INTERNATIONAL. 1956. q. EN. 474

Archive Press, 77 rue des Archives, 75003 Paris, France. Phone (331) 48 04 84 54, fax (331) 48 04 82 00. (US & Canada dist.: Eastern News Distributors, Inc., 1130 Cleveland, Rd., Sandusky, OH, phone 1–800–221–3148). Michael Peppiatt, Jill Lloyd, & Thomas West, Editors.

Subscription: $33, FF250, £22, L60,000, SF60, DM 70 individual; $69, FF450, £45, 95,000 L, SF110, DM125 institution. Microform available from UMI. Back issues $16, FF100. Illus., some color. A4, 124p.

ISSN: 0004–3230. OCLC: 16958417. LC: N1.A7A. Dewey: 705. Formerly: *Continues a publication with the same title issued 1958–1984 in Zurich and Lugano, Switzerland.*

Modern Art.

Focus is on contemporary art. Presents a "Museum of the Month", "The Art Market" reporting on important auction items, and "World Chronicle" reporting on major happenings in the art world.

Reviews: book 6, length 1–2p. each. Interviews. Biographies: brief notes on contributors. Listings: international. Calendar of events. Exhibition information. Indexed: ArtBibMod. ArtHum. ArtI. BioI. RILA. Reviewed: Katz. *Wilson* 63:3, Nov 1988, p.119.

Advertising: Anya Cvikevich, Ad. Director (US: 118A E 65th St., New York, NY 10021, phone 212–288–8978).

ART ISSUES. 198? 7/yr. (every 6 weeks between Sept & June). EN. 475

Art Issues, 8721 Santa Monica Blvd., Suite 535, West Hollywood, CA 90069. Phone 213–656–2913, fax 213–656–2946. Gary Kornblau, Editor & Pub.

Subscription: (prepaid) $18 US, + $10 elsewhere. Illus. b&w, photos, cartoons. Pages and illus. lilac & b&w. 8 x 10½, 36p.

ISSN: 1046–8471. OCLC: 19419400. LC: N6530.C35 A78.

Modern Art.

Freelance work: yes. Contact: editor.

Advertising: Sue Spaid, Ad. Director (phone 213–463–6451).

ART LINE. 1985. m. EN. 476

Greater Birmingham Arts Alliance, 2114 1st Avenue North, Birmingham, AL 35203.

Illus.

OCLC: 11897937. LC: N1.B57. Formerly: *Birmingham Art Line.*

ART MONTHLY AUSTRALIA. 1987. m. EN. 477

Art Monthly, Australia, c/o Arts Centre, Australian National University, GPO Box 4, Canberra ACT 2601 Australia. Phone 062–48–0321. Peter Townsend, Editor.

Subscription: $A29.50. Back issues. Illus.

ISSN: 0819–5838. OCLC: 21123850. Formerly: *Australian and International Art Monthly.*

Presents news and current issues in the visual art world of Australia.

Reviews: book.

Advertising.

ART/WORLD. 1976. 10/yr. EN. 478
Arts Review Inc, 55 Wheatley Rd., Glen Head, NY 11545. Phone 516–626–0914. Bruce Duff Hooton, Editor & Pub.
Subscription: $20 US, foreign $30. Illus. b&w. 11½ x 16, 12–16p.
ISSN: 0194–1070. OCLC: 4736143. LC: N1 .A792. Dewey: 705.
Newspaper focused on New York City.
Reviews: exhibition. Listings: international. Calendar: Gallery guide & museums.
Advertising. Harold Hooton, Ad. Director. Audience: general art audience.

ARTBIBLIOGRAPHIES CURRENT TITLES. See no. 5.

ARTBIBLIOGRAPHIES MODERN. See no. 6.

ARTE AL DIA. 1980. bi–m. SP, EN. 479
C. Peuser Editores, Montevideo 126, Buenos Aires, Argentina. Phone 45–20–40. Jorge Costa Peuser, Editor.
Subscription: $45 (US: Marcelo Llorens, 30 Charles St., No. 22, New York, NY 10014). Illus.
Dewey: 700.

ARTE EN COLOMBIA INTERNACIONAL. 1976. q. SP. EN sum. 480
Arte en Colombia Ltda., Apdo. Aereo 90193, Bogota, Colombia. Celia Sredni de Birbragher, Editor.
Subscription: $18. Illus. some color.
ISSN: 0120–713X. OCLC: 5002670. LC: N7.A7843. Dewey: 700.
Also issued in Spanish edition under title: Arte en Colombia.
Indexed: ArtBibCur. ArtBibMod.
Advertising.

ARTE FACTUM. 1983. 5/yr. DU, EN, FR, or GE. EN & FR tr. (end of issue). 481
Artefactum S.A., Amerikalei 125, 2000 Antwerp, Belgium. Phone 3–238–2089.
Illus., some color.
ISSN: 0771–761X. OCLC: 11481901. LC: N6758.A78. Dewey: 700.
Magazine of contemporary art in Europe.
Reviews: book, exhibition. Indexed: ArtBibCur. ArtBibMod. BHA. Reviewed: Katz.
Advertising.

ARTFORUM INTERNATIONAL. 1962. 10/yr. EN. 482
Artforum International Magazine, Inc, 65 Bleecker St., New York, NY 10012. Phone 212–475–4000, fax 212–529–1257. Ida Panicelli, Editor.
Subscription: $46 US, $62 elsewhere (P.O. Box 3000, Dept. AF, Denville, NJ 07834–9950). Microform available from UMI. Illus. b&w, color, photos. 10½ x 10¼, 200p.
ISSN: 0004–3532. OCLC: 1514329. LC: N1 .A814. Dewey: 705.
Contemporary international art magazine. American "book" of original artists' projects, specially commissioned articles on culture and art, exhibition reviews (24 pages) from around the world and a comprehensive collection of gallery ads. Features painting and sculpture.
Reviews: exhibition approximately 50, length 2 col. plus one b&w illustration/review. Listings: international. Calendar of events. Indexed: ArtBibCur. ArtBibMod. ArtHum. ArtI. BHA. BioI. BkReI. CloTAI. CurCont. Des&ApAI. HumI. IBkReHum. RILA. Reviewed: Katz. *Wilson* 63:3, Nov. 1988, p.119. *New Art Examiner* 14:1, Sept 1986, p.16–17; 14:8, Apr 1987, p.15–16; 15:6, Feb 1988, p.17–18; 16:6, Feb 1989, p.17–18; 16:10, Jun 1989, p.59–60; 17:6, Feb 1990, p.59–60;.
Advertising b&w & color. Knight Landesman, Ad. Director. (UK: Tricha Passes, Associate Ad. Director (93 Barkston Gardens, London SW5, England).

ARTLINK. 1981. q. EN. 483
Artlink Inc., 363 Esplanade, Henley Beach, S.A. 5022, Australia. Phone 08–356–8511. Stephanie Britton, Editor.
Subscription: $A28 surface, $A36 air US. No sample. Back issues. Illus. b&w, color, glossy photos, cartoons. Index. 210 x 275mm., 64p.
ISSN: 0727–1239.
General. Modern Art.

Covers contemporary visual arts in Australia, emerging and established artists, infrastructure of visual arts, publishing, events, new technology, politics, art theory, community arts, aboriginal art, new media arts, and education. Each issue has a special focus.

Reviews: exhibition 3, length 750 wds., book 3 and film 1, length 600 wds. Interviews: artists, artsworkers. Listings: regional–national. Freelance work: yes. Contact: editor. Opportunities: study, competitions. Indexed: ArtBibMod.

Advertising: (rate card 1989): full page $500, ½ page $275, ¼ page $135; color full page $800, ½ page $420, covers + 5–25%. Mailing lists: none. Demographics: Distributed throughout Australia. Circulation: 2300. Audience: art interested public.

ARTPARK. 1976. a. EN. 484

Artpark, Inc., Public Relations Department, Box 371, Lewiston, NY 14092.
Subscription: none, $10–$12 each. Illus. b&w, photos. 7½ x 10, 48–64p., softcover book.
ISSN: 0164–1298. OCLC: 3819051. LC: N6530.N7 A77. Dewey: 709.
Modern Art.

Artpark is a New York State park located seven miles north of Niagara Falls. Each summer, it becomes a gathering place for important contemporary artists to develop new works of art and share their processes and ideas with hundreds of thousands of park visitors. This unique combination of art and leisure has been remarkably successful and Artpark has become a prototype for public art. Through its publication, Artpark shares with the public the work of its project artists. Documents site installations completed during the season and contains descriptive statements by each artist.

ARTPOLICE. 1974. irreg., 3/yr. EN. 485

Art Police, Inc., 133 East 25th St., Minneapolis, MN 55404. Phone 612–331–1721. Frank Gaard, Editor (25 University Ave., SE, No. 305, Minneapolis, MN 55414).
Sample. Back issues. Illus. variable size, 20p.
OCLC: 18434845. Formerly: *Artpolice Comics, Artpolice Gazette, Artpolice Newsletter*.
Drawing. Modern Art.

An alternative publication presenting artists making collective artwork together. "Basically a picture book for a world on the brink of extinction." Title varies with each issue.

Advertising: none. Mailing lists: none. Circulation: 1000. Audience: $15 individual, $20 libraries US & Canada, $25 foreign.

ARTS & THE ISLAMIC WORLD. 1982. q. EN. 486

ICIS House, 145–146 King's Cross Rd., London WC1X 9DH, England. Phone 071–833 8275. Jalal Uddin Ahmed, Editor.
Subscription: £20. Illus., some color. 8½ x 11, 96p.
ISSN: 0264–1828. OCLC: 9639754. LC: N6260.A79.
Modern Art.

Published for the Islamic Arts Foundation, London. Focuses on contemporary art of the Middle East.
Indexed: ArtBibMod. Reviewed: *Art Documentation* Fall 1986, p.139.
Advertising.

ARTS MAGAZINE. 1926. 10/yr. EN. 487

Arts Communications Group, The Singer Bldg., 561 Broadway, New York, NY 10012. Phone 212–431–4410, fax 212–431–4682. Barry Schwabsky, Editor.
Subscription: $29.95 US, foreign + $17 postage. Microform available from UMI. Illus. b&w, some color, glossy photos. Annual index. 8½ x 10½, 112p.
ISSN: 0004–4059. OCLC: 1580772. LC: N1.A415. Dewey: 705. Formerly: *Arts*.
Modern Art.

Contemporary art coverage. Columns include "Art and the Law" and "Art World Information", information on museum and exhibition spaces, fairs, exhibitions and auctions, and appointments in the field.

Reviews: exhibition 8–12, length 1p each. Interviews. Listings: New York, national–international. Calendar of events. Exhibition information. Opportunities: study –lectures and symposia; competitions and awards. Indexed: ArtBibCur. ArtBibMod. ArtHum. ArtI. Avery. BioI. CloTAI. CurCont. Des&ApAI. HumI. RILA. Reviewed: Katz. *Wilson* 63:3, Nov. 1988, p.118. *New Art Examiner* 16:10, Jun 1989, p.59–60; 17:3, Nov 1989, p.57–60.
Advertising: Deborah Gardner–Gray, Ad. Director.

ARTS REVIEW YEARBOOK: Who's Who and What's What in the Art World. 1976. a. EN. 488

Starcity Ltd., 69 Faroe Rd., London W14 0EL, England. Phone 071–603 7530. Graham Hughes, Editor.

Subscription: included with subscription to *Arts Review* £39 UK, £49 overseas, £59 $75 US & Canada air. Illus. A4, 136p. Wandsworth typesetting.
ISSN: ISBN: 0–904831–13–2. OCLC: 8309218. LC: N6761.A84. Dewey: 705. Formerly: *Arts Review Yearbook & Directory.*
Modern Art.

Brief articles. Listings include art awards, competitions, commissions; galleries located in London, regional, and Scotland, Ireland, and Wales; art schools and colleges; and art and design courses.
Listings: national. Exhibition calendar.
Advertising.

ARTScribe: The International Magazine of New Art. 1976. bi–m. EN. 489
Artscribe International Ltd., 41 North Rd., London N7 9DP, England. Phone 071–609 2339/2029, fax 071–609–8462, telex 24453 OMNIBUG. Michael Archer, Editor.
Subscription: $24.95 US & Possessions, $30.95 Canada, $33.95 foreign (US: Artscribe, P.O. Box 1900, JAF Station, New York, NY 10116). No sample. Back issues, no.13–54 £6, no.55 to date £3.50. Illus. b&w, color, photos. A4, 96p.
ISSN: 0309–2191. OCLC: 21895529. LC: N1.A883. Formerly: *Artscribe International.*
Films. Modern Art. Painting. Photography. Printing. Sculpture. Performance.

Covers the most important new art in Europe and the United States. Presents a critical analysis of the most exciting contemporary art and artists in America and Europe today through interviews, views, reviews, news and debate.
Reviews: exhibition 35, length 600 wds.; book 12, length 500–1000 wds.; film 1, length 1000 wds. Interviews: usually 1/issue with an artist/collector. Listings: regional–international. Calendar of events. Exhibition information. Freelance work: yes. Contact: editor. Indexed: ArtBibCur. ArtBibMod. Des&ApAI. RILA. Reviewed: Katz. *Wilson* 63:3, Nov. 1988, p.119. *Art Documentation* Fall 1987, p.138. *New Art Examiner* 14:3, Nov 1986, p.16–17.
Advertising: (rate card): b&w double spread $3000, £1150;, full page $1970, £615; ½ page $1135, £350; ¼ page $740, £230; 2 color spread $4000, £1400; full page $2390, £740; ½ page $1365, £425; ¼ page $880, £275; full color spread $4750, £1600; full page $2730, £850; ½ page $1820, £565; ¼ page $1135, £350; covers (full color only) $2970–3850, £1050–1375. [VAT extra UK only]. Frequency discount. 20% registered non–profit & charity organizations. 15% agency discount. Prepaid + 10% discount. Special position + 10%. Mailing lists: available on application. Circulation: 15,000. Audience: art students, collectors, artists; anyone interested in, working in, or investing in the arts today.

ARTSTUDIO. 1986. q. FR only. 490
Imprimerie Blanchard Le Plessis–Robinson, 30, rue Beaubourg, 75003 Paris, France. Claire Stoullig, Editor.
Subscription: 390 F. Illus. b&w, color, photos.
ISSN: 0767–8150. Dewey: 700.
Modern Art.

Examines contemporary art focusing especially on European art.
Indexed: ArtBibMod. BHA. Reviewed: Katz.
Advertising at back of issue.

ASPECTS. 1977. q. EN. 491
1 Gloucester St., Bath BA1 2SE, England. Colin Painter & Anne Painter, Editors.
Subscription: £3.50 UK, £4 Europe, £13 US. Illus.
ISSN: 0143–537X. OCLC: 15187276.
Modern Art.

Journal of contemporary fine art, most concerned with what artists themselves have to say. Covers a wide range of current practice including extra-painting and sculpture methodologies.
Indexed: ArtBibMod.

ATLAS. 1985. irreg. EN, FR & GE. 492
Woolley Dale Press, 16 Talfourd Rd., London SE15 5NY, England. Jake Tilson, Editor.
Illus.
ISSN: 0267–484X. OCLC: 14908364. LC: N1.A847.
Modern Art.

Chiefly illustrations devoted to pop art.

AUDIO ARTS MAGAZINE: Magazine on Cassette. 1973. q. EN. 493
Audio Arts, 6 Briarwood Rd., London SW4, England. William J. Furlong, Editor.

Subscription: [VAT included] £23 inland, £25 Europe, £27 US. cassette + 18p. booklet.
ISSN: 0306–1159. Dewey: 800. Formerly: *Audio Arts*.
Publication on the audio cassette, with slides. Original recordings of artists including interviews, live performance, documentation and art works specifically conceived for tape and slide form. Main emphasis is on contemporary art. Printed supplement accompanies some numbers. Booklet relates to the tapes.

AUDIOZINE. 1977. irreg. EN.
494

Contemporary Arts Press, Box 3123, San Francisco, CA 94119. Phone 415–431–7672.
Modern Art.

AWARDS IN THE VISUAL ARTS. 1982. a. EN.
495

Southeastern Center for Contemporary Arts, 750 Marguerite Dr., Box 11927, Winston–Salem, NC 27116–1927. Phone 919–725–1904. Virginia S. Rutter, Editor.
Back issues.
Modern Art.

BROADSHEET. EN.
496

Contemporary Art Centre of South Australia, 14 Poster St., Parkside, Australia. Phone 08–272–2682. David O'Halloran, Editor.
Subscription: $A10 Australia, foreign + postage. Available free in Australia upon picking up from street locations, bookshops, galleries, cafes, etc. tabloid, 30 x 40 cm., 12p.
Architecture. Crafts. Films. Modern Art. Painting. Photography. Sculpture.

A journal of contemporary visual art and culture.
Reviews: exhibition 6, length 1500–2500 wds.; book & film 1 each, length 1000 wds. Listings: South Australian. Exhibition information.
Advertising: full page $A700, ½ page $350, ¼ page $180. Frequency discount. Anna Damiano, Ad. Director.

C MAGAZINE. 1984. q. EN.
497

Box 5, Station B, Toronto, Ontario M5T 2T2, Canada. Phone 416–977–0850. Richard Rhodes, Editor & Pub.
Subscription: $18 US & Canada, institutional & foreign $28. Microform available from Micromedia. Sample, postage. Back issues $10 each. Illus b&w, color occasionally, photos. 8 x 10¾, 80p.
ISSN: 0838–0392. OCLC: 17526457. LC: N1. Dewey: 709. Formerly: *Impressions*.
Modern Art.

A journal of contemporary art production with special emphasis on experimental modes of critical address.
Reviews: 6–10 reviews each issue. Freelance work: yes. Contact: editor. Indexed: ArtBibMod. BHA. CanPI. Reviewed: Katz.
Advertising. Circulation: 4500. Audience: contemporary art professionals and students.

CAHIERS DU MUSEE NATIONAL D'ART MODERNE: Histoire & Theorie de l'Art.
1979. q. FR.
498

Centre Georges Pompidou, Paris, France.
Illus.
ISSN: 0181–1525. OCLC: 6078768. LC: N6490.P27a. Dewey: 709.
Modern Art.

Indexed: ArtArTeAb. ArtBibMod. ArtI. RILA.

CARNEGIE INTERNATIONAL. a. EN.
499

Carnegie Institute, Museum of Art, 4400 Forbes Ave., Pittsburgh, PA 15213. Phone 412–622–3205.
OCLC: 10591862. LC: N6490.P69. Dewey: 707. Formerly: *Pittsburgh International Exhibition of Contemporary Art*.
Modern Art.

Catalog of the annual exhibition.

CIMAISE: Present Day Art. 1953. bi–m. EN & FR articles (side by side). Table of contents & book reviews
FR only.
500

8 rue Recamier, 75007 Paris, France, Phone 1–454 4 04 82. (US Dist.: C.I.P.D., 433 Hackensack Ave., NJ 07601). Jean–Robert Arnaud, Editor.

Subscription: $70. Illus. b&w & color, photos. 8¼ x 10½, 164p.
ISSN: 0009–6830. OCLC: 1554704. LC: N2.C57N4.C57. Dewey: 705.
Modern Art.

Focuses on contemporary art and exhibits, European and American artists and their works. Heavily illustrated bilingual journal.
Reviews: book, exhibition. Biographies: focus on works, many full page illustrations. Interviews. Listings: exhibitions. Indexed: ArtBibCur. ArtBibMod. ArtHum. ArtI. CurCont.
Advertising.

CONTEMPORANEA. 1988. 10/yr. EN & IT editions. 501
Contemporanea, Ltd., 20 West Broadway, New York, NY 10013. Phone 212–274–0730, fax 212–274–0737. Joseph D. Watson, Managing Editor, English edition.
Subscription: $59, Canada & foreign $70 (US: Box 834, Farmingdale, NY 11737–9734; Europe: Francesca Rocelli, c/o Contemporanea Venice, San Marco 4255, Italy, phone 041–5287800). Illus. b&w, mainly color. 8½ x 11¼, 112p.
ISSN: 0897–8271. OCLC: 17641552. LC: N6480.C65. Dewey: 709.
Modern Art.

An international art magazine with art world offices in New York, Venice and Turin plus correspondents all over the world. American and European critics cover visual and performing contemporary arts. Two pages on each city with overview of galleries or shows, Florence, Paris, Catania, Chicago, Dusseldorf and New York. One article under each heading: letters, cover story, private collection, studio visit, interview, theater, and emerging artist.
Interviews. Listings: international. Calendar of events. Exhibition information. Reviewed: *Choice* 26:2, Oct 1988, p.104. *Wilson* 63:3, Nov 1988, p.119. *Small Press Review* 6:2, Dec 1988, p.29. *New Art Examiner* 16:7, Mar 1989, p.59–60.
Advertising: Steven M. Estok, U.S. Ad. Manager.

CONTEMPORARY AMERICAN ART CRITICS. 1984. irreg. EN. 502
UMI Research Press, 300 N. Zeeb Rd., Ann Arbor, MI 48106–1346. Phone 313–761–4700. Donald Kuspit, Editor.
OCLC: 11003827.
Modern Art.

CONTEMPORARY ART CENTRE OF SOUTH AUSTRALIA BROADSHEET. 1954. q. EN. 503
Contemporary Art Centre of South Australia, 14 Porter St., Parkside, S.A. 5063, Australia. David O'Halloran.
Subscription: $A10.
ISSN: 0819–677X. Formerly: *Contemporary Art Society of Australia Broadsheet.*
Modern Art.

CTO (Call to Order). 1980. irreg. EN. 504
149 Kathleen Rd., Sholing, Southampton, Hants. SO2 8LP, England. Alex Tsander, Editor.
ISSN: 0260–5821.
Modern Art.

Counter–reactionary journal of contemporary art.

CUBISM. 1923. q. EN. 505
10 Athol St., Belfast BT12 4GX, Northern Ireland. Peter Brooke, Editor.
Subscription: £6.50.
ISSN: 0265–377X. Dewey: 709.
Modern Art.

CV. 1988. q. EN. 506
The Artist's Journal Ltd., 10 Barley Mow Passage, Chiswick, London W4 4PH England. Phone 081–994 6477, fax 081–994 1533, telex 8811418. Nicholas Wegner & Sarah Batiste, Editors & Pubs.
Subscription: (rates June 1990): £12 individual, £15 institution, UK/NI; £20 Europe; elsewhere £20 surface, £30 air. (US: dist.: Ebsco). Sample £6. Back issues £8. Illus. b&w, photos. Cum. index 1988–90. A4, 44p.
ISSN: 0954–1608. OCLC: 20717354.
Ceramics. Crafts. Conservation. Decorative Arts. Drawing. Historic Preservation. Juvenile. Modern Art. Museology. Needlework. Painting. Photography. Sculpture.

Journal of art and crafts contains feature articles and several interviews in each issue which explore the range and vibrant activity generating in the fine and applied arts.

Reviews: exhibition 6, length 200–400 wds.; book 4, length 200 wds. Interviews: recorded dialogues with leading international artists, transcripts amended and approved by subjects prior to publications, several per issue. Biographies: features on major artists. Listings: mainly London, national. Calendar of events. Exhibition information. Freelance work: yes. Contact: editor. Opportunities: study, competitions. Indexed: ArtBibMod. Reviewed: *ARLIS News–Sheet* No.78, May/June 1989, p.10. Advertising: b&w only, full page £450, ½ page £225, ¼ page £125. Classified: £15/100 wds. Frequency discount. N. Wegner, Ad. Director. Mailing lists: none. Circulation: 3000. Audience: A/B readership – specialist, academic.

DADA/SURREALISM. 1971. a. EN.

507

University of Iowa, 425 EPB, Iowa City, IA 52242. Phone 319–335–0324. Rudolf Kuenzli, Editor.
Subscription: included in membership, $12 individuals, $15 institutions. Sample. Back issues $10. 6 x 9, 200p.
ISSN: 0084–9537. OCLC: 1565784. LC: NX600.D3 D34.
Films. Interior Design. Modern Art. Painting. Photography.

Invites a wide range of approaches to the verbal and visual productions of these two movements seen in their least limited senses as historical and living phenomena. Each issue is organized around a specific topic.
Bibliographies in each issue. Indexed: ArtBibMod. RILA. Reviewed: *Serials Review* 11:2, Sum 1985, p.16.
Advertising: full page $100. Mailing lists: available. Circulation: 700. Audience: international, arts, literature 20th century.

DELFIN. 1983. s–a. GE. EN occasionally.

508

Poiesis Verlag, Postfach 2104, D–4848 Rheda–Wiedenbrueck, W. Germany. Phone 05242–35527. Gebhard Rusch & Siegfried J. Schmidt, Editors.
Subscription: DM 27. Illus. b&w, color.
ISSN: 0724–2689. OCLC: 13297575. LC: NX3.D44.
Modern Art.

DETAILS. 1982. m. EN.

509

Details Publishing Corp., 611 Broadway, Room 711, New York, NY 10012. Annie Flanders, Editor.
Illus.
ISSN: 0740–4921. OCLC: 9953684. LC: NX504.D47.
Modern Art.
Reviewed: Katz.

DU DA. 1986, v.2 no.3. 3/yr. EN.

510

c/o Sally Alatalo, P.O. Box 47687, Chicago, IL 60647.
Subscription: $25, $30 foreign. variable size, spiral bound, 12p.
Formerly: *Doda.*
Art works on a single theme, little text, Some issues accompanied by found items. Format and size varies.

EIGHTY: Les Peintres en France dans les Annes 80. FR only.

511

33 rue de la Breche aux Loups, F–75012, Paris, France.
Illus. mainly color, photos. 9½ x 11½, 64p.
ISSN: 0294–1880.
Modern Art.
Mainly illustrations.

ETC MONTREAL. 1987. q. FR only.

512

Association des Galeries d'Art Contemporain de Montreal, 4248, rue de Bullion, Montreal, Quebec H2W 2E7. Phone 514–848–1125.
Subscription: $19 Canada, $25 US, $30 Europe (1435 Bleury, Suite 806, Montreal, Quebec H3A 2H7). Illus. 6¾ x 11.
ISSN: 0835–7641. OCLC: 18242466. LC: N400. Dewey: 709.714. Formerly: *Etc.: Montreal en Revue.*
Modern Art.

Gathers and publishes a collection of original perspectives on the subject of contemporary visual art touching upon vital issues, pertaining to painting, sculpture, video, installation, etc. Each issue examines the thought and activities of purveyors of our present–day culture, dynamics of Quebec, Canada and international art.

Reviewed: *New Art Examiner* 16:9, May 1989, p.63–64.
Advertising.

FLASH ART [International edition]: The Leading European Art Magazine. 1967. bi–m. EN.

Issued also in IT & RU editions.

Giancarlo Politi Editore, 68, Via Farini, 20159 Milan, Italy. Phone (02) 688.7341, fax 866.4784. (US dist.: Flash Art, 799 Broadway, Room 237, New York, NY 10003, phone 212–444–4905, fax 212–477–5016). Giancarlo Politi & Helena Kontova, Editors.

Subscription: $50 Europe; $35 surface, air $60 (521 Fifth Ave., New York, NY 10175) US/Asia; Oceania $70. IT edition same price. RU edition (s–a) $US20, air $25. Microform available. Illus., b&w & color. 8 x 10¼, 170p.

ISSN: 0394–1493. OCLC: 9227733. LC: N1.A1F532. Dewey: 700. With: *Flash Art Italia*, and *Flash Art France*, continues, *Flash Art*.

Modern Art.

Contemporary art with international coverage. Over half the issue consists of advertisements. Includes constructivist and conceptual art. Supplement, *Flash Arts News*, bound with issue, provides a comprehensive current overview of the latest news of individuals and institutions, book reviews, interviews, information on exhibitions, galleries, auctions and sales. *Flash Art Italia* contains a supplement, "Guida Mondiale Della Fotografia", "Photo Diary", which includes section headings in EN & IT. RU edition with EN tr.began in 1989.

Reviews: exhibition, book, 16p. total reviews. Interviews. Listings: international. Calendar of exhibitions. Indexed: ArtBibCur. ArtBibMod. Reviewed: Katz. *Wilson* 63:3, Nov 1988, p.119.

Advertising: ad rates on request (Milan or New York address).

GALERIA. 1986. 5/yr. POR.

Area Editorial Ltda., Alfredo Egidio de Souza Aranha, 75–5 andar., CEP 04726, Sao Paulo, SP, Brazil. Phone 521.0898. Wilson Coutinho, Editor.

Subscription: Cr$ 300,000. Illus. b&w, some color.

OCLC: 16516750. LC: N7.G27. Dewey: 700.

Modern Art.

Focuses on contemporary Brazilian art.

HIGH PERFORMANCE. 1978. q. EN.

Astro Artz, 1641 18th St., Santa Monica, CA 90404. Phone 213–315–9383, fax 213–453–4347. Dylan Tran & Eric Gatierrez, Editors.

Subscription: $20 individual, $24 institution US; $24 Canada & Mexico; foreign $28 surface, $55 air. Microform available from UMI. Illus. b&w. Annual index. 8 x 10¾, 88p. Huttner lithography.

ISSN: 0160–9769. OCLC: 3797950.

Modern Art.

A "magazine for the new arts" devoted to progressive thinking in the arts. Strives to present artists and organizations whose work reflects not only a commitment to quality but a concern for the culture in which that work appears. Sees the arts as an integral part of a healthy society in which the artist provides both intellectual nourishment and social challenge.

Reviews: reviews. Indexed: ArtBibCur. ArtBibMod. ArtI. Reviewed: Katz. *New Art Examiner* 14:3, Dec 1986, p.15–16. *Art Documentation* Sum 1987, p.93.

Advertising: Karla Dakin, Ad. Director.

HOOPOE. 1987. s–a. EN.

Hoopoe, 16 West 85th St., New York, NY 10024. Phone 212–787–4162. Robert Montoya & Danielle Dubray, Editors.

Subscription: $5/issue. No sample. Back issues. Illus. b&w, photos. 8½ x 11, 8–10p.

ISSN: 0897–2168. OCLC: 17454969. Dewey: 700.

General. Modern Art.

Publication of artists writings on other artists' works or events other than Art, that are related to their life. Includes letters, journals, pedagogical writings, poems, dissertations, treatise, sketches, paintings or essays. Special attention given to Oriental or Asian artists. Includes original art works".

Biographies. Freelance work: none. Indexed: ArtBibMod.

Advertising: none.

I.S.C.A. QUARTERLY. 1982. q. EN. **517**

International Society of Copier Artists, 800 West End Ave., New York, NY 10025. Phone 212–662–5533. Louise Neaderland, Director.

Subscription: included in membership. There are 2 kinds of membership: Supporting membership $90 US, $US110 Canada & foreign, air + $25; or Contributing Artist membership to which the artist member must contribute at least 2/yr., $30 US, $US40 Canada & foreign. Illus. b&w, color. format varies from spiral bound, to folio, through boxed collections of book-works. 45–50 prints or bookworks per issue.

ISSN: 0741–2940. OCLC: 10101624. LC: NE3000.I17. Dewey: 760.

Graphic Arts. Modern Art. Printing.

Nonprofit organization founded to promote the use of the copier as a creative tool. The quarterly consists of a compilation of original xerographic artworks created by the members of the Society. Provides a unique vehicle representing current copier art activity. Each issue is produced in a limited edition. Direct imaging, collage, paper stock, computer generated graphics, hand coloring and stamping, varied format and subject matter make for an energetic visual experience. All visual material with the exception of editorial. A typical issue containing prints, post cards and bookworks averages 45 original works of art in folio, bound or boxed format. The organization also publishes an occasional newsletter which contains exhibition opportunities, new technical developments and timely articles about the use of the copier as a creative tool.

Listings: regional–international. Opportunities: study — workshops and lectures offered by the ISCA. Competitions, listings wanted Exhibition opportunities.

Advertising: none. Audience: artists, print collectors, book artists, libraries in museums, colleges and public libraries.

ICA MONTHLY BULLETIN. 1964, no.140. m. EN. **518**

Institute of Contemporary Arts, Nash House, The Mall, London SW1Y 5AH, England. Phone 071–873–0051. Jane Harper, Editor.

Subscription: free. Illus.

OCLC: 8565885. Formerly: *ICA Quarterly.*

Modern Art.

Presents news of the Institute as well as information regarding events, gallery, theater, cinema and talks.

Calendar of events.

ICI NEWSLETTER: Focusing on Contemporary Art. 1986. q. EN. **519**

Independent Curators, Inc., 799 Broadway, Suite 205, New York, NY 10003. Phone 212–254–8200, fax 212–477–4781. Mary La Vigne, Newsletter Coordinator.

11 x 17, 4p. Lithography.

ISSN: 0889–3160. OCLC: 13845963.

Modern Art.

National non–profit traveling exhibition service specializing in contemporary art. Presents previews of exhibits. "Crosstalk" column reserved for essays by artists, critics, and curators.

Reviews: Previews exhibitions. Listings: of exhibits available.

Advertising: none.

IMAGEZINE. 1977. irreg. EN. **520**

Contemporary Arts Press, Box 3123, San Francisco, CA 94119. Phone 415–431–7672.

Modern Art.

INTERNATIONAL EYE. 1979. m. except Jan. EN. **521**

East Village Eye, Inc., 611 Broadway, No. 609, New York, NY 10012. Phone 212–777–6157. Leonard Abrams, Editor.

Subscription: $16.50.

Formerly: *East Village Eye.*

Modern Art.

Tabloid.

Reviews: book. Reviewed: *Art Documentation* Sum 1987, p.67.

Advertising.

ISKUSSTVO. 1933. m. RU. EN titles (end of issue, 1p.). **522**

Izdatel'stvo Iskusstvo, Tsvetnoi bulvar, 25, Moscow K–51, Russian S.F.S.R., U.S.S.R. V.M. Zimenko, Editor.

Subscription: 54 Rub. Illus. b&w, color, plates. 8½ x 11½, 80p.

ISSN: 0021–177X. OCLC: 2027398. LC: N6.I85.
Modern Art.

Articles on Soviet art specializing in contemporary art and news of the art world in the Soviet Union. Well illustrated. Single English page in each issue is limited to just the titles or in addition 1–2 sentences on each article.
Bibliographies. Indexed: ArtBibCur. ArtBibMod. Reviewed: Katz.
Advertising: none.

JONG HOLLAND. 1985. bi–m. DU. EN summaries of feature articles (2p.). **523**
Staatsuitgeverij, Postbus 20014, 2500 EA's–Gravenhage, Netherlands. Phone 070–789111.
Subscription: overseas fl 72. Illus. b&w, photos. A4, 40p.
ISSN: 0168–9193. OCLC: 13800332. LC: N6947.J66.
Modern Art.

Covers modern art, visual art and design in the Netherlands after 1850.
Indexed: ArtBibCur. RILA.
Advertising.

JOURNAL OF CONTEMPORARY ART. 1988. s–a. EN. **524**
John Zinsser & Philip Pocock, Publishers, 330 E. 19th St., P.O. Box CC, New York, NY 10003. Phone 212–460–5683. Klaus Ottmann, Editor (P.O. Box 1472, New York, NY 10023).
Subscription: $12 US & Canada, foreign air $18. No sample. Back issues $10–15. 6 x 9, 94p.
ISSN: 0897–2400. OCLC: 17432962. LC: NX. Dewey: 709.
Art History. Films. Modern Art. Painting. Photography. Sculpture.

Devoted exclusively to interviews with modern artists.
Interviews: content mostly interviews with artists. Freelance work: yes. Contact: editor. Reviewed: Katz.
Advertising: none. Circulation: 3000.

KEWPIESTA KOURIER. 1967. q. EN. **525**
International Rose O'Neill Club, c/o Jack Crotser, P.O. Box E, Nixa, MO 65714. Phone 417–725–3291. Sally Crotser, Editor.
Subscription: included in membership. 8½x11, 4–12p.
Collectibles. Modern Art.

Devoted to preserving works of the artist Rose O'Neill, creator of the kewpie doll in 1909, and her memory through the presentation of information on her art work, illustrations and writing. Features news of members, Club activities and reports of research.
Calendar of events.
Circulation: 1000.

KUNST EN MUSEUMJOURNAAL [English edition]. 1989. bi–m. EN. Issued also in DU edition. **526**
Rijksdienst Beeldende Kunst, Keizersgracht 609, 1017 DS Amsterdam, The Netherlands. Phone 020–276095. Philip Peters, Editor.
Subscription: fl 51 Netherlands, BFr 920 Belgium, others $US40, DM 75, £25, F 256; air fl 185 (P.O. Box 77, 5126 ZH Gilze, The Netherlands, phone 01615–74 50). Illus. b&w, some color. 7½ x 10¼, 60p.
ISSN: 0924–526x. OCLC: 20859786 (EN edition), 20409012 (DU). LC: N6948.K78. Dewey: 700. Formed by the union of: *Museeumjournaal* and, *Dutch Art + Architecture Today*.
Modern Art. Museology.

Issued by the Netherlands Office for Fine Arts. Features essays and encourages debate on international contemporary art, artists, museum policies and related subjects. Includes news, events and installations on 37 Dutch museums and cultural institutions and the Netherlands Office for Fine Arts.
Listings: national. Indexed: ArtBibMod. BHA. RILA.

KUNSTBLATT. 1972. q. GE only. **527**
Interessengemeinschaft Berliner Kunsthaendler e.V., Ludwigkirchstr. 11a, 1000 Berlin 15, W. Germany. Phone 038–8832643, fax 038–883–2642. Hanspeter Heidrich, Editor.
Subscription: DM 35. Illus. b&w, color. 144p.
Dewey: 701.18. Formerly: *Berliner Kunstblatt.*
Covers contemporary painting, sculpture, photography, and architecture exhibitions in museums and galleries in Berlin. Lists museums, galleries, exhibitions, and auctions. Includes an artist index.

Reviews: book.
Advertising. Circulation: 7,000.

KUNSTFORUM INTERNATIONAL. 1973. bi–m. GE.

528

Kunstforum International, Vorgebirgstrasse 25, D–5000 Koln 1, West Germany.
Illus. some color.
ISSN: 0177–3674. OCLC: 2710706. LC: N6480.K86. Dewey: 709.
Each volume has an individual title.
Indexed: ArtBibCur. ArtBibMod. Avery. RILA.

DAS KUNSTWERK: Zeitschrift fuer Moderne Kunst. 1946. bi–m. GE.

529

W. Kohlhammer GmbH (Stuttgart), Hessbruehlstr. 69, Postfach 800430, 7000 Stuttgart 80, W. Germany (US: Wittenhorn und Company, 1018 Madison Ave., New York, NY 10021). Phone 0711/7863–1, telex 7255820. Rolf–Gunter Dienst, Editor.
Subscription: DM 148. Microform available from UMI. Illus. b&w, color, photos, many full page. 8¼ x 10½.
ISSN: 0023–561X. OCLC: 2148582. LC: N3.K95. Dewey: 700.
Modern Art.

Journal of modern art focuses on contemporary German and Western European art. Some issues are dedicated to a special theme.
Reviews: book, exhibition. Indexed: ArtBibCur. ArtBibMod. ArtHum. ArtI. BHA. BioI. CurCont. RILA.
Advertising.

KURIO AFRICANA. See no. 192.

LALIT KALA CONTEMPORARY. 1962. s–a. EN.

530

National Academy of Art – Lalit Kala Akademi, Rabindra Bhavan, New Delhi 110001, India. S.A. Krishnan, Editor.
Subscription: Rs 15, $10. Illus.
ISSN: 0023–7396. OCLC: 1714807. LC: N1.L3. Dewey: 709.
Modern Art. Painting. Sculpture.

Covers contemporary Indian painting and sculpture. Emphasis is on cultural heritage of India in modern life.
Reviews: Exhibitions. Interviews.

LAPIZ: International Art Magazine. 1983. 10/yr. SP & EN editions.

531

LAPIZ, Gravina, 10 First Floor, 28004 Madrid, Spain. Phone 34–1–5222972, fax 34–1–5224707. Rosa Olivares, Editor.
Subscription: $85 US, $C105, £49.5, $A130, BF3.150, DM153, F 495, L 117, Ptas 7.200, 12.000 Yen, SF135 (air mail postage charges included). Illus. b&w, some color. 9 x 11¼, 106p + ads.
ISSN: 0212–1700. OCLC: 14961409. LC: N7.L36.
Modern Art.

First international contemporary art magazine published in Spanish. In–depth analyses and accurate information on today's art. Presents a "complete guide to the most important national and international museum shows. Official or institutional exhibitions of vital interest to all art lovers".
Reviews: book, exhibition (international). Biographies: of artists together with illustrations of their work. Listings: international. Calendar of events. Exhibition information.
Advertising: Isabel L. del Busto, Ad. Director.

LEFT CURVE. 1974. irreg. EN.

532

Box 472, Oakland, CA 94604. Phone 415–763–7193. Csaba Polony, Editor & Pub.
Subscription: (3 issues) $15 individual, $25 institutions worldwide, air + postage. Sample & back issues $5. Illus. b&w, photos. 8 x 11½, 96p.
ISSN: 0160–1857. OCLC: 2303188. LC: NX180.R45L43. Dewey: 700.
Art History. Films. Graphic Arts. International. Modern Art. Painting. Photography. Literature.

Stresses "arts and revolution". An artist produced magazine that addresses the problems of cultural forms emerging from the crises of modernity that strive to be independent from the control of dominant institutions. Publishes original work by individuals, as well as cultural work that are integral, organic parts of emancipatory movements. Orientation is premised on the recognition of the destructiveness of commodity (capitalist) systems to all life, and the need to build a non–commodified culture that could potentially create a more harmonious relationship among people, and between the human and natural world.

Reviews: book 2, film 1. Interviews: in-depth interviews with artists, writers film makers, etc. Freelance work: yes. Contact: editor. Indexed: ArtBibMod.

Advertising: full page $150, ½ page $75, ¼ page $35. Classified: $1/wd. Mailing lists: none. Circulation: 1000. Audience: artists, writers, progressive cultural activists, academics.

LETTER BOMB. 1968. irreg. EN. 533

Transient Press Editions, Box 24292, Los Angeles, CA 90024–9998. Norman Conquest, Editor.

Subscription: $40 US. Sample $8. Back issues. 8½ x 11, 100p.

International Mail Art. Artists Books.

"Originally a magazine of art and pataphysics — a forum for the Eternal Network, correspondence art, visual–experimental writing by artists, artists books, etc. Most issues have been thematic. Today it continues to provide a space for non–commercial expression in a sea of greed".

Reviews: exhibition 10, book 4, journal 4. Listings: international. Information for mail art exhibitions. Freelance work: yes. Contact: editor.

Advertising: none. Circulation: 350–400. Audience: artists.

LIGEIA: Dossiers de l'Art. 1988. q. FR. 534

Ligeia, BP 327, 75266 Paris Cedex 06, France.

Subscription: $70.88 France, $100.07 elsewhere.

ISSN: 0989–6023. OCLC: 21284589. LC: NX2.L54.

LOUISIANA-REVY. 1960. 3/yr. DA. EN summaries (1 p.). 535

Louisiana Museum of Modern Art, 3050 Humlebaek, Denmark. Phone 45–42.19.07.19. Hans Erik Wallin, Hugo Arne Buch & Uffe Harder, Editors.

Subscription: 210 DKr. No sample. Back issues. Illus. b&w, color, photos. 9 x 12, 68p.

ISSN: 0024–6891. OCLC: 6160286. LC: NX28.S8L624. Dewey: 700.

Modern Art.

Normally presents 6 or 7 articles about the artist(s) whose works are currently exhibited at the Museum. Heavily illustrated with many large illustrations.

Biographies: of the artists in question. Freelance work: yes. Contact: editor. Indexed: ArtBibCur. ArtBibMod.

Advertising: none. Circulation: 27,000–50,000. Audience: members of the Louisiana Club.

LUND ART PRESS. 1989. q. EN, GE, FR. 536

Lund University, School of Architecture, Box 1507, S–221 01 Lund, Sweden. Phone 46–46–107610, fax 46–46–104545. Jean Sellem, Editor.

Subscription: SEK 170. Sample. Back issues SEK 50. Illus. b&w, photos. A5, approx 100p.

ISSN: 1101–5462.

Architecture. Art Education. Art History. Modern Art. Photography. Sculpture. Performance Arts. Experimental Arts.

A project supported by the Dept. of Theoretical and Applied Aesthetics. Lund Art Press has established contacts internationally with institutions, movements, artists, architects, museums, schools of art, etc. and is interested in receiving on a continuing basis material related to contemporary art and architecture, its present state and its future development.

Reviews: exhibition, book, journal, film, equipment. Listings: international. Freelance work: yes. Contact: editor. Opportunities: study.

Advertising: b&w only, full page SEK 2.000, ½ page SEK 1.000, ¼ page SEK 500. Audience: artists, art institutes, researchers.

M/E/A/N/I/N/G. 1986. s–a. EN. 537

c/o Susan Bee, 464 Amsterdam Ave., No. 4A, New York, NY 10024. Phone 212–799–4475. Susan Bee & Mira Schor, Co–editors & Pubs.

Subscription: $10 individual, $15 institution US; Canada & foreign + $US6 postage (Mira Schor, 60 Lispenard St., New York, NY 10013). Sample & back issues $5. none. 8½ x 11, 48p.

ISSN: 1040–8576. OCLC: 17793001. LC: NX1.M42. Dewey: 700.

Art Education. Art History. Drawing. Modern Art. Painting. Sculpture.

An artist–run journal of contemporary art committed to creating a meeting ground between practicing visual artists and current critical issues and ideas. Features on and by contemporary artists, lesser–known artists, artists statements & writings, theoretical essays, feminist art history, and critical perspectives on art.

Reviews: book 10. Interviews: occasionally with artists. Biographies occasionally. Freelance work: none. Indexed: ArtBibMod. Reviewed: *New Art Examiner* 17:3, Mar 1990, p.57–58.
Advertising: none. Circulation: 1000. Audience: artists, art historians, critics.

MANHATTAN. 1983. 5/yr. EN. 538
Renee Phillips Associates, 200 E. 72nd St., Suite 261, New York, NY 10021. Phone 212–472–1660. Renee Phillips, Editor.
Subscription: $10 US, foreign $30.
Promotes new artists and covers trends.
Reviews: exhibition. Interviews.

MATRIX BERKELEY. See no. 1767.

MEDIAMATIC. 1985. q. DU & EN. 539
Stichting Mediamatic Foundation, Binnen Kadijk 191, 1018 ze Amsterdam, Netherlands. (US dist.: Bernard de Boer, Nutley, NJ 07110). Phone 020–241054.
Subscription: Dfl 40 individual, Dfl 55 institution + postage; foreign Dfl 16 surface, Dfl 36 air. Illus. b&w, photos. A4, 68p.
Modern Art.

On media art and hardware design with an emphasis on video. Bilingual coverage of modern art, international in scope. Presents theoretical articles, historical overviews, technical essays, coverage of important festivals, and new activities.
Interviews: with artists. Freelance work: yes. Contact: editor. Indexed: ArtBibMod. Reviewed: *Art Documentation* Sum 1987, p.67.

METRONOM ART CONTEMPORANI. 1984. 3/yr. SP. EN tr. 540
Centre de Documentario d'Art Actual, Carrer de la Fussina, 9, 08003 Barcelona, Spain.
Illus.
Covers the European art scene.

MODERN ARTISTS. irreg. EN. 541
Harry N. Abrams, Inc., 100 Fifth Ave., New York, NY 10011. Phone 212–206–7715.
Dewey: 700.

MOMA. See no. 866.

THE MUSEUM OF MODERN ART MEMBERS CALENDAR. See no. 878.

NEW ART EXAMINER: The Independent Voice of the Visual Arts. 1973. 11/yr. EN. 542
Chicago New Art Association, 20 West Hubbard, Suite 2W, Chicago, IL 60610–4106. Phone 312–836–0330. Allison Gamble, Managing Editor (918 F St., NW, Washington, DC 20004).
Subscription: $27 US, + $15 Canada & first class; + $28 foreign air. Illus. b&w, photos. 8¼ x 10¾, 56p.
ISSN: 0886–8115. OCLC: 12996177. LC: N1.N382. Dewey: 701. Formed by the merger of: *New Art Examiner* (Midwest edition); and *New Art Examiner* (East Coast edition).
Modern Art.

Published by The Chicago New Art Association, The Pennsylvania New Art Association, and the Washington, D.C. New Art Association, non–profit organizations whose purpose is to examine the definition and transmission of culture in our society; the decision–making processes with museums and schools and the agencies of patronage who determine the manner in which culture shall be transmitted; the value systems which presently influences the making of art as well as its study in exhibitions and books; and, in particular, the interaction of these factors with the visual art milieu. Supported in part by the Illinois Arts Council, NEA, and a City Arts grant from the Chicago Office of Fine Art. "Art Exchange" presents varied opportunities for artists. News briefs are also included.
Reviews: national exhibitions 30+, journal 1, book, dance, theater. Listings: national. Calendar of events. Opportunities: employment and exhibition opportunities; study – lectures, workshops, conferences, seminars; competitions – call for entries, commissions, grants. Indexed: ArtBibCur. ArtBibMod. ArtI. Avery. BHA. BioI. CloTAI. RILA. Reviewed: Katz. *Art Documentation* Win 1987, p.166.
Advertising: Nancy Zwick, Ad. Director.

NEW ART INTERNATIONAL. 1986. bi–m. FR. 543
Tellut N., 14, rue de la Source, 75016 Paris, France. (US Dist.: Eastern News Distributor, 250 W. 55th St., New York, NY 10014).
Subscription: Europe: 300 F, DM 800, 5400 ptas, £30; US & others $45. US. Illus. b&w, much color, glossy photos. 8½ x 11, 136p.
OCLC: 20944741.
A contemporary international art magazine. Contents include "the best art to be collected, the height of avant garde trends, the top signatures, images and interviews with people who count".
Advertising.

NEW CULTURE. See no. 1776.

THE NEW MUSEUM OF CONTEMPORARY ART QUARTERLY NEWSLETTER. See no. 887.

NEXT: Arte e Cultura. 1985. q. 544
Joyce & Co., Rome, Italy. (Dist.: Casalini Libri, 50014 Fiesole, Florence).
Illus. 26cm., 34p.
OCLC: 87–43985 (LC).

NIKE - NEW ART IN EUROPE. 1983. 5/yr. GE chiefly, also some EN, FR, SP & IT. EN summaries. 545
Neue Kunst Verlags GmbH & Co. Vertriebs KG, P.O. Box 140540, Klenzestrasse 40, D–8000 Munich 5, W. Germany. Phone 089–2603376, fax 089–2608256, telex 524649. Christoph Schmidt, Editor.
Subscription: DM 45 Germany, DM 55 Europe, DM 110 overseas, DM 150 Australia. Sample, postage. Back issues. Illus. b&w, color, photos. 285 x 420 mm., 64p.
ISSN: 0935–2341. OCLC: 14148398. LC: N1.A1N48. Formerly: *Neue Kunst in Europa.*
Art History. Decorative Arts. Drawing. Graphic Arts. Modern Art. Painting. Photography.

An international, professional art periodical with information on current art issues. Central in the editor's information objective is the coverage of the international art activities to include interviews, biographical sketches of artists, reports on art shows, coverage of selected artist works, briefs, and the exhibition calendar which contains current show dates of over 650 major museums and galleries involved in contemporary art in Europe. It is published together with the "Europe Shows" poster. Publishing contributions appear in the original, native language with content summarized in English.
Reviews: exhibition 30–40, book 1–5. Interviews: Exhibitions. Listings: international. Calendar of exhibitions. Freelance work: yes. Contact: editor.
Advertising: (rate card 1/90): full page DM 2500, ½ page DM 1250, ¼ page DM 700, color + DM 500/color. Exhibition Calendar DM 30. Frequency discount. Inserts. Mano Falcke, Ad. Director. Mailing lists: available. Demographics: disseminated throughout Europe, the USA and Canada. Circulation: 10,000.

NOISE. 1985. FR only. 546
Maeght editeur, 42, rue de Bac, 75007 Paris, France. Phone 43 22 73 22. Adrien Maeght, Editor.
Subscription: 560 F France & Europe, 680 F air elsewhere. Illus. b&w, photos, many full page. 10¾ x 14½, 60p.
ISSN: 0765–121X. OCLC: 13620646. LC: NX549.A1N65. Dewey: 700.
Indexed: ArtBibMod.
Advertising.

NORTH. 1976. q. Scandinavian languages & EN. 547
North, Postboks 261, DK–4000 Roskilde, Denmark. Bent Petersen, Editor & Pub.
Subscription: Dkr 260 Scandinavia, elsewhere Dkr 360. Includes 35 issues of *North–Information.* Illus. b&w, color, photos. 7 x 11¾, 144p.
ISSN: 0015–1512.
Published in conjunction with *North Information.* Deals with contemporary Scandinavian art, through many statements and interviews with contemporary Scandinavian artists. Primarily monographs on significant Scandinavian artists or art historical surveys. Many full page illustrations in vibrant color. Provides full text in English translation.
Advertising: none.

NORTH-INFORMATION. 1976. irreg. 35/yr. Scandinavian languages & EN. 548
North, Postboks 261, DK–4000 Roskilde, Denmark. Bent Petersen, Editor & Pub.

Subscription: Dkr 260 Scandinavia, elsewhere Dkr 360. Includes subscription to *North*. Illus. color (full page), photos. 7 x 11¾, 20p.

ISSN: 0105–2624.

Published in conjunction with *North*. Newsletter format. Each issue includes documentation or background information about current exhibitions, other activities of Scandinavian artists, or supplements the material appearing in *North*.

Indexed: RILA.

Advertising: none.

L'OEIL. 1955. m. FR only. 549

SEDO SA, 33, Avenue de la Gare, CH–1001 Lausanne, Switzerland. Phone 021–49 46 19. Dir. Georges Bernier, Editor.

Subscription: 136 SFr. Illus, many full page, b&w, mainly color, photos. Annual index. 9¼ x 12, 94p.

ISSN: 0029–862X. Dewey: 700.

Articles on a variety of contemporary subjects.

Reviews: book. Listings: national. Calendar of galleries. Exhibition information (mainly France). Indexed: ArtBibCur. ArtBibMod. ArtHum. ArtI. Avery. CurCont. Des&ApAI.

Advertising.

OR. 1976. irreg. EN. 550

Uncle Don/Orworks, P.O. Box 868, Amherst, MA 01004. Don Milliken, Editor.

Some back issues. Illus. #120, *The Alchemy of Molehills*, contains a description of all issues. various size booklets.

Modern Art.

Contemporary art, each issue has an individual title. "American artists' multiple in pamphlet form (usually) utilizing inexpensive, readily available materials and methods; a disORiented occidental scrawl".

PARACHUTE: Contemporary Art Magazine. 1975. q. EN & FR. 551

Parachute Inc., 4060 Blvd. St. Laurent, Suite 501, Montreal, Quebec H2W 1Y9, Canada. Phone 514–845–9805. Chantal Pontbriand, Editor.

Subscription: $C25 individual, $C35 institution Canada; $35 individual, $45 US & foreign (Bernhard De Boer, Inc., 113 East Centre St., Nutley, NJ 07110). Sample $C7. Back issues. Illus. b&w, photos. Cum. index nos.1–50, sold separately. 23 x 28 cm., 75p.

ISSN: 0318–7020. OCLC: 2851563, 3348789 (FR). LC: NX1. Dewey: 709.

General. Modern Art.

Provides the reader with a comprehensive and lively view of contemporary art. In–depth articles and interviews with artists and other people involved in international art, and an information section. Articles are written by art critics and artists from Canada, the U.S. and Europe. Covers both visual and performance art.

Reviews: exhibition 19, length 5p.; book 6 & journal 3, length 300 wds.; music 2, length 5p. each; film occasionally. Interviews: with key artists of the contemporary art discourse. Biographies & bibliographies occasionally. Listings: international. Freelance work: yes. Contact: Colette Tougas. Indexed: ArtBibCur. ArtBibMod. CanPI. Reviewed: *New Art Examiner* 16:9, May 1989, p.63–64.

Advertising: full page $600, ½ page $350, ¼ page $200; 2 color full page $800, cover $850; 4 color full page $1000, covers $1100–1200. No classified. Frequency discount. 15% agency discount. Colette Tougas, Ad. Director. Mailing lists: available with exchange. Demographics: international readership, age 25–40, highly educated French and English speaking. Circulation: 5000. Audience: artists, curators, art critics, collectors.

PARKETT. 1984. q. EN & GE. 552

Parkett Verlag AG, Quellenstrasse 27, CH–8005, Zurich, Switzerland. Phone 01–271–8140, fax 01–272–4301. (US: Parkett Publishers Ltd., 636 Broadway, New York, NY 10012).

Subscription: SFr 92 Europe, DM 108 Germany; $63 individual, $73 institution US. Back issues SFr 25, US$14. Illus. b&w, color. 8¼ x 10, 165p + ads.

ISSN: 0256–0917. OCLC: 12226189. LC: NX3.P37.

Modern Art.

Bilingual magazine, each issue is created in collaboration with an artist, who contributes an original work especially for the issue. Work is reproduced in the regular edition. It is also made available in a signed and limited special edition. An interview and a biographical article on the artist is included.

Listings: exhibitions in Swiss art galleries. Indexed: ArtBibMod. Reviewed: Katz. *Art Documentation* Win 1986, p.183. *New Art Examiner*, 14:9, May 1987, p.17-18.

Advertising: large ad section at end of issue.

PLAGES. q. 553

1762, rue du Vieux Pont de Sèvres, 92110 Boulogne, France. Phone 46–08–35–56. Robert Gutierrez, Directeur.
Subscription: (4 issues) 500 F France, 550 F Europe, 600 F America. Illus. color, b&w. 8¼ x 10½, 40p.
ISSN: 0246–814x.

Modern Art.

"Espace de création et d'expression". Printed in limited edition. Size and format vary. Original material included as attachments. Produced on glossy paper with almost no text.

PLEINE MARGE. 1985. s-a. FR. 554

Martine Robineau, 3, rue Friant, 75014 Paris, France.
Illus.
OCLC: 12875648. LC: NX600.S9P53.
"Cahiers de littérature, d'art, plastiques & de critique".

PRO – Pro Art and Architecture. 1987. DU & EN (appear side by side with tr.). Table of contents in DU & EN. 555

Foundation PRO, NL, Prinsenstraat 21, NL–3311 JS Dordrecht, Netherlands. Phone 078/144374. Fre Ilgen, Editor.
Subscription: Lfl 89 US & Canada, Lfl 77 Europe, Lfl 63.50 Benelux. Illus. b&w, photos. A4, 86p.
International magazine for constructivism. All published material is the responsibility of the authors, including the translations.
Advertising. Circulation: 500.

PROJEKT: Sztuka Wizualna i Projektowanie. 1956. bi–m. POL with EN tr. RU, GE, FR, SP summaries. 556

Krajowa Agencja Wydawnicza, 00–679 Warszawa, ul. Wilcza 46, POB 179, Poland. (Dist.: ARS Polona, Krakowskie Przedmiescie 7, 00–068 Warsaw). Tadeur Uielan, Editor.
Sample & back issues $8. Illus. b&w, color, photos, cartoons. 12 1/5 x 9½, 80p.
ISSN: 0033–0957. OCLC: 2829558. LC: N6.P7. Dewey: 705.

General. Modern Art.

Visual art and design, encompassing many mediums, from Poland and other countries. English translation and numerous illustrations accompany each article.
Reviews: exhibition 5, book 4, equipment 2. Biographies: short biographies of artists. Listings: regional–international. Freelance work: yes. Contact: editor. Opportunities: study, competitions. Indexed: ArtBibMod.
Advertising: full page $US400, ½ page $200, ¼ page $100. Frequency discount. Mrs. W. Fadache, Ad. Director. Mailing lists: none. Circulation: 78,000. Audience: artists and designers.

QUE VLO-VE? 1973, 2nd ser. 1982. q. FR. 557

Victor Martin-Schmets, avenue du Petit-Sart, 143, B-5100, Jambes, Belgium.
OCLC: 8354003. LC: PQ2601.P6Z7376.
Publication of the Society for the study of research regarding Guillaume Apollinaire, the French avant-guarde poet who influenced pre World War I esthetic movements through his ideograms (visual poetry).

RAW VISION. 1989. s–a. EN, some FR. FR articles tr. to EN. 558

Raw Visions, Dept. 193, 1202 Lexington Ave., New York, NY 10028 (UK: 42 Llanvanor Road, London NW2 2AP, England). John Maizels, Editor.
Subscription: individual: $16 + $3 postage US; £9 + 90p. UK, F 100 + 16,50 France, SFr 24 + SFr 4 Switzerland. institution: $30 +$3 postage US, £16 + 90p., F 175 + F 16,50, SFr 44 + SFr 4. Illus. b&w, some color, photos. A4.
ISSN: 0955–1182. OCLC: 19906087. LC: N7432.5 A78 R39.

Modern Art.

International journal of outsider art, visionary art, art brut, and contemporary folk art. Aim is to promote interest in and understanding of the vast and varied works of art now outside the mainstream.
Reviews: book. Indexed: ArtBibMod. Reviewed: *Art & Text* no.33.
Advertising.

REFLEX MAGAZINE. 1987. bi–m. EN. 559

Reflex, Etc., 117 Yale Ave. N., Seattle, WA 98109. Phone 206–682–7688. Julie Johnson & Elizabeth Bryant, Editors.
Subscription: $10 US, $20 Canada & foreign. Sample & back issues $2. Illus. b&w, photos. 12 x 17½, 32p.
OCLC: 15465127. LC: NX26.S6 R43. Dewey: 700.

Architecture. Art Education. Ceramics. Films. Modern Art. Painting. Photography. Sculpture.

The Northwest's forum on the visual arts. Each issue contains reviews, news and analysis of arts, politics, artists' projects created for the magazine, and features considering the region's art in the context of contemporary culture.

Reviews: exhibition 10, length 750 wds.; book 1, length 200 wds.; film 1, length 400 wds. Interviews: exclusive interviews with artists, curators critics, or others of interest to the region's art community. Listings: regional, northwest. Freelance work: occasionally. Contact: editor. Opportunities: employment, study, competitions. Reviewed: *New Art Examiner* 18:4, Dec 1990, p.51–52.

Advertising: rate card upon request. Frequency discount. No classified. Allan Hammerschmidt, Ad. Director. Mailing lists: available for a fee. Circulation: 16,500. Audience: the art interested public throughout the Northwest.

REPERES: Cahiers d'art Contemporain. 1982. irreg. FR. 560

Galerie Lelong, 13 rue de Teheran, 75008 Paris, France. Phone 45.63.13.19. Daniel Lelong, Editor.
Subscription: 580 F. Illus.
ISSN: 0761–4241. OCLC: 10187464. LC: N2.R4. Dewey: 700. Formerly: *Derriere le Miroir*.
Each issue focuses on the work of a single artist.
Exhibition information. Indexed: ArtBibMod. Reviewed: *Art Documentation* Sum 1986, p.64.

REVIEW OF THE ARTS: FINE ARTS AND ARCHITECTURE. See no. 18.

SHIFT. 1987. q. EN. 561

San Francisco Artspace, 1286 Folsom St., San Francisco, CA 94103. Phone 415–626–9100. Maureen Keefe, Managing Editor.
Subscription: $25. Illus. b&w & blue. 10¾ x 8½, 60p.
ISSN: 0895–8351.
Reviews: artists. Interviews: artists.

SIKSI. q. FI & EN (side by side). 562

The Nordic Arts Centre, Sveaborg, SF–00190 Helsinki, Finland. Phone 358–0668143. Grete Grathwol, Editor–in–chief.
Subscription: 120 FIM. Back issues. Illus. b&w, color, photos. 8½ x 9½, 52p.
Modern Art.

Reviews: book, exhibition. exhibition. Indexed: ArtBibMod.
Advertising: Cati Hakulin, Ad. Director.

SunStorm ARTS MAGAZINE. EN. 563

SunStorm Arts Publishing Co., Inc., 1014 Drew Ct., Ronkonkoma, NY 11779. Phone 516–737–1212, fax 516–737–4425. Victor Bennett Forbes, Editor.
Illus. color, glossy photos. 9 x 12, 80p.
Modern Art.

Majority of articles on individual artists, their biography and works.
Interviews and biographies: several, well illustrated with their work.
Advertising.

SURREALIST TRANSFORMACTION. 1967. irreg. EN or FR. 564

British Surrealist Group, Transformaction, Peeks, Harpford, Sidmouth, Devon EX10 ONH, England. John Lyle, Editor.
Illus.
ISSN: 0039–6168. Dewey: 700.
Tabloid.
Reviews: book.
Circulation: 1,000.

SZTUKA. 1974. bi–m. POL. EN & RU summaries. 565

Krajowa Agencja Wydawnicza, Ul. Wspolna 32–46, Warsaw, Poland. (Dist.: Ars Polona – Ruch, Krakowskie Przedmiescie 7, Warsaw). Andrzej Skoczylas, Editor.
Subscription: 1200 Zl. Illus. b&w & color.
ISSN: 0324–8232. LC: N6. Dewey: 700. Formerly: *Przeglad Artystyczny*.
Articles on contemporary art both in Poland and worldwide.
Reviews: book. Interviews. Calendar of events. Indexed: ArtBibCur. ArtBibMod.

THE TAM BULLETIN. 1985, 1987 computerized bulletin. m. update on computer, irreg. paper. EN. 566
Postbus 10388, 5000 JJ Tilburg, Netherlands. Phone 013–366106. Ruud A.C. Janssen, Editor & Pub.
Subscription: free. Available by computer with modem on 2 bulletin board services, Infoboard–Venray BBS (Holland)
(0)4780–88119; HCC–FIDO Tilburg–1 (0)13–563150. Outside Holland drop the zero. Illus. b&w, photos. A5 folded, 8–16p.
Dewey: 700.
Art Education. Art History. Modern Art. Mail–Art.

Contains news about mail art projects together with details for submission. Bulletin may be distributed freely.
Listings: national–international mail–art. Exhibition information. Freelance work: none.
Advertising: none. Circulation: 400. Audience: mail artists.

TEMA CELESTE: International Art Review. 1983. 5/yr. IT. 567
Via Augusta 17, 96100 Siracusa, Italy. Phone 931–757.219/491.597, fax 931–491.491. Demetrio Paparoni & Michelangelo
Castello, Editors; Stephen Westfal U.S. editor (Iris Maria Carulli, 324 E. 41st St., New York, NY 10017, phone/fax 212–661–
2901).
Subscription: $US30. Illus. mainly color, glossy photos. 8½ x 11½, 74p.
OCLC: 18912515.
Modern Art.

Contemporary art review provides reviews of exhibitions in New York, Houston, London, Rome, Vienna and Barcelona.
Reviews: exhibition. Interviews. Listings: international. Calendar of events. Indexed: ArtBibMod.
Advertising: Lucia Davies, Ad. Director.

TENDENZEN: Zeitschrift fuer Engagierte Kunst. 1960. q. GE. 568
Pahl–Rugenstein Verlag, Gottesweg 54, D–5000 Cologne 51, W. Germany. Phone (0221)3600239. Ed.Bd.
Subscription: DM 36, students DM 33. Illus.
ISSN: 0495–0887. OCLC: 3171657. LC: N3.T45. Dewey: 701.
A journal of progressive art.
Indexed: ArtBibCur. ArtBibMod.

TENSION. 1983. bi–m. EN. 569
The Xtension Partnership, 1 Oban St., South Yarra, Victoria 3141, Australia. Phone 03–2400654. Ashley Crawford, Editor.
Subscription: $30 US + $18 seamail, + $46.80 air. Back issues. Illus. b&w, color, photos. 235 x 335 cm., 72p.
ISSN: 0725–6639. Dewey: 700.
Art Education. Films. Graphic Arts. International Arts. Modern Art. Painting. Photography. Printing. Sculpture.

Tension focuses on the development of contemporary art in its most innovative forms. It also promotes discussion on the
"cross–over" between other arts, eg. cinema, music, performance, etc.
Reviews: exhibition 5, book 3, & film 2, length 1500 wds. each. Calendar of advertised exhibitions. Freelance work: yes.
Contact: editor. Opportunities: competitions, advertised only.
Advertising: full page $A650, ½ page $A420, ¼ page $A300; color full page $A900. 10% frequency discount. No classi-
fied. Richard Craig, Ad. Director. Mailing lists: none. Circulation: 7000. Audience: visual arts students, collectors, academic
artists.

TERZOOCCHIO. 1975. q. IT & EN, FR or SP. 570
Edizioni Bora S.N.C., Via Jacopo di Paolo, 42, Bologna, Italy. Angelo Mazzei, Editor.
Subscription: L 30000. Illus.
ISSN: 0390–0355. OCLC: 2243022. LC: N6490.T47. Dewey: 753.
Reviews: book. Indexed: ArtBibMod.
Advertising. Circulation: 10,000.

THIRD TEXT Incorporating Black Phoenix. 1987. q. EN. 571
Kala Press, 303 Finchley Road, London NW3 6DT, England. Phone 071–435–3748. (US dist.: Ubiquity, 1050 E 4th St.,
Brooklyn, NY 11230). Rasheed Araeen, Editor.
Subscription: £16 individual, £30 institution UK; $US35 individual, $55 institution Europe; elsewhere air $US45 individual,
$70 institution. Sample. Back issues £4. Illus. 8 x 4½, 96p.
ISSN: 0952–8822. OCLC: 19988920, 19955287. Formerly: *Black Phoenix*.
"Third world perspectives on contemporary art and culture", an international scholarly journal which explores with real sub-
tlety the old oppositions of art and politics, centre and periphery and reexamines the hybrid cultural realities that emerge

when different world views meet. Deals with the relationship between the Third World and the West as it concerns the visual arts.

Interviews: with artists & academics. Obits. Reviewed: *Art Libraries Journal* 13:2, 1988, p.20–21.

Advertising: full page £350, ½ page £190. Frequency discount. Andy Patterson, Ad. Director (LRB Ltd., Tavistock House Sth., Tavistock Square, London WC1H 9J2). Mailing lists: available. Circulation: 1000. Audience: academics & artists.

TWENTIETH-CENTURY ART & CULTURE. 1989. s–a. EN. 572

University of Illinois at Chicago, College of Architecture, Art & Urban Planning, School of Art & Design, Box 4348, Chicago, IL 60680. Ann Lee Morgan, Editor.

Subscription: $20 individual, $36 institution, $15 student and retired North America; elsewhere + $5 surface, + $14 air. Illus. b&w, photos. 7 x 10, 96p.

Modern Art.

Specialized scholarly and critical publication devoted to the visual arts of the 20th Century. Covers history, criticism and theory with interdisciplinary attention given to social, political and philosophical dimensions of art–making and art–reading. Reviews: book.

Advertising. Bonnie Osborne, Ad. Director.

UMBRELLA. 1978. irreg, at least 2/yr. EN. 573

Umbrella Associates, P.O. Box 3692, Glendale, CA 91201. Phone 818–797–0514. Judith A. Hoffberg, Editor.

Subscription: US $15 individuals, $25 institutions; Canada & foreign individuals $20, institutions $30. Sample $5. Back issues, price varies. Illus. b&w, photos. 8½ x 11, 24p., printed offset on light blue paper.

ISSN: 0160–0699. OCLC: 3611863. Dewey: 700.

General. Artists' Books. Photography.

Newsletter which focuses on artists' publications and twentieth century art documentation including books by artists as well as artists' periodicals. Also focuses on photography books since they lend themselves so well to the art of the book. Occasionally presents profiles of publishers/artists who make book works which are outstanding or interviews of an artist who has made a significant contribution to the field of artists' books. "We enjoy emphasizing the alternative media, such as copy art, mail art, rubberstamps, etc.".

Reviews: exhibition 30–40, length short; book 80–100, length 2 paragraphs; journal 10–15, length 1 paragraph. Interviews: occasionally with book artists. Listings: national–international. Calendar of events. Exhibition information for contemporary art and book arts. Freelance work: none. Opportunities: study, courses; competitions, mail art, book art. Reviewed: *Library Journal* 112:10, June 1, 1987, p.92.

Advertising: (camera ready copy only) full page $225, ½ page $150, ¼ page $75. Classified: (prepaid) 35¢/wd., min. $5; artists only 25¢/wd. No agency discount. Mailing lists: none. Circulation: 450. Audience: contemporary art collectors, book artists, museums, libraries, artists.

VARIANT: A Magazine for New Art and Ideas. EN. 574

76 Carlisle St., Glasgow G21 1EF, Scotland. Phone 041–558–1877. Malcolm Dickson, Editor.

Microform available from UMI. Illus. b&w. A4, 62p.

ISSN: 0954–8815.

Also available is *Variant Video*, The Magnetic Magazine, A magazine on video tape produced as a compliment to *Variant* and available through the issue in limited edition only. VHS available only for domestic use, U–matic copies available for institutions.

Reviews: review.

VIDEO AND THE ARTS. 1980. q. EN. 575

Video and the Arts, 650 Missouri St., San Francisco, CA 94107. Phone 514–282–0205. Steven Agetstein, Editor.

Subscription: $10 individual, $18 institution. Illus. 8 x 11, 72p.

ISSN: 0276–0835. OCLC: 13369795. LC: PN1992.8.V5 V53. Formerly: *SEND; Video 80.*

Devoted to video art.

Indexed: ArtBibMod.

Advertising: Anthony Luzi, Ad. Director.

VIDEOZINE. 1977. irreg. EN. 576

Contemporary Arts Press, Box 3123, San Francisco, CA 94119. Phone 415–431–7672.

Dewey: 700.

Videotape.

VIETNAM VETERANS ARTS GROUP—NEWSLETTER TO ARTISTS. bi–m. EN. 577
Vietnam Veterans Arts Group, c/o John S. Rainey, Charitable Trust for Vietnam War Artists, 30 Patewood Dr., Suite 165, Greenville, SC 29615. Phone 803–288–9898, fax 803–288–6167.
Art created by artists who served at least one tour of combat duty in Vietnam reflecting their war experience. Presents details of the touring collections of their art works and information regarding each museum on the tour.Contains reviews of both the art and the artists.

VIEW. 1978. q. EN. 578
Point Publications, 1555 San Pablo Ave., Oakland, CA 94612. Phone 415–835–5104. Robin White, Editor.
Subscription: $15. Illus. 7 x 9, 24p.
ISSN: 0163–9706. OCLC: 4544851. Dewey: 080.
Each issue consists of an interview with an individual artist.
Advertising: none. Circulation: 600.

WOLKENKRATZER ART JOURNAL. 1983. bi–m. GE. EN summaries. 579
Soukup, Krauss Verlag GmbH, Friedrichstr. 45, D–6000 Frankfurt, W. Germany. Phone 069–720237. Roman Soukup & Lothar Krauss, Editors.
Subscription: DM 60. Illus. b&w, some color.
ISSN: 0176–2834. OCLC: 18459982. LC: NX3.W64. Dewey: 700.
Architecture. Modern Art. Photography.

Presents contemporary and avant–garde arts.
Listings: international. Exhibition information. Indexed: ArtBibCur. ArtBibMod. Reviewed: Katz.
Advertising.

XEROLAGE. EN. 580
Xexoxial Editions, 1341 Williamson St., Madison, WI 53703. Miekal And, Editor.
Subscription: $10/4 issues. Back issues $2.50. Illus. b&w. 8½ x 11, 24p.
Devoted to visual poetry, copy art and collage graphics, each issue presents the work of one artist. "Xerolage" is a word coined by Miekel to suggest the new world of 8½ x 11 art propagated by xerox technology. The mimeo of the 80's. The primary investigation of this magazine is how collage techniques of 20th century art, Visual & Concrete Poetry movements and the art of xerox have been combined.

ZYGOS. See no. 252.

Education

3-D EDUCATION: The Journal of the Education Institute of Design, Craft and Technology.
1988. q. EN. 581
Educational Institute of Design, Craft & Technology, 52 Locarno Ave., Gillingham, Kent ME8 6ES, England. Phone 0533 640083. Peter E. Dawson, Editor.
Subscription: £14.50 (c/o Colin Grimes, 852 Melton Road, Thurmaston, Leicester LE4 8BN). Illus.
ISSN: 0943–612x. OCLC: 18974089. LC: TT153.7.T48. Dewey: 371.3. Formerly: *Designing and Making; Practical Education; Practical Education and School Crafts.*
First began publication in 1901.
Reviews: book.
Advertising.

ACTA NEWS. See no. 1189.

AMERICAN ARTIST. See no. 119.

ART & CRAFT DESIGN TECHNOLOGY. See no. 1193.

ART + MAN. 1970. m/school yr. EN. 582
Scholastic Inc., 730 Broadway, New York, NY 10003. Phone 212–505–3000. Margaret Howlett, Editor.
Subscription: $11.50, $5.95/student for orders over 9 (includes separate teacher's edition). Microform available from UMI.
Sample. Limited back issues. Illus. color. Index. 8½ x 11, 16p.
ISSN: 0004–3052. OCLC: 1514262. Formerly: *Artist, Jr.*
Art Education. Art History. Juvenile. Modern Art.

Published under the direction of the National Gallery of Art for grades 7–12. Purpose is to introduce students to fine art through art history lessons and projects. Accompanied by separately paged teachers' edition.
Bibliographies: short, contained in last page of teaching guide. Biographies: of great artists. Interviews: student artists. Freelance work: none. Reviewed: Katz. Katz. *School.*
Advertising: none. Circulation: 200,000 student copies. Audience: 6–12 grades.

ART EDUCATION (Canada). 1972. q. EN. 583
Saskatchewan Society for Education Through Art, P.O. Box 1108, Saskatoon, Sask. S7K 3N3, Canada. Phone 309–975–0800.
Subscription: membership, $C14 Canada, others $C20. Illus.
ISSN: 0708–5354. LC: N365. Dewey: 707. Formerly: *Discovery Through Art.*
Art Education.

The Journal of the Society.

ART EDUCATION (U.S.). 1948. bi–m. EN. 584
National Art Education Association, 1916 Association Dr., Reston, VA 22091. Phone 703–860–8000. Dr. Jerome J. Hausman, Editor (1501 Hinman Ave., Apt. 7A, Evanston, IL 60201).
Subscription: included in membership together with newsletter, *NAEA News*, non–members $50 US, $55 Canada & foreign air. Microform available from UMI. No sample. Back issues $9 each. Illus. 8¼ x 10⅞, 56p. offset process.
ISSN: 0004–3125. OCLC: 1514275. LC: N81.A86. Incorporates: *Art Teacher.*
Art Education.

Articles on innovative art curricula and teaching strategies at any specific instructional level, from preschool through high school and college/university. Topics include art curriculum, instructional methods, resources, innovative programs and approaches, and exemplary teaching. The March issue focus is on the NAEA National Convention.
Bibliographies with specific articles only. Calendar of events. Freelance work: none. Opportunities: study – summer art programs, summer study abroad, and degree programs in studio art, art education, art history, art therapy, and arts management appear in display ads. Indexed: BioI. CIJE. EdI. Reviewed: Katz. Katz. *School.*
Advertising: full page $625, ½ page $445, covers $710, 2 color + $150, 4 color + $400. No classified. Bleed + 10%. Frequency discount. 15% agency discount. 2% cash discount. Beverly Jeanne Davis, Ad. Director. Mailing lists: available. Demographics: art teachers, supervisors and administrators at elementary, secondary and university levels; libraries, museums, and schools in all 50 states, Canada, foreign countries. Circulation: 15,000. Audience: educators in the visual arts.

ART JOURNAL. 1941. q. EN. 585
College Art Association of America, 275 Seventh Ave., 5th Fl., New York, NY 10001–6708. Phone 212–691–1051. Eve Sinaiko, Editor.
Subscription: included in membership, $30 non–members US, foreign + $6. Microform available from UMI. No sample.
Back issues $5–7. Illus. b&w, photos. 8¼ x 10¾, 96p.
ISSN: 0004–3249. OCLC: 1514294. LC: N81.A887. Dewey: 705. Formerly: *College Art Journal.*
Architecture. Art Education. Art History. Modern Art.

Scholarly articles and reviews on modern art and contemporary issues. Each issue organized thematically under the editorial direction of a designated guest editor.
Reviews: exhibition 2 & book 2, length 2–3p. each. Freelance work: yes. Indexed: ArtArTeAb. ArtBibCur. ArtBibMod. ArtHum. ArtI. BHA. BkReI. CloTAI. CurCont. Des&ApAI. HumI. IBkReHum. RILA.
Advertising: (rate card Nov '88): full page $550, ½ page $325, ¼ page $185, covers $625–$725, no color. No classified. 10% frequency discount. 15% agency discount. Jeffrey Larris, Ad. Director. For gallery ads: Elizabeth Morina (50 Lexington Ave., 9E, New York, NY 10010, phone 212–979–2013). Circulation: 12,000.

ART LINE (Canada). 1980. 3/yr. EN. 586
New Brunswick Teachers' Association, Arts Education Council, P.O. Box 752, Fredericton, N.B. E3B 5R6, Canada.
Illus.

ISSN: 0711–1312. OCLC: 9086758. LC: N365. Dewey: 707. Formerly: *Pipeline (New Brunswick Teachers' Association. Art Education Council).*
Art Education.

ART STUDENTS LEAGUE NEWS. 1948. q. EN. 587

Art Students League of New York, 215 W. 57th St., New York, NY 10019. Phone 212–247–4510. Lawrence Campbell, Editor.
Subscription: free to members and other interested persons. Illus. b&w, photos. 11 x 14, 6p.
OCLC: 13677144.
Architecture. Art Education. Art History. Crafts. Drawing. Graphic Arts. International. Landscape Architecture. Modern Art. Painting. Sculpture.

News of the League, its members and current students, instructors, past and present, other artists associated with League. On occasion other information of interest to artists.
Reviews: book 2. Interviews: occasionally with people associated with League. Obits. Listings: international. Exhibitions listed in supplements. Freelance work: none.
Advertising: none. Circulation: 7,000. Audience: students and members of League, libraries, critics, college art departments, museums.

ARTS. 1950. a. EN. 588

University Sydney, Arts Association, c/o G. Little, English Dept., Sydney, N.S.W., Australia. Phone 02–692–2656. Geoffrey Little, Editor.
Subscription: included in membership, $A5 individuals, $A10 institutions. Sample. Back issues. Illus. b&w, photos. 21.5 x 15cm., 90p.
ISSN: 0066–8095. OCLC: 6084820. LC: AS711.A79. Dewey: 300.
Archaeology. Art History. Historic Preservation.

The journal of the Sydney University Arts Association.
Reviews: book occasionally. Bibliographies with articles. Biographies & interviews occasionally. Freelance work: none.
Advertising: none. Audience: graduates, faculty, general.

ARTS ACTION. 1978. 2–3/yr. EN. 589

Canadian Conference of the Arts, 189 Laurier Ave. E,, Ottawa, Ontario, Canada K1N 6P1. Phone 613–238–3561, fax 235–238–4849. C C A Task Force on the Arts and Education.
Subscription: free. Illus. b&w.
ISSN: 0709–6046. OCLC: 5696705. LC: NX180. Dewey: 700. Formerly: *Arts in Action.*
Newsletter of the Council's Task Force on Arts and Education.

ARTS AND ACTIVITIES. 1955. 10/yr. EN. 590

Publishers Development Corp., 591 Camino de la Reina, Suite 200, San Diego, CA 92108. Phone 619–297–8520. Leven Leatherbury, Editor.
Microform available from UMI, B&H. Illus. Index.
ISSN: 0004–3931. OCLC: 1514367. LC: L11.A79. Formerly: *Junior Arts and Activities.*
Art Education.

The teacher's arts and crafts guide containing creative activities for the classroom.
Indexed: BioI. CloTAI. EdI. Reviewed: Katz.
Advertising.

ARTS COUNCIL OF GREAT BRITAIN. EDUCATION BULLETIN. 1979. 3/yr. EN. 591

Arts Council of Great Britain, 105 Piccadilly, London W1V 0AU, England. Phone 071 6299495.
Illus.
ISSN: 0143–4519.
Art Education.

ARTS, THE JOURNAL OF THE SYDNEY UNIVERSITY ARTS ASSOCIATION.
1958. irreg. EN. 592

University of Sydney, Arts Association, Sydney, N.S.W., Australia. Phone 02–692–2656. Geoffrey Little, Editor.
ISSN: 0066–8095. OCLC: 6084820. LC: AS711.A79. Dewey: 300.
The journal contains inaugural lectures, special lectures, and occasional papers of the graduates and faculty.

ARTWORKS. 1978. s–a. EN. 593

Waverley–Woollahra Arts Centre Co–op Ltd., 138 Bondi Rd., Bondi, N.S.W. 2026, Australia. Sabena Winston & Barbara Wade, Editors.
Subscription: $A4. Back issues.
Advertising.

AUSTRALIAN ART EDUCATION. 1977. 3/yr. EN. 594

Australian Institute of Art Education, City Art Institute, P.O. Box 259, Paddington, N.S.W. 2021, Australia. Phone 02–3399555. Dr. Graeme Sullivan, Editor.
Subscription: included in membership, $A35 (Christopher Shelton, Business Manager, Doncaster High, Church Road, Doncaster VIC 3108). Limited back issues $7.50/issue. Illus. occasionally, b&w, photos. A4, 48p.
ISSN: 1032–1942. Formerly: *Journal of the Institute of Art Education.*

Art Education.

Devoted to the scholarly examination of issues in the field of art education both in Australia and overseas. "Commentary Section" contains debate on issues and previous articles.
Reviews: book 6–7, length 250–500/wds. Listings: national. Freelance work: Manuscripts are welcome which deal with significant problems in the field and contributions from people working in areas other than art education are invited. The journal is interested in philosophical and historical material as well as research studies. Papers dealing with the development of new theoretical approaches to the understanding of issues in art education are especially welcome. Indexed: ArtBibMod. Australian Education Index.
Advertising: none. Circulation: 500.

AUSTRALIAN JOURNAL OF ART. 1979. a. EN. 595

Art Association of Australia, c/o Art History Department, University of Queensland, St. Lucia, Brisbane, Qld. 4067, Australia. Margaret Plant, Editor (Dept. of Visual Arts, Monash University, Clayton, Victoria).
Subscription: $A15. Illus. b&w. A4, 115p.
ISSN: 0314–6464. OCLC: 5037582. LC: N7400 .A816. Dewey: 705.

Archaeology. Art History.

Art history and theory as taught in Australia (not just Australian studies). Overseas contributions are welcomed.
Freelance work: none. Indexed: ArtBibMod. RILA.
Advertising: full page $A150, ½ page $A100, ¼ page $A75. No frequency discount. Nancy Underhill, Ad. Director. Mailing lists: none. Circulation: 600. Audience: tertiary academics.

BRITISH COLUMBIA ART TEACHERS' ASSOCIATION JOURNAL. 1960. irreg. EN. 596

B.C. Teachers' Federation, 2235 Burrard St., Vancouver, B. C. V6J 3H9, Canada. Phone 604–731–8121.
Illus.
ISSN: 0316–1544. LC: N365. Dewey: 707. Formerly: *British Columbia Art Teachers' Association. Newsletter.*

Art Education.

Each issue also has a distinctive title.

CAA NEWS. 1976. bi–m. EN. 597

College Art Association of America, 275 Seventh Ave., New York, NY 10001. Phone 212–691–1051. Nancy Boxenbaum, Editor.
Subscription: included in membership. Illus. b&w, photos. 8½ x 11, 16–20p.
OCLC: 21009074. LC: N345.C685. Dewey: 706.273. Formerly: *CAA Newsletter.*

Art Education.

Newsletter of the Association contains brief article, people in the news, programs, letters, Association conference information with a call for papers and a listing of solo shows by artist members.
Obits. Listings: national. Calendar of events, listing of solo shows. Opportunities: employment positions listed, competitions, grants, fellowships, residencies, awards, honors.
Advertising: Classified only: professional or semi–professional nature, members 75¢/wd., non–members $1.25, $15 min.

CANADIAN REVIEW OF ART EDUCATION RESEARCH. 1977. s–a. EN & FR. 598

Canadian Society for Education Through Art, 3186 Newbound Court, Malton, Ontario L4T 1R9, Canada.
Subscription: included in membership together with the *Newsletter* and *Journal*, $C55 Canada, $US45 US. Some back issues.
Illus b&w, photos, cartoons. 100p.

ISSN: 0706–8107. OCLC: 4433000, 4433007. Dewey: 707. Formed by the union of: *Investigart* and, *Canadian Society for Education through Art. Research.*

Art Education. Museology.

Presents reviews and reports on speculative or empirical matters of a scholarly nature in art education. Devoted to promoting ·visual art education. Abstracts included, some translations.

Reviews: 3–5 reviews. Interviews. Biographies. Listings: regional–international.

Advertising: Inserts. Mailing lists: none. Demographics: national organization with membership representing all levels of education: elementary, secondary, ministries of education, continuing education, and galleries. Circulation: 600. Audience: art educators, from the primary school teacher to the university art professor, gallery educators.

CENTER: Research Reports and Records of Activities. 1981. a. EN. 599

National Gallery of Art, Center for Advanced Study in the Visual Arts, Washington, DC 20565. Phone 202–842–6480. Center for Advanced Study in the Visual Arts.

Few small illus., b&w photos. 7 x 9, 100p.

ISSN: 0737–7010. OCLC: 9075136. LC: N330.W3 C457a. Dewey: 707. Formerly: *Research Reports, History of Art.*

Art Education.

Annual report presents a record of the academic year and the research reports of members. The research reports concern work accomplished by fellows of the Center for Advanced Study in the Visual Arts in residence during the year. Each issue includes a list of the center's meetings and members.

Indexed: ArtBibMod. GrArtLAb.

DESIGN & TECHNOLOGY TEACHING. 1978. 3/yr. EN. 600

Trentham Books Ltd., 151 Etruria Rd., Hanley Stoke–on–Trent, Staffs. ST1 5NS, England. Phone 0782–274227, fax 0782–281757. John Eggleston, Editor (Dept. of Education, University of Warwick, Coventry CV4 7AL, phone 0203 523848).

Subscription: £15 UK, £18 US & Canada, air rates on request. Microform available from UMI. Back issues £5. Illus. A4, 64p.

OCLC: 23814545. LC: NK1160.S78. Formerly: *Design Technology Teaching; Studies in Design, Education Craft & Technology.*

Art Education. Crafts.

The journal focuses attention on developments in the whole field of design and technological education ranging from art through the crafts to applied science and technology. It pays particular attention to case studies of new approaches in schools and colleges written by the teachers and tutors undertaking them.

Freelance work: Contributions are welcome but prospective contributors are invited to send a synopsis of their contribution for discussion before completion of the final manuscript. Contact: editor.

Advertising: full page £220, ½ page £110, ¼ page £55, color + 50%. Frequency discount. Bernard Hubbard, Ad. Director (Public Relations & Marketing Ltd., 3 Wolsey Terrace, Cheltenham, Glos. GL5O 1TH, phone 0242 510760, fax 0242 516259). Audience: educators.

DESIGN FOR ARTS IN EDUCATION. 1977. bi–m. EN. 601

Heldref Publications, 4000 Albemarle St., N.W., Washington, DC 20016. Phone 202–362–6445. Sheila Barrows, Managing Editor.

Subscription: $20 individuals, $37 institutions US, + $7 outside US. Microform available from UMI. Sample $6.25. Back issues. Illus. Index in July/Aug issue. 8¼ x 10¾, 48p, saddle stitch.

ISSN: 0732–0973. OCLC: 5004435. LC: NK1160.D4. Formerly: *Design.*

Art Education. Crafts.

The purpose is to discuss major policy issues concerning K–12 education in the various arts. The journal's editorial philosophy is committed to the presentation of a broad range of policy views and questions of concern to the arts education field. It attempts to focus on analysis as a means for finding solutions to problems in the field. It is intended to be a journal of ideas, a forum for debate. It seeks to broaden and deepen perspective. In addition, *Design* seeks to probe a wide variety of issues with direct relationship to specific instruction in the various arts and to explore the context in which that instruction takes place. Aims to develop a holistic view of each question it considers. The journal is particularly directed toward those individuals who have professional or oversight responsibilities concerning the delivery of K–12 arts education.

Reviews: book 1, length 1½p. Freelance work: yes. Contact: editor. Articles must focus on or be related to policy analysis. Such analysis may be applied to the past, the present, or the future, and should lead to recommendations for solutions. Although articles may be based on scholarship, the text must be understandable and helpful to those working in arts education who are not necessarily scholars themselves. Articles may also deal with the presentation of ideas and the reportage of events illustrating those ideas. Texts, however, must avoid blatant promotion of methods, institutions, or personalities. *Design* seeks to enrich the American tradition of a sophisticated policy analysis by maintaining an elegantly provocative style. It is important that articles challenge readers to test their beliefs and assumptions, but this should be done in a way that enhances the

reader's pleasure by the skillful use of language. Indexed: CIJE. CloTAI. Educational Administration Abstracts. RG. Reviewed: Katz.

Advertising: full page $300, ½ page $175, ⅙ page $115, no color. Frequency discount. 15% agency discount. No classified. Mary E. McGann, Ad. Director. Mailing lists: available. Circulation: 3000. Audience: teachers, college professors, academic administrators, government agencies, policy makers.

ESTETICKA VYCHOVA. 1970. 10/yr. CZ or SL. EN, FR, GE & RU summaries. 602

Statni Pedagogicke Nakladatelstvi, Ostrovni 30, 113 01 Prague 1, Czechoslovakia. (Dist.: PNS, Ustredni Expedice a Dovoz Tisku Praha, Zavod 01, Administrace Vyvozu Tisku, Kovpakova 26, 160 00 Prague 6). Frantisek Sedlak, Editor.
Illus.
ISSN: 0014–1283.

FINE ARTS FOCUS. 1989. 3–4/yr. EN. 603

University of Florida, College of Fine Arts, Gainesville, Florida 32611. Phone 392–0207. Susan Marynowski, Editor.
Subscription: free. Sample. No back issues. Illus b&w, photos. 8½ x 11, 8–12p.
Art Education. Art History. Ceramics. Drawing. Graphic Arts. Modern Art. Painting. Photography. Sculpture.

Feature articles on college activities, arts topics, visiting artists, etc. Presents faculty news of grants, commissions, hires, retirements, accomplishments, etc. Includes faculty profiles; alumni news, recognition, support, etc.; and student accomplishments recognition. Also covers both the Dept. of Music and the Dept. of Theatre and all attendant areas.
Interviews: focus on faculty profiles and visiting artist profiles. Listings: regional. Calendar of events. Exhibition information. Freelance work: none. Opportunities: study.
Advertising: none. Audience: faculty, students, alumni, colleagues.

GUILDNOTES. 1937. bi–m. EN. 604

National Guild of Community Schools of the Arts, Inc., 40 North Van Brunt St., Box 8018, Englewood, NJ 07631–8018. Phone 201–871–3337. Lolita Mayadas, Editor.
Subscription: included in membership together with *Employment Opportunities*, $50 individual, $100 business affiliate, $60 service, $35 foreign. Sample free. No back issues. No illus. 8½ x 11, 6p. including insert.
Dewey: 790. Formerly: *The Quarterly of the National Guild of Community Music Schools.*
Art Education. Education.

Newsletter of the Guild. Provides informational items for administration, faculty and board members of community schools of the arts. Information on conferences and meetings; news from national, state, and local agencies and funding sources; news of chapter activities; announcements of publications, films and recordings. Also includes an insert (usually a monograph on a topical subject or a successful project/program).
Listings: regional–international. Freelance work: occasionally. Contact: editor. Opportunities: study, competitions.
Advertising: none. Mailing lists: Membership Directory free to members, $10 non–members; mailing labels of institutional members free to full institutional and individual business affiliation members, $6 all other members, $10 non–members. Circulation: 750. Audience: community arts school administrators.

**GUNMA DAIGAKU KYOIKU GAKUBU KIYO. GEITJUTSU GIJUTSU TAIIKU
 SEIKATSUKAGAKUHEN.** 1981. a. JA & EN. EN summaries. 605

Gunma University, Faculty of Education, Gunma University Library, 4–2. Aramaki, Maebashi, Gunma 371, Japan.
Subscription: available on exchange. Illus.
ISSN: 0533–6627. OCLC: 9938035.
Annual report of the Faculty of Education. Art, technology, health & physical education, and science of human living series.

IAA CATALOG. 1962. a. EN. 606

Interlochen Center for the Arts, Interlochen, MI 49643. Phone 616–276–9221. Rosalyn Ridgway.

INTERACTA. 1971. q. EN. 607

Art Craft Teachers Association of Victoria, Box 121, Parkville, Victoria 3052, Australia. Phone 03 329 2625. Adrian Montana, Editor.
Subscription: included in membership, $A35 Australia, foreign $A45, air $A55. Sample $US10. Limited back issues $US5. Illus. b&w, photos, cartoons. A4, 40p.
ISSN: 0519–9135. Dewey: 707. Formerly: *ACTA Magazine; Art Teachers Association of Victoria. Journal.*
General.

Regular updated information on innovative curriculum for the arts in schools; technological information; reviews, gallery events; essays on fine art–dance–music–crafts media; interviews with artists/arts educators; health and safety information with arts environments and materials. Seeks to keep arts educators in the primary, secondary and tertiary sectors informed on innovative curriculum developments in relation to Frameworks and the VCE. The arts umbrella encompasses work of practising artists, a regular focus on schools, the contribution of the work of galleries and regular contributions from VCE study writers.

Reviews: exhibition 2, length 1000–2000 wds.; book 2, length 1000–1200 wds.; equipment 500–800 wds. Bibliographies: regularly, book listings Interviews: with practising artists and arts educators. Listings: national. Calendar of events. Exhibition information. Freelance work: yes. Contact: editor. Opportunities: study – regular workshops held by ACTA & yearly conference in Sept.

Advertising: full page $A480, ½ page $A240, ¼ page $A120, no color. No classified. Frequency discount. Michael Nichols, Ad. Director. Mailing lists: none. Demographics: art suppliers/exhibition notices. Circulation: 900. Audience: art/craft educators, all levels and type of school or college.

INTERNATIONAL COUNCIL OF FINE ARTS DEANS NEWSLETTER. q. EN. 608

International Council of Fine Arts Deans, P.O. Box 1772, San Marcos, TX 78667. Phone 512–245–2651.
Serves as an exchange of ideas, information and techniques.
Audience: deans of university fine arts schools.

THE JOURNAL - (CSEA). 1988, v.19. s–a. EN & FR. 609

Canadian Society for Education Through Art, 3186 Newbound Court, Malton, Ontario L4T 1R9, Canada.
Subscription: included in membership together with *Canadian Review of Art Education Research* and *Newsletter*, $C55, $US45. Some back issues. Illus. photos, cartoons. 80p.
OCLC: 22715623. LC: N81.C3602. Dewey: 707. Formerly: *CSEA Journal; Annual Journal.*
Art Education.

Presents the current thinking and action in Canadian art education in the areas of curriculum, methodology, policy, and other matters in art education.
Reviews: 3–5 reviews each issue. Freelance work: yes. Contact: editor.
Advertising: Inserts. Mailing lists: none. Circulation: 600. Audience: art educators.

THE JOURNAL OF AESTHETIC EDUCATION. 1966. q. EN. 610

University of Illinois Press, 54 E. Gregory Dr., Champaign, IL 61820. Phone 217–333–0950. Ralph A. Smith, Editor.
Subscription: $18 individual, $30 institution. Microform available from JAE, UMI. Illus. Index.
ISSN: 0021–8510. OCLC: 1754415. LC: N1.J58. Dewey: 701.1707.
Education.

Reviews: book. Indexed: ArtBibMod. ArtHum. ArtI. BioI. BkReI. CIJE. CurCont. EdI. IBkReHum. PsyAb.
Advertising.

JOURNAL OF ART & DESIGN EDUCATION. 1982. 3/yr. EN. 611

Carfax Publishing Co., P.O. Box 25, Abingdon, Oxfordshire OX14 3UE, England. Dr. Stuart Macdonald, Editor.
Illus.
ISSN: 0260–9991. OCLC: 8415688. LC: N81.J68. Dewey: 707.
Art Education.

Publication of the National Society for Education in Art and Design whose aim is to strengthen the role of the arts in general education and promote high standards in art education.
Indexed: ArtBibMod. ArtHum. CIJE. CloTAI. CurCont. Des&ApAI. RILA.

JOURNAL OF PLANNING EDUCATION AND RESEARCH. 1981. 3/yr. EN. 612

Association of Collegiate Schools of Planning, University of Illinois, 907½ W. Nevada, Urbana, IL 61801. Phone 217–333–3890. Lew Hopkins & Gill–Chin Lim, Editors.
Subscription: included in membership, $30 library, $12 individual, $7 student, US; foreign + $4.50 postage. Sample & back issues $6. Illus. b&w. Cum. index every 3 yrs. 8½ x 11, 70p.
ISSN: 0739–456X. OCLC: 8399085. LC: HT392.J68. Dewey: 361.6.
General. Architecture. Historic Preservation. International Planning. Landscape Architecture. Housing.

A refereed journal which is a forum for planning educators and scholars to present new results from pedagogy and research that will advance the discipline and improve professional practice. Unique to the *Journal* is the reviews of other journals.

Reviews: book 5, length 1½p.; journal 1, length 3p. Freelance work: none.

Advertising: full page $250, ½ page $150, ¼ page $100, no color. No classified. No frequency discount. Lew Hopkins, Ad. Director. Mailing lists: available with limitations. Circulation: 1000. Audience: planners, planning educators, public managers.

MIXED MEDIA. 1977. q. EN.

613

Maine Art Education Association, Box 10463, Portland, ME 04104. Phone 207–563–8349. Diane Noble, Editor.

Subscription: free. 8½ x 11, 8p.

Art Education.

Information on art education includes news, contact between teachers, events, and opportunities of interest to Maine teachers. Advertising. Tony Tyler–Millar, Ad. Director. Circulation: 900.

NAEA NEWS. 1958. bi–m. EN.

614

National Art Education Association, 1916 Association Dr., Reston, VA 22091. Phone 703–860–8000. Beverly Jeanne Davis, Editor.

Subscription: through membership in NAEA only, $50. No sample. Some back issues, $3 to non–members. Illus. b&w, photos. 15 x 11½, 24p.

ISSN: 0160–6395. OCLC: 1955811. LC: N81.N32. Dewey: 700; 370. Formerly: *National Art Education Association Newsletter*.

Art Education.

Newsletter focuses on education in the visual arts at all instructional levels. News concerns the Association, its programs, convention, aims, and news, plus news events of national concern in the visual art education field. Regional and state association events and programs, and regular columns by Association Board members responsible for regions and instructional levels; affiliate groups research, reports, and data on art education; as well as news developments in the field of education that affect art education are reported. An affiliate of the National Education Association.

Reviews: book 4–5, length 125 wds. Freelance work: none. Opportunities: employment listings in art education. study, only those sponsored by the Association.

Advertising: full page $350, ½ page $225, ¼ page $125, no color. Classified: $60/10 lines, $30 members. Frequency discount. 15% agency discount. 2% cash discount. Mailing lists: available for sale. Demographics: all 50 states, 150 Canada, 350 foreign. Circulation: 15,000. Audience: members: educators in the visual arts, elementary, secondary, college/university levels.

NEWSLETTER - CANADIAN SOCIETY FOR EDUCATION THROUGH ART.

1957. q. EN. Includes some text in FR.

615

Canadian Society for Education Through Art, 3186 Newbound Court, Malton, Ontario L4T 1R9, Canada.

Subscription: included in membership together with *Canadian Review of Art Education Research* and *The Journal*, $C55, $US45. Some back issues. Illus. photos, cartoons. 35p.

ISSN: 0045–5369. OCLC: 1914972. LC: N81. Dewey: 707.

Art Education. Museology.

Current information pertaining to resources, methods, and curriculum development in art education. Contains items that report on the activities of the Society as well as its affiliates across Canada.

Reviews: 3–5 reviews each issue. Interviews. Biographies. Listings: regional–international. Freelance work: yes. Contact: editor. Opportunities: employment, study, competitions.

Advertising: Inserts. Mailing lists: none. Demographics: memberships represents all levels of education: elementary, secondary, ministries of education, continuing education, and galleries. Circulation: 600. Audience: art educators, from primary school teachers to university art professors, gallery educators.

PACIFIC ARTS NEWSLETTER. 1975. s–a. EN.

616

Pacific Arts Association, Honolulu Academy of Arts, 900 S. Beretania St., Honolulu, HI 96814. Phone 808–538–3693. Philip J.C. Dark, Editor (Upper Castle Road, St. Mawes, Cornwall, TR2 5BZ, UK).

Subscription: included in membership, $20 professional, $10 adjunct. Illus. b&w. Cum. index to nos.1–20 in no.20. 8½ x 11, 40p.

ISSN: 0111–5774. OCLC: 8463121. LC: N7410.P33. Dewey: 700.

General. Archaeology. Art Education. Art History. Crafts. Decorative Arts. Films. Museology. Photography. Ethnic Arts.

Presents information on recent developments in the practice or teaching of Pacific Island art.

Reviews: exhibition 2 & book 3, length 2p. Bibliographies: in each issue on Museum publications and general bibliographies on art publications, culture ethnic art, etc. Listings: international. Exhibition information. Opportunities: study. Indexed: ArtBibMod.

Advertising: none. Circulation: 300. Audience: Pacific scholars, writers, artists, museums.

PEN AND INK. 1985. irreg. EN. 617

British Columbia Art Teachers' Association, c/o Mrs. J. Lymburner, No.111–4800 Arbutus St., Vancouver, B.C. V6J 4A5 Canada.
Illus.
ISSN: 0833–9414. OCLC: 15876403. LC: N81. Dewey: 707. Formerly: *BCATA Newsletter*.
Art Education.

The newsletter of the British Columbia Art Teachers' Association.

THE PRINCETON JOURNAL. See no. 2242.

RESOURCE, THE NEWSLETTER FOR GRADUATE ART HISTORIANS. See no. 108.

SCHOOL ARTS. 1901. 9/yr. (Sept–May). EN. 618

Davis Publications, Inc., 50 Portland St., Printers Bldg., Worcester, MA 01608. Phone 508–754–7201. Kent Anderson, Editor.
Subscription: $20 US, $25 Canada & foreign. Microform available from Access Corp., UMI, B&H. Sample. Back issues $3.
Illus. 8½ x 11.
ISSN: 0036–6463. OCLC: 5457273. LC: N81.S4. Dewey: 707. Formerly: *School Arts Magazine*.
Art Education. Art History. Ceramics. Crafts. Drawing. Films. Modern Art. Painting. Photography. Sculpture.

"The art education magazine for teachers" contains feature articles and includes an annual Buyers' Guide for supplies.
Reviews: book, film. Indexed: BioI. BkReI. CIJE. EdI. CloTAI. Reviewed: Katz. Katz. *School*.
Advertising: (rate card Sept '88): full page $1290, ½ page $822, ¼ page $498, color + $250, 4 color + $600. Frequency discount. 15% agency discount. No classified. Preferred position rates on request. Inserts. Bleed no charge. Frank L. Andrews, Ad. Director (phone 800–533–2847). Demographics: international circulation to art educators and administrators, all levels, public, private and parochial, museums. Circulation: 20,000. Audience: art educators.

SHEFFIELD CITY PRESS. 1982. fortn. EN. 619

Sheffield City Press, Sheffield City Polytechnic, Pond St., Sheffield S1 1WB, England. Phone 0742 737692. Neil Frazer, Editor.
Subscription: free.
An alumni magazine of the Sheffield City Polytechnic.
Advertising.

SKETCH BOARD. 1937. a. EN. 620

Kappa Pi International, 9321 Paul Adrian Dr., Crestwood, MO 63126. Arthur Kennon, Editor.
Subscription: $10.
Dewey: 700.
Published by a national honorary art fraternity for men and women.

SOUTHEASTERN COLLEGE ART CONFERENCE REVIEW. 1973. s–a. EN. 621

Southeastern College Art Conference (SECAC), Department of Art, Memphis State University, TN 38152. Phone 901–454–2216. James R. Ramsey, Editor.
Illus. 8½ x 11, 80p.
OCLC: 2081082. LC: N1.S68. Dewey: 700. Formerly: *Southeastern College Art Review and Newsletter*.
Art Education. Art History.

International journal of art, art history, and art education topics.
Indexed: RILA.
Advertising: none. Circulation: 500.

STUDIES IN ART EDUCATION: A Journal of Issues and Research in Art Education.

1959. q. EN. 622

National Art Education Association, 1916 Association Dr., Reston, VA 22091. Phone 703–860–8000. Dr. Georgia Collins, Editor (307 Fine Arts Bldg., University of Kentucky, Lexington, KY 40506–0022).

Subscription: included in membership together with *NAEA News*, $25 US, foreign + $5 postage. Microform available from UMI. Illus. b&w. 9 x 6, 64p.

ISSN: 0039–3541. OCLC: 1766713. LC: N81.S84. Dewey: 707.

Art Education.

Research articles and commentaries. Empirical, historical, and philosophical research with implications for art education. Exploration of theoretical and practical aspects of art criticism, artistic growth, curriculum, evaluation, etc. Articles are submitted to blind review.

Reviews: book 2, length 2 pages. Biographies: historical figures in art education. Freelance work: none. Indexed: ArtBibCur. ArtBibMod. CIJE. EdI. IBkReHum. Reviewed: Katz.

Advertising: none. Mailing lists: none. Audience: art educators.

TEXAS ART EDUCATION ASSOCIATION NEWSLETTER. EN. 623

Texas Art Education Association, University of Houston, Houston, TX 77004.

Subscription: included in membership together with *Texas Trends Art Education*, $10 North America.

LC: NX280.T482. Dewey: 707.

Art Education.

TEXAS TRENDS IN ART EDUCATION. 1972. a. EN. 624

Texas Art Education Association, University of Houston, Houston, TX 77004.

Subscription: included in membership together with *Texas Art Education Association Newsletter*, $10 North America. Illus.

ISSN: 0495–3460. OCLC: 4742678. LC: NX280.T482. Dewey: 707.

Art Education.

Official publication of the Association.

UNIVERSITY OF ILLINOIS AT URBANA-CHAMPAIGN. SCHOOL OF ART AND DESIGN. NEWSLETTER. 1951. a. EN. 625

University of Illinois at Urbana–Champaign, Continuing Education and Public Service–Visual Arts, 123 Fine and Applied Arts Bldg., Champaign, IL 61820. Phone 217–333–1000.

Subscription: free. 8½ x 11, 16p.

Dewey: 378. Formerly: *University of Illinois at Urbana–Champaign. Department of Art. Newsletter*.

Recent developments and events at the School of Art & Design of interest to alumni.

Advertising: none.

UNIVERZITA KOMENSKEHO. FILOZOFICKA FAKULTA. ZBORNIK: MUSAICA. 626

1961. irreg. CZ or SL. EN & GE summaries.

Univerzita Komenskeho, Filozoficka Fakulta, Gondova 2, 818 02 Bratislava, Czechoslovakia. Bohuslav Novotny, Editor.

Subscription: exchange.

ISSN: 0083–4130.

Deals with the philosophical aspects regarding art study and teaching.

VIEW FINDER. 1967. 3/yr. EN. 627

British Universities Film and Video Council, 55 Greek St., London W1V 5LR, England. Phone 071–734 3687. Murray Weston, Editor.

Subscription: included in membership, £7.50 surface, £10 air. Sample £2. Back issues. Illus. b&w, photos, cartoons. A4, 20p.

ISSN: 0952–4444. Dewey: 778.5, 371.33. Formerly: *BUFVC Newsletter*.

General. Archaeology. Architecture. Art Education. Art History. Films.

Provides news, comment and reviews on the use of film and television for higher education and research. Covers information on most topics taught in universities.

Reviews: book 1, film 4, equipment 1. Listings: international. Opportunities: study, competitions.

Advertising: full page £220, ½ page £150, ¼ page £100, spot color + £40. frequency discount. Geoffrey O'Brien, Ad. Director. Mailing lists: none. Circulation: 5000.

VISION MAGAZINE. 1964. s–a. EN & TA. 628

College of Architecture and Fine Arts, University of Santo Tomas, Espana St., Manila, Philippines. Phone 731–43–43. Marlon L. Antolin, Editor (101 C–P. Parada St., San Juan, M. Manila).

Subscription: $19. No sample. No back issues. Illus. b&w, color, photos. 8½ x 11, 88p.
ISSN: 0042–692X. OCLC: 2185046.
General.

Produced mainly for the students and faculty of the college it serves as a gallery of the college's masterpieces. Features competition winners, thesis works and the best works from the following Departments: Architecture, Advertising Arts, Interior Design, Industrial Design and Painting. The staff is composed of students and each issue is based on a relevant theme. The magazine also has articles based on the theme, interviews, and commentaries as well as an alumni section.
Biographies: college alumni who excelled in their respective fields. Interviews: with prominent Filipino personalities excelling in the field of architecture, advertising interior design, industrial design and painting. Listings: College only. Freelance work: none.
Advertising: none. Audience: students and faculty of College.

VISUAL ARTS RESEARCH. 1973. s–a. EN. 629
University of Illinois at Urbana–Champaign, 143 Art and Design Bldg., 408 East Peabody Dr., Champaign, IL 61820. Phone 217–333–8952. George Hardiman & Theodore Zernich, Editors.
Subscription: $12 individuals, $20 institutions US; $18 individuals, $26 institutions Canada & foreign. Back issues, $8.50–$10. Illus. b&w. 6 x 8½, 100p.
ISSN: 0736–0770. OCLC: 9069635. LC: N81.R49. Dewey: 707. Formerly: *Review of Research in Visual Arts Education.*
General.

Educational, historical, philosophical and psychological perspectives are presented.
Bibliographies: with articles. Freelance work: none. Indexed: PsyAb. Reviewed: Katz.
Advertising: none. Audience: art, education, philosophy, psychology.

WALTER W.S. COOK ALUMNI LECTURE. 1959. irreg. EN. 630
J. J. Augustin, Inc., Locust Valley, NY 11560. Phone 516–676–1510.
ISSN: 0083–7148. OCLC: 1646465. Dewey: 709.

Religious Art

L'AMICO DELL'ARTE CRISTIANA. 1930. q. 631
Scuola Beato Angelico, 19 Viale S. Gimignano, 20146 Milan, Italy. Phone 418787.
Subscription: L 25000.
ISSN: 0003–1747. Dewey: 704.948.

ART PLUS: Reproducible Resource Christian Communicators. 1986. q. EN. 632
Mission Media, P.O. Box 1149, Orange Park, FL 32067–1149. Phone 904–269–5139. Wayne Hepburn, Editor.
Subscription: $59 US & Canada, $79 foreign. Illus. b&w. 8½ x 11, 26p.
Formerly: *Church Bulletin & Newsletter Resource.*
Contains material and information to aid in the publication of religious bulletins and newsletters. Clip art to use is included.
Circulation: 4,000. Audience: churches, religious organizations and schools.

ARTE CRISTIANA: Rivista Internazionale di Storia dell'Arte e di Arti Liturgiche.
 1913, 1983 ns. bi–m. IT only. 633
Scuola Beato Angelico, Viale S. Gimignano 19, 20146 Milan, Italy. Phone 418762. Dr. Arch. Don Valerio Vigorelli, Editor.
Subscription: L 88000. Illus., color, plates. 6½ x 9½.
ISSN: 0004–3400. OCLC: 1774812. LC: N7810.A8. Dewey: 704.9.
Indexed: ArtArTcAb. ArtBibMod. Avery. BHA. RILA.

BUKKYO GEIJUTSU/ARS BUDDHICA. See no. 659.

CFAS NEWSLETTER. q. EN. 634
Catholic Fine Arts Society, c/o Dr. M.F. Capobianco, 191 Bay 14th St., Brooklyn, NY 11214. Phone 718–837–4598. Sister Loretta Hoag, Editor.

Subscription: free.
Information on the fine arts sponsored by sisters of the Catholic church.
Advertising: none.

CHURCH MONUMENTS. See no. 732.

CHURCHSCAPE. 1981. a. EN.

635

Council for the Care of Churches, 83 London Wall, London EC2M 5NA, England. David Williams, Editor.
Illus.
ISSN: 0262–4966.
Architecture.

Devoted to church architecture and church art.
Reviews: book.
Advertising.

THE CUT. 3/yr. EN.

636

Arts Centre Group, 21 Short St., London SE1 8LJ, England. Phone 071 261 1075.
Promotes the interaction of art and Christian faith.

FAITH & FORM: Journal of the Guild for Religious Architecture. 1967. 3/yr.

637

Interfaith Forum on Religion, Art and Architecture, 1777 Church St. N.W., Washington, DC 20036. Phone 202–387–8333.
Betty H. Meyer, Editor (25 Maple St., Auburndale, MA 02166, phone 617–965–3018).
Subscription: included in membership, $20 US, foreign $25. No sample. Back issues. Illus b&w, photos. 8½ x 11, 52p. Offset
lithograph.
ISSN: 0014–7001. OCLC: 1568760. LC: NA4605.F33. Dewey: 720.
Architecture. Historic Preservation. Interior Design. Landscape Architecture. Sculpture. Needlework for Vestments.

Focuses on contemporary religious buildings of all faiths, and the preservation and renovation of designing historical structures. Published as an educational service to the professional, religious and lay community. Its purpose is to provide current information on problems of design and liturgy as related to religious architecture and art. Represents the collaborative efforts of architects, clergy, artists, craftspersons—of all faiths—to develop a forum wherein the interrelationships of theology, architecture and art as a total expression in religious architecture can be shown. The primary goal of IFRAA is to reach a broad audience concerned with the form and function of houses of worship. Seeks to bring together transcendent art and architecture in the design of religious spaces.
Encourages the participation of the artist from the conception of the architectural designs. Hopes to influence the design of American religious architecture. The Forum is the Religious Buildings Affiliate of the American Institute of Architects.
Reviews: exhibition, book, journal. Bibliographies: note relevant journals, books articles, periodicals in field. Biographies. Interviews. Listings: national. Calendar of IFRAA events. Exhibition information. Freelance work: none.
Advertising: full page $1050, ½ page $675, ¼ page $385, cover $1150, 4 color rates on request. Bleeds + $35. Frequency discount. 15% agency discount. Inserts. Tish Kendig, Ad. Director (11521 Maple Ridge Rd., Reston, VA 22090, phone 703–481–5293). Mailing lists: none. Demographics: Members include architects, temple and church administrators, denominational building committees, lay building committees, clergy, acoustical engineers, artists, liturgical design consultants, conservators/restorers, lighting specialists and manufacturers. Audience: architects, artists, educators, liturgists, building committees.

FRIENDS OF THE ACG. bi–m. EN.

638

Arts Centre Group, 21 Short St., London SE1 8LJ, England. Phone 071 2611075.
Newsletter of the Centre which seeks to integrate Christian art and faith.

ICO-ICONOGRAPHISK POST: Nordisk Tidskrift foer Bildtolkning. 1970. q. DA, NOR, SW.
EN summaries.

639

Riksantikvarieambetet – Central Board of National Antiquities, Box 5405, S–114 84 Stockholm, Sweden.
Subscription: Kr 70. Illus. Cum. index.
ISSN: 0106–1348. OCLC: 7695683. LC: N7957.I26. Dewey: 704.948. Formerly: *Iconographiske Post*.
Book reviews appear in one language only.
Reviews: book.

IFRAA NEWSLETTER. 1986. irreg. EN. **640**
Interfaith Forum on Religion, Art, and Architecture, 1777 Church St., N.W., Washington, D.C. 20036.
Architecture.

INTERNATIONAL SECRETARIAT FOR CHRISTIAN ARTISTS BULLETIN. irreg. EN. **641**
International Secretariat for Christian Artists, Rosehill House, Lydiate, Merseyside L31 4JF, England. Phone 51 5260481.
The focus of the organization is Christianity in the arts as well as the contribution of art to society.

INTERNATIONAL SECRETARIAT FOR CHRISTIAN ARTISTS NEWSLETTER. a. EN. **642**
International Secretariat for Christian Artists, Rosehill House, Lydiate, Merseyside L31 4JF, England. Phone 51 5260481.
Promotes the study of ancient and modern art and the relationship of Christianity to art and society. The Society also issues a semi–annual newsletter in German.

ISLAM AND THE MODERN AGE. 1970. q. EN. **643**
Zakir Husain Institute of Islamic Studies, Jamia Nagar, New Delhi 110025, India. Z.H. Faruqi, Editor.
Subscription: $20.
ISSN: 0021–1826. Dewey: 297.
Advertising.

JEWISH ART. 1974. a. EN. **644**
Hebrew University of Jerusalem, Center for Jewish Art, P.O. Box 4262, Jerusalem 91042, Israel. Aliza Cohen–Mushlin, Editor.
Subscription: included in membership to International Society for Jewish Art (Hebrew Publishing Co., 100 Water St., P.O. Box 875, Brooklyn, NY 11202). Microform available from UMI. Back issues. Illus. b&w, color (several full page), glossy photos. 8¼ x 10¾, 138p., hardcover.
ISSN: 0160–208X. OCLC: 17285385. LC: N7415.J68. Dewey: 704. Formerly: *Journal of Jewish Art.*
Covers Jewish art of all time periods. Includes a listing of Jewish museums worldwide which have opened within the past few years. Contains 2 calendars, one of forthcoming events and a retrospective calendar of events of the past year.
Reviews: exhibition, book. Bibliographies of current publications of international journals and books. Listings: international. Calendar of events. Indexed: ArtBibMod. ArtI. BHA. BioI. CurCont. RILA.
Advertising: only 1–2 ads at end of issue.

KUNST UND KIRCHE. 1971. m. GE. EN tr. of cover article only. **645**
Landesverlag, Landstr. 41, A–4020 Linz, Austria.
Subscription: oS 428, DM 64, SFr 61,40. Illus., color; beautifully done. A4, 66p.
ISSN: 0023–5431. OCLC: 4109854. LC: NA4790.K97. Dewey: 704.948. Formed by the union of: *Christliche Kunstblatter* and, *Kunst und Kirche.*
Indexed: ArchPI. ArtBibCur. ArtBibMod. ArtI. Avery.
Advertising.

DAS MUENSTER: Zeitschrift fuer Christliche Kunst und Kunstwissenschaft.
 1947. q. GE. EN & FR summaries. **646**
Verlag Schnell und Steiner GmbH, Paganinistrasse 92, D–8000 Munich 65, W. Germany. H.H. Hofstaetter, Editor.
Subscription: $20. Illus.
ISSN: 0027–299X. LC: N3. Dewey: 704.9.
A magazine for the study of Christian art.
Indexed: ArchPI. ArtBibCur. ArtBibMod. Avery.

NEWSLETTER / THE CHURCH MONUMENTS SOCIETY. 1985. s–a. EN. **647**
Church Monuments Society, Temple Newsam House, Leeds LS15 0AE, England. Phone 0532 647321. Mrs. Moira Gittos, Editor (4, Linden Rd., Yeouil, Somerset BA20 2BH).
Illus. b&w. 6¼ x 8½, 20–24p.
ISSN: 0268–750X. OCLC: 18832183. Dewey: 720. Formerly: *Bulletin (International Society for the Study of Church Monuments).*
Sculpture. Monuments.

Brief articles and notes on churches and monuments together with their historical background. Promotes the study, care and conservation of funerary monuments and related art of all periods and countries.

Bibliographies: exhaustive on–going bibliography on material related to monuments. "News of Books" contains a listing with brief information. Listings: regional. Calendar of excursions to visit churches and monuments.

Audience: art historians, historians, archaeologists, genealogists, geologists, heralds, masons, sculptors, and stone conservators.

SACRED ART JOURNAL. 1981. q. EN. 648

St. John of Damascus Association, Rt. 711 N., Box 738, Ligonier, PA 15658–0638. Phone 412–238–3677. Rev. George Geha, Editor.

Subscription: included in membership, $25 US, $35 Canada, foreign $37. Back issues. Illus. b&w, photos. Index. Cum. index v.1–8 in v.8 no.4. 30p.

ISSN: 0741–9163. OCLC: 8962851.

Architecture. Art Education. Art History. Drawing. Historic Preservation. Museology. Painting. Printing. Textiles.

Presents the liturgical arts from the Orthodox Christian (Byzantine) perspective with emphasis on the painting of the panel icons. Focuses on Byzantine–style panel icons – history, technique, etc., – but also deals with mosaic, fresco, illumination, architecture, and music.

Reviews: exhibition 2–3 & book 3–4, length 1–2p. each. Bibliographies: annotated each issue. Interviews: iconographers of note. Listings: international. Calendar of events. Exhibition information. Freelance work: yes. Contact: editor. Opportunities: study, competitions.

Advertising: full page $125 + $10/half–tone plate, ½ page $70, ¼ page $35, no color. No classified. Frequency discount. Audience: icon painters, informed laity.

IL SANTO: Rivista Antoniana di Storia Dottrina Arte. 1961. 3/yr. IT or EN. Short summaries in other
language. Occasionally FR, GE, SP or LATIN. 649

Centro Studi Antoniani, Basilica del Santo, Piazza del Santo 11, 35123 Padua, Italy. Phone 049–663944. Vergilio Gamboso & Luciano Bertazzo, Editors.

Illus. b&w, photos. Index. 6¾ x 9½, 182p.

ISSN: 0391–7819. OCLC: 1918915. LC: BX4684.S23.

Indexed: BHA.

STUDIES IN ART AND RELIGIOUS INTERPRETATION. 1981. irreg. EN. 650

Edwin Mellen Press, Box 450, Lewiston, NY 14092.

Subscription: $39.95.

OCLC: 8641498.

VISIBLE RELIGION: Annual for Religious Iconography. 1982. a. EN or GE. Illustration captions
in one language only. 651

E.J. Brill, P.O. Box 9000, 2300 PA Leiden, The Netherlands. H.G. Kippenberg, Editor–in–chief.

Illus. b&w, photos, line drawings. 7¼ x 10¼, 300+p.

ISSN: 0169–5606. OCLC: 9901701. LC: BL1.V57. Dewey: 291.3.

Published for the Institute of Religious Iconography, State University Groningen. Each annual has an individual title. Volume 7, 1990 is the proceedings of a conference held in Germany in 1986.

Asian & Islamic Art

ARCHIVES OF ASIAN ART. 1945. a. EN. 652

Asia Society, 725 Park Ave., New York, NY 10021. Phone 212–288–6400. Kathryn Parker, Editor.

Subscription: $25. Illus. b&w. Cum. index 1945–65. 9 x 12, 128p.

ISSN: 0066–6637. OCLC: 1482119. LC: N7260.A68. Dewey: 705. Formerly: *Archives of the Chinese Art Society of America*.

Reports on recent scholarship on Asian art and the major oriental accessions of North American museums.

Indexed: ArtHum. ArtI. BioI. CloTAI. CurCont. Reviewed: Katz.

Advertising: none.

ARS ORIENTALIS. 1954. irreg. EN chiefly, some articles in FR & GE. **653**
Department of History of Art, Tappan Hall, University of Michigan, Ann Arbor, MI 48109. Phone 313–763–5840. Richard Edwards, Editor.
Illus.
ISSN: 0571–1371. OCLC: 1514243. LC: N7260.A7. Dewey: 709.5. Formerly: *Ars Islamica*.
Specializes in the arts of Islam and the East.
Indexed: ArtI. BioI.

ART OF CHINA. CH. (1 article tr. into EN, captions also in EN). **654**
906, Eastern Center, 1065, King's Rd., Quarry Bay, Hong Kong. Phone 5–632181, fax 5–8110855. (US dist: 1102 S. Pine St., San Gabriel, CA 91776, phone 818–287–3228, Shirley S.L. Sun, US representative).
Illus. mainly color, photos. 8¼ x 11¼, 128p.
Art and antiques of China. Profusely illustrated.
Advertising: Many ads are written in both CH & EN.

ARTIBUS ASIAE. 1925. q. EN. FR & GE summaries. **655**
Artibus Asiae Publishers, CH–6612 Ascona, Switzerland (US: Arthur M. Sackler Foundation, One E. 78th St., New York, NY 10021). Alexander C. Soper, Editor.
Subscription: $US65, SF85. Illus. b&w, some color, glossy photos. Annual index. 8¾ x 12, 350–370p./yr.
ISSN: 0004–3648. OCLC: 1514339. LC: N8.A75. Dewey: 709.5.
Archaeology. Art History.
Scholarly articles on Asian art and archaeology published for the Arthur M. Sackler Foundation. Richly illustrated with illustrations of previously unpublished art objects and documents, recent discoveries, new studies or other material.
Reviews: book 4, 2–3p. each. Bibliographies:. Freelance work: yes. Contact: editor. Send manuscripts from Western Hemisphere to: Institute of Fine Art, New York University, 1E 78th St., New York, NY 10021. Send manuscripts from Europe & Asia to publisher's office. Indexed: ArtBibMod. ArtHum. ArtI. Avery. CloTAI. CurCont. IBkReHum. Reviewed: Katz.
Advertising, few at end of the issue. Demographics: worldwide circulation. Audience: all connoisseurs, libraries, and institutions devoted to Asiatic research.

ARTS ASIATIQUES. 1954. a. FR or EN. Abstract in opposite language. **656**
Ecole Francaise d'Extreme Orient, 22, avenue du President Wilson, 75116 Paris, France. Jean Filliozat & Jeannine Auboyer, Editors.
Illus. b&w, photos, charts. 8¼ x 11.
ISSN: 0004–3958. OCLC: 1514371. LC: N2.A83. Dewey: 709. Formerly: *Revue des Arts Asiatiques*.
Architecture.
Scholarly articles on the art and architecture of India, Indo–China and the Far East.
Reviews: book 10, length 8p. Bibliographies with articles. Indexed: ArtI. BioI. RILA.
Advertising: none.

ARTS OF ASIA. 1971. bi–m. EN. **657**
Arts of Asia Publications Ltd., 1309 Kowloon Centre, 29–39 Ashley Rd., Kowloon, Hong Kong. Phone 3–692228, fax 3–3113713. Tuyet Nguyet, Editor & Pub.
Subscription: $HK300 Hong Kong; overseas surface $US53, £30, $A70, $HK400; air + $US36 America & Europe, + $US30 Asia. Illus. b&w, some color, photos. Index cumulates triennially. 9 x 11¾, 176p.
ISSN: 0004–4083. OCLC: 1514382. LC: NX572.A75. Dewey: 709.5.
Heavily illustrated. In addition to several articles each issue presents 2 features in the "Collectors World" section on specific collections of Asian art. "Sales News" includes auctions information — price, description and size together with a photo.
Reviews: book 1, length 2p. Biographies: brief information on contributors. Indexed: ArtArTeAb. ArtBibCur. ArtBibMod. ArtHum. ArtI. Avery. CloTAI. CurCont. Reviewed: Katz.
Advertising: mainly color ads (Contact Advertising Coordinator for rates, phone 3–692228, fax 3–3113713).

ASIAN ART. 1988. q. EN. **658**
Oxford University Press, Journals, 200 Madison Ave., New York, NY 10016. UK: Walton St., Oxford OX2 6DP, England). Phone US: 212–679–7300, UK: 0865–56767. Karen Sagstetter, Editor.
Subscription: $35 individual, $56 institution US; $45 individual, $65 institution outside US, air + $15 (16–00 Pollitt Dr., Fair Lawn, NJ 07410). Illus. b&w, some color. 8½ x 11, 64p.
ISSN: 0894–234X. OCLC: 15897409. LC: N7262 .A877. Dewey: 709.

Published in association with the Arthur M. Sackler Gallery, Smithsonian Institution. Specializes in the arts of Asia, encompassing the works of culture stretching from the eastern Mediterranean to the Pacific Ocean. Welcomes new interpretations as they are represented in the exhibition program of the Arthur M. Sackler Gallery and as they relate to other arts and to religions, cultural and social practices, art on painting, sculpture, decorative arts, art, architecture, photography, or folk tradition from ancient times to the present.

Freelance work: will consider proposals for articles and accompanying illustrations. Contact: editor. Reviewed: Katz.

Advertising: none.

BUKKYO GEIJUTSU/ARS BUDDHICA. 1948. bi–m. JA. EN summaries. 659

Japan Publications Trading Co. Ltd., Box 5030, Tokyo International, Tokyo 100–31, Japan.

Subscription: $71.75. Microform available. Illus.

ISSN: 0004–2889. OCLC: 3010507. LC: N8193.A1B84.

Devoted to Buddhist art.

Advertising.

BULLETIN OF THE ASIA INSTITUTE. 1987, ns no.1. a. EN, FR, GE. 660

Wayne State University Press, Leonard N. Simons Bldg., 5959 Woodward Ave., Detroit, MI 48204. Phone 313–577–4606. C. Bromberg, R. Frye, & B. Goldman, Editors.

Subscription: $30 individual, $50 institutions. Back issues. Illus. b&w, photos. 8 x 11, 160p.

ISSN: 0890–4464. OCLC: 14252536. LC: N7280.A1 I72. Dewey: 709. Formerly: *Bulletin of the American Institute for Iranian Art and Archaeology.*

Archaeology. Architecture. Art History.

Examines the cultures of Western and Central Asia from ancient through Islamic times, and the interconnection of these cultures with the Far East, the Mediterranean, and Europe. Particular emphasis is placed on those centuries when Persian influence reached from the Aegean to the borders of China, and from Armenia to North Africa and India. The *Bulletin* promotes current studies in the arts, archaeology, history, and culture of Asia. It serves as a vehicle for the international exchange of information through informal notes and notices, for features highlighting little–known collections of artifacts, and for summaries of archaeological activities. Published with the assistance of the J. Paul Getty Trust.

Reviews: 15/issue, exhibition, book. Listings: international. Freelance work: none.

Audience: scholarly.

BULLETIN - THE MUSEUM OF FAR EASTERN ANTIQUITIES. 1960. a. EN, FR & GE. 661

Oestasiatiska Museet – Museum of Far Eastern Antiquities, Skeppsholmen, Box 16381, 103 27 Stockholm, Sweden. Jan Wirgin, Editor.

Illus., some color.

ISSN: 0081–5691. OCLC: 3057592. LC: DS714.S7. Dewey: 931.

Features painting, ceramics, sculpture and bronzes. Includes coverage of India and Thailand.

CHANOYU QUARTERLY: Tea and the Arts of Japan. 1970. q. EN. 662

Urasenke Foundation, Ogawa Teranouchi Agaru, Kamikyo–ku, Kyoto 602, Japan (US: Urasenke Chanoyu Center, 153 E 69th St., NY 10021). Gretchen Mittwer, Editor.

Subscription: $25, air + $14 US; elsewhere Y4,400, air + Y2,600 (US write to New York address, all others to Japan). Back issues. Illus. b&w, some color.

ISSN: 0009–1537. OCLC: 4044546. LC: GT2910.C56. Dewey: 394.1. Formerly: *Chanoyu.*

A journal devoted to the Japanese tea ceremony and the arts of Japan related to the ceremony. Subjects include: aesthetics, applied arts, architecture, biographical studies, calligraphy, ceramics, essays, food, gardens, history, literature, painting, religion and philosophy, science, tea procedures, tea utensils, textiles, translations of classical works.

Reviews: book 3, length 2–3p. each. Indexed: ArtBibMod. CloTAI. Reviewed: Katz.

CHINA INSTITUTE IN AMERICA BULLETIN. q. EN. 663

China Institute in America, Inc, 125 E. 65th St., New York, NY 10021. Phone 212–744–8181. Gayle Feldman, Editor.

Subscription: membership only.

OCLC: 17214271. Formerly: *China Institute Bulletin.*

Newsletter updating members on Institute activities.

Reviews: book. Calendar of events.

Advertising: none.

CHINA'S BEST ARTS & CRAFTS. See no. 1202.

CHINESE SNUFF BOTTLE JOURNAL. See no. 1144.

GEIJUTSU SHINCHO. 1950. m. JA only. **664**
Shincho–Sha, Shinjuku–ku, Tokyo, Japan. Phone 266–5381.
Illus. color, photos. 8¼ x 11, 160p.
OCLC: 1570515. LC: N8.G31. Dewey: 701.18.
Profusely illustrated.
Advertising.

THE GEST LIBRARY JOURNAL. 1986. s–a. EN. **665**
Princeton University, Trustees of Princeton University, Friends of the Gest Library, Jones Hall 211, Princeton University, Princeton, NJ 08544. Dr. Howard L. Goodman, Editor.
Subscription: $15 individual, $25 institution US. Illus. b&w, photos. 7½ x 10.
ISSN: 0891–0553. OCLC: 14554217. Dewey: 950.
Art History.
Forum for scholarship, news, notes and reviews on East Asian libraries, particularly Princeton's Gest Oriental Library. Devoted to East Asian art and literature, Chinese and Japanese rare books, and illustrated manuscripts.
Reviews: book.

HERITAGE. See no. 835.

IMPRESSIONS. 1976. s–a. EN. Includes some JA words. **666**
Ukiyo–e Society of America, Inc, Box 665, FDR Station, New York, NY 10150. William E. Harkins, Editor.
Subscription: included in membership, $25. Sample free. Back issues $1. Illus. b&w photos and print reproductions. 8½ x 11, 8–12p.
Art History. Graphic Arts. Prints.
Illustrated articles on Japanese art, especially on Japanese woodblock prints.
Reviews: book, collections and prints. Freelance work: accepts photos of Japanese woodblock prints.
Advertising: none. Circulation: 400. Audience: Japanese art collectors, museum personnel.

ISLAMIC ART. 1981. a. EN. **667**
The Islamic Art Foundation, 57 W 38th St., New York, NY 10018. Ernst J. Grube & Eleanor G. Sims, Editors.
Illus. b&w, some color, photos. A4, 272p.
ISSN: ISBN: 900408527-0.
Architecture. Painting.
"An annual dedicated to the art and culture of the Muslim world". Scholarly study presents research papers covering all aspects of Islamic art. Published together with the Bruschettini Foundation for Islamic and Asian Art (Genova, Italy). Articles are presented in English, the original language of the text is translated by or for the author.
Bibliographies: "Publications Received". Freelance work: yes, welcomes original articles on any aspect of art and architecture of the Muslim world. Contact: Foundation at New York address or London (c/o Roger H. Lloyd, 23 Albemarle St., London W1X 3HA).
Advertising: none.

ISLAMIC ART AND ARCHITECTURE. 1981. irreg. EN. **668**
Mazda Publications, Box 2603, Costa Mesa, CA 92626. Phone 714–751–5252. A. Daneshvari, Editor.
Illus.
ISSN: 0742–1125. OCLC: 10284184.
Architecture.

ISLAMIC CULTURE. 1927. q. EN. **669**
Islamic Culture Board, Box 171, Hyderabad 7, India. Editorial Board.
Subscription: $8. Microform available from UMI. Illus., some color.

ISSN: 0021–1834. OCLC: 1774508. LC: DS36.I74. Dewey: 950.
Indexed: HistAb.

JOURNAL OF ORIENTAL STUDIES. 1954. s–a. EN & CH. EN abstracts for CH articles. 670

University of Hong Kong, Centre of Asian Studies, Pokfulam Rd., Hong Kong. Leung Chi–Keung, Editor.
Subscription: $US20, $HK150 individual; $US25, $HK200 institution & library. Microform available from UMI. Illus. b&w. 7¼ x 10¼, 186p.
ISSN: 0022–331X. LC: DS501. Dewey: 950.
Scholarly. 1980–86 issues alternated language with each issue exclusively one language. Beginning 1987 each issue is bilingual, with articles and reviews in both languages. All articles are refereed. Area of coverage China, Japan, Korea, and Southeast Asia. Subject matter includes both traditional and contemporary issues in the humanities and social science field. Contains 1–2 art articles per issue.
Reviews: book. Indexed: HistAb.
Advertising: full page $US40, $HK320; ½ page $US30, $HK160; ¼ page $US10, $HK80.

KELETI TANULMANYOK/ORIENTAL STUDIES. 1976. irreg. EN, FR, GE, HU, RU

& Oriental languages. 671
Magyar Tudomanyos Akademia Konyvtara, Akademia u.2, P.O. Box 7, 1361 Budapest 5, Hungary. Eva Apor, Editor.
Subscription: available on exchange.
ISSN: 0133–6193. Dewey: 950.
Oriental studies and papers on the documents and the history of the oriental collection of the Academy Library of Hungary.

KOREAN CULTURE. 1980. q. EN. 672

Koran Cultural Service, 5505 Wilshire Blvd., Los Angeles, California 90036. Phone 213–936–7141. Robert Buswell, Editor.
Subscription: $8. Illus. b&w, some color. 8½ x 11, 44p.
ISSN: 0270–1618. OCLC: 6348960. LC: DS904.K62. Dewey: 951.9.
Not primarily an art journal, focus is the culture of Korea. Contains some articles on art with excellent illustrations.

KUNST OG KULTUR. 1910. q. NOR. 673

Norwegian University Press, Kolstadgt. 1, Box 2959–Toeyen, 0608 Oslo 6, Norway (U.S.: Publications Expediting Inc., 200 Meacham Ave., Elmont, NY 11003). Sidsel Helliesen, Editor.
Illus., some color.
ISSN: 0023–5415. OCLC: 1589324. LC: N8.K9.
Indexed: ArtBibCur. ArtBibMod. BHA. RILA.

LALIT KALA. 1956. irreg. EN. 674

Lalit Kala Akademi, Rabindra Bhavan, New Delhi, India 110001. Karl Khandalavala, Editor.
Subscription: no subscription rate, each issue priced individually. Illus. b&w, some color.
ISSN: 0458–6506. OCLC: 1624395. LC: N8.L3.
Covers Indian art and archaeology as well as other Oriental art which influenced Indian art. Includes scholarly articles, original research and news notes on museums.
Reviews: book, journal, catalogues, reports. Obits. Freelance work: Articles must contain either original matter or a new treatment of matter already published. Contributors should have specialized knowledge of the subjects dealt with, honorarium. Photographs and sketches also accepted. Contact: editor. Indexed: ArtBibMod.

MISUL CHARYO: National Museum Journal of Arts. 1960. s–a. KO. EN table of contents and abstracts. 675

National Museum of Korea, Kyongbok Palace, Sejong–ro 1, Jongro–gu, Seoul, S. Korea. Phone 02–720–4723.
Illus. b&w. 7¾ x 10¼, 104p.
ISSN: 0540–4568. OCLC: 4146213. LC: NK1073.6.A1 M58.
Archaeology. Antiquities.
Art magazine of the National Museum of Korea.
Advertising: none.

THE NATIONAL PALACE MUSEUM BULLETIN. 1966. bi–m. EN. 676

National Palace Museum, Wai–Shuang–Hsi, Shih–Lin, Taipei, Taiwan 11102, Republic of China. Phone 02–8812021–3, fax 8821440. Su Tu–Jen, Editor.

Subscription: $19. Illus. b&w, photos.
ISSN: 0027–9846. LC: N3750.T32.A16. Dewey: 069.095.
Articles of scholarly research on artistic and cultural subjects.
Advertising: none.

THE NATIONAL PALACE MUSEUM MONTHLY OF CHINESE ART. 1983. m. CH only. 677

National Palace Museum, Wai–Shuang–Hsi, Shih–Lin, Taipei, Taiwan 11102, Republic of China. Sung Lung–fei, Editor.
Illus. b&w, color, photos. 7½ x 10¼, 144p.
ISSN: 1011–9078. Dewey: 709.5.
Articles and photographs of museum exhibitions of Chinese and oriental art.
Advertising: ad on inside cover only.

NATIONAL PALACE MUSEUM NEWSLETTER & GALLERY GUIDE. 1968. q. EN & CH. 678

National Palace Museum, Wai–Shuang–hsi, Taipei, Taiwan 11102, Republic of China. Suzan Babcock, Editor.
Subscription: free. Illus. color. 6½ x 9¾, 8p.
ISSN: 1011–9086. OCLC: 23065405. LC: N3750.T32 A18. Dewey: 708. Formerly: *Newsletter*.
Provides bilingual description of museum exhibitions accompanied by color illustrations. Highlights Museum's newest publications, exhibitions and activities.
Bibliographies with articles. Listings: National Museum only. Exhibition information.

THE NATIONAL PALACE MUSEUM RESEARCH QUARTERLY. 1966. q. CH only. 679

National Palace Museum, Wai–Shuang–Hsi, Shih–Lin, Taipei, Taiwan 11102, Republic of China. Peter Ch'ang, Editor–in–chief; Fung Ming–ch, Editor.
Subscription: (includes postage), $US34 Asia, Europe, US; $US30 Hong Kong. Illus. b&w. 7½ x 10¼.
ISSN: 1011–9094. Dewey: 709.5. Formerly: *National Palace Museum Quarterly*.
Journal whose purpose is to further an atmosphere of scholarly and professional exchange.
Advertising: none.

NEWSLETTER ON CONTEMPORARY JAPANESE PRINTS. 1971. irreg. EN. 680

Helen & Felix Juda Collection, 644 S. June St., Los Angeles, CA 90005. Irene Drori, Editor.
Subscription: free. Illus.
ISSN: 0085–4174. OCLC: 4626379. LC: NE1310.N48. Dewey: 769.
Modern Art. Prints.

ORIENTAL ART. 1948, ns 1955. q. EN. 681

Oriental Art Magazine Ltd., 12 Ennerdale Rd., Richmond, Surrey TW9 3PG, England. John Sweetman, Editor.
Subscription: Sold by subscription only. Illus. Annual index.
ISSN: 0030–5278. OCLC: 1761503. LC: N8.075. Dewey: 709.5.
Devoted in its entirety to the arts of the Orient and Japan also embracing the arts of India, the Islamic world and South–East Asia. Authoritative articles with many illustrations are written by acknowledged international experts. Illustrated sales reports from Britain, Hong Kong and the U.S. reflect the trends of the dealers' markets.
Reviews: book, lengthy scholarly reviews. Indexed: ArtArTeAb. ArtBibCur. ArtBibMod. ArtHum. ArtI. BioI. CloTAI. CurCont. IBkReHum. Reviewed: Katz.
Advertising: b&w full page $660, ½ page $352, ¼ page $186; color full page $880, ½ page $660. Bleed + 10%. Demographics: worldwide.

ORIENTAL INSTITUTE JOURNAL. 1951. q. EN & SA. 682

Oriental Institute, Maharaja Sayajirao University of Baroda, Baroda 390002, Gujarat, India. R.T. Vyas, Editor.
Subscription: Rs 30. Illus.
ISSN: 0030–5324. Dewey: 709.5.
Scholarly research articles dealing with artistic and cultural subjects.

ORIENTAL STUDIES. 1933. irreg. EN. 683

Freer Gallery of Art, Smithsonian Institution, Jefferson Dr., S.W. at 12th St., Washington, DC 20560. Phone 202–357–1432.
Illus. b&w, some color, maps, plates.
ISSN: 0078–6551. OCLC: 9270641. Dewey: 705.

ORIENTATIONS: The Monthly Magazine for Collectors and Connoisseurs of Asian Art.

1970. m. EN. 684

Orientations Magazine Ltd., 14th Floor, 200 Lockhart Rd., Hong Kong, Hong Kong. Phone 5–892 1368, fax 834 4620, telex 62107 IPLPM HX. Elizabeth Knight, Editor & Pub.

Subscription: $HK355; air $US60, $C80, £40, $A80 (US: China Books & Periodicals, 2929 24th St., San Francisco, CA 94110). Back issues $US5.50, £3.5. Illus. mainly color, b&w, photo. Index for previous year in Jan issue. Cum. index 1970– 89. A4, 74–82p.

ISSN: 0030–5448. OCLC: 1774029. LC: DS501.O73. Dewey: 950.

Antiques. Archaeology. Architecture. Art History. Ceramics. Crafts. Decorative Arts. Modern Art. Painting. Sculpture. Textiles.

Pictorial articles by informed writers on all aspects of the arts of the Far & Near East, Southeast Asia and the Indian subcontinent, accompanied by profuse color illustrations. Presents regular reports on the latest collecting trends in the international Asian arts scene; analysis of current prices at auctions in London, New York, Hong Kong and other centers; and insight into contemporary expert opinion. Compiled with the assistance of eminent art historians, many of them authors whose works are regarded as definitive in their field. Printed on high quality art paper. Includes coverage of contemporary artists.

Reviews: exhibition 1, length 2000–4000 wds.; book 1, length 2000–3000 wds. Bibliographies: suggested reading list accompanies each article. Biographies: profiles on personalities who have contributed to study of Asian art. Interviews: incorporated in reviews/discussions of activities (commercial/institutions) of Asian art. Listings: international. Calendar of events and exhibitions of Asian art. Freelance work: yes from specialists. Contact: editor. Opportunities: study, competitions. Indexed: ArtArTeAb. ArtBibCur. CloTAI. Reviewed: Katz.

Advertising: full page $US685, ½ page $445, ¼ page $255, color full page $1080, ½ page $630, ¼ page $380. Classified: $US10/line. Frequency discount. Mailing lists: available. Circulation: 12,000. Audience: scholars and collectors of Asian art, art dealers and art historians.

SUMI-E. 1963. q. EN. 685

Sumi–e Society of America, Inc., c/o Elizabeth Robinson, 7102 Westbury Rd., McLean, VA 22101. Kay Thomas, Editor.

Subscription: included in membership. 8½ x 11, 8–10p.

Formerly: *Suni–e Notes.*

Newsletter on Society activities. Covers information related to oriental brush painting.

Circulation: 800.

TOKEN BIJUTSU/JOURNAL OF JAPANESE FINE ARTS SWORDS. 1979. q. EN. 686

Nippon Bijutsu Token Hozon Kyokai – Society for Preservation of Japanese Art Swords, 4–25–10 Yoyogi, Shibuya–Ku, Tokyo 151, Japan. Kyojiro Furuya, Editor.

Subscription: 10000 Yen.

ISSN: 0911–4041.

UKIYO-E ART. 1962. q. JA. EN table of contents & summaries (2p.). 687

Japan Ukiyo–e Society, 1–18 Kanda, Jimbocho, Chiyoda–ku, Tokyo, Japan. Asano Shugo, Acting Editor.

Subscription: included in membership, $50 US. Illus. b&w. 7¼ x 10, 40p.

ISSN: 0041–5979. OCLC: 1496493. LC: N8.U34. Dewey: 709.5.

A journal of the Japan Ukiyo–E Society.

Reviews: book. Obits. Freelance work: Invites, regardless of size, contributions of articles, reviews and reports of exhibitions in English by members and subscribers.

Advertising.

Native American Art

AMERICAN INDIAN ART MAGAZINE. 1975. q. EN. 688

Mary G. Hamilton, Publisher, 7314 E. Osborn Dr., Scottsdale, AZ 85251. Phone 602–994–5445. Roanne P. Goldfein, Editor.

Subscription: $20 US, $24 Canada & foreign. Sample $5. Back issues. Illus. b&w, color, photos. Index. Cum. index, vol.1– 13. 8½ x 11, 102p.

ISSN: 0192–9968. OCLC: 4343382. LC: E98.A7 A43. Formerly: *American Indian Art.*

(Within a Native North American Indian context) Archaeology. Art History. Crafts. Historic Preservation. Jewelry. Needlework. Painting. Photography. Pottery. Sculpture.

Devoted to presenting the great variety of native American arts through articles and illustrations appealing to both laymen and professionals. Profusely illustrated articles cover all aspects of native American art.

Reviews: exhibition 4–6, length 4–8p.; book 2, length 2–3p. Bibliographies: included with most articles. Biographies: short & concise biographies of artists, meant only to complement the artist's work. Listings: regional–national. Exhibition information. Freelance work: yes. Contact: editor. Indexed: AmH&L. ArtBibCur. ArtBibMod. ArtI. BioI. CerAb. CloTAI. Reviewed: Katz. *Art Documentation* Fall 1986, p.131.

Advertising: (rate card Aut/Aug '89): full page $910, ½ page $620, ¼ page $345; color full page $1,235, ½ page $840, ¼ page $550. Preferred placement (full and ½ page only) + $100. No classified. Frequency discount. 15% agency discount. Patsy Badger, Ad. Director. Mailing lists: none. Circulation: 11,500. Audience: art collectors, artists, gallery owners, laymen.

AMERICAN INDIAN BASKETRY AND OTHER NATIVE ARTS. 1979. q. EN. 689
American Indian Basketry Magazine, Box 66124, Portland, OR 97266. Phone 503–233–8131. John M. Gogol, Editor & Pub.
Subscription: $30. Back issues. Numerous illus., b&w, photos. 8 x 11, 36p.
Formerly: *American Indian Basketry.*

Antiques. Archaeology. Art History. Crafts. Decorative Arts. Interior Design. Needlework. Photography. Basketmaking. Native American Art.

"Founded to sponsor research and communication in all aspects of the study of Native American traditional arts, of which we consider basketry to be the most important." Some issues have also dealt with beadwork, quillwork, stone art, carving, feather art, and weaving. Includes a variety of types of articles: interviews with contemporary Native American basketmakers, profiles of historic basketmakers, aesthetics as it relates to Native American arts, comparative studies, historic studies, archaeological studies of basketry, etc. Many old historic photos and information about the photographers, as well as contemporary photos.

Reviews: 4–6/issue. Interviews. Biographies. Freelance work: yes. Contact: editor. Reviewed: *Library Journal* Mar 1 1984.
Advertising: full page $800, ½ page $500, ¼ page $300. No classified. Mailing lists: none. Circulation: 5000. Audience: collectors, anthropologists, Native Americans and craft persons.

ART OF THE WEST. See no. 258.

ARTIFACTS. 1972. q. EN. 690
American Indian Archaeological Institute, P.O. Box 260, Washington, CT 06793. Phone 203–868–9348.
Subscription: included in membership, $25 all. No sample. No back issues. Illus. b&w, photos. 12p.
Archaeology. Crafts. Historic Preservation. Museology. Painting. Photography. Sculpture.

Contents include the living traditions of Native Americans, Native American profiles, archaeological research reports, upcoming programs, and general Institute operations.
Biographies: Native American profiles. Obits. Listings: regional. Calendar of events. Exhibition information. Freelance work: yes. Contact: Susan Payne. Opportunities: competitions, study — workshops, conferences.
Advertising: none. Circulation: 1400. Audience: membership.

EARLY MAN. See no. 423.

ETHNOARTS INDEX. See no. 14.

EUROPEAN REVIEW OF NATIVE AMERICAN STUDIES. 1987. s–a. EN. 691
Pallas–Interedition, P.O. Box 223, 1906 Budapest, Hungary. Christian F. Feest, Editor (Museum fuer Volkerkunde, A–1014 Vienna, Austria).
Subscription: $US20. Illus. b&w, photos, maps, cartoons. 7¾ x 11, 64p.
ISSN: 0238–1486.
International coverage of native people. Presents articles and reports of meetings. Bound with *American Indian Workshop Newsletter*.
Reviews: exhibition. Bibliographies with articles.
Advertising: full page $US14, ½ page $80, ¼ page $50 (send photo–ready copy to editor).

HEARD MUSEUM NEWSLETTER. 1984, v.27. bi–m. EN. 692
Heard Museum, 22 E. Monte Vista Rd., Phoenix, AZ 85004. Phone 605–252–8840. Teresa Shaw Lengyel, Editor.
Illus.
OCLC: 11968970.

Archaeology.

THE INDIAN TRADER: The Western and Indian Arts and Crafts Publication. 1971. m. EN. 693

Martin Link, P.O. Box 1421, Gallup, NM 87305. Phone 505–722–6694. Bill Donovan, Editor.
Subscription: $18 US & Canada, foreign $30, air $52 (311 E. Aztec, Gallup, NM 87301). Bulk shipment available to dealers, museums, art galleries, etc. at 66% off retail price. Sample & back issues $2. Illus. b&w, photos. Annual index in Dec issue. 11¼ x 16½, tabloid, 44p.
ISSN: 0046–9076. OCLC: 4112458.

General. Crafts.

Newspaper devoted primarily to Native American arts and crafts, culture, exhibitions and shows, Old West and contemporary Indian news. Articles cover information on Indian artists and craftspeople and current trends of the arts and crafts business as well as the latest discoveries and theories about life and events during the Old West period and attempts to separate myth from reality.
Bibliographies: new and available books on Native Americans, arts and crafts and the Frontier West. Biographies & interviews: of Native American craftspeople, 1–2/issue. Listings: regional–national. Calendar of events. Exhibition information. Freelance work: yes. Contact: editor. Opportunities: study, competitions. Reviewed: Katz.
Advertising: (rate card Jan '90): full page $500, ½ page $275, ¼ page $145, color + $150. Classified: 40¢/wd., min. $7.50. Directory listing (payable in advance) $100/yr. Frequency discount. Inserts. Martin Link, Ad. Director. Mailing lists: available. Circulation: 4,000. Audience: general.

INUIT ART QUARTERLY. 1986. q. EN. 694

Inuit Art Foundation, RR1, Balderson, Ontario K0G 1A0, Canada. Phone 613–267–4353. Marybelle Myers, Editor.
Subscription: $C35 US, $C25 Canada, foreign air $C35 (Suite 200, 16 Concourse Gate, Nepeau, Ontario K2E 7SB). Sample. Back issues $6.25. Illus. b&w, color, photos. 8½ x 10, 52p.
ISSN: 0831–6708. OCLC: 13712412. LC: E99.E7584. Dewey: 704.

Graphic Arts. Modern Art. Sculpture. Textiles.

Transmits Inuit art and culture. Feature articles, news and reviews of exhibitions and publications.
Reviews: exhibition 3–4, length 700 wds.; book 1, length 450 wds. Interviews: artists, collectors Biographies: artists mainly. Listings: international. Calendar of events. Exhibition information. Freelance work: yes. Contact: editor. Opportunities: study, competitions. Indexed: ArtBibMod. Reviewed: *Art Documentation* Fall 1986, p.132.
Advertising: Tom Dryden, Ad. Director. Circulation: 2500. Audience: collectors, scholars, dealers, curators, artists, teachers, libraries.

INUKTITUT. 1959. q. EN & Inuit. Some issues include text in FR. 695

Dept. of Indian and Northern Affairs, Ottawa, Ontario K1A 0H4, Canada. Phone 819–997–9550. David Webster, Editor.
Subscription: free. Illus. b&w, some color.
ISSN: 0020-9872. OCLC: 4146119. LC: E99.E7 I58.

Language and culture relating to the Inuktitut Eskimos including arts and music. Issued separately in romanized Inuit under title *Inuktitun*.
Reviewed: Katz.
Circulation: 10,000.

THE MASTERKEY: For Indian Lore and History. 1983. a. EN. 696

Southwest Museum, Box 128, Highland Park Station, Los Angeles, CA 90042. Phone 213–221–2164. Dr. Steven A. LeBlanc, Editor.
Subscription: $15. Illus. photos.
ISSN: 0887–6665. OCLC: 10491818. LC: E51.M4. Dewey: 970. Formerly: *Masterkey for Indian Lore and History*.

Archaeology.

Devoted to Native American culture, art, and history particularly of the Southwest.
Reviews: book. Reviewed: *Art Documentation* Fall, 1986, p.132.

NAASA NEWSLETTER. EN. 697

Native American Art Studies Association Inc., The Detroit Institute of Arts, 5200 Woodward Ave., Detroit, MI 48202. Joyce Herold & Inga Calvin, Editors.
Subscription: included in membership (Linda Margolin, Sec./Treas.). Illus. b&w, 1 photo. 8½ x 11, 6–8p.

Clearinghouse for information relating to Native American art north of the Rio Grande. Includes exhibits and conference call for papers.

Opportunities: competitions, announces awards.

NATIVE ARTS UPDATE. 1985? q. EN. 698

Atlatl, 402 W. Roosevelt, Phoenix, AZ 85003. Phone 602–253–2731. Erin Younger, Editor.

Subscription: $25. Illus. b&w. 8½ x 11, 12p.

OCLC: 21201918. LC: E75.A1A109. Dewey: 701. Formerly: *ATLATL Newsletter*.

Newsletter of ATATL, a Native American arts service organization. Contains newsbriefs, announcements, new books, opinion, and opportunities (grants, jobs, shows, competition).

Listings: regional. Calendar of events. Exhibition information. Opportunities: employment, study, competitions. Reviewed: Katz.

Advertising: none.

NATIVE PEOPLES: The Arts and Lifeways. 1987. q. EN. 699

Media Concepts Group, Inc. in association with Native American Communication and Career Development, Inc., 1833 North Third St., Phoenix, AZ 85004–1502. Phone 602–252–2236. Gary Avey, Editor & Pub.

Subscription: $18 US, foreign $25 (contributor level members and above of The Heard Museum, The Wheelwright Museum and The Museum of the American Indian subscribe through their dues). Illus. color, glossy photos. 8½ x 11, 56p.

ISSN: 0895–7606. OCLC: 16786745. LC: E78.W5N38. Dewey: 970.

The journal of the Heard Museum is dedicated to the sensitive portrayal of the arts and lifeways of native peoples. Although the main focus is North American natives, the journal also presents articles reflecting international coverage.

Biographies: brief paragraph about each contributor.

Advertising: Paul McCarthy, Ad. Manager. Circulation: 15,000.

NATIVE VISION. 1984. irreg. EN. 700

American Indian Contemporary Arts, 685 Market St., Suite 250, San Francisco, CA 94105. Phone 415–495–7600. Janeen Antoine, Editor.

Subscription: included in membership, $15/6 issues US; automatically sent to AICA donors and Indian artists participating in AICA's registry. Sample. Back issues $2. Illus. b&w, photos. 8½ x 11, 16p.

OCLC: 15726417. LC: N6538.A4N37.

Native American. Crafts.

Features interviews with or profiles on Indian artists from throughout the country, art news, profiles on art organizations, an artists' information update, and "Art Notes", a column which demystifies subjects such as contracts, copyrights, pricing, art, etc. Native American traditional and contemporary fine art and craft exhibits and events.

Reviews: book 1, length 1p. Interviews: 1 artist in each issue. Listings: local–national. Calendar of Native American exhibits & related events.Exhibition information. Freelance work: yes. Contact: editor. Opportunities: study, competitions.

Advertising: none. Circulation: 2500. Audience: general public, Native American artists.

NEWSLETTER / NATIVE ART STUDIES ASSOCIATION OF CANADA. 1986. q. EN. 701

Native Art Studies Association of Canada, Carleton University, Dept. of Art/Blodgett, Ottawa, Ontario K1S 5B6 Canada.

Subscription: included in membership, $15.

ISSN: 0831–2885. OCLC: 16320091. LC: N7595. Dewey: 709.

LAS PALABRAS. 1980. q. EN. 702

Millicent Rogers Museum, P.O. Box A, Taos, NM 87571. Phone 505–758–2462. Dr. Patrick T. Houlihan, Editor.

Subscription: included in membership. Illus. b&w. 8½ x 11, 4–8p.

Newsletter supports the Museum's aim to collect and interpret the art, history, and cultures of the Native American & Hispanic peoples of the Southwest, focusing on northern New Mexico.

Calendar of events.

Advertising: none. Audience: Museum members and visitors.

SHAMAN'S DRUM. 1985. q. EN. 703

Cross–Cultural Shamanism Network, Shaman's Drum, Box 2636, Berkeley, CA 94702. Phone 415–525–5122. Timothy White, Editor.

Subscription: $15 US, elsewhere + $5 surface, + $20 air (Subscriptions, P.O. Box 16507, North Hollywood, CA 91615). Illus. b&w, color. 8½ x 11, 84p.

ISSN: 0887–8897. OCLC: 13441208. Dewey: 291.

Primary focus of the magazine is shamanism but issues contain a section on Native American art accompanied by full color illustrations. Includes a "Resources Directory", an international yellow pages of schools, organizations, professionals and other small businesses offering ongoing services related to shamanism.

Reviews: book. Interviews: with artists include full color illustrations of their work. Bibliographies: "Received and Noted" lists titles and brief information about books and other media. Listings: national–international. "Regional Calendar" free list of classes, workshops and events listed by regions of the U.S. and including out–of–country as one region. Reviewed: *Library Journal* 112:12, Jl 1987, p.59.

Advertising: Rates on request. "Unclassified": $1/wd., $50/col.in. (payment with copy)—suited for small business and cottage industry selling mail order products. Judy Wells, Ad. Director.

TURTLE QUARTERLY. 1986. q. EN. 704

Native American Center for the Living Arts, 25 Rainbow Mall, Niagara Falls, NY 14303. Phone 716–284–2427. Tim Johnson, Editor.

Subscription: $10 US, $15 Canada. Illus. b&w, cartoons. 8½ x 11, 52p.

ISSN: 0896–2022. OCLC: 15074805. LC: E77.T938. Dewey: 974. Formerly: *Turtle Quarterly Magazine; Turtle Newsletter.*

General. Literature.

"America's foremost magazine on Indian life." Funded by the National Endowment for the Arts spotlights Native American art, profiles of elders, and geographic articles on the Indian Nation presented from a native perspective.

Reviews: book. Freelance work: yes. Contact: editor. Reviewed: Katz.

Advertising: Andrea Aubin, Ad. Director. Mailing lists: available to rent.

WESTERN ART NEWS. 1980. m. EN. 705

Art of the Old West, Inc., c/o Judy Spurgin, Box 913, Georgetown, TX 78627. Bob Helberg, Editor.

Illus.

OCLC: 6380774. Dewey: 706.5.

"An objective compilation of information for the collector".

Reviews: book.

Advertising.

WHISPERING WIND MAGAZINE: The American Indian: Past & Present. 1967. bi–m. EN. 706

Written Heritage, 8009 Wales St., New Orleans, LA 70126–1952. Phone 504–241–5866. Jack B. Heriard, Editor.

Subscription: $15 US, $20 Canada & foreign, $35 air. Sample & back issues $4. Illus. b&w, color, photos, cartoons. 8½ x 11, 44p.

ISSN: 0300–6565. OCLC: 1355769. LC: E75.W46. Dewey: 970.004.

Crafts. Hobbies.

Official publication of the Louisiana Indian Hobbyist Association. Scholarly presentations on the American Indian: material culture, crafts, culture, and history. Coverage of the contemporary powwow scene with descriptions of Indian dance clothing. Advertisers are dealers in craft materials, Indian jewelry, and other Native American related merchandise.

Reviews: book 3, length 300+ wds. Biographies. Listings: national. Listing of powwow dates, American Indian organizations. Freelance work: none. Opportunities: study, competitions. Reviewed: Katz.

Advertising: (rate card Sept '90): full page $159, ½ page $82, ¼ page $54; color full page $920, ½ page #54. Classified: 40¢/wd. Frequency discount. 15% agency discount. Mailing lists: available. Demographics: national, all 50 states, 3% of the readership is in Canada and other foreign countries. Circulation: 3000. Audience: general with an interest in the American Indian.

Women

CALYX: A Journal of Art and Literature by Women. 1976. s–a. EN. 707

Calyx, Inc., Box B, Corvallis, OR 97339. Phone 503–753–9384. Magarita Donnelly, Editor.

Subscription: $18 individual, $25 institution US; Canada & foreign + $4 surface, $9 airmail. Sample $8 + $1 postage. Back issues. Illus b&w, photos. 7 x 8, 112p.

ISSN: 0147–1627. OCLC: 3114927. LC: PS508.W7C35. Dewey: 810. Formerly: *Calyx, A Northwest Feminist Review.*

General. International. Art. Literature.

Showcases work by women writers and artists. Includes art, photography, poetry, fiction, and essays. Promotes the work to a wide reading audience. Special issues.

Reviews: book 15–20, length 1000 wds. Bibliographies: in special double issues devoted to special themes. Interviews: occasionally with women artists or writers. Biographies occasionally. Reviewed: *Serials Review* 13:4, Win 1987, p.46–9. *Library Journal* 115:8, Jan 5 1990, p.122.

Advertising: (payment with ad) full page $550, ½ page $285, ¼ page 150, no color. Classified: 75¢/wd. 20%–25% frequency discount to non–profit & feminist organizations. Demographics: mainly women, 80% own original art, read an average of 3 books/month, subscribe to other publications. Mailing lists: $50/1000. Circulation: 3000–5000. Audience: general.

THE CREATIVE WOMAN. 1977. 3/yr. EN. 708

Governors State University, University Park, IL 60466. Phone 312–534–5000. Helen E. Hughes, Editor.

Subscription: $10 individual, $20 institution US & Canada; foreign $12. Sample $3. Back issues $2–3. Illus b&w, photos, cartoons. Index in even–numbered volumes. 8½ x 11, 48p.

ISSN: 0736–4733. OCLC: 8809365. Dewey: 305.

Art Criticism. Painting. Photography. Literature.

Focuses on a special topic in each issue, presented from a feminist perspective. Celebrates the creative achievements of women in many fields and appeals to inquiring minds. Publishes fiction, poetry, book reviews, articles, photographs and original graphics.

Reviews: (3/issue) exhibition, book, film. Bibliographies: A selected bibliography in every issue. Biographies. Interviews. Listings: regional–international. Exhibition information. Freelance work: yes. Contact: editor. Opportunities: study, competitions.

Circulation: 1000. Audience: feminists.

CWAO NEWS. 1982. m. EN. 709

Coalition of Women's Art Organizations, 123 E. Beutel Rd., Port Washington, WI 53074. Phone 414–284–4458. Dorothy Provis, Editor.

Subscription: included in membership, $10 individual, $25 organizations; foreign + postage. Sample free. Back issues $1. no illus. 8 x 14.

Art Education. Art History. Films (women's).

Focus on arts legislation pending in Washington and state arts issues when necessary. A grass roots advocacy organization working for improved legislation for the arts community, dedicated to the achievement of equality for all women in the arts. The newsletter informs its membership of action needed to support or reject arts legislation and attempts to keep its readers aware of the legislative events in the country which affect all artists.

Bibliographies: occasionally list new arts/women's publications. Listings: regional–international. Freelance work: none. Opportunities: study – listing of planned arts/women's conferences.

Advertising: none. Mailing lists: none. Demographics: membership is a network of individual art professionals and art organizations in the U.S. (including both female and male members). Circulation: 15,000. Audience: membership: artists, art historians, art professors, arts community.

FEMINIST ARTS NEWS/FAN. 1987. q. EN. 710

Feminist Arts News, 15 Wordsworth Ct., Shakespeare, Bedford MK40 2EJ England.

Subscription: $33.31.

ISSN: 0264–7060.

Indexed: Des&ApAI.

GALLERIE: WOMEN ARTISTS. 1988. q. EN. 711

Gallerie Publications, 2901 Panorama Dr., North Vancouver, B.C. V7G 2A4 Canada. Phone 604–929–8706, fax 604–922–8340. Caffyn Kelley, Editor.

Illus.

ISSN: 0838–1658. OCLC: 18935907. LC: N7630, NX180.F4G34. Dewey: 704. Formerly: *Gallerie: Women's Art.*

Women artists from across North America discuss their art and concerns. Presents critical and historical articles on Women's art.

Reviews: book. Listings: Canadian. Indexed: ArtBibMod.

Advertising.

HERESIES: A Feminist Publication on Art and Politics. 1977. q. EN. 712

Heresies Collective, Inc, Box 1306, Canal Street Station, New York, NY 10013. Phone 212–227–2108.

Subscription: $23 individual, $33 institution. Illus.
ISSN: 0146–3411. OCLC: 2917688. LC: HQ1101.H43. Dewey: 305.4.
"An idea–oriented journal devoted to the examination of art and politics from a feminist perspective. We believe that what is commonly called art can have a political impact and that in the making of art and all cultural artifacts our identities as women play a distinct role. We hope that *Heresies* will stimulate dialogue around radical political and aesthetic theory, as well as generate new creative energies among women. It will be a place where diversity can be articulated. We are committed to broadening the definition and function of art. Published by a collective of feminists...our fields include painting, sculpture, writing, anthropology, literature, performance, art history, architecture, film making, photography, and video. Each issue will have a different editorial staff composed of members of the mother collective and other women interested in that theme". Funded in part by the New York State Council on the Arts and the National Endowment for the Arts.
Indexed: ArtBibMod. ArtI. Reviewed: *New Art Examiner* 18:1, Sept 1990, p.59–60.

KALLIOPE: A Journal of Women's Art. 1979. 3/yr. EN. 713

Florida Community College, Kalliope Writers' Collective, Center for the Continuing Education of Women, 3939 Roosevelt Blvd., Jacksonville, FL 32205. Phone 904–387–8211. Mary Sue Koeppel, Editor.
Subscription: $10.50. $18 institution US; $16.50 individual, $24 institution Canada & foreign. Microform available from UMI. Sample & back issues $7. Illus. b&w, photos, cartoons. 7¼ x 8½.
ISSN: 0735–7885. OCLC: 8981808. LC: NX504.K34. Dewey: 700.
Modern Art. Photography. Literature.

Provides a forum for the exchange and sharing of ideas for and by women. Presents visual arts, poetry, and fiction. Sponsored by the College and the Florida Dept. of State, Division of Cultural Affairs.
Reviews: book 6/vol. Interviews: 1/issue featuring major woman writer or visual artist. Listings: regional. Freelance work: yes (details in *Art Mkt.*). Contact: editor.
Advertising: none. Circulation: 1200.

K.I.D.: KIDS ILLUSTRATED DRAYTON SUPPLEMENT. See no. 1699.

NATIONAL ASSOCIATION OF WOMEN ARTISTS ANNUAL EXHIBITION. 1889. a. EN. 714

National Association of Women Artists, 41 Union Sq., W., Rm. 906, New York, NY 10003. Phone 212–675–1616. Virginia Block, Editor.
Illus. some color.
OCLC: 7691445, 4914824. Dewey: 706. Formerly: *National Association of Women Painters and Sculptors Annual Exhibition*. Annual exhibition catalog contains lists of exhibiting members plus those receiving awards. B&w reproduction of prize–winning works are included.
Advertising. Marion Klein, Ad. Director. Circulation: 1000.

NATIONAL ASSOCIATION OF WOMEN ARTISTS—NEWS. s–a. EN. 715

National Association of Women Artists, 41 Union Sq., W., New York, NY 10003. Phone 212–675–1616. Virginia S. Block, Editor.
Newsletter covering the activities of women artists including notices of awards and corporate and museum purchases.
Bibliographies: publications list. Calendar of events. Exhibition information. Opportunities: announces awards.

NATIONAL MUSEUM OF WOMEN IN THE ARTS NEWS. 1983. q. EN. 716

National Museum of Women in the Arts, 1250 New York Ave., NW, Washington, DC 20005. Phone 1–800–222–7270, fax 202–393–3235. Brett Topping and Nancy Lutz, Editors.
Subscription: included in membership $25. Illus. 8¼ x 10¾, 8p.
ISSN: 0891–1827. OCLC: 14643889. Dewey: 708.
Devoted to the Museum and to work of women artists.

NATIONAL UPDATE. 1978. q. EN. 717

Moore College of Art & Design, 20th & The Parkway, Philadelphia, PA 19103. Phone 215–854–0922.
Subscription: included in membership.
ISSN: 1052–4959. OCLC: 22427705. Dewey: 700.
Newsletter relating information of interest to women in all the visual arts professions. Presents articles as well as national and chapter news.
Calendar of events. Opportunities: employment and exhibition opportunities.
Audience: professional women in visual arts fields.

P.W.P. NEWSLETTER. See no. 2633.

POLAREYES. 1987. EN. 718
Black Women & Photography, c/o The Cockpit, Cultural Studies Dept., Princeton St., London WC1, England.
Photography.

"A journal by and about black women working in photography".

SIBYL-CHILD. 1975. 3/yr. EN. 719
Sibyl–Child Press, Inc., Box 1773, Hyattsville, MD 20788. Phone 202–723–5468. Saundra Maley & Nancy Prothro, Editors.
Illus.
ISSN: 0161–715X. OCLC: 2568590. LC: N1.S54. Dewey: 700.
"A women's arts & culture journal".
Reviews: book.
Advertising.

SOCIETY OF WOMEN ARTISTS. PUBLICATION. a. EN. 720
Society of Women Artists, Westminister Gallery, Westminister Central Hall, Storey's Gate, London SW1H 9NU England.
Phone 071–222 2723.
Subscription: included in membership, non–members £1.50.
Dewey: 706.
Catalogue of exhibitions.

SPHINX: Women's International Literary Review. 1984. a. EN, occasionally in FR. 721
Sphinx International, 175 Ave. Ledru–Rollin, 75011 Paris, France. Carol Pratl, Editor.
Illus.
ISSN: 0755–964X. OCLC: 18375088. LC: PN471.S68.
Spotlights women artists and authors.

UPDATE [Women's Caucus for Art]. 1978. q. EN. 722
Women's Caucus for Art, c/o Moore College of Art, 20th & the Parkway, Philadelphia, PA 19103. Phone 215–565–1101. Assistant to the President, Editor.
Subscription: included in membership. No sample. No back issues. Illus. b&w. 18p.
Dewey: 700.
Women. Fine Arts.

Tabloid presenting information and short articles of interest to women in the visual arts.
Opportunities: employment, study, competitions.
Advertising: none. Mailing lists: available, screened $75/1000. Circulation: 4000. Audience: women in the visual arts, U.S.

W.C.A. HONOR AWARDS. 1980. a. EN. 723
Women's Caucus for Art, Moore College of Art, 20th & The Parkway, Philadelphia, PA 19103. Phone 215–565–1101. A member of the Advisory Board serves as editor.
Subscription: included in membership, $5. No sample. Back issues. Illus. b&w, photos. 8 x 8, 20p.
OCLC: 21981017. LC: N394.W65; N6512.W597. Dewey: 700.
Art Education. Art History.

Honors five women who have had distinguished careers in the arts. Catalog contains biographical essays of the women honored at the national conference together with a chronology of their work and bibliography.
Freelance work: none.
Advertising: none. Mailing lists: available, screened $75/1000. Circulation: 4000. Audience: art historians, women artists, faculty of educational institutions, librarians, women in the visual arts.

WOMAN'S ART JOURNAL. 1980. s–a. EN. 724
Woman's Art, Inc., 1711 Harris Rd., Philadelphia, PA 19118–1208. Phone 215–233–0639. Elsa Honig Fine, Editor.
Subscription: $13 individual, $17 institution US; + $2 Canada & foreign; air + $6. Microform available from UMI. Sample $8.50. Back issues, v.7–9. Illus. 40, 35 b&w, 5 color. 8½ x 11, 56p.
ISSN: 0270–7993. OCLC: 6497852. LC: N72.F45 W64. Dewey: 704.

Architecture. Art Education. Art History. Ceramics. Crafts. Decorative Arts. Drawing. Films. Modern Art. Painting. Photography. Sculpture.

Devoted to women and issues related to women in all areas of the visual arts. Articles document the lives and works of women artists neglected by history as well as contemporary artists. Coverage includes images of women, art issues related to women, and theoretical issues.

Reviews: book 16, length 2–12 pages. Biographies: on women in all areas of the visual arts, historical and contemporary. Freelance work: none. Indexed: ArtBibCur. ArtBibMod. ArtHum. ArtI. BHA. BioI. CloTAI. CurCont. IBkReHum. RILA. Reviewed: Katz. *New Art Examiner* 18:1, Sept 1990, p.59–60.

Advertising, no classified. No frequency discount. Mailing lists: none. Demographics: Those who buy books on women in the arts for themselves or institutions. Circulation: 2000. Audience: anyone interested in art.

WOMEN AND ENVIRONMENTS. See no. 2155.

WOMEN & PHOTOGRAPHY. See no. 2737.

WOMEN ARTISTS NEWS. 1975. q. EN. 725

Midmarch Associates, Box 3304, Grand Central Station, New York, NY 10163. Phone 212–666–6990. Rena Hansen, Editor.

Subscription: $12 individual, $16 institution US; $16.50 Canada, $26 foreign air. No sample. Back issues $3–4. Illus. b&w, photos. 8½ x 11, 40–68p.

ISSN: 0149–7081. OCLC: 3534670. LC: N6512.W587. Dewey: 704. Formerly: *Women Artists Newsletter*.

General.

Focus is on women in the arts. Purpose is to include information and material of interest so as to increase the visibility of women artists, both contemporary and historical. Publication includes articles, reviews, history of exhibitions across the country, news on publications, opportunities and general information.

Reviews: exhibition 5–6, length 350–700 wds., book 2–6; film 1. Interviews: with women artists, writers etc. Listings: national–international. Calendar of events. Exhibition information. Freelance work: yes (details in *ArtMkt.*). Contact: editor. Opportunities: employment, study – workshops, conferences, competitions, fellowships, grants, shows. Indexed: ArtBibMod. ArtI. BHA. BioI. RILA. Reviewed: Katz. *New Art Examiner* 18:1, Sept 1990, p.59–60.

Advertising: full page $375, ½ page $270, ¼ page $170, no color. Classified: $5/line, $25 min. 10% frequency discount. All ads prepaid (300 Riverside Dr., New York, NY 10025). Mailing lists: none. Demographics: 99% women, 50% readership East Coast, remainder country–wide, Europe, Australia. Circulation: 5,000. Audience: artists, art students, art writers, museum & gallery personnel, interested lay persons.

WOMEN ARTISTS SLIDE LIBRARY JOURNAL. 1986. bi–m. EN. 726

Women Artists Slide Library, Fulham Palace, Bishop's Ave., London SW6 6EA, England. Phone 071–731 7618. Caryn Walker, Editor.

Subscription: included in membership, £10 individual, £20 institution UK; £20 Europe, £30 elsewhere. Back issues. Illus. b&w, photos. Cum. index no.13–33, Oct 1986–Apr 1990. 42p.

ISSN: 0951–0230. OCLC: 18957662. Formerly: *Women Artists Slide Library Newsletter*.

Feature articles, news and reviews of women's art.

Reviews: exhibition. Bibliographies. Listings: WASL free listings service. Indexed: ArtBibMod.

Advertising: Paula Steere, Ad. Director. Demographics: Membership includes any woman practicing visual arts in any media, any woman art historian or art writer of any nationality.

WOMEN IN THE ARTS NEWSLETTER. 1972. bi–m. EN. 727

Women in the Arts Foundation, Inc., c/o Roberta Crown, 1175 York Ave., Apt.2G, New York, NY 10021. Phone 212–751–1915. Jacqueline Skiles, Editor.

Subscription: included in membership; non–members individuals $9 US, $12 Canada, $13 foreign; institutions $18 US, $18 Canada, $19 foreign. Illus. b&w. 8½ x 11, 8p.

OCLC: 3718194. Formerly: *Women in the Arts Bulletin/Newsletter*.

Focuses on issues concerning women artists. Includes news of members, exhibit announcements and other opportunities of interest to women artists.

Reviews: book. Calendar of events. Freelance work: yes. Contact: editor. Opportunities: employment.

Advertising. Circulation: 500. Audience: women artists.

WOMEN'S BUILDING NEWSLETTER. 1981. q. EN. 728

Women's Building, 1727 N. Spring St., Los Angeles, CA 90012. Phone 213–222–2477.
Dewey: 700. Formerly: *Programs of the Women's Building. Newsletter; WGC Newsletter*.

WOMEN'S CAUCUS FOR ART NEWSLETTER. q. EN. 729

Moore College of Art & Design, 20th & The Parkway, Philadelphia, PA 19103. Phone 215–854–0922.
Subscription: included in membership. 10p.

WOMEN'S INTERNATIONAL CULTURAL FEDERATION BULLETIN. 3/yr. EN, FR, GE, IT. 730

Women's International Cultural Federation, 62, rue de Rome, F–75008 Paris, France.
Seeks to unite women artists working in the medium of plastic.

Sculpture

AMERICAN MEDALLIC SCULPTURE ASSOCIATION MEMBERS EXCHANGE. bi–m. EN. 731

American Medallic Sculpture Association, c/o Beverly Mazze, President, 55 5th Ave., 18th floor, New York, NY 10003.
Phone 212–924–0200.
Subscription: included in membership, $25 US, foreign air $35 together with subscription to *Medallic Sculpture*. No illus.
8½x11, 6p.

General. Antiques. Art Education. Art History. Collectibles. Decorative Arts. Sculpture.

Provides information to anyone interested in medallic art — sculptors, collectors, corporate recognition industry, suppliers, mints, foundries, museum curators, and educators. Contains Association news.
Listings: regional–international. Calendar of events. Exhibition information. Freelance work: none. Opportunities: Employment. Study – seminars and workshops. Competitions.
Advertising. Demographics: mints, foundries, suppliers, corporate recognition industry, corporate gifts. Mailing lists: none.
Circulation: 350. Audience: anyone interested in or involved in field of medallic art.

BROOKGREEN NEWSLETTER. See no. 2513.

CHURCH MONUMENTS. 1985. a. EN. 732

Church Monuments Society, c/o The Armouries, H.M. Tower of London, London EC3N 4AB, England. Richard Knowles (30 Newland Ct., Sandal, Wakefield, Yorkshire WF1 5AC & Anthony Wells–Cole (Temple Newsam House, Leeds, Yorkshire LS15 OAE), Editors.
Subscription: included in membership, UK £9 individual, £12 family, £12 corporate (Dr. John Low, Hon. Membership Sec., 13 Wragby Rd., Lincoln LN2 5SH). No sample. Back issues £12. Illus., b&w 30–40 average, color occasionally. 9¾ x 7½, 72p.
ISSN: 0268–7518. OCLC: 16787771. LC: N7943.C55. Dewey: 730. Formerly: Continues in part *Bulletin* (International Society for the Study of Church Monuments); *Church Monuments Society Newsletter*.
Sculpture.

Unique specialist journal containing articles of interest on tomb–sculpture, particularly in Britain, but not necessarily so. 1992 issue planned to cover monuments in other European Community countries.
Freelance work: yes. Contact: editor. Indexed: ArchPI.
Advertising: none. Audience: amateurs and specialists.

COURTAULD INSTITUTE OF ART ILLUSTRATION ARCHIVE 2: 15TH & 16TH
CENTURY SCULPTURE IN ITALY. 1976. irreg. EN. 733

Harvey Miller Publishers, 20 Marryat Rd., London SW19 5BD, England. Phone 081–946 4426. Constance Hill, Editor
(Courtauld Institute of Art, Somerset House, Strand, London WC2R 2LS).
Subscription: $30/issue, special discounts for sets. No sample. Back issues. Illus. photos, plans. Index. 297 x 210mm.
ISSN: 0307–806X. OCLC: 3998337. Formerly: *15th and 16th Century Sculpture in Italy.*.
Art History. Sculpture.

This Archive offers archival material of prime importance for the study of Renaissance art and history. It is based on several special photographic campaigns undertaken by the Institute, covering churches and public monuments in relatively undocu-

mented regions in Emilia and Lombardy, as well as important Renaissance sculpture in Rome, Venice and Naples. Each issue covers a particular geographic area or city.

Advertising: none. Audience: art history students, Renaissance historians.

COURTAULD INSTITUTE OF ART ILLUSTRATION ARCHIVE 3: MEDIEVAL ARCHITECTURE & SCULPTURE IN EUROPE. 1977. irreg. EN. **734**

Harvey Miller Publishers, 20 Marryat Rd., London SW19 5BD, England. Phone 081–946 4426. Peter Lasko & Lindy Grant, Editors (Courtauld Institute of Art, Somerset House, Strand, London WC2R 2LS).

Subscription: $30/issue, special discounts for sets. No sample. Back issues. Illus. photos, plans. Index. 297 x 210mm. ISSN: 0307–8078. OCLC: 3998461.

Architecture. Art History. Historic Preservation. Sculpture.

Offers wide–ranging survey materials for reference and research. It illustrates specific monuments in great detail, but also scans the principal medieval sculpture and architecture in areas which up to now have been rarely documented, or not at all, because of difficulty of access or previous lack of photographs.

Advertising: none. Audience: art history students, architectural historians.

COURTAULD INSTITUTE OF ART ILLUSTRATION ARCHIVE 4: LATE 18TH & EARLY 19TH CENTURY SCULPTURE IN THE BRITISH ISLES. 1977. irreg. EN. **735**

Harvey Miller Publishers, 20 Marryat Rd., London SW19 5BD, England. Phone 081–946 4426. Benedict Read & Philip Ward Jackson, Editors (Courtauld Institute of Art, Somerset House, Strand, London WC2R 2LS).

Subscription: $30/issue, special discounts for sets. No sample. Back issues. Illus. Index. ISSN: 0307–8086. OCLC: 3998285.

Art History. Historic Preservation. Sculpture.

The Institute has been systematically recording all the public statuary and funerary monuments of the period. The illustrated material is presented with many detail views and includes much hitherto unknown works. Each issue covers a particular geographic area or city.

Advertising: none. Audience: art history students.

INTERNATIONAL CHAIN SAW WOOD SCULPTORS ASSOCIATION BULLETIN. m. EN. **736**

International Chain Saw Wood Sculptors Association, c/o Tom Rone, 14041 Carmody Dr., Eden Prairie, MN 55347. Phone 612–934–8400.

Subscription: sculptors, artists.

Newsletter promoting the art of chain saw sculpting.

MARKERS. 1980. a. EN. **737**

Association for Gravestone Studies, c/o Rosalee F. Oakley, Exec. Director, 46 Plymouth Rd., Needham, MA 02192. Phone 617–455–8180. Theodore Chase, Editor.

Illus.

ISSN: 0277–8726. OCLC: 6690897. LC: E159.5.M28. Dewey: 973.

Sculpture.

Scholarly articles relating to the study of gravestones from colonial times to the present, covers many aspects of funerary art, preservation, and history in different parts of the United States.

Advertising: none.

THE MEDAL. 1982. s–a. EN, FR, GE. EN summaries. **738**

British Art Medal Trust, c/o Mark Jones, Editor, Dept. of Coins and Medals, British Museum, London WC1B 3DG, England. Phone 071–636 1555. Mark Jones, Editor.

Subscription: £15 members, £20 non–members. Sample. Some back issues. Illus. b&w, some color, glossy photos, charts. Separate cum. index, nos. 1–10, 1982–86. A4, 136p.

ISSN: 0263–7707. OCLC: 10634993. LC: CJ5501.M43. Dewey: 737.

International news, heavily illustrated, many large photos of art work on coins and new medallic work. Covers both the history of medals and contemporary medals. Published in association with FIDEM (The Federation Internationale de la Medaille).

Reviews: book 4, length 400 wds. Biographies: past and contemporary medallists. Listings: international. Calendar of events. Exhibition information. Freelance work: yes. unpaid. Contact: editor. Indexed: ArtBibMod. RILA.

Advertising: full page £250, ½ page £140, ¼ page £75, color £500. Frequency discount. Helen Frizzel, Ad. Director (A.H. Baldwin & Sons, Ltd., 11 Adelphi Terrace, London WC2N 6BJ). Circulation: 800. Audience: art historians, collectors, curators, dealers and others interested in contemporary and historical medals.

MEDALLIC SCULPTURE. a. EN. 739

American Medallic Sculpture Association, c/o Beverly Mazze, President, 55 5th Ave., 18th floor, New York, NY 10003. Phone 212–924–0200.

Subscription: included in membership, $25 US, foreign air $35 together with subscription to *Members Exchange*. Illus. b&w, photos.

General. Antiques. Art Education. Art History. Collectibles. Decorative Arts. Sculpture.

Provides information on medallic art to sculptors, collectors, corporate recognition industry, suppliers, mints, foundries, museum curators, and educators.

Freelance work: none.

Advertising. Demographics: mints, foundries, suppliers, corporate recognition industry, corporate gifts. Mailing lists: none. Circulation: 350. Audience: anyone interested in or involved in field of medallic art.

MONUMENTAL BRASS SOCIETY BULLETIN. 1987. 3/yr. EN. 740

Monumental Brass Society, East Cliff Cottage, East Cliff Parade, Herne Bay, Kent, CT6 5HU England. Leslie Smith, Editor.

Subscription: included in membership (Hon. Asst. Sec. Martin Struchfield, 21 Stoneham St., Coggeshall, Essex C06 1TT). Illus. b&w, drawings. A4, 19p.

ISSN: 1316–1612.

Brief articles, notes & queries on brasses, meeting reports, and notes of members.

Bibliographies: "Notes on Books and Articles" with brief annotation. Obits. of members. Calendar of events.

Advertising: full page £50, ½ page £30.

NEWSLETTER OF THE ASSOCIATION FOR GRAVESTONE STUDIES. 1977. q. EN. 741

Association for Gravestone Studies, c/o Rosalee F. Oakley, Exec. Dir., 46 Plymouth Rd., Needham, MA 02192. Phone 617–455–8180. Deborah Trask, Editor (Nova Scotia Museum Complex, 1747 Summer St., Halifax, NS B3H 3A6 Canada.

Subscription: included in membership, $20 US. Back issues $3. Illus. Cum. index v.1–5, 1977–81. 8½ x 14, 26–28p.

ISSN: 0146–5783. OCLC: 2970428. Dewey: 709.

Art Education. Art History. Decorative Arts. Historic Preservation. Sculpture.

Focus is on grave markers of all kinds from all parts of the United States and Canada. Includes feature articles, exhibits, research, items for genealogists and conservators, Association information, archival additions, members activities, conference speakers, tours, and reports.

Reviews: book 1–2, length 1p. Freelance work: members submit articles, no pay.

Advertising: none. Circulation: 900. Audience: membership.

NEWSLETTER / THE CHURCH MONUMENTS SOCIETY. See no. 647.

OXFORD ART JOURNAL. See no. 211.

PRIMEVAL SCULPTURE. 1984. q. EN, FR, GE, IT, & SP. 742

Primigenia Editrice, Piazza Paolo da Novi 3–7, I–16129 Genoa, Italy. Pietro Gaietto, Editor.

Subscription: L 27000. Illus.

OCLC: 13844145.

SCULPTORS GUILD—GUILD REPORTER. 1986. s–a. EN. 743

Sculptors Guild, 110 Greene St., New York, NY 10012. Phone 212–431–5669. Phyllis Mark, Editor.

Subscription: free. Illus. photos.

Sculpture.

Newsletter covering occupational health hazards, sculpture exhibitions, and listing of exhibition opportunities.

Obits.

Advertising. Audience: professional sculptors.

SCULPTURE. 1982. bi–m. EN. **744**

International Sculpture Center, 1050 Potomac St., N.W., Washington, DC 20007. Phone 202–965–6066. Penelope Walker, Editor.

Subscription: included in membership, $40 US & Canada, foreign $50. Sample. Back issues $4. Illus. b&w, color, photos. 8¼ x 11, 96p.

ISSN: 0889–728X. OCLC: 14039712. Dewey: 730. Formerly: *National Sculpture*.

Sculpture.

Reviews: exhibition 6–8, length 500 wds.; book 10–12, length 150 wds. Interviews: 1–2 per issue, 1500 wds. Listings: international. Calendar of events. Exhibition information. Opportunities: Study. Competitions. Reviewed: Katz.

Advertising: full page $1030, ½ page $680, ¼ page $470, color full page $1950, ½ page $1300, ¼ page $780. Frequency discount. Laura King, Ad. Director. Mailing lists: available. Demographics: artists, collectors, gallery and museum directors, architects, developers, industry professionals. Circulation: 25,000. Audience: all those interested in contemporary sculpture.

SCULPTURE REVIEW. 1951. q. EN. **745**

National Sculpture Society, 15 E. 26th St., Rm. 1906, New York, NY 10010–1575. Phone 212–889–6960. Theodora Morgan, Editor.

Subscription: free to sculpting members of the NSS; $15 US, $18 Canada & foreign. Microform available from UMI. Sample free. Back issues $4. Illus. b&w, 1 color (tip–in), photos. Cum. index. 8½ x 11, 39p.

ISSN: 0747–5284. OCLC: EN. LC: NB1.N29. Dewey: 730. Formerly: *National Sculpture Review*.

Sculpture.

Deals primarily with contemporary and historical representational American sculpture. Each issue contains about 40 fine reproductions, a color tip–in, news of sculpture, and technical information.

Reviews: exhibition 2 and book 2–4, length 1–2 paragraphs. Listings: national. Exhibition information. Freelance work: rarely. Contact: editor. Opportunities: annual exhibition, runs the youth awards. Indexed: ArtHum. ArtI. BioI. BkReI. CurCont.

Advertising: (rate card Apr '88): full page $390, ½ page $240, ¼ page $175, covers $390–420. Frequency discount. Agency discount. Demographics: national circulation includes fine, applied and commercial art fields—fine and commercial artists, architects, art directors, designers, craftsmen, amateurs, art teachers and schools, art students, art museums, art galleries, art libraries, and those interested in the sculpture phase of American culture. Circulation: 5000. Audience: sculptors, architects, sculpture enthusiasts.

SOCIETY OF PORTRAIT SCULPTORS. PUBLICATION. a. EN. **746**

Society of Portrait Sculptors, 17 Carlton House Terrace, London SW1Y 5BD, England.
Dewey: 730.

Sculpture.

Catalogue of exhibitions. Co–sponsored by the Federation of British Artists.

WILDFOWL CARVING AND COLLECTING. 1985. q. EN. **747**

Stackpole Inc., Cameron and Kelker Sts., Box 1831, Harrisburg, PA 17105. Phone 717–234–5091, fax 717–234–1359. Cathy Hart, Editor.

Subscription: $29.95 US, $35 Canada, $45 foreign. No sample. Back issues. Illus. b&w, color, photos. 8¼ x 10¾, 104p. Offset, perfect bound.

ISSN: 0886–3407. Dewey: 790.13.

Collectibles. Hobbies. Painting. Photography.

Provides in–depth coverage of the world of wildfowl carving, reference and instruction for bird carving enthusiasts. Through detailed photographs, carving demonstrations and thoroughly researched articles, both the amateur and the master carver are kept abreast of the latest happenings in this field. Unique blend of start–to–finish carving projects, detailed reference photos of live birds, and information–packed articles. Profiles of classic carvers. An extensive "Events Directory" provides up–to–date information on competitions and exhibitions across the country. Publishes source articles once a year.

Interviews: with prominent carvers and collectors. Biographies: articles on carvers/collectors important to carving/collecting history. Listings: regional. Calendar of events. Exhibition information. Freelance work: yes (details in *ArtMkt.*). Opportunities: competitions.

Advertising: (rate card Apr '88): full page $645, ½ page $385, ¼ page $225, inside covers $775; 2 color + $250, cover $1075; 4 color + $400, covers $1255–1465. Classified: $16 for 25 wds., $26 for 50 wds. Frequency discount. 15% agency discount. Inserts. Bleed + 10%. Preferred position + 15%. Andrea McClimans, Ad. Director. Demographics: Readers' survey shows that 43% are interested in wood working, 97% read the ads, and 75% bought products advertised. Circulation: 12,000. Audience: decorative bird carvers & decoy collectors in U.S. & abroad.

Painting & Drawing

ART IN WISCONSIN. 1985. m. EN. **748**
Wisconsin Painters and Sculptors, Inc, 7662 N. Sherman Blvd., Milwaukee, WI 53209. Phone 414–354–0171. Gary John Gresl, Editor.
Subscription: $25. Illus.
OCLC: 18214546. Formerly: *Wisconsin Painters and Sculptors, Inc. Newsletter.*
Painting. Sculpture.
Newsletter of the organization.

BEBOP DRAWING CLUB BOOK. 1974. irreg. EN. **749**
Artman's Press, 1511 McGee Ave., Berkeley, CA 94703. Glenn Myles, Editor.
Illus.
Dewey: 740.
Drawing.

BUFFALO FINE ARTS ACADEMY CATALOGUES. 1911, no.91. irreg. EN. **750**
Buffalo Fine Arts Academy, 1285 Elmwood Ave., Buffalo, NY 14222. Phone 716–882–8700, fax 716–882–1958.
Illus.
OCLC: 8646751.
Drawing. Painting.
Catalogues of the Albright–Knox Art Gallery painting and drawing exhibition. Each number also has a distinctive title.

CANADIAN SOCIETY OF PAINTERS IN WATERCOLOUR - NEWSLETTER. 3/yr. EN. **751**
Canadian Society of Painters in Watercolour, c/o Visual Arts Ontario, 439 Wellington St., W., 3rd Floor, Toronto, Ontario, Canada M5V 1E7. Phone 416–591–8883. John Hanson, Editor.
Painting.

DRAWING: The International Review. 1979. bi–m. EN. **752**
Drawing Society, Inc, 15 Penn Plaza, Box 66, 415 Seventh Ave., NY 10001–2050. Phone 212–563–4822. Paul Cummings, Editor.
Subscription: included in membership, non–members $35 US, foreign: + $12.50 for international postage. Illus. b&w, photos, drawings. 8½ x 11, 24p.
ISSN: 0191–6963. OCLC: 4913358. LC: NC1.D76. Dewey: 740.
Drawing.
Scholarly articles, news and information regarding drawings of all cultures. Listings include: "International Auction Review" which lists artist, work, description, price, auction house and date; "Forthcoming Sales", and "Announcements" which contain information about galleries complete with address and hours open.
Reviews: Drawing exhibitions, book, museum & dealer catalogs. Interviews. Listings: international. Exhibition information.
Indexed: ArtBibCur. ArtBibMod. ArtI. Avery. BioI. RILA. Reviewed: Katz.
Advertising: none. Circulation: 1000.

DRAWING & GRAPHICS TODAY. 1975. bi–m. EN. **753**
Kingslea Press Ltd., 18/19 Ludgate Hill, Birmingham B3 1DW England.
Subscription: $26.50 UK, $47.90 elsewhere.
ISSN: 0951–0265. LC: NC. Formerly: *Drawing Paper.*
Drawing.

DRAWING SOCIETY ACTIVITIES. irreg. EN. **754**
Drawing Society, 15 Penn Plaza, Box 66, 415 Seventh Ave., New York, NY 10001. Phone 212–563–4822. Deborah Felstehausen, Editor.
Subscription: included in membership.
Drawing.

Newsletter of membership activities.
Advertising: none.

EDNA HIBEL SOCIETY NEWSLETTER. 1978. q. EN. 755

Edna Hibel Society, Box 9721, Coral Springs, FL 33075. Phone 305–752–8534. Ralph Burg, Editor.
Subscription: included in membership, $10; available free. Sample. Some back issues free. Illus b&w, photos. 15–24p.
Painting. Lithography.

News of Edna Hibel, the painter and lithographer. Information regarding her art as well as relevant articles on tours, exhibitions and receptions.
Biographies & Interviews: Edna Hibel. Listings: international. Exhibition information. Freelance work: seldom. Contact: editor.
Advertising: none. Mailing lists: none. Circulation: 7500. Audience: members.

HANDCLASP LETTER. s–a. EN. 756

Whiskey Painters of America, 103 Hazelwood Ave., Barberton, OH 44203. Phone 216–745–3682.
Subscription: included in membership.
Painting.

Newsletter reports on activities of the Society as well as presenting member profiles. Purpose is to promote the fine art of painting in miniature.
Calendar of events.

ILLUSTRATORS. 1973. bi–m. EN. 757

Association of Illustrators, 1 Colville Place, London W1P 1HN, England. Phone 071–636–4100. Aldam Walker, Editor.
Subscription: included in membership.
ISSN: 0307–319X. Dewey: 741.6.
Indexed: Des&ApAI.

INTERNATIONAL MAGAZINE FOR THE COLLECTOR OF WATERCOLOURS AND DRAWINGS. 1986. q. EN. 758

Consumer Communications Ltd., London House, 271–273 King St., Hammershimt, London W6 England.
Illus.
OCLC: 15543829.
Drawing. Painting.

INTERNATIONAL WATER COLOR GUILD NEWSLETTER. 1985. q. EN. 759

2230 Hillside Ct., Walnut Creek, CA 94596. Audrey Bustanoby, Editor & Pub.
2p.
ISSN: 8756–5285. OCLC: 11580681. Dewey: 751.
Painting.

Museum and gallery listings.

LIBRARY OF GREAT PAINTERS. irreg. EN. 760

Harry N. Abrams, Inc., 100 Fifth Ave., New York, NY 10011. Phone 212–206–7715.
Dewey: 700.
Painting.

MASTER DRAWINGS. 1963. q. EN. Tr. provided for GE, IT, DU & SP. 761

Master Drawings Association, Inc., 29 E. 36th St., New York, NY 10016. Anne–Marie Logan, Editor (Yale Center for British Art, 1080 Chapel St., New Haven, CT 06520).
Subscription: included in membership, $30, foreign $38. No sample. Back issues $50/issue. Illus. b&w. Annual index in 4th issue. Cum. index, v.1–20 (1984). 8⅜ x 10⅜, 104p.
ISSN: 0025–5025. OCLC: 1608040. LC: NC1.M3. Dewey: 741.
Art History. Drawing.

Devoted exclusively to the study and illustration of drawings including drawings for sculpture. Contents of unpublished old master drawings in collections worldwide; new dating for drawings due to new findings; and reattribution of drawings. Covers up to 1900 only.

Reviews: exhibition 3, length 10p.; book 2, length 10p. Listings: international. Freelance work: none. Indexed: ArtHum. ArtI. BHA. CloTAI. CurCont. IBkReHum. RILA. Reviewed: Katz.

Advertising: full page $350, ½ page $275, ¼ page $200, no color. No classified. Frequency discount. Elisabeth R. Agro, Ad. Manager. Mailing lists: none. Audience: art historians, collectors, dealers.

MODERN PAINTERS: A Quarterly Journal of Fine Arts. 1988. q. EN. 762

Fine Art Journals Ltd., 10 Barclay Mow Passage, London W4 4PH, England. (US Dist.: Expeditors of the Printed Word, 11 3545 Ave., Long Island City, NY 11101). Phone UK: 081–994 6477, fax 081–742 1462. US: 201–947–2674. Peter Fuller, Editor.

Subscription: $36 individual, $50 institution US; elsewhere £22 surface, £40 air individual; £33, air £48 institution (Central Books, 14 Leathermarket, London SE1 3ER England). Back issues £5 + postage. Illus. b&w, color, glossy photos. A4, 114–130p.

ISSN: 0953–6698. OCLC: 18302256. LC: N1.M65. Dewey: 759.

Painting.

Covers British artists from the Victorian period onward. Presents feature articles, exhibitions, regular columns, and "Gallery", a 2 page listing with color photo.

Reviews: exhibition & book 8–10 each, length 1–2p. each. Interviews. Indexed: ArtBibMod. Des&ApAI. Reviewed: *Choice* 26:6, Feb 1989, p.1018. *New Art Examiner* 15:11, Sum 1988, p.17–19; 17:3, Nov 1989, p.57–60.

Advertising: Ad. Director, US: Fred Stern (44 Paulin Blvd., Leona, NJ 07605, phone 201–947–2675), UK: Annabel Ludovici.

NATIONAL GALLERY TECHNICAL BULLETIN. See no. 1054.

OBVESTILA. 1975. 4–5/yr. SL. EN summaries. 763

Drustvo Exlibris Sloveniae, Trubarjeva 14, 61000 Ljubljana, Yugoslavia. Phone 061 312–332.
Subscription: free.
Dewey: 740.
Looseleaf publication.

OLD WATER-COLOUR SOCIETY'S CLUB ANNUAL VOLUME. 1924. a. EN. 764

Old Water-Colour Society Club, Bankside Gallery, 48 Hopton St., Blackfriars, London SE1 9JH, England. Phone 071 9287521, fax 071 9282820. James Knox, Editor.
Subscription: included in membership (c/o Michael Spender, Sec.). Illus. 7¾ x 9¾, 88p.
Dewey: 751.422.

Painting.

Majority of the volume presents articles on the life and works of artists complete with illustrations of their works. A publication of the Royal Society of Painters in Water-Colours.
Bibliographies with some articles. Biographies. Indexed: ArtBibMod. RILA.
Advertising: few ads.

PASTELGRAM. 1977. s–a. EN. 765

Pastel Society of America, 15 Gramercy Park, S., New York, NY 10003. Phone 212–533–6931. Barbara Fischman, Editor.
Subscription: included in membership.
Newsletter covering artists, their work, and the techniques of using pastels.
Advertising: none.

PEINTURE/CAHIERS THEORIQUES. 1971. q. 766

Association Peinture, c/o Editor, 37 rue d'Enghien, 75010 Paris, France. Louis Cane, Editor.
Subscription: 160 F (184 rue St. Maur, 75010 Paris). Tabloid.
Dewey: 750.

Painting.

ROYAL INSTITUTE OF OIL PAINTERS. PUBLICATION. a. EN. 767

Royal Institute of Oil Painters, 17 Carlton House Terrace, London SW1Y 5BD, England.

Subscription: included in membership, non–members 50p.
Dewey: 750.

Painting.

Catalogue of exhibitions. Co–sponsored by the Federation of British Artists.

ROYAL INSTITUTE OF PAINTERS IN WATER COLOURS. PUBLICATION. a. EN. 768

Royal Institute of Painters in Water Colours, 17 Carlton House Terrace, London SW1Y 5BD, England.
Dewey: 750.

Painting.

Catalogue of exhibitions. Co–sponsored by the Federation of British Artists.

ROYAL SOCIETY OF PORTRAIT PAINTERS. PUBLICATION. 1981. a. EN. 769

Royal Society of Portrait Painters, 17 Carlton House Terrace, London SW1Y 5BD, England.
Dewey: 757.

Painting.

Catalogue of exhibitions. Co–sponsored by the Federation of British Artists.

SERMENT DES HORACES (LE). See no. 230.

SUMI-E. See no. 685.

THE TURNER SOCIETY NEWS. 1977. q. EN. 770

Turner Society, P.O. Box BCM, London WC1 N3XX, England.
Subscription: included in membership. Illus.
ISSN: 0141–4135. OCLC: 16783908. Formerly: *Turner News.*

Painting.

Devoted to promoting the study and appreciation of the life and work of Joseph Turner, English painter.

UNIEP-INFO. 3–4/yr. EN, FR, & GE. 771

International Union of Master Painters, Maler–und Lackierer–Innung Hamburg, Holstenwall 12, D–2000 Hamburg 36, Germany. Phone 40 343887.

Painting.

Seeks to publicize and defend interests specific to master painters.

WATERCOLOURS AND DRAWINGS MAGAZINE. q. EN. 772

Friends of the Royal Society of Painters in Water–Colours, c/o Bankside Gallery, 48 Hopton St., Blackfriars, London SE1 9JH, England. Phone 071 9287521, fax 071 9282820.
Subscription: Includes subscription to *Friends News Supplement.*

Drawing. Painting.

WINSLOW HOMER: AN ANNUAL. 1986. a. EN. 773

Box 86, New Albany, IN 47150. Phone 812–944–9386. Gene Teitelbaum, Editor.
Subscription: $10. Sample. Back issues $10. Illus. b&w. 8½ x 11, 90p.
ISSN: 0890–7714. OCLC: 14391321. LC: N6537.H58 W56. Dewey: 750.

Art History. Drawing. Painting.

A profusely illustrated periodical devoted to American oil painter and water–colorist, Winslow Homer. Besides publishing original articles on an aspect of his life and career, the annual attempts to chronicle information concerning exhibitions of his works, books, and articles published in the previous year on Homer, and sales of Homers either through dealers or through auction houses.

Reviews: exhibition. book. journal. Bibliographies: both to the main article and to one aspect of his career. Biographies: on some aspect of Homer's life and career. Listings: national. Exhibition information. Freelance work: yes. Contact: editor. Indexed: ArtBibMod.

Advertising. Mailing lists: none. Audience: art libraries (university and museum), art dealers and individuals.

MUSEUMS AND ART GALLERIES

Museum Publications

ACKLAND. EN. **774**
University of North Carolina at Chapel Hill, Campus Box 3400, Chapel Hill, NC 27599–3400.
Illus. b&w, photos. 8½ x 11, 6p.
Newsletter of the Ackland Art Museum includes new acquisitions.

AMERICAN SWEDISH HISTORICAL MUSEUM NEWSLETTER. 1979. q. EN. **775**
American Swedish Historical Museum, 1900 Pattison Ave., Philadelphia, PA 19145. Phone 215–389–1776. V. Trimarco, Editor.
Subscription: included in membership. Back issues.
Dewey: 069.
Historical museum covering the Swedish colonial and immigrant experience in U.S.

AMON CARTER MUSEUM NEWSLETTER. 1972. irreg. EN. **776**
Amon Carter Museum of Western Art, P.O. Box 2365, Forth Worth, Texas 76113–2365. Phone 817–738–1933.
Illus. photos.
ISSN: 0735–5645. OCLC: 6772247. LC: N570.6.A466.
Art History. Photography.
Covers American art and art history.

ART BULLETIN OF VICTORIA. 1969. a. EN. **777**
National Gallery of Victoria, 180 St. Kilda Rd., Melbourne, Victoria 3004, Australia. Phone 03 6180 230. Sonia Dean, Editor.
Subscription: $A10. Microform available from National Gallery (Philip Jago, Publications Officer). Sample. Illus., 50–60 b&w, 4–6 color. 10 x 8½, 80p.
ISSN: 0066–7935. OCLC: 3384942. LC: N3948.A26a. Dewey: 709. Formerly: *Annual Bulletin of the National Gallery of Victoria.*
Art History. Decorative Arts. Drawing. Furniture. Painting. Photography. Sculpture. Textiles.
Addresses a wide range of art historical issues associated with works in the National Gallery of Victoria's collection. Contributors include international scholars.
Biographies: occasionally, painters or art historians. Obits. Freelance work: none.
Advertising: none. Audience: art historians, museum personnel.

THE ART INSTITUTE OF CHICAGO NEWS & EVENTS. 1982. bi–m. EN. **778**
Art Institute of Chicago, Michigan Ave. at Adams St., Chicago, IL 60603.
Illus.
OCLC: 17285201. LC: N530.A36. Formerly: *Mosaic; Bulletin of the Art Institute of Chicago.*

ART TRIBAL/TRIBAL ART. 1978. s–a. EN & FR (side by side). **779**
Association of the Friends of the Barbier–Muller Museum, Musee Barbier–Mueller, 10, rue Jean–Calvin, CH–1204, Geneva, Switzerland. Jean Paul Barbier, Editor.
Illus. b&w, photos, maps. 34p.

OCLC: 16992508. LC: N5310.7.A78. Dewey: 709.

Articles describe the acquisitions of the Museum and provide their history and background. "Museum Activities" reports on the museum's exhibitions and publications.

Bibliographies with articles. Biographies: paragraph on contributor with article.

Advertising: none.

ARTLINE. EN. 780

El Paso Museum of Art, 1211 Montana Ave., El Paso, TX 79902. Phone 915–541–4040.

Subscription: included in membership. No illus. 8½ x 11, 8p.

Newsletter presenting news of the Museum.

Advertising: none.

ARTPLUS. 1990. q. EN. 781

G S & J Publishing, Inc., 2001 W. Sample Rd., Suite 318, Pompano Beach, FL 33064. Phone 305–977–5901. Carol Hobbs, Editor.

Subscription: $20.

Dewey: 700.

A publication of Boca Museum which includes coverage of artists, collectors, and dealers.

ARTS IN VIRGINIA. 1960. 3/yr. EN. 782

Virginia Museum of Fine Arts, Publications Dept., Boulevard and Grove Ave., Richmond, VA 23221. Phone 804–257–0534. George A. Cruger, Editor–in–chief.

Subscription: included in membership, $14 US & Canada, $18 elsewhere. Illus. b&w, color; many full page Illus. 8 x 12, 68p. ISSN: 0004–4032. OCLC: 2954171.

Articles on materials in the museum or on loan. Includes recent acquisitions.

Indexed: ArtBibMod. ArtI. BioI. RILA. Reviewed: Katz.

Advertising: none.

ARTS QUARTERLY. 1978. q. EN. 783

New Orleans Museum of Art, Box 19123, New Orleans, LA 70179. Phone 504–488–2631. Wanda O'Shello, Editor.

Subscription: included in membership, $10, $15 Canada, $25 foreign. No sample. Back issues $1.50. Illus. b&w, color, photos. tabloid, 11 x 15, 32–48p.

ISSN: 0740–9214. OCLC: 3702191. LC: N1.A87. Dewey: 708.

General.

Articles of a scholarly and general nature on the exhibitions and activities of the New Orleans Museum of Art. Exhibitions on view at the Museum include major national and international traveling shows, as well as exhibitions drawn from the Museum's permanent collection. Museum activities include films, lectures, speakers bureau, major fund raisers, etc.

Listings: Museum only. Calendar of events. Exhibition information. Freelance work: yes. Contact: editor. Opportunities: study offered by Museum. Fine arts competitions. Indexed: RILA.

Advertising: full page $1200, ½ page $600, ¼ page $300, 2–color + $200, 4–color + $500. No classified. Frequency discount. Nancy Stathes, Ad. Director (5500B Chestnut, New Orleans, LA 70115). Mailing lists: none. Demographics: art patrons, collectors, artists. Circulation: 20,000. Audience: members.

ASI POSTEN. 1982. 11/yr. EN, some SW. No abstracts or tr. 784

American Swedish Institute, 2600 Park Ave., Minneapolis, MN 55407. Phone 612–871–4907. Jan McElfish, Editor.

Subscription: included in membership, $25 individual, $35 family US, foreign $25. Sample free. Back issues, postage cost. Illus. b&w, photos. 8½ x 11, 12p.

OCLC: 9426740. LC: AS36.A7 A1. Dewey: 069.7. Formerly: *ASI Happenings*.

Antiques. Art Education. Art History. Crafts. Decorative Arts. Films. Historic Preservation. Textiles.

Focuses on activities at the Institute and items of interest to members. Special features include Swedish language lesson, "Swedish–American Forum," "News Briefs from Sweden," and "Archives & Library Update". Also contains information on current exhibits in the museum and information on the permanent collections.

Reviews: (per vol.): exhibition 4, book 1, film 4. Obits. Listings: regional. Calendar of events. Exhibition information. Freelance work: yes. Contact: editor. Opportunities: study.

Advertising: full page $525, ½ page $262.50, no color. Classified: $2.50/line. 10% frequency discount. Jan McElfish, Ad. Director. Mailing lists: none. Demographics: 5,000 Minneapolis/St. Paul, 2,000 non–resident. Circulation: 7,000. Audience: members of Institute and people with interest in Sweden and Swedish–American topics.

B M MAGAZINE. 1969. q. EN. 785
British Museum Society, The British Museum, Great Russell St., London, WC1B 3DG, England. Phone 071–637 9983. Anthony Ellis, Editor.
Subscription: £12. Illus. some color.
OCLC: 22771678. LC: AM101. Dewey: 069. Formerly: *British Museum Society. Bulletin.*
General. Archaeology. Art History. Ceramics. Crafts. Decorative Arts. Drawing. Modern Art. Museology. Painting. Sculpture. Textiles.
Reviews: book. Indexed: RILA.
Freelance work: none.
Advertising. Circulation: 8,000. Audience: Society members.

BANGLADESH LALIT KALA. 1975. 3/yr. EN. 786
Dacca Museum, G.P.O. Box 355, Dacca 2, Bangladesh.
Subscription: $15. Illus.
OCLC: 4072163. LC: N7310.8.B25B35. Dewey: 709.
Journal of the Dacca Museum.

BELSER KUNSTQUARTAL: Vorschau auf Kunstausstellungen des In– und Auslandes.
1967. q. GE. 787
Chr. Belser Verlag, Falkertstr. 73, 7000 Stuttgart, W. Germany. Guenter Beysiegel, Editor.
Subscription: DM 35.
OCLC: 4637843. LC: N4390.B419. Dewey: 708.
Reviews museum and gallery exhibitions both in Germany and abroad.
Calendar of events. Exhibition information.

BERNER KUNSTMITTEILUNGEN. 1971. 5/yr. GE. 788
Kunstmuseum Bern, Hodlerstrasse 12, CH–3011 Berne, Switzerland. Phone 031–220944. M. Landert, Editor.
Subscription: 15 SFr. Illus.
OCLC: 8037243. Dewey: 700. Formerly: *Kunstmuseum Bern. Mitteilungen.*
The publication of the Berne Museum of Fine Arts includes information on works in the collection, articles on special exhibitions, and recent acquisitions.
Exhibition information. Indexed: ArtBibMod. RILA.
Advertising.

BETH HATEFUTSOTH. s–a. 789
Beth Hatefutsoth–Museum of the Jewish Diaspora, P.O. Box 39359, Tel Aviv 61 390, Israel. Phone 03–425161.
Subscription: free.
Dewey: 069.

BETWEEN THE LIONS. 3/yr. EN. 790
Bowdoin College, Museum of Art, Walker Art Bldg., Brunswick, ME 04011. Phone 207–725–3275.
Dewey: 069. Formerly: *Bowdoin College Museum of Art. Newsletter.*

BLANDEN MEMORIAL ART MUSEUM BULLETIN. 1975. 3/yr. EN. 791
Blanden Memorial Art Museum, 920 Third Ave., S., Fort Dodge, IA 50501. Phone 515–573–2316. Dr. Margaret Carney Xie, Editor.
Subscription: included in membership, free. Sample. Back issues, free if available. Illus. b&w, photos. 8½ x 11, 8p.
Formerly: *Blanden Memorial Art Gallery Bulletin.*
Art Education. Art History. Ceramics. Crafts. Decorative Arts. Drawing. Films. Furniture. Graphic Arts. Historic Preservation. Jewelry. Modern Art. Museology. Painting. Photography. Sculpture. Textiles.
Each issue includes an in–depth examination of one object from the permanent collection, membership information, purpose statement of the Museum, special reports on volunteerism, membership and staff, and detailed events information.
Listings: regional–national. Detailed calendar of Museum events and illustrated exhibit schedule for the four–month period.
Freelance work: occasionally. Contact: editor. Opportunities: study – art education classes and workshop announcements; competitions – announcements concerning contests or juried events.
Advertising: none. Circulation: 1000. Audience: museum members and other museum professionals.

THE BRITISH MUSEUM SOCIETY BULLETIN. See no. 785. 792

THE BRONX MUSEUM OF THE ARTS BULLETIN. EN. 793
Bronx Museum of the Arts, 1040 Grand Concourse, Bronx, NY 10456–3999. Phone 212–681–6000, fax 212–681–6181.
Subscription: $35 individual, $50 family, $25 students/seniors. Illus. b&w, photos. 8p.
General.

Museum newsletter.
Listings: Museum only. Calendar of events. Exhibition information. Opportunities: study – educational program.
Advertising: none.

THE BROOKLYN MUSEUM REPORT. 1986. a. EN. 794
Brooklyn Museum, 200 Eastern Parkway, Brooklyn, NY 11238. Phone 718–638–5000.
Illus.
ISSN: 1042–9034. OCLC: 18403942. LC: AM101.B8975. Formerly: *Brooklyn Museum Annual Report.*

BULLETIN - ALLEN MEMORIAL ART MUSEUM. 1944. s–a. EN. 795
Oberlin College, Dept. of Fine Arts of Oberlin College, Oberlin, OH 44074. Phone 216–775–8665. William J. Chiego &
Larry J. Feinberg, Editors.
Subscription: free to members of the Oberlin Friends of Art; non–members $10. Microform available from UMI. Back issues.
Illus. b&w, photos. Cum. index every 10 years. 7¼ x 8½, 48p.
ISSN: 0002–5739. OCLC: 16785886. LC: N650.A3. Formerly: *Bulletin of the Allen Memorial Art Museum.*
Scholarly articles on works of art in the collection of the museum. Some issues tie in with the current exhibition and include a
checklist of the exhibition together with illustrations of works.
Indexed: ArtI. ArtBibMod. BioI. CloTAI. RILA. Reviewed: Katz.
Advertising: none.

BULLETIN - DALLAS MUSEUM OF ART. 1983. q. EN. 796
Dallas Museum of Art, 1717 N. Harwood, Dallas, TX 75201. Phone 214–922–0220. Robert Rozelle, Editor & Pub.
Illus. mainly color, photos. 8 x 10, 40p.
OCLC: 11358077. LC: N558.D36. Formerly: *Dallas Museum of Fine Arts. Bulletin.*
Contains cover story and several articles on the permanent collection and upcoming exhibitions.
Biographies: of artists in exhibitions. Indexed: ArtBibMod.

BULLETIN - GEORGIA MUSEUM OF ART. 1974. 3/yr. EN. 797
Georgia Museum of Art, University of Georgia, Athens, GA 30602. Phone 404–542–3255. Bill Eiland, Editor.
Subscription: included in membership, $3 US & Canada, foreign + postage. Sample. Back issues. Illus. b&w, color, photos. 8
x 10, 30p.
ISSN: 0147–1902. OCLC: 1578078. LC: N514.A8 A23a. Dewey: 708.
General.

The focus of the Museum is on American art from 1850 to the present.
Bibliographies: occasionally related to exhibitions. Freelance work: none. Opportunities: study. Indexed: ArtBibMod. Avery.
BHA. RILA.
Advertising: none. Circulation: 1500. Audience: individual requests, publicity lists, donors, prospective members, other muse-
ums, and scholars.

BULLETIN - MUNSON-WILLIAMS-PROCTOR INSTITUTE. 1941. 7/yr. EN. 798
Munson–Williams–Proctor Institute, 310 Genesee St., Utica, NY 13502–4799. Phone 315–797–0000. Bette Mammome Lon-
don, Editor.
Subscription: included in membership, $20 individual, $30 family, $15 senior citizen, $10 student. Sample. Back issues. Illus.
b&w, color, photos. 8 x 10, 6p.
ISSN: 0027–3627. OCLC: 2500489. LC: N11 .M83 A3.
Art Education. Art History. Decorative Arts. Films. Historic Preservation. Modern Art. Painting. Photography. Sculpture.

Highlights upcoming Institute events. Tabloid format.
Biographies: artists. Interviews: artists, performers. Listings: regional–international. Calendar of events. Exhibition informa-
tion. Freelance work: occasionally. Contact: editor. Opportunities: study.
Advertising: none. Circulation: 3000. Audience: museum enthusiasts.

BULLETIN - MUSEES ROYAUX DES BEAUX-ARTS DE BELGIQUE. 1952. q. DU, EN, & FR.

799

EN articles have short summaries in DU & FR.

Musees Royaux des Beaux–Arts de Belgique – Koninklijke Musea voor Schone Kunsten van Belgie, Museumstr. 9, 1000 Brussels, Belgium. Andre A. Moerman, Editor.

Illus.

ISSN: 0027–3856. OCLC: 1537518. LC: N1830.A3. Dewey: 708. Formerly: *Annuaire des Musees Royaux des Beaux–arts de Belgique.*

Indexed: ArtI. BHA. RILA.

BULLETIN - MUSEUMS OF ART AND ARCHAEOLOGY, THE UNIVERSITY OF MICHI-GAN. 1978. a. EN.

800

University of Michigan, Museums of Art and Archaeology, 525 S. State St., Ann Arbor, MI 48109. Phone 313–764–0395. Marvin Eisenberg & Graham Smith, Editors.

Subscription: optionally included in membership of Friends of Museum of Art and Associates of Kelsey Museum of Archaeology, $7. Sample. Back issues $5–7. Illus. b&w, color occasionally, photos. 7½ x 10, 90–110p.

ISSN: 0076–8391. OCLC: 4422532. LC: N513.A2. Dewey: 708.174. Formerly: *Bulletin (University of Michigan. Museum of Art).*

Archaeology. Architecture. Art History. Ceramics. Decorative Arts. Drawing. Graphic Arts. Modern Art. Painting. Photography. Sculpture. Textiles.

Published jointly by the University of Michigan Museum of Art, the Kelsey Museum of Archaeology, and the Dept. of the History of Art. Presents scholarly articles on works in the collections. Focus may be on single works or groups of related material. Includes annual accessions lists.

Biographies: brief "Notes on Contributors". Freelance work: none. Indexed: RILA.

Advertising: none. Mailing lists: none. Circulation: 1000+. Audience: university educated layman and specialty art historians.

BULLETIN - NORTH CAROLINA MUSEUM OF ART. 1957. irreg. EN.

801

North Carolina Museum of Art, 2110 Blue Ridge Blvd., Raleigh, NC 27607. Phone 919–833–1935.

Subscription: $4. Illus.

ISSN: 0029–2567. OCLC: 2772671. LC: N715.R2 A25. Dewey: 708.1.

THE BULLETIN OF THE CLEVELAND MUSEUM OF ART. 1914. 10/yr. EN.

802

Cleveland Museum of Art, Publications Dept., 11150 E. Blvd., Cleveland, OH 44106–1797. Phone 216–421–7340. Jo Zuppan, Editor.

Subscription: $25 worldwide, included in sustaining & higher memberships. Microform available from UMI. Sample. Back issues $2.50. Illus. b&w, color, photos. Annual index in Dec issue. Cum. author and subject indexes v.67–72, 1980–85 in Dec 1985. 9 x 7½, 32p.

ISSN: 0009–8841. OCLC: 1554906. LC: N552 .A3. Dewey: 069.

General. Art History. Modern Art.

Covers art of all time periods. Two issues consist of the exhibition catalogues for two annual exhibitions and another issue is devoted to the annual report for the Museum.

Obits. Freelance work: none. Indexed: ArtBibMod. ArtI. ArtHum. BHA. BioI. CurCont. RILA. Reviewed: Katz. Katz. *School.*

Advertising: none. Circulation: 6,000. Audience: scholars.

BULLETIN OF THE DETROIT INSTITUTE OF ARTS. 1948. 3/yr. EN.

803

Founders Society, Detroit Institute of Arts, 5200 Woodward Ave., Detroit, MI 48202. Phone 313–833–7960. Judith A. Ruskin, Editor.

Subscription: $10 members, $16 non–members, included in membership at higher levels. Microform available from Johnson Associates (Greenwich, CT), UMI. Sample. Back issues. Illus. b&w, color, photos. 9½ x 10, 60p.

ISSN: 0011–9636. OCLC: 1566317. LC: N560.A42. Formerly: *Bulletin of the Detroit Institute of Arts of the City of Detroit.*

Art History.

Devoted to all aspects of the permanent collection of the Institute and limited to articles on this collection. Includes annual reports of the Detroit Arts Commission and of the Detroit Museum of Art Founders Society. Several numbers accompanied by supplements.

Freelance work: yes. Contact: editor. Indexed: ArtArTeAb. ArtBibMod. ArtI. CloTAI. RILA. Reviewed: Katz.

Advertising: none. Circulation: 6,000.

BULLETIN - PHILADELPHIA MUSEUM OF ART. 1903. q., irreg. EN. **804**
Philadelphia Museum of Art, Box 7646, Philadelphia, PA 19101–7646. Phone 215–763–8100.
Subscription: included in membership. No sample. Back issues. Illus. b&w, color, many full page photos.
ISSN: 0031–7314. OCLC: 2432439. LC: N685.A45. Dewey: 708.1. Formerly: *Philadelphia Museum Bulletin.*
General. Art History.

Published to correspond with exhibitions. Provides article and illustrations relative to one exhibition. Each issue has an individual title and author.
Freelance work: yes. Contact: George H. Marcus. Indexed: ArtBibMod. ArtI. CurCont.
Advertising: none. Mailing lists: members list available. Circulation: 7,000. Audience: members, general, art historians.

BULLETIN - UNIVERSITY OF NEW MEXICO ART MUSEUM. 1966. a. EN. **805**
University of New Mexico, Art Museum, FAC 1017, Albuquerque, NM 87131. Phone 505–277–4001. Susan Nunemaker, Editor.
Illus.
ISSN: 0077–8583. OCLC: 1776109. LC: N512.A5 A3. Dewey: 708.189.
Focus is on Southwestern United States fine arts and history.

BULLETIN VAN HET RIJKSMUSEUM. 1953. q. DU. EN summaries. **806**
Rijksmuseum Amsterdam, Postbus 50673, 1007 DD, Amsterdam, The Netherlands. A. L. den Blaauwen, Editor.
Illus. Annual index.
ISSN: 0165–9510. OCLC: 4272788. LC: N2460.A3. Dewey: 708.94923.
Articles on the Museum's collection.
Reviews: book. Indexed: ArtBibMod. ArtI. Avery. BioI. RILA. Reviewed: Katz.

C.M. RUSSELL MUSEUM NEWSLETTER. 1969. q. EN. **807**
C.M. Russell Museum – Trigg–Russell Foundation, 400 13th St., N., Great Falls, MT 59401. Phone 406–727–8787. Pam Yascavage, Editor.
Subscription: included in membership. Illus. b&w. 8½x11, 16–18p.
Dedicated to the preservation of the art of Charles M. Russell and his contemporaries whose works portray the Old West. Presents news of the Museum and information regarding the permanent collection.
Calendar of events.

THE CAIRN. 1976. 3/yr. EN. **808**
Whyte Museum of the Canadian Rockies, 111 Bear St., Box 160, Banff, Alberta T0L 0C0, Canada. Phone 403–762–2291.
E.J. Hart, Editor.
Subscription: included in membership Friends of the Whyte Museum, $9.16 basic, $22.88 associate, $91.54 corporate. No sample. Back issues. Illus. 8p.
ISSN: 0701–0281. OCLC: 3406145. LC: N908. Dewey: 708.
Newsletter.
Reviewed: *Serials Review* 12:4 Win 1986, p.19.
Advertising: none. Audience: members and selected audience.

CALENDAR. 1986. bi–m. EN. **809**
Huntington Library, Art Gallery and Botanical Gardens, 1151 Oxford Rd., San Marino, CA 91108. Phone 818–405–2147.
Catherine M. Babcock, Editor.
Subscription: included in membership. No back issues. Illus. b&w, photos. 8–12p.
OCLC: 14989404. LC: N741.A51. Formerly: *Huntington.*
Drawing. Furniture. Landscape Architecture. Painting. Photography. Sculpture. Textiles.

Provides information about Huntington exhibitions, events, and special programs, and is directed primarily to members of the institution. Each issue contains an article on one of the art exhibits, library exhibitions, botanical matters, an article on Huntington publications and a column "From the Photo Archive".
Listings: specific to the Huntington. Calendar of events. Exhibition information. Freelance work: none. Opportunities: competitions, awards, grants, fellowships at the Huntington.
Advertising: none. Circulation: 5000. Audience: members of Huntington Support Groups.

THE CARNEGIE: Year in Review. a. EN. 810

The Carnegie, 4400 Forbes Ave., Pittsburgh, PA 15213. Phone 412–622–3131.
8½ x 11, 16p.
Dewey: 069.
Presents highlights of the Carnegie's activities during the past year. A complete annual report is available separately.

CFA NEWS. 1982. 3–4/yr. EN. 811

Center for the Fine Arts, 101 W. Flagler St., Miami, FL 33130. Phone 305–375–3000. Brenda Williamson, Editor.
Subscription: included in membership. Sample. Back issues $2. Illus b&w, photos. 11 x 17, 20–24p.
Architecture. Art Education. Decorative Arts. Drawing. Furniture. Graphic Arts. Modern Art. Painting. Photography. Sculpture.

Publication which highlights all aspects of museum activities. Contents included are calendar, exhibition information and photographs, development news, educational programming, membership activities, and approximately 45 photographic images.
Reviews: exhibition 3, length 2p. each. Listings: regional. Calendar of events. Exhibition information. Freelance work: yes.
Contact: Mike Clary. Opportunities: study.
Advertising: none. Audience: membership, libraries, other museums, galleries, universities.

CHARLES H. MACNIDER MUSEUM NEWSLETTER. 1966. m. EN. 812

Charles H. MacNider Museum, 303 2nd St., S.E., Mason City, IA 50401. Phone 515–421–3666. Richard E. Leet, Editor.
Subscription: included in membership. Sample. No back issues. 8½ x 11, 2p.
Introduces and publicizes changing exhibition. Announces additions to the permanent collection. Announces and describes the museum programs, classes, and other arts and museum related activities.
Advertising: none. Audience: Museum members and exchange or colleagues.

THE CINCINNATI ART MUSEUM BULLETIN. 1930. ns 1950 (Called "new series" in continuation
of the Museum's Bulletin published 1930-1941). a. EN. 813

Cincinnati Art Museum, Publications Department, Eden Park, Cincinnati, OH 45202. Phone 513–721–5204. Carol Schoellkopf, Editor.
Subscription: included in membership, $5 US. Microform available from UMI. No sample. Back issues $5. Illus., 30 b&w.
7½ x 10, 75p.
ISSN: 0069–4061. OCLC: 3145409. LC: N550.A363. Dewey: 708. Formerly: *Cincinnati Art Museum News.*
Financial statement for museum and academy; summaries of departmental activities during the fiscal year; lists of volunteers and staff; list of accessions during the fiscal year; exhibitions; loans to other institutions. Bulletin in process of being revamped and future issues will be different than past ones; not known what the changes will be.
Indexed: ArtBibMod. ArtI. BioI. CloTAI. RILA.
Advertising: none. Circulation: 8500.

COLLECTIONS. 1988. q. EN. 814

Columbia Museum of Art, 1112 Bull St., Columbia, SC 29201.
Illus.
ISSN: 1046–2252. OCLC: 19994091. Dewey: 708. Formerly: *Columbia Museum of Art Magazine.*
The magazine of the Columbia Museum of Art and the Gibbes Planetarium. One issue contains the *Columbia Museum of Art Commission Annual Report.*

COLUMBIA MUSEUMS NEWS. 1983, v.33. q. EN. 815

Columbia Museum of Art and Science, 1112 Bull St., Columbia, SC 29201. Phone 803–799–2810.
ISSN: 0745–9246. OCLC: 9612969. Formerly: *News – Columbia Museum of Art and Science.*
Newsletter.

THE COLUMN. 1973. bi–m. EN. 816

Arnot Art Museum, 235 Lake St., Elmira, NY 14901. Phone 607–734–3697. Carolyn Warner, Editor.
Subscription: included in membership.
Focus is on 17th–19th century European and 19th–20th century American art.

CONNECTICUT MUSEUM OF ART BULLETIN. EN. 817

The William Benton Museum of Art, University of Connecticut, 245 Glenbrook Rd., Storrs, CT 06268.

COOPER-HEWITT MUSEUM NEWS. 1977. q. EN. 818

Cooper–Hewitt Museum, 2 East 91st St., New York, NY 10128–9990. Phone 212–860–6868. Arthur S. Lindo, Editor.
Subscription: included in membership, $45. No sample. No back issues. Illus. b&w, photos. 11 x 8¼, 4p.
ISSN: 0888–9627. OCLC: 4475352. LC: NK460.N5 C78. Dewey: 745.

Antiques. Architecture. Ceramics. Decorative Arts. Furniture. Graphic Arts. Jewelry. Textiles.

The Smithsonian Institution's National Museum of Design presents news of exhibitions, acquisitions, and the museum.
Freelance work: none.
Advertising: none. Mailing lists: none. Circulation: 5,500. Audience: members.

DAWSON AND HIND. 1971. 3/yr. EN. 819

Association of Manitoba Museums, 422–167 Lombard Ave., Winnipeg, Manitoba R3B 0T6, Canada. Phone 204–947–1782.
Marilyn de von Flindt, Editor.
Subscription: included in membership together with *Newsletter*, Manitoba $C20 individuals, $C10 students, & $C30 family
and libraries, museums fee based on annual budget; individuals & institutions outside Manitoba $C30; subscription only
$C15. Sample & back issues $C6. Illus b&w, photos, maps, diagrams, charts, cartoons (occasionally). Index in final issue of
each year. 8½ x 11, 32p.
ISSN: 0703–6507. OCLC: 3412332. Dewey: 069. Formerly: *Grande New Dawson & Hind Quarterly Epistle.*

General.

Features current articles on museum planning and programming, collections research and history, new legislation, conserva-
tion and care of collections, school programs in museums, "how–to" technical advice, and profiles of community museums.
"Manitoba Focus" provides success stories from the people and museums in Manitoba.
Reviews: book 1–2, length 500 wds. or less. Bibliographies as submitted by authors. Interviews: occasionally and as arranged
by the editorial committee.
Advertising: none. Mailing lists: none. Circulation: 250. Audience: museum and gallery volunteers, board members, profes-
sionals, students, supporters of heritage and cultural institutions.

DAYTON ART INSTITUTE BULLETIN. 1931. a. EN. 820

Dayton Art Institute, Box 941, Dayton, OH 45401–0941. Phone 513–223–5277. Eileen Evans Carr, Editor.
Illus. b&w, photos. 7½ x 9, 15p.
Formerly: *Dayton Art Institute Annual Report.*
Two–three articles on recent acquisitions for the Museum presented together with illustrations.
Indexed: ArtBibMod. BHA. CloTAI. RILA.

DELAWARE ART MUSEUM QUARTERLY. 1984. q. EN. 821

Delaware Art Museum, 2301 Kentmere Parkway, Wilmington, DE 19806. Phone 302–571–9590. Melissa H. Mulrooney, Edi-
tor.
Subscription: included in membership. Illus. 20p.
OCLC: 11672705. LC: N868.A145. Formerly: *Delaware Art Museum Bulletin.*
Advertising: none.

DRESDENER KUNSTBLAETTER. 1960. bi–m. GE. 822

Staatliche Kunstsammlungen Dresden, Albertinum, 8012 Dresden, E. Germany. Karin Perssen, Editor.
Subscription: M 3.60. Illus.
ISSN: 0323–4088. OCLC: 7135179. LC: N3.D72. Dewey: 700. Formerly: *Dresdener Galerieblaetter.*
Indexed: ArtArTeAb. RILA.

ELVEHJEM MUSEUM OF ART BULLETIN/ANNUAL REPORT. 1985. a. EN. 823

Elvehjem Museum of Art, University of Wisconsin—Madison, 800 University Ave., Madison, WI 53706. Doug DeRosa, Edi-
tor.
Illus. b&w, photos. 8 x 10½, 120p.
ISSN: 0730–2266. OCLC: 17653879. LC: N582.M231 A21. Formerly: *Elvehjem Museum of Art Bulletin.*
Publication divided about evenly between the *Bulletin* which contains articles on exhibition collections and the *Annual Re-
port* which includes brief descriptions and illustrations of acquisitions.

THE EVERHART MUSEUM NEWSLETTER. q. EN. 824

Everhart Museum, Nay Aug Park, Scranton, PA 18510. Phone 717–346–7186. Beverly Black, Editor.

Subscription: included in membership.

General.

Newsletter of the Museum which presents American art, American Folk Art, Oriental art, Native American art, African Art, and primitive collections.

EVERSON MUSEUM OF ART BULLETIN. 1911. m. EN. 825

Everson Museum of Art, 401 Harrison St., Syracuse, NY 13202. Phone 315–474–6064. Thomas Piche, Editor.
Subscription: included in membership, min. of $35. Sample. Back issues. Illus b&w, photos. 9½ x 8½, 12p.
OCLC: 8489369. Formerly: *Syracuse Museum of Fine Arts Quarterly Bulletin.*

General.

Highlights Everson Museum exhibitions, acquisitions, events, educational programs, and programs of interest to members. Also contains articles. Focus of Museum is on American art and contemporary ceramics.
Listings: specific to the Everson. Calendar of events. Exhibition information. Freelance work: none. Opportunities: study, competitions.
Advertising: none. Circulation: 3,600. Audience: museum members.

FENWAY COURT. 1966. a. EN. 826

Isabella Stewart Gardner Museum, Museum Office, 2 Palace Rd., Boston, MA 02115. Phone 617–566–1401.
Illus. b&w, photos. 7½ x 10, 90p.
ISSN: 0430–3091. OCLC: 2261072. LC: N1.F43. Dewey: 708.
Contains articles on the Museum's collection or related to the Museum. Includes the annual report of the Museum.
Indexed: CloTAI. RILA.

FINE ARTS MUSEUMS OF SAN FRANCISCO REPORT. EN. 827

M.H. de Young Memorial Museum, Golden Gate Park, San Francisco, CA 94118. Phone 415–750–3600.

FORSCHUNGEN UND BERICHTE. 1957. a. GE. 828

Henschel–Verlag, Orienburger Str. 67, 1040 Berlin, E. Germany.
Illus. Cum. index v.1–15, 1957–73, in v.15.
ISSN: 0067–6004. OCLC: 1519594. LC: AM101.B389.
Yearbook of the State Museum of Berlin presents research and reports.

FORT WAYNE MUSEUM OF ART - NEWSLETTER. 1924. bi–m. EN. 829

Fort Wayne Museum of Art, 311 E. Main St., Fort Wayne, IN 46802. Phone 219–422–6467. September McConnell, Editor.
Subscription: included in membership. Illus b&w, photos. 11 x 17, 6p.
Devoted to the events and activities of the Museum and news of research.
Calendar of events.
Advertising: none. Audience: members of museum.

FRIENDS' NEWSLETTER. 1970. 3/yr. EN. 830

Art Museum, Princeton University, Princeton, NJ 08544–1018. Phone 609–258–4341, fax 609–258–5949. Jill Guthrie, Editor.
Illus. b&w. 11 x 17.
News of the Museum and its activities and acquisitions.
Calendar of events.

GALLERY. 1984. 11/yr. EN. 831

Mount Eagle Publications, P.O. Box 84, Heidelberg, Victoria 3084, Australia. Phone 03–459–3911, fax 03 457 5249. Hugo Leschen, Editor.
Subscription: included in membership. No sample. No back issues. Illus b&w, photos. 28p.
ISSN: 0814–7833. Dewey: 708.

General.

Magazine of the National Gallery Society of Victoria.
Listings: regional–national. Exhibition information. Freelance work: none. Opportunities: employment.
Advertising: (rate card 6/89): b&w full page $745, ½ page $390, ¼ page $205; color full page $895, ½ page $490. Frequency discount. Inserts. Circulation: 15,300. Audience: members of the National Gallery Society of Victoria.

GENAVA: Revue d'Archeologie et d'Histoire de l'Art. 1923. a. FR. 832

Musee d'Art et d'Histoire, Geneva, Rue Charles Galland, 1211 Geneva 3, Switzerland.
Subscription: 50 SFr. Illus.
ISSN: 0072–0585. OCLC: 6687147. Dewey: 708.9494. Formerly: *Ville de Geneve Bulletin du Musee d'Art et d'Histoire.*
Review of the Museum of Art and History publishes principally, articles on Museum holdings, Geneva history, and current Museum activities. Each issue contains a list of recent acquisitions.
Indexed: RILA.

GEORGIA MUSEUM OF ART NEWS. 1983. q. EN. 833

Georgia Museum of Art, University of Georgia, Athens, GA 30602. Phone 404–542–3255. Bill Eiland, Editor.
Subscription: included in membership, free. Sample. Back issues. Illus b&w, photos. 7 x 8, 12p.
OCLC: 15311489.
General.

Museum events and information.
Listings: local. Calendar of events. Exhibition information. Freelance work: yes. Contact: editor. Opportunities: study.
Advertising: none. Circulation: 10,000. Audience: individual requests, publicity list, donors, prospective members and other museums.

GRAND RAPIDS ART MUSEUM CALENDAR. 1979. 5/yr., bi–m. except Jl/Aug. EN. 834

Grand Rapids Art Museum, 155 Division N., Grand Rapids, MI 49503. Phone 616–459–4677. Paula Wilkerson, Editor.
Subscription: members only, included in membership. Sample free. Back issues. Illus b&w, photos. 11½ x 17 folded, 4p.
Formerly: *Grand Rapids Art Museum Newsletter.*
General.

Provides information regarding current exhibitions as well as special events going on at the Art Museum.
Interviews: with artists are run whenever possible interviews with curator regarding some exhibitions. Listings: limited to Museum events only. Calendar of events. Exhibition information. Freelance work: design only. Contact: editor. Opportunities: study, competitions.
Advertising: none. Circulation: 4,000. Audience: art museum members, general public.

HEARD MUSEUM NEWSLETTER. See no. 692.

HERITAGE. a. EN. 835

National Museum, Stamford Rd., Singapore 0617, Singapore.
Presents the history and culture of Singapore as reflected in the Museum's collection.

IDEA: Jahrbuch der Hamburger Kunsthalle. 1982. a. GE only. 836

Prestel–Verlag, Gesamtherstellung, Dingwort–Druk GmbH, Hamburg–Altona, Germany.
Illus. b&w, photos. 6½ x 9¼, 208p.
ISSN: 0724–133X. ISBN: 3–7913–0844–0. OCLC: 9469757. LC: N2305.H3 I3. Dewey: 708.3. Continues in part: *Jahrbuch der Hamburger Kunstsammlungen.*
"Werke–theorien–dokumente". The yearbook of the Hamburg Art Museum contains essays as well as a list of new acquisitions.
Indexed: RILA.

INDIANA UNIVERSITY ART MUSEUM BULLETIN. 1977. s–a. EN. 837

Indiana University Art Museum, Bloomington, IN 47405. Phone 812–335–5445. Linda Baden, Editor.
Illus.
ISSN: 0161–1003. OCLC: 3834902. LC: N518.B4A28. Dewey: 798.

INSIGHT. bi–m. EN. 838

J.B. Speed Art Museum, 2035 South Third St., P.O. Box 2600, Louisville, KY 40201–2600.
Illus. b&w. 8 x 8, 22p.
Newsletter of the Museum. Describes activities, acquisitions, new exhibitions, and programs.
Listings: Museum only. Calendar of events. Exhibition information.
Advertising: none.

ISRAEL - THE PEOPLE AND THE LAND. ns. 1984. a. HE. HE & EN table of contents. EN abstracts. **839**
Eretz Israel Museum, 2 Levanon St. Ramat Aviv, Tel Aviv 61170, Israel. Phone 03–415244. Rechavam Zeeby, Editor.
Subscription: included in highest membership, $18 US. Illus., b&w, photos, maps, line drawings. 8½ x 10½ (28 + 21 cm.),
300+p. (HE 280p, EN 22p).
ISSN: 0334–1798. Dewey: 708. Formerly: *Israel – People and Land Ha' Eretz Museum Yearbook.*
Archaeology. Architecture. Ceramics. Crafts. Pottery.

The yearbook of the Eretz Israel Museum. Articles are broadly grouped according to subject matters, corresponding to the
Museum's various divisions: archaeology, historical geography, ethnology and folklore, history of Jaffa and Tel Aviv, and the
material culture of the land of Israel. Reports on the activities of the Museum's various departments.
Freelance work: none.
Advertising: none.

THE ISRAEL MUSEUM JOURNAL. 1982. a. EN. **840**
Israel Museum, P.O. Box 1299, Jerusalem 91012, Israel. Phone 02–698211. Vivianne Barsky, Magen Broshi, and Yona Fi-
scher, Editors.
Subscription: $5. Sample. Back issues $5 + postage. Illus. b&w, photos, diagrams. 7½ x 9¾, 128–146p. + 10p. ads.
ISSN: 0333–7499. OCLC: 8962984. LC: N3750.J5M89. Dewey: 708.95694. Formerly: *Israel Museum News.*
General.

Scholarly studies on items from the Museum's collections. Lists selected acquisitions accompanied by illustration and descrip-
tion.
Bibliographies with articles. Biographies: 1–2 sentences on contributors to issue. Indexed: ArtBibMod. BHA. RILA.
Advertising at end of issue in either EN or HE. Mailing lists: available. Circulation: 3000. Audience: academic libraries, mu-
seums, museum donors.

THE ISRAEL MUSEUM NEWS. 1982. s–a. EN. **841**
Israel Museum, P.O. Box 1299, Jerusalem 91012, Israel. Phone fax 02–631823. Vivianne Barsky, Editor.
Illus. b&w, photos. 16p.
OCLC: 15466566. LC: N3750.J5A35. Dewey: 708.95694.
News of the Museum. Describes and illustrates exhibits. Highlights recent acquisitions.
Calendar of events. Opportunities: awards listed.
Advertising: none.

THE J. PAUL GETTY MUSEUM JOURNAL. 1974. a. EN. **842**
J. Paul Getty Museum, 17985 Pacific Coast Highway, Malibu, CA 90265. Phone 213–459–7611. Andrea P.A. Belloli, Editor.
Glossy Illus. b&w, photos. 8½ x 11, 166p.
ISSN: 0362–1979 ISBN: 0–89236–157–3. OCLC: 2304305. LC: N582.M25A25. Dewey: 708.
Scholarly articles on acquisitions in antiquities, drawings, manuscripts, paintings, sculpture, decorative arts, photographs.
"The Collection and the Year's Activities" (66p.) covers acquisitions. Each acquisition is illustrated and provides: name and
date of artist, title or name of work and date of execution, medium, dimensions, inscriptions, Museum acquisition number,
commentary, provenance and bibliography.
Indexed: CloTAI. RILA.
Advertising: none.

JAHRBUCH DER BERLINER MUSEEN. 1959. a. GE mainly, occasionally FR or IT. EN summaries. **843**
Gebr. Mann Verlag, Lindenstr. 76, Postfach 110303, 1000 Berlin 61, W. Germany. Phone 030–2591–3589.
Illus. photos.
ISSN: 0075–2207. OCLC: 1519595. LC: N3.J16. Formerly: *Yearbook of the Prussian Art Society.*
Art History. Photography.

Yearbook of the Berlin Museum covers art works of all periods owned by Berlin museums.
Indexed: ArtArTeAb. ArtHum. ArtI. Avery. CurCont. RILA.

JAHRBUCH DER STAATLICHEN KUNSTSAMMLUNGEN DRESDEN. 1959. a. GE. **844**
Staatliche Kunstsammlungen Dresden, Dresden, Germany.
Illus.
OCLC: 7920882. LC: N2270.A19. Formerly: *Staatliche Kunstsammlungen Dresden.*

Concentrates on works and exhibitions in Dresden art museums.
Indexed: ArtBibMod. Avery. RILA.

JAHRBUCH DER STAATLICHEN KUNSTSAMMLUNGEN IN BADEN-WUERTTEMBERG.
1964. a. GE. **845**
Deutscher Kunstverlag GmbH, Vohburger Str. 1, 8000 Munich 21, W. Germany.
Illus.
ISSN: 0067–284X. OCLC: 1607086. LC: N2216.B13. Dewey: 709.4346.
The yearbook of the state art museum of Baden-Wuerttemberg.
Indexed: ArtBibMod. RILA.

THE JOHN & MABLE RINGLING MUSEUM OF ART NEWSLETTER. 1974. q. EN. **846**
John and Mable Ringling Museum of Art, 5401 Bay Shore Rd., Sarasota, FL 34243. Phone 813–355–5101. Kathleen Chilson, Editor.
Subscription: included in membership. Sample to prospective members. No back issues. Illus. b&w, color, photos. 8½ x 11, 8–12p.
OCLC: 14074674. LC: N742.S5A28. Dewey: 708.159. Formerly: *Ringling Museums; John & Mable Ringling Museums of Art Member's Calendar.*
General.

Interviews: with staff and trustees. Listings: regional–international. Calendar of events. Exhibition information. Freelance work: none. Opportunities: study, competitions.
Advertising: none. Mailing lists: none. Circulation: 5000. Audience: membership.

JOSLYN NEWS. 1974. bi–m. EN. **847**
Joslyn Art Museum, 2200 Dodge St., Omaha, NE 68102. Phone 402–342–3300. Linda Rajcevich, Editor.
Subscription: included in membership. Illus. 8½x11.
Dewey: 707.4. Formerly: *Joselyn Art Museum Members' Calendar; Joslyn Art Museum Calendar of Events.*
Art History.

Covers ancient through modern art history.
Calendar of events.

JOURNAL OF THE BARBADOS MUSEUM AND HISTORICAL SOCIETY. 1933. a. EN. **848**
Barbados Museum and Historical Society, St. Ann's Garrison, Barbados, W.I. P. F. Campbell, Editor.
Subscription: $20. Illus.
ISSN: 0005–5891. OCLC: 1519178. LC: F2041.B38. Dewey: 972.9.

JOURNAL OF THE MUSEUM OF FINE ARTS, BOSTON. 1989. a. EN. **849**
Museum of Fine Arts, 465 Huntington Ave., Boston, MA 02115. Faith Smith, Editor.
Subscription: $30 (Northeastern University Press, P.O. Box 116, Boston, MA 02117). Illus., b&w, photos. 8¼ x 11, 102p.
ISSN: 1041–2433. OCLC: 18691473. LC: N520.144. Dewey: 708.144.
Vehicle for the publication of scholarly articles pertaining to aspects of the rich and diverse collections. All articles by members of the Museum staff from different curatorial departments and dealing with objects acquired or reconstructed by the Museum in the last decade. Future issues will always pertain to the Museum's permanent collection. Publication supported in part by A.W. Mellon Foundation Publication Fund.

KALORI. 1952. bi–m. EN. **850**
Royal South Australian Society of Arts, Institute Bldg., North Terr., Adelaide, S.A. 5000, Australia. Carrie Button, Editor.
Illus.
ISSN: 0047–312X. OCLC: 6781046. LC: AM1.K144. Dewey: 700.
Journal of the Museums Association of Australia.
Advertising.

KRANNERT ART MUSEUM BULLETIN. 1975. s-a. EN. **851**
Krannert Art Museum, University of Illinois, 500 Peabody Drive, Champaign, IL 61820.
Illus.
ISSN: 0195–3435. OCLC: 5023887. LC: N838.A23.

KUNST-BULLETIN DES SCHWEIZERISCHER KUNST VEREINS. 1968. m. FR & GE. 852
Schweizerischer Kunstverein, Postfach, CH-6010 Kriens, Switzerland. H.R. Schneebeli, Editor.
Subscription: 23.40 F Switzerland, elsewhere 29.40 F (Hallwag AG, Nordring 4, CH-4001 Berne).
Dewey: 700.
Indexed: ArtBibMod. RILA.

THE KWM NEWSLETTER: The Quarterly Newsletter of the Kendall Whaling Museum.
 1983. q. EN. 853
Kendall Whaling Museum, 27 Everett St., Box 297, Sharon, MA 02067. Phone 617–784–5642. David C. Cruthers, Editor.
Subscription: included in membership, $20 all. Sample, postage. Back issues, price varies. Illus. b&w, photos. Cum. index
forthcoming, 5 yr. increments. 8p.
OCLC: 15736421.
Antiques. Archaeology. Art Education. Art History. Ceramics. Historic Preservation. Whaling History.

Art, history, iconography, natural history, ethnology, bibliography, and events having to do with whales and whaling in all
time periods by all peoples. Contents include regular features on museum collections, recent acquisitions, museum events,
publications, annual Collectors' Weekends and annual Whaling Symposium. Columns: "Speaking Frankly" by Stuart M.
Frank, Executive Editor; "Looking Back"; "Recent Acquisitions"; "Coming Events".
Obits. Listings: regional–international. Calendar of exhibitions, workshops, competitions. Freelance work: occasionally.
Advertising: none. Demographics: 35 states and provinces, 20 countries. Circulation: 1000. Audience: members of the mu-
seum, scholars in several fields, environmental scientists.

LINK. 1966. q. EN. 854
The Cleveland Institute of Art Magazine, 11141 East Blvd., University Circle, Cleveland, OH 44106. Paul J. Nichols, Editor.
Illus. b&w, photos. 8½ x 11, 28p.
ISSN: 0733–8503. OCLC: 4555569.
An alumni magazine containing articles, faculty and staff notes, and alumni notes.
Obits. Indexed: ArtBibMod.
Audience: faculty, students, and alumni.

LOS ANGELES COUNTY MUSEUM BULLETIN. EN. 855
Los Angeles County Museum, 5905 Wilshire Blvd., Los Angeles, CA 90036. Phone 213–857–6111, fax 213–931–7347.
Microform available from UMI.
Indexed: RILA.

MAGNES UPDATE. 1982. s–a. EN. 856
Judah L. Magnes Museum, 2911 Russell St., Berkeley, CA 94705. Phone 415–849–2710. Paula Friedman, Editor.
Subscription: included in membership, $30 US. Sample. Back issues SASE. Illus. b&w, photos. 8 x 10, 4p.
OCLC: 8579393. LC: N518.J8A2. Formerly: *Magnes News.*
**Archaeology. Art Education. Art History. Drawing. Graphic Arts. Historic Preservation. Modern Art. Museology. Painting. Photog-
raphy. Sculpture.**

A publication of a Judaica museum containing Jewish ceremonial arts, fine arts, textiles, and costumes. Coverage includes
general Museum information, articles and discussion of exhibit–related art and Museum issues, people of the Museum, an-
nouncements and updates, and new acquisitions and trends.
Reviews: book. Listings: Museum events only. Calendar of Museum events. Exhibition information. Freelance work: none.
Opportunities: competitions, awards.
Advertising: none. Circulation: 2100–3500.

MASTERPIECES. 1955. bi–m. EN. 857
Memphis Brooks Museum of Art, Inc., Overton Park, Memphis, TN 38112. Phone 901–722–3525. Dorothy Lane McClure,
Editor.
Subscription: included in membership. Sample. Limited back issues. Illus. b&w, photos. 8½ x 11, 12p.
Dewey: 708.1. Formerly: *Brooks Memorial Art Gallery Newsletter.*
General.

Details general Museum news, exhibitions, collections, acquisitions, programs, lectures, workshops, and special Museum
events.

Reviews: exhibition 3–4, length 2–3p. Listings: regional. Calendar of events. Exhibition information. Freelance work: yes. Contact: editor. Opportunities: study, competitions.

Advertising: none. Circulation: 5000+. Audience: museum members.

McCORD. 1987. 2/yr. EN & FR. 858

McCord Museum of Canadian History, 690 Sherbrooke St. West, Montreal, Quebec H3A 1E9 Canada. Phone 514–398–7100, fax 514–939–3042. Wanda Palma, Editor.

Subscription: included in membership, $C50 Canada. No sample. Limited back issues. Illus. b&w. 8½ x 11, 8–12p. ISSN: 0840–433X. OCLC: 20370785. LC: AM121. Dewey: 069.

General.

The newsletter is used to describe and promote the Museum's collections, exhibitions, staff and activities. The articles cover a wide range of topics related to the McCord. Museum collections include: Canadian ethnology, costumes and textiles, decorative arts, paintings, prints and drawings, Notman Photographic Archives, and archives.

Listings: Museum only. Calendar of events. Exhibition information. Freelance work: none. Opportunities: employment, study – workshops organized by and/or held at the Museum, competitions.

Advertising: none. Circulation: 2500. Audience: friends/members of Museum, media, cultural institutions.

MEDDELELSER FRA NY CARLSBERG GLYPTOTEK. 1944. a. DA. EN, FR, GE summaries. 859

Ny Carlsberg Glyptotek, Dantes Plads 1556, Copenhagen V, Denmark. Phone 33 91 10 65. Flemming Johansen, Editor. Illus.

ISSN: 0085–3208. OCLC: 3621352. LC: N9.C6.

Research areas focus on Egyptian, Greek, Etruscan and Roman sculpture, classical archaeology, and modern 19th century Danish and French art.

Indexed: BHA.

METROPOLITAN MUSEUM JOURNAL. 1968. a. EN. 860

Metropolitan Museum of Art, 1000 Fifth Ave., New York, NY 10028. M.E.D. Laing, Editor.

Subscription: $60 (University of Chicago Press, Journals Division, Box 37005, Chicago, IL 60637). Illus. 8½ x 11, 150p. ISSN: 0077–8958. OCLC: 1760043. LC: N610.A725. Dewey: 708.1471.

Focuses on objects in the Museum's collections and related topics. Presents scholarly first–time investigations and critical reassessments as well as new information and other scholarly articles.

Indexed: ArtBibMod. ArtHum. ArtI. BHA. CloTAI. CurCont. RILA.

THE METROPOLITAN MUSEUM OF ART BULLETIN. 1905, ns 1942. q. EN. 861

Metropolitan Museum of Art, 1000 Fifth Ave., New York, NY 10028. Phone 212–879–5500 Ext. 3446. Joan Holt, Editor–in–Chief.

Subscription: included in membership, $18. Microform available from UMI. No sample. Some back issues. Illus. b&w, color, glossy photos (many full page). Annual index. 8 x 10¾, 48–64p.

ISSN: 0026–1521. OCLC: 1624350, 13103030, 7546843 (microfilm). LC: N610.A4. Dewey: 708. Formerly: *Notable Acquisitions; Recent Acquisitions: A Selection.*

Art History. General.

Each issue devoted to one subject, artist or period represented in the museum's collection. All aspects of art history and mediums covered depending upon Museum's annual acquisitions by its eighteen curatorial departments. "Recent Acquisitions" is the Fall issue.

Bibliographies: Usually 1/issue, approx 90 entries. Freelance work: none. Indexed: ArtBibMod. ArtHum. ArtI. CloTAI. CurCont. RILA. Reviewed: Katz.

Advertising: none. Circulation: 120,000. Audience: membership and art historians.

MIDWEST MUSEUM BULLETIN. 1979. bi–m. EN. 862

Midwest Museum of American Art, 429 S. Main St., Box 1812, Elkhart, IN 46515. Phone 219–293–6660. Jane Burns, Editor.

Subscription: included in membership.

THE MINNEAPOLIS INSTITUTE OF ARTS BULLETIN. 1905. a. EN. 863

Minneapolis Institute of Fine Arts, 2400 Third Ave. S., Minneapolis, MN 55404. Phone 612–870–3046. Louise Lincoln, Editor.

Microform available from UMI. Illus. 8½ x 11, 100p.

ISSN: 0076–910X. OCLC: 3139157. LC: N11.M66.

Articles by staff members and recognized authors on objects in the Museum's collections.
Indexed: ArtBibMod. ArtI.
Advertising: none.

MINT MUSEUM MEMBER NEWS. bi–m. EN.
864

Mint Museum of Art, 2730 Randolph Rd., Charlotte, NC 28207. Phone 704–337–2000. Phil Busher, Editor.
Subscription: included in membership. Illus.
OCLC: 15049102. Formerly: *Mint Museum Newsletter*.

MISSISSIPPI MUSEUM OF ART - PERSPECTIVE. 1977. bi–m. EN.
865

Mississippi Museum of Art, 201 E. Pascagoula St., Jackson, MS 39201. Phone 601–960–1515. Alisa Terry, Editor.
Subscription: included in membership. Illus. b&w, some color, photos. 8½ x 11, 8p.
Newsletter pertaining to the Museum and museum–related events.
Calendar of events. Freelance work: yes. Contact: editor.
Advertising.

MOMA. 1988. q. EN.
866

Museum of Modern Art, 11 W 53rd St., New York, NY 10019. Christopher Lyon, Editor.
Illus. mainly color, some b&w, photos. 8¼ x 10½, 22p.
Formerly: *Members Calendar – Museum of Modern Art*.

Modern Art. Museology.

The members Museum quarterly contains news, acquisitions, "From the Collection", and "From the Archives".
Advertising: none. Audience: members.

MONTCLAIR ART MUSEUM BULLETIN. 1929. bi–m. EN.
867

Montclair Art Museum, 3 South Mountain Ave., Montclair, NJ 07042. Phone 201–746–5555. Linda Kugler, Editor.
Subscription: included in membership, free to museums & libraries. Sample free. Back issues. Illus. b&w.
ISSN: 0027–0059. OCLC: 4580119. LC: N584.M654. Dewey: 708.149.

Museum News & Activities only.

News of Museum events, exhibitions, acquisitions and special activities (concerts, art school classes, etc.).
Listings: Museum events only. Calendar of events. Exhibition information. Freelance work: none. Opportunities: study, competitions.
Advertising: none. Circulation: membership only. Audience: membership.

MONTEREY PENINSULA MUSEUM OF ART NEWS. bi–m. EN.
868

Monterey Peninsula Museum of Art Association, 559 Pacific St., Monterey, CA 93940. Phone 408–372–5477. Jo Farb Hernandez, Editor.
Subscription: included in membership $25 individual, $15 student. Illus. cover only. 8½ x 11, 8p.

Museology.

Information on exhibitions, museum events, announcements, and staff news.
Calendar of Museum events.
Advertising: none.

MOSAIC. 1966. bi–m. EN.
869

Museum of Fine Arts, St. Petersburg, 255 Beach Dr. NE, St. Petersburg, FL 33701. Phone 813–896–2667, fax 813–894–4638.
Esther Persson, Editor.
Subscription: included in membership. Sample & back issues free. Illus. b&w, color, photos. 8½ x 11, 8p.
Dewey: 708.

General.

Newsletter focuses on news and events associated with the Museum such as exhibitions, acquisitions, events, and acknowledgements. Ranges in scope from local to international depending on the subject matter of the articles submitted. A unique feature is a section titled "Meet Our Trustees" featuring a photo and paragraph of a selected trustee.
Listings: local. Calendar of events. Exhibition information. Freelance work: none.
Advertising: none. Circulation: 3,500–4,000. Audience: membership and visitors.

MOUNT HOLYOKE COLLEGE ART MUSEUM - NEWSLETTER. 1978. s–a. EN. 870

Mount Holyoke College Art Museum, South Hadley, MA 01075. Phone 413–538–2245.
Subscription: included in membership. Illus. b&w, photos. 8½x11, 4–6p.
News of the Museum, articles pertaining to the collection, and information regarding new acquisitions..
Audience: the campus community and the art community nationwide.

MUSE. 1967. a. EN. 871

Museum of Art and Archaeology, University of Missouri–Columbia, One Pickard Hall, Columbia, MO 65211. Phone 314–882–3591. Forrest McGill, Editor.
Subscription: included in membership, $10. Sample. Back issues, no.4–17 $5, no.18–21 $8, no.22 $10. Illus. b&w, photos. 7 x 9, 134p.
ISSN: 0077–2194. OCLC: 1758850. LC: N584.M5. Dewey: 708.178.
General.

Articles written by scholars for educated public audience. Scholarly articles related to excavation sponsored by the Museum, objects in its collection, background of work, acquisitions, etc. Includes the annual report and events of the past year.
Biographies: paragraph on each author. Indexed: ArtBibMod.
Advertising: none. Circulation: 2400. Audience: scholars and public.

MUSEES DE GENEVA: Revue des Musees et Collections de la Ville de Geneve. 1944. m. FR. 872

Beaux–Arts et Culture, Hotel Municipal, Geneva, Switzerland. Andre Comellini, Editor.
Illus. Cum. index 1944–64, 1965–79.
ISSN: 0027–3821. OCLC: 2489474. LC: AM68.G4M8. Dewey: 069.
Museum of art and history of the city of Geneva.
Indexed: HistAb. RILA.
Advertising.

MUSEUM: Art Magazine. 1951. m. JA. EN table of contents has short abstract of articles. 873

Museum Shuppan, Tokukaiya Bldg., 1–12–4 Kudankita, Chiyoda–ku, Tokyo 102, Japan. Phone 03–261–0440. Hisatoyo Ishida, Editor (Tokyo National Museum).
Illus. b&w, color. 7¼ x 10, 34p.
ISSN: 0027–4003. OCLC: 4599865. LC: N8.M98. Dewey: 069.095.
Advertising: none.

MUSEUM & ARTS WASHINGTON. 1986. bi–m. EN. 874

Museum & Arts Washington, Inc., 1707 L St., N.W., Suite 222, Washington, DC 20036. Phone 202–659–5973. Anne Abramson & Mary Gabriels, Editors.
Subscription: $18 US (P.O. Box 809, Farmingdale, NY 11737–0809). Illus. 8¼ x 10¾, 144p.
ISSN: 0884–1918. OCLC: 17360745. LC: AP1.M972. Dewey: 708. Formerly: *Museum Washington*.
Feature articles, departments, and "East Coast/Shuttle News" which covers major museum exhibitions and gallery shows in Boston, New York, and Philadelphia.
Reviews: exhibition, gallery, book. Biographies: "Personality", artist profiles Interviews. Listings: regional. Performance calendar, museum and gallery guide. Indexed: RILA.
Advertising: Stacie Anne Harrison, Ad. Coordinator (202–457–8124). Circulation: 50,000.

MUSEUM NOTES. 1960? bi–m. EN. 875

Eastern Washington State Historical Society, Cheney Cowles Museum, W. 2316 First Ave., Spokane, WA 99204. Phone 509–456–3931. Glenn Mason, Editor.

THE MUSEUM OF CALIFORNIA. 1977. bi–m. EN. 876

Oakland Museum Public Information Office, 1000 Oak St., Oakland, CA 94607. Phone 415–273–3401. Abby Wasserman, Editor.
Illus. b&w, color, photos. 8½ x 11, 30p.
OCLC: 4391711. LC: AM101.02A3.
The publication of the Oakland Museum.
Listings: Museum. Calendar of events. Exhibition information.
Advertising.

MUSEUM OF FINE ARTS, HOUSTON BULLETIN. 1970. 3/yr. EN. 877

Museum of Fine Arts, Houston, P.O. Box 6826, 1001 Bissonnet St., Houston, TX 77005. Phone 713–639–7300, fax 713–639–7399. Celeste Marie Adams, Editor.

Subscription: included in upper–level membership only; $4–$8 depending on size. Available in Museum bookstore. No sample. Back issues $4–$8. Illus. mainly color, photos. 8½ x 11, 96p.
ISSN: 7112–0737.

General.

Produced by the Publication Office in cooperation with the curatorial staff. Presents artistic issues of the museum's collections and exhibitions. Mainly illustrations (many full page glossy photos). Each issue is devoted to a single theme. Special issue, Fall 1990, "Acquisitions of the 80's" consists of major acquisitions together with caption descriptions.
Reviews: none. Indexed: ArtBibMod. RILA. Reviewed: Katz.
Advertising: none. Audience: museum members and visitors.

THE MUSEUM OF MODERN ART MEMBERS CALENDAR. 1980. m. EN. 878

Museum of Modern Art, 11 W 53rd St., New York, NY 10019.
Subscription: included in membership. Illus. b&w, photos. 4½ x 9, 24p.
ISSN: 0195–105X. OCLC: 6386047. Formerly: *Members Calendar – Museum of Modern Art.*

Modern Art.

Contains a brief description of new exhibitions, continuing exhibitions, film and video programs, and educational programs offered by the Museum.
Listings: Museum only. Calendar of events and films. Opportunities: study – Museum programs.
Advertising: none.

MUSEUM OF THE CITY OF NEW YORK QUARTERLY. 1986. q. EN. 879

Museum of the City of New York, Fifth Ave. at 103rd St., New York, NY 10029. Phone 212–534–1672. Beverly Bartow, Editor.
Subscription: restricted to Museum members only, $35 individual membership. Sample. Back issues on special request. Illus. b&w, photos. 11 x 17, 4p.
Dewey: 708. Formerly: *Museum of the City of New York Bulletin.*

General. Antiques. Architecture. Art Education. Art History. Ceramics. Furniture. Historic Preservation. Hobbies—Toys. Juvenile. Painting. Sculpture. Silver. Textiles. Theatre Collection.

Gives Museum members updates on events and special programs, previews of special exhibitions, and a "behind–the–scenes" look at the institution.
Listings: regional. Exhibition information. Calendar of events published in separate brochure. Freelance work: none. Opportunities: study.
Advertising: none. Circulation: 3200. Audience: members.

MUSEUM STUDIES. 1966 (suspended 1979–1982). s–a. EN. 880

Art Institute of Chicago, Michigan Ave. at Adams St., Chicago, IL 60637. Phone 312–962–7600. Rachel A. Dressler, Editor.
Subscription: $15 member, $20 non–members, $32 institution (University of Chicago Press, Box 37005, Chicago, IL 60637). Back issues $8.50 individual, $15.50 institution (University of Chicago Press, Journals Division, P.O. Box 37005, Chicago, IL 60637). Illus. b&w, color plates (8p. in center of issue), photos, line drawings. 8½ x 10¼, 90p.
ISSN: 0069–3235. OCLC: 1554088. LC: N81.C45. Dewey: 700.7.

General. Museology.

Scholarly articles explore the broad range of the Institution's collection, presenting works from different departments, periods and geographical locations. Each issue has an individual title and one theme for articles based on the Museum collection.
Bibliographies. Indexed: AmH&L. ArtBibMod. ArtI. CloTAI. HistAb. RILA. Reviewed: Katz.
Advertising: none. Circulation: 15,000.

MUSEUMS JOURNAL OF PAKISTAN. 1950. a. EN. 881

Museums Association of Pakistan, Victoria Memorial Hall, Peshawar, Pakistan.
Illus., some color.
ISSN: 0077–2348. OCLC: 1642226. LC: AM79.P3M8. Dewey: 708.

NATIONAL GALLERIES OF SCOTLAND. BULLETIN. 1981. bi–m. EN. 882

National Galleries of Scotland, Information Department, Belford Rd., Edinburgh EH4 3DR, Scotland. Robert Dalrymple, Editor.

Subscription: free. Illus. photos.

ISSN: 0953–024X. LC: N1275. Dewey: 708. Formerly: *National Galleries of Scotland. News.*

Information profiles current activities, temporary exhibits, permanent displays, and new acquisitions of the Galleries which consist of the National Gallery of Scotland, the Scottish National Portrait Gallery, and the Scottish National Gallery of Modern Art.

NATIONALMUSEUM BULLETIN. 1977. 3/yr. EN or SW. 883

Nationalmuseum, Box 16176 S–103 24, Stockholm 16, Sweden. Phone 08–666–4250. Gorel Cavilli–Bjorkman, Ulf Cederlof, & Magnus Olausson, Editors.

Illus. b&w, photos. 7 x 8¼, 42p.

ISSN: 0347–7835. OCLC: 3831523. LC: N3540.A28.

Museology.

Publication of the National Swedish Art Museum devoted to Swedish art and artists. Contains numerous illustrations.

Indexed: ArtBibMod. CloTAI. RILA.

Advertising: none.

NETHERLANDS. RIJKSMUSEUM AMSTERDAM. BULLETIN. 1953. q. DU. EN summaries. 884

Staatsuitgeverij, Christoffel Plantijnstraat 1, The Hague, The Netherlands.

Subscription: fl 40. Illus. Index.

ISSN: 0569–9665. Dewey: 709.4. Formerly: *Netherlands. Rijksmuseum. Bulletin.*

Prepared by the National Museum. Contains information on the Museum's collections and activities.

NEVADA STATE MUSEUM NEWSLETTER. 1972. bi–m. EN. 885

Nevada State Museum Docent Council, Capitol Complex, Carson City, NV 89710. Phone 702–885–4810. Jack Gibson, Editor (909 Stafford Way, Carson City, NV 89701).

Subscription: included in membership. No sample. Back issues. 8½ x 11, 8–10p.

OCLC: 13438796. Dewey: 069.09793.

Antiques. Archaeology. Historic Preservation. Museology. Textiles.

Provides news of the Nevada Historical Society, the Nevada State Railroad Museum, the Nevada State Museum & Historical Society, and the Lost City Museum.

Listings: regional. Exhibition information. Freelance work: yes. Contact: editor.

Advertising: none. Mailing lists: none. Circulation: 1000. Audience: membership.

NEW GLEANINGS. 1981. q. EN. 886

Historic Cherry Hill, 523½ S. Pearl St., Albany, NY 12202. Phone 518–434–4791. Anne Ackerson, Editor.

Subscription: included in membership, $15. Sample free. Back issues. Illus. b&w, photos. 8½ x 11, 6p., loose–leaf.

Antiques. Decorative Arts. Furniture.

The newsletter of a historic house of 1787 containing Hudson Valley decorative arts and furniture. Contains updates on ongoing activities at the Museum.

Reviews: book 1. Biographies: as relate to volunteers or the history of Cherry Hill.

Advertising: none. Circulation: 500. Audience: members, local press and area museums.

THE NEW MUSEUM OF CONTEMPORARY ART QUARTERLY NEWSLETTER.

1984. q. EN. 887

New Museum of Contemporary Art, 583 Broadway, New York, NY 10012. Phone 212–219–1222. Sara Palmer, Director of Public Affairs.

Subscription: included in membership starting at $45. Sample. Back issues. Illus. b&w, photos. 6 x 8¾, 8p.

Dewey: 069. Formerly: *New Museum News.*

Art Education. Modern Art.

Provides a schedule and description of New Museum exhibitions, programs, and facilities. Coverage is limited to Museum related issues. The most up–to–date and comprehensive guide to ongoing activities for the Museum.

Listings: solely pertaining to New Museum. Calendar of events. Exhibition information. Freelance work: none. Opportunities: study, competitions.

Advertising: none. Audience: members, public.

NEWARK MUSEUM EXHIBITIONS & EVENTS. 1984. bi–m. EN. 888

Newark Museum Association, 49 Washington St., Box 540, Newark, NJ 07101. Phone 201–596–6550. Robert Manuel, Editor.
Subscription: included in membership, $4. Illus. b&w. 11 x 17, 8p.
ISSN: 0028–9256. OCLC: 10982777. LC: N1.N624. Dewey: 069.097. Formerly: *Newark Museum. News Notes.*
Spotlights Museum events, exhibitions and other related information.
Calendar of events. Opportunities: study – workshops, travel.
Advertising: none.

NEWS FROM THE HARVARD UNIVERSITY ART MUSEUMS. 1963. bi–m. EN. 889

Harvard University Art Museums, Publications Dept., 32 Quincy St., Cambridge, MA 02138. Phone 617–495–2397. Evelyn Rosenthal, Editor.
Subscription: included in membership to Friends of the Harvard Art Museums, $35 individual, $25 students and seniors. Sample. No back issues. Illus. b&w. 11 x 17, 8p.
ISSN: 1046–350X. OCLC: 19786566. Dewey: 708. Formerly: *Newsletter* which incorporated the *Fogg Art Museum Newsletter*, and the *Busch–Reisinger Museum Newsletter; Harvard Art Museums Newsletter.*
General.

Tabloid newsletter covers the Fogg Art Museum, the Busch–Reisinger Museum, and the Arthur M. Sackler Museum.
Reviews: book 4. Interviews: curators, staff members of art museums. Biographies: of donors, past staff. Obits. Listings: of Museum events only. Calendar of events. Exhibition information. Freelance work: none. Opportunities: study.
Advertising: none. Audience: museum members, general public.

OREGON ART INSTITUTE MAGAZINE. 1949. m. EN. 890

Oregon Art Institute, 1219 S.W. Park Ave., Portland, OR 97205. Phone 503–226–2811. Vanessa Kokesh Gallant, Editor.
Subscription: available through membership only US, $C35 Canada. Sample. No back issues. Illus. b&w, color, photos. 8½ x 11, 20–24p.
Dewey: 069. Formerly: *Oregon Art Institute Newsletter.*
Ceramics. Decorative Arts. Drawing. Films. Graphic Arts. Modern Art. Painting. Photography. Sculpture.

Presents information concerning events sponsored by the Institute, forthcoming exhibitions, and programs.
Calendar of events. Exhibition information. Freelance work: yes. Contact: editor.
Advertising: 1–2 color: full page $1010, ⅓ page $510; 4 color: full page $1410, ⅓ page $690. Frequency discount and non–profit rate. Demographics: 71% female, 29% male; 50% age 35–54, 20% 65+; 72% college graduates; annual household income 18% $35–49,999, 16% $75,000 or more; distribution: 10,000 mailed to members, 7,000 distributed through prime downtown retail outlets. Circulation: 17,000. Audience: members.

EL PALACIO. 1913. s–a. EN. 891

Museum of New Mexico Foundation, Box 2065, Santa Fe, NM 87504–2087. Phone 505–982–8594. Karen Meadows, Editor.
Subscription: included in membership $30, subscription only $18. No sample. Back issues. Illus. b&w, some color, photos. 8½ x 11, 60–96p.
ISSN: 0031–0158. OCLC: 1641774. LC: F791.P15. Dewey: 978.9.
General. Folk Art. Fine Art. History—Southwest.

Deals with anthropology, archaeology, history, fine art, folk art, and other topics related to the U.S. Southwest and adjacent areas. Also includes articles about exhibits in the Museum and related topics.
Reviews: book. Bibliographies: books recommended by contributing authors. Interviews: occasionally, with Southwestern figures, eg. Pueblo Indian speaking about art in Pueblo world. Freelance work: Several articles/yr. by commission. Contact: editor. Indexed: ArtBibMod. CloTAI. Reviewed: *Art Documentation* Fall 1986, p.132.
Advertising: none. Circulation: 4500. Audience: those interested in the collections of the Museum and general Southwestern topics.

PHAROS. 1963. a. EN. 892

Museum of Fine Arts, 255 Beach Drive N.E., St. Petersburg, FL 33701. Phone 813–896–2667. Dr. Diane Lesko, Editor.
Subscription: included in membership, $5 US. No sample. Illus. b&w 15, color 2. 8½ x 11, 32p.
ISSN: 0031–7160. Dewey: 708.1.
Antiques. Art Education. Art History. Decorative Arts. Drawing. Graphic Arts. Modern Art. Painting. Photography. Sculpture. Textiles.

Primarily for museum members to showcase accessions to the museum's collection. Includes articles on new accessions and list of accessions for the year.

Freelance work: yes. Contact: editor.
Advertising: none. Circulation: 5000. Audience: Museum members, museums on exchange list.

PHILADELPHIA MUSEUM OF ART BULLETIN. 1902. q. EN. 893

Philadelphia Museum of Art, Box 7646, Philadelphia, PA 19101. Phone 215–763–8100. George Marcus, Editor.
Subscription: free to Museum members, $18 non–members. Illus. 8½ x 11, 34p.
ISSN: 0031–7314. LC: N685. Dewey: 708.1.
Scholarly essays on the collection of the Museum.
Indexed: ArtI. CloTAI. RILA.

PREVIEW. 1983. q. EN. 894

North Carolina Museum of Art, 2110 Blue Ridge Blvd., Raleigh, NC 27607. Phone 919–833–1935. Anna Upchurch & Ann Waterfall, Editors.
Subscription: included in membership, free. Microform available from North Carolina State Library System. Sample & back issues free. Illus. b&w, photos. 7 x 11, 36p.
ISSN: 0892–2896. OCLC: 9444343. LC: N1.P747. Dewey: 708.
Art History. Films. Modern Art. Museology. Painting. Photography. Sculpture.

Routinely includes a letter from the director of the Museum; curatorial essays about current and/or upcoming exhibitions; items of interest regarding loans or acquisitions; general museum news about staff, events, recent publications, educational opportunities; information relating to the Museum's innovative "Art + Landscape" project; travel programs; and, lists of individual and corporate supporters.
Interviews: occasionally, with artists, individuals important to the Museum. Biographies: artists, new staff, key benefactors.
Listings: local. Calendar of exhibitions. Freelance work: none. Opportunities: study.
Advertising: none. Mailing lists: none. Circulation: 11,000. Audience: Museum members.

PREVIEWS. 1911. bi–m. EN. 895

Indianapolis Museum of Art, 1200 W. 38th St., Indianapolis, IN 46208. Phone 317–923–1331. Judy Fries, Editor.
Subscription: included in membership free, non–members $12. Sample & back issues $2 + handling. Illus. b&w, photos. 8½ x 11, 24–28p.
OCLC: 17834875. LC: N577.A43. Dewey: 708.7. Formerly: *Indianapolis Museum of Art Quarterly Bulletin; Newsletter Members Quarterly Newsletter.*
Art Education. Art History. Decorative Arts. Films. Modern Art. Painting. Sculpture. Textiles.

Highlights exhibitions, announcements of events and other activities of the Museum. "News and calendars for museum members".
Listings: regional. Calendar of events. Exhibition information. Freelance work: none.
Advertising: rates on request. Mailing lists: none. Circulation: 15,000. Audience: members.

R.L.C.'S MUSEUM GAZETTE. 1966. irreg. EN. 896

Bentley, Alta. T0C 0J0, Canada. Richard L. Coulton, Editor & Pub.
ISSN: 0035–7154. Dewey: 708.

RAWLS MUSEUM ARTS BULLETIN. 1981. m. EN. 897

Walter Cecil Rawls Museum, Box 318, Courtland, VA 23837. Phone 804–653–2821. K. Paul Johnson, Editor.
Dewey: 069.

RCHA NEWSLETTER. 1971. q. EN. 898

Regional Council of Historical Agencies, 1400 N. State St., Syracuse, NY 13208. Phone 315–475–1525. Jackie Day, Editor.
Subscription: $12.50 individual, $20 institution.
Tabloid.
Includes the *RCHA Technical Information Sheet.*
Reviews: book.
Advertising.

RECORD OF THE ART MUSEUM, PRINCETON UNIVERSITY. 1942. s–a. EN. 899

Princeton University, Art Museum, Princeton, NJ 08544–1018. Phone 609–452–4341. Jill Guthrie, Editor.

Subscription: included in membership of the Friends of the Art Museum, $9. Microform available from UMI. Back issues. Illus. b&w, some color, glossy photos. Index. Cum. index every 10 yrs. 8½ x 11, 40p.
ISSN: 0032–843X. OCLC: 6807782. LC: N1.P83. Dewey: 708.149. Formerly: *Record of the Museum of Historic Art, Princeton University.*
Archaeology.

Scholarly articles presenting history and criticism of pieces in the museum's collection.
Indexed: ArtBibMod. ArtI. Reviewed: Katz.

RECORDS OF THE QUEEN VICTORIA MUSEUM. 1942. irreg. EN. 900
Queen Victoria Museum and Art Gallery, c/o Kaye Dimmack, Wellington Street, Launceston, Tasmania 7250, Australia. C.B. Tassell, Editor.
Illus. b&w, some color.
ISSN: 0085–5278. OCLC: 5297581. LC: AM101.Q84.

REDDING MUSEUM. OCCASIONAL PAPERS. 1980. irreg. EN. 901
Redding Museum and Art Center, Box 427, Redding, CA 96099. Phone 916–243–4994. James Dotta & Margaret Kardell, Editors.
Dewey: 069.5.

THE REGISTER OF THE SPENCER MUSEUM OF ART. 1978. a. EN. 902
Spencer Museum of Art, University of Kansas, Lawrence, KS 66045. Phone 913–864–4710. Carol Shankel, Editor.
Subscription: included in membership (Friends of the Art Museum), $7.50. Back issues $3.50–$7.50. Illus. photos. 8½ x 11, 100p.
ISSN: 0733–866X. OCLC: 5062886. LC: N582.L25 A35. Dewey: 708.181. Formerly: *University of Kansas. Museum of Art. Register.*
Architecture. Art History. Ceramics. Decorative Arts. Drawing. Graphic Arts. Modern Art. Painting. Photography. Sculpture. Textiles.

Academic annual of the Spencer Museum's activities contains several scholarly articles pertaining to objects in the collection. Articles are by American and foreign specialists. Includes reports of Museum programs and acquisitions.
Indexed: ArtBibMod. RILA.
Advertising: none. Circulation: 1,200.

LA REVUE DU LOUVRE ET DES MUSEES DE FRANCE. 1951. bi–m. FR only. 903
Reunion des Musees Nationaux, 60ter, rue de Lille, 75007 Paris, France. Phone 42.22.39.36. Sabine Cotte, Editor.
Subscription: 290F France, 340F elsewhere. Illus. b&w, some color, photos. Annual index. 8¼ x 10½, 88p.
ISSN: 0035–2608. OCLC: 1764141. LC: N2010.R44. Dewey: 705. Formerly: *Revue des Artes. Musees de France.*
Art History.

Scholarly articles with numerous illustrations on works in the Louvre and other French collections. Also presents information on acquisitions.
Reviews: exhibition 10, length 2p. each. Bibliographies with articles. Listings: national. Calendar of exhibitions. Indexed: ArtArTeAb. ArtBibCur. ArtBibMod. ArtHum. ArtI. Avery. BHA. CurCont. RILA. Reviewed: Katz.
Advertising.

ROTUNDA. 1968. q. EN. 904
Royal Ontario Museum, Publication Services, 100 Queen's Park, Toronto, Ontario M5S 2C6, Canada. Phone 416–586–5590. Sandra Shaul, Editor.
Subscription: included in membership, $C16.95 Canada, + $4 elsewhere (1057 McNicoll Ave., Suite 104, Scarborough, Ontario M1W 3W6). Illus. color, photos. 8¼ x 10¾, 64p.
ISSN: 0035–8495. OCLC: 1898685. LC: AM101.T6252. Dewey: 069.
The magazine of the Royal Ontario Museum contains articles on the arts and sciences written by international experts. Profusely illustrated.
Reviews: book. Back issues. Indexed: CanMagI. CanPI. HistAb.
Advertising: b&w & color ads. Jory, High & Associates, 220 Duncan Mill Rd., Suite 504, Don Mills, Ontario M3B 3J5 416–447–7999, fax 416–447–8034).

THE SAINT LOUIS ART MUSEUM BULLETIN. 1914, ns 1965. s–a. EN. **905**
Saint Louis Art Museum, 1 Fine Arts Drive, Forest Park, St. Louis, MO 63110. Phone 314–721–0067. Mary Ann Steiner, Editor.
Subscription: included in membership, $8. Sample & back issues $4 each. Illus. b&w, color. 8½ x 11, 48p.
ISSN: 0009–7691. OCLC: 2571136. LC: N729.A33. Dewey: 708. Formerly: *Bulletin of the City Art Museum.*
Architecture. Art History. Decorative Arts. Drawing. Furniture. Modern Art. Painting. Sculpture. Textiles.
Articles on the Museum's collections.
Indexed: ArtBibMod. ArtI. CloTAI. RILA. Reviewed: Katz.
Advertising: none. Circulation: 15,000. Audience: membership and interested art community.

SCOTTISH MUSEUM NEWS. 1981. q. EN. **906**
Scottish Museum Council, County House, 20–22 Tophichen St., Edinburgh EH3 8JB, Scotland. Phone 031–229–7465.
ISSN: 0266–6898. Dewey: 069. Formerly: *Omnigatherum.*
News and information on events in Scottish museums and the work of the council.

SOUTHERN AFRICAN MUSEUMS ASSOCIATION BULLETIN. 1936. q. **907**
Southern African Museums Association, P.O. Box 61, Capetown 8000, South Africa. E.H. Bigalke, Editor.
ISSN: 0370–8314. Formerly: *Southern African Museums Association Publication.*
Advertising.

SUNRISE. bi–m. EN. **908**
Sunrise Museums, Inc., 746 Myrtle Rd., Charleston, WV 25314. Phone 304–344–8035. Linda Coulter, Editor.
Subscription: included in membership.
Newsletter covering the Sunrise Museum's Art Gallery and Children's Museum and Planetarium.

TRIPTYCH. 1980. 5/yr. EN. **909**
The Museum Society, M.H. de Young Memorial Museum, Golden Gate Park, San Francisco, CA 94118. Phone 750–3636. Pamela Forbes, Editor–in–chief.
Subscription: included in membership. Illus. b&w, color. 8 x 11, 30p.
Describes exhibitions at the Asian Art Museum of San Francisco and the Fine Arts Museums of San Francisco. Articles on the Museums' collections.
Indexed: ArtArTeAb. Avery.
Advertising: none.

TRITON MUSEUM OF ART MEMBERS' BULLETIN. 1967. bi–m. EN. **910**
Triton Museum of Art, 1505 Warburton Ave., Santa Clara, CA 95050. Phone 408–247–3754. Lisa Davoust, Editor.
Subscription: included in membership, individual/family $25, student/senior $15. No sample. No back issues. Illus. b&w, photos. 8½ x 11, 8p.
General. Modern Art.
Specializes in 18th and 19th century American art and contemporary North California artists.
Reviews: exhibition 3, length 500 words. Interviews: profiles of artists, volunteers and staff. Biographies: profiles of donors, artists, and volunteers. Listings: Northern California. Calendar of events. Exhibition information. Freelance work: none. Opportunities: study – workshops sponsored by the Museum, Children's Art Study Grants; competitions – annual printmaking & drawing.
Advertising: none. Mailing lists: none. Circulation: 600. Audience: members.

UNIVERSITY OF KENTUCKY ART MUSEUM NEWSLETTER. 1987. s–a. EN. **911**
University of Kentucky Art Museum, Rose and Euclid Sts., Lexington, KY 40506–0241. Phone 606–257–5716. William Hennessey, Editor.
Subscription: included in membership. Sample. No back issues. Illus. b&w. 14 x 17, 8p.
Dewey: 700.
Tabloid covers news of the Museum, its staff and collection, programs, and exhibitions.
Listings: regional. Calendar of events. Exhibition information. Freelance work: none. Opportunities: study, competitions.
Advertising: none. Circulation: 2500. Audience: general public.

VALENTINE NEWS. 1898. bi–m. EN. 912

Valentine Museum, 1015 East Clay St., Richmond, VA 23219. Phone 804–649–0711. Michael McGrann, Editor.

Subscription: included in membership, $30 individuals, $40 family, $20 seniors, $15 students & classroom. Sample. Some back issues. Illus. b&w, photos. 17 x 22 in., 4p.

Dewey: 069. Formerly: *Profile*.

General. Antiques. Architecture. Art History. Decorative Arts. Furniture. Historic Preservation. Sculpture.

Newsletter devoted to the life and history of Richmond covers Museum exhibitions and events pertaining to American urban and social history, costumes and textiles, architecture and restoration, industrial and commercial artifacts, and minority history.

Listings: Museum or Richmond area. Calendar of Museum & other arts organization events. Exhibition information for the Museum or institutions using the Museum's artifacts. Freelance work: none. Opportunities: study – Museum's or at institutions where the Museum's staff participates, competitions.

Advertising: none. Mailing lists: none. Circulation: 3500 mailed + 2000 visitors. Audience: museum members and guests.

THE VIRGINIA MUSEUM OF FINE ARTS BULLETIN. 1936. bi–m. EN. 913

Virginia Museum of Fine Arts, 2800 Grove Ave., Richmond, VA 23221–2466. Phone 804–367–0534. Monica Hamm, Editor, Editor.

Subscription: included in membership, $5 US, $6 Canada & foreign. Sample. Back issues. Illus. photos. 7 x 10, 20p.

ISSN: 0363–3519. OCLC: 2410390. LC: N716.V45 A18. Dewey: 708. Formerly: *Virginia Museum Bulletin*.

Primarily a calendar of events at the Museum and around the state of Virginia. Also contains other information of interest to Museum members and the general public.

Listings: regional. Calendar of events. Exhibition information. Freelance work: none. Opportunities: study, competitions.

Advertising: none. Circulation: 16,000. Audience: members and others interested in Museum exhibitions and events.

WELLESLEY COLLEGE FRIENDS OF ART NEWSLETTER. 1965. s–a. EN. 914

Wellesley College Museum, Jewett Arts Center, Wellesley, MA 02181. Phone 617–235–0320, x2051. Nancy Gunn, Assistant Director for Museum Development.

Subscription: included in membership. No sample. Back issues (photocopies). Illus. b&w, photos. 22 x 17, 6p.

Dewey: 069.

General.

The newsletter focuses on Wellesley College Museum exhibitions and related programs, including articles on recent Museum and Art Department developments and Friends activities.

Interviews: occasionally with members of Friends of Art. Listings: national. Calendar of Museum events. Exhibition information. Freelance work: yes. Contact: Anita Meyer. Opportunities: competitions.

Advertising: none.

Annual Reports

AKRON ART MUSEUM ANNUAL REPORT. a. EN. 915

Akron Art Museum, 70 East Market St., Akron, OH 44308–2084. Phone 216–376–9185. Ellen Spetrino, Editor.

Illus. b&w, photos. 35p.

Contents consist of reports, acquisitions, exhibitions, events, contributions, and financials. Several full page illustrations.

ALBERTA ART FOUNDATION ANNUAL REPORT. 1972. a. EN. 916

Alberta Art Foundation, Beaver House, 4th Floor, 10158 103 St., Edmonton, Alta. T5J 0X6. Phone 403–427–9968. W. Tin Ng, Editor.

Subscription: free. Illus.

ISSN: 0704–9056. OCLC: 3991376. LC: NX28.C32 A413. Dewey: 706.

ANDREW W. MELLON FOUNDATION REPORT. 1969. a. EN. 917

Andrew W. Mellon Foundation, 140 E. 62nd St., New York, NY 10021. Phone 212–838–8400.

Subscription: free.

ISSN: 0066–1694. LC: AS911. Dewey: 060. Formerly: *Avalon Foundation. Report; Old Dominion Foundation. Report.*

ANNUAL BULLETIN/BULLETIN ANNUEL. Ceased. 918

ANNUAL REPORT - MUSEUM OF MODERN ART. 1985. a. EN. 919
Museum of Modern Art (New York, NY), 11 W 53rd St., New York, NY 10019. Christopher Lyon, Editor.
Illus. 8½ x 11, 64p.
ISSN: 0899–2118. OCLC: 17883468. Dewey: 708. Formerly: *Museum of Modern Art Biennial Report.*
Modern Art.

The annual report of the Museum includes illustrations of its exhibitions.

ANNUAL REPORT - NATIONAL MUSEUM OF TANZANIA. 1966. a. EN. 920
National Museum of Tanzania, Box 511, Dar es Salaam, Tanzania.
Illus.
ISSN: 0082–1675. OCLC: 2566518. Dewey: 708.

ANNUAL REPORT - THE TOLEDO MUSEUM OF ART. 1983. a. EN. 921
Toledo Museum of Art, Box 1013, Toledo, OH 43697. Phone 419–255–8000.
Illus. 8½ x 11, 32–40p.
ISSN: 0888–9643. OCLC: 10517877. LC: N820.A33. Dewey: 708.17. Formerly: *Museum News (1970–1982).*

ANNUAL REVIEW - NATIONAL GALLERIES OF SCOTLAND. 1981. bi–m. EN. 922
National Galleries of Scotland, Information Department, Belford Rd., Edinburgh EH4 3DR, Scotland.
Subscription: free. Illus.
ISSN: 0263–4589. OCLC: 15479564. LC: N1280.A3. Dewey: 708.2. Formerly: *Annual Report.*
Incorporating the *Annual Report of the Galleries.* The National Galleries of Scotland consist of the National Gallery of Scotland, the Scottish National Portrait Gallery and the Scottish National Gallery of Modern Art.
Advertising: none.

THE ART INSTITUTE OF CHICAGO ANNUAL REPORT. a. EN. 923
Art Institute of Chicago, Michigan Ave. at Adams St., Chicago, IL 60603.
Illus. color & b&w. 8½ x 11, 104p.
Includes descriptions of acquisitions.

ART WORKERS GUILD. ANNUAL REPORT. 1885. a. EN. 924
Art Workers Guild, 6 Queen Sq., London WC1N 3AR, England. Phone 071–837–3474. D.G. Pullen, Editor.
Subscription: included in membership. Illus.

THE BULLETIN OF THE CLEVELAND MUSEUM OF ART. See no. 802.
The annual report for the Museum is published as one issue of the *Bulletin.*

BULLETIN OF THE WHITNEY MUSEUM OF AMERICAN ART. 1978. a. EN. 926
Whitney Museum of American Art, 945 Madison Ave. at 75th St., New York, NY 10021. Phone 212–570–3600. Sheila Schwartz, Editor.
Subscription: included in membership, $5. No sample. Illus. b&w, photos. 8 x 11, 120p.
ISSN: 0511–8824. OCLC: 1645072. LC: N618.W45. Dewey: 709. Formerly: *Whitney Review.*
Art Education. Art History. Drawing. Films. Modern Art. Museology. Painting. Photography. Sculpture.

The annual report of the Museum reviews the year's activities of a museum devoted to 20th Century American art.
Advertising: none.

CANADA. NATIONAL MUSEUMS OF CANADA. ANNUAL BULLETIN/CANADA. MUSEES NATIONAUX DU CANADA. BULLETIN ANNUEL. Ceased. 927

THE CARNEGIE ANNUAL REPORT. EN. 928
The Carnegie, 4400 Forbes Ave., Pittsburgh, PA 15213. Phone 412–622–3131. Janet McCall, Editor.
Illus.
Dewey: 069. Formerly: *Carnegie Institute Annual Report.*

Presents a detailed accounting of the activities of the Carnegie and each of its five components: Library of Pittsburgh, the Museum of Art, the Museum of Natural History, the Music Hall, and the Science Center. The report includes lists of events, loans, acquisitions, contributors, programs, and visiting scholars.

CENTER (Washington, DC.) See no. 599.

COLUMBIA MUSEUM OF ART ANNUAL REPORT. a. EN. 929
Columbia Museum of Art and Science, 1112 Bull St., Columbia, SC 29201. Phone 803–799–2810.
8½ x 11.
Decorative Arts. Prints. Sculpture. Tribal Arts.
Advertising.

CONTEMPORARY ARTS MUSEUM, Houston. Annual Report. a. EN. 930
5216 Montrose Blvd., Houston, TX 77006–6598. Phone 713–526–0773.
Illus. b&w. 8½ x 11, 28p.

DALLAS MUSEUM OF ART ANNUAL REPORT. 1984. a. EN. 931
Dallas Museum of Art, 1717 N. Harwood, Dallas, TX 75201. Phone 214–922–0220. Robert Rozelle, Editor.
Illus.
ISSN: 0898–0896. OCLC: 12085096. LC: N558.A3. Dewey: 708. Formerly: *Report – Dallas Museum of Fine Arts.*

DAYTON ART INSTITUTE ANNUAL REPORT. 1931. a. EN. 932
Dayton Art Institute, Box 941, Dayton, OH 45401–0941. Phone 513–223–5277. Pat Koeprick, Editor.
Subscription: $3.50. Illus. 7½ x 9, 48p.
ISSN: 0070–3028. OCLC: 3797888. Dewey: 708. Superseded in part: *Dayton Art Institute Annual Report and Bulletin.*
Scholarly art historical articles by the museum's curators on works in the permanent collection. Covers all fields of art history.
Circulation: 4,000.

DELAWARE ART MUSEUM ANNUAL REPORT. 1912. a. EN. 933
Delaware Art Museum, 2301 Kentmere Parkway, Wilmington, DE 19806. Phone 302–571–9590. Melissa H. Mulrooney, Editor.
Subscription: free.
Dewey: 706. Formerly: *Wilmington Society of the Fine Arts. Report.*

ELVEHJEM MUSEUM OF ART BULLETIN/ANNUAL REPORT. See 823. 934
Publication divided about evenly between the Annual Report which includes brief descriptions and illustrations of acquisitions and the Bulletin which contains articles on exhibition collections.

FLINT INSTITUTE OF ARTS ANNUAL REPORT. a. EN. 935
Flint Institute of Arts, 1120 East Kearsley St., Flint, MI 48503–1991. Phone 313–234–1695.
Illus., few b&w glossy photos. 8½ x 11, 30p.
OCLC: 6344939. LC: AP1.F623.

HECKSCHER ART MUSEUM ANNUAL REPORT. a. EN. 936
Heckscher Museum, Prime Ave. & 25A, Huntington, NY 11743.
Illus.
OCLC: 18335414. LC: N576.H8 A3.

THE HENRY FRANCIS DU PONT WINTERTHUR MUSEUM. ANNUAL REPORT. a. EN. 937
Henry Francis DuPont Winterteur Museum, Inc., Rt. 52, Wilmington, DE 19735. Phone 302–888–4600.
Illus. b&w.
Devoted to American decorative arts and American cultural history.

HIGH MUSEUM OF ART ANNUAL REPORT. 1973. a. EN. 938

High Museum of Art, 1280 Peachtree St. NE, Atlanta, GA 30309. Phone 404–892–3600, fax 404–898–9578. Margaret Miller, Amanda Woods, & Kelly Morris, Editors.

Illus. b&w, photos. 8½ x 10, 56p.

Contains reports by the director and curators as well as a list of acquisitions with several illustrations.

Advertising: none.

THE HUNTINGTON LIBARY, ART COLLECTIONS AND BOTANICAL GARDENS ANNUAL REPORT. a. EN. 939

Illus. small b&w photos. 6 x 9, 60–94p.

"The year in review".

KRESGE ART MUSEUM BULLETIN. 1985, ns v.1. a. EN. 940

Kresge Art Museum, Michigan State University, East Langsing, MI 48824. Phone 517–355–7631. Carol Garrett Fisher, Editor.

Subscription: $7 US. Back issues. Illus. b&w, photos. 7 x 10, 54p.

ISSN: 0887–9222. OCLC: 12873340. LC: N567.A15. Dewey: 708.174. Formerly: *Kresge Art Center Bulletin.*

The annual report of the Museum contains several articles on the collection and lists acquisitions.

Indexed: ArtBibMod. CloTAI.

Advertising: none. Audience: general museum going.

MARION KOOGLER McNAY ART MUSEUM ANNUAL REPORT. 1954? a. EN. 941

600 North New Braunfels Ave., PO Box 6069, San Antonio, TX 78209.

Illus. b&w, photos. 7 x 10, 100p.

METROPOLITAN MUSEUM OF ART ANNUAL REPORT. EN. 942

1000 Fifth Ave., New York, NY 10028. Barbara Burn, Editor.

Illus. b&w. 8½ x 11, 108p.

"Curatorial Reports & Departmental Acquisitions" — by department includes a list of major acquisitions both gifts and purchases.

METROPOLITAN MUSEUM OF ART. RECENT ACQUISITIONS. 1986. a. EN. 943

Metropolitan Museum of Art, 1000 Fifth Ave., New York, NY 10028.

Illus. b&w 52, color 50, photos.

ISSN: 0889–6585. OCLC: 13987056. LC: N610.A677. Dewey: 708. Formerly: *Notable Acquisitions.*

Published as a companion volume to the annual report, contains illustrations of important acquisitions made during the year.

MILWAUKEE ART MUSEUM ANNUAL REPORT. 1918, 5th. a. EN. 944

Milwaukee Art Museum, 750 North Lincoln, Memorial Drive, Milwaukee, WI 53202.

Illus. b&w, photos. 8½ x 11, 104p.

OCLC: 18531419, 7885268. LC: N582.M5 A34a. Dewey: 708.175. Formerly: *Milwaukee Art Center Annual Report.*

Report of year's exhibitions as well as an extensive acquisitions section which incorporates many illustrations with a description of the work and information about the artist.

THE MINNEAPOLIS INSTITUTE OF FINE ARTS. ANNUAL REPORT. 1961. a. EN. 945

Minneapolis Institute of Fine Arts, 2400 Third Ave. S., Minneapolis, MN 55404. Phone 612–870–3046.

Illus.

ISSN: 0076–9096. OCLC: 1757677. LC: N11M66.A1. Dewey: 700.

MONTGOMERY MUSEUM OF ARTS ANNUAL REPORT. EN. 946

Montgomery Museum of Arts, P.O. Box 230819, Montgomery, Alabama 36123–0819. Phone 205–244–5700.

The annual report of a Museum which features 19th and 20th Century American paintings, prints and drawings; 19th Century French paintings; master prints; contemporary regional graphics; porcelain, glass, weapons, historic artifacts, sculpture, and decorative arts.

MONTREAL MUSEUM OF FINE ARTS ANNUAL REPORT/MUSEE DES BEAUX-ARTS DE MONTREAL RAPPORT ANNUEL. 1953. a. EN & FR. 947

Montreal Museum of Fine Arts, 3400 Ave du Musee, Montreal H3G 1K3 Canada. Phone 514–285–1600, fax 514–844–6042.
Illus. b&w, color. 8½ x 11, 54p each.
OCLC: 19049993.
Bilingual edition with two reports bound together on verso with different illustrations in color for the same articles. Includes a list of acquisitions with brief descriptions.
Calendar of events.

MUSEUM NOTES. 1913. a. EN. 948

Rhode Island School of Design, Museum of Art, 224 Benefit St., Providence, RI 02903. Phone 401–331–3511. Judith A. Singsen, Editor.
Subscription: included in membership, $7.50. Sample $5 + postage. Back issues. Illus. b&w, photos. 8 x 10, 60p.
ISSN: 0027–4097. OCLC: 2234930. LC: N714.P7 R495. Dewey: 750. Formerly: *Bulletin of Rhode Island School of Design.*
General.

Functions as the annual report for the Museum of Art, RISD. Focus is on events of the past year (July 1–June 30) organized by department (antiquities, Asian and ethnographic, costume and textiles, decorative arts, education, painting and sculpture, prints, drawings and photographs), with a report from each and scholarly entries on notable acquisitions. An introduction by the Director and listings of all exhibitions, notable acquisitions, publications, lectures and performances, special events, tours, volunteers, committee members, donors, loans, and staff complete the volume.
Freelance work: none.
Advertising: none. Audience: museum membership, faculty, staff, students of RISD.

MUSEUM OF FINE ARTS, HOUSTON ANNUAL REPORT. a. EN. 949

Museum of Fine Arts, P.O. Box 6826, 1001 Bissonnet St., Houston, TX 77005. Phone 713–639–7300, fax 713–639–7399.
Subscription: included in membership free. Illus. b&w, glossy photos. 8 x 10, 48p.
Antiques.

Annual report includes acquisitions information (artist, nationality and birthdate, title, date, medium, size and how acquired).

MUSEUM OF THE CITY OF NEW YORK ANNUAL REPORT. 1923. a. EN. 950

Museum of the City of New York, 5th Ave. at 103rd St., New York, NY 10029. Phone 212–534–1672. Beverly Bartow, Editor.
Subscription: included in membership, also mailed to Museum donors and supporters. Sample. No back issues. Illus. b&w, photos. 8½ x 11, 12–16p.
Dewey: 708.
General.

Summarizes the activities and progress that the Museum has made over the course of its fiscal year. Collections related to present and past social, economic and political history of New York City. Includes costume, furniture, silver, painting, decorative arts, manuscripts, toys, period rooms, sculpture, graphics and textiles. Describes those awards the Museum receives.
Listings: regional. Exhibition information. Freelance work: none. Opportunities: study – describes those events the Museum sponsors.
Advertising: none. Circulation: 3500–4000. Audience: museum members and supporters.

THE MUSEUM YEAR. 1965. a. EN. 951

Subscription: included in membership.
Museum of Fine Arts Boston, 465 Huntington Ave., Boston, MA 02115. Phone 617–267–9300 ext. 437. Cynthia Purvis, Editor.
Illus. b&w, some color, photos. 8½ x 11, 90–110p.
ISSN: 0740–0403. OCLC: 6275614. LC: N520.A3. Formerly: *Annual Report of the Museum of Fine Arts Boston.*
Annual report of the Museum contains reports by departments, section on major acquisitions, listing of gifts, and lengthy listing of appeal donors. Acquisition information consists of illustration, full description, and brief information on the artist or the history of the piece.
Calendar of exhibitions. Freelance work: none.
Advertising: none. Audience: staff, members.

NATIONAL ART COLLECTIONS FUND REVIEW. 1983. a. EN. 952

National Art Collections Fund, 20 John Islip St., London SWIP 4JX, England. Phone 071–821 0404. Stephen Jones, Editor.

Subscription: included in membership together with *NACF Magazine*, $24.94 individual, $41.57 museums & galleries, $83.14 societies, $207.84 companies. Illus. b&w, some color, glossy photos. A4, 224p.

OCLC: 10193316. LC: N12.N3. Dewey: 707. Formerly: *National Art–Collections Fund Annual Report.*

Annual report includes articles on major acquisitions and an extensive listing of all acquisitions (over 50 pages) together with a full description and illustration of each.

Advertising.

NATIONAL GALLERY OF ART ANNUAL REPORT. 1970. a. EN. 953

National Gallery of Art, 4th and Constitution Ave., N.W., Washington, DC 20565. Phone 202–842–6200.

Subscription: $1.50 (NGA Publications Office). Sample. Some back issues $1.50. Illus. b&w, photos. 8 x 10, ca. 130p.

ISSN: 0091–7222. OCLC: 3225099. LC: N856.A2. Dewey: 708.

General.

Review of the past fiscal year contains statements from the president and the director; lists of trustees, donors, lenders, and acquisitions; financial information and reports of activities in various offices. Reporting offices include education, Center for Advanced Study, curatorial, conservation, library, archives, publications, design, and photo services.

Listings: NGA only. Freelance work: for design. Contact: Frances P. Smyth.

Advertising: none. Circulation: 2500–5000. Audience: museum association and institutions, donors, patrons, lenders, members.

THE NATIONAL GALLERY REPORT. a. EN. 954

Published by order of the Trustees, National Gallery Publications, Ltd., Trafalgar Square, London WC2N 5ON England.

Illus. b&w, color, photos. 8½ x 11, 94p.

ISSN: 0143–9065.

The annual report of the Gallery includes a 1–2 page description of the year's exhibitions and major acquisitions together with illustrations.

Advertising: none.

NATIONAL MUSEUM OF MODERN ART ANNUAL REPORT. 1957. a. JA & EN. 955

National Museum of Modern Art, Tokyo, 3 Kitanomaru Koen, Chiyoda–ku, Tokyo 102, Japan. Shigeo Chiba, Editor.

Dewey: 069.

Contains listings of all exhibitions, events, and collected works.

NATIONAL MUSEUM OF TANZANIA ANNUAL REPORT. See no. 920.

NATIONAL PORTRAIT GALLERY ANNUAL REPORT. a. EN. 957

National Portrait Gallery Publications, London WC2H 0HE England.

Illus. b&w, glossy photos. 6 x 9½, 36p.

ISSN: 0955–8942.

"Illustrated Report and List of Acquisitions". Brief description of acquisitions.

Advertising: none.

NEWARK MUSEUM ANNUAL REPORT. 1982. a. EN. 958

Newark Museum, 49 Washington St., P.O. Box 540, Newark, NJ 07101.

Illus.

ISSN: 8755–1411. OCLC: 10370365. LC: N625.A1. Formerly: *Newark Museum Quarterly.*

PHOENIX ART MUSEUM ANNUAL REPORT. a. EN. 959

Phoenix Art Museum, 1625 N. Central Ave., Phoenix, AZ 85004. Phone 602–257–1880.

8½ x 11, 6–8p.

ISSN: 0090–6255. OCLC: 5377322. LC: N696.A25. Dewey: 708.

Report of the Phoenix Art Museum and Affiliates consists mainly of financial statements. Very brief.

QUEEN VICTORIA MUSEUM AND ART GALLERY ANNUAL REPORT. 1902. a. EN. 960

Queen Victoria Museum and Art Gallery, c/o Kay Dimmack, Wellington St., Launceston, Tas. 7250, Australia. C.B. Tassell, Editor.

Subscription: free.
Dewey: 708.

RHODE ISLAND SCHOOL OF DESIGN MUSEUM NOTES. See no. 948.

ROYAL ONTARIO MUSEUM ANNUAL REPORT. 1950. a. EN. 962
Royal Ontario Museum, Publication Services, 100 Queen's Park, Toronto, Ontario M5S 2C6, Canada. Phone 416–586–5582.
Barbara Ibronyi, Editor.
Subscription: free. Illus.
ISSN: 0082–5115. OCLC: 1110968. LC: AM101.T624. Dewey: 069.0871.
Audience: government and public.

THE SAINT LOUIS ART MUSEUM ANNUAL REPORT. a. EN. 963
Forest Park, Saint Louis, MO 63110–1380. Mary Ann Steiner, Editor.
Illus. b&w, some color. 8½ x 11, 54p.
Includes a list of acquisitions, with illustrations for major acquisitions.
Audience: included in membership.

SAMUEL H. KRESS FOUNDATION ANNUAL REPORT. 1963. a. EN. 964
Samuel H. Kress Foundation, 174 E. 80th St., New York, NY 10021. Phone 212-861-4993.
ISSN: 0581-4766. OCLC: 1791727. LC: HV97.S25. Dewey: 361.7.
The report includes information concerning the Foundation's grant programs in art history, preservation, and conservation.

SCOTTISH RITE MASONIC MUSEUM OF OUR NATIONAL HERITAGE. ANNUAL RE-
PORT. a. EN. 965
Scottish Rite Masonic Museum and Library, Inc., P.O. Box 519, 33 Marrett Rd., Lexington, MA 02173. Phone 617–861–6559.
Illus. b&w, photos. 8½ x 9½, 24p.
Decorative Arts. Furniture. Painting. Prints.

Devoted to American history and Masonic collection. Includes American prints, costumes, photographs and memorabilia.

SOLOMON R. GUGGENHEIM MUSEUM ANNUAL REPORT. 1977. a. EN. 966
Solomon R. Guggenheim Museum, 1071 Fifth Ave., New York, NY 10128. Phone 212-360-3500.
Illus. b&w, photos. 8 x 10, 68–72p.
The annual report of the Museum includes the Report of the Peggy Guggenheim Collection in Venice, Italy. Reports on the year's activities, acquisitions, exhibitions and publications, special events, financial report and loans and transfers (art lent to other institutions).

STERLING AND FRANCINE CLARK ART INSTITUTE ANNUAL REPORT. 1978. a. EN. 967
225 South St., Williamstown, MA 01267. Phone 413-458-9545. Mary Jo Carpenter, Editor.
Illus. b&w, photos. 8½ x 11, 64p.
Includes illustrations of major acquisitions as well as a list of all acquisitions for the year.
Advertising: none.

WADSWORTH ATHENEUM ANNUAL REPORT. a. EN. 968
600 Main St., Hartford, CT 06103.
Illus. b&w, glossy photos. 8½ x 11, 40p.
Includes acquisitions list — artist, nationality and dates, title, brief description, how acquired.

WALTERS ART GALLERY ANNUAL REPORT. a. EN. 969
Walters Art Gallery, 600 North Charles St., Baltimore, MD 21201.

THE WARBURG INSTITUTE ANNUAL REPORT. a. EN. 970
Warburg Institute, University of London, Woburn Square, London WC1H 0AB England.
No illus. 18p.

OCLC: 2328030. LC: AS122.L8516.
Brief report.

Museology

AAM/ICOM. 1979, v.6. q. EN. 971
International Council of Museums, Committee of the American Association of Museums, 1225 I St., N.W., Washington, DC 20005. Phone 202–289–1818, fax 202–289–6578. Ellen Herscher, Editor & Director.
Subscription: included in membership.
OCLC: 7360478. Formerly: *ICOM*.
Museology.

Newsletter of the Council's Committee of the American Association of Museums. Discusses issues of concern to museum personnel, members and supporters. Disseminates information on activities, programs and new technical and theoretical concepts of museology abroad to American museum profession and on the American field to colleagues abroad. Also provides a listing of educational opportunities.
Opportunities: study.

ARCHIVES & MUSEUM INFORMATICS. 1987. q. EN. 972
Archives & Museum Informatics, 5600 Northumberland St., Pittsburgh, PA 15217.
ISSN: 1042–1467. OCLC: 18946585. LC: CD973.D3 A7. Dewey: 025.3. Formerly: *Archival Informatics Newsletter & Technical Reports. Part 1, Archival Informatics Newsletter*.
Contains short articles on current developments in archival data and information storage and retrieval.

ASSOCIATION OF INDEPENDENT MUSEUMS BULLETIN. 1977. bi–m. EN. 973
Association of Independent Museums, c/o Park Cottage, West Dean, Chichester, West Sussex PO18 0RX, England. Phone 0243–63364.
Subscription: included in membership £12, non–members £20.
ISSN: 0142–887X. OCLC: 17335038. Dewey: 069.
Purpose of the Association is to improve the standards and effectiveness of independent museums. Encourages exchange of information among member museums.

ASSOCIATION OF MANITOBA MUSEUMS NEWSLETTER. bi–m. EN. 974
Association of Manitoba Museums, 440–167 Lombard Ave., Winnipeg, Manitoba R3B 0T6, Canada. Phone 204–947–1782.
Subscription: included in membership together with *Dawson & Hind*, within Manitoba $20 individual, student $10, family and libraries $30, museums fee based on annual budget; outside Manitoba $30 individuals and institutions.
General.

Features activities and current issues of interest to the members.
Advertising: none. Mailing lists: none. Circulation: 250. Audience: museum and gallery volunteers, board members, professionals, students, supporters of heritage and cultural institutions.

AVISO. 1975. m. EN. 975
American Association of Museums, 1225 I St., N.W., Suite 200, Washington, DC 20005. Phone 202–289–1818, fax 202–289–6578. Bill Anderson, Editor & Pub.
Subscription: included in membership, $30 non–members. No illus. 8½ x 11, 16p.
Dewey: 069. Formerly: *AAM Bulletin*.
Museology.

Looseleaf format contains news, AAM notes, AAM/ICOM, information on museum jobs, legislation, and grant deadlines for federal grant applications.
Calendar of events for national meetings and workshops. Opportunities: employment placement ads; study – workshops, seminars; competitions – grant deadlines.
Advertising: Display ads: $300 members, $600 non–members. Classified & Placement: $1/wd. for members, $2 non–members. Amy Ingram, Editorial Assistant, AAM.

BRITISH ASSOCIATION OF FRIENDS OF MUSEUMS YEARBOOK. 1983. a. EN. 976

British Association of Friends of Museums, 548 Wilbraham Road, Manchester M21 1LB England. Phone 061 236 8585.
Subscription: £1.50 members, £2 non–members (Eddie Cass, Hon. Sec., phone 061 881 8640). Illus. b&w, some color.
OCLC: 12238984. LC: AM41.Y43. Dewey: 069.

Purpose of the Association is to encourage support for museums of all kinds in the United Kingdom and to improve museums and support those who work in them. The yearbook reports on the activities of the Association. A list of members is included.

COMMONWEALTH ASSOCIATION OF MUSEUMS NEWSLETTER. irreg. EN. 977

Commonwealth Association of Museums, Glenbow Museum, 130 9th Ave., SE, Calgary AB, T2G OP3 Canada. Phone 403–264–8300, fax 403–265–9769.

Seeks to promote and strengthen cooperation and interaction among members of the museum profession.
Demographics: museum curators and national museum associations and institutions in 27 Commonwealth countries.

CURATOR. 1958. q. EN. 978

American Museum of Natural History, Central Park W. at 79 St., New York, NY 10024–5192. Phone 212–769–5500. Thomas D. Nicholson, Editor.

Subscription: $25 individuals, $45 organizations US; + $5 postage outside US (Meckler Publishing, 11 Ferry Ln. W., Westport, CT 06880). Microform available from UMI. Sample, free. Back issues $12. Illus b&w, photos, cartoons. Annual index in year–end issue. Cum. index every 5th year in 4th issue. 80p.
ISSN: 0011–3069. OCLC: 1565592. LC: QH70.C8. Dewey: 574.074.

General. Museology.

Articles reflect interests, concerns, and trends in all types of museums. Authorship and readership are international. Articles are often based on extensive research, generally 6–8 articles per issue. The journal is juried; each published article has been reviewed/approved by 4 members of the 24–member review board (curators, museum directors, museum educators) and often revised in accordance with their suggestions. Museum conservation, museum management, museum history, exhibit evaluation, and corporate sponsorship are among areas covered.

Reviews: book 2/vol., length 2p. Biographies: professional activities and lives of people involved in all forms of museum–related areas in all types of museums—archaeologists, exhibit designers, collectors, etc. Freelance work: yes. Contact: Nancy Creshkoff, Asst. Editor. Indexed: ArtArTeAb. ArtI. BioI.

Advertising: none. Circulation: 1500–2000. Audience: museum personnel, educators, students, researchers.

ICOM NEWS/NOUVELLES DE L'ICOM: Bulletin of the ICOM. 1947. q. FR. EN sum. 979

International Council of Museums, c/o Maison de l'Unesco, 1, rue Miollis, 75732 Paris Cedex 15, France. Phone 47340500, fax 43067862. Sabine de Valence, Editor.

Subscription: included in membership, $39 US. No sample.
ISSN: 0018–8999. OCLC: 1753487. Dewey: 069.094.

Dedicated to the improvement and advancement of museums and the museum profession. Provides world wide communication network for museum people of all disciplines and specialties.
Indexed: ArtArTeAb.
Demographics: 8000 members in 120 countries. Audience: museum professionals.

LONDON FEDERATION OF MUSEUM AND ART GALLERIES NEWSLETTER.
1979. s–a. EN. 980

London Federation of Museum and Art Galleries, c/o P. Philo, Gunnersbury Park Museum, Gunnersbury Park, London W3 8LQ, England. Rosemary Weinstein, Editor.
Subscription: included in membership.
ISSN: 0260–7743. Dewey: 707.4.
Reviews: book.
Advertising.

THE MAAM COURIER. 1984. 5/yr. EN. 981

Mid–Atlantic Association of Museums, P.O. Box 817, Newark, DE 19715–0817. Phone 302–731–1424.
Subscription: included in membership. 8½ x 11, 6p.
OCLC: 11614125. Dewey: 069.05. Formerly: *NEM Courier*.

Covers the museums in the Mid–Atlantic states reporting on the activities of the museums, grants available, and grants awarded.
Opportunities: employment, competitions – grants & awards.
Audience: museum personnel.

MDA INFORMATION. 1984. q. EN. 982

Museum Document Association, Building O, 347 Cherry Hinton Road, Cambridge CB1 4DH, England. Phone 0223–242848.
Subscription: £5.
ISSN: 0309-6653. OCLC: 20059815. Dewey: 069.
Covers news and notices of documentation and automation initiatives in museums.

MUSE. 1983. q. EN & FR. 983

Canadian Museums Association, 280 Metcalfe St., Suite 400, Ottawa, Ontario K2P 1R7 Canada. Phone 613–233–5653, fax 613–233–5438. Nancy Hall, Editor.
Subscription: $C25 Canada, $32 US. Microform available from Micromedia. Illus.
ISSN: 0820–0165. OCLC: 9938404, 9938407. LC: AM21. Dewey: 069. Formerly: *CMA Gazette*.
Presents research and provides a forum for the exchange of ideas within the field of Canadian museology. The Association seeks the continuing improvement of the administration and personnel in public museums.
Reviews: book. Indexed: CanPI.
Advertising.

MUSE NEWS. irreg. EN. 984

Museums Association of Australia, Museum of Victoria, 328 Swanston St., Melbourne, Victoria 3000, Australia. Phone 3–6699907.

MUSEOGRAMME. m. 985

Canadian Museums Association, 280 Metcalfe St., Suite 400, Ottawa, Ontario, K2P 1R7 Canada. Phone 613–233–5653, fax 613–233–5438.
Newsletter of the Association which seeks to advance public museums in Canada and to promote better administration of museums.

MUSEUM [English edition]. 1948. q. EN, FR, SP, AR, & RU editions available. 986

UNESCO, 7–9 Place de Fontenoy, 75700 Paris, France. Phone 33–1–45.68.43.81, fax 33–1–45.67.16.90. (US Dist.: Unipub, 4611-F Assembly Dr., Lanham, MD 20706-4391). Arthur Gillette, Editor.
Subscription: 156 F. Microform available from UMI. Illus. b&w. Index. Cum. index.
ISSN: 0027–3996. OCLC: 1758859. LC: AM1.M63. Dewey: 069.05. Formerly: *Mouseion*.
Museology.

"An international forum of information and reflection on museums of all kinds." Contains articles on museums throughout the world, their management and operation. Issued in separate English, French, Spanish, Arabic and Russian editions.
Exhibition information. Indexed: ArchPI. ArtArTeAb. ArtBibMod. ArtHum. Avery. BrArchAb. CloTAI. CurCont. Des&ApAI. Reviewed: Katz. *Art Documentation* Fall 1986, p.132.
Advertising: none. Audience: museum professionals.

MUSEUM ABSTRACTS. 1985. m. EN. 987

Scottish Museum Council, County House, 20–22 Torphichen St., Edinburgh EH3 8JB, Scotland. Phone 031–229–7465.
Subscription: £25 UK, foreign £50.
ISSN: 0267–8594. OCLC: 16623491. Dewey: 069.
A monthly information service covering museums and museum management, exhibit design and display, conservation, and the arts.

MUSEUM ARCHIVIST: Newsletter of the Museum Archives Roundtable, Society of America Archivists. 1986. s–a. EN. 988

Society of America Archivists, Museum Archives Roundtable, Houston, TX.
OCLC: 14960828. LC: QK1.M952.

MUSEUM MANAGEMENT AND CURATORSHIP. 1982. q. EN. 989

Butterworth Scientific Ltd., P.O. Box 63, Westbury House, Bury St., Guildford, Surrey GU2 5BH, England. Phone 0483–300966, telex 859556 SCITEC G. Dr. Peter Cannon–Brooks & Dr. Caroline Cannon–Brooks, Editors (Thrupp House, Abingdon, Oxon, OX14 3NE, England).
Subscription: £40 individual, £80 institution UK; elsewhere £88 institution. (UK & overseas: Westbury Subscription Services, P.O. Box 101, Sevenoaks, Kent TN15 8PL, England, phone 0732–885833, fax 0732–884079; North America: Journals

Fulfillment Dept., Butterworths, 80 Montvale Ave., Stoneham, MA 02180, phone 617–438–8464, telex 88052). Microform available from UMI. Back issues (Wm. Dawson & Sons Ltd., Cannon House, Folkestone CT19 5EE, England, phone 0303–850101). Illus. b&w, photos. Annual index, author and subject. 6¾ x 9½, 110p.
OCLC: 21548198. LC: AM121.I57. Dewey: 069.905. Formerly: *The International Journal of Museum Management and Curatorship.*

Museology.

International forum for exchange of information between museum professionals. Authoritative articles review the whole range of problems confronting curators, administrators, conservators and designers, and assess the solutions that are available to them. Museum architecture, including both the design of new buildings and the modification of existing structures is of particular concern.

Bibliographies: each issue provides a brief overview of publications of interest and importance to museum staff. Biographies: brief notes on contributors. Freelance work: Welcome submissions of original material. Main articles usually 4000–8000 wds., subsidiary articles 1500–3000 wds. Indexed: ArchPI. ArtArTeAb. ArtBibMod. ArtI. Avery. BrArchAb. RILA. Reviewed: Katz.

Advertising: only ads for Butterworths.

MUSEUM NEWS. 1924. bi–m. EN. 990

American Association of Museums, 1225 Eye St., N.W., Suite 200, Washington, DC 20005. Phone 202–289–1818, fax 202–289–6578. Bill Anderson, Editor & Pub.
Subscription: $34 US, overseas air + $40. Illus. b&w, color, photos. Annual index by topic and by author in last issue of year. 8 x 11, 104p.
ISSN: 0027–4089. OCLC: 1758869. LC: AM1.A55. Dewey: 069.

Museology.

Regular columns include: "Recent acquisitions", "International Report" developments in museums outside the U.S.; "Architecture"; "Marketplace" product or service information; "Government Relations" reports on federal issues; "Law" reports on legal issues; "Exhibits" reviews traveling exhibits and, "Museum Directors Journal" an opinion column from museum directors.

Reviews: exhibition, book. Listings: international. Calendar of events. Indexed: ArtArTeAb. ArtBibMod. ArtHum. ArtI. Avery. CloTAI. CurCont.

Advertising: rates on request. Readers service card. Carol T. Hall, Ad. Manager. Audience: museum professionals.

MUSEUM REPORTER. 1988. bi–m. EN. 991

National Museums of Scotland, Chambers St., Edinburgh EH1 1JF, Scotland. Phone 031–225–7534.
Subscription: free.
ISSN: 0954–0423. Dewey: 069.
Collections and activities of the National Museums of Scotland.

MUSEUM ROUND-UP. 1961. m. EN. 992

British Columbia Museums Association, 514 Government St., Victoria, B.C. V8V 4X4, Canada. Phone 604–387–3315. Ms. Terry Russell, Editor.
Subscription: included in membership. Sample. Limited back issues. Illus. b&w, photos. 8p.
ISSN: 0045–3005. OCLC: 2036982. LC: FC3803.5. Dewey: 708.1.

General. Historic Preservation. Museology.

Listings: regional. Calendar of events. Opportunities: employment, study, competitions.
Advertising: none. Circulation: 600. Audience: museum and art gallery personnel and supporters.

MUSEUM TRUSTEES NEWSLETTER. 1971. q. EN. 993

American Association of Museums, 1055 Thomas Jefferson St., N.W., Washington, DC 20007. Phone 202–338–5300. Marifred Cilella, Editor.
Subscription: included in membership. 8½x11, 6–8p.
Carries news of legislation affecting museums, fund–raising ideas and other items of interest to trustees.
Interviews: trustees or museum professionals. Opportunities: conferences.
Audience: trustees of museums.

MUSEUMS ASSOCIATION INFORMATION SHEETS. 1972. irreg. EN. 994

Museums Association, 34 Bloomsbury Way, London WC1A 2SF, England. Phone & fax 071–404–4767. Steve Caplin, Editor.
ISSN: 0306–5332. OCLC: 5748846. LC: AM1.M677. Dewey: 069.

Museology.

Information on a variety of subjects of interest to museum staffs.

MUSEUMS ASSOCIATION OF AUSTRALIA JOURNAL. irreg. EN. 995

Museums Association of Australia, Museum of Victoria, 328 Swanston St., Melbourne, Victoria 3000, Australia. Phone 3–6699907.

Promotes educational, cultural, and aesthetic value of museums.

MUSEUMS AUSTRALIA. irreg. EN. 996

Museums Association of Australia, Museum of Victoria, 328 Swanston St., Melbourne, Victoria 3000, Australia. Phone 3–6699907.

MUSEUMS JOURNAL. 1901. m. EN. 997

Museums Association Publications, 34 Bloomsbury Way, London WC1A 2SF, England. Phone & fax 071–404–4767. Maurice Davies, Editor.

Subscription: included in membership; non–members £30 individual, £48 institution UK; overseas + £6 surface, £30 air. Sample & back issues £5. Illus. b&w, color, photos, cartoons. Cum. index v.82–88 in 89. A4, 54p.

ISSN: 0027–416X. OCLC: 1606681. LC: AM1.M7. Dewey: 069. Incorporates *Museums Bulletin*.

General.

International coverage spotlights Europe. Policy is to present a wide range of views and opinions in order to encourage informed debate on issues of importance to the museum and gallery community. The Association's purpose is to enhance the professionalism and standing of the museum community. The Association's annual report is contained in one of the issues.

Reviews: exhibition 1, length 1000 wds.; book 1, length 500 wds. Interviews & Biographies occasionally. Listings: international. Calendar of exhibitions. Freelance work: yes. Contact: editor. Opportunities: employment, study – Conference guide (q.), competitions. Indexed: ArtBibMod. ArtI. BHA. BrArchAb. CloTAI. Des&ApAI.

Advertising. (Rhinegold Publishing Ltd., 241 Shaftesbury Ave., London WC2H 8EH, phone 071–826–2534). Circulation: 5000. Audience: museum & gallery staff, etc.

MUSEUMS YEARBOOK. 1976. a. EN. 998

Museums Association, 34 Bloomsbury Way, London WC1A 2SF, England. Phone & fax 071–404–4767. Sheena Barbour, Editor.

Subscription: £20 Museums Association members, £35 non–members, surface mail + £2.50, air + £10. No back issues. No illus. A4, 280p.

ISSN: 0307–7675. OCLC: 2651336. LC: AM1.M6734. Dewey: 069. Formerly: *Museums Calendar*.

Museology.

Includes directories of museums and galleries in the British Isles and the Republic of Ireland and their administering authorities plus other reference information, including complete staff lists, admission charges, attendance figures, etc.

Advertising: none. Audience: museum & gallery staff.

MUSEUMSKUNDE: Zeitschrift fuer Verwaltung und Technik Offentlicher und Privater Sammlungen. 1905. irreg. GE. 999

Rheinland Verlag & Betriebsgespf, 2140/Abtei Brauweiler, 5024 Pulheim Brauwlr, West Germany.

Subscription: DM 45. Illus.

ISSN: 0027–4178. OCLC: 1758877. Dewey: 060.

Museology.

Official organ of the Deutscher Museumsbund. Covers museum operations and collections worldwide with special emphasis on Germany. Presents technical and administrative information.

Reviews: book. Bibliographies.

SAMAB: A Journal of Museology. 1936. q. EN & AF. 1000

Southern African Museums Association, P.O. Box 61, Capetown 8000, South Africa. Phone 21 243330. M.A. Raath, Editor.

ISSN: 0370–8314. OCLC: 2243875. LC: AM89.A1S25. Dewey: 069. Formerly: *Southern African Museums Association Publication*.

Museology.

"Objectives of the SAM Association are: to improve and extend the museums service in South Africa; to encourage helpful relations amongst museums of all kinds, other educational and kindred institutions and persons interested in the aims and objectives of the Association and to increase and diffuse knowledge of all matters relating to museums".

VOLUNTEER COMMITTEES OF ART MUSUEMS OF CANADA AND THE UNITED STATES - NEWS. 1952. q. EN.

1001

Volunteer Committees of Art Museums of Canada and the United States, c/o Council of the Virginia Museum of the Fine Arts, Boulevard & Grove Ave., Richmond, VA 23221. Phone 804–367–0844. Suzanne Hamblin, Editor.

Subscription: included in membership. Illus. b&w. 8½ x 11, 4–8p.

Formerly: *Volunteer Committees of Art Museums–Newsletter*.

Newsletter for volunteer organizations affiliated with visual arts museums. Seeks to provide information on how to best serve the American and Canadian visual arts museums. Includes news of members and major museum shows.

Calendar of events. Freelance work: yes. Contact: editor.

Audience: volunteer organizations.

Art Galleries

AGO NEWS. 1985. 11/yr. EN.

1002

Art Gallery of Ontario, 317 Dundas St. W., Toronto, Ontario M5T 1G4, Canada. Phone 416–977–0414. Clara Hargittay, Editor.

Subscription: included in membership. Some back issues. Illus. b&w, photos. 11 x 17, 6p.

ISSN: 0829–4437. OCLC: 13924837. LC: N910. Dewey: 708.11. Formerly: *The Gallery*.

General. Art Education. Art History. Drawing. Films. Modern Art. Painting. Photography. Sculpture.

Newsletter of the Gallery presents information on Gallery activities and news briefs.

Listings: Art Gallery of Ontario only. Calendar of events & exhibitions.

Advertising: none. Mailing list available only to other arts and non–profit organizations. Audience: members, public (limited distribution).

ARIZONA ARTISTS GUILD NEWS. m. EN.

1003

Arizona Artists Guild, 8912 N. 4th St., Phoenix, AZ 85020.

ART GALLERIES, EXHIBITIONS MUSEUMS. 1962. m. EN.

1004

London Information (Rowse Muir) Ltd., 16 Temple Chambers, Temple Ave., London EC4Y 0HP, England.

Dewey: 708.

ART GALLERY OF ONTARIO ANNUAL REPORT. 1967. a. EN.

1005

Art Gallery of Ontario, 317 Dundas St. W., Toronto, Ontario M5T 1G4, Canada. Phone 416–977–0414. Catherine Van Baren, Editor.

Subscription: free upon request in Canada. No back issues. Illus. b&w, photos. 8½x11, 48–52p.

ISSN: 0082–5018. OCLC: 3363924. LC: N910.T6 A35. Dewey: 708.11. Formerly: *Art Gallery of Toronto. Annual Report to Members*.

Contains the president's report, the director's report, list of acquisitions by major areas, works of art purchased with special funds, exhibitions held, list of members and donors, and financial statements. Only the President's report is translated into French.

Freelance work: none.

Advertising: none. Audience: members, public.

ART HAPPENINGS OF HOUSTON. 1977. 5/yr. EN.

1006

Arts Publishing Co, Box 36202, Houston, TX 70036. Phone 713–784–5560.

Illus.

OCLC: 8998661. LC: N4390.A773. Dewey: 708.

Visual art activities are presented.

Advertising. Circulation: 15,000.

ART LINE: International Art News. 10/yr. EN. 1007

Art Line Newspaper, Production House, 3 Garratt Lane, London SW18 England. Phone 01–8700427. Mike von Joel, Editorial Director.

Subscription: (1990): £22 UK, £38 US & Australia air, £25 Europe. Illus. b&w, color, photos. 9½ x 12½, 40p.

Modern Art.

News articles, and interviews concerning galleries. Presents international reports which include the United States. Pullout, quarterly calendar, distributed inside every copy and supplied free to art clubs, galleries, hotels, etc. throughout the United Kingdom.

Reviews: exhibition, galleries. Interviews: artists, dealers. Listings: UK galleries (q. insert) Subscribing UK galleries are listed free. Indexed: ArtBibMod. Des&ApAI.

Advertising: Fay Grosvenor, Ad. Director UK. Demographics: Distributed in Australia, Japan, Singapore, Mexico, Hong Kong, Portugal, Austria, Iceland, U.S., Netherlands, France, Germany, Belgium Italy, and Switzerland.

ART NOW GALLERY GUIDE: BOSTON - NEW ENGLAND EDITION. 1979. m. except

Aug. EN. 1008

Art Now, Inc., 320 Bonnie Burn Rd., Box 219, Scotch Plains, NJ 07076. Phone 201–322–8333. Laurie Carroll, Editor.

Subscription: $20 US, $48 Canada & foreign. Sample free. No back issues. Illus. b&w, some color, maps. 5½ x 8½ x 11, 28p.

Dewey: 708. Formerly: *Art Now/Boston and New England Gallery Guide; Art Now/Boston Gallery Guide.*

Antiques. Ceramics. Crafts. Decorative Arts. Drawing. Furniture. Modern Art. Painting. Sculpture.

Covers Boston and surrounding area and Maine, New Hampshire, Vermont, and Rhode Island. Approximately 100 galleries are included.

Reviews: exhibition 1–2, length 1p. Listings: regional. Exhibition information. Freelance work: none.

Advertising: (rate card '89/90): full page $370, ½ page $200, ¼ page $110; color full page $550, ½ page $410. Classified: $1.50/wd., $25 min.; exhibition listing $75/6 lines; gallery name and location pinpointed on map $11. Frequency discount. Mailing lists: none. Circulation: 15,000. Audience: anyone interested in art exhibitions.

ART NOW GALLERY GUIDE: CALIFORNIA - NORTHWEST EDITION. 1983. m. except

Aug. EN. 1009

Art Now, Inc, 320 Bonnie Burn Rd., Box 219, Scotch Plains, NJ 07076. Phone 201–322–8333, Fax 201–322–1763. Rosalind Ruby, Editor.

Subscription: $20 US, $48 Canada & foreign surface. Sample $3. No back issues. Illus. b&w, some color, maps. 5½ x 8½, 32p.

Dewey: 708. Formerly: *Art Now/California and Northwest Gallery Guide*; formed by the merger of: *Art Now/California Gallery Guide*, and *Art Now/Northwest Gallery Guide.*

Ceramics. Crafts. Drawing. Furniture. Modern Art. Painting. Photography. Sculpture.

Covers California and the Pacific North West. Contains over 200 listings.

Reviews: exhibition 1–2, length 1p. Listings: regional. Exhibition information. Freelance work: none.

Advertising: (rate card '89/90) camera ready art: b&w full page $370, ½ page $200, ¼ page $110; 2–color full page $460, ½ page $305; 4–color full page $550, ½ page $410, cover $660. Exhibition listing $75/6 lines, area map location pinpointed $11. Frequency discount. 15% agency discount. Mailing lists: none. Circulation: 15,000. Audience: anyone interested in art exhibitions.

ART NOW GALLERY GUIDE: CHICAGO - MIDWEST EDITION. 1981. m except Aug. EN. 1010

Art Now, Inc, 320 Bonnie Burn Rd., Box 219, Scotch Plains, NJ 07076. Phone 201–322–8333. Patty Schlager, Editor.

Subscription: $20 US, $48 Canada & foreign. Sample $2. No back issues. Illus. b&w, some color, maps. 5½ x 8½ x 11, 32p., web offset.

Dewey: 708. Formerly: *Art Now/Chicago and Midwest Gallery Guide*; Formed by the merger of *Art Now/Midwest Gallery Guide*, and *Art Now/Chicago Gallery Guide.*

Ceramics. Crafts. Drawing. Modern Art. Painting. Photography. Sculpture.

Gallery Guide provides information about museum and gallery exhibitions throughout the Midwest and Chicago.

Reviews: exhibition 2, length 1p. Listings: regional. Exhibition information.

Advertising: (rate card '89/90): b&w full page $370, ½ page $200, ¼ page $110; 2–color full page $460, ½ page $305; 4–color full page $550, ½ page $410, back cover $660. Bleeds + 15%, full page only. Classified: $1.50/wd., $25 min.; exhibition listing $75/6 lines, location pinpointed on area map $11. Frequency discount. 15% agency discount. Mailing lists: none. Circulation: 18,000. Audience: anyone interested in art exhibitions.

ART NOW GALLERY GUIDE: NATIONAL EDITION. 1980. m. except Aug. EN. **1011**
Art Now, Inc., 320 Bonnie Burn Rd., Box 219, Scotch Plains, NJ 07076. Phone 201–322–8333. Bernice Shor, Editor.
Subscription: $35 US, $58 Canada & foreign. Sample $5. No back issues. Illus. b&w, some color, maps. 5½ x 8½, 280p., web offset.
ISSN: 0745–5720. OCLC: 18821605, 9034078. Dewey: 708. Formerly: *Art Now/U.S.A., The National Art Museum and Gallery Guide.*
Ceramics. Crafts. Drawing. Modern Art. Painting. Photography. Sculpture.

Provides information about museum and art gallery exhibitions of over 1500 galleries and museums throughout the United States. Includes gallery area maps and features on selected exhibitions. Features selected exhibits in color and black & white. Contains all the regional editions.
Reviews: exhibition 12, 1p. Listings: national. Exhibition information. Freelance work: none. Reviewed: Katz.
Advertising: Color full page $500. All listings placed in one of *Art Now's* 7 regional guides will appear automatically in the National Edition free of additional charge. Regional display ad rates include the cost of national advertising. Mailing lists: none. Demographics: Available by paid subscription, at newsstands and bookstores. Circulation: 4500. Audience: the art community.

ART NOW GALLERY GUIDE: NEW YORK EDITION. 1970. m. except Aug. EN. **1012**
Art Now, Inc, 320 Bonnie Burn Rd., Box 219, Scotch Plains, NJ 07076. Phone 201–322–8333, Fax 201–322–1763. Bernice Shor, Editor.
Subscription: $30 US, $53 Canada & foreign. Sample $3. No back issues. Illus. b&w, some color, maps. 5½ x 8½, 120p.
OCLC: 8241069. LC: N4390.A7. Dewey: 708.1. Formerly: *Art Now/New York Gallery Guide; Art Now Gallery Guide.*
Ceramics. Crafts. Modern Art. Painting. Photography. Sculpture.

Over 575 listings cover New York City and surrounding areas. This Guide also includes national listings for galleries and museums with exhibition information organized by geographic area.
Reviews: exhibitions 2–3, 1p. Listings: regional. Exhibition information. Freelance work: none.
Advertising: (rate card '89/90): camera ready, b&w full page $655, ½ page $355, ¼ page $220; 2–color full page $995, ½ page $545; 4–color full page $1350, ½ page $750, back cover $1720. Classified: $1.50/wd., $25 min. Exhibition listing $100/6 lines. location pinpointed on area map $27. Frequency discount. 15% agency discount. Mailing lists: none. Circulation: 35,000. Audience: anyone interested in art exhibitions.

ART NOW GALLERY GUIDE: PHILADELPHIA EDITION. 1979. m. except Aug. EN. **1013**
Art Now, Inc., 320 Bonnie Burn Rd., Box 219, Scotch Plains, NJ 07076. Phone 201–322–8333, Fax 201–322–1763. Laurie Carroll, Editor.
Subscription: $20 US, $48 Canada & foreign. Sample $3. No back issues. Illus. b&w, some color, maps. 5½ x 8½, 20p.
OCLC: 12680455. Dewey: 708. Formerly: *Art Now/Philadelphia Gallery Guide.*
Ceramics. Crafts. Drawing. Furniture. Jewelry. Modern Art. Painting. Photography. Sculpture.
Philadelphia and surrounding areas are listed in this regional guide.
Reviews: exhibition 1–2, 1p. Listings: regional. Exhibition information. Freelance work: none.
Advertising: (rate card '89/90): b&w full page $370, ½ page $200, ¼ page $110; 2–color full page $460, ½ page $305; 4–color full page $550, ½ page $410, back cover $660. Classified: $1.50/wd., $25 min. Exhibition listing $75/6 lines. Location pinpointed on area map $11. 15% agency discount. Frequency discount. Mailing lists: none. Circulation: 11,000. Audience: art interested people.

ART NOW GALLERY GUIDE: SOUTHEAST EDITION. 1981. m. except Aug. EN. **1014**
Art Now, Inc., 320 Bonnie Burn Rd., Box 219, Scotch Plains, NJ 07076. Phone 201–322–8333. Patty Schlager, Editor.
Subscription: $20 US, $48 Canada & foreign. Sample $2. No back issues. Illus. b&w, some color, maps. 5½ x 8½, 16–24p.
Dewey: 069.5. Formerly: *Art Now/Southeast Gallery Guide.*
Ceramics. Crafts. Drawing. Modern Art. Painting. Photography. Sculpture.
Covers Washington D.C., Georgia, North and South Carolina, Maryland, Virginia, Florida, Louisiana, and Tennessee.
Reviews: exhibition 2, length 1p. Listings: regional. Exhibition information. Freelance work: none.
Advertising: (rate card '89/90): camera ready b&w full page $300, ½ page $155, ¼ page $90; 2–color full page $385, ½ page $245; 4–color full page $470, ½ page $330, back cover $550. Classified: $1.50/wd., $25 min. Exhibition listing $50/6 lines. Location pinpointed on area map $11. 15% agency discount. Frequency discount. Circulation: 11,000. Audience: art community.

ART NOW GALLERY GUIDE: SOUTHWEST EDITION. 1981. m. except Aug. EN. 1015

Art Now, Inc., 320 Bonnie Burn Rd., Box 219, Scotch Plains, NJ 07076. Phone 201–322–8333, Fax 201–322–1763. Michelle Fino, Editor.

Subscription: $20 US, $48 Canada & foreign. Sample $3. No back issues. Illus. b&w, some color, maps. 5½ x 8½, 20p. offset.

Dewey: 708. Formerly: *Art Now/Southwest Gallery Guide; Art Now/Texas, Arizona, New Mexico Gallery Guide.*

Ceramics. Crafts. Drawing. Modern Art. Painting. Photography. Sculpture.

Covers Arizona, Colorado, New Mexico, Texas and Utah.

Reviews: exhibition 1–2, 1p. Listings: regional. Exhibition information. Freelance work: none.

Advertising: (rate card '89/90): camera ready b&w $300, ½ page $155, ¼ page $90; 2–color full page $385, ½ page $245; 4–color full page $470, ½ page $330, back cover $550. Classified: $1.50/wd., $25 min. Exhibition listing $50. Location pinpointed on area map $10. 15% agency discount. Frequency discount. Mailing lists: none. Circulation: 11,000.

ARTFINDER. q. EN. 1016

Egret Publications, 594 Broadway, No. 1202, New York, NY 10012. Phone 212–226–1330. Margot Mifflin, Editor.
Dewey: 708.

A complete guide to galleries and events in New York.

ARTSFOCUS. bi–m. EN. 1017

Colorado Springs Fine Arts Center, 30 W. Dale St., Colorado Springs, CO 80903. Phone 303–634–5581.

Subscription: included in membership. Back issues. 11 x 17, 4p.

Newsletter reporting on the exhibitions and activities of the Center.

Exhibition information.

Advertising: none.

BACA CALENDAR OF CULTURAL EVENTS. 1968. m. EN. 1018

Brooklyn Arts and Culture Association – Brooklyn Arts Council, 200 Eastern Parkway, Brooklyn, NY 11238. Phone (718) 783–3077 & 783–4469. Chuck Reichenthal, Editor.

Subscription: included in membership, $10. Sample. No back issues. Illus. b&w, photos. 11 x 3¾, 12p.
ISSN: 0045–3242. Dewey: 708.1.

General.

Lists the vast amounts of cultural and related events available to Brooklyn residents and visitors. Included are activities in cultural institutions, colleges, individual theater, dance, music, other groups. Festivals, lectures, special events. Plus SPOTLIGHTS related to issues. Also special notes and news for artists regarding grants, housing, legislative issues, etc. Covers all visual and performing arts and related works.

Listings: regional. Calendar of events. Exhibition information. Freelance work: none. Opportunities: employment, study, competitions.

Advertising: none. Mailing lists: available on occasion. Circulation: 12,000. Audience: Brooklyn/Manhattan audiences.

BARBICAN. bi–m. EN. 1019

Barbican Art Gallery, Barbican Center, London EC2, England.
Subscription: included in membership.

BELSER KUNSTQUARTAL. See 787.

Reviews art gallery and museum exhibitions both in Germany and abroad.

BENALLA ART GALLERY NEWSLETTER. 1969. q. EN. 1021

Benalla Art Gallery Society, P.O. Box 320, Benalla, Victoria 3672, Australia. Sara Kelly, Gallery Director.

Subscription: included in membership, $A10 individual, $A15 family. Sample. Back issues. Illus. b&w, cartoons. 8¼ x 11½, 8p.

Art Education. Art History. Ceramics. Crafts. Decorative Arts. Drawing. Modern Art. Museology. Painting. Sculpture. Textiles.

Newsletter outlines forthcoming exhibitions, events and activities.

Reviews: exhibition 0–1, length 2 paragraphs. Obits. Listings: regional–national. Exhibition information. Freelance work: none. Opportunities: study.

Circulation: approx. 600. Audience: Gallery members.

BVAU NEWS. 1973. m. EN. 1022

Boston Visual Artists Union, c/o Art Institute of Boston, 700 Beacon St., Boston, MA 02215. Phone 617–266–1101. Laurie Poklop, Editor.
Back issues.

THE CHRISTINE A. JOHNSON MEMORIAL GALLERY ANNUAL REPORT. a. EN. 1023

Middlebury College, Middlebury, VT 05753. Phone 802–388–3711.
Subscription: included in membership. Illus. b&w, photos. 6¼ x 9, 40p.
Listing of acquisitions. Detailed description of major acquisitions includes background of work/artist and illustration.

THE CURRIER GALLERY OF ART ANNUAL REPORT. a. EN. 1024

192 Orange St., Manchester, NH 03104. Phone 603–669–6144.
Few illus. b&w, glossy photos. 7 x 10, 36p.
Annual report includes a list of acquisitions with brief description but no illustrations.

THE GALLERY. included in membership. 10/yr. EN. 1025

Art Gallery of Ontario, 317 Dundas St. West, Toronto M5T 1G4, Canada. Phone 416–977–0414.
Subscription: included in membership. 11 x 17, 4–8p.
ISSN: 0709–8413.
Tabloid newsletter.
Calendar of events.

HEIM GALLERY CATALOGUES. 1966. s–a. EN. 1026

Heim Gallery (London) Ltd., 59 Jermyn St., London SW1Y 6LX, England.
Dewey: 708.

THE JOURNAL OF THE WALTERS ART GALLERY. 1938. a. EN. Articles occasionally in

 FR, IT, SP. No tr. 1027

Trustees of the Walters Art Gallery, 600 N. Charles St., Baltimore, MD 21218. Phone 301–547–9000. William Johnston, Executive Editor.
Subscription: $40 + 2 shipping, + $3 Canada & foreign. No sample. Back issues, variable price. Illus. b&w, color, photos. 8½ x 11, 98–110p.
ISSN: 0083–7156. OCLC: 1769377. LC: N5220.W437. Dewey: 708.1.
Art History. Ceramics. Decorative Arts. Drawing. Furniture. Painting. Sculpture. Textiles.

Covers all aspects of art history through the 19th century with preference given to articles deriving from or related to the museum's collection. Publication made possible through the support of the Andrew W. Mellon Foundation Fund for Scholarly Research and Publications.
Bibliographies with articles. Freelance work: yes. Contact: editor. Indexed: ArtBibMod. ArtI. BHA. RILA.
Advertising: none. Audience: art historians.

LEEDS ARTS CALENDAR. 1947. s–a. EN. 1028

Leeds Arts Collections Fund, Temple Newsam House, Leeds LS15 0AE, Yorkshire, England. Phone 0532–647321. Anthony Wells–Cole, Editor.
Subscription: included in membership. Microform available from UMI. Back issues. Illus. b&w. 9½ x 7, 32p.
ISSN: 0024–0257. OCLC: 5432397. LC: N1403.L42. Dewey: 708.2.
General.

Concentration of articles is on the collections belonging to the Leeds City Art Galleries, The Leeds Art Collections Fund and the three buildings which make up the Art Galleries.
Biographies: occasional brief survey of an artist's work if represented in the Leeds collections. Freelance work: yes but no payment. Contact: editor. Indexed: ArtBibMod. CloTAI.
Advertising: none. Mailing lists: none. Circulation: ca.700. Audience: members of the Friends organization and the international community of scholars.

LOOK ... 1985. m. EN. 1029

Mount Eagle Publications, P.O. Box 84, Heidelberg, Victoria 3084, Australia. Phone 03–459 3911, Fax 03–457–5249. Wendy Symonds, Editor.

Subscription: available to members only (Art Gallery, Art Gallery Rd., Sydney, NSW 2000). No sample. No back issues. Illus. b&w, color, photos. 275 x 210 mm., 24p.

ISSN: 0817–8445. Dewey: 708.

General.

Magazine of the Art Gallery Society of New South Wales. Presents educational articles on particular artists and schools of art, Society news and activities and news of exhibitions.

Reviews: exhibition 4, length 700 wds.; book 2, length 200 wds. Interviews: usually feature interviews with artists. Listings: regional–international. Calendar of events. Exhibition information. Freelance work: none. Opportunities: study.

Advertising: (rate card Jun '89): full page $610, ½ page $350, ¼ page $185; color full page $860, ½ page $495. Frequency discount. No classified. Brett Lloyd Jones, Ad. Director. Mailing lists: none. Demographics: top socio–economic group in Sydney. Circulation: 23,000. Audience: members of Art Gallery Society of New South Wales.

PARALLELOGRAMME. q. EN & FR. Articles tr. 1030

Association of National Non–Profit Artists' Centres (ANNPAC), 183 Bathurst St., Main Floor, Toronto, Ontario M5T 2R7, Canada. Phone 416–869–3854. Lynne Fernie, Editor.

Subscription: $15 individual, $20 institution, worldwide in $US. Microform available. Sample free. Back issues $2. Illus. b&w, photos, cartoons. 8½ x 11, 96p.

ISSN: 0703–8712. OCLC: 3781968. LC: N908. Dewey: 708.

Art Education. Art History. Ceramics. Crafts. Drawing. Films. Modern Art. Painting. Photography. Sculpture. Textiles.

National coverage of artist–run exhibitions, events and conferences in 90 artist–run centers and galleries in Canada. Each issue contains: a comprehensive programming listing as well as submission, requirements, fees, and available equipment in each center; over 50 illustrations of art events and artworks; articles in both French and English on issues pertinent to contemporary art activity; and news items of interest to artists.

Interviews: occasionally with activist artists. Listings: regional–national. Calendar of exhibitions. Freelance work: none. Opportunities: employment, study, competitions. Indexed: ArtBibMod.

Advertising: full page $300, ½ page $165, ¼ page $100, no color. No classified. Frequency discount. Anne–Marie Beneteau, Ad. Director. Mailing lists: available for sale or on exchange basis. Circulation: 5300. Audience: art and culture.

THE PICKER ART GALLERY JOURNAL. 1982. a. EN. 1031

Picker Art Gallery, Colgate University, Hamilton, NY 13346. Phone 315–824–1000x634. Marian Blanchard, Editor.

Subscription: free to Gallery members & publication exchange, $2.50/issue institutions. Illus. b&w, photos. 7 x 10, 44–54p.

ISSN: 0735–6560. OCLC: 19608531. Formerly: *Picker Gallery Annual Report/Bulletin.*

"The word 'journal' conveys our purpose in that it connotes a recent record of experiences, ideas and reflections. Bulletin section called 'Journal Essays', contributions of scholars are analytic or interpretative comments on subjects lodged in the Picker Art Gallery collections. New feature – detailed listing of loans that were in uncataloged travelling exhibitions. Aim to provide checklists for the shows which should prove valuable to researchers in tracking the history of individual pieces".

PORTICUS. 1978. bienniel with vol. 10/11, a vol. 1–9. EN. 1032

Memorial Art Gallery of the University of Rochester, 500 University Ave., Rochester, NY 14607. Phone 716–473–7720. Bernard Barryte, Editor.

Subscription: included in membership Director's Circle and above $1000+ annual donation; $8.50 US, $10 Canada, $13 air. No sample. Back issues vol. 1–9, $2.50. Illus. b&w. approx. 60p.

ISSN: 8755–2035. OCLC: 4540711. LC: N719.P67. Dewey: 708.

Archaeology. Art History. Decorative Arts. Drawing. Graphic Arts. Modern Art. Painting. Sculpture.

The journal is devoted to the examination of the historical, cultural, and artistic significance of the objects in the Gallery's permanent collection. Occasional articles relating to temporary exhibitions are also included.

Freelance work: scholars commissioned for specific articles. Contact: editor. Indexed: ArtBibMod. RILA.

Advertising: none. Circulation: 1500. Audience: membership, scholarly community.

TABLEAU (Frederickton). 1970. q. EN. 1033

Beaverbrook Art Gallery, P.O. Box 605, Fredericton, N.B. E3B 5A6, Canada. Phone 506–458–8545. Ian G. Lumsden, Editor & Director.

Subscription: free. Illus. b&w. 9 x 6, 32p.

ISSN: 0845–8081. OCLC: 20366881. LC: N910. Dewey: 780.11. Formerly: *Beaverbrook Art Gallery.*

A newsletter for members.

Listings: Gallery only. Calendar of events.

Advertising: none.

TABLEAU (Winnipeg). 1972. 9/yr. EN. 1034
Winnipeg Art Gallery, 300 Memorial Blvd., Winnipeg, Manitoba R3C 1V1, Canada. Phone 204–786–6641. Terry Aseltine, Editor.
Subscription: $30 individual, $45 family, $15 youth/senior. Illus. b&w, photos. 11 x 17, 8p.
ISSN: 0841–8012. OCLC: 19038102. LC: N910. Dewey: 708.11. Formerly: *WAGMAGazine/Wag Magazine*.
A publication of the Winnipeg Art Gallery. Contains recent acquisitions together with illustrations, articles on artists featuring both their biography and their work, and descriptions of exhibitions.
Listings: Museum. Calendar of gallery events. Opportunities: study – classes, tours, and lectures of Museum.
Advertising: none. Audience: art lovers and patrons of the Gallery.

UAB VISUAL ARTS GALLERY PAPERS. 1977. irreg. EN. 1035
University of Alabama at Birmingham, Visual Arts Gallery, 101 Honors House, Birmingham, AL 35294. Phone 205–934–4941. John M. Schnorrenberg & Antoinette S. Johnson, Editors.
Subscription: free. Illus.
OCLC: 17360684. LC: N518.B379. Dewey: 708.1.
Contains biographies of artists exhibiting in the Gallery.

UPDATE [Art Dealers Association of America]. 1981. q. EN. 1036
Art Dealers Association of America, 575 Madison Ave., New York, NY 10022. Phone 212–940–8925. Rose R. Weil, Editor.
Subscription: included in membership. No sample. No back issues. Illus. b&w, photos. 8½ x 11, 8p.
LC: N8610.U65. Dewey: 700.
Art History. Drawing. Graphic Arts. Historic Preservation. Modern Art. Museology. Painting. Photography. Sculpture.

Members news digest consists of news of members' activities, catalogues published by members, and Association news. Seeks to improve the standing of the art gallery business in the United States.
Bibliographies: of members' catalogues. Obits. Listings: national. Exhibition information. Freelance work: none.
Advertising: none. Mailing lists: none. Circulation: 1000. Audience: art dealer members, selected art press & selected museum professionals.

VANCOUVER ART GALLERY ANNUAL REPORT. 1971 or 1972. a. EN. 1037
Vancouver Art Gallery, 750 Hornby St., Vancouver, B.C. V6Z 2H7, Canada. Phone 604–682–4668.
Subscription: free. Illus.
ISSN: 0083–5161. OCLC: 3114605. LC: N910. Dewey: 708. Formerly: *Vancouver Art Gallery Association Annual Report*.

VISTA. 1973. q. EN. 1038
Mackenzie Art Gallery, University of Regina, Regina, Saskatchewan S4S 0A2, Canada. Phone 306–779–4849. Bonnie Schaffer, Editor.
Subscription: free. Illus. 8p.
ISSN: 0828–7023. OCLC: 12280780. LC: N910. Dewey: 708.11. Formerly: *Mackenzie Mag.; N.M.A.G.*.
General.

Information on exhibitions, the permanent collection, education classes, art sales, volunteer news and other news of the Gallery.
Listings: regional. Calendar of events.
Advertising: none. Circulation: 4000. Audience: members and general public.

THE WALTERS. 1948. 10/yr. EN. 1039
The Trustees of the Walters, 600 North Charles St., Baltimore, MD 21201. Phone 301–547–9000. Troy Moss, Editor.
Subscription: included in membership, $10 US, foreign $12. Sample, fee. Illus. b&w, color, photos. 8½ x 11, 16p.
ISSN: 1044–8683. OCLC: 19501237. LC: N5220.W4363. Dewey: 708.152. Formerly: *Walters Art Gallery Bulletin; At the Walters Art Gallery; Walters Art Gallery Bulletin and Calendar*.
General.

Contains short articles on current exhibitions and/or the permanent collection written by the curatorial staff as well as listings of museum activities for members. Each issue has a distinctive title.
Listings: regional. Calendar of events. Freelance work: none. Indexed: CloTAI. RILA. Reviewed: Katz. Katz. *School*.
Advertising: none. Circulation: 8000.

YALE UNIVERSITY ART GALLERY BULLETIN. 1926. irreg (2–3/yr.). EN. 1040
Yale University Art Gallery, Box 2006 Yale Station, New Haven, CT 06520. Phone 203–432–0602. Caroline Rollins, Editor.
Subscription: included in membership. Microform available from UMI. Illus. 7¼ x 10, 54p.
ISSN: 0084–3539. OCLC: 2243316. LC: N10.Y3. Dewey: 708. Formerly: *Yale Art Gallery Bulletin*.
Scholarly articles cover all fields pertaining to the collection. Annual acquisitions list.
Indexed: ArtBibMod. ArtI. RILA. Reviewed: Katz.
Advertising: none. Demographics: Circulated to museums and libraries throughout the world. Circulation: 2,000.

Conservation & Restoration

THE ABBEY NEWSLETTER: Bookbinding and Conservation. 1975. 8/yr. EN. 1041
Abbey Publications, Inc., 320 E. Center St., Provo, UT 84606. Phone 801–373–1598. Ellen R. McCrady, Editor.
Subscription: $35 individual, $20 students US. Back issues. No illus. Index. 8½ x 11, 32p.
ISSN: 0276–8291. OCLC: 4447717. LC: Z701.A224. Dewey: 025.84.
Mission is to respond to the information needs of the conservation and preservation community. Contains news of people and events.
Reviews: book. Listings: national–international. Calendar of events. Exhibition information. Opportunities: employment, study – workshop, conference. Indexed: ArtArTeAb. GrArtLAb. Reviewed: *Library Journal* 110:10, June 1, 1985, p.106. *American Lib* 16:4, Apr 1985, p.269.
Advertising: employment only. Circulation: 1200.

AIC ABSTRACTS. 1989, 17th Annual Meeting. a. EN. 1042
American Institute for Conservation of Historic and Artistic Works, 1400 16th St., N.W., Suite 340, Washington, DC 20036. Phone 202–6636.
Subscription: $8 members, $12 non–members. No sample. Back issues. Illus.
LC: AM141.A44a. Dewey: 069.5. Formerly: *Preprints of Papers Presented at the Annual Meeting*.
A collection of abstracts of papers presented at the AIC Annual Meeting.
Advertising: none. Circulation: 1000. Audience: AIC members.

AIC NEWSLETTER. 1975. bi–m. EN. 1043
American Institute for Conservation of Historic and Artistic Works, 1400 16th St., N.W., Suite 340, Washington, DC 20008. Phone 202–232–6636.
Dedicated to the conservation of cultural property. Provides a forum for the exchange of information within the conservation field. Reports on the activities of the organization and provides an update to conservators on techniques, materials, and current activities in the field.
Opportunities: employment, study.
Advertising: (rate card 1989): full page $375, ½ page $200. Marcia Anderson, Ad. Director. Circulation: 2600. Audience: professional conservators, scientists, students, administrators, cultural institutions, and others who feel strongly about the advancement of the conservation profession.

AIC NEWSLETTER: PAINTINGS GROUP. 1984. irreg. EN. 1044
American Institute for Conservation of Historic and Artistic Works, 1400 16th St., N.W., Suite 340, Washington, DC 20008. Phone 202–232–6636.
Illus.
OCLC: 12127630. Dewey: 751.6.
Painting.
Audience: professional conservators and others who feel strongly about the advancement of the conservation profession.

AMERICAN INSTITUTE FOR CONSERVATION OF HISTORIC AND ARTISTIC WORKS. BOOK & PAPER GROUP ANNUAL. 1982. a. EN. 1045
American Institute for Conservation of Historic and Artistic Works, Book and Paper Group, 1400 16th St, N.W., Suite 340, Washington, DC 20036. Phone 202–232–6636.
Subscription: $15 members, $30 nonmembers.

ISSN: 0887–8978. LC: Z700.9. Dewey: 090.75. Formerly: *American Institute for Conservation of Historic and Artistic Works. Postprints.*
A collection of papers presented at the AIC Annual Meetings by members of the AIC Book and Paper Specialty Group. Volume 1, 1982 covers the 10th Annual Meeting.
Audience: book and paper conservators.

ARBEITSBLAETTER FUER RESTAURATOREN. 1968. s–a. GE. 1046
Roemisch–Germanisches Zentralmuseum, Mainz, Ernst–Ludwig–Platz 2, 6500 Mainz, W. Germany.
Subscription: DM 48. Illus. some color. 30 cm.
ISSN: 0066–5738. OCLC: 5165953. LC: N8555.A7.
Indexed: ArtArTeAb. BHA.

BULLETIN / INTERNATIONAL INSTITUTE FOR CONSERVATION OF HISTORIC & ARTISTIC WORKS. 1976. bi–m. EN. 1047
International Institute for Conservation of Historic and Artistic Works, 6 Buckingham St., London WC2N 6BA, England. Phone 071 8395975.
Subscription: included in membership.
OCLC: 2078773. LC: N8560.I23. Dewey: 069.4. Formed by the merger of: *IIC News*, and *Appointments Vacant Bulletin*.

CONSERVATION ADMINISTRATION NEWS. 1979. q. EN. 1048
University of Tulsa, McFarlin Library, 600 S. College Ave., Tulsa, OK 74104. Phone 918–631–2864. Robert H. Patterson, Editor.
Subscription: $18. Microform available. Illus.
ISSN: 0192–2912. OCLC: 4993144. LC: Z701.C667. Dewey: 020.
Concentrates on library and archival preservation.
Reviews: book. Indexed: GrArtLAb.
Advertising.

THE CONSERVATOR. 1977. a. EN. 1049
United Kingdom Institute for Conservation of Historic & Artistic Works, 37 Upper Addison Gardens, Holland Park, London W14 8AJ, England. Phone 071–603 5643. Victoria Todd, Editor.
Subscription: included in membership together with *Conservation News*, £25 individual, £40 institution, students £10 UK; overseas £28 (Treas., c/o The Conservation Dept., City Museums and Art Gallery, Birmingham B3 3DH). Illus. b&w, some color, drawings. A4, 56p.
ISSN: 0140–0096. LC: N8554. Dewey: 333.7.
Each issue consists of 8–10 articles.
Indexed: ArtArTeAb.
Advertising: none.

FRIENDS OF FRENCH ART: Art de Vivre Into Art Conservation. 1979. a. EN. 1050
Friends of French Art, Villa Narcissa, 100 Vanderlip Dr., Rancho Palos Verdes, CA 90274. Phone 213–377–4444. Elin Vanderlip, Editor.
Subscription: included in membership, non–members $25. Back issues $25. Illus b&w, color, photos. 8½ x 11, 80–150p.
Dewey: 700.
Conservation. Decorative Arts. Furniture. Historic Preservation. Landscape Architecture. Modern Art. Painting. Sculpture. Textiles.
Journal providing information on the Friend's conservation and restoration projects in progress and completed. Includes both the group's annual trip to various regions in France to select art conservation projects and to raise money to restore same and the activities of La Coterie, a support group which raises money to sponsor student apprenticeships. Includes balance sheet and financial information.
Freelance work: none. Opportunities: competitions, art scholarship grants.
Advertising: none. Audience: those with an interest in the conservation of art.

THE GETTY CONSERVATION INSTITUTE NEWSLETTER. 1986. 3/yr. EN. 1051
Getty Conservation Institute, 4503 Glencoe Ave., Marina del Rey, CA 90292–6537. Phone 213–822–2299. Jane Slate Siena, Editor.
Subscription: free. Illus..

ISSN: 0898–4808. OCLC: 13222801. LC: N8560.G47. Dewey: 702.

Covers the activities of the Institute's art and architecture conservation programs which includes scientific research and conservation training.

INTERNATIONAL COMMITTEE FOR THE CONSERVATION OF MOSAICS NEWSLETTER. a. EN. 1052

Roman Research Trust, Littlecote Roman Villa, Hungerford, Berks, RG17 0SS, England. Phone 6723 356.

THE JOURNAL OF THE AMERICAN INSTITUTE FOR CONSERVATION. 1970. s–a. EN. 1053

American Institute for Conservation of Historic & Artistic Works, 1400 16th St., N.W., Suite 340, Washington, DC 20036. Phone 202–232–6636. Marjorie B. Cohn, Editor (Center for Conservation & Technical Studies, Harvard University of Art Museums, Cambridge, MA 02138).

Subscription: included in membership, $24 US, foreign $30. No Sample. Back issues. Illus. b&w, color, photos. 7½ x 9½, 64p.

ISSN: 0197–1360. OCLC: 3064874. LC: N8554.A53. Dewey: 069.53. Formerly: *Bulletin of the American Institute for Conservation of Historic and Artistic Works.*

Dedicated to the conservation of cultural property. Contains articles and other contributions written by conservators and scientists dealing with current issues and technical procedures in the conservation field. Topics focus on the conservation of architectural materials, archaeological objects, books and paper, ethnographic materials, objects, paintings, photographic materials, sculpture, and wooden artifacts. Contains technical papers as well as conservation–related articles of more general appeal. Statistics and charts are included.

Reviews: book 1–2, length 1–3p. Bibliographies: references with articles. Freelance work: none. Indexed: ArtArTeAb.

Advertising: (rate card '88/89): full page $325, ½ page $200, covers $350–$375, no color. No classified. No frequency discount. Marcia Anderson, Ad. Director. Circulation: 2500. Audience: professional conservators, conservation students, museum professionals, art and humanities professionals, research libraries.

NATIONAL GALLERY TECHNICAL BULLETIN. 1977. a. EN. 1054

National Gallery Publications, Trafalgar Sq., London WC2N 5DN, England. Dr. Ashok R. Roy, Editor.

Subscription: £7. Illus. b&w, some color, charts. A4, 80p.

ISSN: 0140–7430 ISBN: 0947645632. OCLC: 5858583. LC: ND1630.L66a. Dewey: 751.6.

Painting.

Techniques studies concerning restoration of paintings.

Bibliographies: notes and references with articles. Listings: "Pictures Cleaned and Restored in the Conservation Department of the Gallery" (supplies artist, title and number). Indexed: RILA.

Advertising: none.

NETWORK NEWS. 1987. q. EN. 1055

User Services, Conservation Information Network, 4503 Glencoe Ave., Marina Del Ray, CA 90292.

OCLC: 17245449. LC: N8554.C66.

OCHRONA ZABYTKOW. 1948. q. POL. EN summaries. 1056

Ministerstwo Kultury i Sztuki, Generalny Konserwator Zabytkow, Osrodek Dokumentacji Zabytkow, Ul. Brzozowa 35, 00–258 Warsaw, Poland. (Dist.: Ars Polona–Ruch, Krakowskie Przedmiescie 7, Warsaw). Lech Krzyzanowski, Editor.

Subscription: $17. Illus., plans. Index.

ISSN: 0029–8247. OCLC: 2691085. LC: DK409.O25.

Concerned with restoration techniques, procedures and projects in Poland.

Reviews: book.

ONTARIO CONSERVATION NEWS. 1975. 11/yr. EN. 1057

Conservation Council of Ontario, Suite 506, 489 College St., Toronto, Ont. M6G 1A5, Canada. Phone 416–969–9637. Chris Winter, Editor.

Illus.

ISSN: 0383–6479. Dewey: 333.7. Formerly: *Conservation News.*

Reviews: book.

PAPER CONSERVATION NEWS. 1976. q. EN. 1058

Institute of Paper Conservation, The Secretary, P.O. Box 17, London WC1N 2PE, England.

Subscription: included in membership together with *The Paper Conservator*. Back issues. Illus. b&w, photos. A4, 16p.
ISSN: 0140–1033. OCLC: 7719858. LC: Z701.P215.

Purpose of the Institute is to increase the awareness of contemporary conservation of paper and related documents of historical or artistic significance—prints and drawings, watercolors, printed books, manuscripts, etc. Carries accounts of Institute meetings, news and reports as well as international notes and news.

Reviews: exhibition, book, equipment, conference. Calendar of workshops & conferences. Opportunities: employment.

Advertising: Situations vacant and items for sale by private individuals may be inserted at no charge. For commercial ads contact the Advertising Manager (Institute, Leigh Lodge, Leigh, Worcester WR6 5 LB, phone 0886–32323).

THE PAPER CONSERVATOR. 1976. a. EN. 1059

Institute of Paper Conservation, The Secretary, P.O. Box 17, London WC1N 2PE, England. Phone 0886–32323.

Subscription: included in membership together with *Paper Conservation News*, £20 individual, £14 student, £40 corporate UK; overseas: $US52, £26 individual; $40, £14 student; $104, £52 corporate. Back issues £9, $18 members; £13.50, $27 non-members. Illus. b&w, line drawings. A4, 108p.
ISSN: 0309–4227. OCLC: 3806912. LC: TS1109.P174. Dewey: 676.

Journal of the Institute devoted to the preservation of paper. Scholarly technical research is presented together with charts and statistics. Encourages the exchange of information regarding the conservation of prints, drawings, archives, and books.
Indexed: ArtArTeAb.

Advertising: none. Audience: conservators and others interested in the conservation of paper artifacts.

PREPRINTS OF PAPERS PRESENTED AT THE ANNUAL MEETING. a. EN. 1060

American Institute for Conservation of Historic and Artistic Works, 1400 16th St, N.W., Suite 340, Washington, DC 20036. Phone 202–232–6636. Elisabeth West Fitzhugh, Editor.
Illus.
ISSN: 0272–3727. OCLC: 6797102. LC: AM141.A44a. Dewey: 069.5.
Audience: book and paper conservators.

RESTAURO (Munich): Zeitschrift fuer Kunsttechniken, Restaurierung und Museumsfragen. 1988,
 v.94. q. GE. 1061

Verlag Georg D.W. Callwey, Streitfeldstrasse 35, Postfach 800409, 8000 Munich 80, W. Germany.
Subscription: DM 78.60, students DM 66. Illus. b&w, some color, plans.
ISSN: 0933–4017. OCLC: 20116143. Dewey: 751.6. Formerly: *Maltechnik Restauro*.

Published for the International Association for Conservation of Book, Paper and Archival Material. Devoted to art restoration and conservation methods and techniques.
Reviews: book. Indexed: ArtArTeAb. Avery.
Advertising.

RESTAURO (Naples). 1972. bi–m. 1062

Edizioni Scientifiche Italiane s.p.a., Via Chiatamone, 7, I–80121 Naples, Italy. Roberto Di Stefano, Editor.
Subscription: L 90000. Illus.
Dewey: 711.59.

RESTAURO & CITTA: Rivista Quadrimestrale di Studio, Ricerca e Cultural del Restauro. 1985. q.
 IT. 1063

Marsilio Editori S.p.A., S. Croce 518 -A, 30135 Venezia, Italy. Romeo Ballardini, Editor.
Subscription: L 75000. Illus., plans.
OCLC: 130195969. Dewey: 751.6.

SPACES: Notes on America's Folk Art Environments. 1982. 3/yr. EN. 1064

Saving & Preserving Arts & Cultural Environments, 1804 N. Van Ness, Los Angeles, CA 90028. Phone 213–463–1629.
Subscription: included in membership, $15 individual, $25 institution. Illus. 8p.
ISSN: 0748–8378. OCLC: 10684835. LC: NA208.S28.

Concerned with the identification, documentation and preservation of folk art environments throughout the country. Profiles folk art environments or sites and the artists and architects who function within them. Presents research reports and announcements of grants and appropriations.

Calendar of events. Opportunities: Competitions. Reviewed: *Art Documentation* Fall 1986, p.133.
Advertising: none. Circulation: 1000.

STUDIES IN CONSERVATION. 1952. q. EN chiefly, some FR. EN & GE summaries. 1065
International Institute for Conservation of Historic and Artistic Works, 6 Buckingham St., London WC2N 6BA, England.
Phone 071–839 5975, fax 071–976 1564. David Bomford, Anne Moncrieff & David Scott, Editors.
Back issues. Illus. b&w, photos, drawings. Index. 7 x 9½, 54p.
ISSN: 0039–3630. OCLC: 1184472. LC: N8560.S82. Dewey: 702.8.
Articles on conservation and restoration of art objects together with charts and statistics.
Reviews: book. Freelance work: yes, 25 offprints. Contact: editor. Indexed: ArtArTeAb. ArtI. Avery. Photohi. Reviewed: Katz.
Advertising at end of issue.

TECHNOLOGY & CONSERVATION: Of Art, Architecture & Antiquities. 1976. q. EN. 1066
Technology Organization Inc., 1 Emerson Pl., 16M, Boston, MA 02114. Phone 617–227–8581. Susan Schur, Editor & Pub.
Subscription: free, in US & Canada, to qualified persons working in or managing programs involving analysis and documentation of art, buildings, and monuments, historic sites and antiquities. $15 US & Canada, $32 foreign. Back issues. Illus.
b&w, photos. 8½ x 11, 32p.
ISSN: 0146–1214. OCLC: 2670402. LC: N8554.T4. Dewey: 702.
The magazine for analysis, preservation, restoration, protection and documentation. Contains a few articles, brief reports on
"technology trends" (new applications of materials and equipment) and a "product date" report.
Reviews: book. Listings: national–Canada. Calendar of events. Opportunities: employment. Indexed: ArtI. CloTAI.
GrArtLAb.
Advertising: b&w ads.

DECORATIVE ARTS & CRAFTS

General Works

THE AMERICAN WOODWORKER. 1985. bi–m. EN. **1067**
Rodale Press, Inc., 33 E. Minor St., Emmaus, PA 18098. Phone 215–967–5171. David Sloan, Editor.
Subscription: $27 US, $C35 Canada, foreign $37, air $54. Sample free. Back issues $5 US, $6 Canada. Illus. b&w, photos.
Cum. index due 1990. 11⅞ x 9, 80p, printed by offset press.
ISSN: 8750–9318. OCLC: 11924850. LC: TT194 .A47. Dewey: 694.
Antiques. Crafts. Decorative Arts. Furniture. Historic Preservation. Hobbies. Sculpture. Woodworking.

Addressing the needs and interests of the serious small–shop amateur woodworker actively seeking to improve his skills. Editorial mix of project plans and in–depth articles about woodworking: techniques, materials, design, history. Articles and projects are written by expert woodworkers. Photo feature, "Gallery," shows current work in wood.

Reviews: book 2–3 & video 2, length 300+ wds.; equipment 1, length 1000–3000 wds; exhibitions occasionally. Biographies: profiles of notable woodworkers and furniture designers past and present. Listings: regional–international. Calendar of events. Exhibition information. Freelance work: yes. Contact: editor. Opportunities: "Help wanted" in classified section, study, competitions.

Advertising: (rate card Sept–Oct. 1989): full page $6000, ½ page $3600, ¼ page $1920, no color. Mail order: full page $5400, ½ page $3240, ¼ page $1620. Classified: (payment with order) $45/15 wds., $3/wd. add.; "Wood & Tool Marketplace" or "Situations Wanted" for non–commercial, individual listings only, $5/line, min. 3 lines, max. 6. Frequency discount. 15% camera–ready discount. 15% agency discount. Jim Owens, Ad. Director. Mailing lists: available. Demographics: (1989 subscriber study): 95% men, age 18–49 34.5%, 25–54 48%, average 53.1 yrs., median 55.7 yrs.; 61% college educated, 49% professional/managerial; 1988 income average $46,230, median $41,420; 93% own home, $96,300 median market value of home and land. Circulation: 150,000. Audience: amateur woodworkers and woodworking enthusiasts.

ARS DECORATIVA: Annuaire du Musee des Arts Decoratifs et du Musee d'Art d'Extreme Orient Ferenc Hopp. 1973. a. GE, EN, or FR. **1068**
Iparmuveszeti Muzeum, Ulloi ut 33, 1091 Budapest 9, Hungary. Gyula Rozsa, Editor.
Subscription: exchange basis. Illus. b&w, glossy photos. 6¾ x 9½, 190p.
ISSN: 0133–6673. OCLC: 5592606. LC: NK9.A69. Formerly: *Iparmuveszeti Muzeum. Evkonyv.*
Scholarly articles, heavily illustrated.
Indexed: ArtBibMod. CloTAI.
Advertising: none.

ATHENAEUM ANNOTATIONS. 1976. q. EN. **1069**
Athenaeum of Philadelphia, East Washington Sq., Philadelphia, PA 19106. Phone 215–925–2688.
Subscription: included in membership, $25 Associate. Sample. No back issues. Illus. b&w, photos. 8½ x 11, 4–6p.
OCLC: 5292333. LC: AP1.A867. Dewey: 745.5. Formerly: *Anthenaeum Annals.*
Antiques. Architecture. Art History. Decorative Arts (American 19th Century). Furniture. Historic Preservation. Interior Design. Painting.

Mainly reports on new acquisitions for this 175 year old independent research library housed in a restored national historic landmark building near Independence Hall. Specializes in 19th Century American social and cultural history, especially architecture and decorative arts where the collection is nationally significant.

Listings: regional–national. Exhibition information. Freelance work: none. Opportunities: study, competitions.

Advertising: none. Circulation: 2000. Audience: members and persons interested in 19th Century American architecture and decorative art.

BEADS. 1989. a. EN. 1070
Society of Bead Researchers, 802–2850 Cedarwood Drive, Ottawa, Ontario K1V 8Y4 Canada.
Subscription: included in membership, $12.50. Illus.
ISSN: 0843–5499. OCLC: 21758836. LC: NK7300.B3. Dewey: 391. Formerly: *Bead Forum*.
The Journal of the Society of Bead Researchers.

BULLETIN OF THE IRISH GEORGIAN SOCIETY. See no. 308.

CONNAISSANCE DES ARTS. 1952. m. FR only. 1071
Societe Francaise de Promotion Artistique, 25 rue de Ponthieu, 75008 Paris, France. Phone 43.59.62.00. Philip Jodidio, Editor.
Subscription: $US80, $105 Canada, France 510F, Belgium 3630 F, Italy L 135,000, Luxumberg Fl 3630, Switzerland 153F, others 610F. Microform available from UMI. Illus., mainly color. Annual index. 8½ x 11, 220p.
ISSN: 0293–9274. OCLC: 1564792. LC: N2.C75. Dewey: 700. Formerly: *Connaissance des Arts–Plaisir; Plaisir de France; Connaissance des Arts.*
Antiques. Architecture. Collectibles. Fabrics.

Advertisements, occupying about one half of the issues, provide extensive notice of upcoming auctions. Provides world coverage of the decorative arts with particular emphasis on French items. Beginning with Oct 1990 "presenting a selection of articles or summaries of articles for our English speaking readers. The articles and the interviews appear in their original version". (8p.) These articles are not translations of main issue and do not appear listed in the table of contents. No summaries, abstracts or translations of main issue contents.
Reviews: exhibition, auction sales. Interviews: international figures in the art world. Calendar of events. Indexed: ArchPI. ArtBibCur. ArtBibMod. ArtHum. ArtI. Avery. BHA. BioI. CurCont. Des&ApAI. Reviewed: Katz.
Advertising. Audience: art lovers and collectors.

COUNTRY VICTORIAN ACCENTS. 1989. q. EN. 1072
GCR Pub. Group Inc., 1700 Broadway, 34th Floor, New York, NY 10019.
Subscription: $10.95 US, $12.95 Canada & foreign (P.O. Box 508, Mt. Morris, IL 61054–7995).
ISSN: 1053–9980. OCLC: 22718889. Dewey: 747. Formerly: *Country Victorian Decorating; Victorian Accents.*
Interior Design.

DECORATIVE ARTISTS WORKBOOK. 1987. bi–m. EN. 1073
F & W Publications, 1507 Dana Ave., Cincinnati, OH 45207. Phone 513–531–2222. Michael Ward, Editor.
Subscription: $17 US, + $4 Canada & foreign, + $20 air. Microform available from UMI. Sample $4.65. Back issues $3.50. Illus. b&w, color, photos, cartoons. Index. 8½ x 11, 85p.
ISSN: 0893–1097.
Art History. Decorative Arts. Painting.

Features step–by–step instructions for a wide variety of painting projects — all from the field's top artists. Also provides marketing information, new products, and techniques.
Reviews: book 10–20 & film 1–2, length 40–300 wds. Interviews: 1 human interest article per issue in "The Painting Life" column. Listings: US–Canada. Freelance work: yes (details in *ArtMkt.*). Contact: Sandra Carpenter. Opportunities: study – workshops listed in "Seminar Update" column. Reviewed: Katz. *School.*
Advertising: full page $1095, ½ page $715, ¼ page $395, color full page $550. Classified: $50/inch. Frequency discount. Gigi Grillot, Ad. Director. Circulation: 120,000. Audience: decorative painters.

THE DECORATIVE ARTS SOCIETY NEWSLETTER. 1974. q. EN. 1074
Decorative Arts Society, Fashion Institute of Technology, 227 W. 27th St., Room E–304, New York, NY 10001. Deborah D. Waters, Editor (Museum of the City of New York, 1220 Fifth Ave., New York, NY 10029, phone 212–534–1672).
Subscription: included in membership, $20 individual, $10 student, $25 institution US & Canada; foreign + $10. Sample. Back issues $5. Illus. b&w, photos. 8½ x 11, 12p.
ISSN: 0884–4011. OCLC: 4785982. LC: NK11.D425. Dewey: 745. Formerly: *Decorative Arts Newsletter.*
Antiques. Ceramics. Collectibles. Crafts. Decorative Arts. Furniture. Interior Design. Museology. Textiles.

Purpose of the Society is to provide a forum for those interested in European and American decorative arts of all periods and to encourage scholarly research in the field. Lists museum acquisitions, museum publications, and news of members. The Society is a special chapter of the Society of Architectural Historians.

Reviews: book 2, length 2–3 paragraphs; exhibition 1, length 2–3 p. Obits. Listings: national. Calendar of events. Exhibition information. Freelance work: yes. Contact: editor. Opportunities: employment, competitions, fellowships available, awards announced. Indexed: RILA. Reviewed: *Art Documentation* Fall 1986, p.132.

Advertising: none. Circulation: 600. Audience: professionals in field.

DECORATIVE ARTS TRUST - NEWSLETTER. 1977. q. EN. 1075

Decorative Arts Trust, 106 Bainbridge St., Philadelphia, PA 19147. Phone 215–627–2859. Penny McCaskill Hunt, Editor.

Subscription: included in membership. 8½ x 11, 10p.

Decorative Arts.

Reports, list of exhibitions and information on scholarly opportunities.

Reviews: book, exhibition. Calendar of events.

Advertising: none.

THE DECORATIVE PAINTER. 1973. bi–m. EN. 1076

National Society of Tole and Decorative Painters, P.O. Box 808, Newton, KS 67114. Phone 316–283–9665.

Illus.

OCLC: 12604070.

Goals of the Society are to further interest in the field, increase the quality of teaching and painting, and promote an awareness of quality in the field.

Audience: individuals interested in tole and decorative painting.

THE DECORATOR. 1946. s–a. EN. 1077

Historical Society of Early American Decoration, 19 Dove St., Albany, NY 12210. Phone 518–462–1676. Jane Bolster, Editor.

Back issues $6 (Mrs. Donald Tucker, Elm St., North Berwick ME 03906). Illus. b&w, photos. Cum. index v.1–8, v.9–14, v.15–20, v.21–29, v.30–39. 7 x 8¾, 48 p. + 11 p. of ads at end of issue.

Decorative Arts.

Contents include articles, museum acquisitions and member awards together with photos of items, new members, and bookshelf.

Advertising: yearly. rates: full page $140, ½ page $75, ¼ page $45. Single rates on request. (Mrs. Daniel O'Toole, 89 Kenaware Ave., Delmar, NY 12054).

DESIGN HISTORY SOCIETY NEWSLETTER. q. EN. 1078

Design History Society, c/o Shirley Walker, Membership Sec., 24 Sheldon Avenue, London N6 4JT, England. Phone 071–348 7955.

Indexed: Des&ApAI.

L'ESTAMPILE / L'OBJET D'ART. 1969. m. FR. EN summaries (2p. end of issue). 1079

SFBD/Archedogia S.A, 25, rue Berbisey, 21000 Dijon, France. Phone 80–30–33–80, fax 80–30–15–37, Paris phone (1)43 4181 43. Jean Faton–Boyance, Editor–in–chief.

Subscription: 395 F France, 445 F Europe, 545 F air outside Europe. Illus. color, photos. 8½x11, 120p.

ISSN: 0184–7724. Formed by the merger of *L'Estampille* and *L'Objet d'Art*.

Beautifully illustrated. Specializes in French decorative art of all centuries.

Listings: international. Calendar of exhibitions, auction sales. Indexed: ArtArTeAb. BHA.

Advertising.

FANS. 3/yr. EN. 1080

Fan Circle International, 79 A Falcondale Rd., Westbury on Trym, Bristol BS9 3JW, England.

Promotes interest in fans. Both historical and artistic perspectives are presented.

FINE WOODWORKING. 1975. bi–m. EN. 1081

Taunton Press, 63 S. Main St., Box 355, Newtown, CT 06470. Phone 203–426–8171. Dick Burrows, Editor.

Subscription: $22 US, $26 Canada & foreign, air $22 + $14.40. Sample $4.95. Back issues $5.50. Illus., color, photos. Index in Jan issue. 9 x 12 Web offset, perfect bound.

ISSN: 0361–3453. OCLC: 2246347. LC: TT180.F55. Dewey: 684.

Crafts—Woodworking. Decorative Arts—Wood Finishing, Carving. Furniture. Hobbies.

Leading source of woodworking information. Devoted to the best in cabinetmaking, it offers readers ideas and information not available elsewhere. Furniture making is at the heart of the magazine, but articles regularly cover turning, carving, joinery, finishing, design, wood technology, marquetry, veneer, hand tools, and more. There are demonstrations of tools and techniques, projects that teach new skills, shop tests, tips and examples of the woodworker's art.

Reviews: book 5–6, length 200–1,000 wds.; exhibition 1, journal 1, equipment 1–2, video 1–2. Listings: national. Calendar of events. Exhibition information. Freelance work: none. Opportunities: study. Indexed: ArtArTeAb. ArtI. BioI. CloTAI. Des&ApAI. Hand. Reviewed: Katz.

Advertising: (rate card Jl/Aug '89): full page $10,470, ½ page $4760, ¼ page $2480, color full page $14,030, ½ page $6900, ¼ page $3600; covers b&w $11,520, color $15,430. Classified: $5.75/wd., min 15 wd. Frequency discount. 15% camera–ready discount. 2% cash discount. Bleeds no added charge. James P. Chiavelli, Ad. Director. Mailing lists: available. Demographics: 97% male, 64% amateur woodworkers, 36% professional woodworkers, 47 yrs. old, 51% college graduates, $55,000+ household income, 86% own home, average value of home $149,700. (1988 subscriber survey). Circulation: 280,000. Audience: woodworkers—home shop enthusiasts and professionals.

FURNITURE HISTORY. 1965. a. EN. 1082

Furniture History Society, Victoria and Albert Museum, Dept. of Furniture & Interior Design, London SW7 2RL, England. Phone 0444–413845. Simon Jervis, Editor.

Subscription: included in membership together with *Newsletter*, £12 UK & Eire, £14 rest of Europe, £16 rest of world, $30 or £16 US & Canada (Dr. B. Austin, Membership Sec., 1 Mercedes Cottages, St. John's Rd., Haywards, Health W. Sussex RH16 4EH). No sample. Back issues £10 or $17. Illus b&w, photos. Index. Cum. index every 5–10 volumes. 7¼ x 9¾, 200–250p. ISSN: 0016–3058. OCLC: 1570335. LC: NK2528.F8. Dewey: 749.2205.

Antiques. Architecture. Art History. Crafts. Decorative Arts. Furniture. Interior Design.

Covers the history of furniture on an international basis though most articles are concerned with European furniture and its relation to interior design in general.

Biographies: some material on furniture makers and designers. Indexed: ArtBibMod. ArtI. BioI. BrArchAb. CloTAI. Des&ApAI. RILA.

Advertising: none. Audience: those interested in the history of furniture and interior design.

THE FURNITURE HISTORY SOCIETY NEWSLETTER. 1965. q. EN. 1083

Furniture History Society, Victoria and Albert Museum, Dept. of Furniture & Interior Design, London SW7 2RL, England. Phone 0444–413845. Lady Judith Goodison, Editor.

Subscription: included in membership together with *Furniture History*, £12 UK & Eire, £14 rest of Europe, £16 rest of world, $30 or £16 US & Canada, airmail to overseas destinations (Dr. Brian Austen, Membership Sec., 1 Mercedes Cottage, St. John's Rd., Haywards Health, West Sussex RH16 4EH). Sample free. Back issues 50p. Illus b&w, photos. 7¼ x 9¾, 16p. LC: NK2528. Dewey: 749.2205.

Antiques. Art History. Decorative Arts. Furniture. Interior Design.

Contains short articles and notices relating to the history of furniture. Includes news briefs, reports on activities and lectures, notices of lectures, and descriptions of visits planned by the Society.

Reviews: exhibition & book 3–4 each, length¼–3/4p. Listings: regional. Calendar of events. Exhibition information. Opportunities: study. Indexed: Des&ApAI.

Advertising: leaflets enclosed in mailing. Audience: those interested in the history of furniture and interior design.

GAZZETTA ANTIQUARIA: Rivista dell'Associazione Antiquari d'Italia. 1989, ns. no.7. q. IT. 1084

Umberto Allemandi & srl Societa editrice, 8 via Mancini, 10131 Turin, Italy. Phone 011–88.25.56/7/8, fax 011–87.71.26. Subscription: L 30.000, $US10, F 60, DM 18, ptas 1.150. Illus. b&w, some color, photos. 8¼ x 12, 88p.

Decorative Arts. Furniture.

Advertising.

JAPANESE FLOWER ARRANGING. 1987. bi–m. EN. 1085

c/o S.C. Pototsky, Ed., 44 Lane Park, Brighton, MA 02135. Phone 617–783–0466. Dewey: 745.1.

"Newsletter devoted to the exchange of information about Ikebana, the art of Japanese flower arranging...in a most informal manner".

JOURNAL OF EARLY SOUTHERN DECORATIVE ARTS. 1975. s–a. EN. **1086**

Museum of Early Southern Decorative Arts, Box 10310, Winston–Salem, NC 27108–0310. Phone 919–721–7360. John Bivins, Jr., Editor.

Subscription: available by membership only, $20, foreign air + $5. Sample. Back issues $5 for members. Illus. b&w. Indexes 1978, 1981, 1985, 1987. 75p.

ISSN: 0098–9266. OCLC: 3164140. LC: N6520.J67. Dewey: 709.

General.

Articles treat virtually all facets of southern decorative arts and artisans and regional material culture. Includes both in–house articles and contributed by decorative arts scholars and students throughout the world.

Biographies: occasionally biographies of specific Southern artisans are included with studies of their work. Freelance work: yes. Contact: editor. Indexed: AmH&L. CloTAI. RILA.

Advertising: none. Mailing lists: none. Audience: members of MESDA, decorative arts scholars, general public.

THE JOURNAL OF THE DECORATIVE ARTS SOCIETY 1850 TO THE PRESENT.

1977. a. EN. **1087**

Decorative Arts Society, c/o Brighton Museum, Church St., Brighton Sussex BN1 1UE, England. Phone 0273–603005. rotational editor.

Subscription: included in membership together with *Newsletter*, £8 individual, £14 institution, £5 student/pensioner UK; $25 US individual, $15 student/pensioner. No sample. Back issues, No. 3 on, £3 + postage. Illus. b&w, color, photos, cartoons. 11½ x 8¼, 48p.

ISSN: 0260–9568. OCLC: 17161354. LC: NK1.B911. Formerly: *Journal of the Decorative Arts Society 1890–1940*.

Antiques. Architecture. Ceramics. Decorative Arts. Furniture. Interior Design. Textiles.

Encourages interest in, and research into the decorative arts in Europe, American and Great Britain from 1850 to the present. "Decorative arts" is used in its broadest sense to include the study not only of furniture, ceramics, glass and metalwork but also architecture, interior and industrial design, fashion and textiles, theater, ballet and film design, and the graphic arts. Some issues have also distinctive titles.

Biographies occasionally. Freelance work: yes. Contact: Stella Beddoe. Opportunities: study. Indexed: ArchPI. ArtBibMod. CloTAI. Des&ApAI. RILA.

Advertising: full page £100, ½ page £60, ¼ page £40. Circulation: 1000. Audience: collectors and scholars.

THE LUMINARY. 1975. s–a. EN. **1088**

Museum of Early Southern Decorative Arts, Box 10310, Winston–Salem, NC 27108–0310. Phone 919–721–7360. John Bivins, Jr., Editor.

Subscription: available by membership only together with *Journal of Early Southern Decorative Arts*, individuals $20, institutions $15.

OCLC: 7310051. LC: NK811.L840. Dewey: 709.

General.

The newsletter of the Museum.

Reviews: book. Listings: regional–national. Calendar of events. Exhibition information. Opportunities: study.

Advertising: none. Mailing lists: available. Audience: members of MESDA, decorative arts scholars, general public.

METIERS D'ART: Mieux Connaitre et Apprecier les Metiers d'Art. 1977. irreg. FR. **1089**

Societe d'Encouragement aux Metiers d'Art, 20,, rue La Boetie, 75008 Paris, France. Phone 42.65.74.50. Christian Hubert, Editor–in–chief.

Subscription: 193 F France & CEE, 225 F elsewhere. Back issues. Illus. A4, 108p.

ISSN: 0152–2418. OCLC: 9000371.

Each issue also has a distinctive title. Provides a forum for French artists working in the decorative arts.

Opportunities: "Liste des Professionnels". Indexed: ArtArTeAb.

THE NEWSLETTER OF THE DECORATIVE ARTS SOCIETY 1850—THE PRESENT.

1977. 3/yr. EN. **1090**

Decorative Arts Society, c/o Brighton Museum, Church St., Brighton Sussex BN1 1UE, England. Phone 0273–603005. rotational editor.

Subscription: included in membership together with *The Journal*, £8 individual, £14 institution, £5 student/pensioner UK; $25 US individual, $15 student/pensioner.

LC: NK1.B911.

Antiques. Architecture. Ceramics. Decorative Arts. Furniture. Interior Design. Textiles.

Includes information on the special events of the Society and those of other related societies, news of forthcoming sales and recent publications and provides the opportunity to exchange information and make inquiries concerning current research projects.

Listings: national–international. Calendar of events. Exhibition information. Opportunities: study.

Circulation: 1000. Audience: collectors and scholars.

PRESENT: International Trade Magazine for Giftware, Living Accessories, Handicraft and Applied Art. 1925. m. GE. EN and FR captions.

1091

Meisenbach GmbH, Hainstr. 18, Postfach 2069, 8600 Bamberg, W. Germany. Egon Ochner, Editor.

Subscription: DM 104.

ISSN: 0032–7697. Dewey: 745.5.

TOLE WORLD: Devoted to the Fine Art of Tole. 1978. bi–m. EN.

1092

EGW Publishing Company, P.O. Box 5986, Concord, CA 94524. Phone 415–671–9852. L. Zachary Shatz, Editor.

Subscription: $15 US, + $5 Canada & foreign. Sample free. Back issues $2. Illus. b&w, color, photos, cartoons. 8⅛ x 10⅞, 64–80p.

ISSN: 0199–4514. OCLC: 5884606.

Decorative Arts. Drawing. Painting.

Covers the tole and decorative painting industry, provides 8–10 painting projects per issue with color pictures, line art and step–by–step instructions. Regular features include advice column, worksheet page, industry news, book reviews, seminar listings, personality profile, and special feature articles. Reports on new products related to the craft. Designed to serve practicing painters.

Reviews: book 10–20, length 1 paragraph. Biographies: personality profile in each issue. Listings: national. Calendar of seminars & exhibitions. Freelance work: yes. Contact: editor.

Advertising: Debra Nowak, Ad. Director. Demographics: nationwide. Circulation: 35,000. Audience: tole & decorative painters.

VICTORIA. 1987. 10/yr. EN.

1093

Hearst Corporation, Victoria, 250 W. 55th St., 28th Fl., New York, NY 10019. Phone 212–903–5190. Nancy Lindemeyer, Editor.

Subscription: $13.31 US, Canadian & foreign rates on request. Illus.

ISSN: 1040–6883. OCLC: 18513873. Dewey: 051. Formerly: *Good Housekeeping's Victoria.*

Collectibles. Crafts. Interior Design.

Covers "fashion & beauty, cooking & entertaining, crafts & collectibles".

Antiques

AADA NEWS. bi–. EN.

1094

Associated Antique Dealers of America, Box 320, Corte Madera, CA 94925. Phone 415–924–2171.

Dewey: 745.1.

Describes activities of the Association and its members. Also includes a list of new members.

ANTIEK: Tijdschrift voor Liefhebbers en Kenners van Oude Kunst en Kunstnijverheid. 1966. m. DU.

1095

Antiek Lochem, Nieuweweg 35, 7241 ES Lochem, Netherlands, Phone Editorial Board.

Subscription: fl 126.50. Illus., some color. Index. 20cm.

ISSN: 0003–5653. OCLC: 1711939. LC: NK1125.A25. Dewey: 745.

Indexed: ArtArTeAb. ArtBibCur. ArtBibMod. RILA.

ANTIQUE CLOCKS. 1978. m. EN.

1096

Argus Specialist Publications Ltd., Wolsey House, Wolsey Rd., Hempstead, Herts HP2 4SS, England. Phone 0442–41221. John Hunter, Editor.

Subscription: £27. Illus.

OCLC: 20386702. LC: TS540.C66x. Dewey: 745.5. Formerly: *Clocks*.

Antiques. Clocks. Watches.

"Magazine for horological collectors and restorers".

Indexed: ArtArTeAb.

ANTIQUE COLLECTING. 1965. 11/yr. EN. 1097

Antique Collectors Club, 5 Church St., Woodbridge, Suffolk, 1P12 1DS England. Phone 0394–385501. John Steel, Editor.
Subscription: included in membership, £17.50 UK, $35 US, $45 Canada, overseas £19.50. Sample free. Some back issues £2.
Illus. b&w, some color. Index published in May. Cum. index 1966–1989. 8.2 x 11.8, 80p.
ISSN: 0003–584X. OCLC: 8378269. Dewey: 745.1. Incorporates: *Antique Finder*.

Antiques. Decorative Arts. Furniture. Jewelry. Painting. Sculpture. Textiles.

The journal of the Antique Collectors' Club publishes practical and highly factual articles on antiques as well as information on where to buy them.
Bibliographies: short ones sometimes at end of articles. Listings: national. Calendar of events for antique fairs and auctions.
Exhibition information. Freelance work: none. Opportunities: study. Indexed: ArtBibMod. CloTAI. Des&ApAI. Reviewed: Katz.
Advertising: (rate card): b&w full page £395, ½ page £220, ¼ page £115; color full page £695, ½ page £480, special placement +10–20%. Bleed (whole page only) +10%. Frequency discount. Inserts. Jean Johnson, Ad. Director. Mailing lists: none.
Circulation: 11,800. Audience: collectors, dealers, and intelligent home furnishers.

THE ANTIQUE COLLECTOR. 1930. m. EN. 1098

National Magazine House, 72 Broadwick St., London W1V 2BP, England. David Coombs, Editor.
Subscription: £30 UK, air £40, US & Canada $US55 air, worldwide surface £38 (c/o Quadrant Subscription Services Ltd.,
Freepost, Haywards Heath, Wess Sussex, RH16 3ZA). Microform available from UMI. Illus. b&w, some color.
ISSN: 0003–5858. OCLC: 1481612. LC: NK1125.A28. Dewey: 708.051.

Antiques.

A journal for lovers of the old, rare and beautiful. Covers all fields of antiques and fine art. Prices and values are given.
Reviews: book. Indexed: ArchPI. ArtArTeAb. ArtBibCur. ArtBibMod. CloTAI. Reviewed: Katz.
Advertising. Classified.

ANTIQUE COMB COLLECTORS CLUB NEWSLETTER. 1986. bi–m. EN. 1099

Antique Comb Collectors Club, 237 Society Dr., Holiday, FL 34691. Phone 813–942–7354. Belva Green, Editor.
Subscription: $8.50 US, $11 elsewhere. Illus. b&w. 8½ x 14, 4–6p.
ISSN: 0892–7162. OCLC: 15246789. LC: NK4890.C63 A57. Dewey: 688.5.

Antiques. Jewelry.

Reports on all aspects of antique comb collecting.
Reviews: book.
Advertising: classified. Circulation: 100. Audience: collectors of antique combs.

THE ANTIQUE DEALER AND COLLECTORS' GUIDE. 1946. m. EN. 1100

IPC Magazines Ltd., King's Reach Tower, Stamford St., London SE1 9LS, England. Phone 071–261 6894, Telex 915748
MAGDIV G. Philip Bartlam, Editor.
Subscription: £34 UK, $48 US & Canada air. Sample. No back issues. Illus. b&w, color, photos. Index in Dec issue. Cum.
index on application. 290 x 225 mm., 80p.
ISSN: 0003–5866. OCLC: 3583423. LC: NK1125 .A283. Dewey: 745.1. Incorporates *Art & Antiques*.

Antiques. Collectibles. Decorative Arts.

Devoted to antiques and the fine and decorative arts. Each issue contains wide–ranging and informative feature articles on antique furniture, ceramics, silver, pictures and collectibles, together with comprehensive coverage of price movements in the salerooms, recent discoveries and items coming up for sale. Complete trade, auction, antiques fair and dealer news is provided each month, and the complex matters of restoration and authenticity are regularly examined. An important aspect of the magazine is its publication of new information on well–established aspects of the market alongside pioneer investigation of new areas of potential for the collector, furnisher or investor. The "On View" column covers dealer exhibitions.
Reviews: exhibition 8, book 1–5, & equipment 1–3, length all 250 wds. Bibliographies accompany some articles. Listings: national–international. Calendar of antique fairs & auctions. Exhibition information. Freelance work: yes. Contact: editor. Opportunities: study, competitions. Indexed: ArtBibMod. ArtArTeAb. CloTAI. Reviewed: Katz.

Advertising: (rate card Jan '89): [exclusive of VAT] b&w full page £540, ½ page £295, ¼ page £174; color full page £765, ½ page £405, ¼ page £215, bleed + £110; 2 color +£170; special positions + 15%. Classified: £10.50 col. cm., min. 2.5 cm.; Collectors' Classified 65p/wd., min. £10. Inserts. Charles Harris, Ad. Director. Mailing lists: none. Demographics: 10,000 UK, 3,000 overseas. Circulation: 14,800. Audience: antique dealers, collectors and furnishers.

ANTIQUE DEALERS' ASSOCIATION OF AMERICA. FORUM. s–a. EN. 1101
Antique Dealers' Association of America, Box 335, Green Farms, CT 06436.
Dewey: 745.1.

ANTIQUE MONTHLY. 1967. m. EN. 1102
Boone, Inc., 1305 Greensboro Ave., Drawer 2, Tuscaloosa, AL 35402. Phone 205–345–0272. Gray D. Boone, Editor.
Subscription: $18. Microform available from UMI. Illus. photos. 15¼ x 22¾, 72p.
ISSN: 0003–5882. OCLC: 3969530. LC: NK1125. Dewey: 745. Incorporates *American Antiques; Antique Quarterly.*
Antiques.

"The nation's antiques newspaper" covers the antiques market. Contains information on shows, forums, and seminars. Advertising.

THE ANTIQUE PHONOGRAPH MONTHLY. 1973. m. EN. 1103
APM Press, 502 East 17th St., Brooklyn, NY 11226. Phone 718–941–6835. Allen Koenigsberg, Editor.
Subscription: $14. Sample, free with stamp or IRC coupon. Back issues by volume only. Illus. b&w. 5½ x 8½, 16–24p.
ISSN: 0361–2147. OCLC: 2246370. LC: TS2301.P3 A67. Dewey: 621.389.
Antiques.

APM archives of recorded sound. Devoted to the history of recorded sound from 1877 to 1930, and the restoration of antique phonographs.
Reviews: book. Freelance work: yes. Contact: editor. Indexed: Cum. index.
Advertising: full page $65, ½ page $35, $3/inch. Classified: $1.50/10 wds., $2.50/11–20 wds. Frequency discount.

ANTIQUE REVIEW. 1975. m. EN. 1104
Ohio Antique Review, Inc., 12 E. Stafford Ave., Box 538, Worthington, OH 43085. Phone 614–885–9757, fax 614–885–9762. Charles R. Muller, Editor.
Subscription: $20 2nd class, $40 first class US & Canada; foreign rates on request. Sample. Back issues $3. Illus. b&w, photos, cartoons. Annual index in first issue of next year. 11½ x 15⅝, 100p. Offset.
ISSN: 0883–833X. OCLC: 12032267. Dewey: 745. Formerly: *Ohio Antique Review.*
Antiques. Ceramics. Decorative Arts. Furniture. Painting. Photography. Textiles.

Provides information on the market for American antiques at auctions and antiques shows. Also includes informative articles about the early American material culture. Focuses on the Mid–American antiques market. Newspaper tabloid format printed on newsprint. Each issue accompanied by a supplement called: *Antique Review Preview.*
Reviews: book 3, exhibition occasionally. Listings: national. Calendar of events. Museum exhibition information. Freelance work: yes. Contact: editor. Opportunities: study. Reviewed: Katz.
Advertising: (rate card May, 1990): Dealer: full page $340, ½ page $170, ¼ page $85, business card $37. Event–Show–Auction: full page $400, ½ page $200, ¼ page $100. Classified: 30¢wd. prepaid, min. $8. Frequency discount. JoAnne Geiger, Ad. Director. Mailing lists: available. Demographics: Midwestern about 70%. Circulation: 11,800. Audience: antiques collectors and dealers.

ANTIQUE SHOWCASE. 1963. 13/yr. EN. 1105
Amis Gibbs Publications Ltd., P.O. Box 260, Bala, Ontario P0C 1A0, Canada. Phone 705–762–5631. Barbara Sutton–Smith, Editor.
Subscription: $C28 Canada, + $7 US, includes Annual Directory. Illus. 72p.
ISSN: 0713–6315. OCLC: 9000493. LC: AM313. Dewey: 745.1. Formerly: *Ontario Showcase.*
Antiques.

Canada's oldest antique magazine covers a wide range of subjects. Articles, each written by knowledgeable specialists, focus on providing factual and helpful information.
Bibliographies: "Collector's Bookshelf". Calendar of shows.
Advertising rates on request. Audience: antique collectors both seasoned and beginners.

THE ANTIQUE STOVE ASSOCIATION - YEARBOOK. 1985. a. with q. supplementary pages. EN. 1106

Antique Stove Association, 417 N. Main St., Monticello, IN 47960. Phone 219–583–8593. Clifford Boram, Editor.
Subscription: included in membership.

Antiques.

Reference book on antique stoves. Covers a different type of stove each year.
Advertising: none. Audience: restorers, dealers, collectors, and interested individuals.

ANTIQUE TOY WORLD. 1971. m. EN. 1107

Antique Toy World, P.O. Box 34509, Chicago, IL 60634. Dale Kelley, Editor.
Subscription: $20 US, $28 rest. Illus.
ISSN: 0742–0420. OCLC: 8693543. LC: NK9509.A57. Dewey: 688.7.

Antiques. Collectibles.

The magazine for toy collectors around the world.
Reviewed: Katz.

ANTIQUE TRADER PRICE GUIDE TO ANTIQUES AND COLLECTORS' ITEMS.

1970. bi–m. EN. 1108

Babka Publishing Co., Box 1050–PG, Dubuque, Dubuque, IA 52001. Phone 319–588–2073. Kyle Hustloen, Editor.
Back issues. Illus.
ISSN: 0556–5367, 0882–6897 (a.). OCLC: 11350181 (a.). LC: NK1125. Dewey: 745.1.

Antiques. Collectibles.

Price guide to antiques and collectibles contains a wide variety of collectibles. Annual cumulation: *The Antique Trader Antiques and Collectibles Price Guide*.
Reviewed: Katz. *Booklist* 86:14, Mar 15 1990, p.1493.
Advertising. Ted Jones, Ad. Director.

THE ANTIQUE TRADER WEEKLY. 1957. w. EN. 1109

Babka Publishing Co., Box 1050, 100 Bryant St., Dubuque, IA 52001. Phone 319–588–2073. A. Babka, Editor.
Subscription: $22. Illus. Cum. index. 10½ x 14, 124p.
ISSN: 0161–8342. OCLC: 4029462 (annual). Dewey: 745.1. Formerly: *Antique Trader*.

Antiques. Collectibles.

For those interested in buying and selling antiques by mail. The *Annual of Articles on Antiques* contains complete reprints of all articles which appeared in the weekly, completely indexed by subject. The calendar of shows, sales, and auctions is arranged by date for various regions of the country.
Bibliographies: *The Antique Trader Weekly: Annual of Articles on Antiques*. Listings: regional–national. Calendar of events.
Reviewed: Katz.
Advertising. Classified.

ANTIQUE WEEK. 1970? w. EN. 1110

Mayhill Publications, Inc., 27 N. Jefferson St., Box 90, Knightstown, IN 46148. Phone & fax 1–800–428–4156. Don Johnson, Editor.
Subscription: $19.25 Eastern edition, $20.45 Central edition, includes annual *Antique Shop Guide*. Illus. b&w. 11½ x 17, 40p.
OCLC: 13663341. LC: NK818.A58. Dewey: 381. Formerly: *Antique Week—Tri–state Trader*.

Antiques.

Tabloid regional antique newspaper available in two editions. Contains an extensive selection of antique auctions, antique shows and flea markets. Mainly listings and advertisements but does include articles on a wide variety of antiques. "Directory of Antique Shops", arranged by state and city, provides address, hours, phone, and type of antiques handled. Regular section on genealogy.
Listings: regional. Antique shows, flea markets, and auctions calendars.
Advertising: full page $489.10, ½ page $261.90, ¼ page $136.20, $10.80/col.in., 2 pages $1007.10. Classified: 26¢/wd. 7 pt. type, 36¢/wd. 8 pt., $1.90 min. (ads run in both editions, 10% discount pay in advance or within 10 days of bill). Directory rates 31¢/20 wds., 29¢ add. wd., 6 issue min. Photos accepted at no extra charge. Color available at extra charge and as space permits. Frequency discount. Demographics: more than 25,000 subscribers and addresses in the Mid–Atlantic States with another 35,000 in the Mid–Central states. Eastern and Mid–Central editions. Mid–Central region Ohio/Tenn. to Iowa/Mo. Circulation: 65,000.

ANTIQUES. 1963. q. EN. **1111**

Antique & General Advertising, Old Rectory, Hopton Castle, Craven Arms, Salop SY7 0QJ, England. Tony Keniston, Editor. Annual index.

Dewey: 745.1. Absorbed: *Antiques World*.

Antiques.

Reviews: book, auction sales. Indexed: ArtBibCur. ArtBibMod. ArtHum. ArtI. Avery. BioI. BkReI. CloTAI. CurCont. Reviewed: Katz.
Advertising.

ANTIQUES AND AUCTION NEWS. 1967. w. EN. **1112**

Engle Publishing Company, P.O. Box 500, Rte. 230 W., Mount Joy, PA 17552. Phone 717–653–9797. Doris Ann Johnson, Editor.

Subscription: $15, 3rd class. Sample. No back issues. Illus. b&w, photos. Annual index in next Jan issue. 11½ x 17, 24p. OCLC: 2444873. Dewey: 745.1. Formerly: *Joel Sater's Antiques and Auction News*.

Antiques. Art History. Ceramics. Furniture. Historic Preservation. Painting. Sculpture.

"The most widely read collector's newspaper in the East" for antiquers, collectors, auctioneers, and show promoters.
Reviews: exhibition & book. Listings: regional–international. Calendar of events. Exhibition information. Freelance work: none. Opportunities: study.
Advertising: rate cards sent on request. Mailing lists: none. Audience: antiquers & collectors, auctioneers & dealers, show managers.

ANTIQUES & COLLECTING HOBBIES. 1931. m. EN. **1113**

Dale K. Graham, Publisher, 1006 S. Michigan Ave., Chicago, IL 60605. Phone 312–939–4767. Frances L. Graham, Editor.
Subscription: $22 US, $32 Canada & foreign. Microform available from UMI. Sample. Some back issues $2. Illus. b&w, color. 8¼ x 11 trim, 100p.
ISSN: 0884–6294. OCLC: 12187475. LC: AM201.H6. Dewey: 790.1. Formerly: *Hobbies, the Magazine for Collectors*.

Antiques. Art Education. Ceramics. Collectibles. Glass. Hobbies. Painting. Pottery.

America's oldest antiques and collectibles publication. Devoted to the preservation of the antique arts. Each issue contains articles on art glass, art pottery, china, etc., interesting features, and columns for all collectible fields.
Reviews: book 6. Interviews: occasional dealer or collector interview. Listings: national. Calendar of events. Exhibition information. Freelance work: yes. Opportunities: competitions. Indexed: BioI. BkReI. CloTAI. RG. Reviewed: Katz.
Advertising: b&w full page $525, ½ page $307, ¼ page $175; color full page +$300, ½ page +$200, ¼ page +$100. Classified: 40¢–60¢/wd., min. $8, payment in advance. Frequency discount. 15% agency discount. 10% discount for pre–payment of display ads. David Trout, Ad. Director. Mailing lists: available. Demographics: worldwide subscribers includes 32 foreign countries, distribution through newsstands, bookstores and antiques shops, sample copies distributed at antiques shows and auction houses. Circulation: 15,000. Audience: collectors/antique dealers.

ANTIQUES & FINE ARTS. 1983. bi–m. EN. **1114**

John Finsand Publisher, 255 No. Market St., Suite 120, San Jose, CA 95110. Phone 408–298–2787. Gerri Gallagher, Editor.
Subscription: $19.95 US, + $10 US Possessions & Canada, + $20 foreign. Sample $3.95. Back issues $6. Illus. mainly color, photos. 8¼ x 10¾, 150p.
ISSN: 0886–7208. OCLC: 12962314. Dewey: 705. Formerly: *Art & Antique Collector*.

Antiques. Architecture. Ceramics. Crafts. Decorative Arts. Furniture. Modern Art. Painting. Textiles.

"The magazine for the discerning collector." Focus has been turn–of–the–century and early 20th century artists. Beginning with Jl/Aug 1990 the focus shifted to the 1930s and 1940s and exploring the Modernism movement—the individual artists and the different schools that comprised it. Will pay special attention to the movement's history and the influences and artists that shaped it. Plans to continue to feature the early 20th–century artists.
Reviews: book 1, length 1p. Biographies: brief notes on contributors. Interviews: private collectors or artists. Listings: national. Calendar of Museum events. Gallery Exhibition information. Freelance work: yes. Contact: editor.
Advertising: full page $1839, ½ page $1210, ¼ page $696; color full page $2070, ½ page $1350, ¼ page $780. Classified: $260. Frequency discount. Lisa Chisolm, Ad. Director. Mailing lists: available. Circulation: 25,000. Audience: private art and antique collectors.

ANTIQUES FOLIO. 1964. a. EN. **1115**

Antiques & General Advertising, Old Rectory, Hopton Castle, Craven Arms, Salop SY7 0QJ, England. Tony Keniston, Editor. Illus.

OCLC: 8774130. LC: NK1127.A15. Dewey: 745.1. Incorporates: *Antiques in Britain*.

Antiques.

Five regional sections, each of which is also issued separately, cover antiques in: the Cotswolds and Midlands, the North and Scotland, East Anglia, the West Country, and antiques in and around London.

ANTIQUES TRADE GAZETTE. 1971. w. EN. 1116

Metropress Ltd., 17 Whitcomb St., London WC2H 7PL, England. Ivor Turnbull, Editor.
ISSN: 0306–1051. LC: NK1125.A1 A63. Dewey: 745.1.

Antiques.

ANTIQUEWEEK. 1986. w. EN. 1117

Mayhill Publications, Attn: Carolyne Cloud, 27 N. Jefferson St., Box 90, Knightstown, IN 46148. Phone 317–345–5133. Tom Hoepf, Editor.
Back issues. Illus. 10¼ x 12, 56p.
ISSN: 0888–5451. OCLC: 13663341. LC: NK818.A58. Dewey: 381. Formerly: *Antiqueweek – Tri–State Trader; Tri–State Trader*.

Antiques. Collectibles. Hobbies.

Tabloid contains brief articles on antiques and collectibles, hobbies, genealogy and local history.
Calendar of auctions. Reviewed: Katz.
Advertising. Classified. Marie Peters, Ad. Director.

ART & ANTIQUES. 1978. 10/yr. EN. 1118

Art & Antiques Associates, 623 Third Ave., New York, NY 10017. Phone 212–922–9250. Jeffrey Schaire, Editor.
Subscription: $27 US, $42 Canada, foreign $47 (P.O. Box 11697, Des Moines, Iowa 50340–1697). Microform available from UMI. Sample $4.75. Back issues $6.25 (order from publisher). Illus., color. 9 x 10⅞, 164p., Web offset, Perfect Binding.
ISSN: 0195–8208. OCLC: 10648737. Dewey: 709. Formerly: *American Art and Antiques*.

General. Antiques. Collectibles. Decorative Arts. Furniture.

A consumer magazine dedicated to the fine and decorative arts.
Reviews: exhibition 4, book 2. Biographies: articles about artists. Listings: regional–international. Exhibition information. Freelance work: yes. Contact: editor. Indexed: AmH&L. ArtBibMod. ArtI. Avery. BioI. CloTAI. Reviewed: Katz. *Wilson* 63:3, Nov. 1988, p.119.
Advertising: (rate card Jan '89) b&w full page $5900, ½ page $3890, ¼ page $2370; 2–color full page $6385, ½ page $4220, ¼ page $2560; 4–color full page $7110, ½ page $4690, ¼ page $2845; covers $7455–$8875. special position +15%. Bleed +10%. Classified: $50/2 lines, $20/wd. add. Frequency discount. 15% agency discount. 2% cash discount. Inserts. gatefolds. Gail Boston, Ad. Director. Mailing lists: available for fee. Demographics: median age 40, median household income $86,000, very well educated. Circulation: 110,000+. Audience: adults who love art.

THE AUSTRALIAN ANTIQUE COLLECTOR. 1966. s–a. EN. 1119

Business Press International, 162 Goulburn St., Darlinghurst N.S.W. 2010, Australia. Phone 02–2669711. Roslyn Maguire, Editor.
Subscription: $A7/issue, foreign $A15 air. No sample. Back issues $A5. Illus. b&w, color. 29½ x 21 cm., 115p.
ISSN: 0004–8704. OCLC: 8995971. Dewey: 745.1.

Antiques. Collectibles.

Articles on antiques, mainly Australian. Also covers the collections of private individuals.
Reviews: (average 3/issue): exhibition, length 1000; book, length 500 wds. Biographies: paragraph on contributors. Freelance work: yes. Contact: editor.
Advertising: full page $1200, ½ page $700, ¼ page $400, color $1725. No frequency discount. Nick B. Johnson, Ad. Director. Mailing lists: none. Circulation: 10,000. Audience: general public.

CARTER'S PRICE GUIDE TO ANTIQUES IN AUSTRALIA. 1981. a. EN. 1120

Bomilhold Pty. Ltd., 250 Military Rd., Neutral Bay, N.S.W. 2089, Australia. Phone 02 953 8383. Alan Carter, Editor.

Antiques.

THE COIN SLOT. q. EN. 1121

Hoflin Publishing Ltd., 4401 Zephyr St., Wheat Ridge, CO 80033–3293. Cynthia L. Kerstiens, Editor.
Subscription: $32 US, $36 Canada & foreign. Sample & back issues, $9. Illus b&w, 75–125 photos/issue. 8½ x 11, 80p.

Dewey: 793.

Antiques. Collectibles.

A specialized journal devoted to antique coin–operated machines. Includes a 10–20 page interview in each issue with an important collector.

Freelance work: yes, no pay. Contact: editor.

Advertising: full page $120, ½ page $75, ¼ page $40, color + $300. Classified: 25¢/wd. No frequency discount. Mailing lists: none. Circulation: 1100. Audience: antique coin–op machine fanciers.

COLLECTORS' SHOWCASE. America's Premiere Collectors' Magazine. 1981. m. EN. 1122

Keith Kaonis, 1018 Rosecrans St., San Diego, CA 92106. Phone 619–222–0386. Donna Kaonis, Editor.

Subscription: $36 US, $46 Canada, $78 foreign air. Microform available. Sample $5. Back issues. Illus., color, some b&w, photos. 8¼ x 10¾, 120p. Web fed, perfect bound.

ISSN: 0744–5989. OCLC: 8437762. LC: NK805.C64. Dewey: 745.1. Absorbed: *Spinning Wheel*.

Antiques. Collectibles.

A pictorial magazine devoted to collectors of dolls, toys, antique advertising, and memorabilia. Covers auctions and shows around the world, doll and toy museums plus special items of interest. Classified ads for collectibles, miscellaneous merchandise, catalogs, "wanted," "for trade," etc. are included to encourage reader participation and give the collector the ability to advertise, in color, prime items for sale.

Reviews: book 4, length¼p. each; products, length 2–4p./issue. Listings: international. Calendar of shows, auctions, exhibitions. Freelance work: yes. Contact: editor. Reviewed: Katz. Katz. *School*.

Advertising: (rate card 2/89): b&w full page $565, ½ page $315, ¼ page $220, covers $650–$750, 2 color + $350, 4 color +$350. Classified: $2/line, min. 3 lines, $1.75/line 4–18, $1.60/line 19+; photo classified: $45/photo (color or b&w) not to exceed 2 x 3 inches & 6 lines. bleed + 10%. frequency discount. 15% agency discount. Mailing lists: available. Circulation: 30,000. Audience: collectors of antique and collectible dolls, toys, antique advertising.

HANDBOOK / BRITISH ANTIQUE DEALERS' ASSOCIATION. 1986. a. EN. 1123

British Antique Dealers' Association (BADA), 20 Rutland Gate, London SW7 1BD, England. Phone 071–589 4128, fax 071–589 9083. Helen Wilks, Editor.

Illus., some color.

OCLC: 14450247. LC: NK1125.B86h. Dewey: 745.1.

Antiques.

Advertising.

JOURNAL OF THE ARMS AND ARMOUR SOCIETY. 1953. s–a (6 nos. to a vol.). EN. 1124

Arms and Armour Society, Department of Metalwork, c/o A.R.E. North, Victoria and Albert Museum, London SW7 2RL, England. Phone 071–938–8326. T. Richardson, Editor (Royal Armouries, H M Tower of London, London EC3N 4AB).

Subscription: included in membership, £10 UK & Europe, elsewhere $US20 surface, $US30 air. Illus. b&w, plates. 5½ x 8½, 68p.

Dewey: 739.7.

Scholarly articles on historical research about arms and armours. Includes information on swords, daggers, guns, rifles, and armour making.

Bibliographies: recent publications. Indexed: BHA. BrArchAb.

Advertising: M.J. Sarche, Ad. Director (162 Marsh Lane, Stanmore, Middlesex HA7 4HU).

KOVELS ON ANTIQUES AND COLLECTIBLES: The Newsletter for Dealers, Collectors and Investors. 1974. m. EN. 1125

Antiques, Inc., P.O. Box 22200, Beachwood, OH 44122. Phone 216–752–2252, fax 216–752–3115. Ralph and Terry Kovel, Editors.

Subscription: $25 US & Canada. Sample. Back issues $2.25. Illus. b&w. Annual index. 8½ x 11, 12p.

ISSN: 0741–6091. OCLC: 10161134. LC: NK1125.A39. Dewey: 745.1. Formerly: *Ralph and Terry Kovel on Antiques*.

Antiques. Collectibles. Decorative Arts.

Regularly offers news and reports that affect the value of antiques, enhance the pleasure of collecting, and give up–to–the–minute information on buying, selling, and researching antiques. Regular departments include "Dictionary of Marks", "Collector's Gallery", and "New Price Books".

Reviews: book 4–6. Freelance work: none. Reviewed: Katz.

Advertising: none. Audience: dealer, collectors and investors.

KUNST & ANTIQUITAETEN. 1976. bi–m. GE.

Kunst & Antiquitaeten GmbH, Postfach 19 05 64, D–8000 Munich 19, W. Germany. Phone 089–126904–0.
Subscription: DM 96. Illus.
ISSN: 0341–4159. OCLC: 8998073. LC: N3.K72. Dewey: 701.18.
Contains numerous ads for auctions as well as sales results.
Indexed: ArtArTeAb.
Advertising.

LIVING WITH ANTIQUES. 1981. q. EN.

Bomilhold Pty. Ltd., 250 Military Rd., Neutral Bay, N.S.W. 2089, Australia. Phone 02 953 8383. Alan Carter, Editor.
Subscription: $A16 (P.O. Box 108, Cremorne, N.S.W. 2090, Australia).
Antiques.
Advertising.

THE LYLE OFFICIAL ANTIQUES REVIEW. See no. 72.

THE MAGAZINE ANTIQUES. 1922. m. EN.

Brant Publications, 575 Broadway, New York, NY 10012. Phone 212–941–2800, fax 212–941–2897. Allison E. Ledes, Editor.
Subscription: $38 US, + $20 Canada, foreign + $30, air $150 (Old Mill Rd., Box 1975, Marion, OH 43305). Microform available from UMI. Sample & back issues $5 + postage. Illus. b&w, color, photos. Index 1982–84. Cum. index 1984–89 in preparation. 9¾ x 12 ⅛, 150p. Web Offset, Perfect Bound.
ISSN: 0161–9284. OCLC: 4063090. LC: NK1125.A3. Dewey: 745. Formerly: *Antiques*.
Antiques. Interior Design.

Emphasizes antique furniture, but also covers paintings, architecture, glass, and textiles. Each issue contains tours through America's most magnificent historic homes; examples of the finest in antique furniture, paintings, sculpture, silver, jewelry, ceramics, glass, textiles, carvings, maps, and metals; exhibition reviews with national and worldwide impact; new discoveries; museum accessions; and research in progress.
Reviews: exhibition 1, length 2500 wds.; book 2, length 750 wd. Biographies: monographs on artists, architects and craftsmen. Listings: international. Calendar of events. Exhibition information. Freelance work: occasionally. Contact: editor. Opportunities: study, competitions. Indexed: AmH&L. ArtHum. ArtI. CloTAI. HistAb. RG.
Advertising: (rate card Jan '89): b&w full page $3664, ½ page $2077, ¼ page $1124; 2–color full page $4106, ½ page $2540; 4 color full page $4729, ½ page $2885. Covers +20% frequency discount. Contract advertisers have the corresponding rate in *Art in America*. 15% agency discount. Inserts. Richard Millard, Ad. Representative (Power & Senecal, Inc., phone 212–316–0252). UK: John Jeffcott, Advertising Sales (The Long Cottage Box, Near Stroud GL0S 9HD England, phone 0453–833011). Mailing lists: available. Circulation: 62,544. Audience: scholars, collectors, dealers.

MAINE ANTIQUE DIGEST. 1973. m. EN.

Maine Antique Digest, Inc., Box 645, 71 Main St., Waldoboro, ME 04572. Phone 207–832–4888. Samuel C. Pennington, Editor & Pub.
Subscription: $29 US, $US41 Canada & foreign; air Canada $76, UK $142. Sample. Back issues limited to past few months. Microform available from UMI. Illus. b&w, photos. 11½ x 15½, 300+p.
ISSN: 0147–0639. OCLC: 3078878. Dewey: 745.1.
Antiques. Ceramics. Collectibles. Decorative Arts. Furniture. Painting. Photography. Sculpture.

Tabloid newspaper covers the marketplace for Americana — art, decorative art, folk art, textiles, and ceramics. Lots of prices, pictures and information on what's going on in the art/antiques markets. Hard news and features on legislation and controversies affecting the art/antiques business. Index to shows and auctions arranged by date.
Reviews: exhibition 2, length 1p.; book 1, length½p.; auctions/shows 20–25, length 2–3p. Interviews: important newsmakers in collecting/dealing. Listings: national, few Canada, UK. Calendar of events advertised—shows, auctions. Freelance work: yes, specialized. Contact: editor. Opportunities: study, competitions. Reviewed: Katz.
Advertising: (Dec '89): full page $499, ½ page $260, ¼ page $135. Classified: 50¢/wd., $12.50 min., no color. 10% frequency discount. Alice Greene, Ad. Manager. Mailing lists: available through broker (Steve Millard, Petersborough, NH). Demographics: readership 28.5% New England, 26.8% Mid–Atlantic, 16.8% South, 14.8% Midwest; 1.9% Canada & foreign. Circulation: 26,000. Audience: collectors/dealers in American art and antiques.

MERRY-GO-ROUNDUP. 1973. q. EN.

National Carousel Association, 10511 S.E. Crystal Lake Lane, Milwaukee, OR 97222–7525. Phone 503–653–2482.

Subscription: included in membership, $25 US, $31 Canada & foreign (William Mangels, Jr., P.O. Box 8115, Zanesville, OH 43702–8115). Sample $5. Back issues. Illus. b&w, color, photos. 8½ x 11, 36p.
OCLC: 7465325. LC: GV1860.M4. Dewey: 745.1. Formerly: *Carousel Archives; Carousel Census*.
Antiques. Historic Preservation. Sculpture. Carousels.

Articles on the history of carousels and carousel news.

Reviews: book 1, length 500 wds. Interviews: with people in the carousel world. Biographies: of notables in the carousel world. Listings: regional–national. Calendar of exhibitions. Freelance work: from members only. Contact: editor. Opportunities: study.

Advertising from members only. Linda Lima, Ad. Director (2914 W. Citrus Way, Phoenix, AZ 85017). Mailing lists: available for fee. Circulation: 1600. Audience: anyone interested in carousels.

MILLER'S ANTIQUE PRICE GUIDE. See no. 74.

NATIONAL ASSOCIATION OF DEALERS IN ANTIQUES. BULLETIN. m. EN. 1131
National Association of Dealers in Antiques, Box 421, Barrington, IL 60011. Phone 312–381–7096.
Subscription: included in membership.
Dewey: 745.1.
Educational and association news.
Obits.

SILVER. 1968. bi–m. EN. 1132
Silver Magazine Inc., Box 1243, Whittier, CA 90609. Phone 213–696–6738. Diana L. Cramer, Editor.
Subscription: $21. Illus., photos. 8½x11,48p.
ISSN: 0747–4482. OCLC: 13858326. LC: NK7100.S5. Dewey: 739.2. Formerly: *Silver Magazine*.
Antiques.

Covers the entire field of nineteenth century American silverwork. Each issue is extensively illustrated.
Reviews: book.
Advertising: full page $440. Audience: collectors.

TREASURE CHEST. 1988. m. EN. 1133
Venture Publishing Co., 253 W. 72nd St., Suite 211A, New York, NY 10023. Phone 212–496–2234. Howard E. Fischer, Editor.
Subscription: $15. Illus. photos, 4–/issue. Tabloid.
ISSN: 0897-814X. Dewey: 745.1.
Antiques.

"The information source & marketplace for collectors & dealers". Contains information on antiques and collectibles including recent sales.
Calendar of events for auctions, shows, and flea markets. Freelance work: yes. (details in *ArtMkt.*) and in *PhMkt.*).
Circulation: 50,000.

VAABENHISTORISKE AARBOEGER. 1934. a. DK. EN, FR, or GE summaries. 1134
Vaabenhistorisk Selskab, Danish Arms and Armour Society, "Brobyvang", Freerslev, DK–3400 Hillerod, Denmark. Arne Orloff, Editor.
Subscription: Kr 300. Illus. Cum. index.
ISSN: 0108–707X. OCLC: 7688146. LC: U800.V111. Dewey: 739.7.

DIE WELTKUNST: The World Art Review. 1927. s–m. GE only. 1135
Weltkunst Verlag GmbH, Nymphenburgerstrass, 8000 Munich 19, W. Germany. Phone 089–126990–0, fax 12690–11. H. Josef Koenig, Editor.
Subscription: DM 250.20. Illus. b&w, color. 8¾ x 11¾, 155p.
ISSN: 0043–261X. OCLC: 5510033. Dewey: 745.13.
Antiques.

Provides regular coverage of major exhibitions and collections in Europe and America as well as current news regarding art and antiques. Supplies information on art exhibitions, auctions, art fairs and other events.
Reviews: book. Listings: international. Calendar of events. Indexed: ArtArTeAb. ArtBibCur. ArtBibMod. RILA. Reviewed: Katz.

YESTERYEAR: Your Guide to Antiques & Collectibles. 1975. m. EN. 1136
Yesteryear Publications, Inc., Box 2, Princeton, WI 54968. Phone 414–787–4808. Michael Jacobi, Editor & Pub.
Subscription: $15. Sample & Back issues $2. Illus. newsprint tabloid 10 x 16, 48p.
ISSN: 0194–9349. OCLC: 12488690 [microfilm]. Dewey: 745.1. Formerly: *Yester–Year*.
Antiques. Crafts. Furniture.

A regional guide covering antiques, collectibles and nostalgia.

Reviews: book 2, length 4p. Listings: regional. Calendar of events, shows, flea markets, etc. Exhibition information. Freelance work: yes. Contact: editor. Reviewed: Katz.

Advertising: (rate card Jan '88): full page $360, ½ page $216, ¼ page $144; color full page + $24, ¼ page + $18, covers $240–384. Classified: (payment with ad) $1⁄20 wds., 10¢/wd. add. Frequency discount. 15% agency discount. Mailing lists: none. Demographics: Circulation is maintained through mail subscriptions, and through a network of antique shops, selected dealers, and newsstands throughout the region. Circulation: 8000. Audience: antique/collectible dealers, collectors.

Collectibles

AMERICAN HISTORICAL PRINT COLLECTORS SOCIETY - NEWSLETTER. 1976.
 3/yr. EN. 1137
American Historical Print Collectors Society, Inc., Box 1532, Fairfield, CT 06430.
Subscription: membership only, $30 together with *Imprint*.
Art History. Prints.

Announces museum exhibitions of historical American prints and lists auction prices of prints.
Calendar of events.
Advertising.

THE BOOKPLATE JOURNAL. 1983. s–a. EN. 1138
Bookplate Society, 20A Delorme St., London W6 8DT, England. Phone 071 3867306.
Illus.
ISSN: 0264–3693. OCLC: 9600101. LC: Z993.A1B66.
Specializes in the designing, collecting, and preserving of bookplates.
Demographics: members in 15 countries. Audience: libraries, private groups, bookplate collectors, & artists.

THE BOOKPLATE SOCIETY NEWSLETTER. 1979. q. EN. 1139
Bookplate Society, 20A Delorme St., London W6 8DT, England. Phone 071 3867306.
Illus.
ISSN: 0309–7935. OCLC: 10644849. LC: Z993.A1B662.
Collectibles.

Audience: collectors.

BOOKPLATES IN THE NEWS. 1970. q. EN. 1140
American Society of Bookplate Collectors and Designers, 605 N. Stoneman Ave., No. F, Alhambra, CA 91801. Phone 213–283–1936. Audrey Spencer Arellanes, Editor.
Subscription: $20 US & Canada, $40 together with *Year Book*, + $10 foreign air. Microform available from UMI. Sample $5. Illus. b&w. 8½ x 11, 18p.
ISSN: 0045–2521. OCLC: 2648802. LC: Z993.A1 B6. Dewey: 769.
Art History. Graphic Arts. Printing. Typography.

Devoted to the collection of bookplates. Each issue includes tip–ins of members' bookplates. Loose leaf.

Reviews: exhibition, book, journal. Bibliographies: periodical literature is annotated relating to bookplates. Obits. on artists who created bookplates, collectors and others related to field of bookplates. Listings: regional–international. Exhibition information. Freelance work: yes (details in *ArtMkt.*). Opportunities: competitions.

Advertising: none. Mailing lists: available to members only. Circulation: 250. Audience: any person interested in bookplates: artists, collectors, genealogy, graphic & fine arts, art historians.

THE BOTTLE SHIPWRIGHT. 1983. q. EN. 1141

Ships in Bottles Association of America, c/o President, 403 Amherst Ave., Coraopoles, PA 15108. Alex F. Bellinger, Editor (3 Dexter St., Newburyport, MA 01950).

Subscription: included in membership, $15 US, Canada & foreign air (P.O. Box 550, Coronado, CA 92118). Sample & back issues $4. Illus. b&w, photos, cartoons. 8¼ x 11, 20p.

Dewey: 623.820.

Antiques. Collectibles. Crafts. Decorative Arts (Marine Art). Hobbies.

Journal of the Association dedicated to the promotion of the traditional nautical art of building ships–in–bottles. Covers topics related both to the building of ship models and to other objects in bottles. Articles are submitted by the members, and shared with similar overseas organizations. Translation of French publication *Rose des Jents.*

Reviews: book 1–2, length 1–2p. Bibliographies: of literature related to ships in bottles, updated occasionally Biographies: of ship in bottle builders. Listings: national–international. Calendar of events & exhibitions listed occasionally. Freelance work: yes, no payment. Contact: editor.

Advertising: none. Circulation: 267. Audience: builders and collectors.

BULLETIN / PEWTER COLLECTORS' CLUB OF AMERICA. 1934. irreg. EN. 1142

Pewter Collectors' Club of America, c/o Webster Goodwin, 730 Commonwealth Ave., Warwick, RI 02886. Editorial Bd.

Subscription: included in membership. Illus.

ISSN: 0031–6644. OCLC: 9086135. LC: NK8400.P47. Dewey: 739.533.

Collectibles.

CAPS AND FLINTS. 1966. q. EN. 1143

Antique & Historical Arms Collectors Guild of Victoria, "Wimmera", 5 Latrobe St., Mentone, Victoria 3194, Australia. Phone 03–583–9551. Ray A. Hellier, Editor.

Subscription: included in membership. Sample free. No back issues. Illus. b&w. 8 x 6½, 28p.

ISSN: 0045–5695. Dewey: 683.4.

Antiques. Hobbies.

Freelance work: none.

Advertising: full page $15. No classified. Mailing lists: none. Circulation: 1800. Audience: collectors of antique and historical weapons and military items.

CHINESE SNUFF BOTTLE JOURNAL. 1974. q. EN. 1144

International Chinese Snuff Bottle Society, 2601 N. Charles St., Baltimore, MD 21218. Phone 301–467–9400. Berthe H. Ford & Elsa Grasu, Editors.

Subscription: included in membership, $50. Illus. Index. Cum. index.

ISSN: 0734–5534. OCLC: 6121215. LC: NK9507.J68. Dewey: 730. Formerly: *Newsletter (Chinese Snuff Bottle Society of America).*

Collectibles. Decorative Arts.

The Society promotes scholarship regarding the nature and sources of snuff bottles made only in China toward the beginning of the Ch'ing Dynasty, middle 17th century. Specializes in Chinese snuff bottles and related Ch'ing dynasty decorative arts. Reviews: book.

Demographics: members in 29 countries. Audience: collectors and dealers.

COLLECTOR EDITIONS. 1973. bi–m. EN. 1145

Collector Communications Corp., 170 Fifth Ave., New York, NY 10010. Phone 212–989–8700, fax 212–645–8976. Joan Pursley, Editor.

Subscription: $20 US, $25 Canada, foreign $30 (P.O. Box 1941, Marion, OH 43305). Microform available from UMI. Sample $2. Back issues $5. Illus. b&w, photos (60/issue). 8⅛ x 11, 64p. Web Offset, saddle stitched.

ISSN: 0733–2130. OCLC: 8537989. LC: AM201.C68. Dewey: 069.5. Formerly: *Collector Editions Quarterly; Acquire.*

Antiques. Ceramics. Collectibles. Decorative Arts. Glass. Painting.

Covers limited–edition porcelain (plates and figurines), prints and art glass, plus crystal, silver and other decorative objects. Specializes in contemporary (post–war) collectibles, including reproductions, but also gives limited coverage to antiques. Have regular features on antiques at auction, new products, and short profiles on artists designing for the collectibles market. Reviews: exhibition 3, book 4. Interviews: artists designing collectibles, celebrity collectors, 2–4/issue. Listings: national. Freelance work: yes (details in *PhMkt.*). Contact: Joan M. Pursley. Reviewed: Katz.

Advertising: (rate card Spring 1989): b&w full page $2395, ½ page $1570, ⅓ page $1095; 4 color full page $3250, ½ page $2190; covers $3495–3880; centerspread $7150; guaranteed position + 10%. Bleed no charge. Frequency discount. 15% agency discount. Inserts. Business reply cards. Diane Kane, Ad. Director. Mailing lists: available. Circulation: 80,000. Audience: those interested in collectibles.

COLLECTORS MART. 1976. bi–m. EN. 1146
Web Publications Inc., P.O. Box 12830, 650 Westdale Dr., Suite 100, Wichita, KS 67277. Phone 316–946–0600, fax 316–946–0675. William Bales, Editor (P.O. Box 1729, San Marcos, TX 78667).
Subscription: $21. Illus. 8⅜ x 10⅞, 80p.
ISSN: 0744–9879. OCLC: 8697407. Dewey: 705. Formerly: *Antique & Collectors Mart.*
Collectibles.

The magazine for limited–edition art and collectibles. Focuses particularly on plates, prints, dolls, and figurines. Every issue presents profiles of artists, publishers, and manufactures. Lavish decorating features, giving tips on how to live with and enjoy collectibles. Regular coverage includes industry events, new releases, and a price index.
Interviews: artist and company. Reviewed: Katz.
Advertising: full page $1782, ½ page $1012, ¼ page $546. Classified: 50¢/wd. Frequency discount. Sandy Bales, Ad. Director. Demographics: collectors, retail dealers, publishers, manufacturer for limited–edition collectibles. Audience: collectors of limited editions.

COLLECTORS NEWS & THE ANTIQUE REPORTER. 1959. m. EN. 1147
Collectors News, Inc., 506 Second St., Grundy Center, IA 50638. Phone 319–824–5456, fax 319–824–3414. Linda Kruger, Editor.
Subscription: $18 US, $US25 Canada & foreign surface; air 1st class $US75, 2nd class $45. Sample free. No back issues.
Illus. b&w, color, photos. 14½ x 10, 48–52p.
ISSN: 0162–1033. OCLC: 12960573. Dewey: 745.1.
Antiques. Collectibles. Ceramics. Decorative Arts. Furniture. Glass. Hobbies. Jewelry. Pottery. Textiles.

Focus on 20th century collectibles and memorabilia over a wide range of collecting interests. "Everything for some collectors & something for every collector." Provides editorial coverage for readers actively collecting or interested in nostalgia, Americana, fine antiques and limited edition collectibles. Contents are broad in scope, reflecting the multiple collecting interests of the readers and vary in depth to suit both novice and experienced hobbyists. Emphasis is placed on informative articles, current news and authoritative columns. Sale and auction results with prices realized are reported.
Listings: national. Extensive calendar of shows, auctions and flea markets both large and small. Jan and June issues have 12–month calendars for advance planning. Exhibition information. Freelance work: yes. Contact: editor. Opportunities: study, listed in Special events column. Reviewed: Katz. Katz. *School.*
Advertising: (rate card June 1990): full page $443.10, ½ page $253.05, ¼ page $146.52, color + $310, special position + 10%. Classified: 16¢/wd., min. $3 (payment with ad). Frequency discount. Cherie Henn, Ad. Director. Mailing lists: none. Demographics: nationwide, 60% female, age: 41–50 21%, 51–70 53%, over 71 26%;median household income $41,440, 91% home owners; occupation: 25% antiques dealer (full & part–time), 23% homemaker, 21% professional/managerial, 30% retired. Passalong 2.14 persons/issue. (Reader survey 9/89). Circulation: 14,700. Audience: collectors, antiquers.

COLLECTORS' MARKETPLACE. m. except Jul.–Aug. EN. 1148
Collectors' Marketplace, Box 14179, Baton Rouge, LA 70898.
Dewey: 790.

COLLECTRIX: The Magazine of Books on Antiques & Collectibles. 1982. 3/yr. EN. 1149
Collectrix, 389 New York Ave., Huntington, NY 11743. Phone 516–424–6479. Alida Roochvarg, Editor.
Subscription: $7.50 US, $8.50 Canada, foreign $10.50. Sample $3.50. Back issues $2.50. 50p.
ISSN: 0738–9981. OCLC: 9692833. Dewey: 745.1.
Antiques. Collectibles.

A complete reference guide to new books about antiques and collectibles. Annotated previews, by subject, of all new books, magazines, newsletters in every area of collecting. Feature articles, reviews, and a section on out–of–print books.
Advertising: free listing of forthcoming titles. Display ads (camera ready only): full page $150, ½ page $100, ¼ page $50, business card $12.50, covers $200–$225. Classified: 15¢/wd. Demographics: U.S., Canada and several foreign countries. Circulation: 900. Audience: collectors, libraries, bookstores, and antiques dealers.

COMMEMORATIVE COLLECTORS SOCIETY MEMBERS JOURNAL. q. EN. 1150
Commemorative Collectors Society, 25 Farndale Close, Long Eaton, Notts NG10 3PA, England. Phone 602 727666.

Collectibles.

Provides information on the historical and social background behind the issuance of commemorative pieces. Demographics: members in 32 countries. Circulation: 4600. Audience: private collectors, antique dealers, manufacturers of modern commemorative items.

COMMEMORATIVE COLLECTORS SOCIETY MEMBERS NEWSLETTER. q. EN. 1151
Commemorative Collectors Society, 25 Farndale Close, Long Eaton, Notts NG10 3PA, England. Phone 602 727666.
Collectibles.

Circulation: 4630. Audience: collectors, antique dealers, manufacturers.

CONNOISSEUR. 1901. m. EN. 1152
Hearst Magazine Division, 224 W. 57th St., New York, NY 10019. Phone 212–262–6518. Thomas Hoving, Editor–in–chief.
Subscription: $19.95 (US: P.O. Box 7154, Red Oak, IA 51591; Great Britain & Europe: National Magazine Co. Ltd., National Magazine House, 72 Broadwick St., London W1V 2BP). Microform available. Illus. color, glossy photos, cartoons. 9 x 10¾, 136p.
ISSN: 0010–6275. OCLC: 1564870. LC: N1.C75. Dewey: 705.
Antiques. Architecture. Art. Collectibles. Interior Design. Travel.

Covers all excellence—past, present and future, an elegant magazine about things of lasting quality. Reports highlights of results of outstanding auctions.
Indexed: ArchPI. ArtArTeAb. ArtBibMod. ArtI. Avery. BioI. BkReI. CloTAI. Des&ApAI. RILA. Reviewed: Katz.
Advertising. Mailing lists: available to companies that sell goods and services by mail. Demographics: US & Great Britain.

CORPORATE ARTnews. 1984. m. EN. 1153
ARTnews Associates, 48 W. 38th St., New York, NY 10018. Phone 212–398–1690. Shirley Reiff Howarth (International Art Alliance, P.O. Box 1608, Largo, FL 34294).
Subscription: $110 US, $120 Canada & foreign, + $10 air. Sample free. Back issues $9.16. Illus b&w. 8½ x 11, 8p.
ISSN: 8755–2582. OCLC: 11145497. Dewey: 708.
Antiques. Architecture. Art Education. (employee art–educational services). Ceramics. Collectibles. Crafts. Decorative Arts. Drawing. Graphic Arts. Interior Design. Modern Art. Painting. Sculpture. Textiles.

Newsletter presenting a monthly summary on the corporate art market for paintings, drawings, sculpture, photography, architecture, graphics, crafts, antiques, etc. Monitors the market from boardroom to auction room. An authoritative record of corporate art purchases and de–accessions, corporate art budgets, personnel, donations, acquisitions, commissions, exhibitions. Central source of information on evolving corporate art patronage in the U.S. and abroad. Lists recent commissions by corporations in each issue. Sister–publication of *ARTnews* magazine.
Reviews: reports on upcoming exhibitions. Interviews: corporate art curators and advisors, museum directors. Listings: regional–international. Listing of recent corporate acquisitions in each issue. Corporate exhibitions. Freelance work: none. Opportunities: commissions. Reviewed: *Art Documentation* Sum 1986, p.64.
Advertising: none. Mailing lists: none. Circulation: several thousand. Audience: art dealers, corporate art curators, art consultants and collectors, museum officials, framers/suppliers, architects, interior designers.

DOLL ARTISTRY. 1990. bi–m. EN. 1154
Hobby House Press, Inc., 900 Frederick St., Cumberland, MD 21502.
Subscription: $17.95 US, + $5 Canada, + $11 foreign. Illus.
ISSN: 1052–0805. OCLC: 22177012. LC: GV.
Collectibles. Hobbies.

Issues first appeared as a separately designated section (called "supplement") of *Doll Reader*. With Oct/Nov 1990 issue now separately published.

DOLL CASTLE NEWS. 1961. bi–m. EN. 1155
Castle Press Publications, Inc., P.O. Box 247, Washington, NJ 07882. Phone 201–689–7512. Edwina Mueller, Editor.
Subscription: $13.95. Illus.
ISSN: 0363–7972. OCLC: 2541796. LC: TT175.D58. Dewey: 745.59.
Collectibles. Hobbies.

The doll collector's magazine.
Advertising.

DOLL READER. 1972. 8/yr. EN. 1156

Hobby House Press, Inc., 900 Frederick St., Cumberland, MD 21502. Phone 301–759–3770, fax 301–759–4940.
Illus b&w, color, photos. 296p. Web Offset.
ISSN: 0744–0901. OCLC: 2252973.

Antiques. Collectibles. Crafts. Hobbies.

Clearinghouse for information on dolls.

Reviews: exhibition, book, video. Listings: regional–international. Calendar of events. Exhibition information. Freelance
work: occasionally. Contact: Carolyn Cook. Reviewed: Katz.

Advertising: (rate card July 1989) national display: b&w full page $1350, ½ page $735, ⅓ page $525; 4 color full page
$2260, ½ page $1345; guaranteed position full page only + 10%. No covers. Retail display (available to individual retail
stores, doll dealers, show promoters, museums, doll artists and retail mail order advertisers): b&w only, full page $1150, ½
page $635, ⅓ $440. Classified: 65¢/wd., $6.50 min. Frequency discount. 15% agency discount. Reply cards. Inserts. Kathy
Trenter, Ad. Manager. Circulation: 110,000. Audience: adult collectors.

DOLL TALK. 1937. bi–m. EN. 1157

Kimport Dolls, Box 495, Independence, MO 64051. Ruby S. McKim, Editor.
Illus.
ISSN: 0012–5229. OCLC: 1566869.

Collectibles. Hobbies.

A magazine in miniature for doll enthusiasts and collectors.

DOLLS: The Collector's Magazine. 1982. 8/yr. EN. 1158

Collector Communications, 170 Fifth Ave., Suite 1200, New York, NY 10010. Phone 212–989–8700. Krystyna Poray Goddu,
Editor.
Subscription: #24.95 US. Back issues. Sample $2. Illus b&w, color, photos (75–80/issue). 8½ x 11, 100p. Web Offset. Saddle
Stitch.
ISSN: 0733–2238. OCLC: 8534883. LC: NK4893.D63. Dewey: 688.7.

Antiques. Collectibles. Decorative Arts.

A special–interest consumer magazine for collectors of dolls — antique, modern and contemporary. Publish articles on dolls
of all types, including profiles of artists, visits to museum collections and stories on antique makers. Publish very specific,
highly focused articles for knowledgeable collectors.

Reviews: exhibition, book. Interviews: doll artists. Calendar of events. Exhibition information. Freelance work: yes, (details
in *PhMkt.*). Contact: editor. Opportunities: study, competitions.

Advertising: (rate card Sept/Oct 1989): b&w full page $1575, ½ page $875, ¼ page $325; 4 color full page $2450, ½ page
$1450; covers $2695–$2795. Guaranteed position + 10%. Frequency discount. 15% agency discount. Bleeds no charge. In-
serts. Reply cards. India Thybulle, Ad. Director. Mailing lists: available for rent. Circulation: 82,500. Demographics: nation-
wide. Audience: doll collectors.

DOLLS, DOLLS, DOLLS. 1984. bi–m. EN. 1159

Phyllis Willard, Unit 140, Apt. 720, 6th St., New Westminster, B.C. V3L 3C5, Canada.
Illus.
ISSN: 0829–8017. OCLC: 13453678. LC: NK4893. Dewey: 745.592.

Collectibles. Hobbies.

EXPO INFO. 1971. q. EN. 1160

Expo–Collectors & Historians Association (ECHO), 1436 Killarney Ave., Los Angeles, CA 90065. Phone 213–223–1939. Ed-
ward J. Orth, Editor.
Subscription: included in membership, $10, Canada $US10, foreign air $14. Subscription includes one free 25 word ad. No
sample. Back issues. Illus b&w. Index. 8½ x 11, 24–28p.
ISSN: 0888–4722. OCLC: 13615682. Dewey: 394.

Antiques. Collectibles. Decorative Arts. Modern Art.

The World's fair collectors club for people who love World's fairs memorabilia and/or history. Contains news of visitors
(members), letters, and information about the fairs, memorabilia and collecting. Features include "World's Fair Information
Booth", "UFOs" (unusual fair objects) which describes and prices exceptional materials, "Expo Echoes" reminiscences, and
the "Administration Building Bulletin Board" which offers announcements and general club information. Rare and unusual
items are reprinted. Special pages are devoted to Expo postcards and checklists.

Listings: national–international. Freelance work: none.
Advertising from members only, camera ready copy. Classified: "Searchlights" (want ads), "Souvenir Stands" (for sale). Mailing lists: none. Circulation: 600. Audience: World's Fair & International Exposition collector, dealers and historians.

FRANKLIN MINT ALMANAC. 1969. m. EN. 1161
Franklin Mint Collectors Society, Franklin Center, PA 19091. Phone 215–459–7016. Anna Sequoia, Editor.
Subscription: free. Illus. Index. Cum. index v.1–8, 1976–77.
ISSN: 0092–5039. OCLC: 1570089. LC: CJ5813.F732a. Dewey: 737.
Collectibles.

Reviews: books.
Advertising.

GEISHA GIRL PORCELAIN NEWSLETTER. See no. 1334.

GOEBEL COLLECTORS' CLUB - INSIGHTS. See no. 1335.

INSIGHT ON COLLECTIBLES. 1982. m. EN. 1162
Insight Publications, 201–103 Lakeshore Rd., St. Catherines, Ontario L2V 2T6 Canada. Phone 519–369–5155. Lise Mollon & Leslie Grove, Editors.
Subscription: $30 US, $C24 Canada. Illus.
ISSN: 0836–5873. OCLC: 17463169. LC: NK1125. Dewey: 707. Formerly: *Insight* (Durham, Ontario).
Collectibles.

Tabloid features limited edition art and Royal Daulton. Artist features, new products, trade and show news are included.

INTERNATIONAL DOLL WORLD. 1977. bi–m. EN. 1163
House of White Birches Publishing, 306 E. Parr Rd., Berne, IN 46711. Phone 219–589–8741, fax 219–589–2810. Rebekah Montgomery, Editor.
Subscription: $12.97 US, $17.77 Canada (International Doll World, P.O. Box 11302, Des Moines, IA 50340–1302). Sample $2.50. Illus. b&w, color, photos, cartoons.
ISSN: 0147–4685. LC: TS2301.T7N38. Dewey: 688.7. Formerly: *National Doll World*.
Collectibles. Crafts.

The magazine for doll lovers. Presents feature articles covering doll history, doll patterns included, regular columns, doll shows and other doll interests.
Interviews with contemporary doll artists. Freelance work: yes (details available in *ArtMkt*.). Contact: editor.
Advertising: b&w full page $900, ½ page $630, ¼ page $315, covers $1170–1260, 2 color + $150, 4 color + $350. Classified: (payment with order) $15/20 wds., 75¢/wd. add. Frequency discount. 5% discount for concurrent ads in 2 or more Women's Circle publications. 15% agency discount. 15% discount to mail–order businesses. Janet Price–Glick, Ad. Director.
Demographics: 97% women, 94% over 30, 54% income $25,000+. Circulation: 85,000. Audience: doll enthusiasts of all kinds.

ISRAEL MAP COLLECTOR SOCIETY. JOURNAL. 1986. q. EN. 1164
Israel Map Collectors Society, 4 Brenner St., Jerusalem 92 103, Israel. Phone 02–639711. Eva Wajntraub, Editor.
Dewey: 790.13.
Collectibles.

Advertising.

JOURNAL OF THE HISTORY OF COLLECTIONS. 1989. s–a. EN. 1165
Oxford University Press, Oxford Journals, Pinkhill House, Southfield Road, Eynsham, Oxford OX8 1JJ, England. Phone 0865–56767, fax 0865–882890, telex 837330 OXPRES G. Oliver Impey & Arthur MacGregor, Editors.
Subscription: £37 UK, £40 EEC, $US72 North America, elsewhere £42. Illus. 150p.
ISSN: 0954–6650. OCLC: 19984120. LC: AM135.J686. Dewey: 069.9.
Collectibles.

Journal is dedicated to the study of collections, ranging from the contents of palaces and accumulations in more modest households, to the most systematic collection of academic institutions. The journal is interested in the contents of these collections, the processes which initiated and controlled their formation and the circumstances of the collectors themselves. Will publish papers from international symposia.

Reviews: book. Listings: international. Calendar of events. Indexed: BHA. BrArchAb.
Advertising. Circulation: 800.

THE KENT COLLECTOR. 1974. q. EN. 1166
State University of New York at Plattsburgh, Rockwell Kent Gallery, Plattsburgh, NY 12901. Phone 518–564–2813. Evelyn Heins, Editor.
Subscription: $15 US, $18 Canada, foreign air $20. Sample. Back issues $5. Illus. b&w, photos. 8½ x 11, 45p.
ISSN: 0163–1861. OCLC: 4303638. LC: N6537.K44K44. Dewey: 741.092.
Collectibles. Decorative Arts. Graphic Arts. Painting.

Contains articles regarding Rockwell Kent as an artist, a writer, and as a man. Kentiana items for sale and current auction and dealer prices for his art are included. It is illustrated with Kent's own graphics and paintings. Articles come from subscribers or reprinted articles from other sources. New acquisitions and exhibitions of Kent's work are reported.
Freelance work: yes. Contact: editor.
Advertising.

LOST AND FOUND, BOUGHT AND SOLD. 1967. bi–m. EN. 1167
Enterprises Unlimited, P.O. Box 1244, Dept. NDW, Carson City, NV 89702.
Collectibles.

Current information with prices for what is being bought and sold in the collectibles market.

THE MEDAL COLLECTOR. 1951. 10/yr. EN. 1168
Orders and Medals Society of America, c/o John E. Lelle, Box 484, Glassboro, NJ 08028. Phone 609–863–0148. Albert M. Shaw, Editor (12344 Fairway Pinte Row, San Diego, CA 92128).
Subscription: included in membership, ($5 initiation fee all +) $15 US, $25 Canada & foreign, $40 air. Sample free. Back issues $1.50. Illus. b&w, photos. Annual index in Dec issue, cum. Index 1949–84. 5½ x 8½, 56p.
ISSN: 0025–6633. OCLC: 10818028. Dewey: 737. Formerly: *Medal Collector Bulletin*.
Antiques (orders, decorations & medals). Collectibles. Hobbies.

Devoted to the study and/or collecting of the insignia of the orders of knighthood and merit, the decorations of valor and honor, the medals of distinction and service, and allied material and historical data. Presents the whole spectrum of orders and medals, as well as notices of interest to the collector on events, new books, buy–and–sell advertising, etc.
Reviews: book 2–3, length 500 wds. Listings: regional–national. Calendar of: August convention, exhibitions, seminars, Board of Directors meeting. Freelance work: none. Opportunities: competitions, awards, grants.
Advertising: full page $75, ½ page $45, ¼ page $25. Classified: $3/6 line unit. Frequency discount. Mailing lists: none. Demographics: 1500 members worldwide. Circulation: 1500. Audience: membership.

MFCA NEWSLETTER. 1939. 10/yr. EN. 1169
Miniature Figure Collectors of America, 1988 Foster Dr., Hatfield, PA 19440. Phone 215–855–2232. Arthur Etchells, Editor.
Illus. b&w. 8½x11, 4–6p.
Collectibles. Hobbies.

Newsletter presents news of the Society and its members. Features information regarding military history and miniature figures of uniformed military personnel.
Reviews: book.
Advertising. Audience: military history collectors.

MINIATURE COLLECTOR. 1977. q. EN. 1170
Collector Communications Corp., 170 Fifth Ave., New York, NY 10010. Phone 212–989–8700, Fax 212–645–8976. A. Christian Revi, Editor.
Subscription: $14 US, $19 Canada & foreign (No. 12 Queen Ann Place, Marion, OH 43305). Sample & back issues $5. Illus. b&w, color, photos. 8 x 11, 48p. Web Offset. Saddle Stitched.
ISSN: 0199–9184. OCLC: 6289058. Dewey: 790.132.
Antiques. Collectibles. Hobbies.

Deals with 1–inch–to–the–foot scale (dollhouse size) antique and contemporary artists' miniatures. There are articles about collections, artists, museums and how–to projects.
Reviews: exhibition 5, book 5. Interviews: with artists of museum–quality work with focus on artistic background and current work in miniature. Calendar of events. Exhibition information. Freelance work: yes. Contact: editor. Opportunities: study, competitions. Reviewed: Katz.

Advertising: (rate card Spring '89): Display: full page $895, ½ page $595, ⅙ page $230; 4 color full page $1360, ½ page $820; covers, yearly contract $1295–1445. Guaranteed position + 10%. Retail (available only to individual retail stores, mail order advertisers, museums and show promoters): b&w full page $685, ½ page $445, ⅙ page $175; 4 color full page $1025, ½ page $615. Classified: 60¢/wd. Frequency discount. 15% agency discount. Bleed no charge. Inserts. (P.O. Box 1239, Hanover, PA 17331). Mailing lists: available. Circulation: 25,000. Audience: adult collectors and hobbyists.

THE MINIATURES CATALOG. 1979. a. EN. 1171

Kalmbach Publishing Co., P.O. Box 1612, 21027 Crossroads Circle, Milwaukee, WI 53187. Phone 414–796–8776. Geraldine Willems, Editor.
Subscription: $16.95 US. No sample. No back issues. Illus. b&w, photos. 380p.
OCLC: 5703526. LC: NK8473.U6M56. Dewey: 745.592.
Collectibles. Crafts. Hobbies—Miniatures. Interior Design.

A buyer's guide for the dollhouse miniatures hobby. Hundreds of miniatures are listed complete with photos and descriptions. Freelance work: none.
Advertising: rates upon request. Sara Benz, Ad. Director. Mailing lists: available. Circulation: 12,000. Audience: hobbyists and collectors.

MINIATURES DEALER. 1978. m. EN. 1172

Boynton & Associates, Inc., Clifton House, Clifton, VA 22024. Phone 703–830–1000. Geraldine Willems, Editor.
Illus.
ISSN: 0882–9187. OCLC: 11896928. LC: NK4894.U6M5. Dewey: 688. Formerly: *Miniatures and Doll Dealer; Miniatures Dealer*.
Collectibles.

The business news magazine serving the miniatures trade.
Advertising.

MINIATURES SHOWCASE. 1986. q. EN. 1173

Kalmbach Publishing Co., 1027 N. Seventh St., P.O. Box 1612, Milwaukee, WI 53233–1417. Phone 414–272–2060. Geraldine Willems, Editor.
Subscription: $12.95.
ISSN: 0896–7288. OCLC: 17283402. Dewey: 790.13.
Collectibles. Hobbies.

Each issue showcases a particular decorating theme. Presents original room displays.
Reviewed: Katz.
Audience: miniatures hobbyists and collectors.

THE NATIONAL BUTTON BULLETIN: Devoted to the Promotion of the Hobby of Button Collecting. 1938. 5/yr. EN. 1174

National Button Society, c/o Lois Pool, Sec., 2733 Juno Pl., Akron, OH 44313–3296. Phone 216–864–3296. M.W. Speights, Editor.
Subscription: included in membership, $15, juniors $2 worldwide. Sample $1. Back issues $2.50. Illus. b&w. 50p.
ISSN: 0027–884X. OCLC: 2846774, 7263855.
Collectibles. Hobbies.

The Bulletin includes a roster of the members and clubs, list of the national awards, glossary and classification of buttons, photos of buttons with identification and considerable information for the collector.
Listings: regional–international. Calendar of button events. Exhibition information for the National Show.
Advertising from members only. Mailing lists: membership listed in Bulletin. Circulation: 2350.

NATIONAL VALENTINE COLLECTORS BULLETIN. 1977. q. EN. 1175

National Valentine Collectors Association, P.O. Box 1404, Santa Ana, CA 92702. Phone 714–547–1355. Evalene Pulati, Editor.
Illus. b&w. 8½x11, 8–12p.
Collectibles.

Devoted to the history and collection of valentines. Includes news of research.
Reviews: book. Calendar of conferences and exhibits.
Advertising.

THE OFFICIAL PRICE GUIDE TO PAPER COLLECTIBLES. 1980. a. EN. 1176
Random House, Special Sales, 400 Hahn Rd., Westminister, MD 21157.
Illus.
ISSN: 0747–5373. OCLC: 7901570. LC: AM303.5.O37. Dewey: 790.1.
Collectibles.

OLD TOY SOLDIER NEWSLETTER. 1976. bi–m. EN. 1177
OTSN, Inc., 209 North Lombard, Oak Park, IL 60302. Phone 708–383–6525. Steve Sommers, Editor.
Subscription: $18 bulk, $28 first class US, $28 Canada, $33 foreign air. Sample $3. Back issues. Illus. b&w, photos, cartoons.
Cum. index, 3 yr. and 10 yr. indexes. 8½ x 11, 48p.
ISSN: 8756–7652. OCLC: 9312129. Dewey: 745.
Antiques. Collectibles.

A magazine written for collectors by collectors. Sharing useful information on military and civilian toy figures and the companies which produced them continues to be the primary goal. Total coverage from lead to composition to plastic. Britains and Dimestores in every issue. Information on new toy soldier releases.
Reviews: book 4/yr, length 1p. Listings: international. Calendar of events. Exhibition information. Freelance work: none. Reviewed: Katz.
Advertising: full page $135, ½ page $75, ¼ page $45, no color. One photo reproduction free of charge/display ad. Classified: $5/20 wds, 15¢ add. wd., $5 min. Frequency discount. Inserts. Catheve Strokosch, Ad. Director. Mailing lists: none. Demographics: worldwide readership. Circulation: 1800. Audience: toy soldier collectors.

PHILOBIBLON. 1957. q. GE. 1178
Dr. Ernst Hauswedell und Co. Verlag, Rosenbergstrasse 113, Postfach 10 22 51, D–7000 Stuttgart 10, W. Germany. Reimar W. Fuchs, Editor.
Subscription: DM 96. Illus., some color.
ISSN: 0031–7969. OCLC: 1762265. LC: Z990.P5. Dewey: 010.5. Formerly: *Philobiblon: Die Zeitschrift der Buecherliebhaber*.
Reviews: book.

PICTORIAL JOURNAL. 1977. a. EN. 1179
International Club for Collectors of Hatpins & Hatpin Holders, 15237 Chanera Ave., Gardena, CA 90249. Phone 213–329–2619. Mrs. Lillian Baker, Editor & Pub.
Subscription: by membership only, $35 registration, thereafter $25, worldwide. Illus. b&w, color, photos, cartoons. 8½ x 11, 32p.
OCLC: 11001822. Formerly: *Biennial*.
Antiques. Collectibles. Jewelry.

"News and reviews of hatpins and hatpin holders" transmitted for the education, information, and entertainment of members.
Advertising. Circulation: 400+. Audience: collectors and all interested in historical memorabilia.

POINTS NEWSLETTER. 1977. m. EN. 1180
International Club for Collectors of Hatpins & Hatpin Holders, 15237 Chanera Ave., Gardena, CA 90249. Phone 213–329–2619. Mrs. Lillian Baker, Editor.
Subscription: by membership only, $35 registration, thereafter $25 all. Sample $3.50. Back issues. Illus. b&w, color, photos, cartoons. 8½ x 11, 6p.
Antiques. Collectibles. Jewelry.

Covers all aspects of collecting hatpins, hatpin holders and related accessories. Includes news of research in the field and members news.
Reviews: exhibition 2, book 2, journal 2. Bibliographies: of new publications on subject. Interviews: collectors. Biographies: members/collectors. Listings: regional–national. Calendar of yearly seminars/conventions. Exhibition information. Freelance work: seldom. Opportunities: study, competitions.
Advertising from members only. Circulation: 400+. Audience: collectors and all interested in historical memorabilia.

THE PRINT COLLECTOR'S NEWSLETTER. 1970. bi–m. EN. 1181
Print Collector's Newsletter Inc., 119 E 79th St., New York, NY 10021. Phone 212–988–5959. Jacqueline Brody, Editor.
Subscription: $54 all, air $66. Sample. Back issues $7. Illus. b&w. Index. 8½ x 11, 42p.
ISSN: 0032–8537. OCLC: 1696653. LC: NE1.P69. Dewey: 769.

Art History. Graphic Arts. Modern Art.

Articles and news of print world features drawings, illustrated books, and photographs of all periods. Includes *PCN Directory* of galleries and *International Auction Review: Auction House Supplement* (8 pages) Reports prices traded at auction requiring adjustment for commissions and taxes. Gives artist, title, description, price.

Reviews: book, auction. Listings: international. Calendar of events. Exhibition information. Indexed: ArtBibCur. ArtBibMod. ArtI. CloTAI. RILA. Reviewed: Katz.

Advertising: Classified. Mailing lists: none.

THE STAINED FINGER. 1983. q. EN. 1182

Society of Inkwell Collectors, 5136 Thomas Ave. S., Minneapolis, MN 55410. Phone 612–922–2792. Vincent McGraw, Editor & President.

Illus.

OCLC: 9045858. Dewey: 745.6.

Collectibles.

Newsletter for collectors of inkwells, pens, and accessories encourages research and facilitates the exchange of information concerning the history, identification and market price of inkwells. Includes a section on items wanted.

THE TEDDY BEAR AND FRIENDS: Clearinghouse for Information on Teddy Bears.

1983. bi–m. EN. 1183

Hobby House Press, Inc., 900 Frederick St., Dept. TO–43, Cumberland, MD 21502–9985. Phone 301–759–3770, fax 301–759–4940. Carolyn B. Cook, Editor.

Subscription: $17.95 US, $22.95 Canada, $28.95 foreign. Illus. b&w, color, photos. 8 x 11, 120p.

ISSN: 0745–7189. OCLC: 9401541. LC: NK8740.T43.

Collectibles.

Several articles with over 200 photos. Extensive advertisements.

Listings: national. Calendar of teddy bear shows, "Bear Affairs". Reviewed: Katz.

Advertising b&w & color. Classified: 65¢/wd, $6.50 min., payment with ad. Kathy Trenter, Ad. Director.

TEDDY BEAR REVIEW. 1986. q. EN. 1184

Collector Communications Corp., 170 Fifth Ave., New York, NY 10010. Phone 212–989–8700. Ted Menten, Editor.

Subscription: $14.

ISSN: 0890–4162. OCLC: 14222242.

Collectibles. Hobbies.

THE TEDDY TRIBUNE. 1980. m. EN. 1185

254 W. Sidney, St. Paul, MN 55107. Phone 612–291–7571. Barbara Wolters, Editor.

Subscription: $17. Illus.

OCLC: 11066044.

Collectibles. Hobbies.

"News and views of the bear world".

TOY SOLDIER REVIEW. 1984. q. EN. 1186

Vintage Castings, Inc., 127 74th St., North Bergen, NJ 07047. William Lango, Editor.

Illus.

ISSN: 0747–8615. OCLC: 10828824. LC: U311.T69. Dewey: 745.592.

Collectibles.

Reviewed: Katz.

YEAR BOOK. 1923. a. EN. 1187

American Society of Bookplate Collectors and Designers, 605 N. Stoneman Ave., No. F, Alhambra, CA 91801. Phone 213–283–1936. Audrey Spencer Arellanes, Editor.

Subscription: $30 US & Canada, $40 together with *Bookplates in the News*. No sample. Back issues. Illus. b&w, color, photos. 7½ x 10, 50–98p.

ISSN: 0275–1569.

Art History. Collectibles. Graphic Arts. Printing. Typography.

Loose leaf. Each issue usually contains some original bookplate prints tipped–in.

Biographies: sketch of person commissioning a bookplate or an institution having one designed or the artist, either contemporary or historical sketch of ex libris artist of the past. International (Japan, Europe, Israel, South America). Interviews: articles on bookplate artists and collectors. Freelance work: only bookplate art. Contact: editor.

Advertising: none. Mailing lists: available to members only. Demographics: international. Circulation: 250. Audience: any person interested in bookplates: artists, collectors, genealogy, graphic & fine arts, art historians.

Crafts

ACCI NEWSLETTER. 1976? 3/yr. EN. 1188

Association of Crafts & Creative Industries, 1100–H Brandywine Blvd., Box 2188, Zanesville, OH 43702–2188. Phone 614–452–4541, fax 614–452–2552.

Subscription: included in membership. Illus. b&w. 8½ x 11, 8p.

Crafts. Hobbies.

Newsletter for retailers and owners of craft shops promoting ways to improve retailing and exhibiting crafts. Contains research and news of members.

Calendar of events. Freelance work: yes.

Circulation: 16,000. Audience: members—manufacturers, wholesalers, importers, retailers, and others involved in craft supply industry.

ACTA NEWS. q. EN. 1189

Art Craft Teachers Association of Victoria, Box 121, Parkville, Victoria 3052, Australia.

Subscription: included in membership.

Art Education. Crafts.

Reviews: book.

Advertising.

AMERICAN CRAFT. 1941. bi–m. EN. 1190

American Craft Council, 72 Spring St., New York, NY 10012. Phone 212–274–0630. Lois Moran, Editor.

Subscription: included in membership, $40 US, Canada & foreign +$10. Microform available from UMI & B&H. Sample. Back issues $5. Illus. b&w, color, photos. 8¼ x 10 ¾, 96p. Offset, web–fed, perfect bound.

ISSN: 0194–8008. OCLC: 5024322. LC: NK1.C73. Dewey: 745.5. Formerly: *Craft Horizons (1941–1979)*.

Crafts. Decorative Arts.

Coverage of contemporary crafts includes outstanding work being done in clay, fiber, metal, glass, wood and other media. Numerous color photographs celebrate the importance and sophistication of hand craftsmanship in the 1980s. Regular features include: profiles of master craftsmen, reviews of major exhibitions, commentaries on issues in the arts, a "Portfolio" section on new artists, a "Gallery" of illustrated works from exhibitions across the country, and news of the field in "Craft World".

Reviews: exhibition 2–3, length 800–2000 wds.; book 2, length 500–1500 wds. Biographies: profiles of craftsmen. Listings: national. Calendar of events, extensive listing by state. Exhibition information. Freelance work: yes (details in *PhMkt.*). Contact: editor. Opportunities: "where to show", study, competitions. Indexed: ArtBibMod. ArtI. BioI. BkReI. CerAb. CloTAI. Des&ApAI. IBkReHum. RG. Reviewed: Katz.

Advertising: (rate card Jun–Jul. 1988): b&w full page $1760, ½ page $1045, ¼ page $605; black & 1 color full page $2175, ½ page $1365, ¼ page $790; 4 color full page $2490, ½ page $1620; ¼ page $1050; covers, 4 color only, $2805–$3135. Classified: (payment with order) $1.85/wd., min. 15 wds. Bleeds, full page only, no extra charge. Camera–ready art preferred. Frequency discount. 15% agency discount. Anita Chmiel, Ad. Director (phone 212–869–9435). Mailing lists: available 1 time rental basis, subject to approval. Demographics: read by professional craftsmen, teachers, students, collectors, gallery owners, designers, architects and other professionals in business, the arts and government in the U.S. and 150 foreign countries. Circulation is extensive to colleges and libraries. Distributed nationally to newsstands and book stores. Circulation: 45,000. Audience: craftsmen, interested public.

AMERICANA. See no. 285.

THE ANVIL'S RING. 1973. q. EN. 1191

Artists–Blacksmith Association of North America, Box 1181, Nashville, IN 47448–1181. Phone 812–988–6919. Robert Owings, Editor (230 Keokuk St., Petaluma, CA 94952.

Subscription: included in membership, $35, $25 senior citizen & public library, $40 family, US & Canada; foreign $45. Sample $5. Back issues $8 members, $10 non–members. Illus. b&w, photos. Index available from Association. 8½ x 11, 48p. ISSN: 0889–177x. OCLC: 8005079. LC: TT218. Dewey: 682.

General. Art Education. Decorative Arts. Furniture. Sculpture.

Dedicated to the promotion of the art of blacksmithing, the magazine functions as a technical journal for the field, a showcase for all facets of work being produced and a means to communicate what is occurring within the Association or related blacksmithing activities. Included is a technical question and answer column, a teaching column for beginners, and articles on work techniques.

Listings: regional–international. Calendar of events. Exhibition information. Freelance work: all articles submitted by members. Opportunities: employment. study, competitions. Reviewed: Katz.

Advertising: full page $300, ½ page $160, ¼ page $85, no color. Classified: $15, approx. 2¼ x 1¼. 10% frequency discount. Circulation: 2800. Audience: artist–blacksmiths.

ART AND CRAFTS CATALYST. 1969. bi–m. EN. 1192

Box 433, South Whitley, IN 46787–0433. Phone 219–344–1174. Ann Porter, Editor & Pub.

Subscription: $16 US, $24 Canada. Sample $4. No back issues. Illus. b&w, photos. 8½ x 11, 28–32p. ISSN: 0731–2989. Formerly: *National Calendar of Indoor/Outdoor Art Fairs.*

General. Antiques. Collectibles. Crafts. Hobbies.

Provides entry information for shows and festivals nationwide, including mall shows. Listed chronologically. Provides date of event, city, state, entry deadline, contact person, entry fee, judging, awards, etc. "Everything you need to know to participate in the shows of your choice".

Reviews: exhibition 1–2, length 1p. Listings: national. Calendar of events. Exhibition information. Freelance work: none. Opportunities: competitions.

Advertising: (rate card Jan '89): camera ready copy required, full page $100, ½ page $50, ¼ page $30. Classified: 20¢/wd, min. $5, 15¢/wd. add. Mailing lists: rent approx. 1100 subscribers names $55, printed on self adhesive labels. Circulation: 500. Audience: professional artists and craftspeople; art & craft exhibitors.

ART & CRAFT DESIGN TECHNOLOGY. 1979. m. EN. 1193

Scholastic Publications Ltd., Malborough House, Holly Walk, Leamington Spa, Warks CV32 4LS, England. Phone 0926–813910. Eileen Lowcock, Editor.

Microform available from UMI. Illus.

OCLC: 5079500. LC: N1.A12 A782. Dewey: 745.5. Formerly: *Art & Craft; Art & Craft in Education.*

Art Education. Crafts.

A magazine for all teachers of art and craft.

Reviewed: Katz.

Audience: teachers.

ART AUREA. See no. 1492.

ART LOVER'S ART AND CRAFT FAIR BULLETIN. 197? q. EN. 1194

American Society of Artists, Inc., P.O. Box 1326, Palatine, IL 60078. Phone 312–751–2500.

Subscription: $8.50 US.

ISSN: 0892–1202. OCLC: 14758880. LC: NK835.I3 A7.

Crafts.

Sponsors art and crafts festivals.

Listings: regional, Illinois. Calendar of art & craft shows/art shows/craft shows.

Advertising considered on occasion.

ARTS AND CRAFTS NEWSLETTER. 1971? 4/yr. EN. 1195

Kemp Krafts, 275 Main St., No. 11, Winooski, VT 05404. Phone 802–879–7838. Richard T. Kemp, Editor.

OCLC: 7519980.

Crafts.

ARTS & CRAFTS QUARTERLY. 1987. q. EN.

Steven Becker Publisher, P.O. Box 3592, Station E, Trenton, NJ 08629. Phone 609–396–9530. David Rago, Editor.
Subscription: included in membership to American Ceramic Arts Society, $20. Sample free. Back issues $6. Illus. b&w 30, color 3, photos. 8½ x 11, 36p.

Ceramics. Crafts. Furniture. Pottery.

Devoted entirely to the Arts and Crafts Movement.
Reviews: exhibition 2, book 2. Bibliographies: 2–3. Interviews: 1/issue. Biographies: luminaries in the field, 1/issue. issue Obits. Listings: national. Calendar of events. Exhibition information. Freelance work: yes. Contact: editor. Opportunities: study, competitions. Reviewed: *Art Documentation* Spr 1988, p.37.
Advertising: full page $800.10, ½ page $485.70, ⅓ page $352.30, covers $950–1150. Frequency discount. Suzanne Perrault, Ad. Director (phone 609–585–2546). Circulation: 20,000.

BASKETMAKER MAGAZINE. 1983? q. EN.

MKS Publications, Inc., 38165 Carolon, Westland, MI 48185. Sue Kurginski, Editor.
Illus.
ISSN: 0897–3458. OCLC: 17542090. LC: TT879.B3 B37. Dewey: 746.41. Formerly: *Basketmaker Quarterly.*

Crafts.

Contains historical overviews of the role of basket and basketmaking in other cultures, hands–on patterns and instructions as well as news.
Reviews: book. Reviewed: Katz.
Advertising. Classified.

BETTER HOMES AND GARDENS CHRISTMAS IDEAS. 1952. a. EN.

Meredith Corporation, Special Interest Publications, 1716 Locust St., Des Moines, IA 50336. Phone 515–284–3000.
ISSN: 0405–6590. Dewey: 747.

Crafts.

Reviewed: *Booklist* 86:5, Nov. 1, 1989, p.515.

BETTER HOMES AND GARDENS HOLIDAY CRAFTS. 1974. a. EN.

Meredith Corporation, Special Interest Publications, 1716 Locust St., Des Moines, IA 50336. Phone 515–284–3000.
Dewey: 745.5.

Crafts.

CANADIAN LEATHERCRAFT. 1951. q. EN.

Canadian Society of Creative Leathercraft, 500 Parkinson Rd., Woodstock, Ontario N4S 2N6, Canada. Audrey Gorton, Editor.
Subscription: included in membership. Illus.
ISSN: 0045–5121. OCLC: 2339142. LC: NK6202. Dewey: 745.531.

Crafts.

Reviews: book.

CHILDREN'S ALBUM: Children's Crafts and Creative Writings. 1987, no.10. bi–m. EN.

EGW Publishing Company, 1300 Galaxy Way, Concord, CA 94520. Phone 415–671–9852. Kathy Madsen, Editor (P.O. Box 6086, Concord, CA 94524).
Subscription: $15 US, $20 Canada & foreign. Sample $2.95. Back issues $2.50. Illus b&w, color, photos, cartoons. 32p.
ISSN: 0749–8659. OCLC: 11190043.

Crafts. Juvenile.

Dedicated to developing children's interests and talents. Original stories, plays, and poems written by children are featured. Seasonal and holiday craft projects prepared by adults, play a prominent role in every issue. Craft projects are designed to encourage creativity and foster feelings of accomplishment. Complete step–by step simple instructions written for children. Patterns are presented together with a photo of the finished project.
Reviews: book 3. Freelance work: yes, craft projects $50/published page (complete step–by step instructions & illus. of finished project); fillers including cartoons $5–10; covers $100 (done in any medium that includes the use of vibrant colors and colored background. Gear to anything related to a child's life, capturing the imagination, joy, and adventurous spirit of children 8–14. Gear to seasons, holidays, school, activities – a child's world). Contact: editor.
Advertising: none. Circulation: 26,000. Audience: children ages 8–14.

CHINA'S BEST ARTS & CRAFTS. 1981. EN & CH. 1202
Sino International Trade Promotion Co., Hong Kong, Hong Hong.
Illus.
OCLC: 1337296.
Crafts.

Issues also have distinctive titles.

CHIP CHATS. 1953. bi–m. EN. 1203
National Wood Carvers Association, 7424 Miami Ave., Cincinnati, OH 45243. Phone 513–561–9051 or 561–0627. Edward F. Gallenstein, Editor.
Subscription: included in membership, $8 US, $10 Canada & foreign. Sample $1.50. Illus b&w, color, photos, cartoons. Index. 8½ x 11, 88p.
ISSN: 0577–9294. OCLC: 1642704. LC: TT199.7.C46. Dewey: 731.4.
Crafts. Woodcarving. Sculpture.

Targets anything that promotes woodcarving. Provides how–to articles, patterns, features on woodcarvers and their works, and show and exhibitions information.
Reviews: book 3/issue. Biographies. Interviews. Obits. Listings: regional–international. Calendar of events. Exhibition information. Freelance work: yes. Contact: editor. Reviewed: Katz. *School.*
Advertising: none. Circulation: 33,000. Audience: woodcarvers and whittlers.

COMBINED ARTS BULLETIN. 1988. q. EN. 1204
Combined Arts, 7 Anglo Terrace, Bath BA1 5NH England.
Subscription: free.
ISSN: 0953–7694.
Crafts.

"Newsletter of information on developments at the Combined Arts, a new publishing company devoted to the crafts. Also provides informal commentary on current areas of interest within the crafts". [AD].

COMMUNITY ARTS NEWS. 1979. m. EN. 1205
Footscray Community Arts Centre, 45 Moreland St., Footscray, Victoria 3011, Australia. Tony Hicks, Editor.
Dewey: 745.5.
Covers arts and crafts at the Centre.

CONVENTION PROGRAM. 1984. a. EN. 1206
The Friends of the Origami Center of America, 15 W. 77th St., New York, NY 10024–5192. Phone 212–769–5635.
Subscription: included in convention package free; $15 members, $25 non–members. No sample. Back issues. Illus b&w. 8½ x 11, up to 320p.
Art Education. Crafts. Hobbies. Origami.

A collection of paper folding diagrams that were originally taught at the annual Convention. Documents new and/or unpublished works by creators from around the world. Masters and beginners alike contribute. Special features of this spiral–bound book include an extensive introduction section, a picture table of contents, and cross indices.
Freelance work: none.
Advertising: none. Circulation: 2000. Audience: paperfolders, teachers, artists.

COUNTRY LIVING. See no. 2392.

CRAFT ACT. 1974. m. except Jan. EN. 1207
Crafts Council of the A.C.T. Inc., 1 Aspinall St., Watson, A.C.T. 2602, Australia. Phone (062) 412373.
Subscription: included in membership, $A30, $A18 subscription only, air + postage. Sample, fee. No back issues. Illus b&w, photos, cartoons. 8 x 12, 12p.
ISSN: 0813–6734. Dewey: 745.5.
Art Education. Ceramics. Crafts. Decorative Arts. Furniture. Needlework. Photography. Printing. Sculpture.

Notification of craft related events which may be of interest to members plus special articles on subjects of interest such as health hazards in the arts, business aspects, etc.

Listings: regional–international. Calendar of events. Exhibition information. Freelance work: none. Opportunities: employ-
ment, study, competitions.
Advertising: full page $A70, ½ page $A45, ¼ page $A25, no color. Classified: $8 pre–paid. Frequency discount. Mailing
lists: yes, price on application. Circulation: 300. Audience: craftspeople.

CRAFT & NEEDLEWORK AGE. 1946. m. EN.

1208

Hobby Publications, Inc., 490 Route 9, RD 3, Box 420, Englishtown, NJ 07726. Phone 201–972–1022. Karen Ancona, Editor.
Subscription: (1988) $20 US, foreign $50. Illus. b&w, photos.
ISSN: 0887–9818. OCLC: 13434719, 17205740 (a. directory). LC: TT159.C7. Dewey: 745.5. Formerly: *Craft and Needle-
work Age/World of Miniatures; Craft, Model & Hobby Industry.*

Crafts. Needlework.

Trade magazine containing industry news for art materials, crafts, needlework and yarns. *Craft & Needlework Age Annual Di-
rectory* is published as a regular issue.
Calendar of events.
Advertising.

CRAFT ARTS INTERNATIONAL. 1984. q. EN.

1209

Craft Arts Pty. Ltd., P.O. Box 363, Neutral Bay Junction, N.S.W. 2089, Australia. Phone 02–908–4797, fax 02–953–1576.
Ken Lockwood, Editor.
Subscription: $A36 Australia, overseas $48 surface, $68 air. No sample but brochure will be sent. Back issues $US10.50.
Illus., mainly full color, photos. 30 x 22 cm., 124p.
ISSN: 0814–6586. Dewey: 745.5. Formerly: *Craft Arts.*

Crafts. Modern Art.

Specializing in the presentation, documentation, promotion and marketing of creative works that fall within the broad catego-
ries of the visual and applied arts. Covers the whole spectrum of the contemporary crafts movement, including the lifestyles,
philosophies, artistic concepts, etc. of the modern practitioners in all kinds of media. An information resource on contempo-
rary art, with particular emphasis on 3D work. Its principal objective is the promotion of innovation and originality in me-
dium–oriented, aesthetic expression including: paint, print, ceramic, glass, fiber, precious and non–precious metal, textile,
wood, leather, basketry and art photography.
Reviews: exhibition 6 & book 2, length 800 wds. each. Listings: regional–international. Exhibition information. Freelance
work: yes. Contact: editor. Opportunities: study, competitions. Indexed: ArtBibMod. Des&ApAI.
Advertising: b&w full page $950, ½ page $530, ¼ page $370; 4 color full page $1800, ½ page $1100, ¼ page $600, covers
$2300–$3000. Frequency discount. 10% agency discount. Circulation: 26,000.

CRAFT CONNECTION. 1975. q. EN.

1210

Minnesota Crafts Council, Hennepin Center for the Arts, 528 Hennepin Ave., Room 308, Minneapolis, MN 55403. Phone
612–333–7789. Kay Johnson, Editor.
Subscription: $20. Microform available. Illus.
OCLC: 2250330. LC: NK1.C7. Dewey: 745.

Crafts.

Tabloid.
Reviewed: Katz.

CRAFT HISTORY.International Quarterly of Mediaeval and Modern Craftsmanship. 1988.
q. EN.

1211

Combined Arts, 7 Anglo Terrace, Bath BA1 5NH, England. Phone 0225–337895.
ISSN: 0953–931X. OCLC: 19616435.

Crafts. Decorative Arts.

Indexed: Des&ApAI. Reviewed: *Art Documentation* Win 1988, p.152.

CRAFT INTERNATIONAL. q.

1212

World Crafts Council, Postobks 2045, DK–1012 Copenhagen K, Denmark. Phone 31 461060.

Crafts.

International publication which promotes crafts and serves as a clearinghouse for information on crafts. Affiliated with the
American Craft Council.

CRAFT NEWS. 1988. q. EN. 1213
Crafts Center, 2001 O St., N.W., Washington, DC.
ISSN: 0899–9724. OCLC: 18302343. Dewey: 745.
Crafts.

CRAFT SUPPLY REPORT: The Industry Journal for the Gift Producer. 1989. q. EN. 1214
Hobby Publications, Inc., 225 Gordons Corner Plaza, Box 420, Manalapan, NJ 07726. Phone 201–446–4900, fax 201–446–
5488. Andrew Hecht, Editor.
Subscription: $30 US, foreign $65, includes 3 issues + a. *Directory.* (Box 420, Englishtown, NJ 07726-9982). Illus.
OCLC: 22737460 (*Directory*). LC: TT12.C72. Dewey: 338.
Crafts.

Comprehensive trade publication providing the professional craftsperson with all the information needed to run a profitable
business. Presents business articles, industry trends, new products and business information. In addition the *Annual Directory*
contains a complete buyer's guide including hundreds of sources for wholesale craft supplies. Over 700 categories cross refer-
enced to supplier listings.
Advertising: Rates on request. Classified: $50/50 wds. Readers service card. Vickie Hicks, Ad. Director (phone 317–793–
4626. Audience: professional crafters and wholesalers.

CRAFT VICTORIA. 1970. 10/yr. EN. 1215
Crafts Council of Victoria, 7 Blackwood St, North Melbourne, Vic 3051, Australia. Phone 03–329–0611. Jeffrey Taylor, Edi-
tor.
Subscription: included in membership, $A35. Sample $A5. Back issues $A3.50. Illus b&w, photos, cartoons. A4, 20p.
ISSN: 0158–7048. Dewey: 745.5.
Art Education. Art History. Ceramics. Crafts. Decorative Arts. Furniture. Hobbies. Interior Design. Museology. Needlework.

Reviews: exhibition 4, length 500–1000 wds. Interviews & biographies: craftspeople and art lecturers. Listings: regional–in-
ternational. Calendar of events. Exhibition information. Freelance work: yes. Contact: editor. Opportunities: employment
ads., study, competitions. Indexed: Index to Craft Journals.
Advertising: full page $A130, ½ page $A90, ¼ page $A50, no color. No classified. No frequency discount. Mailing lists:
none. Circulation: 1500. Audience: crafts people.

CRAFTNEWS. 1976. 8/yr. EN. 1216
Ontario Crafts Council, 35 McCaul St., Toronto, Ontario M5T 1V7, Canada. Phone 416–977–3551. Anna Kohn, Editor.
Subscription: included in membership together with *Ontario Craft*, $25 Canada, + $4 postage US. Microform available from
Micromedia. Sample & back issues $1.25. Illus b&w. 11½ x 17, tabloid, 12p. Offset newsprint.
ISSN: 0319–7832. OCLC: 2729175. LC: NK1. Dewey: 745.5. Formerly: *Craft Ontario.*
Art Education. Crafts.

Concentrates on the professional side of craft. It provides craftspeople with useful information on financial and educational
opportunities as well as practical advice on running a small business and avoiding health hazards. Serves as a trade publica-
tion that focuses on practical, behind–the–scenes information. It includes news of Council activities as well as a rundown on
craft–related matters across Canada.
Reviews: exhibition, book. Listings: regional–international. Extensive calendar of events. Exhibition information. Freelance
work: yes. Contact: editor. Opportunities: study, competitions.
Advertising: b&w full page $795, ½ page $435, ¼ page $240. Color rates on request. Classified: (payment with order) $35
min./40 wds., 40¢/wd. add.; $25 for members. Frequency discount. No bleeds. Mailing lists: available. Circulation: 4500. Au-
dience: craftspeople.

**CRAFTRENDS SEW BUSINESS: The Merchandising Magazine for Craft and Needlework Re-
 tailers.** 1982. m. EN. 1217
Century Communications, Inc., 6201 Howard St., Niles, IL 60648. Phone 312–647–1200.
Sample. No back issues. Illus b&w, color, photos, cartoons. 8½ x 11, 85p.
Dewey: 746. Formerly: *Craftrends.*
Crafts. Decorative Arts. Drawing. Films. Hobbies. Interior Design. International. Needlework.

A trade magazine committed to meeting the needs of the retailer, both independents and chains. Primarily have product infor-
mation and feature articles focused on merchandising and store promotion. Each issue has an editorial feature on a different
topic. Also a news section, a letters from retailers section, and a "Just for Kids" section. Covers the entire industry—products,
people, trends and the business concerns.

Interviews & Biographies occasionally. Listings: regional–international. Calendar of events. Exhibition information. Freelance work: yes. Contact: Maggie Frazier & Kathy Di Clementi. Opportunities: study, every issue updating readers; competitions.

Advertising: (rate card Jan '89): b&w full page $2260, ½ page $1440, ¼ page $840; 4 color full page $3310, ½ page $1850, covers $3980–4190. Special positions + 15%. No classified. Frequency discount. 15% agency discount. Inserts. Dixie McDonald, Ad. Director (6405 Atlantic Blvd., Norcross, GA 30091, phone 1–800–221–3435, fax 404–441–9557). Mailing lists: none. Circulation: 25,000. Audience: craft and needlework retailers.

CRAFTS (London): The Decorative and Applied Arts Magazine. 1973. bi–m. EN. 1218

Crafts Council of England and Wales, 1 Oxendon St., London SW1Y 4AT, England. Phone 071–930 4811, fax 071–321 0427. Geraldine Rudge, Editor.
Subscription: £19.50 UK & Eire, overseas £27.50, $US49. Microform available from UMI. Sample, fee. Back issues £2, $US4.25. Illus b&w, color, photos. Annual index. 9¼ x 11½, 90p.
ISSN: 0306–610X. OCLC: 2240657. LC: TT1.C73. Dewey: 745.5.
Ceramics. Crafts. Decorative Arts. Furniture. Needlework.

Features the life and work of leading craftspeople from all areas of the crafts world, traditional and experimental. Includes the latest news, views and reviews of current exhibitions.
Reviews: exhibition 13, book 2–3. Interviews. Biographies. Listings: regional–national. Guide to craft shows and exhibitions. Freelance work: yes. Contact: editor. Opportunities: employment, study. Indexed: ArtBibMod. ArtI. BioI. CloTAI. Des&ApAI. Reviewed: Katz.
Advertising: (rate card 1989, VAT extra): Display full page £600, ½ page £ 330, ¼ page £175; color full page £1100, ½ page £600; "Craftsfile" £165 color picture + 30 wds. Classified: prepaid, 50p/wd. inclusive of VAT, min. £10. Frequency discount. Inserts. Bleed + 10%. Display ads: Alan Le Coyte & Colin Miller (Pearl Communications, Suite 212, Glen House, 200–208 Tottenham Court Rd., London W1P 9LA, phone 01–323–4770, fax 01–631–3667) Classified ads: Stanley Enright (Crafts Magazine, Glebe Cottage, Pear Tree Farm, Swinderby Rd., North Scarle, Lincolnshire LN6 9EU, phone 052 277, fax 052 277 608). Audience: craft workers and public.

CRAFTS (U.S.). 1978. m. EN. 1219

PJS Publications, Inc., News Plaza, Box 1790, Peoria, IL 61656. Phone 309–682–6626. Judith Brassart, Editor.
Illus.
ISSN: 0148–9127. OCLC: 3504120. LC: TT1.C735. Dewey: 746.
Crafts.

Reviews: book.
Advertising.

CRAFTS 'N THINGS. 1975. 10/yr. EN. 1220

Clapper Publishing Company, Inc., 14 Main St., Park Ridge, IL 60068. Phone 312–825–2161. Nancy Tosh, Editor.
Subscription: $15. Microform available from UMI. Illus. Index.
ISSN: 0146–6607. OCLC: 2987677. LC: TT855.C68. Dewey: 745.5. Incorporates *Creative Crafts and Miniatures*; (formed by the merger of: *Creative Crafts, and Miniature Magazine*).
Crafts.

Complete how–to's for quality crafts, popular crafts like cross–stitch, crochet, quilting, tole painting, doll making, and sewing. Full–size patterns provided for hundreds of crafts.
Indexed: Hand. Reviewed: Katz.
Audience: everyone looking for lovely crafts to make.

CRAFTS BAZAAR. See no. 1398.

CRAFTS INTERNATIONAL. 1980. q. EN. 1221

247 Centre St., New York, NY 10013–3216. Phone 212–925–7320. Rose Silvka, Editor.
Dewey: 745.5.
Crafts.

Each issue has thematic or geographic focus.

CRAFTS NEW SOUTH WALES. 1964. bi–m. EN. 1222

Crafts Council of N.S.W., 100 George St., The Rocks, Sydney, NSW 2000, Australia. Phone 02–279126. Craig Boaden & Jill Howell, Editors.

Subscription: included in membership, foreign $A38. Sample & back issues $2. Illus. b&w, photos. A4, 16p. ISSN: 1727–6758. Dewey: 745.5.

Art Education. Ceramics. Crafts. Decorative Arts. Needlework.

The newsletter aims to provide a factual picture of the crafts industry in NSW. It includes news that affects crafts practitioners. Articles from craftspeople and others are invited. There is a comprehensive section called "Craft Events" which is a calendar of exhibitions, conferences, competitions and training in NSW, Australia and international.

Reviews: exhibition 1, length 300 wds.; book 1, length 200 wds. Biographies: articles on craft–practitioners and their work. Listings: regional–international. Calendar of events. Freelance work: yes. Contact: editor. Opportunities: study, competitions. Advertising: full page $220, ½ page $130, ¼ page $70. 10% discount to members. Frequency discount. Enclosures. Mailing lists: none. Demographics: circulation reaches over 1,000 individual members, groups, craft guilds and many organizations and government departments. Readership is over 10,000. Circulation: 1000. Audience: those interested in the crafts industry in NSW and Australia.

CRAFTS NEWS. 1989. q. EN. 1223

Scottish Development Agency, Rosebery House, Haymarket Terrace, Edinburgh EH12 5EZ, Scotland. Phone 031–337–9595. Julia Kochnewitz, Editor.

Subscription: available on request, no subscription fee. Sample. Back issues free. Illus. b&w, color, photos. A4, 4p. OCLC: 22165625. LC: NK1.C896. Dewey: 745.5. Formerly: *Craftwork News*.

Crafts.

To inform craftspeople living and working in Scotland of events and opportunities available to them nationwide. Also projects of general interest to the crafts community, and the work of the Crafts Division of the Agency, which exists to assist the crafts industry in Scotland.

Listings: national. Calendar of events. Exhibition information. Freelance work: none. Opportunities: employment, competitions. Advertising: none. Mailing lists: none. Audience: craftspeople.

THE CRAFTS REPORT. 1975. m. EN. 1224

The Crafts Report Publishing Co., Inc., 700 Orange St., Wilmington, DE 19801. Phone 302–656–2209. Michael Scott, Editor (3632 Ashworth Ave., No., Seattle, WA 98103).

Subscription: $19.95 worldwide. Microform available from UMI. Sample $2. Back issues $2.50. Illus b&w, color, photos, cartoons. 11 x 15, tabloid, 52p. ISSN: 0160–7650. OCLC: 3763022. LC: TT1.C72. Dewey: 658. Formerly: *Working Craftsman; Crafts Report*.

General. Crafts. Marketing. Management.

The newsmonthly of marketing, management and money for crafts professionals. Tabloid format.

Listings: national. Exhibition information. Freelance work: yes. Contact: Christine Yarrow. Opportunities: study, competitions. Indexed: Des&ApAI. Reviewed: Katz. Advertising: full page $600, ½ page $360, ¼ page $190, color rates on request. Classified: 80¢/wd. Frequency discount. Sheila Haynes, Ad. Director. Mailing lists: available to advertisers only. Demographics: national circulation. Circulation: 18,000+. Audience: professional craftspeople.

CRAFTWORKS FOR THE HOME. 1985. bi–m. EN. 1225

All American Crafts, Inc., 70 Sparta Ave., CN 1003, Sparta, NJ 07871. Phone 201–729–4477. Matthew Jones, Editor. Illus.

ISSN: 0891–0588. OCLC: 14561015. Dewey: 745.

Crafts.

Craft projects complete with instructions, diagrams and designs. Projects for beginners through skilled crafters. Reviews: book.

Advertising. Audience: craft enthusiasts.

CREATIVE IDEAS FOR LIVING. 1984. m. EN. 1226

Tandy Corp., Southern Living, Inc., 820 Shades Creek Pkwy., Birmingham, AL 35209. Phone 205–877–6000. Illus.

ISSN: 0747–4768. OCLC: 10847845. LC: TT1.D38. Dewey: 745.5. Merged with *Needle & Craft*. Formerly: *Decorating and Craft Ideas; Decorating Craft Ideas Made Easy.*
Crafts. Interior Design.

Indexed: Hand.
Advertising.

CREATIVE PRODUCTS NEWS. 1980. m. EN. 1227

Cottage Communications, Inc., 1555 Willow St., Box 584, Lake Forest, IL 60045. Linda Lewis, Editor.
ISSN: 0273–9240. OCLC: 7039830. Dewey: 338.
Crafts. Hobbies. Needlework.

"New products for crafts/needlework/art supplies/miniatures".
Reviews: book. Reviewed: Katz.
Advertising.

CV. See no. 506.

DECORATIVE ARTS DIGEST: Sharing the Art of Tole and Decorative Painting. 1985. bi–m. EN. 1228

Clapper Publishing Co., Inc., 14 Main St., Park Ridge, IL 60028. Phone 708–825–2161. Beth Browning, Editor.
Subscription: $24.95.
ISSN: 0888–076X. OCLC: 13460347. Dewey: 745.
Crafts. Decorative Arts.

Directed toward those interested in learning, or increasing skills, in tole and decorative painting.
Advertising.

THE DOLL ARTISAN. 1977. bi–m. EN. 1229

Doll Artisan Guild, 35 Main St., Oneonta, NY 13820. Phone 607–432–4977. Eva Oscarson, Editor.
Subscription: included in membership.
ISSN: 1040–6336. OCLC: 15609182. LC: TT175.D57. Dewey: 738.8.
Ceramics. Collectibles. Crafts.

The magazine for the porcelain dollmaker. Official publication of the Guild. Covers stringing, patternmaking, doll history, and Guild news plus competition winners and new doll artisans.
Reviews: book. Calendar of events.
Advertising.

DOLL CRAFTER. 1983. 8/yr. EN. 1230

Scott Publications, 30595 W. 8 Mile Rd., Livonia, MI 48152. Phone 313–477–6650, fax 313–477–6650. Barbara Campbell, Editor.
Subscription: $21.60 US, $31.60 Canada. Sample. Back issues. Illus b&w, color, photos. 8½ x 11, 112p.
ISSN: 0746–9642. OCLC: 10426329. Dewey: 745.
Collectibles. Crafts.

Reviews: 1–3 reviews. Interviews: profiles. Listings: international. Freelance work: yes. Contact: Annette Malis.
Advertising: b&w full page $920, ½ page $500, ¼ page $275; 4 color full page $1490, ½ page $925; covers $300–$400. "Doll Exchange/Classified" 75¢/wd., min. 20 wds. Frequency discount. 15% agency discount. Inserts. William Latocki, Ad. Director (phone 1–800–999–9917). Mailing lists: none. Circulation: 64,000. Audience: dollmakers and collectors.

DOLL DESIGNS. 1983. q. EN. 1231

House of White Birches Publishing, 306 E. Parr Rd., Berne, IN 46711. Phone 219–589–8741, fax 219–589–2810. Dorothy Coyne Eckrote, Editor.
Back issues.
ISSN: 1050–4796. OCLC: 21498538. Dewey: 745. Formerly: *National Doll World Omnibook.*
Crafts.

Patterns, information, news and advice for the doll, teddy–bear and toy crafting enthusiast. Concentrates on the practical aspects of creating, restoring, dressing, and otherwise caring for well loved dolls, teddy–bears and toys.
Advertising: (rate card July 1989): b&w full page $500, ½ page $325, ¼ page $175, covers $650–700, 2 color + $150, 4 color + $350. Classified: $10/20 wds., 40¢/wd. add. Frequency discount. 5% discount for concurrent ads in 2 or more

Women's Circle publications. 15% agency discount. 15% discount to mail–order businesses. Janet Price–Glick, Ad. Director. Demographics: 98% women, 96% over 30, 54% income $25,000+. Circulation: 23,000.

DOLLMAKING: Projects and Plans. 1985. q. EN. **1232**

Collector Communications Corp., 170 Fifth Ave., New York, NY 10010. Phone 212–989–8700, fax 212–645–8976. Karen Bischoff, Editor.

Subscription: $14 US, $19 Canada (P.O. Box 1921, Marion, OH 43305). Sample & back issues $5. Illus b&w, color, photos. 8½ x 11, 56p., Web Offset, Saddle Stitched.

ISSN: 0885–2707. OCLC: 12615747. Dewey: 745.

Crafts.

Features start–to–finish projects on how to make dolls from porcelain and cloth. Also contains projects for dolls of wax, wood, and modeling compounds. Patterns for doll clothing are given. There are technique pieces. Almost every issue also includes a paper doll.

Reviews: exhibition 1, book 5, equipment 10, catalogs 10. Calendar of events. Exhibition information. Freelance work: yes. Contact: editor.

Advertising: (rate card Spring 1989): b&w full page $945, ½ page $510, ⅓ $350; 4 color full page $1475, ½ page $925; covers $1475–1645. Guaranteed position + 10%. Classified: 50¢/wd. Bleed no charge. Frequency discount. 15% agency discount. Reply cards. Inserts. India Thybulle, Ad. Director. Mailing lists: available. Circulation: 35,000. Audience: dollmakers of all mediums.

ELAGU. 1983. s–a. EN. **1233**

Elagu Committee, P.O. Box 33, Footscray 3011, Australia.

Back issues. Illus.

ISSN: 0814–5288.

Covers crafts and folklore.

ENGINEERING IN MINIATURE. 1979. m. EN. **1234**

TEE Publishing, Edwards Centre, Regent St., Hinckley, Leics. LE10 0BB, England. Phone 0455–637173. C.L. Deith, Editor.

Subscription: $31 UK, $39.72 elsewhere. Annual index in last issue.

Dewey: 745.5.

Crafts. Hobbies.

Reviews: book.

Advertising.

FAIRS AND FESTIVALS IN THE NORTHEAST. 1977. a. EN. **1235**

Arts Extension Service, Div. of Continuing Education, University of Massachusetts, Amherst, MA 01003. Phone 413–545–2360. D. Vanessa Kam, Editor.

Subscription: $7.50 US & Canada. No back issues. No illus. 8½ x 10¾, 140p.

ISSN: 1051–9505. OCLC: 14872452. LC: F2.3F35. Dewey: 394.

Ceramics. Crafts. Jewelry. Needlework. Painting. Photography. Sculpture.

An annual listing of resources for craftspeople. Provides information to artists and craftspeople seeking direct marketing opportunities throughout the Northeast. A compilation of regional festival offerings, the listing includes dates, application deadlines and information, and contact persons for each entry. The publication is also used by the public and media to find arts fairs.

Listings: regional. Calendar of events Jan thru Mar of the next year. Reviewed: Katz.

Advertising: none. Circulation: 2500. Audience: craftspeople, crafts buyers.

FAIRS AND FESTIVALS IN THE SOUTHEAST. 1986. a. EN. **1236**

Arts Extension Service, Div. of Continuing Education, University of Massachusetts, Amherst, MA 01003. Phone 413–545–2360. D. Vanessa Kam, Editor.

Subscription: $7.50 US & Canada. No back issues. No illus. 8½ x 10¾, 140p.

ISSN: 1051–9513.

Ceramics. Crafts. Jewelry. Needlework. Painting. Photography. Sculpture.

Listing of resources for craftspeople seeking direct marketing opportunities throughout the Southeast.

Listings: regional. Calendar of events from Jan thru Mar of next year. Reviewed: Katz.

Advertising: none. Circulation: 1500. Audience: craftspeople, crafts buyers.

FAMILY CIRCLE GREAT IDEAS. See no. 2405.

FIBERARTS. See no. 1464.

FineScale MODELER. 1982. 8/yr. EN. **1237**
Kalmbach Publishing Co., 21027 Crossroads Circle, P.O. Box 1612, Waukesha, WI 53187. Phone 414–796–8776, fax 414–796–0126. Bob Hayden, Editor.
Subscription: $19.95 US, $22.95 Canada, $24.95 elsewhere. Sample $2.95. Illus. color, some b&w, photos (50+/issue). 86p.
ISSN: 0277–979X. OCLC: 7674178. LC: TT154.F54. Dewey: 745.592.
Crafts. Hobbies.

Contains several articles describing models as well as articles on the techniques of modelmaking. Includes series articles such as "the Classic Kits series" and "American Dress and Detail series".
Reviews: book, kits. Calendar of events. Freelance work: yes. Contact: editor. Leaflet outlining in detail the preparation of features, photographs, and drawings available from the Editorial Secretary. (Details also available in *ArtMkt.* and in *PhMkt.*).
Advertising. Classified. Daniel R. Lance, Ad. Director. Circulation: 82,000. Audience: hobbyists building scale models.

FLORA. 1974. bi–m. EN. **1238**
Maureen Foster, Publisher., The Fishing Lodge Studio, 77 Bulbridge Rd., Wilton, Salisbury Wilts. SP2 0LE England. Phone 0722–743207. Russell Bennett, Editor.
Subscription: £11.25 UK & Northern Ireland, overseas £12.35 surface, £15.95 air worldwide air. Illus b&w, color, photos, cartoons. 21 x 29½ cm., 56p.
ISSN: 0306–882X. OCLC: 2329061. LC: SB449.A1F4.
Flower Crafts. Flower Arrangement. Gardens.

The only international magazine for flower arrangers and florists. Designed for both the professional and amateur. Includes features for students.
Reviews: exhibition/shows 14 & book 12, length 200 wds. Interviews: with flower arrangers on their work and their gardens. Biographies: national and international flower arrangers. Listings: national–international. Exhibition information. Freelance work: none. Reviewed: Katz.
Advertising: (rate card Mar '89, VAT extra): full page £230, ½ page £115, ¼ page £75. Color rates on request. Classified: £14 (VAT included)/60 wds. max., check with copy. Frequency discount. 10% agency discount. Inserts. Maureen Foster, Ad. Director. Mailing lists: none. Circulation: 18,000. Audience: flower arrangers and florists.

FLOWER ARRANGER. 1961. q. EN. **1239**
National Association of Flower Arrangement Societies of Great Britain, 21A Denbigh St., London SW1V 2HF, England. Phone 071 828 5145. Jill Grayston, Editor (Little Lions Farm, Ashley Heath, Ringwood, Hants BH24 2EX, phone 0425 471642).
Subscription: included in membership, non–members £5.30. Sample. Back issues. Illus. Index. A4, 100p.
ISSN: 0046–421X. Dewey: 745.92.
Flower Arrangement.

Reviews: book 6, length 150 wds. Listings: regional–international. Exhibition information—national, area, club. Freelance work: yes. Contact: editor.
Advertising: J.H. & M.E. Wright, Ad. Directors. Circulation: 57,000. Audience: flower arrangers and allied crafts.

FORM FUNCTION FINLAND. See no. 1564.

HAANDARBEJDETS FREMME. AARETS KORSSTING. 1960. a. DA, EN & GE. **1240**
Haandarbejdets Fremme, Copenhagen, Denmark.
Subscription: Kr 98.
ISSN: 0107–9611. Dewey: 745. Formerly: *Haandarbejdets Fremme. Kalender.*
Calendar of events.

HANDICRAFT/HOBBY INDEX. See no. 15.

HANDMADE ACCENTS: The Buyers Guide to American Artisans. 1984. q. EN. **1241**
Creative Publications, Inc, 488–A River Mountain Rd., Lebanon, VA 24266. Phone 703–873–7402. Steve McCay, Editor.
Subscription: $15 US, $18 Canada & foreign. Sample & back issues $5. Illus b&w, color, photos. 8½ x 11, 60p.

ISSN: 0894–0924. OCLC: 15793580. Formerly: *Creative Crafters Journal*.

Ceramics. Crafts. Decorative Arts. Jewelry. Modern Art. Painting. Photography. Sculpture. Textiles.

Provide an insiders look into the world of the American artisan, a glimpse into the workshops, studios and galleries of America's first art providers. Each issue contains a "treasured gifts" catalog section of full color ads by American artisans.
Reviews: book 4, length 500 wds. Listings: national. Calendar of events, q. by state. Exhibition information. Freelance work: yes (details in *PhMkt.*). Contact: editor.
Advertising: full page $450, ½ page $250, ¼ page $130, color full page $650. Classified: 50¢/wd. Frequency discount. Bobbie McCay, Ad. Director (P.O. Box 210, Honaker, VA 24260). Demographics: 80% women, married, $35,000+ annual income, every state & many foreign countries. Circulation: 45,000. Audience: patrons of the arts, collectors, decorators, wholesale & retail buyers of fine crafts and arts.

HIGHLAND HIGHLIGHTS. 1959. m. EN. 1242

Southern Highland Handicraft Guild, P.O. Box 9545, Asheville, NC 28815. Phone 704–298–7928. Cornelia W. Graves, Editor.
Subscription: included in membership, $25 non–members. Sample free. Back issues. Illus b&w, photos. 8½ x 11, 4–6p.
Crafts.

The newsletter of membership of the Guild. The needs of the member craftsperson is addressed by fellow craftspeople as well as from the organization's director and its president. Covers a wide variety of crafts. Reports on the activities of the organization and its members. Descriptions of Guild and non–Guild workshops, art and culture tours, films, lectures, exhibitions, etc. are provided in the "FYI" and "Update" columns.
Listings: regional mostly, several national, a few international. Calendar of events. Exhibition information. Freelance work: yes. Opportunities: employment, study, competitions.
Advertising: none. Circulation: 1100. Audience: members and friends of the Guild.

HOBBY MERCHANDISER. 1982. m. EN. 1243

Hobby Publications, Inc., 490 Route 9, Box 425, Englishtown, NJ 07726. Phone 201–972–1022. Dean Hughey, Editor. Illus.
ISSN: 0744–1738. OCLC: 8085732. LC: TT159.H55. Dewey: 382. Formerly: *Craft, Model & Hobby Industry*.
Crafts. Hobbies.

INFORM. 1981. bi–m. EN. 1244

Empire State Crafts Alliance, Inc., 9 Vassar St., Poughkeepsie, NY 12601. Phone 914–471–8188. Terri Lonier, Editor.
Subscription: included in membership.
Dewey: 745.5. Formerly: *Information (Poughkeepsie)*.
Crafts.

Advertising.

INTERNATIONAL WOODWORKING. 1984. q. EN. 1245

Glove Hollow Press, Box 706, Plymouth, NH 03264. Phone 603–536–3768. Doug Werbeck, Editor.
Subscription: included in membership, $20 US, $US 28 Canada. No Sample. Back issues $2. Illus. b&w, photos, cartoons. 8½ x 11, 24p.
Dewey: 694.
Crafts. Hobbies.

The publication of the Woodworking Association of North America is dedicated to the advancement of woodworking as an industry, a hobby and as an art. Targeted for small professional woodworking shops and serious woodworking hobbyists.
Reviews: book 2, length 1p.; equipment 2, length½p. Listings: national. Calendar of events. Exhibition information. Freelance work: yes. Contact: editor. Opportunities: employment (listed in classified section), study, competitions.
Advertising. Mailing lists: available. Circulation: 8000. Audience: woodworkers.

JOURNAL FOR WEAVERS, SPINNERS & DYERS. See no. 1473.

KUNST + HANDWERK: EUROPEAN CRAFTS. 1957. bi–m. GE only. 1246

Verlagsanstalt Handwerk GmbH, Auf'm Tetelberg 7, Postfach 8120, 4000 Dusseldorf 1, W. Germany. Gunter Nicola, Editor.
Subscription: DM 78.
Crafts.

Reviewed: Katz.

THE LEATHER CRAFTSMAN. 1985. bi–m. EN. 1247
Craftsman Publishing, Box 1386, Fort Worth, TX 76101. Phone 817–923–6787. Nancy Sawyer, Editor.
Subscription: $15 US, $18 Canada, foreign $22. Microform available from UMI. Sample $1. Back issues $4. Illus. b&w, photos. 8½ x 11, 68p.
OCLC: 13406687. Dewey: 745.5. Formerly: *Make It With Leather; The Craftsman.*
Crafts.

Dedicated to the preservation of leather craft.
Freelance work: yes. Contact: editor. Indexed: Index. Reviewed: Katz.
Advertising: full page $800, ½ page $640. Classified: 50¢/wd. Frequency discount. Pauline Riley, Ad. Director. Mailing lists: none. Circulation: 10,000.

THE LEATHERCRAFT NEWSLETTER. 1949. m. EN. 1248
The Leathercraft Guild, P.O. Box 734, Artesia, CA 90701. Phone 213–864–2420. Myron Petersen, Editor.
Subscription: included in membership. Illus. b&w. 8½x11, 4p.
Crafts.

Presents news of Guild activities and illustrations of members' current works. Patterns also included.
Reviews: book.
Advertising. Circulation: 300.

THE LIMITED EDITION. 1967. 6/yr. EN. 1249
Michigan Guild of Artists and Artisans, 118 N. Fourth Ave., Ann Arbor, MI 48104. Phone 313–662–3382. Joseph R.W. Jaworek, Ralph Kohloff, and Christopher Maher, Editors.
Subscription: included in membership. Illus. b&w. 8½ x 11, 8–12p.
Formerly: *University Artists and Craftsmen Guild Newsletter; Michigan Guild of Artists and Artisans Newsletters.*
Newsletter contains articles and notices for artists and craftspeople.
Profiles of artists. Calendar of events. Freelance work: yes.
Advertising. Circulation: 1500. Audience: artists, art material distributors, and interested persons.

THE MALLET. 1977. m. EN. 1250
National Carvers Museum Foundation, 14960 Woodcarver Rd., Monument, CO 80132. Phone 303–481–2656. B.J. Henry, Editor.
Illus.
ISSN: 0162–8879. OCLC: 4241329. LC: NK9700.M34. Dewey: 736.
Crafts.

Reviews: book. Reviewed: Katz. Katz. *School.*
Advertising.

McCALL'S CHRISTMAS BAZAAR. 1986. a. EN. 1251
ABC Consumer Magazines, Inc., 825 Seventh Ave., New York, NY 10019. Phone 212–246–4000.
OCLC: 17153650. Formerly: *Christmas Bazaar.*
Crafts.

Handicrafts and decorations for the Christmas holiday.

McCALL'S DESIGN IDEAS. 8/yr. EN. 1252
ABC Consumer Magazines, Inc., 825 Seventh Ave., New York, NY 10019. Phone 212–265–8360.
Dewey: 745.5.
Crafts.

METALSMITH. 1980. q. EN. 1253
Society of North American Goldsmiths, 5009 Londonderry Dr., Tampa, FL 32647. Sarah Bodine, Editor.
Subscription: $26 US, Canada + $6, foreign + $20. Illus. b&w, some color, photos. Annual index.
ISSN: 0270–1146. OCLC: 6343831. LC: NK6400.M43. Dewey: 739. Formerly: *Goldsmith's Journal.*
Crafts.

Specialized journal devoted to all aspects of metal arts. Association news and events as well as artists' profiles are included.

Reviews: exhibition, book. Indexed: ArtI. CloTAI. Des&ApAI. Reviewed: Katz. *Art Documentation* Sum 1987, p.93.
Advertising.

MIDWEST ART FARE. 1970. m. EN. 1254
1056 56th St., Des Moines, IA 50311. Phone 515–274–0675. Manfred Kiess, Editor & Pub.

MINIATURE COLLECTOR. See no. 1170.

NATIONAL CALENDAR OF OPEN COMPETITIVE ART EXHIBITIONS. See no. 107.

NATIONAL GUILD OF DECOUPEURS DIALOGUE. 1974. s–m. EN. 1255
National Guild of Decoupeurs, 807 Rivard Blvd., Grosse Pointe, MI 48230. Phone 313–882–0682. Ann Standish, Editor.
Subscription: included in membership. 8½ x 11, 12p.
Crafts.

Focuses on news of the Guild and articles on decoupage techniques.

THE NATIONAL HOBBY NEWS. 1980. q. EN. 1256
NHN Publishing, Box 602, New Philadelphia, OH 44663–0612. Phone 216–339–6338. E.M. "Woody" Russell, Editor.
Subscription: $3.95 US, $5.95 Canada. Sample. Back issues. Illus. b&w, photos, cartoons. 11½ x 15, 24p.
Dewey: 790.13.
Crafts. Hobbies.

Tabloid newspaper publication for small businesses and the hobbyist. Contains features, mail order news, and ads.
Freelance work: yes. Contact: Kay Conner, staff writer & review editor.
Advertising: $10/col. inch, full page 40% off regular rates. Classified: 25¢/wd., color available. Frequency discount. Kay Conner, Ad. Director. Mailing lists: available for direct mailing only, on plates. Circulation: 5000. Audience: hobby & craft and small businesses.

NEW ZEALAND CRAFTS. q. EN. 1257
Crafts Council of New Zealand, P.O. Box 498, Wellington, New Zealand. Phone 4 727018, fax 4 727003.
Illus.
OCLC: 21634789.
Crafts.

Indexed: ArtBibMod.
Audience: craftspeople.

NEWSLETTER (Crafts Council of New Zealand). 1989, no.22. 5/yr. EN. 1258
Crafts Council of New Zealand, P.O. Box 498, Wellington, New Zealand. Phone 4 727018, fax 4 727003.
OCLC: 21732136.
Crafts.

Audience: craftspeople.

THE NEWSLETTER FOR THE FRIENDS OF THE ORIGAMI CENTER OF AMERICA.
 1980. q. EN. 1259
The Friends of The Origami Center of America, 15 W. 77th St., New York, NY 10024–5192. Phone 212–769–5635. Kathleen O'Regan & Jan Polish, Editors.
Subscription: included in membership, $20 individual, $30 family, $15 junior to age 18, overseas $25. Sample free. Back issues. Illus. b&w, photos, cartoons, diagrams. 8½ x 11, 24p.
Art Education. Crafts—Origami. Hobbies.

The Friends is a cultural and educational arts organization with the goal of elucidation and dissemination of paperfolding as an art and a craft. The *Newsletter* is published to communicate with the members and to share ideas and information about origami, the art of paperfolding. Includes instructional diagrams and announcements of classes and meetings.
Reviews: exhibition, book. Listings: regional. Opportunities: study.
Advertising: none. Circulation: 1800. Audience: individuals interested in promoting origami.

NUTSHELL NEWS: For Creators and Collectors of Scale Miniatures. 1970. m. EN. **1260**

Kalmbach Publishing Co., 633 W. Wisconsin Ave., Suite 304, Milwaukee, WI 53203. Phone 414–273–6332, Fax 414–273–0824. Sybil Harp, Editor.

Subscription: $29 US, $36 Canada & foreign, air rates on request. Sample. Back issues $3.50. Illus. color, photos. 9 x 7, 132p. Sheetfed, Saddle Stitched.

ISSN: 0164–3290. OCLC: 2250513. Dewey: 790.13.

Collectibles. Crafts. Hobbies.

Devoted to the collecting and crafting of scale miniature houses, room boxes, vignettes, furniture and accessories. A consumer magazine with articles covering trends, products, and creative projects. Focuses on work by artisans, how–to–articles, and crafting tips and techniques. Includes features on private collections, antiques, show calendar and coverage, new products, and where–to–find it columns.

Reviews: exhibition 2–3, length 3–4p.; book 2–3, length short. Interviews: working artisans & collectors. Listings: national. Calendar of events. Exhibition information. Freelance work: yes. Contact: editor. Opportunities: study. Reviewed: Katz.

Advertising: (rate card Jun '89): b&w full page $775, ½ page $445, ¼ page $240, 2 color + 15–20%; 4 color + 35%, min. $100; cover & special position + 20%. Classified: 55¢/wd., $28/b&w photo. Frequency discount. 15% agency discount. Bleed no charge. Inserts. Sara L. Benz, Ad. Manager. Demographics: subscriptions obtained by direct–to–publisher renewals, direct mail, space advertising, and distribution to miniatures shops. Circulation: 33,000. Audience: scale miniatures enthusiasts, collectors, crafters, and hobbyists.

ON-CENTER. s–a. EN. **1261**

Worcester Center for Crafts, 25 Sagamore Rd., Worcester, MA 01605. Phone 617–753–8183. Ann Rogol, Editor.

Subscription: free.

Dewey: 745.3.

Crafts.

ONTARIO CRAFT. 1976. q. EN. **1262**

Ontario Crafts Council, 35 McCaul St., Toronto, Ontario M5T 1V7, Canada. Phone 416–977–3551. Anna Kohn, Editor.

Subscription: $C12 Canada, $US17 US, foreign $C22. Sample $3. Some back issues $3. Illus. b&w, color, photos. 8¼ x 11, 48p. offset, Saddle stitched.

ISSN: 0229–1320. OCLC: 8099349. LC: NK1C744. Dewey: 745.5. Formerly: *Craftsman.*

Crafts.

The only full color Canadian magazine that extensively covers professional contemporary craft in all its forms. Includes articles, accounts of craftpeople's lives and reviews of their work, commentary, and special supplements such as the *Directory of Suppliers of Craft Materials.* Increases the national awareness of the finest in craft through profiles of artists and articles on major collections and commissions. Publishes thoughtful commentary by some of the country's best craft makers regarding current developments.

Reviews: exhibition 8 & book 1–2, length 500–700 wds. Listings: regional–international. Calendar of events. Exhibition information. Freelance work: yes. Contact: editor. Opportunities: study, competitions. Indexed: CanPI. Des&ApAI.

Advertising: (rate card Jan '89): full page $685, ½ page $370, ¼ page $200, covers $770; color rates on request. No classified. Frequency discount. Inserts. No bleeds. 15% agency discount. 2% cash discount. Mailing lists: available. Circulation: 5500. Audience: craftpeople, collectors, artists, teachers, students.

THE ORIGAMIAN. 1958. irreg. EN. **1263**

The Friends of The Origami Center of America, 15 W. 77th St., New York, NY 10024–5192. Phone 212–769–5635. Alice Gray, Editor.

Subscription: included in membership, $4/4 issues non–members.

Crafts.

Tabloid includes paper folding diagrams.

Advertising: none.

PACK-O-FUN. 1951. bi–m. EN. **1264**

Clapper Publishing Company, Inc., 701 Lee St., Suite 1000, Des Plaines, IL 60016–4555. Phone 708–297–7400. Marie Petersen, Editor.

Subscription: $11.95 US, $14.95 Canada & foreign. Microform available from UMI. Sample free. Back issues $2.50. Illus. b&w, color, photos, cartoons. 8½ x 5½, 48p.

ISSN: 0330–001X. OCLC: 1761698. Dewey: 745.5.

Crafts. Hobbies. Juvenile.

"The only scrapcraft magazine". Presents no–cost crafts for kids.
Reviews: book 2. Listings: national. Freelance work: yes. Contact: Lois Dahlin. Indexed: Hand. Reviewed: Katz. Advertising: full page only $550. Classified: 50¢/wd., limited. Paul Withington, Ad. Director. Mailing lists: available. Demographics: national audience, female 25–35, income 30,000+, children ages 2+. Circulation: 37,000. Audience: children.

PENNSYLVANIA CRAFTS. 10/yr. EN. 1265
Pennsylvania Guild of Craftsmen, P.O. Box 820, Richboro, PA 18954. Phone 215–860–0731. Ruth Stonesifer, Editor.
Subscription: included in membership. Sample. Illus. b&w, photos. 8½x11, 16p.
Ceramics. Crafts. Pottery.

Carries articles on a range of crafts and news of members and chapters.
Calendar of events.
Advertising: full page $250, ½ page $175, ¼ page $125, no color. Classified. No frequency discount. Mailing lists: available. Audience: craftsmen.

POPULAR CRAFTS. 1974. m. EN. 1266
Argus Specialist Publications Ltd., 1 Golden Square, London W1R 3AB, England.
Subscription: £22.
ISSN: 0144–2937. Dewey: 745.5. Incorporates: *Gem Craft.*
Crafts. Jewelry.

PROFITABLE CRAFT MERCHANDISING. 1965. m. EN. 1267
P J S Publications, Inc., News Plaza, Box 1790, Peoria, IL 61656. Phone 309–682–6626. Michael Hartnett, Editor.
Illus.
Formerly: *Profitable Hobby Merchandising.*
Crafts. Hobbies.

Reviews: book.
Advertising.

PUBLICITY REVIEW. 1965. irreg. EN. 1268
Aubrey Bush Publications, 17 Balmoral Rd., Forest Rd., Nottingham NG1 4HX, England.
ISSN: 0033–3921.
Crafts.

Reviews: book.
Advertising.

RUG HOOKING. 1989. bi–m. EN. 1269
Commonwealth Communications Services, P.O. Box 15760, Cameron & Kelker Sts., Harrisburg, PA 17105–9834. Phone 717–234–5091, fax 717–234–1359. Mary Ellen Cooper, Editor.
Subscription: $19.95 US, $24.95 Canada, foreign $35 air.
ISSN: 1045–4373. OCLC: 20114477. Dewey: 746.
Crafts.

Devoted to the folk art of traditional rug hooking.
Reviewed: *Library Journal* 115:3, Feb 15 1990, p.220.
Advertising. Circulation: 12,000. Audience: craft enthusiasts.

THE RUGGING ROOM BULLETIN. 1987. q. EN. 1270
P.O. Box 824, 10 Sawmill Drive, Westford, MA 01886. Phone 508–692–8600. Jean H. Fallier, Editor.
Subscription: $9 US, foreign $10.50.
ISSN: 1043–2701. OCLC: 19380093. Dewey: 746.
Advertising.

SA CRAFTS. 1979. q. EN. 1271
Crafts Council of South Australia Inc., The Jam Factory, 169 Payneham Rd., St. Peters, S.A. 5069, Australia. Phone 08–363–0383. Sue Averay, Editor.
Subscription: included in membership (P.O. Box 17, Stepney, 5069). Sample postage. 16p.

ISSN: 0819–2936. Dewey: 745. Formerly: *S.A. Crafts News*.

General. Crafts.

Centers on craft–related issues both local and national, news, and feature articles on projects and theory. International information about exhibitions, conferences, workshops, and articles about developments in crafts practice.

Reviews: exhibition, book, journal, other. yes. Listings: regional–international. Calendar of events. Exhibition information.

Freelance work: yes. Contact: editor. Opportunities: study, competitions.

Advertising: Mailing lists: available fee. Circulation: 500. Audience: members, Crafts Council.

THE SCALE CABINETMAKER: The Modeler's Reference Journal. 1976. q. EN. 1272

Dorsett Publications, Inc., 630 Depot St., P.O. Box 2038, Christiansburg, VA 24073. Phone 703–382–4651. James H. Dorsett, Editor.

Subscription: $22 US & Canada, + $5 foreign. Sample $1.50. Back issues $5.50. Illus. b&w, photos, plans. 9 x 11, 48p.

ISSN: 0145–8213. OCLC: 2792355. LC: TT178.S32. Dewey: 745.59.

Architecture. Crafts. Furniture. Hobbies.

"A journal for the miniaturist" with exclusive focus on the needs of the craftsperson. The core content focuses on tools and workbench technique, with plans and text providing a setting for such information.

Reviews: equipment, length 2–4p. Freelance work: none. Reviewed: Katz.

Advertising. Circulation: 1800. Audience: scale modelers in the miniatures hobby and craftpersons in related hobbies.

SOCIETY OF ORNAMENTAL TURNERS BULLETIN. s–a. EN. 1273

Society of Ornamental Turners, c/o Philip Holden, Sec., 17 Chichester Dr., E, Saltdean, W. Sussex BN2 8LD, England.

Promotes ornamental turning and strives to foster the preservation of ornamental turning lathes.

Demographics: members in 14 countries. Circulation: 300. Audience: skilled and semi–skilled amateurs interested in ornamental and other turning.

SUNSHINE ARTISTS U.S.A. See no. 109.

TOOL & TRADES. 1983. a. EN. FR & GE summaries. 1274

Tool and Trades History Society, 60 Swanley Lane, Swanley, Kent BR8 7JG, England. Phone 322 62271.

Illus.

ISSN: 0266–1756. OCLC: 16850854. LC: TJ1195.T6287. Dewey: 680.9.

Journal of the Society.

TOOL AND TRADES HISTORY SOCIETY NEWSLETTER. q. EN. 1275

Tool and Trades History Society, 60 Swanley Lane, Swanley, Kent BR8 7JG, England. Phone 322 62271.

Promotes awareness and understanding of hand tools.

WCC NEWSLETTER. q. 1276

World Crafts Council, Postobks 2045, DK–1012 Copenhagen K, Denmark. Phone 31 461060.

Crafts.

Affiliated with the American Craft Council.

WEEKLY TIMES MELBOURNE SHEEP AND WOOLCRAFT SHOW. 1878. a. EN. 1277

Australian Sheep Breeders Association Inc., Royal Show Grounds, Epsom Rd., Ascot Vale, Victoria 3032, Australia. Phone 03–376–3733. J.C. Hughes, Editor.

Dewey: 745.5.

Crafts.

WESTART. See no. 280.

WOODWORKER PROJECTS & TECHNIQUES. 1960. q. EN. 1278

Davis Publications, Inc., 380 Lexington Ave., New York, NY 10017. Phone 212–557–9100. Stephen Wagner, Editor.

Dewey: 643. Formerly: *Woodworker*.

Crafts. Hobbies.

WOODWORKING. 1987. bi–m. EN. 1279

Guild of Master Craftsman Publications Ltd., 166 High St., Lewes, E. Sussex, BN7 1XU England. Phone 0273–477374, fax 027–43478606. Eric Bignell, Editor.

Subscription: £17.95, $29.50. Sample. Back issues. Illus. b&w, color, photos, cartoons. A4, 80p.

ISSN: 0951–8789. OCLC: 17541729. LC: NK9700.W661. Formerly: *Woodworking International; Woodworking Crafts Magazine.*

Crafts. Furniture. Historic Preservation. Hobbies. Sculpture. Wood Carving. Wood Turning.

Britain's quality woodworking magazine bought by those who are serious about their craft. Each issue carries articles of interest to everyone who loves wood and working with it. Covers the whole spectrum of woodworking. Presents in depth surveys, a comprehensive guide to what's on the market, with advice on buying to suit individual needs and full specifications and contact addresses. News and reviews includes information on new products backed up by individual test reports.

Reviews: book 1, length 1–2p; exhibition 0–1, length 2–4p.; equipment 1, length 2p. Interviews: with designer/artists/craftsmen. Biographies. Listings: national. Calendar of events. Exhibition information. Freelance work: yes. Contact: editor. Opportunities: study – woodworking and craft courses, competitions. Indexed: Des&ApAI.

Advertising: (rate card '88/89): [+ 15% VAT] full page £816, ½ page £414, ¼ page £218, inside cover £1034; color full page £1040. ½ page £525, covers £1300–1448. Classified: £7.80/scc. Frequency discount. Linda Grace, Ad. Director (phone 0273–478449). Mailing lists: none. Circulation: 30,000. Audience: all kinds of woodworkers, professionals, amateurs and hobbyists.

Ceramics

AMERICAN CERAMIC CIRCLE JOURNAL. 1988, v.6. a. EN. 1280

American Ceramic Circle, P.O. Box 1495, Grand Central Station, New York, NY 10163. Meredith Chilton & Olive Koyama, Editors.

Subscription: $15. Microform available from UMI. Back issues $15 + postage. Illus. b&w, glossy photos. 7 x 10, 102p.

ISSN: 0899–806X. OCLC: 18229842. LC: NK3700.A58. Formerly: *American Ceramic Circle Bulletin.*

Ceramics.

Scholarly research which includes charts and statistics.

AMERICAN CERAMICS. 1982. q. EN. 1281

American Ceramics, 15 W. 44 St., New York, NY 10036. Phone 212–944–2180. Michael McTwigan, Editor.

Subscription: $28 US, + $5 Canada, + $20 elsewhere. Back issues $9, Canada + $1.25, elsewhere + $5. Illus. b&w, color. 8½ x 11 x 10¾, 64p.

ISSN: 0278–9507. OCLC: 7938825. LC: NK4005.A46. Dewey: 730.

Ceramics.

Ceramics magazine covering aesthetic, philosophical and social issues.

Reviews: book 2, length 2p., exhibition 7, length ½p. each. Interviews. Indexed: ArtBibMod. ArtI. BioI. Des&ApAI. Reviewed: Katz.

Advertising. Circulation: 6,000.

AMERICAN WILLOW REPORT. 1987. bi–m. EN. 1282

1733 Chase St., Cincinnati, OH 45223. Phone 513–541–2013. Connie Rogers, Editor.

Subscription: $15. Annual index. 8½ x 11, 16p.

Ceramics. Collectibles.

Newsletter reports on willow–pattern china. Presents information regarding its history and collecting.

Advertising: 8 1/2 x 11, 16p. Advertising: Classified Ads. Circulation: 500. Audience: collectors of Willow–Pattern china.

BRITISH CERAMIC. 1984. bi–m. EN. 1283

Institute of Ceramics, Shelton House, Stoke Rd., Shelton, Stoke–on–Trent ST4 2DR England. Phone 0782 202116. W.F. Ford, Editor.

Illus.

ISSN: 0266–7606. OCLC: 11244783. LC: TP785.B685. Formerly: *Transactions and Journal of the British Ceramic Society.*

Ceramics.

Indexed: CerAb.

CANADIAN CERAMICS QUARTERLY: Incorporating Journal of the Canadian Ceramic Society. 1985. q. EN. **1284**

Canadian Ceramic Society, 2175 Sheppard Ave. E., Suite 110, Willowdale, Ontario M2J 1W8 Canada. Phone 416-469-4257. illus.

ISSN: 0831–2974. OCLC: 12642673. LC: TP786.C35. Dewey: 338.4. Formed by the merger of: *The Ceramic Hobbyist*, and *Canadian Clay & Ceramics Quarterly*.

Ceramics. Pottery.

Continues as a section the *Journal of the Canadian Ceramic Society*. The summer issue is the annual *Directory and Buyers' Guide*.

Indexed: CerAb.

Audience: ceramists — technical and scientific.

CERAMIC PROJECTS. 1963. q. EN. **1285**

Scott Advertising & Publishing Co., 30595 W. 8 Mile Rd., Livonia, MI 48152. Phone 313–477–6650. Bill Thompson, Editor. Microform available from UMI.

Dewey: 666. Formerly: *Ceramic Teaching Projects and Trade News; Ceramic Trade News & Catalog File.*

Ceramics.

Reviews: book. Reviewed: Katz.

Advertising.

CERAMIC SCOPE. 1964. bi–m. EN. **1286**

L. Copland Jr., Publisher, 700 Orange St., Wilmington, DE 19899. Phone 302–656–2209. Michael Scott, Editor (3632 Ashworth N., Seattle, WA 98103).

Subscription: $9.75 US, $23.75 Canada & foreign includes annual *Ceramic Scope Buyer's Guide*. Sample $2. Back issues $2.50. Illus b&w, photos. 8½ x 11, 48p.

ISSN: 0009–0247. OCLC: 4028547. Dewey: 738.

Ceramics.

Trade magazine presenting business information for those in the hobby ceramic arts field.

Listings: national. Calendar of events. Exhibition information. Freelance work: yes. Contact: Christine Yarrow. Opportunities: study.

Advertising: full page $700, ½ page $460, ¼ page $285; color rates on request. Classified: 50¢/wd. Frequency discount. David Smith, Ad.Director. Mailing lists: available to advertisers only. Circulation: 14,000+. Audience: hobby ceramic studios, shopowners, distributors, teachers and other suppliers.

CERAMIC STUDY GROUP NEWSLETTER. 1960. 10/yr. EN. **1287**

Ceramic Study Group, c/o Mrs. Thelma Delaney, G.P.O. Box 5239, Sydney, N.S.W. 2001, Australia. Robyn Morris, Editor. Dewey: 738.

Ceramics.

CERAMIC WORLD. 1971. m. EN. **1288**

Daisy Publishing Inc., Box 67A, Mukilteo, WA 98275–0067. Dale Swant, Editor. Illus. color. 5½ x 8½, 208p.

ISSN: 0748–304X. OCLC: 10921187.

Ceramics. Hobbies.

Presents material on how–to–do ceramics for hobbyists.

Advertising.

CERAMICA (Brazil). 1954. m. **1289**

Associacao Brasileira de Ceramica, Caixa Postal 30327, 01051 San Paulo, Brazil. Subscription: $90. Illus.

ISSN: 0366–6913. Dewey: 666.

Ceramics.

Reviews: book.

Advertising.

CERAMICA (Spain). q. SP. 1290
Antonio Vivas, Paseo Acacias 9, 28005 Madrid, Spain.
Subscription: $19.51 Spain, $26.01 elsewhere.
Indexed: ArtBibMod.

CERAMICS ART AND PERCEPTION. 1990 (Sept). q. EN. 1291
35 William St., Paddington NSW 2021 Australia.
Subscription: $36.17.
Ceramics.

CERAMICS MAGAZINE. 1963. m. (bi-m May/June & Nov/Dec). EN. 1292
Scott Advertising & Publishing Co., 30595 West 8 Mile Rd., Livonia, MI 48152. Phone 313-477-6650. Bill Thompson, Editor.
Illus. b&w, some color.
ISSN: 1041-1305. OCLC: 18664829. LC: TT919.C47. Dewey: 738. Formed by the merger of: *Ceramic Teaching Projects* and, *Ceramics* (Fresno, CA).
Ceramics.
Indexed: ArtBibMod.

CERAMICS MONTHLY. 1953. m. Sept–June. EN. 1293
Professional Publications, Inc., Box 12448, 1609 Northwest Blvd., Columbus, OH 43212. Phone 614-488-8236, fax 614-488-4561. William C. Hunt, Editor.
Subscription: $22 US, + $10 outside US. Microform available from UMI, BLH. Sample & back issues $4. Illus. b&w, some color, photos (100/issue). Index in Dec issue. Cum. subject index 1953–72, $1.50. 8½ x 11, 88p.
ISSN: 0009-0328. OCLC: 1553732. LC: TP785.C44. Dewey: 666.
Ceramics. Pottery.

Features handmade pottery and ceramic art including porcelain, stoneware, and sculpture. Focus is on contemporary American ceramics but also presents international and historical material. Listings provide deadline date, contact person and fee. April issue contains "Summer Workshop" with national and international listings arranged by state and city. Also contains news.
Reviews: book 3, length 1p. Bibliographies: "New Books". Obits. Listings: regional–international. "Itinerary" — conferences, exhibitions, fairs (juried, national & international), workshops and other events to attend. Freelance work: yes. Contact: editor. Booklet describing standards and procedures available on request (details also in *PhMkt.*). Opportunities: "Where to Show". Indexed: ArtBibMod. ArtI. BioI. CerAb. Des&ApAI. Reviewed: Katz. Katz. *School.*
Advertising b&w. Classified: 90¢/wd., min. $13.50. Connie Belcher, Ad. Manager. Circulation: 34,200. Audience: both professional and amateur potters.

CFI. CERAMIC FORUM INTERNATIONAL: Bereichte der Deutschen Keramischen Gesellschaft. 1980. bi-m. GW & EN (side by side). 1294
Bauverlag GmbH, P.O. Box 1460, D-6200 Wiesbaden, W. Germany. Phone 0 61 21-791-0. S. Fanzott, Editor.
Illus. b&w, some color.
ISSN: 0173-9913. OCLC: 7014171. LC: TP785.D23. Dewey: 666. Formerly: *Berichte Deutsche Keramische Gesellschaft.*
Ceramics.

Official journal of the German Ceramic Society. Bilingual presentation of ceramic research and information for the ceramic industries.
Bibliographies. Calendar of events.

CRESTED CIRCLE. 1980. bi-m. EN. 1295
c/o F. Owen, 26 Urswick Rd., Dagenham, Essex RM9 6EA, England.
Subscription: ¢4.
ISSN: 0262-7140. Dewey: 745.5.
Collectibles.

A magazine for collectors of the products of the Crested China Manufacturers.
Reviews: book.
Advertising.

ENGLISH CERAMIC CIRCLE TRANSACTIONS. 1933. a (vol. consists of 3 numbers issued over 3 yr. pe-
riod, latest v.13, 1987–89). EN. **1296**
English Ceramic Circle, c/o Mrs. J. Bennett, Secy., 5 The Drive, Beckenham, Kent BR3 1EE, England. John Howell, Editor.
Illus. b&w, few color, photos (140 plates, plates full page, may contain more than one photo/plate). Index. 5¾ x 9½, 250+p.
ISSN: 0071–0547. LC: NK3700.E58. Dewey: 666. Formerly: *English Porcelain Circle Transactions.*
Ceramics.

Scholarly papers related to pottery presented to the Circle.
Obits. Indexed: ArtArTeAb. BrArchAb. RILA.
Advertising: none.

FAENZA: Rivista Bimestrale di Studi di Storici e di Tecnica dell'Arte Ceramica.
1913. bi–m. IT. EN, FR, GE summaries. **1297**
Museo Internazionale delle Ceramiche, Via Campidori 2, 48018 Faenza, Italy. Gian Karlo Bojani, Editor.
Subscription: L 30.000, $US23.76. Illus., plates, mostly b&w, some in color, glossy photos. 94p. + 24p. plates.
ISSN: 0014–679X. OCLC: 1018405. LC: NK3700.F25.
Studies on the art and technology of ceramics.
Reviews: book. Indexed: ArtArTeAb. BHA. RILA.
Advertising.

FENESTRATION. 1987. bi–m. EN. **1298**
Ashlee Publishing Co., Inc., 310 Madison Ave., New York, NY 10017. Phone 212–682–7681. John Swanson, Editor.
Dewey: 666.
Ceramics.

FLASH POINT. 1988. q. EN. **1299**
Tile Heritage Foundation, P.O. Box 1850, Healdsburg, CA 95448. Phone 707–431–8453. Joseph A. Taylor, Editor.
Subscription: included in membership, $20, $30 air. No sample. Back issues $5. Illus. b&w, photos. 8½ x 11, 12p.
Ceramics. Crafts. Historic Preservation. Interior Design.

With emphasis on people, places and special events, the bulletin of the Foundation covers both current and historic informa-
tion about tile and other ceramic surfaces. In addition to three major features, each issue includes an historical quiz, a brain-
teaser entitled "Quarter Round", a listing of recent publications and an assortment of news items. The purpose of the
publication is to promote an awareness and appreciation of ceramic surfaces in the United States.
Biographies: personal histories of people prominent in the industry, past and present. Listings: national. Calendar of tile re-
lated exhibitions. Freelance work: yes. Contact: editor. Opportunities: employment, study, competitions. Reviewed: *Art Docu-
mentation* Fall 1988, p.106.
Advertising: none.

GLASS, POTTERIES AND CERAMIC ANNUAL. 1970. a. EN. **1300**
Praveen Corp., Sayajiganj, Baroda 390005, India. C.M. Pandit, Editor.
Dewey: 745.5. Formerly: *Glass, Potteries and Ceramic Journal.*
Ceramics. Glass. Pottery.

GLASS REVIEW. See no. 1372.

GLAZED EXPRESSIONS. 1981. s–a. EN. **1301**
Tiles & Architectural Ceramics Society, 68–70 South Hill Park, Flat 2, London NW3 2SL, England. Phone 071–794–1369.
Helene Curtis & Carolyn Wraight, Editors.
Subscription: £18 individuals, £6 senior citizens & students, £25 institutions, £15 Europe, overseas £18 individual, £25 insti-
tutions (Kathryn M. Huggins, Membership Sec., Reabrook Lodge, 8 Sutton Rd., Shrewsbury, Shopshire SY2 6DD). No sam-
ple. Back issues. Illus b&w, photos, cartoons. Index in no.18, addends only in subsequent issues. 30 x 21 cm., 12p.
ISSN: 0261–0329. OCLC: 13801272. LC: NK4670.G6.
Ceramics.

The bulletin of the national society responsible for the study and protection of tiles and architectural ceramics. The purpose of
the Society is to represent the collector, historian, craftsmen and conservator interested in any decorative ceramics relating to
buildings; to promote the retention and careful restoration of ceramics in architecture and the study of the history of tiles and

architectural ceramics. The context is both historical and contemporary, art and craft. Identification of tile backs is a unique and regular feature. Concerned with taking a broad view of the subject. Provides illustrated information on historical designs, manufacturers and buildings as well as highlighting the work of modern manufacturers and craftsmen. Draws attention to buildings incorporating important architectural ceramics which may be under threat. Also contains articles on major new topics.

Reviews: book 1–2, exhibition occasionally. Freelance work: yes, unpaid basis. Contact: editor. Indexed: Avery. Des&ApAI. Advertising: none. Circulation: 300–400. Audience: members, academics, collectors, historians, manufacturers, architects, draftsmen, conservators, and craftsmen interested in decorative ceramics relating to buildings.

GROUPE INTERNATIONAL D'ETUDE DE LA CERAMIQUE EGYPTIENNE. BULLETIN DE LIAISON. 1975. a. EN, FR & GE. 1302

Institut Francais d'Archeologie Orientale du Caire, 37 rue el Cheikh Aly Youssef, Mounira, Cairo, Egypt. Helen Jacquet–Gordon, Editor.
ISSN: 0255–0903. Dewey: 745.5.
Ceramics.

L'INDUSTRIE CERAMIQUE: Revue des Materiaux de Construction (edition B) et Largile Reunies. 1947. m. FR. Some issues also in EN. 1303

Septima, 14 rue Falguiere, 75015 Paris, France.
Subscription: 850 F.
ISSN: 0019–9044. OCLC: 2447612.
Ceramics.

Covers the entire ceramic field.
Indexed: CerAb.

JOURNAL OF THE CERAMIC SOCIETY OF JAPAN/YOGYO KYOKAISHI. 1950. m. JA, EN. 1304

Ceramic Society of Japan – Yogyo Kyokai, 2–22–17 Hyakunin–cho 2–chome, Shinjuku–ku, Tokyo 160, Japan. Tatsuo Ohba, Editor.
Illus.
ISSN: 0009–0255. OCLC: 10351149. Dewey: 666. Formerly: *Yogyo Kyokai Zasshi.*
Ceramics.

Advertising.

KADAROT. a. HE. 1305

Association of Ceramic Artists in Israel, 7 Gertz St., Tel Aviv, Israel. Phone (03)245171. Y. Blumenthal, Editor.
Dewey: 666.
Ceramics.

KERAMIKOS: International Ceramics Magazine. 1987. bi–m. IT & EN. 1306

Alberto Greco Editore, Via del Fusaro 8, 20146 Milan, Italy. Phone 02–4819086. Francesco Coppola, Editor.
Subscription: $80 US & Canada. Sample. Back issues $25. Illus., mainly color. 240 x 330 mm.
ISSN: 1120–2394. OCLC: 22037646. Dewey: 666. Formerly: *K.*
Architecture. Ceramics. Modern Art.

"Storia, architettura, arte, arredamento, design, technologia".
Advertising: full page L 3.300.000, ½ page L 2.600.000, color rates + 50%. Circulation: 25,000.

KERAMISCHE ZEITSCHRIFT: Technik – Wissenschaft – Kunst. 1949. m. GE. EN & FR summaries. 1307

Verlag Schmid GmbH (Freiburg), Hartkirchweg 25, Postfach 1722, 7800 Freiburg, W. Germany. Hubertus Reh, Editor.
Subscription: DM 255, air DM 315. Illus.
ISSN: 0023–0561.
Ceramics.

Covers all aspects of the ceramics industry, technology, science and art. Presents the latest information on research and technology, manufacturing, fine ceramic art and decor, tableware, and new products. List of suppliers is included.

THE MANDARIN'S PURSE. s–a. EN. 1308

c/o Conrad Biernacki, Chairman, 39 Medhurst, Toronto, Ontario M4B 1B2 Canada, 416–757–0634.
Devoted to Willow pattern china designed by Josiah Spode in the early 19th century.
Audience: antique dealers and collectors.

NCECA JOURNAL. 1980. a. EN. 1309

National Council on Education for the Ceramic Arts, Dickinson College, Carlisle, PA 17013. Linda Mosley, Editor.
Subscription: included in membership, $30 US, + $5 Canada & foreign (Regina Brown, Exec. Sec., Box 1677, Bandon, OR 97411). Illus. 8½ x 11, 64p.
ISSN: 0739–1544. OCLC: 8586739. LC: NK4005.N37. Dewey: 738.
Art Education. Ceramics. Pottery.

A compilation of writings by and for the members of Council, the contents present a record of events at the annual conference.
Reviewed: Katz.
Advertising: none. Circulation: 3400.

NCECA NEWS. 1977. q. EN. 1310

National Council on Education for the Ceramic Arts, Dickinson College, Carlisle, PA 17013.
Subscription: included in membership together with *NCECA Journal*. Illus.
ISSN: 0739–1552. OCLC: 15515862. Dewey: 745.5. Formerly: *NCECA Newsletter*.
Art Education. Ceramics. Pottery.

Membership newsletter includes news of members, information about the annual conference, and other NCECA activities.
Obits. Freelance work: yes. Contact: editor. Opportunities: employment, study.
Audience: members.

NOTIZIARIO DEL CENTRO ITALIANO SMALTI PORCELLANATI. 1981. s–a. IT. EN short summa-
ries. 1311

Centro Italiano Smalti Porcellanati, Via Melchiorre Gioia 66, 21025, Milan, Italy.
Illus., some color.
ISSN: 0392–6648. OCLC: 9337311. LC: TS700.C37. Dewey: 666.2. Formerly: *Notiziario*.
Devoted to the art of enameling.

POPULAR CERAMICS. 1949. m. EN. 1312

Popular Ceramics Publications, Inc., 3639 San Fernando Rd., Glendale, CA 91204–2989. Phone 818–246–8141. Terry O'Neill, Editor & Pub.
Subscription: $17.60 US, + $6 postage Canada. Microform available from UMI. Sample. Back issues $1.50. Illus. 94p. Web Offset. Saddle–stitched.
ISSN: 0032–4477. OCLC: 2253333. LC: TP785.P65.
Ceramics. Hobbies.

Over 20 short articles describing ceramic projects and techniques. Projects are coded to indicate a simple easy and quick project; an intermediate project for those with some experience; advanced projects for experienced workers; and time necessary to complete project.
Calendar of events in Jan issue. Freelance work: yes. Contact: editor.
Advertising: (rate card): b&w full page $622, ½ page $470–510, ⅙ page $228; 4 color full page $1242, ½ page $659; covers & special positions + 15%. Classified: (payment with order) 90¢/wd., 15 wd. min. 15%. Frequency discount. 15% agency discount. 2% cash discount. Evie Williams, Ad. Director (phone 1–800–654–3296). Circulation: 42,000. Audience: ceramic hobby craft, serious hobbyist and studio owner.

PRACE: CERAMIKA. 1969. irreg. POL, some articles also in EN. EN, POL, or RU summaries. 1313

Ossolineum, Publishing House of the Polish Academy of Sciences, Rynek 9, Warsaw, Poland. (Dist.: Ars Polona–Ruch, Krakowskie Przedmiescie 7, Warsaw). Roman Pampuch, Editor.
Illus.
ISSN: 0079–3264. OCLC: 12658336. Dewey: 666.

DIE SCHAULADE. 1925. m. GE. 1314

Meisenbach GmbH, Hainstrasse 18, Postfach 2069, d–8600 Bamberg, W. Germany. Phone 0951–8610, fax 0951–861–158, telex 662844 meiba d. H. Dirr, Editor.

Subscription: DM 110. Illus.

ISSN: 0036–5947. OCLC: 6428903. LC: NK3.S355. Dewey: 666. Formerly: *Schaulade; Ausg. A. Schaulade; Ausg. B.*

Ceramics.

Independent international trade magazine for china, ceramics, glass, giftware, applied art, living accessories and household articles.

Advertising. Andrea Jauernik, Ad. Director.

SERAMIKKUSU/CERAMICS JAPAN: Bulletin of the Ceramic Society of Japan.

1966. m. JA. EN table of contents. 1315

Ceramic Society of Japan – Yogyo Kyokai, 2–22–17 Hyakunin-cho 2–chome, Shinjuku–ku, Tokyo 160, Japan. Phone 011/81/3/2789223, fax 274/2270. Tatsuo Ohba, Editor.

Subscription: 18,000 Yen. Illus.

ISSN: 0009–031X. OCLC: 11570349. LC: TP785.C43. Dewey: 666.

Ceramics.

Indexed: CerAb.

SOCIETY OF GLASS AND CERAMIC DECORATORS ANNUAL PROGRAM. a. EN. 1316

Society of Glass and Ceramic Decorators, 207 Grant St., Port Jefferson, NY 11777. Phone 516–473–0232. Frank S. Child, Editor.

Subscription: included in membership.

Ceramics. Glass.

Purposes: to advance the profession of glass and ceramic decorating and to advance the theory and practice of glass and ceramic decorating and the applied arts. Lists speakers and subjects of Society's annual seminar.

SOCIETY OF GLASS AND CERAMIC DECORATORS NEWSLETTER. 1961. m. EN. 1317

Society of Glass and Ceramic Decorators, 207 Grant St., Port Jefferson, NY 11777. Phone 516–473–0232. Frank S. Child, Editor.

Ceramics. Glass.

Contains news of the ceramics industry, legislative developments and Society news.

Advertising.

SOCIETY OF GLASS AND CERAMIC DECORATORS PROCEEDINGS. 1961. a. EN. 1318

Society of Glass and Ceramic Decorators, 207 Grant St., Port Jefferson, NY 11777. Phone 516–473–0232. Frank S. Child, Editor.

Subscription: Included in seminar registration fee, $25, non–members $100.

Formerly: *Society of Glass Decorators. Papers Presented at Annual Seminar.*

Ceramics. Glass.

Reports on recent seminars.

SPRECHSAAL. 1868. m. GE. EN summaries. 1319

Sprechsaal–Verlag, Mauer 2, Postfach 401, D–8630 Coburg, W. Germany. Christoph Mueller, Editor.

Subscription: DM 292 Germany, DM 360 else. Illus.

ISSN: 0341–0676. Dewey: 745.5. Formerly: *Sprechsaal fuer Keramik, Glas, Baustoffe; Sprechsaal fuer Keramik, Glas, Email, Silikate.*

Ceramics. Crafts. Glass.

A international forum for ceramics and glass crafts.

STONE WORLD. 1984. mm. EN. 1320

Tradelink Publishing Co., Inc., 485 Kinderkamack Rd., Oradell, NJ 07649. Phone 201–599–0136. M. Lench, Editor.

8½ x 11, 55p.

Dewey: 666.6.

Advertising.

STUDIO POTTER. See no. 1348.

TABLEWARE INTERNATIONAL. 1970. m. EN. 1321

Aggus Business Publications Ltd., Queensway House, 2 Queensway, Redhill, Surrey, RH1 1QS, England. Phone 0–737–768611. Eric Ickinger, Editor.
Subscription: $75 US, $US75 Canada. Sample. Back issues. Illus. b&w, color, photos. A4, 80p.
ISSN: 0143–7755. OCLC: 4375547. LC: TP785.T113. Dewey: 666. Formerly: *Pottery Gazette and Glass Trade Review; Tableware International and Pottery Gazette.*

Ceramics. Glass. Pottery. Tableware.

The foremost international business magazine published for major buyers of tableware, housewares and quality giftware in the following product categories: china, porcelain, earthenware, stoneware, glassware, cutlery, metal tableware, napery, tableware accessories, giftware, houseware/gourmet products, figurines and art pieces. Regular contents include: up to date news from all corners of the tabletop world; exhibition previews; new products; retail focus—major retailer analyses market development, consumer trends and merchandise innovation; and detailed assessments of companies, retailers and suppliers who have achieved considerable advances. Annual *European Tableware Buyers' Guide* issued in Dec.
Reviews: book. Listings: international. Freelance work: yes. Contact: editor. Opportunities: conference: Frankfort (Feb), Tokyo (May). Indexed: ArtBibMod.
Advertising: full page $1875, ½ page $1060, ¼ page $635; color full page $2950, ½ page $1900. 10–15% frequency discount. John De Bone, Ad. Director. Mailing lists: available mailing by publisher only. Demographics: English speaking world, 78 countries (37% UK, 31% US, 18% Europe, 4% Canada). Type of outlet: 72% independent speciality shops, 12% department stores, 8% multiple chains. Promoted to new retail buyers by selective free circulation. Distributed at all major trade shows. Circulation: 9,500. Audience: buyers–specialist shops and dept. stores.

TRADE NEWS. m. EN. 1322

Ceramics International Association, Box 1589, Rte. 2, McAllen, TX 78504. Phone 512–686–4408.
Subscription: included in membership.

Ceramics.

Newsletter covers developments in the ceramics field, containing items on ceramic techniques, suggestions for ceramic instruction, reports on association competitions and programs.
Calendar of events.

VICTORIAN CERAMIC GROUP NEWSLETTER. 1969. m. EN. 1323

Victorian Ceramic Group, Box 4096, Spencer St., Melbourne, Victoria 3001, Australia. R. Hughan, Editor.
Dewey: 745.5.

Ceramics.

Reviews: book.
Advertising.

THE VITREOUS ENAMELLER. 1969. q. EN. 1324

Institute of Vitreous Enamellers, Ripley, Nr. Derby DE5 3EB, England. Phone 0773–43136. T.S. Lardon, Editor.
Illus.
ISSN: 0042–7519. OCLC: 9531041. Formerly: *Institute of Vitreous Enamellers. Bulletin.*
"Bulletin of the Institute of Vitreous Enamellers".
Audience: included in membership, non–members £19.

WEDGWOOD INTERNATIONAL SEMINAR. 1956. a. EN. 1325

Wedgwood International Seminar, c/o Dolores Martin, President, 12526 Martindale Rd., Houston, TX 77048. Phone 713–991–2608. Alison Kelly, Editor.
Subscription: included in membership. Illus.
OCLC: 11938606. LC: NK4335.W43.

Ceramics. Collectibles.

Multinational organization consisting of societies of Wedgwood collectors specializing in 18th–20th century Wedgwood ceramics. The Proceedings contain transcripts of the lectures delivered at the annual seminar. Each volume published by the institution hosting that year's seminar.
Advertising: none. Audience: collectors.

WILLOW EXCHANGE. a. EN. 1326

Willow Society, c/o Conrad Biernacki, Chairman, 39 Medhurst, Toronto, Ontario M4B 1B2 Canada. Phone 416–757–0634.

LC: NK4277. Dewey: 738.2.

Ceramics. Collectibles.

Devoted to Willow pattern china.
Audience: collectors.

WILLOW TRANSFER QUARTERLY. 1983. q. EN. 1327

Willow Society, c/o Conrad Biernacki, Chairman, 39 Medhurst, Toronto, Ontario M4B 1B2 Canada. Phone 416–757–0634.
Illus.
ISSN: 0826–2098. OCLC: 11564254. LC: NK4277. Formerly: *Willow Notebook*.
Devoted to Willow pattern china.
Audience: collectors.

Pottery & Porcelain

ABINGDON POTTERY CLUB NEWSLETTER. q. EN. 1328

Abingdon Pottery Club, c/o Mary Alice Anderson, 664 Peck, Galesburg, IL 61401. Phone 309–343–9306.
Pottery.

Promotes collection of and historical interest in Abingdon pottery.

AMERICAN CLAY EXCHANGE. 1980. s–m. EN. 1329

Page One Publications, Box 2674, La Mesa, CA 92041. Phone 619–697–5922. Susan N. Cox, Editor.
Subscription: $21 individual, $16.80 institution. Back issues. Cum. index 1980–85. 8½ x 11, 16p.
ISSN: 0739–6546. OCLC: 9787420. Dewey: 666.
Antiques. Pottery.

Newsletter on American made pottery with special focus on antiques and collectibles.
Advertising: full page $120, no color.

ARS CERAMICA. 1984. a. EN. 1330

Wedgwood Society of New York, 5 Dogwood Court, Glen Head, NY 11545.
Subscription: included in membership together with *Wedgwood Society of New York Newsletter*, $30 US, + $2.50 Canada & foreign. Illus.
ISSN: 1043–3317. OCLC: 12203891. Dewey: 738.
Pottery.

CAHIERS DE LA CERAMIQUE, DU VERRE ET DES ARTS DU FEU. 1955. q. FR. EN summaries. 1331

Editions des Cahiers de la Ceramique, B.P 5, 75562 Paris Cedex 12, France. Bernard Pernes, Editor.
Subscription: 180 F. Illus., some color, plates.
ISSN: 0007–9790. OCLC: 2097638. LC: NK3700.C13. Dewey: 738.
Glass. Pottery.

Covers the history and technology of French pottery. Includes coverage of glass.

CERAMIC REVIEW. 1970. bi–m. EN. 1332

Craftsmen Potters Association of Great Britain Ltd., 7 Marshall St., London W1V 1FD, England. Phone 071–439 3377. Eileen Lewenstein & Emmanuel Cooper, Editors (21 Carnaby St., London W1V 1PH).
Subscription: £21. No sample. Back issues. Illus b&w, color, photos. Annual index. A4, 52p.
ISSN: 0144–1825. OCLC: 985987. LC: TP808.C47. Dewey: 738.
Crafts. Pottery.

Promotes production of high quality hand–made pottery, particularly work of original design and individual character.
Reviews: book 4, length 200–700 wds. Interviews: with living potters, focusing on their work and techniques. Biographies: with living potters, in greater depth than interviews. Obits. Listings: regional–international. Calendar of events. Exhibition information. Freelance work: occasionally. Contact: editor. Opportunities: employment, study, competitions. Indexed: ArtBibMod. ArtI. BioI. Des&ApAI. Reviewed: Katz.

Advertising: full page £480, ½ page £250, ¼ page £135; color full page £600, ½ page £450; covers + 20–25%. Classified: £6.50/20 wds. + 30p/wd. add. 15% frequency discount. Inserts. Daphne Matthews, Ad. Director. Mailing lists: none. Demographics: distributed mainly by direct subscription to professional and amateur potters, art colleges, school, etc. through out the U.K. and worldwide. Circulation: 9,500. Audience: potters/ceramists and all interested in the craft.

COLOUR PRINTED POTTERY COLLECTORS ASSOCIATION NEWSLETTER. q. EN. 1333
Colour Printed Pottery Collectors Association, 15 Arden Rd., Nuneaton, Warwickshire, England.
Collectibles. Pottery.
Devoted to the collection of underglaze color picture prints of Staffordshire pot lids, plates, jars, and boxes.
Audience: collectors.

GEISHA GIRL PORCELAIN NEWSLETTER. 1982. bi–m. EN. 1334
P.O. Box 394, Morris Plains, NJ 07950. Elyce Litts, Editor & Pub.
Subscription: $12. Illus. 8 1/2 x 11, 8p.
ISSN: 8756–9213. OCLC: 11669901. LC: NK4399.G45 G44. Dewey: 738.2.
Pottery.
Covers all aspects of this porcelain, its history, patterns, markings, and collection.
Circulation: 120.

GOEBEL COLLECTORS' CLUB - INSIGHTS. q. EN. 1335
Goebel Collectors' Club, P.O. Box 11, Pennington, NJ 08534. Phone 609–737–8777.
Subscription: included in membership.
Collectibles. Porcelain.
Provides information on the collection of Hummel figurines and fine porcelain manufactured by the Goebel Company. Includes news of the Club and the members.
Calendar of events.

INCC NEWSLETTER. q. EN. 1336
International Nippon Collectors Club, PO Box 230, Peotone, IL 60468. Phone 312–258–6105.
Collectibles. Porcelain.
Devoted to Nippon porcelain, the hand–painted chinaware manufactured in Japan from 1891–1921.
Advertising. Audience: collectors.

INTERNATIONAL PORCELAIN ARTIST NEWS. bi–m. EN. 1337
International Porcelain Artist, 4125 NW 57th, Oklahoma City, OK 73112. Phone 405–946–7121.

KERAMIK-FREUNDE DER SCHWEIZ. MITTEILUNGSBLATT. 1946. q. EN, FR, GE & IT. 1338
Schweizerisches Landesmuseum, Zurich, Switzerland. Rudolf Schnyder, Editor.
Subscription: included in membership. Illus. b&w, some color.
ISSN: 0023–0553.
Bulletin of the Ceramic Friends of Switzerland.
Indexed: ArtBibMod.

NEW ZEALAND POTTER. 1958. 3/yr. EN. 1339
New Zealand Potter Publications Ltd., P.O. Box 881, Auckland, New Zealand. Howard Williams, Editor (P.O. Box 147, Albany, Auckland).
Sample & some back issues $NZ5. Illus. b&w, color, photos, cartoons. Cum. index. A4, 40p.
ISSN: 0113–583X. LC: NK3700.N48. Dewey: 745.5.
Ceramics. Crafts. Hobbies. Pottery.
Reviews and commentaries on major New Zealand ceramics, exhibitions, awards. Profiles of individual ceramists and potters, their work and philosophies. Technical articles on ceramics, production, materials, kilns, techniques, and aesthetics. Profiles of pottery shops, galleries and co–operatives. News from potters in New Zealand and overseas.
Reviews: exhibition, book, equipment, other. Biographies: potters' profiles. Listings: national, some international. Calendar of events. Exhibition information. Freelance work: yes. Contact: editor. Opportunities: employment; study—national conventions, workshops, college and schools students courses; competitions. Indexed: Des&ApAI.

Advertising: (camera–ready copy required) b&w full page $NZ485, ½ page $NZ295, ¼ page $NZ179; color full page $NZ759, ½ page $NZ550. Classified: $NZ.55/wd., min. 10 wds. Cecilia Parkinson (P.O. Box 147, Albany, Auckland). Mailing lists: none. Circulation: 6000. Audience: studio potters, ceramic artists, collectors, students, etc.

THE OFFICIAL PRICE GUIDE TO POTTERY & PORCELAIN. See no. 76.

POTTERS' SOCIETY OF AUSTRALIA NEWSLETTER. 1971. m. EN.

1340

Potters' Society of Australia, 2/68 Alexander St., Crows Nest, Sydney, NSW 2065, Australia.
Dewey: 745.5.

Crafts. Pottery.

Newsletter of the Society.
Audience: professional potters and others interested in Australian ceramics.

POTTERY IN AUSTRALIA. 1962. q. EN.

1341

Potters' Society of Australia, 2/68 Alexander St., Crows Nest, Sydney, NSW 2065, Australia. Phone 02–436–1681. Janet Mansfield, Editor.
Subscription: $US 40 US, $C40 Canada, foreign $US40, air + $US70. Sample $2. Back issues $8. Illus. b&w, color, photos. 108p.
ISSN: 0048–4954. OCLC: 6597481. LC: TT919.P65. Dewey: 745.5.

Pottery.

Reviews: exhibition, book, equipment. Bibliographies. Interviews. Biographies. Listings: national–international. Calendar of events. Exhibition information. Freelance work: yes. Contact: editor. Opportunities: employment, study, competitions. Indexed: Des&ApAI.
Advertising: full page $330, ½ page $220, color full page $550. Frequency discount. Glenys Waller, Ad. Director. Mailing lists: available $500. Circulation: 5000. Audience: all interested in ceramics.

POTTERY SOUTHWEST. 1974. q. EN.

1342

Albuquerque Archaeological Society, 6207 Mossman Place, N.E., Albuquerque, NM 87110. Phone 505–881–1675. William M. Sundt & Wolky Toll, Editors.
Subscription: $3 US & Canada, $6 air. Sample. Back issues $3/vol. Illus. b&w, photos, cartoons. Cum. index in vol. 13, no.1. 8½ x 11, 7p.
ISSN: 0738–8020// 913. OCLC: 8047616. LC: E98.P8P67.

Archaeology. Pottery.

News, queries and views on archaeological ceramics by Southwesterners.
Reviews: book 1, journal 1. Bibliographies with each article. Listings: regional. Calendar of exhibitions. Freelance work: yes but no fee paid. Contact: Wolky Toll. Opportunities: study, competitions.
Advertising: none. Circulation: 200. Audience: Southwesterners, archaeologists.

Q.P.A. NEWS. 1968. m. EN.

1343

Queensland Potters Association, P.O. Box 231, Broadway, Qld. 4006, Australia. Phone 07–358–5121. Gillian Ksiazek, Editor.
Subscription: included in membership. Sample free. Some back issues, free. Illus. b&w, photos. A4, 11p.
ISSN: 0728–0858.

General. Crafts. Decorative Arts. Juvenile.

Provides members with information on current events within the organization as well as within the Arts and Crafts field. Also provides technical information.
Reviews: exhibition 1, length 1p.; book occasionally. Listings: regional & national. Exhibition information. Freelance work: none. Opportunities: employment, workshops, competitions.
Advertising: full page $150, ½ page $90, ¼ page $50, no color. Classified: $2/2 lines, members only. No frequency discount. Mailing lists: none. Circulation: 800. Audience: membership and libraries.

REAL POTTERY. 1954. irreg. EN.

1344

Northfields Studio, Tring, Herts. HP23 5QW, England. Phone Aldbury Common 229. Murray Fieldhouse, Editor.
Subscription: £7.50, £6.55 trade; $16, $14 trade. Microform available from UMI. Sample. Illus. Index every fourth issue.
ISSN: 0032–5678. OCLC: 16847177. LC: NK3700.P86. Formerly: *Pottery Quarterly*.

Crafts. Pottery.

A review of crafts pottery.

Advertising: Entry in *Buyers Guide* available, free in appropriate cases at discretion of editor. Circulation: 2000. Audience: craft potters, serious amateurs and professionals.

SCOTTISH POTTERY HISTORICAL REVIEW. 1980. a. EN. 1345
Scottish Pottery Society, c/o Mr. Graeme Cruickshank, 21 Warrender Park Terrace, Edinburgh, Scotland.
ISSN: 0144–1302. Dewey: 745.5.
Pottery.

Reviews: book.
Advertising.

SCOTTISH POTTERY STUDIES. 1982. irreg. EN. 1346
Scottish Pottery Society, c/o Graeme Cruickshank, 21 Warrender Park Terrace, Edinburgh, Scotland.
ISSN: 0260–7972. Dewey: 666.3.
Pottery.

SGRAFFITI. 1974. q. AF & EN. 1347
Association of Potters of Southern Africa, Box 10003, Johannesburg 2000, South Africa. M.R. Fisch, Editor.
Dewey: 745.5.
Pottery.

THE STUDIO POTTER. 1972. s–a. EN. 1348
Studio Potter, Box 70, Goffstown, NH 03045. Phone 603–774–3582. Gerry Williams, Editor.
Subscription: $20 US, $22 Canada & foreign. No sample. Back issues $6 each. Illus. b&w, photos. 7½ x 10, 86–96p.
ISSN: 0091–6641. OCLC: 1788043. LC: NK3700.S86. Dewey: 738.
Ceramics. Pottery.

Devoted to pottery and ceramics, functional and non–functional. Each issue deals with a theme. Presents techniques, aesthetics, history, biographies, and health information.
Bibliographies: with major articles. Biographies: historical. Interviews: regional interviews of potters. Obits. Indexed: ArtBibMod. ArtI. BioI. Des&ApAI. Reviewed: Katz. Katz. *School.*
Advertising: none. Circulation: 7000.

TORQUAY POTTERY COLLECTORS' SOCIETY MAGAZINE. q. EN. 1349
Torquay Pottery Collectors' Society, c/o John F. Bailey, Hon. Sec., 355 Westmount Rd., Eltham, London SE9 1NS, England.
Phone 071 8565393.
Collectibles. Pottery.

The objectives of the Society are to: stimulate interest in the history and products of the old South Devon potteries; bring together Torquay pottery collectors; promote the exchange of information; and to preserve records, patterns and the contributions of potters and decorators.
Audience: collectors.

WATERFORD WEDGWOOD REVIEW. 1957. s–a. EN. 1350
Waterford Wedgwood, Barlaston, Stoke–on–Trent ST12 9ES, England. Derek Halfpenny, Editor.
Dewey: 666. Formerly: *Wedgwood Review.*
Pottery.

Covers the Waterford Wedgwood Group, china and crystal manufacturers presenting company, product and production information.

WEDGOOD SOCIETY OF NEW YORK NEWSLETTER. bi–m. EN. 1351
Wedgwood Society of New York, 5 Dogwood Court, Glen Head, NY 11545.
Subscription: included in membership together with *Ars Ceramica*, $30 US, + $2.50 Canada & foreign.
Pottery.

Glass

AMERICAN CARNIVAL GLASS NEWS. 1966. q. EN. 1352
American Carnival Glass Association, c/o Betsy Booth, Sec., 4579 Clover Hill Circle, Walnutport, PA 18088. Phone 215–767–9182. Joan Anderson, Editor (153 Douglas Drive, Rittman, OH 44270, phone 216–927–2496).
Subscription: included in membership, $10. 8½x11, 14–20p.
ISSN: 0738–3290. OCLC: 9000876. Dewey: 666.1.
Glass.

Newsletter containing membership news, auction lists, directory of regional clubs, and club news. Devoted exclusively to old Carnival glass collecting. The objects of this nonprofit educational association are to encourage and promote interest in Carnival glass, to cultivate friendly relations among member collectors, students and dealers, and especially encourage and assist those interested in the history of old Carnival glass.
Calendar of events.

BULLETIN / ARTISTS IN STAINED GLASS. 1983. m. EN. 1353
Artists in Stained Glass, c/o Ontario Crafts Council, 346 Dundas St., West, Toronto, Ontario M5T 1G5.
Illus.
ISSN: 0841–8039. OCLC: 11301069. LC: NK5300. Dewey: 748.5.
Crafts. Glass.

THE BUTTERFLY NET. 1977. bi–m. EN. 1354
Fenton Art Glass Collectors of America, Inc., Box 384, Williamstown, WV 26187–0384. Ferill J. Rice, Editor (302 Pheasant Run, Kaukauna, WI 54130).
Subscription: included in membership, $15. Sample. Back issues $2. Illus. b&w, color. 8½ x 11, 32p.
OCLC: 9022077. Dewey: 745.5.
Collectibles. Glass.

Specialized glassware publication devoted to the collection of Fenton art glass.
Listings: national. Freelance work: yes. Contact: editor.
Advertising: (limited to Fenton Glass) full page $65, ½ page $35, ¼ page $20, no color. Classified: 50¢/item members, $1/item non–members. Frequency discount for dealers. Mailing lists: none. Audience: members.

CAHIERS DE LA CERAMIQUE, DU VERRE ET DES ARTS DU FEU. See no. 1331.

CAITHNESS PAPERWEIGHT COLLECTORS SOCIETY NEWSLETTER. 3/yr. EN. 1355
Caithness Paperweight Collectors Society, Inveralmond, Perth, Tayside PH1 3TZ, Scotland. Phone 738 37373, fax 738 22494, telex 76663 CGPRTH G.
Collectibles. Glass.

Newsletter of the Society devoted to the collection of glass paperweights produced in Caithness Scotland.
Circulation: 3000. Audience: collectors.

CORNING MUSEUM OF GLASS ANNUAL REPORT. a. EN. 1356
Corning Museum of Glass, 1 Museum Way, Corning, NY 14830–2253. Phone 607–937–5371.
Illus. color, glossy photos, mainly full page. 8 x 10¾, 24p.
Glass.

"An educational institution dedicated to the history, art, and science of glass". Contains description.

THE DAZE INC. 1984, v.14. m. EN. 1357
Depression Glass Daze, Inc., 12135 N. State Rd., Otisville, MI 48463.
Illus.
ISSN: 0895–3961. OCLC: 12182643. Dewey: 740. Formerly: *Depression Glass Daze*.
Glass.

"The nation's market place for glass, china and pottery".

FACETS OF FOSTORIA. 1980. 7/yr. EN. 1358

Fostoria Glass Society of America, Inc., P.O. Box 826, Moundsville, WV 26041. Phone 304–845–0362. David Fairchild, Editor.

Subscription: included in membership, $12.50. Sample $2. Back issues $2. 8 x 12, 20p.

OCLC: 15652033.

Antiques. Collectibles. Glass. Historic Preservation.

Newsletter intended to keep members informed about activities of the Society and progress toward establishing and maintaining a museum for the preservation of Fostoria glass and its history. Includes articles on patterns, research, history, collections, rare items, offers, opportunities to buy and sell through advertising. Lists books and resources related to collecting and learning about Fostoria. Official publication of the Society.

Listings: regional–national. Calendar of exhibitions of the Museum. Freelance work: yes. Contact: editor.

Advertising: (camera ready) ½ page $135, ¼ page $75. Classified: 20¢/wd., min. $5. Circulation: 1000+. Audience: glass collectors.

FLAT GLASS INTERNATIONAL. 1981. m. EN. 1359

Roper Davis Ltd., 129 High St., 4 Simon Campion Court, High St., Epping, Essex CM16 4AU, England. Phone 0378 560119. John Roper, Editor.

Illus.

Dewey: 666.

Glass.

Reviews: book.

Advertising.

FUSION. 1954. q. EN. 1360

American Scientific Glassblowers Society, 1507 Hagley Rd., Toledo, OH 43612. Phone 419–476–5478. James E. Panczner, Editor.

Subscription: $32 US; + $5 postage Canada & foreign, air + $12. Sample $8. Back issues. Illus b&w, color, photos. Cum. index every 5 yrs. 6 x 9, 80–90p. photo–offset, center wire stitched.

ISSN: 0016–3155. Dewey: 666.122.

General. Crafts. Drawing. Education. Glass. Graphic Arts. Historic Preservation. International.

Freelance work: yes. Contact: editor.

Advertising: (rate card 1/89): full page $253, ½ page $187, ¼ page $139; color full page only, 2 color $310, 4 color $1650; covers b&w + $55–85, color regular rates; special position + $15. Bleed + $40. Classified: $9/col. inch, pre–paid. Frequency discount. 15% agency discount. 2% cash discount. Inserts. Mailing lists: none. Circulation: 1200.

GLASFORUM: Zeitschrift fuer Architektur, Raumgestaltung, Kunst. 1950. q. GE only. 1361

Verlag Karl Hofmann, Steinwasenstr. 6–8, Postfach 1360, 7060 Schorndorf, W. Germany. Phone 07181–7811. Heinz W. Krewinkel, Editor.

Subscription: DM 48. Illus.

ISSN: 0017–0852. OCLC: 5150860. LC: TP845.G48.

Glass.

Indexed: ArchPI.

GLASS AND GLAZING NEWS. 1977. q. EN. 1362

Glass and Glazing Federation, 44–48 Borough High St., London SE1 1XB, England. Phone 071–403–7177, fax 071–357–7458. Fiona Gane, Editor.

Subscription: free. Sample. Back issues. Illus b&w, color, photos. A4, 2p.

ISSN: 0260–6321. Dewey: 666.1.

Architecture. Glass. Interior Design.

Issues, technical and ethical, affecting the flat glass industry.

Bibliographies. Exhibition information. Freelance work: none.

Advertising: none. Circulation: 30,000. Audience: architects, specifiers, glaziers.

GLASS & GLAZING PRODUCTS. 1982. m. EN. 1363

R.J. Dodd Publishing Ltd., Fairway House, Dartmouth Rd., London SE23, England. R. Kruger, Editor.

Dewey: 666.

Glass.

GLASS ART MAGAZINE. 1985. bi–m. EN. 1364

Glass Art Magazine, 26 Garden Center, Broomfield, CO 80020. Phone 303–465–4965.
Subscription: $20 US, $32 Canada & Mexico, $45 foreign.
ISSN: 0886–8131. OCLC: 12996099.

Glass.

THE GLASS ART SOCIETY JOURNAL. 1976. a. EN. 1365

Glass Art Society, P.O. Box 1364, Corning, NY 14830. Phone 607–936–0530. Caryl Hansen, Editor (2630 Carisbrook Dr., Oakland, CA 94611).
Subscription: included in membership together with all Society publications, $35 individual, $10 student North America, foreign $40 individual, $20 student; non–members $24. No sample. Back issues 1981–87 $12 members, $17 non–members; 1988– $20 members, $24 non–members. Illus. b&w, color, photos, cartoons. Annual index in last issue. Cum. index to be printed in 1991. 8 x 10½, 130–150p.
ISSN: 0278–9426. OCLC: 7921703. LC: NK5112.J68. Dewey: 730. Formerly: *Newsletter – Glass Art Society.*

Glass.

Purpose of the Society is to encourage excellence and to advance the appreciation, understanding and development of the glass arts worldwide. Through documentation of the annual conference the magazine encourages and disseminates new research, basic information and visual material on all subjects relating to glass.
Reviews: book 1–3, exhibition 4–6, equipment 1–2, other 4–6. Interviews: artists or leaders in the field of glass. Listings: international. Exhibition information. Freelance work: yes. Contact: editor. Opportunities: study, competitions. Indexed: ArtBibMod. Des&ApAI. Reviewed: Katz.
Advertising: full page $525, ½ page $370, color full page limited available $1000. 10% frequency discount for ad purchased in Conference Program. Bonnie Startek, Ad. Director. Mailing lists: none. Circulation: 1500. Audience: anyone interested in glass.

GLASS CANADA. 1989. bi–m. EN. 1366

Communications Ltd., 145 Thames Rd. W., P.O. Box 1060, Exeter, Ontario N0M 1S0, Canada. Phone 519–235–2400, fax 519–235–0798. Peter Darbishire, Editor.
Subscription: $35.
Dewey: 666.1.

Glass.

THE GLASS CLUB BULLETIN. 1938. 3/yr. EN. 1367

National Early American Glass Club, P.O. Box 8489, Silver Spring, MD 20907.
Subscription: included in membership together with *Glass Shards*, $15 individual all, student $10, institution $25 (Bill Sheriff, membership chairman, 1222 Pinecrest Circle, Silver Spring, MD 20910). Sample free. Back issues. Microform available from Rakow Library, Corning Museum of Glass, Corning, NY 14831. Illus b&w, photos. Free indexes for nos.1–119 on request. 8½ x 11, 16p.

Antiques. Glass.

A forum for the publication of new research on various aspects of glass and glassmaking. The focus is on the American glass industry and the documentation of European glass exported to North America. The emphasis is on the pre–1920 period. Features in its cover story some recently discovered object of documentary significance, an object that is usually in a public collection. Also publishes transcriptions of primary source material otherwise difficult to find. Most articles are presented in a scholarly fashion with footnotes, but sometimes more informal papers are accepted. Nearly all the articles are contributed by members of the NEAGC.
Reviews: book 1, length½–1p. Listings: NEAGC national seminar only. Freelance work: none.
Advertising: none. Demographics: subscribed to by 50 major museums in the U.S. and abroad. Audience: members, museums, anyone interested in history of glass.

GLASS COLLECTOR'S DIGEST. 1987. bi–m. EN. 1368

201 Acme St., Box 553, Marietta, OH 45750. D. Thomas O'Connor, Editor.
ISSN: 0893–8660. OCLC: 15679841. Dewey: 748.

Glass.

Covers all areas of collectible glass, with features on glassmakers, dealers and collectors.
Advertising.

GLASS MAGAZINE. 1990, No.40. q. EN. 1369
New York Experimental Glass Workshop, 9 East 45 St., New York, NY 10017. Suzanne Ramljak, Editor.
Subscription: $28 US, + $5 Canada, + $20 foreign (Glass, 142 Mulberry St., New York, NY 10013, phone 212–966–1808).
Back issues $9. Illus. color, photos. 8½ x 11, 64p.
Glass.

Insightful articles, in–depth profiles of artists, coverage of glass world events, and reviews of exhibitions designed to keep one informed about developments in contemporary glass. Provides a serious critical look at the glass scene in the U.S. and abroad. Funded in part by the New York State Council on the Arts and by the National Endowment for the Arts.
Advertising: Jane Bruce, Ad. Director (142 Mulberry St., New York, NY 10013).

GLASS MARKET QUARTERLY. q. EN. 1370
National Glass Association, 8200 Greensboro Drive, Suite 302, McLean, VA 22102. Phone 703–442–4890. Debra Levy, Editor.
Glass.

GLASS ON METAL. 1982. bi–m. EN. 1371
The Enamelist Society, P.O. Box 310, Newport, KY 41072. Phone 606–291–3800, fax 606–291–1849. Tom Ellis, Editor.
Subscription: included in membership, $35 individual, $27 institution & school, first class & air mail + $6 US; air postage + $4.50 Canada & Mexico, + $14 elsewhere. Illus. b&w, color, photos. 8½ x 11, 24p.
Enameling.

Newsletter pertaining to vitreous enamel and related arts published by a non–profit corporation dedicated to the promotion of the art of enameling. Has established a international network of correspondents to submit the enameling news of their country. Presents news of enameling events, technical advice, local popular techniques, guild meetings, museum visits, people and organizations.
Listings: Guild and Society. Calendar of events. Exhibition information. Opportunities: study – workshops; competitions. Reviewed: Katz.
Advertising. Audience: enamelists.

GLASS REVIEW. 1945. m. EN, FR, GE & RU editions. 1372
Rapid, Praha, Ul. 28, rijna 13, 112 79, Praha 1, Czechoslovakia. Zdenka Kalabisova, Editor–in–chief.
Subscription: $US41.50 [English edition] (apply to Artia, Foreign Trade Corporation, VeSmeckach 30, Prahl 1 or through agents: US: Ebsco; UK: Collet's Holdings Ltd., Denington Estate, Wellingborough, Northants, NN8 2QT, England). Illus. color, photos. 9¼ x 13¼, 32–40p.
OCLC: 5771679. LC: NK5100.C9. Dewey: 666.
Ceramics. Glass.

Czechoslovak glass and ceramics magazine contains articles on Czechoslovakian glass, lighting fixtures, chandeliers, and sculpture. Articles may focus on the works of an individual company. Many beautiful color illustrations. Some coverage of china and ceramics. French edition title *Revue du Verre*, German edition title *Glas–Revue*.
Interviews. Obits. Indexed: Des&ApAI. Reviewed: Katz.
Advertising.

GLASS SHARDS. 1933. 2/yr. EN. 1373
National Early American Glass Club, P.O. Box 57, Fishers Hill, VA 22626. Phone 703–465–8580. Sylvia Applebee Lyon, Editor.
Subscription: included in membership together with *The Glass Club Bulletin*, $15 individual, $10 student, $25 institution (Bill Sheriff, Membership Chairman, 1222 Pinecrest Circle, Silver Spring, MD 20910). cartoon. 8½ x 11, 4p.
Antiques. Collectibles. Glass.

Newsletter transmitting news, chapter activities and activities pertaining to antique glass.
Listings: national. Calendar of events. Exhibition information. Opportunities: study – seminars.
Advertising: none. Circulation: 1200. Audience: collectors of 18th–20th century glassware.

HEISEY NEWS. 1972. m. EN. 1374
Heisey Collectors of America, Inc., Box 4367, Newark, OH 43055. Phone 614–345–2932. Louise Ream, Editor.
Subscription: included in membership, $15 US & Canada. Sample. Back issues $1.25. Illus b&w, photos. Annual index. 8½ x 11, 24p.
ISSN: 0731–8014. OCLC: 8236899. LC: NK5198.A23 H45. Dewey: 748.29171.

Antiques. Collectibles. Glass.

Articles and illustrations about handmade Heisey glassware made by the A.H. Heisey Company in Newark, Ohio from 1896–1957 and Heisey collectors of America events. Newsletter includes club news, news of research, news of Heisey for sale and a dealer directory.

Listings: regional–national. Freelance work: none.

Advertising: full page $75 members, $112.50 non–members; ½ page $60, $90; ¼ page $30, $45, no color. Classified: 15¢/wd., $1.50 min. No frequency discount. Wanda Lybarger, Ad. Director. Mailing lists: none. Circulation: 4550. Audience: members, collectors and dealers.

THE HOBSTAR. 1979. 10/yr. EN. 1375

American Cut Glass Association, Edmond Professional Bldg., 1603 S.E. 19th St., Suite 12, Edmond, OK 73013. Phone 405–340–2110. Nicholas J. Boonstra, Editor (6 Dutchess Terrace, Beacon, NY 12508 914–831–2566).

Subscription: included in membership, $25. Sample. Back issues $2. Illus b&w, photos. 8½ x 11, 18p.

Antiques. American Cut Glass.

Purpose is to provide information, education, and appreciation of American cut glass. Presents material on the history of cut glass as well as on collecting.

Interviews: members profiles each issue. Listings: regional–national.

Advertising from members only, full page $150, ½ page $90, ¼ page $50. No color. Classified: information requests are free. No frequency discount. Demographics: entire U.S. and Canada. Circulation: 1500. Audience: members and other interested parties.

JOURNAL OF GLASS STUDIES. 1959. a. EN, GE, SP, FR or IT. 1376

Corning Museum of Glass, One Museum Way, Corning, NY 14830–2253. Phone 607–937–5371. David Whitehouse, Editor.

Subscription: $20 + postage & handling all, foreign air rates on request. Microfiche available from Sales Dept., microform UMI. No Sample. Back issues. Cum. index v.1–15, 1959–73. 8 x 10¾, 180p.

ISSN: 0075–4250. OCLC: 1605749. LC: NK5100.J6.

Archaeology. Art History. Glass. International.

Articles on the artistic, historical, and archaeological aspects of glass from classical antiquity through the mid–20th century. The "Checklist of Recently Published Articles and Books on Glass" is included as well as photographs of recent important acquisitions in glass collections in the U.S. and abroad.

Bibliographies: checklist of books and articles added to Museum library. Freelance work: none. Opportunities: competitions. Indexed: ArtBibMod. ArtHum. ArtI. Avery. BioI. BrArchAb. CloTAI. CurCont. RILA. Reviewed: Katz.

Advertising: none. Mailing lists: none. Circulation: 800. Audience: adult professional.

THE KEYSTONER. 1984. EN. 1377

Keystone Carnival Glass Club, 2009 Cullom Drive, Reading, PA 19601. Doug Williams, Editor.

Illus.

OCLC: 11355137.

Glass.

The official newsletter of the Club includes members news and minutes of meetings.

NATIONAL GREENTOWN GLASS ASSOCIATION - NEWSLETTER. 1974. q. EN. 1378

National Greentown Glass Association, P.O. Box 107, Cicero, IL 46936. Phone 312–656–4038. Dr. James Measell, Editor.

Glass.

Covers the Greentown glass, glassware produced by the Indiana Tumber and Goblet Company from 1894–1903 in Greentown, Indiana.

NEUES GLAS/NEW GLASS/VERRE NOUVEAU. 1980. q. EN & GE, same page. 1379

Verlagsanstalt Handwerk GmbH, Postfach 8120, D–4000 Duesseldorf, W. Germany. Phone (02 11) 30 70 73. G. Nicola & H. Ricke, Editors.

Subscription: $US37.50 US & Canada air, DM58 Europe, $US42.50 Australia & New Zealand, $US40 Japan. Back issues $US9.50 each. Illus. mostly color, some b&w, photos. 8¼ x 10¼, 198p.

ISSN: 0723–2454. OCLC: 7860696. LC: NK5100.N48. Dewey: 730.

Glass.

Magazine on contemporary glass art with articles on artists and techniques. *New Glass Review*, the magazine of the Corning Museum of Glass, is included in one issue.

Reviews: book. Biographies: brief information on contributors. Indexed: ArtBibMod. ArtI. BioI. CerAb. Des&ApAI. Reviewed: Katz.
Advertising.

NEW GLASS REVIEW. 1979. a. EN, GE. 1380

Corning Museum of Glass, One Museum Way, Corning, NY 14830–2253. Phone 607–937–5371. Susanne K. Frantz, Editor.
Subscription: included in membership in some categories, $6 + postage & handling, worldwide, air rates on request. Microform available from Sales Dept. No sample. Back issues. Illus. color. 8 x 10¾, 55p.
ISSN: 0275–469X. OCLC: 7148964. LC: NK5110.N48. Dewey: 748.29. Formerly: *Contemporary Glass.*
Art History. Crafts. Decorative Arts. Glass. Jewelry. Modern Art. Sculpture.

Each year, four qualified judges select slides of the 100 most important and exciting glass objects created during the previous year. The winners are published in color with jurors' statements, a bibliography of all pertinent books and periodical articles added to the Museum library, and an index of countries represented. Translation provided.
Indexed: ArtBibMod.
Advertising: none. Circulation: 1200. Audience: adult professionals interested in glass and art.

NEW PRODUCT MAGAZINE. s–a. EN. 1381

Caithness Paperweight Collectors Society, Caithness Glass PLC, Inveralmond, Perth, Tayside PH1 3TZ, Scotland. Phone 738 37373, fax 738 22494, telex 76663 CGPRTH G.
Glass.

Devoted to colored glass encased in crystal produced in Scotland. Provides information of both current and past Caithness glass products.
Demographics: members in 7 countries. Circulation: 3000. Audience: collectors.

NEW WORK. 1982. q. EN. 1382

New York Experimental Glass Workshop, 142 Mulberry St., New York, NY 10013.
Illus.
Glass.

Presents materials on the use of glass as an artistic medium.
Reviews: exhibition. Indexed: Des&ApAI. Reviewed: Katz. *Art Documentation* Win 1987, p.181.
Advertising.

NEW ZEALAND SOCIETY OF ARTISTS IN GLASS. EN. 1383

New Zealand Society of Artists in Glass Inc., Sunbeam Glassworks, 70 MacKelvie St., Grey Lynn, Auckland, New Zealand.
Illus.
OCLC: 23883164.
Glass.

NEWS AND VIEWS. 1974. 10/yr. EN. 1384

National Depression Glass Association, Inc., P.O. Box 69843, Odessa, TX 79769. Jo Ann Schliesmann, Editor (1911 Taylor Ave., Racine, WI 53403).
Subscription: included in membership, $10 individual, $12 family, $25 club. Sample. Illus. b&w, photos, cartoons. 8½ x 11, 12p.
Glass. Pottery. China.

Official publication of the Association whose purpose is to unite people in good fellowship and to provide information and promotion of depression era glassware, china and pottery through an exchange of ideas and information.
Listings: national.
Advertising: full page $20, ½ page $10, ¼ page $5, no color. Classified: 5¢/wd., min. $2. No frequency discount. Mailing lists: none. Audience: members and potential members.

PROFESSIONAL STAINED GLASS. 1981. m. EN. 1385

Edge Publishing Group, 245 W. 29th St., Suite 1303, New York, NY 10001–5208. Phone 212–629–3290. Chris Peterson, Editor.
Subscription: $25 US & Canada, $50 foreign, no air. Sample free. Back issues $3. Illus. b&w, color 16p., photos. 8¼ x 10¾, 64p. Offset. Saddle–stitched.

ISSN: 0885–1808. OCLC: 12573904. Dewey: 748. Formed by the union of: *The Edge*, and *Glass Craft News*, and continues the numbering of the latter.

Glass.

A comprehensive technical journal for the stained glass industry . It provides complete coverage of intermediate to advanced techniques, furnishes business information important to the trade, suggests projects and provides instruction, and reviews products and services available to the industry. All editors are deeply experienced in glassworking techniques and careful attention is paid to accuracy in all aspects of the articles and features. The *Show Issue* appears annually in July and the annual *Buying Guide* in December. The *Show Issue* which is a complete guide to the International Glass Craft Expo includes extensive profiles of exhibiting companies and expanded editorial on their products. The *Buying Guide* is a source book for the entire industry.

Reviews: (per vol.) book 12, length 1000–2000 wds.; journal 1 & film 4, length 1000–1500 wds.; equipment 20, length 1000–3000 wds. Interviews: profile piece, 1. issue. Listings: national. Calendar of events column. Freelance work: yes. Contact: editor. Opportunities: study, column of glass working and related courses; column of all shows. Indexed: ArtArTeAb. Advertising: (rate card Jan '89): full page $1180, ½ page $708, ¼ page $562; color full page $1887, ½ page $1132, ¼ page $562. No classified. Frequency discount. 15% agency discount. Albert Lewis, Ad. Director (phone 1–800–541–8814). Mailing lists: retail and wholesale available. Demographics: retailers and wholesalers, 80% US, 20% foreign. Circulation: 15,700. Audience: industry professionals and accomplished hobbyists.

REFLECTIONS COLOUR MAGAZINE. a. EN. 1386

Caithness Paperweight Collectors Society, Inveralmond, Perth, Tayside PH1 3TZ, Scotland. Phone 738 37373, fax 738 22494, telex 76663 CG PRTH G.

Glass.

Magazine devoted to colored glass encased in crystal produced in Scotland.

Circulation: 3000. Audience: collectors.

SOCIETY OF GLASS AND CERAMIC DECORATORS ANNUAL PROGRAM. See no. 1316.

SOCIETY OF GLASS AND CERAMIC DECORATORS NEWSLETTER. See no. 1317.

SOCIETY OF GLASS AND CERAMIC DECORATORS PROCEEDINGS. See no. 1318.

SPRECHSAAL. See no. 1319.

STAINED GLASS INDEX. 1978. a. EN. 1387

Stained Glass Association of America, 4050 Broadway, Suite 219, Kansas City, MO 64111. Phone 816–561–4404. Darlene Brady & William Serban, compilers.

ISSN: 0038–9161. OCLC: 8903466. LC: NK5300.S72 B72. Dewey: 748.5005.

Crafts. Glass.

A continuation of *Stained Glass Index, 1906–1977*.

STAINED GLASS QUARTERLY. 1906. q. EN. 1388

Stained Glass Association of America, 4050 Broadway, Suite 219, Kansas City, MO 64111. Phone 816–561–3903. Richard L. Hoover, Editor.

Subscription: included in membership, $20 US, $28 Canada & foreign; air variable rates. Microform available from Columbus Microfilm. Sample. Back issues $5 each. Illus. b&w, color, photos. Index. Cum. index 1906–1983. 8¼ x 11, 80p. Sheet fed offset.

ISSN: 0895–7002. OCLC: 16742347. Dewey: 748. Formerly: *Stained Glass; Bulletin of the Stained Glass Association of America; Ornamental Glass Bulletin; The Monthly Visitor.*

Architecture. Art Education. Art History. Crafts. Decorative Arts. Hobbies. Modern Art. Painting.

Devoted to the craft of stained and decorative art glass. Goal is to inspire readers to understand and enjoy the art, craft and business of stained glass, and to undertake stained glass projects using the magazine's expertly detailed information as a reliable guide. The publication is of general interest to the professional stained glass production studio, as well as to those for whom stained glass is an avocation or hobby. It is archival, presents information of a historical nature, showcases contemporary architectural stained glass work, and explores new processes, techniques and concepts. For over 80 years *Stained Glass* has showcased projects in churches, public buildings, businesses and homes with reliable clarity and accuracy. Each issue features information, project analysis, and advice from editors, readers and manufacturers.

Reviews: book. Bibliographies. Biographies. Interviews. Listings: national–international. Calendar of events. Freelance work: yes. Contact: editor. Opportunities: employment, study, competitions. Indexed: ArtArTeAb. ArtBibMod. ArtI. Avery. BioI. Des&ApAI.

Advertising: (rate card Win '89): b&w full page $649, ½ page $432, ¼ page $289; 2 color full page $838, ½ page $622, ¼ page $478; 4 color covers $1534–$1689, full page $1,149, ½ page $933, ¼ page $789. Frequency discount, 15% agency discount, 2% cash discount (not for classified). Classified: "Stained Glass Mart" $9/line; "Sources of Supply" (classified alphabetical listing, by category, of materials, supplies and services. Limited to name, address and phone), $5/line. Bleeds no charge. Inserts. Reader service response available. New products press releases and photographs accepted at no charge. Mailing lists: none. Demographics: reader characteristics: serious stained glass artist, and business person whose product purchases reflect his or her heavy stained glass involvement. Reader data available upon request. Circulation: 6000. Audience: stained glass professionals.

Needlework

101 NEEDLECRAFT & SWEATER IDEAS. 1981. a. EN. 1389
Diamandis Communications, Inc., Woman's Day Special Publications, 1633 Broadway, New York, NY 10019. Phone 212–767–6821. Carol Gallo, Editor.
Illus.
OCLC: 21129334. LC: TT740.O53x. Dewey: 746.405. Formerly: *101 Needlecraft & Sweater Ideas; Woman's Day 101 Sweaters You Can Knit and Crochet.*
Crafts. Needlework.
Contains instructions for knit and crochet items as well as other needle crafts.
Reviews: book.
Advertising. Audience: home knitters.

ANNIE'S QUICK & EASY PATTERN CLUB. 1980. bi–m. EN. 1390
Annie's Attic, Box 212B, Route 2, Big Sandy, TX 75755. Phone & fax 214–636–4303. Annie Potter & Anoy Ashley, Editors.
Subscription: $14.95. Illus. color, photos. Annual index. 5 1/2 x 8 1/2, 48p.
ISSN: 1051–3337. OCLC: 21928381. Formerly: *Annie's Pattern Club Newsletter.*
Needlework.
Presents crochet and sewing patterns complete with full instructions and photos.
Freelance work: considers patterns for publication.

BETTER HOMES AND GARDENS HUNDREDS OF NEEDLEWORK AND CRAFT IDEAS.
1977. s–a. EN. 1391
Meredith Corp., Special Interest Publications, 1716 Locust St., Des Moines, IA 50336.
Illus.
Crafts. Needlework.
Reviewed: Katz.

BLANKET STATEMENTS. 1981. q. EN. 1392
American Quilt Study Group, 660 Mission St., Suite 400, San Francisco, CA 94105–4007. Phone 415–495–0163.
Subscription: included in membership, $35 US, + $1.50 Canada, + $15 foreign.
Needlework.
Newsletter circulates news of AQSG and publishes research queries.
Circulation: 500.

BULLETIN OF THE NEEDLE AND BOBBIN CLUB OF NEW YORK. 1916. s–a. EN. 1393
Needle and Bobbin Club, c/o Mrs. P. Guth, 955 Fifth Ave., New York, NY 10021. Phone 212–288–5525. Jean Mailey, Editor.
Illus. v.1–26, 1916–42 (1944); v.27–44, 1943–60 (1962).
Dewey: 746.
Needlework.

Reviews: book. Indexed: ArtBibMod. CloTAI.
Advertising.

CANADA QUILTS. 1975. 5/yr. EN.

1394

P.O. Box 39 Station A, Hamilton, Ontario L8N 3A2, Canada. Phone 416–549–1055. Deborah Sherman, Editor & Pub.
Subscription: (1991) $C16.68 (includes tax) Canada, $19 US & foreign. Back issues, price varies. Illus. b&w, color (12p.), photos, cartoons. 8½ x 11, 32p.
ISSN: 0381–7369. OCLC: 3209966. LC: TT835. Dewey: 746.4.
Needlework.

The only Canadian quilting publication, concentrating on Canadian content. Features quilts, profiles of quiltmakers, teachers & other professionals, patterns, instructions, reviews of quilt events, and regionalized news. Regular features include a humor page, a Guild building column (help for guild management), and an antique quilt.
Reviews: exhibition, book, equipment. Biographies: profiles of teachers, prize winners, etc. Listings: regional. Calendar of events. Information on U.S. and overseas events are included for convenience of travellers. Freelance work: yes. Contact: editor. Reviewed: *Serials Review* 11:3, Fall 1985, p.17–18.
Advertising: full page $C310, ½ page $180, ¼ page $70, covers $460–$530, 4 color + $410. Classified: 45¢/wd. Mailing lists: none. Demographics: Quiltmakers of all ages in Canada. Circulation: 3,000. Audience: quiltmakers, quilt enthusiasts.

CAST ON: The Magazine for Knitters. 1984. 5/yr. EN.

1395

The Knitting Guild of America, P.O. Box 1606, Knoxville, TN 37901. Phone 615–524–2401. Betty Martin, Editor.
Subscription: included in membership, $18 US, $25 Canada & foreign. Sample & back issues $3.75 each. Illus b&w, color, photos. 8½ x 11, 56p.
Hobbies. Knitting.

Provides approximately 6 hand knit and 2 machine knit designs in each issue with full color photos and instructions. Technique articles (4–5) for both hand and machine knitters. Networking service for readers asking for specific information on materials. Page of knitting tips. Section on local guild activities. Local guild list with addresses and phone numbers of all presidents.
Reviews: book 4, pattern and kit 2, length 100 wds. Biographies: short biographies of contributing artists and authors. Listings: international. Freelance work: yes. Contact: editor. Opportunities: study – seminars, Guild sponsored annual national convention. Competitions, annual, several categories.
Advertising: (rate card Apr '89): b&w full page $300, ½ page $180, ⅓ page $140, covers $360–$410; 4 color full page $380, ½ page $205, ⅓ page $165. Classified: 70¢/wd. $10% frequency discount. 15% agency discount. Mailing lists: none. Circulation: 6,000. Audience: Guild members and knitters.

CHRISTMAS KNIT & CROCHET. 1979. a. EN.

1396

ABC Consumer Magazines, Inc., 825 Seventh Ave., New York, NY 10019. Phone 212–888–9292. Rosemary Maceiras, Editor.
Illus., some color. 80p.
OCLC: 8946675, 22631977 (1990 edition). Dewey: 745.505.
Crafts. Needlework.

Published by the editors of McCall's Needlework & Crafts specialized publications.

COUNTRY BAZAAR. 1979. a. EN.

1397

ABC Consumer Magazines, Inc., 825 Seventh Ave., New York, NY 10019.
Illus., some color.
OCLC: 15096197. Dewey: 745.5.
Crafts. Needlework.

Specialized publication by the editors of McCall's Needlework & Crafts journals.

CRAFT & NEEDLEWORK AGE. See no. 1208.

CRAFTS BAZAAR. 1987, v.24. a. EN.

1398

ABC Consumer Magazine, 825 Seventh Ave., New York, NY 10019. Phone 212–888–9292. Rosemary Maceiras, Editor.
Illus., some color.
OCLC: 17220557. Dewey: 745.505.

Crafts. Needlework.

Published by the editors of McCall's Needlework & Crafts specialized publications.

CROCHET FANTASY. 198? 8/yr. EN. 1399

All American Crafts, Inc., 70 Sparta Ave., CN 1003, Sparta, NJ 07871. Phone 201–729–4477. Carol Lippert Gray, Editor. Illus. photos. 8 x 11, 64p.

ISSN: 8750–8877. OCLC: 11885359. Dewey: 746.

Needlework.

Publication for crochet enthusiasts featuring photographs, instructions, and diagrams for both traditional and contemporary garments, fashion and home accessories, and crafts. Special issue, *Crochet Fantasy's Christmas Special.*

Reviews: book.

Advertising.

CROCHET WORLD. 1977. bi–m. EN. 1400

House of White Birches, 306 E. Parr Rd., Berne, IN 46711. Phone 219–589–8741, fax 219–589–2810. Susan Hankins Andrews, Editor (Crochet Today Fashions, P.O. Box 776, Henniker, NH 03242).

Subscription: $12.97 US, $17.77 Canada, $21 foreign. Sample & back issues $2. 8½ x 11, 64p.

ISSN: 0164–7962. OCLC: 4355050. Dewey: 746.

Crafts. Needlework.

The magazine for crochet lovers. Crochet patterns only, 15–25 per issue. Designs come from freelance designers. Two columnists plus a "problem solving" columnist. Swap shop type letters column. Show–It–Off column for finished designs. Occasional "How to" article. General crochet interest—toys, afghans, bazaar, clothing, household, dolls, filet etc.

Reviews: book 0–2, length filler. Freelance work: yes. Contact: editor.

Advertising: (rate card July 1 1989): full page $1000, ½ page $650, ¼ page $350, covers $1300–1400; 2 color + $150, 4 color + $350. Classified: (payment with ad) $10/20 wds., 75¢/wd. add. Frequency discount. 5% discount for concurrent ads in 2 or more Women's Circle publications. 15% agency discount. 15% discount to mail–order businesses. Janet Price–Glick, Ad. Director. Mailing lists: available. Demographics: 97% women, 96% over 30, 64% income $20,000+. Circulation: 110,000. Audience: Appeals to crocheters of all ages, but mostly the "stay at homers".

CROCHET WORLD SPECIAL. 1978. q. EN. 1401

House of White Birches, 306 E. Parr Rd., Berne, IN 46711. Phone 219–589–8741, fax 219–589–2810. Susan Hankins Andrews, Editor (Crochet Today Fashions, P.O. Box 776, Henniker, NH 03242).

Subscription: $9.95 US, $13.15 Canada, $18 foreign. Sample & back issues $2. Illus. photos. 8½ x 11, 48p.

ISSN: 1041–0759. OCLC: 18631747. Dewey: 746. Formerly: *Crochet Today Fashions; Crochet World Omnibook.*

Crafts. Needlework.

Specialized crocheting magazine limited to crochet clothing and accessory patterns. Each issue contains 15–25 patterns. Freelance work: yes. Contact: editor. Opportunities: competitions – contest in every issue, specialty contests on occasion.

Advertising: (rate card July 1989): b&w full page $600, ½ page $390, ¼ page $210, covers $655–720; 2 color + $150, 4 color + $350. Classified: (payment with ad) $10/20 wds., 30¢/wd. add. Frequency discount. 5% discount for concurrent ads in 2 or more Women's Circle publications. 15% agency discount. 15% discount to mail–order businesses. Janet Price–Glick, Ad. Director. Mailing lists: available. Demographics: 98% women, 96% over 30, 64% income $20,000+. Circulation: 56,000. Audience: those who like to wear handmade clothing and those who sell to boutiques for extra income.

CROSS QUICK. 1402

Meredith Corporation, 1716 Locust St., Des Moines, IA 50336.

With *Cross Stitch Quick & Easy* in 1991 merged into *Cross Stitch & Country Crafts.*

CROSS STITCH & COUNTRY CRAFTS. 1985. bi–m. EN. 1403

Meredith Corporation, 1716 Locust St., Des Moines, IA 50336. Phone 515–284–3000.

Subscription: $19.97. Illus.

ISSN: 0886–6600. OCLC: 12966173. Dewey: 746. Merger of *Cross Stick Quick & Easy,* and *Cross Quick.*

Crafts. Needlework.

Cross stitch magazine with projects for all skill levels. Every issue contains up to 20 new projects, stitchery basics, techniques, new products and buyers' guide.

CROSS-STITCH BAZAAR. 1988, v.27. a. EN. 1404
ABC Consumer Magazine, 825 Seventh Ave., New York, NY 10019. Phone 212–888–9292. Rosemary Maceiras, Editor.
Illus., some color.
OCLC: 18030498. Dewey: 746.4405.
Crafts. Needlework.

Published by the editors of McCall's Needlework & Crafts.

CROSS-STITCH PLUS. 1983. bi–m. EN. 1405
House of White Birches Publishing, 306 E. Parr Rd., Berne, IN 46711. Phone 219–589–8741, fax 219–589–2810. Denise
Lohr, Editor.
Subscription: $12.97 US, $17.77 foreign. Illus.
ISSN: 1054–3430. OCLC: 22850485. Dewey: 746. Formerly: *Counted Cross Stitch; Counted Cross–Stitch and Candlewick-
ing.*
Needlework.

Contains 20 or more patterns, easy–to–follow graphs, interviews with designers & reference material. Reviews new products
and publications.
Advertising: b&w full page $1800, ½ page $1170, ¼ page $630, covers $2340–2520, 2 color + $150, 4 color + $350. Classi-
fied: $10/20 wds., 50¢/wd. add. Frequency discount. 5% discount for concurrent ads in 2 or more Women's Circle publica-
tions. 15% agency discount. 15% discount to mail–order businesses. Janet Price–Glick, Ad. Director. Demographics: 98%
women, 68% under 50, 56% income $25,000+. Circulation: 185,000.

EMBROIDERY. 1932. q. EN. 1406
E G Enterprises Ltd., P.O. Box 42B, East Molesey, Surrey KT8 9BB, England. Phone 081–943 1229. Valerie Campbell–Har-
ding, Editor.
Subscription: £8 UK, overseas £13.50; air US $25, Canada $38.50, Australia $31.50 (The Embroiders' Guild, Apt. 41, Hamp-
ton Court Palace, East Molesey, Surrey, KT8 9AU). Illus. 48p.
ISSN: 0013–6611. OCLC: 2539451. LC: TT770.E42. Dewey: 746.44.
Needlework.

Articles on embroidery, textiles, and techniques. Both historical and current topics are presented. Includes Guild news, other
news and information regarding products.
Reviews: book. Exhibition information. Indexed: CloTAI. Des&ApAI.
Advertising. Don MacLaren (2 Sunfield, Romiley, Stockport, SK6 4BH, phone 061–494 9561).

EMBROIDERY NEWS. 1957. bi–m. EN. 1407
Schiffli Lace and Embroidery Manufacturers Association, Inc., 8555 Tonnelle Ave., North Bergen, NJ 07047–4738. Phone
201–868–7200. I. Leonard Seiler, Editor.
Subscription: included in membership, free to qualified personnel. No back issues. Illus. b&w, photos, cartoons. 8½ x 11, 12p.
Dewey: 677. Formerly: *Schiffle News.*
Needlework.

The Association facilitates the development, exchange, and dissemination of information that effects the well–being of its
member companies and the embroidery industry. The trade paper provides a forum for the exchange of ideas and opportuni-
ties for members to discuss business relationships and undertake cooperative projects. Covers fashion and business news plus
industry applicable information.
Listings: regional. Calendar of events. Freelance work: none. Opportunities: competitions.
Advertising: full page $390, ½ page $250, ¼ page $165, no color. Frequency discount. Mailing lists: none. Circulation: 800.

FASHION AND CRAFT. 1967. q. EN. 1408
Blenheim Publications Ltd., 1 Quebec Ave., Westerham, Kent TN16 1BJ, England. Phone 0959 62459. Hilary McKenzie, Edi-
tor.
Dewey: 746. Formerly: *Creative Needlecraft.*
Crafts. Needlework.

Advertising.

FASHION CROCHET. 1986. q. EN. 1409
All American Crafts, Inc., 70 Sparta Ave., CN 1003, Sparta, NJ 07871. Phone 201–729–4477. Kathleen Neville, Editor.
Illus.

ISSN: 1043–3600. OCLC: 17949446. Dewey: 746.

Needlework.

Publication for crochet enthusiasts featuring garment patterns, designs, instructions, and diagrams for all skill levels.

FIBERARTS. See no. 1464.

THE FLYING NEEDLE. 1978. q. EN. 1410

National Standards Council of American Embroiderers, 588 St. Charles Ave., NE, Atlanta, GA 30308. Phone 404–873–3550. Jeane Hutchins, Editor.

Subscription: included in membership, $20 US, $25 elsewhere. Sample. Back issues. Illus., mostly b&w, color, photos. Index in Feb issue. 8½ x 11, 32p.

ISSN: 0270–2959. OCLC: 3821169. LC: TT740.F58. Dewey: 746.44.

Art Education. Crafts. Fabrics. Historic Preservation. Needlework. Textiles.

Dedicated to promoting the art of needlework. Features artists' work in most areas of fiber and member news.

Reviews: exhibition 1–2, length 1–4p., book 1 & equipment 1, length 1p.; other 8–10, length 1–4p. Interviews: members, artists working in fiber. Listings: international. Calendar of events. Exhibition information. Freelance work: yes. Contact: editor. Opportunities: seminars, competitions. Indexed: CloTAI. Reviewed: Katz.

Advertising: (rate card Nov 1978, camera–ready copy): full page $250, ½ page $175, ⅙ page $65, color rates on request. Classified: 40¢/wd., min. $15. 10% frequency discount. 30% discount to NSCAE members. Donalene Poduska, Ad. Director (852 Roanoke Rd., Cleveland Heights, OH 44121, phone 216–381–6941). Mailing lists: none. Demographics: readership consists of artists, designers, teachers, authors, shop owners and practitioners of all forms of needlework. Audience includes members, libraries and museums. Circulation: 3,500. Audience: membership.

HOLIDAY CRAFTS & GRANNY SQUARES. 1973. a. EN. 1411

Diamandis Communications, Inc., 1633 Broadway, New York, NY 10019. Phone 201–767–5816. Carolyn Galla, Editor.

Subscription: $2.95 US, $3.50 Canada. Illus. b&w, some color.

OCLC: 22426249. LC: TT900.C4 H64x. Dewey: 745.594. Formerly: *Granny Square and Craft Ideas; Woman's Day Granny Squares.*

Crafts. Needlework.

Advertising.

INTERNATIONAL OLD LACERS INC. [Bulletin]. 1981. q. EN. 1412

International Old Lacers, Inc., 1347 Bedford, Grosse Pointe Park, MI 48230. Trenna E. Ruffner, Editor.

Subscription: included in membership, $15 US, $22 Canada & foreign; air $30 Europe, $32 Asia (Carolyn Regnier, Membership Chairman, 2409 S. Ninth, Lafayette, IN 47905). Sample $1. Back issues $12/yr. Illus. b&w, photos, cartoons. 8½ x 11, 32p.

ISSN: 0740–6746. OCLC: 9986457. Formerly: *International Old Lacers Inc. Bulletin.*

Collectibles. Needlework.

The bulletin of a non–profit organization of people interested in the study and crafts of lace and lacemaking. Contents include features about the history and study of old lace or the preservation and expansion of the crafts of lace, regular tatting column, illustrations of members' work, patterns, ideas and news. Crafts of bobbin and needle lace, knitted, tatted, and crocheted laces are featured. The principal publication of the group serves to increase communication among members regarding educational opportunities, exhibitions and competitions. Aims of the publication are to provide current news of lace activities, improvement of skills and inspiration for new ventures.

Reviews: book 6. video occasionally. Interviews: occasionally, particularly of elderly lacemakers who were trained as professionals. Biographies: profiles of members. Listings: regional–international. Calendar of events. Exhibition information. Freelance work: All volunteer staff. Contact: editor. Opportunities: study, competitions. Reviewed: *Serials Review* 15:1 Spr 1989, p.69.

Advertising: (camera ready) full page $140, ½ page $75, ¼ page $40. Frequency discount. Gladys Caldroney, Ad. Director (5530 Grayton, Detroit, MI 48224, phone 313–885–0154). Mailing lists: none. Demographics: members in all 50 United States, Puerto Rico, Canada and 20 other countries. Circulation: 2000. Audience: people who love lace, who like to study, to make, to collect and to use lace.

KNIPLEBREVET. 1985. q. DA. Separate EN supplement (16p.). 1413

Knipling i Danmark, Postboks 37, DK 6230 Rodekro, Denmark. Phone 74 69 39 34. Holger Moller, Editor (Postparken 30 DK 2770).

Subscription: included in membership, DKK 150 overseas. Sample free. Back issues DKK 35. Illus. b&w, photos. A4, 24–32p.
ISSN: 0900–8799.

Crafts. Decorative Arts. Needlework. Textiles.

Devoted to lacemaking and lacemakers. Includes patterns.

Reviews: book 1, length 1p. Bibliographies occasionally. Interviews: occasionally. Listings: regional. Calendar of events. Exhibition information. Freelance work: none. Opportunities: study. Indexed: Index. Reviewed: *Serials Review* 15:1, Spr 1989, p.70.

Advertising: full page DKK 1.000, ½ page DKK 600, ¼ page DKK 350. Classified: none. 10% frequency discount. Mailing lists: none. Circulation: 3000. Audience: lacemakers.

KNITTER'S MAGAZINE. 1984. q. EN. 1414

Golden Fleece Publications, P.O. Box 1525, Sioux Falls, SD 57101–1525. Phone 605–338–2450. Elaine Rowley, Editor.
Subscription: $14.40 US, $18.40 Canada & foreign. No sample. Back issues $5. Illus. b&w, color, photos. 8½ x 11, 60p. Web offset, saddle–stitch.
ISSN: 0747–9026. OCLC: 10821083. Dewey: 746.

Crafts. Needlework.

Editorial goal is to inform, educate, challenge, and delight the audience as their knitting horizons are expanded. Offers knitting news, projects, articles, pertinent historical information, and technical advice.

Reviews: book 3–6/volume. Interviews: knitting personalities and designers. Listings: international. Exhibition information listed in the Spring issue only. Freelance work: yes but not for photography. Contact: editor. Opportunities: study, in Spring issue only. Reviewed: *Serials Review* 12:1, Spr 1986, p.29.

Advertising: (rate card): b&w full page $$780, ½ page $444, ¼ page $249; 4 color full page $1230, ½ page $725, ¼ page $400; position requests + 10%. Classified: 80¢/wd., $55/col. in. 10% frequency discount, 15% agency discount. Linda Scarmon, Ad. Director (phone 1–800–722–2558). Circulation: 31,000.

KNITTING WORLD. bi–m. EN. 1415

House of White Birches Publishing, 306 E. Parr Rd., Berne, IN 46711. Phone 219–589–8741, fax 219–589–2810. Anne Jefferson, Editor.
ISSN: 0194–8083. OCLC: 5033149. Dewey: 746.43.

Needlework.

Each issue features 25–30 clear, easy–to–follow patterns, as well as reviews, regular & feature articles. Coverage includes specialities like lace knitting and machine knitting.

Advertising: b&w full page $400, ½ page $260, ¼ page $180, covers $520–560; 2 color + $150, 4 color + $350. Classified: (payment with order) $10/20 wds., 25¢/wd. add. Frequency discount. 5% discount for concurrent ads in 2 or more Women's Circle publications. 15% agency discount. 15% discount to mail–order businesses. Janet Price–Glick, Ad. Director. Demographics: 94% women, 96% over 30 yrs. of age, 53% income $25,000+. Circulation: 20,000. Audience: For both beginners and skilled knitters.

LACE. 1976. q. EN. 1416

The Lace Guild, "The Hollies", 53 Audnam, Stourbridge, West Midlands DY8 4AE, England. Phone 0384–390739.
Subscription: included in membership, (1990) £17 US & Canada.
ISSN: 6308–3039.

Needlework.

Reviewed: *Serials Revide* 15:1, Spr 1989, p.70.

Advertising: (rate card Jan '91): [+ VAT] full page £280, ½ page £140, ¼ page £70, inside cover £300, spot color available. Classified: 35p/wd., £7.50 min. Frequency discount. Inserts. Mailing lists: none. Circulation: 9000+.

LACE & CRAFTS. 1987. q. EN. 1417

Laces and Lace Making, 3201 E. Lakeshore Dr., Tallahassee, FL 32312. Phone 904–385–5093. Eucine Sein–Jurado, Editor.
Subscription: $20 US, $25 Canada & foreign, $36 air. Sample $5. Back issues $6.50. Illus. color, photos. 8½ x 11, 64p.
OCLC: 22577002. Dewey: 746. Formerly: *Lace Crafts Quarterly*.

Crafts. Needlework.

Covers the entire world of art embroidery, lacework, sewing with lace and other related crafts, with the advice, technique and tips of the world experts to help achieve professional results with sewing machine or by hand. Full size patterns.

Reviews: book 2 & video 1, length 1p. Interviews: with designers and shop owners or manufacturers. Listings: international. Calendar of events. Exhibition information. Freelance work: yes. Contact: editor. Opportunities: study, competitions. Reviewed: *Serials Review* 15:1, Spr 1989, p.70–71.

Advertising: full page $800, ½ page $480. Classified: $35/inch, 12 lines max. Frequency discount. Mailing lists: available. Demographics: women crafters, ages 25–65, 75% housewifes. Circulation: 20,000. Audience: crafters and needleworkers.

THE LACE COLLECTOR: A Quarterly Newsletter for the Study of Lace. 1991. q. EN. 1418

Lace Merchant, P.O. Box 222, Plainwell, MI 49080. Phone 616–685–9792. Elizabeth M. Kurella, Editor & Pub.

Subscription: $20 individual, $15 institution. Illus. b&w, photos (many of the illustrations are available as slides). Annual index will appear in Oct issue. 8½ x 11, 12p.

Collectibles. Needlework.

Devoted to helping the reader identify what they have. Each issue features a photographic and textual exploration of a particular type of lace, comparisons that distinguish it from other lace work, reference works helpful to the study of lace, a guide to museums with collections of antique laces, market information including pieces for sale, and prices realized at auction. Detailed photographs provide close–up examination of lace work. Occasional articles will appear on how to wash, repair, display, store and use antique lace.

Reviews: book.

Audience: handicrafters, collectors, and the browser who may have inherited a box of old laces and linens.

LADY'S CIRCLE PATCHWORK QUILTS. 1982? bi–m. EN. 1419

Lopez Publications, Inc., 105 E. 35th St., New York, NY 10016. Phone 212–689–3933. Carter Houen, Editor. 8⅛ x 11.

ISSN: 0731–9916. Dewey: 746.

Needlework.

Features present–day quilts and provides instructions for selected designs.

Interviews: quilters around the U.S. Reviewed: *Serials Review* 11:3, Fall 1985, p.17–18.

Advertising.

MACHINE KNITTING MONTHLY. 1986. m. EN. 1420

Machine Knitting Monthly Ltd., 3 Bridge Ave., Maidenhead, Berkshire SL6 1RR, England. Phone 0628–770289, Fax 0628–783245. Anne Smith, Editor & Pub.

Subscription: £16.80 + surface or air postage. Sample free. Back issues. Illus. b&w, color, photos, cartoons. A4, 96p.

ISSN: 0269–9761. Dewey: 746.

Crafts—Machine Knitting.

News, features, hints and tips, in–depth articles, exclusive designs for all machine knitters, letters, "Helpline" column, and a competition with major prizes. Written by machine knitters for machine knitters.

Reviews: exhibition, book, journal, other. Interviews occasionally. Listings: national. Freelance work: yes. Contact: editor.

Advertising: rates on application. Frequency discount. Fiona Lewis, Ad. Manager. Mailing lists: none. Audience: all machine knitters with all types of machine, all age groups.

MACHINE KNITTING NEWS. 1984. m. EN. 1421

Litharne Ltd., P.O. Box 9, Stratford–upon–Avon, Warwickshire CV37 8RS, England. Phone 0789–720133, Fax 0789–720888. Jean Ryder, Editor.

Subscription: 19.20£ UK only; overseas rates on application. (US dist.: Margaret M. Brossary, Knitting Machine Centre, 5442 Cannas Drive, Cincinnati, OH 45238). Illus. b&w, color, photos, cartoons. 128p.

ISSN: 0266–8505. Dewey: 746.43.

Machine Knitting.

Reviews: book. Listings: national UK. Calendar of events & exhibitions. Freelance work: yes. Contact: editor. Opportunities: study, competitions.

Advertising: (rate card Jan '89 [+ VAT]): b&w full page £630, ½ page £360, ¼ page 220; spot color full page £660, ½ page £400, ¼ page £245; 4 color full page 880, ½ page £610, ¼ page £465, covers £890–1000. Classified: 75p/wd., min. 15 wds., semi display £13/scc, min. 3 cc., classified display £16/scc, min. 5 cc. Frequency discount. Agency discount. Maggie Michaells, Ad. Manager (081–807–1185). Circulation: 58,000.

MAGIC CROCHET. 1983. bi–m. EN. 1422

Editions de Saxe, 20 rue Croix Barret, 69364 Lyon Cedex 7, France (US: Robin Hill Park, Rt. 22, Patterson, NY 12563).

Subscription: $16.25.
ISSN: 0246–5957. OCLC: 9141787. Dewey: 746.
Needlework.

McCALL'S COUNTRY QUILTING. EN. 1423
ABC Consumer Magazines, Inc., 825 Seventh Ave., New York, NY 10019. By the Editors of McCall's Needlework & Crafts.
Subscription: $7.99. Illus. some color.
OCLC: 17423229. Dewey: 746.46.
Needlework.

McCALL'S NEEDLEWORK & CRAFTS. 1935. bi–m. EN. 1424
ABC Consumer Magazines, Inc., 825 Seventh Ave., New York, NY 10019. Phone 212–246–4000. Rosemary Maceiras, Editor.
Subscription: $13.97. Illus. 8 x 10¾.
ISSN: 0024–8924. OCLC: 4117390. Dewey: 746.4.
Crafts. Needlework.

Designed for the active woman who wants to create beautiful things to wear and to decorate her home. Each issue emphasizes leisure–time activities: fashions to knit and crochet, decorating ideas, bazaar items, and gift ideas. Contains instructions for a variety of craft projects, especially knitting and crocheting, embroidery, and sewing Instructions and patterns are given for making each item.
Indexed: Hand. Reviewed: Katz. Katz. *School*.
Advertising. Steve Levinson, Ad. Director.

NEEDLE ARTS. 1970. q. EN. 1425
Embroiderers Guild of America, 335 W. Broadway, Suite 100, Louisville, KY 40202. Phone 203–426–2665. Marjorie L. Beck, Editor.
Subscription: included in membership, $24. Illus. b&w, color, photos, patterns. 8⅛ x 10⅞, 48p.
ISSN: 0047–925X. OCLC: 11732811. LC: TT770.N43. Dewey: 746.44.
Needlework.

Although the focus is on embroidery of all kinds, articles on the other needle arts are also presented. Guild news and information for members is included.
Reviews: book, exhibition. Listings: national. Calendar of events. Indexed: ArtArTeAb. CloTAI. Reviewed: Katz. *Art Documentation* Fall 1986, p.132.
Advertising.

NEEDLECRAFT NEWS. 1983. bi–m. EN. 1426
Happy Hands Publishing Company, 4949 Byers, Ft. Worth, TX 76107. Phone 817–732–7494. Betty James, Editor.
Subscription: $6. 16p.
Crafts. Needlework.

Presents information and instruction aimed at beginning crafters.

NEEDLEPOINT BULLETIN. 1973. m. EN. 1427
Needlepoint, Inc., Box 1585, Jupiter, FL 33468–1585. Phone 305–694–0890. Sharlene Weldon, Editor & Pub.
Subscription: $12. 6p.
Dewey: 746.
Needlework.

Although the focus is needlepoint, all stitchery is represented. Transmits news, trends, and information regarding products.
Reviews: book.
Advertising: none.

NEEDLEPOINT PLUS. 1974. bi–m. EN. 1428
EGW Publishing Co., 1320 Galaxy Way, Concord, CA 94520. Phone 415–671–9852. Judy Swager, Editor.
Subscription: $15 US, $20 elsewhere (Box 5967, Concord, CA 94524). 8⅛ x 10⅞),36p.
ISSN: 1040–5518. OCLC: 18448758. Dewey: 746. Formerly: *Needlepoint News*.
Needlework.

Geared to all levels of needlepointers with the focus on developing one's skills, expanding options in the field of needlework, and enhancing creativity. Consists of a collection of original projects by often well–known designers with graph, stitch diagrams, step–by–step instructions and photographs. Technical articles of various needlework techniques and use of fabrics and materials are included along with new products on the market, tips and gift ideas.
Reviews: book. Freelance work: yes, payment.
Advertising: full page $750. Circulation: 25,000.

OLD-TIME CROCHET. 1979. q. EN. 1429
House of White Birches, 306 E. Parr Rd., Berne, IN 46711. Phone 219–589–8741, fax 219–589–2810. Kemis Rodgers, Editor.
Subscription: $9.95 US, $13.15 Canada. Illus.
ISSN: 1050–9518. OCLC: 20705165. Dewey: 746. Formerly: *Old–time Crochet Patterns & Designs.*

Crafts. Needlework.

A generous selection of intricate and fascinating old–fashioned crochet patterns. Presents the best from the needlecraft magazines of yesteryear. Most of these now–back–in–style designs are more than fifty years old.
Advertising: (rate card Jan '89): full page $600, ½ page $315–340, covers $780–840; 2 color + $150, 4 color + $350. Classified: (payment with ad) $10/20 wds., 25¢/wd. add. Frequency discount. 5% discount for concurrent ads in 2 or more
Women's Circle publications. 15% agency discount. 15% discount to mail–order businesses. Janet Price–Glick, Ad. Director.
Demographics: 99% women, 73% over 60, 52% income $25,000+. Circulation: 80,500.

PATCHWORK PATTER. 1973. q. EN. 1430
National Quilting Association, Inc., P.O. Box 393, Ellicott City, MD 21043. Phone 301–461–5733.
Illus. b&w. 8½x11, 44p.

Needlework.

Objectives are to further understanding of quilts or quilting and to compile information on quilting past and present. Promotes quiltmaking as both a skill and an art. Includes Association news and reports on shows and seminars.
Reviews: book. Calendar of events. Freelance work: yes. Contact: editor. Reviewed: *Serials Review* 11:3, Fall 1985, p.16–17.
Advertising.

THE PROFESSIONAL QUILTER. 1983. q. EN. 1431
Oliver Press, Box 75277, Saint Paul, MN 55175–0277. Phone 612–426–9681. Jeannie M. Spears, Editor.
Subscription: $20 US, Canada & foreign $25 surface, $32 air. Sample $5. Back issues $4-$5. Illus. b&w, photos. 8½ x 11, 24p.
ISSN: 0891–5237.

Needlework.

Editorial mission is to provide support, networking opportunities and essential information for the quilting professionals who are responsible for encouraging the continued growth and enthusiasm for quilting as an art and craft. Two major focuses: to bring practical and helpful information to those who make a business of quilting and to provide a forum for discussion of issues of concern to professionals and serious quilters.
Reviews: book 6–10, length 150–500 wds. Freelance work: yes, payment $25–$100 for articles of 500–1500 wds. on practical business information or focus on issues of concern; shorter articles, up to 500 wds. for regular columns. Send for writers' guidelines. Contact: editor. Opportunities: study, competitions. Reviewed: *Serials Review* 11:3, Fall 1985, p.20.
Advertising: (rate card Sept 1990): full page $125, ½ page $75, ¼ page $50, no color. Classified: 25¢/wd. Frequency discount. Mailing lists: none. Circulation: 900, also sold as single copies at quilt shows and by mail order. Audience: serious and career quilters; influential people in the quilt world: teachers, lecturers, writers, designers, publishers, and shop owners.

QUICK & EASY CRAFTS. 1967. bi-m. EN. 1432
House of White Birches Publishing, 306 E. Parr Rd., Berne, IN 46711. Phone 219–589–8741, fax 219–589–2810. Jenine Howard–Nuiver, Editor.
Subscription: $12.97 US, $17.77 Canada (P.O. Box 11309, Dem Moines, IA 50340–1302). Illus.
ISSN: 1048–3659. OCLC: 20928044. LC: TT740.Q53. Dewey: 746. Formerly: *Women's Circle Country Needlecraft; Stitch 'n Sew.*

Crafts. Needlework.

Selection of 20 to 30 needlecraft patterns in each issue covering cross–stitch, crochet, embroidery, quilting, knitting, sewing and other needle–oriented crafts. Regular needlecraft columns share helpful hints and reference information.
Advertising: b&w full page $1500, ½ page $975, ¼ page $525, covers $1950–2100, 2 color + $150, 4 color + $350. Classified: (payment with ad) $10/20 wds., 50¢/wd. add. Frequency discount. 5% discount for concurrent ads in 2 or more

Women's Circle publications. 15% agency discount. 15% discount to mail–order businesses. Janet Price–Glick, Ad. Director. Demographics: 99% women, 73% over 60, 52% income $25,000+.

QUICK & EASY QUILTING. 1979. q. EN. **1433**

House of White Birches, 306 E. Parr Rd., Berne, IN 46711. Phone 219–589–8741, fax 219–589–8093. Sandra Hatch, Editor (RR1, Box 137, Lincoln Center, ME 04458).
Subscription: $9.95 US, $14.75 Canada, $18 foreign. Illus. b&w, color, photos, cartoons. 8 x 11, 48p.
ISSN: 1045–5965. OCLC: 20154893. LC: TT835.Q535. Dewey: 746.46. Formerly: *Quilt World Omnibook*.

Crafts. Fabrics. Needlework.

Geared to today's quilter, the ones with too much to do and no time to do it. The magazine shares tips and techniques to help a quilter make quicker quilts but with style—they don't look quick! Focuses on speed–quilting techniques that make it possible to complete a full–size quilt in a short time. Contains patterns & a directory of quilt shows.
Reviews: 2–4 reviews/issue. Interviews: well–known quick–quilters, 1. issue. Freelance work: yes (details in *PhMkt.*). Contact: editor.
Advertising: (rate card Oct '89): full page $800, ½ page $520, ¼ page $280, spread $1360, covers $2040–1120, 2 color + $150, 4 color + $350. Classified: $10/20 wds., 30¢/wd. add. Frequency discount. 5% discount for concurrent ads in 2 or more Women's Circle publications. 15% agency discount. 15% discount to mail–order businesses. Janet Price–Glick, Ad. Director (phone 1–800–589–8093). Mailing lists: available. Demographics: 99% women, 69% over 50, 48% income $25,000+. Circulation: 60,500. Audience: quilters.

THE QUILT DIGEST. 1983. a. EN. **1434**

Quilt Digest Press, 955 14th St., Dept. E, San Francisco, CA 94114. Phone 415–431–1222. Michael M. Kile, Editor.
Illus. b&w, some color.
ISSN: 0740–4093. OCLC: 9763519. Dewey: 746.

Needlework.

Reviewed: *Library Journal* 110:12, June 1985, p.50.

QUILT WORLD: A Quilter's Dream Come True! 1974. bi–m. EN. **1435**

House of White Birches, 306 E. Parr Rd., Berne, IN 46711. Phone 219–589–8741, fax 219–589–8093. Sandra Hatch, Editor (RR1, Box 137, Sweet Rd., Lincoln Center, ME 04458).
Subscription: $12.97 US, $17.77 Canada, $21 foreign. Sample $3.50. Back issues. Illus. b&w 32, color 32, photos 30+, cartoons 1–2. 8 x 11, 64p.
ISSN: 0149–8045. OCLC: 3552353. LC: TT835.Q53. Dewey: 746.9.

Antique Quilts. Collectibles. Crafts. Fabrics.

A general publication geared to all facets of the craft and art of quilting. Covers the best of traditional and contemporary quilt design. Contains 15 to 20 full–size patterns, feature articles, regular columns and a directory of quilt shows in North America.
Reviews: book 3, length 1p. each, equipment 2–3, length 1p. total. Interviews: profile of quilters, 1/issue. Listings: by state, some international. Calendar of quilt shows. Freelance work: yes (details in *ArtMkt.* and in *PhMkt.*). Contact: editor. Opportunities: competitions, section for contests in show directory. Reviewed: *Serials Review* 11:3, Fall 1985, p.17–18.
Advertising: (rate card Oct '89): b&w full page $1100, ½ page $715, ¼ page $385, spread $1870, covers $1430–1540, 2 color + $150, 4 color + $350. Classified: $10/20 wds., 75¢/wd. add. Frequency discount. 5% discount for concurrent ads in 2 or more Women's Circle publications. 15% agency discount. 15% discount to mail–order businesses. Janet Price–Glick, Ad. Director. Demographics: 99% women, 95% over 50 yrs. of age, 52% income $25,000+, 59% read *Quilt World* as their only quilting magazine. Circulation: 125,000. Audience: quilters.

QUILTER'S NEWSLETTER MAGAZINE. 1969. m. EN. **1436**

Leman Publications, Inc., 6700 W. 44th Ave., Box 394, Wheatridge, CO 80033. Phone 303–420–4272. Bonnie Leman, Editor.
Subscription: $14.95. Illus. color, photos. Index. 8¼ x 10⅞, 60p.
ISSN: 0274–712X. OCLC: 6533923. LC: TT835.Q53. Dewey: 746.46.

Needlework.

Each issue features 5–15 quilts with complete instructions from start to finish. Includes full–size pattern pieces as well as yardage requirements.
Reviews: book. Reviewed: Katz. *School. Serials Review* 11:3, Fall 1985, p.17–18.
Advertising. Nadene Hartley, Ad. Director. Circulation: 130,000+.

QUILTERS GUILD NEWSLETTER. 1979. q. EN. **1437**

Quilters Guild, 56 Wilcot Rd., Pewsey, Wilts. SN9 5EL, England. Frances Kemble, Editor.

Subscription: included in membership, non–members £1.50/issue. Illus.
ISSN: 0261–7420. Dewey: 746.

Needlework.

Research and recording of the history of the craft of quilting.
Reviewed: *Serials Review* 11:3, Fall 1985, p.17.

QUILTING INTERNATIONAL. 1987. bi–m. EN. 1438

All American Crafts, Inc., 70 Sparta Ave., CN 1003, Sparta, NJ 07871. Phone 201–729–4477, fax 201–729–5426. Mitzi Roberts, Editor.
Sample and back issues $4.95. Illus. color, photos. 10½ x 8, 64p.
Dewey: 746. Formerly: *Quilting USA.*

Crafts. Decorative Arts. Fabrics. Needlework.

"The ultimate quilt magazine" features the fine art of international quiltmaking through articles, color photographs showcasing prize–winning and artistic quilts, and quilting techniques with how–to's and patterns for several projects from small and easy to more intricate, full–sized quilts. Presents a melting pot of traditional and new quilt designs.
Reviews: exhibition 1, length 1p.; book 3, length 1 column; equipment 1. Biographies: background information on artists whose work is being featured. Interviews: with quilters and quilt teachers. Listings: international. Calendar of shows. Exhibition information. Freelance work: yes. Contact: editor.
Advertising: (rate card Aug 1990): full page $1208, ½ page $774, ¼ page $464; 4–color full page $1388, ½ page $875, ¼ page $525, covers $1471–1625. Frequency discount. Multiple insertion discounts for ads in more than one of publishers magazines. 15% agency discount. Demographics: readers are 75% female, affluent, most report high levels of education; interested in arts, crafts, decoration and history. Sold via subscription, on newsstands and in craft, sewing and quilting shops. Distributed at trade and consumer shows and through mailed media kits. Audience: fabric artists and quilters.

QUILTING TODAY. 1987. bi–m. + a. special issue. EN. 1439

Chitra Publications, 300 Church St., Box 437, New Milford, PA 18834. Phone 717–465–3306. Patti Bachelder, Editor.
Illus.
ISSN: 1040–4457. OCLC: 18419680. LC: TT835.Q547. Dewey: 746.46.

Needlework.

QUILTMAKER. 1982. s–a. EN. 1440

Leman Publications, Inc., 6700 W. 44th Ave., Box 394, Wheatridge, CO 80033. Phone 303–420–4272. Bonnie Leman, Editor.
Illus. color, photos. 8¼ x 11.
Dewey: 746.

Needlework.

"The pattern magazine for today's quiltmakers" each issue features 12–15 original patterns illustrated in full color with complete yardage listings, full size patterns, and step–by–step instructions.
Reviewed: *Serials Review* 11:3, Fall 1985, p.18.
Advertising: Nadene Hartley, Ad. Director.

SAGA NEWS. bi–m. EN. 1441

Smocking Arts Guild of America, P.O. Box 42, Great Falls, VA 22066. Phone 703–481–0180.
Dewey: 746.

Crafts. Needlework.

Newsletter which includes patterns and chapter news.

SMOCKING ARTS MAGAZINE. 1979. bi–m. EN. 1442

Smocking Arts Guild of America, P.O. Box 42, Great Falls, VA 22066. Phone 703–481–0180. Joy Payne, Editor.
Dewey: 746.

Crafts. Needlework.

Works to establish a high standard of quality of workmanship and further the appreciation of smocking, a decorative embroidery.
Reviews: book.
Advertising. Audience: manufacturers, designers, show owners, instructors and others interested in smocking.

STITCH 'N SEW QUILTS. 1982. bi–m. EN. 1443

House of White Birches, 306 E. Parr Rd., Berne, IN 46711. Phone 219–589–8741, fax 219–589–2810. Sandra L. Hatch, Editor (RR1 Box 137, Sweet Rd., Lincoln Center, ME 04458).

Subscription: $12.97 US, $17.77 Canada, $21 foreign. Sample $3.50. Back issues $2. Illus. b&w, color, photos, cartoons. 8 x 11, 64p.

ISSN: 0744–1649. OCLC: 8077510. Dewey: 746.46.

Crafts. Needlework.

Devoted to quilting patterns and designs each issue focuses on a single theme such as — star designs, bird patterns, hearts, etc. All articles are related to the issue theme. Full patterns and instructions are provided. Published on alternating months from *Quilt World*).

Reviews: book 3, length 1 page. Freelance work: yes (details in *PhMkt.*). Contact: editor. Reviewed: *Serials Review* 11:3, Fall 1985, p.17–18.

Advertising: (rate card Jl '89): b&w full page $800, ½ page $520, ¼ page $280, spread $1360, covers $1040–1120, 2 color + $150, 4 color + $350. Classified: (payment with ad) $10/20 wds., 40¢/wd. add. Frequency discount. 5% discount for concurrent ads in 2 or more Women's Circle publications. 15% agency discount. 15% discount to mail–order businesses. (phone 800–589–8093) Janet Price–Glick, Ad. Director. Demographics: 95% women, 72% over 50, 52% income $25,000+, 41% read this as their only quilting magazine. Circulation: 125,000. Audience: quilters, both beginners and experienced.

STITCH 'N SEW QUILTS CHRISTMAS ANNUAL. 1982. a. EN. 1444

House of White Birches Publishing, 306 E. Parr Rd., Berne, IN 46711. Phone 219–589–8741, fax 219–589–2810. Sandra Hatch, Editor.

Illus.

OCLC: 14146345. Dewey: 746.46.

Crafts. Needlework.

Advertising: Janet Price–Glick, Ad. Director.

STUMPWORK SOCIETY CHRONICLE. 1979. q. EN. 1445

Stumpwork Society, Box 122, Bogota, NJ 07603. Phone 201–224–3622. Sylvia C. Fishman, Editor.

Subscription: $10. Sample $2.50. Back issues. Illus. b&w, photos. 8½ x 11, 8p.

ISSN: 0194–4193. OCLC: 5431395. Dewey: 746.

General. Fiber Arts.

Devoted to the art of stumpwork–raised embroidery.

Reviews: exhibition, book, equipment. Bibliographies occasionally. Interviews: curators, colleagues peers of interest. Biographies: highlight fiber artists working with stumpwork techniques. Listings: regional–international. Calendar of events. Exhibition information. Freelance work: rarely. Contact: editor. Opportunities: study, competitions.

Advertising: none. Mailing lists: none. Audience: fiber artists.

THREADS. 1985. bi–m. EN. 1446

Taunton Press, 63 South Main St., Box 355, Newtown, CT 06470. Phone 203–426–8171, fax 203–426–3434. Betsy Levine, Editor.

Subscription: $20 US, $24 Canada & foreign, air + $14. Sample $3.95. Back issues $5. Illus. color, photos. Annual index in Oct/Nov issue. 8⅞ x 11¼. Web offset, perfect bound.

ISSN: 0882–7370. OCLC: 11951760. LC: TT697.T48. Dewey: 746.

Crafts. Needlework. Textiles.

Each issue is filled with practical articles by talented craftspeople eager to help the reader make beautiful things to wear and use. Focuses primarily on sewing and knitting and on the design, construction and detailing of fine clothing. Covers every facet of the textile arts and needlecrafts, including embroidery, quilting, weaving and more. Backs up each informative article with crystal–clear graphics that help detail the "how–to" process. Technical drawings and photographs of finished pieces provide plenty of design ideas and inspiration..

Reviews: exhibition 2–3, book 5–6, video 1–2, equipment 1–2. Bibliographies: reference readings, recommend suppliers Interviews. Listings: state–international. Calendar of events. Exhibition information. Freelance work: none. Opportunities: study, competitions. Indexed: ArtArTeAb. CloTAI. Des&ApAI. Hand. Textile Arts Index. Reviewed: Katz. *Serials Review* 12:1 Spr 1986, p.32.

Advertising: (rate card Jun/Jl '89): b&w full page $2970, ½ page $1655, ¼ page $875, cover $3265; 4 color full page $3980, ½ page $2215, ¼ page $1175, cover $4375. Classified: $3/wd., min. 15 wds. Frequency discount. 15% discount for camera–ready art. Inserts. Roy Swanson, Ad. Director (1–800–243–7252). Mailing lists: available. Demographics: predominantly female audience dedicated to sewing, knitting, weaving and other fiber arts. Range from serious amateurs to professionals.

Over ⅓ earn money from their craftwork; 51% work on their own designs; highly educated; average household income $50,000; average reader spends about $900/yr. on supplies and equipment. Subscriber survey available. Circulation: 110,000. Audience: fiber artists/needle workers, fashion sewers/knitters.

VOGUE KNITTING INTERNATIONAL. 1982? s–a. EN.

1447

Butterick Fashion Marketing Co., 161 Ave. of the Americas, New York, NY 10013. Phone 212–620–2500.
Subscription: $4.50/issue. Illus.
ISSN: 0890–9237. OCLC: 14273949. LC: TT820.V625. Dewey: 746.9. Formerly: *Vogue Knitting*.
Needlework.

WOMEN'S CIRCLE CROCHET. 1981. q. EN.

1448

House of White Birches, 306 E. Parr Rd., Berne, IN 46711. Phone 219–589–8741, fax 219–589–2810. Anne Jefferson, Editor.
Illus. 8 x 10¾.
ISSN: 0279–1978. OCLC: 7624661.
Crafts. Needlework.

Companion publication to *Crochet World*, presents clear easy–to–follow crochet patterns both practical and decorative designs.
Advertising: (rate card Jl '89): full page $500, ½ page $325, ¼ page $175, covers $650–700; 2 color + $150, 4 color + $350. Classified: (payment with ad) $10/20 wds., 40¢/wd. add. Frequency discount. 5% discount for concurrent ads in 2 or more Women's Circle publications. 15% agency discount. 15% discount to mail–order businesses. Janet Price–Glick, Ad. Director. Demographics: 98% women, 96% over 30, 64% income $20,000+. Circulation: 47,000.

WOMEN'S HOUSEHOLD CROCHET. 1981. q. EN.

1449

House of White Birches, 306 E. Parr Rd., Berne, IN 46711. Phone 219–589–8741, fax 219–589–2810. Susan Hankins Andrews, Editor (Women's Household Crochet, P.O. Box 776, Henniker, NH 03242).
Subscription: $9.95 US, $13.15 Canada, foreign $18. Sample & back issues $2. Illus. 8½ x 11, 48p.
ISSN: 0745–0575. OCLC: 17948347, 8770658. Dewey: 746.434. Formerly: *Crochet for Women Only*.
Crafts. Needlework.

Covers crochet patterns only with regular contest for best work (2 winners/issue). Freelance designers are mainstay with minimal columnist contributions. Letters column–swap shop type. General help column offering advice to common crochet complaints. General crochet—clothing, bazaar, household, toys, dolls, doilies, afghans, filet. etc. Occasional manuscripts which offers helpful hints in marketing crochet work.
Reviews: book 0–2. Freelance work: yes. Contact: editor.
Advertising: b&w full page $500, ½ page $325, ¼ page $175, 2 color + $150, 4 color + $350. Classified: (payment with ad) 10¢/20 wds., 25¢/wd. add. Frequency discount. 5% discount for concurrent ads in 2 or more Women's Circle publications. 15% agency discount. 15% discount to mail–order businesses. Janet Price–Glick, Ad. Director. Mailing lists: available. Demographics: 98% women, 96% over 30, 66% income $20,000+. Circulation: 35,500. Audience: Appeal to young and old, but mostly the stay–at–home crocheters.

WOOL GATHERING. 1969. s–a. EN.

1450

Schoolhouse Press, 6899 Cary Bluff, Pittsville, WI 54466. Phone 715–884–2799. Meg Swansen, Editor.
Subscription: (3 yrs.) $10 US & Canada, $15 foreign air. Sample $2. Back issues $1–2. Illus. b&w, photos, cartoons. 6 x 8½, 12p.
Dewey: 745.5. Formerly: *Newsletters (1959–1969)*.
Crafts. Needlework.

Each issue contains an original design by Elizabeth Zimmermann and Meg Swansen, general chit–chat and free "plugs" for knitting–related products. Accompanying video tapes on the knitting of the garment are available for recent issues.
Reviews: book 6–8, length ½ page. Freelance work: none.
Advertising: none. Mailing lists: none. Circulation: 5000. Audience: hand–knitters.

THE WORKBASKET AND HOME ARTS MAGAZINE. 1935. bi–m. EN.

1451

Modern Handcraft, Inc., 4251 Pennsylvania Ave., Kansas City, MO 64111–9990. Phone 816–531–5730. Roma Jean Rice, Editor.
included in membership. Illus. 5¼ x 7⅞, 72p.
ISSN: 0162–9123. OCLC: 5396033. Dewey: 746. Formerly: *Workbasket*.
Crafts. Needlework.

Special interest in needlework especially knitting and crochet patterns.
Indexed: Hand. Reviewed: Katz. Katz. *School.*
Advertising. Stephen Hedlund, Ad. Director. Circulation: 1,500,000+.

WORKBOX: For Everyone Who Loves Needlecrafts. 1984. q. EN. 1452

Workbox Enterprises, 40, Silver St., Wiveliscombe, nr. Taunton, Somerset TA4 2NY, England. Phone 0984 24033. Audrey
Babington, Editor & Pub.
Subscription: £6 UK; £8 US, Canada, & foreign; air £10. Sample & back issues £1.50. Illus., b&w, color, photos, cartoons.
A4, 48p.
ISSN: 0268–5175. Dewey: 746.

Crafts. Hobbies. Needlework.

Caters to all those who love needlecrafts, giving interesting features and information on a very wide range, including holidays, books, courses, etc. Does not present patterns nor feature knitting.
Listings: national. Exhibition information. Freelance work: none. Opportunities: employment, study, competitions.
Advertising: full page £800, ½ page £425, ¼ page £250. Classified: £25 & £50 [+ VAT]. Color rates on application. Frequency discount. Mailing lists: none. Circulation: 50,000.

Textiles & Weaving

ACPTC NEWSLETTER. 1975. q. EN. 1453

Association of College Professors of Textiles and Clothing, Inc., Box 1360, Monument, CO 80132. Phone 719–488–3716. Editor varies by 2 year term.
Subscription: included in membership, free to interested parties. Sample. No back issues. Illus. b&w, photos. 8½ x 11, 8–16p.
OCLC: 8881587. LC: TS1300.A887x. Dewey: 687.

Textiles.

Tabloid. Purpose is to provide timely dissemination of information to members of the association. Geared toward educators
of textile and apparel. Include news of members.
Reviews: (2 reviews per issue): exhibitions, book, film, equipment. Bibliographies: publications by members, theses dissertations for the year. Interviews occasionally. Listings: regional–international. Calendar of events. Exhibition information. Freelance work: items are submitted and selected by the editor. Opportunities: "Position announcements", and "Conferences,
Competitions, Calls". Indexed: CloTAI.
Advertising: Classified: $5/80 characters. No color. Sandra S. Hutton, Ad. Director. Circulation: 900. Audience: ACPTC
members, clothing & textiles college and university professors.

ACPTC PROCEEDINGS: National Meeting. 1944. a. EN. 1454

Association of College Professors of Textiles and Clothing, Inc., Box 1360, Monument, CO 80132. Phone 719–488–3716.
Sandra S. Hutton, Managing Editor.
Subscription: included in membership, $22 US, $25 Canada & foreign, surface only. No sample. Some back issues, price varies. Illus. b&w, photos. 8½ x 11, 150p.
Dewey: 687.

Textiles.

Abstracts of research or other presentations (fiber art, etc.) of interest to members reported at the yearly conference.
Freelance work: no, all articles are juried or invited. Indexed: CloTAI.
Advertising: none. Circulation: 950. Audience: researchers of clothing & textiles.

BULLETIN DU CIETA. 1989. a. EN & FR. EN & FR summaries. 1455

Centre International d'Etude des Textiles Anciens, 34 rue de la Charite, 69002 Lyon, France.
Subscription: $45 individual, $50 library, $100 institution. Illus.
ISSN: 0008–980X. OCLC: 22337995. LC: NK8806.C46a. Dewey: 677. Formerly: *Textiles Anciens.*

Textiles.

Bilingual publication devoted to ancient textiles, their history and information regarding cataloging.
Audience: curators, conservators, and textile specialists.

THE CLOTHING AND TEXTILE ARTS INDEX. See no. 10.

CLOTHING AND TEXTILES RESEARCH JOURNAL. 1982. q. EN. **1456**
Association of College Professors of Textiles and Clothing, Inc., Box 1360, Monument, CO 80132. Phone 719–488–3716.
Nancy J. Owens, Editor (2210 Marine St., Santa Monica, CA 90405).
Subscription: included in membership, $35 US, $42 Canada, foreign air $45. Sample. Back issues $8.75. Illus b&w, photos.
8½ x 11, 56p.
ISSN: 0887–302X. OCLC: 9746357. LC: TS1300.C54. Dewey: 646.
Textiles. Clothing.

Purposes of the journal are to strengthen the research base in clothing and textiles, facilitate scholarly interchange, demonstr-
ate the interdisciplinary nature of the field and inspire further research. Includes abstracts of articles together with the author's
address.
Freelance work: no, all submissions are juried selections. Indexed: CloTAI. PsyAb.
Advertising: rates upon request. Circulation: 1100. Audience: researchers.

COSTUME. 1967. a. EN. **1457**
Costume Society, 3 Meadway Gate, London NW11 7LA, England. Dr. Ann Saunders, Editor.
Subscription: included in membership, £12 US & Canada (Mrs. H. Wood, Birtle Edge House, Bury, Lancs. BL9 6UW). No
sample. Back issues. Illus b&w, photos. Cum. index, vols. 1–20. 150p.
ISSN: 0590–8876. OCLC: 2070784. Dewey: 391.
Art History. Clothing. Crafts. Decorative Arts. Museology. Textiles.

Study of significant examples of historic and contemporary clothing.
Reviews: exhibition 2–4, book 20, variable length. Bibliographies as needed. Listings: national–international. Indexed:
ArtArTeAb. ArtBibMod. BrArchAb. CloTAI. Des&ApAI. RILA.
Advertising: none. Mailing lists: none. Circulation: 1200. Audience: scholars, historians.

CSA NEWS. 1975. 3/yr. EN. **1458**
Costume Society of America, 55 Edgewater Dr., Box 73, Earleville, MD 21919. Phone 301–275–2329. Margaret Vincent, Ed-
itor.
Subscription: included in membership together with *Dress.*
Dewey: 659.152. Formerly: *Costume Society of America Newsletter.*
Dress and Adornment. Textiles.

Tabloid.
Bibliographies. Interviews.
Advertising: none. Audience: members.

CSO NEWS. 1971. 3/yr. EN. **1459**
Costume Society of Ontario, Box 981, Station F, Toronto, Ontario M4Y 2N9, Canada. Betty Ann Crosbie, Editor.
Subscription: included in membership. No sample. Some back issues. Illus b&w, photos, cartoons. 9½ x 11, 14p.
ISSN: 0834–2520. OCLC: 16309329. LC: GT500. Dewey: 391. Formerly: *Costume Society of Ontario Newsletter.*
Costume. Decorative Arts. Fabrics. Historic Preservation. Needlework. Textiles.

Reviews: (4/issue) exhibition, book, other. Listings: regional–international. Calendar of events. Exhibition information. Freel-
ance work: none. Opportunities: study.
Advertising: none. Circulation: 350. Audience: members.

DECORATIVE RUG. 1987. m. EN. **1460**
Oriental Rug Auction Review, Inc., P.O. Box 709, Meredith, NH 03253. Phone 603–744–9191, fax 603–744–6933. Ron
O'Callaghan, Editor.
Subscription: free to dealers. $45 bulk mail, $60 first class US; $US65 air Canada, $85 foreign air. Reduced rate in combina-
tion with *Oriental Rug Review.* Sample free. Back issues $5. Illus b&w, color, photos. 8½ x 11, 75–80p.
ISSN: 1045–8816. Dewey: 347.5. Formerly: *Decorative Rug Review.*
Interior Design. Rugs. Textiles.

Journal of oriental rugs and rug literature for the collector and the dealer. Prime audience is the oriental rug professional.
Reviews: book. Interviews: importers, retailers manufacturers of Oriental rugs. Biographies: family histories of prominent im-
porters. Listings: international. Calendar of events. Exhibition information. Freelance work: yes. Contact: editor. Reviewed:
Library Journal Apr 1989.

Advertising: (rate card Mar '88): b&w full page $1100, ½ page $575, ¼ page $410; 4 color full page $2200, ½ page $1225. Peter Woodaman, Ad. Director. Mailing lists: available. Audience: importers, dealers, interested laypeople.

DESIGN AND SIGN. 1990. s–a. EN.

1461

Fashion Institute of Technology, Shirley Goodman Resource Center, 7th Ave. at 27th St., New York, NY 10001–5992. Subscription: $9.
ISSN: 1051–4082. OCLC: 21953763. Dewey: 745.
Textiles.

Published by the Center in association with the Educational Foundation for the Fashion Industries. Companion publication to: *Textile & Text.*

DRAFTS & DESIGN. Sept–June. EN.

1462

Robin & Russ Handweavers, Inc., 533 N. Adams, McMinnville, OR 97128. Phone 503–472–1882. Russell E. Groff, Editor.
Subscription: $10 US, $15 Canada & foreign. No sample. Back issues. Illus.
Weaving.

A 6 to 12 harness weaving publication with very detailed instruction in the use of a variety of fabrics. A sample swatch is enclosed with each issue.

DRESS. 1975. s–a. EN.

1463

Costume Society of America, 55 Edgewater Dr., Box 73, Earlville, MD 21919. Phone 301–275–2329. Patricia A. Trautman, Editor.
Subscription: included in membership. No sample. Back issues. Illus. b&w, photos. 8½ x 10½, 95p.
ISSN: 0361–2112. OCLC: 2246361. LC: GT605.D74. Dewey: 391.
Dress and adornment.

A scholarly journal, juried, addressing all aspects pertaining to dress and adornment. Special attention is given to history and preservation. Articles relate to CSA membership interests and affiliations: costume history, theatrical costuming, museum collections, historic construction, etc.
Reviews: exhibition, book, journal. Indexed: ArtArTeAb. CloTAI. Des&ApAI. RILA. Reviewed: *Art Documentation* Fall 1986, p.133.
Advertising: none. Circulation: 2000. Audience: membership.

FIBERARTS. 1975. 5/yr. EN.

1464

Nine Press Inc., 50 College St., Asheville, NC 28801. Phone 704–253–0468. Ann Batchelder, Editor.
Subscription: $18 US, $20 Canada, foreign $24, air $44. Sample $4. Back issues $3–4. Illus b&w, color, photos. 72p.
ISSN: 0164–324X. OCLC: 3301202. LC: TT697.F52. Dewey: 746. Formerly: *Fibercraft Newsletter.*
Crafts. Decorative Arts. Historic Preservation. Interior Design. Needlework. Textiles.

For enthusiasts of contemporary weaving, handmade clothing, knitting, crochet, needlework, quilting, dyeing and other craft/art fiberwork activities. Covers profiles and interviews with individual artists, presenting photo portfolios of their work, techniques, equipment and life–styles.
Reviews: 8 reviews/issue. Listings: international. Calendar of events. Exhibition information. Freelance work: yes. Contact: editor. Opportunities: study, competitions. Indexed: ArtArTeAb. ArtI. BioI. CloTAI. Des&ApAI. Reviewed: Katz.
Advertising. Audience: fiber artists and fiber art–interested.

FIBERWORKS QUARTERLY. 1985. s–a. EN.

1465

P.O. Box 49770, Austin, TX 78765. Phone 512–343–6112. Bobbie S. McRae, Editor & Pub.
Sample & back issues $6. 8½ x 11, 12–16p.
Weaving.

Newsletter covering the fiber arts, textile design and trends in textiles.
Freelance work: yes, no payment.
Circulation: 1000.

HALI. 1978. bi–m. EN. GE supplement.

1466

Hali Publications Ltd., Kingsgate House, Kingsgate Pl., London NW6 4TA, England. Phone 071–328 9341, fax 071–372 5924, telex 940 13138 HALIG. (US: Hali Publications Ltd., c/o Expediters of the Printed Word, 515 Madison Ave., Suite 917, New York, NY 10022). Alan Marcuson, Editor.

Subscription: $85 US & Canada, £48 UK, £53 Europe, £58 rest. (US, Canada & South America to: Hali Publications Ltd., c/o D.M.G. Inc., 207 Meadow Rd., Edison, NJ 08817). Back issues. Illus., glossy, some color, photos. Cum. index, v.1–11, 1978–89 (1990). A4, 228p.

ISSN: 0142–0798. OCLC: 5083241. LC: NK2808.H17. Dewey: 746.7.

Fabrics. Textiles.

The only international magazine devoted to fine carpets and textiles. Profusely illustrated. Targets market place news, auction reports, auction price guide, galleries previews and reviews. Cumulative indexes by subject, author, exhibition, and publication. Reviews and listing of over 1200 books and catalogs. German language supplement for subscribers in Germany, Austria and Switzerland is published as an integral part of each issue.

Reviews: exhibitions, book, galleries. Bibliographies. Exhibition information. Freelance work: yes. Contact: editor. Indexed: ArtArTeAb. ArtBibMod. CloTAI. Reviewed: Katz.

Advertising: Sebastian Ghandchi, International Ad. Manager. Nicholas Fripp, Ad. Manager, US & Canada. Demographics: readers in 44 countries.

HANDWOVEN. 1979. 5/yr. EN. 1467

Interweave Press, 201 E. Fourth St., Loveland, CO 80537. Phone 303–669–7672, 1–800–272–2193. Jane Patrick, Editor.

Subscription: $21 US, Canada & foreign $26. Illus., b&w, color, photos, cartoons. 8½ x 11, 108p. Web offset, saddle–stitched.

ISSN: 0198–8212. OCLC: 6758062. LC: TT848.H356. Dewey: 746.1. Formerly: *Interweave*.

Crafts. Hobbies. Textiles. Weaving.

Addresses the interests of handweavers at all levels of mastery. Each issue includes photographed woven projects, complete step–by–step instructions, in–depth articles, reviews, columns, tips, and product information. Articles range from features on special techniques, history, and people to general weaving instructions. Two special theme issues each year are thoroughly researched for permanent reference value. Covers weaving, spinning, and dying.

Reviews: book 3, length ⅓p. Bibliographies: occasionally small bibliographies or resource lists with articles. Biographies: weavers. Interviews: famous weavers. Listings: regional–international. Calendar of events. Exhibition information. Freelance work: yes. Contact: editor. Opportunities: study, competitions. Indexed: CloTAI. Reviewed: Katz.

Advertising: (rate card May 1988): full page $989, ½ page $555, ¼ page $310; 4 color full page + $350, ½ page + $250. Classified: display $50/inch camera–ready, word ads $1.25/wd., min. $25 pre–paid. Special positions + 10–15%. 10–15% frequency discount. 15% agency discount. 2% cash discount. Sharon Altergott, Ad. Manager. Mailing lists: available to current advertisers. Demographics: all 50 states and numerous foreign countries, as well as weaving and yarn shops, bookstores, and on newsstands in U.S. and foreign countries. 95% female, average age 45, highly educated, household income $30,000–$75,000. Circulation: 35,000. Audience: hand weavers.

HANDWOVEN'S DESIGN COLLECTION. 1981. EN. 1468

Interweave Press, 201 E. Fourth St., Loveland, CO 80537. Phone 303–669–7672, 1–800–272–2193.

Illus.

OCLC: 12125415. LC: TT848.H36x. Dewey: 746.1.

Crafts. Textiles. Weaving.

Contains weaving patterns.

Indexed: CloTAI.

Circulation: 35,000. Audience: hand weavers.

HOME TEXTILES TODAY. 1979. bi–w (except May & Ocy). EN. 1469

Home Textiles Today, 41 Madison Ave., 5th Floor, New York, NY 10010. Phone 212–679–9755.

Subscription: $49.95 US, $60 Canada, $95 foreign. No sample. Back issues $5/issue. Illus. b&w, color, photos. 10¾ x 14½, 52p.

ISSN: 0195–3184. OCLC: 5523644. Dewey: 338.

Textiles.

Trade newspaper presenting business and fashion for the home textiles industry.

Listings: national. Calendar of events. Freelance work: yes. Contact: editor. Opportunities: employment, study.

Advertising: Frequency discount. Sheila Rice, Ad. Director. Mailing lists: none. Circulation: 12,000. Audience: home textiles/furnishings industry.

IMAGO MODA: Rivista di Storia del Costume. 1987. 1470

Edifir s.r.l., Via Fiume, 8–50123 Florence, Italy. Phone 055–289639/289506, fax 055–289478. Gianni Mancassola, Direttore.

Illus. b&w. A4, 92p.

Costume.

Covers costumes of all time periods including current fashion.
Advertising.

INFO-TEX: Textilindustriens Maanedsblad. 1984. m. 1471
Bibliotekscentralen, Telegrafvej 5, DK–2750 Ballerup, Denmark.
Subscription: included in membership.
ISSN: 0901–4233. Dewey: 677.

Textiles.

INTERNATIONAL HAJJI BABA SOCIETY NEWSLETTER. m. EN. 1472
International Hajji Baba Society, c/o Virginia Day, Sec., 6500 Pinecrest Ct., Annadale, VA 22063. Phone 703–354–4880.
Textiles.

Promotes interest in oriental rugs and textiles.

JOURNAL FOR WEAVERS, SPINNERS & DYERS. 1952. q. EN. 1473
Association of Guilds of Weavers, Spinners & Dyers, BCM 963, London WC1N 3XX, England. Phone 0432–59066.
Subscription: £9.80 UK, foreign £12.50. Illus.
ISSN: 0267–7806. OCLC: 11611682. LC: TS1300.Q21. Dewey: 677.028. Formerly: *Weavers Journal; Guilds of Weavers,
Spinners and Dyers. Quarterly Journal.*

Crafts. Weaving.

Purpose is to preserve and improve craftsmanship in hand weaving, spinning and dyeing. Includes technical notes.
Reviews: book. Indexed: CloTAI.
Advertising.

JOURNAL OF THE TEXTILE INSTITUTE. 1910. q. EN. 1474
Textile Institute, 10 Blackfriars St., Manchester M3 5DR, England. Phone 061–834–8457. (US Dist.: Allen Press, Inc., 1041
New Hampshire St., Lawrence, KS. J.W.S. Hearle, Editor.
Subscription: £80 UK, $160 US & Canada. Sample. Back issues. Illus. Index. Cum. index vol. 1–61, 1910–70. 100p.
ISSN: 0400–5000. OCLC: 1767380. LC: TS1300.T215. Dewey: 677.

Textiles.

The scholarly journal of the Textile Institute. A refereed publication on developments in fiber science and textile technology.
Also being extended into design, economics and management plus special issues on particular theories.
Reviews: book 3, length 1p. Freelance work: none. Indexed: ArtArTeAb.
Advertising: none. Circulation: 1500. Audience: professional textile engineers, scientists, designers, and managers.

THE LOOMING ARTS. 1966. 5/yr. (often late). EN. 1475
The Pendleton Shop, P.O. Box 233, Sedona, AZ 86336. Phone 602–282–3671. Mary Pendleton, Editor.
Subscription: $8.50 includes 1 or more 4–harness designs; $10.50 includes additional multi–harness design (5–8 harnesses);
US, Canada, Mexico, Pan–American and foreign + $2. Sample $2. Back issues $2.25. Illus. b&w, photos. 8½ x 11, 8p.
Fabrics. Weaving.

A textbook type publication with "how to" projects complete with actual fabric and yarn samples. All articles devoted to hand-
weaving or related subjects. Samples are generous, minimum 3 x 3 inches. Detailed directions. Features the editor's handwo-
ven designs; occasionally contains a handwoven and handknit combination project. "Pendleton Peddler" section helps
handweavers find supplies and offers other unusual items. Each issue is hand–tied with yarn.
Freelance work: occasionally. Contact: editor.
Advertising: none. Mailing lists: none. Circulation: 700. Audience: fiber art people.

MARINE TEXTILES. 1986. 9/yr. EN. 1476
Robert C. Mead, Pub., 12 Oates Center, No. 922, Wayzata, MN 55391. Phone 612–473–5088. Mary Stadick, Editor.
Subscription: $24 US & Canada, foreign air $75. Back issues $5. Illus. b&w, color, photos. Annual index. 8⅛ x 10⅞, 70p.
ISSN: 0885–9949. OCLC: 12792523. Dewey: 677.

Decorative Arts. Fabrics. Furniture. Graphic Arts. Interior Design. Textiles.

Reports on fabrics, fabric products and furnishings used in the boating industry. Its focus is on new products, design, color,
trends, materials and changes in technology. Design, specifications, markets, manufacturing and fabrication, installation and
service are among the topics covered. The editorial calendar is timed to cycles of the boating business. Departments include

"Regions" a review of trends within six regions in the U.S. and Canada covering the trends and news within the region; "Designer's Profile" a pictorial review of individual designers and their work in the marine area with a profile on their views on design. "New Products"; "Fabricator's Portfolio" a pictorial look at an individual fabricator's work with comments about his/her business outlook; "Cliff Noel's Fabrication Guide" a continuing series on the fabrication of marine fabric products; "Reference Corner"; and "Marketplace".

Bibliographies: "Reference Corner, marine fabrics reference materials—books, reprints, videos. Listings: national–international. Calendar of events. Exhibition information. Freelance work: yes. Contact: editor. Opportunities: study, competitions. Advertising: full page $1450, ½ page $995, ¼ page $560, color + $240, 4 color + $690. Classified: 50¢/wd. Frequency discount. R. Mead, Ad. Director. Mailing lists: service available. Demographics: comprehensive coverage of firms who use textile and textile products in the boating market; 55% manufacturers of marine fabric products for boat owners, 17% boat manufacturers; 20% Great Lakes, 18% Southwest; 16% Southeast, 12% Canada. Circulation: 6700. Audience: marine textile market.

ORIENTAL RUG. 1928. m. EN. 1477

Oriental Rug Importers Association of America, 267 Fifth Ave., Rm. 302, New York, NY 10016. Phone 212–685–1761. Archie Cherkezian, Editor.

Illus.

ISSN: 0030–5332. OCLC: 6880123.

Interior Design.

Reviews: book.

Advertising.

ORIENTAL RUG REVIEW. 1981. bi-m. EN. 1478

Oriental Rug Auction Review, Inc., P.O. Box 709, Meredith, NH 03253. Phone 603–744–9191, fax 603–744–6933. George W. O'Bannon, Editor (1810 Rittenhouse Square, Suite 1910, Philadelphia, PA 19103, phone 215–732–4110).

Subscription: $55 first class, $45 bulk rate US; $60 Canada, foreign air $75. Reduced rate when combined with subscription to *Decorative Rug*. Sample free. Back issues $8. Illus. b&w 40%, color 60%, photos, cartoons occasionally. Annual index with Nov/Dec issue for prior year. Cum. index vol. 1–7, 1981–June 1987. 8½ x 11, 55–64p.

ISSN: 1044–4807. OCLC: 8771903. Dewey: 746. Formerly: *Oriental Rug Auction Review*.

Art History. Collectibles. Oriental Rugs. Textiles.

A journal of oriental rugs and other textiles, the only American periodical dedicated to classical, antique, and contemporary Oriental rug weaving. Articles, commentaries, and reviews cover a wide range of material from scholarly discussions to lighter reading. In–depth reports on major Oriental rug auctions are provided. Authors include scholars from museums and academia, rug collectors and dealers, private researchers, international travelers, and scientists.

Reviews: exhibition 1–3, length 1p. each; book 2–6, length 1–3p.; journal 1, length 1p. Bibliographies: focused issues always include a comprehensive bibliography of the topic; scholarly articles usually include a bibliography. Interviews: oriental rug collector. Biographies: dealer profiles, rug personality stories, museum directors. Listings: international. Calendar of events. Freelance work: yes. Contact: editor. Opportunities: study, competitions—notification of availability under "Rug Notes" column.

Advertising: full page b&w $1000, ½ page $615, ¼ page $400; 4 color full page $1560, ½ page $845, ¼ page $525. Frequency discount. Agency discount. Peter Woodaman, Ad. Director (editor's address). Mailing lists: available through editor. Demographics: international collectors, scholars on Oriental rugs. Circulation: 5000. Audience: dealers, collectors of old antique oriental rugs, interior designers, auction house rug specialists, educators, and students of art history.

RUG HOOKING. See no. 1269.

SHUTTLE, SPINDLE & DYEPOT. 1969. q. EN. 1479

Handweaver's Guild of America, 120 Mountain Ave., Suite B101, Bloomfield, CT 06002. Phone 203–242–3577. Judy Robbins, Editor.

Subscription: included in membership, $25 US, $29 Canada & foreign, no air. Microform available from UMI. Sample & back issues $6.50. Illus. b&w, photos and computer graphics. Annual index. Cum. index every 10 yrs. 8½ x 11, 84p.

ISSN: 0049–0423. OCLC: 2244941. LC: TT848.S53. Dewey: 746.1.

Art Education. Art History. Decorative Arts. Historic Preservation. Textiles. Weaving.

The Guild through its magazine, seeks to provide a network of support among fiber artists, guilds, and related organizations. It encourages professionalism and supports the education of fiber artists, promotes the preservation of textiles and weaving traditions, and develops public awareness of the fiber arts. Articles include weaving, spinning, and dyeing how–to's, artist profiles, and ethnic subjects. Articles are largely written by members of the Guild.

Reviews: book 4, length 400 wds.; equipment, length 800 wds. Bibliographies: about half of articles contain short & concise bibliographies. Biographies: artist profiles, 1/issue Interviews: with fiber artists. Listings: national–international. Calendar of events. Museum showings information. Freelance work: yes. Contact: Carol Arnold, Assistant Editor. Opportunities: study, workshops, competitions. Indexed: ArtI. BioI. CloTAI. Hand. Reviewed: Katz. *Serials Review* 12:1, Spr 1986, p.29–30. Advertising: (rate card Mar '89): full page $833, ½ page $459, ¼ page $266; 2 color + $155; 4 color full page + $365, ½ page + $290; covers + 15–25%. Special positions + 10%. Classified: $1.10/wd., $25 min. Frequency discount. Elizabeth Curran, Ad. Director. Mailing lists: available. Circulation: 16,000. Audience: handweavers, spinners and dyers.

SPIN-OFF. 1977. q. EN.

1480

Interweave Press, 306 N. Washington Ave., Loveland, CO 80537. Phone 303–669–7672. Deborah Robson, Editor.
Subscription: $14. Illus.
ISSN: 0198–8239. OCLC: 3900873. LC: TT847.S677. Dewey: 746.1.
Devoted to hand spinning.

SURFACE DESIGN JOURNAL. 1976. q. EN.

1481

Surface Design Association, P.O. Box 20799, Oakland, CA 94620. Phone 213–392–2274. Charles Talley, Editor (phone 415–567–1992).
Subscription: included in membership, $75 US, + $5 elsewhere (4111 Lincoln Blvd., Suite 426, Marina del Rey, CA 90292). Illus. color, photos.
ISSN: 0197–4483. OCLC: 6035770. LC: NK8800.S95. Formerly: *Surface Design*.
Textiles.

Surface design, the coloring, patterning/designing of fabric, fiber and other materials. A publication of a non-profit educational organization whose purposes are to stimulate, promote, and improve education in the area of surface design; to encourage the surface designer as an individual artist; to educate the public with regard to surface design as an art form; to improve communication and distribution of technical information among artists, designers, educators, and with industry; to disseminate information concerning professional opportunities in surface design through galleries, studios, workshops, small businesses, industry, and education; to provide opportunities for surface designers to exhibit their work; and to provide a forum for exchange of ideas through conferences and publications.
Reviews: book. Calendar of events. Indexed: CloTAI. Des&ApAI. Reviewed: Katz.
Advertising: Joy Stocksdale, Ad. Manager.

TEXTILE & TEXT. 1989. q. EN.

1482

Fashion Institute of Technology, Shirley Goodman Resource Center, 227 W 27th St., New York, NY 10001–5992. Phone 212–760–7970.
Subscription: $12.50 No. America, $18 elsewhere. Illus.
ISSN: 1051–4090. OCLC: 20468845. LC: Z6153.T4 T49. Dewey: 746. Formerly: *Textile Booklist*.
Textiles.

Bibliography on textile crafts and costume design. Has companion publication: *Design and Sign*.
Circulation: 1600.

TEXTILE ARTISTS' NEWSLETTER: A Journal of the Textile Arts & History. 1978. q. EN.

1483

Textile Artists' Supply, 3006 San Pablo Ave., Berkeley, CA 94702. Phone 415–548–9988. Susan C. Druding, Editor.
Subscription: $9. Illus.
OCLC: 9537031. LC: TT699.T48x. Dewey: 677.
Textiles.

"A quarterly review of the fiber arts".
Reviews: book.
Advertising.

TEXTILE FIBRE FORUM: The Fibre Magazine of the Australian Region. 1981. 3/yr. EN.

1484

Australian Forum for Textile Arts, P.O. Box 192, Sturt Crafts Centre, Mittagong, NSW 2575, Australia. Phone 048–711.291, fax 048–713.169. Janet De Boer, Editor.
Subscription: $US13 air US & Canada, $A16.50 Australia, $NZ21 New Zealand. Sample $US5 or $NZ7 includes airmail. Back issues $US3. Illus. b&w, color, photos, cartoons. Index in first issue of next year. Cum. index 1981–86. 280 x 210 mm., 60p, (30+p. in color).
ISSN: 0818–6308. OCLC: 18767944. Dewey: 746.05. Formerly: *Fibre Forum*.
Crafts. Textiles.

The national textile magazine includes all the textile arts. Articles on exhibitions, events and special features. Contains resources, ideas on making, designing, and dyeing using color. Something for everyone who cares about textiles. At least half the magazine is in color.

Reviews: exhibition 3, length 300 wds.; book 25 and journal 3, length 25–50 wds.; equipment 2–3, length 50–100 wds. Interviews: form part of articles at times. Biographies: sometimes features. Listings: regional–international. Exhibition information. Freelance work: yes. Contact: editor. Opportunities: study & competitions listed when known, usually in "Subscriber's–only Newsletter". Indexed: Des&ApAI.

Advertising: (rate card 1991): b&w full page $400, ½ page $250, ¼ page $125. Color rates on request. Frequency discount. Classified: pre–paid only, 50¢/wd. Mailing lists: none. Demographics: Marketed from Australia; also for New Zealand and the USA. Readers mainly in New Zealand and Australia. Reaches an estimated 12,000 readers/issue. Circulation: 8,000. Audience: textile devotees.

TEXTILE HISTORY. 1968. s–a. EN. 1485

Pasold Research Fund, London School of Economics, Houghton St., London WC2A 2AE, England. S.D. Chapman (Dept. of History, the University, Nottingham NG7 2RD) & Donald King (5 Taylor Ave., Kew Richmond, Surrey TW9 4EB), Editors.

Subscription: includes *USITT Newsletter* £10 $US 20 individual, £20 $US40 institution surface, air rates on request. Illus. b&w, glossy photos. 7 x 9¾, 106p.

ISSN: 0040–4969. OCLC: 1767378. LC: HD9850.1 T52. Dewey: 338.4.

Textiles.

Launched by the Fund as part of its policy of fostering research and publication on the history of textiles, their technological development, design, conservation, the history of dress and other uses of textiles.

Reviews: exhibition, book 15 & short reviews. Freelance work: original manuscripts of major articles, max. 10,000 wds. Indexed: ArtBibMod. ArtI. BrArchAb. CloTAI. RILA.

Advertising: none.

TEXTILE MUSEUM BULLETIN. 1971. q. EN. 1486

Textile Museum, 2320 S St., N.W., Washington, DC 20008. Phone 202–667–0441. George Rogers, Editor.

Subscription: included in membership. Illus.

OCLC: 5669242. LC: N1.N665, TS1300.T49. Dewey: 677. Formerly: *Textile Museum Newsletter.*

Textiles.

Includes information regarding exhibitions, news, development, travel, education, special events, and news of the Museum Shop.

Calendar of events.

THE TEXTILE MUSEUM JOURNAL. 1962. a. EN. 1487

Textile Museum, 2320 S. St. N.W., Washington, DC 20008. Phone 202–667–0441. Dolores Fairbanks, Editor.

Subscription: $15, must be ordered directly from Museum Shop each year. Back issues, 1962–71 photocopies $20 each, 1972–87 $15 each. Illus. b&w, photos. 8½ x 11, 100p.

ISSN: 0083–7407. OCLC: 1769413. LC: NK8802.W3 A3. Dewey: 069. Formerly: *Workshop Notes.*

Textiles.

Purpose is to foster research and publication on the history of textile arts from artistic or technical perspectives. Emphasis is placed primarily upon original research relating to textiles from the geographic areas represented in the museum's collections: the Near East, Central, South and Southeast Asia, and South and Central America. Some volumes include the annual report of the Museum.

Bibliographies: occasionally, bibliographic notes accompany each article. Freelance work: yes, invites submission of original articles that fall within its aim and scope. Contact: Eileen Martin. Indexed: ArtArTeAb. ArtBibMod. ArtI. CloTAI. Reviewed: *Art Documentation* Fall 1986, p.133.

Advertising: none. Circulation: 3,000. Audience: those interested in the history of textile arts.

UNCOVERINGS: Research Papers of the American Quilt Study Group. 1980. a. EN. 1488

American Quilt Study Group, 660 Mission St., Suite 400, San Francisco, CA 94105–4007. Phone 415–495–0163. Laurel Horton, Editor (302 East South Third St., Seneca, SC 29678).

Subscription: included in higher membership levels, $18 + $2 shipping US & Canada, foreign + $4 surface, + $7.50 air. No sample. Back issues, prices vary, request price list. Illus. b&w, photos. Index. Cum. index available on request. 5½ x 7, 176p.

ISSN: 0227–0628. LC: TT835.

Crafts. Decorative Arts. Historic Preservation. Textiles. Textile History.

National non–profit group dedicated to uncovering the accurate history of quilts, textiles, and the people who made them and to educating others about quilt history. Devoted to the finding and dissemination of the history of quiltmaking as a significant American art. Contains edited versions of papers selected for presentation at the annual Seminar. Papers which must pertain to quilts, quiltmakers, or related textile history are selected from abstracts submitted in the Spring for the Fall Seminar. Biographies: quiltmakers. Freelance work: yes. Presenters need not be members of the Group. Contact: editor. Indexed: CloTAI.

Advertising: none. Audience: textile historians, women's studies, folklorists.

WARP & WEFT. 1947. m. (except Jul–Aug). EN. 1489
Robin & Russ Handweavers, Inc., 533 North Adams St., McMinnville, OR 97128. Phone 503–472–5760. Russell E. Groff, Editor.
Subscription: $12 US, $15 Canada & foreign. No sample. Back issues. Illus.
ISSN: 0732–6890. OCLC: 8741712.
Weaving.

Covers four–harness patterns. Detailed instructions on how–to weave a variety of fabrics and patterns as well as a sample swatch of each.
Reviews: book, each issue has a detailed review of a recently published work. Reviewed: *Serial Review* 12:1, Spr 1986, p.30.

WEAVER'S. 1981, 1988 ns. q. EN. 1490
Golden Fleece Publications, 335 N. Main Ave., Sioux Falls, SD 57102. Phone 605–338–2450. A. David Xenakis, Editor.
Subscription: $16 US, $20 foreign. Illus. b&w, some color.
ISSN: 1042–7643. OCLC: 18928354. LC: TT848.P69. Dewey: 746.1. Formerly: *Prairie Wool Companion*.
Weaving.

Reviews: book. Indexed: CloTAI.
Advertising.

Jewelry & Clocks

AGS NEWSLETTER. bi–m. EN. 1491
American Gem Society, 5901 West Third St., Los Angeles, CA 90036. Phone 213–936–4367. Charlotte Preston, Editor.
Subscription: included in membership.
Formerly: *Guild*.
Jewelry.

Technical reports concerning gems.
Circulation: 4400.

ANTIQUE CLOCKS. See no. 1096.

ART AUREA: Schmuck Mesch Objekte. 1986. q. EN & GE. 1492
Ebner Verlag GmbH, Postfach 3060, D–7900 Ulm/Donau, W. Germany. Phone 0731–1520–67. R.J. Ludwig, Editor.
Subscription: DM 68. Illus. b&w, photos.
ISSN: 0179–647X. OCLC: 20769767. LC: N1.A1A47. Dewey: 739.27.
Crafts. Jewelry.

International magazine for design, jewelry and art. Presents art and design in the personal environment. Covers trends in design.
Reviews: book. Indexed: ArtBibMod. Des&ApAI.
Advertising.

AURUM [English edition]. 1979. q. EN. Available also in FR, GE, IT & SP editions. 1493
Aurum Editions SA, 64 Rue de Monthoux, CH–1201 Geneva, Switzerland. Phone 022–738–3000, fax 022–38–3031.
Illus.

ISSN: 1011–0127. 1011–0119 (French), 1011–0143 (Italian), 1011–0151 (Spanish). OCLC: 9163148. LC: NK7100.A931. Dewey: 739.27.
Jewelry.

"The international review for manufacturers, designers and retailers of gold jewelry".
Indexed: ArtArTeAb. Des&ApAI.

THE AUSTRALIAN GEMMOLOGIST. 1985, v.15. q. EN. 1494
Gemmological Association of Australia, P.O. Box 35, South Yarra, Victoria 3141, Australia. W.H. Hicks, Editor.
ISSN: 0004–9174. OCLC: 3755071. LC: TS720.A93.
Jewelry.

BIJOU. 1952. q. FR only. 1495
Canam Publications Ltd., 8270 Mountain Sights, Suite 201, Montreal, Quebec H4P 2B7, Canada. Phone 514–731–9517. Andree Harvey, Editor.
Subscription: included in membership, $C25 Canada, $US30 and foreign. Sample free. No back issues. Illus. 8¼ x 10 ¹⁵⁄₁₆, 40p.
ISSN: 0006–2316. OCLC: 1726953. LC: NK7415. Incorporates: *Loupe; Bijoutier.*
Jewelry. Watches.

A specialized Canadian jewelry and horology magazine. Specifically for the Quebec jewelry industry. Presents stories, trends, and industry news.
Listings: national–international. Freelance work: yes. Contact: Andree Harvey.
Advertising. Classified. Bruce Jones, Ad. Director. Circulation: 4,000. Audience: jewelry industry.

CANADIAN JEWELLER. 1879. m. EN. 1496
Maclean–Hunter Ltd., Business Publication Division, Maclean–Hunter Bldg., 777 Bay St., Toronto, Ontario M5W 1A7, Canada. Phone 416–596–5733, fax 416–593–3189. Simon Hally, Editor.
Illus. 8 x 10¾, 62p.
ISSN: 0008–3917. OCLC: 1868292. LC: NK7300. Dewey: 739.27. Formerly: *Trader and Canadian Jeweller.*
Jewelry.

Presents merchandising information, new products, trade news, business management, and market reports.
Reviewed: Katz.
Advertising. Grace Somers, Ad. Director. Circulation: 7,000. Audience: jewelry store owners.

DIAMOND WORLD. 1973. bi–m. EN. 1497
Gem & Jewellery Information Centre of India, A–95 Journal House, Janta Colony, Jaipur 302004, India. Phone 44398, fax 91 141 67760 ATTN KALA, telex 365–24110 KALA IN. Vidya Vinod Kala, Editor.
Illus. 27 x 21 cm.
ISSN: 0970–7727. OCLC: 4694002. Dewey: 739.
Jewelry.

Advertising: b&w full page $US700, ½ page $375, ¼ page $200; 4 color full page $1000, ½ page $700, covers $2000–$4500. Frequency discount. Bleed + %20.

GEMS & GEMOLOGY. 1934. q. EN. JA tr. available. 1498
Gemological Institute of America, 1660 Stewart St., Santa Monica, CA 90404. Phone 213–829–2991. Alice S. Keller, Editor.
Subscription: (1989): $39.95 US, elsewhere $49. Back issues. Illus. b&w, some color. Index.
ISSN: 0016–626X. OCLC: 7921950. LC: TS720.G4. Dewey: 736.
Jewelry.

Presents articles, industry news and technological and historical information on gems. Japanese translation available from the Association of Japan Gen Trust, Okachimachi Cy Bldg., 5–15–14 Ueno, Taito–ky, Tokyo 110, Japan.
Reviews: book. Freelance work: Welcomes the submission of articles on all aspects of the field. Contact: editor. Indexed: ArtArTeAb.
Audience: jewelry industry.

JEWELERS' CIRCULAR-KEYSTONE: JCK. 1869. m. EN. 1499
Chilton Co., Chilton Way, Radnor, PA 19089. Phone 215–964–4474. George Holmes, Editor.

Subscription: $28 US individuals & firms in field, $60 Canada, $75 firms out of field. Available online, DIALOG. Microform available from UMI. Illus. Index.

ISSN: 0194–2905. OCLC: 20844671. LC: TS720.C46. Dewey: 671. Formerly: *Chilton's Jewelers' Circular–Keystone.*

Jewelry.

Trade publication which features jewelry design and promotion. Contains industry news, trends, and product information. Reviews: book. Calendar of trade shows and craft fairs. Reviewed: Katz.

Advertising. Lee Lawrence, Ad. Director. Audience: retail jewelers.

JEWELLERS ASSOCIATION OF AUSTRALIA. NATIONAL NEWSLETTER. 1985. q. EN. 1500

Australian Jewellers' Association, P.O. Box E 446, Queen Victoria Terrace, Canberra, A.C.T. 2600, Australia. Phone 062–95–2822, Fax 062–95–2707. Barry Simon, Editor.

Subscription: included in membership. Sample free. Back issues. Illus. b&w. A4, 16p.

ISSN: 0816–6706. Dewey: 739.27. Formerly: *Australian Jewellers Association. National Newsletter.*

Jewelry.

Focuses on issues of likely relevance to Association membership, from insurance to trade fairs, competitions, latest jewellery instruments, statistics on imports, exports, etc., Dept. of Taxation decisions, membership news, and customs decisions. Reviews: 4 reviews/issue. Calendar of events. Exhibition information. Freelance work: none. Opportunities: employment, study, competitions promoted by the Association.

Advertising: full page $400, ½ page $200, ¼ page $100. Frequency discount. Circulation: 770. Audience: Australian jewellers.

JEWELLERY STUDIES. 1984. a. EN. 1501

Society of Jewellery Historians, London, England.

Illus. b&w, some color.

ISSN: 0268–2087. OCLC: 15585899. Dewey: 739.27.

Jewelry.

Includes bibliographies.

JEWELLERY WORLD. 1982. bi–m. EN. 1502

Canadian Jewellers Association, 20 Eglington Ave. West, Suite 1203, Toronto, Ontario M4R 1K8, Canada. Phone 416–480–1450, Fax 416–480–2342. Joanne McGarry, Editor.

Subscription: includes *JW PLUS*, $C75 US, $C45 Canada. Sample. Back issues. Illus. b&w, color, photos. 8½ x 11, 44p. Sheet fed offset.

ISSN: 0823–1346. OCLC: 10061637. LC: HD9747. Dewey: 384.

Jewelry.

Canada's jewelry industry magazine contains articles which detail trends and ideas for the manufacture and sale of fine and costume jewellery. News, columns and features are topical, thought–provoking and educational.

Listings: regional–international. Calendar of events. Freelance work: yes. Contact: editor. Opportunities: study, competitions. Advertising: (rate card Jan '89): full page $2200, ½ page $1375, color + $325–950, covers contract only. Frequency discount. 15% agency discount. Special positions + 25%. Bleeds + 15%. Inserts. Demographics: national 8,046, US 85, foreign 25, 5,746 retail jewellery and department stores, 955 manufacturers, wholesalers and distributors, 775 jewellery salespeople, 188 graduate jewellers. Circulation: 8,156. Audience: jewelry retailers & manufacturers.

JEWELRY MAKING, GEMS AND MINERALS: Gems, Gem Cutting, Minerals, Silverwork, Geology. 1937. m. EN. 1503

Gemac Corporation, c/o Jewelers Bench, Box 226, Cortaro, AZ 85652–0226. Jack R. Cox, Editor.

ISSN: 0274–8193. Dewey: 549. Formerly: *Gems and Minerals*; Incorporating: *Mineralogist.*

Jewelry.

October issue, directory of businesses and individuals serving the jewelry making, lapidary and mineral trades. Reviews: book.

Advertising.

JOURNAL OF GEM INDUSTRY. 1963. bi–m. (EN & HI editions published in alternate months). EN. Also available in HI edition. **1504**

Journal of Gem Industry, Journal House, A–95, Janta Colony, Jaipur 302 004, India. Phone 44398, 40906, fax 91–141–67760 Attn. KALA, telex 365–2410 KALA IN. Mr. Alok Kala, Editor.

Subscription: Rs 120 inland, overseas $US20 sea, $45 air. Sample. Back issues. Illus. 8½ x 10¾, 112p. Offset.

ISSN: 0022–1244. OCLC: 10258156. LC: TS720.J75. Dewey: 736.2.

Trade publication about half of each issue is composed of advertisements, mainly in color. Covers fine jewelry and trade information.

Opportunities: announces jewelry design contest winners.

Advertising: b&w full page $US400, ½ page $200, ¼ page $100; 4 color full page $900, ½ page $650, covers $1000. Frequency discount. Bleed + 20%. Demographics: circulates in 40 countries.

JW PLUS. 1976. bi–m. EN. **1505**

Canadian Jewellers Association, 20 Eglington Ave. West, Suite 1203, Toronto, Ontario M4R 1K8, Canada. Phone 416–480–1450, Fax 416–480–2342. Joanne McGarry, Editor.

Subscription: includes *Jewellery World*, $C75 US, $C45 Canada. Sample. Back issues. Illus. b&w, photos. 9¼ x 15, 16p.

LC: HD9747. Dewey: 338.4.

Jewelry.

"Canada's Jewellery Newspaper" issued in the alternate months from *Jewellery World*.

Listings: regional–international. Calendar of events. Freelance work: yes. Contact: editor. Opportunities: study, competitions.

Advertising: (rate card Jan '89): full page $1800, ½ page $1150, ¼ page $950. Frequency discount. 15% agency discount. Inserts. Demographics: national 8,046, US 85, foreign 25, 5,746 retail jewellery and department stores, 955 manufacturers, wholesalers and distributors, 775 jewellery salespeople, 188 graduate jewellers. Circulation: 8,156. Audience: jewellery retail & manufactures.

LAPIDARY JOURNAL. 1947. m. EN. **1506**

Lapidary Journal, Inc., Box 80937, San Diego, CA 92138–0937. Merle Berk, Editor (Devon Office Center, 60 Chestnut Ave., Suite 201, Devon, PA 19333).

Subscription: (1990): $21 US & possessions, foreign $30, $98 air (Circulation Dept., P.O. Box 645, Holmes, PA 19043–9914). Includes *Annual Buyers' Guide*. Illus. b&w, color. Index. 8¼ x 10¾, 130p.

ISSN: 0023–8457. OCLC: 1755549, 17804717 (annual). LC: NK7300.L36. Dewey: 739.27.

Hobbies. Jewelry.

Aimed at the hobbyist each issue features hobby ideas, "Workshop" easy–to–follow cutting tips and faceting diagrams, and gem news from all over the world. Regular departments include shop helps, product news and show news. *Annual Buyers Guide* in April is a "where–to–find–it product and services index" which lists more than 5000 dealers, suppliers and clubs in over 500 categories.

Reviews: book. Listings: national–international. Calendar of gem and mineral shows. Freelance work: Manuscripts about and photos of gems and related mineral and jewelry are invited, paid. Contact: editor. Reviewed: Katz. Katz. *School*.

Advertising: Classified: 35¢/wd., min. 25 wd. Arthur F. Dulac, National Sales Manager (phone 619–275–3505, fax 619–275–1856). Audience: gem cutters, collectors and jewelers.

MART OF THE NAWCC. bi–m. EN. **1507**

National Association of Watch and Clock Collectors, Inc., 514 Poplar St., Columbia, PA 17512. Phone 717–684–8261.

Subscription: included in membership.

OCLC: 12027011. Dewey: 681.1.

Collectibles. Clocks. Watches.

Tabloid for members' horological items.

Advertising. Audience: collectors, historians, craftsmen, dealers and others interested in timekeeping devices and horology.

MODERN JEWELER. 1901. m. EN. **1508**

Vance Publishing Corp., 400 Knightsbridge Pakway, Lincolnshire, IL 60069. Joseph Thompson, Editor (7950 College Blvd., Overland Park, KS).

Subscription: $35 US & Canada, foreign $100. Microform available from UMI. Sample free. Back issues $4. Illus. b&w, color, photos, charts. 8 x 10¾, 100p.

ISSN: 0774–2513. OCLC: 8134534. LC: HD9747.U5M63. Dewey: 381. Formerly: *Modern Jeweler (National Executive Edition)*.

Jewelry.

Aimed at the jewelry trade, includes feature articles, industry news and people, and business "Barometers" with charts and statistics.

Interviews. Biographies. Listings: national–international. Calendar of events. Exhibition information. Freelance work: none. Opportunities: employment, study, competitions.

Advertising: full page S3455, ½ page $1990, ¼ page $1215, 2 color + $600–770, 4 color + $1285. Classified: $67/inch. Frequency discount. Barry H. Weinberg (122 E. 42nd St., New York, NY). Mailing lists: available. Demographics: national. Circulation: 37,000. Audience: retail jewelers.

NATIONAL JEWELER. 1906. bi–m. EN. 1509

Gralla Publications, 1515 Broadway, New York, NY 10036. Phone 212–869–1300. Gerald Egyes, Editor.
Subscription: $100. Illus. 10¾ x 14¾, 150p.
ISSN: 0027–9544. OCLC: 2850451. Dewey: 739.27. Formerly: *National Jeweler and National Watchmaker*.

Jewelry. Watches.

Contents devoted to all aspects of the jewelry field and related events, trends, activities, and costs of products. Advertising.

NATIONAL JEWELER ANNUAL FASHION GUIDE. 1976. a. EN. 1510

Gralla Publications, 1515 Broadway, New York, NY 10036. Phone 212–869–1300. Nancy Pier Sindt, Editor.
Dewey: 646.

Jewelry.

Intended for jewelry retailers, wholesalers and for in–store consumer use.

NAWCC BULLETIN. 1946. bi–m. EN. 1511

National Association of Watch and Clock Collectors, Inc., 514 Poplar St., Columbia, PA 17512. Phone 717–684–8261. Amy J. Smith, Editor.
Subscription: $25. Illus.
ISSN: 0027–8688. OCLC: 13483943. LC: NK11.N37. Dewey: 681.1.

Collectibles. Clocks. Watches.

Contains historical, technical, and "how–to" articles on clocks, watches and other items related to the study of time. Chapter news, research news and activities are also noted.
Reviews: book. Obits. Indexed: Index. Cum. index.
Advertising. Audience: collectors, historians, craftsmen, dealers and others interested in timekeeping devices and horology.

THE NORTHWESTERN JEWELER. 1910. m. EN. 1512

Trades Publishing Co., Washington & Main St., Albert Lea, MN 56007. Phone 507–373–2316, fax 507–373–0605. J. Gregory Hayek, Editor.
8¼ x 11¼, 48p.
ISSN: 0029–3490. OCLC: 1760724. Dewey: 739.27.

Jewelry. Watches.

Official publication of the Iowa Jewelers and Watchmakers Association and other similar organizations. Contains Association news plus news of individual jewelers and watchmakers and their businesses.
Advertising. Circulation: 3700.

ORNAMENT: A Quarterly of Jewelry and Personal Adornment. 1974. q. EN. 1513

Ornament Inc., 1221 S. La Cienega, Box 35029, Los Angeles, CA 90035–0029. Phone 213–652–9914. Robert K. Liu, Editor.
Subscription: $25 US, elsewhere $29. Sample $8. Back issues. Illus. b&w, color, photos. 8¼ x 11, 96p.
ISSN: 0148–3897. OCLC: 3526104. LC: NK7300.B42. Dewey: 739.27. Formerly: *Bead Journal*.

Jewelry.

Specializes in articles on ancient, ethnic and contemporary jewelry as well as personal adornment including costume adornment. Ethnography and the history of beads from all over the world are also featured. Presents news and reviews of events.
Reviews: exhibition, book. Indexed: ArtBibMod. ArtI. BioI. CloTAI. Des&ApAI. Reviewed: Katz. *Art Documentation* Fall 1986, p.133.
Advertising: b&w & color, no classified. Demographics: national distribution. Circulation: 9,000.

RETAIL JEWELLER. 1963. fortn. EN.

International Thomson Publishing Ltd., 100 Avenue Road, London NW3 3TP, England. Phone 071–935 6611, Fax 071–586 5339, Telex 299973 ITP LN G. Emma Cullinan, Deputy Editor.

Subscription: £30, $69.52 UK; foreign $93.36 £39, air £55. Sample free. Back issues (6 m. only) cover price. Illus. b&w, color, photos. tabloid 38 x 27 cm., 28p. sheet fed litho.

ISSN: 0034–6063. OCLC: 6288182. Dewey: 739.2705. Incorporates: *Goldsmiths Journal, The Gemmologist and Horological Review.*

Jewelry. Watches. Antiques.

Trade newspaper presents topical news, in–depth information. Policy is to help readers to compete effectively for the available discretionary income by providing them with up–to–date business news and information. Particular emphasis is placed on the point of sale – the retailer in the watch, clock, jewelry, silverware and ancillary trades in the UK and Erie but coverage also includes news and information of value to manufacturers, wholesalers, and importers.

Reviews: exhibition, book. Listings: international. Calendar of events. Exhibition information. Freelance work: yes. Contact: editor. Opportunities: employment, study, competitions.

Advertising: (rate card Jan '90): £1720, ½ page £960, color + £190–320. Classified: £13 s.c.c., min. 3 cm., £4.90/line, min. 3 lines. Special positions + 15%. Frequency discount. Inserts. Mailing lists: breakdowns available by geographical area, type of products stocked, size of shop by number of staff employed, and status of reader. Mike W. Goodwin, Ad. Director. Demographics: 9,619 UK, 225 Erie, 106 Western Europe; retailers and department stores 8,106; manufacturers, importers, wholesalers and other 1,925. Circulation: 10,031. Audience: jewelry retailers; wholesalers and manufacturers of jewelry, clocks, watches, silverware, etc.; dealers and designers.

ROCK & GEM. 1971. m. EN.

Miller Magazines, Inc., 2660 E. Main St., Ventura, CA 93003–2888. Phone 805–643–3664. W.R.C. Shedenhelm, Editor. Illus.

ISSN: 0048–8453. OCLC: 3876808. LC: QE420.R6. Dewey: 549.

Jewelry.

Reviewed: Katz. *School.*

SWISS WATCH AND JEWELRY JOURNAL. 1876. bi–m. EN.

Editions Scriptar S.A., 23 Av. de la Gare, 1001 Lausanne, Switzerland.

Subscription: 64 SFr. Illus.

ISSN: 0039–7520. OCLC: 13100745.

Jewelry. Clocks. Watches.

Official bulletin of the European Watch, Clock and Jewellery Fair in Basle.

Advertising.

TIMECRAFT: Clocks & Crafts. 1981. m. EN.

Watch & Clock Book Society, Box 22, Ashford, Kent TN23 1DN, England. Norman Stuckey, Editor.

ISSN: 0260–5988. Dewey: 681.11.

Clocks. Watches.

Reviews: book.

Advertising.

VICTORIAN GEMMOLOGY NEWSLETTER. q. EN.

Research Publications Pty. Ltd., 12 Terra Cotta Dr., Blackburn South, Victoria 3130, Australia. Phone 03–877–3677. N.P. Jamieson, Editor.

ISSN: 0725–0568.

Jewelry.

Reviews: book.

Advertising.

AbraCadaBrA. 1988. q. (2 full issues & 2 calendars). EN. **1519**
Alliance for Contemporary Book Arts, P.O. Box 24415, Los Angeles, CA 90024. Phone Gerald Lange, Editor.
Subscription: included in membership. Illus. b&w. 8¼ x 11, 12p.
OCLC: 19024562. LC: Z119.A27. Dewey: 760.
A newsletter meant to make information accessible to people who read and are interested in book arts. Contains news, fine press and artists books. Printing, typography, papermaking, calligraphy, bookbinding, and illustration are covered. One edition per year will include original ephemera by members of ACBA. The four issues consist of two full issues and two calendars.
Bibliographies: listing of publications. Calendar of events. Exhibition information.

AMPHORA. 1965. s–a. EN. **1520**
Alcuin Society, P.O. Box 3216, Vancouver, BC, Canada V6B 3X8. Phone 604–688–2341. Barbara Hemphill, Editor.
Subscription: included in membership. Illus. b&w. 5½ x 8½, 24p.
ISSN: 0003–200X. OCLC: 2225811. LC: Z990.A55. Formerly: *Notes from the Alcuin Society.*
Covers fine printing, calligraphy, fine papers, woodcuts, and other related subjects.
Reviews: book. Freelance work: yes. Contact: editor.
Advertising. Circulation: 300.

BINDERS' GUILD - NEWSLETTER. 1978. 8/yr. EN. **1521**
Binders' Guild, Box 289, Rte. 3, Zebulon, NC 27597. Phone 919–269–6381. Jim Dorsey, Editor.
Subscription: included in membership. Illus. b&w, color, photos. 8½x11, 25p.
Devoted to hand bookbinding. Provides information on techniques and reprints relevant articles from other publications.
Reviews: book. Freelance work: articles on techniques from those experienced in hand bookbinding. Contact: editor. Opportunities: study – workshops and special courses.
Circulation: 45.

BOOK ARTS REVIEW. 1982. q. EN. **1522**
Center for Book Arts, 626 Broadway, New York, NY 10012. Phone 212–460–9768. Peter Buck, Editor.
Subscription: included in membership. Illus. b&w, photos. 8½x11, 8p.
ISSN: 0739–7895. OCLC: 8342935. LC: Z116.A3 B57. Dewey: 686. Formerly: *Book Arts.*
Newsletter devoted to the arts of the book. Covers printing, bookbinding, papermaking, calligraphy, and preservation. Presents news of small presses and information regarding arts suppliers.
Reviews: exhibition, book, conferences. Interviews: people active in book arts. Listings: international. Calendar of events.
Freelance work: yes. Contact: editor. Opportunities: study – workshops & seminars; also programs sponsored by the Center.

CALLIGRAPHY REVIEW. 1982. q. EN. **1523**
Calligraphy Review, Inc., Box 1511, 2421 Wilcox Drive, Norman, OK 73070. Phone 405–364–8794. Karyn L. Gilman, Editor.
Subscription: $36 US, $40 Canada, foreign air $58. Sample $11. Back issues. Illus b&w, color, photos. Cum.index vols.1–5 in v.5, no.4. 8½ x 11, 64p.
ISSN: 0895–7819. OCLC: 16796362. LC: Z43.A1 C35. Dewey: 745.6. Formerly: *Calligraphy Idea Exchange.*
Art Education. Art History. Calligraphy.
The only international journal for the lettering arts community. Each issue is dedicated to the fine art of hand lettering. Features vary in scope from ancient manuscripts to contemporary three–dimensional works.

Reviews: exhibition 1, length 1000–1500 wds.; book 2, length 500–1500 wds. Interviews: occasionally with contemporary artists. Biographies: leading calligraphers or past leaders in the field. Listings: international. Calendar of events. Freelance work: yes. Contact: Leslie Howe. Opportunities: sponsors a yearly competition. Indexed: Des&ApAI. Reviewed: Katz. *Wilson* 62:8, Apr 1988, p.108.

Advertising: (rate card 1989): full page $550, ½ page $400, ¼ page $250; color + $200–450. Bleeds + 10%. Preferred positions + 10%. Classified: $25/25 wds. min., $1/wd. add. Frequency discount. Inserts. 15% agency discount. Demographics: 50 states, 31 countries, foreign approx. 12% of circulation. Circulation: 5,500. Audience: calligraphers, graphic designers, art directors, commercial artists.

CCC NEWSLETTER. 1978. q. EN. 1524

Chicago Calligraphy Collective, P.O. Box 11333, Chicago, IL 60611. Phone 312–943–3585. Jacklyn M. Petchenik, Editor.

Subscription: included in membership. Illus. b&w. 5½ x 8½, 4–8p.

Formerly: *CCC Bulletin; CCC Newsletter.*

Focuses on calligraphy but also includes information on typography, bookbinding, papermaking, and graphic design. Presents news regarding activities of the Collective and members.

Calendar of events. Freelance work: yes. Contact: editor.

Advertising.

COLORADO CALLIGRAPHERS' GUILD - NEWSLETTER. 1977. q. EN. 1525

Colorado Calligraphers' Guide, Box 6413, Cherry Creek Station, Denver, CO 80206. Phone 303–753–9158. Margaret Stookesberry, Editor.

Subscription: included in membership. 8½x11, 10p.

Reports the business of the Guild. Presents tips on techniques and materials used as well as news of other calligraphy organizations. Lists educational opportunities.

Reviews: book.

ESCRIBIENTE. 1978. m. EN. 1526

Albuquerque's Calligraphy Society, P.O. Drawer 26718, Albuquerque, NM 87125. Cathy Davey, Editor.

FINE PRINT: The Review for the Arts of the Book. 1975. q. EN. 1527

Pro Arte Libri, Box 193394, San Francisco, CA 94119. Phone 415–543–4455. Sandra D. Kirshenbaum & E.M. Ginger, Editors (665 Third St., Suite 280, San Francisco, CA 94107).

Subscription: included in membership, $45 North America 2nd class, $59 first class; foreign $57, air $65; library & institution + $14. No sample. Back issues. Illus b&w, photos. 9 x 12, 50p.

ISSN: 0361–3801. OCLC: 2246344. LC: Z119.F55. Dewey: 686.2.

Decorative Arts. Graphic Arts. Printing. Typography. Bookbinding. Calligraphy.

Dedicated to reviewing the history of typography and contemporary book design, the journal focuses on graphic design, calligraphy, bookbinding, and printing techniques with an emphasis on letterpress. Primarily a reference for printing technique, the use of type, and design. Interested in the visual aspect of printing which includes photo–gravure and collotype. Includes articles the history of the book. Book reviews focus on limited edition fine press books.

Reviews: exhibition 1, book 9, other 2. Bibliographies: history of an imprint, one/issue Interviews: bookbinders, printers, graphic arts. Biographies: typographers, printers. Listings: regional–international. Calendar of events. Exhibition information. Freelance work: yes. Contact: editor. Opportunities: competitions. Indexed: ArtBibMod. ArtI. BioI. BkReI. Des&ApAI. Reviewed: *Choice* 23:2, Oct 1985, p.265–6.

Advertising: full page $900, ½ page $500, ¼ page $250, no color. Classified: $50–$150. Frequency discount. Deborah Bruce, Ad. Director. Mailing lists: none. Demographics: suppliers, fine presses. Circulation: 3,500. Audience: bibliophiles, typographers, printers, graphic designers, bookbinders.

GUTENBERG-JAHRBUCH. 1926. a. EN, FR, GE, IT, & SP. 1528

Gutenberg–Gesellschaft e.V., Liebfrauenplatz 5, 6500 Mainz, W. Germany. Phone 06131–226420. Hans–Joachim Koppitz, Editor.

Subscription: DM 100.

ISSN: 0072–9094. LC: Z1008.

Historical research into printing methods, typography and related areas worldwide. Published by the International Association for Past and Present History of the Art of Printing.

Indexed: HistAb.

HAND PAPERMAKING. 1986. s–a. EN. 1529

Hand Papermaking, Box 10571, Minneapolis, MN 55448. Phone 612–788–9440. Michael Durgin & Amanda Degener, Editors & Pubs.(8409 Flower Ave., Takoma Park, MD 20912–6734).

Subscription: together with *Newsletter*, (until Jul '91): $15 US, $18 Canada & foreign, air $24. Sample $7.50. Back issues $8.50. Illus b&w, photos, cartoons. 9 x 12, 32p. Printed on Mohawk Superfine paper. ISSN: 0887–1418. OCLC: 13109938. LC: NK8553.H36. Dewey: 676.

Art Education. Art History. Crafts. Graphic Arts. Modern Art. Printing. Typography.

Hand Papermaking is a non–profit organization dedicated to advancing traditional and contemporary ideas in the art of hand papermaking.Designed to serve as a resource for papermakers and those interested in handmade paper. Covers Eastern and Western hand papermaking traditions as well as contemporary approaches to the art. Printed offset on archival quality paper each issue includes at least one sample handmade paper, with description. These featured samples are made by papermakers from around the world whose work is distinctive and exemplary. An educational resource with emphasis on the art of papermaking as well as the craft and on process and technique, historic and contemporary.

Reviews: exhibition 1, book 1–2 & video 1; length 500–1000 wds. Interviews: occasionally with paper artists or craftsmen. Biographies. Freelance work: yes. Contact: editor. Reviewed: *Library Journal* 112:12, Jl 1987, p.59. *Choice* 25:3, Nov 1987, p.446.

Advertising: (rate card Jan '89): full page $325, ½ page $175, ¼ page $105. Classified (appears in the *Newsletter*): 45¢/wd. No color. No frequency discount. Mailing lists: available. Demographics: 80% US, 10% Canada; mostly artists, 80% female. Circulation: 1800. Audience: papermakers, paper and book artists, printers, binders, librarians, calligraphers, conservators, printmakers, book and art collectors, and historians.

HAND PAPERMAKING NEWSLETTER. 1988. q. EN. 1530

Box 10571, Minneapolis, MN 55448. Phone 202–829–0619. Michael Durgin, Editor & Pub. (8409 Flower Ave., Takoma Park, MD 20912–6734).

Subscription: available only to subscribers of *Hand Papermaking* magazine, (until Jul '91): $15 US, $18 Canada & foreign, air $24. No illus. 8½ x 11, 4p.

Dewey: 676.

Art Education. Art History. Crafts. Fabrics. Graphic Arts. Modern Art. Printing. Textiles. Typography.

Summer and Winter issues distributed with *Hand Papermaking* with Spring and Fall issues mailed separately. Provides timely information regarding recent conferences and exhibits. Offers free listings about upcoming classes, conferences, events, exhibits, and opportunities. All classified advertising appears in the *Newsletter*.

Advertising: (rate card Jan '89): Classified 45¢/wd. No color. No frequency discount. Mailing lists: available. Circulation: 1800. Audience: papermakers, bookmakers, collectors, visual artists, conservators, calligraphers, etc.

IAPMA BULLETIN. s–a. EN. 1531

International Association of Hand Papermakers and Paper Artists, Falckensteinstrasse 5, D–1000 Berlin 36, West Germany. Phone 30 6187282.

International organization which provides information and a means of communication for those interested in paper art and hand papermaking.

Demographics: 33 countries are represented. Audience: interested in paper art and hand papermaking.

INK & GALL: A Marbling Journal. 1987. s–a. EN. 1532

Dexter Ing, Pub., Box 1469, Taos, NM 87571. Phone 505–776–8659. Polly Fox, Editor.

Subscription: $25 US, $30 Canada & foreign, air $44. Sample. Back issues. Illus. b&w, tipped in samples of hand marbled paper in each issue. 8½ x 11, 40p. ISSN: 0894–0479. OCLC: 15793247. LC: Z271.3.M37I56. Dewey: 741.

Art Education. Art History. Collectibles. Crafts. Decorative Arts. International. Textiles.

Devoted to furthering the art of marbling, both traditional and modern techniques.

Listings: regional–international. Calendar of events. Exhibition information. Freelance work: yes. Contact: editor. Opportunities: study, competitions.

Circulation: 1000. Audience: marblers, collectors, historians, designers, libraries.

INK, INC. 1978. 3/yr. EN. 1533

New Orleans Lettering Arts Association, Inc., P.O. Box 4117, New Orleans, LA 70178–4117. Elizabeth G. Blaise, Editor (5033 N. Rampart St., New Orleans, LA 70117).

Subscription: included in membership, $15. No sample, will send membership information. No back issues. Illus. b&w, color. 8½ x 11, 12–15p.

General. Decorative Arts. Graphic Arts. Historic Preservation. Typography.

Devoted to the various aspects of lettering, calligraphy and the related arts. Presents articles, related matters of historical value, Association news, reviews of calligraphy workshops, both local and national and anything that will be of interest to members in their pursuit of the study of calligraphy.

Reviews: book. Biographies: profiles of successful calligraphers and typographers. Calendar of events. Exhibition information. Freelance work: art work is by members or with permission from other calligraphers. Contact: editor. Opportunities: study – classes.

Advertising: ¼ page $20, business card $10. Mailing lists: available to calligraphy related requests only. Circulation: 130. Audience: members, other Calligraphy groups, anyone interested in lettering arts.

JOURNAL OF THE SOCIETY FOR ITALIC HANDWRITING. 1952. a. EN. 1534

Society for Italic Handwriting, c/o John Fricker, Sec., Highfields, Nightingale Road, Guildford GU1 1ER, England. Phone 0483–68443. Duncan Ellison, Editor.

Subscription: included in membership, £8 UK, $16 US, air $19. Sample free. Back issues $5. Illus. b&w, photos, cartoons. Occasional cum. Index. 32p.

ISSN: 0037–9743. OCLC: 4141958. LC: Z43.A1S64a. Dewey: 652. Formerly: *Society for Italic Handwriting. Bulletin.*

Art Education. Graphic Arts. Calligraphy. Handwriting Education.

Promotes the use of italic handwriting for everyday use.

Biographies: occasional articles on calligraphers. Calendar of events. Exhibition information. Freelance work: unpaid only. Contact: editor. Opportunities: study, competitions.

Advertising on application. Contact: Gay Pierpoint (16 Park Crescent, Regent's Park, London W1N 3PA). Circulation: ca. 1000. Audience: membership and public interested in handwriting, calligraphy and education.

MINIATURA: Arte dell'Illustrazione e Decorazione dell Libro. 1988. s–a. IT. EN summaries. 1535

Societa' di Storia della Miniatura, Largo Fratelli Alinari 15, I–50123, Florence, Italy. Maria Grazia Ciardi Dupre Dal Poggetto, Editor.

Subscription: (1989) L 40.000 members, L 50.000 non–members. Illus. b&w, some color, photos. 7¼ x 11, 190p.

ISSN: ISBN: 88–7292–086–8, 88–7292–114–7.

Scholarly articles, profusely illustrated on miniatures and the illumination of books and manuscripts.

Reviews: book.

Advertising.

PRINT. See no. 1649.

THE QUILL. 1978. 3/yr. EN. 1536

Michigan Association of Calligraphers, P.O. Box 55, Royal Oak, MI 48068–0055. Phone 313–540–2065. Susan Skarsgard, Editor.

Subscription: included in membership. Illus. b&w. 8½ x 11, 4–6p.

General articles on calligraphy, news of research and members.

Reviews: book. Calendar of events. Exhibition information. Freelance work: yes. Contact: editor. Opportunities: study – workshops.

THE SOCIETY FOR CALLIGRAPHY AND HANDWRITING - NEWSLETTER. 1975.
bi–m. EN. 1537

Society for Calligraphy and Handwriting, P.O. Box 31963, Seattle, WA 98103.

Subscription: included in membership. Illus. b&w. 7 x 8½, 12–16p.

Includes articles on techniques and methods, news from other societies, reviews of workshops, meeting minutes, and membership list. Related topics of interest include bookbinding, papermaking, and typography.

Reviews: book. Bibliographies. Calendar of events. Opportunities: study.

Advertising. Audience: persons in the Seattle, Washington and Puget Sound area interested in furthering the knowledge and enjoyment of calligraphy.

SOCIETY FOR ITALIC HANDWRITING. BULLETIN. s–a. EN. 1538

Society for Italic Handwriting, c/o J. Fricker, Sec., Highfields, Nightigale Road, Guildford, Surrey BN26 6PH, England. Phone 0483–68443. S. Paterson, Editor.

Subscription: included in membership, non–members 50p. Illus.

ISSN: 0264–3898. Dewey: 741.

Art Education.
Devoted to presenting information on the use of italic handwriting.

SOCIETY OF SCRIBES AND ILLUMINATORS JOURNAL. 3/yr. EN. 1539
Society of Scribes and Illuminators, 54 Boileau Rd., London SW13 913L, England.

SOCIETY OF SCRIBES - NEWSLETTER. 1976. 3–4/yr. EN. 1540
Society of Scribes, P.O. Box 933, New York, NY 10150. Barry Morentz & Ann Pinto, Editors.
Subscription: included in membership. Illus. b&w. 8½ x 11, 4–8p.
Formerly: *Palimpsest*.
Newsletter whose purpose is to promote calligraphy and related lettering arts. News of Society activities.
Reviews: book. Calendar of Society events. Exhibition information. Freelance work: yes. Contact: editor. Opportunities:
study – workshops.
Advertising. Audience: calligraphers & those interested in the book arts.

U&lc. See no. 1667.

UMBRELLA. See no. 573.

THE VALLEY CALLIGRAPHY GUILD NEWSLETTER. 1976. q. EN. 1541
Valley Calligraphy Guild, 3280 Storey Blvd., Eugene, OR 97405. Phone 503–484–0053.
Subscription: included in membership. Illus. b&w. 8½ x 11, 24–36p.
Mainly handwritten calligraphy newsletter. Dedicated to preserving the art of calligraphy. Presents articles, technical informa-
tion, and news of related interest. Includes information regarding bookbinding and paper making.
Calendar of meetings. Freelance work: yes. Contact: editor. Opportunities: study – classes, workshops.

Design

A.R.P. ENVIRONMENT DESIGN. See no. 2263.

ART ET METIERS DU LIVRE: Revue Internationale de la Reliure, de la Bibliophie et de l'Estampe. 1891. bi–m. FR. **1543**
Editions Technorama, 31 Place Saint–Ferdinand, 75017 Paris, France. Phone 1–4574–6743. Remy Baschet, Editor.
Subscription: 400 F. Illus.
ISSN: 0758–413X. OCLC: 6613082. LC: Z267.R46. Dewey: 655.7. Formerly: *Reliure; Reliure–Brochure–Dorure.*
An international review of book binding and design.
Indexed: ArtArTeAb.

AXIS. 1981. q. JA. Table of contents in both JA & EN. Some EN summaries. **1544**
Akushisu, 5–17–1, Roppongi, Minato–Ku, Tokyo 106, Japan. Phone 03 (587) 2781, fax 02 (586) 5246.
Subscription: 5,150 Yen; overseas sea mail 10,000 Yen all; air: No. America/Oceania, 15,000 Yen; Europe/So. America, 16,000 Yen; Asia 13,000 Yen (subscription available through Faxon, Ebsco). Illus., color mainly, some b&w, photos. A4, 144p.
OCLC: 15566776. LC: NK1160.A94.
Design.
"Quarterly on trends in design". Well illustrated. "World Pulse" covers London, Milan, New York, San Francisco, Sydney, and Toyko. Each issue contains several feature articles on one theme. "Creative Trends" is for readers to show their work and describe their ideas or their backgrounds. Completely unrestricted as to distinctions of genre. Illustrations and descriptions appear in both languages. Supplement, called "Excerpts", contains English translations of selected articles. Japanese text includes articles translated from English.
Indexed: Des&ApAI.
Advertising.

DD BULLETIN. See no. 1547.

DESIGN (Bergamo): Strumento per Migliorare la Qualita Della Vita. 1974. q. IT. EN summaries. **1546**
Via Tremana 1, 24100 Bergamo, Italy. Elio Cenci, Editor.
Illus.
Dewey: 745.

DESIGN (Copenhagen). 1980. bi–m. EN & DA. **1547**
Danish Design Council, H.C. Andersen Blvd. 18, 1553 Copenhagen V, Denmark. Phone 01 14 66 88. Jens Bernsen, Editor.
Subscription: Kr 240. Illus., some color.
ISSN: 0900–3517. OCLC: 18851454. Formerly: *DD Bulletin.*
Indexed: Des&ApAI.

DESIGN (London). 1949. m. EN. **1548**
Design Council, 28 Haymarket, London SW1Y 4SU, England. Phone 071–329 8000. M. Hancock, Editor.

Subscription: £29.75. Microform available from UMI. Illus.
ISSN: 0011–9245. OCLC: 1160420. LC: TA175.D38. Dewey: 745.4305.
Focuses on industrial design. Covers product, interior, textiles and graphic design with particular reference to business.
Indexed: ArchPI. ArtBibMod. ArtHum. Avery. ArtI. BioI. CloTAI. CurCont. Des&ApAI.

DESIGN AND APPLIED ARTS INDEX. See no. 11.

DESIGN & DRAFTING NEWS. 1959. bi–m. EN. 1549
American Design Drafting Association, 5522 Norbeck Rd., Suite 391, Rockville, MD 20853. Phone 301–460–6875. Rachel Howard, Editor.
Subscription: included in membership, $50 US & Canada, foreign air $60. Sample. No back issues. Illus. b&w, photos. 8½ x 11, 8p.
Publication of membership organization for design/drafting professionals. Presents news of members and the Association as well as new developments, techniques and products regarding design and drafting.
Reviews: book. Calendar of events.
Advertising: call or write for current rates. Mailing lists: none. Circulation: 2500. Audience: members.

DESIGN FROM SCANDINAVIA. 1966. a. EN, GE, FR, & SW. 1550
World Pictures, Martinsvej 8, DK–1926 Frederiksberg C, Denmark. Phone 45 31 37 00 44, fax 45 31 37 04 81. (US dist.: Rockport Publishers Inc., P.O. Box 396, Rockport, MA 01966). Kirsten Bjerregaard, Editor.
Subscription: $US21 US & Canada, air + $8. No sample. Back issues $14, 90 DKr, £9. Illus. Index. 160p.
ISSN: 0108–0695. OCLC: 1788285. LC: NK1457.A1D47. Dewey: 745.2. Formerly: *Design from Denmark.*
Architecture. Ceramics. Furniture. Interior Design. Jewelry. Textiles.

Presentation of noteworthy Scandinavian design; a production in furniture, textiles, illumination, arts and crafts and industrial design. Provides comprehensive index with cross references to manufacturers and agents.
Circulation: 50,000. Audience: everyone with interest in modern design especially professionals: interior designers, architects, industrial designers, furniture retailers, office furniture designers.

DESIGN INTERNATIONAL INDEX. See no. 12.

DESIGN ISSUES. 1984. s–a. EN. 1551
MIT Press Journals, 55 Hayword St., Cambridge, MA 02142. Phone 312–996–3337. Richard Buchanan & Lawrence Salomon, Editors (University of Illinois at Chicago, School of Art and Design, M/C 036, Box 4348, Chicago, IL 60680).
Subscription: $20 individual, $40 institution, $15 student & retired US; outside US + $7 surface, + $15 air. Illus. b&w. 7 x 10, 92p.
ISSN: 0747–9360. OCLC: 10836452. LC: NK1160.D47. Dewey: 745.
Design.

Published for the University of Illinois at Chicago School of Art and Design. Provides a scholarly forum for the history, theory and criticism of design. Offers a view of the cultural and intellectual role of non–architectural fields from graphic design to industrial designs. Original documents often presented in translation.
Reviews: book. Indexed: ArtBibMod. Des&ApAI. Reviewed: Katz. *Art Documentation* Spr 1986, p.33. *Library Journal* 111:20, Dec 1986, p.78. *Choice* 23:2, Nov 1985, p.418.
Advertising contact Ad. Manager, MIT Press Journals.

DESIGN PERSPECTIVES. 1981. 10/yr. EN. 1552
Industrial Designers Society of America, 1142 E. Walker Rd., Great Falls, VA 22066–1836. Phone 703–759–0100, fax 703–759–7679. Denise Piastrelli–Kocan, Editor.
Subscription: included in membership, non–members $30 US & Canada, $37 foreign, no air. Sample, free. Back issues $5. Illus. occasionally, photos, cartoons sometimes. 8½ x 11, 8p.
OCLC: 11583863. LC: TS171.A1 D47. Dewey: 740. Formerly: *IDSA Newsletter.*
General. Architecture. Art Education. Furniture. Graphic Arts. Historic Preservation. Interior Design. International. Industrial Design.

Provides members with timely information on people, resources and issues making news in industrial design.
Reviews: exhibition 1 & book 1, length 2 columns. Interviews: with members, award–winning designers. Listings: regional–international. Calendar of events. Exhibition information. Freelance work: none. Opportunities: employment, study, competitions.

Advertising: Classified: $1.50/wd., min. $60. No color. No frequency discount. Mailing lists: available 21¢/name, min. $75. Demographics: mostly U.S. industrial designers and design–related industries. Circulation: 2600. Audience: industrial designers.

DESIGN PROCESSES NEWSLETTER: History/Theory/Criticism. 1984. 3/yr. EN. 1553
Design Processes Laboratory, Institute of Design, Illinois Institute of Technology, I.I.T. Center, 3360 S. State St., Chicago, IL 60616–3793. Phone 312–567–6461. Charles L. Owen, Editor–in–chief.
Subscription: $15 US, Canada & foreign air. Sample. Back issues $5. Illus. b&w, photos. Index in each issue. 8½ x 11, 12p. ISSN: 1046–980X. OCLC: 17388452. LC: TA174.D47. Dewey: 620.
General. Architecture. Design.

At least one major article on a design theme in each issue. Covers design, design methods, computer–supported design, design theory, engineering design, communications design, and product design issues.
Bibliographies: annotated, each issue related to a research topic. Listings: international. Calendar of events. Freelance work: none. Opportunities: study, competitions. Reviewed: *Art Documentation* Sum 1987, p.68.
Advertising: none. Circulation: 2000. Audience: design educators, researchers, professionals.

DESIGN QUARTERLY. 1954. q. EN. 1554
MIT Press, 55 Hayward St., Cambridge, MA 02142. Phone 617–253–5646. Mildred Friedman, Editor (Walker Art Center, Vineland Pl., Minneapolis, MN 55403).
Subscription: $22 individual, $45 institution US; foreign $34 individual, $57 institution. Microform available from UMI. Illus. b&w, color, photos. 8½ x 11, 32p.
ISSN: 0011–9415. OCLC: 1566298. LC: NK1.E9. Dewey: 745.05. Formerly: *Everyday Art Quarterly*.
Architecture. Interior Design.

Published for the Walker Art Center. Covers a variety of subjects in architecture, design and contemporary graphics. Biographies: brief information on contributing authors. Indexed: ArchPI. ArtArTeAb. ArtBibMod. ArtHum. ArtI. Avery. CurCont. Des&ApAI.
Advertising: none.

DESIGN REPORT INTERNATIONAL EDITION. irreg. EN. 1555
German Design Council, Ludwig–Erhard Anlage 1, Messagelande, Postfach 970287, D–6000 Frankfort 1, West Germany. Phone 69 747919, fax 69 7410911.
Promotes excellence in design for German commercial products.

DESIGN WORLD. 1983. 3/yr. EN. 1556
Design Editorial Pty. Ltd., 11 School Rd., Ferny Creek, Victoria 3786, Australia. Phone 03–755 1149, fax 3 755 1155, telex AA30625 Attention ME1114 (US dist.: Eastern News, 1130 Cleveland Rd., Sandusky, OH 44870, phone 419–627–1311). Colin Wood, Editor.
Subscription: $A38 Australia, $A44 elsewhere surface, air rates available. Back issues. Illus., some color. 140p.
ISSN: 0810–6029. OCLC: 10190384. LC: NK1490.D457.
Interior Design.

"The international journal of design" features design articles in a wide variety of areas.
Interviews. Indexed: ArtBibMod. Des&ApAI. Reviewed: *Art Documentation* Spr 1988, p.38.
Advertising.

DESIGNER. q. EN. 1557
University and College Designers Association, 2811 Mishawaka Ave., South Bend, IN 46615. Phone 219–288–8232.
Art Education.

Newsletter of visual communication design. Includes design areas such as graphics, photo, signage, films, and other related fields of communication design.

DESIGNERS WEST: Public, Corporate & Residential Spaces. 1953. m. with special 13th issue at midyear. EN. 1558
Arts Alliance Corp, 8914 Santa Monica Blvd., Floor 3, P.O. Box 69660, Los Angeles, CA 90048. Phone 213–657–8231, fax 213/657–3673. Carol Soucek King, Editor.
Subscription: $30 US, $35 Canada & foreign, air Americas/Europe $80, rest of world $100. No sample. Back issues $3.95 + ship. Illus., color, photos. 17 x 11, 200p. Web offset, Perfect binding.

ISSN: 0192–1487. OCLC: 4087182. LC: NK2004.D45. Dewey: 729.
Interior Design.

Serves the field of Western interior design, including both contract and residential work. The field spans interior design; space planning; the specification, purchasing or design of products and furnishings; architecture; and industrial design. Special annual issue, *Designers West Resource Directory*.
Freelance work: none.
Advertising: (rate card Jan '89): b&w full page $2640, ½ page $1595, ¼ page $1055; 2 color + $1035–$1110; 4 color full page $3870, ½ page $2825, ¼ page $2285, covers $4455–4855. Frequency discount. 15% agency discount. Inserts. Mailing lists: available for rent. Demographics: 48% Pacific states, 97% U.S. Circulation: 40,000. Audience: interior designers.

DESIGNEWS. 1990 (May). 10/yr. EN. 1559
Design Editorial Pl, 11 School Road, Ferny Creek, Vic 3786 Australia.
Subscription: $32.48.
ISSN: 1035–0500.

DESIGNLINE. 1984. bi–m. EN. 1560
Boston Design Center, 6 St. James Ave., Boston, MA 02116.
Illus.
ISSN: 0894–4776. OCLC: 12903025. Dewey: 729.
The newsletter of the Center.

DesigNZ. bi–m. EN. 1561
New Zealand Society of Designers, P.O. Box 3432, Aukland, New Zealand. Phone 9 776012, fax 9 3664713.

EMIGRE: Non–Stop Design: The Magazine That Ignores Boundaries. 1982. q. EN. 1562
Emigre Graphics, 48 Shattuck Sq., Ste. 175, Berkeley, CA 94704. Phone 415–841–9021, fax 415–644–0820. Rudy Vander Lans, Editor.
Subscription: $US34, $39 air, US, Canada & Mexico; $36, $52 air, Europe; $36, $62 air, Asia & Australia. Illus. color, b&w. 11¼ x 16¾.
ISSN: 1045–3717. OCLC: 16977449. LC: AP2.E44. Dewey: 760.
Graphic Arts.

Features both established and emerging graphic design talents worldwide with focus on a specific design topic. Showcases works which are often experimental in nature.
Interviews: graphic designers. Indexed: Des&ApAI.
Advertising: back cover only.

FORM. 1905. 8/yr. SW. EN summaries (6p.). 1563
Swedish Society of Crafts and Design, Renstiernas gata 12, S–116 31, Stockholm, Sweden. Phone 08–44 33 03, fax 08–44 22 85. Ulf Beckman, Editor–in–chief.
Subscription: 340 within SEK, SEK 590 outside of Nordic countries includes *Design Annual*. Illus. b&w, color, glossy photos. A4, 80p.
ISSN: 0015–766X. OCLC: 1569795. LC: N1.F76. Dewey: 747.
Ceramics. Crafts. Design. Furniture. Glass. Interior Design. Textiles.

Society promotes good Swedish design and works to spread knowledge of good design and beauty to users, designers and manufacturers. Reports on and highlights the design work and handicraft art in Sweden, the Nordic countries, and the rest of the world, often in issues with special themes. Coverage includes interior and industrial design, furniture, textiles, ceramics, glass and handicraft products.
Indexed: Des&ApAI.
Advertising: Gerd Nystrom AB, Ad. Director (Skyttevagen 22, S–19 51 Stollentuna, phone 08–92 80 03, fax 08–623 09 42).

FORM FUNCTION FINLAND. 1980. q. EN. 1564
Finnish Society of Crafts and Design, Korkeavuorenkatu 19 A 4 B, 00130 Helsinki 13, Finland. Phone 171621 (US dist.: Art Consulting Scandinavia, 25777 Punto de Vista Drive, Calabasas, CA 91302, phone 818–884–6280). Eeva Siltavuori, Editor, Diana Tullberg, English Editor.
Subscription: FIM 130 Finland & Scandinavia, FIM 180 Europe & overseas air, approx. $US42. Illus. b&w, some color. Annual index in last issue. 7 x 9⅞, 66p.

ISSN: 0358–8904. OCLC: 7782355. LC: NK1471.F5 F67.

Interior Design.

Interested in promoting Finnish design and art. Contains a wide variety of articles. Includes news, information regarding exhibitions and products.

Reviews: book. Interviews. Exhibition information. Indexed: ArtBibMod. Des&ApAI. Reviewed: *Art Documentation* Sum 1986, p.64. Katz.

GIFTS & DECORATIVE ACCESSORIES. 1917. m. EN.

1565

Bob Chiara & Phyllis Sweed, Publishers, 51 Madison Ave., New York, NY 10010. Phone 212–689–4411. Phyllis Sweed, Editor.

Subscription: $33 includes *Gifts & Decorative Accessories Buyers Directory*. Illus b&w, color, photos. 8 1/8 x 107/8, 300p. ISSN: 0016–9889. OCLC: 1751222. LC: HD9999.G49 G54. Dewey: 381. Formerly: *Gift & Art Buyer*.

General. Ceramics. Crafts. Decorative Arts. Furniture (small, accent). Glass. Pottery.

A merchandising magazine for and about quality gift and decorative accessories retailers. Covers store management concepts, provides new product previews and "guides to" new merchandise. Also coverage of foreign exhibitions to broaden the overview of the world markets. This international business magazine includes coverage of gifts, tabletop items, and home accessories.

Reviews: exhibition 2–4, book 3–5. Interviews: "Meet", interviews with industry executives in the news. Bibliographies: Jan issue contains a listing of articles for the previous year. Listings: national–international. Calendar of events. Exhibition information. Freelance work: yes. Contact: editor.

Advertising: Christine Bertchie, National Sales Manager. Mailing lists: available. Audience: gift retailers, wholesalers and reps.

INFORMATION DESIGN JOURNAL. 1979. 3/yr. EN.

1566

Information Design Journal Ltd., P.O. Box 185, Milton Keynes MK7 6BL, England. Paul Stiff, Editor (Typography Dept., University of Reading, P.O. Box 239, Reading).

Subscription: $30 individual, $66 institution US & Canada, foreign air + $12. Microform available. Sample. Back issues $20/vol. Illus. b&w, photos. 21 x 21 cm., 84p. ISSN: 0142–5471. OCLC: 7115409.

Graphic Arts. Typography.

Publishes theoretical, experimental and case study papers of a multi–disciplinary nature. It is the major research journal of relevance to graphic designers and others concerned with clear communication.

Reviews: book 2. Freelance work: yes, no payments. Articles are refereed. Indexed: ArtBibMod. Des&ApAI.

Advertising: none. Circulation: 750. Audience: graphic designers.

INTERNATIONAL DESIGN: ID. 1954. bi–m. EN.

1567

Design Publications, Inc, 330 W. 42nd St., New York, NY 10036. Phone 212–695–4955, fax 212–868–4019. Annetta Hanna, Editor.

Subscription: $50 US & Canada, $65 elsewhere. Microform available. Back issues. Illus. mainly color, photos. 8 1/4 x 10 3/4, 90–150p. OCLC: 22873973. LC: TS1.I515. Dewey: 745.205. Formerly: *ID/Magazine of International Design*.

Interior Design.

Focus is planning, design, and marketing. Columns feature news and events, new and notable products together with addresses for these sources, and design resources. The July/Aug issue is the *Annual Design Review*.

Reviews: book 2, length 1p each. Listings: national–international. Calendar of conferences and fairs, deadlines for awards and competitions. Exhibition information. Opportunities: positions available; listing of U.S. design schools; competitions, call for entries. Indexed: ArtI. Avery. BioI. Reviewed: Katz.

Advertising, color. Display rates available on request. Classified: $2.40/wd., $70 min. Jere Gradone, Ad. Director.

JOURNAL OF DESIGN HISTORY. 1988. q. EN.

1568

Oxford University Press, Oxford Journals, Pinkhill House, Southfield Road, Eynsham, Oxford OX8 1JJ, England. Phone 0865–882283, fax 0865–882890, telex 837330 OXPRES G. Christopher Bailey, Editor (The Polytechnic, Wolverhampton, WV1 1SR).

Subscription: £20 members of Design History Society, £38 non–members UK; £38 EEC, $US80 North America, £49 elsewhere. Sample. Back issues £10. Illus. b&w, photos. 9 3/4 x 7 1/2, 96p. ISSN: 0952–4649. OCLC: 18336226. LC: NK1175.J68.

Design.

Published for the Design History Society. Provides a forum, for dialogue and debate, to publish new research and to address current issues of interest on a wide and interdisciplinary basis. Promotes links with other disciplines and exploration of material culture, such as anthropology, architectural history, business history, cultural studies, design management studies, economic and social history, history of science and technology and sociology.

Reviews: book 40/vol., length 750 wds. Freelance work: none. Indexed: ArtBibMod. Avery. Des&ApAI. HistAb. Reviewed: *Choice* 26:3, Nov 1988, p.581. *Library Journal* 114:7, May 15 1989, p.105.

Advertising: rates available on request. Circulation: 1000. Audience: design historians, designers, museum and education staff.

LIGHTVIEW INTERNATIONAL. q. EN. 1569

International Association of Lighting Designers, 18 East Sixteenth St., Suite 208, New York, NY 10003. Phone 212–206–1281, fax 212–206–1327.

Subscription: free. 202p.

Interior Design.

Journal for design professionals especially lighting designers. Master design series and European update.
Reviews: free.
Advertising.

MESSAGES. 1978. q. EN. 1570

Society of Environmental Graphics Designers, 47 Third St., Cambridge, MA 02141. Phone 617–577–8225, fax 617–577–1769. Neal Kane, Sarah Speare, & Tina Lang, Editors.

Subscription: included in membership, $25 all non–members. Sample. Back issues. Illus. b&w, photos. 11 x 16 ½, 20–24p. ISSN: 0895-5719. OCLC: 16699827. LC: NA2750.M47. Dewey: 729.

Architecture. Art Education. Art History. Decorative Arts. Graphic Arts. Interior Design. Landscape Architecture. Typography.

Tabloid offering professional design and technical information. Reports on the activities of the Society and members news.

Reviews: exhibition, book, & film, length half page each. Interviews with speakers for Society conference meetings. Listings: international. Calendar of events. Exhibition information. Freelance work: none. Opportunities: employment, study, competitions. Indexed: Des&ApAI.

Advertising: full page $1800 members, $3500 non–members; ½ page $850 members, $2000 non–members; color rates, full page only, inquire. Mailing lists: available $100. Circulation: 1200. Audience: environmental graphic designers, graphic designers, architects, interior designers, industrial designers, educators, sign manufacturers.

METROPOLIS: The Architecture and Design Magazine of New York. 1981. 10/yr. EN. 1571

Bellerophon Publications, Inc., 177 E. 87th St., New York, NY 10128. Phone 212–722–5050, fax 212–427–1938. Susan S. Szenasy, Editor.

Subscription: $28 US, $65 Canada & foreign, air $145. No sample. Back issues $6.95. Illus. b&w, color, photos. 11 x 15, 110p., Webb. ISSN: 0279-4977. OCLC: 7750778. LC: N6535.N5M47. Dewey: 709.

Architecture. Ceramics. Crafts. Decorative Arts. Fabrics. Furniture. Graphic Arts. Historic Preservation. Interior Design. Landscape Architecture. Textiles. Typography.

Covers new trends and concepts in architecture and design, with emphasis on the metropolitan New York area. Includes articles on neighborhoods and–or buildings of interest. Attention is also paid to interiors, furniture, preservation, urban design, graphics, and crafts.

Reviews: book. Biographies: 2–3/yr. about significant architects, designers and planners. Interviews: mostly in context of stories. Listings: predominantly New York, some West Coast. Calendar of lectures, shows, walking tours. Exhibition information of architecture or design. Freelance work: yes. Contact: editor. Opportunities: study, competitions. Indexed: ArtBibMod. Avery. Des&ApAI. Reviewed: Katz.

Advertising, request rate card. Beth Dickstein, Ad. Director. Circulation: 30,000. Audience: professional designers and consumers of design and design ideas.

MODO: Design Magazine. 1977. m. IT. EN tr. (3p.). 1572

Ricerche Design Editrice s.r.l., Via Roma 21, 20094 Corsico, Milan, Italy. Phone 02–4491149, 4405544, fax 02–4405544. Cesare Secondi, Editor.

Subscription: L 120000. Illus. mainly color. A4, 80p.
Dewey: 745.2.
Indexed: ArchPI. ArtBibMod. Avery. Des&ApAI.
Advertising.

NATIONAL ACADEMY OF DESIGN ANNUAL EXHIBITION. 1825. a. EN. **1573**
National Academy of Design, 1083 Fifth Ave., New York, NY 10128. Phone 212–722–8027. Barbara S. Krulik, Editor.
Subscription: each artist member or person in exhibition receives a copy for free; $8 US. No sample. Some back issues. Illus.
b&w, photos. 7 x 11, 35p.
Dewey: 700.
Catalog listing of works in exhibition and photographs of those which won awards.
Listings: members' addresses and specifics of exhibition. Freelance work: none.
Advertising: none.

NEW ZEALAND SOCIETY OF DESIGNERS UPDATE. bi–m. EN. **1574**
New Zealand Society of Designers, P.O. Box 3432, Aukland, New Zealand. Phone 9 776012, fax 9 3664713.

NewSDIary. m. EN. **1575**
Society of Designers in Ireland, 8 Merrion Sq., Dublin 2, Republic of Ireland. Phone 1–807646, fax 1–807506.
Covers all aspects of design and provides a forum for discussion of ideas.
Audience: designers, photographers, design educators.

QUALITY BY DESIGN. 1987. bi–m. EN. **1576**
A/E Quality Management Association, P.O. Box 97, Bethel, CT 06801.
Illus. 8p.
ISSN: 0893–360X. OCLC: 15514568. Dewey: 658.
"The planing and design professionals' quality management newsletter." Purpose is to help professionals tasked with managing quality in practice.
Audience: planning & design professionals.

RISD VOICE. 1975. m. EN. **1577**
Rhode Island School of Design, Box F–15, RISD, 2 College St., Providence, RI 02903. Phone 401–331–3511.
Subscription: free. 8p.
Formerly: *RISD Press & Express–O*.
Student newspaper concentrates on college and national news.
Advertising: full page $275. Audience: college students.

STORE PLANNING & DESIGN REVIEW. 1935? m. EN. **1578**
Retail Reporting, 101 Fifth Ave., New York, NY 10003. Phone 212–255–9595. Martin Pegler, Editor.
Subscription: $540 + postage US & Canada, foreign $550 includes air mail post. Sample free. Some back issues. Illus.
ISSN: 0896–8772. OCLC: 17311877. Dewey: 747. Formerly: *Store Planning Service*.
Interior Design.
Advertising: Mailing lists: none. Audience: anyone affiliated with designing, building, architect, of retail stores.

SWEDISH DESIGN ANNUAL. 1986. a. EN. Tr. in SW. EN & SW table of contents. **1579**
Swedish Society of Crafts and Design, Renstiernas gata 12, S–116 31, Stockholm, Sweden. Phone 08–44 33 03, fax 08–44 22
85.
Subscription: 340 within SEK, SEK 590 outside of Nordic countries includes *Form*. Illus. mainly color, photos. A4, 168p.
OCLC: 18207526. LC: NK9.S94. Dewey: 747.
Ceramics. Crafts. Design. Furniture. Glass. Interior Design. Textiles.
Society promotes good Swedish design and works for spreading knowledge of good design and beauty to users, designers and
manufacturers. Coverage includes interior and industrial design, furniture, textiles, ceramics, glass and handicraft products.
Issued as no. 7 of *Form*.
Indexed: Des&ApAI.

**THEATRE DESIGN AND TECHNOLOGY: The Journal for Design & Production Professionals
in the Performing Arts.** 1965. q. (5/yr. with 1/92) EN. **1580**
United States Institute for Theatre Technology, Inc., 8–10 West 19th St., Suite 5A, New York, NY 10011–4606. Phone 212–
563–5551. Eric Fielding & Cecelia Fielding, Editors.
Subscription: membership only $60, except libraries, $30 US, $35 foreign. Microform available from UMI. Back issues.
Illus. b&w, photos, plans. Annual index. 8¼ x 10¾, 72p.

ISSN: 0040–5477. OCLC: 9975917. LC: NA6821.T45. Dewey: 792.

Journal of the Institute includes news on the construction of theaters, costume design, stage design, new technical developments and products, and education.

Reviews: book. Freelance work: yes. Contact: editor. Opportunities: employment. Indexed: ArchPI. Avery. CloTAI. Des&ApAI.

Advertising: Tina Margolis, Ad. Manager.

THEMATA CHOROU + TECHNON/DESIGN AND ART IN GREECE. 1972. a. EN & GR. **1581**

Architecture in Greece Press, P.O. Box 3545, GR–102 10 Athens, Greece. Orestis B. Doumanis, Editor. Illus.

ISSN: 0074–1191. OCLC: 5663412. LC: NK1451.T45. Dewey: 705. Formerly: *Themata Es Oterikou Chorou/Design in Greece.*

Architecture.

Indexed: ArchPI.

Advertising.

TOOLS: Tools Design Journal. 1985. 8/yr. EN. **1582**

Designlab A–S, Maglekildevej 1, 1853 Copenhagen V, Denmark. Per Mollerup, Editor (Antoinettevej 5 DK–2500 Valby).

Subscription: Kr 400. (US agent: Art Consulting Scandinavia, 25777 Punto de Vista, Calabassas, CA 91302, phone 818–884–6280). Illus., color.

ISSN: 0900–3347. OCLC: 12283463. LC: NK1160.T66. Dewey: 746.92.

Reviews: book. Calendar of events. Indexed: Des&ApAI.

Advertising.

VISUAL MERCHANDISING & STORE DESIGN. See no. 1583.

VM&SD. 1922. m. EN. **1583**

Signs of the Times Publishing Co., 407 Gilbert Ave., Cincinnati, OH 45202. Phone 513–421–2050. P.K. Anderson, Editor.

Subscription: $30 US, $50 Canada, foreign $55. Microform available from UMI. Illus. color, photos. 8¼ x 10¾, 150p.

ISSN: 0745–4295. OCLC: 9093674. LC: HF5801.D55. Dewey: 659.1. Formerly: *Visual Merchandising; Display World.*

Design publication presenting the latest trends in creation of retail space. Emphasis is on the total merchandising concept.

Reviews: book. Listings: regional display source directory. Opportunities: employment. Reviewed: Katz.

Advertising: $350 per in./yr., listings $75/yr., "Opportunity Exchange" $30/col.in. (payment in advance)

Graphic Arts

ADVERTISING & GRAPHIC ARTS TECHNIQUES. 1983. m. EN. **1584**

Advertising Trade Publications, Inc., 10 E. 39th St., New York, NY 10016. Phone 212–889–6500. Hedi Levine, Editor. Back issues. Illus. 34p.

ISSN: 0747–3168. OCLC: 9848384. Dewey: 659.1. Formerly: *Advertising Techniques & A A T/Ad Art Techniques.*

Graphic Arts.

Reviews: book. Biographies. Calendar of events.

Advertising: Jo Ben–Atar, Ad. Director.

AIGA JOURNAL OF GRAPHIC DESIGN. 1982. q. EN. **1585**

American Institute of Graphic Arts, 1059 Third Ave., New York, NY 10021. Phone 212–752–0183, Fax 212–755–6749. Steven Heller, Editor (New York Times, 229 W 43rd St., New York City).

Subscription: included in membership, $20 non–members. Sample. Back issues $20. Illus. tabloid, 16p.

ISSN: 0736–5322. OCLC: 8962753. LC: NC997.A1 A43. Dewey: 760. Formerly: *Journal of the American Institute of Graphic Arts.*

Graphic Arts.

Criticism, analysis and reporting on graphic design and related fields including the history of graphic design.

Reviews: exhibitions & book 1, length 500 wds. Freelance work: none. Indexed: Des&ApAI. Reviewed: *Art Documentation* Sum 1987, p.69.

Advertising: none. Circulation: 6500.

AIRBRUSH ACTION. 1985. 5/yr. EN. 1586

Air Nouveau, 400 Madison Ave., Lakewood, NJ 08701. Phone 201–364–2111, Fax 201–367–5908. Clifford S. Stieglitz, Editor.

Subscription: $16 US, $35 Canada, foreign air $50 (Box 3000, Dept. MM, Denville, NJ 07834). Sample $5.50. Back issues $4 + postage & handling. Illus. 8¼ x 11, 72p. Webb offset, saddle stitched.

ISSN: 1040–8509. OCLC: 15044933. Dewey: 741.

Graphic Arts. Hobbies.

Covers the spectrum of airbrush and general art applications, the latest in progressive, contemporary art techniques, professional how–to's, personalities, and product evaluations.

Advertising: (rate card Jan '89): b&w full page $1815, ½ page $1179–$1500, ¼ page $650; color full page $2465, ½ page $1629–$1950, ¼ page $1100. Premium positions +15%. Classified: $85/col.in. (payment with order). Frequency discount. 15% agency discount. 20% off earned frequency for museums, galleries, and non–profit art associations. Bleeds no extra charge. Inserts. Mailing lists: available. Circulation: 50,000. Audience: commercial/graphic artist, students, and hobbyists. Edited for art professionals & enthusiasts.

AMERICAN INSTITUTE OF TECHNICAL ILLUSTRATORS ASSOCIATION - NEWSLETTER. q. EN. 1587

American Institute of Technical Illustrators Association, c/o John F. White, 2513 Forest Leaf Parkway, Suite 906, Ballwin, MO 63011. Phone 314–458–2248.

ANNUAL OF ADVERTISING ART IN JAPAN/NENKAN KOKOKU BIJUTSU. 1957. a. EN & JA. 1588

Bijutsu Shuppan–sha, Inaoka Bld., 2–36, Kanda Jinbo–cho, Chiyoda–ku, Tokyo 101, Japan.

Illus., some color.

ISSN: 0548–1643. OCLC: 2945976. LC: NC997.A1A62. Dewey: 741.6.

Tokyo Art Directors Club Annual.

Advertising.

ANNUAL OF AMERICAN ILLUSTRATION. 1959. a. EN. 1589

Society of Illustrators, 128 E. 63rd St., New York, NY 10021. Phone 212–838–2560. Art Weithas, Editor.

Subscription: $49.95. Illus. color.

Full-color reproductions of illustrations done by new and established illustrators in America during the past year.

Advertising. Janet Weithas, Ad. Director.

APPLIED ARTS QUARTERLY. 1986. q. EN. 1590

Applied Arts Quarterly, 20 Holly St., Suite 208, Toronto, Ontario M4S 9Z9 Canada. Phone 416–488–1163, fax 416–488–8417. Peter Giffen, Editor.

Illus. 9⅝ x 12¾.

ISSN: 0829–9242. OCLC: 15466251. LC: NC997. Dewey: 741.6.

Explores the many areas within the applied arts fields.

Indexed: Des&ApAI.

Advertising. William Cotric, Ad. Director. Audience: designers, art directors, photographers, illustrators.

ART AND DESIGN. See no. 471.

ART DIRECTION: The Magazine of Visual Communication, Serves the Field of Advertising Art, Photography, Typography and Related Graphic Arts Field. 1949. m. EN. 1591

Advertising Trade Publications, Inc., 10 E. 39th St., 6th Fl., New York, NY 10016. Phone 212–889–6500.

Subscription: $24 US, $US36 Canada & foreign. Microform available from UMI. Sample S4. Back issues. Illus. b&w, photos.

ISSN: 0004–3109. OCLC: 1774809. LC: NC997.A1 A684. Dewey: 741.6.

Graphic Arts. Photography. Printing. Typography. Advertising. Television Commercials.

The national trade news magazine for visual professionals. Reports on the best and most exciting work in current advertising, design, photography, illustration, etc. Coverage includes in–depth articles on people, events, new books, agency news, and information on award and trade shows.

Listings: national. Calendar of events. Exhibition information. Freelance work: only upcoming artists & photographers, unpaid. Contact: Shoshana Somers (details in *ArtMkt.* and in *PhMkt.*). Indexed: ArtBibMod. ArtI. BioI. BkReI. CloTAI. Des&ApAI.

Advertising: (rate card Jan 89): General ads (for manufacturers and distributors of art and photo materials: paper mills, type foundries, color labs): full page $985, ½ page $590–610, ¼ page $350, spread $1640, covers $1225–$1430. Art & photo ads (for art and photo studios, art stores, printers, lithographers, typographic shops) full page $840, ½ page $505–520, ¼ page $305, spread $1405. color full page + $135–$475. Preferred positions + 15%. Bleed full page only $50. Classified: $10/line, min $30 pay with order. Frequency discount. 15% agency discount. Inserts. Tom Davis, Editor. Demographics: buyers of advertising art, photography and graphic arts products and services, including art directors, art buyers, advertising managers, editors, production personnel, etc. Circulation: 12,000. Audience: advertising & graphic arts professionals.

ART DIRECTORS ANNUAL AND THE ... ANNUAL INTERNATIONAL EXHIBITION. 1921. a. EN.

1592

ADC Publications, 250 Park Ave. S., New York, NY 10003. Phone 212–674–0500. Dan Forte, Editor.
Illus., some color.
ISSN: 0735–2026. OCLC: 17395645. LC: NC998.5.A1 A77. Formerly: *Art Directors Annual; Annual of Advertising, Editorial and Television Art and Design with the Annual Copy Awards.*

ARTQUEST NEWSLETTER & ARTQUEST UPDATE. 1984. bi–m. EN.

1593

International Association of Freelance Artists, Box 25176, Rochester, NY 14625. Phone 716–359–3456. John H. Armstrong, Editor.
Subscription: $25. Illus. Index. 8½ x 11, 12p.
ISSN: 0891–4990. Dewey: 741. Formerly: *Artquest Newsletter.*
Current opportunities in freelance commercial art field presented in a loose–leaf format.
Reviews: book.
Advertising. Circulation: 1000. Audience: creative professionals.

BEST IN ADVERTISING. 1975. a. EN.

1594

R C Publications, Inc., 104 Fifth Ave., 9th Fl., New York, NY 10011. Phone 301–229–9040.
Dewey: 659.1. Formerly: *Best in Advertising Campaigns.*
Graphic Arts.

BOARD REPORT FOR GRAPHIC ARTISTS. 1978. m. EN.

1595

Board Report Publishing Co., Inc., Box 1561, Harrisburg, PA 17105. Phone 717–774–5382. Drew Allen Miller, Editor & Pub.
Subscription: $92 US, $102 Canada, foreign $122. Sample free. Back issues. Illus. b&w, photos. 8½ x 11, 12–20p.
Graphic Arts. Printing. Typography. Advertising. Design.

An innovative service consisting of three newsletters, *The Graphic Artists Newsletter*, the *Designer's Compendium*, and *Trademark Trends* (one subscription price) which provides news, tips, techniques, how–to–information, creative samples and ideas on what's working in the field of graphic art and design.
Reviews: book, equipment. Listings: national. Freelance work: yes. Contact: editor. Opportunities: competitions.
Advertising: none. Audience: graphic artists, designers, ad agencies.

BRITISH DESIGN & ART DIRECTION. 1962. a. EN.

1596

Polygon Editions S.A.R.L., 12 Carlton House Terrace, London SW1Y 5AH, England. Edward Booth–Clibborn, Editor.
Illus.
OCLC: 12581422. LC: NC998.6.G7 D45. Dewey: 741.6. Continues: *British Design and Art Direction: D & AD* which continued: *British Design and Art Direction.*
The annual of the best British advertising, graphics, television and editorial design.

COMMUNICATION ARTS. 1969. 8/yr. EN.

1597

Coyne & Blanchard, Inc, 410 Sherman Ave., Box 10300, Palo Alto, CA 94306. Phone 415–326–6040. Patrick Coyne, Editor.
Subscription: $50 US, $US67 Canada, $US95 foreign. Back issues $7–$21. Illus. b&w, color, photos. Annual index. 8½ x 11, 144p.
ISSN: 0010–3519. OCLC: 1798163. LC: NC997.A1 C2. Dewey: 741.6.

Made up of four regular issues and four special issues, "Illustration Annual" Jl, "Photography Annual" Aug, "Design Annual" Nov, and "Advertising Annual" Dec.

Listings: national and Canadian. Opportunities: study – clubs, conferences and seminars; call for entries for annual exhibition. Indexed: ArtBibMod. ArtI. BioI. CloTAI. Des&ApAI. GrArtLAb.

Advertising. Michael Krigel, Ad. Director.

COVER. See no. 1838.

CPIA NEWSLETTER. q. EN & FR. 1599
Canadian Printing Industries Association, 75 Albert St., Suite 906, Pttawa, Ontario, Canada K1P 5E7. Phone 613–236–7208.
Publication for companies involved in graphic arts and printing in Canada.

CRAFTSMEN REVIEW. 1990, v.70. bi–m. EN. 1600
International Association of Printing House Craftsmen, 7599 Kenwood Rd., Cincinnati, OH 45236. Phone 513–891–0611, fax 513–891–3848.
Subscription: included in membership.
ISSN: 1053–9409. OCLC: 22695286. Dewey: 686. Formerly: *Review*.
The official publication of the Association reports on the activities of the Association's member clubs. A directory of clubs is included.
Advertising. Circulation: 13,000.

CREATIVE SOURCE AUSTRALIA: The Wizards of Oz. 1982. a. EN. 1601
Armadillo Publishers Pty. Ltd., 205–207 Scotchmer St., Fitzroy North, Victoria 3068, Australia. Phone 03–489–9559. Elaine Howell, Editor.
Subscription: $A70. Microform available from Watson Guptill. No sample, will send brochure. Back issues. Illus. (40p.), color, photos (100p.). 30 x 22 cm., 288p.
ISSN: 0726–3589. OCLC: 12325335. LC: NC997.A1 C74. Dewey: 770. Formerly: *First Art Directors Guide to Photographers in Australia.*
Architecture. Drawing. Film Commercials. Graphic Arts. Modern Art. Painting. Photography.

Pictorial guide to creative photographers, illustrators, designers, etc. working in a commercial sphere in Australia. Full color publication with exciting book design as a background. Includes listing of creative people together with their phone numbers.
Advertising: full page only, $830, color $1128. No classified. Circulation: 4000. Audience: advertising agencies, corporate clients, libraries, students.

CREATIVITY. 1971. a. EN. 1602
Art Direction Books Co., 10 E. 39th St., 6th Fl., New York, NY 10016. Phone 212–889–6500. Don Barron, Editor.
Subscription: $55. Back issues. Illus., color, photos. 8⅝ x 11½, 400p.
ISSN: 0097–6075. OCLC: 1790885. LC: NC997.A682. Dewey: 659.13. Formerly: *Advertising Directions.*
Advertising Art. Photography.

Presents award winning advertising art and illustration, design, and television commercials. Contains 1100 illustrations.
Freelance work: none.
Advertising: none.

ECB NEWSLETTER. m. EN. 1603
Graphic Arts Technical Foundation, 4615 Forbes Ave., Pittsburgh, PA 15213. Phone 412–621–6941. Gary A. Jones, Editor.
Illus.
ISSN: 0895–6928. OCLC: 16747766. Dewey: 686.
Graphic Arts.

EIKASTIKA. 1986, no.52. 10/yr. GR. EN summaries. 1604
Eikastika S.A., 14 Iassiou St., 11521 Athens, Greece. Phone Anthony Bouloudjas, Editor.
Back issues. Illus.

OCLC: 21537177. Dewey: 700.
Reviews: book.
Advertising.

EUROPEAN ILLUSTRATION. 1975. a. EN, FR, & GE. 1605
Polygon Editions S.A.R.L., 12 Carlton House Terrace, London SW1Y 5AH, England. Edward Booth–Clibborn, Editor.
Subscription: £1. Illus.
OCLC: 1196134. LC: NC998.6.E87 E9. Dewey: 741.6.
Annual of European editorial, book, advertising, television, cinema and design art.

FLEXO. 1976. m. EN. 1606
Flexographic Technical Association, 900 Marconi Ave., Ronkonkoma, NY 11779–7212. Phone 516–737–6023. Joel J. Shulman, Editor.
Subscription: included in membership, $33 US, $US33 Canada, foreign $42 air. Sample free. Back issues $4. Illus b&w, color, photos, cartoons. Index in Jan issue of following yr. 8½ x 11, 68p.
ISSN: 0734-6980. OCLC: 10499536. Formerly: *Flexographic Technical Journal.*
Graphic Arts.

Reviews: exhibition, book, equipment, other. Listings: national–international. Calendar of events. Exhibition information. Freelance work: none. Opportunities: employment, study, competitions. Indexed: GrArtLAb.
Advertising: full page $1595, ½ page $850, ¼ page $480. color. Classified. Frequency discount. Mailing lists: none. Circulation: 9000. Audience: flexographic printers/converters.

FLEXO ESPANOL. 1986. q. SP. 1607
Flexographic Technical Association, 900 Marconi Ave., Ronkonkoma, NY 11779–7212. Phone 516–737–6023. Joel J. Shulman, Editor.
Subscription: free to qualified recipients. Sample. Back issues $3. Illus b&w, color, photos, cartoons. Indexed in first issue of following year. 8½ x 11, 36p.
Dewey: 686.2.
Graphic Arts.

Translations provided.
Reviews: exhibition, book, equipment, other. Listings: international. Calendar of events. Exhibition information. Freelance work: none. Opportunities: employment, study, competitions.
Advertising, inquire for rate card. Mailing lists: none. Circulation: 5700. Audience: flexographic printer/converters.

GAERF/GATF TEACHERS REPORT. 1976. irreg. EN. 1608
Graphic Arts Technical Foundation, 4615 Forbes Ave., Pittsburgh, PA 15213. Phone 412–621–6941. Jennifer L. Hohman, Editor.
Subscription: included in membership, $10 non–members.
Formerly: *NPEA/GATF Teachers' Report; NPES/GATF Teachers Report.*
Art Education. Graphic Arts.

Covers the instructional aspects of graphic arts communication. Includes articles on GATF and industry–wide educational programs. Contains information regarding problems encountered in day–to–day printing production.
Circulation: 7000. Audience: international graphic communications industries.

GATFWORLD. 1947. bi–m. EN. 1609
Graphic Arts Technical Foundation, 4615 Forbes Ave., Pittsburgh, PA 15213–3796. Phone 412–621–6941, Fax 412–621–3049, Telex 9103509221. Maria Harris, Editor.
Subscription: included in membership, $90 non–members worldwide, qualifying libraries $75. Sample. Back issues. Illus b&w, color, photos. 8½ x 11, 48p.
ISSN: 1048–0293. OCLC: 19571360. LC: Z119.G72x. Dewey: 760. Incorporates: *Graphic Arts Abstracts* as a section; Formerly: *GATF Capsule Reports; ECB Newsletter; GATF Environmental Control Report;* and *GATF.*
Graphic Arts. Photography. Printing. Typography. Environmental Concerns.

Consists of papers, articles, and news items of interest to the international graphics arts community. "Graphic Arts Abstracts" continues as a section in this magazine. *Gatfworld* supports the active role GATF is taking in the advancement of the industry. Presents technical information and products to meet the needs of graphic communicators.Dedicated to the advancement of the

graphic communications industries worldwide. Timely articles report the newest research and trends in all facets of graphic arts industry and education. The publication reflects the complex environment of the graphic communications industries. Reviews: book 8, length 150 wds. Bibliographies: abstracts of important articles taken from the GATF Library of 200 current periodicals. Full text can be ordered from the library. Listings: international. Calendar of GATF events. Freelance work: photos, illustrations, and articles. Contact: editor. Opportunities: GATF study & competitions. Advertising: none. Audience: graphic arts industry.

GRAFICA. 1985. IT only.

1610

Arte Tipografica di A. Rossi, Naples, Italy. (Dist.: Promeco Srl, 29 Via C. Torre, Milan). Illus. b&w, some color, photos, cartoons. 6¾ x 9½, 104p.

Art History. Graphic Arts.

Focuses on Italian graphic arts although some articles, complete with photos, are of art history subjects. Advertising.

GRAFIK-DESIGN AUSTRIA MITTEILUNGEN. 4–6/yr. EN & GE.

1611

Schoenbrunner Stratte 38/8, A–1050 Vienna, Austria. Phone & fax 222 5876501.

Graphic Arts.

Presents information for professional Australian graphic artists.

GRAPHIC ARTISTS GUILD—NATIONAL NEWSLETTER. q. EN.

1612

Graphic Artists Guild, 11 W 20th St., 8th Floor, New York, NY 10011. Phone 212–463–7730. Margi Trapani, Editor. Subscription: included in membership.

Graphic Arts.

Focuses on industry activities, artists' rights, legislation, and Guild business. Circulation: 5000.

GRAPHIC ARTISTS GUILD—THE UPDATE. m. EN.

1613

Graphic Artists Guild, 11 W 20th St., 8th Floor, New York, NY 10011. Phone 212–463–7730. Margi Trapini, Editor. Subscription: for members only,.

Graphic Arts.

Newsletter featuring industry and legislative news together with meeting and program announcements.

GRAPHIC ARTS IN FINLAND. 1972? 3/yr. EN. EN & FI summaries.

1614

Graafisen Tekniikan Tutkimussaatio, Tekniikantie 3, SF–02150 Espoo 15, Finland. Phone 90–460 049. Pirkko Oittinen, Editor. charts, no other illus.

ISSN: 0359–2464. OCLC: 7588572.

Graphic Arts.

Publishes articles on research and development in graphic arts technology. "Thesis Abstracts" — lists recently completed Masters.

GRAPHIC ARTS LITERATURE ABSTRACTS: An Expansion of the Graphic Arts Index. 1954. m. EN.

1615

Rochester Institute of Technology, Technical and Education Center of the Graphic Arts, 1 Lomb Memorial Drive, Box 9887, Rochester, NY 14623. Phone 716–475–2739. Rick Schmidle, Editor.

Subscription: $90. Author and keyword indexes in each issue. Annual cum. author/keyword index. ISSN: 0090–8207. OCLC: 2447267. LC: Z119.G869. Dewey: 760. Formerly: *Graphic Arts Progress.*

Graphic Arts.

Contains informative summaries of current literature about the graphic arts. Abstracts articles from approximately 250 domestic and foreign trade publications, scientific and technical journals, annuals, and conference proceedings received by the Center's Information Service. Each abstract is a summary of a selected article. Subject arrangement organized into 10 major categories.

Reviewed: Katz.

GRAPHIC ARTS MONTHLY. 1929. m. EN. 1616

Cahners Publishing Co., Inc., Book Publishing & Printing Group, 249 W. 17th St., New York, NY 10011. Phone 212–645–0067. Rodger Ynostroza, Editor.

Available online, Dialog. Microform available. Sample $10. Illus., cartoons.

ISSN: 1047–9325. OCLC: 17406060, 1586043; 17406109 (a.). LC: Z119.G87. Dewey: 655. Formerly: *Graphic Arts Monthly and the Printing Industry*; Merger of: *Graphic Arts Monthly* and, *The Printing Industry*.

Graphic Arts.

"The magazine of the printing industry" contains 8–10 articles, Washington news, industry news, news of people in the industry, new products, and "How'd They Print That?" (examples of unusual printing). Annual special issue *Graphic Arts Buyers' Guide*.

Indexed: BioI. CloTAI. GrArtLAb.

Freelance: yes (details in *ArtMkt*.).

Advertising, classified. Circulation: 94,000. Audience: For corporate management and senior staff in the printing industries.

GRAPHIC DESIGN: USA. 1980. m. EN. 1617

Kaye Publishing Corporation, 120 E. 56th St., New York, NY 10022. Phone 212–759–8813. Susan Benson, Editor.

Subscription: $50. Illus.

OCLC: 12653724. LC: NC998.5.A1 G67. Dewey: 741.6. Formerly: *Graphics Design, USA; Graphics: U.S.A; Graphics: New York*.

Graphic Arts.

America's largest audited circulation of graphic designers and art directors.

Indexed: CloTAI. GrArtLAb.

GRAPHIC DESIGN USA: The Annual of the American Institute of Graphic Arts. 1980. a. EN. 1618

American Institute of Graphic Arts, 1059 Third Ave., New York, NY 10021. Phone 201–752–0813. (Dist. US & Canada: Watson–Guptill Publications, Inc., 1515 Broadway, New York, NY 10036. Dist. elsewhere: RotoVision S.A., 10 rue de l'Arquebuse, case postal 434, CH–1211 Geneva 11, Switzerland).

Subscription: included in membership, non–members $59.95. Illus. b&w, color. Index. 9 x 12, 340p.

ISSN: 0275–9470. LC: NC998.5.A1 A37. Dewey: 760. Formerly: *AIGA Graphic Design USA; AIGA Best Books Show; Communication Graphics; Covers; Insides*.

Graphic Arts.

AIGA is a national non–profit agency which promotes excellence in graphic design. The annual was developed to provide archival attention to ongoing programs and competitions that identify excellent design. Contains reproductions of works presented at AIGA exhibition which then travels nationally. Almost entirely illustrations. Information provided: title, type of publication, art director, designer, design firm, publisher/client, typographer and printer. Indexed by person, firm, and "publishers, publications and clients".

Biographies: winners of the AIGA Medal.

Advertising: none. Audience: designers, graphic artists.

GRAPHIC NEWS. 1985. m. EN. 1619

Printing Industry of Minnesota, Inc., 450 N. Syndicate, Suite 200, St. Paul, MN 55104. Phone 612–646–4826. Julie Devane, Editor.

Subscription: included in membership. Sample free. Back issues. Illus b&w, photos. 8½ x 11, 16p.

Formerly: *Member Update*.

Graphic Arts.

The newsletter covers industry trends, governmental affairs and information and events of interest to the graphic arts (printing, publishing, related businesses) industry in Minnesota.

Listings: regional–national. Calendar of PIM programs & events. Book arts Exhibition information. Freelance work: sometimes. Contact: editor. Opportunities: operates resume referral, study, competitions.

Advertising: none. Circulation: 3,500. Audience: PIM members and graphic arts company executives.

GRAPHICS WORLD. 1977. bi–m. EN. 1620

Graphics World Publications Ltd., 7 Brewer St., Maidstone, Kent ME14 1RU, England. Phone 0622 50882. Mandie Rickaby, Editor.

Illus., some color.

ISSN: 0142–8853. OCLC: 17755215. Dewey: 760.

Graphic Arts.

Indexed: ArtBibMod. Des&ApAI. GrArtLAb.
Advertising.

GRAPHIS. 1944. bi–m. Published simultaneously in EN, GE, & FR editions. 1621
B. Martin Pedersen Graphis Press Corp, Dufourstrasse 107, CH–8008 Zurich, Switzerland. (US: Graphis US Inc., 141 Lexington Ave., New York, NY 10016). Phone 01–383.82.11, fax 01–383.16.43. US: 212–532–9387, fax 212–213–3229. Marisa Bulzone, Editor.
Subscription: $59 US, $C82 Canada; surface £48 UK, DM 156, SFr 126 (US & Canada send to New York address, all others Switzerland). Back issues. Illus. color, glossy photos (many full page), posters. Annual index. 9 x 11¾, 112p.
ISSN: 0017–3452. OCLC: 1751402. LC: N8.G73. Dewey: 705.
Graphic Arts.

The international journal of visual communication. Mostly illustrations, few articles. Information about design, graphics and illustration includes art director, designer, description, and illustrator. 1–2 posters are included in each issue.
Interviews: with artist and includes illus. of posters. Indexed: ArtI. ArtBibMod. ArtHum. BioI. CloTAI. CurCont. Des&ApAI.
Advertising: Fran Black, Ad. Director (212–725–3806).

GRAPHIS ANNUAL REPORTS. 1974. a. EN, FR & GE. 1622
B. Martin Pedersen Graphis Press Corp, 107 Dufourstrasse, 8008 Zurich, Switzerland. (US: Graphis US, Inc., 141 Lexington Ave., New York, NY 10016). B. Martin Pedersen, Editor & Pub.
Subscription: $65, $C98; foreign surface £45, DM 138, SFr 112. Illus. color, photos. hardcover.
Graphic Arts.

Mainly illustrations, ½ and full page size. Captions are in all 3 languages. Covers material printed and published in connection with the annual report of a company or other organization. Presented as double–page spreads.
Freelance work: yes, send to Zurich address. Entry fee except for students. Opportunities: includes "call for entries" for Graphis International Yearbooks.
Advertising: none.

GRAPHIS DESIGN: The International Annual of Design and Illustration. 1953. a. EN, FR, & GE. 1623
Graphis Press Corp, 107 Dufourstrasse, CH–8008 Zurich, Switzerland. US & Canada: Graphis U.S. Inc., 141 Lexington Ave., New York, NY 10016. B. Martin Pedersen, Editor & Pub.
Subscription: $65 US, $C91.50, £46.50, DM 148, SFr 118. Illus., mainly color, glossy photos. 9 x 12, 280p., hardcover.
ISSN: 0036–7370. OCLC: 18968333. LC: NC997.A1G73. Dewey: 741.6. Formerly: *Graphis Design Annual; International Annual of Advertising and Editorial Graphics.*
Graphic Arts.

Juried collection of the best graphic design produced in the world in the preceding year. Selection of materials based on entries sent by designers from all over the world. Almost entirely illustrations, little text.
Freelance work: yes, send to Zurich address. Entry fee except for students.

GRAPHIS POSTER: The International Annual of Poster Art. 1973. a. EN, FR & GE. 1624
B. Martin Pedersen Graphis Press Corp, 107 Dufourstrasse, 8008 Zurich, Switzerland. (US: Graphis US, Inc., 141 Lexington Ave., New York, NY 10016). B. Martin Pedersen, Editor & Pub.
Subscription: $65, $C91.50; foreign surface £46.50, DM 148, SFr 118. Illus. color, photos. 9½ x 12, 240p., hardcover.
ISSN: ISBN: 3–85709–390–0. OCLC: 1786992, 14950913. LC: NC1800.G7. Dewey: 769.5.
Graphic Arts. Photography.

Mainly illustrations, ½ and full page size. Captions are in all 3 languages. Posters announcing exhibitions and events of all kinds as well as advertising posters. Contains six indexes—art directors, designers, artists, photographers, agencies & clients.
Freelance work: yes, send to Zurich address. Entry fee except for students. Opportunities: includes "call for entries" for Graphis International Yearbooks.

GRAPHIX. m. EN. 1625
Peter Isaacson Publications, 45–50 Porter St., Prahran, Victoria 3181, Australia. M. Halliwell, Editor.
Microform available from UMI.
Dewey: 760.
Graphic Arts.

GRAVURE ASSOCIATION OF AMERICA—NEWSLETTER. 8 yr. EN.

1626

Gravure Association of America, 90 Fifth Ave., New York, NY 10011. Phone 212–255–0070.

GRAVURE ENVIRONMENTAL REPORTER. irreg. EN.

1627

Gravure Association of America, 90 Fifth Ave., New York, NY 10011. Phone 212–255–0070. Harvey F. George, Editor.
Newsletter.
Indexed: GrArtLAb.

GRAVURE MAGAZINE. 1950. q. EN.

1628

Gravure Association of America, Inc, 90 Fifth Ave., New York, NY 10011. Phone 212–255–0070. Sarita E. Gansler, Editor.
Subscription: $38. Illus.
Dewey: 760. Formerly: *Gravure Bulletin; Gravure Technical Association Bulletin.*
Journal providing technical, marketing and scientific coverage of the industry. Also contains information on new literature, products and overseas news.
Indexed: GrArtLAb.
Advertising.

GREAT BRITAIN. VICTORIA AND ALBERT MUSEUM. ILLUSTRATED BOOKS. 1951.
 irreg. EN.

1629

Victoria and Albert Museum, South Kensington, London SW7, England. Phone 071–938–8521, fax 071–938–8661.
Dewey: 708. Formerly: *Great Britain. Victoria and Albert Museum. Illustrated Booklets.*

GREETINGS MAGAZINE. 1960. m. EN.

1630

Mackay Publishing Corp, 309 Fifth Ave., New York, NY 10016. Phone 212–679–6777. Milton J. Kristt, Editor.
Subscription: $12.50 US, $25 Canada, $37.50 foreign, air $75. Sample $2.50 (will be applied to subscription). Back issues $2 + postage. Illus b&w, photos. 8¼ x 10⅞, 32p.
Dewey: 740. Formerly: *Greeting Card Magazine.*
Graphic Arts.

The business magazine of greeting cards, stationery and allied products brings readers up–to–date information on industry news, trends and developments, new products and personnel changes. Regularly reports on new resources, industry surveys, leaders' opinions and other functions relative to the making, displaying and selling of greeting cards, social stationery and all allied products. Each issue deals with seasonal themes.
Listings: national–international. Calendar of industry events. Exhibition information. Freelance work: yes. Contact: editor.
Advertising: (rate card Jan '89): full page $1050, ½ page $620, ¼ page $340, color full page + $330–355. Classified: 60¢/wd., min $10. Frequency discount. Cover and special positions, rates on request. Inserts. R.J. McInerney, Ad. Director.
Mailing lists: available only to advertisers. Demographics: pass–along, management–executive perusers total over 50,000.
Circulation: 7000. Audience: retailers of greeting cards.

GRIDS. bi–m. EN.

1631

Society of Publication Designers, 60 E 42nd St., Suite 1416, New York, NY 10165. Phone 212–983–8585, fax 212–983–6043.
Subscription: included in membership.
Newsletter. Society members design and layout of newspapers and other publications.

HARRISON FISHER SOCIETY - NEWSLETTER. 1980. a. EN.

1632

Harrison Fisher Society, P.O. Box 8188, Redlands, CA 92375–9998. Phone 714–798–5755.
Subscription: free.
Newsletter for enthusiasts and collectors of the works of Harrison Fisher, illustrator of books and magazines. Features classified ads.
Advertising. Circulation: 500.

HOW. 1984. bi–m. EN.

1633

F&W Publications, Inc., 1507 Dana Ave., Cincinnati, OH 45207. Phone 513–531–2222 or 1–800–283–0963, fax 513–531–4744. Laurel Harper, Editor.
Subscription: $41 US, + $9 Canada (POB 12575, Cincinnati, OH 45212–0575); foreign send inquires to RotoVision SA, Route Suisse 9, 1295 Mies, Switzerland, fax 022–55–40–72). Microform available from UMI. Sample $8.50. Back issues $6.50–8.50. Illus b&w, color, photos. 8½ x 11, 150p.
ISSN: 0886–0483. OCLC: 12818188. LC: NC1000.H68. Dewey: 741.6.

Graphic Arts. Photography. Printing. Typography.

The business magazine for graphic art professionals. Deals with the "how–to's" of graphic design — from illustrative techniques to computer graphics. Profiles of noted companies or individuals are offered, as well as business articles, setting up your own workspace, new techniques, new products, exciting projects, and much more. Special issues include the Nov/Dec *Business Annual* which covers all aspects of doing business in graphic design, and the *HOW's Self Promotion* issue in which the winners of the annual Self Promotion contest are revealed.

Reviews: book 4, length 4 inches each; software 1, length 1200 wds. Interviews: profiles with innovators in graphics design – – individuals or firms. Listings: international. Calendar of events. Exhibition information. Freelance work: yes. Contact: editor. Opportunities: study, competitions.

Advertising: full page $1885, ½ page $1,185, ¼ page $705; color + $395–690; 4 color + $795. Premium positions + 15%. Classified: $95/inch, $2.75/wd, 20 wd. min. Frequency discount. 15% agency discount. Inserts. Gigi Grillot, Ad. Director. Demographics: reaches industry's decision–makers at all levels, 41% own their company. Circulation: 35,000. Audience: graphic designers/students.

IDEA: International Advertising Art. 1953. bi–m. JA & EN. 1634
Seibundo Shinkosha Publishing Co., Ltd., 1–5–5 Kanada Nishiki–cho, Chiyoda–ku, Tokyo 101, Japan. Minora Takita, Editor–in–chief.
Subscription: 22,620 Yen (Nippon IPS Co., Ltd., 3–11–6 Lidabashi, Chiyodaku, Tokyo 102). Sample & back issues 5020 yen including seamail postage. Illus. b&w, color, photos. Index. 29.7 x 22.5, 150p.
ISSN: 0019–1299. OCLC: 1846290. LC: NC1.A28.
Drawing. Graphic Arts. Modern Art. Painting. Photography. Printing. Sculpture.

Bilingual publication devoted to presenting world level authors in advertising art centered on the graphic design field and their circumferential domains.

Reviews: exhibition & book, Japanese domestic information only. Biographies: short biographies on issue authors. Listings: national. Exhibition information. Opportunities: employment, study, competitions. Indexed: ArtBibMod. Des&ApAI.
Advertising: full page 145.000–200.000 Yen, ½ page 80.000 Yen, ¼ page 45.000 Yen; color full page 260.000–300.000 Yen. Frequency discount. Mr. Kinzaburo Iwao, Ad. Director. Mailing lists: none. Demographics: ad agencies, clients, advertisers 33.4%; creators, production firms, etc. 17.6%. Circulation: 32,000. Audience: designers of graphics, creators, artists, design students.

ILLUSTRATION IN JAPAN. 1981. a. EN. Captions in JA and EN. 1635
Kodansha Ltd., 12–21, Otowa 2–chome, Bunkyo–ku, Tokyo 112, Japan. US: Kodansha International, 114 5th Ave., New York, NY 10011.
Subscription: $52. Illus.
OCLC: 8071057. LC: NC991.I4. Dewey: 741.6.

ILLUSTRATION 63: Zeitschrift fuer die Buchillustration. 1964. 3/yr. GE. 1636
Curt Visel, Weberstrasse 36, Postfach 1636, D–8940 Memmingen, West Germany. Phone 08331–2853.
Subscription: DM 148. Illus.
ISSN: 0019–2457. OCLC: 2673241. LC: NC960.I42. Dewey: 700.
Devoted to 20th century artistic book illustration. Each issue contains four original graphics.
Reviews: book. Indexed: ArtBibMod.

THE ILLUSTRATOR. See no. 182.

ILLUSTRATORS: The Annual of American Illustration. 1959. a. EN. 1637
Madison Square Press, Inc., 10 E. 23rd St., New York, NY 10010. Phone 212–505–0950. (Dist. Watson–Guptill, 1 Astor Plaza, 1515 Broadway, New York, NY 10036). Art Weithas, Editor.
Subscription: $49.95. Back issues. Illus. color, photos full and ½ page. Indexed by artists with address and phone number, art directors, magazine publishers and publications, and agencies. 9 x 11¾, 550+p., hardcover, printed in 4 color process.
ISSN: 0073–5477. OCLC: 1752685. LC: NC975.A1I5. Dewey: 741.64058.
"The Society of Illustrators Annual of American Illustration" represents an exhibition of works from across the nation. A showcase of the entire field of contemporary illustration presenting over 500 full–color reproductions of illustrations done by new and established illustrators in the past year. Exhibition section contains examples of artists' work together with brief description of the exhibit as a whole.
Biographies: 3 "Hall of Fame" biographies, several pages each, honors the work of illustrators for their contribution to the art of illustration. Brief biographies of award winners.
Advertising, 10–12p. at end of book.

ILLUSTRATORS DESPATCH. 1980. bi–m. EN. 1638

Thomas Skinner Directories Ltd., Windsor Court, Grinstead House, East Grinstead, W. Sussex RH19 1XE, England. Phone 0342–326972.

Illus.

ISSN: 0260–8324. Dewey: 740.

IN HOUSE GRAPHICS. 1984. m. EN. 1639

United Communications Group, 4550 Montgomery Ave., Suite 700–N, Bethesda, MD 20814–3382. Phone 301–961–8777. Ronnie Lipton, Editor.

Subscription: $97 US. Sample. Back issues $8.08. Illus. b&w, color, photos, cartoons. 8½ x 11, 12p.

ISSN: 0883–6973. OCLC: 12570859. Dewey: 760.

Drawing. Graphic Arts. Photography. Printing.

An instructional graphics newsletter which gives help, ideas, and tips to people who produce publications and print promotions in an in–house department. Includes print buying, marketing, advertising, copywriting, editing, paper buying, print design, brochure ideas, newsletter design, desktop publishing.

Reviews: exhibition 0–3, book & equipment 0–4 each. Listings: national. Calendar of exhibitions. Opportunities: study, competitions.

Advertising: none. Audience: in house graphics, ad, art, marketing, desktop publishing, editorial departments.

INTERNATIONAL ADVERTISING DESIGN. 1924. a. EN. 1640

Cassell, Artillery House, Artillery Row, London SW1P 1RT, England. Phone 071–222 7676 (Dist. US & Canada: Rizzoli International Publications, 300 Park Ave. S., New York, NY 10010).

Subscription: £40, $51.50. Illus. mainly color, photos. Index by agencies and studies, and by advertisers. A4.

ISSN: 1046–3658. OCLC: 20398026. LC: NC997.A1 M6. Dewey: 659. Formerly: *World Advertising Review; Modern Publicity (1930-1984).*

Graphic Arts.

International coverage provides a showcase for the brightest ideas conceived in all countries in the field of printed advertising. Text attempts to explain the relevance of those ideas to the marketing conditions in which the advertisers and agencies concerned have to work. Arrangement is by broad subjects such as "automotive" and "tobacco". Mostly illustrations (over 400), text consists of captions (title, city, agency) and 1–2 sentences about the work. Reproduces original images from print advertising campaigns all over the world.

Listings: List of credits (title, city, advertiser, agency, account director, art director, copywriter, & photographer).

INTERPRESSGRAPHIC: International Quarterly for Visual Culture and Communication.

1970. q. 1641

International Organization of Journalists, Parizska 9, 110–10 Prague, Czechoslovakia. Andras Szekely, Editor.

ISSN: 0209–7494 (Russian ed.). Dewey: 655. Formerly: *Interpressgrafik.*

Devoted to the questions of visual art, layout of newspapers, magazines, books advertising materials and posters.

Reviews: book. Indexed: ArtBibMod.

Advertising.

LITHO WEEK. 1979. w. EN. 1642

Haymarket Publishing Ltd., 38–42 Hampton Rd., Teddington, Middx. TW11 0JE, England. Phone 081–943–5000. Simon Kanter, Editor.

Subscription: £128. Illus.

ISSN: 0264–732X. OCLC: 9163580. Dewey: 763. Formerly: *Lithoprinter Week.*

Reviews: book.

Advertising.

THE NATIONAL. q. EN. 1643

Society of Graphic Designers of Canada, P.O. Box 2728, Station D, Ottawa, Ontario, Canada K1P 5W7. Phone 604–688–9975.

Graphic Arts.

Newsletter of the Society provides exchange of information among members.

Audience: graphic designers, administrators, educators, students and organizations promoting graphic design in Canada.

NOUVELLES GRAPHIQUES/GRAFISCH NIEUWS. 1950. s–m. DU & FR editions. 1644
Internationale Drukkerij en Uitgeverij Keesing N.V., 2–20 Keesinglaan, B–2100 Deurne, Belgium. Phone 03–34–38–98.
Alain Vermeire & Steven Van De Rijt, Editors.
Subscription: 1500 BFr.
ISSN: 0029–4926. Dewey: 760.

NOVUM GEBRAUCHSGRAPHIK. 1982, v.53. m. EN, GE, FR, & SP (each language follows in same article). 1645
Bruckmann Munich, Nymphenburger Strasse 86, D–8000 Munich 20, W. Germany. Phone (089)1257341, fax (089)1257269.
(US dist.: Publications Expediting, Inc., 200 Meacham Ave., Elmont, NY 11003). Erhardt D. Stiebner, Editor.
Subscription: $US109 US & Canada air, DM159. Illus. b&w, color, photos. 9 x 11¾, 72p.
ISSN: 0302–9794. OCLC: 8546227. LC: NC997.A1G4. Dewey: 741.6.
Graphic Arts.

International journal of commercial art. Includes articles on designers, advertising, and education.
Indexed: ArtBibMod. ArtI. CloTAI. Des&ApAI.
Advertising.

PACIFIC PRINTERS PILOT. 1979. m. EN. 1646
583 Monterey Pass Rd., Monterey Pk., CA 91754. Phone 213–576–1538. Wynn Kessler, Editor.
ISSN: 0552–7511. OCLC: 5121907. Dewey: 760.
Graphic Arts.

The graphic arts journal for the West.
Reviews: book.
Advertising.

PLAN AND PRINT: The Magazine for Design and Reprographic Management. 1928. m. EN. 1647
International Reprographic Association, 611 E. Butterfield Rd., Suite 104, Lombard, IL 60148–5603. Phone 312–852–3055,
Fax 312–852–3194. Elizabeth Cicchetti, Editor.
Subscription: controlled circulation to members of the American Institute for Design & Drafting and the International Repro-
graphic Association, $36 US, $42 Canada, $60 foreign. Microform available from UMI. Sample. Back issues $6. Illus. b&w,
color, photos. 8⅛ x 10⅞, 44p. Offset. Saddle Stitch.
ISSN: 0032–0595. OCLC: 4849087. Dewey: 772.2. Formerly: *International Blue Printer.*
Architecture. Printing. Typography. Reprographics.

The official magazine of the American Institute for Design and Drafting is edited for and serves the decision makers who
buy: design and drafting supplies; computer graphics users; architects, in–plant reproduction department supervisors; com-
mercial reprographic company owners and managers and dealers in architects', engineers' and drafters' supplies and equip-
ment. Editorial encompasses phases and aspects of graphic communications systems management and reports on methods,
techniques and operations of members of the two Associations and technical processes and equipment of manufacturers. Fea-
tures include areas of design/drafting, pin graphics, computer aided design; reprographic techniques including offset, micro-
film, diazo, photography, electrostatics, and related management.
Reviews: exhibition. equipment. Interviews: occasionally. Listings: national–international. Calendar of events. Exhibition in-
formation. Freelance work: yes. Contact: editor. Opportunities: employment, study, competitions.
Advertising: (rate card 1989): full page $3218, ½ page $1931, ¼ page $966; 2 color + $461–575, 4 color + $1370; covers
$3370–4006 (12x). Classified display: $103/col. inch, min. 3 times, max. 3 inch. Frequency discount. 15% agency discount.
Inserts. Mailing lists: available. Circulation: 30,000. Audience: architects, engineers and reprographers.

POST GUTENBERG. 1987? bi–w. EN. 1648
Lee Publications, Inc., Box 121, Grand St., Palatine Bridge, NY 13428. Phone 518–673–3237. Tom Mahoney, Editor.
OCLC: 18476668. Dewey: 686.
Graphic Arts.

A tabloid graphic arts newspaper for the Northeastern United States.
Advertising.

PRINT: America's Graphic Design Magazine. 1940. bi–m. EN. 1649
RC Publications, Inc., 104 Fifth Ave., 9th Fl., New York, NY 10011. Phone 212–682–0830, fax 212–989–9891. Martin Fox,
Editor.
Subscription: $50 US, $62 Canada & Mexico. Microform available from UMI. Illus., mainly color.

ISSN: 0032–8510. OCLC: 1762867. LC: Z119.P8985. Dewey: 070.5. Formerly: *Printing Art; Print Collectors' Quarterly.*
Graphic Arts.

Showcase for the newest and the best in visual communication around the world. See what is taking place in advertising, graphic design, corporate identity, television, film, computer–aided design, and much more. Lavishly illustrated with many visuals in four color the magazine offers features on every facet of graphic design. Coverage offers insight into today's graphic trends and future directions. Regularly includes "The Rare Book Market" section. The Jul/Aug issue is the *Regional Design Annual* which presents in six separate sections all the major regions of the country. (One section is devoted to New York City). The Annual tracks the shifts in design activity throughout America—points out particular characteristics, developments and trends that exist from region to region.
Reviews: book. Indexed: ArtBibMod. ArtI. CloTAI. Des&ApAI. IBkReHum.
Advertising: Virginia Berke, Ad. Director. Audience: graphic design professionals.

PRINT & GRAPHICS. 1980. m. EN. 1650
Box 25498, Washington, DC 20007. Phone 703–525–4800. Richard C. Koman, Editor.
ISSN: 0273–9550. OCLC: 7042700. Dewey: 760.
Graphic Arts.
"The newspaper of the printing and graphics arts industry of the Mid–Atlantic region".
Reviews: book.
Advertising.

THE PRINTER'S DEVIL. 1986. s–a. EN. 1651
Mother of Ashes Press, Box 135, Harrison, ID 83833–0135. Phone 208–689–3738. Joe M. Singer, Editor.
Subscription: available on request, mailed bulk rate in US, surface printed matter outside US. Sample free. No back issues.
Illus. b&w, color, photos, cartoons. 9½ x 12½, 24p.
Dewey: 760.
Graphic Arts. Printing. Typography.

A graphic arts newsletter for the small press whose motto is "A press in every home/a home in every press". Purposes are to provide the small press with accurate and timely information on all phases of the graphic arts, and to promote "art" and "craft" in contemporary printing. Presents how–to information, both do–it–yourself (mainly offset–litho, mimeo and photocopy) and dealing with printers, etc. Letters column includes letters from readers and news releases from industry sources. Discusses niceties of design, typography, binding, etc.
Reviews: 2 review columns — one graphic arts, one very short publishers' resources. book, journal, equipment, & other, 5 each, length to 250 wds. exhibition occasionally, length feature. Freelance work: yes. Contact: editor.
Advertising: rates on request. Classified: .12 ½¢/agatge line. Frequency discount. Mailing lists: none. Circulation: 500. Audience: small press publishers, hobby printers, other low–tech graphic artists.

PRINTING HISTORICAL SOCIETY BULLETIN. s–a. EN. 1652
Printing Historical Society, St. Bride Institute, Bride Lane, London EC4Y 8EE, England.
Purpose of the Society is to foster interest in the history and traditions of printing and its methods, equipment, materials, and products.

PRINTING HISTORICAL SOCIETY JOURNAL. irreg. EN. 1653
Printing Historical Society, St. Bride Institute, Bride Lane, London EC4Y 8EE, England.

PRODUCTIVITY AND TRAINING REPORT / GATF. 1968. irreg. EN. 1654
Graphic Arts Technical Foundation, 4615 Forbes Ave., Pittsburgh, PA 15213. Phone 412–621–6941. Bonetta Winters, Editor.
Illus.
OCLC: 10550743. Dewey: 760. Formerly: *Education Report.*
Education. Graphic Arts.
Industry report concerned with education and training in the graphic arts field.
Calendar of events.

PROFESSIONAL ENGRAVER. 1982. q. EN. 1655
National Association of Professional Engravers, 21010 Center Ridge Rd., Rocky River, OH 44116. Phone 216–333–7417.
B.J. Imburgia, Editor.
Subscription: membership only, free.

Formerly: *National Association of Professional Engravers—Newsletter*.
Newsletter for professional hand and machine engravers of wood, plastic, and metal. Includes trade show news.
Advertising.

PROFILE. q. EN. 1656
British Printing Industries Federation, 11 Bedford Row, London WC1R 4DX, England. Phone 071 2426904, fax 071 4057784.

PUBLICATION DESIGN ANNUAL. 1982. a. EN. 1657
Madison Square Press, Inc., 10 E. 23rd St., New York, NY 10010. Phone 212–505–0950.
Illus. b&w, some color.
ISSN: 0885–6370. OCLC: 9348497. LC: NC975.P83. Dewey: 741.65. Formerly: *Publication Design*.
A catalog specializing in magazine design and illustrations of magazines and covers.

RESEARCH PROJECT REPORT - GRAPHIC ARTS TECHNICAL FOUNDATION. 1947. irreg.
EN. 1658
Graphic Arts Technical Foundation, 4615 Forbes Ave, Pittsburgh, PA 15213. Phone 412–621–6941.
ISSN: 0361–1140. OCLC: 2015558. Dewey: 760. Formerly: *GATF Research Progress Report*.
Graphic Arts.

SIGNCRAFT. 1980. bi–m. EN. 1659
Signcraft Publishing Co., Inc., Box 06031, Ft. Myers, FL 33906. Phone 813-939-4644. Tom McIltrot, Editor.
Subscription: $21. Sample $3. Illus. b&w, color, photos (100+/issue).
ISSN: 0270–4757. OCLC: 6770111. LC: HF5841.S54. Dewey: 338.4.
Freelance work: yes (details in *PhMkt.*).
Advertising. Circulation: 21,000. Audience: sign artists and shop personnel.

SOCIETY OF GRAPHIC ARTISTS. PUBLICATION. a. EN. 1660
Society of Graphic Artists, 17 Carlton House Terrace, London SW1Y 5BD, England.
Dewey: 740.
Graphic Arts.

SOUTHERN GRAPHICS: Covering the Graphic Arts in the South. 1924. m. EN. 1661
Coast Publishing, Inc., 1680 S.W. Bayshore Blvd., Pt. St. Lucie, FL 34984. Phone 305–879–6660. Kenneth Moran, Editor.
Subscription: $22. Illus.
ISSN: 0274–1370. OCLC: 6582613. Dewey: 760. Formed by the merger of: *Graphics*, and *Southern Printer*.
Graphic Arts.

Covers the industry in 14 Southern states. Issued in a Southern edition and a Florida edition which contains some additional regional material.
Indexed: GrArtLAb.

STEP-BY-STEP GRAPHICS. 1985. 7/yr. EN. 1662
Dynamic Graphics, Inc., 6000 N. Forest Park Dr., Peoria, IL 61614–3592. Phone 309–688–2300, fax 309–698–0831, telex 269331DGUS UR. Nancy Aldrich–Ruenzel, Editorial Director; John Fennell, Editor (2577 N. Downer, Suite 208, Milwaukee, WI 53211, phone 414–962–9126, fax 414–962–9129).
Subscription: $42 US, $51 elsewhere. Sample $7.50. Illus. b&w, color, photos (130/issue). 8¼ x 10¾, 148p.
ISSN: 0886–7682. OCLC: 12747820. LC: NC845.S73. Dewey: 760.
Graphic Arts.

"The how–to reference magazine for traditional and electronic graphics". Contains several feature articles. Departments include "Career Tips" — helpful hints covering a variety of professional issues.
Reviews: "Reference Shelf" — book reviews, length 2p. Listings: national. Calendar of events lists upcoming seminars, trade shows, exhibitions and other events in visual communication. Freelance work: yes (details in *PhMkt.*). Opportunities: annual cover competition. Indexed: Des&ApAI.
Advertising: color. Readers service card. Robert J. Behrends, Ad. Director. Circulation: 45,000. Audience: graphic designers, illustrators, art directors, studio owners, photographers.

THE STUDIO MAGAZINE. 1983. 7/yr. EN.

1663

Roger Murray & Associates Inc., 124 Galaxy Blvd., Toronto, Ontario M9W 4Y6, Canada. Phone 416–675–1999, fax 416–675–6093. Barbara J. Murray, Editor.

Subscription: $C35 Canada, $US42 US & foreign includes 6 regular issues + the Awards Issue published in Dec. Sample free. Back issues $5 each. Illus. b&w, some color.

ISSN: 0715–6626. OCLC: 9658151. LC: NC997. Dewey: 741.6.

Graphic Arts.

A professional publication designed to inspire and inform. It presents ideas, artistic and photographic portfolios, new product releases and events relating to the advertising and professional design community. The Dec issue is a special awards issue. A new magazine *The Electronic Studio* is contained within each issue. *The Electronic Studio* is dedicated to serving the needs of graphic designers and design educators who see computers and desktop publishing as a logical medium for creative expression, experimentation and graphic production. Each issue features articles on the use of specific hardware and software for use in design studios, publication departments of corporations and design schools. The main feature is an overview of a complete design work station within a specific company, and displays the results achieved by the firm's designers.

Indexed: ArtBibMod. CanPI.

Advertising. Demographics: distributed in over 30 countries. Circulation: 16,000. Audience: graphic designers, illustrators, photographers, creative graphic arts personnel and computer and A/V production personnel.

T & E NEWS. 1961. 9/yr. EN.

1664

Rochester Institute of Technology, Technical and Education Center, One Lomb Memorial Dr., Rochester, NY 14623. Phone 716–475–2737. Tom Petronio, Editor.

Subscription: free US. Sample. Back issues. Illus. b&w, photos. 8¼ x 10½ folded, 8p.

ISSN: 0895–6529. OCLC: 14715701. LC: Z119.T336. Dewey: 760. Formerly: *GARC Newsletter; T and E Center Newsletter.*

Graphic Arts. Printing.

Focus is on the training seminars, research, testing, and quality control materials produced and/or taking place at the Technical & Education Center. Special section within focuses on quality improvement and quality management issues.

Listings: internally sponsored events only. Freelance work: none. Opportunities: study, competitions.

Advertising: none. Mailing lists: none. Circulation: 45,000. Audience: graphic arts professionals.

THE TABLOID. m. EN.

1665

Screen Printing Association International, 100015 Main St., Fairfax, VA 22031. Phone 703–385–1335, fax 703–273–0456, telex 904059 WSH.

Subscription: included in membership.

Dewey: 764.8.

Information regarding screen process printing.

Audience: printers who use screen process of printing and educational institutions.

TODAY'S ART AND GRAPHICS. 1980. m. EN.

1666

Syndicate Magazines, Inc., 390 Fifth Ave., New York, NY 10018. Phone 212–613–9700. George Magnan, Editor.

Illus.

ISSN: 0274–5828. OCLC: 6432461. LC: N1.T583. Dewey: 741.6. Formed by the merger of: *Graphics Today* and, *Today's Art.*

Graphic Arts.

Reviews: book.

Advertising.

U&lc: The International Journal of Typography. 1974. q. EN. FR & GE summaries.

1667

International Typeface Corp., 2 Hammarskjold Plaza, New York, NY 10017. Phone 212–371–0699. Margaret Richardson, Editor.

Subscription: free to qualified personnel, others $20 US & Canada, $25 foreign, inquire for air rates. Sample. Some back issues, $1.50. Illus. b&w, color. 11 x 14¾, 72–80p.

ISSN: 0362–6245. OCLC: 2328696. LC: Z119.U14. Dewey: 686.2.

Printing. Typography.

A tabloid devoted to typography and printing.

Freelance work: none. Indexed: ArtBibMod. Des&ApAI. GrArtLAb.

Advertising: (rate card Jl '89): b&w full page $4625, ½ page $2700, ¼ page $1500, junior page $3470; 4 color full page $6100, ½ page $3550, ¼ page $2000, covers $7200–7500, junior page $4575. Frequency discount. J. Travison, Ad. Director.
Mailing lists: none. Circulation: 190,000. Audience: artists, art directors, designers, specifiers of type by any job title.

VOLK CLIP ART. 1987. m. EN. 1668
Volk Clip Art Inc., P.O. Box 347, Washington, IL 61571.
Subscription: $234 includes plastic file (Volk Artfile). Illus.
OCLC: 22980236. Dewey: 741.6.
Issues filed alphabetically by subject in plastic file (Volk Artfile).

Computers and Art

COMPUTER PICTURES. 1983. m. EN. 1669
Montage Publishing, Inc., 25550 Hawthorne Blvd., Suite 314, Torrance, CA 90505. Phone 213–373–9993. Jim Strotham, Editor.
Available on Dialog. Illus.
ISSN: 0883–5683. OCLC: 9470312. LC: TR894.B88. Dewey: 778.5. Formerly: *Business Screen.*
Contains articles on the computer–generated animation and graphics industry as well as information on a wide range of computer products.

COMPUTERS AND THE HISTORY OF ART. 1985. bi–m. EN. 1670
Harwood Academic Publishers, 270 Eighth Ave., New York, NY 10011, phone 212–206–8900.
Subscription: $138 (Harwood, P.O. Box 786, Cooper Station, New York, NY 10276, UK: P.O. Box 90, Reading, Berkshire RG1 8JL, England).
ISSN: 1048–6798. OCLC: 21015776. Dewey: 759. Formerly: *CHArt Newsletter.*
Interested in the use of computer systems for research in the history of art. Reports on projects using electronic imaging in order to produce high quality low priced computer images. Includes information on scanning directly from original paintings.

DESIGN SYSTEMS STRATEGIES. 1977. m. EN. 1671
Design & Systems Research Publishing Co., Inc., Box 20, Scarborough, ME 04074–0020. Phone 207–767–6324. Daniel S. Raker, Editor & Pub.
Subscription: $149 US, $180 outside US. 8½x11, 16p.
ISSN: 0895–6790. OCLC: 16729070. Dewey: 620. Formerly: *A/E Systems Report.*
"The management report on automation and productivity". Includes a "monthly management problem". For professionals using computers for design purposes.
Reviews: book.
Audience: design professionals, architects, engineers.

DRAUGHTING & DESIGN. fortn. EN. 1672
Electronic Design Automation Ltd., 31–33 High Holborn, London WC1V 6BD, England. Phone 071 404 0564. Loilitta Taylor, Editor.
Back issues.
ISSN: 0951–5704. Dewey: 745.2.

F.A.S.T. ELECTRONIC BULLETIN BOARD. EN. 1673
Leonardo, Box 75 1442A Walnut, Berkeley, CA 94709.
Subscription: (exclusive of on–line costs): $40 individual, $20 ISAST members, $100 libraries. Send email to LEONARDO @Well.UU.NET with MCI or WELL logon name or for more information. Sample free.
Bulletin board available on–line on MCI and ACEN on the WELL. Covers all applications of computers to the arts. Contents: calendar of events, conferences, exhibitions; directory of resources, grants, job listings; and bibliographies and book lists.

FINEART FORUM. bi–w. EN. 1674
Leonardo, Box 75 1442A Walnut, Berkeley, CA 94709.
Subscription: free send EMAIL address to LEONARDO @Well.UU.NET.

Bulletin board distributed free over the academic networks. Moderated by Professor Raymond Lauzzana. Covers art and computers, artificial intelligence, vision research, holography, new music technology, video, telecommunications, new materials, space art, computer literature and more.

THE PAGE (Chicago). 1987. m. EN. 1675

Pageworks, P.O. Box 14493, Chicago, IL 60614. Phone 312–549–4219. David Doty, Editor.
Subscription: $45 US, $50 Canada & Mexico, $60 foreign. 7 x 11.
Presents information regarding McIntosh computer desktop publishing.
Audience: designers, writers, and illustrators.

PAGE (London). 1969. q. EN. 1676

Computer Arts Society, 50–51 Russell Square, London WC1B 4JX, England. Phone 071 5802410. John Lansdown, Editor.
Illus.
ISSN: 0030–9362. OCLC: 13807876. LC: NX458.P3.
The bulletin of the Society encourages the use of computers in the arts and acts as a forum for the exchange of information.

SMALL COMPUTERS IN THE ARTS NEWS: SCAN. 1982. 3/yr. EN. 1677

Small Computers in the Arts Network, Inc., 5132 Hazel Ave., Philadelphia, PA 19143. Dick Moberg, Editor.
ISSN: 0748–2043. OCLC: 10899835. Dewey: 702.
Feature articles on music and graphics education. Each issue features an artist with reproductions and an explanation of their work. Includes news briefs and a guide to the relevant articles, books and other sources of information.
Reviews: software & hardware.
Advertising.

STUDIO SYSTEMS JOURNAL. 1985. bi–m. EN. 1678

Studio Systems, P.O. Box 13859, San Luis Obispo, CA 93406.
Illus.
ISSN: 0888–1308. OCLC: 13528298.
Tabloid devoted to innovative computer design techniques for professionals.
Reviewed: *Art Documentation* Sum 1987, p.68.

SYMPOSIUM ON SMALL COMPUTERS IN THE ARTS - PROCEEDINGS. 1981. a. EN. 1679

SCAN, Inc., Box 1954, Philadelphia, PA 19105.
Subscription: (IEEE Computer Society, P.O. Box 80452, Worldway Postal Center, Los Angeles, CA 90080). Illus. b&w, some color.
ISSN: 1042–2994. OCLC: 8362479. LC: NX260.S96a. Dewey: 621.3.
Proceedings of the annual symposium sponsored by the IEEE Computer Society and IEEE Philadelphia Section.

TECHNOLOGY WATCH: The Graphic Arts and Information Industries. 1980. m. EN. 1680

Technology Watch, Inc., Box 2206, Springfield, VA 22152. Henry B. Freedman, Editor.
Subscription: $95.
ISSN: 0738–9507. OCLC: 9708080.
Graphic Arts.
Computer applications and computer graphics.
Indexed: GrArtLAb.

THE VISUAL COMPUTER. 1985. bi–m. EN. 1681

Springer–Verlag New York Inc., Service Center Secaucus, 44 Hartz Way, Secaucus, NJ 07094. Phone 030–8207–1. T.L. Kunii, Editor.
Microform available from UMI. Illus.
ISSN: 0178–2789. OCLC: 13104790. LC: T385.V57. Dewey: 006.6.
Graphic Arts.
International journal of computer graphics presents practical applications of technics for business and graphic arts.

Comics & Cartoons

AMAZING HEROES. 1981. s–m. EN. 1682
Fantagraphics Books, Inc., 1800 Bridgegate St., Suite 101, West Lake Village, CA 91361. Phone 805–379–1881. Chris McCubbin, Editor (7563 Lake City Way, Seattle, WA 98115).
Sample $3.50. Illus. b&w, photos, cartoons. 7 x 10, 76p.
ISSN: 0745–6506. OCLC: 7616065. LC: PN6725.A47.
Comics.

Emphasizes news and features concerning popular comic books and comic related publications and film. Devoted to comic news, and reviews, interviews.
Reviews: book. Interviews. Freelance work: original artwork and cartoons (details in *ArtMkt.*). Contact: editor. Reviewed: *Serials Review* v.12:1, Spring 1986, p.21.
Advertising: full page $150. Circulation: 20,000.

ANNIE PEOPLE. EN. 1683
Stanley Steamer for Lulu Collectors, c/o Jon Merrill, P.O. Box 431, Cedar Knolls, NJ 07927.
Comics.

THE BIG LITTLE TIMES. 1981. bi–m. EN. 1684
Big Little Book Club of America, P.O. Box 1242, Danville, CA 94526. Larry Lowery, Editor.
Subscription: $10 US, $12 Canada, $16 foreign air. Sample $2. Back issues $2. 8½ x 5½, 28p.
Antiques. Collectibles. Juvenile.

Big Little Books and similar books were published from 1932 through 1989. The more collectible items preceded 1950. The books reprinted comic strips, promoted motion pictures, radio programs, and many contained original material similar to pulp westerns and crime novels. The *Big Little Times* publication includes nostalgic and research articles about the books and the characters or movies they represent. It also serves as a vehicle for collectors to contact each other to buy, sell or trade items.
Bibliographies: each issue, summaries of themes reviewed. Listings: regional–national. Freelance work: yes. Contact: editor.
Advertising: full page $10, ½ page $5, ¼ page $2.50. Classified: $2/50 wds. No frequency discount. Mailing lists: none. Demographics: 95% U.S. subscribers. Circulation: 450. Audience: collectors of big little books.

CAPA-ALPHA (K-a). 1964. m. EN. 1685
Joel Thingvall, 2097 Niles Ave., St. Paul, MI 55116. Phone 612–699–3638.
Subscription: included in membership. Members maintain an account with the Central Mailer and the cost of packaging and mailing the copy is deducted from this account. Membership (40 members + waitlist) is limited to keep costs down and the level of communication on a personal level. Sample $5. Back issues $3. Illus. b&w, color, photos, cartoons. 8½ x 11, 290p.
Comics.

An amateur press alliance, an organization through which members run their own written or drawn publications. CAPA–ALPHA is an association of comic fans which collectively publishes mailings of comics–oriented fanzines distributed monthly through a Central Mailer to all members. Membership is limited at any one time to 40 members. Each member produces 50 like copies of some work of interest to the membership, at least 4 pages of original material every three months. Zines usually are run off by photocopying, or mimeograph, or ditto. Done out of love of comics and a desire to communicate with like–minded people. Reproduced by membership for membership. Included in the Michigan State University collection of comic related material.
Reviews: book, film. Interviews, biographies and bibliographies on comic book personalities. Listings: regional–international. Calendar of events. Exhibition information. Freelance work: none. Opportunities: study, competitions.
Circulation: 50. Audience: comic fans and collectors.

CARTOON TIMES. 1986. q. EN. 1686
Cartoon Art Museum, 665 Third St., San Francisco, CA 94107. Phone 415–546–3922. Mark Vaz, Editor.
Subscription: included in membership, $25. No sample. No back issues. Illus b&w, photos, cartoons. 6p.
OCLC: 14374021. LC: PN6705.U5 C26.
Cartoons.

The newsletter of the Museum provides news and information about the cartoon world for Museum members.

Interviews: major cartoon figures. Listings: regional. Calendar of Museum events & exhibitions. Freelance work: none. Opportunities: study – marketing conferences.
Advertising: none. Circulation: 450. Audience: museum members.

CARTOONIST PROFILES. 1969. q. EN. 1687

Box 325, Fairfield, CT 06430. Jud Hurd, Editor.
Subscription: $25 individual, $30 institution. Microform available from UMI. Illus. 8½ x 11, 84p.
ISSN: 0008–7068. OCLC: 1775711. LC: NC1300.C35. Dewey: 741.5.

Cartoons.

Famous cartoonists relate how they became successful.
Reviewed: *Serials Review* 12:1 Spr 86, p.22. *Booklist* 82:19 Jan 6, 1986, p.1+.
Advertising: rates on request.

COMIC ART COLLECTION. 1979. q. EN. 1688

Michigan State University Libraries, Special Collections Division, East Lansing, MI 48824–1048. Phone 517–353–4526.
Randall W. Scott, Editor.
Subscription: available free or by exchange only; prospective members of the mailing list must explain their interest in comics research, or produce something of interest to our researchers that can be exchanged. Sample. Back issues. Illus. rarely, b&w. 8½ x 11, 8p.
ISSN: 0192–5881. OCLC: 5069175.

Drawing. Graphic Arts. Comics.

Published to facilitate communication about the Comic Art Collection at the Michigan State University Library, and communication about public comics collecting in general.
Bibliographies: subject bibliographies or collection listings. Listings: whatever scope, if timely. Exhibition information, will announce if timely. Freelance work: unpaid. Contact: editor. Opportunities: study, competitions. Reviewed: *Library Journal* 114:5, Mar 15 1989, p.92. *Serials Review* 12:1, Spr 1986, p.22.
Advertising: none. Circulation: 500. Audience: librarians, researchers and book dealers in comics.

COMIC BUYER'S GUIDE. EN. 1689

700 E. State St., Iola, Wisconsin 54990.

Comics.

Reviewed: *Serials Review* 12:1 Spr 1986, p.22.

COMICS INTERVIEW. 1983. m. EN. 1690

Fictioneer Books, 234 Fifth Ave., Suite 301, New York, NY 10001.
Subscription: $36 US, foreign $51. Sample $4. Back issues, price varies. Illus. 64p.

Collectibles. Comics Art. Drawing. Films. Juvenile.

"The Johnny Carson Show" of comics. Magazine interviews today's top comics artists, yesterday's legendary greats, and all the people involved in every aspect of the comics field – from writers and artists to editors and publishers to celebrities and actors. *Comics Interview* is a unique inside–the–industry forum where the pros speak for themselves.
Interviews: every level of comics field past and present, creators thru retailers. Freelance work: yes to conduct interviews. Contact: David Anthony Kraft.
Advertising: full page $125. Frequency discount. M. Kay McGonnell, Ad. Director. Mailing lists: none. Demographics: college/professional, 20–35 yrs. age group. Circulation: 10,000. Audience: career–oriented artists/writers.

THE COMICS JOURNAL. 1977. m. EN. 1691

Fantagraphics Books, Inc, 7653 Lake City Way, Seattle, WA 98115. Phone 805–379–1881. Gary G. Groth, Editor.
Subscription: $35 US, $39 foreign. Illus. b&w, cartoons. 8½ x 11, 128p.
ISSN: 0194–7869. OCLC: 4521305. Dewey: 741. Formerly: *Nostalgia Journal*.

Comics.

The magazine of news, criticism, feature articles, and interviews.
Reviews: reviews. Interviews: discuss comic work. Freelance work: yes, articles, photos, cartoons, and reviews. Contact: editors. Reviewed: *Utne Reader* Sept 10, 1989. p.136–7. *Serials Review* 12:1 Spr. 1986, p.23.
Advertising: (payment with ad): full page $120, ½ page $65, ⅓ page $45. Frequency discount. Kim Thompson, Ad. Director.

COMICS WEEK. 1987. w. EN. 1692
Paragon Q Publishing, Box 1146, Maplewood, NJ 07040. Phone 201–763–2147. Mark Waid, Editor.
Illus.
OCLC: 17650467. LC: PN6725.C673.
Comics.

ESCAPE. 1986. bi–m. EN. 1693
Escape Publishing, 156 Munster Rd., London SW6 5RA, England. Phone 071–731 1372. Paul Gravett, Editor.
Subscription: £9.95 UK, £12.50 Europe, £13.50 North America, £18 elsewhere. Illus.
ISSN: 0266–1667. OCLC: 14156253. LC: PN6738.E75. Formerly: *Escape Magazine*.
Comics.

"Comics of style & vision." Magazine of and about comics and cartoons. Covers contemporary work from Britain and around the world, presenting interviews, reviews, articles and the strips themselves.

FA. 1966. m. EN. 1694
Trident Comics, Unit 3, 28 Canal St., South Wigston, Leicester LE8 2PL England. Phone 0533–477661. Martin Skidmore, Editor.
Subscription: £17, £22 US & Canada; inquire for air rates. Sample. Back issues. Illus. b&w, photos, cartoons. 6¾ x 10, 76p.
Formerly: *Fantasy Advertiser*.
Comics. Graphic Arts. Hobbies.

Focuses on comics in all forms. Scope includes news round–up, interviews, discussion, in–depth criticism — strongest political analysis of comics anywhere.
Reviews: book 2, length 400 wds.; comics 13–18, length 300–5,000 wds. Interviews: 2–3/issue with comic artists, writers or editors. Discussion of career, methods, comics in general. Biographies: 1/issue. Summary of career, analysis of styles, themes, influences, importance. Listings: national–international. Exhibition information. Freelance work: yes. Contact: editor. Opportunities: employment, study, competitions.
Advertising: full page £75, $120; ½ page £45, $70; ¼ page £25, $40, color, back cover only $230. Classified: 60p., $1/line. Frequency discount. Nigel Mackay, Ad. Director. Mailing lists: none. Demographics: 90% male, 90% 16–30, higher than average income. Circulation: 3000. Audience: comic readers.

FANDOM DIRECTORY. See no. 27.

FCA AND ME, TOO! NEWSLETTER: Fawcett Collectors of American and Magazine Enterprise, Too. 1973. irreg, approx 4/yr. EN. 1695
Harpers, 301 East Buena Vista Ave., North Augusta, SC 29841. Phone 803–278–0437. William and Teresa Harper, Editors & Pubs.
Subscription: $5/4 issues US & Canada, $10 foreign. Sample $1. Back issues $2 (mostly photo copies). Illus. b&w, photos. 8½ x 11, 8p.
Formerly: *FCA*.
Collectibles. Comics.

Newsletter for Fawcett collectors of American and Magazine Enterprise comics.
Interviews: artists, writers editors, etc. of Fawcett & Magazine Enterprise. Biographies: thumb nail sketches of those interviewed. Obits. Freelance work: yes. Contact: editor.
Advertising: full page $20, ½ page $10, ¼ page $5. Classified: free with subscription. Circulation: 150. Audience: Golden Age comic collectors especially Fawcett and Magazine Enterprise fans.

THE FORT MUDGE MOST. 1987. bi–m. EN. 1696
Spring Hollow Books, 6908 Wentworth Ave. South, Richfield, MI 55423. Phone 612–869–6320. Steve Thompson, Editor.
Subscription: $15 US, $US15 Canada, $US20 foreign. Sample $3. Back issues $5. Illus. b&w, photos, cartoons. 8½ x 11, 48p.
Collectibles. Comics. Drawing. Graphic Arts.

Focus is the study and analysis of the art and career of Walt Kelly, creator of the comic strip "Pogo". Includes all aspects of Kellyana, including biographical data and anecdotes/reminiscences, information on Kelly collectibles, analyses of his work and career, and reprints of scarce and previously unpublished material.
Reviews: book 1, length 300–500 wds. Interviews: with Kelly's former associates and co–workers, as well as those currently involved with Kellyana. Biographies: Kelly's career and associates. Bibliographies: separately published (bi–a). Listings: regional–international. Exhibition information. Freelance work: yes. Contact: editor. Opportunities: study.

Advertising: (camera ready) full page $50, ¼ page $25, no color. Classified: 1 ad with subscription, $5 additional ads. No frequency discount. Demographics: Active collectors of comic and cartoon collectibles, ages 12–75. Mailing lists: available on occasion. Circulation: 400. Audience: comics collectors, fans, investors.

FOUR COLOR MAGAZINE. 1986. m. EN. 1697

Paragon Q Publishing, Box 1146, Maplewood, NJ 07040. Phone 201–763–2147. David Caruba, Editor.

Comics.

For comic book connoisseurs.

FUNNYWORLD. 1966. q. EN. 1698

1716 Barkston Ct., Atlanta, GA 30341. William Engeler, Editor.
Microform available from UMI. Illus.
ISSN: 0071–9943. OCLC: 3067704, 8497297 (microfilm). LC: PN6725.F86. Dewey: 741.5.

Comics.

Deals with animated film and comic art.
Advertising.

K.I.D: KIDS ILLUSTRATED DRAYTON SUPPLEMENT. q. EN. 1699

International G.G. Drayton Association, 864 Heritage Lane, Salem, OH 44460. Phone 216–332–0959.
Subscription: included in membership. Illus.

Cartoons.

Newsletter presents research into the life and works of Grace Grebbie Drayton, illustrator and author of children's books. Creator of the Campbell soup kids, she is considered America's first woman cartoonist.

LI'L ABNER by Al Capp. 1988. q. EN. 1700

Kitchen Sink Press, 2 Swamp Rd., Princeton, WI 54968. Phone 414–295–6922. Dave Schreiner, Editor.
Subscription: $59.95 softcover, $99.50 hardcover. Sample & back issues $16.95 softcover, $27.95 hardcover. Illus. b&w, photos, cartoons. 9 x 12, 160p.

Graphic Arts. Comics.

A complete reprinting of the comic strip, Li'L Abner. Each issue contains at least one years worth of daily strips, and historical text and photos.
Advertising: none. Audience: general, all ages.

LOSING FAITH COMIX. 1986. q. EN. 1701

P.O. Box 10533, Minnesota, MN 55458.
Subscription: $5. Illus. b&w. 7 x 8½, 22p.

Comics.

Freelance work: yes, send 6½ x 8 photostat.

MARVEL AGE. EN. 1702

387 Park Ave. South, New York, NY 10016.

Comics.

MARVEL AGE ANNUAL. EN. 1703

387 Park Ave. South, New York, NY 10016.

Comics.

NEMO: The Classic Comics Library. 1983. bi–m. EN. 1704

Fantagraphics Books, Inc., 1800 Bridgegate St., Suite 101, Westlake Village, CA 91361. Phone 805–379–1881. Richard Marschall, Editor.
Subscription: $21 US, elsewhere $US30. Back issues $3.50. Illus. b&w, comics. 8¼ x 10¾.
ISSN: 0746–9438. OCLC: 10406833. Dewey: 741.

Comics.

History of the comics medium and all its treasures. Devoted to classic comics. Presents full episode.

Reviews: book. Interviews: with cartoonists.
Advertising.

THE OFFICIAL OVERSTREET COMIC BOOK PRICE GUIDE. 1970. a. EN. 1705

Overstreet Publications, Inc., 780 Hunt Cliff Dr., N.W., Cleveland, TN 37311. (Dist.: House of Collectibles, 201 E. 50th St., New York, NY 10022). Phone 615–472–4135. Robert M. Overstreet, Editor.
Subscription: $14.95 each, no subscriptions. Back issues. Illus. b&w over 1300, color 100. 5¼ x 8½, 800+p.
ISSN: 0891–8872. OCLC: 15023972. LC: Z1000.O94. Dewey: 741.5. Formerly: *The Comic Book Price Guide.*
Collectibles. Comic Books.

Listings: international. Reviewed: *ARBA* 19, 1988, p.387.
Advertising: rates upon request. Jeff Overstreet, Ad. Director. Mailing lists: none. Circulation: 100,000+. Audience: comic book fans.

ON THE LINE MAGAZINE. 1977. q. EN. 1706

Benkate Publishing Co., 152 E. 22nd St., New York, NY 10010. Kate Murray, Editor.
Illus.
ISSN: 0147–4693. OCLC: 3175884. Dewey: 741.5.
Contains political cartoons.

RAW: Open Wounds from the Cutting Edge of Commix. 1981. irreg. 2/yr. EN. 1707

Penguin Books USA Inc., 40 West 23rd St., New York City, NY 10010. Co–published by Raw Books and Graphics, 27 Greene St., NY NY 10013. Phone 212–226–0146. Art Spiegelman & Francoise Mouly, Editors.
Illus. b&w, some color, cartoons.
ISSN: 0742–4434. ISBN: 0–14–012265–6. OCLC: 20384674 (book). LC: AP101. Dewey: 741.5973.
Comics.

Comics for adults. "Graphic novels" or "pictorial sequential narratives," commix are a co–mixing of words and pictures. Collection of the best in international comic strips (a.k.a. comix) and graphics.
Indexed: ArtBibMod. Reviewed: *Serials Review* 12:1, Spr 1986, p.29. *Utne Review* 19, Jan/Feb 1987, p.93.
Advertising. Audience: adults.

SPEAKEASY. 1979. m. EN. 1708

John Brown Publishing Ltd., The Boathouse, Crabtree Lane, London SW6 8NJ England. Phone 071–381 6007, fax 071–381 3930. Nigel Curson, Editor (45 Winns Terrace, Walthamstow, London E77 5EJ).
Subscription: £25, $US50. No sample. Illus. b&w, photos, cartoons. A4, 72p.
Comics. Drawing. Films. Graphic Arts. Hobbies. Juvenile.

The organ of the comics world presents news, reviews, and criticism on comics worldwide with particular emphasis on material from the United Kingdom or the United States.
Reviews: comic books 8. Interviews: 4–6 interviews with writers or artists in each issue. Listings: international. Calendar of events. Exhibition information. Freelance work: yes. Contact: Nigel Curson. Opportunities: study, competitions.
Advertising: full page £300, ½ page £175, ¼ page £100, covers £350–500. Classified: 25p./wd. [15% VAT extra]. Frequency discount. Demographics: Principally circulated through comic stores. Circulation: 7000. Audience: comic book fans and professionals.

THE SPIRIT by Will Eisner. 1971. m. EN. 1709

Kitchen Sink Press, 2 Swamp Rd., Princeton, WI 54968. Phone 414–295–6922. Dave Schreiner, Editor.
Subscription: $24 US, foreign $27, air $48. Sample & back issues $2.50. Illus. b&w 6⅞ x 10⅞, 32p.
ISSN: 0886–7267. OCLC: 12745793. LC: PN6728.5 K5 S63. Formerly: *Will Eisner's The Spirit.*
Graphic Arts. Comics.

Reprints Will Eisner's post World War II stories, printed chronologically from 1946. Backgrounds on all stories are provided in each issue, with Eisner himself talking about them. Numbers 1–11 are in full color, numbers 12 on are black and white.
Advertising: none. Audience: general, all ages.

STEVE CANYON. irreg. EN. 1710

Kitchen Sink Press, No. 2 Swamp Road, Princeton, WI 54968. Phone 414–295–6922. Dave Schreiner, Editor.
Subscription: not available on subscription. Some back issues, variable prices. Illus. b&w. 8½ x 11, 104p.
Comics. Graphic Arts.

Milton Caniff's Steve Canyon is a quarterly book, collected comic strips in magazine format, printing in sequence his great newspaper comic strip. Steve Canyon was published as a magazine through 21 issues. The chronology has been picked up in squarebound softcover books published 2–3/yr. The magazines feature Milton Caniff talking about the respective adventures, articles of historical interest Caniffs' career art, and other pieces related to Steve Canyon.
Freelance work: none.
Audience: general, all ages.

TARGET. 1981. q. EN. 1711
461 Sharon Dr., Wayne, PA 19087. Richard Samuel West, Editor.
Illus.
Dewey: 741.5.
Cartoons.

"The political cartoon quarterly".

WITTYWORLD: International Cartoon Magazine. 1988. q. EN. 1712
WittyWorld Publications, P.O. Box 1458, North Wales, PA 19454. Phone 215–699–2626. John A. Lent, Managing Editor.
Subscription: $25 US, $36 international air. Back issues. Illus. color, cartoons. 8½ x 11, 94p.
ISSN: 0892–9807. Dewey: 741.5.
Cartoons.

WittyWorld contains articles on a wide spectrum of international cartooning, including animation, comics, caricatures, gag and political cartoons. Includes reports on competitions, and examples of cartoons.
Reviews: comics, cartoons, animation, journals. Interviews with leading cartoonists. Calendar of events & festivals worldwide. Freelance work: Manuscripts and art work welcome. Reviewed: Katz.
Advertising: Classified: $5/line, min. $20. For display or classified ads contact Ad. Director. Mailing lists: available. Audience: professional and aspiring cartoonists; professionals in related fields of graphics, advertising, illustration, animation and commercial arts; students and academicians; art, communication and cultural programs and cartoon fans and collectors.

General Works

4 TAXIS. 1978. q. FR primarily, some material also in EN. 1713
3 rue Canihac, 33000 Bordeaux, France. Michel Aphesbero, Editor & Pub.
Subscription: 90 F. Illus.
ISSN: 0181–687X. OCLC: 16736654. LC: NX2.Q3.
Advertising.

303 ARTS, RECHERCHES ET CREATIONS. 1984. q. FR. 1714
Tour de Bretagne, Hotel de la Region, Ile Beaulieu, 44047 Nantes CEDEX 02, France.
Illus.
ISSN: 0762–3291. OCLC: 16912218. LC: NX549.A3L6x. Formerly: *303*.

ABSA BULLETIN. q. EN. 1715
Association for Business Sponsorship of the Arts, Nutmeg House, 60 Gainsford St., London SE1 2NC, England. Phone 071 3788143.
Provides information for corporations interested in arts sponsorship.
Audience: corporations.

THE ACT. 1985. irreg., 1–2 yr. EN. 1716
Performance Project, Inc., P.O. Box 3192, Church St. Station, New York 10008–3192. Jeffrey Greenberg, Editor.
Subscription: (3 issues) $12 individual, $40 institutions, US & Canada; foreign $16 individual, $45 institution; air $30 individual, $60 institution. Illus. b&w, photos.
ISSN: 0885–6702. OCLC: 12869471. Dewey: 705.
Received National Endowment for the Arts and New York State Council for the Arts support.
Freelance work: yes. Contact: editor. Indexed: ArtBibMod. Reviewed: *Art Documentation* Sum 1987, p.67.
Advertising: none.

AFRICAN ARTS. 1967. q. EN. 1717
African Studies Center, University of California, 405 Hilgard Ave, Los Angeles, CA 90024–1310. Phone 213–825–1218.
Donald J. Cosentino, John Povey, & Doran H. Ross, Editors.
Subscription: $36 individual, $50 institution US; $44, $58 outside US. Microform available from UMI. Back issues $10–$25 each. Illus. b&w, color, photos. Annual index $5. Cum. index, vol.1–10 $10; vol.11–15 $10. 8½ x 11, 104p. Offset lithography.
ISSN: 0001–9933.
Modern Art.

Authoritative international journal covering the whole range of traditional and contemporary African arts. Devoted to the plastic and graphic arts of Africa, broadly defined to encompass sculpture in wood, metal, ceramic, ivory, and stone, and less familiar work in fiber, hide, mud and other materials. Included in this mandate are architecture, arts of personal adornment, contemporary fine and popular arts, and arts of the African diaspora. In addition the journal encourages dialogue on other forms of African expressive culture: film, theater, dance, and music. Presents reports on current openings and new exhibitions, portfolios of the works of contemporary African artists, major collections of traditional African art, and critical research by both Africans and non–Africans.

Reviews: exhibition & book 6 each, length 1/2–1 1/2p. each; film. Bibliographies: new publications. Listings: regional–international. Indexed: ArtBibCur. ArtBibMod. ArtHum. ArtI. BioI. CloTAI. CurCont. HumI. IBkReHum. Reviewed: Katz. *Art Documentation* Fall 1986, p.131.

Advertising: (rate card June 1989): b&w full page $1160, ½ page $660, ¼ page $425, covers $1440–2000; 4 color full page $1530, ½ page $1030, ¼ page $800, covers $1750–2500. Classified: $1.20/wd., $30 min. Frequency discount. 15% agency discount. 10% discount to art galleries and pulishers. Demographics: worldwide readership. Circulation: 18,000.

AHA! HISPANIC ARTS NEWS. 1975. 10/yr. EN. 1718

Association of Hispanic Arts, 173 E. 116th St., 2nd Fl., New York, NY 10029. Phone 212–369–7054. Dolores Prida, Editor. Subscription: $15 individual, $25 organization. Sample free. Back issues $1 each. Illus. b&w, photos, cartoons. 8½ x 11, 16p. ISSN: 8755–500X. OCLC: 10782857. LC: NX7.H576. Dewey: 705. Formerly: *Hispanic Arts.*

Art Education. Ceramics. Crafts. Drawing. Film. Painting. Photography. Sculpture. Performing Arts.

The primary objective of AHA is to promote Hispanic arts as an integral part of the art life of the nation. Dedicated to the gathering and dissemination of information on Hispanic arts activities as well as exhibitions focusing on Hispanic visual arts, history, cultural experiences and achievements. Announces grant/competition awards.

Reviews: book & journal 2–3 each, length 2p. Listings: regional. Calendar of events. Exhibitions. Freelance work: none. Opportunities: employment, study, competitions.

Advertising: full page $200, ½ page $100, ¼ page $50. No classified. No frequency discount. Circulation: 6000. Audience: general public and Hispanic artists.

AMERICAN FEDERATION OF ARTS NEWSLETTER. 1980. EN. 1719

American Federation of Arts, 41 East 65th St., New York, NY 10021.
Subscription: included in membership.

AMERICAN REVIEW. 1977. m. EN. 1720

15 Burchfield Ave., Cranford, NJ 07016. Phone 201–276–6222. Allen G. Weakland, Editor & Pub.
Back issues. Illus.
Formerly: *New American Review.*
Art. Literature. Music.

ART BUSINESS. 5/yr. EN. 1721

Queen Elizabeth II Arts Council of New Zealand, P.O. Box 3806, Wellington, New Zealand. Phone 4 730880, fax 712865.
General. Crafts.

Publication of the Council which promotes all fields of New Zealand arts and crafts.

ART MATTERS. irreg. EN. 1722

Arts Council, 70 Merrion Squart, Dublin 2, Ireland. Phone 1 611840.
Promotes Irish arts.

ART NEWS. 3/yr. EN & WEL. 1723

Welsh Arts Council, Museum Place, Cardiff, S. Glam CF1 3NX, Wales. Phone 222 394711, fax 222 221447.
Promotes appreciation and development of the arts in Wales.

ART PRESS. 1980. m. FR only. 1724

Art Press, 12 avenue Matignon, 75008 Paris, France.
Illus.
ISSN: 0245–5676. OCLC: 8102256. LC: NX2.A78. Dewey: 700. Formerly: *Art Press International.*
Modern Art.

Calendar of events. Exhibition information. Indexed: ArtBibCur. ArtBibMod.
Advertising: none.

ART TIMES. q. EN. 1725

Queen Elizabeth II Arts Council of New Zealand, P.O. Box 3806, Wellington, New Zealand. Phone 4 730880.
Promotes the arts and crafts of New Zealand.

ARTERY. 1975, v.8. s–a. EN. 1726
Artery Publications, 19 Lyme St, London NW1 0EH, England. Phone 071–267 5803. Jeff Sawtell, Editor.
Illus.
ISSN: 0144–8412. OCLC: 18267038.
Art. Literature.
The only broad cultural journal produced by the Left in Britain concerned with the development of the Second Culture and
Revolutionary Art.
Indexed: ArtBibMod.

ARTS & HUMANITIES CITATION INDEX. See no. 7.

ARTS BULLETIN/BULLETIN ARTS. 1979. q. EN & FR (FR text on inverted pages). 1727
Canadian Conference of the Arts, 189 Laurier Ave. East, Ottawa K1N 6P1 Canada. Phone 613–238–3561. Jocelyne Rouleau,
Editor (126 York St., Suite 400, Ottawa, Ontario K1N 5T5).
Subscription: included in membership. Sample free. No back issues. Illus. b&w, photos, cartoons. 8½ x 11, 60p.
ISSN: 0707–9532. OCLC: 6054185. LC: NX28. Formerly: *Arts.*
General. Architecture. Art Education. Crafts. Films. Photography. Sculpture. Music.
Covers mostly art and music policies.
Listings: national–international. Calendar of events. Exhibition information. Freelance work: yes. Contact: editor. Opportuni-
ties: employment, study, competitions.
Advertising: none. Circulation: 1200. Audience: members, arts associations, artists.

ARTS COUNCIL OF AUSTRALIA. ANNUAL REPORT. 1948. a. EN. 1728
Arts Council of Australia, Suite 605, 6th Fl., Phoenix House, 32–34 Bridge St., Sydney, N.S.W. 2000, Australia. Jennifer
Bott, Editor.

ARTS COUNCIL OF GREAT BRITAIN. ANNUAL REPORT AND ACCOUNTS. 1946. a. EN. 1729
Arts Council of Great Britain, 105 Piccadilly, London W1V 0AU, England. Phone 071–629 9495, fax 3554389.
Illus. b&w, some color. 8 x 8, 112p.
ISSN: 0066–8133. OCLC: 20474902, 1846311. LC: NX28.G7 A78. Formed by the union of: *Arts Council of Great Britain.*
Annual Report, and *Arts Council of Great Britain. Annual Accounts.*
Annual report published to provide Parliament and the general public with an overview of the year's work and to record all
grants and guarantees offered in support of the arts. Main section is annual accounts. A description of the highlights of the
Council's work and a discussion of its policies appear in the newspaper *Arts in Action* published in conjunction with the an-
nual report and available free from the Council.
Exhibition information for the past year. Opportunities: competitions, lists grants and awards.

ARTS D'AFRIQUE NOIRE. 1972. q. FR only. EN tr. available. 1730
Raoul Lehuard, Publisher, B.P. 24, 95400 Arnouville, France. Phone 1–39.87.27.52. Raoul Lehuard, Editor in chief; John
McKesson, Associate Editor (880 Fifth Ave., 19E, New York, NY 10021).
Subscription: 210 F France, elsewhere sea mail 260 F, $45; air 360 F, $60 (US send to: A.A.N. – B.P.24, 95400 Arnouville,
France). Sample. Illus. b&w, glossy photos. Cum. index no. 1–57. 8¼ x 10¾, 60–72p.
ISSN: 0337–1603.
Anthropology. Arts. Ethnography. Ethnology.
An evolving magazine on traditional African arts. Contains anthropological, ethnographic, ethnological and artistic research,
as well as documents relative to travel in Black Africa, to museums, to exhibits, to private collections, to public auctions, etc.
The editors would like its pages to be a meeting place where eye–witness accounts, opinions, hypotheses and refutions might
be freely expressed. Contains many illustrations.
Reviews: exhibition, book, other. Freelance work: none.
Advertising: (rate card 1990): b&w full page 4.150 F, ½ page 2.850 F, ¼ page 1.800 F, color full page 6.195 F. No frequency
discount. Mailing lists: available 4.150F. + postage.

ARTS INTERNATIONAL - NEWSLETTER. 1983. q. EN. 1731
Arts International, Inc., 606 18th St., N.W., Washington, DC 20006. Phone 202–789–0600. Ramona K. Silipo, Editor.

**ARTS INTERNATIONAL PROGRAM OF THE INSTITUTE OF INTERNATIONAL EDUCA-
TION NEWSLETTER.** irreg. EN. **1732**
Institute of International Education, 809 U.N. Plaza, New York, NY 10017. Phone 212–984–5370, fax 212–984–5452.
Newsletter which encourages international collaboration in the arts. Reports on international arts activities.

ARTS REVIEW (Jamaica). 1976. 3/yr. EN. **1733**
University of the West Indies, Creative Arts Centre, Box 97, Mona, Kingston 7, Jamaica.
OCLC: 5046274. LC: NX28.J2A687. Dewey: 700.

ARTS REVIEW (London). 1961. bi–w. EN. **1734**
Starcity Ltd., 69 Faroe Rd., London W14 0EL, England. Phone 071–603 7530. Graham Hughes, Editor.
Subscription: £39 UK, $80 US & Canada air. Microform available from UMI. Illus.
ISSN: 0004–4091. OCLC: 823835. LC: N1.A77. Formerly: *Art News and Review.*
Modern Art.

Covers the arts, especially modern visual arts, worldwide. It incorporates special features, artists' profiles, and art information.
Reviews: book. Calendar of exhibitions. Indexed: ArtBibCur. ArtBibMod. ArtI. BioI. CloTAI. RILA. Reviewed: Katz. *Serials
Review* 11:2, Sum 1985, p.24–25.

BLACK ARTS ANNUAL. 1988. a. EN. **1735**
Garland Publishing, Inc., 136 Madison Ave., New York, NY 10016. Phone 1–800–627–6273. Donald Bogle, Editor.
Subscription: $35. Illus.
ISSN: 1042–7104. OCLC: 19113957. LC: NX512.3A35 B58.
Provides information on today's black artists and their achievements in literature, art, music and the performing arts.
Reviewed: *Reference Books Bulletin* Nov. 1989, p.600. *ARBA* 21, 1990, p.409–10.

BOMB. 1981. q. EN. **1736**
New Art Publications, 177 Franklin St., New York, NY 10013. Phone 212–431–3943. Betsy Sussler, Editor & Pub.
Subscription: $16 individual, $20 library, $26 foreign (P.O. Box 2003, Canal Station, New York, NY 10013). Back issues.
Illus. b&w, photos. 10½ x 14½.
ISSN: 0743–3204. OCLC: 10226319. LC: NX458 .B65.
Modern Art. Literature. Theater.

Supports new art and writing. Serves as a forum for artists and writers to speak for themselves. Dedicated to presenting the
work in its own light. Purpose is to develop and expand the parameters of the original work. The magazine's contents are
predicated upon the discourse between artists. This discourse dictates its form––original art, fiction and extensive interviews
between professionals in art, literature, poetry, theater and film. Artists–writers–actors–directors; profiles–features–new writ-
ing–portfolios–design.
Interviews: several/issue. Indexed: ArtBibMod. Reviewed: Katz. *Small Press* 7:1, Feb 1989, p.34; 7:5 Oct 1989, p.78–79.
Choice 23:10, Jan 1986, p.513. *Library Journal* 110:13, Aug 1985, p.74; 113:4, Mar 1, 1988; 115:8, Jan 5 1990, p.122. *Seri-
als Review* Spr 1991, p.42+.
Advertising: Don Gatterdam, Ad. Director.

CANADA COUNCIL ANNUAL REPORT. 1958. a. EN & FR. (FR text on inverted pages). **1737**
Canada Council, Communications Service, Box 1047, 99 Metcalfe St., Ottawa, Ontario K1P 5V8, Canada. Phone 613–598–
4365, fax 613–598–4390.
Illus., some color.
ISSN: 0576–4300. OCLC: 2248729. LC: AS42.C207.
Purpose of the Council is to promote the study, appreciation, and production of the arts.

CANADIAN CONFERENCE OF THE ARTS. ART NEWS. 1969. irreg. EN, FR. **1738**
Canadian Conference of the Arts, 189 Laurier Ave. E., Ottawa, Ontario K1N 6P1, Canada. Phone 613–238–3561. Jocelyne
Rouleau, Editor.
Subscription: included in membership.
Formerly: *Canadian Conference of the Arts. Miscellaneous Reports.*

CANADIAN CONFERENCE OF THE ARTS—MONTHLY BULLETIN. 1980. m. EN, FR.
Canadian Conference of the Arts, 126 York St., Suite 400, Ottawa, Ontario K1N 5T5, Canada. Phone 613–238–3561.
Jocelyne Rouleau, Editor.
Subscription: free. 9 x 11, 12p.
Bilingual newsletter covering arts policy in Canada.
Calendar of events. Freelance work: yes. Contact: editor. Opportunities: job listings.
Audience: arts organizations and artists in Canada.

1739

CHRONIKA AISTHETIKES/ANNALES D'ESTHETIQUE. 1962. a. GR, EN, FR.
Fondation Michelis – Michelis Foundation, Vassilissis Sophias 79, Athens 115 21, Greece.
Illus.
ISSN: 0066–2119. OCLC: 3146127. LC: NX1.A1C48. Dewey: 700.

1740

CIMAL: Arte Internacional. 1979? bi–m. CATALAN & SP.
Cimal, Avda, Republica Agrentina, 42, Grandia, Pais Valenciano, Spain.
Illus. b&w, some color.
ISSN: 0210–119X. OCLC: 7980274. LC: NX7.C54. Dewey: 700.
Indexed: ArtBibMod.

1741

LA CITTA DI RIGA: Periodica Quadrimestrale d'Arte. 1976. q. IT, EN, or FR.
Nuova Foglio S.p.A., Piane di Chienti 12, 62010 Pollenza (Macerata), Italy Elisabetta Rasy, Editor.
Illus.
OCLC: 5214077. LC: NX4.C498. Dewey: 700.

1742

THE CLASSICAL TRADITION IN LITERATURE, MUSIC AND ART FROM THE RENAIS-SANCE TO THE PRESENT. 1988. a. EN.
Peter Land Publishing, 62 West 45th St., New York, NY 10036.
ISSN: 0891–4109.
Art. Art History. Literature. Music.

1743

COLOQUIO: ARTES: Revista Trimestral de Artes Visuais, Musica e Bailado. 1971. q. POR, SP, or IT, occasionally EN. FR summaries.
Fundacao Calouste Gulbenkian, Ave. Berna 56, 1093 Lisbon, Codex, Portugal. Phone 793–51–31, fax 793–51–39, telex 12345 Gulben P. Jose–Augusto Franca, Editor.
Subscription: $US25, £12, F.F.150. Back issues. Illus. b&w, some color (full page), photos. 9 x 12, 84p.
ISSN: 0870–3841. OCLC: 3611474. LC: NX7.C64. Formerly: *Coloquio; Revista de Arte e Letras.*
Indexed: ArtBibCur. ArtHum. CurCont. RILA.

1744

CORADDI. 1897. bi–m. EN.
University of North Carolina at Greensboro, University Media Board, Coraddi Publications, Room 205, Elliott Center, Greensboro, NC 27412. Phone 919–379–5572. Elizabeth House, Editor.
Subscription: $4. Illus.
ISSN: 0574–0126. OCLC: 4470245.
Art. Literature. Dance.

Covers art, dance and literature.
Reviews: book.
Advertising.

1745

CORNFIELD REVIEW. 1976. a. EN.
Ohio State University, Marion Campus, 1465 Mt. Vernon Ave., Marion, OH 43302–5695. Phone 614–389–2361. David Citino, Editor.
Illus.
ISSN: 0363–4574. OCLC: 2473895. LC: NX1.C58.
An annual of the creative arts.

1746

CREFFT. 3/yr. EN & WEL. **1747**

Welsh Arts Council, Museum Place, Cardiff, S. Glam CF1 3NX, Wales. Phone 222 394711, fax 222 221447.
Promotes the appreciation and development of all the arts in Wales.

CRESCENDO. 1964. 3/yr. EN. **1748**

Interlochen Center for the Arts, Interlochen Arts Academy/National Music Camp, Interlochen, MI 49643. Phone 616–276–9221. Betty Parsons, Editor.
Subscription: free. Illus b&w, photos. 17 x 11½, 2 issues 8p., 1 issue 20p.
Art Education. Visual Arts. Dance. Music. Theatre. Creative Writing.
Covers the Interlochen Arts Academy, the nation's first arts boarding school; the National Music Camp, the oldest, biggest music camp; Interlochen Festivals, a year round series of guest activities; and WIAA–FM, a fine arts radio station. Emphasis on arts for all children as part of education; recruitment of talented and arts–interested students; need for communication among arts institutions; and need for financial support of arts.
Listings: regional–national. Calendar of events. Exhibition information. Freelance work: none. Opportunities: study, all arts and education related; competitions.
Advertising: none. Circulation: 47,000. Audience: alumni, parents, donors, friends.

CRISS-CROSS ART COMMUNICATIONS. 1976. q. EN. **1749**

Criss–Cross Foundation, Box 2022, Boulder, CO 80306.
Illus. some color. 21 x 23 cm.
ISSN: 0270–6857. OCLC: 4186498. LC: NX1.C63. Formerly: *Criss–Cross Communications.*
Advertising.

EMPIRICAL STUDY OF THE ARTS. 1983. s–a. EN. **1750**

Baywood Publishing Co. Inc, Box D, Farmingdale, NY 11735. Phone 516–691–1270. Colin Martindale, Editor.
Illus.
ISSN: 0276–2374. OCLC: 7342535. LC: NX1.E47.
Reviews: book.

EXETER STUDIES IN AMERICAN & COMMONWEALTH ARTS. 1970. irreg. 1–2/yr. EN. **1751**

University of Exeter, American Arts Documentation Centre, Queens Building, Exeter EX4 4QJ, England. R. Maltby, Editor.
Dewey: 709. Formerly: *American Arts Pamphlet Series.*
Art. Literature. Music.

FANTASMA: Rivista d'Arte. 1986. IT. EN or FR summaries. **1752**

Campanotto, Udine, Dist: Casalini Libri, Via Benedetto da Maiano 3, 50014 Fiesole, Florence, Italy.
Illus.
OCLC: 18251741. LC: NX4.F23.
Foucses on Italian arts, literature and aesthetics.

FOR YOUR INFORMATION. 1985. q. EN. **1753**

New York Foundation for the Arts, 5 Beekman St., Suite 600, New York, NY 10038. Phone 212–233–3900. Sarah Montague, Editor.
Subscription: $5. Illus. 8½x11, 16p.
ISSN: 0890–2992. OCLC: 11843243. Dewey: 700. Formerly: *FYI.*
"Practical information for those who create and work in the arts." Condensed information on issues, events, and entities affecting the arts. Includes funding deadlines and information on residencies. Published by the New York Foundation for the Arts in association with the New York City Dept. of Cultural Affairs and Arts International.
Circulation: 30,000.

FREMANTLE ARTS REVIEW. 1986. m. EN. **1754**

Fremantle Arts Centre, 1 Finnerty St., P.O. Box 891, Fremantle, Western Australia, 6160. Phone (09) 335–8244. Ian Templeman, Editor.
Subscription: included in membership, overseas $A36. Sample & back issues $A2 Australia, $A3 elsewhere. Illus. b&w, color, photos. A4 16p (+ 8p. suplements 4/yr).
ISSN: 0816–6919.

General. Arts. Crafts. Literature. Theatre.

Examines Australian arts, crafts, and literary issues on a national basis, mixing articles and interviews with book reviews, poetry and prose fiction.

Reviews: exhibition occasionally, published as 1500–1800 wd. articles; book 2, length 500–800 wds. Interviews: some articles are interviews or written from interviews. Usually with artists/writers/arts administrators. Biographies. Listings: regional. Freelance work: yes. Contact: Paul Hetherington, Assistant editor. Opportunities: study, competitions, only Centre activities. Advertising: none. Circulation: 3500. Audience: general public.

FUSE MAGAZINE. 1978. 5/yr. (includes one double issue). EN. **1755**
Arton's Cultural Affairs Society and Publishing Inc., 1st Floor, 183 Bathurst St., Toronto, Ontario M5T 2R7, Canada. Phone 416–367–0159. Joyce Mason, Editor.
Subscription: $12 individual, $18 institution Canada; + $3 outside Canada. Microform available from Micromedia. Illus. 8¼ x 10¾, 52p. Web.
ISSN: 0838–603X. OCLC: 18241642, 21486110 (microform). LC: NX1. Dewey: 700. Formerly: *Fuse*.
Covers cultural issues from a critical perspective. Features news, artists' profiles, reviews and cultural events.
Reviews: film, visual art, video, books, and performance. Indexed: ArtBibMod. CanPI.
Advertising.

GENDERS: Art, Literature, Film, History. 1988. 3/yr. EN. **1756**
University of Texas Press, 2100 Comal, Austin, TX 78722. Ann Kibbey, Editor (Dept. of English, Campus Box 226, University of Colorado at Boulder, Boulder, CO 80309).
Subscription: $21 individual, $35 institution US; $24 individual, $38 institution Canada & foreign (Journals Dept., Box 7819, Austin, TX 78713). Microform available from UMI. Illus. b&w, photos. 7 x 10, 176p.
ISSN: 0894–9832. OCLC: 16388863. LC: PN56.S5 G46, GN479.65.S49 G46. Dewey: 810.
General.

Welcomes essays in art, literature, film and history that focus on sexuality and gender. Approx. 8 articles per issue, 1–2 on art topics. Published in cooperation with the University of Colorado at Boulder, CO.
Reviews: book. Indexed: AmH&L. ArtBibMod.
Advertising: few ads at end of issue.

GILAGAMESH. 1986. q. EN. **1757**
Dar Al–Ma'mun for Translation & Publishing, P.O. Box 24015, Baghdad, Iraq. Naji al–Hadithi, Editor.
Dewey: 700.
Journal of modern Iraqi arts.
Advertising.

HISPANIC AMERICAN ARTS. 1974. 3/yr. SP. EN & SP summaries. **1758**
Juan Carlos Gomez 1439, Montevideo, Uruguay. E. Darino, Editor & Pub.
Subscription: (US: Darino, Box 1496, Grand Central Station, New York, NY 10163–1496). Illus.
ISSN: 0738–5625. OCLC: 5004402. LC: NX7.H57. Dewey: 700. Formerly: *Latinamerican Arts* Incorporating: *CBA Boletin.*
Art. Music. Theater.

Subtitled: "All you want or must know, about everything, in all the fields of Hispanic American arts". Consists of photocopies of journal articles on art, music and theater.

IBEU: Instituto Brasil–Estados Unidos. 1938. bi–m. EN or POR. **1759**
Instituto Brasil–Estados Unidos, Av. N.S. de Copacabana 690, Rio de Janeiro, R.A., Brazil.
Subscription: free. Illus.
ISSN: 0020–367X. OCLC: 1099605. LC: AS80.I51. Dewey: 370.

THE INSTITUTE OF MODERN RUSSIAN CULTURE. NEWSLETTER. 1980. s–a. EN. **1760**
Printing Palace, 513 Wilshire Blvd., Santa Monica, CA 90401. Phone 213–394–7062. John E. Bowlt, Editor (Slavic Dept. USC, Los Angeles, CA 90089).
Subscription: included in membership, $25 (Institute of Modern Russian Culture, P.O. Box 4353, USC, Los Angeles, CA 90089–4353). Sample free. Back issues free if individual copies. Illus. b&w, photos. 11 x 9, 26p.
ISSN: 0738–7105. OCLC: 8041293.
Art History. Films. Modern Art.

Devoted to Russian arts and intellectual life.

Bibliographies: updated listing of new books on Russian art. Listings: international. Calendar of events. Exhibition information. Opportunities: study.

Advertising: none. Circulation: 1000. Audience: Slavists, collectors, art historians.

INTER. 1978. q. FR only. 1761

Editions Intervention, 345 Du Pont, Quebec G1K 6M4, Canada. Phone 418–529–9680. Alain Richard, Editor.

Subscription: $C20 Canada, foreign $25, air $30. Sample. Back issues $4. Illus. b&w, photos. 9 x 13, 56p.

ISSN: 0825–8708. Formerly: *Art Actual*.

Architecture. Art History. Graphic Arts. Modern Art. Photography. Printing. Sculpture. Performing Art.

Follows up the new forms in arts: performance, theater, art events, critics, theory as they appear in non–commercial institutions.

Reviews: exhibition 5, book 8. Listings: regional–international. Freelance work: yes. Contact: editor.

Advertising: full page $1000, ½ page $500, ¼ page S250. Nathalie Perreault, Ad. Director. Audience: art crowd.

JOURNAL OF THE FANTASTIC IN THE ARTS (JFA). 1988. q. EN. 1762

Orion Publishing, 1401 North Salina St., Syracuse, NY 13208. Phone 315–471–3139. Carl B. Yoke, Editor (1157 Temple Tr., Stow, OH 44224).

Subscription: included in membership, $20 individuals, $25 institutions US & Canada; foreign + $7, no air. Microform available from UMI. Sample & back issues $6. Illus. b&w, photos. Index in winter issue. 5½ x 8½, 96p.

ISSN: 0897–0521. OCLC: 17376518. Dewey: 700.

General. Fantasy in the Arts.

Sponsored by the International Association for the Fantastic in the Arts, the journal publishes primarily scholarly articles on the fantastic in literature, art, and film. Will also entertain articles on the fantastic in other arts areas (i.e., music, dance, etc.).

Reviews: book 2, length 3000–3500 wds. Bibliographies occasionally. Freelance work: yes. Contact: Art Director (at Orion).

Reviewed: Katz. *Choice* 26:2, Oct 1988, p.405. *Library Journal* 113:19, Nov 15, 1988, p.54.

Advertising: full page $150, ½ page $95. No classified. Frequency discount. Robert C. Gray, Jr., Ad. Director. Mailing lists: available. Circulation: 400. Audience: fantasy/science fiction writers, artists, filmists, and academics who study their works.

KALAKSHETRA QUARTERLY. 1978. q. EN. 1763

Besant Cultural Centre, Kalakshetra (International Arts Centre), Tiruvanmiyur, Madras 600 041, India.

Subscription: Rs 32. Illus. full page b&w, photos. 8½ x 11 x 11¾, 28–32p.

OCLC: 6009454. LC: NX576.A1K34. Dewey: 700. Formerly: *Kalakshetra*.

Articles on the various arts of India.

KULTUR CHRONIK: News and Views from the Federal Republic of Germany. 1983. bi–m. EN, GE, FR, & SP editions. 1764

Inter Nationes e.V., Kennedyallee 91–103, D–5300 Bonn 2, W. Germany. Phone 0228–880–0. Dr. Dieter W. Benecke, Editor-in–chief.

Subscription: free. Illus. b&w, photos. 5¾ x 8¼, 51p.

ISSN: 0724–343X; 0934–1706 (EN edition), 0934–1692 (GE). OCLC: 11280892. LC: DD260.3.K84. Dewey: 943.005.

General.

Devoted to news and views concerning art, literature, theater, education and science, architecture, photography, film, television and music in West Germany. Each issue contains 1–2 articles per subject. Issued in four separate language editions.

Biographies: "portrait, one page per issue. Calendar of events & exhibitions.

Advertising: none.

LEONARDO. 1967. bi–m. EN. FR abstracts. 1765

Pergamon Press, Inc., Journals Division, Maxwell House, Fairview Park, Elmsford, NY 10523. UK: Headington Hill Hall, Oxford OX3 0BW England. Phone US: 914–592–7700. UK: 0865–64881. Dr. Roger F. Malina, Executive Editor, Pamela Grant–Ryan (Managing Editor (2030 Addison St., Suite 400, Berkeley, CA 94704).

Subscription: included in membership ISAST, $225 US & Canada, foreign surface 470 DM, air on request. Microform available from publisher & UMI. Sample free. Back issues, 25% discount when order current subscription. Illus. b&w, color, photos. Annual index. Cum. author/subject index, v.1–20, 1968–1988. 8½ x 11, 100–160p., offset litho.

ISSN: 0024–094X. OCLC: 1755782. LC: N6490.L42. Dewey: 705.

General. Art Education. Art History. Graphic Arts. Modern Art. Painting. Photography. Sculpture. Music.

Journal of the International Society for the Arts, Sciences and Technology. A journal for artists and others interested in the contemporary arts. Features illustrated articles written by artists about their own work, and is particularly concerned with issues related to the interaction of the arts, sciences and technology. Focuses on the visual arts but also addresses music, video, performance, language, environmental, and conceptual arts — especially as they relate to the visual arts or make use of the tools, materials and ideas of contemporary science and technology. New concepts, materials and techniques and other subjects of general artistic interest are treated, as are legal and political aspects of art. Serves as an international forum for promoting communication among artists, art theorists and historians, architects, art teachers and students, designers, engineers and scientists.

Reviews: book 20, journal 5, exhibition 5, equipment 4, other 5. Bibliographies: 1/yr. on special topic. Biographies: historical surveys of of the life and works of artists and scientists. Listings: international. Calendar of events. Exhibition information. Opportunities: "Opportunities for Artists" rather than just job ads; study; competitions. Indexed: ArtArTeAb. ArtBibCur. ArtBibMod. ArtHum. ArtI. BioI. CloTAI. CurCont. RILA. Reviewed: Katz.

Advertising: (rate card Sept '88): full page $400 £270, ½ page $250 £170, 2nd color + $200 or £140, 4 color + $800 or £540. Bleeds $50 or £35. Frequency discount, combined discounts available on all Pergamon journals. 15% agency discount. Inserts. Arnold Kranzler, Ad. Director, the Americas (Elmsford), Steve Harper, Ad. Director, rest of the world (Oxford). Mailing lists: available. Demographics: estimated average readership per copy 25. Total estimated readership 25,000. 47% US, 23% Europe, 30% rest of world. Circulation: 2000. Audience: working artists in all fields of contemporary arts; students; art schools; art educators; academic libraries in the fields of art and the sciences concerned with art and its interaction with the sciences; curators; conservators; manufacturers of art materials; musicians and music teachers; gallery owners; computer professionals; individuals interested in contemporary arts.

LITERATURE, MUSIC, FINE ARTS. 1968. s–a. EN. 1766

Institute for Scientific Co–Operation, Landhausstrasse 18, D–7400 Tuebingen, W. Germany. Dr. J. Hohnholz, Editor. Subscription: DM 43. Microform available. 115p.
ISSN: 0024–4775. OCLC: 2441400. LC: NX1.L555. Dewey: 700.
General. Art. Literature. Music.

Review of German–language research contributions on literature, music and fine arts. A current survey in English. Contains reviews of recent publications, and a selected bibliography of new studies. The original German titles appear in brackets. Translation of the titles into English does not imply that the books and articles themselves have been translated.
Reviews: book 20, length 1–2p. each. Bibliographies: of new studies in each area. Indexed: ArtHum.

MATRIX BERKELEY: A Changing Exhibition of Contemporary Art. 1978. irreg. EN. 1767

University Art Museum, University of California at Berkeley, Berkeley, CA 94720. Phone 415–642–1207.
Illus. b&w, photos, cover from exhibit. Indexes: no.1–30, Feb/Apr 1978–Oct 1989/Jan 1980. 5½ x 8½, 4p.
OCLC: 8891657. LC: NX427.B4M3.
Modern Art.

Issued in conjunction with exhibits. Contains a description of the exhibit, the artist and the art. Coverage includes painting, performance, sculpture, and video, as well as experimental forms not commonly presented within a museum context. Loose-leaf format.

MCM: LA STORIA DELLE COSE: Rivista Delle Arti Minori. 1985. s–a. IT only. 1768

Maria Cristina de Montemayor Editore, Viale Alessandro Volta, 173, 50131 Florence, Italy. Phone 055/579800–476014.
Maria Cristina de Montemayor, Editor.
Subscription: L 15.000 Italy, L 30.000 elsewhere. Illus. b&w, some color, photos. 9 x 11¾, 80p.
ISSN: 0393–8190. OCLC: 14263738. LC: NX4.M36. Dewey: 700.
General. Crafts.

Mainly features articles on arts and crafts but also includes news on a wide variety of topics.
Advertising.

METRO RIQUET. 1989. irreg. EN, FR. 1769

18 Allee des Orgues de Flandre, 75019 Paris, France. Francoise Duvivier, Editor & Pub.
Subscription: $5/issue. No sample. No back issues. Illus. b&w.
ISSN: 0995–2071.
Modern Art.

International audio and visual magazine. Wants to be a connection between foreign artists from alternative expression out of the ordinary. It is open to any kind of audio and visual material as new, experimental, industrial music, sound and visual po

etry, performances, activist art, etc. Includes interviews and tapes, records, publication reviews.
Advertising: none. Circulation: 500.

MIZUE. m. JA. EN summaries. 1770
Bijutsu Shuppan-sha, 15 Ichigaya Hommura-cho, Shinjuku-ku, Tokyo, Japan.
Illus. some color.
OCLC: 5693261. LC: N1.M615.
"A monthly review of the fine arts".

MOVEMENTS IN THE ARTS. 1985. irreg. EN. 1771
Greenwood Press, Inc., 88 Post Rd. W., Box 5007, Westport, CT 06881–9990. Phone 203–226–3571.
ISSN: 8756–890X. OCLC: 11684449. Dewey: 700.
General. Art. Literature. Music.

MUSIC OF THE SPHERES. 1988. q. EN. 1772
Music of the Spheres Publishing, Box 1751, Taos, NM 87571. Phone 505–758–0405. John Patrick Lamkin, Editor.
Subscription: S12.
ISSN: 0892–2721. OCLC: 15140862.
Art. Music.
"A magazine of art and music for the new age".
Reviews: book.
Advertising. Circulation: 10,000.

NATIONAL ENDOWMENT FOR THE ARTS ANNUAL REPORT. 1967. a. EN. 1773
National Endowment for the Arts, Office of Communication, 1100 Penn Ave., N.W., Washington, DC 20506. Phone 202–682–5400. Joan Bowersox Jurenas, Editor.
Subscription: free. Illus. b&w, photos. 8½ x 11, 250p.
ISSN: 0083–2103. OCLC: 2533080. LC: NX22.N314. Dewey: 700.
Art Education. Ceramics. Crafts. Decorative Arts. Drawing. Films. Historic Preservation. Modern Art. Painting. Photography. Sculpture. Textiles. Music. Theater. Dance. Folk Arts.
Lists all grants awarded by the NEA during a given fiscal year. Grant recipients, amounts awarded, and projects are summarized for each grant according to program (artistic discipline). In addition, the report contains financial information.
Advertising: none. Audience: Congress and public.

NATIONAL FOUNDATION FOR ADVANCEMENT IN THE ARTS ANNUAL REPORT. 1981. a.
EN. 1774
National Foundation for Advancement in the Arts, 3915 Biscayne Blvd., 2nd Fl., Miami, FL 33137. Cornelia Pereira, Editor.
Subscription: free.
Dewey: 700.
Art. Literature. Dance.

THE NEW CRITERION. 1982. m. (except July & Aug). EN. 1775
Foundation for Cultural Review, 850 Seventh Ave., New York, NY 10019. Phone 212–247–6980. Hilton Kramer, Editor.
Subscription: $32. Microform available from UMI. 8 x 10, 80p.
ISSN: 0734–0222. OCLC: 8672257. LC: NX503.N48. Dewey: 700.
Criticism on artistic and cultural life in America.
Reviews: book, exhibition. Indexed: ArtBibMod. ArtI. BHA. BioI. CloTAI. RILA. Reviewed: Katz. *New Art Examiner* 15:9, May 1988, p.17–18+.
Advertising: Kate Shanley, Ad. Representative (799 Broadway, Room 237, New York, NY 10003, phone 212–477–4905).

NEW CULTURE: A Review of Contemporary African Arts. 1978. m. EN. 1776
African Designs Development Centre Ltd., New Culture Studios, N6A Adeola Crescent, Oremji, P.M.B. 5162, Ibadan, Nigeria. D. Nwoko, Editor.
Illus.
OCLC: 7254289.

Modern Art. Music. Theater.

NEW OBSERVATIONS. 1982. 8/yr. EN. 1777
New Observations Ltd., 142 Green St., New York, NY 10012. Phone 212–966–6071. Ciri Johnson, Editor.
Subscription: $22 US, + $2 Canada & foreign, air + $23. Sample & back issues $5. Illus. b&w, photos. 8½ x 11, 28p.
ISSN: 0737–5387. OCLC: 9410530. LC: NX504.N45. Dewey: 700.
General.

English translations accompany some foreign language articles.

Interviews: of artists/critics occasionally. Listings: regional–international. Calendar of exhibitions. Opportunities: study, competitions.

Advertising: full page $125, ½ page $85, ¼ page $50. Frequency discount. Rise Cale, Ad. Director. Audience: arts community.

NEWSLETTER HADASHOT. 2–3/yr. EN. 1778
America–Israel Cultural Foundation, 41 E. 42nd St., Suite 608, New York, NY 10017. Phone 212–557–1600. Patricia Schwarz & Vera Stern, Editors.
Illus. b&w, photos. 8½ x 11, 8–12p.
LC: NX684.A46.
General. Art Education. Films. Juvenile. Modern Art. Painting. Sculpture. Music. Dance. Theater.

Activities relevant to AICF and Jewish arts in the United States and Israel.

exhibitions in Israel. Freelance work: none.

Advertising: none. Audience: membership.

NFAA NEWSLETTER. 1982. 3/yr. EN. 1779
National Foundation for Advancement in the Arts, 3915 N. Biscayne Blvd., 2nd Fl., Miami, FL 33137. Phone 305–573–0490. Cornelia Pereira, Editor.
Art. Dance. Music. Theater.

Provides information on foundation–sponsored training opportunities, theater productions, art exhibits, music and dance programs.

Opportunities: training.

NORMAL. 1986. q. EN. 1780
Rizzoli International Publications, Inc., 300 Park Ave. South, New York, NY 10010. Phone 212–982–2300. Gini Alhadeff, Editor.
10 x 13, 100p.
ISSN: 0892–5836. OCLC: 15232639. LC: NX1N84. Dewey: 700.
General. Art. Architecture. Literature.

Collection of arts and ideas — new fiction, poetry, architecture, fashion and art.

NOTES FROM EUROPE/CAHIERS EUROPEENS/EUROPAEISCHE HEFTE: European Literature Cultural Review. 1974. q. GE, FR & EN. 1781
Bertelsmann Fachzeitschriften GmbH, Carl–Bertelsmann–Str. 270, Postfach 5555, 4830 Gutersloh 1, W. Germany. Pierre Moortgat, Editor.
Illus.
Art. Literature. Music.

OCTOBER. 1976. q. EN. 1782
MIT Press, 55 Hayward St., Cambridge, MA 02142. Phone 617–253–2889. Terri L. Carafo, Editor.
Subscription: $25 individual, $60 institution, $20 student and retired US & Canada; elsewhere + $12 surface, + $18 air. Microform available from UMI. Back issues. Illus. b&w, photos. 7 x 9, 144p.
ISSN: 0162–2870. OCLC: 2576782. LC: NX1.O27. Dewey: 700.
General.

Concerned with art, theory, criticism, and politics.

Indexed: ArtArTeAb. ArtBibCur. ArtBibMod. ArtHum. ArtI. BHA. CurCont. RILA. Reviewed: Katz.

ONTARIO REVIEW. 1974. s–a. EN. 1783
O.R. Press, Inc., 9 Honey Brook Dr., Princeton, NJ 08540. Phone 609–737–9542. Raymond J. Smith, Editor.
Illus.
ISSN: 0316–4055. OCLC: 2240867. LC: NX1.O57. Dewey: 700.
Art. Literature.

"A North American journal of the arts" funded in part by a grant from the National Endowment for the Arts.
Biographies: brief notes on contributors. Freelance work: yes, especially fiction, poetry, personal essays, and graphics. Indexed: Cum. index.

OPUS INTERNATIONAL: Revue d'Art. 1967. q. FR only. 1784
Editions Georges Fall, 57 quai des Grands–Augustins, 75006 Paris, France. Phone 43.254458, fax 43298063.
Subscription: 180 F. Microform available from UMI. Illus. b&w, color. 8½ x 11¼.
ISSN: 0048–2056. OCLC: 822978. LC: NX2.O6. Dewey: 700.
Calendar of events. Indexed: ArtBibMod.

ORIEL BULLETIN. s–a. EN & WEL. 1785
Welsh Arts Council, Museum Place, Cardiff, S. Glam CF1 3NX, Wales. Phone 222 394711, fax 222 221447.

OVERSEAS JOURNAL. q. EN. 1786
Royal Overseas League, Over–Seas House, Park Place, St. James's St., London SW1A 1LR, England. Phone 071 4080214, fax 071 4996738.
Art. Literature. Music.

International organization which promotes art, music, and literature throughout the Commonwealth, especially among young people.

OverSight. 1989. a. EN. 1787
California Institute of the Arts, Cal Arts Student Council, 25000 Hawkbryn, No. 17, Newhall, CA 91321. Phone 805–254–6686. Franklin Odel, Editor.
Illus. b&w, photos. tabloid.
Art. Photography.

Presents the photographic and fine arts works of members of the Cal Arts community.
Reviews: book. Reviewed: *High Performance* Fall 1989, p.80.
Advertising.

OZARTS. 1978. 3/yr. EN. 1788
Australia Council, 168 Walker St., North Sydney, N.S.W. 2060, Australia. Sue Boaden, Editor.
ISSN: 0157–9169. Dewey: 700.
Guide to arts organisations in Australia.

PAUL VI INSTITUTE FOR THE ARTS NEWSLETTER. EN. 1789
Paul VI Institute for the Arts, 924 G St., N.W., Washington, DC 20001. Phone 202–347–1450. Judy Antonucci, Editor.
Illus. b&w, photos.
Audience: art lovers.

POLISH ART STUDIES. 1979. a. EN mainly or FR tr. 1790
Ossolineum, Publishing House of the Polish Academy of Sciences, Rynek 9, 50–106 Warsaw, Poland. (Dist.: Ars Polona, Krakowskie Przedmiescie 7, 00–068 Warsaw). Phone 386–25. Stefan Morawski, Editor.
Illus. 7 x 9¼, 350+p.
ISSN: 0208–7243. OCLC: 6654851. LC: NX571.P6P63. Dewey: 700.
Art History. Films. Photography. Theater.

Presents scholarly formulated image of Polish history and theory, past and present, and of different art domains including photography as a subject. Chronicle of scholarly events of the past year. Articles appear in one language only.
Reviews: Book. Bibliographies: current publications. Indexed: ArtBibMod. RILA.
Advertising: none.

PRAXIS. 1975. s–a. EN.

Praxis, Dickson Art Center, UCLA, Los Angeles, CA 90024. Ronald Reimers, Editor.
Illus.
Dewey: 700.

Art. Performing Arts.

"A journal of cultural criticism" covers the visual and performing arts.

PROBLEMI NA IZKUSTVOTO [PROBLEMS OF ART]. 1969. q. BU. Table of contents also in EN, FR &
RU. EN & RU summaries (end of issue).

Publishing House of the Bulgarian Academy of Sciences, Acad. G. Bonchev St., Bldg. 6, 1113 Sofia, Bulgaria. (Dist.: Hemus,
6, Rouski Blvd., 1000 Sofia). A. Stoikov, Editor.
Illus. b&w, some color. 8 x 11¼, 64p.
ISSN: 0032–9371. OCLC: 2266479. LC: NX6.P75. Dewey: 700.
Indexed: ArtBibCur. ArtBibMod.

RENAISSANCE QUARTERLY. 1954. q. EN.

Renaissance Society of America, 1161 Amsterdam Ave., New York, NY 10027. Phone 212–280–2318. Editorial Board.
Subscription: included in membership. Microform available from Kraus Reprint Co., UMI. Illus. Index.
ISSN: 0034–4338. OCLC: 5372932. LC: Z6207.R4 R393. Dewey: 940. Incorporating: *Studies in the Renaissance; Renaissance News.*

Art History. Literature. Music.

Society promotes research and publication in the field of Renaissance studies, especially of interchanges among various fields
of specialization such as art, music, and literature.
Bibliographies: list of new bibliographic tools. Obits. Indexed: ArtHum. BkReI. CloTAI. CurCont. HistAb. HumI.
IBkReHum.
Advertising.

REPRESENTATIONS. 1983. q. EN.

University of California Press, Journals Division, 2120 Berkeley Way, Berkeley, CA 94720. Editorial Board (322 Wheeler
Hall, University of California, Berkeley, CA 94720).
Subscription: $24 individual, $48 institution, $16 students. Microform available from UMI. Back issues. Illus., a few b&w.
6½ x 9¾, 150–190p.
ISSN: 0734–6018. OCLC: 8781433. LC: NX1.R46. Dewey: 700.

Art History. Literature.

A forum for new work in cultural studies, art, history, literature, anthropology, and social history. 6–8 scholarly essays per
issue, literature and philosophy account for a majority, 2–3 art related.
Freelance work: yes. Contact: Barrett Watten, Associate Editor. Indexed: ArtBibMod. BHA. MLA. RILA.
Advertising at end of issue. Rates available on request.

RIVISTA DI ESTETICA. 1956. 3/yr. IT, EN, FR.

Rosenberg & Sellier, Via Andrea Doria 14, 10123 Turin, Italy. Phone 011–532150. Gianni Vattimo, Editor.
Subscription: L 50000.
ISSN: 0035–6212. OCLC: 1894787. LC: BH4.R62.
Covers topics related to all aspects of aesthetics in Western arts and literature.
Reviews: book. Bibliographies: list of books received. Indexed: ArtBibMod.
Advertising.

RSA JOURNAL. 1852. m. EN.

Royal Society for the Encouragement of Arts, Manufactures & Commerce, 8 John Adam St., London WC2 6EZ, England.
Phone 071–930 5115, fax 071–839 5805. Sarah Curtis, Editor.
Subscription: included in membership, non–members £38 EC countries, elsewhere £45. Illus. b&w, photos. Index. 7½ x
10¾, 62p.
ISSN: 0958–0433. OCLC: 17404748. LC: T1.S64. Dewey: 700. Formerly: *Journal of the Royal Society of Arts; Journal of
the Society of Arts.*
General.

Reviews: book 6. Biographies. Obits. Calendar of regional meetings of the Society. Opportunities: competitions, awards. Indexed: ArchPI. ArtArTeAb. Avery. BrArchAb. Des&ApAI. IBkReHum. RILA.
Circulation: 15000+.

SALMAGUNDIAN. 3/yr. EN.

1797

Salmagundi Club, 47 Fifth Ave., New York, NY 10003. Phone 212–255–7740.
Subscription: included in membership.
Newsletter of a professional art club of painters, sculptors, writers and artists. Highlights Club activities as well as presenting profiles of artists and their works.
Calendar of events. Indexed: BioI. IBkReHum.
Circulation: 600.

SIBYL-CHILD. See no. 719.

SPECTATOR MAGAZINE. 1978. w. EN.

1798

Spectator Publications, Inc., 1318 Dale St., Box 12887, Raleigh, NC 27605. Phone 919–828–7393. R.B. Reeves, III, Editor.
Subscription: $15. Illus.
Dewey: 700.
Art. Music.

Tabloid covering art, music and motion pictures.
Reviews: book, film.
Advertising.

TEMENOS. 1981. s–a. EN.

1799

Lindisfarne Press, P.O. Box 778, 195 Main St., Great Barrington, MA 01230. Europe: P.O. Box 72, London, WC2H OLN, England.
Illus. b&w, some color, photos. 300p.
ISSN: 0262–4524. OCLC: 8180630. LC: NX1.T44. Dewey: 700.
Art. Literature. Music.

"A review devoted to the arts of the imagination." Contains articles on literature, poetry, art and music.
Reviews: book 8. Biographies: brief notes on contributors. Indexed: CurCont.

TUITION, ENTERTAINMENT NEWS, VIEWS. 1976? 2/yr. EN.

1800

Oxford Area Arts Council, Old Fire Station Arts Centre, Oxford, England.
Illus.
Dewey: 700. Formerly: *Oxford Area Arts Council. Newsletter*.
Art. Music. Theater.

UMENI/ARTS. 1953. bi–m. CZ. EN table of contents. Short summaries mainly in EN & RU, occasionally in GE or FR.

1801

Academia, Publishing House of the Czechoslovak Academy of Sciences, 112 29 Prague 1, Vodickova 40, Czechoslovakia.
Phone 221–413. Rostislav Svacha, Editor (116 92 Prague 1, Hastalska 6).
Subscription: DM 277 (Socialist countries: Artia, Ve Smeckach 30, 111 27, Prague 1. Dist. in Western countries: Kubon & Sagner, P.O. Box 683401 080–8000 Munich 34, Germany). Illus. b&w, glossy photos. A4, 184p.
ISSN: 0049–5123. OCLC: 2123295. LC: N6.U45. Dewey: 709.
Published by the Czechoslovak Academy of Sciences Institute of the Theory and History of Art. Focuses on Central European art, both contemporary and historical, and covers a wide range of topics.
Reviews: book. Indexed: ArtArTeAb. ArtBibCur. ArtBibMod. Avery. BHA.

UPDATE: ACA. 1979. m. EN.

1802

American Council for the Arts, 1285 6th Ave., 3rd Fl., New York, NY 10019. Phone 212–245–4510. Amy Jennings, Editor.
Subscription: included in membership. 5½ x 8½, 16p.
OCLC: 6027591. LC: NX1.U63. Dewey: 700. Supersedes: *Update & ACA Word from Washington*.
News for arts leaders. Spotlights legislation and government action affecting the arts.
Calendar of events. Opportunities: employment.
Advertising.

VANTAGE POINT: Issues in American Arts. 1984. bi–m. EN.

American Council for the Arts, 1285 6th Ave., 3rd Fl., New York, NY 10019. Phone 212–245–4510. William Keens, Editor.
Subscription: included in membership. Illus. some color. 8½ x 10¼, 16p.
ISSN: 0748–6723. OCLC: 11000836. LC: NX503.V36. Dewey: 700.973. Formerly: *American Arts; ACA Reports*; Incorporating: *Arts in Common.*
Brief articles, 1–2 pages each, concerning American arts.
Interviews.
Advertising: ad on back cover only.

VIE DES ARTS. 1956. q. FR.

La Vie Des Arts, 500, rue Saint Francois Xavier, Montreal, Que. H2Y 2T5, Canada. Phone 514–282–0205, fax 514–282–0235. Jean–Claude Leblond, Editor.
Subscription: $C27 Canada, foreign $C35. No sample. Back issues $1. Illus. b&w, color. Cum. index 1956–66, 1966–76, 1976–86. 8½ x 11, 80p. Lithogravure (offset).
ISSN: 0042–5435. OCLC: 6188006. LC: NX2.V53. Dewey: 700.
Architecture. Art History. Drawing. Modern Art. Museology. Painting. Sculpture.
Presents information on visual arts as well as the arts in general.
Reviews: Critical reviews of exhibitions in Canada, North American countries and Europe. Indexed: ArtBibCur. ArtBibMod. CanPI. Reviewed: Katz. *New Art Examiner* 16:9, May 1989, p.63-64.
Advertising: (rate card Sept '86): full page $800, ½ page $525, ¼ page $300, double page $1300; 4 color full page $1750, ½ page $975, ¼ page $550, double page $2500. 15% frequency discount. Chantal Charbonneau, Ad. Director. Mailing lists: none. Circulation: 7500.

VISTAS. 1979. irreg., approx. 2/yr. EN.

V.O.L.N. Press, Box 93, Merion Station, PA 19066. Phone 215–667–3067. Ellen Homsey, Editor.
Subscription: none, prices varies, approx. $10/issue. No sample. Back issues, price varies. Illus. b&w. 9 x 6, 150p.
ISSN: 0278–7660. OCLC: 7500154. LC: NX1.B37a. Dewey: 700. Formerly: *The Barnes Foundation Journal of the Art Department.*
General. Art Education. Painting.
The essays, etc., appearing in the journal are for the most part, derived from the work of seminar students, alumni, and members of the staff of The Barnes Foundation. On occasion articles and pieces not directly concerned with the Foundation's philosophy but representing original work by the Art Department's students and outside contributors which the editorial staff considers to be of general interest are published.
Advertising: none. Audience: students and those interested the philosophy and appreciation of art, the art in art, the art in life.

VLAANDEREN: Tweemaandelijks Tijdschrift. 1951. bi–m. DU.

Christelijk Vlaams Kunstenaarsverbond, A. van Daele Lindenlaan 18, B–8880 Tielt, Belgium. Robert Declerck, Editor.
Illus. b&w, photos.
ISSN: 0042–7683. Dewey: 700. Formerly: *West–Vlaanderen.*
General. Art. Performing Arts.
General coverage of the the visual and performing arts.
Advertising.

WASHINGTON INTERNATIONAL ARTS LETTER. 1962. 10/yr. EN.

Washington International Arts Letter, Box 15240, Washington, DC 20003. Phone 202–328–1900. Nancy A. Fandel, Editor.
Subscription: $40 individuals, $57.60 institutions. Microform available from UMI. Illus. b&w. 8½x11, 8p.
ISSN: 0043–0609. OCLC: 1769429. LC: NX1.W3.
"A letter service and digest concerning 20th century patronage, support programs, and developments in the arts and government, humanities and education, and books and publications." Reports on federal action affecting the arts.
Reviews: book. Bibliographies. Opportunities: employment; announcements of scholarships, grants and other forms of assistance. Reviewed: Katz.

WESTWIND. 1957. s–a. EN.

University of California, Los Angeles, College of Letters and Science, Division of Honors, A–311 Murphy Hall, Los Angeles, CA 90024. Erik P. Bucy, Editor.
Art. Literature. Music. Photography.

"UCLA's journal of the arts" covers art, literature, music and photography.

XPRESS. 1986. bi–m. EN. 1809
A & E Xpress, 2A Bayswater Rd., Kings Cross, Sydney, N.S.W. 2011, Australia. Phone 02 358 4077. Alexandra Morphett, Editor.
Subscription: $A48 (P.O. Box 1195, Potts Point, N.S.W. 2011).
ISSN: 0817–4628.
Features topics on popular culture art, theater, and fashion design.
Reviews: book.
Advertising.

Regional Arts

THE 13TH STREET JOURNAL. 1988. 8/yr. EN. 1810
Boulder Center for the Visual Arts, 1750 Thirteenth St., Boulder, CO 80302. Phone 303–443–2122. Ina Russell, Editor & Pub.
Subscription: included in membership; free, available from publisher and 220 metropolitan area distribution points. Sample.
Back issues. Illus. b&w, photos, cartoons. 11½ x 17 tabloid, 16–20p.
ISSN: 0896–4971. OCLC: 18759692. Formerly: *Art Review.*
General. Modern Art. Photography. Literature.

News and notes as well as cover article on events in the Boulder/Denver area. Includes fiction, poetry, and photos. "Show News Art Beats" column presents paragraph description of opportunities, publications, workshops, conventions and festivals. Reviews: book 1; exhibitions 2, performance 2, fair–festival 1, length 50–1500 wds. each. Interviews: 4/yr with prominent local people. Obits. for individuals with long–time connection with the Center. Listings: regional. Calendars of community and cultural events, galleries and exhibitions. Freelance work: yes, photos (preferably related in someway to downtown Boulder). Pays standard costs for film and processing. Contact: editor. Opportunities: employment, study, competitions.
Advertising: full page $697.50, ½ page $348.75, ¼ page $173.05, color + $80 per ad pro rata. Classified: regular rates. 10% frequency discount. Ina Russell & Jean Bendon, Ad. Directors. Mailing lists: available. Demographics: Boulder & No. Colorado area. Circulation: 13,000. Audience: culturally literate people in Boulder/Denver area and Northern Colorado.

ALABAMA ARTS. 1969. q. EN. 1811
Alabama State Council on the Arts, One Dexter Ave., Montgomery, AL 36130–5801. Phone 205–261–4076. Sharon Heflin, Editor.
Subscription: free. No back issues. Illus. b&w, photos. 36–44p.
OCLC: 15546601. LC: NX24.A2 A35. Formerly: *Ala–Arts; Art News in Brief.*
General.

Purpose is to make constituents aware of arts happenings statewide, nationally and regionally; to assist artists with information regarding exhibitions; to announce grants funds; and to highlight Alabama artists.
Interviews: spotlight Alabama artists. Listings: regional–national. Calendar of exhibitions. Freelance work: yes. Contact: editor. Opportunities: study, competitions.
Advertising: none. Mailing lists: available. Circulation: 4700. Audience: arts constituents.

ALASKA. STATE COUNCIL ON THE ARTS. BULLETIN. 1973. m. EN. 1812
State Council on the Arts, 619 Warehouse Ave., Suite 220, Anchorage, AK 99501–1682. Phone 907–279–1558.
Subscription: free.
Dewey: 792. Formerly: *Arts in Alaska.*

THE ALBANY REVIEW. 1987. m. EN. 1813
Albany Review Associates, Inc., 4 Central Ave., Albany, NY 12210. Phone 518–436–5787. Theodore Bouloukos, II, Editor.
Subscription: free (newstands), $15 US, $20 Canada, foreign $50. Sample $1.50. Some back issues $1.50. Illus. b&w, photos.
11 x 14, 56p.
ISSN: 0895–559X. OCLC: 16700279.
General. Literature.

Cross–cultural coverage of the arts, literature, fashion, politics, and satire.

Reviews: exhibitions 1–4, length 750 wds; book 10, length 250 wds.; dance, architecture. Interviews: area personalities who fall into monthly theme, artists writers, dancers, etc. Freelance work: yes.
Advertising: (rate card): full page $1045, ½ page $530, ¼ page $330, cover $1150–$1385, no color. No classified. Frequency discount. Mailing lists: none. Demographics: rich, literate, educated, young. Circulation: 12,500. Audience: upscale baby–boomers.

ARC: The Rural Arts Newsletter. Ceased.

1814

ARIZONA COMMISSION ON THE ARTS. REPORT. a. EN.

1815

Commission on the Arts, 417 W. Roosevelt St., Phoenix, AZ 85003. Phone 602–255–5882.
Subscription: free. Illus.
ISSN: 0098–7387. OCLC: 11039521. LC: NX24.A6 A73a. Dewey: 353.979. Formerly: *Arizona Commission on the Arts and Humanities. Report to the Governor.*

ART PAPERS. 1977. bi–m. EN.

1816

Atlanta Art Papers, Inc, P.O.Box 77348, Atlanta, GA 30357. Phone 404–885–1837. Glenn Harper, Editor.
Subscription: $20 US & Canada, $30 foreign. Microform available. Sample. Back issues $4.50. Illus. b&w, photos. 10½ x 13, 80p.
ISSN: 0278–1441. OCLC: 7219444. LC: NX506.A77. Formed by the merger of: *Contemporary Art – Southeast* and *Atlanta Art Papers; former titles: Atlanta Art Workers Coalition.*
General. Modern Art. Performing Arts.

Contemporary art in the Southeast as well as current national and international dialogue on art. The focus is on the visual arts with some coverage of performance arts.
Reviews: exhibition 39 & book 1, length 1000 wds. Biographies: occasionally, artists and arts professionals. Interviews: artists, two per issue. Listings: regional. Calendar of events. Exhibition information. Freelance work: yes. Contact: editor. Opportunities: employment, study, competitions. Indexed: ArtBibMod. Reviewed: Katz. *Art Documentation* Win 1987, p.181. *New Art Examiner* 16:3, Nov 1988, p.17-18.
Advertising: full page $400, ½ page $200, ¼ page $100, spot color $100. Classified: 35¢/wd. Carolyn Griffin, Ad. Director. Mailing lists: available. Circulation: 3500. Audience: teachers, students, artists, people interested in art.

ART TO GO. 1984. a. EN.

1817

The South Carolina Arts Commission Touring Programs, 1800 Gervais St., Columbia, SC 29201.
Illus.
OCLC: 10691566. Formerly: *Program Guide.*

Arts programs packaged to go and ready to tour all over the state. Provides descriptions of programs accompanied by a small photo. Visual programs, literary programs, performing artists and exhibits are available.

ARTIFACTS. 1984. q. EN.

1818

South Carolina Arts Commission, 1800 Gervais St., Columbia, SC 29201. Phone 803–734–8696. Jayne Darke, Editor.
Subscription: free. Sample. Some back issues. Illus. b&w, color, photos. 11 x 13½, 24p.
OCLC: 11215752.
General.

Informations/applications on Arts Commission grants, services and programs. Additional information on South Carolina artists and arts organizations as received.
Listings: regional–national. Calendar of events. Exhibition information. Freelance work: yes. Contact: editor. Opportunities: competitions for South Carolina artists/organizations.
Advertising: none. Mailing lists: available for fee. Circulation: 17,000. Audience: artists, arts organizations, arts patrons.

ARTS & CULTURAL TIMES. 1987. bi–m. EN.

1819

Rhode Island State Council on the Arts, 95 Cedar St., Suite 103, Providence, RI 02903. Phone 401–277–3880. Dick Upson, Editor.
Subscription: free. Illus. b&w photos only. 11 x 17, 12p.
OCLC: 17724344. LC: NX24.R4 A82. Formerly: *Rhode Island State Council on the Arts Report.*
General.

Tries to focus on primary material profiling and detailing the activities of Rhode Island State Council on the Arts' grantees which it is mandated to do by law. Each issue contains a "Great Moments Guide" listing of activities by these grantees.

Interviews: strives to conduct as many original interviews as possible. Listings: regional–national. Calendar of events. Exhibition information. Freelance work: none. Opportunities: employment, study, competitions.
Advertising: rates available on request. Mailing lists: none. Circulation: 3350 direct mail, 500 distributed. Audience: arts patrons, consumers, artists.

ARTS ALIVE OF MERSEYSIDE. 1969. m. EN. 1820
Merseyside Arts, 6 Bluecoat Chambers, School Lane, Liverpool L1 3BX, England. Steve Roberts, Editor.

ARTS BEAT. 1976. 9/yr. EN. 1821
Hamilton and Region Arts Council, P.O. Box 2080, Station 'A', Hamilton, Ontario L8S 3W6, Canada. Phone 416–529–9485. Deborah Bunka, Editor.
Subscription: included in membership, Canada $C15 individual, SC40 groups under 75, $C60 groups over 75. Sample free. Limited back issues, postage. Illus. b&w, photos. 11 x 17, 16–20p.
ISSN: 0843–2260. OCLC: 19769976. LC: NX1. Formerly: *Art–I–Fact*.
Art Education. Art History. Ceramics. Crafts. Drawing. Graphic Arts. Modern Art. Painting. Photography. Printing. Sculpture.
Newsletter aims primarily to serve the needs of the membership. This comprises six disciplines: crafts, visual arts, music, drama, theater, and dance. Provides the community–at–large with up–to–date information about events and issues of concern (political, financial, etc.). Aims for an informational, educational, and interesting publication.
Reviews: exhibition 1–2, length 1/2p. each; book 1, length 500 wds.; equipment occasionally. Bibliographies: usually accompanying a specific article. Lists library books available for certain disciplines or topics. Interviews: playwrights, artists politicians, craftspersons, award winners, etc. Listings: regional. Freelance work: people can submit or they are asked to do an article by editor. Contact: editor. Opportunities: study, competitions, informations on grants, fund–raising.
Advertising: full page $600, ½ page $300, no color. Classified: free to members. Frequency discount. Mailing lists: available. Demographics: primarily Hamilton and Region, mailed to membership, media, political and public relations contacts; distributed through Hamilton schools and recreation centres, public places, restaurants, and retail outlets in the city. Circulation: 2,500 (1989), 5,5000 (1990 projection). Audience: membership, Hamilton and Region Arts Community.

ARTS INDIANA. 1979. m. EN. 1822
Arts Indiana, Inc., 47 S. Pennsylvania St., Suite 701, Indianapolis, IN 46204. Phone 317–632–7894. N.J. Stanley, Editor.
Subscription: $14. Illus.
ISSN: 0738–9787. OCLC: 16723807. LC: NX1.I5. Formerly: *Arts Insight*.
Newsmagazine devoted to statewide coverage of the arts in Indiana.
Indexed: ArtBibMod.

ARTS INK. q. EN. 1823
Wisconsin Citizens for the Arts, Inc., 212 W. Wisconsin Ave., No. 223, Milwaukee, WI 53203. Phone 414–223–3311. Pam Garvey, Editor.
Formerly: *Artlines*.
Provides coverage of legislative matters and the internal operations of the organization.
Advertising: none. Audience: membership.

ARTS JOURNAL. 1975. m. EN. 1824
Arts Journal Co., 324 Charlotte St., Asheville, NC 28801. Phone 704–255–7888. Thomas Patterson, Editor.
Subscription: $18 individual, $15 institution. Illus.
State–wide information on the current arts community in North Carolina. Regional developments are also covered.
Reviews: book.
Advertising.

ARTS LONDON REVIEW. 1981. m. EN. 1825
Woodstock Gallery Press, 16 Woodstock St., London W.1., England. Maria Alford–Rehorst, Editor.
Illus.
ISSN: 0260–6801.
The "trade paper of the artist".
Indexed: RILA.

ARTS NOW. 1980. bi–m. EN. 1826

Waterloo Regional Arts Council, P.O. Box 1570, Station C, Kitchener, Ontario N2G 4P2, Canada. Phone 519–744–4552. Ruth Russell, Editor.
Subscription: included in membership, $C15. No sample. No back issues. Illus. cover only, b&w. 16p.
ISSN: 0825–9267. OCLC: 14259737. LC: NX430.
General.

Attempts to serve two purposes: to promote all the arts by informing all residents of the community about current artistic activity and also to promote the activities of the members (93 group or organization members and 190 individual members). Interviews: many with artists of all descriptions. Listings: regional. Calendar of events. Exhibition information. Freelance work: yes, no pay. Contact: editor. Opportunities: employment, study, competitions.
Advertising: none. Circulation: 2,000. Audience: residents of the Waterloo Region who are interested in the arts.

ARTS WASHINGTON. 1982. 10/yr. EN. 1827

Cultural Alliance of Greater Washington, Stables Art Center, 410 8th St., NW, Suite 600, Washington, DC 20004. Karen Eisenberg, Editor.
Subscription: included in membership. Illus. b&w, photos. 11½ x 15, 4p.
OCLC: 8574359.
General.

Tabloid format. Trade paper of the Washington area arts community. A service to the region's arts community. Working on behalf of artists, arts organizations and the community, the paper presents news, rules and regulations, announcements, and information concerning members. "Applause" lists appointments and awards received by members or organizations.
Listings: regional. Opportunities: employment; announcements of workshops, conferences, competitions, awards, and grants. Advertising.

ARTS WEST. 1971. m. EN. 1828

Regional Magazines Ltd., Finance House, Barnfield Rd., Exeter, Devon EX1 1QR, England. Jan Beart–Albrecht, Editor. Illus.
ISSN: 0951–1997. Formerly: *Arts South West; SW; SWAA Broadsheet*.
Art. Music. Theater.

Tabloid covering art, theater and music.

ARTSATLANTIC. 1977. 3/yr. EN. 1829

Confederation Centre Art Gallery and Museum, P.O. Box 848, Charlottetown, P.E.I. C1A 7L9, Canada. Phone 902–566–2464, Fax 902–566–4648. Joseph Sherman, Editor.
Subscription: $C15.50 Canada, outside Canada +$C8. Microform available from Micromedia. Limited back issues $4.95. Illus. b&w, photos. 9 x 12 trim, 80p., offset.
ISSN: 0704–7916. OCLC: 3945753. LC: NX513.A3 M373.
Art. Crafts.

Atlantic Canada's award–winning journal of the arts, reports on and features the region's fine arts, cinema/video, artists, performance, and other manifestations of culture–making. An average of eight major articles per issue plus arts news from all over. Covers both visual and performing arts and crafts in or about the four Atlantic provinces.
Reviews: exhibition 30–35 & film 1–2, length 800–1500 wds.; book 2–4, length 600–1200 wds.; other 4–6, length 1000–1800 wds. Interviews: with artists. Listings: regional. Calendar of events. Exhibition information. Freelance work: yes. Contact: editor. Opportunities: employment, study, competitions. Indexed: ArtBibMod. CanMagI. CanPI.
Advertising: (rate card Jl '88): b&w full page $664, ½ page $493, ¼ page $310, spread $1202; 4 color full page $1151, ½ page $848, spread $2226, covers $1239–$1669. Classified: 80¢/wd., min. 10 wds. Preferred position + 15%, bleed + 15%. Frequency discount. Joseph Sherman, Ad. Director. Demographics: international readership.

ARTSPACE (Albuquerque). 1976. bi–m. EN. 1830

Artspace, Inc., P.O. Box 4547, Albuquerque, NM 87196. Phone 502–842–1560. William Peterson, Editor.
Subscription: $23 US, $42 Canada, foreign $60. Sample $5. Back issues. Illus. b&w, color, photos, cartoons. 8½ x 11, 72–100p.
ISSN: 0193–6596. OCLC: 3711496. LC: NX508.6.A77.
Architecture. Films. Modern Art. Painting. Photography. Printing. Sculpture. Music.

A magazine of contemporary art covers painting, photography, sculpture, new music, film and architecture.
Reviews: 6–7/issue. Freelance work: yes. Contact: editor. Indexed: ArtBibMod. RILA. Reviewed: Katz.

Advertising: (rate card 1989): b&w full page $800, ½ page $650, ¼ page $400 inside covers $850; color full page $1395–1595, ½ page $995–1095, covers $1500–2300. No classified. Frequency discount. No agency discount. Jan Schmitz, Ad. Director (P.O. Box 4547, Alburquerque, NM 87196, phone 505–266–3144). Mailing lists: none. Demographics: nationwide distribution in U.S. & Canada, sold in all major cities, most major museum shops in the U.S. and in two major chain bookstores, Waldenbooks & B. Dalton Booksellers. Audience is a target group, those who are interested in and buying contemporary art. Circulation: 15,000. Audience: contemporary art collectors, artists, dealers, historians, teachers.

ARTSPACE (Columbus). 1968. q. EN. 1831

Ohio Arts Council, 727 E. Main St., Columbus, OH 43205. Phone 614–466–2613. Charles G. Fenton, Editor.
Subscription: free on request. No sample. No back issues. 16p.
Formerly: *Viewpoint; OAC Newsletter.*
General.

Features and timely news on arts related topics.
Listings: regional. Exhibition information. Freelance work: no pay. Opportunities: study, competitions.
Advertising: none. Circulation: 7,600. Audience: anyone in Ohio interested in the arts.

ARTSWEST MEMBER. 1984. m. except Jan. EN. 1832

Artswest Foundation Ltd., P.O. Box 1424, Parramatta, N.S.W. 2124, Australia. Phone 02–831–1441 or 1439. Katherine Knight, Editor.
Subscription: included in membership, $A18 individual, $A30 institution, $A10 student or pensioner. Illus. b&w, photos. A4, 4p.
ISSN: 0817–6264.
General.

"Supporting and promoting the arts in western Sydney." Information and news of members and of the Foundation reflecting the growth and change in Sydney's western regions, the company's home–base. Coverage includes the visual arts.
Listings: regional. Calendar of events, "Artwest Diary". Exhibition information. Opportunities: employment.
Advertising: (rate card Apr 1989): ½ page $A500, ¼ page $250, $10 col cm. Diary $20/insert, for events automatic free diary entry. Classified: (goods and services) 50¢/wd., min. 20 wds., prepaid. Frequency discount. Non–members + 25%. Circulation: 1000.

ARTVIEWS. 1973. q. EN. 1833

Visual Arts Ontario, 439 Wellington St., 2nd Floor, Toronto, Ontario M5V 1E7, Canada. Phone 416–362–2546. Fred Gaysek, Editor.
Subscription: includes subscription to *Visual Arts Ontario*, $C20. Illus. 8½ x 11, 48p.
ISSN: 0381–9515. OCLC: 11830171. LC: NX8. Dewey: 709. Formerly: *Visual Artviews.*
First–hand observations by artists and members of the Canadian art community presents thoughtful commentary on current issues in the arts. Reports on technology and the arts are also presented.
Advertising. David McClyment, Ad. Director.

ASSEMBLY OF BRITISH COLUMBIA ARTS COUNCILS - NEWSLETTER. 1986. bi–m. EN. 1834

Assembly of British Columbia Arts Councils, 3737 Oak St., No. 201, Vancouver, BC, Canada V6H 2M4. Phone 604–738–0749. Deborah Meyers, Editor.
Subscription: included in membership. Illus. b&w. 8 x 10½, 16p.
General. Crafts.

Reports on the activities of the 86 arts councils in British Columbia and provides general art news, with an emphasis on items of community or regional interest. Carries notices of publications and other resources available.
Bibliographies. Calendar of events. Freelance work: yes. Opportunities: calls for papers.
Advertising. Circulation: 1000. Audience: Arts councils throughout British Columbia, provincial arts service organizations, education institutions, government.

BACA CALENDAR OF CULTURAL EVENTS. See no. 1018.

BORDER CROSSINGS: A Magazine of the Arts from Manitoba. 1977. q. EN. 1835

Arts Manitoba Publications Inc., 301–160 Princess St., Winnipeg, Man. R3B 1K9, Canada. Phone 204–942–5778. Robert Enright, Editor.
Subscription: $C15, $US19 US & foreign. Also available on–line in the Canadian Business & Current Affairs Database. Sample & back issues $4.50. Illus. b&w, color, photos. 8½ x 11, 64p.

ISSN: 0831–2559. OCLC: 14954880. LC: NX1. Formerly: *Arts Manitoba*.
General.

In addition to the arts in general also includes arts politics, fiction, outsider art, and poetry.
Reviews: 8 reviews/issue, regularly review all of the arts. Biographies: profiles on artists. Interviews: lengthy with artists, writers critics. Freelance work: yes. Contact: Meeka Walsh. Indexed: CanMagI.
Advertising: no classified. Mailing lists: selective. Deborah Russell, Ad. Director. Demographics: university educated, frequent travellers, artists, arts administrators, professionals. Circulation: 3500. Audience: general interest in arts and culture.

CARNEGIE MAGAZINE. 1927. bi–m. EN. 1836
The Carnegie, 4400 Forbes Ave., Pittsburgh, PA 15213. Phone 412–622–3315. R. Jay Gangewere, Editor.
Subscription: $12 US, + $9 foreign. Microform available from UMI. Back issues $2 + postage. Illus. 8½ x 11, 44p.
ISSN: 0008–6681. OCLC: 5453926. LC: AS36.P765. Dewey: 607.11. Formerly: *Bulletin of the Carnegie Institute*.
General. Art. Literature. Music.

Dedicated to the understanding and enjoyment of art, science, literature and music. Feature articles, regular columns and photography on the arts, natural history, science, literature, and music with regular editorial and news columns. Covers the Library of Pittsburgh, the Museum of Art, the Museum of Natural History, the Buhl Science Center and the Music Hall. Calendar of Carnegie events. Indexed: ArtBibMod. ArtHum. Avery. CloTAI. CurCont. RILA. Reviewed: Katz.
Advertising: Carol Winterhalter, Ad. Manager (412–776–1432). Circulation: 17,000. Audience: members and friends.

CENTER OF ATTENTION: Events at the Art School and in the Arts Community. 1987. m. EN. 1837
The ArtsCenter, Box 789, 300–G East Main, Carrboro, NC 27510–0789. Phone 919–929–ARTS. Beth Wilson, Editor.
Subscription: included in membership $50; subscription only $25 US. Sample free. No back issues. Illus b&w, photos, cartoons.
Formerly: *Artscope*.
The newsletter of the ArtsCenter, a multi–faceted non–profit organization, which prints articles and photos on upcoming performers and gallery exhibits. Plans call for expansion to a much broader arts magazine in approximately two years.
Biographies: short articles on upcoming performers. Listings: ArtsCenter events only. Calendar of events. Exhibition information. Opportunities: employment, study, competitions.
Advertising: none. Circulation: 13,500.

COVER/ARTS NEW YORK. 1986. m. EN. 1838
Box 1215, Cooper Station, New York, NY 10276. Phone 212–673–1152. Jeffrey C. Wright, Editor & Pub.
Subscription: $15/2 yrs. US. Sample $2. No back issues. Illus. b&w, photos. 11½ x 15, 44p. Web offset.
ISSN: 0277–6723. OCLC: 7057701. LC: AP1.C85.
General. Arts. Performing Art.

Covers all the arts including dance, theatre, and film. Covers the works and personalities, the trends and events making New York the cultural core of the world.
Reviews: exhibitions. 24, length ¼–2p.; book 8, length ¼p.; music 20, length ¼–2p. Interviews: artists, authors musicians, directors, etc. Listings: regional. Freelance work: yes. Contact: editor.
Advertising: (rate card May 1989): full page $1100, ½ page $600, ¼ page $350, covers $1200–1300. Frequency discount. 15% discount for pre–payment. Inserts. Mackenzie Andersen, Ad. Director. Mailing lists: available. Circulation: 30,000. Audience: broader arts enjoyers and practitioners.

ENNUI. 1980. bi–m. EN. 1839
Ennui Publications, 4196 Main St., Suite 4, Vancouver, B.C. V5V 3P7, Canada.
Illus.
ISSN: 0228–1244. OCLC: 6858710 [80]. LC: NX1.
Covers arts of the Vancouver region.

LEHIGH VALLEY ARTS ALIVE! 1982. m. EN. 1840
Admar Associates, 4555 Hamilton St., Box 33951, Allentown, PA 18106–3395. Marilyn J. Roberts, Editor.
Dewey: 792. Formerly: *Theatrical Faces*.
A magazine for arts audiences.
Advertising.

LIAISON: Le Magazine Culturel de l'Ontario Francais. 1978. 5/yr. FR. **1841**
Editions L'Interligne, Case Postale 358, Succ. A, Ottawa, Ontario K1N 8V3, Canada. Phone 613–236–3133. Paul–Fraincois Sylvestre, Editor.
Subscription: included in membership, SC15 Canada, $US15 US. Sample free. Some back issues $3. Illus. b&w, many photos. 8½ x 11, 48p.
ISSN: 0227–227X. OCLC: 6563700. LC: PN2305. Dewey: 792.
Art Education. Films. Modern Art. Photography. Sculpture. Literature. Theater.

Franco–Ontarian arts and culture magazine with a view of other French–Canadian art activities outside Quebec. Contains visual arts, features on specific themes, and creative writing.
Reviews: exhibition 1, length 2p.; book 5, length 1p. each. Interviews: singers, writers artists. Listings: Ontario. Calendar of exhibitions. Freelance work: yes. Contact: editor. Opportunities: competitions.
Advertising: full page $380, ½ page $235, ¼ page $125. Frequency discount. Rachel Carriere, Ad. Director. Mailing lists: none. Circulation: 2000. Audience: arts and culture, teachers.

LONDON INFORMATION, ARTS GUIDE. 1918. m. EN. **1842**
London Information (Rowse Muir) Ltd., 16 Temple Chambers, Temple Ave., London EC4Y 0HP, England.
Dewey: 069.5. Formerly: *London Information, Galleries, Exhibitions, Museums; Art Gallery Guide.*

MADISON AREA MAGAZINE OF THE ARTS. 1976. q. EN. **1843**
Gallery 853, 853 Williamson St., Madison, WI 53703.
Illus.
OCLC: 3363689. LC: NX1.M33. Dewey: 700.
"An unbound portfolio of original & offset prints—drawings, photographs, poems, writings, montages & experiments".

MAINE ARTS COMMISSION NEWS. 1988. q. EN. **1844**
Maine Arts Commission, Station No. 25, 55 Capitol St., Augusta, ME 04333. Phone 207–289–2724. Dick Dyer, Editor.
Subscription: free. Sample. No back issues. Illus. b&w, photos. 11 x 17, 8p.
Dewey: 700. Formerly: *Update & Perspective.*
General.

Arts related news from national and state sources of importance to Maine artists or arts sponsors.
Freelance work: occasionally. Contact: editor. Opportunities: employment, study, competitions.
Advertising: none. Circulation: 2,500. Audience: artists and arts organizations.

MICHIGAN COUNCIL FOR THE ARTS. LEGISLATIVE REPORT. a. EN. **1845**
Michigan Council for the Arts, 1200 Sixth Ave., Detroit, MI 48226. Phone 313–256–3731.
Subscription: free.
Dewey: 340.
Spotlights laws and legislating relating to art.

NEW HAMPSHIRE ARTS. 1984. q. EN. **1846**
State Council on the Arts, 40 N. Main St., Concord, NH 03301. Phone 603–271–2789. Rebecca Lawrence, Editor.
Subscription: free.
Dewey: 700. Formerly: *Artsheaf.*
Tabloid.
Reviews: book.

NEWORLD. 1974. bi–m. EN. **1847**
Inner–City Cultural Center, 1309 S. New Hampshire Ave., Los Angeles, CA 90006. Phone 213–387–1161. Fred Beauford, Editor.
Subscription: $7.50 (6331 Hollywood Blvd., Suite 624, Los Angeles CA 90028).
Formerly: *New World Quarterly of the Inner–City Cultural Center.*
"The multicultural magazine of the arts".
Reviews: book.
Advertising.

IL NONCELLO: Rivista d'Arte e di Cultura. 1950. s–a. IT.
Societa di Cultura per Il Friuli Occidentale, Via Montello 99, 33170 Pordenone, Italy. Daniele Antonini, Editor.
Subscription: L 2500. Illus.
ISSN: 0029–1080. OCLC: 7231311. LC: DG975.F85N65. Dewey: 945.
Specializes in the arts of the Italian Province of Udine.

ONTARIO ARTS COUNCIL ANNUAL REPORT. 1963. a. EN & FR.
Ontario Arts Council, Suite 500, 151 Bloor St. W., Toronto, Ontario M5S 1T6, Canada. Phone 416–961–1660. Adrian Mann, Editor.
Dewey: 700.

RADIUS: RESOURCES FOR LOCAL ARTS. 1979. bi–m. EN.
Rural Arts Services, P.O. Box 1547, Mendocino, CA 95460. Phone 916–447–7811. Ken Larsen, Editor.
Subscription: $15. Illus. b&w. 8½ x 11, 16p.
ISSN: 0886–7771. OCLC: 12998691. Formerly: *ARC: The Rural Arts Newsletter.*
Provides articles and information for community arts groups and rural artists including news of funding and research.
Reviews: book. Biographies: profiles of artists and groups. Listings: national. Freelance work: yes. Opportunities: to exhibit and to publish.
Advertising. Audience: rural artists and community arts groups.

SARASOTA MAGAZINE. 1979. 10/yr (Oct–July). EN.
Clubhouse Publishing, Inc., Box 3312, Sarasota, FL 34230. Phone 813–366–8225.
Subscription: $18 US. No sample. Back issues $3. Illus. color, some b&w, cartoons. 150p.
Formerly: *Clubhouse.*
General.

City magazine for culturally oriented resort area. Chronicles the community's lifestyle and doings.
Reviews: book. Listings: regional. Calendar of events. Exhibition information. Freelance work: yes. Contact: editor. Opportunities: study – workshops.
Advertising, mainly color. Bobbie Costello–Cook, Ad. Director. Mailing lists: none. Circulation: 13,000.

SEATTLE ARTS. 1978. m. EN.
Seattle Arts Commission, 305 Harrison St., Seattle, WA 98109. Phone 206–684–7171. Jack Duggan, Editor.
Subscription: free. Back issues (may be xerox copies). Illus. b&w, photos. Annual index. 11 x 17 tabloid, 4–12p.
Dewey: 700. Formerly: *Seattle and King County Arts Commission Newsletter.*
Art Education. Art History. Ceramics. Crafts. Decorative Arts. Drawing. Films. Graphic Arts. Landscape Architecture. Modern Art. Painting. Photography. Sculpture. Textiles.

Published as an official record of the Commission and to inform artists, the arts community and the general public about opportunities and activities of the Commission.
Listings: national except calendar. Calendar for SAC sponsored events only. Freelance work: rarely. Contact: editor. Opportunities: employment, study, competitions.
Advertising: none. Mailing lists: available to 501(c)3 non–profits only, subject to approval for purpose; cost of printing; one–time use only. Circulation: 7300 direct mail; 2400 City delivered. Audience: arts community, general public.

SFC: Going Places with the Arts. 1987? s–a. EN.
Santa Fe Gallery, 200 Old Santa Fe Trail, Santa Fe, NM 87501. Phone 505–988–3103. Alma S. King, Editor.
Subscription: $5 US, $7 Canada, $10 foreign. Back issues. Illus. mainly color, some b&w, photos. 8½ x 11, 32p.
Art. Performing Arts.

Publication of arts and living in Santa Fe featuring artists, performing arts, cultural events, museums.
Reviews: exhibition. Interviews. Listings: regional.
Advertising.

SITE SOUND: Art Galleries/Theatre/Music, London/Southwestern Ontario. 1988. 10/yr. EN.
Society for the Advancement of Regionalism in the Arts, P.O. Box 23015, City Centre Mall, London, Ontario N6A 5N9, Canada. Phone 519–432–9211, fax 519–663–9096. Robert McKenzie, Editor.
Subscription: $15. Illus.
ISSN: 0843–8838. OCLC: 20279185. LC: NX120. Dewey: 700.9713.

General. Art. Music. Theater.

Advertising.

SOUTH CAROLINA ARTS COMMISSION ANNUAL REPORT. 1968. a. EN.

1855

Arts Commission, 1800 Gervais St., Columbia, SC 29201. Phone 803–734–8696. Jayne Darke, Editor.
ISSN: 0081–2684. Dewey: 700.

SOUTHERN ARTS ASSOCIATION. PUBLICATION. 1980. irreg. EN.

1856

Southern Arts Association, 19 Southgate St., Winchester, Hants. SO23 9DQ, England.
Subscription: free. Illus.
Dewey: 700. Formerly: *Southern Arts Bulletin.*

Purpose is the maintenance, improvement and development of artistic performance, taste and knowledge.

STAGES: Magazine of the Victorian Arts Centre Magazine. 1982. m. EN.

1857

Victorian Arts Centre Trust, 100 St. Kilda Rd., Melbourne, Victoria 3004, Australia. Phone 03–617–8211. Michael Kaye, Editor.
Subscription: $A74 US & Canada, foreign air $A80 Europe, $A68 Asia. Sample. Back issues $A3.50. Illus. b&w, color, photos, cartoons. A4, 32p.
ISSN: 1033–3975. Formerly: *Victorian Arts Centre Magazine.*
General. Films. Modern Art. Photography. Performing Arts.

Brings together top arts writers with lively and entertaining news and features on all that's happening at the Centre and behind–the–scenes in music, drama, ballet, opera and the visual arts.

Interviews: performing artists, directors visual artists. Biographies: musicians, opera singers, actors, dancers. Listings: regional–national. Calendar of events. Exhibition information. Freelance work: yes. Contact: editor. Opportunities: study, competitions.

Advertising: full page $A600, ½ page $A480, ¼ page $A290; color full page $A800, ½ page $A650. Frequency discount. Harry Black, Ad. Director (526 Punt Rd., South Yarra, Melbourne, Victoria). Mailing lists: available. Demographics: 25–54 yrs. Circulation: 5,000. Audience: performing/visual arts.

TENNESSEE ARTS REPORT. 1980, v.12. q. EN.

1858

Tennessee Arts Commission, 320 Sixth Ave. N., Suite. 100, Nashville, TN 37219. Phone 615–741–1701. Brenda Nunn, Editor.
Subscription: free. Sample. Illus. b&w, photos. 11 x 17, 8p.
OCLC: 6727452. LC: N1.T46.
General.

Reports on the activities of the Tennessee Arts Commission and major arts happenings in Tennessee.

Listings: state. Exhibition information. Freelance work: yes (paste up only). Contact: editor. Opportunities: study & competitions, state, regional & national.

Advertising: none. Mailing lists: available, contact Assistant Director Rich Boyd. Circulation: 3600. Audience: anyone interested in the arts in Tennessee.

VENUE MAGAZINE. 1982. fort. EN.

1859

D.A. Templeton, 37–39 Jamaica St., Bristol BS2 8JP, England. Phone 0272–428491, fax 0272–420369. D. Higgitt, Editor.
Subscription: £34.50 all. No sample. Back issues. Illus. 297 x 210mm.
Formerly: *Out West.*
Art. Theater.

"Bristol & Bath's biggest whats on guide".
Reviews: book.
Advertising: (rate card Apr '88): [+ VAT] full page £395, ½ page £195, ¼ page £110, cover £400–490; full color back cover only, full page £650. Guaranteed position + 10%. Frequency discount. 10% agency discount. Circulation: 18,000. Audience: Bath and Bristol.

VIEW. q. EN.

1860

Michigan Council for the Arts, 1200 Sixth Ave., Detroit, MI 48226. Phone 313–256–3731.
Dewey: 700.
General.

YORKSHIRE ARTSCENE. 1970. 10/yr. EN.
Yorkshire Arts, Glyde House Association, Glyde Gate, Bradford BD5 0BQ, England. Phone 0274–723051, fax 0274–394919.
Tony Phillips, Editor.
Subscription: free. Illus.
Dewey: 700. Formerly: *Arts Yorkshire*.
General.

Literary & Art Anthologies

AILERON. 1980. s–a. EN. 1862
Aileron Press, Box 891, Austin, TX 78767–0891. Edwin Buffaloe & Michael Gilmore, Editors.
Art. Literature. Photography.

A literary journal which includes art and photography.

ALTERNATIVE PRESS. 1969. 3/yr. EN. 1863
3090 Copeland Rd., Grindstone City, MI 48467. Ann Mikolowski & Ken Mikolowski, Editors.

AMACADMY. a. EN. 1864
American Academy in Rome, 41 E. 65th St., New York, NY 10021–6508. Phone 212–535–4250. Calvin G. Rand, Editor.
Illus. b&w, photos. 11 x 14, 18p.
Newsletter of the Academy.

AND: Journal of Art & Art Education. 1989. irreg. EN. 1865
Writers Forum, 10 Swanfield St., London E2 7DS, England. Phone 071–739–7380. Jenni Boswell–Jones & Ismail Saray, Editors.
Subscription: £4.50 UK, £6.50 Europe, elsewhere £10. Back issues. Illus. b&w, photos, many full page. 9½ x 12, 64p.
ISSN: 0266–6057.
Art Education. Poetry.

Covering experimental poetry and performance art, the purpose is "to continue to bring forward the challenge of artists against the dangerous illogic of isolated individualism. Challenge...arts into its proper role as a component of revolutionary dynamics". General articles plus an educational section.
Reviews: exhibition. Indexed: ArtBibMod.
Advertising: none.

ANEMONE. 1979. q. EN. 1866
Anmone Press, Inc, Box 369, Chester, VT 05143. Phone 802–885–3985. Nanette Morin, Editor.
Subscription: $10. Sample $2.50. Back issues $3. Illus. 10 x 15, 28p.
ISSN: 8756–7709. OCLC: 11652646. LC: PN4878.5.A53.
Art. Literature. Photography.

Presents poetry, fiction, articles, art, photos, interviews and critical reviews.
Reviews: book. Freelance work: yes (details in *ArtMkt*.). Contact: editor.
Advertising. Circulation: 5,000.

L'APACHE. 1986. q. EN. 1867
William Ellis Jackson, Drawer G, Wofford Heights, CA 93285. Kathryn Vilips, Editor.
Subscription: $18 US, foreign $25. Illus.
Art. Literature.

An international journal of literature and art.

APPEARANCES. 198? 3/yr. EN. 1868
The Print Center, 165 W. 26th St., New York, NY 10001. Phone 212–675–3026. Robert Witz and Joe Lewis, Editors.
Subscription: $15, foreign $20. Illus. b&w, photos. 8½ x 11¼, 64p. glossy.

ISSN: 0884–2213. OCLC: 12226088. LC: NX504.A7.

Modern Art. Literature.

Sponsored in part by the New York State Council on the Arts. Contains poems, painting, sculpture, photos, and stories. Illustrations include title, size, date, photo credit, and medium.

Advertising: none.

ARIEL: A Review of Arts and Letters in Israel. 1962. q. EN, FR, GE & SP editions. 1869

Jerusalem Post Publications Ltd., P.O. Box 3349, Jerusalem 91002, Israel. Phone 02–551616. Asher Weill, Editor.

Subscription: $19 [V.A.T. included] Israel; elsewhere $27 [V.A.T. included] sea mail. Microform available from UMI. Illus. b&w, some color, photos. Cum. index 1970–1981 (1984, 44p.). 6¼ x 9, 192p.

ISSN: 0004–1343. OCLC: 1514045. LC: AP8.A68. Dewey: 052. Formerly: *Cultural Events*.

Art. Literature.

Covers both art and literature. Extensive illustrations accompany articles.

Reviews: book 1–2, length 3p. Reviewed: *Times Literary Supplement*, 4283, May 3 1985, p.496.

Advertising: none.

ART AND POETRY TODAY. 1976. q. EN. 1870

Samkaleen Prakashan, 2762 Rajguru Marg, New Delhi 110055, India. Phone 523520. Krisman Khullar, Editor.

Subscription: Rs 80 inland; overseas $US24, $32 air. Microform available. Sample, postal charges. Back issues available as photostat only, cost charges. Illus. b&w, photos. 20p.

ISSN: 0970–1001. OCLC: 5817473. LC: NX456.A68. Dewey: 700. Formerly: *Criteria*.

General. Drawing. Modern Art. Poetry.

Highlights poetry and art from various countries. Contains graphics, drawings, paintings and photographs of sculptures. Presents translations of Hindi and Bengali poets, a number of Indo–English poets, guest poets from other countries, and essays on criticism of art and the role of the artist. Presents book reviews of poetry and art published worldwide in English and Hindi languages.

Reviews: book. Interviews: occasionally. Listings: international. Calendar of events and book fairs.

Advertising appear in EN & HI; full page Rs 500, ½ page Rs 300. Mailing lists: available. Circulation: 1800.

ART/LIFE: Communication for the Creative Mind. 1981. m. (except Jan). EN. 1871

P.O. Box 23020, Ventura, CA 93002. Joe Cardella, Editor & Pub.

Subscription: $450, outside US + $7/issue air. Limited back issues, $50 each. Illus. color. 8½ x 11.

ISSN: 8756–0895. OCLC: 11464055. LC: N1.A72.

Modern Art. Poetry.

Published in limited edition on colored paper with attachments included. Mainly original art works in all mediums, some poetry.

Freelance work: Visual artists and poets wishing to exchange their works with other artists and kindred spirits internationally should send 200 signed, high quality reproductions, originals or proofsheets. All mediums. Contributors will receive a copy of the issue in which their work appears.

Demographics: New York, Los Angeles, San Francisco & Chicago, Europe and Japan.

ARTEXTREME. 1982. 2/yr. EN. 1872

P.O. Box 18039, Philadelphia, PA 19147. Edward Waisnis, Editor & Pub.

Subscription: No subscriptions, $2/issue US, foreign rates on request. Available at fine bookstores or direct mail. Sample. Illus. b&w, mostly drawings, photos, cartoons. 7 x 8½, 30p.

ISSN: 0278–3827.

Art. Drawing. Graphic Arts. Poetry.

Contains drawings and poetry.

Freelance work: yes. Contact: editor.

Advertising: full page $400, ½ page $200, ¼ page $100, no color. No classified. Kristine Cesare, Ad. Director. Mailing lists: none. Circulation: 500. Audience: artists and scholars.

ARTSCAPE: Poems, Prose and Drawings by Southwestern Oregon Writers and Artists. 1991. s–a. EN. 1873

Port Orford Arts Council, P.O. Box 771, Port Orford, OR 97465.

Illus.

OCLC: 23921886. LC: PS570.A77.
Art. Literature.
"The literary and arts magazine of the southern Oregon coast".

ATHENA INCOGNITO MAGAZINE: A Journal of Surrealistic Writing. 1980. a. EN. **1874**
Athena Press, 1442 Judah St., San Francisco, CA 94122. Phone 415–665–0219. Ronn Rosen & Chris Custer, Editors.
Subscription: $4 US, $6 Canada & foreign. Back issues. Illus. b&w, cartoons. 8½ x 11, 60p.
Formerly: *Scops and Bards, RAA.*
Drawing. Graphic Arts. Poetry. Prose.

Avante–garde and/or experimental art and writing of all sorts.
Reviews: book 2, length 1p. Interviews: occasionally with artists. Listings: national–international. Freelance work: yes. Contact: editor.
Advertising: full page $20, ½ page $10, ¼ page $5. No frequency discount. Mailing lists: none. Circulation: 1200. Audience: all openminded people.

AURORA: Jahrbuch der Eichendorff–Gesellschaft. 1953. a. GE. GE & EN summaries. **1875**
Jan Thorbecke Verlag, Postfach 546, D–7480 Sigmaringen, W. Germany. Phone (07571)3016.
Illus.
ISSN: 0341–1230.
Yearbook of the Eichendorff Society.

AUSGABE: Ein Kunst– und Literaturmagzin. 1976. a. GE. **1876**
Bruesseler Strasse 29, D–5000 Cologne 1, W. Germany. Phone 221–23 79 44, fax 221–24 91 46. Armin Hundertmark, Editor & Pub.
Subscription: DM 20. 21 x 15 cm., 100–160p.
General. Drawing. Films. Graphic Arts. Modern Art. Photography. Literature—Poetry.

An art and literature magazine.
Advertising: full page DM 150.

AVANT GARDE: Revue Interdisciplinaire et Internationale des Arts et Litteratures du XXe Siecle. 1988. 3/yr. EN, FR, & GE. **1877**
Editions Rodopi B.V., Keizersgracht 302–304, 1016 EX Amsterdam, The Netherlands. Phone 020–227507. Fernand Drijkoningen, Editor.
Subscription: fl.35 individual, fl.100 institution. Illus.
ISSN: 0921–2515. OCLC: 17858783.
Art. Literature.

Presents research in avant–garde modernism and post–modernism. Covers both literature and art. Each issue has a distinctive title.

BIRTHSTONE. 1975. irreg. EN. **1878**
Birthstone Magazine, c/o Dan Brady, Ed., 1319 6th Ave., San Francisco, CA 94122.
Reviews: book.

BLAC. irreg. AF & EN. **1879**
Black Literature and Arts Congress, 1 Long St., Mowbray, South Africa.
Dewey: 910.03.

CALYX. See no. 707.

CHICAGO RENAISSANCE. 1976. a. EN. **1880**
Natural Resources Unlimited, 3531 Roesner Dr., Markham, IL 60426. Joe H. Mitchell, Editor.
Dewey: Presents literary and photographic works.
Photography. Literature.

CLOCKWATCH REVIEW. 1983. 2/yr. EN. 1881
Driftwood Publications, 737 Penbrook Way, Hartland, WI 53029. Phone 414–367–8315. James Plath, Editor (Dept. of English, Illinois Wesleyan University, Bloomington, IL 61702, phone 309–556–3352).
Subscription: $8. Illus. 5½ x 8½),48*p.*
ISSN: 0740–9311. OCLC: 10047741.
Art. Poetry.
A not–for–profit journal of the arts.
Reviews: book. Freelance work: yes, manuscripts and art.
Advertising.

COLORADO-NORTH REVIEW. 1974. 3/yr. EN. 1882
University of Northern Colorado, University Center, Greeley, CO 80639. Phone 303–351–1333. Colette E. Strassburg, Editor.
Subscription: $6 US, $7 Canada, Mexico & UK. Back issues. Illus. 5 ½ x 8½, 66p.
ISSN: 0194–0589. OCLC: 4455867. LC: PS1.C63. Dewey: 810.
Art. Photography. Literature.
Contents consist of visual art, poetry, and short fiction.
Freelance work: invites contributions of two–dimensional visual art including photography. Contributors receive 2 free copies of issue in which their work appears.
Advertising. Circulation: 2500.

CROSSCURRENT. 1972. q. EN. 1883
Outrigger Publishers Ltd., P.O. Box 13–049, Hamilton, New Zealand. Norman Simms, Editor.
Back issues. Illus.
Incorporates: *Rimu; formerly: Pacific Quarterly Moana; New Quarterly Cave; Cave.*
Art. Literature.
Reviews: book.
Advertising. Audience: $38 individuals, $46 institutions.

ETHOS. 1983. q. EN. 1884
Ethos Cultural Development Foundation, 316 Dupont St., Toronto, Ontario M5R 1V9, Canada. Janis Rapoport, Editor.
Illus.
ISSN: 0714–0339. OCLC: 9951369. LC: C810.
Art. Literature. Photography.
Advertising.

EX UMBRA. 1963. 3/yr. EN. 1885
North Carolina Central University, c/o Student Union, Durham, NC 27707. Phone 919–683–6486.
Illus.
ISSN: 0014–3944. OCLC: 3246359.
"The magazine of the arts".

EXPANSIONS: Collective Black Artists' Newsletter. 1973. q. EN. 1886
Collective Black Arts, Inc., 157 W. 57th St., New York, NY 10019. Phone 212–245–7711. Kenneth A. Smikle, Editor.
Illus.
Art. Literature.

FORUM DER LETTEREN: Tijdschrift Voor Taal– en Letterkunde. 1960. q. 1887
Nederlandse Organisatie voor Zuiver–Wetenschappelijk Onderzoek, c/o Smits B.V., Westeinde 135, 2512 The Hague, Netherlands.
Subscription: fl 53.33.
ISSN: 0015–8496. LC: PN9. Dewey: 800. Formerly: *Museum.*

FRANK. 1983. s–a. EN. 1888
Frank Books, B.P. 25, F–94301 Vincennes Cedex, France. Phone 43–65–64–05. David Applefield, Editor.
Subscription: 150Findividual, 250F institution. Illus.

ISSN: 0738–9299. OCLC: 9689986. LC: PN771.F72. Dewey: 700.

Modern Art. Literature.

An international journal of contemporary writing and art. Presents works by both new and established artists.
Advertising. Circulation: 4,000.
Reviews: book. Interviews.

GNOME BAKER. 1972. s–a. EN. 1889

Tongue Press, Box 337, Great River, NY 11739. Madeleine Burnside & Andrew Kelly, Editors.
Back issues.

Art. Literature.

THE GREEN BOOK. 1987. q. EN. 1890

The Green Book, 49 Park St., Bristol BS1 5NT, England. Phone 0272–290158. Keith Spencer, Editor.
Subscription: $34 US & Canada. Sample £3.95 + postage. Back issues £3.50 + postage. Illus. b&w, color, photos. 6½ x 9½, 85p.
ISSN: 0265–0088.

Drawing. Modern Art. Painting. Sculpture.

A quarterly review of the visual and literary arts.
Reviews: book, poetry. Interviews. Freelance work: yes. Contact: editor. Indexed: ArtBibMod.
Advertising: full page £225, ½ page £135, ¼ page £95.; color full page £400, ½ page £275, ¼ page £175. Frequency discount. Richard Gundry, Ad. Director. Circulation: 2500. Audience: art/poetry reader.

HARVESTER. 1972. a. EN. 1891

Lincoln Land Community College, Humanities Division, Shephard Rd., Springfield, IL 62708. Phone 217–786–2200. Marcel E. Pacatte, Sr, Editor.
Back issues.

ICARUS. 1950. irreg., 3/yr. EN. 1892

University of Dublin, Regents House, Trinity College, Dublin, Ireland.
Subscription: $20.
ISSN: 0019–1027. OCLC: 3296329.

IMPULSE. 1971. q. EN. 1893

Impulse Society for Cultural Presentations, 16 Skey Lane, Toronto, Ontario M6J 3S4, Canada. Phone 416–537–9551. Eldon Garnet, Executive Editor.
Subscription: $24 individual, $36 institution US; $40, $64 Canada; foreign $28, $44 surface; $48, $80 air. Microform available from Micromedia. Available online – Canadian Business & Current Affairs. Illus. b&w, color, photos. 8½ x 11, 75–100p. Sheetfed offset.
ISSN: 0315–3694.

General. Architecture. Theater.

Internationally recognized magazine of arts and culture. Editorial mandate has been to publish primary works by artists, representing new Canadian fiction and international fiction in translation, interviews with filmmakers, philosophers, architects and other cultural producers, together with in–depth essays and works by established and emerging artists. The artworks have been created specifically for the journal. *Impulse* treats its advertising with the same eye to strong visual impact in keeping with the general aesthetic sensibility of the magazine. Since 1987 expanded to also include photography, architecture, visual arts, theater, fashion, and general cultural analysis.
Freelance work: yes. Contact: editor. Indexed: ArtBibMod. CanMagI.
Advertising: full page $700, ½ page $400, ¼ page $250; covers b&w $1000–2000, 4 color $1200–2000. Frequency discount. Mailing lists: none. Demographics: Distributed in Canada, the U.S., Europe, Japan and Australia. Circulation: 5000.
Audience: arts and literary community.

IRON. 1973. 3/yr. EN. 1894

Iron Press, 5 Marden Terrace, Cullercoats, North Shields, Tyne & Wear NE30 4PD, England. Phone 091–253–1901. Peter J.G. Mortimer & I.A.M. McMillan., Editors.
ISSN: 0140–7597.

ISHMAEL. s–a. EN.　　　　　　　　　　　　　　　　　　　　　　　　　　1895
Brown University, Box 1947, Providence, RI 02912. Phone 401–863–1000. Bruce B. Redford & Jane Kallir, Editors.
Dewey: 810.
Art. Literature.

Co–sponsored by the Rhode Island School of Design.

KALDRON: A Journal of Visual Poetry & Language Art. 1976. irreg. EN.　　1896
Box 7164, Halcyon, CA 93420. Karl Kempton, Editor & Pub.
Subscription: $5. Illus. 11½ x 17½, 24p.
OCLC: 9690286. LC: PN6110.V56K35x.
Modern Art. Poetry.

Tabloid. Covers visual poetry from around the world.

KALEIDOSCOPE: International Magazine of Literature, Fine Arts, and Disabilities. 1979. s–a. EN.　1897
Kaleidoscope Press, United Cerebral Palsy and Services for the Handicapped, 326 Locust St., Akron, OH 44302. Phone 212–762–9755. Darshan Perusek, Editor.
Subscription: $9 individual, $12 institution, + $5 Canada & foreign, + $8 air. Sample $2. Back issues $3. Also available on audio cassette through the Braille Institute. Illus. b&w, color (cover only), photos. 8½ x 11, 58–64p.
ISSN: 0748–8742. OCLC: 10224877. LC: PS153.P48. Dewey: 810.8.
Art Education. Drawing. Modern Art. Sculpture. Disability.

Addresses the experience of disability through literature and the fine arts. Provides realistic, thought–provoking images of people with disabilities and adamantly avoids the sentimental and the tried. Part of the emerging field of disability studies.
Reviews: generally of anthologies that deal with the experience of disability, 2/issue. Biographies: profiles of writers or artists with disabilities that emphasize how they do their craft. Freelance work: yes. Contact: Gail Willmott, Senior Editor (details in *ArtMkt.*). Reviewed: Katz. *Serials Review* 13:3, Fall 1987, p.54. *Serials Review* 11:2, Sum 1985, p.16–17.
Advertising: No paid ads, exchange basis only. Circulation: 1500. Audience: people with disabilities, rehabilitation professionals, anyone interested in fine arts and literature.

KUNST UND LITERATUR: Zeitschrift fuer Fragen der Aesthetik und Kunsttheorie. 1953. m.
　GE.　　　　　　　　　　　　　　　　　　　　　　　　　　　　　　　　　1898
Verlag Volk und Welt, Glinkastr. 13–15, 1086 Berlin, E. Germany.
Subscription: M 30. Illus.
ISSN: 0023–544X. OCLC: 1924742. LC: N3.S58. Dewey: 700.
Art. Literature.

Journal of questions on aesthetics and art theory.
Indexed: ArtBibCur. ArtBibMod.

LEGACY. 1984. s–a. EN.　　　　　　　　　　　　　　　　　　　　　　　1899
Trevecca Nazarene College, 333 Murfreesboro Rd., Nashville, TN 37203. Phone 615–248–1200. Scott A. Stargel, Editor.
Subscription: free. Illus.

LETTER AMONG FRIENDS. 1977. 3/yr. EN.　　　　　　　　　　　　　　1900
Letter Among Friends, Box 1198, Groton, CT 06340. Stratton, Editor.
Art. Poetry.

A magazine of poetry and art.
Reviews: book.
Advertising.

LOST GENERATION JOURNAL: Americans in Paris in the Twenties and Thirties. 1973. s–a.
　EN.　　　　　　　　　　　　　　　　　　　　　　　　　　　　　　　　1901
Rural Route 5, Box 134, Salem, MO 65560. Phone 314–265–8594. Dr. Thomas and Deloris Wood, Editors.
Subscription: $8 each. Back issues. Illus.
ISSN: 0091–2948. OCLC: 1786705. LC: NX504.L67. Dewey: 700.
American writers, performers, and artists in Europe, chiefly in Paris, from 1919–1939.
Reviews: book, film.

MAGIC CHANGES. 1979. a. EN. 1902
Celestial Otter Press, 25424 Emerald Green Dr., No. F, Warrenville, IL 60555–9269. Phone 312–393–7856. John Sennett, Editor.
Subscription: $5 US & Canada, foreign $7, air $8. Sample & back issues $5. Illus. b&w, color, photos, cartoons. 8½ x 11, 100p.
ISSN: 0196–8432. OCLC: 5912951.
General. Drawing. Films. Graphic Arts. Modern Art. Photography. Sculpture. Literature.

Theme oriented publication with focus on literary and visual arts, natural and urban settings, and fantasy and the supernatural. Reviews: book 3, length to 1,000 wds.; exhibition 1, length to 750 wds.; film 2, length to 750 wds. Listings: regional. Calendar of exhibitions. Freelance work: yes, need good drawings, send SASE for current themes. Contact: editor. Opportunities: competitions.

Advertising: full page $90, ½ page $47, ¼ page $25. Classified: 10¢/wd. Inquire for color rates. Frequency discount. Mailing lists: none. Circulation: 250. Audience: artistically minded.

MALLIFE. 1981. s–a. EN. 1903
Bomb Shelter Propaganda, Box 12268, Seattle, WA 98102. Mike Miskowski, Editor.
Subscription: $10. Sample $2.97. 5 1/2 x 8 1/2, 60p.
ISSN: 0888–0972. OCLC: 13518844. Dewey: 760.
Art. Photography. Literature.

Poetry, fiction, art, photography and news. "Concise works focusing on the Comsumerist Tradiion," both in form and content. Includes 1 audio tape issue each year.
Reviews: book. Freelance work: yes.
Advertising. Circulation: 300.

THE MANILA REVIEW: The Philippine Journal of Literature and the Arts. 1974. q. EN. 1904
Department of Public Information, c/o Bureau of National and Foreign Information, U P L Building, Box 3396, Intramuros, Manila, Philippines. Gregorio C. Brillantes, Editor.
Illus.
ISSN: 0115–205X. OCLC: 2038884. LC: NX1.M34. Dewey: 700.
Art. Literature.

THE MERVYN PEAKE REVIEW. 1976. s–a. EN. 1905
Mervyn Peake Society, The Studio, 43 Bond St., Ealing, London W5 5AS, England. Phone & fax 081–567–9307. Brian Sibley, Editor.
Subscription: included in membership. Microform available from UMI. Back issues. Illus.
ISSN: 0309–1309. OCLC: 5458099. LC: PR6031.E183Z77a. Dewey: 741. Formerly: *Newsletter – Mervyn Peake Society.*
Art. Literature.

Society exists to promote wider understanding and appreciation of the work of Mervyn Peake, the British writer and illustrator, through the establishment of a responsible corpus of critical opinion.
Freelance work: yes. Contact: editor.

MUDFISH TWO. 1983. a. EN. 1906
Box Turtle Press, 184 Franklin St., New York, NY 10013. Phone 212–219–9278.
Formerly: *Mudfish (Year).*
Modern Art. Poetry.

A forum for contemporary art and poetry.

THE NEW RENAISSANCE. 1968. s–a. EN. 1907
Friends of the New Renaissance, Inc., 9 Heath Rd., Arlington, MA 02174. Phone 617–646–0118. Louise T. Reynolds, Editor.
Illus.
ISSN: 0028–6575. OCLC: 2290784. LC: NX1.N48. Dewey: 700.
Art. Literature.

An international magazine of ideas and opinions, emphasizing literature and the arts. Presents fiction, poetry, art, and essays. Reviews: book. Indexed: Index.

NEW VIRGINIA REVIEW. 1979. a. EN. 1908
New Virginia Review, Inc., 1306 E, Cary St., Suite 2A, Richmond, VA 23219. Phone 804–782–1043.
Illus.
ISSN: 0163–2299. OCLC: 4320580. LC: PS558.V5N48. Dewey: 810.
"An annual anthology of Virginia literary and visual works".

NORTHWARD JOURNAL. 1979. q. EN & FR. Includes some text in various native languages. 1909
Penumbra Press, 439 Wellington St. West, 3rd Floor, Toronto M5V 1E7, Canada. Robert Stacey, Editor.
Microform available from Micromedia. Illus. b&w, photos, cartoons. 8½ x 7½, 96p.
ISSN: 0706–0955. OCLC: 5528418, 16854445. LC: NX1.N67x. Dewey: 700. Formerly: *Boreal*.
Drawing. Literature.

"A quarterly of Northern Arts" published with assistance from The Canadian Council and the Ontario Arts Council. In 1987 the journal received the Art Library Society of North America's George Wittenborn Award of Excellence for publishing art historical documents.
Reviews: film. Biographies: articles. Also, brief 1–2 sentences on each contributor. Freelance work: correspondence, manuscripts and artwork dealing with the North and Northern art and literature are invited. Contact: editor.

PAN-EROTIC REVIEW. 1989. q. EN. 1910
Red Alder Books, Box 2992, Santa Cruz, CA 95063. Phone 408–426–7082. David Steinberg, Editor.
Subscription: $30 US. No sample. No back issues. Illus. b&w, photos. 5½ x 8½, 224p, Smyth sewn and hand bound.
ISSN: 0896–2898. OCLC: 16990201.
Collectibles. Drawing. Films. Modern Art. Photography.

A survey of quality, non–exploitive, non–pornographic erotica, including reviews, photography, short fiction, artwork of various media.
Reviews: exhibition, book, film. Bibliographies: new erotica, each issue. Listings: national. Calendar of events. Exhibition information. Freelance work: yes. Contact: editor.
Advertising: none. Audience: general.

PARAGONE: Rivista Mensile di Arte Figurativa e Letteratura. 1950. m. IT. 1911
Casa Editrice G. C. Sansoni Editore Nuova S.p.A., Via Benedetto Varchi 47, 50132 Florence, Italy. Cesare Garboli & Mina Gregori, Editors.
Subscription: L 300000. Illus., some color, plates.
ISSN: 0031–1650. OCLC: 1642907. LC: N4.P37; PN5.P3.
Reviews: book. Indexed: ArtHum. ArtI. BHA. CurCont. RILA.

PERPJEKJA E JONE/OUR EFFORT. 1970. s–a. EN. 1912
Albanian American Islamic Center New York – New Jersey, 2 Lourae Dr., Massapequa Park, NY 11762. Dr. Fejzi I. Domni, Editor.
Illus.

PERSPECTIVE. m. EN. 1913
Pakistan Publications, Box 183, Shahrah Iraq, Karachi 1, Pakistan. M. R. Siddiqui, Editor.
Dewey: 800.

PRATIBHA INDIA. 1981. q. EN tr. from various Indian languages. 1914
B–2, I.P. Staff Flats, Shamnath Marg, Delhi 110 054, India. Phone 292 7815. Aruna Sitesh & Sitesh Aloke, Editors.
Subscription: Rs 50, $15 North America. Illus.
"Journal of Indian art, culture and literature".

PROZA: Literary and Art Magazine. 1976. m. 1915
P.O. Box 969, Ramat Gan 52 109, Israel. Yossi Creme, Editor.
ISSN: 0334–4975.
Art. Literature.

PUBLIC ILLUMINATION MAGAZINE: International edition. 1979. irreg. EN. 1916
Bazzano Superiore, 29, 06049 Spoleto (PG) Italy. Zagreus Bowery, Editor.

Subscription: none, $1/issue, available in shops. Illus. green & white. 2¾ x 4½, 24p.
Dewey: 700.
Modern Art.

Specific theme for each issue deals with some aspect of contemporary art and poetry.

RAMPIKE MAGAZINE. 1979. bi–a. EN, some FR. 1917
Rampike, 95 Rivercrest Rd., Toronto, Ontario M6S 4H7, Canada. Phone 416–767–6713. Karl E. Jirgens, Editor.
Subscription: $16 US & Canada, foreign $18. Sample $8. Back issues. Illus. b&w, photos. Cum. index. 6 x 15, 80p.
ISSN: 0711–7646.
Contemporary Art. Contemporary Writing.

Published for the Ontario Arts Council. Contains contemporary art and writing as well as critical theory.
Reviews: book 30. Interviews: artists and writers of international scope. Listings: international. Calendar of events. Exhibition information. Freelance work: yes. Contact: editor. Opportunities: employment, study, competitions. Indexed: ArtBibMod. Advertising. Fausto Bedoya, Ad. Director. Circulation: 2000. Audience: artists, writers.

REVISTA CULTULUI MOZAIC. 1956. bi–m. EN, HE, RO, YI. 1918
Federatia Comunitatilor Evreiesti din Republica Socialista Romania, Str. Sf. Vineri nr.9, Bucharest, Rumania. Illus.
ISSN: 0034–754X. Dewey: 700.
Reviews: book.

SCORE: A Magazine of Visual Poetry. 1983. a. EN. 1919
Score Publications, 491 Mandana Blvd., No. 3, Oakland, CA 94610. Phone 415–268–9284. Craig Hill, Bill Di Michele & Laurie Schneider, Editors.
Subscription: $12 for 2 issues US, $14 Canada & foreign surface, air $20. Sample $6. Back issues. Illus. b&w, color. 8½ x 11, 36p.
Dewey: 808.81.
Graphic Arts. Printing. Literature.

Contains visual poetry and experimental texts from around the world. Focuses on the interface of verbal and visual media, blurring the boundaries between image and text, painting and poetry, and written language and abstract art. Some original art work hand glued on paper.
Reviews: book 1–2, length 1–4p. Freelance work: yes. Contact: Bill Di Michele (2390 Lake Meadow Circle, Martinez, CA 94553).
Advertising: none. Circulation: 200. Audience: artistic poets.

THE SIGNAL: Network International. 1987. s–a. EN. 1920
Box 67, Emmett, ID 83617. Phone 208–365–5812.
ISSN: 1040–4724. OCLC: 18426008. Dewey: 810.
Reviews: book.

SKETCH. 1935. s–a. EN. 1921
Iowa State University, Government of the Student Body, Memorial Union, 203 Ross Hall, Ames, IA 50010. Phone 515–232–2477.
Subscription: $3.
Dewey: 378.198.
Art. Photography. Literature. Poetry.

Student publication consists of poetry, prose, photography and artwork.

SPHINX. See no. 721.

STAFFRIDER MAGAZINE. 1978. ireg. EN. 1922
Ravan Press Pty. Ltd., P.O. Box 31134, Braamfontein 2007, South Africa. Chris Van Wyk, Editor.
ISSN: 0258–7211.
Advertising.

WASHINGTON REVIEW: Art and Architecture. 1975. bi–m. EN.

Friends of the Washington Review of the Arts, Inc., Box 50132, Washington, DC 20004. Phone 202–638–0515. Clarissa Wittenberg, Editor.

Subscription: $12 US, Canada + $6, foreign + $25. Microform available. Sample $2.50. Back issues, variable price. Illus. tabloid, 16 x 11¾, 32–40p. offset.

ISSN: 0163–903X. OCLC: 4526135. LC: NX1.W37. Dewey: 700. Formerly: *Washington Review of the Arts.*

Architecture. Ceramics. Crafts. Decorative Arts. Drawing. Films. Graphic Arts. Modern Art. Painting. Photography. Sculpture.

Journal of arts and literature including poetry, fiction, essays on the arts, and, original art work. One special issue on a single topic each year. Emphasis on arts in Washington, D.C.

Reviews: exhibition 6–10, book 2, film 0–1. Interviews: D.C. artists. Freelance work: yes. Contact: editor.

Advertising: (rate card Apr '89): (camera ready) full page $250, ½ page $175, ⅓ page $135, covers full page SS215–S275. Frequency discount. 15% agency discount. 20% discount for non–profit organizations and artists. Mary Swift, Ad. Director. Mailing lists: available. Demographics: Washington, D.C. area. Circulation: 1500–2000.

WHITEWALLS: A Journal of Language and Art. 1978. 3/yr. EN.

White Walls, Inc., Box 8204, Chicago, IL 60680. Phone 312–274–4699. Timothy Porges & Buzz Spector, Editors.

Subscription: $13 US, overseas $18, air $28. Illus. b&w, photos, most full page. 6¼ x 8½, 72p.

ISSN: 0190–9835. OCLC: 6741708. LC: N1.W49.

WhiteWalls supported in part by a grant from the Illinois Arts Council contains writings by visual artists together with illustrations of art.

Freelance work: yes. Contact: editor. Indexed: ArtBibMod. Reviewed: Katz. *New Art Examiner* 14:5, Feb 1987, p.19–20+.

Advertising: Laurie Palmer, Ad. Director. Circulation: 1,000.

WISCONSIN ACADEMY REVIEW. 1954. q. EN.

Wisconsin Academy of Sciences, Arts and Letters, 1922 University Ave., Madison, WI 53705. Phone 608–263–1692. Patricia C. Powell, Editor.

Illus.

ISSN: 0512–1175. OCLC: 1770019.

WITTENBERG REVIEW OF LITERATURE AND ART. 1976. a. EN.

Wittenberg University, Box 1, Recitation Hall, Springfield, OH 45501. Phone 513–327–6231. Marty Lammon and Jill Gassaway, Editors.

Illus.

ISSN: 0147–0868. OCLC: 3106041. LC: PS580.W57. Dewey: 811.5.

Art. Photography. Literature.

"Student funded–student edited" publication covering art, design, fiction, poetry, photography and other creative pursuits.

WOODROSE: Arts Today. 1980. irreg. EN.

Woodrose Editions, Box 2537, Madison, WI 53701. Phone 608–249–0959. Perry L. Peterson & Ann M. Hayes, Editors.

ISSN: 0272–6742. OCLC: 6885999.

Art. Literature.

Presents poetry and art.

Advertising.

YELLOW SILK. 1981. q. EN.

Verygraphics, Box 6374, Albany, CA 94706. Phone 415–644–4188. Lily Pond, Editor.

Subscription: $24 individual, $30 institution. Microform available from B&H. Sample $6. Illus. color, photos (15–20/issue, all by one artist).

ISSN: 0736–9212. OCLC: 8853950, 12772720 (microform).

Art. Literature.

Journal of erotic arts and literature. Erotica is defined in its widest sense as fine arts not pornography.

Reviews: book. Freelance work: yes (details in *ArtMkt.* and in *PhMkt.*). Reviewed: *Serials Review* 11:2, Sum 1985, p.19. *Utne Review* Jan/Feb 1987, p.81.

Advertising. Circulation: 15,000.

ZYZZYVA. 1985. q. EN.

Zyzzyva, Inc., 41 Sutter St., Suite 1400, San Francisco, CA 94104. Phone 415–255–1282. Howard Junker, Editor & Pub. Subscription: $20 US, $40 Canada, foreign $60 air. Sample $8. Back issues $10. Illus. b&w, photos. Cum. index, Winter 1988. 6 x 9, 136p.
ISSN: 8756–5633. OCLC: 11585815. LC: PS561.Z9.

Architecture. Drawing. Films. Graphic Arts. Modern Art. Photography. Printing.

A publication by West Coast writers and artists. Consists of reproduction of works on paper originally in black and white only. Presents mini–profiles of fine printers.

Biographies: in short story or poetry form — memoirs. Freelance work: yes. Contact: editor. Indexed: AmHumI. Reviewed: *Serials Review* 14:4, Win 1988, p.71. *Small Press Review* 7:6, Dec 1989, p.34. *Choice* 24:5 Jan 1986, p.736. *Times Literary Suplement* 4317, Dec 27, 1986, p.1+.

Advertising: full page $450, ½ page $275, ¼ page $150, no color. Frequency discount. No classified. Mailing lists: available. Circulation: 3500. Audience: intelligent, literate readers.

Architects - Association Publications

AIBC NEWSLETTER. 1981. bi–m. EN. **1930**
Architectural Institute of British Columbia, 970 Richards St., Vancouver, B.C. V6B 3C1 Canada. Phone 604–683–8588, Fax 604–683–8568. Nancy E. Woo, APR, Editor.
Subscription: included in membership. Sample free. No back issues. Illus. (rare), b&w, photos. 8½ x 11, 8+p, offset printed. Dewey: 720. Formerly: *News, Views and Reviews*.
Architecture.

Informs members of AIBC Council news, news of members, and professional development news.
Listings: regional–international. Calendar of events. Exhibition information. Freelance work: none. Opportunities: employment in classified ads; study – courses, seminars; competitions.
Advertising: full page $C300, ½ page $C150, ¼ page $C75, business card $30. Classified: $50/50 wds. to members. Camera–ready art only. Inserts. No frequency discount. Mailing lists: a directory of firms, $25. Demographics: sent to all registered architects, architects–in–training, associates, & affiliates throughout the province of British Columbia. Circulation: 1300 – 1400.

THE ARCHITECT (Malta). EN. **1931**
Crest Publicity Ltd., Britannia House, 9/4, Old Bakert St., Valleta, Malta. Phone 224876.
"The Journal of the Chamber of Architects & Civil Engineers".

DE ARCHITECT (Netherlands). 1970. m. DU only. **1932**
Ten Hagen B. V., Box 34, 2501 AG The Hague, Netherlands. Phone (070)924311. C. Zwinkels, Editor.
Subscription: fl 308. Illus. b&w, color, photos, plans. 8¼ x 11½, 110p.
ISSN: 0044–8621. Dewey: 720.
Architecture.

Covers architecture, building and construction.
Indexed: ArchPI. Avery.
Advertising. Audience: architects, interior designers, city planners.

ARCHITECT (South Melbourne, Australia. 1939. m. EN. **1933**
Royal Australian Institute of Architects, Victorian Chapter, 30 Howe Crescent, South Melbourne, Victoria 3205, Australia. Phone (03) 699 2922. Ian McDougall, Editor.
Architecture.

Covers all aspects of concern to architects, including continuing education, current projects, law and finance.
Reviews: book. Indexed: ArchPI.

THE ARCHITECT. [Western Australia]. 1939. q. EN. **1934**
Ray Burns Media, 99 Outram St., West Perth 6005 Western Australia. Phone 09–322–2066, fax 09–481–6201. Simon Anderson & Peter Moran, Editors.
Subscription: $A22 Australia, elsewhere $A30 including postage surface, + postage air. Illus. b&w, photos, plans. A4, 48p.
ISSN: 0003–8393. Dewey: 720. Formerly: *Architect*.
Architecture.

A publication of the Western Australian Chapter of the Royal Australian Institute of Architects.
Reviews: book. Interviews. Indexed: Avery.
Advertising b&w & color. Malcolm Birch, Ad. Director.

ARCHITECTS' EMPLOYMENT CLEARINGHOUSE. 1988. m. EN. 1935

The Louisiana Architects Association of the AIA, 521 America St., Baton Rouge, LA 70802.
Illus.
OCLC: 18881802. LC: NA1.A73.

Architecture.

Contains announcements and short news items related to the architecture job market. Classified ad section lists jobs available by state.
Opportunities: employment.

ARCHITECTURE BULLETIN. 1944. m. (except Jan). EN. 1936

Royal Australian Institute of Architects, New South Wales Chapter, 3 Manning St., Potts Point, N.S.W. 2011, Australia. Phone 02–356–2955. Howard Tanner, Editor.
Subscription: included in membership, $4 Australia, $55 US. Sample free. Back issues $4. Illus. b&w, photos. 340 x 250 mm., 16p.
ISSN: 0729–8714. Dewey: 720.

Architecture.

Consists of R.A.I.A. news and information plus articles on current architectural projects.
Reviews: book 1, length 500 wds. Interviews: in depth. Obits. of members. Listings: regional–international. Calendar of events. Exhibition information. Freelance work: yes. Contact: Sally Corkill. Opportunities: employment, study, competitions.
Circulation: 3200. Audience: architects.

ARCHITECTURE CALIFORNIA/ CCAIA. 1979. bi–m. EN. 1937

American Institute of Architects, California Council, 1303 J St., Suite 200, Sacramento, CA 95814–2916. Phone 916–448–9082. Lian Hurst Mann, Editor.
Sample $5. Illus. photos (20/issue). 8½ x 11, 40p.
ISSN: 0738–1131. OCLC: 9506820. LC: NA730.C2 A74. Dewey: 720.

Architecture.

News and issues relevant to the architectural profession in California.
Freelance work: yes (details in *PhMkt.*). Opportunities: employment positions. Indexed: Avery.
Advertising. Peggy Lindono, Ad. Director. Circulation: 11,000. Audience: architects.

ARCHITECTURE NEW JERSEY. 1967. bi–m. EN. 1938

New Jersey Society of Architects, 900 Route Nine, Woodbridge, NJ 07095. Dir. Eve. Koktish.
Subscription: included in membership, $15. Illus. 8 x 10⅞, 48p.
ISSN: 0003–8733. OCLC: 5094822. LC: NA11.A75. Dewey: 720.

Architecture.

The purpose of the publication is to increase public awareness of the built environment. It covers projects of current interest, news of architects, and issues in architecture.
Indexed: Avery.
Advertising. Dick Timpone, Ad. Director. Demographics: distributed to all members of the Society, to consulting engineers, to people in fields related to architecture, and to those leaders in business and government who are concerned with architecture. Audience: members, consulting engineers and people in related fields.

ASI JOURNAL. bi–m. EN. 1939

Architects and Surveyors Institute, St. Mary House, 15 St. Mary St. Chippenham, Wilts., SN15 3JN, England. Phone 0249 444505, fax 0249 443602. W.R. Cowap, Editor.
Dewey: 720. Incorporates: *Construction Surveyor*. Formerly: *Faculty of Architects and Surveyors Diary*.
Provides up to date information on changes within the profession. Seeks to maintain a high standard of education and training for members.
Advertising. Demographics: architects and surveyors in 54 countries.

ATRIUM. 1974. m. EN.

British Institute of Architectural Technicians, 397 City Rd., London EC1V 1NE, England. Phone 071–278 2206. David Wood, Editor.
Subscription: included in membership, £15, Europe £30, elsewhere £40.
ISSN: 0951–8088. Dewey: 720. Formerly: *Architectural Technology & SAAT News.*
Architecture.

Seeks to enhance the professional status and role of architectural technicians.
Indexed: ArchPI.

CALIFORNIA ARCHITECTURE AND ARCHITECTS. 1980. irreg. EN.

Hennessey & Ingalls, Inc, 8321 Campion Dr., Los Angeles, CA 90045. Phone 213–458–9074. David Gebhard, Editor.
Dewey: 720.
Architecture.

COLUMNS. 1987. 5/yr. EN.

Alberta Association of Architects, Duggan House, 10515 Saskatchewan Dr., Edmonton, Alberta, T6ED 4S1, Canada. Phone 432–0224.
Subscription: included in membership. Sample. Back issues.
ISSN: 0836–1517. OCLC: 18110649. LC: NA1. Dewey: 720. Formerly: *Alberta Association of Architects Newsletter.*
Architecture.

Newsletter.
Advertising: full page $550, ½ page $275, ¼ page $140, business card $75–100. handouts 1–5p., $150–200. Mailing lists: Register, $15. Audience: architects, public.

FACULTY OF ARCHITECTS & SURVEYORS DIARY. a. EN.

Welbecson Ltd., Strawberry Street, Hull, Humberside, HU9 1EX, England.
Dewey: 720.
Architecture.

HANDASAH VE-ADRIKHALUT. 1958. m. HE. EN summaries.

Association of Engineers and Architects in Israel, 200 Dizengoff Rd., P.O.B. 3082, Tel Aviv, Israel. Phone 03–240274. Nira Kolton, Editor.
Subscription: $50. Illus.
ISSN: 0017–7164. OCLC: 2240960. LC: TA113.I75A84a. Formerly: *Agudat Ha–ing Inerim Veha–Arkhtektimbe–Yisrael.*
Journal of the Association of Engineers and Architects in Israel.
Advertising.

IN SITU. q. EN.

Zambia Institute of Architects, Box 76105, Ndola, Zambia.
Illus.
OCLC: 8971731. LC: NA17.Z3Z314. Dewey: 720.
Architecture.

Journal of the Zambia Institute of Architects. Co-sponsored by the Surveyors Institute of Zambia and issued also as that Institute's journal.

JOURNAL OF THE INDIAN INSTITUTE OF ARCHITECTS. 1934. q. EN.

Architects Publishing Corp. of India, 51 Sujata, Rani Sati Marg, Malad East, Bombay 400097, India. Akhtar Chauhan, Editor (Prospect Chambers Annexe, Dr. D.N. Rd., Bombay 400 001).
Subscription: Rs 50. Illus.
ISSN: 0019–4913. OCLC: 1752884. LC: NA1.I48. Dewey: 720.6254.
Architecture.

Indexed: ArchPI.

JOURNAL - ROYAL INSTITUTE OF BRITISH ARCHITECTS [Overseas edition].

1893. m. EN. **1947**

RIBA Magazine Ltd., The Finsbury Mission, 39 Moreland St., London EC1V 8BB, England. Phone 071–251–5885, fax 071–253–1085. Richard Wilcock, Editor.

Subscription: included in membership, non–members £42.50, students £18.75 UK; £55 overseas. Microform available from UMI. Illus. b&w, color, photos, plans. Annual index. A4, 98–114p.

ISSN: 0953–6973. OCLC: 17285107. LC: NA12.J68. Dewey: 720. Formerly: *Architect* [overseas ed.]; *Journal of the Royal Institute of British Architects*; Incorporates *RIBA Interiors*.

Architecture.

Architectural publication which carries a regular interior design feature in every issue. Also carries a monthly special feature produced by the editorial team in conjunction with outside contributors, acknowledged as experts in their field, covering topics of major interest to its Chartered Architect readers. Contents include short articles, news, new products information, and brief news of members. Volumes from 1986 on contain the supplement *Practice*.

Reviews: book 3, length total 1p. Diary of RIBA events, other events. Opportunities: employment; study – conferences, courses; competitions: synopsis of information about UIA approved competitions includes international competitions. Indexed: ArchPI. BioI. RILA.

Advertising: b&w full page £1248, ½ page £830, ¼ page £533, 2 color + £250, full color + £650. Inserts. Reader inquiry cards. Frequency discount. Tony Chapman, Ad. Manager. Amanda Miller, Classified Ad. Manager. Demographics: Sent free to all 25,200 members; total circulation 22,025 UK, 5,261 other countries. Circulation: 27,286.

MAA NEWSLETTER. 4/yr. EN. **1948**

Manitoba Association of Architects, 100 Osborne St., S. 2nd Floor, Winnepeg, MB, Canada R3L 1Y5. Phone 204–477–5290. Gerri Stempler, Editor.

Subscription: included in membership. 11 x 17, 4p.

Freelance work: yes. Opportunities: employment.

Advertising. Audience: Canadian architects.

MEMO. 1947. m. EN. **1949**

American Institute of Architects, 1735 New York Ave., N.W., Washington, DC 20006. Phone 202–626–7465. Laurie Anderson, Editor.

Subscription: included in membership, $24 US. Sample. Back issues. Illus. b&w, photos, cartoons. tabloid 11 x 17, 16p.

ISSN: 0001–1487. OCLC: 2520596. LC: NA1.A468. Formerly: *AIA Memo*.

General. Architecture. Historic Preservation. Interior Design. International.

The official newsletter of the American Institute of Architects carries announcements and news of specific AIA and AIA–related programs, services, and products. Includes "Practice", a monthly information exchange for architectural professionals interested in the array of ideas, developments, and techniques that contribute to better architectural practice. Presents advice and tips on how to build a strong practice.

Interviews: convention speakers, etc. Biographies: "Architect Spotlight" profile on architect who's done something noteworthy. Listings: national. Calendar of events. Exhibition information. Freelance work: yes, only for special issues. Contact: Kevin Fry. Opportunities: employment, in classified ads; study – continuing education, programs, development opportunities; competitions.

Advertising: (rate card Jan '89): full page $4000, ½ page $1100, ¼ page $550, color + $200. Classified: $50/col. inch. Inserts. Philip Bujakowski, Ad. Director. Mailing lists: none. Demographics: worldwide. Circulation: 58,000. Audience: AIA members.

MIDWEST ARCHITECT. 1972. bi–m. EN. **1950**

Fan Publications, Kansas City, MO.

Illus.

OCLC: 12136737. LC: NA730.M8M52. Formed by the union of: *Missouri Architect* and *Skylines*.

Architecture.

Official publication of the Missouri Council of Architects.

MISSISSIPPI STATE BOARD OF ARCHITECTURE ANNUAL REPORT. a. EN. **1951**

Board of Architecture, Box 16273, Jackson, MS 39206. Phone 601–981–2961.

Dewey: 720.

Architecture.

MSA BULLETIN. 1926. 8/yr. EN.
Michigan Society of Architects, 553 E. Jefferson, Detroit, MI 48226. Phone 313–965–4100. Rae Dumke, Editor.
Subscription: included in membership. No back issues. Illus. b&w, photos. 8½ x 11, 8–12p.
ISSN: 0024–8363. OCLC: 4219532. LC: NA11.M5. Dewey: 720. Formerly: *Monthly Bulletin*.
Architecture. Historic Preservation. Interior Design. Landscape Architecture.

Issued as the official publication of all Michigan chapters of the American Institute of Architects.
Reviews: book. Listings: regional–national. Calendar of events. Exhibition information. Freelance work: none. Opportunities: employment, study, competitions.
Advertising: full page $625. Mailing lists: available to advertisers only. Circulation: 2000. Audience: architects.

NEWS - NEW YORK STATE ASSOCIATION OF ARCHITECTS. 1985. bi–m. EN.
New York State Association of Architects, Inc., 235 Lark St., Albany, NY 12210. Phone 518–449–3334, fax 518–4268–8176.
Barbara J. Rodriguez, Editor.
Subscription: included in membership, $12 US & Canada, foreign $20. Sample & back issues, $2. Illus b&w, photos. 8½ x 11, 12p.
ISSN: 1053–7643. Formerly: *Column*.
Architecture. Historic Preservation.

Report on activities relative to the profession and of the Association, government affairs, legal issues and those effecting the practice and profession of architecture.
Interviews: with members or regarding the profession, occasionally obits. Listings: regional. Calendar of events. Freelance work: none. Opportunities: study, competitions.
Advertising: full page $1000, ½ page $650, ¼ page $400. Frequency discount. No classified. Inserts. Roberta A. Rodriguez–Bacchus, Ad. Director. Mailing lists: available for fee. Circulation: 5,000. Audience: New York State architects.

NIA JOURNAL FOR THE ADVANCEMENT OF THE ARCHITECTURAL PROFESSION:
 Journal of the Nigerian Institute of Architects. 1985. EN.
Nigerian Institution of Architects, 2, Idowu Taylor St., Victoria Island, PO Box 178, Lagos, Nigeria.
ISSN: 0189–1162.
Indexed: ArchPI.

NORTH CAROLINA ARCHITECT. 1978. bi–m. EN.
Spectator Publications, Inc., Box 12887, Raleigh, NC 27605. Phone 919–833–6656. Sharon Kilby, Editor.
Subscription: included in membership. Illus. 8½ x 11, 40p.
ISSN: 0029–2427. OCLC: 9845440. LC: NA1.N6. Dewey: 720. Formerly: *NC Architect*.
Architecture.

The official publication of the North Carolina Chapter of American Institute of Architects.
Advertising: Greg Carft, Ad. Director.

NORTHERN ARCHITECT. 1961. irreg. EN.
Paull & Goode Publishing Ltd., Clavering House, Newcastle–upon–Tyne NE99 1LR, England. Roy Gazzard, Editor.
Illus.
ISSN: 0305–0173. OCLC: 4935773 [83]. LC: NA1.N76. Dewey: 720.
Architecture.

Reviews: book. Indexed: ArchPI.
Advertising.

NOVA SCOTIA ASSOCIATION OF ARCHITECTS NEWSLETTER. m. EN.
Nova Scotia Association of Architects, 1361 Barrington St., Halifax, N.S. B3J 1Y9, Canada. Phone 902–423–7607. Diane Scott, Editor & Pub.
Subscription: included in membership.
Dewey: 720.
Architecture.

ORDRE DES ARCHITECTES DU QUEBEC. BULLETIN/ORDER OF ARCHITECTS OF QUEBEC. BULLETIN. 1966. m. EN & FR.

<div style="text-align:right">1958</div>

Ordre des Architectes du Quebec, 1825 W. Blvd. Dorchester, Montreal, Que. H3H 1R4, Canada. Phone 514–937–6168. J.P. Pelletier, Editor.

ISSN: 0316–9200. Dewey: 720. Formerly: *Association des Architects de la Province de Quebec. Bulletin.*

Architecture.

PERSPECTIVES. 1987. EN.

<div style="text-align:right">1959</div>

Ontario Association of Architects, 50 Park Rd., Toronto, Ontario, M4W 2N5 Canada. Phone 416–968–0188. Paul Lebel, Editor.

Subscription: included in membership. Sample. Back issues. Illus. b&w, photos. 11 x 17, 6p.

Architecture.

The purpose of the newsletter is to establish a lively, dynamic forum between the Association and its members. While the interests and concerns of the members were established as the prime focus of the newsletter, over time it is intended to appeal to non–members associated, or related to, the profession.

Reviews: exhibition 1, length 500 wds.; book 1, length 1000 wds. Biographies: profiles on people appear in a small column like an announcement. Listings: regional–national. Calendar of events (regional). Exhibition information (national). Freelance work: yes. Contact: Mrs. Phyllis Clasby. Opportunities: employment, regional; study, regional; competitions, national. Advertising: none. Circulation: 4000.

PLACE: The Clients, Architects, Contractors, and Developers. 1989. q. EN.

<div style="text-align:right">1960</div>

Michigan Society of Architects, 553 E. Jefferson, Detroit, MI 48226. Phone 313–965–4100. Timothy Casai, Editor.
Subscription: $10. Illus.
OCLC: 22176675. LC: NA730.M5 P55. Dewey: 720.
Focuses on all members of the building team who influence Michigan's built environment.

PROSPECT. Architecture. Scotland. 1979. q. EN.

<div style="text-align:right">1961</div>

Royal Incorporation of Architects in Scotland, 15 Rutland Square, Edinburgh EH1 2BE, Scotland. Phone 031–229 7545, fax 031–228 2188. Stuart Campbell, Editor.
Subscription: included in membership, £10 non–members. Sample & back issues free.
ISSN: 0143–8883. Dewey: 720.

Architecture.

Advertising: full page $600, ½ page $350, ¼ page $150, color + $450. David Carson, Ad. Director (55 Belford Rd., Edinburgh EH4 3BR). Mailing lists: none. Circulation: 4000. Audience: architects.

QUEENSLAND ARCHITECT. 1971. irreg. EN.

<div style="text-align:right">1962</div>

Powell Lorkin and Associates Pty. Ltd., 24 Little Edward St., Brisbane, Qld 4000, Australia. Phone Royal Australian Institute of Architects, Queensland Chapter, Information Services Division.
ISSN: 0310–687X. Dewey: 720.
Architecture.

RAIA MEMO. 1984. irreg. EN.

<div style="text-align:right">1963</div>

Royal Australian Institute of Architects, National Headquarters, 2A Mugga Way, Red Hill, A.C.T. 2603, Australia. Simon Johnstone, Editor.
Subscription: included in membership.
ISSN: 0818–1233. Dewey: 720. Formerly: *RAIA News.*
Architecture.

REGISTER OF ARCHITECTS. 1932. a. EN.

<div style="text-align:right">1964</div>

Architects' Registration Council, 73 Hallam St., London W1N 6EE, England.
Dewey: 720.
Architecture.

SASKATCHEWAN ASSOCIATION OF ARCHITECTS NEWSLETTER. 1960. m. EN.

1965

Saskatchewan Association of Architects, 326–11th St. E., Saskatoon, Sask. S7N 0E7, Canada. Phone 306–242–0733, fax 664–2598. Ann March, Editor.

Subscription: included in membership. No back issues.

Dewey: 720.

Architecture.

Listings: regional–international. Calendar of events. Exhibition information. Opportunities: employment, study, competitions. Advertising: none. Audience: members, provincial associations in Canada.

SIAJ: Journal of the Singapore Institute of Architects. 1966. bi–m. EN.

1966

Singapore Institute of Architects, 20 Orchard Rd., SMA House, No.02–00, Singapore 0923, Singapore. Phone 3388977, fax 3368708, telex RS 22652. Joseph Cheang, Editor.

Subscription: distributed free to all members of the Institute, quantity surveyors, allied professional bodies, educational institutions and public libraries in Singapore, Malaysia and overseas. $S50 Singapore, $S54 Malaysia, others $S60. Illus. b&w, photos, plans. A4.

ISSN: 0049–0520. OCLC: 2038904. LC: NA1.S58. Dewey: 720.

Architecture.

Contents include articles, news, and project feature. Listing of exhibitors "one–stop shopping mart for building materials" (company, address, product, contact phone). Lists building plan approvals submitted by members providing date, company, location and description.

Reviews: product. Listings: Institute only. Exhibition information. Indexed: ArchPI.

Advertising b&w & color.

SOCIETY OF ARCHITECTURAL ADMINISTRATORS. NEWS JOURNAL. m. EN.

1967

Society of Architectural Administrators, c/o Deborah Worth, Hennington, Durham, and Richardson, 11225 S.E. Sixth St., Suite 200, Bellevue, WA 98004. Phone 206–453–1523.

Journal designed for administrative, secretarial, or non–technical employees of architects and architectural firms.

SOCIETY OF ARCHITECTURAL ADMINISTRATORS. NEWS UPDATE. a. EN.

1968

Society of Architectural Administrators, c/o Deborah Worth, Hennington, Durham, and Richardson, 11225 S.E. Sixth St., Suite 200, Bellevue, WA 98004. Phone 206–453–1523.

News for administrative, secretarial, and non–technical employees of architects and architectural firms.

TENNESSEE ARCHITECT. 1976. EN.

1969

The Publishing Company, 1805 Hayes St., Nashville, TN 37203. Phone 615–321–5594. Michael Emrick, Editor (P.O. Box 5601, Nashville, TN 37208).

Subscription: included in membership, $12.50. Sample. Back issues $4. Illus. b&w, some color. Offset lithography.

OCLC: 12186933. LC: NA1.T455. Dewey: 724.

General. Architecture. Furniture. Graphic Arts. Historic Preservation. Interior Design.

The official publication of the Tennessee Society of Architects, the state organization of the American Institute of Architects. Reviews: book. Listings: regional–national. Calendar of events. Exhibition information. . Opportunities: study, competitions. Advertising: (rate card '88–89): b&w full page $700, full page $450, 1/3 page $340; 2nd color + $100; 4 color full page $1200, 1/2 page $775, 1/3 page $510, special position $1200–1450, covers $1150–1560. Frequency discount. 15% agency discount. Service Directory $60 member, $70 non–member. New products page, member only b&w 1/4 page $250. Inserts. Demographics: Average education 17 yrs., 74% read magazine at office; 52% top management; 43% spec personnel; 68% make/influence product purchases. Circulation: 2500. Audience: architects and related industries.

VIRGINIA RECORD. 1977. q. EN.

1970

Virginia Publishers Wing, Inc., P.O. Drawer 2Y, Richmond, VA 23205. Phone 804–644–6717. Joe H. Young, Executive Editor.

Subscription: $12.50 US, foreign + $5 surface. Sample free. Back issues, cover price + postage & tax. Illus. 8½ x 11, 60–120p. offset.

ISSN: 0042–6768. OCLC: 16974220. Dewey: 720. Formerly: *Virginia Record Magazine.*

Architecture. Historic Preservation. Interior Design. Landscape Architecture.

Published with the cooperation The Virginia Society, American Institute of Architects. Presents news, articles, projects from Virginia architects, and construction related items. Winter issue presents Virginia officials.

Freelance work: very infrequent. Contact: editor.

Advertising: (rate card Jan '89): full page $1400, ½ page $760, ¼ page $420, covers $1600–1700; spot color + $425/color, 4 color + $1225. Classified: none. Special positions + 20%. 10% frequency discount. 15% agency discount. 2% cash discount. Bleeds + 15%. Demographics: primarily Virginia, Maryland, D.C., No. & So. Carolina, West Virginia. Circulates to Virginia's federal, state, city and county officials. Circulation: 3000. Audience: members of design & construction industry; economic development offices, anyone interested in architecture/construction.

WISCONSIN ARCHITECT. 1933. m. EN. 1971

Wisconsin Architect, Inc., 321 S. Hamilton St., Madison, WI 53703–3606. Phone 608–257–8477. Bill Babcock, Editor.
Subscription: $30. Illus. 8½ x 11, 50p.
OCLC: 2253943. LC: NA1.W81. Dewey: 720.
Architecture.

Published for the State Association of Wisconsin Architects. Covers architecture in Wisconsin, projects, topics, and news in the design and construction industry and related fields.
Advertising: Nancy Baxter, Ad. Director. Circulation: 2300.

YORKSHIRE ARCHITECT. 1968. bi–m. EN. 1972

Paull & Goode Publishing Ltd., Clavering House, Newcastle–upon–Tyne NE99 1LR, England. John Billingham, Editor.
Illus.
ISSN: 0044–0582. Dewey: 720.
Architecture.

Reviews: book.
Advertising.

Architecture

A & V. 1985? q. SP. EN summaries. 1973

S.G.V., Sociedad Estatal de Gesti on para la Rehabilitaci on y Construcci on de Viviendas, Casado del Alisal 5, 29014 Madrid, Spain.
Illus. b&w, some color.
OCLC: 16630487. LC: NA7385.A2. Dewey: 720.
Architecture.

Each issue has a distinctive title.
Indexed: Avery.

A + U (ARCHITECTURE AND URBANISM). 1971. m. JA. Complete EN tr. of articles. 1974

A & U Publishing Co., Ltd., 2–30–8 Yushima, Bunkyo–ku, Tokyo 113, Japan. Toshio Nakamura, Editor.
Subscription: 21,000 Yen. Illus.b&w, color, photos, drawings. Index. 60p.
Dewey: 720.
Architecture.

International review of current architecture.
Reviews: book. Indexed: ArchPI. ArtHum. ArtI. BioI. CurCont. Reviewed: Katz.
Advertising.

A/R/C, ARCHITECTURE RESEARCH CRITICISM. 1990. q. EN. 1975

Atlas of the City Publications, 15B Sullivan St., Toronto, Ontario M5T 1B8, Canada.
Subscription: $22.62 individual, $31.66 institution, $27.14 businesses & architectural practices. Illus.
ISSN: 1180–0933. OCLC: 22470944. LC: NA1. Dewey: 724.6.
International journal of architectural criticism.

ABACUS: Tecnica e Progetto in Architettura e Ingegneria/Technique & Project in Architecture and Engineering. 1985. bi–m. IT. EN, FR & SP summaries. 1976

Via G. Murat 84, 20159 Milan, Italy. Guido Boni, Editor.

Subscription: L 70000. Illus. b&w, some color.
OCLC: 15563781. Dewey: 624.
Indexed: ArchPI. Avery.
Advertising.

ABC NEWSLINE. EN.

Associated Builders and Contractors, 729 15th St., N.W., Washington, DC 20005.
8½ x 11, 8p.
ISSN: 0888–014X.
Architecture.

AMC. 1983. q. FR.

Societe des Architectes Diplomes par le Gouvernement, 100 rue du Cherche–Midi, 75006 Paris, France. Patrice Noviant & Jacques Lucan, Editors.
Illus., some color.
ISSN: 0336–1675. OCLC: 10170324. LC: NA1048.A15. Dewey: 720. Formerly: *Architecture Mouvement Continuite.*
Architecture.

ARC (Scottsdale). q. EN.

Arcosanti Foundation, 6433 Doubletree Rd., Scottsdale, AZ 85253. Phone 602–948–6145.
Architecture.

Covers the Arcosanti Project, the building of an energy–efficient town which combines ecology and architecture to create an integrated city.

L'ARCA: The International Magazine of Architecture, Design and Visual Communication.

1986. 10/yr. EN & IT.

L'Arca Edizioni SpA, Ufficio Abbonamenti, Viale Bianca Maria 11, 20122 Milan, Italy. Phone 02 790240.
Illus. b&w, some color.
OCLC: 16945470. LC: NA680.A67.
Architecture.

Indexed: ArchPI. Avery. Des&ApAI.

ARCHITECTES - ARCHITECTURE. 1969 ns. 10/yr.

Ordre des Architectes, 140 Avenue Victor Hugo, 75116 Paris, France. Francis Rambert, Editor.
Dewey: 720. Formerly: *Architectes.*
Architecture.

Indexed: ArchPI. Avery.

ARCHITECTS INDIA. 1951. bi–m. EN.

Architects Publishing Corp. of India, 51 Sujata, Rani Sati Marg, Malad East, Bombay 400097, India. Santosh Kumar, Editor.
Subscription: Rs 150. Illus.
LC: NA9.A35. Dewey: 720. Formerly: *Architects Trade Journal; Architects Annual.*
Presents technical articles, building industry projects, and news.
Advertising. Audience: architects, engineers, interior designers, builders & contractors.

THE ARCHITECTS' JOURNAL. 1919. w. EN.

Architectural Press Ltd., 9 Queen Anne's Gate, London SW1H 9BY, England. Phone 071–222 4333, fax 071–222 5196, telex 8953505. Colin Davies, Editor.
Subscription: included in membership, UK & Eire £48, £30 students; foreign £90, students £67.50; air rates on application. Subscription includes supplements and annual index. Microform available from UMI. Back issues £2–2.75. Illus. b&w, color, photos, cartoons. Annual index. A4, 100p.
ISSN: 0003–8466. OCLC: 4651322. LC: TH1.A7. Dewey: 720.5. Formerly: *Architects' and Builders' Journal.*
Architecture.

Presents comprehensive news coverage of the world of architecture and building; detailed studies of new buildings; technical features; articles on issues concerning architects in practice; and a weekly five page arts review. "Masters of Building," a se-

ries of major articles on landmark buildings in the history of architecture is a regular feature. There are two supplements, *Renovation* and *Architech* (Information, Technology in Architecture, Buildings and Construction).

Reviews: exhibition 2 & theater 1, length 360 wds. each; book 1, length 230 wds. Listings: regional–national, approximately 30/issue. International events of particular importance are also listed. Calendar of regional events. Opportunities: classified section advertises professional positions, practices for sale and other career opportunities; "Competitions" page provides information on national and international competitions. Indexed: ArchPI. ArtArTcAb. Avery. Reviewed: Katz.

Advertising: b&w full page £1080, ½ page £630, ¼ page £390; color full page £1655, ½ page £1205. Classified: £22/s.c.cm. Frequency discount. John Goss, Ad. Director. Mailing lists: none. Audience: architectural profession.

ARCHITECTURA: Zeitschrift fuer Geschichte der Baukunst/Journal of the History of Architecture. 1971. s–a. GE mainly or EN. No summaries.

1984

Deutscher Kunstverlag GmbH, Vohburger Str. 1, 8000 Munich 21, W. Germany.
Subscription: DM 85. Illus. b&w, photos, plans. Annual index. 7½ x 10, 100p.
ISSN: 0044–863X. OCLC: 1639523. LC: NA200.A69. Dewey: 720.

Architecture History.

Scholarly articles on all periods and styles. Articles appear in one language only.
Reviews: book, lengthy. Indexed: ArchPI. ArtI. Avery. CurCont. IBkReHum. RILA.

ARCHITECTURAL & BUILDING INFORMATION SELECTOR. 1971. a. EN.

1985

B & M Publications (London) Ltd., Box 13, Hereford House, Bridle Path, Croydon, Surrey CR9 4NL, England. D.V. Wilson, Editor.

Architecture.

ARCHITECTURAL ANNUAL REVIEW. 1977. a. EN.

1986

Diplomatic & Consular Year Book International Ltd., 11–13 Cricklewood Lane, London NW2 1EJ, England. Phone 081–450 9322. Joyce Blake, Editor.
Dewey: 720. Formerly: *Architectural Association Annual Review*.

Architecture.

ARCHITECTURAL DESIGN: A.D. 1971. bi–m. EN.

1987

Academy Editions Ltd., 42 Leinster Gardens, London W2 3AN, England. Phone 071–402 2141. Dr. Andreas C. Papadakis, Editor.
Subscription: £39.50, overseas £49.50 $75. Illus. b&w, some color, photos.
ISSN: 0003–8504. OCLC: 8353757. LC: NA1.A563. Dewey: 720. Formerly: *AD*.

Architecture.

Provides up–to–date information on architects of the present and past. Each issue presents an in–depth analysis of a theme of relevance to architectural practice today, whether it be the work of an important new architect, a currently influential figure or movement, or the emergence of a new style or consensus of opinion.
Reviews: book. Indexed: ArchPI. ArtHum. ArtI. Avery. BrArchAb. CloTAI. CurCont. Reviewed: Katz.
Advertising. Audience: anyone interested in the art of architecture.

ARCHITECTURAL HERITAGE SOCIETY OF SCOTLAND. JOURNAL AND ANNUAL REPORT. 1972. a. EN.

1988

Architectural Heritage Society of Scotland, 43b Manor Place, Edinburgh EH3 7EB, Scotland. Phone 031–2259724. Deborah Howard, Editor.
Subscription: included in membership together with s–a newsletter; non–members £2.25.
Dewey: 720. Formerly: *Scottish Georgian Society. Annual Report and Bulletin; Scottish Georgian Society. Annual Report; which incorporated: Scottish Georgian Society. Bulletin*.

Architecture.

Indexed: RILA.

ARCHITECTURAL HISTORY. 1958. a. EN.

1989

Society of Architectural Historians of Great Britain, Rm. 208, Chesham House, 30 Warwick St., London W1R 6AB, England. Phone 071–734 8144 (Frank Kelsall, Hon. Sec.). Peter Draper, Editor.
Subscription: included in membership together with *Newsletter* £12, retired members & students £8, overseas £16. Illus.
ISSN: 0066–622X. OCLC: 1481858. LC: NA190.A72. Dewey: 720.

Architecture. History.

Indexed: ArtHum. ArtI. ArchPI. Avery. BioI. CurCont. IBkReHum. RILA.

ARCHITECTURAL INDEX. See no. 1

ARCHITECTURAL LIGHTING. 1987. m. EN.

1990

Gralla Publications, 1515 Broadway, New York, NY 10036. Phone 212–869–1300, fax 212–302–6273, telex 6973314GRAL. Wanda Jankowski, Editor.

Subscription: $54 US & possessions, $97 Canada, $125 others; free to qualified subscribers. Microform available from UMI. Illus. color, plans. 8⅛ x 10⅞, 72p.

ISSN: 0894–0436. OCLC: 15272445. LC: TH7703 .A7. Dewey: 338.

Architecture. Lighting.

Presents articles on design features and planning and technique. Regular columns include "pro talk", new products, product literature, and product review.

Reviews: products. Listings: national–international. Calendar of conferences and expositions, seminars and workshops. Indexed: Avery. Search.

Advertising. Classified. Readers service card.

ARCHITECTURAL MONOGRAPHS. 1978. irreg. EN. FR, GE, IT & SP summaries.

1991

Academy Editions Ltd., 42 Leinster Gardens, London W2 3AN, England. Phone 071–402 2141. Dr. Andreas C. Papadakis, Publisher; Frank Russell, Editor (7/8 Holland St., London W8, England (US: St. Martin's Press, 175 5th Ave., New York, NY 10010).

Subscription: (7/8 Holland St., London W8). Illus. b&w, color, photos, plans.

ISSN: 0141–2191. OCLC: 4212244. LC: NA40.A72. Dewey: 720.

Architecture.

The magazine devoted to the work of individual architects. Providing up–to–date information on the work of pioneering architects, ranging from the forerunners of the Modern Movement to the best of architects working today. Each issue provides a carefully chosen selection of the architect's work illustrated with drawings and photographs. Essays by leading architectural writers are fully complemented by extensive chronologies and bibliographies. The express aim of the journal is to maintain a high standard of editorial content and reproduction without advertising.

Bibliographies.

Advertising: none.

ARCHITECTURAL PERIODICALS INDEX. See no. 2.

ARCHITECTURAL RECORD. 1891. m. (s–m. in April & Sept). EN.

1992

McGraw Hill Information Services, 1221 Ave. of the Americas, New York, NY 10020. Phone 212–512–4566. Carolyn D. Koenig, Managing Editor.

Subscription: $42.50 US & Canada, air Europe $150, Japan $160, elsewhere $125. Microform available from UMI. Sample & back issues $7. Illus. color, photos. Annual index. Cum. index. 9 x 12, 80p. Web Offset. perfect bound (glued).

ISSN: 0003–858X. OCLC: 1481864. 7378543 (*Record Interiors*). LC: NA1 .A6. Dewey: 720. Combined with *American Architect* and, *Western Architect and Engineer*.

Architecture. Interior Design.

Business, design and engineering features for practicing architects and architectural engineers. One issue reprinted annually as: *Record Interiors*.

Reviews: book, journal, film. Listings: national. Calendar of events. Exhibition information. Freelance work: yes. Contact: Paul Sachner. Opportunities: employment, study, competitions. Indexed: ArchI. ArchPI. ArtHum. ArtI. Avery. BioI. CloTAI. CurCont. IBkReHum. RG. Search. Reviewed: Katz.

Advertising: (rate card Jan '89): b&w full page $7060, ½ page $4240–5300, ¼ page $2140; 2 color full page $7980–8190, ½ page $5180–6440, ¼ page $3070–3280. Frequency discount. Regional rates available. Bleed no charge. Inserts. 15% agency discount. Mailing lists: advertisers may use subscription list to mail information to readers. Circulation: 75,000.

THE ARCHITECTURAL REVIEW. 1896. m. EN.

1993

Architectural Press Ltd., 9 Queen Anne's Gate, London SW1H 9BY England. Phone 071–222 4333. Peter Davey, Editor.

Subscription: $11 US, $US11 Canada, £4.25 UK, air $US99.50. Microform available from UMI. Sample. Back issues. Illus. b&w, color, photos, cartoons. Index.

ISSN: 0003–861X. OCLC: 1481867. LC: NA1.A69. Dewey: 720.

Archaeology. Architecture. Art History. Crafts. Decorative Arts. Drawing. Furniture. Graphic Arts. Interior Design. Landscape Architecture. Modern Art. Museology. Painting. Sculpture. Textiles.

Consists of articles on historic buildings and new designs.

Reviews: book 8, length 200 wds; exhibition. Interviews: occasionally. Biographies: history and theory. Obits. Freelance work: yes. Contact: editor. Indexed: ArchPI. ArtHum. ArtI. Avery. BioI. CloTAI. CurCont. Des&ApAI. IBkReHum. RILA. Search. Reviewed: Katz.

Advertising: Susan Gentle, Ad. Manager. Mailing lists: none. Circulation: 20,000. Audience: architects, allied artists, historians.

ARCHITECTURAL SCIENCE REVIEW. 1957. q. EN.

1994

University of Sydney, Department of Architectural Science, Sydney, N.S.W. 2006, Australia. Phone 612 692 4108. Prof. H.J. Cowan, Editor.

Subscription: $US40 worldwide air. Microform available from UMI. Sample free. Back issues. Illus. b&w, photos. Index every 2 yrs. Cum. index every 10 yrs. A4, 32p.

ISSN: 0003–8628. OCLC: 1481868. LC: NA1 .A744. Dewey: 720.

Architecture.

The only refereed papers published relating to the scientific aspects of architecture.

Reviews: 10 book, length 6p. Freelance work: yes. Contact: editor. Indexed: ArchPI. Avery.

Advertising: full page $200. Mailing lists: none. Circulation: 850. Audience: architects & engineers.

ARCHITECTURAL SERVICES BOOKS OF PLANS. 1969. a. EN.

1995

Plan Magazines Ltd., 45 Station Rd., Redhill, Surrey, England. John Bailey, Editor.

Dewey: 720.

Architecture.

ARCHITECTURE (Kenya). 1974. bi–m. EN.

1996

News Publishers Ltd., P.O. Box 30339, Nairobi, Kenya. Clive Mutiso, Editor.

Subscription: EAs. 240. Illus.

Formerly: *Build Kenya*; Supersedes: *Plan*.

Architecture.

Reviews: book.

Advertising.

ARCHITECTURE (New York). Incorporating Architectural Technology.

1913. m. EN. FR & SP summaries.

1997

Published by Billboard Publications, Inc. for the American Institute of Architects Press, 1515 Broadway, New York, NY 10036. Phone 212–764–7300. Deborah K. Dietsch, Editor–in–chief (1130 Connecticut Ave., N.W., Suite 625, Washington, DC 20036, phone 202-828-0993).

Subscription: $39 US, $US45 Canada, elsewhere surface $63 (P.O. Box 2063, Marion, OH 43305–2063). Microform available from UMI. Many illus. mainly color, photos, plans, drawings. Annual index. 9 x 12, 130–160p.

ISSN: 0746–0554. OCLC: 9715411. LC: NA1.A326. Dewey: 720. Formerly: *AIA Journal; Architectural Technology; American Institute of Architects. Journal*.

Architecture.

The official magazine of the American Institute of Architects features about 12 articles in each issue related to a single theme. Sections: design, technology & practice, and departments. The March issue is an *Annual Review of American Architecture*.

Indexed: ArchI. ArchPI. ArtHum. ArtI. Avery. BioI. CurCont. IBkReHum. Search. Reviewed: Katz. *New Art Examiner* 17:9, May 1990, p.67–68.

Advertising, b&w & color. Reader service card. Regional sales offices. Audience: architects, architectural, architectural–engineering firms, design firms, consulting engineering firms, contractors & builders.

ARCHITECTURE & COMPORTEMENT/ARCHITECTURE & BEHAVIOUR. 1980. q. EN or FR.

Table of contents and summaries in both EN & FR.

1998

Georgi Publishing Co., c/o Kaj Noschis, Editor, Dept. of Architecture, Fed. Institute of Technology, POB 555, 1001 Lausanne, Switzerland.

Subscription: (1989) SFr 60 individual, SFr 130 institution. Illus. b&w, photos. 6 x 9¼, 94p.

ISSN: 0379–8585. OCLC: 7360243. LC: NA2542.A47. Dewey: 720.
Architecture.

Devoted to the various areas of investigation of the relationship between human beings and the built environment, the relationship between architecture and behaviour. The journal covers various disciplines such as psychology, sociology, history, anthropology, economics, psycho–analysis, epistemology, semiotics, methodology, in as much as they relate to architectural research. Includes research papers on specific disciplines or periods.
Reviews: book. Bibliographies: "Books Received". Interviews. Freelance work: yes. Contact: editor. Indexed: ArchPI. Avery.
Advertising: none.

ARCHITECTURE AND URBAN DESIGN. 198? irreg. EN.

1999

UMI Research Press, 300 N. Zeeb Rd., Ann Arbor, MI 48106. Phone 313–761–4700. Stephen Foster, Editor.
Illus.
OCLC: 11712619. Dewey: 720. Formerly: *Studies in the Fine Arts. Architecture.*
Architecture.

ARCHITECTURE CONTEMPORAINE/CONTEMPORARY ARCHITECTURE.

2000

1980. a. EN & FR; with occasional text in GE, IT, and SP.
Bibliotheque Des Arts (Paris), Lausanne, Switzerland.
Illus.
ISSN: 0258–1051. OCLC: 6685093. LC: NA680.A688. Dewey: 724.9.
Architecture.

L'ARCHITECTURE D'AUJOURD'HUI: Recherche–Formes Interieures–Arts–Urbanisme. 1930.

2001

bi–m. FR. EN & SP summaries of feature articles.
Groupe Expansion, Le Ponant–25, 75842 Paris Cedex 15 France. Phone 33.1 40 60 40 60, fax 33.1 40 60 41 27. Francois Chaslin, Editor.
Subscription: 645 F. Microform available from UMI. Illus. b&w, some color, photos, plans. Index. 9½ x 12, 190–260p.
ISSN: 0003–8695. OCLC: 1481879. LC: NA2.A7. Dewey: 720. Formerly: *Architecture Francaise.*
Architecture. Architecture History.

Presents articles on contemporary architecture worldwide. Each issue features the work of one architect or subject as well as a section which focuses on a specific building.
Reviews: book. Indexed: ArchPI. ArtHum. ArtI. Avery. BioI. CurCont. Reviewed: Katz.
Advertising. Readers service card.

ARCHITECTURE INTERIEURE-CREE. 1969. bi–m. FR.

2002

Architecture Interieure C.R.E.E., 106 Bd Malesherbes, 75017 Paris, France. (US: European Publishers Rep., Inc., 11–03 46th Ave., Long Island, NY 11101).
Subscription: $141.83 France, $165.29 elsewhere. Illus.
ISSN: 0294–8567. OCLC: 3782050. LC: NA2.A83. Dewey: 720. *: Formed by the union of Architecture Interieure with Cree.*
Architecture.

Indexed: ArchPI. Avery.

ARCHITECTURE JOURNAL. 1983. a. EN.

2003

National University of Singapore, School of Architecture, Singapore.
Illus.
ISSN: 0129–5829. OCLC: 11335273.
Architecture.

Indexed: ArchPI.

ARCHITECTURE TODAY. 1958. bi–m. EN.

2004

Hill Group Publications, Draper St., Ormond, Victoria, 3204, Australia.
Illus.
ISSN: 0003–8741. Dewey: 720. Incorporates: *Building Trend.*
Architecture.

Indexed: ArchPI.

ARCHITEKTUR + WETTBEWERBE/ARCHITECTURE + COMPETITIONS: International Buildings Competitions. 1939. q. GE. GE & EN table of contents. EN summaries and legends. **2005**

Karl Kraemer Verlag Stuttgart + Zurich, Schulze–Delitzsch–Strasse 15, D–7000 Stuttgart 80, W. Germany. Phone 0711/620893, fax 0711/628955, telex 722203 kkbaud. Karl H. Kraemer, Editor.

Subscription: DM 98, students DM 82. No sample. Back issues. Illus., b&w (approx. 330), color (approx. 5), photos (approx. 100), cartoons (approx. 230), plans, drawings. 24 x 30 cm., 96p.

ISSN: 0341–2784. OCLC: 3953936. LC: NA2335.A72. Dewey: 720. Formerly: *Architektur Wettbewerbe*.

Architecture.

Contributions on current architectural theory and criticism, latest trends and the comments of experts, realized projects both in Germany and abroad. Each issue has a theme. Presents a storehouse of ideas for practising architects, students, developers and building owners. Provides an overall view of the most interesting competition designs arranged according to subject area. Comments on each topic in the magazine provided by competent authors. Interviews include illustration of work and chronology of major works. Extensive illustrations of examples of students' works, competitions and portrait.

Interviews: One page with an illustration of work and a chronology of major works. Listings: international. Freelance work: yes. Contact: editor. Opportunities: competitions are the main part of the magazine. Indexed: ArchPI. Avery.

Advertising: full page DM 1800, approx $US1060; ½ page DM 950, $US560; ¼ page DM 490, $US290; color + DM 610, $US360/color. Frequency discount. Ms. Kohn, Ad. Director. Mailing lists: none. Circulation: 4000. Audience: architects and planners who wish to observe the latest trends in competition results and for those who participate in competitions themselves.

ARCHITEKTUR DER D.D.R: Zeitschrift fuer Staedtebau und Architektur. 1951. m. GE. EN, GE, FR & RU summaries. **2006**

VEB Verlag fuer Bauwesen, Franzoesische Str. 13/14, 1086 Berlin, E. Germany. Gerhard Krenz, Editor.

Subscription: DM 140.40. Illus. b&w, photos, drawings.

ISSN: 0323–3413. Dewey: 720. Formerly: *Deutsche Architektur*.

Architecture. Planning.

A journal of architecture and municipal planning.

Reviews: book. Bibliographies. Indexed: ArchPI. Avery.

Advertising.

ARCHITEKTUR UND LADENBAU: Europaeische Fachzeitschrift fuer Modernen Ladenbau, Schaufenster und Display. 1972? bi–m. GE. **2007**

SHZ–Forster Fachverlag AG, Alte Landstrasse 43, CH–8700 Kusnacht–Zurich, Switzerland. Esther Bollmann, Editor.

Subscription: 62 SFr.

Formerly: *Ladenbau; Architektur und Ladenbau*.

Architecture. Interior Design.

Trade news on modern shop–design, window display and architecture.

Indexed: Avery.

L'ARCHITETTURA: Cronache e Storia. 1955. m. IT mainly. Articles occasionally also in EN, FR, GE or SP. **2008**

Etas Periodici S.p.A., Via Mecenate 91, 20138 Milan, Italy. Phone 02–5075721, fax 02–5064867, telex 331342 ETASPE 1. Bruno Zevi, Direttore.

Subscription: L 90000. Illus. b&w, some color, photos, plans, drawings. Index. Cum.index.

ISSN: 0003–8830. OCLC: 2054286. LC: NA4.A778. Dewey: 720.

Architecture. Architecture History.

International with focus on Italian architectural projects particularly public projects. Emphasis on current architecture, urban design and architectural history in Italy.

Reviews: book. Indexed: ArtI. Avery. Reviewed: Katz.

Advertising.

ARCHITETTURA, STORIA E DOCUMENTI: Rivista Semestrale di Storia dell'Archittura del Centro di Studi Storico–Archivistici per la Storia dell'Arte e dell'Architettura Medioevale e Moderna. 1985. s–a. IT. IT & EN abstract. **2009**

Marsilio Editori, S. Croce 518/A, 30125 Venice, Italy. Phone 041/707188. Renato Bonelli, Editor.

Subscription: L 50000. Illus. b&w, photos, plans. 6¾ x 9½, 192p.

ISSN: ISBN: 88–317–519–x. OCLC: 13019353. Dewey: 720.5.

Architecture.

Reviews: book in IT. Indexed: ArchPI.

Advertising: none.

ARCHITHESE: Zeitschrift und Schriftenreihe fuer Architektur. Revue Thematique d'Architecture. 1980. bi–m. GE. EN caption heads only.

Verlag Arthur Niggi Ltd., FSAI–Verband Frierwerbender Schweizer Architekten, Rosenstrasse 8, CH–9410, Heiden, Switzerland. Phone 071–914110. Arthur Tischhauser, Editor.

Illus. b&w, photos. A4, 100p.

ISSN: ISBN: 3–7212–0231–7. Continues in part: *Werk/Archithese.*

Architecture. Design.

Series on architecture.

Reviews: book. Indexed: ArchPI. Avery.

Advertising: none. Inserts.

ARCHIVES D'ARCHITECTURE MODERNE. 1990, no.40. FR & EN side-by-side.

Archives d'Architecture Moderne, 14 Rue Defacqe, 1050 Bruxelles, Belgium. Phone 537–87–45.

Subscription: 1600 BFr Belgium, 300 F France, others 2,000 BFr. Illus. b&w, color, photos. A4, 84p.

Architecture.

Contains several articles on modern architecture with many full page color illustrations. Each issue is devoted to a single theme. Articles on both theory and criticism.

Reviews: book.

Advertising.

ARKHITEKTURA/ARCHITECTURE. 1954. bi–m. BU. EN, FR, GE & RU summaries.

Union of Architects in Bulgaria, 1, Evlogi Georgiev Str., BG–1504 Sofia, Bulgaria. Phone 003592 441011 & fax, telex 23569 ARCH BG. Dr. Zdravko Guentcmev, Editor.

Subscription: (1990) $US72 foreign surface. Sample. No back issues. Illus. b&w, color, photos, cartoons. 29 x 33, 96p. Dewey: 720. Formerly: *Architect (1927–1936).*

Architecture. Architectural Education.

The only Bulgarian journal of architectural design, architectural theory and criticism.

Reviews: 20–35/issue. Bibliographies related to reviews. Biographies. Interviews: with architects and public persons related to building. Listings: international. Calendar of events. Exhibition information. Freelance work: yes. Contact: editor. Opportunities: study. (Appears in Special issues), competitions.

Advertising. Mailing lists: available. Demographics: 3500 architects in Bulgaria. Circulation: 6500. Audience: architects and related arts public.

ARKITEKT. 1931. q. TU. EN & FR summaries.

Anadolu Han No. 33, Eminonu, Istanbul, Turkey. Dr. Zeki Sayar, Editor.

ISSN: 0004–1971. Dewey: 720.

Architecture.

Advertising.

ARKITEKTUR: The Swedish Review of Architecture. 1959. 10/yr. SW. EN summary of feature article only (2p. at end).

Arkitekturfoerlag AB, Box 1742, S–111 87 Stockholm, Sweden.

Subscription: SEK 460, air + SEK 80. Illus. b&w, color, photos, plans. 8½ x 11½, 54–64p. + 44p. ads.

ISSN: 0004–2021. OCLC: 1514168. Dewey: 720.

Many color illustrations and advertisements.

Indexed: ArchPI. Avery.

ARKKITEHTI/FINSK ARKITEKTURTIDSKRIFT/FINNISH ARCHITECTURAL REVIEW.

1921. m. FI & SW. FI, SW & EN table of contents. EN & FI summaries. **2015**

Finnish Association of Architects, Etelaesplanadli 22A, 00130 Helsinki, Finland. Phone 90–640801, fax 601123. Kaarin Taipale, Editor.

Subscription: (1991) 540 FIM. Illus. b&w, color, photos, plans. 8¾ x 11¾, 96p.

ISSN: 0004–2129. OCLC: 1514178. LC: NA6.A793. Dewey: 720. Formerly: *Arkitekten* Incorporating: *Arkkitehtuurikilpailuja/Architectural Competitions in Finland.*

Architecture.

Includes articles on architectural subjects from other countries. English language description of competition only (2p.). Opportunities: lists architectural competitions in Finland. Indexed: ArchPI. Avery.

Advertising: Anja Sarmiola, Ad. Director.

ARQUITETURA-R S. 1976. m. **2016**

Sindicato dos Arquitetos No Estado do Rio Grande do Sul, Porto Alegre, Rio Grande do Sul, Brazil.

Dewey: 720.

Architecture.

ART AND DESIGN. See no. 471.

ASSEMBLAGE: A Critical Journal of Architecture and Design Culture. 1986. 3/yr. EN. **2017**

MIT Press Journals, 55 Hayward St., Cambridge, MA 02142. Phone 617–253–2889. K. Michael Hays & Alicia Kennedy, Editors (148 Foster St., Cambridge, MA 02138).

Subscription: $48 individual, $80 institution, $35 students US & Canada, others + $12 surface, + $18 air. Microform available from UMI. Back issues. Illus. b&w, photos, drawings. 8¼ x 10¼, 130–140p.

ISSN: 0889–3012. OCLC: 13832217. LC: NA1.A86. Dewey: 720.

Architecture.

Contains six to eight articles which explore contemporary issues in architecture and design culture. Bibliographies: notes with articles. Freelance work: yes. Contact: editor. Indexed: ArchPI.

Advertising for other MIT publications and journals only.

ATHENAEUM ANNOTATIONS. See no. 1069.

AVERY INDEX TO ARCHITECTURAL PERIODICALS (SUPPLEMENT). See no. 8.

BAUMEISTER: Zeitschrift fuer Architektur, Planung, Umwelt. 1902. m. GE. EN summaries of articles and

captions accompanying illus. **2018**

Verlag Georg D.W. Callwey, Streitfeldstrasse 35, Postfach 800409, 8000 Munich 80, W. Germany. Phone 089–436005–0, fax 089–4361161, telex 5216752 calv d. Paulhans Peters, Editor.

Subscription: DM 139.20. Illus. b&w, color, photos, plans. A4, 110p.

ISSN: 0005–674X. OCLC: 1519264. LC: NA3.B34.

Architecture. Planning.

Journal covers contemporary architecture, planning, and the environment. Focuses on Germany but includes coverage of other countries as well.

Reviews: book. Indexed: ArchPI. Avery.

Advertising.

BAUTENSCHUTZ UND BAUSANIERUNG: Zeitschrift fuer Bauinstandhaltung und

Denkmalpflege. 1978. bi–m. GE. EN & GE summaries. **2019**

Verlagsgesellschaft Rudolf Mueller, Stolberger Str. 84, D–5000 Cologne, W. Germany. Phone 0221–5497–202. Franz Lubinski, Editor.

Subscription: DM 106. Illus.

ISSN: 0170–9267. OCLC: 11308845. Dewey: 690.

Architecture.

A journal of building maintenance and memorial care.

Reviews: book. Indexed: Avery.

Advertising.

BAUWELT. 1952. w. GE only.

Bertelsmann Fachzeitschriften GmbH. Phone Carl Bertelsmann–Str. 270, 4830 Guetersloh 1, W. Germany. Ulrich Conrads, Editor.

Subscription: DM 328.80. Illus. b&w, photos, plans. 9 x 11½, approx. 100p.

ISSN: 0005–6855. OCLC: 8115903. LC: TH3.B32. Dewey: 720. Formerly: *Neue Bauwelt*.

Architecture.

Last number of each quarter is the publication *Stadtbauwelt*.

Indexed: ArchPI. Avery.

Advertising.

BEST-SELLING HOME PLANS FROM HOME MAGAZINE. 1972. q. EN.

Home Magazine Publishing Co., Knapp Communications Corp., 5900 Wilshire Blvd., Los Angeles, CA 90036. Phone 213–410–9546. Nancy Roberts, Editor.

ISSN: 0743–2461. OCLC: 10539501. Dewey: 728. Formerly: *Hudson Home Plans*.

Architecture.

Includes an annual special edition: *Contemporary Home Plans and Traditional Home Plans*.

BETTER HOMES AND GARDENS BUILDING IDEAS. 1937. q. EN.

Meredith Corporation, Special Interest Publications, 1716 Locust St., Des Moines, IA 50336. Phone 515–284–3000. William Yates, Editor.

Subscription: $2.95/issue. Illus.

ISSN: 0093–0938. Dewey: 728.3.

Architecture.

How–to–information for readers seriously concerned about a new single–family home, townhouse, condominium or vacation home.

Reviewed: Katz.

Advertising. David Cohen, Ad. Director. Circulation: 450,000.

BINARIO: Revista de Arquitectura, Construcao e Equipamento. 1958. m. POR. EN summaries.

Praca de Londres 10, Lisbon 1, Portugal. Jose Luis Quintino, Editor.

Subscription: $12. Illus.

ISSN: 0006–2804. LC: NA5. Dewey: 721.

Architecture.

BLUE PRINT: The Leading Magazine of Architecture and Design. 10/yr. EN.

Wordsearch Ltd., 26 Cramer St., London W1M 3HE, England. Phone 01–486–7419, fax 01–486–1451. (US Dist.: Speedimpex, 45–45 39th St., Long Island City, New York, NY 11104). Deyan Sudjie, Editor.

Subscription: $US80, £25. Illus. b&w, color, photos. 10¾ x 14¾, 62p.

ISSN: 0268–4926.

Architecture. Interior Design. Design.

Tabloid covering design, architecture and the visual arts. Presents comment and criticism.

Reviews: book. Calendar of events. Exhibition information. Opportunities: employment, study. Indexed: ArchPI. ArtBibMod. Avery.

Advertising: full page £2400, ½ page £1300, ¼ page £700. Classified. Richard Leeks, Ad. Director. Craig Pearson, Classified. Audience: design professionals.

BLUEPRINTS. 1981. q. EN.

National Building Museum, Judiciary Square, N.W., Washington, DC 20001. Phone 202–272–2448. Joyce Elliott, Editor.

Subscription: $25 US, foreign + $5. Back issues $2. Illus. b&w, photos. 11 x 17, 8p.

ISSN: 0742–0552. OCLC: 7622121. LC: NA705.B54. Dewey: 720. Formerly: *Blueprints (Committee for a National Museum of the Building Arts)*.

Architecture. Building. Built Environment.

Reviews: book 1, length 1000 wds.; film occasionally. Obits. Freelance work: sometimes, rarely pay. Contact: editor. Indexed: Avery.

Advertising: none. Circulation: 5,000.

BUILDING: For the Design and Construction Team. 1842. w. EN. 2026

Building (Publishers) Ltd., Builder House, 1 Millharbour, London E14 9RA, England. Phone 071–537 2222, Fax 071–537 2007, telex 25212 Builda–G. Graham Rimmer, Editor.

Subscription: foreign £93, air £150. Microform available from UMI. Illus. b&w, color, photos, cartoons. Index. A4.

ISSN: 0007–3318. OCLC: 1537651. Dewey: 720.5. Formerly: *The Builder.*

Archaeology. Architecture. Landscape Architecture. Construction.

Provides readers with comprehensive and detailed news coverage and comment on all aspects of the industry. Editorial policy is to inform its readers of events and developments in the industry, providing a challenging mix of news, features, comments and criticism. Includes up–to–date news coverage, balanced opinion, and informed analysis. It also provides market information, forecasts, feature articles, market surveys, product reports and technology briefs. Each month, features concentrate on those parts of the building that are of most current concern to designers, specifiers and builders. Provides monthly product supplements on diverse subjects, product supplements, refurbishment and building homes special supplements and technology features.

Interviews: profiles of young architectural practices. Listings: national. Opportunities: employment, extensive listings. Indexed: ArchPI. Avery.

Advertising: (rate card Jan '89): b&w full page £1,095, ½ page £565, ¼ page £325; color + £215–£630; covers + £150–340. Frequency discount. Bleeds + £10 full page. 10% agency discount. Inserts. (Fax 01 537–2005). Mailing lists: none. Demographics: pass–on readership 8.7/copy. Circulation: 21,000. Audience: building industry managers and design professionals.

BUILDING & ARCHITECTURE. 1972. 10/yr. EN. 2027

Archipress, G.P.O. Box 1031, Adelaide, S.A. 5001, Australia. David Ness, Editor.

Architecture.

Reviews: book.

Advertising.

BUILDING DESIGN. 1969. w. EN. 2028

Morgan–Grampian (Construction Press) Ltd., 30 Calderwood St., London SE18 6QH, England. Phone 081–885 7777. Paul Finch, Editor.

Subscription: £45 UK& Erie, elsewhere $US118 (40 Beresford St., London SE18 6BR). Microform available from UMI. Illus. b&w, color. tabloid, 11½ x 15¾, 48p.

ISSN: 0007–3423. OCLC: 4677701. LC: TH1.B825. Dewey: 720.

Architecture.

"The weekly newspaper for the design team" contains news, comment, perspective, and letters.

Calendar of events. Opportunities: appointments listed. Indexed: ArchPI. Avery. Des&ApAI.

Advertising b&w & color. Classified: £25/s.c.c. [+ VAT], min. 3 col.cm. Readers service card. David Jones, Ad. Manager.

BULLETIN COMMISSION ROYALE DES MONUMENTS ET DES SITES. 1949. a. FR. 2029

Commission Royale des Monuments et des Sites, Rue Joseph II, 30, B–1040 Brussels, Belgium.

Illus. Cum. index every 10 vol.

ISSN: 0522–7496. OCLC: 1772051. LC: N2.B42. Dewey: 722. Formerly: *Commissions Royales d'Art et d'Archeologie. Bulletin.*

Architecture. Monuments.

BYGGEKUNST: The Norwegian Review of Architecture. 1919. 8/yr. NOR.

EN summaries of feature article (1p.). 2030

Norske Arkitekters Landsforbund – Norwegian Architects' League, Josefines gate 34, Oslo 3, Norway. Phone 60 22 90, fax 69 59 48. Ulf Gronvold, Editor.

Subscription: Kr 450. Illus. mainly color, plans. 8½ x 11½, 128p.

ISSN: 0007–7518. OCLC: 1537946. LC: NA6.B78. Dewey: 720.

Architecture.

Includes detailed floor plans.

Reviews: book. Indexed: ArchPI. Avery. Reviewed: Katz.
Advertising.

CASABELLA. 1928. 10/yr. IT. Some articles tr. into EN (same page, small print). Captions in IT & EN.
EN summaries (6p.). **2031**
Electa Periodici SRL, Via Trentacoste 7, 20134 Milan, Italy. Phone 02–215631, fax 02/26410847, telex 350523 ELEPER I.
Vittorio Gregotti, Editor.
Subscription: L 90.000. Illus. some color, photos, plans. Annual index. 9½ x 11½, 64p.
ISSN: 0008–7181. OCLC: 1553457. LC: NA4.C3. Dewey: 720.5. Formerly: *Casabella Continuita.*
Architecture.

International architectural review concerned with urban design, architectural and industrial design. Emphasis is on contemporary architecture but does include some coverage of historical subjects.
Exhibition information. Opportunities: competitions, conventions. Indexed: ArchPI. ArtHum. ArtI. Avery. CloTAI. CurCont.
Reviewed: Katz.
Advertising.

CASTELLUM: Rivista dell'Istituto Italiano dei Castelli. 1965. s–a. IT. EN summaries. **2032**
Istituto Italiano dei Castelli, Via Cernaia, 5, I–20121 Milan, Italy.
Dewey: 720.
Architecture.

CENTER: A Journal for Architecture in America. 1985. a. EN. **2033**
Center for the Study of American Architecture, School of Architecture, University of Texas at Austin. (Dist.: Rizzoli International Publications, 300 Park Ave. South, New York, NY 10010). Phone 212–982–2300. Anthony Alofsin & Lawrence W. Speck, Editors.
Subscription: $15
Illus. b&w, color (20+p.), photos, plans. 8½ x 11¼, 128p.
ISSN: 8755–2019. OCLC: 11240914. LC: NA705.C4. Dewey: 720.
Architecture.

Each issue also has a distinctive title. Contains 10–12 articles and includes case studies, short articles which document the results of modern planning notions that have been tested in the real milieu of the city over a period of time.
Bibliographies. Indexed: ArchPI. Avery. Reviewed: Katz.
Advertising: none.

CHICAGO ARCHITECTURE FOUNDATION NEWS. q. EN. **2034**
Chicago Architecture Foundation, 1800 S. Prairie, Chicago, IL 60616. Phone 312–326–1393. Donna Palladino, Editor.
Subscription: included in membership.
Dewey: 720.
Architecture.
Tabloid.

CIVIC TRUST AWARDS. 1967. a. EN. **2035**
Civic Trust, 17 Carlton House Terrace, London SW1Y 5AW, England. Phone 071–930 0914. Sarah Wilson, Editor.
Illus. A4, 75p.
OCLC: 7937813, 7936787. LC: NA9052.C49a. Dewey: 720. Formerly: *Civic Trust Award.*
Architecture.

Reviews: Listing of award and commendation winners, it includes a foreword on relevant issues by the director and a brief assessment of each winning scheme illustrated by photographs. Freelance work: none.
Advertising: none. Audience: architects, designers, developers, general public.

COLIMPEX ARCHITECT'S EXECUPAD. a. AF & EN. **2036**
Colimpex Africa (Pty) Ltd., P.O. Box 889, Wendywood 2144, South Africa.
Dewey: 720.
Architecture.
Advertising.

CONSTRUCTION HISTORY. 1985. a. EN. 2037

Carfax Publishing Co., P.O. Box 25, Abingdon, Oxfordshire, OX14 3UE, England. Mark Swenarton, Editor.

Subscription: included in membership, $80 US (Carfax Publishing Co., 85 Ash St., Hopkinton, MA 01748). Microform available from publisher. Sample. Back issues. Illus b&w, photos. 10 x 7, 96p.

ISSN: 0267-7768. OCLC: 13019433. LC: TH15.C58. Formerly: *Construction Science*.

Architecture History. Crafts. Historic Preservation. Building Materials. Construction Technology.

International journal of the Construction History Society is devoted to all aspects of the history of building and construction, and to development of construction history as a scholarly discipline. Articles do not normally exceed 6,000 words. The only English language periodical on the subject.

Reviews: (1 issue/vol.) book 8, length 600+ wds.; journal occasionally. Bibliographies: abstracts of periodical literature, approximately 20/issue, length 150-200 wds. each. Freelance work: yes. Contact: editor. Indexed: ArchPI. Reviewed: *Art Documentation* Spr 1988, p.37.

Advertising: full page $100. Mailing lists: none. Circulation: 400. Audience: historians in fields of construction, architecture and related fields.

CONSTRUCTION MODERNE: Revue d'Architecture. 1884. q. 2038

Syndicat National des Fabricants de Ciments et Chaux, 47 rue des Renaudes, 75017 Paris, France. Editorial Board.

Subscription: free. Illus.

ISSN: 0010-6852. LC: NA2. Dewey: 720.

Architecture.

Indexed: ArchPI.

CONSTRUCTIONAL REVIEW. 1927. q. EN. 2039

Concrete Publishing Co. Pty. Ltd., 25 Berry St., North Sydney, N.S.W. 2060, Australia. Phone 02-923-1244, fax 02-923-1925. Diane Kell, Editor.

Subscription: $A30 Australia, $A44 elsewhere. Available online DIALOG. Sample, mailing cost. Back issues. Illus b&w, color. A4, 64p, offset.

ISSN: 0010-695X. OCLC: 3882266. LC: TA401.C7507. Dewey: 720, 690. Formerly: *Highways*.

Architecture.

Serves the design professions in the building industry. Concentrates on presenting technical data on the design, construction and detailing of significant buildings and structures, in a form to encourage both immediate study and retention for future reference. Provides useful and usable detailed information on current building activity. Format consists of 6-8 page reviews of recently completed structures, providing a showcase for the work of the building industry as well as illustrating design trends. Covers buildings of architectural merit or innovation which have employed concrete in their construction.

Reviews: book. Freelance work: none. Opportunities: competitions. Indexed: ArchPI.

Advertising: (rate card Jan 89): full page $750, ½ page $460, spot color +$300, 4 color +$600. Bleed no charge. Frequency discount. Inserts. Demographics: over 2000 architects, including all active architectural firms; the full design and construction management team responsible for current building developments in the country. High degree of multiple readership in design offices. Circulation: 5000. Audience: principally architects, engineers.

COVJEK I PROSTOR. 1954. m. SCR. EN abstracts. 2040

Crotian Association of Architects (Savez Arhitekata Hrvatske), Trg bana J. Jelacica 3/I, 41000 Zagreb, Yugoslavia. Phone 041-274-796. Nikola Polak, Editor.

Sample. Back issues. Illus. b&w 40, color 20, photos 30, 30 arch. design. 26.5 x 32 mm., 36p.

ISSN: 0011-0728. Dewey: 720.

Architecture. Art History. Decorative Arts. Graphic Arts. Historic Preservation. Interior Design. Landscape Architecture. Modern Art. Painting. Sculpture.

Interviews cover actual problems in architecture.

Reviews: exhibition 2, book 2, journal 2. Interviews. Biographies: architect's opus. Obits. Listings: regional-international. Exhibition information. . Freelance work: yes. Contact: Ana Buljan. Opportunities: study, competitions. Indexed: ArchPI.

Advertising: full page DM 1.000, color full page DM 2.000. 5% frequency discount. Circulation: 3000.

EL CROQUIS: De Arquitectura y de Diseno. 5/yr. SP. SP & EN table of contents.

EN summaries (with articles). 2041

El Croquis Editorial, Barcelo 15, 28004 Madrid, Spain. Richard C. Levene & Fernando Marquez Cecitia, Editors.

Subscription: 11.000 ptas Europe, 12.350 ptas US, 15.150 ptas Asia. Illus., mainly full page color, some b&w, photos, plans. 9½ x 13½, 174p.
ISSN: 0212–5683.
Architecture.

Each issue almost entirely on a single architect and his/her work. Includes interview, list of works, and criticism of the works. Interviews: entire issue interview with one architect. Indexed: ArchPI. Avery.
Advertising.

CUSTOM BUILDER. 1987. m. EN. 2042

Willows Publishing Group, Inc., 38 Laffayette St., P.O. Box 998, Yarmouth, ME 04096–0470. Phone 207–846–1561. John Andrews, Editor.
Subscription: $38 US, elsewhere + $22, air + $48. Back issues. Illus. b&w, some color. 8 x 10¾, 64p.
ISSN: 0895–2493. OCLC: 16520871. LC: TJ810.S4866. Dewey: 690. Formerly: *Progressive Builder; Solar Age.*
Architecture. Interior Design.

The business magazine for builders of premier homes. Covers innovations in building techniques, practices and products directly of interest to the builder of custom homes. Includes product update and product literature.
Interviews: feature article, builder of the month. Indexed: ArchI.
Advertising: Grace Brown, Ad. Director. Mailing lists: available for rent. Circulation: 30,000.

DAF YIDIOT. 1979. s–a. 2043

Institute for Development of Educational and Social Welfare Structures, Rehov Yehuda Hamacabi 56, Tel Aviv 62 300, Israel.
Subscription: free.
Dewey: 720.
Architecture.

DAIDALOS: Architektur Kunst Kultur. 1981. q. EN & GE (side by side). Table of contents in both EN
& GE. 2044

Bertelsmann Fachzeitschriften GmbH, Carl–Bertelsmann–Strasse 270, D–4830 Guetersloh 1, W. Germany. Ulrich Conrads, Editor.
Subscription: DM 148, students DM 100. Back issues. Illus. some color, photos, plans. 9½ x 11½, 146p.
ISSN: 0721–4235. OCLC: 8343763. LC: NA1.A1D34. Dewey: 720.
Architecture.

Covers architecture, art, and culture. Each issue has an individual theme and title.
Indexed: ArchPI. Avery. BHA. RILA.
Advertising.

DAILY MAIL BOOK OF HOME PLANS. 1954. a. EN. 2045

Plan Magazines Ltd., 45 Station Rd., Redhill, Surrey RH1 1QH, England. Phone 0737 767213. John M. Bailey, Editor.
Illus.
OCLC: 6235157. LC: TH4809.G7 D34. Dewey: 728.3.
Architecture.

DB - DEUTSCHE BAUZEITUNG: Fachzeitschrift fuer Architekten und Bauingeneure.
1867. m. GE. EN summaries (1p. total, 1 paragraph/article). 2046

Deutsche Verlags–Anstalt GmbH, Neckarstr. 121, Postfach 10 60 12, 7000 Stuttgart 10, W. Germany. Phone 0711 26–31–297, fax 26–31–292. Wilfried Dechau, Editor.
Subscription: DM 126.60. Illus. b&w, some color, plans. Index. A4, 154p.
ISSN: 0721–1902. Formerly: *D B – Deutsche Bauzeitung – Die Bauzeitung.*
Architecture.

German construction newspaper, a technical journal for architects and construction engineers. Heavily illustrated with many illustrations of buildings.
Reviews: book, products. Listings: national.
Advertising: ½ page DM 1680, ¼ page DM 840.

DEADLINES. 1985. 15/yr. EN. 2047

Design Competition Registry, 17 West Hawley Rd., Hawley, MA 01339. Phone 413–339–4018 & fax. Peter Beck & Ken Bertsch, Editors.

Subscription: $24 US, $45 fax in continental US, SC30, SUS25 Mexico, foreign $US35. 5½ x 8½, 15p.

ISSN: 0889–1931. OCLC: 13812276. Dewey: 705.

Architecture. Art. Graphic Arts. Interior Design.

Contains notices concerning upcoming architectural and design competitions. Provides description, contact person, deadline, registration details, fee, judges. Also presents information updates. Established by the University of Miami with funding from the Design Arts Program of the National Endowment for the Arts.

Listings: international. Opportunities: competitions.

DEMEURES ET CHATEAUX. 1978. q. FR. EN summaries. 2048

21 rue Cassette, 75006 Paris, France. Magali Lucas, Editor.

Subscription: 70 F. Illus.

ISSN: 0291–1191. Formerly: *Demeures et Chateaux en France.*

Architecture.

DESIGN. 1957. q. EN. 2049

Builders Publications of India (P) Ltd., 11, Amrita Sher–gill Marg, New Delhi 110003, India. Patwant Singh, Editor.

Subscription: Rs 30, foreign Rs 120. Illus. 50p.

ISSN: 0011–9261. OCLC: 1774298. LC: NA1.D45. Dewey: 745. Formerly: *Indian Builder.*

Architecture. Interior Design. Landscape Architecture.

Magazine of arts and ideas on a variety of subjects. Covers architecture, design, landscaping, conservation, preservation, aesthetics, education and history.

DESIGN BOOK REVIEW: DBR. 1983. q. EN. 2050

Design Book Review, 1418 Spring Way, Berkeley, CA 94708. Phone 415–486–1956. Elizabeth Snowden, Editor.

Subscription: $24 individual, $36 institution. Illus. b&w, photos. Index. 8½ x 11, 130p.

ISSN: 0737–5344. OCLC: 9361004. LC: NA2599.9.D47. Dewey: 720.

An international critical review of English language architecture and design publications. Coverage includes interviews, essays, and design criticism in design, architecture, and landscape architecture.

Reviews: book, lengthy. Bibliographies. Indexed: Avery. BkReI. Des&ApAI. RILA. Reviewed: Katz. *Art Documentation* Fall 1986, p.132.

Advertising: Kathryn Snowden, Ad. Director.

DESIGN COST & DATA: The Cost Estimating Magazine for Architects, Builders and Specifiers.
1968. bi–m. EN. 2051

Allan Thompson Publishers, 1200 E. Alosta, Suite 103, Glendora, CA 91740. Phone 818–914–2835. Allan Thompson, Editor.

Subscription: $20 US, $25 Canada & Mexico, foreign $40, air $50. Microform available from UMI. Sample. Back issues $5. Illus b&w, some color, photos. Annual cum. index. 8⅝ x 11⅛, 36–52p.

ISSN: 0739–3946. OCLC: 9523104. LC: NA1.A713x. Formerly: *Design Cost & Data for Building Design Management; Design Cost and Data for the Construction Industry; Architectural Design, Cost and Data.*

Architecture. Graphic Arts. Historic Preservation. Interior Design. Landscape Architecture.

Provides architects and builders with a benchmark reference file of actual project costs and data, designed for filing as a permanent reference source. Also "Preliminary Estimating Guides" of key construction materials and systems, "Research and Development" information on building products, and practical articles and news.

Reviews: book. Listings: national. Freelance work: rarely. Contact: editor. Reviewed: Katz.

Advertising: (rate card Dec '88): full page $2085, ½ page $1420–$1490, ¼ page $830, covers $2500–$3400; color + $300–$580, 4 color + $800. Bleeds no charge. Frequency discount. 15% agency discount. 2% cash discount. Inserts. Mailing lists: none. Demographics: readership is 98.7% top executives of architectural, building, development and contractor companies. Circulation: 8000. Audience: architects, professional builders, contractors, estimators, specifiers.

DESIGN ISSUES. See no. 1551.

DESIGN LINE. 1970. q. EN. 2052

Sierra Printing, 2900 Rio Linda Blvd., Sacramento, CA 95815. Phone 916–447–2422. Tammy Thomas, Editor (1412 19th St., Sacramento CA 95814).

Subscription: included in membership. Sample free. Back issues. Illus., photos, cartoons occasionally. 8½ x 11, 16p.

General. Architecture. Drawing. Graphic Arts. Landscape Architecture.

Newsletter which informs members of activities and events happening within the American Institute of Building Design. Articles dealing with architectural design and design matters are included.

Reviews: plan book, roster. Interviews: AIBD members. Biographies: new members, membership activity in AIBD. Listings: national. Freelance work: yes. Contact: editor. Opportunities: employment, study, competitions.

Advertising: (camera ready) full page $150 members, $250 non–members; ½ page $90, $190; ¼ page $50, $150, covers $250, $350; business card $25, $125. Mailing lists: available. Demographics: designers in over 30 states and Canada. Circulation: 1000. Audience: members of the American Institute of Building Design (residential, commercial and industrial designers and other related professionals or trainees).

DESIGN RESEARCH NEWS. 1969. q. EN. 2053

Environmental Design Research Association, Box 24083, Oklahoma City, OK 73124. Phone 405–848–9762, fax 405–232–3152. Sherry Ahrentzen, Editor.

Subscription: included in membership, $24 US, foreign $28. 8½x11, 28p.

OCLC: 6192316. LC: TH6021.D47. Dewey: 712.

Architecture.

"Official newsletter of the longest–established professional organization dedicated to improving quality of human environments through research–based design". Purpose is to advance the art and science of environmental research and to improve understanding of the relationships between people and their surroundings. Promotes design and building processes that incorporate more information about user requirements. Encourages the education of design. Contains articles, provides information on research/projects in progress.

Reviews: book. Freelance work: yes. Contact: editor. Opportunities: job opportunities, meetings and conferences, funding opportunities.

Audience: design professionals, social scientists, students, educators and environmental managers.

DESIGN SOLUTIONS. 1981. q. EN. 2054

Architectural Woodwork Institute, 2310 S. Walter Reed. Dr., Arlington, VA 22206–1199. Phone 703–671–9100. Elaine Ferri, Editor.

Subscription: included in membership, $18 US & Canada. Sample free. Back issues. Illus., color, photos. 8¼ x 11, 72p., Saddle Stitch.

ISSN: 0277–3538. OCLC: 7537179. LC: NA2750.D415. Dewey: 729.

Architecture. Decorative Arts. Furniture. Historic Preservation. Interior Design.

Features architectural woodwork projects, custom designed and fabricated.

Reviews: book 5, equipment 5. Listings: international. Freelance work: none. Opportunities: study – AWI Award of Excellence program. Indexed: Avery.

Advertising: (rate card Apr '88): b&w full page $1945, ½ page $1145–$1320, ¼ page $670, spread $3695; color + $390–605, 4 color + $1025, covers $3120–$3510. No classified. Frequency discount. Guaranteed position, full page only, + 15%. Bleeds no charge. 15% agency discount. 20% discount AWI Active Members. Andrea Sugarman, Ad. Director. Mailing lists: none. Demographics: national. Circulation: 33,000. Audience: architects, interior designers, specifiers.

DESIGN STUDIES. 1979. q. EN. 2055

Butterworth Scientific Ltd., P.O. Box 63, Westbury House, Bury St., Guildford, Surrey GU2 5BH, England. Phone 0483–300966, telex 859556 SCITEC G. Nigel Cross, Editor.

Subscription: £22 members, £97 non–members, overseas £113 surface, air rates on request, airspeeded to US & Canada at no extra charge (UK: Westbury Subscription Services, P.O. Box 101, Sevenoaks, Kent TN15. North America: Butterworth Publishers, 80 Montvale Ave., Stoneham, MA 02180 USA). Microform available from UMI. Back issues. Illus., few b&w, photos. 8 x 11½, 56p.

ISSN: 0142–694X. OCLC: 5523939. LC: NA2750.D416. Dewey: 745.2.

Architecture.

Published in co–operation with the Design Research Society. Refereed journal, scholarly providing a forum for promoting contact and communication between people involved in or interested in research into design and interdisciplinary understanding of design.

Reviews: papers 6, book 4. Listings: international. Calendar of events. Freelance work: papers about 5000 wds + illustrations. Contact: editor. Indexed: ArchPI. ArtBibCur. ArtBibMod. Avery. Des&ApAI. Advertising: none.

DESIGNER HOME PLANS. 1986. 3/yr. EN. 2056
Davis Publications, Inc., 380 Lexington Ave., New York, NY 10017. Phone 212–557–9100. Stephen Wagner, Editor. Illus. plans. 8 x 11, 160p.
OCLC: 16412309. LC: NA7205.D45. Dewey: 728.3.
Architecture.

America's leading architects present over 200 home plans.

DESIGNER'S COLLECTION HOME PLANS. q. EN. 2057
HomeStyles Publishing, 275 Market St., Suite 521, Minneapolis, MN 55405. Phone 612–927–6767. Roger Heegaard, Editor. Subscription: $12 libraries. Sample. Illus. plans. 212p.
OCLC: 17571586. Dewey: 728.
Architecture.

DETAIL: Zeitschrift fuer Architektur & Baudetail. 1961. bi–m. GE. 2058
Institut fuer Internationale Architektur–Dokumentation GmbH, Innere Cramer–Klett Str. 6, 85 Nuremberg 1, W. Germany. Phone 0911–5325–0.
Subscription: DM 86. Illus., some color.
ISSN: 0011–9571. OCLC: 1566304. LC: NA2835. Dewey: 720.
Architecture.

Journal of architecture and building documentation.
Indexed: ArchPI. Avery.

DETAIL/DITERU: Magazine for Architects and Engineers. 1964. q. JA. EN summaries. 2059
Shokokusha Publishing Co., Ltd., 25 Sakamachi, Shinjuku–ku, Tokyo 160, Japan. Takashi Hosoda, Editor.
Illus.
ISSN: 0012–4133. Dewey: 720.
Architecture.

DISTINGUISHED HOME PLANS. 1981. q. EN. 2060
HomeStyles Publishing, 6800 France Ave. South, Suite 115, Minneapolis, MN 55435. Phone 612–927–6767. Roger Heegaard, Editor.
Subscription: $15. Sample. Illus. plans. 212p.
ISSN: 0897–6236. OCLC: 13801599. LC: NA7205D58. Dewey: 728.
Architecture.

Emphasizing quality construction and affordable family living. Features over 200 pages of newly designed classic and traditional homes. Each issue also has a distinctive title.

DO IT YOURSELF. 198? s–a. EN. 2061
Meredith Corporation, Special Interest Publications, 1716 Locust St., Des Moines, IA 50336. Phone 515–284–2484.
Illus. 8½ x 11. Web offset.
OCLC: 14903301. LC: TH4817.D6. Dewey: 643. Formerly: *Do It Yourself Home Improvement and Repair*.
Interior Design.

Advertising: (rate card Jan '89): b&w full page $14,150, ½ page $8,850, ⅓ page $6,100; 4 color full page $20,300, ½ page $14,600, ⅓ page $11,650, covers $22,250–24,300. Frequency discount, discount for any combination of Better Homes and Gardens Special Interest publications. 15% agency discount. Bleeds + 15%. Readers Service (Information worth writing for). Des Moines: Jerry Ward, Publisher; New York: David Cohen, Ad. Director (750 Third Ave., New York, NY 10017, phone 212–551–7083); Chicago: Jim Day, Manager (330 North Michigan Ave., Chicago, IL 60601, phone 312–580–1615). Circulation: 450,000.

DOME. 1988. q. EN. 2062
4401 Zephyr St., Wheat Ridge, CO 80033. Donald R. Hoflin, Editor & Pub.

Subscription: $32. Illus.
ISSN: 1041–1607. OCLC: 18666049. LC: TH2170.D635. Dewey: 720.
Architecture.

Dedicated to the development of low–cost housing worldwide through the use of domes.

EAA REVIEW. 1957. a. EN. **2063**
Edinburgh Architectural Association, 15 Rutland Sq., Edinburgh EH1 2BE, Scotland. Phone 031-229-7205/6. Roger Taylor, Editor.
Subscription: included in membership.
ISSN: 0307–1634. Dewey: 720. Formerly: *Edinburgh Architectural Association E A A Yearbook.*
Architecture.

Advertising.

ELEVATIONS. m. EN. **2064**
Royal Australian Institute of Architects, Victorian Chapter, 30 Howe Crescent, South Melbourne, Victoria 3205, Australia. Phone 03–699–2922. Mary Popov, Editor.
Subscription: $A40.
Dewey: 720. Formerly: *State Electricity Commission Newsletter.*
Architecture. Planning.

Covers architecture and urban development in Australia.
Advertising.

ENVIRONMENT AND PLANNING B: PLANNING & DESIGN. 1983. q. EN. **2065**
Pion Ltd., 207 Brondesbury Park, London NW2 5JN, England. Phone 081–459 0066, fax 081–451 6454, telex PION G. M. Batty & L. March, Editors.
Subscription: $122 US. Sample. Back issues. Illus b&w, color, photos. Index bound in last issue. 120p.
ISSN: 0265–8135. OCLC: 10070935. LC: 720. Dewey: 720. Formerly: *Environment & Planning. B.*
Architecture.

An international journal in architecture and planning publishing research with a particular emphasis on systematic and formal approaches to the planning and design process. Aims to publish research into the design and decision making process as well as evaluate the appropriateness of new methods in practice. Provides a forum for critical comment on systems approaches to planning as well as on the role of quantification and formal method in the design process. Includes abstracts.
Reviews: book 5–6. Listings: international. Freelance work: none. Opportunities: study. Indexed: Avery.
Advertising: (rate card 1989): full page £95, ½ page £50, bleed + 10%. Frequency discount. Inserts. Artwork suitable for photographic reproduction for litho printing is required. Sue Thorn, Ad. Director. Mailing lists: none. Audience: planners, researchers in architectural design.

**ENVIRONMENTAL DESIGN RESEARCH ASSOCIATION. ANNUAL CONFERENCE PRO-
 CEEDINGS.** 1969. a. EN. **2066**
Environmental Design Research Association, P.O. Box 24083, Oklahoma City, OK 73124. Phone 405–848–9762.
Dewey: 720.

Purposes is: to advance the art and science of environmental design research; improve understandings of the relationships between people and their surroundings; and help create environments responsive to human needs. Promotes design and building processes that incorporate more information about user requirements. Each issue has an individual title.

EUPALINO: Cultura Della Citta e Della Casa. 1984. q. IT & EN. Table of contents in both languages. **2067**
L'Erma di Bretschneider, Via Cassiodoro, 19, P.O. Box 6192, I–00193 Rome, Italy. Phone 06–687.41.27, fax 06–687.41.29. Paolo Portoghesi, Editor.
Subscription: L 125.000, $104. Back issues. Illus. b&w, some color, photos, maps, plans. Annual index. 11 x 16½, 100p.
ISSN: 0394–1043. OCLC: 11767731. LC: NA680.E92. Dewey: 724.9.
Architecture. Decorative Arts. Furniture. Interior Design. Landscape Architecture.

City & House Culture. "A review that will record and promote the great change that has contributed to link architecture and history. Review will start a dialogue between architecture and other fields of culture and communication." Covers a wide variety of urban and interior design works. An article on art theory is found in each issue as well.
Reviewed: *Art Documentation*, Sum 1986, p.64.

Advertising: (rate card 1989): b&w full page L 3.300.000, ½ page L 1.900.000. Frequency discount. Mrs. Annamaria Russo, Ad. Director. Demographics: architects & engineers 56.7%, professional 20.84%, circulation worldwide. Circulation: 16,200+. Audience: architects and architectural students.

EXTERIORS. 1983. q. EN.

2068

Harcourt Brace Jovanovich, Inc., 7500 Old Oak Blvd., Cleveland, OH 44130. Phone 216–243–8100. Mike Russo, Editor. ISSN: 0886–5949. Dewey: 747.

Architecture.

Design and technical information for architects and specifiers involved in designing or specifying residential, commercial and industrial roof, wall and glazing systems.

FINE HOMEBUILDING. 1981. 7/yr., bi–m. + Spring issue. EN.

2069

Taunton Press, 63 S. Main St., Box 355, Newtown, CT 06470. Phone 203–426–8171, fax 203–426–3434, telex 510–600–4860. Mark Feirer, Editor.

Subscription: $26 US, $30 Canada & foreign, air + $16.80. Sample $4.95. Back issues $5.50. Illus., color, photos (120/issue). Annual index in Dec/Jan issue. Cum. index no.1–42. 9 x 12, 124p. Web offset, perfect bound. ISSN: 0273–1398. OCLC: 7011591. LC: TH4805.F55. Dewey: 690.

Architecture. Crafts. Historic Preservation. Building Construction.

The only magazine written by builders, for builders—both professionals and homeowners looking for professional results. A special–interest magazine for people who want to learn all they can about building and rebuilding homes. Used to swap ideas and practical information in the custom home–building field. Feature articles cover a wide variety of home–building topics, including tools, construction techniques, materials, and design. In–depth articles from today's best builders with every step shown in full color including photographs and technical drawings. A special issue each spring, "Houses", is devoted entirely to home design and showcases a variety of well–constructed and beautifully designed homes.

Reviews: exhibition 1, length 300–750 wds.; book 4, equipment 5. Listings: state–national. Calendar of events. Exhibition information. Freelance work: yes (details in *PhMkt*.). Opportunities: study. Indexed: ArchPI. Avery. Hand. Search. Reviewed: Katz. Katz. *School.*

Advertising: (rate card Apr/May '89): b&w full page $7990, ½ page $4440, ¼ page $2400, cover $9190; 4 color full page $11,190, ½ page $6220, ¼ page $3360, cover $12,870. Classified: $4.50/wd., 15 wd. min., payment with order. Frequency discount. 15% discount for camera–ready art. 2% net discount. Inserts. Reader Service Card no extra charge. James P. Chiavelli, Ad. Director. Mailing lists: available. Demographics: 48% home–building professionals, 94% male, 41 years old., $67,000+ household income, 82% own home, average value of home $205,000, 36% plan to build a new home in the next 2 yrs. (1988 subscriber survey). Circulation: 235,000. Audience: builders and homeowners.

FRIENDS OF KEBYAR. 1983. q. EN.

2070

Friends of Kebyar, Inc., P.O. Box 5122, Berkeley, CA 94705. Illus. ISSN: 0890–9717. OCLC: 11420127. LC: NA1.F74. Dewey: 720.

Architecture.

Indexed: Avery.

FRIENDS OF TERRA COTTA NEWSLETTER. 1981. q. EN.

2071

Friends of Terra Cotta, Inc., c/o Susan Tunick, President, 771 West End Ave., No. 10E, New York, NY 10025. Phone 212–932–1750.

Subscription: included in membership. Illus. 8½ x 11, 12p. ISSN: 0884–9897. OCLC: 10622750. Dewey: 720.

Architecture. Historic Preservation.

Goal is to raise the awareness of the general public and particularly architects, engineers and owners of terra-cotta clad buildings, to the value of and the difficulties associated with the preservation of terra cotta. Presents regional news—by sections of country.

Calendar of Friends meetings only.

Advertising. Audience: architects, engineers and owners of terra-cotta clad buildings.

GA (GLOBAL ARCHITECTURE): A Serial Chronicle of Modern Architecture. 1980. q. EN & JA.

Table of contents in each language.

2072

A.D.A. Edita Tokyo Co. Ltd., 3–12–14 Sendagaya, Shibuya–ku, Tokyo, Japan. Phone (03) 403.1581. Yukio Futagawa, Editor & photographer.

Back issues from v.13. Illus. color, b&w, photos, plans. 300 x 297mm., 120–240p., 30–48 color p.
ISSN: 0389–0066. OCLC: 7099622. LC: NA680.G32. Dewey: 720.

Architecture.

Documents the latest developments and significant works from all over the world as they happen and as realistically as possible. Abundant illustrations supplement critical essays by prominent architectural critics and historians. Each issue focuses on a several modern buildings or projects worldwide.

Interviews: architect whose work is featured. Indexed: ArchPI. Reviewed: Katz. *Art Documentation* Spr 1987, p.41–42.

GA (GLOBAL ARCHITECT) HOUSES. 1985. s–a. EN & JA. 2073
A.D.A. Edita Tokyo Co., Ltd., 3–12–14 Sendagaya, Shibuya–ku, Tokyo, Japan. Wayne N.T. Fujii, Editor.
Illus. mainly color, photos.
OCLC: 17474277.

Devoted to new residential architecture from around the world. Focuses on new works and "residential works from the past now considered epochmaking".

Indexed: ArchPI. Avery. Reviewed: Katz.

GARLINGHOUSE HOME PLAN GUIDES. 1948. m. EN. 2074
L.F. Garlinghouse Co., Inc, Box 1717, Middletown, CT 06457. Phone 203–632–0500. Edward Rotherall, Editor.
Illus., plans. 8 x 11, 112p.
Dewey: 720. Formerly: *Home Plans to Build/Build It Yourself Homes.*

Architecture.

New home designs and building product information.

GREAT BRITAIN. ROYAL COMMISSION ON THE HISTORICAL MONUMENTS OF ENGLAND. INTERIM REPORT. 1982. a. EN. 2075
Royal Commission on the Historical Monuments of England, Fortress House, 23 Savile Row, London W1X 2JQ, England.
Phone 071–973–3500, fax 071–494–3998.

Formerly: *Great Britain. Royal Commission on the Ancient and Historical Monuments and Constructions of England. Interim Report.*

Archaeology. Architecture.

GUIDELINES LETTER. 1971. m. EN. 2076
Guidelines, P.O. Box 456, Orinda, CA 94563. Phone 415–254–9393, 1–800–634–7779. Fred Stitt, Editor & Pub.
Subscription: $56 US, $US56 or + 30% $C Canada, foreign $56 + $10 postage. Sample free. Back issues $2. Illus b&w. 8½ x 11, 4p.
OCLC: 4083472. Dewey: 720. Formerly: *Guidelines Architectural Letter.*

Architecture.

New directions and techniques in the design professions. Technical and business information on aspects of office management and articles on production methods.

Advertising: none. Circulation: 3000. Audience: architects, engineers, design professionals.

HABITATION. 1929. m. FR only. 2077
Union Suisse pour l'Amelioration du Logement, Section Romande, 8, rue Clos–de–Bulle, 1004 Lausanne, Switzerland.
Phone 021–23–45–82. Francois–Joseph Z'Graggen, Editor.
Subscription: SFr 40, foreign SFr 55. Illus. b&w, photos, plans. Index. A4, 20p. + 12p. ads.
ISSN: 0017–6419. OCLC: 2261708. Dewey: 720.

Architecture.

Calendar of events.
Advertising.

HISTORIC ENVIRONMENT. 1981. q. EN. 2078
Council for the Historic Environment, P.O. Box 1057, Carlton, Victoria 3053, Australia.
Back issues.
ISSN: 0726–6715.

Architecture.

HISTORIC HOUSE. 1981. q. EN. 2079

Historic Houses Association, Publishing Dept., 2 Chester St., London SW1X 7BB England. Phone 071–259–5688, fax 071–259–5590. Sarah Greenwood, Editor.
Subscription: (Hall McCartney Ltd., P.O. Box 21, Spirella House, Bridge Rd., Letchworth, Herts. SG6 4ET). Illus. b&w, color, photos. A4, 54p.
ISSN: 0260–8707. Dewey: 720.

Architecture. Historic Preservation. Landscape Architecture.

The Association magazine represents owners of over 1300 privately owned historic houses, parks, and gardens through out Great Britain. Represents members interest in political circles and provides practical advice.
Reviews: book. Calendar of events — open to members, friends, and all others. Calendar of tours — open to members and friends only. Indexed: ArchPI. Avery.
Advertising. Classified: 40 pence/wd. + 15% VAT prepaid. Semi–display £5 scc. Hall McCartney Ltd., Ad. Representatives.
Audience: membership.

HOCHSCHULE FUER ARCHITEKTUR UND BAUWESEN WEIMAR.
WISSENSCHAFTLICHE ZEITSCHRIFT. 1953. bi–m. GE. GE, EN, & FR table of contents. 2080

Hochschule fuer Architektur und Bauwesen, Wilhelm–Bode–Str. 1, DDR–5300 Weimar, E. Germany.
Subscription: (Buchexport, Leninstr. 16, DDR–7010 Leipzig). Illus.
ISSN: 0509–9773. OCLC: 1672802. LC: NA14.W4. Dewey: 720.

HOMESTYLES HOME PLANS. 1986? q. EN. 2081

HomeStyles Publishing, 6800 France Ave. South, Suite 115, Minneapolis, MN 55435. Phone 612–927–6767. Roger Heegaard, Editor.
Sample. Illus. plans. 180p.
ISSN: 0897–621X. OCLC: 17570788. LC: NA7205.H675. Dewey: 728.

Architecture.

Features recreational, vacation, starter and retirement homes. Focus on energy efficient economical homes and home for "do–it–yourselfers. Contains home designs for which blueprints are available.
Audience: those who plan to build a new home.

HOUSE BEAUTIFUL'S HOUSES AND PLANS. 1986, v.7. 5/yr. EN. 2082

Hearst Magazines, House Beautiful Home Interest Group, 1700 Broadway, New York, NY 10019. Phone 212–903–5050. Gordon Firth, Editor.
Subscription: $2.95/issue. Illus., plans, diagrams.
ISSN: 0073–3571. OCLC: 13751213, 6899838. LC: NA7100.H68x. Dewey: 728.37.

Architecture.

INFORM: ARCHITECTURE, DESIGN THE ARTS. 1990. bi–m. EN. 2083

Virginia Society of the American Institute of Architects, The Barret House, 15 S. 5th St., Richmond, VA 23219.
Subscription: $16. Illus. 28 cm.
ISSN: 1047–8353. OCLC: 20790475. Dewey: 720.

Architecture.

INSITE. 1986. EN. 2084

Insite Video Communications Ltd., 44 Berwick St., London W1V 3RE England.

Architecture.

The video magazine for architects.
Reviewed: *Art Documentation*, Fall 1988, p.106.

IRISH ARCHITECTURE. 1980. a. EN. 2085

Clavis Press Ltd., 33 Priory Dr., Stillorgan Co., Dublin, Ireland. Phone 881395/832220. Editorial office 8 Merrion Square, Dublin 2.
Illus., some color.
ISSN: 0790–8342. OCLC: 18089027.

Architecture.

Journal of the Royal Institute of the Architects of Ireland.
Advertising.

ISLAMIC ART AND ARCHITECTURE. See no. 668.

JOURNAL OF ARCHITECTURAL AND PLANNING RESEARCH. 1984. q. EN. 2086

Elsevier Sci. Pub. Co., 655 Ave. of the Americas, New York, NY 10010. Andrew D. Seidel, Roberta M. Feldman & Martin Symes, Editors.
Subscription: $81 US, $US93 Canada & foreign, air + $15 US, Canada & Mexico, $30 all others. Sample free. Back issues, sold by volume only. Illus. b&w, photos, charts. 7 x 10, 90p.
ISSN: 0738–0895. OCLC: 9512258. Dewey: 720. Formerly: *Journal of Architectural Research.*
General. Architecture. Historic Preservation. Interior Design. Landscape Architecture.

An interdisciplinary resource for professionals and scholars in architecture, design and urban planning. Reports both recent research findings and innovative new practices providing a link between theory and practice for researchers and practicing professionals.
Reviews: book 3–4. Freelance work: none. Indexed: ArchPI. Avery. PsyAb. Reviewed: Katz.
Advertising: none. Mailing lists: none. Audience: architects, planners, environmental designers, interior designers.

JOURNAL OF ARCHITECTURAL THEORY AND CRITICISM. 1988. a. EN. 2087

Rizzoli International Publications, Inc., 300 Park Ave. South, New York, NY 10010. Phone 212–982–2300. Jorge Glusberg, Editor.
Subscription: $25. Illus. b&w, some color. 100p.
ISSN: 0953–220X. OCLC: 18073298. LC: NA2500.J68. Dewey: 720.

Architecture.

Journal of the International Union of Architects. Coverage includes a wide range of projects by major international architects of architectural theory and criticism.
Reviewed: *Library Journal*, Apr 1989. *Choice* 26:2, Oct 1988, p.406.
Advertising: none.

JOURNAL OF THE SOCIETY OF ARCHITECTURAL HISTORIANS. 1946. q. EN. 2088

Society of Architectural Historians, 1232 Pine St., Philadelphia, PA 19107–5944. Phone 215–735–0224. Tod A. Marder, Editor.
Subscription: $55 individual, $95 institution, US & Canada; foreign + $5 postage. Microform available from UMI. Sample. Back issues. Illus. b&w. Index in Dec issue. 8½ x 11, offset lithography.
ISSN: 0037–9808. OCLC: 2392510. LC: NA1.A327. Dewey: 720. Formerly: *Journal of the American Society of Architectural Historians.*
Architecture. Art History.

Articles on architectural history and criticism.
Reviews: book. Freelance work: none. Indexed: AmH&L. ArchPI. ArtHum. ArtI. BHA. BrArchAb. CurCont. HistAb. IBkReHum. RILA. Reviewed: Katz. *Design Book Review* 17, Win 1989, p 40–43.
Advertising: full page $275, ½ page $175, covers $325–375. Frequency discount. Circulation: 3600.

KENCHIKU BUNKA. 1946. m. JA. EN table of contents & summaries (1p./article). 2089

Shokokusha Publishing Co., Ltd., 25 Sakamachi, Shinjuku–ku, Tokyo 160, Japan. Nobuo Kametani, Editor.
Subscription: 26,000 Yen. Illus. b&w, some color, photos, plans. 9 x 12, 168p.
ISSN: 0003–8490. OCLC: 2667802. LC: NA6.K4. Dewey: 720.
Architecture.

Profusely illustrated.
Indexed: Avery.
Advertising: Toshio Takahasi, Ad. Manager.

KENCHIKU TECHO/ARCHITECT. 1957. m. 2090

Kinryudo Co. Ltd., 2–3, Higashi Ueno 5 chome, Taito–ku, Tokyo 110, Japan. Shigeru Kikuchi, Editor.
Dewey: 720.

Architecture.

Advertising.

KONGGAN/SPACE. 1966. m. KO. EN summaries.

2091

Space Group of Korea, 219 Wonso–dong, Chongro–ku, Seoul 110, S. Korea. Swoo Geun, Editor.

Subscription: 48000 Won.

ISSN: 0454–3114. LC: NX8.K8. Dewey: 720.

Advertising.

KWARTALNIK ARCHITEKTURY I URBANISTYKI. 1956. q. POL. EN summaries.

2092

Panstwowe Wydawnictwo Naukowe, Ul. Miodowa 10, 00–251 Warsaw, Poland. (Dist.: Ars Polona, Krakowskie Przedmiescie 7, 00–068 Warsaw). W. Kalinowski, Editor.

Illus.

ISSN: 0023–5865. OCLC: 2690156. LC: NA6.K9. Dewey: 720.

Architecture.

LITHIQUES. 1985. FR. EN & GE summaries.

2093

Creaphis, 79 rue du Faubourg Saint Martin, 75010 Paris, France. Phone 42.38.08.43. Pierre Gaudin & Claire Reverchon, Editors.

Subscription: 260 F.

ISSN: 0769–3397.

Architecture.

LIVING ARCHITECTURE: Architecture & Design from Denmark–Finland–Norway–Sweden.

1983. s–a. EN. DA tr. enclosed in issues for Scandinavia.

2094

Box 2076, 1456 Copenhagen K, Denmark. Per Nagel, Editor.

Subscription: Fmk 192, Kr302 Norway, Kr284 Sweden, Kr 300 Denmark, $US40, $C64, £26, DM 78. Illus. color mainly.

ISSN: 0108–4135. OCLC: 10600059. Dewey: 720.

Architecture.

Mainly advertising. Features the latest in Scandinavian architecture and design.

Indexed: ArchPI. Avery.

Advertising.

LOG HOME GUIDE FOR BUILDERS AND BUYERS. 1978. q. EN.

2095

Muir Publishing Co. Ltd., 1 Pacific St., Suite Anne de Bellevue, Quebec H9X 1C5, Canada. Phone 514–457–2045. Allan T. Muir, Editor.

Subscription: $C18. Illus. b&w, some color.

ISSN: 0707–5006. OCLC: 4307072. LC: NA8470.L63. Dewey: 728.3. Formerly: *Log Home Decor for Builders and Buyers.*

Architecture.

Reports on developments in the log home industry. Contains how–to articles on buying and/or building a log house in North America.

Indexed: RILA.

Advertising.

LOG HOUSE. 1979. a. EN.

2096

Log House Publishing Co. Ltd., P.O. Box 1205, Prince George, B. C. V2L 4V3, Canada. Mary Mackie, Editor.

Subscription: $C6. Illus.

ISSN: 0708–6458. OCLC: 5322712. LC: TH4818. Dewey: 694. Formerly: *Canadian Log House.*

Architecture.

Reviews: book.

LOTUS INTERNATIONAL. 1964. q. EN & IT (side by side).

2097

Electa Periodici SRL, Via D. Trentacoste 7, 20134 Milan, Italy. Phone (02) 215631. (Dist.: Rizzoli International Publications, Inc., 597 Fifth Ave., New York, NY 10017). Pierluigi Nicolin, Editor.

Subscription: $100. Illus.(200+) some color, photos, drawings. 10¼ x 10¼, 130p.

OCLC: 3076558. LC: NA4.L68. Dewey: 720. Formerly: *Lotus*.
Architecture. Planning.

Architectural review covering international architecture and art. Articles on contemporary architecture and planning. Subjects cover wide range of topics.
Indexed: ArchPI. ArtHum. ArtI. Avery. CurCont. Reviewed: Katz. *Design Book Review* 5, Fall 1984, p.13.

MAGYAR EPITOMUVESZET. 1952. bi–m. HU. EN, FR, GE & RU summaries (1p. each). **2098**
Pallas Lap-es Komyvkiado Vallalat, Lenin korut 9–11, 1073 Budapest 7, Hungary. Phone 222–408. Elemer Nagy, Editor.
Subscription: $36 (Kultura, P.O. Box 149, H-1389 Budapest, Hungary). Illus., some color. 64p.
ISSN: 0025–0082. OCLC: 2554823. LC: NA6.M3. Dewey: 720.
Architecture.

Hungarian architecture.
Indexed: ArchPI.

METROPOLIS. See no. 1571.

METROPOLITAN REVIEW. 1988. bi–m. EN. **2099**
Metropolitan Press Publications, Box 3680, Merchandise Mart Plaza, Chicago, IL 60654. Phone 312–829–9650. Christian K. Laine, Editor.
Subscription: $25 US, $50 Canada. No sample. Back issues $6. Illus. b&w, some color. photos. 8½ x 11½, 112p.
ISSN: 0893–8490. OCLC: 15670354. LC: NA1.M48. Dewey: 725.
Architecture. Interior Design. Planning.

Covers contemporary architecture, art, design, urban planning, interiors, culture, theory, and history.
Reviews: exhibition, book, journal, 20 each. Freelance work: none. Reviewed: Katz.
Advertising: Glen J. Ryniewski, Ad. Director. Mailing lists: available. Demographics: Chicago, Midwest, U.S. Circulation: 25,000. Audience: architects, developers, corporation executives.

MILLION DOLLAR PROJECT PLANNED LIST. 1965. bi–m. EN. **2100**
Live Leads Corp., 200 Madison Ave., Suite 1806, New York, NY 10016. Phone 212–689–7202. David Weintraub, Editor.
Dewey: 720.
Architecture.

MIMAR: Architecture in Development. 1981. q. EN. **2101**
MIT Press, 55 Hayward St., Cambridge, MA 02142 (Concept Media Pte Ltd., 1 Grange Rd. No. 05–11/12, Orchard Bldg., Singapore, phone 65–7340910, fax 65–7371439). Phone 617–253–2889. Hasan–Uddin Khan, Editor–in–chief.
Subscription: $US40 individual, $60 institutions, $30 students US & Canada; foreign + $US4 surface, + $25 air. Microform available from UMI. Back issues. Illus. mainly color, glossy photos, plans. A4, 84p.
ISSN: 0129–8372. LC: NA380.
Architecture.

An international architectural magazine exploring environments in developing countries. Covers contemporary design in the developing countries. Acts as a forum on the unification of modern buildings and design with cultural traditions, especially those of Islam, throughout the industrial world. The cover illustration includes a cut out.
Reviews: book. Interviews: include illustrations of work. Indexed: ArtI. Avery. BioI. Reviewed: *Art Documentation* Sum 1986, p.93.
Advertising: Laura Ayr, Ad. Director.

DAS MODERNE HEIM: Mit der "Internationalen Bauchronik". 1950. a. GE, EN, FR. **2102**
Schottenring 28, A–1010 Vienna, Austria. Oskar Riedel, Editor & Pub.
Subscription: S 100. Illus.
ISSN: 0026–8607. Dewey: 720.
Architecture.

MUEMLEKVEDELEM. 1957. q. HU. EN & FR summaries. **2103**
Hirlapkiado Vallalat, Blaha Lujza ter 3, Budapest 8, Hungary. Laszlo Gero, Editor.
Illus. b&w, photos. Annual index. 6½ x 9¼, 80p.

ISSN: 0541–2439. OCLC: 2980761. LC: NA6.M8. Dewey: 720.5.

Architecture History.

Review of the history of architecture and of conservation of historical monuments presented by the Committee for Historical Monuments of the Federation of Hungarian Architects. Tip–in section in front of issue presents a paragraph summary of each article and illustrations (4p.).

Indexed: ArtArTeAb.

MUOTO. 1980. q. FI & EN. 2104

Rakennuskirja Oy Building Book Ltd., P.O. Box 1004, 00101 Helsinki, Finland. Phone 90 6944911. Heikki Hyytiaeinen, Editor.

Subscription: Fmk 275.

ISSN: 0358–3511. Dewey: 720.

Architecture.

Indexed: ArtBibMod. Des&ApAI.

NEW PUBLICATIONS FOR ARCHITECTURE LIBRARIES. 1979. m. EN. 2105

Vance Bibliographies, Inc., 112 N. Charter St., Box 229, Monticello, IL 61856. Phone 217–762–3831. Mary Vance, Editor.

Subscription: $120 US, $130 Canada & foreign, air $150. Sample. Back issues. Illus. 8½ x 11, 40p.

ISSN: 0271–0994. OCLC: 6397027. LC: Z5945.N48; NA2550. Dewey: 016.72.

Architecture. Furniture. Historic Preservation. Interior Design. Landscape Architecture.

Architectural bibliography.

Advertising: none. Circulation: 100. Audience: architecture librarians.

NEW ZEALAND HOME & BUILDING. 1936. bi–m. EN. 2106

Associated Group Media Ltd., Private Bag 15, Newmarket, Auckland, New Zealand. Phone 09–795–393. Kirsty Robertson, Editor.

Subscription: $N29.70. Sample $NZ5.95. Back issues. 297 x 210 mm.

ISSN: 0110–098X.

Architecture. Interior Design.

Offers an insight into the country's houses, interior design, home renovation, products and materials, landscaping, home furnishings, architecture, commercial and civic development, design trends and overseas influences. Articles appeal to consumers and the decision–making design professionals.

Advertising: (rate card May '89): b&w full page $NZ2610, ½ page $NZ1499–1727, ⅙ page $NZ547; 2 color + $NZ495–605; 4 color full page $NZ3844, ½ page $NZ2326–2675, ⅙ page $NZ998, covers $NZ4797. Frequency discount. 15% agency discount. Gill Chambers, Ad. Director. Mailing lists: none. Demographics: professionals reached by controlled circulation — every architect (private, government, local body, in industry), landscape architects, interior and industrial designers, planners, residential and commercial building owners, financial institutions, related building and design professionals. Circulation: 28,000. Audience: architects/designers and public.

NEWSLETTER - SOCIETY OF ARCHITECTURAL HISTORIANS. 1957. bi–m. EN. 2107

Society of Architectural Historians, 1232 Pine St., Philadelphia, PA 19107–5944. Phone 212–735–0224. Mary Lee Thompson, Editor (784 Columbus Ave, Apt. 5M, New York, NY 10025).

Subscription: included in membership together with *Journal of the Society*, $55 individual, $20 student, $95 institution; outside North America + $5. Illus.

ISSN: 0049–1195. OCLC: 1765904. Dewey: 720.

Architecture.

Provides information on national and international architecture, chapter news, schools, current publications, information on news of members, upcoming meeting, exhibitions, and tours.

Bibliographies. Obits. Opportunities: employment; study – courses, conferences; competitions – fellowships and grants. Advertising.

OLD-HOUSE JOURNAL. 1973. bi–m. EN. 2108

Old–House Journal Corporation, 435 Ninth St., Brooklyn, NY 11215. Phone 718–788–1700, fax 718–788–9051. Patricia Poore, Editor.

Subscription: $21 US, $US29 Canada (P.O. Box 50214, Boulder, CO 80321–0214). Back issues $4.95. Illus. b&w, color, photos, plans. 8½ x 11, 120p.

ISSN: 0094–0178. OCLC: 1393566. LC: TH3401.O43. Dewey: 643.

Architecture. Historic Preservation.

Restoration techniques, "renovation and maintenance ideas for the antique house", the pre–1939 home. Presents "how–to" and technical data, period house styles, decorating and products. Regular departments include "Questions", a listing of "Restoration Services", and "Product Network".

Reviews: book. Freelance work: yes. Contact: editor. Indexed: ArchPI. Avery. Reviewed: Katz.

Advertising: William J. O'Donnell, Ad. Director.

OLD-HOUSE JOURNAL CATALOG. 1976. a. EN. 2109

Old–House Journal Corporation, 69A Seventh Ave., Brooklyn, NY 11217. Phone 718–636–4514. Patricia Poore, Editor. Illus.

ISSN: 0271–7220. OCLC: 5804163. LC: TH455.O43. Dewey: 690. Formerly: *Old–House Journal Buyers' Guide*.

Architecture. Historic Preservation.

Extensively indexed listing of over 1,500 companies providing restoration and renovation products or special services.

Advertising: William J. O'Donnell, Ad. Director.

OPEN HOUSE INTERNATIONAL. 1989, v.14. q? EN. 2110

Stichting Architecten Research, Postbus 429, 5600 AK Eindhoven, The Netherlands. N. Wilkinson, Editor–in–chief (University of Newcastle upon Tyne, Cardo, School of Architecture, Newcastle upon Tyne, NE1 7RU England, phone 091–222–6008, telex 53654 UNINEWG). N.K. Hamdi, North American editor (MIT, School of Architecture & Planning, Dept. of Architecture, 77 Mass. Ave., Cambridge, MA 02319 phone 617–253–8376, telex 921473 MIT CAM).

Illus. b&w, photos, plans and sketches. 8½ x 11¾, 52p.

ISSN: 0168–2601. OCLC: 10416572. LC: NA7100.O63. Dewey: 728.05. Formerly: *Openhouse*.

Architecture. Housing. Planning.

Housing – Design – Development, Theories, Tools & Practice—special emphasis on local scale. The journal of an association of institutes and individuals concerned with in the built environment. International in scope, refereed journal. Articles including abstracts to 3500 words.

Reviews: book 2, length 2p. total. Freelance work: refereed journal, submit manuscripts to editor. Indexed: ArchPI. Avery.

Advertising: none.

PERIODICA POLYTECHNICA. ARCHITECTURE. 1968, v.12. q. EN, FR, GE & RU. 2111

Akademiai Kiado, Publishing House of the Hungarian Academy of Sciences, P.O. Box 24, H–1363 Budapest, Hungary. I. Szabo, Editor.

Illus.

ISSN: 0055–9669. OCLC: 2252180. LC: NA1.P455. Dewey: 720.

Architecture.

PICTURE HOUSE. 1982. 2/yr., irreg. EN. 2112

Cinema Theatre Association, 53 Wenham Drive, Westcliff–on–Sea, Essex 5S0 9BJ, England. Allen Eyles, Editor (44 Warlingham Road, Thornton Heath, Surrey CR4 7DE).

Subscription: included in membership, together with *CTA Bulletin* (bi–m. newsletter), £12 (remittances only accepted in sterling £ or money order). Sample £2. Back issues. Illus. b&w, color occasionally, photos. Index included in every 8th issue. A4, 32p.

ISSN: 0263–7553.

Architecture.

Supplies heavily illustrated, in–depth coverage of aspects of British movie theater history and current developments, including architecture, management, social history, programming.

Interviews: with cinema operators, architects Biographies: cinema architects, owners, etc. Freelance work: yes. Contact: editor. Indexed: ArchPI. Reviewed: *Film Quarterly* 42:1 Fall 1988, p.32.

Advertising: none. Circulation: 1200. Audience: persons interested in British cinema buildings, their architecture and history.

PLACES: A Quarterly Journal of Environmental Design. 1983. q. EN. 2113

The Design History Foundation, 330 W 42nd St., New York, NY 10036. Phone 415–642–9322. Donlyn Lyndon, Editor (University of California, Berkeley, Center for Environmental Design Research, 390 Wurster Hall, Berkeley, CA 94720).

Subscription: $40, $25 students US; $48 Canada, others $60, air + $30. Microform available from UMI. Illus. b&w, color, photos, plans, sketches. 8½ x 11, 96p.

ISSN: 0731–0455. OCLC: 8097845. LC: NA2542.35.P53. Dewey: 720.

Architecture.

Multidisciplinary view of all aspects of public and private places published for the College of Environmental Design, University of California, Berkeley and the School of Architecture and Planning, Massachusetts Institute of Technology. Dedicated to providing a forum in which professionals of all concerned disciplines can address the design issues that shape the built environment. A record of significant design achievements and exploration of the essential interaction of all design disciplines. Editorial commitments: to consider how places enter people's lives, to explore the means through which places are imagined and represented to promote discussion regarding the character of public environments, to nurture interest in the ways that people can care about places and contribute to their making.

Indexed: Avery. CurCont. Des&ApAI. Reviewed: Katz. *Art Documentation* Win 1986, p.183.

Advertising: Laura Ayr, Ad. Director. Circulation: 2,500.

PLANAHOME HOME IMPROVEMENT GUIDE. a. EN. 2114

Plan Magazines Ltd., 45 Station Road, Redhill Surrey, England. John Bailey, Editor.

Subscription: £2.95.

Dewey: 720. Formerly: *Planahome Book of Home Plans*.

Architecture.

PLANNING & BUILDING DEVELOPMENTS. 1973. bi–m. EN. 2115

Avonwold Publishing Co. (Pty), Ltd., Avonwold House, 24 Baker St., Rosebank, Johannesburg 2196, South Africa. Phone 011–788–1610. J. Nuttall, Editor.

Subscription: Box 52068, Saxonwold 2132, Transvael, South Africa. Illus.

ISSN: 0377–2780. OCLC: 1791073. LC: TH119.S66P57. Dewey: 690.

Architecture.

Features architecture projects, property developments, and professional news of interest to architects in South Africa.

POLITECHNIKA KRAKOWSKA. ZESZYTY NAUKOWE. ARCHITEKTURA. 1956. irreg. POL.
EN, FR, GE, RU summaries. 2116

Politechnika Krakowska, Ul. Warszawska 24, 31–155 Krakow, Poland. (Dist.: Ars Polona–Ruch, Krakowskie Przedmiescie 7, 00–068 Warsaw).

Illus.

ISSN: 0137–1371. Dewey: 720.

Architecture.

POLSKA AKADEMIA NAUK. ODDZIAL W KRAKOWIE. KOMISJA URBANISTYKI I
ARCHITEKTURY. TEKA. 1967. a. POL. EN & RU summaries. 2117

Ossolineum, Publishing House of the Polish Academy of Sciences, Rynek 9, 50–106 Warsaw, Poland. (Dist.: Ars Polona–Ruch, Krakowskie Przedmiescie 7, Warsaw). Janusz Bogdanowski, Editor.

Architecture. Planning.

Composed of papers on problems in architecture and planning.

PORTICO. 1929. q. EN. 2118

Architects & Surveyors Institute, 15 St. Mary St., Chippenham, Wilts, SN15 3JN England. Phone 0249–444505, fax 0249–443602.

ISSN: 0032–4914. Dewey: 720.

Architecture.

PRACTICING ARCHITECT. 1977. q. EN. 2119

Society of American Registered Architects, 1245 S. Highland Ave., Lombard, IL 60148. Phone 312–932–4622. Stanley Banash, Editor & Pub.

Subscription: $15. Illus. b&w. 8½ x 11, 20–24p.

Dewey: 720.

Architecture.

Covers all aspects of operating an architectural business. Articles focus on technical architectural subjects as well as presenting legal, accounting and other business topics. Contains Society news, related professional news, and reports on seminars and conventions.

Reviews: book. Indexed: Avery.

Advertising. Len Mifflin, Ad. Representative. Audience: architects.

PROCEEDINGS OF THE ACSA ANNUAL MEETING. 1977. a. EN. 2120
Association of Collegiate Schools of Architecture, 1735 New York Ave., N.W., Washington, DC 20006. Phone 202–785–2324.
Architecture.

Advertising: none. Audience: included in membership.

PROCESS: ARCHITECTURE. 1977. m. EN & JA (both on the same page). 2121
Process Architecture Publishing Co. Ltd., 3–1–3 Koishikawa Bunkyo–Ku, Tokyo, 112, Japan. Ching–Yu Chang, Editor.
Subscription: 30.000 Yen (Eastview Editions Inc., Box 783, Westfield, NJ 07091). Microform available from UMI. Illus. b&w, some color, photos, plans, drawings.
ISSN: 0386–037X. OCLC: 4049049. LC: NA673.P76. Dewey: 724.910952.
Architecture.

Each volume has a distinctive title and theme.

Indexed: ArchPI. Avery. Reviewed: Katz.

PROFESSIONAL BUILDER/PROFESSIONELE BOUER. 1977. bi–m. AF & EN. EN summaries. 2122
Keeble Publishing, P.O. Box 3080, Johannesburg 2000, South Africa. Simon Keeble, Editor.
Subscription: included in membership, R 60.
Dewey: 690.
Architecture.

Advertising.

PROGRESSIVE ARCHITECTURE. 1945. m. (except s–m. in Oct). EN. 2123
Penton Publishing, Reinhold Division, 600 Summer St., Box 1361, Stamford, CT 06904. Phone 203–348–7531, fax 203–348–4023. John Morris Dixon, Editor.
Subscription: professionals: $39 US, $48 Canada, $80 foreign — (archaeological and archaeological–engineering firm personnel & architects, designers, engineers and draftsmen employed in allied fields). Non–professionals: $45, students $36, US; $60 Canada, $90 foreign (1100 Superior Ave., Cleveland, OH 44197–8120). Available online, Dialog. Illus. mainly color, photos, plans. Annual index. 9 x 11¾, 178p.
ISSN: 0033–0752. OCLC: 4967033. LC: NA1.P7. Dewey: 720. Formerly: *Pencil Points*.
Architecture.

Divided into sections: "Design" (8–10 articles), "Technics", "Practice", and departments. Includes brief descriptions of new products and information relative to architectural law and government developments. Focus is on current information regarding building, design, and technology.

Reviews: products, 1 feature, length 1p.; book 3. Interviews. Listings: national–Canadian. Calendar of exhibitions, competitions, and conferences. Freelance work: yes (details in *PhMkt*.). Opportunities: positions listed in classified ads. Indexed: ArchPI. ArtArTeAb. ArtHum. ArtI. Avery. BioI. CloTAI. CurCont. IBkReHum. Search. Reviewed: Katz.

Advertising: display ads, rates upon request. Classified: "Situation open" $200/col.in., max. 6 col.in.; "Situation wanted" $85/col.in. (Lynne McLaughlin, Classifieds, 1100 Superior Ave., Cleveland, OH 44114, Phone 216–696–7000, ext. 2524, fax 216–696–1267). Inserts. Readers service card. Richard Strachan, Ad. Director. Audience: architectural professionals. Circulation: 75,000.

PROJEKT: Revue Slovenskej Architektury. 10/yr. CZ. EN, FR, GE or RU summaries. 2124
Ceskoslovenskej Armady 35, 815 85 Bratislava, Czechoslovakia (Dist.: Slovart, Gottwaldovo nam 48, 805 32 Bratislava).
Subscription: $78.
Dewey: 720.
Architecture.

Indexed: ArchPI. Avery.

QUASAR: Quaderni di Storia dell'Architettura e Restauro. IT only. 2125
University Degli Studi Di Florence, Faculty of Architecture, Dipartimento di Storia dell'Architetturae Restauro delle Strutture Architettoniche, Via P.A. Micheli, 8–50121 Florence, Italy. Phone 055/572207. Marcello Fagiolo, Director.
Subscription: L 40.000 Italy, elsewhere L 50.000. Illus. b&w.
Architecture.

Indexed: BHA.
Advertising: none.

QUESTIONS. 1981. s–a. 2126
Institut Superieur d'Architecture Saint–Luc de Bruxelles, Secretariat de l'I.S.A., 64, rue Wilmotte, 1060 Brussels, Belgium.
Reviewed: *Art Documentation*, Fall 1988, p.106.

RASSEGNA. 1979? IT only. 2127
CIPIA, via Stalingrado 97/2, 40128 Bologna, Italy.
Subscription: L 95.000 Italy, elsewhere L 130.000. Illus. b&w, color, photos, line drawings. 120p.
Indexed: ArchPI. RILA.

REHAB AGE. 1981. m. EN. 2128
Second City Communications, Box 95174, Schaumburg, IL 60195. James W. Wickliff, Editor.
Subscription: $18.
Dewey: 728.

RESTAURANT - HOTEL DESIGN INTERNATIONAL: The Magazine for the Hospitality Design Team. 1978. m. EN. 2129
Bill Communications, Inc., 633 Third Ave., New York, NY 10017. Phone 212–984–2436. M.J. Madigan, Editor.
Subscription: controlled to industry, $40 US, $52 Canada, foreign air $80. Microform available from UMI. Sample $4. Back issues. Illus. b&w, color, photos. Annual index in Dec issue. 112p.
ISSN: 0745–4929. OCLC: 17944086. LC: NA7800. Dewey: 725. Formerly: *Restaurant and Hotel Design (1983–87), Restaurant Design (1978–83)*.
Architecture. Ceramics. Furniture. Historic Preservation. Interior Design. Landscape Architecture. Textiles.

Features full four–color stories on the design of new hotels, restaurants, senior living facilities, bars, clubs, lounges, and other hospitality related projects.
Reviews: book 1, length 700 wds. Interviews: with industry leaders. Biographies: "Spotlight" – monthly profiles of designers, architects industry leaders. Listings: national. Calendar of events. Freelance work: yes, very limited. Contact: editor. Opportunities: competitions (a. design competition); platinum circle awards. Indexed: RILA.
Advertising: full page $3880, ½ page $2160, ¼ page $1290, color + $1550. Frequency discount. Mailing lists: available. Michelle Finn, Ad. Director (Bill Communications, 180 N. Michigan Ave., Chicago, IL 60601). Circulation: 35,773. Audience: architects, interior designers, developers.

REVIEW OF ARCHITECTURE AND LANDSCAPE ARCHITECTURE. See no. 2542.

REVIEW OF THE ARTS: FINE ARTS AND ARCHITECTURE. See no. 18.

REVUE FORMES NOUVELLES/NEUE FORMEN/NEW FORMS. 1952. irreg. EN, FR & GE. 2130
20 rue des Trevires, Luxembourg, Luxembourg. J.A. Schmit, Editor.
Dewey: 720.
Architecture.

RIBA DATA. 1972. 3/yr. EN. 2131
RIBA Services Ltd., Finsbury Mission, 39 Moreland St., London EC1V 8BB, England. Phone 071–251 5885. Bob Harrold & Robert Broderick, Editors.
Subscription: £120.
Incorporates: *RIBA Practice Data & RIBA Product Data*.
Architecture.

RIVISTA DI STUDI LIGURI/REVUE D'ETUDES LIGURES. 1934. q. FR, EN, IT.
Istituto Internazionale di Studi Liguri, Via Romana 39 bis, 18012 Bordighera, Italy.
Subscription: L 50000. Illus.
ISSN: 0035–6603. Dewey: 945.
Architecture.

2132

ROMA: Attualita, Storia, Arte, Curiosita, Miti e Folclore della Citta Piu Bella del Mondo.
1988. m.
Eagle s.r.l., via Galla Plascidia 184, 00159 Rome, Italy.
Architecture History.
Scholarly coverage of architecture in Italy from Medieval into the 19th century.

2133

SCHWEIZER BAUMARKT. See no. 2281.

SEARCH. See no. 20.

SECTION DESIGN. 1988. q. FR.
Lee Messageries de Press Benjamin Enr., 160, rue Jean Milot, Ville La Salle, Quebec, H8R 1X7, Canada.
Illus. b&w, some color.
ISSN: 0835–863X. OCLC: 19038601. LC: NA7100. Dewey: 690.
Architecture.
Reviewed: *Art Documentation* Winter 1988, p.153.

2134

SILO: Revue d'Architecture Contemporaine. 1987. s–a. FR.
Centre de Documentation du Departement de Design, Universite du Quebec a Montreal, Local 1610, Case Postale 8888,
Succursale "A," Montreal, Quebec H3C 3P8, Canada.
Illus., plans.
ISSN: 0835–4936. OCLC: 18633757, 16871356.
Architecture. Planning.
Covers architectural design and city planning. Each issue also has a distinctive title.

2135

SINTEZA. 1964. q. SL. Some issues contain summaries in EN & SCR.
Revija Sinteza, Erjavceva Cesta 15–1, 61000 Ljubljana, Yugoslavia. Phone 061 221–596. Stane Bernik, Editor.
ISSN: 0049–0601.
Architecture.
Indexed: ArchPI. ArtBibMod.

2136

SITES. 1979. 3/yr. EN.
Lumen, Inc., 446 W. 20 St., New York, NY 10011. Phone 212–989–7944. Dennis L. Dollens, Editor.
Illus.
ISSN: 0747–9409. OCLC: 9271032. LC: NX1.S53. Dewey: 700.
Architecture.
Reviews: book. Indexed: RILA. Reviewed: Katz.

2137

SKALA. 1985. bi–m. DA.
Art Consulting Scandinavia, 25777 Punto de Vista, Calabassas, CA 91302.
Subscription: : Nordisk Magasin for Arkitektur og Design. Illus., plans.
ISSN: 0900–0518. OCLC: 15563839.
Architecture.
Devoted to Nordic design and architecture.
Indexed: Avery. BHA. RILA.

2138

SOCIETY OF ARCHITECTURAL HISTORIANS OF GREAT BRITAIN NEWSLETTER. 1968. s–a. EN.

2139

Society of Architectural Historians of Great Britain, Chesham House, 30 Warwick St., Room 208, London W1R 6AB, England. Phone 071–734 8144. Elizabeth Williamson, Editor (Buildings of England, Penguin Books Ltd., 27 Wrights Lane, London W8 5TZ).

Subscription: included in membership together with *Architectural History*, £12, retired members & students £8, overseas £16 (Frank Kelsall, Treas., 4 Woodlands Ave., Finchley, London N3 2NR). No illus. 7¼ x 9¾, 16p.

Dewey: 720, 942.

Architecture.

Society newsletter contains news, notes, conferences and visits. Membership list included.

Reviews: book 11, length 9–16p. Calendar of events. Opportunities: study – conference. Indexed: Avery. RILA.

Advertising: none.

SOUTH AFRICAN JOURNAL OF ART AND ARCHITECTURAL HISTORY. See no. 369.

STORIA ARCHITETTURA: Rivista di Architettura e Restauro. 1982. a. IT or EN.

2140

Multigrafica Editrice, Viale Quattro Venti 52/A, 00152 Rome, Italy.

Illus.

LC: NA4.S88. Dewey: 720.

Architecture.

Indexed: ArtArTeAb. RILA.

STUDIA I MATERIALY DO TEORII I HISTORII ARCHITEKTURY I URBANISTYKI. 1959. irreg. POL. EN and RU summaries.

2141

Panstwowe Wydawnictwo Naukowe, Miodowa 10, 00–251 Warsaw, Poland. (Dist.: Ars Polona, Krakowskie Przedmiescie 7, 00–068 Warsaw).

ISSN: 0081–6566.

Architecture.

TECHNIQUES ET ARCHITECTURE. 1941. bi–m. FR & EN tr. of feature articles. SP summaries (2p. end of issue).

2142

Societe des Editions Regirex–France, 54, bis rue Dombasle, 75015 Paris, France. Jean–Michel Hoyet, Editor.

Subscription: 810 F. Illus. Index.

ISSN: 0373–0719. OCLC: 1589987. LC: TH2.T4. Dewey: 721.

Architecture.

"International review of architecture and design". Each issue has a theme. Reports on exhibitions, competitions, and new products.

Reviews: book. Indexed: ArchPI. Avery. Reviewed: Katz.

Advertising.

TERRAZZO: Architecture and Design. 1988. s–a. EN.

2143

Terrazzo srl, Foro Buonoparte 54, 20121 Milan, Italy. (Dist.: Rizzoli International Publications, 300 Park Ave., So., New York, NY 10010). Phone 212–982–2300, fax 212–982–3866. Barbara Radice, Editor.

Subscription: $25/issue paperback US, $35 Canada. Back issues $20/issue. Illus. color, some b&w, photos. 9½ x 13½, 150–160p.

ISSN: 0–8478–5532–5. Dewey: 700.

Architecture. Photography.

Journal on contemporary international architecture. Intended to blend art, design, and architecture with photography and related literature. Contributors are writers, designers, artists and lecturers.

Interviews. Indexed: Des&ApAI. Reviewed: *Choice* 26:7, Mar 1989, p.1261.

Audience: art, design, architecture.

THE TIMES. 1970. 3–4/yr. EN.

2144

Council on Tall Buildings and Urban Habitat, Leigh University, Bldg. 13, Bethlehem, PA 18015. Phone 215–758–3515. L.S. Beedle, Editor.

Subscription: included in membership, $60 all. Sample free. Back issues. Illus. b&w, photos. 8½ x 11, 4p.

Architecture. Interior Design. Landscape Architecture. Urban Planning.

Provides latest information on tall building conferences, publications, research, etc., plus the latest news from the Council. Covers tall buildings from planning and design through operation and interface with the urban environment.
Listings: regional–international. Calendar of events. Exhibition information. . Freelance work: none. Opportunities: employment, study, competitions.
Advertising: none. Mailing lists: some available. Circulation: 1200. Audience: tall building professionals.

TRADITIONAL DWELLINGS AND SETTLEMENTS REVIEW. 1989. s–a. EN. 2145

The International Association for Traditional Environments (IASTE), Center for Environmental Design Research, 390 Wurster Hall, University of California, Berkeley, CA 94720. Nezar Alsayyad & J.P. Bourdier, Editors.
Subscription: included in membership, $35 individual, $70 institutions US; $70 institutional member Canada & foreign, air $80. Sample free. Back issues. 8½ x 11, 120p.
ISSN: 1050–2092.

Archaeology. Architecture. Art History. Historic Preservation. Landscape Architecture.

Multi–disciplinary journal covering architecture, art history, anthropology, cultural geography, folklore, and material culture.
Advertising: b&w only, camera–ready, payment with ad, full page $300, ½ page $160–180, ¼ page $100. Mailing lists: available for fee. Circulation: 300–400. Audience: architects, planners, cultural anthropologists and geographers.

TRADITIONAL HOMES: Renovation, Upkeep, Furnishing. 1984? m. EN. 2146

CFE Publishing Ltd., Monmouth House, 87 The Parade, High St., Watford, Herts WD1 1LN, England.
Illus. b&w, some color.
ISSN: 0950–2181. OCLC: 19931185. Dewey: 728.05. Formerly: *Period Homes.*

Architecture.

Focuses on remodeling and restoration of homes. Accompanied by supplement, *The Traditional Garden.*
Indexed: ArchPI. Des&ApAI.

TRIGLYPH: A Journal of Architecture and Environmental Design. 1984. s–a. EN. 2147

Tempe College of Architecture & Environmental Design, Arizona State University, Tempe, AZ 85287.
Illus.
ISSN: 1048–0129. OCLC: 11860351. LC: NA1.T754.

Architecture.

Goal is to feature Southwestern architectural topics infrequently covered by other periodicals. Coverage includes urban design, landscape architecture and interior design, as well as news of new buildings and projects.
Reviews: book. Interviews: with major architects. Reviewed: *Art Documentation* Sum 1987, p.69.

TVAI. 1966. a. HE. EN abstracts & captions. 2148

TVAI, 27 Shlomo Hamelech St., Tel–Aviv, Israel. Phone 5238948, 5239152. Aba Elhanani, Editor & Pub.
Subscription: US $32 seamail, $45 air. Sample. Back issues. Illus.
ISSN: 0041–4549. Dewey: 720.

Architecture. Planning.

Periodical for architecture, town planning, industrial design and the plastic arts.
Indexed: ArchPI.

Advertising: full page $1000, ½ page $650, cover $1500; color full page $1600, ½ page $1100. 20% agency discount. Circulation: c.1200. Audience: Israeli architect, libraries, and foreign subscribers.

UIA NEWSLETTER. 1948? m. EN & FR editions. 2149

International Union of Architects, 51, rue Raynouard, 75016 Paris, France. Phone (1) 45 24 36 88, fax (1) 45 24 02 78, telex 614855. Catherine Hayward, Editor.
Subscription: included in membership, F 340, F 200 student, F 500 institution Europe; F 450 individual, F 250 student, F 550 institution US & Canada (US orders to: American Institut of Architects, Committee on International Relations, 1735 New York Ave., N.W., Washington, DC 20006). Sample free. Back issues F 50. Illus. b&w, photos. 21 x 29.7 cm, 8p.
Dewey: 720. Formerly: *UIA Information.*

Architecture. Education. Interior Design. Landscape Architecture. Town Planning.

Briefly reports on UIA activities, its National Sections and its Work Groups, international architectural competitions, major architectural events throughout the world, activities of related international organizations. Presents problems related to housing, construction, architecture and town planning on an international level.

Reviews: exhibition, book, film, other. Bibliographies on different architects. Interviews: with competition winners or promoters. Listings: international. Calendar of events. Freelance work: none. Opportunities: study, competitions.

Advertising: none. Demographics: UIA is composed of 98 member nations through National Sections from 5 continents. Includes nearly 900,000 architects. Audience: architects worldwide.

UNIVERSITY OF EDINBURGH. ARCHITECTURE RESEARCH UNIT. REPORT. 1966.

irreg. EN. 2150

University of Edinburgh, Architecture Research Unit, 55 George Sq., Edinburgh EH8 9JU, Scotland.
ISSN: 0070–8992. Dewey: 720.
Architecture.

UNSERE KUNSTDENKMAELER ALER/NOS MONUMENTS D'ART ET D'HISTOIRE. See no. 376.

VAISSEAU DE PIERRES. 1977. irreg. FR. 2151

Presses Universitaires de France, Departement des Revues, 14 Avenue du Bois–de–l'Epine, B.P.90, 91003 Evry Cedex, France.
Illus.
ISSN: 0981–6445. OCLC: 20471676. LC: NA2.I96. Dewey: 720. Formerly: *L'Ivre de Pierres.*
Architecture.

VERNACULAR ARCHITECTURE. 1971. a. EN. 2152

Vernacular Architecture Group, 16 Trefor Rd., Aberystwyth Dyfed SY23 2EH Wales.
Subscription: $12.91 UK, $14.90 elsewhere. Illus. Index. Cum. index every 4 years, bound in issue.
ISSN: 0305–5477. OCLC: 2390970. LC: NA208.V47. Dewey: 728.
Architecture.

Indexed: ArchPI. ArtArTeAb. Avery. RILA.

VILLE GIARDINI. 1956. m (except Jan/Feb and Jl/Aug). IT only. 2153

Gruppo Editoriale Electa S.p.A., Via Goldoni 1, 20129 Milan, Italy.
Subscription: L 30000. Illus., plans.
ISSN: 0042–6237. OCLC: 4601086. LC: N4.V72. Dewey: 720. Formerly: *Ville e Giardini.*
Architecture.

Indexed: Avery.

WERK, BAUEN +. WOHNEN. 1980. 10/yr. GE only. 2154

Werk AG, Verlag Bauen + Werk GmbH, Vogelsangstrasse 48, Postfach, CH–8033 Zurich, Switzerland. Phone 01/362 95 66, fax 01/362 70 32.
Subscription: SFr 150, SFr 100 students, overseas SFr 160, DM 150, DM 100 students. Index.
Continues in part: *Werk–Archithese.*
Official organ of the Swiss Federation of Architects.
Indexed: ArchPI. BioI. RILA.

WOMEN AND ENVIRONMENTS. 1976. q. EN. 2155

The Weed Foundation, c/o Centre for Urban & Community Studies, 455 Spadina Ave., Toronto, Ontario M5S 2G8, Canada. Phone 416–978–4478. Judith Kjellberg, Editor.
Subscription: $15 individual, $25 institution. Sample. Back issues. Illus. b&w, photos. Cum. index v.1–5 in v.6 no.1, v.6–9 in v.9 no.3. 8½ x 11, 28p.
ISSN: 0229–480X. Formerly: *Women and Environments International Newsletter.*
Architecture. International—(Women and Development). Landscape Architecture.

Explores women's relationships to natural, built and social environments. Fields include architecture, design, housing, urban planning, and environmentalism. Not primarily art–oriented.

Reviews: book 1–2. Interviews. Listings: international. Calendar of events. Exhibition information. Freelance work: yes. Opportunities: employment, study, competitions. Indexed: Avery. CanPI.
Advertising: full page $225, ½ page $120, ¼ page $70; color inside cover only, + $25. Classified: business cards $45. Frequency discount. Accepts exchange advertising. Inserts. Mailing lists: available. Demographics: 50% Canada, 30% US, 10% international; majority live in larger urban centers; university educated; work in university–related activities or else tend to be professional women working in housing, planning, consulting and researching in these area, and architecture. Circulation: 1200. Audience: women in environmental fields — natural, social, built.

WOMEN'S BUILDING NEWSLETTER. See no. 728.

WORLD ARCHITECTURE. 1989. q. EN.

2156

Grosvenor Press International, Ltd., Holford Mews, Cruikshank St., London WC1X 9HD England. Dennis Sharp, Editor.
Subscription: $40. Illus. b&w, color, photos, drawings, plans.
ISSN: 0956–9758. OCLC: 22379084.
Architecture.

Each issue contains a review of the works of a single contemporary architect along with an interview and a chronology. The official magazine of the International Academy of Architecture.
Reviews: book. Indexed: ArchPI. Des&ApAI. Reviewed: *Art Documentation* Spr 1991, p.47.
Advertising.

WYKAMOL PRESERVER. 1973. s–a. EN.

2157

Cementone Beaver Ltd., Tingewick Rd., Buckingham MK18 1AN, England. Phone 0280 814000. P.S. Leeds, Editor.
Subscription: free.
Dewey: 711.59.

YARDSTICKS FOR COSTING. 1968. a. EN.

2158

Southam Business Information and Communications Group, 1450 Don Mills Rd., Don Mills, Ontario M3B 2X7, Canada.
Phone 416–445–6641. Jas. A. Murray, Editor.
Subscription: $C85. Illus.
ISSN: 0319–3438. OCLC: 2443079. LC: TH435.Y374x. Dewey: 692.
Architecture.

Consists almost entirely of tables. Issued as a supplement to the *Canadian Architect*.
Advertising.

ZENTRALINSTITUTS FUER KUNSTGESCHICHTE. JAHRBUCH. See no. 332.

ZODIAC [English edition]. 1988. a. EN. Also issued in IT edition.

2159

Rizzoli International Publications, 300 Park Ave. South, New York, NY 10010. Phone 212–982–2300.
Subscription: $37.50 US, $50 Canada. Back issues. Illus. b&w, some color, photos, drawings. 8¼ x 10⅝, 200p.
ISSN: 0394–9249. ISBN: 0–8478–5531–7. OCLC: 20961830. LC: NA1.Z63. Dewey: 720.
Architecture.

"An international review of architecture".
Audience: architects.

Regional Works

AD&D ARCHITECTURE DESIGN & DEVELOPMENT NEWS. 14 x 17, 12p. EN.

2160

The Architectural Design & Development Communities of South Florida, P.O. Box 17875, West Palm Beach, FL 33416.
Architecture.

Newspaper. A communication forum.

APUROCHI/APPROACH. 1964. q. JA. EN summaries. 2161

Takenaka Komuten Co., Ltd., No. 27, 4–chome, Hommachi, Higashi–ku, Osaka 541, Japan. Hiroyuki Iwamoto, Editor.
Subscription: free. Illus.
ISSN: 0003–7117. OCLC: 1843871. LC: NA6.A65. Dewey: 720.
Architecture.

ARCHITECTURE AUSTRALIA. 1904. 11/yr. EN. 2162

Architecture Media Australia Pty. Ltd., 10A Beach St., Port Melbourne, Victoria 3207, Australia. Phone 03–646–4760, Fax 03–646–4918. Tom Heath, Editor.
Subscription: included in membership, $A70 Australia, foreign $A90, air $A145. Sample. Back issues SA6.50/issue. Illus. b&w, color, photos, cartoons. A4, 100p.
OCLC: 3076514. LC: NA1 .A775. Dewey: 720. Formerly: *Architecture in Australia.*
Architecture. Historic Preservation. Interior Design. Landscape Architecture.

The official national journal of the Royal Australian Institute of Architects whose purpose is to cover the best of architecture in Australia by Australian architects. Each issue focuses on one or two subjects. The primary objective is to foster communication between members of the profession. The greater part of the editorial content consists of illustration and explanation of Australian architecture of significance. Also includes regular reports from experts on developments in areas such as building law, architectural practice management, and computing. News letters, details and product news are also regular departments.
Reviews: book. Biographies. Interviews. Obits. Listings: regional–international. Calendar of events. Exhibition information. Freelance work: yes, editorial submissions for the features opposite are welcomed, printed material, color photographs and transparencies are all acceptable. Opportunities: study; competitions; Dec issue contains the RAIA awards, a comprehensive record of the best of Australian architecture for the year. Indexed: ArchPI. Avery.
Advertising: full page b&w $A1750, ½ page $1070, ¼ page $650, double spread $3330; spot color full page $2170, ½ page $1480, ¼ page $1060; 4 color full page $2620, ½ page $1960, ¼ page $1510, double spread $4980. Frequency discount. Covers + $550, preferred positions + $500. Inserts. Carolyn Rivers, Ad. Director. Mailing lists: available. Demographics: goes to every architect who is a member of the Royal Australian Institute of Architects. Circulation: 11,039. Audience: architects, building and construction industry, interior designers.

ARCHITECTURE MINNESOTA. 1936. bi–m. EN. 2163

Minnesota Society, American Institute of Architects, 275 Market St., Suite 54, Minneapolis, MN 55405. Phone 612–338–6763. Eric Kudalis, Editor.
Subscription: $15. Illus. b&w, color, photos. 8 x 11, 64p.
ISSN: 0149–9106. OCLC: 2253666. LC: NA730.M6 A73. Dewey: 720. Formerly: *Northwest Architect.*
Architecture.

The regional design arts magazine. Presents articles and "Previews", a brief description of regional shows and exhibitions complete with address, date and time.
Listings: regional. Indexed: Avery.
Advertising: Judith Van Dyne, Ad. Director.

ARCHITECTURE NEW ZEALAND. 1988. bi–m. EN. 2164

Associated Group Media Ltd., Private Bag 15, Newmarket, Auckland 1031, New Zealand. Phone 09 795–393, fax phone 09–3089–523. Carol Bucknell, Editor.
Subscription: $NZ29.70 NZ, overseas + $NZ24.50 postage Australia & Pacific Islands, + $NZ44 elsewhere. Sample free. Limited back issues. Illus. b&w, color, photos, cartoons, plans, drawings. A4, 100p. Sheet fed offset.
ISSN: 0113–4566. OCLC: 17631762. Dewey: 720. Formerly: *NZ Architect.*
Architecture. Landscape Architecture.

The basic objective is to extend both the content and performance of architectural publishing in New Zealand. The magazine embraces the dual functions of architect to architect communications and architecturally driven communication outward to the full infrastructure of the building process. Provides a basis for wide–ranging coverage of building design, management, construction and news matters. Regular columns keep readers up to date on new building starts, people, technology, products, and overseas development.
Reviews: exhibition & book, length 500 wds. Interviews: architects & designers, both New Zealand and overseas. Listings: national. Exhibition information. . Freelance work: yes. Contact: editor. Opportunities: study, competitions, awards. Indexed: ArchPI.
Advertising: (rate card May 1989): b&w full page $NZ1683, ½ page $NZ988, ¼ page $NZ557; 4 color full page $2195, ½ page $1458; spot color + $285–375; covers + 20%. Preferred position + 10–15%. Frequency discount. 15% agency discount. Christopher Ballard, Ad. Director. Mailing lists: none. Demographics: readership profile: controlled distribution to all mem-

bers of the New Zealand Institute of Architects & Registered Architects (2153), the Society of Designers (306), the NZ Association of Interior Designers (72), central and local government administrators (171), libraries (182), building supply firms (696), and other professionals. Circulation: 8500. Audience: architects and related building professionals.

ARCHITECTURE SA/ARGITEKTUUR SA. 1978. bi–m. EN, occasionally AF.　　2165
George Warman Publications (Pty.) Ltd., Warman House, 77 Hout St. 8001, P.O. Box 704, Cape Town 8000, South Africa. Phone 021–24–5320, fax 021–26–1332, telex 5–21849. John Kench, Editor.
Subscription: R 60, R 84 overseas. Illus. b&w, color, photos, plans, charts, sketches. A4, 56p.
ISSN: 0250–054X. Dewey: 725.
Architecture.

Refereed journal of the Institute of South Africa Architects. Articles and news. Four page supplement, "Architectural Products and News" containing a brief look at what's new—new products, new projects, news.
Indexed: ArchPI. Avery.
Advertising: b&w & color. Readers service.

DER ARCHITEKT. 1952. m. GE.　　2166
Forum–Verlag GmbH, Postfach 70 02 62, Schrempfstr. 8–10, 7000 Stuttgart 70, W. Germany. Phone 0711–764025, fax 0711–767624, telex 7 255 849 foru d. Ingeborg Flagge, Editor (Bund Deutscher Architekten BDA, Ippendorfer Allee 14 b, 5300 Bonn 1).
Subscription: DM 94. Illus.
ISSN: 0003–875X. OCLC: 1723978. LC: NA3.A668. Dewey: 720.
Indexed: ArchPI. Avery.
Advertising. Ursula Hassenpflug & Klaus Mueller, Ad. Directors.

ARCHITEKTONIKA THEMATA/ARCHITECTURE IN GREECE. 1967. a. GR. EN summaries.　　2167
Architecture in Greece Press, P.O. Box 3545, GR–102 10 Athens, Greece. Orestis B. Doumanis, Editor.
Subscription: $US35 + $5 postage. Illus.
ISSN: 0066–6262. OCLC: 1481887. Dewey: 720.9495.
Indexed: ArchPI. Avery.
Advertising.

ARCHITEKTURA: The Polish Review of Architecture. 1947. m. POL. POL & EN table of contents. EN summaries with article. FR, GE, RU, SP summaries (2p. end of issue).　　2168
Wydawnictwo Arkady, Ul. Sienkiewicza 14, 00–950 Warsaw, Poland (Dist.: Ars Polona–Ruch, Krakowskie Przedmiescie 7, Warsaw, Poland. Andrzej Glinski, Editor.
Subscription: 42000 Zl. Illus.
ISSN: 0003–8814. OCLC: 1664014. LC: NA6.A7225. Dewey: 720.
Architecture.

Journal of the Association of Polish Architects.
Indexed: ArchPI. Avery.

ARCHITEKTURA CSR. 1938. bi–m. CZ or SL. EN, FR, GE, RU summaries.　　2169
Svaz Ceskych Architektu, Letenska 5, 118 45 Prague 1, Czechoslovakia. Jan Novotny, Editor.
Subscription: 144 Kcs.(Artia, PO Box 790, Ve Smeckach 30, Prague 1). Illus.
ISSN: 0300–5305. OCLC: 1723931. LC: NA6.A693. Dewey: 720.
Architecture.

Indexed: ArchPI. Avery.

ARHITECTURA. 1965. bi–m. RO. EN table of contents. EN, FR, GE, & RU summaries.　　2170
Uniunea Arhitectilor din Republica Socialista Romania Redactia Revistei Arhitectura, Str. Academiei Nr. 18–20, Bucharest, Romania. Phone 13.98.80. (Dist.: Rompresfilatelia, Import–Export Presa, P.O. Box 12201, Calea Grivitei 64–66, Bucharest). Stefan Radu Ionescu, Editor.
Subscription: $68. Illus. b&w, photos, plans. 10 x 10½, 84p.
ISSN: 0300–5356. OCLC: 2144633. Dewey: 720. Formerly: *Arhitectura R.P.R.*.
Architecture.

Indexed: ArchPI.
Advertising: none.

ARHITEKTURA. 1947. q. SCR. EN, FR, GE & RU summaries.　　　　　　　　　　　　**2171**
Savez Drustava Arhitekata Hrvatske, Trg Republike 3/I, 41000 Zagreb, Yugoslavia. Aleksander Laslo, Editor.
Illus.
ISSN: 0350–3666. OCLC: 14282819　1748025. LC: NA6.A695. Dewey: 720. Formerly: *Arhitektura–Urbanizam.*
Architecture.
Indexed: ArchPI.

ARKHITEKTURA S.S.S.R. 1933–1948, 1951. bi–m. RU only.　　　　　　　　　　**2172**
Stroiizdat, Ul. Shchousseva, Rm.60, 3 Moscow 103001, Russian S.F.S.R., U.S.S.R. A.P. Koudriavtsev, Editor.
Subscription: 46.80 Rub. Microform available from UMI. Illus. b&w, glossy photos, plans. 8¾ x 11½, 128p.
ISSN: 0004–1939. OCLC: 1514160. LC: NA6.A74. Dewey: 720.
Architecture.
Profusely illustrated periodical covering Russian architecture.
Indexed: ArchPI.
Advertising: none.

ARKHITEKTURAH/ARCHITECTURE IN ISRAEL. a. HE. EN summaries.　　　　**2173**
8 Glitzenstein Str., Tel–Aviv, Israel. Lony Gershoni, Editor.
Illus.
OCLC: 12860450. LC: NA6.A73. Formerly: *Adrikhalut.*
Architecture.

ARQUITECTURA: Revista del Colegio Ofical de Arquitectas de Madrid.
　　1959. bi–m. SP. EN summaries with article (about ⅓p.　　　　　　　　　　　**2174**
Colegio Oficial de Arquitectos de Madrid, Barquillo 12, 28004 Madrid, Spain. Phone 521 82 00/532 54 99.
Subscription: 8.700 ptas. $US106. Microform available from UMI. Illus., mainly color, b&w, photos, plans. 9½ x 11¾, 130–160p. + ads.
ISSN: 0004–2706. OCLC: 3580083. LC: NA5.A795. Dewey: 720.
Architecture.
Heavily illustrated. About ½ of the articles contain summaries.
Indexed: ArchPI. Avery.
Advertising.

ARQUITECTURA CUBA. 1960. s–a. SP. FR & EN summaries.　　　　　　　　　**2175**
Ediciones Cubanas, Obispo No. 527, Aptdo. 605, Havana, Cuba. Phone 32–5556/60.
Subscription: $23 No. & So. America, $25 Europe. Illus.
ISSN: 1010–3821. OCLC: 6020230, 2444992. LC: NA5.A84. Dewey: 720. Formerly: *Arquitectura y Urbanismo; Arquitectura.*
Architecture.
Organ of the Colegio Nacional de Arquitectos de Cuba.
Indexed: ArchPI.

ARQUITECTURA E URBANISMO. 1984. bi–m. POR.　　　　　　　　　　　　　**2176**
Editora Pini, 964 Anhala, San Paolo SP, Brazil.
Subscription: $20. Illus.
ISSN: 0102–8979. OCLC: 19250176. LC: NA5.A8347. Dewey: 720.
Architecture.

ARTPARK.　See no. 484.

CAHIERS DU CCI. 1986. a. FR only. 2177

Centre de Creation Industrielle, Centre National d'Art et de Culture Georges Pompidou, 75191 Paris, France. Jean Mahew, Editor.

Illus. b&w, color, photos. 7¾ x 9½, 200+p.

ISSN: 0766–6756.

Architecture. Design.

Focuses on industrial design in France. Issues have individual titles.

CANADIAN ARCHITECT. 1955. m. EN. 2178

Southam Business Information and Communications Group. Inc., 1450 Don Mills Rd., Don Mills, Ontario M3B 2X7, Canada. Phone 416–445–6641. Robert Gretton, Editor & Pub.

Subscription: included in membership, $37 Canada. Microform available from UMI. Illus. 8 x 11, 70p.

ISSN: 0008–2872. OCLC: 1553038. LC: NA1.C29. Dewey: 720.971. Formerly: *Royal Architectural Institute of Canada. Bulletin.*

Architecture.

For those concerned with design and specification in architecture and in related fields. Issues *The Canadian Architect Yearbook*, an annual directory issue, and a supplement, *Yardsticks for Costing*.

Indexed: ArchPI. ArtI. Avery. BioI. CanPI. Reviewed: Katz.

Advertising: none.

THE CHICAGO ARCHITECTURE JOURNAL. 1981. a. EN. 2179

Chicago Architectural Club, 4 West Burton Place, Chicago, IL 60610. (Dist.: Rizzoli International Publications, 300 Park Ave. South, New York, NY 10010). Phone 212–982–2300. Michael Lustig, Editor.

Subscription: $20.

Illus. b&w, photos, plans, drawings. 8½ x 9, 140–200p.

ISSN: 0731–8545. LC: NA1. Dewey: 724.

Architecture. Design.

Contains annual competition prize projects with brief description, renderings and photos. Examines current and historical issues in the field.

Biographies: 1–2 paragraphs about each contributor accompanies the work. Calendar of past year's events. Indexed: Avery. Reviewed: Katz.

Advertising: none.

CHURCH OF ARCHITECTURE. 1988. EN. 2180

Church of Architecture, 1815 Effie St., Los Angeles, CA 90026. Charles Crawford & Dennis Hollingsworth, Editors.

Subscription: $15. Illus. photos.

OCLC: 21018419.

Architecture.

Opinions on the urban environment and discussions of current projects particularly in the Los Angeles area.

Reviewed: *High Performance* Fall 1989, p.80.

CITE: The Architecture and Design Review of Houston. 1982. s–a. EN. 2181

The Rice Design Alliance, P.O. Box 1892, Houston, TX 77251–1892. Phone 713–524–6297. William F. Stern & Bruce C. Webb, Editors.

Subscription: included in membership, $8. Sample. Some back issues $5. Illus. b&w, photos. tabloid, 11 x 17, 24p.

ISSN: 8755–0415.

Architecture. Historic Preservation.

The journal of the Alliance, a non–profit educational organization whose purpose is to stimulate greater public awareness of the built environment. *Cite* addresses current architectural, design and planning issues in the greater Houston area. The RDA thus creates a public forum that stimulates discussion, involvement, and cooperation between the many groups of citizens able to improve the quality of life within Houston and Harris County.

Reviews: exhibition & book 2 each, length 1–1/2p.; buildings 2–3, length 3–4p. Interviews: occasionally with famous architect. Obits. of famous architects. Listings: local. Freelance work: yes. Contact: Linda Sylvan. Indexed: Avery. RILA.

Advertising: Linda Sylvan, Ad. Director. Mailing lists: none. Circulation: 6000. Audience: architects, designers, urban planners, government officials.

DEUTSCHES ARCHITEKTENBLATT. 1969. s–m. GE. 2182
Forum–Verlag GmbH, Schrempfstr. 8–10, 7000 Stuttgart 70, W. Germany. Phone 0711–764025. Gerhard Schoeberl, Editor.
Subscription: DM 85. Illus.
ISSN: 0012–1215. OCLC: 4678477. Dewey: 720.
Architecture.

German architecture.
Indexed: Avery.

DIMENSIONS. 1980. q. EN. 2183
University of Nebraska, College of Architecture, Lincoln, NE 68588–0106. Richard L. Austin, Editor.
Subscription: $14 individual, $20 institution US; + $6 foreign. Illus. b&w, photos, plans. 28cm., 28p.
ISSN: 0884–9986. OCLC: 7640179. LC: NA1.D55.
Architecture. Interior Design. Landscape Architecture.

The journal for architecture, planning and the design arts published jointly by the University of Nebraska College of Architecture and the Nebraska Society of Architects. Represents the design professions of architecture, planning, interior design and landscape architecture.
Opportunities: announces awards.
Advertising: rate cards available on request (Business Ofice, University of Nebraska, College of Architecture, phone 402–472–1456). Demographics: design professionals in Mid–West area. Audience: design professionals.

INDIAN ARCHITECT. 1959. m. EN. 2184
Prints India, A 15 Pamposh Encl., Delhi 48, India. D.N. Dhar, Editor.
Subscription: $Rs 20. Illus.
ISSN: 0019–4409. OCLC: 1752833. LC: NA1.I46. Dewey: 720.
Architecture.

A magazine for the architect, town planner and construction engineer.

INLAND ARCHITECT: The Midwestern Magazine of the Building Arts. 1957. bi–m. EN. 2185
Inland Architect Press, Box 10394, Chicago, IL 60610. Phone 312–321–0583. Cynthia C. Davidson, Editor.
Subscription: $20 US, $28 Canada & foreign. Sample $5. Back issues. Illus. b&w, color, photos, cartoons. 8¾ x 11½, 96p., offset sheetfed, perfect binding.
ISSN: 0020–1472. OCLC: 1753153. LC: NA722.I54. Dewey: 720.
Architecture. Decorative Arts. Furniture. Historic Preservation. Interior Design. Landscape Architecture.

The independent voice reporting on architecture and design in the Midwest for readers in the Midwest and around the nation. Continually reviews architectural and urban design projects in the Midwest and projects around the globe designed by midwestern–based architects. Concerned with the building arts, the environment and quality of design. The May/June issue is an annual review of the best in interior architecture. The July/August issue is devoted to a specific midwestern city.
Reviews: exhibition 2, length 750 wds.; book 2–4, length 500 wds.; building 5–6, length 500–2000 wds. Interviews: occasional questions/answers with architects. Listings: regional. Calendar of events. Exhibition information. Freelance work: yes. Contact: editor. Opportunities: employment, study, competitions. Indexed: ArchPI. Avery. Search.
Advertising: (rate card Jan '89): full page $860, ½ page $600, ¼ page $490, 2 color + $225–400, 4 color + $400, covers $1150–1270. Special positions + 15% to b&w rates. Bleed no charge. Frequency discount. 15% agency discount. 2% cash discount. Inserts. Timothy W. Hill, Ad. Director. Mailing lists: none. Demographics: edited for architecture and design professionals and their clients in the 8–state Midwest region encompassing Illinois, Michigan, Ohio, Wisconsin, Missouri, Indiana, Iowa, and Minnesota. Circulation across the nation, but primarily located in Chicago and the 8–state region. Circulation: 7000. Audience: architects and designers.

IOWA ARCHITECT. 1953. 5–6/yr. EN. 2186
Kimberley Press, 11071 Aurora Ave., Urbandale, IA 50322. Phone 515–270–0402. Bill Anderson, Editor (512 Walnut St., Des Moines, IA 50309).
Subscription: included in membership for Iowa Chapter, AIA, $15 US (512 Walnut St., Des Moines, IA 50309). Sample & limited back issues $3.50. Illus. color, photos. 8½ x 11, 48p. Sheetfed offset, saddlestitched.
ISSN: 0021–0439. OCLC: 2728419. LC: NA1.I64. Dewey: 720.
Architecture. Furniture. Historic Preservation. Interior Design. Landscape Architecture.

Presents "the face of architecture in Iowa" through feature articles on architecture and allied arts of Iowa and the entire Midwest region. Covers not only architecture but also art museums and product development throughout the area.

Reviews: exhibition 3, book 1, equipment 3, total length 1p. Listings: Midwest. Calendar of events. Exhibition information. Freelance work: yes. Contact: editor. Opportunities: competitions – design. Indexed: Avery.

Advertising: (rate card Jan '89): full page $620, ½ page $405, ¼ page $295, 2 color + $245–300, 4 color + $500, covers $1230–1395. Bleeds + $70. Frequency discount. 15% agency discount. Inserts. Stan Pshonik, Ad. Director. Mailing lists: none. Demographics: Iowa region. Circulation: 5,600. Audience: Midwest readers interested in architecture.

THE JAPAN ARCHITECT [International edition of: Shinkenchiku]. 1956. q. EN mainly, JA occasionally.
SP summaries. 2187

Shinkenchiku–Sha Co., Ltd., 31–2, Yushima 2–chome, Bunkyo–ku, Tokyo 113, Japan. Phone 03–816–2935, fax 03–816–2937. Shozo Baba, Editor.

Subscription: 17,000 Yen + 800 Yen postage, overseas 17,000 Yen + 2,5000 Yen sea. Illus. b&w, some color, photos, drawings. Annual index. A4, 68p.

ISSN: 0021–4302. OCLC: 1754197. LC: N1.S16. Dewey: 720.

Architecture.

Consists of articles, news of Japanese architects and architecture plus winners of design competition complete with photo and plans of the work. In 1991 expanded in size to include approximately 200 pages of text and photographs. Each issue addresses a timely theme in contemporary Japanese architecture. Title and occasional text also in Japanese.

Indexed: ArchPI. ArtHum. ArtI. Avery. BioI. CloTAI. CurCont. Reviewed: Katz.

Advertising on covers only.

KIBBUTZ PLANNING BULLETIN. q. 2188

United Kibbutz Movement, Planning Department, 27 Soutine St., Tel Aviv 64 684, Israel. Phone 03–245271. Emanual Tal, Editor.

Subscription: free.

Dewey: 720.

Architecture.

LUXURY HOMES OF WASHINGTON. See no. 2500.

MODERN BUILDING ARCHITECTURE AND ENGINEERING IN AUSTRALIA. 1967.
bi–m. EN. 2189

J. Carroll and Co., P.O. Box 36, Drummoyne, N.S.W. 2047, Australia.

Architecture.

NAPOLI NOBILISSIMA. See no. 272.

NEWS - SOCIETY OF ARCHITECTURAL HISTORIANS, SOUTHERN CALIFORNIA CHAPTER. 1982. bi–m. EN. 2190

Society of Architectural Historians, Southern California Chapter, Hollyhock House, 4808 Hollywood Blvd., Los Angeles CA 90027–5302.

Illus.

OCLC: 15743072. LC: NA11.S62. Dewey: 720. Formerly: *Newsletter – Society of Architectural Historians, Southern California Chapter.*

Architecture.

PERSPECTIVE / SOCIETY OF ARCHITECTURAL HISTORIANS, TEXAS CHAPTER.
1972. 3/yr. EN. 2191

Society of Architectural Historians, Texas Chapter, University of Texas at Arlington, Arlington, TX 76019.

Illus.

OCLC: 9736669. LC: NA1.P76.

Architecture.

PROA: Urbanismo, Arquitectura, Industrias. 1946. m. SP. 2192

Ediciones Proa, Calle 40, no. 19–52, Bogota, Colombia. Lorenzo Fonseca, Editor.

Illus., maps.

ISSN: 0032–9150. OCLC: 5320653. LC: N1.P96. Dewey: 720.

Architecture.

Focus is on the architecture of Bogota, Columbia.

QUADERNS D'ARQUITECTURA I URBANISME. 1981. bi–m. CA & SP. EN tr. (small print alongside article). Caption titles tr. 2193

Colegio Oficial de Arquitectos de Cataluna y Baleares, Plaza Nueva Num.5, Barcelona 2, Spain. (Dist.: Libreria Internacional, Corcega 428, Barcelona 9). Josep–Lluis Mateo, Editor.

Subscription: 8268 ptas Spain, 10500 ptas others. Illus., some color.

ISSN: 0211–9595. OCLC: 8272678. LC: NA1301.Q3. Dewey: 720.5. Formerly: *Cuadernos de Arquitectura y Urbanismo.*

Architecture.

Articles dealing with Spanish architecture and planning. Unnumbered extra issues published irregularly.

Indexed: ArchPI. Avery.

Advertising.

TEXAS ARCHITECT. 1950. bi–m. EN. 2194

114 W. 7th St., Suite 1400, Austin, TX 78701. Phone 512–478–7386. Joel W. Barna, Editor.

Subscription: $18 US. Back issues $5. Illus. b&w, color, photos, cartoons. 8½ x 11, 60p. Offset. Saddle stitch.

ISSN: 0040–4179. OCLC: 2144339. LC: NA1.T4. Dewey: 720.5.

Architecture. Historic Preservation. Interior Design. Landscape Architecture.

Focuses on the needs and development of the Southwest. Editorial objective is to inform readers of the latest developments in architecture in the Southwest region. Features cover debates over style, technology, interior design, and urban spaces as well as topics ranging from the pioneer traditions of Texas regionalism to the latest innovations in high–tech computer–aided design. Each issue also showcases a portfolio of the best recent architectural work in and around Texas and news of government and business affairs affecting architects and designers. Features, portfolios, and news stories are profusely illustrated with high–quality photographs and architectural drawings.

Reviews: book 1, length 1 page, architectural supplies 15, length 1 page. Interviews: architects and clients. Listings: regional. Calendar of events. Exhibition information. . Freelance work: yes. Contact: Ray Don Tilley, Assoc. editor. Opportunities: study, competitions. Indexed: Avery.

Advertising: (rate card Jan/Feb '88): full page $1205, ½ page $730; 4 color + $450, pms color + $275, process color + $250; covers $1975–2280. Special position + 10%. Classified: 50¢/wd., $50/col.in. Frequency discount. 15% agency discount. Inserts. Bleed no charge. Reader inquiry service cards. Charles E. Gallatin, Ad. Director. Mailing lists: available for sale. Demographics: all of Texas, majority in Houston & Dallas. Circulation: 7300, newsstand sales 500–600 copies/issue. Audience: design professionals and architects throughout Texas and the Southwest in universities and private, corporate, and institutional practice.

Architectural Education

THE 100 PERCENT RAG. irreg. EN. 2195

Syracuse University, School of Architecture, Syracuse, NY 13210.

Architecture.

AA FILES. 1981/82. irreg., approx. 2/yr. EN. 2196

Architectural Association, 36 Bedford Sq., London WC1B 3ES, England. Phone 071 6360974, fax 071 4368740. Mary Wall, Editor.

Subscription: (covers 3 issues and can start with any number) £40 UK only, £45 overseas. No sample. Back issues. Illus. b&w, color, photos, cartoons. 296 x 245 mm., 112p.

ISSN: 0261–6823. OCLC: 9116240. LC: NA1.A1 A22. Dewey: 720. Formerly: *A A Quarterly.*

Architecture. Historic Preservation. Interior Design. Landscape Architecture.

The Annals of the Association. The Architectural Association has an unique position at the center of the international architectural scene. *AA Files* records the rich variety of activities that take place within the AA School of Architecture — lectures by architects and scholars of international renown, the innovative exhibitions program, and the prolific output of students as well as staff, many of whom are associated with major architectural practices.

Reviews: exhibitions & book, 6 each, length 1500–4500 wds. Freelance work: none. Indexed: ArchPI. Avery. RILA. Reviewed: Katz.
Advertising: none. Circulation: 2000. Audience: anyone interested in the visual arts.

ACCREDITED PROGRAMS IN ARCHITECTURE. 1980. a. EN. 2197

National Architectural Accrediting Board, 1735 New York Ave., N.W., Washington, DC 20006. Phone 202–783–2007.
Subscription: free. No back issues.
OCLC: 4669115. LC: NA2000.N25. Formerly: *Accredited Schools of Architecture; List of Accredited Schools of Architecture.*
Architecture Education.

Lists accredited programs together with contact information, address and phone number, program type and term of accreditation.
Advertising: none. Audience: prospective students.

ACROSS ARCHITECTURE. 1984. s–a. EN. 2198

Across Publications, 40 Radnor Mews, London W2 2SA, England. Phone 071–262 1557, fax 071–262 1773. Roland Cowan & Dimitri Vannas, Editors.
Sample. Back issues. Illus. b&w, photos. A4, 64p. Heatset web–offset.
ISSN: 0266–6200. OCLC: 11008826. Dewey: 720.
Architecture. Art History. Decorative Arts. Interior Design. Landscape Architecture. Modern Art. Painting. Sculpture.

Co–published by the Great Britain Architectural Association, School of Architecture. A platform for selected architectural polemics, experiments, ideas and views concerning architecture and the relationship of art to architecture. Presents profiles on international artists, sculptors, and architects.
Reviews: exhibition 2, length 2p. each. Listings: national–international. Calendar of events. Exhibition information. Freelance work: yes. Contact: editor. Opportunities: employment, study, competitions.
Advertising: full page £250, ½ page £150; color full page £600, ½ page £450; spot color + 20%, covers + 30–50%. Inserts. Sioban Cunningham, Ad. Director. Mailing lists: available. Circulation: 2000. Audience: Architects, artists, students, critics, & anyone interested in architecture, art and the crossovers.

ACSA NEWS. See no. 2229.

AIAS NEWSFLASH. q. EN. 2200

American Institute of Architecture Students, Inc., 1735 New York Ave., N.W., Washington, DC 20006. Phone 202–626–7472.
David T. Kunselman, Editor.
Illus. b&w. 11 x 17, 8–12p.
Formerly: *ASC/AIA News.*
Architecture.

Presents information of importance to architectural students. Includes news of design contests, news of research, member news, conventions and the historic preservation of old buildings.
Calendar of events. Opportunities: employment.
Advertising. Audience: architectural students, educators & practitioners.

AMENAGEMENT. 1986. a. FR. 2201

Universite de Montreal, Faculte de l'Amenagement, C.P. 6128, succ. A, Montreal, Quebec H3C 3J7 Canada. Phone 514–343–6835. Denys Marchand, Editor.
Subscription: free. Back issues. Illus. b&w, photos, cartoons. 11 x 17m 8p.
Architecture. Historic Preservation. Landscape Architecture. Industrial Design. Town Planning.

Tabloid school publication presents a retrospective of the past year.
Biographies: short notes concerning professors taking their retreat. Listings: exhibitions held by schools or departments of the faculty. Opportunities: study, held by faculty, competitions, won by faculty or students.
Advertising: none. Circulation: 5000. Audience: universities, colleges, public administrations, professionals.

AMPERSAND. bi–w. EN. 2202

University of Nebraska, College of Architecture, Lincoln, NE 68588–0106.
Subscription: free. Illus. b&w. 4p., offset.
Architecture.

ARCHIMAGE. 1982. irreg. EN. 2203

University of Wisconsin, School of Architecture and Urban Planning, University of Wisconsin – Milwaukee, P.O. Box 413, Milwaukee, WI 53201. Phone 414–229–4014. Ignacio Correa–Ortiz, Editor.

Sample. Back issues. Illus. b&w, drawings. 8½ x 11, 16p.

Architecture. Crafts. Drawing. Graphic Arts.

A publication by the students whose purpose is to provide students, faculty, alumni and friends of the school with a forum in which ideas pertinent to the practice and study of design can be expressed and discussed. A monthly supplement provides the opportunity to creative an active printed dialogue of topics related to common concerns.

Reviews: exhibition 1, length 1p.; Back issues 2, length 2p. Freelance work: yes. Contact: editor.

Advertising: none. Audience: faculty, alumni, students.

ARCHITECTURE AND PLANNING. 1980. s–a. EN. 2204

University of California at Los Angeles, Graduate School of Architecture and Urban Planning, Los Angeles, CA 90024.

Subscription: free. Illus. b&w, some color. 35cm., 28p.

OCLC: 6385056.

Architecture. Planning.

A publication of the UCLA School of Architecture and Urban Planning.

Indexed: Avery.

ARCHITECTURE AT ILLINOIS. EN. 2205

School of Architecture, University of Illinois at Urbana–Campaign, 608 East Lorado Taft Drive, Champaign, IL 61820.

Illus. b&w, photos. 8½ x 11, 24–28p.

Architecture.

Newsletter account of faculty and students in the design division includes news of alumni.

Listings: local. Calendar of school events. Opportunities: competitions – announcement of competitions and of awards winners.

Advertising: none.

AVANT GARDE. 1989. bi–a. EN. 2206

University of Colorado at Denver, School of Architecture and Planning, 1200 Larimer St., Campus Box 126, Denver, CO 80204–5300. Phone 303–556–3382. Diane Wilk Shirvani, Editor.

Subscription: US individuals $15/issue, institutions $45/yr; Canada & foreign individuals $30/issue, institutions air + $15.

Back issues $15. Illus. b&w, photos. 5 x 7, 100p.

ISSN: 1040–446X. OCLC: 18424766. LC: NA2599.5.A93. Dewey: 720.

Architecture Education. Art History. Landscape Architecture. Modern Art.

A forum for the exchange of ideas, thoughts and intellectual debates among educators, researchers, critics, practitioners and students of architecture and the arts. The journal views architecture as both a method of production as well as a means of investigation and thus it is comprised of papers as well as projects. Features architects and designers of local, national and international acclaim.

Freelance work: none.

Advertising: none. Audience: architects, designers, landscape architecture.

AVENU. 1972. 3/yr. EN. 2207

University of Oregon, School of Architecture & Allied Arts, Eugene, OR 97403.

Subscription: free. Illus. 40 cm., 14p.

Architecture.

Tabloid.

BOSTON ARCHITECTURAL CENTER YEARBOOK. 1989. a. EN. 2208

Boston Architectural Center, 320 Newbury St., Boston, MA 02115. Phone 617–536–3170. Russ Gerard, Editor.

Illus. b&w, plans, drawings. 9 x 12, 48p.

Architecture.

Published until 1929 then discontinued. Started up again with 1989 edition. The 1989 issue shows thesis projects from the past three graduating classes. Double page illustrations or plans and line drawings with brief statement of project, name, place, date.
Advertising: none.

CATCH MAGAZINE. irreg. EN.

Technical University of Nova Scotia, School of Architecture, Halifax, N.S. B3J 2X4 Canada.
Illus. 22cm., 20p.
Architecture.

CEDRS NEWSLETTER. m. EN.

Ball State University, College of Architecture and Planning, Center for Environmental Design, Research and Service, Muncie, IN 47306.
Subscription: free. 4p. 38cm. offset.
Architecture.

CENTER. See no. 2033.

CENTRAL PAPERS ON ARCHITECTURE. 1980. a. EN.

East Central Region of the Association of Collegiate Schools of Architecture, Ohio State University, Dept. of Architecture, Columbus, OH 43210.
Illus. 27cm., 80p.
ISSN: 0895–9870. OCLC: 7032894. LC: NA1.C42. Dewey: 720.
Architecture Education.

Editorship rotates yearly among sponsoring institutions in the East Central Region of the Association of Collegiate Schools of Architecture.

CLEMSON UNIVERSITY COLLEGE OF ARCHITECTURE NEWSLETTER. 1986. s–a. EN.

Clemson University, College of Architecture, Clemson, SC 29634. Phone 803–656–3081. Martin A. Davis, Editor.
Subscription: free. Sample. Back issues. Illus. b&w, photos, cartoons. 8 p.
Architecture. Architecture Education. Art History. Historic Preservation. Landscape Architecture. Modern Art. Sculpture.

Focus is on college activities in terms of education, research and public services. Visiting lectures are covered and articles pertaining to current issues in architecture, planning, landscape architecture, building science and management, visual arts, and art history are presented.
Reviews: exhibition, book. Interviews: visiting architects and visual artists. Listings: regional. Calendar of college events. Exhibition information for the Gallery, College of Architecture. Opportunities: study – continuing education, conferences, coursework.
Advertising: none. Circulation: 3500. Audience: alumni of college.

COLUMN 5. 1987. a. EN.

College of Architecture and Urban Planning, Dept. of Architecture, 208 Gould Hall J0–20, University of Washington, Seattle, WA 98195.
Illus.
OCLC: 19533552. LC: NA1.C64.
Architecture.

Student–produced school publication.

CONCRETE. 1977. irreg. EN.

University of California, Berkeley, College of Environmental Design, Berkeley, CA 94720.
Subscription: free. Illus. 28cm., 12p. offset.
Architecture.

Journal of the College of Environmental Design.

CRIT: The Architectural Student Journal. 1976. s–a. EN. 2215
American Institute of Architecture Students, 1735 New York Ave., N.W., Washington, DC 20006. Phone 202–626–7472.
Leigh Hubbard, Editor.
Subscription: included in membership AIAS, non–members $6. Back issues $2. Illus. b&w, photos. 8½ x 11, 48p.
ISSN: 0277–6863. OCLC: 4597325. LC: NA1.T37. Dewey: 720. Formerly: *Telesis.*
Architecture.

Articles and news items cover architectural education and developments in the profession. The Fall 1989 issue, (no.23), "Issues in Review" is a retrospective edition covering some of the most interesting articles from numbers 1–20.
Reviews: book. Freelance work: yes. Contact: editor. Opportunities: study. Indexed: ArchPI.
Advertising: rate card available on request. Circulation: 30,000.

DAAP NEWS. 1983. 3/yr. EN. 2216
University Publications, University of Cincinnati, Cincinnati, OH 45221–0141. Phone 513–556–4933. Nancy Koch, Editor
(College of DAAP, University of Cincinnati, Cincinnati, OH 45221–0016).
Subscription: included in membership DAAP alumni & friends. Sample. No back issues. Illus. b&w, photos. 8½ x 11, 20p.
Autumn, 12p. Winter & Spring.
Architecture. Art Education. Drawing. Interior Design. Industrial Design. Urban Planning.

An architectural school publication provided primarily for students, faculty, alumni, and friends of the College of Design, Architecture, Art and Planning.
Biographies: Faculty and occasionally students. Obits. Calendar of College events. Exhibition information. Freelance work: none. Opportunities: study, competitions.
Advertising: none.

DESIGN METHODS AND THEORIES. 1966. q. EN. 2217
Design Methods Group, Box 5, San Luis Obispo, CA 93407. Donald P. Grant, Editor.
Subscription: $30 US, elsewhere $34, air $38. Back issues. Illus. (few) diagrams. 6½ x 8½, 48p.
ISSN: 0147–1147. OCLC: 2287206. LC: NA9000.D15. Dewey: 711. Formerly: *D.M.G.–D.R.S. Journal.*
Architecture Education.

"Journal of the DMG" sponsored by California Polytechnic State University. Scholarly articles devoted to education and applied design methods as well as the fields of study of theories of design and designing. Contains articles and announcements.
Opportunities: competitions – announces winners of awards. Indexed: Avery. Des&ApAI.
Demographics: subscribers in over 40 countries and on all continents.

EAR. 1973. a. EN. 2218
University of Edinburgh, Department of Architecture, c/o Prof. C.B. Wilson, 20 Chambers St., Edinburgh EH1 1JZ, Scotland.
Illus.
ISSN: 0140–5039. OCLC: 6887600. LC: NA2000.E17. Dewey: 720.
Architecture.

Indexed: ArchPI. Avery.

THE FIFTH COLUMN: Canadian Student Journal of Architecture/Revue Canadienne des Etudiants en Architecture. 1980. q. EN & FR. 2219
McGill University, School of Architecture, 8151 Sherbrooke West, Montreal, Que. H3A 2K6, Canada. Phone 514–398–6700.
Back issues. Illus. b&w, photos. 8 x 10½, 40–50p.
ISSN: 0229–7094. OCLC: 9137695. LC: NA1. Dewey: 720.
Architecture.

Magazine promotes the study of architecture in Canada at the present in terms of both the past and the future. It attempts to stimulate and foster a responsible, critical sensitivity in both its readers and its contributors. Provides an alternative forum to established views not for the sake of opposing them, but to make it possible to objectively evaluate them. Articles by students, academics and professionals. Each issue has a distinctive title and presents a series of articles exploring a specific and relevant theme which contributes to an understanding and a greater awareness of current architecture.
Freelance work: yes. Contact: editor. Indexed: ArchPI. Avery.
Advertising: none.

GSD NEWS. 1983. q. EN. 2220

Harvard University Graduate School of Design, 48 Quincy St., Cambridge, MA 02138. Phone 617–495–4004. Joseph Ryan, Editor.

Subscription: free. Illus. b&w, photos, maps, plans. 11 x 11, 16p.

ISSN: 0746–3677. OCLC: 9977318. LC: NA2300.H34 G73. Dewey: 712. Formerly: *HGSD News*.

Architecture Education.

School and alumni newsletter covering student, faculty and alumni news; brief articles; and reports on recent lectures. Its primary purpose is to inform readers about news and events at the school.

Listings: college. Calendar of lectures and exhibitions. Opportunities: study – professional development courses, competitions, announcements. Indexed: Avery.

Advertising: none. Audience: alumni, students, faculty and others interested in design education at Harvard.

THE HARVARD ARCHITECTURE REVIEW. 1980. a. EN. 2221

Rizzoli International Publications, Inc, 300 Park Ave. South, New York, NY 10010. Phone 212–982–2300. Editors (c/o George Gund Hall, 48 Quincy St., Cambridge, MA 02138).

Subscription: $27.50.

Microform available from UMI. Illus. b&W, some color. 8 x 12, 192p.

ISSN: 0194–3650. OCLC: 5384482. LC: N1.H34. Dewey: 720.

Architecture.

A publication of the students of the Graduate School of Design, Harvard University. Each issue has an individual title. Contains exhibition theses and essays.

Interviews & biographies: architects, brief 1. paragraph biographies of contributors. Indexed: ArtI. Avery. CurCont. Reviewed: Katz. *Design Book Review*, 5, Fall 1984, p.114–117.

Advertising: none.

THE IDP. 1977. q. EN. 2222

IDP Coordinating Committee, AIA–NCARB, IDP Headquarters, Suite 700, 1735 New York Ave., NW, Washington, DC 20006.

Illus. b&w, photos, plans. 8½ x 11, 8p.

Architecture.

The newsletter of the National Council of Architectural Registration Board for intern–architects and the architects who support them in the Intern–Architect Development Program. Its purpose is to contribute to the development of competent architects. Each newsletter is organized around several departments including general news items, feature articles, case studies, descriptions of program resources, previews of new resources and technological information. A series of feature articles present in–depth descriptions of the IDP training areas. Case studies are used to illustrate practical applications in both large and small firms.

Advertising: none.

JOURNAL OF ARCHITECTURAL EDUCATION. 1947. q. EN. 2223

Association of Collegiate Schools of Architecture, Inc., 1735 New York Ave., N.W., Washington, DC 20006. Phone 202–785–2324 (Dist.: Butterworth, 80 Montvale Ave., Stoneham, MA 02180, phone 617–438–8464). Diane Ghirardo, Editor.

Subscription: included in membership. Microform available from UMI. Illus.

ISSN: 1046–4883. OCLC: 16633988. LC: NA1.J77. Dewey: 720. Formerly: *JAE*.

Architecture Education.

Contains articles on architectural design, education theory and practice.

Reviews: book. Indexed: ArchPI. RILA.

Advertising: none. Circulation: 3800.

MASS. 1983. a. EN. 2224

University of New Mexico, School of Architecture and Planning, 2414 Central SE, Albuquerque, NM 87131. Phone 505–277–2903. Dorothy Dyer, Editor.

Subscription: free. Some back issues. Illus. b&w, photos. 28 cm., 40–45p.

ISSN: 0897–1420. OCLC: 9708863. LC: NA730.N4M3.

Architecture. Landscape Architecture. Planning.

Journal of the School of Architecture and Planning, a journal of opinions dealing with specific and general issues of architecture, landscape architecture and planning. Each annual has its own theme.

Reviews: book. Indexed: Avery.
Advertising: none. Circulation: 4000.

MATRIX. 1981. a. EN. 2225
Howard University, School of Architecture and Planning, 2366 6th St. NW, Washington, D.C. 20059. Phone 806–7420. Christine B. Vina, Editor.
Subscription: free. Sample. Back issues. Illus. b&w, photos. 8½ x 11, 32p.
Architecture.

Retrospective of all events (exhibits, faculty profiles, awards, thesis juries, alumni notes, etc.) which pertain to the School of Architecture & Planning during the past year.
Reviews: exhibition (The University as participant or host) 1–2. Biographies: faculty. Listings: School only. Exhibition information. Freelance work: none. Opportunities: study, competitions.
Advertising: none. Circulation: 1000. Audience: current and prospective architecture students, architecture faculty (within and outside University), Howard University personnel.

MODULUS. 1964. a. EN. 2226
Rizzoli International Publications, Inc., 300 Park Ave. South, New York, NY 10010. Phone 212–982–2300. Rosanna Liebman, Editor.
Illus. b&w, some color.
ISSN: 0191–4022. OCLC: 1639578. LC: NA1.M63. Dewey: 720.
Architecture.

Published for the University of Virginia School of Architecture.
Indexed: ArchPI. Reviewed: Katz. *Design Book Review* 5, Fall 1984, p.114–117.
Advertising: none.

MONTANA STATE ARCHITECTURAL REVIEW. 1983. a. EN. 2227
Montana State University, School of Architecture, Bozeman, MT 59717.
Illus., maps, plans. 28cm., 32p.
ISSN: 0741–6849. OCLC: 9789090. Dewey: 720.
Architecture.

Indexed: Avery.

NEWS [University of Texas at Austin]. 1985? irreg. EN. 2228
University of Texas at Austin, School of Architecture, Austin, TX 78712.
Subscription: free. 26cm., 16p.
Architecture.

Tabloid.

NEWS - ASSOCIATION OF COLLEGIATE SCHOOLS OF ARCHITECTURE.
1972. m. (during academic yr.). EN. 2229
Association of Collegiate Schools of Architecture, Inc, 1735 New York Ave., N.W., Washington, DC 20006. Phone 202–785–2324. Karen L. Eldridge, Editor.
Subscription: included in membership. Back issues $5. Illus. b&w, photos, drawings. 9 x 12, 20p.
ISSN: 0149–2446. OCLC: 3464468. LC: ND4153. Dewey: 720. Formerly: *ACSA Newsletter.*
Architecture Education.

Association is dedicated to the enhancement of architectural education. Transmits "Opportunities," employment opportunities, conferences, meetings, programs, seminars, news of summer programs, design competitions for students of architecture, members news, and meetings of the board.
Reviews: book. Obits.
Listings: national. Calendar of ACSA events. Opportunities: positions available; study; awards announced.
Advertising. Position available ads $25/line.

NEWSLETTER. [Syracuse University]. 1982. irreg. EN. 2230
Syracuse University, School of Architecture, Architecture Alumni Program, Syracuse, NY 13210.
Subscription: free. Illus. 28cm.

Architecture.

NEWSLETTER [University of Illinois at Chicago]. 1985. 3/yr. EN. 2231

University of Illinois at Chicago, School of Architecture, Chicago, IL 60680.
Illus. 43 cm., 8p.

Architecture.

Tabloid.

NEWSLETTER [University of Washington]. 1984? 3/yr. EN. 2232

University of Washington, College of Architecture and Urban Planning, Seattle, WA 98195.
Subscription: free. 27 cm., 14p. offset.

Architecture.

NOTRE DAME ARCHITECTURE REVIEW. 1982. s–a. EN. 2233

University of Notre Dame, Notre Dame, IN 46617.
Illus. 28cm.

Architecture.

OFFRAMP. 1988. s–a. EN. 2234

Southern California Institute of Architecture, c/o SCI–ARC, 1800 Berkeley St., Santa Monica, CA 90404. Phone 213–829–3482. Editorial Bd.
Subscription: $20/3 issues. No sample. Back issues $7. Illus. b&w, photos. tabloid.
OCLC: 18467194. LC: NA1.O34.

Architecture. Drawing. Films. Graphic Arts. Modern Art. Photography. Typography.

A student publication encompassing all the arts that affect the art of building. Format varies, the design is a major aspect of the magazine. Published in collaboration with students from the California Institute of the Arts.

Reviews: book 2, length 1p. Interviews: architects, photographers designers or artists of the avant–guarde. Freelance work: none. Reviewed: *High Performance* Fall 1989, p.80.

Advertising: all ads to be negotiated, no color, no classified. Frequency discount. Mailing lists: none. Demographics: architectural students, schools and offices international, graphic designers. Audience: architects, artists, students, graphic designers.

OZ. 1979. a. EN. 2235

College of Architecture and Design, Seaton Hall, Kansas State University, Manhattan, KS 66506. Phone 913–532–7996. Editor changes annually.
Subscription: $20 all. No sample. Back issues. Illus. b&w, some color, photos. 28cm., 80p.
ISSN: 0888–7802. OCLC: 7985211. LC: NA712.O9. Dewey: 720.

Architecture. Architectural History.

Dedicated to exploring ideas in architecture through the work of distinguished architects, educators and students.
Freelance work: yes. Contact: editor. Indexed: Avery.
Advertising: none. Circulation: 750. Audience: architects, architecture students and educators.

PENN IN INK. 1980? 3/yr. EN. 2236

University of Pennsylvania, Graduate School of Fine Arts, Center for Environmental Design and Planning, 102 Meyerson Hall, Philadelphia, PA 19104–6311. Phone 215–898–8799. Margaret L. Irish, Editor.
Subscription: free. Limited back issues, free. Illus., b&w, photos, plans, maps. 9 x 10, 36–40p. Fall/Spr issue, 8–16p. Sum issue.
ISSN: 0898–8854. OCLC: 7974319. LC: NA1.P45.

Architecture. Art Education. Drawing. Historic Preservation. Landscape Architecture. Painting. Photography. Planning. Sculpture.

A review of the Graduate School of Fine Arts presents city planning, regional planning, urban design, energy management and policy, appropriate technology, and transportation planning.

Interviews: lecturers, faculty and visiting critics. Biographies: new and departing faculty, special lecturers, award–winning students or alumnus. Listings: regional–international related to GSFA only. Calendar of lecture series events. Freelance work: from alumni, no payment. Contact: editor. Opportunities: study, those offered by School.

Advertising: none. Circulation: 10,000. Audience: alumni.

PERSPECTA: The Yale Architectural Journal. 1952. a. EN. 2237

Rizzoli International Publications, Inc., 300 Park Ave. South, New York, NY 10010. Phone 212–982–2300.
Illus. b&w, some color. 9 x 12, 150p.
Subscription: $30.
ISSN: 0079–0958. OCLC: 1588272. LC: NA1.P46. Dewey: 720.
Architecture.

A publication of the Yale University's School of Architecture.
Indexed: ArchPI. ArtI. Avery. CurCont. Reviewed: Katz. *Design Book Review* 5, Fall 1984, p.14–17.
Advertising: none.

PLAN. 1977. q. EN. 2238

Massachusetts Institute of Technology, School of Architecture and Planning, 77 Massachusetts Ave., Cambridge, MA 02139.
Phone 617–253–4401.
Subscription: free. Illus. 43cm., 8p.
ISSN: 8755–1128. OCLC: 4348426. Dewey: 720. Formerly: *MIT Newsletter*.

Architecture. Planning.
Review of the MIT School of Architecture and Planning.

PRACTICE NEWSLETTER. s–a. EN. 2239

British Institute of Architectural Technicians, 397 City Road, Islington, Lindon EC1V 1NE, England. Phone 071 2782206.
Architecture Education.

Purpose of the Institute is to promote the professional status of architectural technicians.

PRATT JOURNAL OF ARCHITECTURE. 1985. a. EN. 2240

Rizzoli International Publications, Inc., 300 Park Ave. South, New York, NY 10010. Phone 212–982–2300. Stephen Perrella, Editor.
Subscription: $10. Illus. Index. 9 x 9, 180p.
ISSN: 0883–7279. OCLC: 12223821. LC: NA1.P67. Dewey: 720.
Architecture.

Pratt Institute School of Architecture student journal with articles by students, faculty, and working architects. Each issue has a distinctive title. Presents an interdisciplinary focus, architecture together with related activities in the arts.
Indexed: Avery. Reviewed: Katz.
Advertising: none.

PRECIS. 1979. a. EN. 2241

Rizzoli International Publications, Inc., 300 Park Ave. South, New York, NY 10010. Phone 212–982–2300. Gianmarco Vergani, Editor.
Illus. b&w, photos. 8½ x 10¼, 160p.
ISSN: 0887–8781. OCLC: 7386733. LC: NA2300.C35P74. Dewey: 720.
Architecture. Historic Preservation. Planning.

A publication of the Columbia University, Graduate School of Architecture and Planning. Each issue is devoted to one theme related to architecture, planning or preservation and reflects the urbanity of its New York City campus.
Reviewed: Katz.

THE PRINCETON JOURNAL. 1983. a. EN. 2242

Princeton Architectural Press, 158 Valley Road, Princeton, NJ 08540.
Illus.
ISSN: 0741–1774. OCLC: 10089940. LC: NA1.P69. Dewey: 720.
Architecture.

Published for the School of Architecture at Princeton University.
Indexed: ArchPI. Avery. Reviewed: *Design Book Review* 5, Fall 1984, p.114–117.

RE: CAP. 1970. irreg. EN. 2243
Ball State University, College of Architecture and Planning, Center for Environmental Design, Research and Service, Muncie, IN 47306.
Illus. b&w, some color. 28cm., 25p.
Architecture.

REFLECTIONS. 1983. a. EN. 2244
School of Architecture, University of Illinois at Urbana–Champaign, 608 E. Lorado Taft Dr., Champaign, IL 61820–6967.
Phone 217–333–1330. Ronald E. Schmitt, Editor.
Subscription: $18 all. Back issues. Illus. b&w, photos, maps, plans. 8½ x 11, 85p.
ISSN: 0739–9448. OCLC: 9846351. LC: NA2000.R39. Dewey: 720.
Architecture. Architectural Education. Decorative Arts. Furniture. Historic Preservation. Landscape Architecture. Modern Art. Urban Design.

The journal of the School of Architecture is devoted to theory and criticism. Main focus is landscapes, townscapes, and memorials.
Interviews & biographies: occasionally as an article or paper. Freelance work: yes. Contact: editor. Indexed: Avery.
Advertising: none. Audience: architects, students and faculty of architectural schools.

RETROSPECTA. 1977/78. a. EN. 2245
Yale University School of Architecture, 180 York St., New Haven, CT 06510. Phone 203–432–2289. Dolores Gall, Staff coordinator.
Subscription: free. No sample. Back issues. Illus. 28 cm., 20p.
Architecture.

The yearly booklet is intended as a summary of the activities in the School of Architecture for a given year. Edited by students it includes design studio student work, exhibitions, alumni news, and graduation awards.
Advertising: none. Audience: alumnae and prospective students.

S/ARC UPDATE: The S/ARC Alumni Newsletter. 1986. s–a. EN. 2246
Mississippi State University, School of Architecture, P.O. Drawer AQ, Mississippi State, MS 39762. Phone 601–325–2202.
Gary Shafer, Editor.
Subscription: free to all. Sample. No back issues. Illus. b&w. 8½ x 14, 4p.
Architecture.

Publication contains alumni news and forum as well as faculty and school news and events.
Reviews: lecture 1, length 200 wds. Interviews: faculty members, alumni professionals. Listings: local. Calendar of events.
Exhibition information for School Gallery. Freelance work: yes. Contact: editor. Opportunities: study, competitions, student and alumni design awards, faculty grants, design competitions.
Advertising: none. Circulation: 500. Audience: all alumni of the School of Architecture and selected architectural practitioners in Mississippi.

SEQUENCE. 1984. s–a. EN. 2247
University of North Carolina at Charlotte, College of Architecture at UNC–Charlotte, Charlotte, NC 28223.
Subscription: free. Illus. 40 cm., 10p.
Architecture.

Tabloid produced by the students of architecture at UNC–Charlotte. .

STUDENT PUBLICATION OF THE SCHOOL OF DESIGN. 1951. irreg. EN. 2248
North Carolina State University, School of Design, Raleigh, NC 27695–7701. Phone 919–737–2202.
Illus. b&w, some color.
ISSN: 0078–1444. OCLC: 4417343. LC: N11.N68. Dewey: 720.
Architecture.

TEACHING ARCHITECTURE. 1979. a. EN. 2249
Association of Collegiate Schools of Architecture, Inc, 1735 New York Ave., N.W., Washington, DC 20006. Phone 202–785–2324.
Illus.
ISSN: 0194–410X. OCLC: 9586392. LC: NA2000.A77a. Dewey: 720. Formerly: *Proceedings of the ACSA Annual Meeting.*

Architecture Education.

Proceedings of the annual meeting of the Association.

THRESHOLD. 1982. a. EN.　2250

University of Illinois at Chicago, School of Architecture, Office of Publication Services (M–C 291), Box 4348, Chicago, IL 60680. (Dist. Rizzoli International Publications, 300 Park Ave. South, New York, NY 10010). Phone 212–982–2300.
Subscription: $15. Illus.(100+), maps, plans. 8½ x 11, 128p.
ISSN: 0736–1149. OCLC: 8852109. LC: NA1.T47. Dewey: 720.
Architecture.

Reviewed: Katz. *Design Book Review* 5, Fall 1984, p.114–17.
Advertising: none.

TULANE SCHOOL OF ARCHITECTURE REVIEW. 1980/1981. a. EN.　2251

Tulane University, School of Architecture, New Orleans, LA 70118.
Illus., plans. 27cm., 93p.
OCLC: 8637777. LC: NA9.T75. Formerly: *Tulane Architectural View*.
Architecture.

UCLA ARCHITECTURE JOURNAL. 1986. a. EN.　2252

UCLA Graduate School of Architecture and Urban Planning, University of California at Los Angeles, Los Angeles, CA 90024.
Illus.
ISSN: 0890–0558. OCLC: 14871438. LC: NA2300.U56 U27. Dewey: 720.
Architecture.

THE UNIVERSITY OF TENNESSEE JOURNAL OF ARCHITECTURE. 1982. a. EN.　2253

University of Tennessee, School of Architecture, Knoxville, TN 37996–2400.
Illus. b&w, some color, maps, plans. 26 cm., 100p.
ISSN: 0748–4917. OCLC: 10117215. LC: NA2300.T4 P67. Formerly: *Portfolio*.
Architecture.

Each issue also has a distinctive title.

URBIS. 1983. EN.　2254

Catholic University of America, School of Engineering & Architecture, Dept. of Architecture and Planning, Washington, D.C. 20064.
Architecture.

WATERLOO. 1983. irreg. EN.　2255

University of Waterloo, Waterloo School of Architecture, Waterloo, Ontario N2L 3G1, Canada.
Subscription: free. 42 cm., 12p.
Architecture.

Tabloid.

Planning

ARCH +: Zeitschrift fuer Architektur und Staedtebau. 1968. 5/yr. GE only.　2256

Arch Verlag GmbH, Charlottenstrasse 14, D–5100 Aachen, W. Germany. Phone 0241–508329, fax 0241/54831. Editorial Board.
Subscription: DM 64, foreign DM 72. Illus. b&w, photos, plans. 8½ x 11½, 90p.
ISSN: 0587–3452. OCLC: 5211240. LC: NA3.A68.
Architecture.

Journal of architecture and municipal planning, a studybook for planning practice and planning theory.
Indexed: Avery.

ARCHITEKTURA A URBANIZMUS. 1967. q. CZ. GE, EN & RU summaries.　　　　**2257**
Veda, Publishing House of the Slovak Academy of Sciences, Klemensova 19, 814 30 Bratislava, Czechoslovakia. E. Hruska, Editor.
Subscription: fl.58. Illus.
ISSN: 0044–8680. OCLC: 1811163. LC: NA6.691. Dewey: 720.
Architecture.
Architecture and urbanism.

L'ARREDO DELLA CITTA. 1987. bi–m. IT.　　　　**2258**
Editore Sinopia srl, Via G. Murat 84, 20159 Milan, Italy.
Illus. b&w, some color, maps, plans.
OCLC: 19769725.
Reviewed: *Art Documentation* Fall 1988, p.105–106.

CARLTON NEWSLETTER. 1967. irreg. EN.　　　　**2259**
Carlton Association, Box 52, North Carlton, Victoria 3054, Australia. Richard Malone, Editor.
Dewey: 711.

DOWNTOWN IDEA EXCHANGE. 1954. s–m. EN.　　　　**2260**
Alexander Research & Communications, Inc., 1133 Broadway, Suite 1407, New York, NY 10010. Phone 212–206–7979, fax 212–727–3487. Laurence A. Alexander, Editor.
Subscription: $109 US & Canada, $139 foreign. Illus. b&w. 8½ x 11, 8p.
ISSN: 0012–5822. Dewey: 658.8.
Essential information for downtown revitalization. Devoted to redeveloping and promoting the downtown area, the central business district. Presents articles on planning, design, development, preservation, parking, transit, traffic, funding, organization, etc.

EKISTIC INDEX OF PERIODICALS.　See no. 13.

EKISTICS: The Problems and Science of Human Settlements. 1991, v.58. bi–m. EN.　　　　**2261**
Athens Technological Organization, Athens Center of Ekistics, 24 Strat. Syndemou St., 106 73 Athens, Greece. Panayis Psomopoulos, Editor.
Subscription: (1991) $US80, students $48. Microform available from UMI. Back issues $US14 current year, $17 previous years. Illus.
ISSN: 0013–2942. OCLC: 2446600. LC: HN1.E45. Dewey: 711.05.
Original articles plus a selection of up–to–date information pertaining to development of human settlements from a variety of fields.
Indexed: ArchPI. CloTAI.

ENVIRONMENT AND PLANNING A. 1974. m. EN.　　　　**2262**
Pion Ltd., 207 Brondesbury Park, London NW2 5JN, England. Phone 081–459 0066, fax 081–451 6454, telex 94016265 PION G. A. Wilson, Editor.
Illus.
ISSN: 0308–518X. OCLC: 1945034. LC: HT166.E55. Dewey: 309.2. Formerly: *Environment and Planning*.
"International journal of urban and regional research".
Indexed: Avery.

ENVIRONMENTAL DESIGN: Journal of the Islamic Environmental Design Research Centre.
　1985. EN.　　　　**2263**
Carucci Editore Roma, V. le Trastevere, 60–00153, Rome, Italy. Phone 06–5806274. Attilio Petruciolli, Editor
Subscription: £47.25 (Italy: P.O. Box 6218, 00195, Rome. Abroad: Lavis Marketing, 75 Lime Walk, Heidington, Oxford OX3 7AD, phone 0865/67575). Illus. b&w, photos, plans, line drawings.
ISSN: 0393–5183. OCLC: 13019779. LC: N1.A13. Dewey: 720. Incorporates: *AARP Journal*.

Architecture. Design.

"The Garden as a City, The City as a Garden". Journal of the Islamic Environmental Design Research Center. Issues have individual titles with all articles on the title theme.

Freelance work: yes. Contact: send manuscripts to Loc. Poggidoro, 14, 00045 Genzano di Roma, phone 06–9633810.

Reviews: book.

HOUSING AND PLANNING REVIEW. 1964. q. EN. 2264

National Housing and Town Planning Council, 14–18 Old St., London EC1V 9AB, England. Phone 071–251–2363. R. Walker, Editor.

Illus.

ISSN: 0018–6589. OCLC: 6498426. Formerly: *Housing and Planning News–Bulletin; British Housing and Planning Review.*

Architecture.

Indexed: Avery.

ITPI JOURNAL. 1985. bi–m. EN. 2265

Institute of Town Planners, India, 4–A Ring Rd., Indraprastha Estate, New Delhi, India.

Illus.

OCLC: 13201541. LC: HT169.I5. Dewey: 711. Formerly: *Journal of Institute of Town Planners, India..*

JOURNAL OF PLANNING EDUCATION AND RESEARCH. See no. 612.

JOURNAL OF THE AMERICAN PLANNING ASSOCIATION. 1925. q. EN. 2266

American Planning Association, 1313 E. 60th St., Chicago, IL 60637–2891. Phone 312–955–9100. Eugenie L. Birch & Peter D. Salins, Editors (Dept. of Urban Affairs & Planning, Hunter College, 695 Park Ave., New York, NY 10021).

Subscription: $23 members, $36 non–members US, $30 members, $48 non–members, Canada & foreign. Microform available from UMI. Sample & back issues $12. Illus. b&w, photos, cartoons. Cum. index every 4 yrs. (v.50–54, 1984–88 in Aut '88). 8½ x 11, 128p.

ISSN: 0194–4363. OCLC: 4626214. LC: HD87.5.A46a. Dewey: 361.6. Formerly: *Journal of the American Institute of Planners.*

Architecture. Historic Preservation. Landscape Architecture.

Published by the Association whose objective is to encourage the planning of communities and environments that serve the public well–being. The editorial office rotates among prominent schools of planning. Covers current research, practice, and opinion.

Reviews: book 15, length 4 manuscript pages. Bibliographies: in each issue new books, reports and documents received, selected periodicals. Listings: national–international. Conference calendar. Freelance work: yes. Contact: editor. Opportunities: study, competitions. Indexed: AmH&L. ArchPI. ArtI. Avery. SocSciI.

Advertising: full page $660, ½ page $415, ¼ page $225, no color. No classified. Frequency discount. Raquel Lavin, Ad. Director (APS, 1776 Massachusetts Ave., N.W., Washington, DC 20036). Mailing lists: available, contact Barbara Baldwin, Member Services Cord. (Chicago Office). Circulation: 13,000. Audience: planning practitioners and academics; anyone interested in planning issues— social scientists, architects, landscape designers, and people in government at all levels.

MAKING CITIES LIVABLE NEWSLETTER. 1987. q. EN. 2267

Center for Urban Well–Being, Box QQQ, Southampton, NY 11968.

Illus.

ISSN: 0891–8821. OCLC: 15025524. Dewey: 307.

Devoted to protecting the quality of life in the city. Focuses on public spaces and how they can best be designed and managed to achieve the city's historic human mission.

METRO PLANNING REVIEW. 1986. q. EN. 2268

Edmonton Metropolitan Regional Planning Commission, 600, 10025 106th St., Edmonton, Alta. T5J 1G4, Canada. Phone 403–423–5701. Phillippa Fairbairn, Editor.

Subscription: free.

ISSN: 0829–9153. OCLC: 15492415. LC: NA9415. Dewey: 307.

Loose–leaf regional update of the Planning Commission.

MITTEILUNGEN DER DEUTSCHE AKADEMIE FUER STAEDTEBAU UND LANDESPLANUNG. 1957. a. EN.

2269

Deutsche Akademie fuer Staedtebau und Landesplanung, Kaiserplatz 4, D–8000 Munich 40, W. Germany. Phone 089–332077.
Illus.
ISSN: 0011–9822. OCLC: 8090642. LC: HT169.G32M57. Dewey: 720.

NATIONAL CAPITAL DEVELOPMENT COMMISSION ANNUAL REPORT. 1958. a. EN.

2270

National Capital Development Commission, G.P.O. Box 373, Canberra, A.C.T. 2601, Australia.
Subscription: $A2. Illus.
ISSN: 0067–1517. OCLC: 1330643. LC: NA9280.C3A8. Dewey: 354.940081.

PARAMETRO: Rivista di Architettura e Urbanistica. 1950. m. IT & EN. IT, FR, EN, & GE summaries.

2271

Faenza Editrice S.p.A., Via Pier de Crescenizi, 44 48018 Faenza, Italy. Phone 0546–663488, fax 0546–660440. Giorgio Trebbi & Glauco Gresleri, Editors.
Subscription: L 88000. Illus.
ISSN: 0031–1731. OCLC: 4910132. LC: NA9000.P22. Dewey: 720.
Architecture.

International review of architecture and town planning.
Indexed: ArchPI. Avery.

PHILIPPINE PLANNING JOURNAL. 1969. s–a. EN.

2272

University of the Philippines, School of Urban and Regional Planning, E. Jacinto St., Diliman, Quezon City 3004, Philippines.
Subscription: $12. Illus.
ISSN: 0048–3850. OCLC: 2858809. LC: HT169.P6P5. Dewey: 309.2.
Architecture.

PLAN: Tidskrift foer Planering av Landsbygd och Taetorter/The Swedish Town and Country Planning Review. 1947. bi–m. SW. EN summaries.

2273

Foereningen foer Samhaellsplanering – Swedish Society for Town and Country Planning, Box 15013, S–800 15 Gaevle, Sweden. Phone 26–687500. Goeran Cars, Editor.
Subscription: Kr 200, $US50. Illus.
ISSN: 0032–0560. OCLC: 13047532. LC: HT169.S8 P5. Dewey: 352. Formerly: *Plan International*.
Architecture.

Planning concepts for both urban and rural areas are presented.
Reviews: book.
Advertising.

PLAN CANADA. 1959. bi–m. EN & FR, side–by–side.

2274

Institute of Urban Studies, University of Winnipeg, 515 Portage Ave., Winnipeg, Manitoba R3B 2E9 Canada. Phone 204–786–9409, fax 204–786–1824. Brijesh Mathur & Tom Carter, Editors.
Subscription: included in membership to Canadian Institute of Planners, $C40 individual, $45 institution Canada; outside $C45, $50. Microform available from Micromedia (Toronto). Back issues $7 members, $8 individual. Illus. b&w. 8½ x 11, 46p.
ISSN: 0032–0544. OCLC: 2103577. LC: NA9000.T582. Dewey: 711.3. Formerly: *Plan*.
Architecture. Planning.

Journal of the Canadian Institute of Planners (Revue de l'Institut Canadien des Urbanestes). Publishes both refereed and non–refereed articles of interest to planning practitioners and academics from diverse streams within planning. Comprises theme articles, newsletter, planning notes, reports of original research, professional planning viewpoints, research notes, statistics and charts. Generally, articles are chosen of the basis of their appeal to a wide readership.
Reviews: book. Freelance work: yes, manuscripts not to exceed 6000 words. Contact: editor. Opportunities: study – conferences. Indexed: Avery. CanPI. CanMagI.
Advertising: full page $C400, ½ page $250, ¼ page $160. Classified: "Professional Directory" $C65. Frequency discount. Demographics: 3300 Canadian members & 600 subscribers world wide. Circulation: 3900.

THE PLANNER. 1973, v.59. m. EN. 2275

Royal Town Planning Institute, 26 Portland Place, London W1N 4BE, England. Phone 071–636 9107, fax 071–323 1582. Anthony Fyson, Editor.

Subscription: included in membership. Illus.

ISSN: 0309–1384. OCLC: 2505244. LC: HT169.G7P71. Dewey: 711.405. Formerly: *Journal of the Royal Town Planning Institute*.

Journal devoted to city planning.

Indexed: ArchPI. Avery.

PLANNING. 1972. m. EN. 2276

American Planning Association, 1313 E. 60th St., Chicago, IL 60637. Phone 312–955–9190. Sylvia Lewis, Editor.

Subscription: included in membership, $40 US, $45 foreign. Microform available from UMI. Illus. b&w, some color, glossy photos, cartoons. Index. Cum. index v.38–48. 8¼ x 10¾, 50p.

ISSN: 0001–2610. LC: NA9000.A44x. Dewey: 352. Formerly: *American Society of Planning Officials. ASPO Newsletter*; which superseded *Practicing Planner; Planner's Notebook*.

Planning.

Articles and news of Washington and the Association. Covers land use, housing, transportation, and the environment.

Calendar of events. Freelance work: yes (details in *ArtMkt.* and in *PhMkt.*). Opportunities: employment, study – Continuing Education calendar. Indexed: Avery.

Advertising. Classified: "Consultant Directory" — firms offering planning services. Raquel Lavin, Ad. Manager, (1776 Massachusetts Ave., NW, Washington DC 20036 phone 202–872–0611) or C. Lynn Coy & Associates, Inc., national ad. representatives (55 Forest St., Stamford, CT 06902, phone 203–327–4626). Circulation: 25,000. Audience: urban and regional planners.

PLANNING & ZONING NEWS. 1982. m. EN. 2277

Planning & Zoning Center, Inc., 400 Everett Dr., Lansing, MI 48915–1106. Phone 517–484–3333. Mark A. Wyckoff, Editor. Illus. Cum. index.

ISSN: 0738–114X. OCLC: 9491466. LC: HD211.M5P57. Dewey: 346.77404.

PLANNING OUTLOOK. 1948. s–a. EN. 2278

University of Newcastle–Upon–Tyne, Department of Town and Country Planning, Newcastle–Upon–Tyne NE1 7RU, England. Paddy Whitehead, Editor.

Illus.

ISSN: 0032–0714. OCLC: 1762464. LC: NA9000.P58. Dewey: 711.

Reviews: book.

Advertising.

PROJECT MONOGRAPH. 1984. q. EN. 2279

Institute for Urban Design, 4253 Karensue Ave., San Diego, CA 92122. Phone 619–455–1251. David Wallace, Editor.

Subscription: included in membership together with Newsletter, *Urban Design Update*, $100 individual & library, $60 student or retiree, $500 organization & city US; $150 individual & library, $90 student, $700 organization Canada; foreign $170 individual, $120 student, $850 organization. No sample. No back issues. Illus. color. 8p.

OCLC: 12338414. LC: NA9000.P76.

Architecture. Landscape Architecture. City Planning. City Development.

Series dealing with the design of cities, new communities, revitalization, transportation and public environment. Each number also has a distinctive title.

Freelance work: none.

Advertising: none. Audience: architects, landscape architects, public administrators and developers.

SASKATCHEWAN PLANNING NEWS. s–a. EN. 2280

Community Planning Association, Saskatchewan Division, 2837 Dewdy Ave., Regina, Sask. S4T 0X8, Canada.

Subscription: free. Illus.

Dewey: 711.

SCHWEIZER BAUMARKT: Aktuelles Bauen Plan. 1984. 15/yr. GE. 2281

Vogt–Schild AG, Zuchwilerstr. 21, CH–4501 Solothurn, Switzerland. Phone 065–247247. K.J. Verding, Editor.

Subscription: 75 SFr. Illus. b&w, some color.
ISSN: 0255–6898. OCLC: 17685929. LC: NA9000. Dewey: 660. Formerly: *Aktuelles Bauen*.
Advertising: full page DM 2075, ½ page DM 1140, ¼ page DM 620. Frequency discount.

STORIA DELLA CITTA: International Review of Town Planning History. 3/yr. IT.

EN, FR & GE summaries (3p. end of issue). **2282**
Via D. Trentacoste 7, 20134 Milan, Italy. Phone 02–215631, fax 02–26410847, telex 350523 ELEPER I. Lucio Maninetti, Editor.
Subscription: L. 70,000 Italy, L. 90,000 elsewhere. Illus. b&w, color, photos. 128p.
Indexed: ArtArTeAb.

TOWN & COUNTRY PLANNING. 1932. w. EN.

2283
Town & Country Planning Association, 17 Carlton House Terrace, London SW1Y 5AS, England. Phone 071–930 8903/5. Helen Dwyer, Editor.
Annual index.
ISSN: 0495–9728. Dewey: 711.43.
Indexed: ArchPI. ArtI.

THE TOWN PLANNING REVIEW. 1910. q. EN.

2284
Liverpool University Press, Box 147, Liverpool L69 3BX, England. Phone 051–794 3128/3112, fax 051–708 6502, telex 627095 UNILPL G. David Massey, Editor (Department of Civic Design, University of Liverpool, Box 147).
Subscription: £16 individual, £35 institution, £9 students UK & Erie; elsewhere £18 $38 individual, £38 $76 institution, £11.50 $23 student. Microform available from publisher. Illus. b&w, some color, charts. Annual index. 6¾ x 9½.
ISSN: 0041–0020. OCLC: 1641371. LC: NA9000.T6. Dewey: 711.43.
Contains articles, reviews, and book notes.
Reviews: book 10p. Bibliographies: "Books Received". Indexed: ArchPI. ArtI. Avery.
Advertising: rates on request.

TRAMES: Revue de l'Amenagement. 1988. 3/yr. FR only.

2285
Editions du Meridien/Meridian Press, 1980 Sherbrooke Ouest, No. 520, Montreal, Quebec Canada H3H 1E8. Phone 514–932–9037. Denys Marchand, Editor (Faculte de l'Amenagement Universite de Montreal, C.P. 6128, succ. A, Montreal Quebec H3C 3J7).
Subscription: included in membership, $C30 institution, $15 individual. Sample fee. Back issues $C6–10. Illus. b&w, photos, cartoons. 8½ x 11, 80p.
ISSN: 0847–9119. OCLC: 20676786. Dewey: 711.
Architecture. Historic Preservation. Landscape Architecture. Modern Art. Town Planning. Urban Design. Urban Policies.
Reviews: exhibition 1–2, book 1–2. Interviews: occasionally in relation with the theme of the issue. Bibliographies with related articles. Freelance work: none.
Advertising: full page $C875, ½ page $C550, ¼ page $C300, color back cover only. No classified. Frequency discount. Circulation: 600. Audience: planners, architects, landscape architects, designers, urban administrators, consultants.

UNCHS HABITAT NEWS. 1979. 3/yr. EN. FR, SP & Arabic tr. provided.

2286
United Nations Centre for Human Settlements, P.O. Box 30030, Nairobi, Kenya (US: UNCHS (Habitat), DC2 Room 946, United Nations, New York, NY 10017. Phone 333930/520600. Ellen Kitonga, Editor.
Subscription: free to developing countries; postage only to developed countries. Sample. Some back issues. Illus. b&w, color, photos, cartoons occasionally. Index. Cum. index 1978–83, 1984–86, new cum. index in preparation. 40p.
ISSN: 0255–271x. OCLC: 20078099. LC: HT101.H125x. Dewey: 307. Formerly: *Habitat News*; which absorbed: *Habitat Foundation News*, and *Vision Habitat News*.
Architecture.
Offers coverage not only of its activities (technical co–operation, research and development, information) but of its co–operation with other agencies, and of events/courses for human settlements professionals.
Reviews: book 8, journal 3, film 1, length all 1/5 page each. Interviews: occasionally with prominent personalities in human settlements development. Bibliographies: as inserts. Notes twice a year on selected topics. Listings: international. Calendar of events. Exhibition information. Freelance work: none. Opportunities: study, competitions.
Advertising: none. Circulation: 10,500. Audience: human settlement workers, researchers, professors, students.

URBAN AFFAIRS QUARTERLY. 1965. q. EN. 2287

Sage Publications, Inc., 2111 W. Hillcrest Dr., Newbury Park, CA 91320. Phone 805–499–0721. Dennis R. Judd & Donald Phares, Editors.

Subscription: $30 individual, $78 institution. Microform available from UMI. Back issues.

ISSN: 0042–0816. OCLC: 1768857. LC: HT101.U67. Dewey: 309.2.

Reviews: book. Indexed: AmH&L.

Advertising.

URBAN DESIGN UPDATE. 1985. bi–m. EN. 2288

Institute for Urban Design, 4253 Karensue Ave., San Diego, CA 92122.

Subscription: included in membership together with *Project Monograph*, $100 individual & library, $60 student or retiree, $500 organization & city US; Canada $150 individual, $90 student, $700 organization; foreign $170 individual, $120 student, $850 organization. Illus.

ISSN: 0895–8076. OCLC: 13120089. Dewey: 352.

Architecture. City Planning. City Development.

Newsletter of the Institute. Reports on new projects, cutting edge issues, books and other matters of interest to urban designers. Members are encouraged to submit news of their projects or other commentary for publication.

URBANISMO: Revista del Colegio Oficial de Arquitectos de Madrid. 1987. 3/yr. SP. EN &

FR summaries. 2289

Urbanismo COAM, Barquillo no. 12, 5a Planta, 28004 Madrid, Spain.

Microform available from UMI. Illus. b&w, some color, maps.

OCLC: 16171177.

"International review of urban planning and design, with particular emphasis on Europe". Focuses on regional and city planning, current development and planning of historic cities. Some special issues devoted to individual cities.

Bibliographies: list of recent books. Indexed: ArchPI. RILA.

ZONE. 1986. 3/yr. EN. 2290

John Hopkins University Press, Journals Publishing Division, 701 W. 40th St., Suite 275, Baltimore, MD 21211.

Illus., maps.

ISSN: 0887–0411. OCLC: 13067101. LC: HT101.Z66. Dewey: 307.7.

"A publication of ideas in contemporary culture".

Reviewed: *New Art Examiner* 14:5, Jan 1987, p.19–20.

ZONING NEWS. 1984. m. EN. 2291

American Planning Association, 1313 E. 60th St., Chicago, IL 60637. Phone 312–955–9100. Tracy Burrows, Editor.

Subscription: $25 US, $30 Canada. Sample. Back issues. Illus. Annual index. 8½ x 11, 4p.

ISSN: 8755–3856. OCLC: 10580093. LC: HT169.7.Z66. Dewey: 307.

Architecture. Historic Preservation. Landscape Architecture. Planning.

Newsletter presents trends in land use and real–estate development, sampler of local growth policies, and analysis of local zoning codes. Issued as a supplement to *Land Use Law & Zoning Digest* and *OAS Memo*.

Reviews: book 3, length½ inch. Freelance work: none.

Advertising: none. Circulation: 4000. Audience: planning commissions, zoning officials.

Historic Preservation

APT BULLETIN: The Journal of Preservation Technology. 1969. q. EN, FR occasionally. Tr. of FR
articles. 2292

Small Homes Council, University of Illinois–Urbana–Champaign, 1 E. St. Mary's Rd., Champaign, IL 61820. Phone 217–333–1801. Marylee MacDonald, Editor.

Subscription: included in membership together with subscription to Newsletter *Communique* (APT, Box 8178, Fredericksburg, VA 22404). Microform available from APT. No sample. Back issues $10. Illus. b&w, color occasionally, photos. Index. Cum. index 1969–1983. 8½ x 11, 64p.

ISSN: 0044–9466. OCLC: 15324781. 1748050. Dewey: 720. Formerly: *Bulletin – Association for Preservation Technology*.

Architecture. Historic Preservation. International. Landscape Architecture.

Contains articles about historic building technology and hi–tech conservation methods. The publication has one or more special theme issues each year. All articles are written by architects, conservators, and crafts people who have done the work. The direct experience of these authors with their projects makes this magazine unique.

Reviews: book 3, length 1500 wds. Freelance work: yes, no fee paid. Indexed: ArchPI. ArtArTeAb.

Advertising: none. Mailing lists: available with Board approval. Circulation: 3000. Audience: historic preservation professionals and craftspeople.

ASSOCIATION FOR PRESERVATION TECHNOLOGY—COMMUNIQUE. 1975. bi–m. EN.　**2293**

Association for Preservation Technology, P.O. Box 2165, Albuquerque, NM 87103. Phone 505–265–3838. Barbara L. Daniels, Editor.

Subscription: included in membership, $10 non–members. 8½ x 11.

ISSN: 0319–4558. Formerly: *Association for Preservation Technology Newsletter*.

Historic Preservation.

Newsletter includes articles, meeting announcements and reports as well as extensive periodical abstracts and research updates.

Calendar of events. Indexed: Avery.

Advertising, no color.

BAYERISCHE DENKMALPFLEGE. JAHRBUCH. 1969. a. GE.　**2294**

Deutsche Kunstverlag GmbH, Vohburger Str. 1, 8000 Munich 21, W. Germany.

Subscription: DM 48. Illus.

ISSN: 0341–9150. OCLC: 1786776. LC: N6873.J33. Dewey: 700.

Concerned with the conservation and restoration of Bavarian monuments.

THE BEACON. 1982. q. EN.　**2295**

Great Lakes Lighthouse Keepers Association, P.O. Box 580, Allen Park, MI 48101. Phone 313–728–7943. Michelle T. Wilson, Editor.

Subscription: included in membership. 16–24p.

Historic Preservation.

Newsletter forum for exchange of information on history of Great Lakes lighthouses, keepers and preservation activities throughout the region. Includes conference reports. Focuses on preservation and restoration. Reports on projects in progress and those completed.

Reviews: book. Calendar of events.

Advertising: none.

THE BROWNSTONER. 1969. 5/yr. EN.　**2296**

The Brownstone Revival Committee, 200 Madison Ave., New York, NY 10005. Phone 212–561–2154. Dorothy Zweighaft, Editor.

Subscription: included in membership. Illus. b&w. 8½x11, 12p.

Architecture. Historic Preservation.

Specializes in New York City's brownstone houses. Covers includes restoration, renovating tips, historical landmarks, and demolition.

Reviews: book.

Advertising.

CHARLES RENNIE MACKINTOSH SOCIETY NEWSLETTER. 1973. 3/yr. EN.　**2297**

Charles Rennie Mackintosh Society, Queens Cross, 870 Garscube Rd., Glasgow G20 7EL, Scotland. Phone 041–946 6600. Frank A. Walker & Patricia Douglas, Editors.

Subscription: included in membership. Back issues.

ISSN: 0141–559X. Dewey: 720.

Historic Preservation.

Purpose is to develop an interest in the works of Charles Rennie Mackintosh, the Scottish architect, artist and furniture designer, and to conserve the conditions of buildings he designed.
Reviews: book. Indexed: Avery. Des&ApAI.

COLONIAL WILLIAMSBURG. 1979. q. EN. 2298
Colonial Williamsburg Foundation, P.O. Box C, Williamsburg, VA 23187. Wayne Barrett, Editor.
Subscription: included in membership, available to donors of $25 or more (Mrs. Polly Barnes). Back issues $3.50 issue. Illus. full–color, photos. 8½ x 11, 58p.
OCLC: 10830339. LC: F234.W7 C88. Dewey: 975.5. Formerly: *Colonial Williamsburg Today.*

Architecture. Decorative Arts. Historic Preservation.

Journal of an educational organization responsible for the restoration, preservation and interpretation of the 18th Century capital of the colony of Virginia. Presents in–depth articles and news on social, cultural, architectural and decorative arts of the Tidewater, Virginia area.
Calendar of Williamsburg events.
Advertising: Robert R. Henn & Associates, Ad. Director (20500 Hellenic Dr., Olympia Fields, IL 60461, phone 708–748–1446).

COMMON BOND. 1985. q. EN. 2299
New York Landmarks Conservancy, 141 5th Ave., New York, NY 10010. Phone 212–995–5620. Edward T. Mohylowski, Editor.
Subscription: $15, free to religious community, non–profits, government. Sample. Back issues. Illus. b&w. Index. Cum. index. 12p.
OCLC: 17867817.

Architecture. Historic Preservation.

A newsletter devoted to maintenance and preservation for owners of architecturally significant religious buildings. Covers preservation, maintenance, resources, technical information and financial resources. "Preservation profile" written by members of congregation. Focus on some aspect of preservation work. Technical feature: varies from fund raising to organ restoration to stone repair. "Ask the Technical Preservation Services Center" – question and answer format.
Listings: regional–national. Exhibition information. Freelance work: yes. Contact: editor. Opportunities: study, competitions. Indexed: Avery. Reviewed: *Art Documentation* Fall 1988, p.106.
Advertising: none. Circulation: 3000. Audience: owners and caretakers of architecturally significant religious properties.

COMMUNIQUE. bi–m. EN. 2300
Small Homes Council, University of Illinois–Urbana–Champaign, 1 E. St. Mary's Rd., Champaign, IL 61820. Phone 217–333–1801.
Subscription: included in membership together with subscription to *APT Bulletin* (APT, Box 8178, Fredericksburg, VA 22404). 16p.
Dewey: 720.

Architecture. Historic Preservation. International. Landscape Architecture.

Reviews: book, journal. Listings: international. Calendar of events. Exhibition information. Opportunities: employment, study, competitions.
Advertising. Circulation: 3000. Audience: historic preservation professionals and craftspeople.

CONSERVE NEIGHBORHOODS NEWSLETTER. 1978. 10/yr. EN. 2301
National Trust for Historic Preservation, 1785 Massachusetts Ave., N.W., Washington, DC 20036. Phone 202–673–4000. Susan Hyatt, Editor.
Subscription: $2/issue. Illus. 8½ x 11.
ISSN: 0732–1708. Dewey: 352.7.

Historic Preservation.

Preservation newsletter contains tips on improving the quality of life in local communities and neighborhoods.
Reviews: book. Indexed: Avery.
Advertising: none. Circulation: 7000.

CONTEXT. q. EN. 2302
Association of Conservation Officers, c/o Ms. E. Marten, Sec., 25 Willington Rd., Cople, Bedford MK44 3TH, England. Phone 234 686500.

Historic Preservation.

Newsletter promotes conservation of Great Britain's national heritage and serves as a forum for the exchange of conservation information.

COUNTRY TIMES AND LANDSCAPE. 1988. m. EN. 2303

Evro Publishing Co., Twickenham, Middlesex, London, England
Illus. b&w, some color.
ISSN: 0954–7843. OCLC: 19008990. Formed by the merger of: *Country Times*, and *Landscape*.
Historic Preservation. Landscape Architecture.

Indexed: BrArchAb.

COVERED BRIDGE TOPICS. 1944. q. EN. 2304

National Society for the Preservation of Covered Bridges, Inc., 130 Westfield Drive, Holliston, MA 01746. Phone 617–756–4516. Joseph S. Cohen, Editor.
Subscription: available through membership only, $10.50 (J. Austris Kruza, P.O. Box M, Franklin, MA 02038). Sample. Back issues $3. Illus b&w, photos. Cum. index. 8½ x 11, 16p.
ISSN: 0011–071X. OCLC: 1565368. LC: TG1.C6. Dewey: 624.1.
Historic Preservation. Covered Bridges.

Official magazine of the Society, a non–profit organization. Presents articles and information on covered bridges and their preservation.
Reviews: book 2, length 100–200 wds. Listings: national. Freelance work: yes. Contact: editor.
Advertising: full page $100, ½ page $55, ¼ page $30. Classified: $5/col. Mailing lists: none.

DISCOVERY. 1964. a. EN. 2305

Association for the Preservation of Virginia Antiquities, 2300 E. Grace St., Richmond, VA 23223–7152. Phone 804–648–1889. Catherine A. Long, Editor.
Subscription: included in membership, $20 individual, $30 family. Sample $1. Some back issues $1. Illus b&w, photos. 8½ x 11, 16p.
ISSN: 0890–6033. OCLC: 14352211. Dewey: 975. Formerly: *APVA Discovery*.
Antiques. Archaeology. Architecture. Decorative Arts. Furniture. Historic Preservation.

Summary of restoration projects accomplished during the year by the Association. Contains articles on significant Association research projects—historical, architectural, or archaeological. Also scholarly preservation–related articles.
Listings: statewide. Freelance work: yes. Contact: editor.
Advertising: none. Mailing lists: none. Circulation: 4500. Audience: members.

FLORIDA PRESERVATION NEWS. 1985. bi–m. EN. 2306

Florida Trust for Historic Preservation, Box 11206, Tallahassee, Florida 32302.
Subscription: included in membership. Illus.
OCLC: 17646623. LC: F312.F6.
Historic Preservation.

Published in cooperation with the Bureau of Historic Preservation of the Florida Department of State.

FORUM NEWSLETTER. 1987. bi–m. EN. 2307

National Trust for Historic Preservation, 1785 Massachusetts Ave., N.W., Washington, D.C. 20036. Phone 202–673–4296.
Subscription: included in membership together with *Preservation Forum*, *Preservation News*, and *Historic Preservation*.
Illus. b&w. 8½ x 11, 8p.
ISSN: 0896–8179. OCLC: 16819684. LC: E159.F67. Dewey: 363.
Historic Preservation.

Covers news, publications, and newsmakers.
Opportunities: study, competitions, awards announced.
Advertising: none.

GUIDE TO OVER 100 PROPERTIES. 1931. a. EN. 2308

National Trust for Scotland, 5 Charlotte Sq., Edinburgh EH2 4DU, Scotland. Phone 031–226–5922, telex 727955. P.E. Rooney, Editor.

ISSN: 0269–0934. LC: DA873. Formerly: *National Trust for Scotland Yearbook.*
Historic Preservation.

Details facilities and attractions available at the National Trust for Scotland.

HERITAGE EDUCATION QUARTERLY. 1986? q. EN.

2309

Preservation Library & Resource Center, 498 S. Main St., Madison, GA 30650.
ISSN: 0897–6775. OCLC: 17597436.
Historic Preservation.

HERITAGE SCOTLAND. 1983. q. EN.

2310

National Trust for Scotland, 5 Charlotte Square, Edinburgh EH2 4DU, Scotland (US: Expediters of the Printed Word, Ltd.,
527 Madison Ave., New York, NY 10022). Phone 031–226–5922, telex 727955. Peter Reekie, Editor.
Illus. color, photos. 8¼ x 11, 24p.
ISSN: 0264–9144. OCLC: 10378568.
Historic Preservation.

The magazine of the National Trust is concerned with historic buildings and sites in Scotland.
Listings: national. Calendar of events.
Advertising: Colin Pegley, Ad. Director (Jackson–Rudd & Associates Ltd., Oldebourne House, 46/47 Chancery Lane, London
WC2A 1JB, phone 071–405–3611/2. Scottish Office thru publisher.

HISTORIC DEERFIELD QUARTERLY. 1952. q. EN.

2311

Historic Deerfield, Inc., Box 321, Deerfield, MA 01342. Phone 413–724–5581. Grace Friary, Editor.
Subscription: free. 8½ x 11, 6p.
Historic Preservation.

Historic Deerfield owns and maintains 51 buildings including 12 houses open to public and furnished with antique furniture,
textiles, ceramics and other early American decorative arts. The journal presents new acquisitions in museum collections, interesting features and staff activities.
Advertising: none.

HISTORIC HAWAII. 1975. m. EN.

2312

Historic Hawaii Foundation, 119 Merchant St., Suite 402, Honolulu, HI 96813. Phone 808–537–9564. Phyllis G. Fox, Editor.
Illus. 8½ x 11, 24p.
OCLC: 11490794. LC: DU624.3.H57. Dewey: 720. Formerly: *Historic Hawaii News.*
Archaeology. Architecture. Historic Preservation.

Presents historic preservation in Hawaii through information on Hawaiian history, architecture and archaeology.

HISTORIC PRESERVATION. 1949. bi-m. EN.

2313

National Trust for Historic Preservation, 1785 Massachusetts Ave., N.W., Washington, DC 20036. Phone 202–673–4000 or
4071, fax 202–673–4038. Thomas J. Colin, Editor.
Subscription: included in membership together with *Preservation News, Preservation Forum*, and *Preservation Forum Newsletter*; $15 all. Microform available from UMI. Sample $2.50. Back issues $4.50. Illus b&w, color, photos (45/issue). 8¼ x
11, 90p. Webb offset, saddle stitched.
ISSN: 0018–2419. OCLC: 4604083, 1752108. LC: E151.H5. Dewey: 973. Formerly: *National Council for Historic Sites and
Buildings Quarterly Report..*

Antiques. Architecture. Decorative Arts. Furniture. Historic Preservation. Interior Design. Landscape Architecture.

America's showcase of the restoration arts focuses on preservation and restoration of structures and areas with importance to
American history and culture. Captures the magnificence and excitement of today's preservation movement while examining
the fascinating sweep of our nation's architectural and cultural heritage. Gives the insider's story on unique residential restorations. Examines some of the nation's most difficult and fascinating adaptive–use projects. Offers practical advice on all aspects of restoration including the care of antiques and artifacts. Profiles preservation activists. Presents photo portfolios.
Jan/Feb "Annual Home Restoration Issue" explores the work of owners and craftspeople who make restoration happen, and
details techniques and products in renovating old homes. May/June "Report on the Business of Preservation," provides indepth coverage on rehabilitation and preservation projects, emphasizing the dollars and cents of preservation. Nov/Dec "A
Year of Triumphs" salutes the winners of the National Preservation Honor Awards for individual, organizational or corporate
excellence in the field of preservation.

Reviews: book, equipment. Listings: regional–national. Calendar of events. Exhibition information. Freelance work: yes (details in *ArtMkt.* and in *PhMkt.*). Contact: editor. Opportunities: study. Indexed: AmH&L. ArchPl. ArtArTeAb. ArtI. Avery. BioI. CurCont. Search. Reviewed: Katz. *Art Documentation* Fall 1986, p.132.

Advertising: (rate card July '89): full page $3740, ½ page $2200, ⅙ page $750, center spread $8160; 4 color full page $5540, ½ page $3270, center spread $12,070, covers $6640–7200. No classified. Frequency discount. 15% agency discount. Missy Browne, Ad. Director (phone 1–800–333–6847, fax 202–673–4172). Mailing lists: available. Demographics: 50% female, 50% male, median age 53, upper income, $50,000 median household income, 95% college educated, over 80% home-owners; decidedly urban, 40% reside in California, New York, Virginia, Maryland, Pennsylvania, Illinois and Florida. average number of readers per copy 2.3. Circulation: 225,000.

HOUSE GUIDE. a. EN.
2314

Society for the Preservation of New England Antiquities (SPNEA), 141 Cambridge St., Boston, MA 02114. Phone 617–227–3956. Nancy Curtis, Editor.

Historic Preservation.

ICOMOS - INFORMATION. 1985. q. FR, EN & IT.
2315

International Council on Monuments and Sites, 75, rue du Temple, F–75003 Paris, France. Phone 1 42773576, fax 1 4277512. Illus.

OCLC: 13028852. LC: N8849.I572x. Formerly: *ICOMOS Newsletter.*

Information concerning the conservation and rehabilitation of historic monuments and sites.

INDUSTRIAL HERITAGE NEWSLETTER. 1–2/yr. EN.
2316

International Committee for the Conservation of the Industrial Heritage, Bissegemplaats 6, B–8620 Kortrijk, Belgium. Phone 56–359102.

Historic Preservation.

Devoted to historical preservation and regional conservation. Promotes international cooperation in the conservation, research, and presentation of industrial heritage worldwide.

INTERNATIONAL CENTRE FOR THE STUDY OF THE PRESERVATION AND THE RESTORATION OF CULTURAL PROPERTY NEWSLETTER. a. EN & FR.
2317

International Centre for the Study of the Preservation and the Restoration of Cultural Property, Via di San Michele 13, I–00153 Rome, Italy. Phone 6 587901, fax 6 6884265, telex 613114 ICCROM I.

Archaeology. Historic Preservation.

Promotes the preservation, restoration, and preventive conservation of historic buildings, archaeological sites, museum collections, and library and archival material.

IRISH GEORGIAN SOCIETY NEWSLETTER. 1958. a. EN.
2318

Irish Georgian Society, Leixlip Castle, Leixlip, Co. Kildare, Ireland. Phone 01–6244211. Desmond Guinness, Editor. Subscription: included in membership. Sample free. Back issues. Illus. b&w, photos. 5¾ x 8½, 32p.

LC: DA900.I6295. Dewey: 720.

Architecture. Decorative Arts. Historic Preservation.

International Society dedicated to preserving Irish art and architecture especially of the Georgian period. Contains news of Society and chapters' activities.

Obits.

Demographics: international society with members from 23 countries. Circulation: 3500.

LHAT BULLETIN. 1977. 10/yr. EN.
2319

League of Historic American Theaters, 1511 K St., N.W., Suite 923, Washington, DC 20005. Phone 202–783–6966, fax 202–393–2141. Tara S. Dicken, Editor.

Subscription: included in membership. Illus. b&w, photos.

OCLC: 20617688. LC: NA6830.L43. Formerly: *Bulletin; League of Historic American Theaters – Newsletter.*

Historic Preservation.

Covers the restoration and operation of historic American theater buildings.

Reviews: book. Freelance work: yes. Contact: editor. Indexed: Index. Cum. index 1986–89.

Advertising.

MARQUEE. 1969. q. + a. issue. EN. 2320
Theatre Historical Society of America, 624 Wynne Rd., Springfield, PA 19064.
Subscription: included in membership together with the Special Annual publication. Back issues (Archive and Research Center, 2215 W. North Ave., Chicago, IL 60647). Illus. b&w. Index. Cum. index biennially. 8½x11, 16–24p.
ISSN: 0025–3928. OCLC: 1756706, 17022303 [microform]. LC: PN2000.A3M376, NA6830.M37. Dewey: 792.
Architecture. Historic Preservation.

The journal of the Theatre Historical Society presents news concerning theater buildings, their restoration, history, architecture and entertainment functions. Some volumes accompanied by supplement, *THS Newsletter*, devoted to a single theater. Indexed: RILA.

MONUMENTS HISTORIQUES. 1936. bi–m. FR. 2321
Casse Nationale des Monuments Historiques et des Sites, Hotel De Bethune–Sully, 62, rue Saint–Antoine, 75004 Paris, France. Phone (1) 42–74.22.22. Ms. Veronique Hartmann, Editor.
Subscription: 360 F. No sample. Back issues. Illus. b&w (⅔), color (⅓), photos. Annual index issued as leaflet. Cum. index 1955–1975 (18,50 F). 27 x 21.5 cm., 124p.
ISSN: 0153–3673. OCLC: 4183106. LC: N8997.M64. Dewey: 720.28. Formerly: *Monuments Historiques de la France; Palladio.*
Architecture. Historic Preservation. Interior Design. Landscape Architecture.

Devoted to the conservation and restoration of historical monuments and buildings in France.
Reviews: exhibition, book. Bibliographies in each issue. Obits. Listings: national–international. Calendar of events. Exhibition information. Freelance work: yes. Contact: editor. Indexed: ArchPI. ArtArTeAb. ArtHum. Avery. CurCont. RILA.
Advertising: none. Circulation: 12,000.

MUEMLEKVEDELEM. See no. 2103.

NATIONAL SOCIETY FOR THE PRESERVATION OF COVERED BRIDGES BULLETIN.
 bi–m. EN. 2322
National Society for the Preservation of Covered Bridges, c/o Mrs. Christine Ellsworth, Sec., 44 Cleveland Ave., Worcester, MA 01603. Phone 617–756–4516.
Dewey: 974.
Historic Preservation.

NATIONAL SOCIETY FOR THE PRESERVATION OF COVERED BRIDGES NOTICES.
 bi–m. EN. 2323
National Society for the Preservation of Covered Bridges, 44 Cleveland Ave., Worcester, MA 01603. Phone 617–756–4516.
Historic Preservation.

NATIONAL TRUST FOR PLACES OF HISTORIC INTEREST OR NATURAL BEAUTY MAG-AZINE. 3/yr. EN. 2324
National Trust for Places of Historic Interest or Natural Beauty, 36 Queen Anne's Gate, London SW1H 9AS, England. Phone 071 2229251, fax 071 2225097.
Subscription: available to members only, included in membership.
Historic Preservation.

Devoted to the preservation of historic buildings or sites of natural beauty in the United Kingdom.

NEWSLETTER - SOCIETY FOR THE PRESERVATION OF LONG ISLAND ANTIQUITIES.
 1967. a. EN. 2325
Society for the Preservation of Long Island Antiquities, 93 North Country Rd., Setauket, NY 11733. Phone 516–941–9444.
ISSN: 0583–9181. OCLC: 2063221. Dewey: 709.
Antiques. Historic Preservation.

OESTERREICHISCHE ZEITSCHRIFT FUER KUNST UND DENKMALPFLEGE.
 1952. 5/yr. GE. 2326
Verlag Anton Schroll und Co., Spengergasse 39, A–1051 Vienna, Austria. Ernst Bacher, Editor.

Subscription: $17. Illus.
ISSN: 0029–9626. OCLC: 5063070. LC: N3.O48. Dewey: 705. Formerly: *Osterreichische Zeitschrift Fuer Denkmalplfege.*
Historic Preservation.

Austrian journal for art and monument protection. Covers art and architectural conservation in Austria.
Reviews: book. Bibliographies. Indexed: ArchPI. ArtArTeAb. ArtBibCur. ArtBibMod. BHA. RILA.
Advertising.

OLD MILL NEWS. 1972. q. EN. 2327

Society for the Preservation of Old Mills, 604 Ensley Dr., Rt. 29, Knoxville, TN 37920. Phone 615–577–7757. Michael LaForest, Editor & Pub.
Subscription: included in membership, $10 US & Canada, foreign surface $11. Sample & back issues $2.50. Illus. b&w, photos, cartoons. 8½ x 11, 24p.
ISSN: 0276–3338. OCLC: 4828943. LC: TJ859.043. Dewey: 621.2.
Archaeology. Historic Preservation.

Articles about existing old mills with emphasis on preservation activities. The Society also publishes new research material.
Reviews: book 1, length 500 wds. Listings: national. Freelance work: yes. Contact: editor. Opportunities: study. Indexed: RILA.
Advertising: ½ page $75, ¼ page $35. No color. Classified: free to members. Frequency discount. Howard Wikoff, Ad. Director (RD 1, Box 211, Walnford Rd., Allentown, NJ 08501). Demographics: primarily eastern U.S. Circulation: 1800. Audience: persons interested in old mills.

POLLEN: The ICOMOS Canada Historic Gardens and Landscapes Committee Newsletter.
1988. 3/yr. EN, some FR. 2328

ICOMOS Canada, P.O. Box 737, Station B., Ottawa, Ontario K1P 5R4, Canada. Phone 613–236–5184. Linda Fardin & Edwinna von Baeyer, Editors (131 Sunnyside, Ottawa, Ontario K1S 0B2).
Subscription: included in membership, $C21, $C30 foreign. Sample & some back issues $7. Illus. b&w, photos. 8½ x 11, 8p.
ISSN: 0840–9218. OCLC: 19770109. LC: NA109.
Architecture. Art Education. Art History. Historic Preservation. Landscape Architecture. Sculpture.

Devoted to the conservation of historic parks, gardens and landscapes in Canada. The objective of the newsletter is to acquaint those working within the many areas of Canadian historic garden and landscape preservation with the current events and resources in this expanding field. Columns include news, museums, landscape preservation projects, threatened sites, construction technology, designations, and legislation. Some North American and international news is included. ICOMOS Canada supports the activities and programs of the International Council of Monuments and Sites, an organization established under the auspices of UNESCO to promote the study and conservation of historic monuments, buildings, landscapes, and districts, and to cultivate the interest of the people of every country in the protection of their cultural heritage. Articles published in the language of submission. Abstract in EN articles.
Reviews: exhibition 1–3 & book 3, length 100–150 wds. Bibliographies: related to garden history and landscape preservation, an ongoing bibliography of relevant journal articles. Interviews: with people about historic landscapes, past history, present conditions. Biographies: on landscape architects or other designers whose work has historical interest.. Listings: regional–national. Calendar of events. Exhibition information. Freelance work: yes, no pay. Contact: E. von Baeyer. Opportunities: study – conferences, courses, travel; competitions, announces awards.
Advertising: full page $C1100, ½ page $500, ¼ page $300, no color. Frequency discount. Linda Fardin, Ad. Director (401 Wood Ave., Village of Rockcliffe Park, Ontario, K1M 1J3). Mailing lists: available. Audience: landscape historians and preservationists, landscape architects.

PRESERVATION FORUM. 1987. q. EN. 2329

National Trust for Historic Preservation, 1785 Massachusetts Ave., N.W., Washington, DC 20036. Phone 202–673–4296.
Subscription: included in membership together with *Forum Newsletter, Preservation News,* and *Historic Preservation,* $75; $18 non–members. Illus.
ISSN: 0893–9403. OCLC: 15699541. LC: E159.P74. Dewey: 363.
Historic Preservation.

Forum to facilitate the exchange of preservation information and to encourage the expression opinions and debate.
Indexed: RILA.

PRESERVATION IN ACTION. 1984. s–a. EN. 2330

Architectural Heritage Fund, 17 Carlton House Terrace, London SW1Y 5AW, England. Phone 071–925 0199. Rosemary Watt, Editor.

Subscription: free to Fund distribution list; subscription includes annual report, £12. Illus. b&w. 8p.
ISSN: 0267–4343. Dewey: 720.

Architecture. Historic Preservation.

The newsletter for building preservation trusts in the United Kingdom, a means of providing up–to–date useful information as well as a showcase for work. It also helps to keep national and local government informed of the work of these charitable trusts.
Advertising: none. Circulation: 2500. Audience: local building preservation trusts in the UK, and those interested in their work.

PRESERVATION IN PRINT. 1978. m. EN. 2331
Preservation Resource Center, 604 Julia St., New Orleans, LA 70130. Phone 504–581–7032. Nancy Stathes, Editor.
Subscription: included in membership, $15 individual US. Sample. Back issues. Illus. b&w, photos. 11 x 14, 24–28p.
ISSN: 0734–4481. OCLC: 7835064. LC: HT177.N43P776. Dewey: 720. Formerly: *New Orleans Preservation in Print.*

Architecture. Historic Preservation. Landscape Architecture.

Concerned with preserving historic buildings and other preservation issues through lobbying. Tabloid format.
Listings: national–international. Calendar of events. Exhibition information. Opportunities: study, competitions.
Advertising: full page $800, ½ page $400, ¼ page $200, 2 color + $300, 4 color + $400. Frequency discount. No classified.
Mailing lists: available upon approval of Board. Demographics: age 30–65, income $50,000+. Circulation: 7,000.

PRESERVATION LAW REPORTER. 1982. q. EN. 2332
National Trust for Historic Preservation, 1785 Massachusetts Ave., N.W., Washington, DC 20036. Phone 202–673–4000. Stefan Nagel, Editor.
Subscription: available to members only, $195. 6 x 9½, 100p.
Dewey: 340.

Historic Preservation.

Legal publication reports on developments in historic preservation and related fields. loose–leaf with updating service.
Advertising: none. Circulation: 400.

PRESERVATION LEAGUE OF NEW YORK STATE NEWSLETTER. 1975. q. EN. 2333
Preservation League of New York State, 307 Hamilton St., Albany, NY 12210. Phone 518–462–5658. Peter D. Shaver, Editor.
Subscription: $25 individual, $35 organizational. Sample. Back issues $1.50. Illus. b&w, photos. Cum. index in preparation. 8½ x 11, 8–14p.

Architecture. Historic Preservation. Landscape Architecture.

Devoted to preservation of buildings and historic sites and to presenting information regarding the architectural history of buildings in the state. Includes information on funding sources and regional organizations interested in preservation.
Reviews: book 5, length 100 wds. Interviews: noted preservationists. Biographies: architects and landscape architects who practiced in New York State. Listings: regional–national. Calendar of events. Freelance work: none. Opportunities: study & competitions—League events. Indexed: Avery.
Advertising: none. Mailing lists: available by arrangement. Circulation: 2200. Audience: preservationists and historians.

PRESERVATION NEWS. 1961. m. EN. 2334
National Trust for Historic Preservation, 1785 Massachusetts Ave., N.W., Washington, DC 20036. Phone 202–673–4000 or 4072. Arnold Berke, Editor.
Subscription: included in membership, together with 3 other publications, $15 all. Microform available from UMI. Sample. No back issues. Illus. b&w, photos (20/issue), cartoons. 11½ x 15 tabloid, 24p.
ISSN: 0032–7735. OCLC: 1714947. LC: E159.N355. Dewey: 973.

Architecture. Historic Preservation.

Covers all aspects of historic preservation, both at home and around the world. The newspaper contains news and feature articles, viewpoint pieces, profiles and bulletins covering the latest trends and activity in the preservation community. Reports on sites and buildings in danger, and proposed for preservation, also legislation, zoning and law affecting historic preservation.
Reviews: occasionally. Freelance work: yes (details in *ArtMkt.*) and in *PhMkt.*. Contact: editor. Opportunities: employment. Indexed: Avery. Reviewed: Katz.
Advertising: (rate card Jl '89): full page $3,120, ½ page $1,870, ¼ page $970, spread $5,670, 2 color + $30. Classified: $1.75/wd., 25 wd. min. Frequency discount. 15% agency discount. Inserts. Missy Browne, Ad. Director (phone 202–673–46847, fax 202–673–4172). Mailing lists: available. Demographics: readers survey : members of the National Trust, 50% male, 50% female, median age 53, $50,000 median household income, 95% college educated, over 80% own their own

home, over 60% plan to purchase major household furnishings and floor coverings; decidedly urban, 40% reside in California, New York, Virginia, Maryland, Pennsylvania, Illinois and Florida. Pass–along rate 3.2. Circulation: 225,000+.

PRESERVATION NOTES. 1965. s–a. EN. 2335

Society for the Preservation of Long Island Antiquities, 93 North Country Rd., Setauket, NY 11790. Phone 516–941–9444. Barbara Ferris VonLiew, Editor (P.O. Box 416, St. James, NY 11780).
Subscription: available through membership only. Sample & back issues, postage & handling. Illus. b&w, photos. Index. 12p.
ISSN: 0885–7326. OCLC: 6469082. Dewey: 974. Formerly: *Preservation News*.
Architecture. Historic Preservation. Landscape Architecture.

Covers historic preservation issues on Long Island including Brooklyn, Queens and Fishers Island. The purpose is to alert people to the threats to the built environment. Covers endangered buildings and historic house museums. Devotes one page each to "Houses for Sale, Endangered and Saved".
Reviews: book 10, length 1p. each, journal. Freelance work: yes but no pay. Contact: editor.
Advertising: none. Circulation: 2000. Audience: membership, libraries, preservation organizations.

PRESERVATION PERSPECTIVE. 1981. bi–m. EN. 2336

Preservation New Jersey, Inc., 180 Township Line Rd., Belle Mead, NJ 08502. Phone 201–359–4557. Jenni Buhr, Editor.
Illus.
OCLC: 8741599. Dewey: 974.905.
Architecture. Historic Preservation.

Issued jointly with the New Jersey Office of Cultural and Environmental Services.
Indexed: RILA.

QUAPAW QUARTER CHRONICLE. 1974. bi–m. EN. 2337

Quapaw Quarter Association, Box 165023, Little Rock, AR 72216. Phone 501–371–0075. Jane Browning, Editor.
Subscription: included in membership, $10. Sample. Some back issues. Illus. b&w, photos. 10 x 16, 16p. Newsprint offset.
OCLC: 6980056. Dewey: 917.67731.
Architecture. Decorative Arts. Historic Preservation. Landscape Architecture.

Tabloid promoting historic preservation in Little Rock. Includes features on local personalities.
Listings: regional. Calendar of events. Exhibition information. Freelance work: yes. Contact: editor. Opportunities: study.
Advertising: (rate card Jan '87): full page $525, ½ page $290, ¼ page $155. Classified: $10/20 wds., 25¢/wd. add. Frequency discount. 15% agency discount. Mailing lists: none. Circulation: 12,000. Audience: members of Association and general public.

RESTORICA. 1960. s–a. EN, AF. 2338

Simon van der Foundation, Box 1743, Pretoria 0001, South Africa. Mrs. E. Laruschagne, Editor.
Illus.
Dewey: 720. Supersedes: *Simon van der Foundation. Bulletin.*
Architecture. Historic Preservation.

Articles concerned with the preservation, restoration and history of Southern African buildings.

SOCIETY FOR THE PROTECTION OF ANCIENT BUILDINGS NEWSLETTER. q. EN. 2339

Society for the Protection of Ancient Buildings, 37 Spital Square, London E1 6DY, England. Phone 071 377 1644.
Architecture. Historic Preservation.

SOCIETY OF ARCHITECTURAL HISTORIANS—THE FORUM. 1979. s–a. EN. 2340

Society of Architectural Historians, 1232 Pine St., Philadelphia, PA 19107–5944. Phone 215–735–0224. Michael A. Tomlan, Editor.
Subscription: included in membership.
Architecture. Historic Preservation.

Newsletter providing articles on historic preservation of architecture.
Advertising: none.

SPNEA NEWS. 3/yr. EN. 2341

Society for the Preservation of New England Antiquities, 141 Cambridge St., Boston, MA 02114. Phone 617–227–3956. Nancy Curtis, Editor.

Subscription: included in membership. Illus.

ISSN: 0749–5242. OCLC: 9562919. LC: F1.S67. Dewey: 974.

Antiques. Historic Preservation.

Newsletter on SPNEA historic conservation and preservation projects with updates on historical properties owned by the Society.

Calendar of events.

Advertising: none.

STOP PRESS. s–a. EN & FR. 2342

International Centre for the Study of the Preservation and the Restoration of Cultural Property, Via di San Michele 13, I–00153 Rome, Italy. Phone 6 587901, fax 6 884265, telex 613114 ICCROM I.

Historic Preservation.

Newsletter of the Center.

WORLD HERITAGE NEWSLETTER. s–a. EN. 2343

United States Committee – International Council on Monuments and Sites, 1600 H St., N.W., Washington, DC 20006. Phone 202–842–1866, fax 202–842–1861.

Subscription: included in membership.

Historic Preservation.

News regarding international historic preservation activities and information regarding cultural sites on the World Heritage list.

WRIGHT ANGLES. 1975. q. EN. 2344

Frank Lloyd Wright Home and Studio Foundation, 951 Chicago Ave., Oak Park, IL 60302. Phone 708–848–1976, fax 708–848–1248. Arlene Sanderson, Editor.

Subscription: included in membership. Illus., b&w, photos. 6p.

Architecture. Historic Preservation.

Newsletter of the Foundation formed to restore and preserve architect Frank Lloyd Wright's Oak Park, Illinois home and studio. The Foundation also maintains a research center housing archives and collections on Wright and other Prairie school architects.

Advertising: none. Audience: members of the Foundation.

Architecture & Interiors

ABITARE. 1960. 11/yr. IT & EN (same page). Some summaries in FR, GE, & SP. 2345

Editrice Abitare Segesta S.p.A., Corso Monforte 15, 20122 Milan, Italy. Phone 02–76004251, fax 02–791904, telex ABIT 1–315302. (Dist. Agenzia Italiana Esportazione, A.I.E. 20151, via Gadames 89, Milasr, phone 02–3012200). Renato Minetto, Editor & Pub.

Subscription: L 64,000 Italy, abroad $85 (6725 Allot Ave., Van Nuys, CA 91401, phone 1–800–238–8462, in California 818–994–4462). Back issues 2 times regular price. Illus., some color, b&w, photos, plans. Annual index. 9 x 11¾, 28p.

ISSN: 0001–3218. OCLC: 1460559. LC: NK1700.A24. Dewey: 747.

Architecture. Interior Design.

Articles on cities and countries worldwide includes articles on renovation or restructuring as well as architectural topics. "Design Guide" appears as a supplement to Sept issue.

Reviews: exhibition. book. Opportunities: study – conventions and seminars, meetings, courses; competitions & awards. Indexed: ArtI. Avery. CloTAI. Des&ApAI. Search. Reviewed: Katz.

Advertising b&w & color; ads account for first 1/3–1/2 of the magazine. Demographics: Worldwide, found in quality bookstores all over the world.

AIT/ARCHITEKTUR, INNENARCHITEKTUR TECHNISCHER AUSBAU. 1980, v.88.

10/yr. GE. **2346**

Verlagsanstalt Alexander Koch GmbH, Postfach 102741, D–7000 Stuttgart 10, W. Germany. Phone 0711 7591–1, fax 0711 7591–267 telex 7255609 drw. Eberhard Hoehn, Editor.

Subscription: DM 159. Illus. b&w, color, plans, photos. 9¼ x 11.

ISSN: 0173–8046. OCLC: 6351416. LC: NK1700.I5. Dewey: 720. Formerly: *Architektur + Wohnwelt.*

Architecture. Furniture. Interior Design.

Each issue has an individual title. Official publication of the Bund Deutscher Innenarchitekten. Includes product information. Reviews: book. Indexed: ArchPI. Avery.

Advertising. Hermann Gaese, Ad. Director.

ARCHITECTURAL DIGEST. 1975. m. (except s–m. in Aug) EN. Also available in IT, SP & FR editions. **2347**

Knapp Communications Corp., 5900 Wilshire Blvd., Los Angeles, CA 90036. Phone 213–965–3700, Customer Service 1–800–234–4378. Paige Rense, Editor.

Subscription: $39.95 US, territories and possessions, $59.95 Canada & foreign (Architectural Digest, P.O. Box 10040, Des Moines, IA 50340–0040). Back issues $8 each + $2 shipping. Illus. color, photos. 8¼ x 10¾, 260–300p.

ISSN: 0003–8520. OCLC: 1481856. LC: NA730.C2 A7. Dewey: 747.

Architecture. Antiques. Interior Design.

"The international magazine of fine interior design" consists of four sections: "Interior Design", "Art and Antiques", "Travel", and "Special Features". Profiles current projects and ideas in interior design. Includes both contemporary and period work. A showcase for the finest the world has to offer. For the consumer and trade worlds alike. Features the private homes of world–famous celebrities. Presents the decorating expertise of today's best–known interior designers. Separate editions are published in Italy, Spain, and France.

Reviews: book. Freelance work: yes (details in *ArtMkt.* and in *PhMkt.*). Indexed: ArtHum. ArtI. Avery. BioI. CloTAI. CurCont. RG. Search. Reviewed: Katz.

Advertising: color. Ad. Director East: Bruce E. Lennox (140 E 4th St., New York, NY 10017, phone 212–297–5400). West: Steven K. Mosher (phone 213–965–3700).

ARCHITECTURE CONCEPT. 1969. bi–m. FR only. **2348**

Editions C.R. Inc., P.O. Box 1010, Victoriaville, QC G6P 8Y1 Canada. Phone 819–752–4243, fax 819–758–8812. Rene Lejeune, Directeur de Production.

Subscription: $24 Canada, $40 US, $US50 foreign. Illus. b&w, photos. 8¼ x 10¾, 30p.

ISSN: 0003–8687.

Architecture. Interior Design.

A magazine published in French intended for those who work in architecture, as well as interior planning and decoration. Its editorial content deals with interior as well as exterior design in the conception of a building, keeping in mind artistic, technical and socio–economic aspects.

Advertising: none.

ARCHITEKTUR & WOHNEN. 1958. bi–m. GE. EN summaries. **2349**

Jahreszeiten–Verlag GmbH, Possmoorweg 5, 2000 Hamburg 60, W. Germany.

Subscription: DM 83.40. Illus.

OCLC: 19319206. LC: NA1700.A7. Dewey: 720. Formerly: *Architektur und Kultiviertes Wohnen.*

Architecture.

Interior architecture.

ARKITEKTUR DK. 1972. 8/yr. DA. DA, EN, & GE summaries. **2350**

Arkitektens Forlag, Nyhavn 43, DK–1051 Copenhagen K, Denmark. Phone 33 13 62 00. Kim Dirckinck–Holmfeld, Editor.

Subscription: (1990) 700 DKr. (postage included) outside Scandinavia. Illus., mainly color, plans. 8½ x 12.

ISSN: 0004–2013. OCLC: 3958508. Dewey: 720. Formerly: *Arkitektur.*

Architecture. Interior Design.

Each article appears in all three languages.

Indexed: ArchPI. Avery.

AUSTRALIAN HOME BEAUTIFUL. 1926. m. EN. 2351
Herald & Weekly Times Ltd., 44–74 Flinders St., Melbourne, Victoria 3000, Australia. A.J. Hitchin, Editor.
Illus.
ISSN: 0004–928X. Dewey: 747.
Architecture. Interior Design.

BELLE. 1972. bi–m. EN. 2352
Richard Walsh, Publisher, 54 Park St., Sydney, N.S.W. 2000, Australia. Phone 02–282 8000, Telex CPHLTD AA120514, Fax 02–267 2150. Michaela Dunworth, Editor.
Subscription: $A5, $A7.50 collectors' edition. Sample. Back issues, cover price. Illus., some color. 310 x 235mm.
ISSN: 0310–1452. OCLC: 12124489.
Antiques. Decorative Arts. Fabrics. Furniture. Interior Design. Landscape Architecture.

Contains ideas on design and decoration and product information. A magazine about houses and the people who live in them, highlights the personalities behind the design. Regular product features on all aspects of decorating keeps readers up–to–date on the latest developments, what's new, and availability. Also included are features on antiques, art, crafts, and books.
Freelance work: yes. Contact: editor.
Advertising: b&w full page $3375, ½ page $2195, ¼ page $1350; color full page $4965, ½ page $3475, ¼ page $1985. Frequency discount. Gaye Murray, Ad. Director. Demographics: upper socio–economic. Circulation: 52,900. Audience: professionals & homemakers.

CANADIAN INTERIORS. 1964. m. EN. 2353
Maclean–Hunter Ltd., Business Publication Division, Maclean–Hunter Bldg., 777 Bay St., Toronto, Ontario M5W 1A7, Canada. Phone 416–596–5881. Dean Shalden, Editor (416–596–5976).
Subscription: $C33 Canada, $69 elsewhere. *Annual Sources/Directory* $C16 Canada, $28 elsewhere. Microform available from UMI. Illus. 8 x 10¾, 90p.
ISSN: 0008–3887. OCLC: 1855305. LC: NK1700.C21. Dewey: 747.
Architecture. Interior Design.

Contains news, new developments and technical articles relating to interior design and architecture of buildings. *Annual Sources/Directory* published in Jul/Aug.
Calendar of events. Opportunities: awards announced.
Advertising (phone 416–596–5881). Circulation: 8700.

CASA VOGUE. 1969. m. IT. EN tr. for all articles (end of issue). 2354
Edizioni Conde Nast S.p.A., Piazza Castello 27, 20121 Milan, Italy. Phone 02–85611, fax 02–869–2363. (US: 560 Lexington Ave., New York, NY 10022, phone 212–980–5700, telex 421389 CNDE U1, fax 212–754–0069). Paolo Pietroni, Editor.
Illus. color. 8¾ x 11¼, 180p.
ISSN: 0008–7173. OCLC: 1553456. LC: NK1700.C33. Dewey: 747.
Architecture. Interior Design.

Indexed: ArtBibMod. Des&ApAI.
Advertising. Giuseppe Mondano, Ad. Director.

CONCEPT: Man–made Environment & Commercial Interior Design. 1970. q. EN. 2355
Hill Group Publications, 69 Draper St., Ormond, Victoria 3204, Australia.
Illus.
ISSN: 0010–5112. Dewey: 720.
Architecture. Interior Design.

DLW NACHRICHTEN: Zeitschrift fuer Architektur und Innenausbau. 1927. a. GE, EN, FR. 2356
D L W Aktiengesellschaft, Postfach 140, 7120 Bietigheim–Bissingen, W. Germany. Frank Werner, Editor.
Subscription: free. Illus.
ISSN: 0172–2867. Dewey: 747. Formerly: *DLW Informationen zur Bau– und Einrichtungspraxis.*
Architecture. Interior Design.

DOMUS. 1928. 11/yr. IT & EN.

2357

EN tr. following each article.

Domus Editoriale, Domus SpA, 5/7, Via Archille Grandi, 1–20089 Rozzano, Milan, Italy. (US Dist.: Speedimpex USA, Inc., 45–45 39th St., Long Island City, New York, NY 11104). Giovanna Mazzocchi Bordone, Editor & Pub.

Subscription: $175, L114.000, FF782, DM220. Illus. color, little b&w, glossy photos, plans, drawings. Annual index. 9½ x 12¾, 80p. + ad section.

ISSN: 0012–5377. OCLC: 2108210. LC: N4.D6. Dewey: 720.

Architecture. Decorative Arts. Interior Design.

Journal of modern architecture, design and the decorative arts. New products presented. Extensive advertising section occupies a substantial portion of each issue.

Reviews: (in IT only) book. Listings: international (Italy & Europe). Calendar of exhibitions and meetings. Indexed: ArchPI. ArtHum. ArtI. Avery. BioI. CurCont. Des&ApAI. Reviewed: Katz.

Advertising.

FLOORS. 1982. m. EN.

2358

Maple Publishing Limited, 21A Brighton Rd., South Croydon, Surrey CR2 6EA, England. Phone 081 686 0141. Malcolm Bowen, Editor.

ISSN: 0263–7693. Dewey: 747. Formerly: *Floor & Flooring.*

Architecture. Interior Design.

FORM: Zeitschrift fuer Gestaltung. 1957. q. GE.

2359

Verlag Form GmbH, Ernsthoefer Str. 12, D–6104 Seeheim–Jugenheim, W. Germany. Phone 06257–81395.

Subscription: DM 61. Illus.

ISSN: 0015–7678. OCLC: 1569793. LC: TS149.F6. Dewey: 747.

Architecture. Interior Design.

Journal of design.

Indexed: Des&ApAI.

FORM & ZWECK: Fachzeitschrift fuer Industrielle Formgestaltung.

2360

1969. bi–m. GE. EN. FR. RU summaries.

Amt fuer Industrielle Formgestaltung beim Ministerrat, Breite Str. 11, DDR–1020 Berlin, E. Germany.

Subscription: DM 70.20.

ISSN: 0429–1050.

Architecture. Interior Design.

A technical journal of industrial design.

HOME. 1955. m. EN.

2361

Home Magazine Publishing Co., 5900 Wilshire Blvd., Suite 1500, Los Angeles, CA 90036. Phone 213–932–1400. Channing Dawson, Editor.

Subscription: $15. Illus. plans.

ISSN: 0278–2839. OCLC: 7674501. LC: TX311.H77. Dewey: 643. Formerly: *Hudson Home Magazine; Hudson Home Guides.*

Architecture. Interior Design.

Presents "creative ideas for home improvement" featuring home design and architecture for the homeowner.

Indexed: Search.

Advertising.

HOUSE & BUNGALOW. 1969. q. EN.

2362

Plan Magazines Ltd., 45 Station Rd., Redhill, Surrey, England. John Bailey, Editor.

ISSN: 0018–6392. Dewey: 720.

Architecture. Interior Design.

Tabloid journal of the Architectural Service Planning Partnership.

Reviews: book.

Advertising.

OTTAGONO. 1986, v.80. q. IT & EN. 2363
CO.P.IN.A, Via Melzi d'Eril 26, 20154 Milan, Italy. Phone 02–35508–3494030, fax 02–349473 (Dist.: Rizzoli International Publications, 300 Park Ave. South, New York, NY 10010). Marco De Michelis, Editor.
Subscription: $19.95 US, L 50,000 Italy, L 70,000 elsewhere. Illus. b&w, photos, plans. 8 x 11, 168p. + 25p. ads.
ISSN: 0391–7487. OCLC: 13563760, 4088181. LC: TS171.O89. Dewey: 747.
Architecture. Interior Design.

Each issue addresses a subject of topical interest to the world of contemporary design and architecture. Provides international coverage and includes furniture and product design. Each issue presents a 16 page portfolio by an architect, designer, artist or photographer. Full translation, both languages on same page.
Indexed: ArtBibMod. Avery. Des&ApAI.
Advertising b&w & color. Giusi Brivio, Ad. Director.

SPACIOLOGY. 1971. q. EN. 2364
Kyoto University, Department of Architecture – Kyoto Daigaku Kogakubu Kenchikugakka, Yoshida Hon–cho, Sakyo–ku, Kyoto 606, Japan.
Subscription: available on exchange.
Dewey: 721.
Architecture. Interior Design.

SUMMA. 1963. m. SP only. 2365
Ediciones Summa, Peru 726, P1S0 1, 1068 Buenos Aires, Argentina. Phone 361–5054/6722. Lala Mendez Mosquera, Editor.
Illus. b&w, some color, photos, plans.
ISSN: 0325–4615. OCLC: 6574083. LC: NA830.S86. Dewey: 720.
Architecture. Interior Design.

Supplements accompany some issues.
Indexed: ArchPI.

Interior Design

1,001 HOME IDEAS. Ceased 1991. 2366

L'AMBIENTE CUCINA/KITCHEN. 1977. bi–m. EN & IT. 2367
Propaganda Editoriale Grafica S.p.A., Via Fratelli Bressan 2, 20126 Milan, Italy. Phone 02 25–79–841. Grazia Gamberoni, Editor.
Subscription: $65.
ISSN: 0392–5730. Dewey: 747.
Interior Design.
Advertising.

ARREDOSTILE MIDDLE EAST. 1983. s–a. AR & EN. 2368
Editore Rima s.r.l., Via Luigi Barzini 20, 20125 Milan, Italy.
Subscription: L 12000.
ISSN: 0393–5132.
Antiques. Furniture. Interior Design.
Advertising.

ASID REPORT. 1975. 5/yr. EN. 2369
American Society of Interior Designers, 1430 Broadway, New York, NY 10018. Phone 212–944–9220. Maureen P. Mangan, Editor.
Subscription: members only, free. 8½ x 11, 24p.
Interior Design.
Newsletter of the Society. Presents industry news for professionals.

Obits. Calendar of events.
Advertising. Audience: members, interior designers.

AT HOME. 1990. q. EN. 2370
KQED, Inc., 680 Eighth St., San Francisco, CA 94103. Phone 415–553–2855.
Dewey: 051.
Covers articles about home decoration together with service information.

**IL BAGNO OGGI E DOMANI/BAIN AUJOURD'HUI ET DEMAIN/BATHROOM TODAY AND
 TOMORROW/BAD HEUTE UND MORGEN.** 1974. bi–m. IT, EN, FR, & GE. 2371
Propaganda Editoriale Grafica S.p.A., Via Fratelli Bressan 2, 20126 Milan, Italy. Phone 02 25–79–841. Grazia Gamberoni,
Editor.
Subscription: $112. Illus.
ISSN: 0392–2715. Dewey: 747.
Interior Design.

BARBOUR COMPENDIUM BUILDING PRODUCTS. 1977. a. EN. 2372
Barbour–Builder Ltd., New Lodge, Drift Rd., Windsor, Berks SL4 4RQ, England. Carol Barnes, Editor.
ISSN: 0260–9169.
Interior Design.

Advertising.

BATH & KITCHEN MARKETER. 1979. EN. 2373
Southam Communications Ltd., 1450 Don Mills Rd., Don Mills, Ontario M3B 2X7, Canada. Phone 416–445–6641. Ronald
H. Shuker, Editor.
Illus.
ISSN: 0225–9206. OCLC: 6183488. LC: TH6014. Dewey: 747.7.
Interior Design.

BATHROOMS. 1986. m. EN. 2374
Maclean Hunter Ltd., Maclean Hunter House, Chalk Lane, Cockfosters Rd., Barnet, Herts EN4 0BU, England. Phone 081–
441 6644. Barbara Field, Editor.
ISSN: 0950–0197. Dewey: 749.
Interior Design.

BATHROOMS, KITCHEN & TILES. 1985. m. EN. 2375
B & M Publications (London) Ltd., P.O. Box 13, Hereford House, Bridle Path, Croydon, Surrey CR9 4NL, England. I. Aird,
Editor.
Dewey: 747.
Interior Design.

BEDROOM & BATH IDEAS. 1941. a. EN. 2376
Meredith Corp., 1716 Locust St., Des Moines, IA 50336.
Illus. some color.
OCLC: 18672137. LC: NK2117.B4 B42. Dewey: 747.7. Formerly: *Bedroom & Bath Decorating Ideas.*
Interior Design.

Reviewed: Katz.
Circulation: 450,000.

BETTER HOMES AND GARDENS HUNDREDS OF IDEAS. a. EN. 2377
Meredith Corporation, Special Interest Publications, 1716 Locust St., Des Moines, IA 50336. Phone 515–284–2484.
Illus. 8½ x 11. Web offset.
ISSN: 0090–6433. OCLC: 2247154. LC: TX315.B47. Dewey: 747.
Interior Design.

Advertising: (rate card Jan '89): b&w full page $14,150, ½ page $8,850, ⅓ page $6,100; 4 color full page $20,300, ½ page $14,600, ⅓ page $11,650, covers $22,250–24,300. Frequency discount, discount for any combination of Better Homes and Gardens Special Interest publications. 15% agency discount. Bleeds + 15%. Readers Service (Information worth writing for). Des Moines: Jerry Ward, Publisher; New York: David Cohen, Ad. Director (750 Third Ave., New York, NY 10017, phone 212–551–7083); Chicago: Jim Day, Manager (330 North Michigan Ave., Chicago, IL 60601, phone 312–580–1615).

CABINET MAKER & RETAIL FURNISHER. 1880. w. EN. 2378

Benn Publications Ltd., P.O. Box 20, Sovereign Way, Tonbridge, Kent TN9 1RW, England. Phone 0732 364422. George White, Editor.
Subscription: $143.48 UK, $194.13 elsewhere together with *Directory to the Furnishing Trade*. Illus.
ISSN: 0007–9278. OCLC: 10119402. Formerly: *Cabinet Maker; Carpet World & Furniture Record Incorporating: Furnishing World*.
Furniture. Interior Design.

Reviews: book.
Advertising.

CANADIAN HOME STYLE MAGAZINE. 1989. bi–m. EN. 2379

Lorell Communications Inc., 100 York Blvd., Suite 404, Richmond Hill, Ontario L4B 1J8, Canada. Phone 416–889–7898, fax 416–886–7701. Lauri Merkel, Editor.
Subscription: $C15 Canada, $20 US, foreign $25.
Dewey: 747.
Interior Design.

CASARREDO & CONTRACT. 1977. s–a. EN, FR, GE, IT. 2380

Editore RIMA s.r.l., Via Luigi Barzini 20, 20125 Milan, Italy.
Subscription: L 12000.
Dewey: 747. Formerly: *Casarredo International*.
Interior Design.

Advertising.

CASARREDO MIDDLE EAST. 1977. s–a. AR & EN. 2381

Editore RIMA s.r.l., Via Luigi Barzini 20, 20125 Milan, Italy.
Subscription: L 12000.
ISSN: 0393–5140. Dewey: 747.
Interior Design.

Advertising.

CEILING NEWS. 1981. s–a. EN. 2382

Paul Marsh Associates, 9 Mays Way, Potterspury, Towcester, Northants NN12 7PP, England. Paul Marsh, Editor.
Subscription: free.
Dewey: 747. Formerly: *Suspended Ceiling News*.
Interior Design.

CHILTON'S DECORATIVE PRODUCTS WORLD. 1980. 9/yr. EN. 2383

Chilton Co., Decorative Products World, P.O. Box 2095, Radnor, PA 19089.
Illus.
ISSN: 1045–5914. OCLC: 20150358. LC: TP934.A5. Dewey: 698. Formerly: *Decorative Products World* which absorbed: *Paint & Decorating Magazine* (National edition), and: *Paint & Decorating Magazine* (Western edition).
Interior Design.

Trade magazine serving retailers of paint, wallcoverings, window treatments and related decorating products and other buyers and specifiers of decorative products in the United States. Regular departments include industry news, products and literature. Also publishes *Annual Raw Materials Source Directory* available separately.
Calendar of events.
Advertising, classified.

CITY & COUNTRY HOME. 1982. q. EN.

Maclean–Hunter Ltd., Business Publication Division, Maclean Hunter Bldg., 777 Bay St., Toronto, Ontario M5W 1A7, Canada. Phone 416–596–5900. Barbara Jean Neal, Editor.
Illus., some color.
ISSN: 0715–5689. OCLC: 9387051. LC: NK2013. Dewey: 747. Formerly: *Home Decor Canada; Canadian Home Decor.*
Interior Design.

Advertising.

COLONIAL HOMES. 1975. bi–m. EN.

Hearst Magazines, House Beautiful Home Interest Group, 1790 Broadway, New York, NY 10019. Phone 212–830–2900. Richard Beatty, Editor.
Subscription: $14.97 US & possessions, + $10 Canada & foreign (P.O. Box 7142, Red Oaks, IA 51591). Microform available from UMI. Illus. color, photos. 8½ x 11, 152p.
ISSN: 0195–1416. OCLC: 5306121. LC: E162.H68. Dewey: 728.3. Formerly: *House Beautiful's Colonial Homes.*
Crafts. Interior Design.

Heavily illustrated journal with focus on 18th century American architecture or 18th century style. Presents building and remodeling ideas; covers houses, arts and crafts, decorative accents, and furniture; some issues feature a particular area. Contains many short articles.
Freelance work: yes (details in *PhMkt.*). Indexed: Avery. Reviewed: Katz.
Advertising. Circulation: 600,000.

COMMERCIAL INTERIORS INTERNATIONAL. 1985. a. EN.

Grosvenor Press International, Holford Mews, Cruickshank St., London WC1X 9HD, England. Phone 071–278 3000, fax 071–278 1674. Richard Parkes, Editor.
Subscription: $29.95 US.
Dewey: 747.
Interior Design.

CONTRACT. 1960. m. EN.

Gralla Publications, 1515 Broadway, New York, NY 10036. Phone 212–869–1300. Len Corlin, Editor.
Microform available from UMI. Illus.
ISSN: 0010–7832. LC: TS840. Dewey: 747.
Interior Design.

The business magazine of commercial institutional design, planning and furnishing.
Indexed: Search. Reviewed: Katz.
Advertising.

CONTRACT MAGAZINE. 1986. bi–m. EN, includes some text in FR.

Victor Publishing Co. Ltd., 7777 Keele St., Unit 8, Concord, Ontario L4K 1Y7, Canada. Phone 416–669–6606. Michael Knell, Editor.
Illus., some color.
ISSN: 0833–9406. OCLC: 15465497. LC: HF5521. Dewey: 725. Formerly: *Canada's Contract Magazine.*
Interior Design.
Advertising.

COUNTRY ALMANAC. 1981. q. EN.

Harris Publications, Inc., 1115 Broadway, New York, NY 10010. Jack C. Davis, Editor.
Illus. photos. 104p.
Interior Design.

Presents a variety of articles and how-to's regarding country decorating and living. Views of several country homes and lifestyles are presented.
Reviewed: Katz.
Advertising.

COUNTRY DECORATING IDEAS. 1981. q. EN.

Harris Publications, Inc., 1115 Broadway, New York, NY 10010. Jack C. Davis, Editor.
Illus.
ISSN: 0731–2164. OCLC: 8145046.
Interior Design.
Reviewed: Katz.

COUNTRY KITCHEN IDEAS. s–a. EN.

Meredith Corporation, Special Interest Publications, 1716 Locust St., Des Moines, IA 50336. Phone 515–284–2484.
Illus. 8½ x 11. Web offset.
ISSN: 1044–0909. OCLC: 19645532. LC: TH4816.3.K58 C68. Dewey: 643.
Interior Design.

Remodeling ideas for country kitchens.

Advertising: (rate card Jan '89): b&w full page $14,150, ½ page $8,850, ⅓ page $6,100; 4 color full page $20,300, ½ page $14,600, ⅓ page $11,650, covers $22,250–24,300. Frequency discount, discount for any combination of Better Homes and Gardens Special Interest publications. 15% agency discount. Bleeds + 15%. Readers Service (Information worth writing for). Des Moines: Jerry Ward, Publisher; New York: David Cohen, Ad. Director (750 Third Ave., New York, NY 10017, phone 212–551–7083); Chicago: Jim Day, Manager (330 North Michigan Ave., Chicago, IL 60601, phone 312–580–1615). Circulation: 450,000.

COUNTRY LIVING. 1978. m. EN.

Hearst Magazines, Country Living, 224 W. 57th St., New York, NY 10019. Phone 212–649–3190. Rachel Newman, Editor.
Subscription: $15.97. Microform available from UMI. Illus. b&w, color, photos. Web offset. Perfect.
ISSN: 0732–2569. OCLC: 8316132. LC: TX1.G727. Dewey: 640. Formerly: *Good Housekeeping's Country Living.*
Antiques. Architecture. Ceramics. Collectibles. Crafts. Decorative Arts. Furniture. Historic Preservation. Interior Design. Textiles.
The magazine of American living featuring interior design and crafts.
Reviews: exhibition 2/yr., book 3. Country calendar. Exhibition information. Freelance work: yes. Contact: Juuo Vega. Reviewed: Katz.
Advertising: (rate card Jan '89): full page $31,940, ½ page $19,090, ⅓ page $11,190; 2 color full page $37,495, full page $27,330, ⅓ page $16,880; 4 color full page $43,700, ½ page $31,765, ⅓ page $19,635, covers $44,495–50,910. Frequency discount. 15% agency discount. 15% discount for qualified front–of–book mail order advertisers. Regional rates available along state lines. Bleed no charge. Inserts. E. Michael Peterson, Ad. Director. Mailing lists: none. Circulation: 1,700,000.

CREATIVE IDEAS FOR LIVING. See no. 1226.

DECORATING REMODELING. 1966. 8/yr. EN.

New York Times Co., 110 Fifth Ave., New York, NY 10011. Phone 212–463–1572. Olivia Buehl, Editor.
Subscription: $16 US, + $12 Canada. Sample. Back issues $3. 8 x 10½, 132p. Perfect bound.
ISSN: 0886–1056. OCLC: 12874827. LC: NK2002.D4. Dewey: 728. Formerly: *Family Circle's Decorating Remodeling.*
Antiques. Architecture. Crafts. Decorative Arts. Fabrics. Furniture. Historic Preservation. Interior Design. Landscape Architecture.

Dedicated to showing excellent residential design in a variety of styles as an attainable goal for the discerning, upper–end home enthusiast. Blends inspiration with detailed information upon which readers can take action. A commitment to retail sources – encouraging the purchase process – is a key element of the editorial philosophy. "The magazine of style and design" is edited for homeowners who are actively involved in enhancing the appearance of their homes. Information on subjects ranging from architecture, renovation and decorating to collectibles, home furnishings, antiques and landscape design. Freelance work: yes. Reviewed: Katz.
Advertising: (1991 rates): b&w full page $22,300, ½ page $13,580; 2 color full page $25,815, ½ page $15,735; 4 color full page $28,470, ½ page $18,025; covers $32,680–$37,045. Frequency discount. Bleed 10%. (phone 212–463–1636). Circulation: 650,000. Audience: affluent homeowners.

DECORATION. 9/yr.

Editions Rusconi, 90 rue de Flandre, 75019 Paris, France.
Subscription: 360 F.
Dewey: 745.
Interior Design.

DESIGN IN FINLAND. 1981. a. EN. 2395
Finnish Foreign Trade Association, POB 908, Arkadiankatu 4–6B, SF–00101 Helsinki, Finland.
Subscription: Fmk 53. Illus., some color.
OCLC: 9025526. LC: HF1044.5F5D48. Dewey: 747. Formerly: *Designed in Finland.*
Special issue of: *Finnish Trade Review.*
Indexed: Des&ApAI.

DESIGN INTERNATIONAL. ISSUE A. 1976. bi–m. GE & EN. 2396
Design International, Kantering 57, 5330 Koenigswinter, W. Germany.
Dewey: 747. Supersedes in part: *Design International.*
Interior Design.
Advertising.

DESIGN SOUTH MAGAZINE. 1977. 10/yr. EN. 2397
Promotional Design–Media Associates, Inc., 1000 Lincoln Rd., Miami Beach, FL 33139. Phone 305–534–2858. Gloria Jean
Blake & Al Alschuler, Editors.
Subscription: $30. Back issues. Illus. 8¼ x 11, 112p.
ISSN: 1044–0372. OCLC: 19658867; 15685706. LC: NK1700.F55. Dewey: 051. Formerly: *FDQ Design South; Florida Designers Quarterly.*
Interior Design.

Trade publication catering to the design/architectural industry. October issue is the annual buyers guide.
Advertising.

DESIGN TODAY. 1983. q. EN. 2398
Communications Today Publishing Ltd., 200 S. Main St., Box 2754, High Point, NC 27261. Phone 919–889–0113. Judith Z.
Cushman, Editor.
Subscription: $19.95. Microform available from UMI. Illus. 8¼ x 11, 50p.
OCLC: 17700232. LC: TS840.F832. Dewey: 747.
Interior Design.

The business magazine for interior design. Special supplement to: *Furniture Today Newspaper.*
Circulation: 25,500.

**THE DESIGNER SPECIFIER: America's Most Influential Magazine for the Designer/Specifier
and Interior Architect.** 1957. m. EN. 2399
North American Publishing Co., 401 N. Broad St., Philadelphia, PA 19108. Phone 215–238–5300, fax 215–238–5457. Miriam Furman, Editor (322 Eighth Ave., New York, NY 10001 phone 212–620–7300).
Subscription: free for those who qualify (interior designers, architects), $110 US, + $25 Canada & foreign. Microform available from UMI. Sample. Back issues. Illus. Annual index in last issue. 10¾ x 13½, 75p.
ISSN: 1047–5362. OCLC: 10234676. LC: NK1700.D4. Dewey: 747. Incorporates *Professional Office Design*; formerly *Designer.*
Antiques. Architecture. Decorative Arts. Furniture. Historic Preservation. Interior Design. Textiles.

A trade magazine showcasing new products, trends and techniques as well as news and stories on projects and firm profiles.
Provides examples of interior design.
Reviews: book. Biographies: profiles on architectural firms and interior designers. Interviews: designer on particular projects.
Listings: regional–national. Calendar of events. Opportunities: employment, study, competitions.
Advertising: rates on request. Diana DiScipio (phone 212–620–7339). Circulation: 41,500. Audience: interior designers, architects, and design specifiers.

DESIGNERS' JOURNAL. 1983. m., 10/yr. EN. 2400
Architectural Press Ltd., 9 Queen Anne's Gate, London SW1H 9BY, England. Phone 071–222 4333, fax 071–222 5196,
Telex 8953505. Alastair Best, Editor.
Subscription: £12. Sample free. Back issues £2. Illus b&w, color, photos. A4, 130p.
ISSN: 0264–8148. OCLC: 11489887. Dewey: 720.
Architecture. Decorative Arts. Furniture. Graphic Arts. Interior Design. Modern Art. Painting. Photography. Sculpture. Textiles.

Contract interior design magazine covering new and interesting projects in the retail, restaurant, office and product areas. Each issue includes case studies focussing on one particular theme; galleries, and product survey providing in–depth analysis of latest developments in the market. Offer extensive coverage of recent jobs plus shorter items in news pages, and pays particular attention to the business of design in the business pages. Include review sections and diary listings. Covers both the aesthetics and the business of design; articles stress costs and schedules as well as aesthetics. Issued as a supplement to: *Architects' Journal* and *Architectural Review*.

Reviews: exhibition 1, length 350–1200 wds.; book 3, length 700 wds. Interviews: in–depth interview for a profile feature, small scale interviews for business stories and some news items. Listings: national, mostly London. Exhibition information. Freelance work: yes. Contact: Michele Couston, Art Editor. Opportunities: study, competitions. Indexed: ArchPI. ArtBibMod. Avery. Des&ApAI.

Advertising: (rate card 1/89): full page £940, ½ page £400, ¼ page £320; 2 color + £240–260, 4 color £+ 420, covers £130–265. Bleed + £40. Frequency discount. Inserts. Demographics: 34% architects, 32% interior designers, 72% private design or consultancy practice. Circulation: 15,000. Audience: architects and interior designers working in the UK.

DESIGNS. 1986. q. EN & FR. 2401
Association Communication Innovation Designs, 4, C.P. 692, succ. Place D'Armes, Montreal, Canada H2Y 3H8. Phone 514–842–4436, fax 514–848–9730. Gilles Favier, Editor.
Subscription: free. Illus.
ISSN: 0835–2526. OCLC: 16723337, 16687833. LC: NK1160. Dewey: 745.4.
The newsletter of the International Design Centre.
Reviewed: *Art Documentation* Fall 1988, p.106.

DOMOV. 1960. bi–m. CZ. EN, FR, GE, RU summaries. 2402
Nakladatelstvi Technicke Literatury, Spalena 51, 113 02 Prague 1, Czechoslovakia (Dist.: Artia, Ve Smeckach 30, 111 27 Prague 1). Jiri Barta, Editor.
Subscription: $36.40.
ISSN: 0012–5369. Dewey: 747.
Interior Design.

EARLY AMERICAN LIFE. 1970. bi–m. EN. 2403
Historical Times, Inc., Box 8200, Harrisburg, PA 17105. Phone 717–657–9555. Frances Carnahan, Editor.
Subscription: $15 US, $21 foreign. Microform available from UMI. Illus. 8 x 10¾.
ISSN: 0012–8155. OCLC: 1775554. LC: E162.E214. Dewey: 917.3.
Collectibles. Crafts. Furniture. Interior Design.

Articles on all aspects of Americana.

Reviews: book. Listings: national. Calendar of events. Indexed: AmH&L. Reviewed: *Art Documentation* Fall 1986, p.132.
Advertising: Classified: $3.55/wd., 20 wd. min. Frequency discount. Gretchen Van Denbergh, Ad. Director.

FACILITY MANAGEMENT. 1986. bi–m. EN. 2404
Maple Publishing Ltd., 21A Brighton Rd., South Croydon, Surrey CR2 6EA, England. Phone 081 686 0141. Malcolm Bowen, Editor.

FAMILY CIRCLE GREAT IDEAS. 1975. 9/yr. EN. 2405
Family Circle, Inc., 488 Madison Ave., New York, NY 10022. Phone 212–593–8184.
Illus.
ISSN: 0163–1306. OCLC: 4300674. LC: TX1.F34. Dewey: 640.
Crafts. Interior Design.

Each edition dedicated to a different topic.
Advertising.

FDM, FURNITURE DESIGN & MANUFACTURING. 1979? m. EN. 2406
Delta Communications, Inc. (Chicago), 400 N. Michigan Ave., 13th Fl., Chicago, IL 60611. Phone 312–222–2000. Michael Chazin, Editor.
Microform available from UMI. Illus. Index.
ISSN: 0192–8058. OCLC: 1570331. LC: TS880.F13. Dewey: 749. Formerly: *Furniture Design and Manufacturing.*

Furniture. Interior Design.

Advertising. Classified. Reader service card.

FIRA BULLETIN. 1962. q. EN. 2407
Furniture Industry Research Association (FIRA), Maxwell Rd., Stevenage, Herts. SG1 2EW, England. Phone 0438 313433,
fax 0438 727607. Spillard, Editor.
Illus.
ISSN: 0014–5904. OCLC: 1645759. LC: TS840.F672. Dewey: 338.4. Formerly: *FIRA Technical Bulletin.*

Furniture. Interior Design.

FORUM. bi–m. EN. 2408
International Society of Interior Designers, 433 Spring St., 10th Floor, Los Angles, CA 90013. Phone 213–680–4240, fax
213–680–7704.
Subscription: Included in membership.

Interior Design.

Newsletter presenting activities of the membership.
Advertising.

GABRIEL'S INTERIORS MAGAZINE. 1984. q. EN. 2409
Hay Street Publications Pty Ltd, 405–411 Sussex St, Sydney, NSW 2000, Australia. Maria Quinn, Editor.
Dewey: 747. Formerly: *Gabriel's Interiors Annual.*

Interior Design.

HABITAT UFFICIO. 1981. bi–m. IT & EN. 2410
Alberto Greco Editore, Via del Fusaro 8, 20146 Milan, Italy. Phone 02 4819086. Alessandro Ubertazzi, Editor.
Subscription: $105 US. Sample. Back issues. 245 x 325 cm., 144p.
ISSN: 1120–236X.

Architecture. Furniture. Interior Design.

Advertising: full page L 2.750.000, ½ page L 1.595.000, color + 50%. Circulation: 21,000.

HABITAT/NEW INTERIORS. 1966. 3/yr. SP, EN, FR. 2411
Editorial Blume, Tuset 17, Barcelona 6, Spain. Dir. Marta Ribalta, Editor.
Illus.
Dewey: 747. Formerly: *Nuevo Ambiente; Ambiente.*

Interior Design.

Advertising.

HOME MAGAZINE: Creative Ideas for Home Design. 1955. m. EN. 2412
Knapp Communications Corp., 5900 Wilshire Blvd., 15th Floor, Los Angeles, CA 90036. Phone 213–932–1400. Joseph C.
Ruggiero, Editor.
Formerly: *Harper's Home Magazine.*

General. Interior Design.

Source book of home improvement ideas. Each issue is loaded with unique ideas, up–to–date practical information and cre-
ative inspirations on remodeling, redecorating, landscaping, furnishings.
Listings: national. Reviewed: Katz.

HOUSE AND HOME/HUIS EN TUIS. m. EN. 2413
Furniture Traders Association of South Africa, Albert & Eloff Sts., Box 5492, Johannesburg 2001, South Africa. Wally Kriek,
Editor.
Subscription: R 7.
Dewey: 747.

Furniture.

Advertising.

HOUSE BEAUTIFUL'S HOME REMODELING & DECORATING. 1964. q. EN. **2414**

Hearst Magazines, House Beautiful Special Publications, 1700 Broadway, Suite 2801, New York, NY 10019. Phone 212–903–5050. John Driemen, Editor.

Subscription: $2.95/issue. Illus.

LC: NK1700.H8. Dewey: 747. Formed by the merger of: *House Beautiful's Home Decorating* and *House Beautiful's Home Remodeling*.

Interior Design.

Reviewed: Katz.

Advertising.

HOUSE BEAUTIFUL'S KITCHENS, BATHS. 1980. 3/yr. EN. **2415**

Hearst Magazines, House Beautiful Home Interest Group, 1790 Broadway, Suite 2801, New York, NY 10019. Phone 212–903–5050. Timothy Drew, Editor.

Subscription: $2.95/issue. Illus., some color.

OCLC: 8645436. LC: NK2117.K5 H6. Dewey: 747.

Interior Design.

Reviewed: Katz.

Advertising.

I.D.E.A.S. INTERIORS, DESIGN ENVIRONMENT, ARTS, STRUCTURES. 1976. q. EN. **2416**

DoDi Publishing Corporation Inc., Box 343392, Coral Gables, FL 33114. Phone 305–662–8924. Sam Hirsch, Editor.

Illus.

ISSN: 0161–1895. OCLC: 3863958. Dewey: 747.

Interior Design.

IDEAL HOME. 1939. m. EN. **2417**

IPC Magazines Ltd., Women's Monthly Magazines Group, King's Reach Tower, Stamford St., London SE1 9LS, England. Phone 071–261 5000, fax 071–261–5918. T. Whelan, Editor.

Illus.

ISSN: 0019–1361. Dewey: 747.

Interior Design.

Indexed: Des&ApAI.

IDEAS FOR BETTER LIVING. 1945. m. EN. **2418**

Boulevard Publications, 1755 Northwest Blvd., Columbus, OH 43212. Phone 614–488–8252. Ellen Buesing, Editor.

Subscription: free to qualified personnel. Illus.

Interior Design.

Reviews: book.

Advertising.

IN-SPACE. irreg. EN. FR, GE, & SP summaries. **2419**

International Federation of Interior Architects/Interior Designers, Waterlooplein 219, Postbus 19126, NL–1000 GC Amsterdam, Netherlands. Phone 20 276820.

Interior Design.

Demographics: national professional associations and institutions in 30 countries representing interior design and architecture.

INSIDE/OUTSIDE: The Indian Design Magazine. 1977. bi–m. EN. **2420**

Ashok Advani, Wadia Building, 17/19 Dalal Street, Fort Bombay 400001, India. Phone 2024422, 2024424. Sheila Shahani, Editor.

Subscription: Rs 525 or $US40 air; Rs 225 or $US17 sea mail. Sample. Back issues. Illus.

ISSN: 0970–1761. OCLC: 4469629. LC: NK2076.A1I57. Dewey: 745.4.

Antiques. Architecture. Furniture. Interior Design. Textiles.

Serves as a forum for designers from all disciplines — interior, landscape, graphic, product, textile and industrial. Publishes two special issues each year focusing on a theme.

Advertising: (rate card Apr '90): full page Rs 12,000, ½ page Rs 6,600, ¼ page Rs 3,600; color full page Rs 22,000, covers Rs 25,000–31,000. Classified: Rs 200/col. cm., Rs 600 min.. Bleeds + 10%. Special position + 25%. Frequency discount. Pheroza Bilimoria, Ad. Director (Nirmal, 18th Floor, Nariman Point, Bombay 400 021, phone 204–1974, Telex 11 3557 BZIN IN). Demographics: Read by India's leading architects and professionals in the field of design. Also widely read by design conscious people who refer to the magazine for fresh ideas to change and improve their homes and work environment.

INSIDER. 1980. bi–m. EN.
2421

International Society of Interior Designers, 433 South Spring St., Suite 6D, Los Angeles, CA 90013. Phone 213–680–4240. Subscription: included in membership.
Interior Design.

Newsletter. Members activities.
Advertising: none.

INTERIOR DESIGN (England). 1957. 10/yr. EN.
2422

AGB Publications Ltd., Audit House Field End Rd., Eastcote Ruislip, Middlesex HA4 9LT, England. Phone 081–868–4499, Fax 081–429–3117, Telex 926726 AGB PUB G. Katherine Tickle, Editor.
Subscription: £30 England, £35 all foreign surface, no air. Available online, Dialog. Sample & back issues £2.50. Illus. color, photos. Annual index. 8¼ x 11¾, 74 p. Web Offset.
ISSN: 0020–5494. OCLC: 5851922. LC: NK1700.I54. Dewey: 747. Incorporates: *Decor and Contract Furnishing.*
Interior Design.

Articles and financial services for interior designers, architects, and specifiers. Sponsors student competition and the international contract furnishing and interior design exhibition.
Reviews: book. Opportunities: employment ads. Indexed: ArchPI. ArtBibMod. Des&ApAI.
Advertising: (rate card Jan '89): full page £900, ½ page £490, ¼ page £290, spot color + £200, 4 color + £425, covers + £100–250. Classified: £35/double col.cm., min. £105. Bleed. + 10%. Frequency discount. Inserts. Anna Gardiner, Ad. Director. Demographics: 44% architects/interior designers, 50% end user organizations. Circulation: 10,000. Audience: designers, architects and other specifiers.

INTERIOR DESIGN (New York). 17/yr. (m. with s–m. issues in Jan, Feb, May, Sept & Nov). EN.
2423

Cahners Publishing Co., Inc., 249 W. 17th St., New York, NY 10011. Phone 212–645–0067, fax 212–242–6987. Stanley Abercrombie, Editor.
Subscription: together with *Interior Design Market* & annual *Buyer's Guide & Market* issues, $47.95 US, $US74.95 Canada, foreign $97.95 (P.O. Box 173306, Denver CO 80217–9570, phone 1–800–542–8138 US only, others 1–303–388–4511). Microform available from UMI. Illus. b&w, mainly color, photos. 8¼ x 10¾, 264p. Web Offset, Perfect Bound.
ISSN: 0020–5508. OCLC: 5965672, 1587908. LC: NK1700.D55. Formerly: *Interior Design and Decoration.*
Interior Design.

Serves all concerned with the planning, design, specification and/or purchase of interior furnishings and products for all types of contract/commercial and residential installations. Provides coverage of both contract and residential design projects and furnishings. Includes information on trends and new products.
Indexed: ArtI. Avery. CloTAI. Des&ApAI. Search.
Advertising: (rate card Jan '89): b&w full page $4,160, ½ page $2,545, ¼ page $1,540; color + $850–$1,030; 4 color ½ page $6,060, ½ page $4,445, ¼ page $3,440, covers + $1200. Special positions + 10%. Frequency discount. 15% agency discount. Bleeds no charge. Inserts. Regional rates available. Bill Ash, Ad. Director. Circulation: 55,000.

INTERIOR DESIGN BUYERS GUIDE. 1970. a. EN.
2424

Cahners Publishing Co., Inc., Interior Design Group, Division of Reed Publishing USA, 249 W. 17th St., New York, NY 10011. Phone 212–645–0067. Neil H. Feinstein, Editor.
Subscription: $10. Illus.
OCLC: 6216571. Dewey: 747. Formerly: *Interior Design Directory.*
Interior Design.

Contract and residential reference tool which covers the industry's products and services.
Advertising: (rate card Jan '89): b&w full page $4,160, ½ page $2,545, ¼ page $1,540; color + $850–1,030; 4 color full page $6,060, ½ page $4,445, ¼ page $3,440, covers + $1,200. Special positions + 10%. Frequency discount. 15% agency discount. Bleed no charge. Inserts. Regional rates available. Bill Ash, Ad. Director.

INTERIOR DESIGN MARKET. 1986. 3/yr. EN.
2425

Cahners Publishing, 249 W 17th St., New York, NY 10011. Phone 212–645–0067. Andrea Loukin, Editor.

Subscription: together with subscription to *Interior Design & Buyer's Guide*, $47.95 US, $US67.95 Canada & foreign (Interior Design, P.O. Box 1970, Marion, OH 43305). No sample. Back issues. Illus. b&w, color, photos. tabloid, 10⅞ x 14³⁄₁₆, 200p., Web Offset. Perfect Bound.
ISSN: 0020–5508. OCLC: 16804328. LC: NK1700.D55.
Crafts. Decorative Arts. Fabrics. Furniture. Interior Design. Textiles.

A publication for products used in interior design. Includes news on new and classic items in the categories of seating, furniture, fabrics, floor coverings, accessories, interior building products, lighting and discussion on design and production of said products. First issue appeared as a supplement to October (Fall), 1986 issue of *Interior Design*.
Interviews: designers of products, manufacturers. Freelance work: none.
Advertising: (rate card Jan '89): b&w full page $4160, ½ page $2545, ¼ page $1540; color + $850–1030; 4 color full page $6060, ½ page $4445, ¼ page $3440, covers + $1200. Special position + 10%. Frequency discount. 15% agency discount. Inserts. Bleed no charge. Regional rates available. Bill Ash, Ad. Director. Circulation: 55,000. Audience: interior designers, architects, facility managers, store planners, etc.

INTERIOR DESIGN ONTARIO. 1986. 10/yr. EN.
2426

Association of Registered Interior Designers of Ontario, 168 Bedford Road, Toronto, Ontario M5R 2K9, Canada. Phone 416–921–2127. Phillip Moody, Executive Editor; Lorraine Johnson, Managing Editor.
Subscription: included in membership. Sample. Back issues. Illus. b&w, photos, cartoons occasionally. 11 x 17, 16p., sheet fed offset, saddle stitch, tabloid fold.
ISSN: 0836–3803. OCLC: 18028034. LC: NK1700. Dewey: 338.4.
Interior Design.

Devoted to the encouragement of the design industry and the enhancement of the profession. In–depth articles on design trends, industry news and issues, personalities behind creative interiors, business practices, and professional development.
Reviews: book 2, ½p each. Biographies: designer of the year. Listings: regional–international. Calendar of events. Exhibition information. Freelance work: yes. Contact: editor. Opportunities: employment, competitions.
Advertising: (rate card Apr '89): full page $2100, ½ page $1350, ¼ page $800, spread $3600, spot color + $300, 4 color + $600, covers $2600. Classified: $52/col. inch prepaid. Frequency discount. ARIDO Affiliate discount. 15% agency discount. 2% cash discount. Inserts. Mailing lists: none. Demographics: interior designers, architects, manufacturers, suppliers, services to interior design industry. Circulation: 7500. Audience: interior design industry professionals.

THE INTERIOR DESIGN YEARBOOK. a. EN.
2427

Weidenfeld and Nicolson in association with The Interior Design House Ltd., London, England.
Illus. mainly color, b&w.
OCLC: 21050836. LC: NK1700.I573.
Interior Design.

INTERIOR DESIGNER'S HANDBOOK. 1984. a. EN.
2428

Grosvenor Press International, West Garden Place, Kendal St., London W2 2AQ, England. Richard Parkes, Editor.
Illus. b&w, some color.
OCLC: 11616357. LC: NK1700.I57x. Dewey: 747.
Interior Design.

Advertising.

INTERIORS. 1888. m. EN.
2429

Billboard Publications, Inc., 1515 Broadway, 39th Fl., New York, NY 10036. Phone 212–764–7300. Paula Rice Jackson, Editor.
Subscription: $35 US, $US53 Canada, foreign $70 surface. Microform available from UMI. Sample. Back issues. Illus. b&w, color, photos. 8½ x 11, 200p., Web offset, Perfect bound.
ISSN: 0164–8740. OCLC: 16752733. LC: TS1300.I67. Dewey: 747. Formerly: *Contract Interiors*.
Architecture. Decorative Arts—Furnishings/Accessories. Fabrics. Furniture. Interior Design. Modern Art. Textiles.

"The Business/design publication." Serves the contract/commercial interior design field. Devoted to the profession of interior design in the commercial field.
Reviews: book 1, length 1000 wds.; other 1, length 50 wds. Listings: national–international. Calendar of events. Exhibition information. Opportunities: study, competitions. Indexed: ArchPI. ArtBibMod. ArtI. Avery. BioI. CloTAI. Des&ApAI. Search.
Advertising: (rate card Jan '89): full page $3635, ½ page $2185, ¼ page $1375, color + $650–770, 4 color + $1660, covers + $550–650, special positions + 10% of b&w rate. Classified: $1.75/wd., min. $77, display $85/col. inch. Frequency discount. 15% agency discount. Inserts. Mailing lists: none. Demographics: designers, space planners, dealers, end–users, archi-

tects, buyers and builders/developers; all 50 states, 91% of circulation; Canada approx. 1000, foreign approx. 1100. Circulation: 24,400. Audience: interior designers, design professionals and student of design.

THE INTERNATIONAL COLLECTION OF INTERIOR DESIGN. 1984. a. EN. 2430
Grosvenor Press International, West Garden Place, Kendal St., London W2 2AQ, England. Richard Parkes, Editor.
Illus.
OCLC: 12047768. LC: NK1700.I52. Dewey: 747.
Interior Design.

Advertising.

INTERNATIONAL DESIGN CONFERENCE IN ASPEN REPORT. 1951. a. EN. 2431
International Design Conference, Box 664, Aspen, CO 81612.
ISSN: 0534–9710. Dewey: 745.
Interior Design.

THE INTERNATIONAL DESIGN YEARBOOK. 1986. a. EN. 2432
Abbeville Press, 505 Park Ave., New York, NY 10022 (UK: Thames and Hudson, 30 Bloomsbury St., London WC1B 3QP England, phone 071–278 3000).
Illus.
ISSN: 0883–7155. OCLC: 12226030 (US), 19979805 (UK). LC: NK1160. Dewey: 745.4.
Interior Design.

Indexed: Des&ApAI. Reviewed: *Art Documentation* Sum 1987, p.68.

INTERNATIONAL TEXTILES INTERIOR. 1960. 3/yr. EN, FR, GE. 2433
Interior Textiles Benjamin Dent Ltd., 33 Bedford Place, London WC1B 5JX, England. Phone 071–637 2211. Nina Hirst, Editor.
Subscription: £86.
ISSN: 0954–1438. Dewey: 677.
Interior Design. Textiles.

INTERNI. 1954. m. (except Jan-Feb & Jul-Aug). IT. IT & EN table of contents. EN summaries. 2434
Elemond Periodici s.r.l., Via Trentacoste 7–20134 Milan, Italy. Phone 02–215631, fax 26410847. Dorothea Balluff, Editor.
Subscription: $65. Illus., some color.
ISSN: 0020–9538. OCLC: 8937074. LC: NK1700.I65. Dewey: 747. Formerly: *Rivista dell'Arredamento.*
Interior Design.

Issues special annual editions in addition to the monthly issues: *Interni Annual* (became an autonomous s–m in 1990); *Interni International Bathroom Fittings; Interni International Office Furniture; Interni International Kitchen Furniture; Interni International Light Fittings.*
Indexed: ArtBibMod. Des&ApAI.

KITCHEN & BATH CONCEPTS. 1985. bi–m. EN. 2435
Q R Publishing, Inc., 20 E. Jackson Blvd., Chicago, IL 60604. Phone 312–922–5402. Anne Patterson, Editor.
Subscription: free to architects & designers; $25 others (Readers' Service Center, 650 S. Clark, Chicago, IL 60605–1799).
ISSN: 8750–9504. OCLC: 11950890.
Interior Design.

KITCHEN AND BATH IDEAS. 1956. q. EN. 2436
Meredith Pub. Corp., Special Interest Publications, 1716 Locust St., Des Moines, IA 50310. Phone 515–284–2130. Kay Sanders, Editor.
Subscription: no subscriptions, available at newsstand only. Illus. b&w, some color, photos. 8 x 10½ trim, 132p.
ISSN: 0731–5600. OCLC: 9825088, 8201383. LC: TH4816.K58, TX653B47.643. Dewey: 643.
Architecture. Interior Design.

Magazine focuses on remodeling kitchens and bathrooms. Goal is to provide homeowners with information, inspiration and ideas.
Interviews: occasionally with architects and designers. Freelance work: none. Reviewed: Katz.

Advertising: (rate card Jan '89): full page $14,150, ½ page $8,850; color full page $20,300, ½ page $16,750; covers $22,250–24,300. Frequency discount. Combination discounts for ads in other Special Interest Publications. Reader Service card. David Cohen, Ad. Director (750 Third Ave., New York, NY 10017). Mailing lists: none. Circulation: 450,000. Audience: homeowners planning to remodel kitchen or bath.

KITCHENS & BATHROOMS: For the Dealer, Developer & Architect. 1975. 10/yr. EN. 2437

AGB Publications Ltd., Audit House, Field End Rd., Ruislip, Middx. HA4 9LT, England. Phone 081–868 4499, fax 081–429 3117. Grahame Morrison, Editor.
Illus.
OCLC: 6123357. LC: NK2117.K5K582. Dewey: 749.
Interior Design.

Supplements accompany some issues.

LIGHTVIEW INTERNATIONAL. See no. 1569.

MADE IN EUROPE. FURNITURE AND INTERIORS. 1978. bi–m. EN. 2438

Made in Europe Marketing Organization GmbH & Co. KG, Unterlindau 21–29, D–6000 Frankfurt 1, W. Germany. Phone (069)720896. H.E. Reisner, Editor.
Subscription: $40. Illus.
ISSN: 0171–6042. OCLC: 14866629. Dewey: 749.
Furniture. Interior Design.

"A decorator's import guide." Annual Buyers' Guide included in subscription.
Reviews: book.
Advertising.

MAGAZINE FOR LONDON LIVING. 1982. m. EN. 2439

Magazine Publishing Co. Ltd., Fredrica House, 12 Oval Rd., London NW1 7DH, England. Lucy Tuck, Editor.
Dewey: 747.
Interior Design.

Reviews: book.
Advertising.

LA MAISON FRANCAISE. 1946. 10/yr. FR. 2440

P.V.L., 17, rue d'Uzes, 75002 Paris, France. (US: Speedimpex USA Inc., 45–45 29th St., Long Island City, NY 11104). Phone 1–40 26 47 47, fax 40 26 55 87. Claude Berthod, Editor.
Subscription: 250 F. Illus., some color.
ISSN: 0025–0953. OCLC: 1756533. LC: N2.M24, TX1.M26. Dewey: 747.24.
Interior Design.

Indexed: Avery.
Advertising.

McCALL'S BEST DECORATING & HOME-CARE IDEAS. EN. 2441

McCall Pub. Co., 230 Park Ave., New York, NY, 10017.
Illus.
ISSN: 0161–4231. OCLC: 3909049. LC: TX311.M22. Dewey: 643.
Interior Design.

MD. 1955. m. GE. EN & FR summaries and captions. Table of contents in GE only. 2442

Konradin–Verlag Robert Kohlhammer GmbH, Postfach 100252, 7022 Leinfelden-Echterdingen, W. Germany. Phone (0711)7594–0, fax 0711–7594–3 90, telex 7255421. Gisela Schultz, Editor.
Subscription: DM 189. Illus. b&w, some color. 9½ x 12¼, 106p.
ISSN: 0343–0642. Dewey: 747. Formerly: *Md Moebel Interior Design*; which was formed by the merger of: *Innenarchitektur* und *Moebel; Decoration.*
Furniture. Interior Design.

"International journal of interior furnishing & design." Offers a unique editorial and advertising platform for trendsetting problems and solutions in the fields of furniture, interior furnishings and design. Covers planning, consultation, interior design and sales.
Reviews: (in GE) book. Indexed: ArchPI. ArtBibMod. CloTAI. Des&ApAI.

MOBILA. 1964. q. RO, EN occasionally. RO, EN, FR, RU summaries. 2443
Ministerul Industrializarii Lemnului si Materialelor de Constructii, Oficiul de Informare Documentara, Bd. Magheru Nr. 31, Bucharest, Romania. (Dist.: Rompresfilatelia, P.O. Box 12–201, Calea Grivitei 64–66, Bucharest). Claudiu Lazarescu, Editor.
Subscription: $48. Illus.
ISSN: 0026–7104. Dewey: 747.
Interior Design.

N.Z. FURNITURE. 1960. bi–m. EN. 2444
Trade Publications Ltd., Box 1614, 13 Cheshire St., Parnell, Auckland 1, New Zealand. K. Wright, Editor.
Subscription: $NZ15. Illus.
Dewey: 747. Formerly: *Decor*.
Furniture. Interior Design.
Advertising.

NEWSLETTER (International Federation of Interior Architects).
bi–m. EN. FR, GE, & SP summaries. 2445
International Federation of Interior Architects/Interior Designers, Waterlooplein 219, Postbus 19126, NL–1000 GC Amsterdam, Netherlands. Phone 20 276820.
Dewey: Contains membership news and conference reports.
Calendar of events.
Demographics: national professional associations and institutions in 30 countries representing the field of interior design and interior architecture.

OFFICIAL REFERENCE BOOK - BRITISH INSTITUTE OF INTERIOR DESIGN.
1983. a. EN. 2446
Sterling Publications Ltd., 86–88 Edgware Road, London, W2 2YW, England. Phone 071–258 0066.
Illus.
ISSN: 0263–2047. OCLC: 12581344. LC: NK1700.B862. Dewey: 747.
Interior Design.

PERSPECTIVE. q. EN. 2447
Institute of Business Designers, 341 Merchandise Mart, Chicago, IL 60654–1104. Phone 312–467–1950. Lana Lawrence, Editor.
Interior Design.
Association and industry newsletter.
Calendar of events.
Advertising. Audience: professional contract interior designers actively engaged in the nonresidential contract field.

PORTFOLIO. 1977. m. EN. 2448
Interior Design Society, 405 Merchandise Mart, Chicago, IL 60654. Phone 312–836–0777. Linda Irvine, Editor.
Microform available from UMI.
Formerly: *IDS National News; IDS Newsletter*.
Interior Design.
Indexed: RILA.

PRACTICAL HOUSEHOLDER. 1956. m. EN. 2449
IPC Magazines Ltd., Practical Group, Westover House, West Quay Rd., Poole, Dorset BH15 1JG, England. Denis Gray, Editor.
Subscription: 34.24 UK, elsewhere S57.68, S71.75 air. Illus. b&w, some color.
OCLC: 15473090. Dewey: 747. Incorporated: *Practical House Building & Decorating*, and *New Home Maker*.

Interior Design.

PROFESSIONAL OFFICE DESIGN. 1985. 8/yr. EN. 2450
New York Law Publishing Co., 111 Eighth Ave., New York, NY 10011. Phone 212–463–5800. Muriel Chess, Editor.
Subscription: $24 US. Sample $3. Back issues. Illus. b&w, color, photos, cartoons. 8½ x 11⅛, 78p. Web Offset.
ISSN: 0882–6781. OCLC: 12166802. Dewey: 725.

Interior Design.

Serves the total design team including professionals as end–users and designers and architects as specifiers. Serves to provide information about developments in the world of office design.
Interviews: with facility managers, interior designers. Listings: national. Calendar of exhibitions. Freelance work: yes. Contact: editor. Opportunities: study, competitions.
Advertising: (rate card Jan '89): b&w full page $3400, ½ page $2475, ¼ page $1325, 2 color + $650, 3 color + $900; 4 color + $1100, covers $5300–5400. Premium positions + 10%. Frequency discount. Bleed no charge. 15% agency discount. Regional rates. Inserts. Carrie Enfield, Ad. Director. Circulation: 50,000. Audience: facility managers, executives.

PROFESSIONAL PAINTER & DECORATOR. 1880. bi–m. EN. 2451
Turret–Wheatland Ltd., 12 Greycaine Rd., Watford, Herts. WD2 4JP, England. Alison Davis, Editor.
Illus. b&w, some color.
OCLC: 14230700. LC: NK1160.J683. Dewey: 747. Formerly: *Painting & Decorating; Painting & Decorating Journal.*

Interior Design.

Journal of the National Federation of Painting and Decorating Contractors.
Reviews: book.
Advertising.

PROFILE. a. 2452
International Association of Lighting Designers, 18 E. 16th St., Suite 208, New York, NY 10003. Phone 212–206–1281.

Interior Design.

RE-NEW. 1983. 5/yr. EN. 2453
Bluestone House, 21 Dorset St. E., Port Hope, Ontario L1A 1E2, Canada. Phone 416–885–2449. Joan Rumgay, Editor.
Illus.
ISSN: 0845–5341. OCLC: 19962559. LC: TH4816. Dewey: 728. Formerly: *Century Home; Canada Century Home.*

Architecture.

"The magazine of residential renovation and restoration".
Advertising.

SKOENA HEM. 1979. q. SW. EN summaries. 2454
Aahlens & Aakerlunds Foerlag AB, Skoena Hem, S–105 44 Stockholm, Sweden. Phone 08–736–4000. Boerge Bengtsson, Editor.
Subscription: $25.
Dewey: 747.

Interior Design.

SOURCEBOOK FOR INTERIOR PLANNING AND DESIGN. 1953. m. EN. 2455
Design World Productions, 4988 N. Figueroa, Los Angeles, CA 90042. Rex R. Goode, Editor.
ISSN: 0038–190X. Dewey: 747.

Interior Design.

TAIWAN FURNITURE. Furniture. bi–m. EN. 2456
China Economic News Service, 561 Chungsiao East Rd., Sec. 4, 5th floor, Taipei 105, Taiwan, Republic of China.
Subscription: $50.
Dewey: 749.

TRADITIONAL HOME. 1985? q. EN.

2457

Meredith Corporation, Special Interest Publications, 1716 Locust St., Des Moines, IA 50336. Phone 515–284–3000. Karol DeWulf Nickell, Editor.

Subscription: $14.97 US, $20.97 Canada & foreign. Illus. b&w, some color. 8 x 10, 128p.

ISSN: 0883–4660. OCLC: 12120606. LC: NK2002.T73. Dewey: 747.213.

General. Interior Design.

A Better Homes and Gardens publication. Helps readers create the traditional lifestyle with ideas for decorating, renovating, entertaining and collecting. Includes tours of beautiful gardens and homes. Complemented by *Traditional Home* (Annual).

Listings: national. Freelance work: yes. Contact: editor. Indexed: Avery.

Advertising: full page $15,650, ½ page $9700, ⅓ page $6750; color full page $22,450, ½ page $16,150. Frequency discount. No classified. David Cohen, Ad. Director (750 Third Ave., New York, NY 10017). Demographics: upscale, $62,000+ household income. Audience: mass market consumer.

TROWEL. 1949. bi–m. EN.

2458

Journal of Commerce Ltd., 2000 W. 12th Ave., Vancouver, B.C. V6J 2G2, Canada. Phone 604–731–1175. J.L. Whitehead, Editor.

Subscription: free.

Dewey: 690 747.

Interior Design.

WOMAN AND HOME. 1926. m. EN.

2459

IPC Magazines Ltd., Women's Monthly Magazines Group, King's Reach Tower, Stamford St., London SE1 9LS, England. Phone 071–261 5000, fax 071–261 5918. Sue Dobson, Editor.

Dewey: 746.96.

Interior Design.

WOMAN'S DAY COUNTRY DECORATING. 1988. a. EN.

2460

Diamandis Communications, Inc., 1633 Broadway, New York, NY 10019. Phone 212–767–6000.

Subscription: $2.25. Illus.

Dewey: 747.

Interior Design.

Reviews: book.

Advertising.

THE WORLD OF INTERIORS. 1981. 11/yr. EN.

2461

Conde Nast Publications Ltd., 234 King's Rd., London SW3 5UA, England. Phone 071–351 5177. Min Hogg, Editor.

Subscription: £56 air. No sample. Back issues. Illus. color, photos. 220 x 280 cm., 180p.

ISSN: 0264–083X. OCLC: 10853678. LC: NK1700.W64. Dewey: 729. Formerly: *Interiors*.

Antiques. Art History. Ceramics. Crafts. Decorative Arts. Furniture. Interior Design. Textiles.

Covers interior decoration, antique and modern.

Reviews: exhibition 8, book 6. Listings: international. Freelance work: yes. Contact: editor. Indexed: ArtBibMod. Avery. Des&ApAI. Reviewed: Katz.

Circulation: 69,182. Audience: general.

Home Furnishings

ANNUARIO ARTICOLI CASALINGHI E ARTICOLI REGALO. 1980. a. EN, FR or IT.

2462

Edispe s.n.c., Via Melchiorre Gioia 71, 20144 Milan, Italy. Vincenzo Vaccaro, Editor.

Subscription: $30.

Issued in English, French and Italian editions.

Advertising.

BETTER HOMES AND GARDENS WINDOW & WALL IDEAS. 1975. s–a. EN. 2463

Meredith Corporation, Special Interest Publications, 1716 Locust St., Des Moines, IA 50336. Phone 515–284–3000. Subscription: $2.95/issue. Illus. 8 x 10½.

ISSN: 0277–836X. OCLC: 7632792. LC: NK2121.B47. Dewey: 747. Formerly: *Window and Wall Decorating Ideas.*

Interior Design.

Ideas and how–to information on effective window and wall treatments.

BLINDS AND SHUTTERS. 1952. q. EN. 2464

Wheatland Journals Ltd., Penn House, Penn Place, Rickmansworth, Herts. WD3 1SN, England. Joan Barraclough, Editor. ISSN: 0305–733X. Dewey: 747.3. Formerly: *Blindmaker.*

Interior Design.

Reviews: book.

Advertising.

CANADIAN HOUSE AND HOME. 1984, v.6. EN. 2465

Telemar Pub., Suite 305, 491 Eglinton Ave., West, Toronto, Ontario M5N 1A8, Canada. Illus., some color.

ISSN: 0826–7642. OCLC: 11868873. LC: TX307. Dewey: 747. Formerly: *House and Home.*

Interior Design.

CARPET & FLOORCOVERINGS REVIEW. 1982. bi–w. EN. 2466

Benn Publications Ltd., Sovereign Way, Tonbridge, Kent TN9 1RW, England. Phone 0732 364422. Mrs. Joy Lawrence, Editor.

Illus.

ISSN: 0263–4236. OCLC: 9662854. LC: TS1772.C284. Formerly: *Carpet Review Weekly.*

Interior Design.

Reviews: book.

Advertising.

DRAPERIES & WINDOW COVERINGS. 1981. m. with a. EN. 2467

L.C. Clark Publishing Co., Inc., 840 US Hwy. 1, Suite 330, North Palm Beach, FL 33408–3833. Phone 407–627–3393, fax 407–627–3347. Katie Renckens, Editor.

Subscription: $27 US & Canada, foreign $90. Sample. Back issues. Illus b&w, color, photos, cartoons. Index in Dec issue. 8½ x 11, 200p., Web offset. Perfect bound.

ISSN: 0279–4918. OCLC: 7910156. LC: HD9939.D72. Dewey: 338.

Fabrics. Furniture. Interior Design. Textiles.

The magazine for the American coverings industry. Editorial coverage is given to new products introductions and applications, management methods and techniques, retail advertising and display ideas, industry trends and profiles of leading retail and industry personalities. Regular departments include contract and retail product reviews, advertising planning service, reader information exchange and industry news items. A 13th issue each year serves as the "Who's Who in Window Coverings". This *Directory & Buyer's Guide* is a comprehensive sourcebook to suppliers of window coverings and related products, services and equipment.

Reviews: products. Interviews: profiles of successful industry companies. Listings: national–international. Calendar of events. Exhibition information. Freelance work: yes. Contact: editor. Opportunities: employment in classified ads, study, competitions.

Advertising: (rate card Jan '90) national ads: b&w full page $2800, ½ page $1680 ¼ page $975; 2 color full page $3175, ½ page $2055, ¼ page $1350; 4 color full page $3850, ½ page $2730, ¼ page $2025. Regional ads (targeted to one or more specific market areas): b&w full page $1000, ½ page $695; 2 color full page $1275, ½ page $970; 4 color full page $1575, ½ page $1270. Frequency discount. 15% agency discount. Bleeds + 10%. Inserts. Darlene Mickelson, Production Manager. Mailing lists: available to frequency advertisers. Circulation: 25,100. Audience: edited for specialty retailers, interior designers, decorators, department stores, workrooms, distributors and manufacturers in the drapery, window coverings and related products industry.

FLORIDA HOMEFURNISHINGS. 1980. bi–m. EN & SP. 2468

Rabcom International, 530 Fifth Ave., Pelham, NY 10806. ISSN: 0274–8983. OCLC: 667881.

Interior Design.

Advertising.

FURNISHINGS & DECORATING IDEAS. a. EN.

2469

Meredith Corporation, Special Interest Publications, 1716 Locust St., Des Moines, IA 50336. Phone 515–284–2484. Illus. 8½ x 11. Web offset.

ISSN: 0092–7961. OCLC: 6845301. Dewey: 747.05.

Interior Design.

Advertising: (rate card Jan '89): b&w full page $14,150, ½ page $8,850, ⅓ page $6,100 ; 4 color full page $20,300, ½ page $14,600, ⅓ page $11,650, covers $22,250–24,300. Frequency discount, discount for any combination of Better Homes and Gardens Special Interest publications. 15% agency discount. Bleeds + 15%. Readers Service (Information worth writing for). Des Moines: Jerry Ward, Publisher; New York: David Cohen, Ad. Director (750 Third Ave., New York, NY 10017, phone 212–551–7083); Chicago: Jim Day, Manager (330 North Michigan Ave., Chicago, IL 60601, phone 312–580–1615).

FURNISHINGS RECORD. 1981. s–a. EN.

2470

International Thomson Publishing Ltd., 100 Avenue Road, London NW3 3TP, England. Phone 071–935–6611, fax 071–586–5339, telex 299973 ITP LN G. Cliff Waller, Editor.

Subscription: included in subscription to *DR*. Microform available from UMI. Illus.

Formerly: *Furnishings International; Home Furnishings International*.

Interior Design.

Advertising.

GOLV TILL TAK. 1972. 8/yr. SW. EN summaries.

2471

Foerlags AB Golv till Tak, Box 5306, S–102 46 Stockholm, Sweden. Catharina Clinton, Editor.

Subscription: Kr 250.

ISSN: 0345–3979. Dewey: 747.5.

"Scandinavian magazine for floor coverings, wallcoverings and ceilings. Co–sponsor: Sveriges Golvhandlares Riksfoerbund Golventreprenoerernas Branschorganisation.

HOME FASHION MAGAZINE. 1979. m. EN.

2472

Fairchild Publications, Inc., 7 E. 12th St., New York, NY 10003. Phone 212–337–3476. Barbara Solomon, Editor.

Subscription: $30. Illus., some color. 8 x 11, 84p.

ISSN: 0896–7962. OCLC: 17252938. LC: TS1760.H65. Dewey: 338. Formerly: *Home Fashions Textiles*.

Fabrics. Interior Design. Textiles.

Focuses on bed and bath linens, table linens, window coverings, and area rugs. Deals with developments in the manufacturing and retailing of home textiles.

Reviewed: Katz.

Advertising. Sheila Rice, Ad. Director.

INTERNATIONAL ASSOCIATION OF LIGHTING DESIGNERS—NEWSLETTER.

1970. 6–8/yr. EN.

2473

International Association of Lighting Designers, 18 East 16th St., Suite 208, New York, NY 10003. Phone 212–206–1281. Stephen D. Bernstein, Editor.

Subscription: included in membership, $30 non–members.

Interior Design.

Association and industry newsletter.

Calendar of events.

Advertising: none.

INTERNATIONAL CARPET BULLETIN. 1970. 9/yr. EN.

2474

W.R. Publications Ltd., 76 Kirkgate, Bradford BD1 1T8, England. Martin Black, Editor.

ISSN: 0268–2966. Dewey: 747.

Interior Design.

INTERNATIONAL LIGHTING REVIEW. 1949. q. EN, FR, GE, SP & IT editions. 2475
Foundation Prometheus, Box 721, 5600 AS Eindhoven, Netherlands. J. F. Caminada, Editor.
Subscription: fl 57. Illus. color.
ISSN: 0020–7853 (EN edition), 0035–3388 (FR), 0165–9863 (GE), 0167–7608 (SP). OCLC: 1753626. LC: TK1.I56.
Deals with all aspects of lighting. Issued in separate language editions: French, *Revue Internationale de l'Eclairage*; German, *Internationale Licht Rundschau*; Spanish, *Revista Internacional de Luminotecnia*.
Indexed: ArchPI.
Demographics: e.

INTERNI ANNUAL. 1981. a. EN & IT. 2476
Electa Periodici SRL, Via Trentacoste 7, 20134 Milan, Italy.
Subscription: L 5.000. Illus.
OCLC: 7806171. LC: HD9773.I79I57. Dewey: 338.4.
Supplement to *Interni*. Became an autonomous publication in 1990. Covers the home furnishings industry.
Indexed: ArtBibMod.

LAURA ASHLEY HOME FURNISHINGS. 1981. s–a. EN. 2477
Laura Ashley, Dept. HF84, Box 5308, Melville, NY 11747.
Subscription: free. Illus. color, print guide.
OCLC: 8464040. Dewey: 747.
Interior Design.
Catalog of home furnishings available from Laura Ashley.

LDB INTERIOR TEXTILES. 1927. m. EN. 2478
Columbia Communications, 370 Lexington Ave., New York, NY 10017. Phone 212–532–9290. Rene Bennett, Editor.
Subscription: $15 US, $50 Canada & foreign. Sample. Back issues. Illus. b&w, color, photos. 8½ x 11, 60–120p.
ISSN: 0892–743X. OCLC: 15249831. LC: HD9850.1.L32. Dewey: 338.4. Formed by the merger of: *Linens, Domestics & Bath Products* and *Interior Textiles*. Continues the numbering of the former.
Fabrics. Interior Design. Textiles.
Glossy magazine presents the business of home fashions. Provides an overall perspective on current trends and new products.
Reviews: exhibition 1, length 1–2p.; equipment 1, length½ page. Biographies: of top retailers. Interviews: manufacturers and retailers of home textiles. Listings: national. Calendar of events. Exhibition information. Freelance work: yes. Contact: editor. Opportunities: employment, study.
Advertising: full page $2370, ½ page $1515, ¼ page $880, color + $775. Classified: $30/inch. Frequency discount. Readers response cards. Janice Gunn, Ad. Director. Mailing lists: available. Demographics: home textile buyers at department stores, specialty stores, mass merchants. Circulation: 25,000. Audience: home textile buyers.

LIGHTING DESIGN + APPLICATION: LD + A. 1972. m. EN. 2479
Illuminating Engineering Society of North America, 345 E. 47th St., New York, NY 10017. Phone 212–705–7923. Kevin Heslin, Editor.
Subscription: included in membership, $35 US, + postage Canada & foreign. No Sample. Back issues. Microform available from UMI. Illus. b&w, color, photos, cartoons. 56p.
ISSN: 0360–6325. OCLC: 9663517. LC: TK1.L23. Dewey: 729. Formerly: *Lighting Design & Application; Illuminating Engineer*.
Architecture. Interior Design. Lighting.
Features articles on current lighting applications, the latest news of energy, products, industry, and Society news.
Reviews: book 1, theater 1. Listings: national–international. Calendar of events. Freelance work: none. Indexed: index.
Advertising: full page $1395, ½ page $875, ¼ page $525, + $400/color, + $895 4 color. Classified: $15/line. Frequency discount. Readers card. Michael S. Craft, Ad. Director. Mailing lists: available. Demographics: specifiers, consulting engineers. Circulation: 10,000. Audience: lighting designers, engineers, interior designers, architects, and all others concerned with illumination.

NATIONAL FEDERATION OF PAINTING AND DECORATING CONTRACTORS YEAR BOOK. 1982. a. EN. 2480
Comprint Ltd., 177 Hagden Lane, Watford WD1 8LW, England.
Dewey: 747.

Interior Design.

Advertising.

RASSAGNA BAGNO CUCINA. 1979. q. IT.

2481

Alberto Greco Editore, Via del Fusaro 8, 20146 Milan, Italy. Phone 02–4819086. Pieralberto Maria Greco, Editor.
Subscription: $55. Sample. Back issues $25. 220 x 285 mm.
ISSN: 1120–2343.

Ceramics. Furniture. Modern Art.

Features bathroom and kitchen furniture and accessories.
Advertising: full page 3.300.000 L, ½ page 2.600.000, color rates + 50%. Circulation: 65,000.

SMALL WORLD. 1949. m. EN.

2482

Earnshaw Publications, Inc., 225 W. 34th St., No.1212, New York, NY 10001. Phone 212–563–2742. Thomas W. Hudson, Editor.
Subscription: $18. Sample. Illus. photos (10/issue).
ISSN: 0037–7260. OCLC: 4947217.

Furniture.

The magazine of nursery furniture, wheel goods, toys and accessories.
Reviews: book. Freelance work: yes (details in *PhMkt*.).
Advertising. Circulation: 8,000. Audience: retailers and manufacturers.

THE WALL PAPER. 1980. m. EN.

2483

Tapis Publishing Co. Inc., 570 7th Ave., Suite 500, New York, NY 10018. Phone 212–869–4960. Janet Vendeguer, Editor.
Subscription: $18 US, $30 Canada, $42 foreign, $100 air. Sample free. No back issues. Illus. b&w, color, photos, cartoons.
tabloid, 10⅞ x 14½, 42p. Web offset, saddle stitch.
ISSN: 0273–6837. OCLC: 6820822. Dewey: 747.

General. Decorative Arts. Historic Preservation. Interior Design. Textiles. Wallpaper.

Tabloid edited for the wallcovering industry. Covers all aspects of the industry, reporting on selling, merchandising, sales training, new products, paper hanging techniques, shows, conventions, dealer activities, personnel changes, and manufacturer and distributor activities.
Reviews: book 15, length 2 inches. Listings: regional–national. Calendar of events. Exhibition information. Freelance work: yes. Contact: Maurice S. Murphy. Opportunities: study, competitions.
Advertising: (rate card Jan '89): full page $2160, ½ page $1330, ¼ page $925; 4 color + $885, covers + 10–20%. Classified: $30/in. Frequency discount. Preferred positions + 10%. Inserts. Bleeds 10%. 15% agency discount. Judson H. Spencer, Ad. Director. Mailing lists: available. Demographics: wall covering retailers, distributors, manufacturers, paperhangers, industry suppliers. Circulation: 16,500. Audience: wallcovering industry.

WINDOW FASHIONS: Design & Education Magazine. 1981. m. EN.

2484

Grace McNamara Publishing, 6 Fifth St. W., Suite 300, St. Paul, MN 55102–1420. Phone 612–293–1544, fax 612–293–9497. Susan Schultz, Editor.
Subscription: $30 US, $36 Canada, foreign $67, air $76. Sample & back issues $5. Illus. b&w, color, photos. 8½ x 11, 88–100p., Web offset, perfect binding.
ISSN: 0886–9669. OCLC: 13079568. Dewey: 747. Formerly: *WES; Window Energy Systems*.

Architecture. Decorative Arts. Fabrics. Furniture. Historic Preservation. Interior Design. Photography (Interiors). Textiles.

Coverage includes window treatments, fabrics, hardware and accessories. Each issue includes a supplier directory, product showroom, tech–style, motorization and panorama or specialty of the house. The November issue is a design portfolio issue.
Reviews: exhibition 2, length 2–4p. Bibliographies: on outside writers or quoted statistical information. Interviews: suppliers, designers retailers, and craftspeople where applicable to story. Biographies: historical in nature — reoccurring trends, styles epitomized by featured designers. Listings: regional–international. Calendar of trade shows, seminars. Exhibition information related to interior design. Freelance work: occasionally. Contact: editor. Opportunities: study – window fashions, Education and Design Conference. Competitions – annual design competition.
Advertising: (rate card 1989): full page $2390, ½ page $1540–1740, ¼ page $875; color + $350/color, 4 color + $900, covers $3200–3840. Frequency discount. 15% agency discount. Inserts. Preferred positions + 10%. Direct response cards. Janelle Sundquist, Ad. Director. Mailing lists: available to advertisers only (by zip code and business type), $125/M + postage & handling. Circulation: 22,000. Audience: interior designers, decorators, specialty retailers, installers, workrooms.

WOMAN'S DAY HOME DECORATING IDEAS. 3/yr. EN. 2485

Diamandis Communications, Inc., Woman's Day Special Publications, 1633 Broadway, New York, NY 10019. Phone 212–767–6815.

Illus.

ISSN: 0361–638X. OCLC: 2247074. LC: TX311.W65. Dewey: 747.

Interior Design.

Advertising.

WOMAN'S DAY KITCHEN & BATH NEW PRODUCT IDEAS. 1990. a. EN. 2486

Diamandis Communications, Inc., 1633 Broadway, New York, NY 10019. Phone 212–767–6749.

Subscription: $3.50. Illus.

Dewey: 643.

Interior Design.

Information about kitchen or bath products available for use in remodeling.

Reviews: book.

Advertising. Circulation: 450,000.

Lifestyles

AUSTIN HOMES & GARDENS. 1979. m. EN. 2487

Posada Publishing, Box 1684, Austin, TX 78767. Phone 512–479–8936. June W. Hayes, Editor.

Subscription: $12. Illus.

ISSN: 0199–1531. OCLC: 5215715. LC: NK1700.A87.

Architecture. Interior Design.

Upscale regional journal featuring architecture, interior design, food, fitness, fashion and local events.

AUSTRALIAN HOUSE AND GARDEN. m. EN. 2488

Australian Consolidated Press, 54 Park St., Sydney, N.S.W. 2000, Australia. Phone 2828000. Rose–Marie Hillier, Editor.

Subscription: overseas $A94. No sample. No back issues. Illus. b&w, color, photos. 290 x 220 mm. bleed, 200p.

ISSN: 0004–931X. OCLC: 5451883. Dewey: 747.

General.

Coverage includes travel, food, entertaining, gardening, practical house directory, shopping.

Interviews: homeowners, artisans. Listings: national. Freelance work: yes. Contact: editor.

Advertising: full page $A3080, ½ page $A1850, ¼ page $A1080, color full page $A4400. Frequency discount. Pamela Cass, Ad. Director. Mailing lists: none. Circulation: 120,000.

BETTER HOMES AND GARDENS. 1922. m. EN. 2489

Meredith Corporation, 1716 Locust St., Des Moines, IA 50336. Phone 515–284–3000.

Subscription: $14.97. Microform available from UMI.

ISSN: 0006–0151. LC: NA7100. Dewey: 747.

General. Architecture. Interior Design.

Provides ideas and how–to–information on interior decorating, building and remodeling, gardening, crafts, landscape design and home entertainment. Home and family living authority. Published in seven regional editions.

Indexed: CloTAI. Hand. RG. Reviewed: Katz.

Circulation: 8,000,000+.

BETTER HOMES AND GARDENS TRADITIONAL HOME. See no. 2457.

CALIFORNIA HOMES AND LIFESTYLES. 1982. 10/yr. EN. 2491

McFadden Publishing Company, 2900 A Bristol, Suite 204, Costa Mesa, CA 92626. Phone 714–241–9221.

Illus.

ISSN: 0734–5453. OCLC: 8767702. Dewey: 720. Formerly: *California Homes*; Incorporating: *Southern California Home and Garden*.

Architecture. Interior Design.

"The magazine of architecture, the arts, and distinctive design".
Reviewed: Katz.
Advertising.

COLORADO HOMES & LIFESTYLES. 1981. bi–m. EN. 2492

Garrett Giann, 2550 31st St., Suite. 154, Denver, CO 80216. Phone 303–455–1944, fax 303–455–7490. Darla J. Worden, Editor.
Subscription: $15 US, $19 Canada, foreign $24. Sample. Back issues. Illus b&w, color, photos. 8⅜ x 10⅞.
ISSN: 0272–6904. OCLC: 6901285. LC: TX301.C56. Dewey: 640.

General. Interior Design.

Interviews: can be feature or included in department section. Biographies: occasionally as a feature. Listings: regional. Calendar of events. Freelance work: yes. Contact: editor. Reviewed: Katz.
Advertising. Mailing lists: none. Circulation: 25,000. Audience: affluent homeowner.

COUNTRY HOME. 1983. bi–m. EN. 2493

Meredith Corporation, Special Interest Publications, 1716 Locust St., Des Moines, IA 50336. Phone 515–284–3000. Jean Lem Mon, Editor.
Subscription: $16.97 US, $21.97 Canada. Sample $2.95 postage. Back issues $3.95. Illus., photo. 8 x 10½, 152p. Web offset, Perfect binding.
ISSN: 0737–3740. OCLC: 9947733, 9364452. LC: TH4850.C68. Dewey: 643.3. Formerly: *Country Home & Kitchen Ideas*.

Antiques. Architecture. Ceramics. Collectibles. Crafts. Decorative Arts. Furniture. Historic Preservation. Interior Design. Landscape Architecture.

Purpose is to serve and enhance a growing interest in the origins and traditions of American design, architecture, decoration, social custom, gardening, cookery and art. The magazine treats these subjects from the point of view of people who preserve and cultivate them today. Subjects are presented in–depth in both text and photography.
Editorial creed: "We believe in lasting values, an interest in history, respect for craftsmanship, an appreciation of traditions, and a deep commitment to home. We are a lifestyle magazine for and about people who share those same beliefs".
Listings: national. Freelance work: yes. Contact: editor. Reviewed: Katz.
Advertising: (rate card Sept '89): b&w full page $26,800, ½ page $16,000; black + 1 color full page $32,500, ½ page $21,100; 4 color full page $38,300, ½ page $26,700, covers $42,100–49,800. Bleed + 15%. 10–15% frequency discount. 15% agency discount. 2% cash discount. Inserts. Rex B. Wheeler, Ad. Director (330 North Michigan Ave., Chicago, IL, phone 312–580–1628). Mailing lists: available. Demographics: reader is typically well–educated, affluent and committed to a full, rich lifestyle based in the choice of country style. Total readership per issue nearly 5 million U.S. adults. Circulation: 1,000,000.

COUNTRY LIFE. 1897. w. EN. 2494

IPC Magazines Ltd., King's Reach Tower, Stamford St., London SE1 9LS, England. Phone 071–261 5000, fax 071–261 5918, Telex 915748 MAGDIV G. Jenny Greene, Editor.
Subscription: £130 UK, foreign air $175 US, $295 Canada. Sample free. Back issues. Illus b&w, color, photos. 318 x 235mm., 150p. printed litho.
ISSN: 0045–8856. OCLC: 6506223, 1565327. Dewey: 630.1. Formerly: *Country Life Illustrated*.

General. Antiques. Architecture. Interior Design. Landscape Architecture.

About life in the country and country landowners. Every other issue is devoted to a special topic. Provides coverage of architecture, gardening, fine art, antiques, and fashion. Covers are specially commissioned and designed to attract more casual purchasers. About ½ of issue comprised of ads.
Listings: national. Freelance work: yes. Contact: editor. Opportunities: employment & study listed in classified ads. Indexed: ArchPI. ArtBibMod. Avery. BrArchAb. Des&ApAI. RILA. Reviewed: Katz.
Advertising: (rate card Jan '89, VAT 15% extra): Display rates: b&w full page £1521, ½ page £836, ¼ page £458; 2–color + £230, 4 color full page £2050, ½ page £1127, ¼ page £580. Antique & Fine Art Rates: full page £1060, ½ page £590, ¼ page £345; color full page £1745, ½ page £1100, ¼ page £725. Classified: £12.50 10 wds, 70p/wd. add., min. 10 wds. Frequency discount. B. Slyfield, Ad. Director. Mailing lists: none. Demographics: national but primarily London and S. East, women 51%, men 49%, age 25–44 38%, 45–64 34%. Circulation: 55,004.

FLORIDA ARCHITECTURE. 1942. a. EN. 2495

Carolyn T. Powers, Pub., 3090 Kirk St., Coconut Grove, FL 33133. Phone 305–858–7900. Ann R. Keyes, Editor.
Subscription: $15 + $3 postage US, Canada & Mexico; foreign $23 postage paid surface, air quoted individually. No sample.
Back issues. Illus., color, photos. 9¾ x 13¼ trim, 150p. Offset lithography, perfect bound.
ISSN: 1040–0893. OCLC: 7708919. LC: NA730.F5 F54x. Dewey: 720. Formerly: *Architecture International.*

Antiques. Architecture. Decorative Arts. Furniture. Historic Preservation. Interior Design. Landscape Architecture.

"The luxury magazine of architecture, interior design, and landscaping" presents custom life styles in homes and offices in
Florida. Each article integrates architecture, landscape architecture and interior design.
Freelance work: yes. Contact: Olivia Hammar, V.P.
Advertising: 4 color $2900, ½ page $1900, 5th color + $450. Susan Gage, Ad. Director. Mailing lists: none. Demographics:
prepaid to the trade and leading executives in the industry. Distributed nationally and internationally through major book-
stores, newsstands and airports. Circulation: 12,000. Audience: trade and affluent.

FLORIDA HOME AND GARDEN. 1984. m. (+ 2 special a. issues). EN. 2496

South Florida Home & Garden, c/o Graham K. Gloss, P.O. Box 019068, Miami, FL 33101. Phone 305–374–5011. Kathryn
Howard, Editor.
Subscription: $24.95 US, $39 Canada & foreign. No sample. No back issues. Illus. b&w, mainly color, photos. 124p.
ISSN: 0898–9494. OCLC: 17699910. Dewey: 747. Formerly: *South Florida Home and Garden.*

Antiques. Architecture. Collectibles. Crafts. Decorative Arts. Furniture. Interior Design. Gardening.

Focuses on architecture and design. Features: homes, gardens, products, and cuisine. Departments: products, real estate, how
to, travel, and design news. Reflects the style, the flair and the lifestyle of the people who live in Florida. Special Annual is-
sues: *Resource Annual*, and *Real Estate.*
Listings: regional. Freelance work: yes. Contact: editor. Opportunities: competitions, design news awards. Reviewed: Katz.
Advertising: (rate card May '90): b&w full page $3600, ½ page $2120, ⅙ page $760; 4 color full page $4260, ½ page
$3070. Classified: $4.50/wd., 15 wd. min. Frequency discount. 15% agency discount. Guaranteed position + 15%. Inserts.
Bleed 10%. Muriel Sommers, Ad. Director. Demographics: (reader study 1/89): 66% managerial/professional; 65% age 25–
55; 94% homeowners; $109,731 average income, $236,990 average home value, $825,363 average household net worth;
56% used decorating/landscaping ideas from magazine. Circulation: 55,000. Audience: upwardly mobile homeowners.

GARDEN STATE HOME AND GARDEN. 1985. bi–m. EN. 2497

Micromedia Affiliates, Business Journal of New Jersey, Inc., 55 Park Place, Morristown, NJ 07960. Phone 201–644–5554.
Barbara S. Greene, Editor.
Subscription: $9.95.
ISSN: 1044–3576. OCLC: 19757703. Dewey: 747. Formerly: *New Jersey Home & Garden.*

Architecture.

Feature articles on New Jersey homes and architecture but also contains material regarding gardening, antiques and galleries.
Listings: state. Calendar of events. Reviewed: Katz.

HOUSE & GARDEN. 1901. m. EN. 2498

The Conde Nast Publications Ltd. Inc., Conde Nast Bldg., 350 Madison Ave., New York, NY 10017. Phone 212–880–8800.
UK: Vogue House, Hanover Square, London W1R OAD, England. Phone 071–499 9080. Nancy Novogrod, Editor–in–chief.
Subscription: $24 US, + $14 Canada. Microform available from UMI. Illus. mainly color, some b&w, photos. 9 x 11, 226p.
ISSN: 0018–6406 (US), 0043–5759 (UK). OCLC: 1752319 (US edition), 3817918 (microfilm), 1752317 (UK edition). LC:
NA7100.H6. Dewey: 640. Formerly: US edition: *American Homes and Gardens; Living for Young Homemakers.* UK edition:
Wine and Food Magazine.

Interior Design.

Dedicated to the international art of creative living. Focus is on decorating, architecture and design, and gardening. Includes a
"Product Information and Advertiser Service Directory." Since 1948 also issued in a British edition. Articles profile archi-
tects, designers, historical places and current design ideas.
Reviews: book. Freelance work: yes (details in *ArtMkt.*). Indexed: ArchPI. Avery. BioI. CloTAI. Des&ApAI. RG. Search. Re-
viewed: Katz.
Advertising: mainly color. Inserts. Readers Service card. Susan Rerat, Ad. Director. Circulation: 500,000.

HOUSE BEAUTIFUL. 1896. m. EN. 2499

Hearst Corporation, 1700 Broadway, New York, NY 10019. Phone 212–903–500. Louis Oliver Group, Editor–in–chief, Mar-
garet Kennedy, Editor.

Subscription: $17.97 US, Canada & foreign + $16 (House Beautiful, P.O. Box 7174, Red Oak, IA 51591–2172). Microform available from UMI. Illus. mainly color, photos, plans.
ISSN: 0018–6422. OCLC: 1752321. LC: NA7100.H65. Dewey: 729.
Architecture. Design. Landscape Architecture.

4–6 articles on "Design and Architecture", plus 2–3 specifically on retail design. Regular features include "Role Model", "Your Collectibles", question and answers, and "Product Information". Presents practical money–saving ideas for home–decorating–furniture– and furniture arrangement, new kitchen elegance, and landscaping.
Reviews: book. Indexed: Avery. RG. Reviewed: Katz.
Advertising: rates upon request. Readers service card. Jeffrey Burch, Ad. Director.

LUXURY HOMES OF WASHINGTON. 1988. 3/yr. EN. 2500
Regardie's, 1010 Wisconsin Ave., NW, Suite 600, Washington, DC 20007. Phone 202–342–0410, Fax 202–342–0515. Michael Pretzer, Editor.
Subscription: $3/issue. Sample free. Back issues $3. Illus. b&w, color, photos, cartoons. 8½ x 11, 125p. offset, perfect binding.
ISSN: 0279–5965.
Antiques. Architecture. Collectibles. Decorative Arts. Furniture. Interior Design. Landscape Architecture. Photography. Textiles.

Home and garden magazine covering the metropolitan Washington area. Features regional reports on a particular county in Maryland or Virginia. The Autumn issue includes residential landscape awards.
Freelance work: yes. Contact: Cindy Jaffe.
Advertising: (rate card Sept '89): b&w full page $4510, ½ page $3220–3970, ⅙ page $1140, spread $8110; 2 color + $650–750; 4 color full page $5805, ½ page $4510–4780, covers $8170–9130. Guaranteed positions + 15% frequency discount. 15% agency discount. 2% cash discount. Bleed 10%. Inserts. Demographics: readership profile: 45 yrs. average; average household income $167,300, homes average $472,997; personal investment portfolio: value $942,900 average, collectibles/art 26%; pass–along rate 2.6 additional readers/issue. Circulation: 65,000. Audience: higher income Washington metropolitan residents.

METROPOLITAN HOME: Style for Our Generation. 1969. m. EN. 2501
Meredith Corporation, Special Interest Publications, 1716 Locust St., Des Moines, IA 50336. Phone 515–284–3000. Dorothy Kalins, Editor.
Subscription: $18. Microform available from UMI. Illus. photos. 9 x 10⅞.
ISSN: 0273–2858. OCLC: 7045895. LC: NK1700.A57. Dewey: 747. Incorporates *Apartment Life*; Apartment Ideas.
Architecture. Interior Design.

An idea guide, a magazine of contemporary home decorating, furnishings, renovation, architecture, and design. Contains practical ideas for the home: "before–and–after" renovation projects, coverage of the latest styles, products, materials and ideas. Also, tips on colors, fabrics, lighting and accessories, and antiques and collectibles. Each issue contains a listing of product sources.
Interviews with trend–setting designers. Indexed: Avery. Search. Reviewed: Katz.
Advertising. Circulation: 700,000+. Audience: affluent homeowners.

NORTHERN CALIFORNIA HOME & GARDEN. 1987. m. EN. 2502
Peninsula Magazine, Inc., 2317 Broadway, Suite 330, Redwood City, CA 94063. Phone 408–998–3177. Rachael Grossman, Editor.
Sample $2. Illus.
ISSN: 0898–1191. OCLC: 17739479. Dewey: 747.
Architecture. Interior Design. Landscape Architecture.

Focus is on design in architecture, interior design, landscaping, and gardens.
Freelance work: yes (details in *ArtMkt.*).
Advertising. Circulation: 50,000.

PHOENIX HOME/GARDEN. 1980. m. EN. 2503
PHG, Inc., 3136 N. Third Ave., Phoenix, AZ 85067. Phone 602–234–0840. Manya Winsted, Editor.
Illus. b&w, color.
ISSN: 0270–9341. OCLC: 6542756. LC: TX311.P48. Dewey: 640.
Interior Design.

Covers interior design, architecture, gardening, landscaping, and art with focus on the home.

Reviews: book. Freelance work: yes (details in *ArtMkt.*). Reviewed: Katz.
Advertising. Circulation: 35,000. Audience: affluent.

SAN ANTONIO HOMES & GARDENS. 1985. m. EN. 2504

Duena Development Corporation, 900 West Ave., Austin, TX 78701. Phone 512–479–8936. June W. Hayes, Editor.
ISSN: 0893–2697. OCLC: 15481197. Dewey: 747.

Architecture. Interior Design.

Upscale regional magazine featuring architecture, interior design, food, fitness, fashion and local events.

SAN DIEGO HOME/GARDEN: How We Live. 1979. m. EN. 2505

Westward Communications, 445 "G" St., San Diego, CA 92101. Phone 619–233–4567. Peter Jensen, Editor.
Subscription: $16. Index in Dec issue. 8½ x 11, 150p.
ISSN: 0274–483X. OCLC: 6346713. LC: TX1.S245. Dewey: 640.

Antiques. Architecture. Ceramics. Crafts. Decorative Arts. Furniture. Historic Preservation. Interior Design. Landscape Architecture.

A consumer magazine directed at the well–educated homeowner.
Biographies: focus on one San Diego artist or art institution per issue. Listings: regional. Calendar of events. Exhibition information. Freelance work: yes, local. Contact: Gretchen Pelletier. Reviewed: Katz.
Advertising: rates available on request. Circulation: 40,000. Audience: homeowners.

SELECT HOMES & FOOD: Canada's Magazine for Better Living at Home. 1982. 8/yr. EN. 2506

Telemedia Publishing, Inc., 50 Holly St., Toronto, Ontario M4S 3B3 Canada. Phone 416–482–8600. Diane McDongall, Editor.
Subscription: $16.95 Canada, $25 US & foreign (797 Don Mills Rd., 13th Floor, Don Mills, Ontario, phone 696–1170). Sample. Back issues $3.50. Illus. b&w, some color, photos. 100p.
ISSN: 0713–8076. OCLC: 9096505. LC: NA7100. Dewey: 747.05. Formed by the merger of: *Canadian Living's Food*, and *Select Homes* which had absorbed *1001 Decorating Ideas* and *Cottage Country; Home Design and Decor.*

Architecture. Decorative Arts. Fabrics. Furniture. Interior Design. Landscape Architecture. Textiles.

Full color coverage of home decor and architecture. Each issue contains Canadian home profiles, decorating tips, gardening and landscaping advice, house plans, and family/lifestyle features. Published for people who place a high value on the time they spend at home, Canadian homeowners looking to improve their living spaces, inside and out.
Reviews: exhibition 2 times/yr, length 2p; book 4, length 100 wds. each; equipment 10, length 100–1000 wds. Interviews: home–owners, architects interior designers, artists, etc. Listings: regional–national. Calendar of events. Information on exhibitions – home shows. Freelance work: yes. Contact: editor. Opportunities: competitions, design contest.
Advertising: (rate card Feb '90): b&w full page $6920, ½ page $4670–5540 cover $9650–11,310; 4 color full page $8650, ½ page $5800–6925, covers $9945–11,660. Regional rates available for Ontario or Western region. Special position + 15%. Frequency discount. Bleed no charge. Inserts. David Titcombe, Ad. Director (2300 Yonge St., Suite 401, Toronto M4P 3C4, phone 416–8260, fax 416–482–1239). Demographics: 67% 25–49 yrs. old, 79% of readers own home, 57% $35,000+ household income, 76% married, 56% children under 18, 83% high school graduate +. Circulation: 150,000. Audience: homeowners, age 25–45.

SOUTHERN ACCENTS: The Magazine of Fine Southern Interiors and Gardens.
1977. 10/yr. EN. 2507

Southern Accents, Inc., 2100 Lakeshore Drive, Birmingham, AL 35209. Phone 205–877–6000. Karen Phillips Irons, Editor.
Subscription: $24.95 US, $40 foreign. Microform available from UMI. Sample. Illus. color, photos (200/issue). 8½ x 11, 144–164p.
ISSN: 0149–516X. OCLC: 3496530. LC: NK2002.S68. Dewey: 747.

Antiques. Architecture. Collectibles. Furniture. Historic Preservation. Interior Design.

America's most affluent regional magazine. Blending of features reflecting the South's affluent lifestyle. Each issue showcases the South's best designed homes; introduces readers to the region's most noteworthy artists and craftsmen; and depicts a lifestyle. Includes antiques, art, architecture, interior design, gardens, collections, and restoration.
Freelance work: yes (details in *ArtMkt.* and in *PhMkt.*). Indexed: Avery. Reviewed: Katz.
Advertising: Anthony P. Glaves, Ad. Director Eastern (405 Lexington Ave., New York, NY 10017, phone 212–986–9010). Demographics: readers median net worth $740,000. Circulation: 500,000.

VICTORIAN HOMES. 1982. 5/yr. EN.

2508

Renovator's Supply, Renovator's Old Mill, Millers Falls, MA 01349. Phone 413–659–3785. Carolyn Flanerty, Editor (550 7th St., Brooklyn, NY 11215).

Subscription: $15 US, $18 Canada, foreign + $3. Sample free. Back issues $4 each, $40 for all available. Illus. b&w, color, photos. 7¾ x 10⅞, 96p. Web offset. Saddle–stitched.

ISSN: 0744–415X. OCLC: 8256866. LC: NK2115.5.V53 V52. Dewey: 747.213.

General – Victorian era. Architecture. Decorative Arts. Interior Design.

Focuses on architecture and decorative arts of the Victorian era with 4–5 features per issue. Dedicated to enriching the lifestyle of those living in homes or apartments built from 1840 to 1930. Each issue features a historic Victorian or turn–of–the–century house, to provide decorating inspiration for readers. Features homes lived in by people who have renovated and decorated it themselves, complete with decorating ideas and how–to instructions. Each issue contains articles on some facet of Victorian decoration or on renovation of a single room. Regular editorial covers a full range of reader interest, including Victorian gardens, furniture, collectibles, crafts, care of antique clothing and fabrics, ands books of the era.

Reviews: exhibition 6, length 100 wds.; book 4, length 250 wds. Biographies: on leading architects, writers or leaders in the field of decorative arts in the 19th century. Listings: national. Calendar of events. Exhibition information. Freelance work: yes. Contact: editor. Opportunities: study, competitions. Indexed: Avery. Reviewed: Katz.

Advertising: (rate card Win '89): b&w full page $1585, ½ page $945; 4 color full page $2160, ½ page $1360; covers $2270–2810. No classified. Frequency discount. 15% agency discount. Mail order advertisers 10% discount. Inserts. Donna Jeanlozor & Larissa Daigle, Ad. Directors. Mailing lists: available. Demographics: (readers survey Dec, 1988): 70% female; total readership 2.6 persons/copy; 43 average age; 80% college educated; average income $75,800; 91% owned home, average value $181,000; 49% lived in a home of the Victorian era; 81% plan to repair or redecorate within 12 months; 82% have responded to an ad in *Victorian Homes*; 75% have purchased by mail order. Circulation: 120,000 (P.O. Box 61, Millers Falls, MA 01349). Audience: Victorian era homeowners or students of the period.

VOGUE LIVING. 1967. 10/yr. EN.

2509

Bernard Leser Publications Pty. Ltd., 170 Pacific Highway, Greenwich, N.S.W. 2065, Australia. Phone 02–964–3888, fax 02–964–3882, telex AA72201. Robyn Holt, Editor.

Subscription: $A51, air $A203 US & Canada. No sample. Back issues. 22 x 28.6 cm. Web offset.

ISSN: 0042–8035. Dewey: 747. Formerly: *Vogue's Guide to Living.*

Interior Design.

Each issue focuses on a theme and includes coverage of decoration, design, architecture, antiques, interiors, artists, people, and gardens.

Reviewed: Katz.

Advertising: (rate card Feb '90): b&w full page $A3000, ½ page $1800, ¼ page $1050; 4 color full page $A4500, ½ page $3200, ¼ page $1850, covers $A5100–5300. Frequency discount. 10% agency discount. Stephanie Goodmanson, National Ad. Manager. Demographics: readers are conspicuous consumers of everything to do with living in style, affluent and open-handed. Circulation: 51,370.

WASHINGTON HOME & GARDEN. 1990. q. EN.

2510

Regardie's Inc., 1010 Wisconsin Ave., N.W., Suite 600, Washington, DC 20007. Phone 202–342–0410, fax 202–343–0515. William Regardie, Editor.

Illus.

ISSN: 1047–577X. OCLC: 20720367. Dewey: 640.

Architecture. Interior Design.

Covers luxury homes in the Washington area.

Advertising. Audience: affluent Washington home owners and home buyers.

Landscape Architecture

ANTHOS: Garten– und Landschaftsgestaltung. 1962. q. GE, FR & EN for all articles.

2511

Graf und Neuhaus A.G., Moehrlistr. 69, CH–8033 Zurich, Switzerland. H. Mathys, Editor.

Subscription: SFr 52 individual, SFr 23.50 student Europe; SFr 58 individual, SFr 26 student US and other overseas (Abonnementsdienst Postfach 205, CH–8003 Zurich, Switzerland). Illus. b&w, plans, drawings. 8½ x 11, 56–60p.

ISSN: 0003–5424. OCLC: 1811443. Dewey: 712.

Landscape Architecture.

Tri–lingual periodical for landscape architecture and landscape planning. Official organ of International Federation of Landscape Architects. Presents specialists with information that readers can integrate immediately into their daily work. Articles with references.

Reviews: book (appears in one language only). Calendar of events. Indexed: ArchPI. Avery. Reviewed: Katz. Advertising.

BROOKGREEN JOURNAL. 1971. q. EN. 2512

Brookgreen Gardens, U.S. Hwy. 17 S., Murrells Inlet, SC 29576. Phone 803–237–4218. Robin Salmon, Editor.
Subscription: included in membership together with *Brookgreen Newsletter*, $25 individual, family $35. Sample. Back issues. Illus. b&w, photos. 8½ x 11, 8–16p.
ISSN: 0884–8815. OCLC: 12494143. Dewey: 730. Formerly: *Brookgreen Bulletin*.

Art Education. Art History. Landscape Architecture. Sculpture. Horticulture. Botany. Zoology. American History.

Supports the purposes and programs of one of the leading garden museums in the Southeast whose collection of American figurative sculpture is the largest permanent outdoor exhibit in the country. Articles pertain to the collections of sculpture, plants and animals, aspects of the physical property and its history, tributes and memorials to outstanding supporters, information on landscape design and horticulture techniques, information on the founders and the gardens' development.

Bibliographies: occasionally to support articles. Interviews: sculptors, trustees and staff. Biographies: sculptors, trustees, advisors. Obits. Freelance work: occasionally. Contact: editor.

Advertising: none. Circulation: 3500. Audience: Brookgreen members, Brookgreen Cooperators (museums, botanical gardens, zoos, historical organizations).

BROOKGREEN NEWSLETTER. q. EN. 2513

Brookgreen Gardens, U.S. Hwy. 17 S., Murrells Inlet, SC 29576. Phone 803–237–4218. Robin Salmon, Editor.
Subscription: included in membership, $25 individual, family $35 together with *Brookgreen Journal*. Sample free. Back issues free. Illus. b&w, photos. 8½ x 11, 8p.
OCLC: 20339261. Dewey: 730.

Art Education. Art History. Landscape Architecture. Sculpture. Horticulture. Botany. Zoology. American History.

Includes articles pertaining to the current and future events at Brookgreen Gardens; items of interest pertaining to the collections of sculpture, plants and animals; news items pertaining to trustees, advisors, volunteers, staff, awards, honors, grants, etc.; current listings of new members, donors, matching gifts, etc.

Reviews: book 1. Biographies: volunteer and staff profiles. Obits. Calendar of Brookgreen events. Exhibition information. Freelance work: none. Opportunities: study.

Advertising: none. Circulation: 3500. Audience: Brookgreen members, Brookgreen Cooperators (museums, botanical gardens, zoos, historical organizations).

THE CATALOG OF LANDSCAPE RECORDS IN THE UNITED STATES. NEWSLETTER.
1987. q. EN. 2514

Catalog of Landscape Records in the U.S., Wave Hill, 675 West 252nd St., Bronx, NY 10471.
ISSN: 1046–2627. OCLC: 17912324. Dewey: 712.

Landscape Architecture.

"The Catalog and its Newsletter are projects of the American Garden and Landscape History Program at Wave Hill".

FINE GARDENING. 1988. bi–m. EN. 2515

The Taunton Press, 63 South Main St., Box 355, Newtown, CT 06470. Phone 203–426–8171. Roger Holmes, Editor.
Subscription: $22 US, $27 Canada & foreign, + $14.40 air. Sample $3.95. Back issues $5. Illus. b&w, color, photos. Annual index in May/June issue. 85p. Web offset, perfect bound.
ISSN: 0896–6281. OCLC: 17223836. Dewey: 635.

Gardening. Landscaping.

Experienced gardeners take readers into their gardens to show how they've worked their magic. The magazine covers fundamentals and practical design ideas as well as how to care for specific plants, build garden structures, etc. Each issue has full–color photographs and concise, accurate drawings.

Reviews: book 3–5, length 200–1000 wds. Listings: state. Calendar of events. Exhibition information. Freelance work: none. Opportunities: study.

Advertising: (rate card Jl/Aug '89): b&w full page $3000, ½ page $1670, ¼ page $885, cover $3300; color full page $4020, ½ page $2240, ¼ page $1185, cover $4420. Classified: $3/wd., min. 15 wds. Frequency discount. 15% discount for camera–

ready art. Roy Swanson, Ad. Director. (1–800–243–7252). Mailing lists: available. Demographics: 42 yrs. old, 60/40 female/male. Circulation: 100,000. Audience: home gardeners.

GARDEN DESIGN: The Fine Art of Residential Landscape Architecture. 1982. q. EN. 2516

American Society of Landscape Architects, 4401 Connecticut Ave., NW, Suite 500, Washington, DC 20008–2302. Phone 202–686–2752, fax 202–686–1001. Karen D. Fishler, Editor.
Subscription: $20 US, foreign $25 (PO Box 55455, Boulder, CO 80321–5455). Sample $5. Illus. color, photos (80/issue), plans. 8½ x 10¾, 96p.
ISSN: 0733–4923. OCLC: 8610163. LC: SB469.G27. Dewey: 712.
Landscape Architecture.

Contents include site plans, garden news, design details, gardens abroad, modern small scale gardens, plant features, and lavish full color photographs. Both garden history and trends are gathered.
Reviews: book. Freelance work: yes (details in *PhMkt.*). Contact: editor. Indexed: Avery. Reviewed: Katz.
Advertising b&w & color. Maureen W. McNamara, Ad. Director. Audience: landscape architects, architects, gardeners, home owners.

GARDEN HISTORY. 1972. s–a. EN. 2517

Garden History Society, c/o Secretary, 5 The Knoll, Hereford HR1 IRU, England. Phone 0432 354479. Jane Krawley & Elizabeth Whittle, Editors.
Subscription: included in membership. Illus. b&w, photos, drawings. 7¼ x 10½, 106p.
ISSN: 0307–1243. OCLC: 1795341. LC: SB451.G34. Dewey: 635.9. Formerly: *Occasional Paper; Garden History Society Newsletter.*
Landscape Architecture.

The journal of the Society whose purpose is to promote study into the history of all areas of gardening and horticulture and to protect historical gardens. Seeks to bring together those interested in its various aspects—garden and landscape design and their relation to architecture, art, literature, philosophy and society, and other related subjects. Scholarly articles related to the United Kingdom, Ireland and Australia.
Bibliographies with articles. Freelance work: yes. Contact: editor. Payment 20 free offprints. Indexed: ArchPI. Avery. BrArchAb. RILA.

GARTEN UND LANDSCHAFT. 1890. m. GE. GE & EN table of contents. 2518

Verlag Georg D.W. Callwey, Postfach 800409, Streitfeldstrasse 35, 8000 Munich 80, W. Germany. Phone 089–433096, fax 43607–29.
Subscription: DM 114. Illus.
ISSN: 0016–4720. OCLC: 1570441. LC: NP2.G24.
Landscape Architecture.

Journal of landscape architecture and landscape planning.
Indexed: Avery.

HORTUS: A Gardening Journal. 1987. q. EN. 2519

The Neuadd, Rhayader, Powys LD6 5HH, Wales. Phone 0597–810227. David Wheeler, Editor & Pub.
Illus.
ISSN: 0950–1657. OCLC: 15720918. LC: SB450.9.H6. Dewey: 635.
Landscape Architecture.

Privately published journal devoted to the decorative aspects of horticulture. Covers history, design and ornament, plants, books and people.
Reviews: book.
Advertising.

IFLA NEWS. EN. 2520

International Federation of Landscape Architects, 4, rue Hardy F–78009 Versailles Cedex, France. Phone 1 30211315.
Illus.
OCLC: 20153698.
Landscape Architecture.

Promotes the worldwide growth of the landscaping profession and seeks to foster high standards of quality in design, planning, development and conversation within the field.

JOURNAL OF GARDEN HISTORY. 1981. q. EN & FR. 2521

Taylor & Francis Ltd., 4 John St., London WC1N 2ET, England. Phone 0256 840366. (US Dist.: Publications Expediting Inc., 200 Meacham Ave., Elmont, NY 11003). John Dixon Hunt, Editor (Dunbarton Oaks, Trustees for Harvard University, 1703 32nd St., N.W., Washington, DC 20007).

Subscription: £75, $135 (US, Canada & Mexico: Taylor & Francis Inc., 1900 Frost Rd., Suite 101, Bristol, PA 19007). Microform available from UMI. Illus. b&w, photos, plans. 11 x 8½, 86p.

ISSN: 0144–5170. OCLC: 7132577. LC: SB451.J76. Dewey: 712.

Landscape Architecture.

An international multi–disciplinary approach to garden history. Main emphasis on documentation of individual gardens in all parts of the world and conservation and restoration of historic gardens. Also includes articles on other relevant topics — iconography, aesthetics, botany and horticulture, conservation and restoration of historic gardens, etc.

Freelance work: yes, 50 offprints. Contact: editor. Indexed: AmH&L. ArchPI. ArtBibMod. ArtHum. ArtI. Avery. BrArchAb. BrHumI. CloTAI. CurCont. HistAb. RILA.

Advertising (phone Basingstoke 0256–840366 or New York 212–725–1990).

LA: LANDSCHAFTSARCHITEKTUR. GE. GE, EN & RU table of contents. 2522

Verlag und Redaktion, Reinhardtstrasse 14, Berlin 1040, Berlin 19 Germany.

Subscription: M 2.50. Illus. b&w, photos. A4, 32p.

Formerly: *Deutsche Gartenarchitektur.*

Landscape Architecture.

LANDSCAPE (South Africa). bi–m. 2523

Phase Four (Pty) Ltd., P.O. Box 784279, Sandton 2146, South Africa.

Dewey: 712.

Landscape Architecture.

Covers a broad range of subjects relating to the landscape planning professions. Includes information on projects and new products.

Interviews.

LANDSCAPE (U.S.). 1951. 3/yr. EN. 2524

Landscape, Inc., P.O. Box 7107, Berkeley, CA 94707. Phone 415–549–3233. Blair Boyd, Editor.

Subscription: $22 individual, $42 institution, $18 student, world surface; air + postage. Microform available from UMI. Sample & back issues $6.95. Illus., photos, maps. 8½ x 11, 48p.

ISSN: 0023–8023. OCLC: 1589006. LC: G1.L2. Dewey: 712.

Architecture. Historic Preservation. Landscape Architecture.

Presents topics from a social, historical and contemporary perspective. Coverage includes landscape architecture, architecture, planning, architectural and landscape history, and cultural geography.

Reviews: book 2–4, length 1–2p. Indexed: AmH&L. CurCont. HistAb.

Advertising: none. Circulation: 3000.

LANDSCAPE & GARDEN CONTRACTOR. 1987. bi–m. EN. 2525

Peter Neale & Associates, Maltravers House, 28 London Rd., Cheltenham, Glos. GL52 6DX, England. Phone 0242 518141. Brent Krefield, Editor.

Subscription: free.

Dewey: 712.

Landscape Architecture.

Published for the Landscape Industry International.

LANDSCAPE ARCHITECTURAL REVIEW: Revue d'Architecture de Paysage. 2526
1980. 5/yr. EN & FR.

Z.P. Communications Inc., 250 Adelaide Str. West, Toronto, Ontario M5H 1X6, Canada. Phone 416–596–0211. Nick Van Vliet, Editor.

Subscription: $C20 Canada, $20 US (24 Kensington Ave., Willowdale, Ontario M2M 1R6). Illus.

ISSN: 0228–6963. OCLC: 7857879. LC: TS190.5. Dewey: 712.

Landscape Architecture.

Reviews: book. Indexed: RILA.
Advertising.

LANDSCAPE ARCHITECTURE. 1910. 10/yr. EN.

2527

American Society of Landscape Architects, Publication Board, 4401 Connecticut Ave., N.W., 5th Floor, Washington, DC 20008–2302. Phone 202–686–2752. James G. Trulove, Editor.

Subscription: $38. Sample $4. Illus. b&w, color cover only, photos (50–75/issue). Annual index. 8½ x 11¾, 80p.
ISSN: 0023–8031. OCLC: 1755527. LC: SB469.L3. Dewey: 712.

Landscape Architecture.

Features landscape architecture, urban design, parks and recreation, architecture, and sculpture. Includes an international section.

Reviews: book. Freelance work: yes (details in *PhMkt*.). Indexed: ArchPI. ArtHum. ArtI. Avery. BioI. CurCont. Reviewed: Katz. *Library Journal* 114:18, Nov 1, 1989, p.420.

Advertising. Circulation: 18,000. Audience: planners and designers.

LANDSCAPE ARCHITECTURE NEWS DIGEST. 1959. 10/yr, combined July/Aug &

Dec/Jan issues. EN.

2528

American Society of Landscape Architects, 4401 Connecticut Ave., N.W., 5th Floor, Washington, DC 20008–2302. Phone 202–466–7730. Sharon B. Nazari, Editor.

Subscription: included in membership, $12.50 schools & libraries, $19 others US, foreign + $3.50. Microform available from UMI. Sample. Back issues. Illus. b&w, photos. 8½ x 11, 16p.
ISSN: 0023–754X. OCLC: 15812040. LC: SB469.L27. Dewey: 712. Formerly: *LAND—Landscape Architectural News Digest*.

General. Architecture. Art Education. Art History. Historic Preservation. Landscape Architecture.

Reports news pertinent to members and interested parties connected with the Society. Legislative issues and news affecting the field in general are also covered. "People and Places" section notes member honors received.

Reviews: book 2–3, length 1 paragraph each. Listings: national–international. Calendar of events. Freelance work: none. Opportunities: employment; study included in calendar.

Advertising: Classified: (employment) $1.50/wd., first 100 wds., $3/wd. add., $50 min. Circulation: 12,500. Audience: landscape architects.

LANDSCAPE AUSTRALIA. 1979. q. EN.

2529

Landscape Publications, 17 Carlyle Crescent, Mont Albert, Victoria 3127, Australia. Phone 03–890–5764, Fax 03–899–6789. Ralph P. Neale, Editor.

Subscription: $A29 Australia, $A40 elsewhere. No Sample. Back issues $A5. Illus. Index in Nov issue. Cum. index, v.1–10, 1979–1988, $A12. A4, offset.
ISSN: 0310–9011. OCLC: 6578502. Dewey: 712.

Landscape Architecture.

Covers landscape architecture, land use planning, urban design and landscape construction both within Australia and overseas. Details current projects and professional offices active in practice, conveys the rapid expansion in the landscape field and serves as a means of promotion for landscape professionals, clients, government departments, councils, contractors, allied suppliers and nurseries. Provides information about design of open space in all its aspect.
Indexed: ArchPI.

Advertising: Australian advertisers only. (rate card Jan '89): full page SA665, ½ page $A400, ¼ page SA230; 4 color full page $A1085, ½ page $A400. Frequency discount. 10% agency discount. Demographics: all landscape architects & everyone of any consequence in landscape development whether in design, construction or management. Circulation: 3,300. Audience: landscape architects.

LANDSCAPE DESIGN. 1971. 10/yr. EN.

2530

Landscape Design Trust, 5a West St., Reigate, Surrey RH2 9BL, England. Phone 0737–223144, fax 0737–224206. Ken Fieldhouse, Editor.

Subscription: includes *Landscape News*, $45.64 US & Canada, £21.50 UK, £26 Europe; Hong Kong, Australia & New Zealand £34; all others £29 (12 Carlton House Terrace, London SW1Y 5AH phone 01–839–4044). Illus. b&w, color, photos, plans, charts. Annual index. A4, 64p.
ISSN: 0020–2908. OCLC: 1606022. LC: SB469.L33. Dewey: 712. Formerly: *Journal of the Institute of Landscape Architects*.

Landscape Architecture.

Journal of the Institute contains feature articles, regular columns, and news notes. An index of practices, products and services is provided.

Reviews: book 4, length¼p. Bibliographies: checklist of articles appearing in recent journals. References with articles. Listings: national–international. Calendar of events. Opportunities: employment. Indexed: ArchPI. Avery.

Advertising: Ad. Director (Landscaping Publishing House, Northside House, Tweedy Rd., Bromley, Kent BR1 3WA, phone 081–290–6666, fax 290–0205).

LANDSCAPE HISTORY. 1979. a. EN. 2531

Society for Landscape Studies, c/o Dr. D. Hooke, School of Geography, University of Birmingham, P.O. Box 363, Birmingham B15 2TT, England. Dr. Della Hooke, Editor.

Subscription: included in membership, foreign £12 surface. Sample £12. Back issues. Illus. b&w, photos. A4, 100p.
ISSN: 0143–3768. OCLC: 7122596. LC: GF101.L35. Dewey: 333.73.

Archaeology. Historic Preservation. Landscape Architecture.

Multi–disciplinary studies of landscape, all periods, mostly British but usually one paper in six beyond Britain.
Reviews: book 20. Indexed: ArchPI. BrArchAb. HistAb.
Circulation: 600. Audience: academic and amateur.

LANDSCAPE INDUSTRY INTERNATIONAL. 1982. bi–m. EN. 2532

Peter Neale & Associates, Maltravers House, 28 London Rd., Cheltenham, Glos. GL52 6DX, England. Phone 0242 518141. Johanna Saffari, Editor.

Subscription: £40.
ISSN: 0266–9455. Dewey: 712.

Landscape Architecture.

Covers the entire field of gardens and landscape design.
Reviews: book.
Advertising.

LANDSCAPE ISSUES. 1984. s–a. EN. Tr. provided. 2533

School of Landscape Architecture, Gloucestershire College of Arts & Technology, Oxstalls Lane, Gloucester GL2 9HW, England. Phone 0452–426771. Robert J. Moore, Editor.

Subscription: £5. Sample free. Back issues £2.50. Illus. b&w, photos. Cum. index in v.5, no.2. A5, 50p.
ISSN: 0265–9786. Dewey: 720.

Architecture. Drawing. Historic Preservation. Landscape Architecture.

Reviews: book 3, length 500 wds. Freelance work: yes. Opportunities: competitions.
Advertising: none. Demographics: mainly libraries and environmental agencies in UK, but also in Germany, US, and Hungary. Audience: landscape architects, environmental planners.

LANDSCAPE JOURNAL: Design, Planning, and Management of the Land. 1981. s–a. EN. 2534

University of Wisconsin Press, Journal Division, 114 N. Murray St., Madison, WI 53715. Phone 608–262–4952. Robert Riley (Dept. of Landscape Architecture, University of Illinois, Urbana, IL 61801) & Arnold Alanen, Editors.

Subscription: $19 individual, $45 institution, US, Canada & Mexico; foreign + $8, + $11 air. Microform available from UMI. Back issues. Illus. b&w, photos. 8½ x 11, 60p.
ISSN: 0277–2426. OCLC: 7534225. LC: SB469.L35. Dewey: 333.73.

Landscape Architecture.

Dedicated to the dissemination of the results of academic research and scholarly investigation of interest to practitioners, academics, and students of landscape architecture. Explores a variety of topics related to design, planning and management. Reports results of research and scholarly investigation. Typical subject areas include: visual quality assessment, human behavior and the environment, historic and cultural landscape preservation and management, landscape history, planting design, vegetation management, landscape restoration and reclamation, landscape information systems and landscape–related energy concerns. Tables and statistics are presented.

Reviews: book 8, length 9p. Freelance work: yes. Contact: editor. Indexed: ArchPI. Avery. Reviewed: Katz.
Advertising.

LANDSCAPE RESEARCH. 1968. 3/yr. EN. 2535

Landscape Research Group Ltd., Leuric, North Road, South Kilworth, Lutterworth, Leics. LE17 6DU, England. Phone 085–881–530 (Sec. Mrs. Carys Swanwick). Dr. P. J. Howard, Editor (Kerswell House, South Broadclyst, Exeter EX5 3AF, phone 0392 61390).

Subscription: included in membership together with newsletter *Landscape Research Extra*, £15 individual, £20 corporate UK; overseas individuals £34, institutions £40 (Mrs. Carys Swanwick, Sec.). Sample £5. Back issues pre 1987 £3.50, 1987 and after £5. Illus. b&w, photos, cartoons. Cum. index v.1–13. A4 32p.

ISSN: 0142–6397. OCLC: 4266219. Dewey: 712. Formerly: *Landscape Research News*.

Architecture. Landscape Architecture.

Interdisciplinary and international, specializing in work from one discipline that needs dissemination to others. Purpose of the Group is to promote the study of landscape and interest in landscape research and the human environment. Not an "arts" periodical per se but publishes such material as well as science, planning, and social sciences. *Landscape Research Extra*, a supplement, includes landscape news, a diary of events, and conference reports. The main means of communication between members of the group. Offers the opportunity for those involved in different fields of interest to publish their work.

Reviews: exhibition 1–2, length 500 wds.; book 6–8, length 250–1000 wds.; journal occasionally. Bibliographies: with each of 6 articles per issue. Listings: national–international. Freelance work: yes. Contact: editor. Opportunities: study.

Advertising: full page £100, ½ page £50, ¼ page £25, no color. No classified. Frequency discount. Inserts. Mailing lists: none. Demographics: 50% libraries in UK, most with an academic interest in landscape studies. Circulation: 550. Audience: academics and practitioners.

LANDSCAPE RESEARCH EXTRA. 3/yr. EN. 2536

Landscape Research Group, North Rd., South Kilworth, Lutterworth, Leics. LE17 6DU, England. Phone 858 575530.

Landscape Architecture.

LANDSCAPE SOUTHERN AFRICA. 1986. bi–m. 2537

Phase Four (Pty) Ltd., P.O. Box 784279, Sandton 2146, South Africa. Phone 011–804–1566. Caroline Windeler, Editor.

Subscription: R30.

Dewey: 712.

A publication of the Institute of Landscape Architects of South Africa. Presents articles on landscape planning and projects.

LANDSCHAFT UND STADT. 1969. q. GE. EN & GE summaries. 2538

Verlag Eugen Ulmer, Wollgrasweg 41, Postfach 700561, 7000 Stuttgart 70, W. Germany. Phone (0711)4507–0. U. Schlueter, Editor.

Subscription: DM 98.40. Illus.

ISSN: 0023–8058. OCLC: 3136832. LC: QH77.G3B442. Dewey: 712. Formerly: *Beitraege zur Landespflege*.

Landscape Architecture.

Indexed: ArtArTeAb.

LANDSKAB: Tidsskrift for Planlaening af have of Landskab. 1981. 8/yr. DA. EN summaries. 2539

Arkitektens Forlag, Nyhavn 43, DK–1051 Copenhagen K, Denmark. Annemarie Lund, Editor.

Subscription: Kr 430. Microform available from UMI. Illus. photos.

ISSN: 0023–8066. OCLC: 7525367. Dewey: 712.05. Formerly: *Landskap; Havekunst*.

Landscape Architecture.

Review for garden and landscape planning published for the Association of Danish Landscape Architects.

Indexed: ArchPI. Avery. CloTAI.

Advertising.

NLA LANDSCAPE NEWS. bi–m. EN. 2540

National Landscape Association, 1250 I St., N.W., Suite 500, Washington, DC 20005. Phone 202–789–2900. David L. Peiffer, Editor.

Subscription: included in membership only. Illus. b&w, photos. 8½ x 11, 8p.

Formerly: *News Notes; Tech Notes*.

Landscape Architecture.

Listings: national. Freelance work: none. Opportunities: competitions, annual national residential landscape awards program. Advertising: none.

PARKS AND GROUNDS: The Technical Magazine for Landscape Design, Construction and Maintenance. 1977. bi–m. EN. **2541**

Avonwold Publishing Co., Box 52068, Saxonwold 2132, South Africa. Phone 011–788–1610. Christine Michelson, Editor. Subscription: R 31 South Africa, R 37 overseas. Sample free. Back issues R 7. Illus. b&w, color, photos. A4, 160p. ISSN: 0261–2399. OCLC: 5811580. LC: SB469.P3. Dewey: 712.

Landscape Architecture. Horticulture.

Advertising: full page R 890, ½ page R 570, ¼ page R 360, color + R 360. No classified. 15% frequency discount. E.T. Braby, Ad. Director. Mailing lists: none. Circulation: 4500. Audience: landscapers, horticulturalists, parks departments, sports clubs, etc.

POLLEN. See no. 2328.

REVIEW OF ARCHITECTURE AND LANDSCAPE ARCHITECTURE. 1977. irreg. EN. **2542**

c/o Irving Grossman, Alumni Association, Faculty of Architecture and Landscape Architecture, Sultan St., Toronto, Ontario M5S 1L6, Canada. Phone 416–978–2011.

Illus.

ISSN: 0705–1913. OCLC: 4589984. LC: NA1. Dewey: 720. Formerly: *After School*.

Architecture. Landscape Architecture.

596 / CANADIAN CENTRE OF PHOTOGRAPHY AND FILM. 1983. bi–m. EN. **2543**
Canadian Centre of Photography and Film, 596 Markham St., Toronto, Ontario M6G 2L8, Canada.
Illus.
ISSN: 0822–4331. OCLC: 10381562. LC: TR640. Dewey: 779. Formerly: *Focus – Canadian Centre of Photography and Film.*

ADVANCED IMAGING. 1969. 10/yr. EN. **2544**
PTN Publishing Corp., 210 Crossways Park Dr., Woodbury, NY 11797. Phone 516–496–8000.
Illus.
ISSN: 1042–0711. OCLC: 18929091. Dewey: 770. Formerly: *Tech Photo Pro Imaging Systems* formed by the union of *Technical Photography*, and *Functional Photography*.
Reviews: book.
Advertising.

AERIAL ARCHAEOLOGY. See no. 389.

AFT: Semestrale dell'Archivio Fotografico Toscano. 1985. s–a. IT. **2545**
Archivio Fotografico Toscano, Via Cairoli, 25, 50047 Prato, Italy.
Subscription: L 20000. Illus.
OCLC: 18430436.

AFTERIMAGE: Photography/Independent Film/Video/Visual Books. 1972. 10/yr. EN. **2546**
Visual Studies Workshop, 31 Prince St., Rochester, NY 14607. Phone 716–442–8676. Nathan Lyons, Editor.
Subscription: $28 individual, $32 institution. Microform available from UMI. Sample free. Back issues $3 each. Illus. Annual index. tabloid, 11 x 17, 28p.
ISSN: 0300–7472. OCLC: 1335227. LC: TR640 .A2. Dewey: 770.
Art Education. Films. Photography. Video. Book Arts.

A newspaper journal of media arts — independent photo, film, video, and publishing — with an emphasis on cultural politics and theoretical issues. It includes critical and historical features, news, and an extensive notices section.
Reviews: (per vol.) exhibitions, book, & film/video 15–20; journal 4. Interviews: with artists, cultural activists, art workers.
Listings: international. Calendar of events. Exhibition information. Freelance work: none. Opportunities: employment, study, competition. Indexed: ArtBibCur. ArtBibMod. ArtI. BioI. BkReI. RILA. Reviewed: Katz.
Advertising: free notices of exhibits, film/video, events, positions, calls for work, etc. classified style ads — submit press release. Mailing lists: available for fee. Circulation: 5000. Audience: educators, artists in photo, film, video, visual books; cultural activists.

AMATEUR PHOTOGRAPHER. 1884. w. EN. **2547**
Prospect Magazines, Reed Business Publishing Ltd., Quadrant House, The Quadrant, Sutton, Surrey SM2 5AS, England.
Phone 081–661 3500. Keith Wilson, Editor.
Subscription: £52.80, $122 US & Canada, air rates on application. (UK: Reed Business Publishing Ltd., Oakfield House, Perrymount Rd., Haywards Heath, Sussex RH16 3DH, phone 0444 441212. US dist.: Worldwide Media Services Inc., 115 E. 23rd St., New York, NY 10010). Microform available from UMI. Illus. Index. 80+p.
ISSN: 0002–6840. OCLC: 3989867. LC: TR1.A35. Dewey: 770. Formerly: *Amateur Photographer & Cinematographer.*
Articles include feature stories, articles on techniques and equipment, photo features, and news.

Reviews: equipment.

Advertising: Loretta Sales, Ad. Manager. (Prospect House, 9–13 Ewell Road, Cheam, Surrey SM1 4QQ, phone 081–661–6600) (081–661–6744).

AMERICAN PHOTO. 1978. bi–m. EN. 2548

Hachette Magazines Inc., 1633 Broadway, New York, NY 10019. Phone 212–719–6000. David Schonauer, Editor.

Subscription: $17.90 US & possessions, $23.90 elsewhere (P.O. Box 2616, Boulder, CO 80321–2616). Microform available from UMI. Illus., mainly color, photos. 9 x 10¾, 114p.

ISSN: 1046–8986. OCLC: 20553467. LC: TR1.A563. Dewey: 770. Formerly: *American Photographer (1978–1989)*.

About great photos and the people who make them. "Showcase for pictures special section" focuses on one subject. Articles contain many photographs.

Reviews: book 5, length 2p.; exhibition. Interviews: "Profile". Listings: national. Exhibition information. Opportunities: study – ads for workshops and schools. Indexed: ArtBibMod. ArtI. BioI. CloTAI. PhoMI. Photohi. Reviewed: Katz.

Advertising: b&w & color. Classified. Readers service card. Steven Aaron, Ad. Director (Sales 1–800–445–6066, in New York State, call collect 212–503–5999). Audience: people who want to get the most out of their own picture taking.

AMERICAN SOCIETY OF PHOTOGRAPHERS - NEWSLETTER. 1937. q. EN. 2549

American Society of Photographers, Inc., P.O. Box 52900, Tulsa, OK 74152. Phone 918–743–2122. Jerry L. Cornelius, Editor.

Subscription: members only. 12p.

Contains how–to– articles on photography.

Obits. Opportunities: competitions – awards information.

ANNUAL OF INDIAN PHOTOGRAPHY. 1978. a. EN. 2550

Sooriya Publishing House, 52 Thaiyappa Mudali St, V.O.C. Nagar, Madras 600001, India.

Subscription: Rs 12. Illus.

OCLC: 6428176. LC: TR1.A586. Dewey: 770.

APERTURE. 1952. q. EN. 2551

Aperture Foundation, 20 E. 23rd St., New York, NY 10010. Phone 212–505–5555, fax 212–979–7759. Charles Hagan, Editor.

Subscription: $36 US, $40 outside US. Microform available from UMI. Illus. b&w, some color, photos (60/issue). Majority of photos are ½ page or larger. 9½ x 11¼, 78p.

ISSN: 0003–6420. OCLC: 1481673. LC: TR1.A62. Dewey: 770.

Founded by Ansel Adams, Dorothea Lange, Beaumont and others. The Foundation's non–profit status provides it with the independence and integrity fundamental to its efforts to publish, without compromise, the most significant work in photography. Each issue has a theme represented by 10–12 photographic essays.

Freelance work: yes (details in *PhMkt*.). Indexed: ArtBibCur. ArtBibMod. ArtHum. ArtI. BioI. CurCont. HumI. Reviewed: Katz. *New Art Examiner* 14:11, Sum 1987, p.17–18.

Advertising: few ads at end of issue. Audience: for photographers and creative people.

APIDEA. 1970. 11/yr. EN. 2552

Associated Photographers International, P.O. Box 2½, Chatsworth, CA 91313. Phone 818–888–9270. Bert Eifer, Editor & Pub.

Subscription: included in membership.

Newsletter for the freelance photographer helps members locate markets. Covers all areas of photography and new developments in the field.

THE ARCHIVE. 1990, no.26. s–a. EN. 2553

Center for Creative Photography, University of Arizona, Tucson, AZ 85721. Phone 602–621–7968. Nancy Solomon, Editor.

Subscription: included in membership, $25 all, $18 student, air by request. No sample. Back issues. Illus. b&w, color, photos. 8½ x 11, 65p.

ISSN: 0735–5572. LC: TR640. Dewey: 779. Formerly: *Center for Creative Photography*.

Each issue is drawn from available materials taken from the extensive collection of photographs, negatives, and manuscripts in the Center's archives. The Center is a research museum devoted to 20th century photography. Has complete archives of photographers who have made significant and creative contributions to the field of art. Most issues feature an essay and a plate selection of facsimile reproductions. Supported in part by a NEA Visual Artists Forum Grant.

Biographies: of photographers whose work is in issue. Freelance work: occasionally. Contact: editor. Indexed: ArtBibMod. Advertising: none.

ARTBIBLIOGRAPHIES CURRENT TITLES. See no. 5.

ASMP BULLETIN. 1944. m. EN. 2554

American Society of Magazine Photographers, 419 Park Ave, S., Suite 1407, New York, NY 10016. Phone 212–889–9144. Terri Guttilla & Helen Canavan, Editors.
Subscription: available to members only. Illus. b&w, color, photos, cartoons. 8½ x 11, 16p.
ISSN: 0744–5784. LC: TR820.A18a. Dewey: 770.
Focus is on the legal and business aspects of the professional photographic industry. The goal of the Bulletin is to inform and educate. Includes ASMP news, member news, contest and exhibit information.
Reviews: exhibition & book 1–2 each; equipment occasionally. Biographies: autobiographical articles, personal philosophies regarding the profession/industry. Listings: national–international. Exhibition information. Opportunities: study, competitions.
Advertising: (rate card Jan '90): full page $1270, ½ page $875–955, ¼ page $580, color + $340–$370/color, 4 color + $1020, covers $1735–2040. Classified: $3.50/line members, $7 non–members. Frequency discount. 15% agency discount. Bleeds + 15%. Pattis Group/3M Jules Wartell, Ad. Representative (310 Madison Ave., No. 1804, New York, NY 10017, phone 212–953–2121). Mailing lists: requests must be in writing and mailed to ASMP National, attention Executive Director. Demographics: ASMP is an organization of more than 5,000 of the leading professional photographers in the U.S. and abroad. Its members work in every area from advertising and corporate/industrial to documentary and photojournalism in print, film, tape, and related visual media. Circulation: 5000+. Audience: ASMB members.

AUSTRALIAN CAMERA CRAFT. 1979. m. EN. 2555

Iris Publishing Co, 727 Pittwater Road, Dee Why, N.S.W. 2099, Australia. Peter Eastway, Editor.
Back issues.
ISSN: 0158–2658. Dewey: 770.

AUSTRALIA CAMERA CRAFT PHOTOGRAPHER'S HANDBOOK. a. EN. 2556

Iris Publishing Co., 727 Pittwater Rd., Dee Why, N.S.W. 2099, Australia. Phone 02–981–511. Peter Eastway, Editor.
Dewey: 770.

AUSTRALIAN PHOTOGRAPHY. 1950. m. EN. 2557

Yaffa Publishing Group, 17–21 Bellevue St., Surry Hills, N.S.W. 2010, Australia. Phone 02–218–2333.
Illus.
ISSN: 0004–9964. Dewey: 770.
Advertising.

BLIND. 1988/89. q. EN. 2558

Stichting Pretentieus, Prinsengracht 218, 1016 HD, Amsterdam, Netherlands. Phone 020–258146, fax 020–238892. Gerald Van Der Kaap, Peter Klasmorst & Paul Groot, Editors.
Subscription: $US36. Illus. 20 cm.
ISSN: 0923–6511. OCLC: 20551138. LC: TR1.B59. Formerly: *Zien.*
Photographs the arts, fashion and design. Vol. 1, no.1 in Dutch, with no.2 became English language only.
Reviews: book. Indexed: ArtBibMod.
Advertising.

BLITZ MAGAZINE. 1980. m. EN. 2559

Jigsaw Publications Ltd., 1 Lower James St., London W1R 3PN, England. Phone 436 5211. Simon Tesler, Editor.
Back issues.
ISSN: 0263–2543.
Reviews: book. Indexed: Des&ApAI.
Advertising.

BRITISH JOURNAL OF PHOTOGRAPHY: Technical, Professional, Scientific. 1860. w. EN. 2560

Henry Greenwood & Co. Ltd., 24 Wellington St., London WC2E 7DH, England. Phone 071–583 0175. Chris Dickie, Editor.
illus. Annual index.

ISSN: 0007–1196. OCLC: 5928805. Dewey: 770. Formerly: *Photographic Journal*.
Indexed: ArtBibMod. ArtI. Photohi.

THE BRITISH JOURNAL OF PHOTOGRAPHY ANNUAL. 1964. a. EN. 2561
Henry Greenwood & Co. Ltd., 24 Wellington St., London WC2E 7DH, England. G.W. Crawley, Editor.
Microform available. illus.
ISSN: 0068–2217. OCLC: 3661763. LC: TR1.B83. Dewey: 770. Formerly: *British Journal Photographic Annual and Photographer's Daily Companion*.
Advertising.

BULGARSKO FOTO: A Journal of Photographic Art, Technique, and Photojournalism.
1966. m. BU. RU, EN, GE & FR summaries. 2562
Komitet za Izkustvo i Kultura, 39, Dondukov Blvd., Sofia, Bulgaria. (Dist.: Hemus, 6, Rouski Blvd., 1000 Sofia). Albert Koen, Editor.
Subscription: $12. Illus., some color.
ISSN: 0007–4012. OCLC: 1791280. LC: TR1.B835. Dewey: 770.
Advertising.

LES CAHIERS DE LA PHOTOGRAPHIC. 1981. q. FR. 2563
Association de Critique Contemporaine en Photographie, 32 bd Ulysse–Casse, F–47200 Marmande, France.
Subscription: 385 F, $US70. Illus.
ISSN: 0294–4081. OCLC: 7727063. LC: TR7.C25. Dewey: 770.
Reviews: book. Indexed: ArtBibMod.

CAMERA. See no. 2572.

CAMERA & DARKROOM PHOTOGRAPHY. 1979. m. EN. 2565
Larry Flint Publications, Inc., 9171 Wilshire Blvd., Suite 300, Beverly Hills, CA 90210. Phone 213–858–7100. Thom Harop, Editor.
Subscription: $19.95 US, + $2 Canada, + $4 foreign (P.O. Box 16928, N. Hollywood, CA 91615). Microform available from UMI. Back issues. Illus. some color, photos.
ISSN: 1056–8484. OCLC: 22700574. LC: TR287.D37. Dewey: 770. Formerly: *Darkroom Photography*.
"The magazine for creative photographers" officially endorsed by the Photography Instructors Association. 6–8 articles per issue plus regular departments offering readers tips, product update, photographers marketplace, and questions and answers.
Freelance work: yes (details in *PhMkt.*). Indexed: GrArtLAb.
Advertising. Circulation: 80,000.

CAMERA AUSTRIA. 1980. q. GE & EN. 2566
Forum Stadpark, Graz, Austria.
Illus.
OCLC: 9878990. LC: TR1.C23.
Journal of photography.
Indexed: ArtBibMod.

CAMERA CANADA. 1969. q. EN, FR. 2567
National Association for Photographic Art, 22 Abbeville Road, Scarborough, Ontario, M1H 1Y3 Canada. Phone 416–438–0252. Mary Visser, Editor (20 Burton Road, Brampton, Ontario L6X 1M7).
Subscription: included in membership together with *FotoFlash*, $C16 non–members. Illus. 8¼ x 11, 52p.
ISSN: 0008–2090. OCLC: 1805849, 1043827. LC: TR650; TR1.C216x. Dewey: 770.
Aims of the Association are to promote good Canadian photography, promote the advancement of photography as an art form in Canada, and to provide useful information for photographers. Showcases portfolios of Canadian photographers.
Freelance work: submission of articles and photographic portfolios is welcomed from all Canadian citizens and residents.
Contact: editor. Indexed: CanMagI. CanPI.
Advertising. Charles Stahl, Ad. Director.

CAMERA CLUB JOURNAL. 1885. q. EN. 2568
Camera Club, 8 Great Newport St., London WC2H 7JA, England. Phone 071–240 1137.
Subscription: included in membership. Illus.
ISSN: 0008–2104. Dewey: 770.

CAMERA COUNTER. 1981. q. EN. 2569
Marketing & Publishing Services Ltd., 202 Kensington Church St., London W8 4DP, England.
Illus.
ISSN: 0262–5008. Dewey: 770.
The magazine for the retailer of popular photographic equipment.

CAMERA INTERNATIONAL. 1984. 5/yr. FR chiefly, some EN. 2570
Camera International, 51, rue de l'Amiral, Mouchez 75013, Paris, France. Phone (1) 45.65.46.00, telex 202548. Claude Nori and Jacques Ascher, Editors.
Illus. b&w, some color, photos. Index. 9½ x 11¾, 88–98p.
ISSN: 0765–9849. OCLC: 12748430. LC: TR1.C118. Dewey: 770.
Mainly photos, little text. "Portfolio" section features the work of one photographer and includes many full page photos. Each issue is devoted to a single subject.
Reviews: exhibition. Biographies. Interviews: appear in both languages. Listings: international. Indexed: ArtBibMod.
Advertising. Philippe Heullant, Ad. Director.

CAMERA IRELAND. m. 2571
Allograph Publications Ltd., 56 Pembroke Rd., Dublin 4, Ireland. Kyran O'Neill, Editor.
Dewey: 770.

CAMERA NEW ZEALAND. 1953. bi–m. EN. 2572
Photographic Society of New Zealand, P.O. Box 51–354, Pakuranga Auckland, New Zealand. John E.A. Reece, Editor.
Illus.
Dewey: 770. Formerly: *Camera; New Zealand Camera.*
The official journal of the Society.

CAMERART: The International Magazine of Japanese Photography. 1958. m. EN. 2573
Camerart, Inc., c/o Hinode Bldg., 5–4, Kyobashi 2–chome, Chuo–ku, Tokyo 104 Japan. Phone (03) 563–4871. Kunika Toloroki, Editor.
Subscription: 5,520 Yen Japan, $US52.50; air: $US98.50 US, Canada, Central America, West Indies; $US89.50 Asia, Australia, New Zealand, Midway, Oceania; $US107.50 Europe, Africa, South America, Middle & Near East (C.P.O. Box 620, Tokyo or subscription agents, US—Ebsco; Canada—Vancouver Magazine Service). Sample. Back issues. Illus. b&w, color, photos. 29 x 20.5 cm., 60p.
ISSN: 0008–2082. OCLC: 2251577. LC: TR1.C184. Dewey: 770.
Japan's first English–language photography magazine presents articles covering the full range of photography. Describes activities in the Japanese photography industry. Includes information on Japanese cameras and other photographic equipment and materials, tests as well as the work of leading Japanese photographers.
Indexed: ArtBibMod.
Advertising: full page $US1,000, color $2500. Masao Yasui, Ad. Director. Circulation: 18,000.

CANADIAN PHOTOGRAPHER. 1990. q. EN. 2574
Canadian Photographer, 847 Sweetwater Cresent, Port Credit, Ontario L5H 4A7 Canada.
Subscription: $C28.95.

CENTER QUARTERLY: A Journal of Photography and Related Arts. 1979. q. EN. 2575
Center for Photography at Woodstock, 59 Tinker St., Woodstock, NY 12498. Phone 914–679–9957. Kathleen Kenyon, Editor.
Subscription: included in membership, $15 US, $23 Canada, foreign $35. Sample. Back issues $5. Illus b&w. 32p.
ISSN: 0890–4634. OCLC: 9569211. LC: TR1.C46. Dewey: 770.
Photography. Films. Video.

Journal of photography and media art. Focuses on creative photography, film, and video. Addresses both contemporary and historical critical issues.

Interviews. Freelance work: yes. Contact: editor.

Advertising: (camera ready copy) full page $550, ½ page $285, ¼ page $150, no color. 10–15% frequency discount. Inserts. Colinda Taylor, Ad. Director. Demographics: international readership. Arts councils, bookstores, camera shops and art centers receive bulk packages for distribution. Circulation: 10,000. Audience: artists, collectors, dealers, art historians, scholars, general.

CHICAGO RENAISSANCE. See no. 1880.

CMP BULLETIN: Wrap–up, A Communication of the CMP Member Board. 1981. q. EN. 2576
California Museum of Photography, University of California, Riverside, CA 92521. Phone 714–787–4787. Stacy Miyagawa, Editor.
Subscription: included in membership. No sample. Back issues, price varies. Illus b&w, color, photos. 9¾ x 8½, 32p.
ISSN: 1731–2377. OCLC: 18397895. LC: TR640.B84. Dewey: 770. Formerly: *Bulletin CMP*.
Photographic History. Photography.

A scholarly journal on the history, technology and art of photography. Each issue reports on aspects of the Museum's collection, exhibitions and research. Essays by the director, curators and guest editors. Partially supported by a grant from the California Arts Council and the NEA.
Freelance work: none. Indexed: ArtBibMod. Photohi. Reviewed: Katz.
Advertising: none. Circulation: 2000. Audience: photography, scholarly, general.

COLLECTORS PHOTOGRAPHY. 1985. bi–m. EN. 2577
Melrose Publishing Group, Inc, 9021 Melrose Ave., Suite 301, Los Angeles, CA 90069. Phone 213–275–3076. Karre Slafkin, Editor.
ISSN: 0896–9043. OCLC: 17338556. Dewey: 770. Formerly: *Collector's Editions Review*.

COMBINATIONS. 1977. q. EN. 2578
Middle Grove Rd., Greenfield Center, NY 12833. Phone 518–584–4612. Mary Ann Lynch, Editor & Pub.
Illus.
ISSN: 0145–899X. OCLC: 2988195. LC: TR640.C65. Dewey: 770.

THE CREATIVE BLACK BOOK. 1984. a. EN. 2579
Creative Black Book, 401 Park Ave. So., New York, NY 10016. Phone 212–684–4255.
Illus., over 1000 in color. Name index. 1200p.
ISSN: 0740–283X. OCLC: 9906480. LC: HF5840.C74. Dewey: 659.
"Print–Photography–Illustration–TV". Published in January. Arranged by sections: "Design, Illustration, Creative Services", "Photography", "Supplies and Equipment, Typography", "Prints, Chromes and Retouchers", "Printers and Engravers", "Models and Talent, Stylists, Props, Sets and Locations", "TV Production", and "Music and Sound, Radio, Recording Studios". Each section is sub–divided by up to 6 geographic areas (4 for North America and 2 for Europe—the Continent and British Isles.
Advertising.

CREATIVE CAMERA. 1968. bi–m. EN. 2580
CC Publishing Ltd., Battersea Arts Centre, The Old Town Hall, Lavender Hill, London SW11 5TF, England. Phone 071–924 3017. David Brittain, Editor.
Subscription: £24 individual, £35 institution UK; elsewhere £30 $40, £40 $60. Illus. b&w., color, photos. 8 x 10¾, 38p.
ISSN: 0011–0876. OCLC: 1792886. LC: TR640.C74. Dewey: 770. Formerly: *Creative Camera Owner*.
A voice for independent photography.
Reviews: book. Freelance: "welcome contributions from all who share our belief in the vitality of the art of photography." Indexed: ArtBibCur. ArtBibMod. ArtI. BioI. CloTAI. Reviewed: Katz.

DARKROOM & CREATIVE CAMERA TECHNIQUES. 1979. bi–m. EN. 2581
Preston Publications, 7800 N. Merrimac Ave., PO Box 48312, Niles, IL 60648. Phone 708–965–0566, fax 708–965–7639. David Jay, Editor.
Subscription: $13.95 US, + $3 Canada & foreign. Sample & back issues $4.50. Illus. b&w, color, photos. Annual index in Nov/Dec issue. Cum. index updated annually. 8⅛ x 10⅞, 72p.
ISSN: 0195–3850. OCLC: 11823585. LC: TR287.D375. Dewey: 770. Formerly: *Darkroom Techniques*.

Provides an abundance of technical information. Presents darkroom techniques and procedures, creative camera use, and photographic experimentation and innovation.

Listings: regional–national. Freelance work: yes Freelance work: yes, free photographer's and writer's guidelines (details in *PhMkt.*). Contact: editor. Opportunities: study. Reviewed: Katz.

Advertising: (rate card Jan '90): b&w full page $2015, ½ page $1270, ¼ page $800; 2 color full page $2400, ½ page $1520; 4 color full page $3130, ½ page $1975. Classified: $150 1 inch. Frequency discount. 15% agency discount. Covers & preferred positions +10%. Bleeds +10%. Inserts. S. Tinsley Preston III, Ad. Director. Mailing lists: available to qualified people.

Demographics: 83.5% college educated, 68% professionals/managers/owners, average income $57,300, average value of equipment owned $9,810, 98% own an average of 4 35mm cameras (1988 reader survey). Circulation: 45,000. Audience: people who take photography seriously, from the dedicated amateur to the experienced professional, including anyone who wishes to fully understand the photographic process.

DBCC PHOTOGRAPHIC SOCIETY NEWSLETTER. 1978. q. EN. 2582

Photo Society of Dayton Beach Community College, 1200 Volusia Ave., Box 1111, Dayton Beach, FL 32014. Phone 904–254–3057. Ed Davenport, Editor.

Subscription: free.

DEALERAMA. 1985. m. EN. 2583

Bowman Publishing Ltd., 12 Leagrave Rd., Luton, Bedfordshire LU4 8HZ, England. Phone 0582 26276. Stephen Web, Editor.

ISSN: 0268–8115. Dewey: 770.

DOUBLE PAGE. 1980. m. FR. 2584

Nathan Abonnements, BP 183, 75665 Paris Cedex 14, France.

Subscription: $107.14 France, $126.53 elsewhere. Illus.

OCLC: 9630323. LC: TR640.D6.

Indexed: ArtBibMod.

ENTRY: A Guide to Photographic Competitions and Juried Exhibitions. 1984. 10/yr. EN. 2585

Box 7648, Ann Arbor, MI 48107. Phone 313–663–4686. Jennifer Hill, Editor & Pub.

Subscription: $18 US & Canada, foreign air $30. Sample $2. No back issues. Illus b&w, photos. 8½ x 11, 8–10p.

ISSN: 0886–845X. OCLC: 13026938. Dewey: 770.

Films. Photography.

A specialized newsletter which publishes detailed information on upcoming calls for entry to photographic competitions and juried exhibitions. Also includes information on film/video competitions, grants, workshops, exhibition screenings or open calls for submissions. Aim is to be an accurate and informative opportunity resource for active photographers, from the amateur or student to the fine artist or professional. Publishes only current information verified directly from the organizers and actively solicits information from them.

Reviews: book occasionally. Listings: regional–international. Calendar: Calls for work for juried exhibitions or exhibition screenings. Freelance work: photos which have placed in a photo competition. (send with a SASE). Opportunities: study, competitions.

Advertising: none. Mailing lists: available for rent. Circulation: 5000+.

EUROPEAN PHOTOGRAPHY (Germany). 1980. q. EN & GE (articles in both languages, one

following the other; reviews in 1 language only). 2586

P.O. Box 3043, D–3400 Goettingen, W. Germany. Phone 0551–248 20. (US dist.: Photo–Eye Books, P.O. Box 2686, Austin, TX 78768). Andreas Mueller–Pohle, Editor & Pub.

Subscription: DM 40 Europe, $US28 all surface; air: $US38 US & Canada; $45 Far East, Australia, N.Z. Sample $7. Back issues $5–7. Complete edition, v.1–5 DM 800, $485. Illus. b&w, some color, photos. Index in every 8th issue. 21.5 x 28 cm., 56p.

ISSN: 0172–7028. OCLC: 7466750. LC: TR640.E78. Dewey: 770. Formerly: *Print Letter.*

Modern Art. Photography.

"The international magazine for contemporary photography and new media". Each issue explores a specific theme in depth and presents portfolios, essays, reports, and up–to–date information about the European photography scene.

Reviews: exhibition 2–3, book 5–6, other 2–3. Bibliographies: "New Publications" section in each issue. Interviews. Listings: international. Exhibition information. Freelance work: yes. Opportunities: study, competitions. Indexed: ArtBibCur. ArtBibMod. Photohi.

Advertising: full page $850, ½ page $450, ¼ page $250, color + $350/color. No classified. Frequency discount. Mailing lists: available on request. Circulation: 3800. Audience: creative people.

EUROPEAN PHOTOGRAPHY (London). 1981. a. EN, FR, & GE. 2587
D & AD European Illustration, Nash House, 12 Carlton House Terrace, London SW1Y 5AH, England. (Dist.: H.N. Abrams, 100 Fifth Ave., New York, NY 10011). Edward Booth–Clibborn, Editor.
Chiefly illus., chiefly color.
OCLC: 8057841. LC: TR690.E87. Dewey: 779.
Indexed: Photohi.

EXPOSURE. 1963. q. EN. 2588
Society for Photographic Education, University of Colorado, Campus Box 318, Boulder, CO 80302. Phone 303–492–0588. Patricia Johnston, Editor.
Subscription: included in membership together with *The SPE Newsletter* and *The SPE Directory and Resources Guide*, $4, foreign £2.50. Sample. Back issues $4. Illus b&w, photos. 6 x 9, 56p.
ISSN: 0098–8863. OCLC: 2242622. LC: TR1.E93. Dewey: 770.
Photographic Education. Photography.

The Society serves as the national representative voice of photography teachers at the college level. The journal of the Society is exclusively devoted to the analysis and understanding of photography. It includes criticism, essays, articles on education and reviews of contemporary photographic exhibitions and publications.
Reviews: book 3. Freelance work: yes. Contact: editor. Indexed: ArtBibMod. Reviewed: Katz.
Advertising: (rate card June 1987, camera ready artwork): full page $500, ½ page $300, ¼ page $185. Special positions + $50. Frequency discount. 25% discount to nonprofit organizations. 15% agency discount. Sanford Goldrich, Ad. Director (133 Stockton Lane, Rochester, NY 14625, phone 716–671–1194, fax 671–4494). Mailing lists: available. Demographics: 91% of members are active photographers, 75% also teach photography. Circulation: 1,700. Audience: college and university teachers.

FOCUS. 1983. bi–m. EN. 2589
Prosper Communications, Seddon House, Seddon St., Radcliffe, Manchester M26 9TF, England. Jennifer Whitelaw, Editor. Dewey: 770.

FOCUS ON PHOTOGRAPHY. 1979. a. EN. 2590
Australian Hi–Fi & Specialist Magazines Group Pty. Ltd., Box 341, Mona Vale, N.S.W. 2103, Australia. Phone 02 913–1444. Don Norris, Editor.
Dewey: 770. Formerly: *Photoworld Annual; Photographic World Annual*.
Covers photographic equipment and technical advice.

FOTO. 1954. m. 2591
Lapkiado Vallalat, Lenin korut 9–11, 1073 Budapest, Hungary. Phone 222–408.
Subscription: $24 (Kultura, Box 149, H-1389 Budapest, Hungary). Illus.
ISSN: 0427–0576. Dewey: 770.

FOTO FLASH. 1969. q. EN. 2592
National Association for Photographic Art, 22 Abbeville Rd., Scarborough, Ontario M1H 1Y3, Canada. Phone 416–438–0252. Mary Visser, Editor (20 Burton Rd., Brampton, Ontario L6X 1M7).
Subscription: included in membership as a supplement to *Camera Canada*. No sample. Back issues. Illus b&w, photos, cartoons. 8½ x 11, 16p.
ISSN: 0318–7500. OCLC: 2012234. LC: TR1. Dewey: 770.
Newsletter to inform the Association's members of pertinent information related to the Association. Presents events, competitions, general news, elections, etc. plus technical "how to" articles and interesting news in photography (general/global).
Listings: regional–international. Exhibition information. Freelance work: yes, no payment. Contact: editor. Opportunities: study, competitions.
Advertising: none. Circulation: 2200. Audience: members.

FOTO GALAXIS. irreg. EN & SP. 2593
Galaxis, S.A., Zamora 46–48, Barcelona, Spain.
Illus.

OCLC: 3697094. LC: TR690.F56. Dewey: 770.

FOTODOK. 1988. irreg. **2594**
c/o Hans Zonneville, Remrandtkade 58–2, 3583 TS Utrecht, The Netherlands.

FOTOGRAFIA. 1986. q. **2595**
La Focus Galleria, Via Ruggiero Settimo 68, 90141, Palermo, Italy.

FOTOGRAFIEu: Zeitschrift fuer Kulturpolitische, Aesthetische und Technische Probleme der Fotografie. 1947. m. GE. EN, FR, RU summaries with some issues. **2596**
VEB Fotokinoverlag Leipzig, Postfach 67, DDR–7031 Leipzig, E. Germany. (Dist.: Buchexport, Leninstrasse 16, DDR–7010 Leipzig). Phone 71370.
Subscription: DM 48, $21.87. Illus.
ISSN: 0015–8836. Dewey: 770. Formed by the union of: *Gebrauchsfotografie, Fotografische Rundschau, Kleinbild, Farben–fotografie* and others.
Covers cultural, political, aesthetical, and technical aspects, as well as Association news and information. Includes list of exhibitions. Over ½ of each issue composed of photos.
Indexed: ArtBibMod.
Advertising. Classified.

FOTOMAGAZIN. m. GE & EN editions. **2597**
Ringier Verlag Gmbh, Gustav Heinemann Ring 212, W 8000 Munich 83, Germany.
Subscription: DM 90. Illus., some color.
ISSN: 0340–6660. OCLC: 818152 (GE). LC: TR1.F756. Formerly: *Foto Magazin; Camera* (Lucerne, Switzerland).
Issued in separate English and German editions.
Indexed: Photohi.

FRAME/WORK. 1987. 3/yr. EN. **2598**
Los Angeles Center for Photographic Studies, 1052 W. 6th St., Suite 424, Los Angeles, CA 90017–2059. Phone 213–482–3566. Robert Muffoletto, Editor.
Subscription: $15 individual, $25 institution US, foreign $20 individual. Sample $5. Back issues. Illus. 8½ x 11, 48p.
ISSN: 0895–6030. OCLC: 16503884. LC: TR183.F72. Dewey: 770. Formerly: *Obscura*.
Art History. Films. Modern Art.
"A journal of images and culture". Concerns itself with new critical photographically generated images (photography, film, video, television) on culture, interdisciplinary in nature. The journal will explore the relationship between lens–made imagery and the forces that direct what that imagery is, what it looks like, and how it is responded to. Images will be treated as texts, produced and read within a social–cultural context. Historical and contemporary notions of how images function will be explored and the disciplines of art, history, sociology, education, anthropology, and science, etc. will be treated wholistically rather than departmentally. Critical discourses will be offered ranging from structuralist to post–structuralist analyses.
Freelance work: none.
Advertising: rates upon request. Mailing lists: none. Circulation: 600.

FREELANCE PHOTO NEWS. irreg. EN. **2599**
National Free Lance Photographers Association, Box 629, Doylestown, PA 18901. Phone 215–348–5578.
Subscription: included in membership.
Newsletter monitors developments and opportunities in the field of free lance photography. News of Association activities including photography contests and exhibitions.
Opportunities: competitions.

FREE-LANCE WRITING & PHOTOGRAPHY. See no. 105.

THE GALLERY [British Empire ed.]. 1933. m. EN. **2600**
G.T. Chesire & Sons, Ltd., Kidderminster, England.
OCLC: 13454053.
A monthly review of international pictorial photography.

GRADUATE PHOTOGRAPHY AT YALE. 1970? a. EN. 2601
Yale University, School of Art, 212 York St., New Haven, CT 06520. Phone 203–432–2622. Tod Papageorge, Editor (Yale University, Dept. of Photography).
Subscription: Distributed to School of Art Alumni. Illus b&w, color, photos. 24–32p.
Dewey: 770. Formerly: *Still.*
Photographic Education. Photography.

Published in the form of a catalog or portfolio to show a selection of work by the graduating class as well as to teach that class about the mysteries and techniques of making halftone negatives, plates and printing on an ink press.
Advertising: none. Circulation: 200–500. Audience: alumni & friends.

GRAPHIS PHOTO. 1966. a. EN, FR, & GE. 2602
Pedersen Graphis Press Corp., 107 Dufourstrasse, CH–8008 Zurich, Switzerland. (US: Graphis US, Inc., 141 Lexington Ave., New York, NY 10016). B. Martin Pedersen, Editor.
Subscription: $65 US, $C91.50; foreign surface £46.50, DM 148, SFr 118. Illus. color, glossy photos. 250+p.
OCLC: 18500689. LC: TR1.P576. Formerly: *Photographis.*
International annual of advertising photography consists mainly of illustrations.
Freelance work: yes, send to Zurich address, entry fee except for students.

THE GUIDE TO PHOTOGRAPHY WORKSHOPS. 1990. a. EN. 2603
Shaw Associates, 625 Biltmore Way, Dept. 1406P, Coral Gables, FL 33134.
Subscription: $14.95.
ISSN: 1044–9108. OCLC: 19946340. Dewey: 770.

HISTORY OF PHOTOGRAPHY. 1977. q. EN. 2604
Taylor & Francis Ltd., 4 John St., London WC1N 2ET England. Heinz K. Henisch, Editor (Dept. of Art History, Pennsylvania State University, 221B Arts Building, University Park, PA 16802 USA).
Subscription: (1990) £60, $US95 (Rankine Rd., Basingstoke, Hants. RG24 0PR, England, phone 0256 840366. US, Canada & Mexico order from Taylor & Francis Inc., 1900 Frost Rd., Suite 101, Bristol, PA 19007 USA). Illus. Annual index in last issue. A4, 116p.
ISSN: 0308–7298. OCLC: 2691911. LC: TR15.H57. Dewey: 770.
Graphic Arts. Photographic History. Photography.

An international journal devoted to the publication of original findings and the assessment of their significance. One of the principle purposes of the journal is to promote an understanding of the subtle relationships between photography and the other graphic arts.
Reviews: book. Bibliographies: "Books Received & Noted". Obits. Freelance work: yes. Contact: editor. Indexed: ArtArTeAb. ArtBibCur. ArtBibMod. ArtHum. ArtI. Avery. BioI. CloTAI. CurCont. Photohi. RILA. Reviewed: Katz.
Advertising (UK: Basingstoke, phone 0256–840366, fax 0256–479438; US: Taylor & Francis Inc., 79 Madison Ave., Suite 1110, New York, NY 10016–7892, phone 212–725–1999, fax 213–8368). Audience: Readers with serious interest in the field, art historians, art teachers, librarians and archivists, students of journalism and social historians.

HOLOGRAPHICS INTERNATIONAL. 1987. q. EN. 2605
BCM Holographics, Holographics International, London WC1N 3XX, England. Phone 01–584 4508. Sunny Bains, Editor.
Illus. color, photos, holograms.
ISSN: 0951–3914. OCLC: 19692139.
Devoted to holography, international in scope, each issue examines current art and technical trends in holography. Editor promises at least one holograph per issue. Aim is the examination of all applications of display holography in every country.
Indexed: ArtBibMod. Reviewed: *British Journal of Photography* Apr 28 1988, p.29.
Advertising.

HOT SHOE INTERNATIONAL. 1979. q. EN. 2606
Hot Shoe International Ltd., 35 Britannia Row, London N1 8QH, England. Phone 071–226 1739. Robert T. Prior, Editor.
Subscription: £15. Illus.
Dewey: 741.67. Formerly: *Hot Shoe.*
For people in advertising and the editorial world who use professional photography, video and film.
Reviews: book. Indexed: Des&ApAI.
Advertising.

IMAGE (Australia). 1964. bi–m. EN. **2607**
Naracoorte Herald, 93 Smith St., Naracoorte 5271, Australia. Phone 087–622555. Tom Tame, Editor (185 Breton St., Coopers Plains 4108).
Subscription: included in membership, $A18 Australia, $23.44 elsewhere (APS Inc., P.O. Box 53, Hackett 2602). Sample & back issues, $2.50 + postage. Illus. b&w, photos, cartoons. 29 x 21 cm., 24p.
ISSN: 0728–5701. OCLC: 15242105. Dewey: 770.
The journal of the Australian Photographic Society presents photo articles and portfolios, members' competitions, Society news and information.
Reviews: book 2, length¼p. Listings: international. Calendar of exhibitions. Freelance work: yes but unpaid. Contact: editor. Opportunities: competitions.
Advertising: full page $A190, ½ page $A135, ¼ page $95, no color. No classified. Frequency discount. Inserts. (Business Manager, APS, Inc., P.O. Box 53, Hackett 2602). Mailing lists: none but mail outs can be undertaken for a fee. Demographics: most subscribers are Australian, serious amateur photographers, all ages. Circulation: 1600. Audience: all persons interested in photography.

IMAGE (London). 1969. m. EN. **2608**
Association of Photographers, 9–10 Domingo St., London EC1Y 0TA, England. Phone 071–608–1441, fax 071 2533007. Lynne Pembridge, Editor.
Subscription: included in membership, £36 all. Sample. Back issues £3. Illus. photos — b&w & color. Cum. Index, issue 167, Aug 1989. A4, 40p.
Dewey: 770. Formerly: *AFAEP News Release.*
Written by professional photographers for photographers. Aims to be the best showcase in the United Kingdom for commercial (not fine art) photography. Each issue majors on one area of photography such as still life, advertising, fashion. Includes material on business practice and media law.
Reviews: exhibition 10, length 50 wds.; book 2, length 150 wds.; equipment 6, length 1500 wds. Interviews: leading U.K. photographers or top internationals discuss their work/views. Listings: national. Calendar of exhibitions. Freelance work: none. Opportunities: study, workshops organized by the Association; competitions, coverage of all major photographic awards/grants.
Advertising: b&w full page £400, ½ page £250, ¼ page £125; color double b&w rates. Classified: £20 min. No frequency discount. Mailing lists: none. Demographics: London and southeast of England; individuals who own their own business. Circulation: 2500. Audience: professional photographers, art directors.

IMAGE (Rochester, New York). 1952. q. EN. **2609**
International Museum of Photography at George Eastman House, 900 East Ave., Rochester, NY 14607. Phone 716–271–3361. James L. Enyeart, Editor.
Subscription: included in membership together with *Newsletter*, $30 US, $40 Canada & foreign. Sample free. Back issues $5. Illus. b&w, some color. 16p.
ISSN: 0536–5465. OCLC: 1752688. LC: TR1.I47. Dewey: 770.974789.
Art History. Films. Historic Preservation. Photography.
Journal of photography and motion pictures. Currently a scholarly and/or technical journal. Focus will change in 1990 or 1991 by adding articles for those with an amateur's eye for photography and motion pictures.
Indexed: ArtBibMod. ArtI. CurCont. RILA.
Advertising: none. Mailing lists: none.

IMAGING ON CAMPUS. 1987. bi–m. EN. **2610**
Executive Business Media, Inc, 825 Old Country Rd., Box 1500, Westbury, NY 11590. Phone 516–334–3030. Barry Tenenbaum, Editor.
ISSN: 0893–1925. OCLC: 15434211. Dewey: 770.
Advertising.

INCIDENTS OF THE WAR. 1986. q. EN. **2611**
Yo–Mark, Box 765, Gettysburg, PA 17325. Phone 717–334–0751. D. Mark Katz, Editor.
Illus.
OCLC: 13393126. LC: E468.7.I523. Dewey: 973.705.
Collectibles. Photographic History. Photography.
The magazine for the discriminating collector and student of Civil War photography.

INDUSTRIAL AND COMMERCIAL PHOTOGRAPHY. 1962. bi–m. EN.　　　　　　2612
Yaffa Publishing Group, 17–21 Bellevue St., Surry Hills, N.S.W. 2010, Australia. Phone 02–281–2333. David Adermann, Editor.
Microform available from UMI. Illus.
ISSN: 0313–4393. Dewey: 778. Formerly: *Industrial Photography and Commercial Camera.*
Advertising.

INDUSTRIAL PHOTOGRAPHY. 1952. m. EN.　　　　　　2613
PTN Publishing Corp., 445 Broad Hollow Rd., Suite 25, Melville, NY 11747. Phone 516–845–2700. Lynn Roher, Editor.
Subscription: $25. Microform available from UMI. Sample free. Illus. b&w, color, photos.
ISSN: 0019–8595. OCLC: 1639191. Dewey: 770.
Applications and techniques of photography in business and industry.
Reviews: book. Freelance work: yes (details in *PhMkt.*).
Advertising. Circulation: 45,000. Audience: industrial photographers.

INSTANT RECORD. 1980. 2–3/yr. EN.　　　　　　2614
Polaroid (UK) Ltd., Ashley Rd., St. Albans, Herts. AL1 5PR, England. Phone 07072–78209. Pat Wallace, Editor.
Sample free. Back issues. Illus. b&w, color, photos. A3, 12p.
ISSN: 0260–9363. Dewey: 771.
General.

A newspaper published by Polaroid for its business and professional customers.
Interviews: carried out to prepare articles. Listings: national. Calendar of events. Exhibition information. Freelance work: yes.
Contact: editor. Opportunities: study, competitions.
Advertising: none. Mailing lists: none. Circulation: 20,000–30,000.

INTERNATIONAL PHOTOGRAPHY. 1987. EN.　　　　　　2615
Eastman Kodak Co., Professional Photography Division, 343 State St., Rochester, NY 14650.
Subscription: free.
Spotlights individual photographers. Each photograph accompanied by information on the type of Kodak film used.

INTERNATIONAL WIDESCREEN. 1964. bi–m. EN.　　　　　　2616
Widescreen Association, 48 Dorset St., London W1H 3FH, England. Phone 071–935 2580. Tony Shapps, Editor.
Dewey: 770. Formerly: *Widescreen.*

JAPAN CAMERA TRADE NEWS. 1950. m. EN.　　　　　　2617
Genyosha Publications, Inc., 3–18–2 Shibuya, Shibuya–ku, Tokyo 150, Japan. K. Eda, Editor.
Subscription: $74. Illus. tabloid.
ISSN: 0021–4345. OCLC: 8891266. LC: HD9999.P5J3. Dewey: 771.
Information on the photographic industry focussing on cameras, optical instruments and accessories.
Advertising.

THE JOURNAL: NEW ENGLAND JOURNAL OF PHOTOGRAPHIC HISTORY.
　　1988, no.119. q. EN.　　　　　　2618
Photographic Historical Society of New England, P.O. Box 189, West Newton, MA 02165.
Subscription: included in membership, $24 US, $35 elsewhere. Illus.
OCLC: 22200960. LC: TR1.J86. Formerly: *Photographica Journal; New England Journal of Photographic History.*
Photographic History. Photography.

Continues numbering of earlier publication.
Indexed: Photohi.

JOURNAL OF AMERICAN PHOTOGRAPHY. 1983. 5/yr. EN.　　　　　　2619
Calmut Photographic Society, 890 Supreme Dr., Bensenville, IL 60016. Phone 1–800–225–8638.
Illus. 8½ x 11.
ISSN: 0737-3295. OCLC: 9237506. LC: TR1.J83. Dewey: 770.

KODAK TECH BITS. 1963. q. EN. 2620
Eastman Kodak Co., 343 State St., Rochester, NY 14650. Phone 716–724–4000. Elizabeth Eggleton, Editor.
Illus.
ISSN: 0452–2591. OCLC: 9687744. Dewey: 770.

LENS. 1925. bi-m. 2621
Photographic Society of Ireland, 38-39 Parnell Sq., Dublin, Ireland. Joseph Webb, Editor.
Subscription: included in membership.
Dewey: 770.

LIGHT AND SHADE. 1916. m. (Oct–June). EN. 2622
Pictorial Photographers of America, c/o –Henry D. Mavis, 299 W. 12 St., New York, NY 10014. Phone 212–242–1117. Sylvia Mavis, Editor.
Subscription: included in membership, $30. Sample. No back issues. Illus. b&w. 8 x 10½, 8p.
OCLC: 5537581. LC: TR640.L558. Dewey: 770.
Loose–leaf publication whose purpose is to help photographers, both professional and amateur, improve their photographic techniques.
Reviews: book. Listings: regional–international. Calendar of events. Freelance work: yes. Contact: editor. Opportunities: study.
Advertising: none. Mailing lists: none. Circulation: 100. Audience: amateur photographers.

LIGHTWORKS: Illuminating New & Experimental Art. 1975. 1–2/yr., irreg. EN. 2623
Lightworks Magazine, Inc., Box 1202, Birmingham, MI 48012–1202. Phone 313–626–8026. Charlton Burch & Gary S. Vasilash, Editors.
Subscription: $20 individual, $25 institution US; $US25 Canada & foreign, air $65. Sample $5. Back issues $2–5. Illus. b&w, photos, color covers, oftentimes tip–ins are included. 8½ x 11, 56p.
ISSN: 0161–4223. OCLC: 3940893. LC: NX1.L5. Dewey: 700.
Drawing. Films. Graphic Arts. Modern Art. Mail Art. Photography.

A magazine for and about innovators in the arts. A forum for new work which presents art, de facto, in addition to a document which preserves a history of creative activities which might otherwise go unacknowledged. The editorial scope is "pan–arts" with special interest in visual forms including photography, mail art, artist stamps, xerography, performance art and networks of artists whose work remains largely outside the conventional framework of galleries, collectors and museums. All other areas which challenge traditional notions of art and, hopefully expand our understandings of the forms art may take. The accent is on exploration. Magazine is highly visual. Visual and concrete poetry.
Reviews: book 30, journal 10 & other 10, length 100 wds. each. Listings: international. Freelance work: yes. Contact: editor.
Advertising: none. Mailing lists: possibly available. Circulation: 2000. Audience: artists, museum and university libraries, and others with an interest in the visual arts.

THE MAGIC LANTERN BULLETIN. 1979. q. EN. 2624
Magic Lantern Society of the U.S. and Canada, 1585 Maple Rd., Cleveland Heights, OH 44121. Phone 216–382–1891. Larry Rakow, Editor.
OCLC: 13454087. Formerly: *ML Bulletin.*
Photographic History.

Disseminates information on the early phase of film using photographic lantern slides, and promotes the preservation and collection of the devices and related materials.

MASTER PHOTOGRAPHER. 1966. m. EN. 2625
Icon Publications Ltd., 12 Ollerton Rd., Tuxford, Newark, Notts NG22 0LF, England. Phone 0895 630876. David Kilpatrick, Editor.
Illus.
ISSN: 0047–6196. Dewey: 770.

MFM FOTOTECHNIK. 1953. m. 2626
A.G.T. Verlag Thum GmbH, Teinacher Strasse 34, Postfach 109, D–7140 Ludwigsburg, W. Germany. Phone 07141–33046. Wolfgang J. Schaezler, Editor.
Subscription: DM 90.70. Cum. index.
Dewey: 770. Formerly: *MFM – Moderne Fototechnik.*

Journal deals with all fields of applied photographic, film and AV technology.
Indexed: Photohi.

NEW MAGIC LANTERN JOURNAL. 1978. irreg. EN. 2627
Magic Lantern Society of Great Britain, 36 Meon Rd., London W3 8AN, England. Phone 081–993 2859. David Henry, Editor.
Illus.
ISSN: 0143–036X. Dewey: 770.
Reviewed: *Film Quarterly* 42:1, Fall 1988, p.31.

NEWS PHOTOGRAPHER. 1946. m. EN. 2628
National Press Photographers Association, Inc., 3200 Croasdaile Dr., Suite 306, Durham, NC 27705. Phone 919–383–7246.
James Gordon, Editor (1446 Conneaut Ave., Bowling Green, OH 43402, phone 419–354–5435).
Subscription: included in membership ($55 professional, $30 student); subscription $28 US. Sample free. Back issues $3.
Illus. b&w, color, photos (50/issue). 8¼ x 11, 48p.
ISSN: 0199–2422. OCLC: 2251750. LC: TR820.N272. Dewey: 770. Formerly: *National Press Photographer*.
Dedicated to the service and advancement of news photography.
Reviews: book occasionally. Listings: regional–national. Calendar of events. Freelance work: occasionally (details in
PhMkt.). Contact: editor. Indexed: GrArtLAb. Reviewed: Katz.
Advertising: full page $1085, ½ page $660, ⅓ page $500, color full page $1985. Classified: $3/line. Frequency discount.
Mailing lists: available from publisher. Circulation: 11,000. Audience: newspaper, TV, freelance and student photojournalists.

NEWSPRINT. bi–m. EN. 2629
Print Club, 1614 Latimer St., Philadelphia, PA 19103–6398. Phone 215–735–6090. Anne Schuster, Director.
Subscription: included in membership, free with $20 membership. Sample free. Back issues. No illus. 8½ x 11, 2p.
Photography. Fine Art Prints. Printmaking.

Provides information to members of The Print Club on the organization's exhibitions and programs, which are devoted to encouraging the arts of printmaking and photography and their audience, and informs practitioners of professional opportunities
in the fields. There are plans to expand the publication to include further texts and illustrations.
Calendar of events. Exhibition information. Freelance work: none. Opportunities: employment, study, competitions.
Advertising: none. Audience: membership.

NUEVA LUZ. 1985. q. EN & SP. 2630
En Foco, Inc., 32 East Kingsbridge Rd., Bronx, NY 10468. Phone 212–584–7718. Charles Biasiny–Rivera, Editor.
Subscription: $12 individual, $30 institution US; Canada & foreign $18, $40 air. Sample. Back issues $6. Illus. b&w photos.
Index. 11 x 16, 34p.
ISSN: 0887–5855. OCLC: 13313213. Dewey: 770.
Education. Photography.

Nueva Luz (New Light), the first photographic journal to feature minority artists. Each issue contains portfolios by three photographers—from barrios, inner cities, rural towns and reservations. The bilingual critical commentary offers an introduction
to some of America's finest photography. The combination of bilingual text and pictures is also used as a learning tool in
classrooms. The journal is made available to public schools to aid teachers in this process.
Begun to show the finest work possible emanating from people of color. Contains editorial page, one page commentary on
the artists presented. Rest of the work is devoted to photographs. Photos contain caption title, size, date and type of print.
Funding from the New York City Dept. of Cultural Affairs, the New York State Council on the Arts, NEA, and the Bronx
Council on the Arts.
Biographies: photo and biographical paragraph on each artist plus one or two sentence commentary by the photographer.
Freelance work: portfolios of at least 15 unmounted prints or copy slides may be submitted. Contact: editor.
Advertising: none. Demographics: distributed nationally. Circulation: 5000. Audience: art professionals, photographers.

OCCASIONAL READINGS IN PHOTOGRAPHY. 1986. irreg., usually a. EN. 2631
Columbia College Chicago, 600 South Michigan Ave., Chicago, IL 60605–1996. Phone 312–663–1600. Lynn Sloan–Theodore, Editor (Photography Dept., Columbia College).
Subscription: Free. Sample. Back issues. Illus. b&w, photos, cartoons. 8½ x 11, approx. 30p.
A series of publications written by graduate students in the Bibliography and Research course addressed to photographic matters of interest to the larger community involved with photography. Titles in series: no.1 "Visual Resonances: August Sander
and Richard Avedon" (1986), no.2 "Art, Photography and Marketing" (1987), and no.3 "A Chronology of Changes: The History of NEA Photography Fellowships" (1988).

Bibliographies with articles. Biographies: critical essays.
Advertising: none. Circulation: 2800. Audience: photographic educators and visual artists.

OVO MAGAZINE. [English edition]. 1970. q. EN. 2632
307 Ouest rue Suite Catherine, Local 300, Montreal, Quebec H2X 2A3, Canada. Phone 514–849–6253. Denyse Gerin–Lajoie
& Jorge Guerra, Editors.
Subscription: $20. Illus. 8½ x 11¾, 52p.
ISSN: 0704–9153. OCLC: 3983901. LC: TR640.018. Dewey: 770. Formerly: *Ovo Photo. [English edition]*.
Reportage and special thematic issues. Also available in a French edition with title *Magazine Ovo*.
Advertising. Circulation: 5,000. Audience: children.

P.W.P. NEWSLETTER. 1985. bi–m. EN. 2633
Professional Women Photographers, c/o Photographics Unlimited, 17 W. 17th St., New York, NY 10011–5510. Meryl
Meisler, Editor.
Subscription: included in membership (membership open to all women and men photographers), $20 New York City vicinity,
$15 students and out of towners. Illus. b&w, photos. 8½ x 11, 8p.
Formerly: *PWP Times*.
Purpose of the organization is to promote public interest and support for the art of photography in general and the work of the
members in particular. Several 1–2 page articles focus on the work of women photographers particular those who have shown
their work at recent meetings.
Listings: local. Calendar of meetings. Notice of members exhibitions. Opportunities: competitions, call for work.
Advertising. Circulation: 500+.

PAI NEWSLETTER. 1960. 10/yr. EN. 2634
Photographic Administrators, Inc., 1150 Ave. of the Americas, New York, NY 10036. Phone 212–997–1800, fax 212–869–
4796. Regina Reynolds, Editor.
8½ x 11.
Provides for the New York photographic community a network for sharing ideas and experiences. Covers activities of the or-
ganizations and its members.
Freelance work: yes. Contact: editor.

PERSPEKTIEF: Quarterly Photography Magazine/: Tijdschrift voor Fotografie.
1980. q. DU & EN (side by side). 2635
Stichting Perspectief, Eendrachtsweg 21, 3012 LB Rotterdam, The Netherlands. Phone 010 4145766, fax 010 4145265. Bas
Vroege, Editor.
Subscription: $55. Illus. b&w, some color, glossy photo. 9½ x 11¾, 66p.
ISSN: 0167–9104. OCLC: 13527182. Dewey: 770.
Contains theory concerning creative photography and a portfolio. Also contains FOTODOK, an international bibliographical
service, indexing 35 magazines.
Reviews: book (reviews appear in language of publication only), exhibition. Interviews. Indexed: ArtBibMod.

PETERSEN'S PHOTOGRAPHIC. 1971. m. EN. 2636
Petersen Publishing Co., 8490 Sunset Blvd., Los Angeles, CA 90069. Phone 213–854–2222, fax 213–854–6823. Bill Hurter,
Editor.
Subscription: $19.94 US, Canada +$12.10 (includes GST), foreign +$10 (Box 2200, Los Angeles, CA 90078. phone 1–800–
800–FOTO). Microform available from UMI. Sample $3. Illus. photos (100/issue). 8 x 10⅞, 104p.
ISSN: 0199–4913. OCLC: 5937411. Dewey: 770. Formerly: *Petersen's PhotoGraphic Magazine*.
For photographers who are interested in improving their photographic abilities. Specializes in photo techniques. Regular col-
umns include user reports, photo news, new product news, questions & answers, and a monthly contest.
Freelance work: yes (details in *PhMkt.*). Indexed: BioI. BkReI. CloTAI. Hand. PhoMI. RG. Reviewed: Katz.
Advertising. Peter Clancey, Ad. Director. Circulation: 284,000.

PHOTO & VIDEO RETAILER. See no. 2651.

PHOTO BUSINESS. 1986. m. EN. 2637
Billboard Publications, 1515 Broadway, 39th Floor, New York, NY 10036. Phone 212–764–7300. Willard Clark, Editor &
Pub.

Subscription: $40 (Subscription Dept., P.O. Box 2072, Mahopac, NY 10541). Microform available from UMI. 10¼ x 13¼, 52p.

ISSN: 0890–8753. OCLC: 14442033. Dewey: 381. Formerly: *Photo Weekly*.

Provides complete coverage of camera, film and photo accessory retailing, and photo finishing. In–depth editorial coverage delivers the information necessary to aid both the professional and semi–professional photographer in making all their buying decisions.

Advertising: Doris Burke, Ad. Director.

PHOTO COMMUNIQUE. 1979. bi–m. EN & FR. 2638
Box 155, Station "B", Toronto, Ontario M5T 2T3, Canada. Phone 416–868–1443. Gail Fisher–Taylor, Editor & Pub.
Illus. 8½ x 11, 56p.
ISSN: 0708–5435. OCLC: 5258179. LC: TR640. Dewey: 770.
Serious and sensitive presentation of photography as both a fine art and as a cultural medium.
Reviewed: Katz.
Advertising. Circulation: 11,000. Audience: children.

PHOTO DISTRICT NEWS. 1980. 15/yr (m. + 2nd issue in Mar, June and Nov). EN. 2639
49 East 21st St, New York, NY 10010. Phone 212–677–8418, fax 212–995–0183. Elizabeth Forst, Editor.
Subscription: $30 US; + $US40 (1st class), + $10 (2nd class) Canada; + $US75 (1st class), + $25 (2nd class) foreign. Illus. b&w, photos. 11 x 16, 132p.
ISSN: 1045–8158. OCLC: 20254856. Dewey: 650.
The international publication for the professional photographer dedicated to bringing professional photographers all the information they need to stay on top. Contains theme stories, news and features, columns, a professional services directory and technical departments. Some issues have an individual theme. Available in Eastern, Southern, Midwestern and Western editions.
Reviews: new products. Opportunities: employment, study.
Advertising. Classified: $1.50/wd. Inserts. Scott Luksh, Ad. Director. Audience: professional photographer.

PHOTO EDUCATORS. 1971. EN. 2640
Eastman Kodak Co., 343 State St., Rochester, NY 14650. Phone 716–724–4000. Mary–Helen Maginn, Editor.
Subscription: free to qualified personnel. Illus.
OCLC: 18376250. Dewey: 770. Formerly: *Newsletter for Photo Educators; Newsletter for Photography Instructors*.
Photographic Education. Photography.
Newsletter covering wide range of professional photography. Issued also as Kodak publication no. ED3–20–2.

PHOTO FORUM. 1980. m. EN. 2641
Horwitz Grahame, P.O. Box 306, Cammeram, N.S.W. 2062, Australia. Phone 02–929 6144. Margaret Brown, Editor.
Subscription: $A44. Sample $A4, No back issues. Illus. b&w, photos. A4, 36p.
ISSN: 0159–5962. Dewey: 770.
Trade publication directed to serving the needs of the photographic industry including retail camera stores, mini–labs, professional labs, supplies.
Reviews: back issues, video tape & equipment occasionally. Interviews: with those in the industry. Biographies: occasionally when individual is very important in the industry. Listings: regional–national. Freelance work: none.
Advertising: full page $900, ½ page $600, ¼ page $350, color $1550, covers £1200–1650. Frequency discount. 10% agency discount. Bleed + 10%. preferred position + 10%. Jim Preece, Ad. Director. Mailing lists: none. Demographics: subscription only to retail outlets and industry members. Circulation: 1500. Audience: photographic retailers and mini–lab operators.

PHOTO INTERPRETATION: Images Aeriennes et Spatiales. 1962. bi–m. FR, EN & SP. 2642
Editions Technip, 27 rue Ginoux, 75737 Paris Cedex 15, France. M. Guy and F. Verger, Editors.
Subscription: 990 F. Illus. color plates.
ISSN: 0031–8523. OCLC: 1762300. LC: TR810.P47. Dewey: 778.3.
"The main goal of the periodical...is to act as a teaching aid for the interpretation of remote–sensing images. For this it contains either interpretation case studies or methodological syntheses possibly dealing with a topic, a geographic region, a sensor, a processing method, etc". Issue consists of a folder with 5 separate article inserts including color plates.

PHOTO ITALIA. m. IT. 2643
Publimedia s.r.l., Corso Venezia 18, 20121 Milan, Italy. Francesco Buffa di Perrero, Editor.

Subscription: L 100000.
Dewey: 770. Formerly: *Photo Italiana*.
Advertising.

PHOTO LAB MANAGEMENT. 1979. m. EN. 2644
PLM Publishing, 1312 Lincoln Blvd., Box 1700, Santa Monica, CA 90406. Phone 213–451–1344, fax 213–395–9058. Carolyn Ryan, Editor.
Subscription: $15 US, outside USA + $10. Illus. 8½ x 11, 52-78p.
ISSN: 0164–4769. OCLC: 4750398. Dewey: 771.
Articles cover process chemistries, equipment maintenance and selection, industry developments and effective marketing and management techniques. "Mini Lab Management" section, new products, and news items included.
Freelance work: yes. Articles submitted for renumeration must specify "submitted at usual rates". Contact: editor.
Advertising: rates upon request. Audience: photo lab management personnel.

PHOTO LETTER. q. EN. 2645
Texas Photographic Society, Box 3109, Austin, TX 78764. Phone 512–477–0811. Barbara McCandless, Editor.
Dewey: 770.

PHOTO LIFE. 1976. 10/yr. EN. 2646
Camar Publications, 130 Spy Court, Markham, Ontario L3R 5H6, Canada. Phone 416–475–8440. Jane Giffen, Editor.
Subscription: $C21.95 Canada, +$10 elsewhere. Microform available from Micromedia. Sample free. Illus., photos (50/issue). 8⅛ x 10⅞, 52p.
ISSN: 0700–3021. OCLC: 3248520. LC: TR1. Dewey: 770.
Presents articles, technical information, new products, portfolio of photographs, and a feature story on professional photographer. Canada's only consumer magazine in the photovideo market.
Reviews: book. Calendar of events. Freelance work: submission of articles in encouraged (details in *PhMkt.*). Contact: editor.
Indexed: CanMagI.
Advertising. Circulation: 65,000. Audience: amateur and professional photographers.

PHOTO MADE IN ITALY. 1981. q. EN. 2647
Mediaspazio, V. M. Melloni 17, 20129 Milan, Italy. Andreas Demetriou, Editor.
Subscription: free.
OCLC: 10489245. Dewey: 770.
Official organ for Assofoto. Published by the group Foto–notiziario.

PHOTO MARKETING NEWSLINE. 1969. s–m. EN. 2648
Photo Marketing Association, 3000 Picture Place, Jackson, MI 49201. Phone 800–762–9287, 517–788–8100. Gary Pageau, Editor.
Subscription: included in membership, $36 US. Sample free. Back issues free. No illus. 4p.
ISSN: 0031–8531. OCLC: 7793142. LC: TR1.P38. Dewey: 331.
A business digest concerning photo industry firms and technological developments. Includes coverage of electronic imaging. A trade publication presenting news of interest to photo business.
Interviews: frequently speak with photo industry leaders. Freelance work: none.
Advertising: none. Mailing lists: none. Circulation: 12,000. Audience: photo industry members.

PHOTO NEWS. 1955. w. EN. 2649
Photo News Publishers, Inc, 2405 N. Dixie Hwy., W. Palm Beach, FL 33402. Phone 305–833–4511.
ISSN: 0031–854X. Dewey: 770.
Tabloid.

PHOTO PRO. 1989. q. EN. 2650
Icon Publications Ltd., Maxwell Lane, Kelso TD5 788, United Kingdom. Phone 0573–26032. David Kilpatrick, Editor.
Subscription: included in membership, £20, $35 (Ag8 Impress, Farringdon Rd., London). Sample & back issues £2.50. Illus. b&w, color, photos. A4, 68p.
ISSN: 0956–2745.
Graphic Arts. Photography.

Glossy technical magazine.

Reviews: book, equipment. Biographies: of professional photographers. Interviews: with professional photographers. Listings: national. Freelance work: yes. Contact: editor. Opportunities: study, competitions.

Advertising: full page £250, ½ page £150, ¼ page £85, color full page £450. Classified: £10/4cm. box. Frequency discount. Mailing lists: none. Circulation: 10,000. Audience: professional and enthusiast photographers.

PHOTO RETAILER. 1951. m. EN. 2651

Yaffa Publishing Group, 17–21 Bellevue St., Surry Hills, N.S.W. 2010, Australia. Phone 02–281–2333. Mark Ray, Editor. Illus.

ISSN: 0816–1909. Dewey: 771. Formerly: *Photo Trade News*.

Title has changed to *Photo & Video Retailer*.

THE PHOTO REVIEW. 1976. q. EN. 2652

Philadelphia Photo Review, 301 Hill Ave., Langhorne, PA 19047. Phone 215–757–8921. Stephen Perloff, Editor.

Subscription: included in membership together with *Newsletter*, $22 US, $24 Canada, foreign $28, air $32. Sample & back issues $5. Illus. b&w, photos. 8½ x 11, 24p.

ISSN: 0363–6488. OCLC: 12870977. Dewey: 770.5. Formerly: *Philadelphia Photo Review*.

Critical journal of photography of national scope and international readership. Covers photography events throughout the Mid–Atlantic region. Contains critical reviews, portfolios, interviews, new books, essays, news, and exhibition listings from New York, Philadelphia, Baltimore, and Washington, DC.

Reviews: exhibition 2–6, book 4–10. Listings: regional. Freelance work: yes. Contact: editor. Reviewed: Katz.

Advertising: full page $250, ½ page $150, ¼ page $90, no color. No classified. 10% frequency discount. Mailing lists: available sometimes. Circulation: 1000. Audience: photographers, artists, critics, curators, historians, general public.

PHOTO SELECTION: Le Magazine Quebecois de la Photographie. 1981. 8/yr. FR. 2653

Les Editions Carni Ltee, 910 aveune Ducharme, Ville de Vanier, Quebec G1M 2H6, Canada. Phone 418–687–3550. Yolande Racine, Editor.

Subscription: $19 Canada, $28 US, foreign $32. No Sample. Back issues $2.95. Illus. b&w, color, photos, cartoons. 8¼ x 10⅞, 52p.

ISSN: 0226–9708. Dewey: 770.

A contemporary magazine attuned to the latest high tech information. Contributors are renowned in the field of photography. Goal is to make known every facet of photography and to encourage readers to take more pictures. Several sections of the magazine showcase the works of readers.

Listings: national. Calendar of exhibitions. Freelance work: yes. Contact: editor. Opportunities: study, competitions.

Advertising: full page $2135, ½ page $1280, ½ page $705, color + $390–425. Classified: $45/col. inch. Frequency discount. Jacques Dumont, Ad. Director. Mailing lists: none. Demographics: Province of Quebec. Circulation: 18,000. Audience: amateur and professional photography buffs.

PHOTO TECHNIQUE. 1972. m. EN. 2654

Penblade Publishing, 93 Sirdar Rd., London W11 4EQ, England. Phone $15.33. Jack Schofield, Editor. Illus.

OCLC: 9696261. Dewey: 770.

PHOTO TECHNIQUE INTERNATIONAL. English edition. 1954. q. EN. 2655

Verlag Grossbild – Technik GmbH, Rupert– Mayer– Str. 45, 8000 Munich 70, W. Germany. Nikolaus Karpf, Editor.

Subscription: $32 (US: H.P. Marketing Corp., 216 Little Falls Rd., Cedar Grove, NJ 07009). Illus., some color. 82p.

OCLC: 10790691. LC: TR1.I64. Dewey: 770. Formerly: *International Photo Technique. English edition*.

Also available in French and German editions.

PHOTO-CINE-EXPERT: La Revue Suisse au Service des Photographes et Cineastes.

1979. 9/yr. 2656

Editions Jean Spinatsch SA, 13, route de Bellebouche, CH–1246 Corsier–Geneva, Switzerland. Jean Spinatsch, Editor.

Subscription: 55 SFr. Illus.

Formerly: *Nouveau Photo–Cine–Expert; Photo–Cine–Expert*.

PHOTO/DESIGN: For the Creative Team. 1984. bi–m. EN.

2657

Billboard Publications, Inc., 1515 Broadway, 39th Fl., New York, NY 10036. Phone 212–764–7300. Steve Pollock, Editor–in–chief.
Subscription: $42 US; Canada & foreign $47 surface, $70 air (Subscription Dept., P.O. Box 1958, Marion, OH 43305, phone 1–800–347–6969). Illus. color, photos. 8½ x 11, 84–112p.
ISSN: 0888–5680. OCLC: 13140999. LC: TR640.P43. Dewey: 770.

Addresses the informational and inspirational needs of creative professionals who commission and produce photography for advertising, editorial and corporate communications. Common threads throughout are graphic excellence and the promotion of photography as the most versatile art option.
Interviews: "Portfolio" contains photos with comment by the photographers.

PHOTOBULLETIN. 1985. w. EN.

2658

PhotoSource International, Pine Lake Farm, Osceola, WI 54020. Phone 715–248–3800. Lori Johnson & Lynette Layer, Editors.
Subscription: $450 US & Canada, foreign $510. Sample fee. Back issues. Illus. b&w. 8½ x 11, 3p.
ISSN: 0885–4270. OCLC: 12644819. Dewey: 779.

An electronic information service that lists the specific photographic needs of advertising agencies, public relation firms, corporations, and major book and magazine publishers. Includes information regarding deadlines and prices.
Listings: international. Freelance work: yes. Contact: editor. Opportunities: employment.
Advertising: none. Audience: photographers.

PHOTOEDUCATION. 1981. q. EN.

2659

Polaroid Corporation, 575 Technology Square, Cambridge, MA 02139.
Subscription: free. Illus.
OCLC: 19034235. LC: TR1.P8842.
Photographic Education. Photography.

PhotoEducation is the Polaroid newsletter for teachers of photography.

PHOTOFINISHING NEWS LETTER. 1984. bi–w. EN.

2660

Photofinishing News, Inc., 548 Goffle Rd., Hawthorne, NJ 07506. Phone 201–427–9384. Donald Franz, Editor.
ISSN: 0889–2393. OCLC: 13827234. Dewey: 338.

Presents information for both the professional and amateur photo finisher. Covers marketing and technical developments worldwide.
Advertising: none.

PHOTOFLASH: Models and Photographers Newsletter. 1980. q. EN.

2661

Models & Photographers of America, Box 25099, Colorado Springs, CO 80936–5099. Ron Marshall, Editor.
Illus. b&w, photos. 8½x11, 6p.
Dewey: 770.

Provides a forum for both models and photographers to present their art. Industry news, reports and other items of interest in the industry are also covered.
Freelance work: articles and photos. Contact: editor.
Audience: models, photographers, publishers, advertising agencies, modeling agents.

PHOTOFOLIO: Photography Collectors' Newsletter. 1980. EN.

2662

Photocollect, 740 West End Ave., New York, NY 10025. Alan Klotz, Editor.
Subscription: $20. Illus. 8½ x 11, 10p.
Dewey: 770.
Collectibles. Photographic History. Photography.

Covers photographic history, conservation, photograph collecting, market analysis and auction summery.
Circulation: 500.

THE PHOTOGRAMMETRIC RECORD. 1953. s–a. EN.

2663

Photogrammetric Society, Department of Photogrammetry & Surveying, University College London, Gower St., London WC1E 6BT, England. Phone 071–387 7050, fax 071–380 7145, telex 296273 UCLENG G. K.B. Atkinson, Editor.
Subscription: included in membership, £14.50 non–members. Illus. Cum. index every 3 yrs.

ISSN: 0031–868X. OCLC: 1762307. LC: TA501.P5. Dewey: 526.9.
Devoted to the art and science of photogrammetry, the mapping and surveying by aerial photography and measurement of other subjects through the use of photography.
Indexed: Photohi.

THE PHOTOGRAPH COLLECTOR: The Newsletter of Photography as Art and Investment.
1980. m. EN. **2664**
Photographic Arts Center Ltd., 163 Amsterdam Ave., Suite 201, New York, NY 10023. Phone 212–838–8460. Robert S. Persky, Editor.
Subscription: $125, overseas air + $24. 8½ x 11, 8–16p.
ISSN: 0271–0838. OCLC: 6546552. LC: TR1.P567.
Collectibles. Photography.

Newsletter concerned with all aspects of collecting and selling collectible photographs. Includes news of research, major acquisitions, statistics, auction news, and the international photography market.
Reviews: book. Listings: national–international. Calendar of events includes auctions and trade fairs. Gallery exhibition information. Opportunities: study – seminars.
Advertising. Audience: collectors, curators and dealers.

PHOTOGRAPHE. m.
2665
Publications Denis Jacob, 103, Bd. St. Michel, 75005 Paris, France.
Subscription: 265 F.
ISSN: 0369–9560. Dewey: 770.
Magazine for French photography professionals.
Advertising.

PHOTOGRAPHER (Canada). 1974. q. EN.
2666
Box 24954, Station C, Vancouver, B.C. VST 4G3, Canada. Gary Wilcox, Editor & Pub.
Illus.
Dewey: 770.

THE PHOTOGRAPHER (England). 1922. m. EN.
2667
British Institute of Professional Photography, Fox Talbot House, 2 Amwell End, Ware, Hertfordshire SG12 9HN, England. Phone 0920 487268/464011, 0920–487056. Ian Buchanan, Editor (6, Whittons Close, Hook Norton, Oxfordshire, OX15 5QG).
Subscription: 22£ UK & Erie, overseas £33. Sample. Back issues £2. Illus. b&w, color, photos, cartoons. A4, 64p. Sheet Fed Offset Litho.
ISSN: 0031–8698. Dewey: 770. Formerly: *Institute of Incorporated Photographers Record.*
Graphic Arts. Photography. Printing.

Focuses closely on the needs and interests of its readers. Notes previews of professional shows and the latest equipment surveyed.
Reviews: book 1, length½p.; equipment 1, length 3p.; exhibition occasionally, length 2p. Interviews: occasionally. Listings: regional–international. Calendar of events. Exhibition information. Freelance work: yes. Contact: editor. Opportunities: study, competitions.
Advertising: (rate card 1989): full page £695, ½ page £402, ¼ page £225, spread £1322, covers + 15–25%, color + £165–390. Classified: £10/scc., min. 3 cms. Frequency discount. 10% agency discount. Inserts. Reader service card. Mark Peacock, Ad. Director (phone 0992 487268). Mailing lists: available. Demographics: (readership survey); 72% self–employed, 22% working in government or company photographic departments; 80% employ fewer than 5 staff, 3% employ over 50; 36% general practice; 34% industrial, 31% portrait, 30% wedding; 68% have own studio, £11,400 average value of equipment. Circulation: 11,443. Audience: working professional photographers.

PHOTOGRAPHER'S FORUM. 1979. q. EN.
2668
Serbin Communications, Inc., 614 Santa Barbara St., Santa Barbara, CA 93101. Phone 805–963–0439. Glen R. Serbin, Editor.
Subscription: $12. Illus.
ISSN: 0194–5467. OCLC: 4815062. LC: TR1.P557. Dewey: 770. Formerly: *Student Forum.*
Advertising: Jules Wartell, Ad. Director.

PHOTOGRAPHER'S MARKET: Where and How to Sell Your Photographs. 1978. a. EN. 2668A
F&W Publications for Writer's Digest Books, 1507 Dana Ave., Cincinnati, OH 45207. Phone 513–531–2222. Sam A. Marshall, Editor.
Illus. b&w, photos, cartoons. Index. 6¼ x 9¼, 615p., hardbound.
ISSN: 0147–247X. ISBN: 0-89879-424-2. LC: TR12.P5. Dewey: 770. With *Artists Market*, supersedes: *Artist's and Photographer's Market*.
Photography.

Directory listing "over 2,500 places to sell news, publicity, product, scenic, portrait, fashion, wildlife, audiovisual, sports, and travel photos!" Contains 13 different market categories. Provides detailed information containing contact person, specifications, tips (insights into the photo buyer's needs), and interests of purchasers. Contains a "First Market Index," "good for freelancers breaking into photography or wanting to build up their portfolios in a new category".
Interviews: each section includes "Close–up", 1–2 interviews with guest experts who address specific market conditions and needs. Listings: national. Freelance work: buy reprints of work published by freelancers (details in *PhMkt.*). Contact: editor. Advertising: none. Mailing lists: none. Audience: freelance photographers.

PHOTOGRAPHIC ART MARKET. 1981. a. EN. 2669
Photographic Arts Center, 127 E. 59 St., New York, NY 10022. Phone 212–620–3196. Robert S. Persky, Editor.
Subscription: $69.50. Illus.
OCLC: 9612305. LC: TR6.5.P52. Dewey: 779.075093.
Provides auction price results and analysis.

PHOTOGRAPHIC CANADIANA. 1975. bi–m. (except Jul–Aug). EN. 2670
Photographic Historical Society of Canada, P.O. Box 115, Postal Station S, Toronto, Ontario M5M 4L6, Canada. Everett Roseborough, Editor (10 Northolt Court, Etobicoke, Ontario M9A 3B1).
Subscription: included in membership, $24 outside Canada. Back issues. Illus. Index with last issue.
ISSN: 0704–0024. OCLC: 5018235. LC: TR1. Dewey: 770.
Photographic History. Photography.

Focuses on articles on the history of photography.
Calendar of events. Freelance work: yes, no pay. Contact: editor. Indexed: ArtBibMod. Photohi.
Advertising.

PHOTOGRAPHIC INsight. 1987. q. EN. 2671
Photographic INsight Foundation, 474 Thames St., Bristol, RI 02809. Phone 401–253–2351. Stephen Brigidi, Editor.
Subscription: $20 individual, $35 institution US; + $6 Canada, foreign + $12 air. Sample $6–12. Back issues $6 + postage.
Illus. b&w, photos. 11 x 9, 48p.
ISSN: 0898–7572. OCLC: 17896370. Dewey: 770.
Drawing. Graphic Arts. Historic Preservation. Modern Art. Painting. Photography.

Photographic INsight presents critical issues and ideas on photography and its related visual arts and applications. A forum for opinion and dialogue. Provides a showcase for the images and intellect which drive the evolving art of photography. Also provides a gallery for image makers, insightful interviews and essays, aesthetic criticism and iconoclastic opinions within the photographic world. Features photographic news and information from featured regions throughout the international arts community. Published in a non–commercial magazine style.
Reviews: 2–3 exhibition & book, length 1000–1500 wds. Interviews: each issue features artist, critic or historians. Listings: national–international. Freelance work: yes. Contact: editor. Opportunities: study, competitions. Indexed: ArtBibMod.
Advertising: full page $900, ½ page $600, covers $1200–1500. Frequency discount. Patricia Gilmore, Ad. Director. Mailing lists: available. Demographics: international academic arts community, libraries, museums. Available in select book stores.
Multiple audience estimate 30,000/issue. Distributed throughout the world. Circulation: 3000–5000. Audience: international arts community.

THE PHOTOGRAPHIC JOURNAL. 1853. m. EN. 2672
Royal Photographic Society of Great Britain, The Octagon, Milsom St., Bath BA1 1DN, England. Phone 0225 462841. Roy Green, Editor (75 Crofters Mead, Courtwood Lane, Croydon CR0 9HT, phone 081–657 8210).
Subscription: included in membership; non–members £45 UK, £50 overseas. Microform available from UMI. Sample. No back issues. Illus. b&w, color, photos, cartoons. A4, 52p.
ISSN: 0031–8736. OCLC: 5813487. LC: TR1.P778. Dewey: 770. Formerly: *Photographic Journal. Section A, Pictorial & General Photography*.
A journal of photographic science.

Reviews: book 5–6, length 200–300 wds.; exhibition 1–2, length varies; equipment 10–12, length short. Interviews: leading photographers and others in photography. Biographies. Listings: national–international. Calendar of exhibitions. Freelance work: yes. Contact: editor. Opportunities: study, competitions. Indexed: ArtBibMod. ArtI. BioI. GrArtLAb. Photohi. Circulation: 9,700. Audience: members of Society and experienced photographers.

PHOTOGRAPHIC PROCESSING. 1964. m. EN. 2673

PTN Publishing Corp., 210 Crossways Park Drive, Woodbury, NY 11797. Phone 516–496–8000, 516–496–8013. Back issues. Illus. 8⅛ x 10⅞, 60p. ISSN: 0031–8744. OCLC: 7201985. Dewey: 771. Presents technical articles, news, and information regarding new products. Indexed: GrArtLAb. Advertising. Classified. Tom Martin, Ad. Director. Audience: those working in photo labs.

PHOTOGRAPHIC RESOURCE CENTER NEWSLETTER. 1977. 9/yr. EN. 2674

Photographic Resource Center, 602 Commonwealth Ave., Boston, MA 02215–2503. Phone 617–353–0700. Tom Block, Editor. Subscription: included in membership, $25. Sample & back issues $1. Illus. b&w, photos. 10p. ISSN: 8755–3902. OCLC: 10874819. LC: TR1.P468. Dewey: 770. Lists of exhibits, contests, and workshops pertaining to New England photographers. Covers events and shows at the Photographic Resource Center as well. Reviews: exhibition 1, book 9. Interviews: artists with shows at the Center. Listings: regional. Calendar of events. Exhibition information. Freelance work: none. Opportunities: employment listed occasionally, study, competitions. Advertising: Classified: 30¢/wd. Mailing lists: available for purchase. Circulation: 2500. Audience: New England photographers.

PHOTOGRAPHIC VIDEO TRADE NEWS. 1937. s–m. EN. 2675

PTN Publishing Corp., 101 Crossways Pk. West, Woodbury, NY 11797. Phone 516–496–8000, fax 516–496–8013. Subscription: Includes *PTN Master Buying Guide & Directory*, $6. Illus. 10½ x 14, 36p. ISSN: 0031–8779. Dewey: 771. Formerly: *Photographic Trade News*. Trade publication by the world's largest publisher of professional and trade magazines and newspapers for the photography industry. Accompanied by an annual *Master Buying Guide & Directory*. Advertising. Steven Ryan, Ad. Director. Audience: photo video and photofinishing retailers.

THE PHOTOGRAPHIC YEARBOOK. 1972. a. EN, FI, & SW. Full tr. 2676

The Photographic Museum of Finland, Box 596, SF–00101, Helsinki 10, Finland. Phone (0)596 544. Ritva Tahtinen, Editor. Subscription: $25 + postage $5 surface, $12 air. Back issues, $10–$25. Illus. 9/10 b&w, 1/10 color, photos. 195 x 210 cm, 160p. ISSN: 0356–8075. OCLC: 2472248. LC: TR1.V34. Dewey: 770. Contains a listing of events of last year, Finnish photography, Finnish photography abroad, and foreign photography in Finland. Listings: national. Exhibition information. Freelance work: none. Opportunities: study, competitions. Advertising: full page $900, ½ page $500, ¼ page $300, 4–color full page $1800. No frequency discount. Mailing lists: none. Audience: photographers, researchers in photography museums.

PHOTOGRAPHICA. 1968. q. EN. 2677

American Photographic Historical Society, 520 W. 44th St., New York, NY 10036. Phone 212–594–5056. George Gilbert, Editor. Subscription: included in membership, $25 US, $30 foreign. Microform available from World Micro (London). Sample. Back issues. Illus. b&w, photos. 8½ x 11, 16p. OCLC: 11991988. LC: TR1.P6417. Dewey: 770. Formerly: *Photographica/Journal*. **Antiques. Collectibles. Photographic History. Photography.** Articles discuss the history of photography as well as photography as a collecting hobby. Reviews: equipment & book 2 each, length ½ column each. Biographies: photographers of 19th and early 20th centuries. Listings: national–international. Calendar of exhibitions in New York City. Freelance work: none. Advertising: full page $250, ½ page $125, ¼ page $75, no color. No classified. No frequency discount. Mailing lists: none. Demographics: photographers, curators, historians, writers. Circulation: 400. Audience: membership.

PHOTOGRAPHIES MAGAZINE. 1983. 3/yr. FR only.
Photographies Magazine Edition, 51, rue de l'Admiral–Mouchez, 75013 Paris, France.
Illus. b&w, photos. 8 x 10¾, 126p.
Portfolios by individual photographers, photostories around a particular theme, news of exhibitions and contemporary photographers, and technical information on cameras. International in scope. Photos accompany articles, journal not mainly photographs.
Reviews: book.

PHOTOGRAPHY. 1983. m. EN.
Argus Specialist Publications Ltd., Argus House Boundary Way, Hempstead Herts HP2 7ST, England. Nigel Skelsey, Editor.
Subscription: £23.40 UK, $57.45 US, £30.50 Europe, £33.45 Far East; air rates on request (Infonet, 5 River Park Estate, Berkhamsted, Herts HP4 1HL. US subscription agent: Wise Owl Worldwide Publications, 4314 West 238th St., Torrance, CA 90505). Microform available from UMI. Back issues (Infornet). Illus. color, photos. 70p.
ISSN: 0031–8809. OCLC: 14950966. LC: TR1.T441. Dewey: 770. Formerly: *35MM Photography; Photography;* which incorporated: *Thirty–Five MM; Sub–Miniature Photography.*
Presents articles and portfolios regarding professional photographers and their works.
Reviews: book. Interviews. Freelance work: manuscripts and photos. Contact: editor. Indexed: Index with issue.
Advertising: display and classified ads. Paul Kavanagh, Ad. Director.

PHOTOGRAPHY IN JAPAN. 1953. m. JA. EN captions.
Photographic Society of Japan – Nihon Shashin Kyokai, c/o Kyodo Bldg., 2–2 Kanda Nishiki–cho, Chiyoda–ku, Tokyo 101, Japan.
Subscription: 100 Yen. Illus.
OCLC: 2245399. LC: TR1.P644. Dewey: 770.
Advertising.

PHOTOGRAPHY MAGAZINE INDEX. 1983. a. EN.
Paragon Publishing, Box 53, Santa Rosa, CA 95402. Phone 707–527–8185. Stu Berger, Editor.
OCLC: 18544567, 11813223, 20647142. Dewey: 770.
Loose–leaf subject index to several U.S. photography magazines.
Reviewed: Katz.
Advertising.

THE PHOTOHISTORIAN. 198? q. EN.
Royal Photographic Society of Great Britain, The Octagon, Milsom St., Bath BA1 1DN, England. Phone 0225–462841.
Illus.
ISSN: 0956–1455. OCLC: 21187143. LC: TR1.R6826. Formerly: *Newsletter (Royal Photographic Society of Great Britain. Historical Group).*
Photographic History.

Supplements accompany some issues.

PHOTOHISTORICA (Belgium). See no. 17.

PHOTOHISTORICA (England). s–a. EN, FR & GE.
European Society for the History of Photography, Acorn House, 74–94 Cherry Orchard Rd., Croydon CR0 6AB, England.
Phone 081 6813939.
Photographic History.

PHOTOJOURNALIST: The New Jersey Press Photographers Association Annual / NJPPA.
1987. a. EN.
New Jersey Press Photographers Association, Down the Shore, Box 353, Harvey Cedars, NJ 08008. Phone 201–242–1111.
Ray Fisk, Editor.
Illus.
ISSN: 0893–5610. OCLC: 15581788. LC: TR820.P553. Dewey: 779. Formerly: *N.J.P.P.A. Photojournalist.*
Advertising.

THE PHOTOLETTER. 1976. m. EN. 2685

PhotoSource International, Pine Lake Farm, Osceola, WI 54020. Phone 715–248–3800. Lori Johnson & Lynette Layer, Editors.

Subscription: $75 US & Canada, foreign $80, air $95, fax $12 monthly. Available online through: Genie (phone 1–800–638–9636), MCI Mail (phone 202–293–4255) and NewsNet (phone 215–527–8030). Sample, fee. Illus. b&w. 8½ x 11, 4p. ISSN: 0190–1400. OCLC: 6757850. Dewey: 779.

Provides photographers with the names and photographic needs of magazines and book companies throughout the United States. "The newsletter serving the nation's photo editors and photo illustrators".

Listings: international. Freelance work: yes. Contact: editor. Opportunities: employment.

Advertising: none. Audience: photo editors, photo illustrators, and photographers.

PHOTOLIFE U.S.A. 1979. m. EN. 2686

Dyno Publishing Corp., 26903 W. Eight Mile Rd., Detroit, MI 48240. Linda A. Wasche, Editor. Dewey: 770.

"Magazine of the entrepreneur photographer".

PHOTOMAGAZINE: Magazine des Photographes et Cineastes Amateurs. 1920. m. 2687

Publications Paul Montel, 189 rue Saint Jacques, 75005 Paris, France. Dir. B. Troyan. Subscription: 210 F. Illus.

Formerly: *Photocinema; Nouveau Photocinema; Photo–Cinema, Film, Amateur–Son.*

PHOTOMARKET. 1985. bi–w. EN. 2688

PhotoSource International, Pine Lake Farm, Osceola, WI 54020. Phone 715–248–3800. Lori Johnson & Lynette Layer, Editors.

Subscription: $260 US & Canada, foreign $296. Sample fee. 8½ x 11, 3p. ISSN: 0885–4262. OCLC: 12644974. Dewey: 779.

An electronic information service that lists the specific photographic needs of middle–range magazine and book publishers, providing detailed information on buyers picture needs, deadlines, and other pertinent details.

Listings: international. Freelance work: yes. Contact: editor. Opportunities: employment.

Advertising: none. Audience: photographers & photobuyers.

PHOTOMETHODS. 1958. m. EN. 2689

Professional Photographers of America, 1090 Executive Way, Des Plaines, IL 60018. Phone 312–299–8161. Lief Ericksenn, Editor.

Subscription: $18. Microform available from UMI. Illus. 8 x 10⅞, 56p. ISSN: 0146–0153. OCLC: 8081110 (microfilm). LC: TR1. Dewey: 771. Formerly: *PMI, Photo Methods for Industry.*

The magazine for photographic and audio–visual professionals. A communication tool for decision makers responsible for visual communication in business, industry, government, and the military.

Reviews: book. Indexed: GrArtLAb. Reviewed: Katz.

Advertising: Donna McMahon, Ad. Director.

PHOTOpaper. 1986. q. EN. 2690

Blatent Image/Silver Eye, 1015 East Carson St., Pittsburgh, PA 15203. Phone 412–431–1810.

Subscription: included in membership, membership basic level $35, subscription $15. No sample. Back issues $5. Illus. b&w, photos. 8 x 12, 8–18p.

PHOTOpaper is a publication to promote photography as a fine art. It is not to be advertisement for the Blatent Image, but rather a serious regional publication offering critical articles and reviews.

Reviews: exhibition 2–3, length 1–2p; book 1, length 1–2 columns. Interviews: on photographer currently exhibiting. Listings: regional–national. Calendar of events. Exhibition information. Freelance work: yes. Contact: Jody Guy. Opportunities: study, competitions.

Advertising. Mailing lists: available. Circulation: 1300.

PHOTOPRO. 1990. q. EN. 2691

Patch Communications, 5211 S. Washington Ave., Titusville, FL 32780. Phone 407–268–5010. Michael Chiusano, Editor. Subscription: $8.97.

ISSN: 1049–8974. OCLC: 21344988. Dewey: 770.

Contains reports on lighting tests and in–depth optical tests of professional lenses.
Reviews: equipment.

PhotoResearch. s–a. EN, FR & GE. 2692
European Society for the History of Photography, Acorn House, 74–94 Cherry Orchard Rd., Croydon CR0 6AB, England.
Phone 081 6813939.
Photographic History. Photography.

PHOTOVIDEO. 1984. 9/yr. EN. 2693
AVS Publishing Inc., 209–77 Mowat Ave., Toronto, Ontario M6K 3E3, Canada. Phone 416–532–6161, fax 416–536–1009.
Don Long, Editor & Pub.
Subscription: $C21. Microform available from UMI. Illus. 8⅛ x 10⅞, 24p.
OCLC: 19096348. LC: TR690.P48x. Dewey: 770. Formerly: *Canadian Photography; Photo Trade.*
Advertising. Albert Howard, Ad. Director.

PHOTOWORLD. 1978. m. EN. 2694
Australian Hi–Fi Publications Pty. Ltd., Box 341, Mona Vale, N.S.W. 2103, Australia. Phone 02 997–1188. Neil Sudbury, Editor.
ISSN: 0727–3959. Dewey: 770. Formerly: *Photographic World.*
Stresses photographic equipment and travel photography.

PICTORIALIST. 1941. m. EN. 2695
Photo Pictorialists of Milwaukee, Inc., 2909 S. 101 St., West Allis, WI 53227. Ronald M. Buege, Editor.
Subscription: included in membership.
Dewey: 770.

PICTURE SHOW. 1986. irreg. EN & SW. 2696
ETC Produktion, Luntmakargatan 70, 113 51, Stockholm, Sweden.
Illus. b&w, some color. size varies.
OCLC: 20684750.
An international photo documentary journal consisting chiefly of illustrations.

POLAREYES. See no. 718.

POPULAR PHOTOGRAPHY. 1937. m. EN. 2697
Diamandis Communications, Inc., 1633 Broadway, New York, NY 10036. Phone 217–767–6000. Sean Callahan, Editor.
Subscription: $11.97. Microform available from UMI. Available online via Dialog. Illus. b&w, some color, photos. 7⅞ x 10½, 120p.
ISSN: 0032–4582. OCLC: 1762661. LC: TR1.P8845. Dewey: 770. Merged with: *Modern Photography.* Formerly: *Photography.*
Extensive analysis of new cameras and equipment, articles on techniques, and photo folios by leading photographers.
Freelance work: yes (details in *PhMkt.*). Indexed: ArtBibMod. BioI. CloTAI. GrArtLAb. PhoMI. Photohi. RG. Reviewed: Katz.
Advertising: Richard Rabinowitz, Ad. Director.

PRACTICAL PHOTOGRAPHY. m. EN. 2698
EMAP National Publications Ltd., Bushfield House, Orton Centre, Peterborough PE3 0UW, England. Dominic Boland, Editor.
Illus.
ISSN: 0032–6445. OCLC: 11890336. LC: TR1.P72. Dewey: 770.

PROFESSIONAL AND INDUSTRIAL PHOTOGRAPHIC EQUIPMENT. 1971. a. EN. 2699
Yaffa Publishing Group Pty. Ltd., 17–21 Bellevue St., Surry Hills, N.S.W. 2010, Australia. Phone 02–281–2333.
Subscription: $A4.
Formerly: *Australian Photography Professional and Industrial Catalogue.*

PROFESSIONAL PHOTOGRAPHER (England). 1980. m. EN. **2700**

Market Link Publishing, Wenden Court, Wendens Ambo, Saffron Walden, Essex CB11 4LB, England. Phone 0799 41675, fax 0799 41682. Jon Tarrant, Editor.

Subscription: £26 UK, overseas including Eire £38. Microform available from UMI. Back issues. Illus. b&w, photos. A4, 46p. ISSN: 0019–784X. OCLC: 6340329. LC: TR690.A1I5. Dewey: 770. Formerly: *Industrial and Commercial Photographer*.

Contains 1–2 articles as well as information on news, products, and equipment. Supplement to the April issue, "Pro Lab Guide" reviews professional processing labs and contains a directory for England and Scotland.

Reviews: book, exhibition. Exhibition information. Opportunities: study, workshops; awards announced.

Advertising. Classified: £10/scc + VAT. Readers service card. Andy Rice, Ad. Director.

PROFESSIONAL PHOTOGRAPHER (U.S.). 1907. m. EN. **2701**

Professional Photographers of America, PPA Publications and Events, Inc., 1090 Executive Way, Des Plaines, IL 60018. Phone 708–299–8161, fax 708–299–2685. Alfred DeBat, Editor.

Subscription: $22.10 US, $35 Canada & foreign. Microform available from UMI. Sample $3.25. Index. Illus. mainly color, b&w, photos (25–35/issue). 8½ x 11, 80p.

ISSN: 0033–0167. OCLC: 1696399. LC: TR690.N3. Dewey: 770. Formerly: *National Professional Photographer*.

"The business magazine of professional photography", the official journal of the Professional Photographers, the oldest exclusively professional photographic publication in the Western Hemisphere founded in 1907 by Charles Abel. Covers the entire field through feature articles, regular columns offering technical pointers and information on new and state of the art products.

Reviews: book. Freelance work: yes (details in *PhMkt.*). Indexed: GrArtLAb. Reviewed: Katz.

Advertising: rates on request. Classified: $1.10/wd., min. $24. Donna McMahon, Ad. Director. Circulation: 30,000. Audience: professional photographers, photographic services, and educators.

PROFESSIONAL PHOTOGRAPHY. 1984. a. **2702**

Editrice Progresso s.r.l., Viale Piceno 14, 20129 Milan, Italy. Phone (02) 71.59.39.

Subscription: L 10000. Illus.

Dewey: 770.

PROFESSIONAL PHOTOGRAPHY IN AUSTRALIA. 1944. m. EN. **2703**

Horwitz Grahame Pty Ltd., P.O. Box 306, Cammeray, N.S.W. 2062, Australia. Phone 02–929–6144. Paul Burrows, Editor.

Subscription: included in membership (AIRP), $A54 Australia, foreign $A64. Sample $A4.50 + postage. Back issues $A4.50. Illus. b&w, some color. 274 x 210mm.

ISSN: 0159–8880. Dewey: 770. Formerly: *I.A.P. Professional Photography in Australia*.

New and views for professional photographers.

Advertising: full page $A1025, ½ page $A660, ¼ page $A400, 2 color + $A180, 4 color full page $A1650, covers $A1350–2090. Frequency discount. 10% agency discount. Bleed + 10%. Preferred position + 10%. Jim Preece, Ad. Director. Mailing lists: available. Circulation: 4000. Audience: professional photographers.

PROFESSIONELE FOTOGRAFIE. bi-m. DU. **2704**

Vereniging van Beroepsfotografen in Nederland, Nieuwe Keizersgracht 58, 1018 DR, Amsterdam, Netherlands. Phone 020–247151.

Dewey: 770.

Indexed: Photohi.

PSI PRODUCTS PREVIEWS. m. EN. **2705**

Photographic Society International, 1380 Morningside Way, Venice, CA 90291. Phone 213–392–6537.

Publication of the Society which promotes better world understanding through photography. Presents information designed to improve members' skills.

THE RANGEFINDER. 1952. m. EN. **2706**

Steve Sheanin, Publisher, P.O. Box 1703, 1312 Lincoln Blvd., Santa Monica, CA 90406. Phone 213–451–8506, Fax 213–395–9058. Arthur Stern, Editor.

Subscription: $15 US, + $10 postage elsewhere. Sample & Back issues $2. Illus. b&w, color, photos. 8½ x 11, 70p. offset lithography.

ISSN: 0033–9202. OCLC: 830999. LC: TR1.R35x. Dewey: 770. Formerly: *School Photographers Digest*.

Videography. Business Management.

Trade journal for professional photographers, covering all aspects of the industry: portrait, commercial, wedding, stock, business management, video, computer software, profiles, how–to, new products, and industry news and personnel. Some special theme issues.

Reviews: book 7 and videos 5, length½p. each. Interviews: profiles of professionals. Biographies. Listings: regional–international. Calendar of events. Exhibition information. Freelance work: yes 75%. Contact: editor. Opportunities: study, competitions. Indexed: GrArtLAb. PhoMI. Reviewed: Katz.

Advertising: (rate card Jan '89): full page $4395, full page $2875–3050, ¼ page $1860; 2 color + $375–510; 4 color + $1075 full page, covers $6260–6615. Special position + 15%. Bleeds + 15%. Classified: $1 wd., min. $20; "Merchandise Mart" $182/1 col. x 1 inch. 15% agency discount. 2% cash discount. Inserts. Mailing lists: none. Jerry Goldstein, Ad. Director. Demographics: coverage throughout the 50 states and additional foreign coverage. Circulation: 50,000. Audience: professional photographers who earn their living in portrait, wedding, commercial, industrial and school photography.

RE: VIEW. 1978. m. EN. 2707
Friends of Photography, 101 The Embarcadero, Suite 210, San Francisco, CA 94105. Phone 415–391–7500, fax 415–495–8517. David Featherstone & Debra Heimerdinger, Editors.
Subscription: included in membership together with *Untitled*, $50. Illus. 8½ x 11, 4p.
ISSN: 0891–5326. OCLC: 14879921. LC: TR640.R48. Dewey: 770. Formerly: *Friends of Photography. Newsletter.*
Newsletter of the nonprofit arts organization. Contains essays and information about the field of creative photography and the activities of the organization.
Reviews: book, lengthy.
Advertising: none.

LA RECHERCHE PHOTOGRAPHIQUE. 1986. s–a. FR. EN & FR summaries. 2708
Paris Audivisuel, 35, rue de La Boetie, 75008 Paris, France. Phone 1933 1 43 59 33 61. Andre Rouille (19, rue Levert, 75020 Paris).
Subscription: 140 F, $US20 + postage US & Canada; air + 20F, $US3. No sample. Back issues. Illus. 21 x 29 cm., 104p.
ISSN: 0983–8430. OCLC: 17641090.
Reviews: photography 9. Bibliographies: recent publications on photography. Biographies: historical criticisms on contemporary or past photographers or schools of photography. Interviews. Listings: international. Exhibition information. Freelance work: yes. Contact: Mr. Hermange. Indexed: ArtBibMod. Photohi.
Advertising: full page 8000 F, ¼ page 2000 F. Classified. Frequency discount. Mr. Hermanage, Ad. Director. Mailing lists: available, negotiable. Audience: specialists in photography.

ROYAL PHOTOGRAPHIC SOCIETY HISTORICAL GROUP QUARTERLY. q. EN. 2709
Royal Photographic Society Historical Group, The Octagon, Milsom St., Bath BA1 1DN England.
OCLC: 12935418.
Photographic History.
Indexed: Photohi.

SBI'S STUDIO TECHNIK. 1985. s–a. EN. 2710
Sinar Bron, Inc., 17 Progress St., Edison, NJ 08820. Phone 201–754–5800. Don Jakubowski, Editor.
Subscription: free. No back issues. Illus. b&w, color, photos. 8½ x 11, 6p.
Dewey: 770.
Graphic Arts. Photography.
Interviews, technical tips, SBI news, and questions and answers.
Interviews: with professional photographers. Listings: national. Calendar of events. Freelance work: yes. Contact: editor. Opportunities: study at Sinar Bron.
Advertising: none. Audience: photographers.

SCOTTISH PHOTOGRAPHY BULLETIN. 1989. s–a. EN. 2711
Scottish Society for the History of Photography, c/o Scottish Photography Archive, Scottish National Portrait Gallery, 1 Queen St., Edinburgh EH2 1JD, Scotland.
Illus.
ISSN: 0269–1787. OCLC: 19781141. LC: TR1.S367. Dewey: 770.
Photographic History.
Indexed: ArtBibMod.

SELECT. 1982. q. 2712
Moser und Colby GmbH, Duisburger Str. 44, 4 Dusseldorf 30, W. Germany.
Subscription: Select America, 153 West 18th St., New York NY 10011. Illus., photo.

SHOTS: A Journal about the Art of Fine Photography. 1986? bi–m. EN. 2713
Shots, Box 109, Joseph, OR 97846. Daniel Price, Editor & Pub.
Subscription: $15 US, $20 Canada, $20 foreign surface. Sample $2. Back issues $2. Illus. b&w, photos, drawings. 8¼ x 10¼, 56+p.
ISSN: 1048–793X.
Hand made journal that publishes the work of all photographers working in the b&w medium. Devoted to publishing the work of little known but accomplished artists.
Listings: international. Exhibition information. Freelance work: none. Reviewed: *Art Documentation* Spring 1989, p.23.
Advertising: full page $300. Mailing lists: available. Circulation: 1500. Audience: photographers.

SHUTTERBUG. 1971. m. EN. 2714
Patch Communications, 5211 S. Washington Ave., Titusville, FL 32780. Christi Ashby, Editor.
Subscription: $16 US, + $30 Canada, + $40 foreign. Index. 10 x 13, 148p.
ISSN: 0895–321X. LC: TR. Dewey: 771. Formerly: *Shutterburg Ads Photographic News*.
Photo equipment magazine for advance amateur and professional photographers. Features articles on camera systems and techniques, including test reports and accessory updates.
Advertising. Russell Gilchrist, Ad. Director. Audience: photographers, amateur and professional.

SHUTTERBUG ADS PHOTOGRAPHIC NEWS. 1984. m. EN. 2715
Patch Communications, 5211 S. Washington Ave., Titusville, Florida 32780. Phone 407–268–5010.
Illus.
OCLC: 11414752. LC: TR1.S539. Formerly: *Shutterbug Ads*.

SIX. 1987. 2716
Comme des Garcons Co. Ltd., 5–11–5 Minami Aoyama, Minato–Ku, Tokyo, Japan.
Subscription: free? Illus. photos.
Reproduces work by fashion photographers. Each issue features works by a famous 20th–century photographer.

SLR PHOTOGRAPHY. 1985. m. EN. 2717
Bushfield House, Orton Centre, Peterborough PE2 0UW, England. Barry Hunter, Editor.
Illus.
OCLC: 15876750. LC: TR1.S52. Dewey: 770. Formerly: *SLR Camera*.
Devoted to single–lens reflex cameras.
Reviews: book.
Advertising.

SOCIETY OF PHOTOGRAPHERS AND ARTIST REPRESENTATIVES. NEWSLETTER.
bi–m. EN. 2718
Society of Photographers and Artist Representatives, 1123 Broadway, Suite 910, New York, NY 10010. Phone 212–924–6023.
Dewey: 770.

SOUTHERN EXPOSURE. 1950. q. EN. 2719
Southeastern Professional Photographers Association, Inc., Box 355, Talladega, AL 35160. Phone 205–362–3485. Van Blankenship & MaryLee Blankenship, Editors.
Subscription: included in membership.
ISSN: 0038–4070. Dewey: 770.
Publication of the Southeastern Professional Photographers Association.

SOVETSKOE FOTO. 1926. m. RU, EN, FR & GE. 2720
Soyuz Zhurnalistov S.S.S.R., M. Lubyanka 14, Tsentr. 101878 GSP Moscow, Russian S.F.S.R., U.S.S.R. Phone 925–00–27. O. Suslova, Editor.
Subscription: 8.40 Rub. Illus. some color.

ISSN: 0038–5190. OCLC: 7798678. LC: TR654.F58. Dewey: 770.
Photographs by Soviet professionals and amateurs compiled by the editors of the magazine.
Indexed: ArtBibMod.

THE SPE NEWSLETTER. 1963. 5/yr. EN. 2721
Society for Photographic Education, Campus Box 318, Boulder, CO 80302. Phone 303–492–0588. Patricia Johnston, Editor.
Subscription: included in membership together with *Exposure* and *The SPE Directory and Resources Guide*. 6p.
ISSN: 0748–6413. OCLC: 9495932. LC: TR1.S636. Dewey: 770.
Photographic Education. Photography.

Functions as a vehicle for information and exchange of Society business, bulletin boards and job listings. It provides a net-work for communicating members' concerns, news items and reports from the Society's eight regions.
Calendar of events. Exhibition information. Opportunities: employment, study, conferences, competitions.
Advertising: (rate card Jun '87): $300 8½ x 11 pre–printed insert folded to 8½ x 5½. Mailing lists: available. Sanford Gold-rich, Ad. Director (133 Stockton Lane, Rochester, NY 14625, phone 716–671–1194, fax 671–4494). Demographics: 91% of members are active photographers, 75% also teach photography.

SPOT. 1983. q. EN. 2722
Houston Center for Photography, 1441 W. Alabama, Houston, TX 77006. Phone 713–529–4755. April Rapier, Editor.
Subscription: $15. Tabloid, 28p.
Dewey: 770 370. Formerly: *Image*.
A publication of the Houston Center for Photography, a non–profit organization. Serves the photographic community as a resource for educational exchange.
Exhibition information. Opportunities: study. Indexed: ArtBibMod.
Advertising. Stephen Peterson, Ad. Director. Circulation: 1,000.

STEREO WORLD. 1974. bi–m. EN. 2723
National Stereoscopic Association, P.O. Box 14801, Columbus, OH 43214. Phone 614–263–4296. John Dennis, Editor.
Subscription: included in membership, US $30 first class, $22 third; Canada & foreign $US32, air $46. Membership includes a membership directory. Sample fee. Back issues, price varies. Illus. b&w, color, photos. 8½ x 11, 40–48p.
ISSN: 0191–4030.
Collectibles. Photographic History. Stereography.

The purposes of the organization are to promote the study and collecting of stereographs, stereo cameras, and related materi-als; to provide a forum for collectors and students of stereoscopic history; to promote the practice of stereophotography; to en-courage the use of stereoscopy in the visual arts and technology; to foster the appreciation of the stereograph as a visual historical record; and to provide for the Stereoscopic Research Library. Covers all aspects of 3–D photography. The journal provides high–quality reproductions of stereo views on coated paper. Publishes original research by noted authorities on ste-reo photographers, their publishing histories, the great events and subjects they depicted, and their equipment and techniques. It also features articles of interest to the contemporary stereophotographer, discussing cameras and other equipment, special stereo techniques, 3–D films and T.V. and news about latest developments.
Reviews: book 1, equipment 2. Listings: regional–national. Calendar of photo shows. Exhibition information. Freelance work: none. Opportunities: competitions, contests.
Advertising: (rate card May '88): (camera ready only) full page $95, ½ page $55, ⅓ page $40. Classified: 20¢/wd., members 3 free ads/yr. total 100 wds. No frequency discount. Inserts. John Waldsmith, Ad. Manager. Mailing lists: none. Circulation: 2400.

STEREOSCOPIC SOCIETY BULLETIN. q. EN. 2724
Stereoscopic Society, 195 Gilders Rd., Chessington, Surrey KT9 2EB, England.
Devoted to the study of three dimensional imagery. Society's purpose is to advance stereoscopic photography.
Demographics: subscribers in 6 countries.

STUDIO LIGHT. 1901. s–a. EN. 2725
Eastman Kodak Co., 343 State Street, Rochester, NY 14650. Marlene Morgan, Editor.
Subscription: free to qualified personnel. Illus.
ISSN: 0039–4122. Dewey: 770.
A Kodak house organ.

STUDIO PHOTOGRAPHY. 1964. m. EN. 2726
Stanley Sill, Owner, 210 Crossways Park Dr., Woodbury, NY 11797. Phone 516–496–8000. G. Faye Guercio, Editor.
Subscription: $10, free to qualified personnel. Sample. Illus. 8⅛ x 10⅞.
ISSN: 0746–0996. OCLC: 7439104. LC: TR1.P5. Dewey: 770. Formerly: *Photographic Product News; Photographic Business and Product News.*
Official publication of the Professional School Photographers of America. A business magazine for professional portrait, wedding and commercial photographers.
Reviews: book. Indexed: GrArtLAb. Reviewed: Katz.
Advertising. Mailing lists: available. Circulation: 61,000. Audience: professional photographers.

TECH BITS. 1963. 3/yr. EN. 2727
Eastman Kodak Company, 343 State St., Rochester, NY 14610. Phone 716–724–4557. Elizabeth Eggleton, Editor.
Subscription: free. Illus.
Dewey: 770.
Technical information.
Circulation: 40,000. Audience: scientists and engineers who use photographs in their professions.

TEN.8. 1981. q. EN. 2728
Ten.8 Ltd., 9 Key Hill Drive, Hockley, Birmingham B18 5NY, England. Phone 021–554 2237, fax 021–554 5970. John Taylor, Editor.
Subscription: £15 individual, £30 institution inland; £18 $US31.59 individual, Europe/rest of world surface. Illus. b&w, photos. A4, 72p.
ISSN: 0142–9663. OCLC: 8767723. LC: TR820.T3. Dewey: 770. Formerly: *Ten.8 Photography Magazine.*
Education. Photography.

International photographic magazine, each issue has an individual theme. Presents photography, documentary photography, image-making and representation from a broad spectrum of contemporary theory and practice. Review section provides detailed critical comments on new books and exhibitions. Also section devoted to the issues of photography in education.
Indexed: ArtBibMod. Reviewed: Katz.

UNTITLED. 1972. irreg. EN. 2729
Friends of Photography, 101 The Embarcadero, Suite 210, San Francisco, CA 94105. Phone 415–391–7500. David Featherstone, Editor.
Subscription: included in membership together with *Re: View*, $50. Illus. b&w, some color. 64p.
ISSN: 0163–7916. OCLC: 1724552. LC: TR1.U585. Dewey: 770.
Series of publications on serious photography presented by a not–for–profit organization with a commitment to photography as a fine art, and to the discussion of photographic ideas through critical inquiry. The publication emphasizes contemporary photography but is also concerned with the criticism and history of the medium. Each issue devoted to a different theme.
Indexed: ArtBibMod. Reviewed: Katz.
Advertising: none. Circulation: 13,000.

UPAA NEWSLETTER. 1961. q. EN. 2730
University Photographers' Association of America, c/o Donald Pavloski. Phone 607 Cohodas, Northern Michigan University, Marquette, MI 49855.
Subscription: included in membership.
Dewey: 770.
Newsletter of the Association for college and university personnel who are engaged professionally in photography, teaching of photography, audio visual work or journalism.
Advertising: none.

VIEW CAMERA. 1988. bi–m. EN. 2731
Steve Simmons Photography, P.O. Box 8166, Sacramento, CA 95818.
Subscription: $21 US, +$8 Canada, foreign +$14. Illus. some color.
OCLC: 20285618. LC: TR1.V54.
"The journal of large format photography".

VIEWFINDER JOURNAL OF FOCAL POINT GALLERY. 1982. a. EN. 2732
Focal Point Press, 321 City Island Ave., New York, NY 10464. Phone 212–885–1403. Ron Terner, Editor.
Dewey: 770.

VIEWS: The Journal of Photography in New England. 1977. 3/yr. EN. 2733
Photographic Resource Center, 602 Commonwealth Ave., Boston, MA 02215. Phone 617–353–0700. Dan Younger, Editor.
Subscription: included in membership, $25 individuals. Sample free. Back issues $2. Illus. b&w, photos. 28p.
ISSN: 0743–8044. OCLC: 5281985. LC: TR1.V538. Dewey: 770.
Photographic History. Photography.
Specializes in the history of photography and photographic criticism.
Reviews: exhibition 5 & book 5, length 350 wds.; conference/symposia reports 1, length 350–500 wds. Interviews: often include interview with working photographer, usually Boston/New England region. Freelance work: yes freelance writing. Contact: editor. Indexed: ArtBibMod. Reviewed: Katz. *School.*
Advertising: full page $400, ½ page $230, ⅓ page $190, no color. Classified: none. 10% frequency discount. Mailing lists: available, fee. Demographics: academics, libraries. Circulation: 3000. Audience: photohistorians, photographers.

VIEWS / TORONTO PHOTOGRAPHERS WORKSHOP. 1983. 5/yr. EN. 2734
Toronto Photographers Workshop, 80 Spadina Ave., Suite 310, Toronto, Ontario M5V 2J3 Canada. Lorne Fromer, Editor.
Subscription: free, included in membership. Illus.
ISSN: 0827–9306. OCLC: 13172042. LC: TR690. Dewey: 779.

VISUAL RESOURCES ASSOCIATION BULLETIN. See no. 94.

WEDDING PHOTOGRAPHERS INTERNATIONAL. 1975. m. EN. 2735
Wedding Photographers International, Box 2003, 1312 Lincoln Blvd., Santa Monica, CA 90406. Phone 213–451–0090. Julia Miller, Editor.
Subscription: included in membership. Illus. b&w, photos. 8½ x 11, 4–12p.
Dewey: 770.
A forum for information exchange related to the entire field of wedding photography.
Interviews: professionals in the field. Calendar of events. Freelance work: yes. Contact: editor. Opportunities: study – seminars and conventions; awards announced.

WHAT CAMERA? Incorporating Camera Weekly. 1988. m. EN. 2736
IPC Magazines, Ltd., Prospect Magazines, 9–13 Ewell Rd., Cheam, Surrey SM1 4QQ, England. Phone 081–661 6600. Chris George, Editor.
Subscription: £15 UK; £25 air freight, £45 airmail US, Canada, Asia, Australia; £35 Middle East, No. Africa (US: 205 E 42nd St., New York, NY 10017). Sample & back issues £1.60. Illus. b&w, color, photos, cartoons. 21 x 29 cm., 124p.
ISSN: 0956–148x. Dewey: 770. Formerly: *Camera Weekly.*
Covers all aspects of photography with emphasis on field tests of equipment, "how to do it" articles and the best photographs from around the world. Purpose is to help people to use cameras creatively, to show the beginner how exciting photography can be and show those with a little more expertise how to master new techniques. Contains news and reviews of cameras and equipment with a particular emphasis on how new products can help the photographer take better pictures.
Reviews: book 5, length 150 wds.; equipment 5, length 1500 wds. Interviews: celebrities and their cameras, top photographers, and readers regarding their work. Listings: regional–national. Exhibition information. Freelance work: yes. Contact: editor. Opportunities: study, competitions.
Advertising: (rate card Sept '88): full page £620, ½ page £315, ¼ page £165; color full page £1150, covers £1150–1325. Classified: full page £575, ½ page £320, ¼ page £170, £7.50 scc., min. 3cm. Frequency discount. Inserts. Bleeds + 10%. Special positions + 10%. Mark Boden, Ad. Manager. Mailing lists: none. Circulation: 60,034. Audience: hobby photographers.

WOMEN & PHOTOGRAPHY. 1986. irreg. EN. 2737
Camerawork, 121 Roman Rd., Bethnal Green, London E2 OQN England.

YOU AND YOUR CAMERA. 1979, no.13. w. EN. 2738
Eaglemoss Publications Ltd., 7 Cromwell Rd., London SW7 2HR, England. Jack Schofield, Editor.
I!!us.

OCLC: 13182446. LC: TR1.Y682. Dewey: 771.
Advertising.

ZHONGGUO SHEYING/CHINESE PHOTOGRAPHY. 1957 (suspended Apr 1966–Aug 1974). bi–m.
CH. **2739**
China Books & Periodicals, Inc., 2929 24th St., San Francisco, CA 94110. Phone 415–282–2994.
Subscription: $64.40. Illus. photos.
OCLC: 1799808. LC: TR640.C5. Dewey: 770.
Indexed: ArtBibMod.

ZOOM (Milan). 1972. m. IT. **2740**
Editrice Progresso s.r.l., Viale Piceno 14, 20129 Milan, Italy. Phone 02 71.59.39.
Subscription: L 90000. Illus.
ISSN: 0393–4330 (IT). OCLC: 9355057. LC: TR640.Z683. Dewey: 770.
Available also in English and French language editions.
Reviews: book.

ZOOM (Paris): Le Magazine de l'Image. 1969. m. FR. **2741**
2, rue du Fg Poissonniere, 75010 Paris, France. Joel Laroche, Editor.
Subscription: 350 F (for US: Zoom USA, 11–03 46th Ave., Box 2000, Long Island City, NY 11101).
LC: TR640.Z68. Dewey: 770.
The international image magazine. Available also in bi–monthly English edition.
Indexed: Des&ApAI.

A.M.I. NEWSLETTER. 1950. bi–m. EN.　　　　　　　　　　　　　　　　　　　　　　　**2742**
Association of Medical Illustrators, 2692 Huguenot Springs Rd., Midlothian, VA 23113. Phone 804–794–2908. Brian Lee Mitchell, Editor.
Illus.
ISSN: 0001–1916. Dewey: 610.
Purpose is to promote the study and to encourage the advancement of medical illustration and allied fields of medical education.
Audience: medical illustrators.

AMERICAN ART THERAPY ASSOCIATION NEWSLETTER. 1974. q. EN.　　　　　　　　**2743**
American Art Therapy Association, Inc., 1980 Isaac Newton Sq., S., Reston, VA 22090. Phone 703–437–6012. Dr. Harriet Wadeson, Editor.
Subscription: included in membership, $9 non–members. 20p.
Provides legislative news, members news, and information on related organizations and available resources.
Calendar of events.

THE AMERICAN JOURNAL OF ART THERAPY. 1962. q. EN.　　　　　　　　　　　　　**2744**
Vermont College of Norwich University, Montpelier, VT 05602. Phone 806–223–8810. Gladys Agell, Editor.
Subscription: individuals $25 US, $30 Canada & foreign, air $42; libraries $45 all. Microform available from UMI. Sample.
Back issues $5.25 US, $6.75 foreign. Illus. b&w, photos. Annual index last issue of volume. Cum. index v.1–10, v.11–20.
ISSN: 0007–4764. OCLC: 1798034. LC: RC489.A7 B8. Dewey: 616.8515. Formerly: *Bulletin of Art Therapy*.
Art Therapy.
Covers art in education, rehabilitation, and psychotherapy. Deals with the graphic and plastic arts as they contribute to human understanding and mental health. Contents include new theoretical formulations, reports of research, case studies, descriptions of actual programs, reviews, bibliographic information, news of opportunities for training and of international developments in the field.
Reviews: book, film. Interviews: occasionally. Listings: regional–international. Calendar of events. Opportunities: employment (occasionally listed), study, competitions. Indexed: ArtBibMod. BioI. EdI. Reviewed: Katz. *School*.
Advertising: full page $200, ½ page $150, ¼ page $75, no color. Kathi Smith, Ad. Director. Demographics: 85% national, 15% international in 37 countries. Circulation: 2000. Audience: university and hospital libraries, art therapists and other mental health professionals, art and special educators, and others interested in art and rehabilitation.

ART & DESIGN NEWS. 1979. bi–m. EN.　　　　　　　　　　　　　　　　　　　　　**2745**
Grady Publishing Co., Drawer 117, St. Petersburg, FL 33731. Phone 813–821–6064, fax 813–821–2520. John E. Grady, Jr., Editor.
Subscription: $15 US, + $15 Canada, + $33 foreign. 11 x 14, 24p.
ISSN: 0163–7460. OCLC: 4473270. Dewey: 702.8. Formerly: *Art Product News*.
Coverage of material used by artists and designers. Lists new materials available on the market.
Advertising. Jeanne Pulliam, Ad. Director. Circulation: 52,000.

ART BUSINESS NEWS. 1973. m. + a. *Buyer's Guide*. EN.　　　　　　　　　　　　　**2746**
Myers Publishing, 777 Summer St., 60 Ridgeway Plaza, Stamford, CT 06905. Phone 203–356–1745, fax 203–356–1903. Jo Yanow–Schwartz, Editor.
Subscription: free (controlled circulation to qualified trade); others $30 US & Canada, foreign $60, air $120. Sample $3.50.
Back issues. Illus. b&w, color, cartoons. 10¾ x 14¼, 130p.

ISSN: 0273–5652. OCLC: 7079011. LC: N1.A414. Dewey: 706. Formerly: *Art Dealer and Framer*.

Framing.

Trade magazine presenting "art business news for the business side of art". In gathering all the national news of importance to the industry, ABN's editorial provides an ongoing update on the art and framing markets, the dealers, the publishers' programs, and products. Provides information on prints, paintings, posters, photography and sculpture; on mouldings, matboards and equipment; covers imagery in the art the public is buying; new gallery and frame shop openings; art prices at retail and auction; art marketing; community–related art and local art gallery association activities. Reports on a range of international shows. "Art Hotline," a sign–off page in every issue on national and international art developments and museum exhibits. A regular column that updates information about art thefts and forgeries. Includes a print index analyzing prices taken from auction results from around the world.

Reviews: book 2 & equipment 4, length 400 wds. Interviews: dealers/art and framing, others as relative to art business. Listings: international. Calendar of events. Exhibition information. Freelance work: yes (details in *ArtMkt.*). Contact: editor. Opportunities: study – conferences, courses, seminars.

Advertising: (rate card Jan '90): b&w full page $1860, ½ page $1010, ¼ page $695; color full page $265–825; covers 20% premium. Frequency discount. 15% agency discount. Inserts. John R. Myers, Ad. Director & Pub. Mailing lists: circulation list available for rent to any ABN advertiser using 3 or more insertions/yr, min. charge $250. (Mailing lists are not released to clients. For information contact Circulation Mgr., P.O. Box 3837, Stamford, CT 06905). Demographics: The widest read, largest audited circulation publication in the art dealer, framer and related businesses marketplace. Serves retail galleries (31%), picture framers (28%), art dealers and framers (19.5%), art supply stores, department stores, mirror shops, photo studios, suppliers/distributors, interior designers and others allied to the field. Geographical breakdown: U.S. 94.4%, 28,000; Canada 1602; New England 6%, Middle Atlantic 13.5%, So. Atlantic 16%; No. Central 19%; So. Central 13%, Mountain 7%, Pacific 19%. Circulation: 30,000+. Audience: art dealers and framers.

ART HAZARDS NEWS. 1978. 10/yr. EN. 2747

Center for Safety in the Arts, 5 Beekman St., Suite 1030, New York, NY 10038. Phone 212–227–6220. Dr. Michael McCann, Editor.

Subscription: $18.50 US, + $2 Canada and PanAm countries, elsewhere + $3. Illus. 4p.

ISSN: 0197–7903. OCLC: 4575060. LC: N1.A647. Dewey: 614.8.

News on research and education pertaining to hazards in the arts both visual and performing arts, museums and educational facilities. Covers such topics as hazards, precautions, government legislation and regulations, lawsuits, and other topics related to hazards in the arts. The Center is a national clearinghouse for research and education partially supported with public funds from the National Endowment the Arts, the New York State Council on the Arts, the New York State Dept. of Labor, and the New York City Dept. of Cultural Affairs.

Indexed: ArtArTeAb.

Circulation: 4500. Audience: teachers, educators.

ART MATERIAL TRADE NEWS: The Journal of All Art, Engineering and Drafting Supplies.

1949. m. + a. Directory. EN. 2748

Communication Channels, Inc, 6255 Barfield Rd., Atlanta, GA 30328–4369. Phone 404–256–9800, Fax 404–256–3116, Telex 4611075 COMCHANI. Tom C. Cooper, Editor.

Subscription: $38 US, $58 elsewhere, air $106 includes annual *International Art Material Directory & Buyers' Guide*. Sample free. Limited back issues $2.95. Illus. b&w, color, photos. 8 x 11, 64p., Web offset, Saddle stitch binding.

ISSN: 0004–3265. OCLC: 1514295. LC: N8530 .A67. Dewey: 707.8.

General.

The official publication of the National Art Materials Trade Association. Reports on the art supply industry. Includes news and features on store selling and management techniques, trends, personnel, new products in the fine art and commercial art area, engineering and drafting market, framing and crafts. One issue each year is a directory of art and craft materials.

The directory is compiled from questionnaires sent to each company listed. The main listing is an alphabetical list of U.S. companies with separate listings for Canada and international companies. Additional sections: products section (more than 700 product categories with a complete list of the suppliers of each product), trade names (trade or brand names of products, brief description, and manufacturer), industry organizations (organizations formed for and by industry professionals with key contacts), and a cross index of products.

Listings: international. Calendar of events. Freelance work: yes. Contact: editor.

Advertising: (rate card Aug '89): full page $2185, ½ page $1595, ¼ page $990; color + $245 standard, + $270 matched, + $640 4 color. Bleeds + 10% full page only. Special positions + 15%. Classified: $90/ 1 inch min., $80/add. inch. Frequency discount. 15% agency discount. Inserts. (390 Fifth Ave., New York, NY 10018, 212–613–9700). Demographics: Qualified recipients are art material dealers, college bookstores, department stores, hobby shops, paint & wallpaper dealers, frame shops, blueprint & silk screen supply houses, manufacturers, manufacturers' representatives, plus merchandising and sales personnel for all the above who handle products related to the industry. Audience: art retailers.

ART THERAPY. 1983. 3/yr. EN. **2749**
American Art Therapy Association, Inc, 1202 Allanson Rd., Mundelein, IL 60060–2419. Phone 312–949–6064. Gary Barlow, Editor.
Subscription: included in membership, $23 US & Canada, $30 foreign. No sample. Back issues $9 + postage. Illus. b&w, color, photos. 40p.
ISSN: 0742–1656. OCLC: 10294649.
Art Education. Art Therapy.

The purpose of the journal is to advance the understanding of how art functions in the education, enrichment, development, and treatment of people. The journal provides a scholarly forum for divergent points of view on art therapy and strives to present a broad spectrum of ideas in therapy, practice, and research. An emphasis is placed on the visual arts but articles in related disciplines that have relevance to art therapists are also published.
Reviews: book. Listings: regional–national. Opportunities: study, competitions. Indexed: ArtBibMod.
Advertising: none. Mailing lists: available. Circulation: 3000.

ART TODAY: The Magazine of New Art Forms & Design. 1986. q. EN. **2750**
Web Publication Co, Box 12830, Wichita, KS 67277. Phone 316–946–0600, fax 316–946–0675. William E. Bales, Editor & Pub.
Subscription: $24 US, + $7 US Possessions, + $10 elsewhere. 8½ x 11, 80p.
ISSN: 0885–9361. OCLC: 12792734.
Coverage of fine art and artists, with an emphasis on art–related travel. Special features of interest to collectors and others who travel and enjoy/buy art at home and abroad. Includes news of art today.
Reviews: book. Indexed: ArtBibMod. Reviewed: Katz. *Art Documentation* Fall 1987, p.138.
Advertising. Classified. Sandy Bales, Ad. Director.

ARTISTS EQUITY FUND—NEWSLETTER. 1983. q. EN. **2751**
Artists Equity Fund, Inc., Box 28068, Central Station, Washington, DC 20038. Phone 202–628–9633. James Minden, Editor.
Subscription: included in membership.
Newsletter concerned with legislative, economic and legal issues of interest to visual artists.
Freelance work: yes. Contact: editor.

THE ARTS IN PSYCHOTHERAPY. 1973. 5/yr. EN. **2752**
Pergamon Press, Inc., Maxwell House, Fairview Park, Elmsford, NY 10523. Phone 914–592–7700. David Read Johnson, Editor–in–Chief (Veterans Administration Medical Center, West Spring St., West Haven, CT 06516), editor–in–chief changes every 3 yrs.
Subscription: (1990 prices): libraries and multi–purpose institutions $130, individuals $40 (lower price to members of special societies) US; North & South America $130, $144 other countries – libraries; Japan $189 via air. Microform available from publisher, UMI. Sample free. Back issues $37/issue, $148/vol. Illus. b&w, photos. Annual index in 4th issue of year. 7½ x 10, 85–90 + ad pages.
ISSN: 0197–4556. OCLC: 6035558. LC: RC489.A7A76. Dewey: 616.89. Formerly: *Art Psychotherapy*.

An international journal for professionals in the fields of mental health and education. The journal publishes articles (including illustrations) by art, dance, music, drama and poetry psychotherapists, as well as social workers, psychologists, and psychiatrists that reflect the theory and practice of these disciplines. Reports news and comments on national and international conferences and current education information relevant to the creative arts in therapy. Invites letters to the editors and welcomes dialogue among contributors.
Reviews: book 2–3. Indexed: ArtBibMod. CloTAI. PsyAb.
Advertising: full page $360, ½ page $300, 2–color + $200, 4–color + $800. No classified. Frequency discount. Mr. A. Kranzler, Ad. Director. Demographics: national and international. Mailing lists: none. Audience: creative arts, therapists, psychologists, psychiatrists, professions in mental health and education.

BCA NEWS. 1968. bi–m. EN. **2753**
Business Committee for the Arts, Inc, 1775 Broadway, Suite 510, New York, NY 10019. Phone 212–664–0600. Joel W. Dein, Editor.
Subscription: included in membership. Illus. 10p.
ISSN: 0005–2841. OCLC: 8860628.
Newsletter featuring articles, trends, research and general information about business support to all of the arts throughout the U.S. Also includes association and affiliate news.
Advertising: none.

CARDOZO ARTS & ENTERTAINMENT LAW JOURNAL. 1982. s–a. EN. **2754**
Cardozo School of Law, Yeshiva University, 55 Fifth Ave., Room 121, New York, NY 10003. Phone 212–790–0292. Gary T. Holtzer, Editor.
Subscription: $15 US. Sample. Back issues $8/issue. No illus. Cum. index. 300–350p.
ISSN: 0736–7694. OCLC: 8791727. LC: K3.A687. Dewey: 344.73.
International Law.

Devoted to the legal issues involving arts and entertainment law and the first amendment.
Advertising: none. Circulation: 1500. Audience: arts and entertainment community.

COLOURAMA: Colour–Light–Art Research. 1970. s–a. EN. **2755**
International Association of Colour Therapists (IACT), Brook House, Avening Tetbury GL8 8NS, England. Jo Anne Haigh, Editor.
Subscription: £6, $15.
Formerly: *Colour Circle.*
Advertising.

COLUMBIA - VLA JOURNAL OF LAW & THE ARTS: Quarterly Journal of Law and the Arts, Entertainment, Communications and Intellectual Property. 1975. q. EN. **2756**
Volunteer Lawyers for the Arts, 1285 Avenue of the Americas, 3rd Fl., New York, NY 10019–6021. Phone 212–977–9270. Michael Simon, Editor.
Subscription: $35. Back issues. Index. 6 x 9, 150p.
ISSN: 0888–4226. OCLC: 13162259. LC: K1.R56. Dewey: 344. Formerly: *Art and the Law.*
A journal of arts entertainment and community published in conjunction with the Columbia University School of Law.
Reviews: book.
Advertising. Barry Slinker, Ad. Director.

CONNECTIONS MONTHLY. 1978. m. EN. **2757**
National Assembly of Local Arts Agencies, 1420 K. St., Suite 204, Washington, DC 20005. Phone 202–371–2830.
Subscription: included in membership.
Service organization seeks to enhance and strengthen the management and development of local arts agencies. Provides information on employment opportunities and new publications.
Audience: local and community art agencies, state arts association, universities.

CONNECTIONS QUARTERLY. 1981. q. EN. **2758**
National Assembly of Local Arts Agencies, 1420 K. St., N.W., Suite 204, Washington, DC 20005. Phone 202–371–2830. Barbara Schaffer Bacon, Editor.
Subscription: $20.
Articles about arts programming and activities, arts administration and trends in the field. Includes membership activities and new members listing.
Advertising: none. Audience: local and community arts agencies, state arts associations, universities.

CRITICAL INQUIRY. 1974. q. EN. **2759**
University of Chicago Press, 5720 S. Woodlawn Ave., Chicago, IL 60637. Phone 312–702–8477. W.J.T. Mitchell, Editor (University of Chicago, Wieboldt Hall 202, 1050 E. 59th St., Chicago, IL 60637).
Subscription: $29 individuals, $62 institutions, $20 students. Microform available from UMI. Sample & back issues $6.50. Illus. b&w, color, photos, cartoons. Annual index in summer issue. 9 x 12, 220p.
ISSN: 0093–1896. Dewey: 051.
General.

General publication covering the humanities with articles of interest in art. Scholarly articles covering theory in all fields, explores the principles and practices of criticism.
Freelance work: none. Indexed: ArtBibMod. CloTAI. CurCont. HumI. RILA.
Advertising: Sally Merar, Ad. Director (5720 S. Woodlawn, Chicago, IL 60637). Mailing lists: available. Circulation: 4000.
Audience: general intellectual reader.

FRAMING + ART. 1986. 10/yr (m. except Aug & Dec). EN. **2760**
Framing Publications, 11 Amershan Rd., Chesham Bois, Amersham, Buckinghamshire HP6 5PD, England. Phone 02 0494 722696, fax 0494 432411. Sammy Self, Editor (11 Field Court, Oxted, Surrey).
Subscription: all foreign £30, air £40. Sample free. Back issues £3. Illus b&w, color, photos. A4, 24p.
ISSN: 0952–3197. Formerly: *Framing, Fine Art & Wall Decor; Framing and Wall Decor.*
Picture Framing.

The United Kingdom trade magazine for picture framers and galleries.
Reviews: exhibition 1, length 2p.; book 1, equipment 1, other 2, length 1p. each. Interviews: leading trade figure, gallery owners. Listings: international. Calendar of events. Exhibition information. Freelance work: yes. Contact: editor. Opportunities: employment, study, competitions.
Advertising: (rate card 'Sept 89): b&w full page £350, ½ page £180, ¼ page £95;spot color + £100/color; full color full page £600, ½ page £320, ¼ page £200, centre spread £1200, covers £700–750. Classified (pre–paid): 20p./wd., min. £5. Frequency discount. 10% agency discount. Inserts. Circulation: 5000. Audience: picture framers, art galleries, art stores.

GRAPHISCHE KUNST: Zeitschrift fuer Graphikfreunde. 1973. s–a. GE. **2761**
Weberstrasse 36, Postfach 1636, 8940 Memmingen, W. Germany. Phone 08331–2853. Curt Visel, Editor & Pub.
Subscription: DM 50. Illus.
ISSN: 0342–3158. OCLC: 2493891. LC: NE1.G73. Dewey: 760.
The journal for friends of graphics. Covers prints and printmaking. Each number issued in four sections.
Indexed: ArtBibMod.

HUNT INSTITUTE FOR BOTANICAL DOCUMENTATION. BULLETIN. 1979. s–a. EN. **2762**
Carnegie Mellon University, Hunt Institute for Botanical Documentation, 5000 Forbes Ave., Pittsburgh, PA 15213. Phone 412–268–2434. T.D. Jacobsen, Editor.
Formerly: *Hunt Institute for Botanical Documentation. Journal.*

HUNTINGTON LIBRARY, ART GALLERY AND BOTANICAL GARDENS. COLLECTIONS.
1936. bi–m. EN. **2763**
Huntington Library, Art Gallery and Botanical Gardens, 1151 Oxford Rd., San Marino, CA 91108. Phone 818–405–2170. Catherine M. Babcock, Editor.
Illus.
Dewey: 707.4.
Devoted to botanical art and illustration.

INFORMATION MEDIA & TECHNOLOGY. 1967. q. EN. **2764**
CIMTECH, P.O. Box 109, Hatfield Polytechnic, College Lane, Hatfield, Herts. AL10 9AD, England. Phone 0707–279691, telex 262413. B.J.S. Williams, Editor.
Illus.
ISSN: 0266–6960. OCLC: 11829202. LC: Z48.N3. Dewey: 686.4. Formerly: *Reprographics Quarterly; NRCD Abstracts; NRCD Bulletin.*

INTERNATIONAL CONGRESS OF PSYCHOPATHOLOGICAL ART. PROGRAM. PRO-
GRAMME. irreg. EN, FR & GE. **2765**
International Society of Art and Psychopathology, c/o Dr. C. Wiart, Clinique de la Faculte, 100 rue de la Sante, 75014 Paris, France.
ISSN: 0534–9168.

JAPANESE BULLETIN OF ART THERAPY. 1969. a. **2766**
Societe Japonaise de Psychopathologie de l'Expression, c/o Neuropsychiatric Research Institute, 91 Bentencho, Shinjuku–ku, Tokyo 162, Japan. Dr. Yoshihito Tokuda, Editor.
Illus.
Advertising.

JAPANESE SWORD SOCIETY OF THE U.S. BULLETIN. 1959. 1–2/yr. EN. **2767**
Japanese Sword Society of the U.S., c/o Dr. T.C. Ford, Box 712, Breckenridge, TX 76024. Dr. T.C. Ford, Editor.

Subscription: included in membership together with the *Newsletter*; $25 North America; foreign $35. Illus. b&w, photos. 6 x 9, 128p.

Dewey: 650.

Swords.

Fully vetted, researched scholarly presentations of subjects pertaining to Japanese swords and all related material. The Society supports the study, preservation and history of the Samurai swords and makes available to members translations of articles originally in languages other than English.

Reviews: book. Listings: national–international. Freelance work: yes. Contact: editor.

Advertising. Circulation: 1000. Audience: members and others interested.

JAPANESE SWORD SOCIETY OF THE U.S. NEWSLETTER. 1969. bi–m. EN. 2768

Japanese Sword Society of the U.S., c/o Dr. T.C. Ford, P.O. Box 712, Breckenridge, TX 76024. Phone 314–832–3477. Dr. T.C., Editor.

Subscription: included in membership together with *Bulletin*; $25 North America, foreign $35. Some back issues. Illus. b&w. 8½ x 11, 24–28p.

Dewey: 739.7.

Swords.

Articles by members and others, and sources of information related to Japanese Samurai swords and all related items such as armor and history. .

Interviews: with recognized knowledgeable persons/experts in the field. Listings: national–international. Freelance work: yes. Contact: editor.

Advertising: write editor for rates. "Wants & Sales". Mailing lists: none. Circulation: 1000. Audience: members and others interested.

JOURNAL OF REGIONAL CRITICISM. 1979. irreg. EN. 2769

Arjuna Library Press, 1025 Garner St., Box 18, Colorado Springs, CO 80905. Phone 719–475–2787. Joseph A. Uphoff, Jr., Editor.

7 x 20, 40p., looseleaf.

Dewey: 510.

Nonlinear mathematical theories applied to the fine arts and surrealism. Covers visual arts, poetics, criticism, dramatics and martial arts.

LCA QUARTERLY. 1984. q. EN. 2770

Lawyers for the Creative Arts, 623 S. Wabash, No. 300–N, Chicago, IL 60605. Tammi Franke, Editor.

OCLC: 12060458. LC: KF4288.A15L32. Dewey: 347. Formerly: *Lawyers for the Creative Arts. Bulletin*.

Reviews: book.

LIVRUSTKAMMAREN. 1937. q. SW. EN summaries (2–3 p.). 2771

Kungliga Livrustkammaren – Royal Armoury, Kungliga Slottet, Slottsbacken 3, S–111 30 Stockholm, Sweden. Agneta Lundstroem, Editor.

Subscription: Kr 60. Illus.

ISSN: 0024–5372. OCLC: 3057568. LC: U800.A1L5. Dewey: 739.

The journal of the Royal Armoury devoted to coverage of arms and armor.

MB NEWS. 1945. m. EN. 2772

Monument Builders of North America, 1612 Central St., Evanston, IL 60201. Phone 312–869–2031. Ronnveig Ernst, Editor.

Subscription: included in membership, $20 US, $25 Canada, foreign $40. Sample $3. Back issues. Illus. b&w, color, photos, cartoons. 8½ x 11, 50–60p. Offset, Saddle–stitched.

ISSN: 0192–2491. OCLC: 3826757. Dewey: 731.76. Formerly: *Monument Builder News*.

Architecture. Historic Preservation. Monument Art.

Official journal of the Association devoted to contemporary monument and memorial art. Primarily of interest to monument builders, wholesale and retail, and their suppliers. Contains articles about sales skills, shop techniques, new design, new equipment, information about meetings and seminars and conventions, personnel promotions, profiles, safety and insurance features, legal matters, and promotes Association services.

Reviews: book 1–3, 1p. Interviews: people in the industry who are "newsworthy". Listings: international. Calendar of events. Freelance work: yes. Contact: editor. Opportunities: employment, study, competitions.

Advertising: (rate card Mar '87): full page $320, ½ page $220, ¼ page $150, spread $600, covers $325–375 (available on a 12–issue basis only); 2 color full page + $150, ½ page $75, 4 color + $425. Frequency discount. 15% agency discount. Inserts. (US: phone 1–800–1233–4472, Canada: 1–800–247–6358) Mailing lists: none. Demographics: Distribution to all members, all advertisers, major producers and suppliers of the industry, and a selected group of cemetery and related internment association. US and Canada, Great Britain, Europe, Asia, Africa, Central and South America, Australia and New Zealand. Circulation: 2250. Audience: members and associate members of MBNA and their suppliers.

MEDIA ARTS QUARTERLY. 1982. q. EN. 2773
National Alliance of Media Arts Centers, c/o Robin Reidy, 911 Contemporary Art Center, 8540 18th Ave., N.W., Seattle, WA 98117. Phone 206–789–2997. David Trend, Editor.
Subscription: included in membership.
ISSN: 0889-8928. OCLC: 14155849. Dewey: 791.
Promotes greater understanding and support for media arts. Reports on news, legislation, and policy. Issued in association with the Academy of Motion Picture Arts and Sciences and others.
Calendar of events.
Audience: media centers, museums, video artists.

NATIONAL ART MATERIALS TRADE ASSOCIATION NEWS & VIEWS. 1960. m. EN. 2774
National Art Materials Trade Association, 178 Lakeview Ave., Clifton, NJ 07011. Phone 201–546–6400. Hope Crawley, Editor.
Subscription: free, available to members only. Illus. b&w. 8½ x 11, 6p.
Dewey: 702.8. Formerly: *NAMTA News and Views*.
Newsletter of membership activities and of the art materials industry. Includes management tips and other information that "will help members run their business".
Obits.
Advertising: none. Circulation: 2000.

NATIONAL TATTOO ASSOCIATION—NEWSLETTER. 1974. bi–m. EN. 2775
National Tattoo Association, P.O. Box 2063, New Hyde Park, NY 11040. Phone 516–747–6953. Flo Makofske, Sec./Treas.
Subscription: included in membership.
Promotes tattooing as a viable contemporary art form.
Advertising: none. Audience: tattoo artists and enthusiasts.

THE NEW BOOKBINDER: Journal of Designer Bookbinders. 1981. a. EN. 2776
Carfax Publishing Co., P.O. Box 25, Abingdon, Oxfordshire OX14 3UE, England (US Dist.: Carfax Publishing Co., 85 Ash St., Hopkinton, MA 01748). Editorial Board (Designer Bookbinders, 6 Queen Square, London, WC1N 3AR).
Illus. 84p.
ISSN: 0261-5363. OCLC: 8152885. LC: Z267.N8. Dewey: 686.3. Formerly: *Designer Bookbinders Review*.
Published on behalf of Designer Bookbinders.
Reviews: book 3. Biographies: notes on contributors. Indexed: ArtArTeAb. ArtBibMod. Des&ApAI.
Advertising.

NOUVELLES DE L'ESTAMPE. 1972. bi–m. FR. 2777
Comite National de la Gravure Francaise, 58 rue de Richelieu, 75084 Paris Cedex 02, France.
Subscription: 275 F. Illus.
ISSN: 0029-4888. OCLC: 8351276. LC: NE1. Dewey: 655.
Indexed: ArtArTeAb. ArtBibCur. ArtBibMod. RILA.

THE OLD PRINT SHOP PORTFOLIO. 1941. irreg. EN. 2778
Old Print Shop, 150 Lexington Ave. at 30th St., New York, NY 10016.
Illus.
ISSN: 0891-7604. OCLC: 1586527. LC: NE1.O63. Dewey: 760.5.

LA PART DE L'OEIL. 1985. a. 2779
Presses de l'Academie Royale des Beaux–Arts de Bruxelles, Bruxelles.
Illus. b&w.
LC: N2P37. Dewey: 701.

Psychoanalytic articles dealing mainly with the role of perception in art.
Indexed: RILA. Reviewed: *Art Documentation* Sum 1986, p.64.

PRINT QUARTERLY. 1984. q. EN. 2780

Print Quarterly Ltd., 80 Carlton Hill, London NW8 0ER, England. Phone 071–625 6332. David Landau, Editor.
Subscription: (1990): $56 surface, $68 air US & Canada; foreign £32, air £50. Sample free. Back issues $20. Illus. 245 x 190 cm., 120p.
ISSN: 0265–8305. OCLC: 10635032. LC: NE1.P757. Dewey: 760.
Art History. Graphic Arts. Modern Art. Printing. Prints.

The leading scholarly publication devoted to the history of printmaking. Covers the field from the fifteenth century to the present and approaches the subject from a variety of styles. Material is in the form of main articles, shorter notices, notes, and reviews.
Reviews: book 4, exhibition. Bibliographies. Freelance work: yes. Contact: editor. Indexed: ArtArTeAb. ArtBibCur. ArtBibMod. ArtHum. Avery. CurCont. HistAb. RILA. Reviewed: Katz. *Choice* 23:8, Apr 1986, p.1187–8.
Advertising: [+ VAT] full page £360, covers £564–684; ½ page £204. Classified: (pre–paid) £45 or $75/50 wds. Frequency discount. Mailing lists: none. Demographics: 50% US, 50% Europe. Circulation: 1450. Audience: art historians, collectors.

PRINTS. 1979. bi–m. EN. 2781

Art on Paper Incorporated, Box 1468, Alton, IL 62002. Phone 618–462–1468. Gretchen E. Schmitz, Editor.
Illus.
ISSN: 0274–5097. OCLC: 5277980. LC: NE1.P768. Dewey: 760.
Reviews: book.
Advertising.

QUAERENDO. 1971. q. EN mainly, FR or GE occasionally. 2782

E.J. Brill, Postbus 9000, 2300 PA, Leiden, The Netherlands. Phone 071–312624. A.R.A. Croiset van Uchelen, Executive Editor (c/o University of Amsterdam, Singel 425, 1012 WP Amsterdam).
Few illus. b&w, photos. Index. Cum. index v.1-16, 1971-86. 6 x 9¼, 82p.
ISSN: 0014–9527. OCLC: 1643642. LC: Z161.Q156. Dewey: 090.5.
Printing. Typography. Book Illustration.

"A quarterly journal from the low countries devoted to manuscripts and printed books". Contains 2–3 scholarly articles, reviews of recent past exhibits, and news.
Reviews: book 5, length 2–3p. each; exhibition 30–40. Biographies: book collectors, artists and printers. Indexed: RILA.
Advertising.

RUBBERSTAMPMADNESS. 1981. bi–m. EN. 2783

RSM Enterprises, Inc., Box 6585, Ithaca, NY 14851. Phone 607–277–5431. Roberta Sperling, Editor.
Subscription: $18 US, $20 Canada, foreign $20, air $35 (420 South Geneva, Ithaca, NY 14850). Sample. Back issues $4.
Illus. b&w, color, photos. tabloid, 48p.
ISSN: 0746–7672. OCLC: 10259548. Dewey: 730.
Rubber Stamps.

Devoted to the artistic use of rubber stamps. Issues focus on themes, such as "stamping on fabric", "stationery stamping", "making your own stamps from erasers", "mail art", and "comic characters in rubberstampland". Feature stories on artists using stamps, on rubberstamp companies, and stamping techniques. Keeps readers informed of the latest stamp news. From 70 to 90 rubberstamp companies advertise in each issue.
Reviews: catalogs 5. Interviews: artists, company owners and stamp collectors. Listings: national–international. Exhibition information of mail art, mail art conventions. Freelance work: yes. Contact: editor.
Advertising: (rate card Jan '89): full page $465, ¼ page $285, ¼ page $175, additional color full page +$95, ½ page +$75, ¼ page +$65, full color full page $790. ½ page $490, ¼ page $340. 10% frequency discount. Mailing lists: none. Demographics: 40% of readers on West Coast. Sold at all rubber stamp conventions and at numerous newsstand outlets. Circulation: 3000–3200. Audience: collectors of rubber stamps.

SCREEN PRINTING. 1953. 13/yr. (m. with 2 issues in July). EN. 2784

Signs of the Times Publishing Co., 407 Gilbert Ave., Cincinnati, OH 45202. Phone 513–421–2050. Sue Venell, Editor.
Subscription: $27. Illus.
ISSN: 0036–9594. OCLC: 12033459. LC: TT273.S334. Dewey: 686.2. Formerly: *Screen Printing Technology and Management; Screen Printing Magazine.*

"The journal of technology and management." Some volumes have supplements.
Reviews: book. Indexed: GrArtLAb.
Advertising.

STONE IN AMERICA. 1889. m. EN. 2785
American Monument Association, 933 High St., Suite 200, Worthington, OH 43085. Phone 614–885–2713. Robert J. Moon, Editor & Pub.
Subscription: $15. Illus. 11 x 16 ¾, 64p.
ISSN: 0160–7243. OCLC: 3735817. LC: NB1.M8. Dewey: 338.4. Formerly: *Monumental News–Review*.
"Journal of the American Monument Association" a trade journal for retail monument dealers with emphasis placed on marketing and promotion of the concept of upright monuments.
Reviews: book.
Advertising: Diane McCorkle, Ad. Director. Mailing lists: available for rent. Audience: monument dealers.

THE TAMARIND PAPERS: A Journal of the Fine Print. 1974. a. (with v.11, 1988). EN. 2786
Tamarind Institute, University of New Mexico, 108 Cornell Ave. S.E., Albuquerque, NM 87106. Phone 505–277–3901. Clinton Adams, Editor.
Subscription: (2 issues) $20 US, $US20 Canada, $25 foreign. Back issues. Illus. b&w, color occasionally, photos. Cum. index v.1–10 (1987). 11 x 8½, 80–88p.
ISSN: 0276–3397. OCLC: 4546587. LC: NE2250.T35. Dewey: 763. Formerly: *Tamarind Technical Papers*.
Art History (19th & 20th century). Printmaking.
The only journal in the U.S. devoted exclusively to publication of scholarly historical, technical, and critical articles on fine print. Also reports on technical research conducted at Tamarind Institute, principally on artists' lithography.
Reviews: Book and exhibition catalogues 6, length 500–2000 wds. Interviews: with contemporary artist–printmakers. Biographies: monographic, art historical, articles on individual artist–printmakers of the 19th or 20th centuries. Freelance work: yes. Contact: editor.
Advertising: none. Audience: curators, scholars, printmakers, collectors.

TATTOO ADVOCATE. 1988. s–a. EN. 2787
Tattoo Advocacy Inc., 380 Belmont Ave., Haledon, NJ 07508. Phone 201–790–0429. Shotsie Gorman, Editor.
Subscription: $15 US, foreign $18.50 (P.O. Box 8390, Haledon, NJ 07538–0390). Sample $5. Illus. b&w, color, photos (200/issue).
ISSN: 0896–8063. OCLC: 17291265. Dewey: 391.
The "journal of international tattoo arts" covers a wide range of topics regarding tattoo art both present and historical.
Freelance work: yes (details in *PhMkt.*). Reviews: book.
Advertising. Circulation: 5,000.

TATTOO HISTORIAN. 1982. s–a. EN. 2788
Tattoo Art Museum, 30 Seventh St., San Francisco, CA 94103. Phone 415–775–4991. Judith Tuttle, Editor.
Illus. photos.
Covers the history of tattooing worldwide, focuses on tattoo artists, designs, and photos. Includes information on machines and patents.
Advertising.

TATTOO NEWS. 1971. q. EN. 2789
Newsletter Publishing Co., Box 780, Midtown Station, New York, NY 10018. Roger Kaufman, Editor.
Subscription: $10.
Dewey: 700.
Looseleaf.
Reviews: book.
Circulation: 500.

VISIBLE LANGUAGE: The Quarterly Concerned With All That Is Involved in Our Being Literate. 1967. q. EN. 2790
Rhode Island School of Design, Graphic Design Dept., 2 College St., Providence, RI 02903. Phone 401–331–3511. Sharon Poggenpohl, Editor (6 Cold Spring Lane, Media, PA 19063–4510, phone 212–565–9747).

Subscription: (all orders prepaid) $25 individual, $40 institution, outside US + $4. Microform available from UMI. Back issues, v.1–20 $5/v. individual, $6 institution; v.21– $6 individual, $7 institution. Illus. b&w. Index. 6 x 9, 136p.

ISSN: 0022–2224. OCLC: 1387812. LC: Z119.J88. Dewey: 001.5. Formerly: *Journal of Typographic Research*.

The journal for research on the visual media of language expression. Concerned with research and ideas that help us define the unique role and properties of written language. It is a basic premise of the journal that writing/reading form an autonomous system of language expression which must be defined and developed on its own terms. Maintains a policy of having no formal affiliation with any professional organization. Produced using Apple Mac computer and Pagemaker.

Indexed: ArtBibMod. ArtI. CIJE. CloTAI. CurCont. GrArtLAb. MLA.

WORD & IMAGE. 1985. q. EN.

Taylor & Francis Ltd., Rankine Rd., Basingstoke, Hampshire RG24 OPR, England (Distributor US, Canada & Mexico: Taylor & Francis, Inc., 1900 Frost Rd., Suite 101, Bristol, PA 19007). John D. Hunt (Dumbarton Oaks, 1703 32nd St., NW, Washington, DC 20007).

Subscription: (1990) £89 UK, $160 US. Illus. b&w, photos. 8½ x 11, 118p.

ISSN: 0266–6286. OCLC: 11856748. LC: NX1.W64. Dewey: 700.

"A journal of verbal/visual enquiry". Scholarly articles on all aspects of the diverse relationship between words and images, drawing upon literary criticism, art history, semiotics, linguistics, anthropology, philosophy, and socio–cultural history.

Bibliographies with articles. Indexed: ArtBibCur. ArtBibMod. ArtHum. BHA. CloTAI. CurCont. HistAb. RILA. Reviewed: Katz. *Art Documentation* Spr 1986, p.33; Sum 1986, p.64. *Choice* 23:2, Oct 1985, p.267.

Advertising, no color. Phone UK: 0256–840366 Basingstoke or US: 212–725–1999 New York. Audience: scholarly.

TITLE INDEX

- B -

- C -

- D -

- E -

- I -

- J -

- K -

- L -

- M -

- N -

- Q -

- X -

- Y -

- Z -

PUBLISHER & ORGANIZATION INDEX

- B -

Bazzano Superiore 1916
BCM Holographics 2605
Beaux–Arts et Culture 872
Beaverbrook Art Gallery 1033
Becker, Steven, Publisher 1196
Bell, Ervin J., Editor & Pub. 1
Bellerophon Publications, Inc. 1571
Benalla Art Gallery Society 1021
Benkate Publishing Co. 1706
Benn Publications Ltd. 2378 2466
Bernard Leser Publications Pty. Ltd. 2509
Bernische Kunstgesellschaft 788
Bertelsmann Fachzeitschriften GmbH 1781 2044
Besant Cultural Centre, Kalakshetra (International Arts Centre) 1763
Beth Hatefutsoth–Museum of the Jewish Diaspora 789
Biblical Archaeology Society 410
Bibliotekscentralen 1471
Bibliotheque Des Arts (Paris) 2000
Big Little Book Club of America 1684
Bijutsu Shuppan–sha 1588 1770
Bijutsu–shi Gakkai 302
Bill Communications, Inc. 2129
Billboard Publications, Inc. 119 1997 2429 2637 2657
Binders' Guild 1521
Birthstone Magazine 1878
Black Literature and Arts Congress 1879
Black Women & Photography 718
Blanden Memorial Art Museum 791
Blatent Image 2690
Blenheim Publications Ltd. 1408
Bluestone House 2453
Board of Architecture 1951
Board Report Publishing Co., Inc. 1595
Bob Chiara & Phyllis Sweed, Publishers 1565
Boca Museum 781
Bomb Shelter Propaganda 1903
Bombay Art Society 263
Bomilhold Pty. Ltd. 1120 1127
Bookplate Society 1138 1139
Boone, Inc. 1102
Bordone, Giovanna Mazzocchi, Editor & Pub. 2357
Boston Architectural Center 2208
Boston Design Center 1560
Boston University 432
Boston Visual Artists Union 1022
Botanical Gardens and Fine Arts Center at Cheekwood 265
Boulder Center for the Visual Arts 1810
Boulevard Publications 2418
Bouvier Verlag Herbert Grundmann 251
Bowdoin College, Museum of Art 790
Bowman Publishing Ltd. 2583
Box Turtle Press 1906
Boynton & Associates, Inc. 1172
Brant Publications 133 1128
Braun, Gerd 141
Britannia Art Publications Ltd. 136
British Antique Dealers' Association (BADA) 1123
British Archaeological Association 413 414
British Architectural Library 2
British Art Medal Trust 738
British Association of Friends of Museums 976
British Blind & Shutter Association 2464
British Ceramic Society 1283
British Columbia Art Teachers' Association 617
British Columbia Museums Association 992
British Institute of Architectural Technicians 1940 2239
British Institute of Professional Photography 2667
British Museum Society 785
British Printing Industries Federation 1656
British School at Athens 400
British Society of Aesthetics 159
British Surrealist Group 564
British Universities Film and Video Council 627

Bronx Museum of the Arts 793
Brookgreen Gardens 2512 2513
Brooklyn Arts and Culture Association 1018
Brooklyn Arts Council 1018
Brooklyn Museum 794
Brown University 1895
Brownstone Revival Committee 2296
Bruckmann Munich 1645
Bruckmann Verlag und Druck GmbH 305
Bruschettini Foundation for Islamic and Asian Art 667
Budapesti Muszaki Egyetem 2111
Buffalo Fine Arts Academy 750
Builders Publications of India (P) Ltd. 2049
Building (Publishers) Ltd. 2026
Bulgarska Akademiia na Naukite, Institut za Izkustvoznanie 1792
Bulletin du Centre International de Design 2401
Bund der Architekten der Deutschen Demokratischen Republik 2522
Bund Deutscher Architekten 2166
Bund Schweizer Architekten 2154
Bundesarchitektenkammer 2182
Bureau for Scientific Publications 369
Bureau of National & Foreign Information. Dept. of Public Information (Philippines) 1904
Burlington Magazine Publications Ltd. 310
Busch–Reisinger Museum 889
Bushfield House 2717
Business Committee for the Arts, Inc. 2753
Business Press International 1119
Bustanoby, Audrey, Editor & Pub. 759
Butterfield & Butterfield 42 43
Butterick Fashion Marketing Co. 1447
Butterworth Scientific Ltd. 989 2055

- C -

C. Peuser Editores 479
C.H. Beck'sche Verlagsbuchhandlung 332
C.M. Russell Museum – Trigg–Russell Foundation 807
Cahners Publishing Co., Inc. 1616 2423-25
Caithness Paperweight Collectors Society 1355 1381 1386
California Institute of the Arts 2234
California Institute of the Arts, Cal Arts Student Council 1787
California Museum of Photography 2576
Calligraphy Review, Inc. 1523
Calmut Photographic Society 2619
Calyx, Inc. 707
Camar Publications 2646
Cambridge University, Dept. of Archaeology 401
Camera Club 2568
Camera International 2570
Camerart, Inc. 2573
Camerawork 2737
Campanotto, Udine, Publisher 1752
Canada Council 1737
Canada. Dept. of Indian and Northern Affairs 695
Canadian Art Libraries 89
Canadian Artists' Representation 161
Canadian Association of Non–Profit Artist Centres 1030
Canadian Centre of Photography and Film 2543
Canadian Ceramic Society 1284
Canadian Conference of the Arts 589 1727 1738 1739
Canadian Institute of Planners 2274
Canadian Jewellers Association 1502 1505
Canadian Museums Association 983 985
Canadian Photographer 2574
Canadian Printing Industries Association 1599
Canadian Society for Education Through Art 598 609 615
Canadian Society of Creative Leathercraft 1200
Canadian Society of Painters in Watercolour 751
Canam Publications Ltd. 1495
Cardella, Joe, Editor & Pub. 1871
Cardozo School of Law 2754

Carfax Publishing Co. 611 2037 2776
Carlton Association 2259
Carnegie 810 928 1836
Carnegie Institute, Museum of Art 499
Carnegie Mellon University, Hunt Institute for Botanical Documentation 2762
Carr, Elizabeth, Editor & Pub. 68
Carribbean Cultural Center 162
Cartoon Art Museum 1686
Carucci Editore Roma 2263
Casa Editrice Edam 121
Casa Editrice Felice Le Monnier 339
Casa Editrice G. C. Sansoni Editore Nuova S.p.A. 1911
Casa Editrice Leo S. Olschki 361
Casse Nationale des Monuments Historiques et des Sites 2321
Cassell 1640
Castle Press Publications, Inc. 1155
Catalog of Landscape Records in the U.S. 2514
Catholic Fine Arts Society 634
Catholic University of America 2254
Cazana Group, Inc. 271
CBH Publishing Inc. 274
CC Publishing Ltd. 2580
Celestial Otter Press 1902
Cementone Beaver Ltd. 2157
Centaur Ltd. 64
Center for Advanced Study in the Visual Arts 34
Center for Book Arts 1522
Center for Creative Photography 2553
Center for New Art Activities 1736
Center for Photography at Woodstock 2575
Center for Safety in the Arts 2747
Center for the Fine Arts 811
Center for the Study of American Architecture, School of Architecture, University of Tex 2033
Center for Urban Well–Being 2267
Central Board of National Antiquities 639
Central Hall Artists Inc. 264
Centre de Creation Industrielle 2177
Centre de Documentario d'Art Actual 540
Centre de Documentation du Departement de Design 2135
Centre Georges Pompidou 498
Centre International d'Etude des Textiles Anciens 1455
Centro Camuno di Studi Preistorici 411
Centro de Arte y Comunicacion, Escuela de Altos Estudios 223
Centro Di della Edifimi s.r.l. 355
Centro Internazionale di Documentazione e Informazione sull'Arte Contemporanea 470
Centro Italiano Smalti Porcellanati 1311
Centro Studi Antoniani 649
Century Communications, Inc. 1217
Ceramic Society of Japan 1304 1315
Ceramic Study Group 1287
Ceramics International Association 1322
Ceskoslovenskej Armady 35 2124
CFE Publishing Ltd. 2146
Charles H. MacNider Museum 812
Charles Rennie Mackintosh Society 2297
CHArt 1670
Chicago Architectural Club 2179
Chicago Architecture Foundation 2034
Chicago Artists' Coalition 266
Chicago Calligraphy Collective 1524
Chicago New Art Association 542
Chicago Renaissance Workshop 1880
Chilton Co. 1499 2383
China Books & Periodicals, Inc. 2739
China Economic News Service 2456
China Institute in America, Inc. 663
Chitra Publications 1439
Chr. Belser Verlag 787 1020
Christelijk Vlaams Kunstenaarsverbond 1806
Christie's 41 45 46 47

Church Monuments Society 647 732
Church of Architecture 2180
Cimal, Avda 1741
CIMTECH 2764
Cincinnati Art Museum 813
Cincinnati Museum Association 813
Cinema Theatre Association 2112
CIPIA 2127
CIRCA Publications Ltd. 164
Civic Trust 2035
Clapper Publishing Co., Inc. 1220 1228 1264
Clark, Willard, Publisher 2637
Clavis Press Ltd. 2085
Clemson University, College of Architecture 2212
Cleveland Institute of Art Magazine 854
Cleveland Museum of Art 802
Clio Press Ltd. 5 6 30
Clubhouse Publishing, Inc. 1851
CO.P.IN.A 2363
Coalition of Women's Art Organizations 709
Coast Publishing, Inc. 1661
Colegio Nacional de Arquitectos de Cuba 2175
Colegio Oficial de Arquitectos de Cataluna y Baleares 2193
Colegio Oficial de Arquitectos de Madrid 2174
Colgate University, Picker Art Gallery 1031
Colimpex Africa (Pty) Ltd. 2036
Collectif d'Histoire de l'Art de l'Universite de Paris I 315
Collective Black Arts, Inc. 1886
Collector Communications Corp. 1145 1158 1170 1184 1232
Collectors News, Inc. 1147
Collectors' Marketplace 1148
Collectrix 1149
College Art Association of America 293 585 597
Colonial Williamsburg Foundation 2298
Colorado Calligraphers' Guide 1525
Colorado Springs Fine Arts Center 1017
Colour Printed Pottery Collectors Association 1333
Columbia College Chicago 2631
Columbia Communications 2478
Columbia Museum of Art 814
Columbia Museum of Art and Science 815 929
Columbia University, Avery Architectural and Fine Arts Library 8
Columbia University, Graduate School of Architecture and Planning 2241
Columbia University. Graduate School of Architecture and Planning and Preservation 2241
Columbia University. School of Law. 2756
Combined Arts 1204 1211
Comite Francais d'Histoire de l'Art 359
Comite National de la Gravure Francaise 2777
Comme des Garcons Co. Ltd. 2716
Commemorative Collectors Society 1150 1151
Commission on the Arts 1815
Commission Royale des Monuments et des Sites 2029
Committee for Historical Monuments of the Federation of Hungarian Architects 2103
Commonwealth Association of Museums 977
Commonwealth Communications Services 1269
Communication Channels, Inc. 2748
Communications Ltd. 1366
Communications Today Publishing Ltd. 2398
Community Planning Association, Saskatchewan Division 2280
Comprint Ltd. 2480
Computer Arts Society 1676
Concordia University 333
Concrete Publishing Co. Pty. Ltd. 2039
Conde Nast Publications Ltd. 2461 2498
Confederation Centre Art Gallery and Museum 1829
Consejo Superior de Investigaciones Cientificas 290
Conservation Council of Ontario 1057
Construction History Society 2037
Consumer Communications Ltd. 758
Contemporanea, Ltd. 501
Contemporary Art Centre of South Australia 496 503

Michigan Council for the Arts 1845 1860
Michigan Guild of Artists and Artisans 1249
Michigan Society of Architects 1952 1960
Michigan State University Libraries, Special Collections Division 1688
Micromedia Affiliates, Business Journal of New Jersey, Inc. 2497
Mid–Am Antique Appraisers Association 73
Mid–Atlantic Association of Museums 981
Mid–Atlantic Association of Museums of the American Association of Museums 981
Middlebury College 1023
Middlesex Polytechnic, Related Studies Office 158
Midmarch Associates 725
Midwest Museum of American Art 862
Miller, Drew Allen, Editor & Pub. 1595
Miller Magazines, Inc. 1515
Millicent Rogers Museum 702
Milwaukee Art Museum 944
Minetto, Renato, Editor & Pub. 2345
Miniature Figure Collectors of America 1169
Ministerie van W V C 2635
Ministero per i Beni Culturali e Ambientali, Ufficio Centrale per i Beni Ambientali, Arc 304
Ministerstvo Skolstvi Ceske Socialisticke Republiky 602
Ministerstvo Kul'tury 522
Ministerstwo Kultury i Sztuki, Generalny Konserwator Zabytkow, Osrodek Dokumentacji Zabytkow 1056
Ministerul Industrializarii Lemnului si Materialelor de Constructii 2443
Ministry for Foreign Affairs, Cultural and Scientific Relations Division 1869
Ministry of Culture, Archaeological Receipts Fund (TAP Service) 408
Ministry of Welfare, Health, and Cultural Affairs 170
Minneapolis Institute of Arts. Report 945
Minneapolis Institute of Fine Arts 261 863 945
Minneapolis School of Art. Report 945
Minneapolis Society of Fine Arts. Report of the Annual Meeting of the Governing Members 945
Minnesota Crafts Council 1210
Minnesota Society, American Institute of Architects 2163
Mint Museum of Art 864
Mission Media 632
Mississippi Museum of Art 865
Mississippi State University 2246
MIT Press 1551 1554 1782 2017 2101
MKS Publications, Inc. 1197
Models & Photographers of America 2661
Modern Handcraft, Inc. 1451
Montage Publishing, Inc. 1669
Montana State University 2227
Montclair Art Museum 867
Monterey Peninsula Museum of Art Association 868
Montgomery Museum of Arts 946
Montreal Museum of Fine Arts 947
Monument Builders of North America 2772
Monumental Brass Society 740
Moon, Robert J., Editor & Pub. 2785
Moore College of Art & Design 717 729
Morgan–Grampian (Construction Press) Ltd. 2028
Moser und Colby GmbH 2712
Mother of Ashes Press 1651
Motion Picture and Center for New Art Activities 1736
Mount Eagle Publications 831 1029
Mount Holyoke College Art Museum 870
Movipress, S.A. 166
MSP Publications, Inc. 261
Mueller–Pohle, Andreas, Publisher 2586
Muir Publishing Co. Ltd. 2095
Multigrafica Editrice 2140
Munson–Williams–Proctor Institute 798
Munson–Williams–Proctor Institute. Community Arts Program 798
Musee d'Art et d'Histoire, Geneva 832
Musee Historique Lorrain 447
Musees Royaux des Beaux–Arts de Belgique – Koninklijke Musea voor Schone Kunsten van Belgie 799

Museo Internazionale delle Ceramiche 1297
Museum & Arts Washington, Inc. 874
Museum of African American Art (Santa Monica, Calif.) 185
Museum of American Folk Art 165
Museum of Art and Archaeology 871
Museum of Early Southern Decorative Arts 1086 1088
Museum of Far Eastern Antiquities 661
Museum of Fine Arts, Boston 849 951
Museum of Fine Arts, Houston 877 949
Museum of Fine Arts, St. Petersburg 869 892
Museum of Modern Art 866 878 919
Museum of New Mexico 1342
Museum of New Mexico Foundation 891
Museum of the City of New York 879 950
Museum Shuppan 873
Museum Society (San Francisco) 909
Museum voor Fotografie 17
Museums Association (London) 994 997-98
Museums Association of Australia 984 995 996
Museums Association of Pakistan 881
Music of the Spheres Publishing 1772
Museum Document Association 982
Myers Publishing 2746

- N -

Nadel, Carol, Editor & Pub. 75
Nakladelstvi Technicke Literatury 2402
Naracoorte Herald 2607
Nathan Abonnements 2584
National Academy of Art – Lalit Kala Akademi 530 674
National Academy of Design 1573
National Alliance of Media Arts Centers 2773
National Architectural Accrediting Board 2197
National Art Collections Fund 952
National Art Education Association 584 614 622
National Art Materials Trade Association 2774
National Art Museum of Sport 203
National Art–Collections Fund 138
National Assembly of Local Arts Agencies 2757 2758
National Assembly of State Arts Agencies 202
National Association for Photographic Art 2567 2592
National Association of Artists Organizations 200
National Association of Dealers in Antiques 1131
National Association of Flower Arrangement Societies of Great Britain 1239
National Association of Professional Engravers 1655
National Association of Watch and Clock Collectors, Inc. 1507 1511
National Association of Women Artists 714 715
National Building Museum 2025
National Button Society 1174
National Capital Development Commission 2270
National Carousel Association 1130
National Carvers Museum Foundation 1250
National Centre for the Performing Arts 196
National Council of Architectural Registration Boards 2222
National Council on Education for the Ceramic Arts 1309 1310
National Depression Glass Association, Inc. 1384
National Early American Glass Club 1367 1373
National Endowment for the Arts 102 106 110-11 1773
National Federation of Painting & Decorating Contractors 2451
National Foundation for Advancement in the Arts 1774 1779
National Free Lance Photographers Association 2599
National Galleries of Scotland 882 922
National Gallery of Art 599 953
National Gallery of Scotland 922
National Gallery of Victoria 777
National Gallery of Zimbabwe 273 281
National Gallery Publications (London) 954 1054
National Gallery Society of Victoria 831
National Glass Association 1370
National Greentown Glass Association 1378

- O -

School of Landscape Architecture, Gloucestershire College of Arts and Technology 2533
Schoolhouse Press 1450
Schur, Susan, Editor & Pub. 1066
Schweizerischer Kunstverein 852
Schweizerisches Landesmuseum 386 1338
Score Publications 1919
Scott, Diane, Editor & Pub. 1957
Scott Advertising & Publishing Co. 1285 1292
Scott Publications 1230
Scottish Development Agency 1223
Scottish Museum Council 906 987
Scottish National Gallery of Modern Art. 922
Scottish National Portrait Gallery 922
Scottish Pottery Society 1345 1346
Scottish Rite Masonic Museum and Library, Inc. 965
Scottish Society for the History of Photography 2711
Screen Printing Association International 1665
Sculptors Guild 743
Scuola Beato Angelico 631 633
Search Pub. Inc. 20
Seattle Arts Commission 1852
Second City Communications 2128
SEDO SA 549
Seibundo Shinkosha Publishing Co., Ltd. 1634
Septima 1303
Serbin Communications, Inc. 2668
SFBD 1079
Shaw Associates 2603
Sheanin, Steve, Publisher 2706
Sheffield City Press 619
Sherman, Deborah, Editor & Pub. 1394
Shinkenchiku–Sha Co., Ltd. 2187
Ships in Bottles Association of America 1141
Shokokusha Publishing Co., Ltd. 2059 2089
Shots 2713
SHZ–Forster Fachverlag AG 2007
Sibyl–Child Press, Inc. 719
Sidney University Arts Association 592
Sierra Printing 2052
SIGGRAPH 1679
Signcraft Publishing Co., Inc. 1659
Signs of the Times Publishing Co. 1583 2784
Sill, Stanley, Owner 2726
Silver Eye 2690
Silver Magazine Inc. 1132
Simon van der Foundation 2338
Sinar Bron, Inc. 2710
Sindicato dos Arquitetos No Estado do Rio Grande do Sul 2016
Singapore Institute of Architects 1966
Sino International Trade Promotion Co. 1202
Small Computers in the Arts Network 1677 1679
Small Homes Council 2292 2300
Smith, Anne, Editor & Pub. 1420
Smithsonian Institution 289 683
Smithsonian Institution Traveling Exhibition Service 232
Smocking Arts Guild of America 1441 1442
Society of Photographers and Artist Representatives 2718
Societ'a Editrice Umberto Allemandi & C. srl 176
Societa di Cultura per Il Friuli Occidentale 1848
Societa l'Arte Tipografica 272
Societa' di Storia della Miniatura 1535
Societe d'Archeologie Lorraine 447
Societe d'Encouragement aux Metiers d'Art 1089
Societe des Amis du Musee National de Ceramique 1331
Societe des Architectes Diplomes par le Gouvernement 1978
Societe des Editions Regirex–France 2142
Societe Francaise d'Archeologie 306 418
Societe Francaise de Promotion Artistique 1071
Societe Japonaise de Psychopathologie de l'Expression 2766
Societe pou la Diffusion des Recherches et des Etudes sur Apollinaire et son temps 557
Society for Calligraphy and Handwriting 1537

Society for Historical Archaeology 426
Society for Italic Handwriting 1534 1538
Society for Landscape Studies 2531
Society for Medieval Archaeology 440
Society for Photographic Education 2588 2721
Society for Post–Medieval Archaeology 452 458
Society for Preservation of Japanese Art Swords 686
Society for Renaissance Studies 309 357 367
Society for the Advancement of Regionalism in the Arts 1854
Society for the Preservation of Long Island Antiquities 2325 2335
Society for the Preservation of New England Antiquities (SPNEA) 2314
Society for the Preservation of New England Antiquities 2341
Society for the Preservation of Old Mills 2327
Society for the Promotion of Art History Publications in Canada 356
Society for the Promotion of Hellenic Studies 400 433
Society for the Promotion of Roman Studies 435
Society for the Protection of Ancient Buildings 2339
Society of America Archivists, Museum Archives Roundtable 988
Society of American Registered Architects 2119
Society of Animal Artists 233
Society of Antiquaries of London 394
Society of Antiquaries of Scotland 453
Society of Architectural Administrators 1967 1968
Society of Architectural Historians 1074 2088 2107 2340
Society of Architectural Historians of Great Britain 1989 2139
Society of Architectural Historians, Southern California Chapter 2190
Society of Architectural Historians, Texas Chapter 2191
Society of Bead Researchers 175 1070
Society of Designers in Ireland 1575
Society of Environmental Graphics Designers 1570
Society of Glass and Ceramic Decorators 1316 1317 1318
Society of Graphic Artists 1660
Society of Graphic Designers of Canada 1643
Society of Illustrators 1589 1637
Society of Inkwell Collectors 1182
Society of Jewellery Historians 1501
Society of North American Goldsmiths 1253
Society of Ornamental Turners 1273
Society of Portrait Sculptors 746
Society of Publication Designers 1631 1657
Society of Scribes 1540
Society of Scribes and Illuminators 1539
Society of Swiss Art History 376
Society of Wildlife Artists 234
Society of Women Artists 720
Solomon R. Guggenheim Museum 966
Sooriya Publishing House 2550
Sotheby's 55 56 57 58 59
Soukup, Krauss Verlag GmbH 579
South African Association of Art Historians. 369
South African Institute of Building 2122
South Carolina Arts Commission 1818
South Carolina Arts Commission Touring Programs 1817
South Florida Home & Garden 2496
Southam Business Information and Communications Group 2158 2178
Southam Communications Ltd. 2373
Southeastern Center for Contemporary Arts 495
Southeastern College Art Conference (SECAC) 621
Southeastern Professional Photographers Association, Inc. 2719
Southern Accents, Inc. 2507
Southern African Museums Association 907 1000
Southern African Rock Art Research Association (SARARA) 449
Southern Arts Association 1856
Southern California Institute of Architecture 2234
Southern Highland Handicraft Guild 1242
Southwest Museum 696
Soyuz Arkitektorov S.S.S.R. 2172
Soyuz Khudozhnikov S.S.S.R. 243 522
Soyuz Zhurnalistov S.S.S.R. 2720
Space Group of Korea 2091
Spaulding, Kitty, Publisher 262
Spectator Publications, Inc. 1798 1955
Spencer Museum of Art 902

- T -

- U -

ISSN	No.	ISSN	No.	ISSN	No.	ISSN	No.
0018–2419	2313	0025–5025	761	0032–0714	2278	0042–0816	2287
0018–6392	2362	0025–6633	1168	0032–2970	354	0042–238X	78
0018–6406	2498	0026–1521	861	0032–3721	215	0042–5435	1804
0018–6422	2499	0026–7104	2443	0032–4477	1312	0042–6237	2153
0018–6589	2264	0026–8607	2102	0032–4582	2697	0042–6768	1970
0018–8999	979	0027–0059	867	0032–4914	2118	0042–692X	628
0019–1027	1892	0027–299X	646	0032–5678	1344	0042–7519	1324
0019–1299	1634	0027–3627	798	0032–6445	2698	0042–7683	1806
0019–1361	2417	0027–3821	872	0032–7697	1091	0042–8035	2509
0019–2457	1636	0027–3856	799	0032–7735	2334	0043–0609	1807
0019–2465	182	0027–3996	986	0032–843X	899	0043–261X	1135
0019–4409	2184	0027–4003	873	0032–8510	1649	0043–3357	280
0019–4913	1946	0027–4089	990	0032–8537	1181	0043–5759	2498
0019–784X	2700	0027–4097	948	0032–9150	2192	0043–8243	464
0019–8595	2613	0027–416X	997	0032–9371	1792	0043–9363	35
0019–9044	1303	0027–4178	999	0033–0167	2701	0044–0582	1972
0020–1472	2185	0027–5247	347	0033–0752	2123	0044–2135	250
0020–2908	2530	0027–7835	272	0033–0957	556	0044–2186	251
0020–367X	1759	0027–8688	1511	0033–3921	1268	0044–2992	385
0020–5494	2422	0027–884X	1174	0033–9202	2706	0044–3476	386
0020–5508	2423	0027–9544	1509	0034–4338	1793	0044–8621	1932
0020–5508	2425	0027–9846	676	0034–6063	1514	0044–863X	1984
0020–7853	2475	0028–6575	1907	0034–754X	1918	0044–8680	2257
0020–9538	2434	0028–9256	888	0035–077X	358	0044–9008	291
0020–9872	695	0029–1080	1848	0035–1326	359	0044–9466	2292
0021–0439	2186	0029–2427	1955	0035–2608	903	0045–2521	1140
0021–1206	308	0029–2567	801	0035–3388	2475	0045–3005	992
0021–177X	522	0029–3490	1512	0035–6212	1795	0045–3242	1018
0021–1826	643	0029–4322	208	0035–659X	225	0045–5121	1200
0021–1834	669	0029–4888	2777	0035–6603	2132	0045–5369	615
0021–2059	429	0029–4926	1644	0035–7154	896	0045–5695	1143
0021–4302	2187	0029–8247	1056	0035–8215	226	0045–8856	2494
0021–4345	2617	0029–862X	549	0035–8495	904	0046–1865	103
0021–8510	610	0029–9626	2326	0036–5947	1314	0046–421X	1239
0021–8529	186	0030–5278	681	0036–6463	618	0046–9076	693
0022–1244	1504	0030–5324	682	0036–7370	1623	0047–1569	425
0022–2224	2790	0030–5332	1477	0036–9594	2784	0047–312X	850
0022–331X	670	0030–5448	684	0037–5314	231	0047–6196	2625
0023–0553	1338	0030–5529	209	0037–5411	365	0047–925X	1425
0023–0561	1307	0030–672X	352	0037–7260	2482	0048–2056	1784
0023–3609	337	0030–9362	1676	0037–9743	1534	0048–3850	2272
0023–5415	673	0031–0158	891	0037–9808	2088	0048–4954	1341
0023–5431	645	0031–0352	213	0038–190X	2455	0048–8453	1515
0023–544X	1898	0031–1650	1911	0038–4070	2719	0049–0423	1479
0023–561X	529	0031–1731	2271	0038–5190	2720	0049–0520	1966
0023–5865	2092	0031–3394	447	0038–7134	370	0049–0601	2136
0023–7396	530	0031–6644	1142	0038–9161	1387	0049–1195	2107
0023–754X	2528	0031–7160	892	0039–3541	622	0049–5123	1801
0023–8023	2524	0031–7314	804	0039–3630	1065	0055–9669	2111
0023–8031	2527	0031–7314	893	0039–3983	235	0065–6410	117
0023–8058	2538	0031–7969	1178	0039–4122	2725	0065–6801	344
0023–8066	2539	0031–8329	448	0039–6168	564	0065–9991	436
0023–8422	193	0031–8523	2642	0039–7520	1516	0066–1333	287
0023–8457	1506	0031–8531	2648	0039–7946	461	0066–1694	917
0024–0257	1028	0031–854X	2649	0039–8977	238	0066–2119	1740
0024–094X	1765	0031–868X	2663	0040–4179	2194	0066–3263	36
0024–4775	1766	0031–8698	2667	0040–4969	1485	0066–5738	1046
0024–5372	2771	0031–8736	2672	0040–5477	1580	0066–5983	397
0024–6891	535	0031–8744	2673	0041–0020	2284	0066–622X	1989
0024–8363	1952	0031–8779	2675	0041–2953	462	0066–6262	2167
0024–8924	1424	0031–8809	2679	0041–4549	2148	0066–6637	652
0025–0082	2098	0032–0447	450	0041–4565	243	0066–7927	255
0025–0953	2440	0032–0544	2274	0041–5979	687	0066–7935	777
0025–2913	196	0032–0560	2273	0041–6320	244	0066–8095	588
0025–3928	2320	0032–0595	1647	0041–9400	90	0066–8095	592

ISSN	No.	ISSN	No.	ISSN	No.	ISSN	No.
0066–8133	1729	0083–7407	1487	0142–0798	1466	0161–0546	98
0067–1517	2270	0083–9981	245	0142–5471	1566	0161–1003	837
0067–284X	845	0084–0416	383	0142–6397	2535	0161–1232	66
0067–6004	828	0084–1498	79	0142–6540	211	0161–1895	2416
0067–7698	300	0084–2982	248	0142–6702	136	0161–4223	2623
0068–1288	413	0084–3539	1040	0142–694X	2055	0161–4231	2441
0068–2217	2561	0084–4276	465	0142–8853	1620	0161–715X	719
0069–3235	880	0084–6783	55	0142–887X	973	0161–8342	1109
0069–4061	813	0084–9537	507	0142–9663	2728	0161–9284	1128
0069–8881	418	0085–3208	859	0143–036X	2627	0162–1033	1147
0070–024X	419	0085–4174	680	0143–0688	38	0162–2870	1782
0070–3028	932	0085–5278	900	0143–3245	158	0162–6469	396
0070–7546	313	0090–6255	959	0143–3768	2531	0162–8445	7
0070–8992	2150	0090–6433	2377	0143–4519	591	0162–8879	1250
0071–0547	1296	0090–8207	1615	0143–537X	491	0162–9123	1451
0071–9943	1698	0090–9114	285	0143–7755	1321	0163–1306	2405
0072–0585	832	0091–2948	1901	0143–8883	1961	0163–1861	1166
0072–9094	1528	0091–6641	1348	0143–9065	954	0163–2299	1908
0073–3571	2082	0091–7222	953	0144–1302	1345	0163–7460	2745
0073–5477.	1637	0092–5039	1161	0144–1825	1332	0163–7916	2729
0074–1191	1581	0092–7961	2469	0144–2937	1266	0163–903X	1923
0074–1922	49	0093–0938	2022	0144–5170	2521	0163–9706	578
0075–2207	843	0093–1896	2759	0144–8277	59	0164–1298	484
0075–4234	431	0093–4690	432	0144–8412	1726	0164–324X	1464
0075–4250	1376	0094–0178	2108	0145–7241	67	0164–3290	1260
0075–4269	433	0097–6075	1602	0145–8116	185	0164–4769	2644
0075–4358	435	0098–7387	1815	0145–8213	1272	0164–7962	1400
0075–4390	334	0098–8863	2588	0145–899X	2578	0164–8740	2429
0076–2725	341	0098–9266	1086	0146–0153	2689	0165–9510	806
0076–2792	439	0098–9444	410	0146–1214	1066	0165–9863	2475
0076–6097	440	0102–6550	146	0146–3411	712	0166–4492	237
0076–6127	343	0102–8979	2176	0146–5783	741	0167–7608	2475
0076–8391	800	0105–2624	548	0146–6607	1220	0167–9104	2635
0076–9096	945	0106–1348	639	0147–0639	1129	0168–2601	2110
0076–910X	863	0107–9611	1240	0147–0868	1926	0168–9193	523
0077–1899	346	0108–0695	1550	0147–1147	2217	0169–1198	326
0077–2194	871	0108–4135	2094	0147–1627	707	0169–4855	340
0077–2348	881	0108–707X	1134	0147–1902	797	0169–5606	651
0077–8583	805	0109–7687	163	0147–247X	2668A	0169–6726	348
0077–8958	860	0110–098X	2106	0147–4685	1163	0170–9267	2019
0078–0537	350	0110–1102	137	0147–4693	1706	0171–6042	2438
0078–1444	2248	0111–5774	616	0148–1029	373	0172–2867	2356
0078–6551	683	0113–4566	2164	0148–3897	1513	0172–3456	275
0079–0958	2237	0113–583X	1339	0148–9127	1219	0172–7028	2586
0079–3264	1313	0115–205X	1904	0149–2446	2229	0173–2781	125
0079–4236	452	0120–713X	480	0149–516X	2507	0173–8046	2346
0080–2530	454	0129–5829	2003	0149–7081	725	0173–9913	1294
0080–262X	360	0129–8372	2101	0149–8045	1435	0176–2834	579
0080–3472	362	0133–1531	292	0149–9106	2163	0177–3674	528
0081–1564	453	0133–6193	671	0152–2418	1089	0177–9878	332
0081–2684	1855	0133–6673	1068	0153–3673	2321	0178–2789	1681
0081–5691	661	0137–1371	2116	0157–4043	80	0179–647X	1492
0081–6566	2141	0140–0096	1049	0157–9169	1788	0181–1525	498
0081–7104	372	0140–1033	1058	0158–2658	2555	0181–687X	1713
0082–1675	920	0140–5039	2218	0158–7048	1215	0184–7724	1079
0082–5018	1005	0140–7430	1054	0159–5962	2641	0185–4569	197
0082–5115	962	0140–7597	1894	0159–8880	2703	0189–1162	1954
0083–2103	1773	0140–7880	404	0160–0699	573	0190–1400	2685
0083–4130	626	0140–9220	389	0160–1857	532	0190–9835	1924
0083–4270	325	0141–0016	380	0160–208X	644	0191–4022	2226
0083–5161	1037	0141–2191	1991	0160–6298	48	0191–4030	2723
0083–6079	379	0141–4135	770	0160–6395	614	0191–6963	752
0083–6737	438	0141–559X	2297	0160–7243	2785	0192–1487	1558
0083–7148	630	0141–6790	294	0160–7650	1224	0192–2491	2772
0083–7156	1027	0141–8971	399	0160–9769	515	0192–2912	1048

ISSN	No.	ISSN	No.	ISSN	No.	ISSN	No.
0310–687X	1962	0369–9560	2665	0563–9239	398	0731–5600	2436
0310–9011	2529	0370–8314	1000	0566–263X	376	0731–8014	1374
0311–0095	154	0370–8314	907	0569–9665	884	0731–8545	2179
0313–4393	2612	0373–0719	2142	0570–6084	400	0731–9916	1419
0314–6464	595	0376–9569	270	0570–6483	1	0732–0973	601
0315–3694	1893	0377–2780	2115	0571–1371	653	0732–1619	299
0315–4297	333	0379–8585	1998	0574–0126	1745	0732–1708	2301
0315–940X	335	0381–7369	1394	0576–4300	1737	0732–2569	2392
0315–9906	356	0381–9515	1833	0577–2168	411	0732–6890	1489
0316–1544	596	0383–6479	1057	0577–9294	1203	0733–2130	1145
0316–4055	1783	0386–037X	2121	0581–4766	964	0733–2238	1158
0316–9200	1958	0389–0066	2072	0583–9181	2325	0733–463X	31
0318–7020	551	0390–0355	570	0587–3452	2256	0733–4923	2516
0318–7500	2592	0390–4555	242	0590–8876	1457	0733–8503	854
0319–3438	2158	0391–7487	2363	0700–3021	2646	0733–866X	902
0319–4558	2293	0391–7819	649	0701–0281	808	0734–0222	1775
0319–7832	1216	0391–9064	297	0702–7249	89	0734–4481	2331
0323–3413	2006	0391–9854	304	0703–6507	819	0734–5453	2491
0323–4088	822	0392–0895	455	0703–8712	1030	0734–5534	1144
0324–8232	565	0392–2715	2371	0704–0024	2670	0734–6018	1794
0325–4615	2365	0392–4513	371	0704–7916	1829	0734–6980	1606
0330–001X	1264	0392–5730	2367	0704–9056	916	0735–2026	1592
0333–7499	840	0392–6648	1311	0704–9153	2632	0735–5572	2553
0334–1798	839	0393–4330	2740	0705–1913	2542	0735–5645	776
0334–4975	1915	0393–439X	144	0705–2650	161	0735–6560	1031
0334–9810	198	0393–5132	2368	0706–0955	1909	0735–7885	713
0336–1675	1978	0393–5140	2381	0706–8107	598	0736–0770	629
0337–1603	1730	0393–5183	2263	0707–5006	2095	0736–1149	2250
0340–6660	2597	0393–5949	374	0707–9532	1727	0736–4733	708
0340–7403	189	0393–8190	1768	0708–5354	583	0736–5322	1585
0341–0676	1319	0394–0543	176	0708–5435	2638	0736–7694	2754
0341–1230	1875	0394–0802	355	0708–6458	2096	0736–9212	1928
0341–2784	2005	0394–1043	2067	0709–6046	589	0737–0407	124
0341–4159	1126	0394–1493	513	0709–8413	1025	0737–3295	2619
0341–9150	2294	0394–4298	278	0711–1312	586	0737–3740	2493
0342–1201	345	0394–8072	470	0711–7646	1917	0737–4003	18
0342–3158	2761	0394–8501	283	0713–6315	1105	0737–4453	368
0343–0642	2442	0394–9249	2159	0713–8076	2506	0737–5344	2050
0345–3979	2471	0400–5000	1474	0714–0339	1884	0737–5387	1777
0347–4240	469	0405–6590	1198	0715–5689	2384	0737–7010	599
0347–7835	883	0427–0576	2591	0715–6626	1663	0738–0895	2086
0350–3666	2171	0429–1050	2360	0720–0056	305	0738–1131	1937
0355–1822	460	0430–3091	826	0721–1902	2046	0738–114X	2277
0356–8075	2676	0440–9213	426	0721–4235	2044	0738–3290	1352
0358–3511	2104	0452–2591	2620	0723–2454	1379	0738–5625	1758
0358–8904	1564	0454–3114	2091	0724–133X	836	0738–7105	1760
0359–2464	1614	0458–6506	674	0724–2689	508	0738–8020	1342
0360–2699	26	0495–0887	568	0724–343X	1764	0738–8063	463
0360–6325	2479	0495–3460	624	0725–0568	1518	0738–8357	173
0360–8727	224	0495–9728	2283	0725–6639	569	0738–8365	75
0361–1140	1658	0509–9773	2080	0726–3589	1601	0738–9299	1888
0361–2112	1463	0511–8824	926	0726–6715	2078	0738–9507	1680
0361–2147	1103	0512–1175	1925	0727–1239	483	0738–9787	1822
0361–3453	1081	0519–9135	607	0727–3959	2694	0738–9981	1149
0361–3801	1527	0522–7496	2029	0728–0858	1343	0739–1544	1309
0361–6029	407	0525–5260	785	0728–5701	2607	0739–1552	1310
0361–638X	2485	0533–6627	605	0729–8714	1936	0739–196X	221
0361–946X	342	0534–9168	2765	0730–2266	823	0739–3946	2051
0362–1979	842	0534–9710	2431	0730–5036	323	0739–456X	612
0362–6245	1667	0536–5465	2609	0730–6466	15	0739–6546	1329
0363–3519	913	0540–4568	675	0730–7187	84	0739–7895	1522
0363–4574	1746	0541–2439	2103	0730–9023	101	0739–9448	2244
0363–6488	2652	0548–1643	1588	0731–0455	2113	0740–0403	951
0363–7972	1155	0552–7511	1646	0731–2164	2390	0740–283X	2579
0366–6913	1289	0556–5367	1108	0731–2989	1192	0740–4093	1434

ISSN	No.	ISSN	No.	ISSN	No.	ISSN	No.
0740–4921	509	0752–5222	315	0838–1658	711	0887–9222	940
0740–5723	140	0755–964X	721	0838–2239	329	0887–9818	1208
0740–6746	1412	0757–2271	156	0838–603X	1755	0888–014X	1977
0740–9214	783	0758–413X	1543	0840–433X	858	0888–076X	1228
0740–9311	1881	0761–4241	560	0840–9218	2328	0888–0972	1903
0741–1774	2242	0762–3291	1714	0841–8012	1034	0888–1308	1678
0741–2940	517	0765–121X	546	0841–8039	1353	0888–4226	2756
0741–3351	151	0765–9849	2570	0843–2260	1821	0888–4722	1160
0741–6091	1125	0766–6756	2177	0843–5499	1070	0888–5451	1117
0741–6849	2227	0767–8150	490	0843–8838	1854	0888–5680	2657
0741–9163	648	0769–3397	2093	0845–5341	2453	0888–7802	2235
0741–9597	349	0771–761X	481	0845–8081	1033	0888–9627	818
0742–0242	34	0774–2513	1508	0847–9119	2285	0888–9643	921
0742–0420	1107	0790–8342	2085	0870–3841	1744	0889–003X	107
0742–0552	2025	0791–038X	179	0882–6781	2450	0889–177x	1191
0742–1125	668	0795–8560	192	0882–6897	1108	0889–1931	2047
0742–1656	2749	0810–6029	1556	0882–7370	1446	0889–2393	2660
0742–4434	1707	0813–0426	457	0882–9187	1172	0889–3012	2017
0743–040x	82	0813–6734	1207	0883–4660	2457	0889–3160	519
0743–2461	2021	0814–5288	1233	0883–5683	1669	0889–6585	943
0743–3204	1736	0814–6586	1209	0883–6973	1639	0889–6607	32
0743–5517	123	0814–7833	831	0883–7155	2432	0889–728X	744
0743–8044	2733	0816–1909	2651	0883–7279	2240	0889–8928	2773
0744–0901	1156	0816–6706	1500	0883–833X	1104	0890–0558	2252
0744–1649	1443	0816–6919	1754	0884–1918	874	0890–2992	1753
0744–1738	1243	0817–4628	1809	0884–2213	1868	0890–4162	1184
0744–415X	2508	0817–6264	1832	0884–4011	1074	0890–4464	660
0744–5784	2554	0817–8445	1029	0884–6294	1113	0890–4634	2575
0744–5989	1122	0818–1233	1963	0884–8769	472	0890–4901	366
0744–9879	1146	0818–6308	1484	0884–8815	2512	0890–5908	266
0745–0575	1449	0819–2936	1271	0884–9897	2071	0890–6033	2305
0745–4295	1583	0819–5838	477	0884–9986	2183	0890–7714	773
0745–4929	2129	0819–677X	503	0885–1808	1385	0890–8753	2637
0745–5720	1011	0820–0165	983	0885–2707	1232	0890–9237	1447
0745–6506	1682	0822–4331	2543	0885–4262	2688	0890–9717	2070
0745–7189	1183	0823–1346	1502	0885–4270	2658	0891–0553	665
0745–9246	815	0824–5991	279	0885–6370	1657	0891–0588	1225
0746–0554	1997	0825–3854	160	0885–6702	1716	0891–1827	716
0746–0996	2726	0825–8708	1761	0885–7326	2335	0891–4109	1743
0746–3677	2220	0825–9267	1826	0885–9361	2750	0891–4990	1593
0746–7672	2783	0826–2098	1327	0885–968X	318	0891–5237	1431
0746–9438	1704	0826–7642	2465	0885–9949	1476	0891–5326	2707
0746–9642	1230	0827–9306	2734	0886–0483	1633	0891–7604	2778
0747–3168	1584	0828–7023	1038	0886–1056	2393	0891–8821	2267
0747–4482	1132	0829–0784	259	0886–2427	87	0891–8872	1705
0747–4768	1226	0829–4437	1002	0886–3407	747	0892–1202	1194
0747–5284	745	0829–8017	1159	0886–5949	2068	0892–2721	1772
0747–5373	1176	0829–9153	2268	0886–6600	2651	0892–2896	894
0747–5705	76	0829–9242	1590	0886–7208	1114	0892–3582	112
0747–6388	172	0831–2559	1835	0886–7267	1709	0892–4201	286
0747–6566	50	0831–2885	701	0886–7682	1662	0892–5836	1780
0747–8615	1186	0831–2974	1284	0886–7771	1850	0892–7162	1099
0747–9026	1414	0831–6708	694	0886–8115	542	0892–743X	2478
0747–9360	1551	0833–0891	69	0886–8131	1364	0892–9807	1712
0747–9409	2137	0833–9406	2388	0886–845X	2585	0893–0120	14
0748–2043	1677	0833–9414	617	0886–9669	2484	0893–0139	16
0748–304X	1288	0834–2520	1459	0887–0411	2290	0893–1097	1073
0748–4917	2253	0835–2526	2401	0887–1418	1529	0893–1925	2610
0748–6413	2721	0835–4936	2135	0887–2937	10	0893–2697	2504
0748–6723	1803	0835–7641	512	0887–302X	1456	0893–360X	1576
0748–8378	1064	0835–863X	2134	0887–5855	2630	0893–3901	95
0748–8742	1897	0836–1517	1942	0887–6665	696	0893–5610	2684
0748–9579	276	0836–3803	2426	0887–8781	2241	0893–8490	2099
0749–5242	2341	0836–5873	1162	0887–8897	703	0893–8660	1368
0749–8659	1201	0838–0392	497	0887–8978	1045	0893–8857	74

ISSN	Ref	ISSN	Ref	ISSN	Ref	ISSN	Ref
0893–9403	2329	0921–2515	1877	1032–1942	594	1048–6798	1670
0894–0436	1990	0923–6511	2558	1033–3975	1857	1048–793X	2713
0894–0479	1532	0924–526x	526	1035–0500	1559	1049–8974	2691
0894–0924	1241	0933–4017	1061	1040–0893	2495	1050–2092	2145
0894–234X	658	0934–1692	1764	1040–211x	218	1050–2548	86
0894–3133	83	0934–1706	1764	1040–4457	1439	1050–4796	1231
0894–4776	1560	0934–5191	288	1040–446X	2206	1050–9518	1429
0894–9832	1756	0935–2341	545	1040–4724	1920	1051–0869	63
0895–2493	2042	0943–612x	581	1040–5518	1428	1051–3337	1390
0895–321X	2714	0950–0197	2374	1040–6336	1229	1051–4082	1461
0895–3961	1357	0950–1657	2519	1040–6883	1093	1051–4090	1482
0895–559X	1813	0950–2181	2146	1040–8509	1586	1051–9505	1235
0895–5719	1570	0951–0230	726	1040–8576	537	1051–9513	1236
0895–6030	2598	0951–0265	753	1041–0759	1401	1052–0805	1154
0895–6529	1664	0951–1997	1828	1041–1305	1292	1052–4959	717
0895–6790	1671	0951–3914	2605	1041–1607	2062	1053–7643	1953
0895–6928	1603	0951–5704	1672	1041–2433	849	1053–9409	1600
0895–7002	1388	0951–8088	1940	1042–0711	2544	1053–9980	1072
0895–7606	699	0951–8789	1279	1042–1467	972	1054–3430	1405
0895–7819	1523	0952–3197	2760	1042–2994	1679	1056–8484	2565
0895–8076	2288	0952–4444	627	1042–6477	77	1101–5462	536
0895–8351	561	0952–4649	1568	1042–7104	1735	1120–2343	2481
0895–9870	2211	0952–8822	571	1042–7643	1490	1120–236X	2410
0896–2022	704	0953–024X	882	1042–9034	794	1120–2394	1306
0896–2898	1910	0953–0681	11	1042–9808	194	1180–0933	1975
0896–4971	1810	0953–220X	2087	1043–0946	20	1316–1612	740
0896–6281	2515	0953–6698	762	1043–2701	1270	1727–1182	467
0896–7288	1173	0953–6973	1947	1043–3317	1330	1727–6758	1222
0896–7962	2472	0953–7694	1204	1043–3600	1409	1731–2377	2576
0896–8063	2787	0953–931X	1211	1044–0372	2397	6308–3039	1416
0896–8179	2307	0954–0423	991	1044–0909	2391	7112–0737	877
0896–8772	1578	0954–1438	2433	1044–3576	2497	8750–8877	1399
0896–9043	2577	0954–1608	506	1044–4807	1478	8750–9024	62
0897–0521	1762	0954–6650	1165	1044–8683	1039	8750–9318	1067
0897–1420	2224	0954–7843	2303	1044–9108	2603	8750–9504	2435
0897–2168	516	0954–8815	574	1044–9140	187	8755–0415	2181
0897–2400	524	0955–1182	558	1045–3717	1562	8755–1128	2238
0897–3458	1197	0955–8942	957	1045–4373	1269	8755–1411	958
0897–621X	2081	0956–1455	2682	1045–5914	2383	8755–2019	2033
0897–6236	2060	0956–148x	2736	1045–5965	1433	8755–2035	1032
0897–6775	2309	0956–2745	2650	1045–8158	2639	8755–2582	1153
0897–814X	1133	0956–9758	2156	1045–8816	1460	8755–3856	2291
0897–8271	501	0958–0433	1796	1045–8913	257	8755–3902	2674
0898–0896	931	0970–1001	1870	1046–2252	814	8755–4305	71
0898–1191	2502	0970–1761	2420	1046–2627	2514	8755–500X	1718
0898–4808	1051	0970–7727	1497	1046–350X	889	8756–0895	1871
0898–7572	2671	0981–6445	2151	1046–3658	1640	8756–0925	202
0898–8854	2236	0983–8430	2708	1046–4883	2223	8756–5285	759
0898–9494	2496	0989–6023	534	1046–8020	94	8756–5633	1929
0899–1782	277	0995–2071	1769	1046–8471	475	8756–7172	70
0899–2118	919	0995–6824	230	1046–8986	2548	8756–7652	1177
0899–806X	1280	1010–3821	2175	1046–980X	1553	8756–7709	1866
0899–9724	1213	1011–0119	1493	1047–5362	2399	8756–775X	68
0900–0518	2138	1011–0127	1493	1047–577X	2510	8756–8349	27
0900–3347	1582	1011–0143	1493	1047–8353	2083	8756–890X	1771
0900–3517	1547	1011–0151	1493	1047–9325	1616	8756–9213	1334
0900–8799	1413	1011–9078	677	1048–0129	2147		
0901–4233	1471	1011–9086	678	1048–0293	1609		
0911–4041	686	1011–9094	679	1048–3659	1432		

COUNTRY OF PUBLICATION INDEX

SUBJECT INDEX

Subject headings were assigned using the *Art & Architecture Thesaurus* as the primary source and the *Library of Congress Subject Headings* as a secondary source.

- A -

ABINGDON POTTERY 1328
ADVERTISING 1268 1583 1584 1588 1595 1604 2579 2606
ADVERTISING ART 1565 1592 1594 1602 1617 1634
ADVERTISING PHOTOGRAPHY 1601 2587 2593 2602 2693 2700-1
AERIAL PHOTOGRAPHY 389
AESTHETICS 124 159 171 186 189 222-3 225 251 557 610 1752 1795
AFRICAN AMERICAN ART 185 1776
AFRICAN AMERICAN ARTISTS 185
AFRICAN AMERICAN ARTS 1735
AFRICAN AMERICAN WOMEN—PHOTOGRAPHY 718
AFRICAN ART 114 162 192 1717
AFRICAN ARTS 1717 1730
AIRBRUSHING 1586
AKRON ART MUSEUM 915
ALBERTA ART FOUNDATION 916
ALLEGORY 373
ALLEN MEMORIAL ART MUSEUM 795
AMERICAN ACADEMY IN ROME 1864
AMERICAN ART 118-9 257 289 366 484 714 723 725 776 795 910 926 1118 1129 1908
AMERICAN ARTISTS 117 266
AMERICAN ARTS 1775 1777 1803 1816 1868 1901
AMERICAN COLONIAL ARCHITECTURE 2385
AMERICAN COLONIAL ART 1086 1088
AMERICAN LITERATURE 537 707 1873 1882 1888 1897 1908 1929
AMERICAN PAINTERS 750
AMERICAN PAINTING 750
AMERICAN POTTERY 1281 1329
AMERICAN SWEDISH HISTORICAL MUSEUM 775
AMON CARTER MUSEUM 776
ANATOLIAN ART 287
ANCIENT ART 393 459
ANDREW W. MELLON FOUNDATION 917
ANIMATION 1605 1698
ANNUAL REPORTS 379 384 823 871 915-7 919-21 923-6 928-33 935-42 944-54 957-60 962-70 1005 1023-24

1037 1356 1728-9 1737 1773-4 1815 1849 1855 1951 1988 2270
ANTIQUE DEALERS 1094 1109 1123
ANTIQUES 39 63 66 69 72-74 123 1095 1098-1122 1125-9 1131 1133 1136 1143 1147 1162 2368 2507
ANTIQUES—BIBLIOGRAPHIES 1149
ANTIQUES—PRICES 56-7 72 74
APOLLINAIRE, GUILLAUME, 1880-1918 557
APPRAISING 61 63 68 71 73 77-78
ARCHAEOLOGICAL SPECIMENS 406 425-6 445 450 891 1097
ARCHAEOLOGY 3 201 276 358 388-9 391-2 394-407 409 411-14 416-7 419-24 426 430 432 437-8 441-2 445-6 448 451-2 454-5 457-64 696 2263
ARCHAEOLOGY—AMERICA 406 696 891
ARCHAEOLOGY—GERMANY 439
ARCHAEOLOGY—ITALY 344 435
ARCHAEOMETRY 405
ARCHITECT-DESIGNED HOUSES 2042 2056
ARCHITECTS 1931 1933-5 1942-3 1948-50 1954 1957 1959 1964-5 1987 1970 1991 2119 2166 2222
ARCHITECTURAL CRITICISM 1999 2017 2206
ARCHITECTURAL DECORATION 2002
ARCHITECTURAL DESIGN 1551 1570 2012 2050 2052 2054-5 2113 2135 2217
ARCHITECTURAL DRAWINGS 2123
ARCHITECTURAL FIRMS 2076 2119
ARCHITECTURAL HERITAGE SOCIETY OF SCOTLAND 1988
ARCHITECTURAL LIBRARIES 2105
ARCHITECTURAL LIGHTING 1569 1990 2452
ARCHITECTURAL PERSONNEL 1967-8 2239
ARCHITECTURAL THEORY 2017 2087 2244
ARCHITECTURE See Architecture sections 166 190 196 340 376 414 471 500 536 1069 1554 1572 1580 2336 2344-8 2351-3 2356 2360 2362-5 2491 2500 2504 2510 2542
ARCHITECTURE AND ENERGY CONSERVATION 2056
ARCHITECTURE AND ENVIRONMENT 1998 2035 2113 2147
ARCHITECTURE AND HISTORY 2033
ARCHITECTURE—ARGENTINA 2365
ARCHITECTURE—AUSTRALIA 2064 2162 2352
ARCHITECTURE AWARDS 2005 2035
ARCHITECTURE—BELGIUM 2029
ARCHITECTURE—BIBLIOGRAPHIES 21-22 26
ARCHITECTURE—BOOK REVIEWS 2050

- D -

- E -

EAST ASIA 437 661 684
EASTERN ORTHODOX CHURCH AND ART 648
EASTERN WASHINGTON STATE HISTORICAL SOCIETY
 875
EDUCATION 590 591 593 602 605 608 1557
EGYPT 431 436 444
EISNER, WILL 1709
EL PASO MUSEUM OF ART 780
ELECTRIC LIGHTING 2475 2479
ELVEHJEM MUSEUM OF ART 934
EMBLEMS 286 318 578
EMBROIDERY 1403-6 1410 1417 1425 1441-2 1445
 1452
EMBROIDERY INDUSTRY 1407
EMPLOYMENT 101 103 1935
ENAMELING 1311 1371
ENGINEERING 1944 1976 1994 2105
ENGINEERING DESIGNS 1553
ENGLISH FURNITURE 1082 1083
ENGRAVERS 1655
EPITAPHS 737
ERETZ ISRAEL MUSEUM 839
EROTICA 1910 1928
ESKIMO ARTS 695
ETHNOLOGY 222 424
EUROPE 445
EUROPEAN ART 326 481 545 579
EVERHART MUSEUM 824
EVERSON MUSEUM OF ART 825
EXCAVATIONS 398 409 415 425
EXHIBITIONS 232 512 2660
EXPERTIZING 1066

- F -

FANDOM 27
FANS 1080
FANTASTIC ART 1762
FANZINES 27 1682
FEDERAL AID 1773
FEMINISM 712
FEMINISM AND THE ARTS 711 712
FENTON ART GLASS 1354
FENWAY COURT 826
FIBERWORK 1445 1446 1464-5 1483
FIGURED GLASS 1358 1375 1384-5
FINE ARTS MUSEUMS OF SAN FRANCISCO 827 909
FISHER, HARRISON, 1875-1934 1632
FLEXOGRAPHY 1606-7
FLINT INSTITUTE OF ARTS 935
FLOORING 2358
FLOORS 2358 2471
FLOWER ARRANGEMENT 1085 1238-9
FLOWER GARDENS 1238
FOLK ART 165 173-4 210 215 558 1064 1190
FOLKLORE 242 1233
FORT WAYNE MUSEUM OF ART 829
FOSTORIA GLASS 1358
FRANCE 306 418 447 1714
FREELANCE 104-5 1593
FREELANCE PHOTOGRAPHY 2599
FREEMASONS 965
FRENCH ART 546

FRENCH LITERATURE 554
FRENCH PRINTS 2777
FURNITURE 1082 2345-6 2349 2378 2413 2422 2425
 2438 2444 2446 2456
FURNITURE DESIGN 2134
FURNITURE INDUSTRY 2398 2406-7
FURNITURE MAKING 1067 1081
FURNITURE—COLLECTING 1100 1128
FUTURE CITIES 1979

- G -

GARDENING 2366 2487-8 2492 2503 2505 2515 2519
GARDENS 265 2496 2502 2507 2512-2517 2519
GARDENS—DESIGN 2516
GARDENS—HISTORY 2517 2521
GEISHA GIRL PORCELAIN 1334
GEMS 1491 1494 1497 1518
GEODESIC DOMES 2062
GEORGIA MUSEUM OF ART 833
GEORGIAN ARCHITECTURE 308 2318
GERMAN ART 125 250
GERMANY 288 1764
GEST ORIENTAL LIBRARY AND EAST ASIAN COLLEC-
 TIONS 665
GIFTWARES 1091 1565
GLASS 1300 1317 1319 1355-6 1359 1363-4 1366-70
 1373 1375-6 1378 1381-2 1386-7
GLASS ART 1316 1318 1365
GLASS CONTAINERS 1141
GLASS INDUSTRY 1361-2
GLASS MANUFACTURE 1372
GLASSBLOWING 1360
GLASSMAKERS 1383
GLASS SCULPTURE 1379
GLASSWARE 1321 1372 1379 1380
GLASSWARE—COLLECTING 1352 1354 1357-8 1374
 1377 1384
GOLD 1493
GOLDWORK 1493
GOVERNMENT POLICY 140 200 202 253 1817 2773
GRAND RAPIDS ART MUSEUM CALENDAR 834
GRANTS 100
GRAPHIC ARTS TECHNICAL FOUNDATION 1608-9
GRAPHIC DESIGN 1562 1570 1595
GRAPHIC DESIGNERS 1612 1631 1643
GREAT BRITAIN 389 394-5 397 422 440
GREECE 400 408 433
GREENTOWN GLASS 1378
GREETING CARDS 1630
GROTESQUES 570
GROUNDS MAINTENANCE 2541
GUILD OF NATURAL SCIENCE ILLUSTRATORS 177

- H -

HAND SPINNING 1473 1479-80
HAND TOOLS 1275
HAND WEAVING 1467 1473 1475 1479 1490
Handicraft See CRAFTS
HANDMADE PAPER 1529 1530-1
HANDWRITING 1537
HARDWARE 2109
HARVARD UNIVERSITY ART MUSEUMS 889

ORNAMENT 1513 1548 1556
ORNAMENTAL TURNING 1273

- P -

PAINT INDUSTRY—UNITED STATES 2383
PAINTERS 240 246 748 750-1 760 762 766 770-3
PAINTING 482 685 687 750 756 762 764 767 768
 806 1061
PAINTING—CONSERVATION 1044 1054
PAINTING—EXPERTIZING 1054
PAINTINGS—PRICES 79
PALESTINE 415 429
EL PALACIO 891
PAPER PRESERVATION 1041 1053 1058 1059
PAPER 1529-30
PAPERMAKING 1519 1529 1530 1531 1537
PARAPSYCHOLOGY 2765
PASTELS 765
PEAKE, MERVYN LAURENCE, 1911-1968 1905
PERFORMING ARTS 101 1716 1819 2623 2754
PERIODICAL ILLUSTRATIONS 1657
PETER WHYTE GALLERY 808
PETROGLYPHS 443 449 456
PEWTER 1142
PHILADELPHIA MUSEUM OF ART 804 893
PHILOSOPHY 130 249
PHOENIX ART MUSEUM 959
PHONOGRAPH COLLECTING 1103
PHOTOGRAMMETRY 2642 2663
PHOTOGRAPHERS 2548 2549 2678 2726
PHOTOGRAPHIC EQUIPMENT 2565 2569 2590 2620
 2637 2644 2648 2675 2693 2694 2699 2714 2736
PHOTOGRAPHIC INDUSTRY 2614 2617 2637 2693
PHOTOGRAPHIC PROCESSES 2565 2581 2660 2673
PHOTOGRAPHS 94 2611 2664 2669
PHOTOGRAPHS—PRICES 2669
PHOTOGRAPHY See Photography Section 105 166 1787
 1880
PHOTOGRAPHY—BIBLIOGRAPHY 22
PHOTOGRAPHY—CANADA 2567 2638 2670
PHOTOGRAPHY—EDUCATION 2601 2630 2640
PHOTOGRAPHY—HISTORY 2553 2576 2604 2609 2618
 2624 2670 2677 2682-3 2692 2708-9 2711 2729
PHOTOGRAPHY—INDEXES 17 2681
PHOTOGRAPHY—TEACHING 2588 2659
PHOTOGRAPHY—UNITED STATES 2548 2674 2733
PHOTOGRAVURES 2570
PHOTOJOURNALISM 2628 2684 2728
PHOTOMECHANICAL PROCESSES 1664
PICKER GALLERY 1031
PICTOGRAPHS 443 456
PICTURE FRAMING 2746 2760
PLANNING 2086 2117 2155 2224 2259 2266 2274
 2280 2282-4 2291
PLANS 1995
PLASTIC 730
POETRY 1863 1865 1871-2 1874 1878 1881 1899-900
 1903 1906 1916 1919 1924 1926-7
POLAND—ART 248 354 1056
POLISH ARTS 1790
POLISH PHILOLOGY 354
POLITICAL CARTOONS 116 1706 1711
POP ART 492
POPULAR CULTURE 467

PORCELAIN 76 1280-81 1295 1334 1335 1336 1337
PORCELAIN DOLLS 1229
PORCELAIN ENAMEL 1324
PORTRAIT PAINTERS 769
PORTRAIT SCULPTORS 746
POSTERS 1624 1640
POTTERS 1339 1348
POTTERY 76 1280-2 1296-7 1300 1310 1321 1325
 1328-33 1338-41 1343-51
POTTERY CRAFT 1284 1292
POTTERY—TEACHING 1310
POTTERY—UNITED STATES 1309 1342
PRECIOUS STONES 1498 1515
PRESERVATION 2146 2298 2301 2305 2332-3 2336
PRIMITIVE ART 222 616 779
PRIMITIVE ART—INDEXES 14
PRINCETON UNIVERSITY ART MUSEUM 830 899
PRINTERS 1600
PRINTING 1519 1522 1527-8 1537 1616 1625 1628
 1639 1644 1650-1 1654 1664 1667 2782 2790
PRINTING—ABSTRACTS 1615
PRINTING—HISTORY 1519 1528 1652-3
PRINTMAKING 1648 2629 2761 2780
PRINTS 48 330 666 680 1137 1181 2629 2761 2778
 2780-1 2786
PRINTS—PRICES 48
PSYCHOANALYSIS AND ART 2779
PSYCHOTHERAPY 2743
PUBLIC ART 217-8 484
PURCHASING 1565

- Q -

QUEEN VICTORIA MUSEUM 900
QUEEN VICTORIA MUSEUM AND ART GALLERY 960
QUILTING 1392 1394 1430 1431 1433 1435-40 1443-44
 1439
QUILTING—MACHINE 1433
QUILTING—PATTERNS 1423
QUILTMAKERS 1392 1431 1488
QUILTS 1419 1434 1488

- R -

RADIO STATIONS 1748
RAWLS MUSEUM ARTS 897
REDDING MUSEUM 901
REGIONAL PLANNING 2261-2 2266 2268-69 2276-8
 2285-6 2524
REGIONAL PLANNING—TEACHING 612
RELIGION 334 651
RELIGION AND ARCHITECTURE 640
RELIGION AND ART 636 638 640 641 642 649-51
RELIGIOUS PUBLICATIONS 632
RELIGIOUS SYMBOLISM 633 637 639 646 732
REMODELING 2260 2412 2486
REMOTE-SENSING 2642
RENAISSANCE 309 343 367 374 382
RENAISSANCE ART 357 1793
RENAISSANCE SCULPTURE 733
RENAISSANCE—BOOK REVIEWS 309
RENOVATION 2106 2108 2330
RESTAURANTS—UNITED STATES 2129
RESTORATION 1049 2108 2305 2315 2317

- S -

- T -

- U -